Caribbean
Popular Culture

CARIBBEAN POPULAR CULTURE
POWER, POLITICS AND PERFORMANCE

Edited by
Yanique Hume and Aaron Kamugisha

IAN RANDLE PUBLISHERS
Kingston • Miami

First published in Jamaica, 2016 by
Ian Randle Publishers
16 Herb McKenley Drive
Box 686
Kingston 6
www.ianrandlepublishers.com

Introduction and Editorial material
© 2016 Yanique Hume and Aaron Kamugisha

National Library of Jamaica Cataloguing-In-Publication Data

Caribbean popular culture : power, politics and performance / Yanique
Hume and Aaron Kamugisha.

pages : illustrations ; cm.
ISBN 978-976-637-621-5 (pbk)

1. Popular culture – Caribbean Area 2. Caribbean Area – Social life and customs
I. Hume, Yanique II. Kamugisha, Aaron
306 dc 23

Cover Artwork: 'Leibi' by Marcel Pinas
Cover and book design by Ian Randle Publishers

Printed and bound in the United States of America

To the artists of our region and the many voices that give expression to our existence

Table of Contents

Acknowledgements

The creative process of writing, compiling and editing is seldom a singular exercise. We owe many of our perspectives to the legacies of the scholars who have inspired us and enriched our own thinking during the course of our academic training. We are also indebted to the scholars whose essays we have reproduced here, for their work has broadened our knowledge and enhanced our understanding of the Caribbean and its rich intellectual tradition and expressive terrain. Our editor, Christine Randle at Ian Randle Publications, immediate enthusiasm about the project has been a great inspiration. We like to thank her for her commitment and guidance over the last year. We are also indebted to a wonderful artist, Marcel Pinas, who provided the image for the cover of this volume.

At the University of the West Indies, we extend our gratitude to the Vice Chancellor, Professor Sir Hilary Beckles and the Pro-Vice Chancellor for Graduate Studies and Research, Professor Dale Webber, for their enthusiastic support for this project. The Arts and Sports Promotion Fund of the Government of Barbados made a grant available to us without which the completion of this project would have been unlikely. We would like to express our appreciation to our team of research assistants, Lesvie Archer, Margaret Harris and Tricia Herman for their diligent work on this project and Code Mantra, for rendering it ready for submission. We would also like to thank Samuel Furé Davis for his translation work and advice on the collection, and Stefan Walcott for reproducing the musical chords in certain articles. We have also benefitted tremendously from the support and assistance of colleagues and friends who have provided their advice and comments on the selection of the articles presented in this volume. For this, we want to take this opportunity to thank Michael Bucknor and Therese Hadchity for their suggestions and gracious input along the way.

Yanique would like to especially acknowledge the many artists and producers of culture she has had the privilege to work with over the years. Heartfelt gratitude are extended to Baba Richard Gonzalez, Mona Estime Amira and Pat Hall, who were among the first teachers to introduce her to the rich tapestry of Caribbean sacred and popular dances. A special thanks goes out to artistic director and choreographer L'Antoinette 'Osun Ide" Stines who has been a great inspiration and champion of creating embodied nation languages through the dance. Yanique further honors the memory of Cuban dance pioneer and pan-Caribbean visionary, Eduardo Rivera Walker. Special thanks go to my co-editor and co-author, Aaron Kamugisha, for his valued friendship, intellectual companionship, his unique critical insights and humor, all of which were invaluable to the process of publishing this anthology.

Aaron would like to thank Percy Hintzen, Patrick Taylor and Sylvia Wynter, for their scholarship, mentorship and counsel; and so many others from his journeys in Toronto, Chicago and Berkeley, particularly Alissa Trotz, Peter Hudson and Paget Henry. Special thanks to my co-

editor, co-author and friend Yanique Hume, who made the long process of creating this volume intellectually exciting, and despite the inevitable tedium, fun.

Finally, we are grateful to our families who have nurtured our intellectual development and continue to provide us with a space for further growth and development. Yanique would like to thank her mother Yvonne, siblings Rae, Howard, Greg, Patsy, and Steve (who is among the ancestors), her in-laws, Fern and Andrew Lewis and brother-in-law Sean, partner Peter Lewis and daughters Naia and Thaïs: words cannot fully capture the gratitude and love I have for all of you. Yanique further extends her love and deep affection to her *familia santoral*...ache madrina Aceitu Ochun, padrino Omi Ero Eyerke. and Omi Curo. *Modupue Egun Modupue Ocha*! Many thanks, Much Love and *Muito Axé*! Aaron would like to express his love and appreciation to his mother and grandmother (both now among the ancestors), sister and aunt, respectively Stephanie, Dorin, Kemi and Arlette: my love always!

Publishers' Acknowledgements

The editors and publisher would like to thank the following for permission to reproduce the material in this volume:

Sylvia Wynter:
Sylvia Wynter, 'Rethinking "Aesthetics": Notes Towards a Deciphering Practice,' in *Ex-Iles: Essays on Caribbean Cinema*, ed. Mbye B. Cham, 237–39 (Trenton, NJ: Africa World Press, 1992).

Stuart Hall:
Stuart Hall, 'Notes on Deconstructing the "Popular,"' in *People's History and Socialist Theory*, ed. Raphael Samuel, 227–40 (London: Routledge, 1981).

Michael Dash:
Michael Dash, 'The Indigenous Movement,' in *Literature and Ideology in Haiti, 1915–1961* (London and Basingstoke: Macmillan, 1981), 65–97.

Rogelio Martínez Furé:
Rogelio Martínez Furé, 'Imaginary Dialogues on Folklore,' in *Díalogos Imaginarios*, trans. Samuel Fure Davis (Havana: Editorial Arte y Literatura, 1979), 257–79.

Hilary Beckles:
Hilary Beckles, 'Popular Art and Cultural Freedom,' in *The Development of West Indies Cricket Volume 1: The Age of Nationalism* (Mona, Jamaica: University of the West Indies Press, 1998), 101–116.

Carolyn Cooper:
Carolyn Cooper, 'Erotic Marronage: Embodying Emancipation in Jamaican Dancehall Culture,' Paper Presented at the Ninth Annual Gilder Lehrman Center International Conference at Yale University: The Legacies of Slavery and Emancipation: Jamaica in the Atlantic World, November 1–3, 2007. Reprinted with permission of Carolyn Cooper.

Gordon Rohlehr:
Gordon Rohlehr, 'The Calypsonian as Artist: Freedom and Responsibility,' *Small Axe* 9 (March 2001): 1–26.

Aimé Césaire:
Aimé Césaire, 'Poetry and Knowledge,' in *Aimé Césaire, Lyric and Dramatic Poetry 1946–1982*, trans. Clayton Eshleman and Annette Smith (Virginia: University of Virginia Press, 1990), xlii–lvi.

Kamau Brathwaite:
Kamau Brathwaite, *History of the Voice: The Development of Nation Language in Anglophone Caribbean Poetry* (excerpt) (London: New Beacon Books, 1984), 5–17.

Édouard Glissant:
Édouard Glissant, 'Natural Poetics, Forced Poetics,' in *Caribbean Discourse: Selected Essays*, trans. Michael Dash (Virginia: University of Virginia Press, 1989), 120–34.

Roger Abrahams:
Roger Abrahams, 'Joking: The Training of the Man-of-Words in Talking Broad,' in *The Man-of-words in the West Indies: Performance and the Emergence of Creole Culture* (Baltimore: John Hopkins University Press, 1983), 55–76.

Velma Pollard:
Velma Pollard, 'Globalization and the Language of Rastafari,' in *Exploring the Boundaries of Caribbean Creole Languages*, ed. Hazel Simmons-McDonald and Ian Robertson, 230–41 (Kingston: University of the West Indies Press, 2006).

Marlene Nourbese Philip:
Marlene Nourbese Philip, 'Discourse on the Logic of Language,' in *She Tries Her Tongue, Her Silence Softly Breaks* (Charlottetown, Prince Edward Island: Ragweed Press, 1989), 30–33.

Michael Smith:
Michael Smith, 'Me Cyaan Believe It,' in *Voiceprint: An Anthology of Oral and Related Poetry from the Caribbean*, ed. Stewart Brown, Mervyn Morris and Gordon Rohlehr, 143–45 (San Juan, Trinidad: Longman Caribbean, 1989).

David H. Brown:
David H. Brown, 'Thrones of the Orichas: Afro-Cuban Altars in New Jersey, New York, and Havana', *African Arts* 26:4 (October, 1993), pp. 44–59. © 1993 by Regents of the University of California.

Kate Ramsey:
Kate Ramsey, 'Without One Ritual Note: Folklore Performance and the Haitian State, 1935–1946,' *Radical History Review* 84 (Fall 2002): 7–42.

Katherine Smith:
Katherine Smith, 'Atis Rezistans: Gede and the Art of Vagabondaj,' in *Obeah and Other Powers: The Politics of Caribbean Religion and Healing* (Durham and London: Duke University Press, 2012), 121–48.

Donna Hope:
Donna Hope, 'From the Stage to the Grave: Exploring Celebrity Funerals in Dancehall Culture,' *International Journal of Cultural Studies* 13, no. 3 (May 2010): 254–70.

Carrie Viarnés:
Carrie Viarnés, '*Muñecas* and Memoryscapes: Negotiating Identity and Understanding History in Cuban Espiritismo,' in *Activating the Past: History and Memory in the Black Atlantic World*, ed. Andrew Apter and Lauren Derby, 319–69 (Newcastle Upon Tyne: Cambridge Scholars Publishing, 2010). Published with the permission of Cambridge Scholars Publishing.

Yanique Hume:
Yanique Hume, 'From Bush to Stage: The Shifting Performing Geography of Haitian Rara and Cuban Gagá,' *E-misférica: Journal of the Hemispheric Institute for Performance and Politics, Caribbean Rasanblaj* 12, issue 1 (2015), ed. Gina Athena Ulysse.

Krista Thompson:
Krista Thompson, 'The Evidence of Things Not Photographed: Slavery and Historical Memory in the British West Indies,' *Representations* 113 (Winter 2011): 39–71. Published with the permission of University of California Press Journals.

Claire Tancons:
Claire Tancons, 'Curating Carnival? Performance in Contemporary Caribbean Art,' in *Curating in the Caribbean*, ed. David A. Bailey, Alissandra Cummins, Axel Lapp and Allison Thompson, 37–62 (Berlin: The Green Box, 2012).

Ama:
Ama, 'From Mythologies to Realities: The Iconography of Ras Daniel Heartman,' *Small Axe* 23 (2007): 66–87. The images of Ras Heartman's work are reproduced with the permission of his son, Ato Roberts.

Veerle Poupeye:
Veerle Poupeye, 'Intuitive Art as a Canon,' *Small Axe* 11, no. 3 (2007): 73–82.

Sylvia Wynter:
Sylvia Wynter, 'Africa, the West and the Analogy of Culture: The Cinematic Text after Man,' in *Symbolic Narratives/African Cinema: Audiences, Theory and the Moving Image*, ed. June Givanni, 25–76 (London: British Film Institute, 2000).

Pamela R. Franco:
Pamela R. Franco, 'The Invention of Traditional Mas and the Politics of Gender,' in *Trinidad Carnival: The Cultural Politics of a Transnational Festival*, ed. Garth L. Green and Philip W. Scher, 25–47 (Bloomington and Indianapolis: Indiana University Press, 2007).

Elizabeth McAlister:
Elizabeth McAlister, 'Rara in New York City: Transnational Popular Culture,' in *Rara!: Vodou, Power and Performance in Haiti and Its Diaspora* (Berkeley: University of California Press, 2002), 183–207.

Judith Bettelheim:
Judith Bettelheim, 'Performing Religion: Folklore Performance, Carnaval and Festival in Cuba,' unpublished paper.

Aisha Khan:
Aisha Khan, 'Muharram Moves West: Exploring the Absent-Present,' unpublished paper.

Kenneth Bilby:
Kenneth Bilby, 'Surviving Secularization: Masking the Spirit in the Jankunnu (John Canoe) Festivals of the Caribbean,' *New West Indian Guide* 84, nos. 3–4 (2010): 179–223.

Joan Fayer and Joan F. McMurray:

Joan Fayer and Joan F. McMurray, 'The Carriacou Mas' as "Syncretic Artifact,"' *The Journal of American Folklore* 112, no. 443 (1999): 58–73.

Jocelyne Guilbaul:

Jocelyne Guilbault, 'On Interpreting Popular Music: Zouk in the West Indies,' in *Caribbean Popular Culture*, ed. John Lent, 79–97 (Ohio: Bowling Green State University Popular Press, 1990).

Nadi Edwards:

Nadi Edwards, 'States of Emergency: Reggae Representations of the Jamaican Nation State,' *Social and Economic Studies* 47, no. 1 (1998): 21–32.

Gage Averill:

Gage Averill, 'Anraje to Angaje: Carnival Politics and Music in Haiti,' *Ethnomusicology* 38, no. 2 (1994): 217–47.

Robin Moore:

Robin Moore, 'Black Music in a Raceless Society: Afrocuban Folklore and Socialism,' *Cuban Studies* 37, no. 1 (2006): 1–32.

Deborah Pacini Hernández:

Deborah Pacini Hernández, 'Love, Sex, and Gender,' in *Bachata: A Social History of Dominican Popular Music* (Philadelphia: Temple University Press, 1995), 153–84.

Susan Harewood:

Susan Harewood, 'Transnational Soca Performances, Gendered Re-Narrations of Caribbean Nationalism,' *Social and Economic Studies* 55, nos. 1&2 (2006): 25–48.

Umi Vaughan:

Umi Vaughan, 'Timba Brava: Maroon Music in Cuba,' in *Rebel Dance, Renegade Stance: Timba Music and Black Identity in Cuba* (Ann Arbor: University of Michigan Press, 2012), 11–46.

Keith Nurse:

Keith Nurse, 'Caribbean Creative Economies,' unpublished paper.

Mike Alleyne:

Mike Alleyne, 'Globalization and Commercialization of Caribbean Music,' in *World Music: Roots and Routes*, ed. Tuulikki Pietilä, 76–101 (Helsinki: Helsinki Collegium for Advanced Studies, 2009).

Suzanne Burke:

Suzanne Burke, 'Literary Arts and Book Publishing,' in *Policing the Transnational: Cultural Policy Development in the Anglophone Caribbean (1962–2008)* (Saarbrücken, Germany: LAP Lambert Academic Publishing, 2010), 216–51.

Deborah Thomas:

Deborah Thomas, 'Development, "Culture" and the Promise of Modern Progress,' *Social and Economic Studies* 54, no. 3 (2005): 97–125.

Caribbean Popular Culture:
Power, Politics and Performance – An Introduction

Intellectuals should prepare the way for the abolishment of the intellectuals as embodiment of culture.
C.L.R. James, "The Responsibility of Intellectuals"[1]

This collection of articles examines the Caribbean popular – an idea that has been an important and contested terrain for exploring the dynamic and often times subversive cultural expressions of the region. The Caribbean popular arts, whether embodied in hybrid musical genres or vernacular performance and festival traditions, has historically provided a space for social and political critique, the performance of visibility and also articulations of a temporal emancipatory ethos with its attendant acquisition of power and status. Beyond the spaces of their local/regional enactments and social realities of which they emerged and continue to circulate, Caribbean popular culture has over time contributed to contemporary understandings of global and diasporic cultures, and at the same time, the dynamics of intercultural encounters. Within the region, these forms allow for expanding discourses on the performance of identities, especially those that do not fit neatly into the conservative Christian orthodoxy of the prevailing status quo, middle-class institutions or social mores, heteronormative gendered or sexual identities or exclusionist nationalist narratives. Indeed, many of the forms we include in this volume are seemingly transgressive, but also exhibit the dynamic range and distinctive registers within which Caribbean popular forms operate.

The story we tell of the popular and the texts we mobilize are always conjunctural. Indeed, all new disciplinary moments, Stuart Hall reminds us, are born out of specific conjunctures – the socio-historical moments that allow for their genesis, the problems emergent that seem irreconcilable with current intellectual paradigms, the political moments that sunder allegiances and force us to think our world anew.[2] The story of this volume is part of a larger attempt to proffer a way of considering the Caribbean intellectual tradition, and presenting it to another generation of scholars, students and a larger Caribbean intelligentsia. About five years ago, we commenced a serious consideration of the intellectual history of the cultural thought of the region, influenced by our location as lecturers in Cultural Studies at the pre-eminent university in the Anglophone Caribbean, the University of the West Indies. In our attempt to take a critical appraisal of the wealth of cultural criticism on, and epistemological developments in, the study of Caribbean societies, we crafted a volume titled *Caribbean Cultural Thought: From Plantation to Diaspora*, a reader which explored regional cultural politics and debates concerning anti-colonial thought, nationalism, the plantation, identity and social change, aesthetics, gender and sexuality, religions and spirituality and diaspora.[3] In the process of preparing this collection the immense scope of the critical work on culture within the Caribbean intellectual tradition became clear. It also became evident to us that addressing the question of the Caribbean popular would require a volume of its

own, in which the intellectual history of the region would be less fundamental than interrogating the popular – with the result being this volume, *Caribbean Popular Culture: Power, Politics and Performance.*

The last generation of Caribbean scholarship has certainly witnessed an outpouring of work on the popular in the region and numerous high quality studies of carnival, music, film and visual studies have been published during this time.[4] Yet the question of what constitutes the Caribbean popular, and an explicit theorizing of its contours, remains it seems embedded *within* articles and books whose major concerns are elsewhere and seek to articulate a related, but not identical project. This is despite the recognition that Caribbean popular culture is the most powerful force that socializes contemporary Caribbean citizens into an understanding of their identities, the limits of their citizenship, and the meaning of their worlds. The terrain of the popular has quite simply been a *generative* site for the study of Caribbean societies, and has produced enduring theoretical postulations that have been pivotal to the shaping of the intellectual production on the Caribbean. Concepts which have become synonymous to the field of Caribbean Studies such as creolization, indigenization, mimicry, marronage and broader epistemological debates such as new world Africanisms, creativity vs. continuity, reputation and respectability have all been rooted in the study of some form of popular expression.[5] It is this that makes the stakes of the popular so immense and the value of critical work on it so pressing.

John Lent's 1990 text *Caribbean Popular Culture* was pioneering in the scope of its interests, and its idea that popular forms like music, carnival, drama, sport and radio could be profitably grouped under its title.[6] The interest in this text in the insular Caribbean would be extended by Christine Ho and Keith Nurse, whose collection *Globalization, Diaspora and Caribbean Popular Culture* highlighted the centrality of diaspora and transnationalism to any theorization of Caribbean popular culture.[7] Here, the impact of Caribbean popular culture is not just on its regional-resident citizens, or on its diasporic populations, but on a worldwide audience. This is best seen in its music and carnival, with the latter constituting the "world's largest transnational celebration of popular culture."[8] These key collections have certainly made a valuable contribution to the study of Caribbean popular culture. Yet the crucial question of *why* the popular deserves a distinctive charting of its own history, beyond questions of its contemporary socio-economic relevance, remained still to be answered.

An acute observation by C.L.R. James, reproduced in the epigraph of this introduction, is a critical guide to our thoughts here. Speaking at the First Cultural Congress of Havana, James controversially declared that "intellectuals should prepare the way for the abolishment of the intellectuals as embodiment of culture."[9] The discernment of James, the author just five years previously of *Beyond a Boundary*, widely considered one of greatest works of cultural criticism written in the twentieth century deserves some exploration. The key word here may well be embodiment, through which the authority of intellectuals as legislators and interpreters allows them to attribute meaning and value to cultural phenomena. What James perceives here, and is in concert with his work of the 1960s, is that the *terrain* of the popular will eclipse the intellectual's ability to explain its meaning. One of James's greatest interpreters, Sylvia Wynter said it best when she noted the following:

> The great unifying forms of our times are no longer, as in the case of cricket, coded, under the hegemony of middle-class cultural mores. What we are experiencing is a cultural shift of historical magnitude, a shift that (C.L.R.) James pointed to in the lectures on modern politics given in Trinidad. The great unifying forms of our times, beginning with the jazz culture and

its derivatives, are popular. This is the significance of calypso and Carnival, of the reggae and Rastafarianism. This is the significance of the Jamesian poiesis.[10]

The shift that Wynter suggests above points towards a universal acceptance of the legitimacy of popular forms, "an ongoing cultural revolution of an emergent global and popular imaginary", yet the interest in the study of these forms has a long history.[11] As Nadi Edwards indicates in the introduction to a special issue of *Small Axe* on "The Popular", "since the late 1920s, Caribbean popular culture has been the subject of an incessant critical conversation among the cultural practitioners, intellectuals and critics of the region…and it frames the discourses of political and cultural decolonization, the sentiments of the nationalist moment, and the claims of citizenship, identity and belonging.[12] The stakes of the popular have been profound over the last century, as while it is perpetually perceived to be "the ground of nativist aesthetics and philosophy", "in its noisy corporeality, its carnivalesque mobility and its border crossing propensity (it) cannot be easily accommodated as respectable citizen, despite its indisputable status as native."[13] The debates also extend to include broader intersecting topics such as identity politics and globalization. With this in mind, this volume takes a critical appraisal of the debates concerning the place of the popular and creative expressions to broader social, political and cultural discourses on the development of Caribbean culture. It also extends the conversation to metropolitan centres which have both influenced and have been impacted by the cultural production of the region.

We commence our first section "Framing the Popular" with the work of two Caribbean thinkers who have made an outstanding contribution to theories of the popular, Stuart Hall and Sylvia Wynter. Until his death in 2014, Hall was arguably the most influential living Caribbean intellectual, whose decisive role in the creation of the field of Cultural Studies is too well known to recount. His article "Notes on Deconstructing the Popular" is republished in this collection less for its European-specific periodisation of the emergence of the popular, but rather for its multi-layered definition of what it actually is. For Hall, "relations of power" and contests over them are central to comprehending the stakes of the popular, and his nuanced description of cultural hegemony, while disavowing its complete control over dominated subjects, is one each generation continues to learn again in the Caribbean. Hall settles on a definition of the popular as "those forms and activities which have their roots in the social and material conditions of particular classes; which have been embodied in popular traditions and practices," with the added crucial caveat that "what is essential to the definition of popular culture is the relations which define 'popular culture' in a continuing tension (relationship, influence and antagonism) to the dominant culture."[14] Hall closes his article with the declaration that if popular culture is not the site for contesting oppressive power and where "socialism might be constituted" he couldn't "give a damn about it"[15] – with a fascinating echo of W.E.B. Du Bois' 1926 speech "Criteria of Negro Art", in which Dubois controversially declared that:

> all art is propaganda and ever must be, despite the wailing of the purists. I stand in utter shamelessness and say that whatever art I have for writing has been used always for propaganda for gaining the right of black folk to love and enjoy. I do not care a damn for any art that is not used for propaganda.[16]

Sylvia Wynter's contribution to the study of the Caribbean popular as author, playwright, dancer, scholar and theorist constitutes a genuine labyrinth of ideas in which few of the crucial questions of modern human existence are left untouched. Her essay "Rethinking "Aesthetics": Notes Towards a Deciphering Practice" is one of the most sophisticated attempts in Caribbean letters to undo the legacy of colonialism in the arena of taste and value. The rise of the Western

middle classes to global ascendancy has engendered and maintained a colonial knowledge now hegemonic, in which the distinction between "high" and "low" culture is secured by "the hierarchy between the *taste of reflection* of the middle class and the *taste of sense* of the lower classes."[17] The deciphering practice that Wynter proposes would be a triumph over the mystification that bedevils our species in which one genre of man (Western bourgeois man) is overrepresented as the human.[18] It also would inaugurate the "autonomy of human cognition with respect to the reality of the social universes of which we are always already discursively instituted speaking/knowing/feeling subjects, and, therefore, with respect to the processes which govern our modes of being/behaving" in effect, an inauguration of the human *after* Western man.[19]

Wynter and Hall's considerations of the range and importance of the popular is echoed in each of the remaining five essays that constitute this section. The complex relationship between folklore and the popular in the Caribbean is clarified in the essays by Michael Dash and Rogelio Martínez Furé. The Indigenism movement of the 1920s "signified the end of Haiti's isolation in cultural terms," and Dash's essay reminds us that it was contemporaneous with the Harlem Renaissance and negritude movement, though scarcely as widely known as either.[20] Nor was this connection merely a temporal one, as "the strong anti-bourgeois sentiment, the intense racial feeling and the desire to create an authentic black literary style through the use of folk material were common to both movements."[21] Furé's "Imaginary Dialogues on Folklore" alters us to the decisive cultural impact of the Cuban Revolution, often overshadowed by its political impact in the region.[22] His dialogue presents a powerful case for the relevance of folklore, linking the concepts of "tradition" and the "popular" in the statement that "folklore...(is) the most authentic expression of the traditional popular culture."[23] The Cuban counterpoint here becomes African and Hispanic culture, yoked together on the same soil.

Over the last generation in the Anglophone Caribbean, scholars Hilary Beckles, Carolyn Cooper and Gordon Rohlehr have each taken an expressive form with deep roots and immense popularity and through path-breaking scholarship on it decisively contributed to its regional and global study. Beckles charts the transformation of the imperial game of cricket through performance on the field, poetry and song dedicated to the game, and the carnivalesque atmosphere of the spectators on the verge of the boundary. Cooper's erotic maroonage announces sexual liberation from patriarchy and social ascendancy as part of the battle for space by a Jamaican massive who refuse to be relegated to condescension and social scorn. Gordon Rohlehr's analysis of freedom and responsibility for the calypsonian reveals a world of immense influence despite the shadow of state power throughout its history, and multiple temptations given the tactical proffers of government patronage in the post-colonial state. The work done in their respective areas – Hilary Beckles (cricket/Barbados), Carolyn Cooper (dancehall/Jamaica), Gordon Rohlehr (calypso/Trinidad and Tobago) has been among the most important in clarifying debates around the question of national and diasporic culture, the interpellation of colonialism into all of our lives, and the contours and pitfalls of a resistance culture mediated through the popular. Through their intellectual investment in analyzing these national popular forms they each demonstrate the politicized and participatory dimensions of the popular in both forging national unity and subverting hegemonic structures of power.

In his path-breaking text *The Development of Creole Society in Jamaica, 1770-1820*, Kamau Brathwaite shrewdly observed that it was in his mis-use of the master's language that the enslaved African most effectively rebelled.[24] Caribbean thought is particularly rich in its reflections on the power of the creole languages forged in the crucible of colonialism. This thought on language and orality, allied to the innovations in the field of creole linguistics but independent from it,

has resuscitated creole languages from ridicule and didain. It has also engendered a growing appreciation of the stylistic innovations of these languages and the power of the spoken word. Kamau Brathwaite's monograph *History of the Voice*, in its combination of cultural history and literary analysis and introduction of the concept of "nation language" stands here as an early, decisive contribution.[25] The yearning for expression free of the power of coloniality is best seen in Edouard Glissant's "Natural Poetics, Forced Poetics" in which he "define(s) as a free or natural poetics any collective yearning for expression that is not opposed to itself either at the level of what it wishes to express or at the level of the language that it puts into practice."[26] For both Brathwaite and Glissant, African culture is, to use Brathwaite's phrase, the "submerged mother" that haunts discourses about Caribbean creole languages, an influence once angrily denied but now accepted, though too often without a transformation of the value ascribed to these languages. This diasporic connection also links the Caribbean to North America, where Roger Abrahams' work on the linguistic culture of the West Indies reveals its deep connections to African-American oral traditions. While the black experience in the New World engendered creole languages, diasporic linkages in contemporary times have made their spread possible, as Velma Pollard shows in her analysis of the global reach of Rastafari dread talk.[27] Caribbean popular culture has created dub poetry, which for literary critic Michael Bucknor is "Jamaica's gift of a new art-form to the literary world."[28] The power of this art-form, recalling a centuries-old oral tradition in the now, reminds us of the conclusion of Aimé Césaire's mesmerizing 1944 essay "Poetry and Knowledge": "The poet is that very ancient yet new being, at once very complex and very simple, who at the limit of dream and reality, of day and night, between absence and presence, searches for and receives in the sudden triggering of inner cataclysms the password of connivance and power."[29]

Besides the cultural spheres of language and orality and the diverse musical landscape that have long catapulted artists into an international arena, the region's festive and sacred manifestations have drawn sustained and unequivocal attention from visitors and academics alike. From the earliest colonial accounts of plantation life, the festive forms, although pejoratively reported, reveal the agency and cunning of the enslaved population in honing new popular traditions.[30] Under the repressive colonial regime, suppressed cultural forms born out of a repertoire of embodied memories were re-enlivened through their encounter and accommodation of hegemonic structures – thus creating new and more expansive aesthetic and performative modalities. With the adoption of the Christian liturgical calendar and through marking the cycles of their agricultural labor in publicly sanctioned communal festivals, neo-African practices became embedded into the social landscape shaping the seasonal rhythms of quotidian life on and beyond the plantation. As such, Jonkonnu, Carnival, Rara, Crop Over and other Caribbean rites and festive forms became pivotal sites for examining what Jamaican cultural theorists, Sylvia Wynter describes as the pattern of duality between the plantation and plot.[31] "New World carnivals" became examples of the cultural process of indigenization whereby transplanted populations utilized the resources available to them to rekindle and fortify their spiritual and social universe.[32] These communal rites of remembrance and solidarity became steeped in overlapping sacred worlds that overtime became part of the folklore of a people. Through the creative process of borrowing, re-blending and layering, masquerade forms became more than recreational outlets. Indeed, these heightened events created critical spaces of "camouflaged agency"[33] for transplanted cultural practices and the honing of hybridized subjectivities. Enveloped within the social matrix of plantation life, festive forms became aesthetic tactics of opposition and part of the arsenal levied against the structures of enslavement and colonization, which were essential to the process of re-humanization.

The extensive scholarship on Caribbean carnivals and festive traditions demonstrate the longevity and breadth of critical engagement with this popular form.[34] However we wish to highlight the conceptual interventions of two publications, Richard Burton's *Afro Creole* and Gerard Aching's *Masking and Power* and utilize them as a framing device for they speak directly to and across themes covered in the essays included in this volume. Moreover, we spend a considerable amount of time speaking about the festival arts in part because they represent the one site where a multiplicity of vernacular, popular expressions converges.

In his exploration of power, opposition and play as manifested in a range of Afro-Creole expressive forms, Richard Burton maintains that masquerade practices, like their religious counterparts, are ambivalent cultural forms that exhibit clear tendencies towards accommodation and opposition. However, because they are complicit within the structures of domination, these cultural expressions do not fully realize the complete subversion and subsequent restructuring of the status quo. Accordingly, Burton argues:

> Part of the reason for this, I suggest, is that Afro-Creole cultures are themselves a paradoxical amalgam of the radical and the conservative that…simultaneously challenges and confirms the dominant order by turning the latter's resources against it in a complex double game of oppositionality – a game that can lead into, but also often militates against, the possibility of actual *resistance*, in the more circumscribed sense [of acting wholly outside of the system of dominance][35]

Consequentially in Burton's estimation, political radicalism in the cultural domain, whether through overt or subtle displays, is hence attenuated. Moreover, the intensification of everyday life witnessed in carnival celebrations do not, in the traditional Bakhtinian sense, temporarily reverse social roles. Instead, the play of inversion actually reveals the reification of the status quo. While Burton's work draws our attention to the analytical purchase of "play" in exploring Afro-Atlantic performance genres,[36] his dismissal of the critical range of "masking and masking practices" forecloses an engagement with the deeper analysis of masquerade and festive traditions as arenas for the enactment of transformative politics.

In his similar interest in exposing tactics of subversion that take place within oppressive and dominant structures, Gerard Aching in his *Masking and Power* offers an alternative and more redemptive appraisal of the latent resistive force of the popular, and specifically, masquerade forms.[37] To this end, Aching makes a case for "the critical evaluation of masking tactical activities that go beyond romanticized notions of masks and masking practices as pre-or even antimodern expressions of folkloric innocence and festive abandon."[38] As such his work and the chapters we have assembled in this volume stands as a corrective to the "limited view that Caribbean masking practice and other manifestations of popular urban culture are *merely* symbolic sites of subversive activities and, by implication, *failed* attempts at transforming the social order."[39] Adopting Paul Gilroy's formulation of "politics on a lower frequency" or "lower-frequency" politics,[40] Aching proceeds to track tactical strategies evident in the carnival and oral popular cultures deployed by the popular masses as they retool the weapons of the oppressors for their own decisive means.

Masquerade and the festive traditions in the final analysis function as empowering agents for the public representation and recognition of subaltern expressions and identities. It is this point of juxtaposition and negotiations between "degrees of recognition, misrecognition and non-recognition between masked subjects and the viewing subject"[41] that is particularly productive. For as Aching shows, masking provides an opportunity for Caribbean people to ritually present and likewise confront that which often remains invisible – those people, histories and social realities often systematically ignored. Thus, the transformative politics is not in revolutionary upheavals

but manifested through the "performance of visibility."⁴² The subject of the gaze is thus central to festive forms and the transformative power they engender. In other words it is through this act of being and becoming visible that change becomes a possibility.

An example of the tension between what is visible yet invisible or present yet rendered absent because it falls out of categories of analysis or the contemplation of popular ludic and sacred forms, is found in Indo-Caribbean cultural performances. In her examination of Hosay in Trinidad, Aisha Khan invites readers to question what she calls the "absent-present" and more specifically to reflect on the ways in which certain "popular masses" and communities get captured and/or elided in prevailing discussions and understandings of the Caribbean popular. The popular is thus not rendered a possibility for all and as a result our ability to appreciate the shared humanity across disparate social identities becomes skewed. Demanding recognition through one's visibility therefore serves to reshape and remap the contours of the highly stratified and ambivalent socio-relational domains, which would otherwise render certain publics, identities and histories invisible and hence silent.

Cultural responses to experiences of foreign domination, disempowerment, misrecognition and non-recognition, provides an important scaffold for analyzing the conceptualization of the popular that we advance in this volume. The popular festival terrain, as the articles reveal, circulates in diverging semantic fields as they are called upon to fulfill multiple mandates and oft times contradictory agendas. The popular, as Argentine anthropologist, Nestor García Canclini, has asserted with respect to Latin America is no longer consigned to antiquated practices of peasant communities, but extends outside of the control of "popular masses" to include the state and multinational incorporations.⁴³ Once insular/rural traditions and cultural performances are, for example, gaining a renewed life as national signs of cultural difference, iconic emblems of multicultural heritage.⁴⁴ As an example, Yanique Hume's essay on Cuban Gagá in this volume analyses the ever-expanding performance contexts for Haitian-heritage communities in Cuba, thus illuminating the power of popular festivities in creating new publics and social imaginaries.

Folklore, once seen as the epitome of cultural resistance to the market economy is now fully enrolled in the neoliberal economic domain of late capitalism. The term "culture," which has been variably collapsed or conflated with that of "folklore" and/or "popular traditions," is now what George Yudicé accurately labels as an "expedient resource." Its expediency is in part because it is valuable and can be utilized in concrete economic ways – a subject we elaborate on in our closing section on Caribbean creative economies.⁴⁵

An underlying but crucial theme in our discussion of festive and masquerade politics in the Caribbean is the place of the sacred within these forms. Whether submerged because of the onslaught of secularization (Bilby) or activated as part of expanding folkloric repertoires in late socialist Cuba (Hume and Bettelheim), Caribbean festival practices and cultural performances slide seamlessly along a continuum of sacred and secular registers. Often inscribed within overlapping sacred cosmologies, the festival arts and the sacred arts share similar spiritual geographies as they build on the cultural logic and ritual grammars of old world systems. Moreover, the popular aesthetic vocabularies of assemblage and the cultural pastiche we see in festive and masquerade practices find new and ever-changing expression in the sacred and visual domain.⁴⁶

Within the corpus of work produced on the Caribbean sacred arts we come to appreciate the inherent performative dimension of the region's religious cultures. Through concentrated ritual action, divine energies are invoked through libations, prayers/chants, through sacred markings drawn on the ground or gestured in air, and accompanied by music, songs and dance, to make

xxiv | **Caribbean Popular Culture**

the world of the invisible part of the tangible world of the visible. These embodied practices, stored in the muscle memory of practitioners and passed down through generations, have been crucial in the reclamation of self and community. However, the very performance-centred nature of their practice has extended beyond the confines of temples to include their use in state-sanctioned performances of cultural difference. The collapse of the sacred, popular and festive domains in the construction and subsequent staging of "folklore" as national identity is a common feature of state politics in Haiti and Cuba dating back to the early 1920s and continuing through the present. Kate Ramsey's, "Without one Ritual Note" traces these developments of the folklorization process amidst Haiti's repressive penal regime and shows the negotiations and strategies deployed by intersecting agents. The *movement folklorique* of the 1940s, as Ramsey shows, became a space where certain *sèvite* (religious practitioners) used their participation in the codification of Vodou as folklore to "protest persecution by the church and state."

The varying examples of accommodation and resistance are also evident in the aesthetic and performative dimensions of Santería. David H. Brown, in his critical monograph *Santería Enthroned*, tracks the "epochal transformations" within the Yoruba-Lucumí complex in Cuba across "three kinds of systems and their attendant meanings: institutional, ritual and iconographic.[47] In his deliberate and specific use of the terminology of "change," "innovation," "reform," and "invention," Brown is able to provide a nuanced reading of transformations in administrative institutional structures, aesthetic conventions and cosmological orientations. Through his discussion of the change in colonial institutions from cabildos to casa templos and the incorporation of new ceremonial practices, Brown elaborates on how invention, often interpreted as intervention, and innovation can lead to permanent structural changes. The expansive taxonomy utilized to capture what was before reduced to simply *change* and *continuity* enables a more engaged and detailed analysis of the dynamic and contested process of "culture building" and "self-making."

It is perhaps this latter point of "self-making" that the sacred arts throws into constant relief. Brown in his seminal article on the construction of Oricha thrones included in this volume speaks to this phenomenon of utilizing the resources available to construct new and expansive social worlds and identities. Ordinary citizens dressed in the sacred vestment identified with their guardian spirits manifest the regal authority of the divine. Likewise their elaborate thrones to the Orichas or altar-spaces built to honor the divine and mark ritually numinous occasions is a place where the themes of ritual regality and authority, which is part of the rich vocabulary of oppositional tactics utilized in festive traditions, also find dynamic expression.

The power to name and proclaim titles of authority and royalty such as kings, queens, president, colonel, which abound in the sacred and festive domain, is also evident in the polyvocality of the urban, sub-cultural form – dancehall. As a musical genre, within its attendant socio-political, economic and cultural fields, dancehall encapsulates the transgressive politics of the underclasses who use their performance to be seen, as much as to disturb. The "ostentatious aesthetics" and conspicuous consumption patterns that come together in a chaotic cacophony of symbolic meaning speak to the ability of popular expressions, such as dancehall to recast sacred practices within new modalities of self-making. Thus as Donna Hope shows in her essay, "From the Stage to Grave", the "blurred nexus" of bling funerals inscribe within the body a personhood status otherwise not fully actualized in life. Indeed, the negotiation and performance of identity finds differing modes of elaboration across the sacred arts. As an example, the "reimaginings of the dead" invoked through the "spirit dolls" associated with Espiritismo as discussed by Carrie Viarnés and the hypersexualized – larger than life sculptors in honor of the Haitian god of death – Gede, presented by Katherine Smith, further demonstrate the innovative constructions of identity across the sacred-secular domains.

While the element of the visual cuts across the festive and sacred forms found across the region, the visual arts – as a specific disciplinary field and cultural practice – is perhaps the least theorized within conceptions of the Caribbean popular. The critical work on the communal and populist appeal of vernacular Caribbean forms were not historically in conversation with visual arts production in the Caribbean. This is in part because the arts, such as painting were imagined to be elitist, market-driven, individualist and not necessarily of or for the masses. As noted art historian, Leon Wainwright suggests, "Painting harked back to the old colonial order."[48] The contemporary art criticism of the region, particularly the scholarship developed on the Anglophone Caribbean, have been instrumental in showing the legacies of this colonial imprint on the art history of the region. In particular scholars such as Krista Thompson have been pivotal in interrogating the dominance and endurance of the trope of tropicality and the picturesque within the visual regimes of the Caribbean.[49] In her work on representing slavery reproduced in this volume, Thompson revisits some of the themes concerning the imagining of the Anglophone Caribbean but through the lens of late nineteenth-century images of the slave past. As a point of departure Thompson asks the pertinent question of how can things rendered un-representable and unimaginable be given visual form especially in the context of an absent visual archive.

The visual practice of the contemporary Caribbean represents a radical shift from the discourses presented by Thompson and the narrative concerning the canonization of "intuitive" art as a nationalist visual field presented by Verlee Poupeye. Caribbean art practice today finds itself branching into new expansive, collaborative fields, adopting diverse digital media and engaging in transdisciplinary conversations, as the recent "Caribbean Queer Visualities" symposium at Yale University demonstrates.[50] It is to this idea of intersecting dialogues and integrative approaches to art that Claire Tancons' intervention speaks. Her call to Caribbean visual artists to look to the performative and exhibitionary model of carnival aesthetics echoes in many ways the decisive dynamism of the vernacular espoused by Annie Paul.[51] Tancons turn to the "artistic lingua-franca" of carnival as a way of revising the "ethnocentric notion of performance art" provides a critical platform for art practitioners to interface with the global contemporary art scene. To a large degree, the enlistment of carnival and dancehall as specific festive modes of collaborative and populace engagement within contemporary art practice is thus shifting the terrain of the visual arts and indeed the process of making and representing culture in the Caribbean.

The study of the Caribbean carnivalesque has perpetually been twinned with the study of Caribbean music, and the leading monographs on the latter have inevitably made a profound contribution to the work on the former.[52] Caribbean music is arguably *the* preeminent site of the region's cultural production for its people – or put differently, it is the popular form that elicits the most joy, recognition and pride in Caribbean people. Here, the histories of past unfreedom and the abridgement of full citizenship in the contemporary moment indelibly marks the themes emergent in these musics. And it is here that its consciousness becomes revealed.

In an arresting comment on the "social allegory" that he suggests is fundamental to most New World African music, Timothy Brennan states that popular music's overwhelming popularity resides in the fact that it "offers its listeners a coded revenge on the modern, and that..is *why it is popular*."[53] This popular music, based on neo-African forms, "constitutes nothing less than an alternative history of Western civilization," and for Brennan, is in effect the Caribbean's literature, engendering a "popular and national sense of self" as no other cultural form quite can.[54] Consciousness has always been central to Caribbean music, which has perpetually responded to state power, whether as critics, supplicants, or apathetic clients.[55] It has often been the only

consistent opposition to the injustice of elite abuse of power, with a militancy expressed through the most searing lyrics and melodies. Simultaneously, however, the consciousness expressed in Caribbean popular music contains a thorny mix of gendered, racialized and sexual themes that range from radical to conservative articulations of social identities. Thus, the status of music marks it as a perpetual terrain of struggle for social meaning and radical change in the Caribbean.

The tremendous global appeal of Caribbean music cultures has a longer history than the past generation when that influence has become undeniably clear. Alejo Carpentier, in his pioneering criticism knew this only too well, as he noted in 1949 that Cuba had "powerfully created a distinctive music that has long enjoyed extraordinary success abroad."[56] The sites of reception and popularity of these musics have long caused surprise, a well known example being calypso's outrageous popularity in mid-twentieth century America. Caribbean music remain indelibly marked by transnational cultural processes, well seen in the much remarked upon creation of the global hip-hop movement from the clash between Jamaican and African-American sound systems in the late 1970s. The rapidity of changes caused by the internet revolution, have certainly altered the ways in which Caribbean music is produced, heard, and distributed, well into the twenty-first century.[57] However, the indelible link between music and popular consciousness shows no signs of lying down and being still.

The terrain of cultural policy in the Caribbean is complicated by the deeply felt investments in cultural production and the distribution of its rewards by artists, governments, the private sector, and the wider society. Most Caribbean countries are beset by chronic economic instability, but have created forms of popular culture that have contributed disproportionately to the global entertainment industry, and have provided an experience of leisure and enjoyment for publics beyond their shores. The attraction of harnessing the economic potential of these forms for national development has been immense, and it is not uncommon to hear state managers claim that the one growth area left in their economies is the cultural industries. The tension between state managers' interests and those of artists (particularly those in the musical or carnival sphere) over the distribution of resources and the integrity of their vision has been a recurring debate over the last generation, but much of the work on Caribbean cultural policy lies within technical reports produced for governments and international agencies. The articles in our section "The Caribbean Creative" all consider the often fraught nature of cultural production and its links to the commercial sector in small island developing states. The dominant neocolonial reality that Caribbean economies remain enmeshed within becomes evident here, because, as Keith Nurse points out, "Caribbean countries have a significant and widening deficit in the trade of cultural goods," despite their outstanding production in the realm of popular culture.[58] The debates here on Caribbean cultural policy, well articulated in Deborah Thomas' closing article of our collection, are less about the weight that should be given to cultural policy in cultural studies, but rather the balance between the search for cultural sovereignty and creativity at the heart of Caribbean cultural thought and the imperatives of economic survival. These remain troubling questions, with no easy or apparent solution.

We make no claim to comprehensiveness in this volume, and regret the absence of sections on popular theatre, dance and sport. We also do not address the literary tradition in this work as Caribbean literary studies has such a well-developed and sophisticated body of work surrounding

it that our attention is simply not needed here.[59] However, rather than the dreamy fiction of comprehensiveness, we hope this collection is indicative of key trends and moments in Caribbean popular culture. In this collection we do not engage the question of cultural imperialism in the Caribbean, or put differently, the hegemonic influence on Caribbean culture from North America popular culture. We do this not to deny its reality, but the overwhelming effect and power of Caribbean popular culture left little room for it as a separate item, and the study of the Caribbean popular shows how consistently the region has incorporated and transformed influences from beyond its shores. It is the vibrancy and creativity of the Caribbean popular, endlessly transforming itself in ways that will undoubtedly soon make this volume an artifact of Caribbean thought rather than a definitive mapping of our moment, which we wish to share with our readers, for their recognition and enjoyment.

<div align="right">

Yanique Hume and Aaron Kamugisha
Barbados, February 2015

</div>

Notes

1. C.L.R. James, "The Responsibility of Intellectuals." Unpublished talk at the First Cultural Congress of Havana, Cuba, 4–11 January 1968, The C.L.R. James Archive, University of the West Indies, St. Augustine Campus, Trinidad & Tobago.
2. Stuart Hall, "Cultural Studies and its theoretical legacies," in *Stuart Hall: Critical Dialogues in Cultural Studies* edited by David Morley and Kuan-Hsing Chen (London and New York: Routledge, 1996), 262–75.
3. Yanique Hume and Aaron Kamugisha eds., *Caribbean Cultural Thought: From Plantation to Diaspora* (Kingston, Jamaica: Ian Randle Publishers, 2013). Two allied texts emerged simultaneously under the editorship of Aaron Kamugisha, *Caribbean Political Thought: The Colonial State to Caribbean Internationalisms* (Kingston, Jamaica: Ian Randle Publishers, 2013) and *Caribbean Political Thought: Theories of the Post-Colonial State* (Kingston, Jamaica: Ian Randle Publishers, 2013).
4. Assessing the most noteworthy contributions to each field would be impossible, and here we turn our readers to the recommended reading lists at the end of each section of this volume. In these lists, we have limited ourselves to a compilation of no more than 25 key texts in each field – itself a very difficult process.
5. For a detailed charting of these traditions, see Yanique Hume and Aaron Kamugisha eds., *Caribbean Cultural Thought: From Plantation to Diaspora* (Kingston, Jamaica: Ian Randle Publishers, 2013).
6. John A. Lent ed., *Caribbean Popular Culture* (Bowling Green, Ohio: Bowling Green State University Popular Press, 1990).
7. Christine Ho and Keith Nurse eds., *Globalization, Diaspora and Caribbean Popular Culture* (Kingston, Jamaica: Ian Randle Publishers, 2005).
8. Ibid., vii.
9. C.L.R. James, "The Responsibility of Intellectuals." See also Andrew Salkey, *Havana Journal* (Harmondsworth: Penguin, 1967), 110.
10. Sylvia Wynter, "Beyond the Categories of the Master Conception: The Counterdoctrine of the Jamesian Poiesis," in *C.L.R. James's Caribbean* edited by Paul Buhle and Paget Henry (Durham and London: Duke University Press, 1992), 63–91.
11. Sylvia Wynter, "Rethinking "Aesthetics": Notes Towards a Deciphering Practice," in Mbye B. Cham ed., *Ex-Iles: Essays on Caribbean Cinema* (Trenton, NJ: Africa World Press, 1992), 239.
12. Nadi Edwards, "Talking About Culture: Re-thinking the Popular," *Small Axe* 9 (March 2001): v.
13. Ibid., vi.
14. Stuart Hall, "Notes on Deconstructing 'The Popular'," in Raphael Samuel ed., *People's History and Socialist Theory* (London: Routledge, 1981), 234–35.
15. Ibid., 239.
16. W.E.B. Du Bois, "Criteria of Negro Art," in David Levering Lewis ed., *W.E.B. Du Bois: A Reader* (Holt, 1995), 514.

17. Sylvia Wynter, "Rethinking "Aesthetics": Notes Towards a Deciphering Practice," in Mbye B. Cham ed., *Ex-Iles: Essays on Caribbean Cinema* (Trenton, NJ: Africa World Press, 1992), 251, original emphasis.

18. On this also see Sylvia Wynter, "Africa, the West and the Analogy of Culture: The Cinematic Text after Man." In *Symbolic Narratives/ African Cinema: audiences, theory and the moving image.*Edited by June Givanni. London: British Film Institute, 2000, reprinted in this volume.

19. Ibid., 239.

20. Michael Dash, "The Indigenous Movement," in *Literature and Ideology in Haiti, 1915-1961* (London and Basingstoke: Macmillan, 1981), 95.

21. Ibid., 73. Here Dash refers to the Harlem Renaissance and the Indigenous movement.

22. See Robert Young's key text *Postcolonialism: An Historical Introduction* which argues that the 1966 Tricontinental Congress in Cuba "represents the formal initiation of a space of international resistance of which the field of postcolonial theory would be a product." *Postcolonialism: An Historical Introduction* (Wiley-Blackwell, 2001), 213.

23. Rogelio Martínez Furé, "Imaginary Dialogues on Folklore," in *Díalogos Imaginarios*(Havana: Editorial Arte y Literatura, 1979), 257–79. Translated by Samuel Furé Davis in this volume. The tension between the description of folklore articulated by leading members of the Cuban Revolution and the critical appraisals of state manipulation of folklore in recent scholarship (including authors in this volume) should be noted here.

24. Kamau Brathwaite, *The Development of Creole Society in Jamaica, 1770-1820* (Oxford: Clarendon Press, 1971).

25. Kamau Brathwaite, *History of the Voice: The Development of Nation Language in Anglophone Caribbean Poetry* (London: New Beacon Books, 1984).

26. Édouard Glissant, *Caribbean Discourse: Selected Essays.* Translated by J. Michael Dash (Charlottesville, Virginia: University of Virginia Press, 1989), 120. It is important to note Brathwaite's knowledge and appreciation of Glissant's essay, which was first published under the title "Free or Forced Poetics" in the journal *Alcheringa* 2, 2 (1976), three years before Brathwaite's first rendition of "History of the Voice" as a lecturer at Harvard University. For Brathwaite's comments on "Free or Forced Poetics," see Brathwaite, *History of the Voice*, p. 16. This volume of *Alcheringa* also contained an important contribution by Sylvia Wynter, titled "Ethno or Socio Poetics," *Alcheringa* 2, 2 (1976): 78–94.

27. Velma Pollard, "Globalization and the Language of Rastafari," in Hazel Simmons-McDonald and Ian Robertson eds., *Exploring the Boundaries of Caribbean Creole Languages* (Jamaica: University of the West Indies Press, 2006): 230-41.

28. Michael Bucknor, "Dub Poetry as a Postmodern Art Form Self-Conscious of Critical Reception," in Michael A. Bucknor and Alison Donnell eds., *The Routledge Companion to Anglophone Caribbean Literature* (London and New York: Routledge, 2011).

29. Aimé Césaire, "Poetry and Knowledge," in Aimé Césaire, *Lyric and Dramatic Poetry 1946-1982.* Translated by Clayton Eshleman and Annette Smith (University of Virginia Press, 1990), lvi. This landmark essay of Caribbean thought is re-printed in this volume. For Sylvia Wynter's interpretation of the importance of this essay, see Sylvia Wynter and Katherine McKittrick, "Unparalleled Catastrophe for Our Species? Or, to Give Humanness a Different Future: Conversations," in Katherine McKittrick ed., *Sylvia Wynter: On Being Human as Praxis* (Durham and London: Duke University Press, 2014), 64–65.

30. Roger Abrahams and John Szwed, eds., *After Africa* (New Have, CN: Yale University Press, 1983)

31. See Sylvia Wynter's essays "Jonkonnu in Jamaica," *Jamaica Journal* 4, 2 (1970): 34–48 and "Novel and History, Plot and Plantation." *Savacou* 5 (June 1971): 95–102.

32. Peter Burke, "The Translation of Culture: Carnival in Two or Three Worlds," in *Varieties of Cultural History* (Ithaca, New York: Cornell University Press 1997).

33. Yvonne Daniel (2011) uses the term "camouflaged agency" in her discussion of creole *contra* dances adapted from European salon dances and colored with the syncopated rhythms of African drumming and polyrhythmic movement of the lower extremities. She specifically speaks of the hidden oppositional practices cloaked beneath the mimed European gestures and movement vocabulary associated with this popular creole dance form. See Yvonne Daniel, *Caribbean and Atlantic Diaspora Dance: Igniting Citizenship* (Urbana Champaign, Illinois: University of Illinois Press, 2011). For more see Peter Manuel, ed. *Creolizing Contradance in the Caribbean* (Philadelphia:Temple University Press, 2009).

34. See David Crowley, "Trinidad Carnival Issue." *Caribbean Quarterly*, Vol. 3–4 (1956); John Nunley and Judith Bettelheim, ed. *Caribbean Festival Arts: Every Bit of Difference* (Seattle: University of Washington Press, 1988); Clement E. Bethel, *Junkanoo: Festival of the Bahamas* (London: Macmillan, 1991); Judith Bettelheim, ed. *Cuban Festivals: A Century of Afro-Cuban Culture* (Kingston: Ian Randle Publishers 2001); Millio Cozart Riggio ed., *Carnival: Culture in Action: the Trinidad Experience* (New York: Routledge, 2004; Frank J. Korom, *Hosay Trinidad: Muharram Performances in an Indo-Caribbean Diaspora* (Philadelphia: University of Pennsylvania Press, 2003); Elizabeth McAlister, *Rara: Vodou, Power and Performance in Haiti and its Diaspora* (Berkeley: University of California Press, 2002); Garth Green and Philip Scher, ed. *Trinidad Carnival: The Cultural Politics of a Transnational Festival* (Bloomington: Indiana University Press 2007).

35. Richard D. E. Burton, *Afro-Creole: Power, Opposition, and Play in the Caribbean* (Ithaca: Cornell University Press, 1997), 8.

36. For further discussion of "play" as an analytical construct juxtaposed with that of "work" see Elizabeth McAlister, "Work and Play, Pleasure and Performance," in *Rara: Vodou, Power and Performance in Haiti and its Diaspora* (Berkeley: University of California Press, 2002), 25–57.

37. Gerard Aching, *Masking and Power: Carnival and Popular Culture in the Caribbean*. (Minnesota: University of Minnesota Press, 2002).

38. Ibid., 2.

39. Ibid., 2, original emphasis.

40. Paul Gilroy, *Black Atlantic: Modernity and Double Consciousness* (Harvard University Press, 1993).

41. Aching, 4–5.

42. The "performance of visibility" is adapted from the title of art historian, Krista Thompson's critical 2007 essay, "Performing Visibility." In her analysis of the racial, spatial and class dimensions of an urban street festival in Atlanta, Freaknic, Thompson demonstrates how public performances are a divisive exhibitionary mode that allows subaltern identities to be seen. Public enactments of marginal identities are given an almost exaggerated form so that they incite the spectator's gaze and public recognition through photography and other forms of media coverage. See Krista Thompson, "Performing Visibility: Freaknic and the Spatial Politics of Sexuality, Race and Class in Atlanta," *The Drama Review* 51, 4 (Winter 2007): 26–46. This is a point she develops further in her latest publication, *Shine: The Visual Economy of Light in African Diasporic Aesthetic Practice* (Durham and London: Duke University Press, 2015).

43. Nestor García Canclini, *Hybrid Cultures: Strategies for Entering and Leaving Modernity*. (Minneapolis: University of Minnesota Press, 1995), 155–56. See also David Guss, *The Festive State: Race, Ethnicity, and Nationalism as Cultural Performance* (Berkeley: University of California Press 2000).

44. See Kate Ramsey in this volume and also her *The Spirits and the Law: Vodou and Power in Haiti* (Chicago: University of Chicago Press, 2011). See also Philip Scher, "Heritage Tourism in the Caribbean: The Politics of Culture after Neoliberalism," *Bulletin of Latin American Research*, Vol. 30, 1 (2011): 7–20.

45. George Yúdice, *The Expediency of Culture: Uses of Culture in the Global Era* (Durham and London: Duke University Press, 2003), 161–62.

46. See Robert Farris Thompson and Joseph Cornet, *Four Moments of the Sun: Kongo Arts in Two Worlds* (Washington, DC: National Gallery of Art, 1981); Robert Farris Thompson, *Flash of the Spirit: African & Afro-American Art & Philosophy* (New York: Random House, 1983); *Face of the Gods: Art and Altars of Africa and the African Americas* (New York: Museum of African Art, 1993); *The Aesthetics of the Cool: Afro-Atlantic Art and Music* (UK: Periscope, 2011); Donald Cosentino, *Sacred Arts of Haitian Vodou* (Los Angeles: UCLA Fowler Museum, 1995); Donald Cosentino, *In-Extremis: Death and Life in 21st Century Haitian Art* (University of Washington Press, 2012); David H. Brown, *Santería Enthroned: Art, Ritual, and Innovation in an Afro-Cuban Religion* (Chicago: University of Chicago Press, 2003); Bárbaro Martínez-Ruiz, *Kongo Graphic Writing and Other Narratives of the Sign* (Philadelphia: Temple University Press (2013).

47. David H. Brown, *Santería Enthroned: Art, Ritual, and Innovation in an Afro-Cuban Religion* (Chicago: University of Chicago Press, 2003), 8.

48. Leon Wainwright, *Timed Out: Art and the Transnational Caribbean* (Manchester University Press, 2011), 27.

49. See in particular, Krista Thompson, *An Eye for the Tropics: Tourism, Photography and Framing the Caribbean Picturesque* (Durham & London: Duke University Press, 2007). See also Patricia

Mohammed, *Imaging the Caribbean: Culture and Visual Translation* (London Palgrave Macmillan, 2010).

50. The Caribbean Queer Visualities Symposium at Yale is the first event of a two-year initiative by the journal *Small Axe*. See http://smallaxe.net/caribbean-queer-visualities.

51. Annie Paul, "To the Wirl (World)!" in Yona Backer and Kristina Newman-Scott eds., *Rockstone and Bootheel: Contemporary West Indian Art* (Hartford, CT: Real Art Ways, 2010).

52. To take two key texts on Trinidad & Tobago, see Gordon Rohlehr, *Calypso and Society in Pre-Independence Trinidad* (San Juan, Trinidad: Lexicon Trinidad, 1990), Jocelyne Guilbault, *Governing Sound: The Cultural Politics of Trinidad's Carnival Musics* (University of Chicago Press, 2007).

53. Timothy Brennan, *Secular Devotion: Afro-Latin Music and Imperial Jazz* (London and New York: Verso, 2008), 2, 4, original emphasis.

54. Ibid., 9.

55. For an example amidst a voluminous literature, see Louis Regis, *The Political Calypso: True Opposition in Trinidad and Tobago, 1962-1987* (Kingston, Jamaica: UWI Press, 1999).

56. Alejo Carpentier, *Music in Cuba*. Edited and with an introduction by Timothy Brennan. Translated by Alan West-Duran (London and Minneapolis: University of Minnesota Press, 1995), 59. Originally published 1949.

57. Curwen Best, *The Politics of Caribbean Cyberculture* (Palgrave Macmillan, 2008)

58. Keith Nurse, "The Creative Economy and Creative Entrepreneurship in the Caribbean," this volume.

59. For the most outstanding effort to map the field of Anglophone Caribbean literary criticism, see Michael A. Bucknor and Alison Donnell eds., *The Routledge Companion to Anglophone Caribbean Literature* (London and New York: Routledge, 2011).

Framing the Popular

Rethinking "Aesthetics":
Notes Towards a Deciphering Practice

Sylvia Wynter

The effectiveness of repressed people in the communications struggle, either as senders or receivers through systems influenced by this hierarchy (the "Image hierarchy" and "Ideological contours of representation" of what Michel Foucault calls "power/knowledge"), depends on their realization of the obsolescence of the contest over the nature of truth beside the contest over the control of truth, and the irrelevance of "beauty" beside the power to choose and name beauty.

From the beginning, the question of aesthetics is always a non-dialogue between those who subscribe to the conditioned world order and those who stand to gain from a reconstructed forum.

Clyde Taylor[1]

A Black neighborhood is a "high-risk" area because it is Black and because the bulk of the population is trapped there...A high risk area is expensive because...those who batter on it—salesmen and landlords and lawyers, for example—must turn their profits with ruthless speed, for the territory occupied by the Blacks, or the non-White poor, swiftly becomes a kind of devastation.

This means that the citizens of the ghetto have absolutely no way of imposing their will on the city, still less on the State. No one is compelled to hear the needs of a captive population.

James Baldwin[2]

But as sure as the sun will shine
I'm gonna get my share, what's mine
But the harder they come
The harder they fall
One and all!
 Ivan's Title song from *The Harder They Come*

"Fight the Power"
 [Public Enemy's theme song in *Do The Right Thing*]

Introduction and Overview

I HAVE DIVIDED THE ESSAY INTO two parts. Part One gives a summary of the major concepts related to the rethinking of "Aesthetics," as well as to the major proposal which comes out of the rethinking. This proposal is that we replace the present practice of film criticism as a "deutero-canonical" extension of literary criticism[3] and move, instead, towards a new (and post-deconstructionist) practice of decipherment. Unlike film criticism, which *must constrain* the contestatory signifying practices and video-type aesthetics of rhythm of the new cultural forms of films such as *The Harder They Come* (1972) and *Do The Right Thing* (1989)—both of which embody

Reprinted with permission from *Ex-Iles: Essays on Caribbean Cinema*, ed. Mbye B. Cham, 237–39 (Trenton, NJ: Africa World Press, 1992).

a dually *Underclass* "high-risk area" and Black popular point of view—a deciphering practice is able to "uncover" the working of these counter-practices and forms part of an ongoing Nietzschean transvaluation of values and, therefore, of aesthetics, an emerging praxis, therefore, of a second intellectual mutation as far-reaching as the first intellectual mutation of humanism which made possible the realization of the natural sciences.

Part II proposes that such a deciphering practice is itself linked to an ongoing cultural revolution of an emergent global and popular imaginary, for which the securing of the well-being of the concrete individual human subject is the referent telos, against our present hegemonic imaginary, for which the securing of the well-being of the middle class *mode* of the subject is the telos. It further proposes that, in the same way as the practice of literary criticism had emerged, in its first Renaissance "civic humanist" form, as a central part of the "battle of the cultural Imaginary" (or of "tastes") by means of which the "counter-exertion" of European humanism had initiated the first stage of the struggle to attain to the autonomy of human cognition with respect to physical and organic reality, a deciphering practice is inextricably linked to a parallel goal. The goal this time is that of realizing, at long last, the autonomy of human cognition with respect to the reality of the social universes of which we are always already discursively instituted speaking/knowing/feeling subjects, and, therefore, with respect to the processes which govern our modes of being/behaving, in the context of the increasing hegemony of cinematography's and audio-visual technology's "combination of the iconic and linguistic sign." Given the "visual and oneiric power" of the film's image to shape and control our human perception and, therefore, our behavioral responses; we can no longer afford what Clyde Taylor calls our "innocence" with respect to the phenomenon of the aesthetic.

It proposes that in the same way, as in the wake of the first intellectual mutation, Descartes provided the "ground" that would make the physical world mathematizable and, therefore, alterable in accordance with our human purposes, the rethinking of aesthetics provides the "ground" that can make "decipherable" the systems of meaning (or signaling systems), by which those always culture-specific "purposes" have been hitherto instituted by our cultural imaginaries (outside the conscious awareness of their bearer-subjects) and, thereby, make those "purposes," now, consciously and consensually alterable.

A deciphering practice is therefore part of the attempt to move beyond our present "human sciences" to that of a new science of human "forms of life" and their correlated modes of the aesthetic: to move beyond what Adorno defined in the wake of Auchwitz as that "evil" which still haunts human existence as the "world's own unfreedom."

PART I – To Rethink Aesthetics: To Fight the Power

My rethinking of the phenomenon of aesthetics is carried out in the wake of two essays by Clyde Taylor, "We Don't Need Another Hero: Anti-Theses on Aesthetics" and "Black Cinema in the Post-Aesthetic Era."[4] In the first essay, Taylor proposes that scholars of Black cinema should aim at "the development of post-aesthetic creative practices and interpretations." To do so, they should attempt to construct a new model of critical practice based on the organization of knowledge around the given text. Such a model should be used to free the text from the present "specious autonomy" that separates "cultural production" from "social and material production" and to open it up to "intercommunion with other texts" as well as to the "significations of every day life."

Such a model would, however, call for scholars first to free themselves from their addiction to the "opiate of aestheticism," if it were to serve the purpose of bringing to Black cinema a perception of its cultural practices as a "crucial site of the contest out of which the human is being rewritten."

Taylor then proposes a provisional post-aesthetic critical practice which could provide "a platform for the assemblage of reconstructive knowledge" during the interregnum before the invention of more "powerful and humane modes of explanation."

The point of my ongoing rethinking of aesthetics is to propose a practice of decipherment as a progression on, and extension of, Taylor's "post-aesthetic critical practice" within the context of an imperatively needed "rewriting" of the human. Such an approach, I shall argue, necessarily negates not only the "specious autonomy" of cultural production but also, even more centrally, the represented autonomously determinant roles of social and material production. Because our present conceptual system of aesthetics and the models of analysis of literary and film criticism are themselves based on the premise of the "specious autonomy" of "cultural production" (as indeed of "social and material production"), a deciphering approach must necessarily move beyond the limits of even the most radical forms of literary criticism and theory—that of deconstruction as well as that of the "critical theory" frontier that David Bordwell recently parodied as SLAB theory, i.e., film criticism based on the scriptural theories of Saussure, Lacan, Althusser, Barthes.[5]

The summary which follows is intended to provide the major hypotheses and new conceptual terminology on which the proposal for a deciphering turn is based. These hypotheses and new conceptual terms arise from my attempt to answer the following questions: *What* does *aesthetics* do? What is its function in human life? What, specifically, is its function in *our* present "form of life"? What correlation does it bear with the "social effectivities" of our present order, including that into which the real-life citizens and "captive populations" of the U.S. inner cities and the Third World shantytown archipelagoes—like the hero, Ivan, in *The Harder They Come* and the Raheems and others of *Do The Right Thing*—are locked? What correlation therefore is there with the non-linear structuring dynamics of our present global order, as well of its nation-state subunits?

What Does Aesthetics Do? Summary Towards an Answer

"Human Life" is *not,* as it is believed to be in our present system of knowledge, that of a natural organism which exists in a relation of pure continuity with organic modes of life. Rather, human "forms of life" are a third level of existence, which institutes itself in a dual relation of continuity and discontinuity with that of organic life. It is, therefore, hybridly organic and meta-organic (i.e., discursive-symbolic).

While all organic modes of life are genetically "speclated"[6] and regulated in their behaviors, the aggregating and co-speciating behaviors of human "forms of life" are instead induced and regulated by the orders of discourse instituting of each culture. Human life cannot, therefore, *pre-exist,* as it is now believed to do, the phenomenon of culture. Rather, it comes into being simultaneously with it.

Consequently, if all purely organic species are bonded and co-speciated on the basis of their degrees of altruism-inducing genetic kin-relatedness (AGKR), then all human population groups are bonded and co-aggregated on the basis of their discursively instituted degrees of altruism-inducing symbolic kin-relatedness (ASKR).

The transcultural phenomenon of *aesthetic* is, therefore, I propose, the expression, at the level of human forms of life, of the AGKR that operates at the level of purely organic forms of life. As such a phenomenon, therefore, it is the *discursively and meta-organically* regulated expression of what Robert Wright defines as the "recurring logic behind organic coherence" of all life, "from the borderline case of the slime mold upwards,"[7] and, within the context of the evolution of cooperative behaviors, from that between cells to that between peoples, with both forms of cohesion being based on differing forms of communications whether chemical or, in our case, discursive-semantic.

Because it is a function of the securing of the modes of social cohesion based on the inducing of culture-specific cooperative behaviors on the part of its human subjects, the phenomenon of

Aesthetics and its discursive-semantic practice or rhetorical strategies, by means of whose meaning-signals such inter-altruistic behaviors are stably induced, must be governed by rules, at the level of human "forms of life," that are *analogous to the rules which govern the securing of "cooperative coherence"* at the level of organic life, rules which must all function, therefore, according to the semantic closure principle (SCP) which alone ensures such coherence.[8]

It is the rules of this governing principle, I further propose, which also govern the locking in, at the level of empirical reality, of Baldwin's "captive population" into the "high-risk areas" of the *First World's* (the "developed world's") inner cities, the locking in of those of the shantytown/favela poverty archipelagoes[9] of the "underdeveloped world" and, at the level of correlated fictional reality, the "locking" in of the Ivans and the Raheems into the no-win situation of shantytowns of Kingston and the decaying brownstones of Bedford-Stuyvesant.

To Redefine Aesthetic 1 and Aesthetic 2: The Role of Signifying Practices and Semiotic Strings

The recent point made by Gladstone Yearwood about the constancy of signifying practices of mainstream Hollywood paradigm, as one in which Black characters are always represented in a subordinate position to dominant white characters,[10] can therefore be seen as one that is predetermined by the rules of the semantic closure principle (SCP) which govern the instituting of our present culture-specific mode of the aesthetic or ASKR.

Consequently, Yearwood's further proposal, that we take all such signifying practices as *the* object of knowledge of our critical inquiry into the genre of film, if linked to Thomas Seboek's concept of "semiotic strings" of discourse whose meaning signals can directly induce physiological responses in the human body, thereby regulating behaviors, can provide the basis for a deciphering practice which seeks to identify the rules which govern their production *as* such practices and, therefore, the rules which govern the processes instituting of our present culture-specific mode of ASKR within a general theory of the rules of functioning of the processes instituting of human "forms of life."[11]

I have therefore used the terms Aesthetic 1 and Aesthetic 2 to draw a distinction between our present culture-specific definition of aesthetics and the new transcultural and, hopefully, scientific usage that the process of rethinking will propose; the phenomenon, therefore, of whose *class* our present mode of aesthetics is a member.[12] So that if Aesthetic 1 must necessarily function within the parameters of a specific imperative which I define below, our present mode of aesthetics and the signifying practices which institute its psycho-affective field must necessarily function within a parallel yet culture-specific imperative.

The imperative of Aesthetic 1 is to secure the social cohesion of the specific human order of which it is a function. It aims to produce the "unitary system of meanings" able to induce the altruistic psycho-affective field whose cohering mechanisms serve to integrate each specific mode of ultra-sociality or "form of life," doing this as stably as do the genetically induced modes of kin-related altruism (AGKR) at the level of purely organic life.

As a result, the rules which govern the production of all culture-specific, altruism-inducing, and cohering systems of meanings *must* function both rule-governedly and in ways that have hitherto transcended the "normal" consciousness of each order's individual subjects.

The constancy of signifying practices such as those of Yearwood's Hollywood paradigm derives, therefore, from the fact that they are, as practices instituting the aesthetics of our present ASKR, rule-governedly generated in ways that transcend not only the consciousness of the normal scriptwriter but also that of the mainstream cinematic critic whose model of analysis is that of

"literary criticism" extrapolated to the genre of cinema, whose disciplinary model, therefore, is itself transformatively generated from the same "paradigm of values and authority" which govern the instituting of our present mode of the aesthetic. i.e., Aesthetic 2.

On Paradigms of Value and Authority and Aesthetic 2: Danielli's Internal Reward System (IRS) and the Overriding of the Genetic Telos

The concept of "paradigm of value and authority" was used by the historian, J. G. A. Pocock, to differentiate the term "paradigm," as deployed in the "acts of communication" effected by the "public languages" of the disciplines whose object of knowledge is our societal mode of reality, from the term "paradigm," as used in the "separate languages" of the natural sciences whose objects of knowledge are those of physical (and organic) reality. Pocock's "paradigm of value and authority," I propose here, gives expression to what Ernesto Grassi calls the governing code by means of which human "forms of life" are instituted and their specific ensemble of behaviors regulated.[13] And, because this code is everywhere instituted about the representation of symbolic "life" (projected as *culture*) and "death" (projected as *raw nature*). It both governs the processes by means of which each human mode of the subject is socialized as such a subject and defines the semantic closure principle that integrates each order as a living system.

Humans, as Peter Winch points out, never live merely animate but always symbolic modes of "life."[14] So that Grassi's governing code can be seen as embodied and expressed everywhere in the mode of what Frantz Fanon defined as the always sociogenic and never purely ontogenic subject.[15] And, because the mode of sociogeny (of the subject) then predetermines the mode of the ASKR and semantic closure principle aggregative of each human order, the sociogenic principle instituting of such mode of being can therefore be seen to function at the level of human "forms of life," as the analogue of the genomic principle which governs the species-specific behaviors of all organic forms of life.

In the same way as each such genomic principle specifies and governs the way in which each member of a species *can* and *do know* their world with reference to the securing of the well-being and stable replication of its genome, so also, the sociogenic principle instituting of each order's mode of the subject, of being, presets the rules by means of which each such culture-specific mode of the subject *must* know (the episteme) and feel about (the psycho-aesthetics) its Self, Other, and social world.

Pocock's seminal differentiation between the "separate language" of the natural sciences and the "public language" of our societal knowledge, therefore, indicates that the disciplinary discourses of the latter are transformatively generated from the specific "paradigms of value and authority" which encode the sociogenic principle instituting of each mode of the subject. In effect, therefore, "Paradigms," in the sense used by the "public languages" of our disciplinary discourses (whose object of knowledge is their societal reality), are generated from the code of "culture" to "nature" or sociogenic principle which performatively enacts the "comprehension of being" of our present "form of life."[16] And, given that each such "form of life" is instituted, as such, by both the imaginative and the disciplinary discourses generated from the "tropic matrix"[17] of a specific governing code of symbolic "life" and "death" and its related criterion of "good" (life) and of "evil" (death), our present disciplinary practice of literary and film criticism is itself necessarily engaged in generating the "unitary system of meanings" or semantic closure principle (SPC) by means of which the psycho-affective field instituting of our present aesthetics (Aesthetic 2) is dynamically brought into being and stably replicated.

The systems of signification of literary and cinematic criticism must therefore necessarily function as a central part of what the biologist James F. Danielli calls, after Marx, the "opium of the people" order of discourse. Since it is on their basis alone, he further proposes, that the social cohesion of human orders can be secured. Writing in 1980, Danielli noted the importance of recent discoveries as regards the endogenous opiate receptors (endorphins) in the brain which, as another researcher, Candace Pert, later suggested, function to regulate the behaviors of organic species by triggering opiate-rewards whenever a member of the species displays the behaviors designed to ensure its own well-being as well as the stable perpetuation of its genome.[18] Using insights from these discoveries, Danielli put forward a central hypothesis with respect to all human "orders of discourse," including those of our present "public language" modes of knowledge.

The hypothesis is that the function of all orders of discourse is to recode the IRS or behavior-regulating internal reward system of the brain, that they do this by "conditioning" each culture-specific internal reward system in symbolically coded terms that can dynamically induce the mode of psycho-affective feelings by which the social cohesion of each order is then ensured. Each order of discourse must, therefore, function, in a literal sense, as the Marxian "opium of the people," whose "truth" is to be defined by the exactitude with which the value-connotations that their signifying practices place on the representation of symbolic "life" (which then serves as the icon of Sameness or of fake kin-relatedness) are positively marked ones that are then able to activate the internal reward system (IRS), thereby triggering its opiate-induced euphoria coefficient.

It is the correlation of each order of discourse (the semantic level) with the IRS (i.e., the biochemical reward and punishment level) which constitutes what Danielli defines as the "social program," by means of which the genetically programmed imperative of "group selfishness" (which is experienced at the purely organic level of life in terms of the degrees of genetic kin-relatedness) is, in the case of the human, overridden and recoded in the new terms of a symbolically defined mode of "artificial" kin-relatedness and of "group selfishness."[19] I shall propose here that the "social program" of each human "form of life" is clearly the same phenomenon as that of Aesthetic 1. "Social program" here designates the central mechanism by means of which each culture-specific ensemble of collective cohering behaviors are "conditioned" and induced, each order thereby integrated and stably replicated as a living system. However, because the "unitary system of meaning" or "semantic game" which conditions the psycho-affective fields of each mode of aesthetics must provide "truths," which, whilst "true" for those who are subjects of the culture-specific "form of life," are non-true for those who are not, I have adapted the term "Cultural Imaginary" in place of Danielli's "social program" to define the systemic dynamics of the phenomenon of Aesthetic 1.

I have taken the term from Cornelius Castoriadis's concept of the *Imaginary*. Castoriadis uses the term to refer to collective values that provide for unitary meaning and that are, however, logically unprovable.[20] Because each imaginary is necessarily culture-specific, with its "regime of truth" definable by the efficacy with which the signifying practices of its order of discourse serve to generate the positively/negatively marked "life"/"death" *meanings*, (Seboek's "semiotic strings") by means of which the IRS of each order is "conditioned" and recoded, the term, *Cultural Imaginary*, enables the phenomenon of aesthetics to be grasped in both its transcultural form, Aesthetic 1, and in the form specific to our present order, Aesthetics 2.

Universalizing the Particular of Aesthetic 2, Recoding the IRS in Terms of "Taste": "Locking" in the "Captive Population"

In his seminal book, *Distinction: A Social Critique of the Judgement of Taste,*[21] Pierre Bourdieu identifies the binary opposition ("taste of reflection"/"taste of sense") specific to our present aesthetics as one whose terms are also correlated, in its value-hierarchy, with the dominance of the middle class over the lower class at the level of the socio-political structure of our present order. Bourdieu's correlation of the discourse of the aesthetic with the social relation of dominance and subordination at the socio-political level of *class* is also replicated at the global socio-cultural level of *race*. At that level, the "taste of reflection" ("pure taste")/"taste of sense" ("impure taste") opposition and its socio-economic hierarchy, based on class difference, is correlated with the socio-economic value hierarchy between the western and non-western peoples and, since the rise of Japan after the Second World War, in the context of a consumer-driven economy, between, more generally, the peoples of the "developed" and those of the "underdeveloped" worlds.

If, as Bourdieu notes, the discourses of philosophical aesthetics take as their "sole datum" the lived experience of a *homo aestheticus* who is none other than the middle-class mode of the subject represented as "the universal subject of aesthetic experience," they also represent the lived experience of the western European and now, more generally, the "developed" world's middle classes, as the experience of the generic human subject of aesthetic experience. For, by its enabling of the socio-cultural categories of both *class* and *race* to be comprehended, as Bourdieu points out, in the case of class, "in the form of highly sublimated categories, such as the oppositions between beauty and charm, pleasure and enjoyment of culture and civilization," the discourse of Aesthetic 2 is then able to project *the taste* of the middle classes of the "developed" worlds—and therefore its culture-specific mode of aesthetic gratification and "preference" and, by extrapolation, its existential experiencing of our present socio-global universe—as the general equivalent of human "taste" and, therefore, its world and class-specific existential experience as the general equivalent of *all* human existence.

As Bourdieu points out, the "ideological mechanism" used by Kant in his philosophical aesthetics serves to represent the "taste" of the middle classes as a "taste" whose highly evolved nature had been "selected" by the evolutionary processes of natural selection. As such, it is further representable as the hierarchically higher "taste" of those humans who are sufficiently genetically evolved so as to be "occupied with thoughts as well as with their senses" and who are, therefore, able to give expression to the "taste of reflection." This is to be contrasted to the taste of the non-middle classes as the expression of the evolutionarily "backward" taste of "men wholly absorbed by their senses." Once in place, the "semantics of many steps"[22] generated from this binary opposition and its tropic matrix then enables the bearers of this "evolved" taste to be represented as the ostensibly a-culturally determined criterion of human "life value," whose behavioral model and existential experience, also evolutionarily selected, should be optimally imitated. Consequently, the way in which, for example, Hilton, the music industry entrepreneur in *The Harder They Come,* and Sal, the pizzeria owner, as well as the Korean produce retailer in *Do The Right Thing experience* the world *existentially* and psycho-affectively, in their roles as the embodiment of the ideal mode of the middle-class subject whose behaviors are optimal because regulated by the prescriptive Free Trade telos of "bettering their condition,"[23] is therefore both normalized and universalized by means of the "ideological mechanism" of our present discourse of aesthetics. It is by means of these processes of normalization and universalization that the Hilton/Sal/Korean group is enabled to embody the optimal behavioral model in relation to whose specific criterion the ensemble of global collective

behaviors, which bring our present global order into being, are dynamically induced and regulated. From the perspective of the Black and jobless Ivans and Raheems, the narrational procedures and signifying practices of *The Harder They Come* and *Do The Right Thing* forcefully call into question the "life-activity" and behavioral model embodied in the Hilton/Sal/Korean group of characters.

In a recent book, Lawrence Levine traces the first phase of the institution of this ideological mechanism at the level of "race," and the processes by which the terms *highbrow* and *lowbrow* were put forward as terms which marked the distinction between *evolved, cultivated,* and *pure taste,* on the one hand, and *backward impure taste,* on the other. Totemized in the opposition between Indo-European peoples and non-European "natives," these terms, derived from the pseudo-science of phrenology, were now used to separate the aesthetically *crude* (lowbrow) from the aesthetically *refined* (highbrow) and, therefore, to represent the "taste" of the middle class mode of the subject as being as genetically determined as was the brow of the "highbrow."[24] The pseudo-science of phrenology had itself been founded on the belief that differential degrees of intelligence—with the culture specific intelligence of the middle-class mode of the subject being represented as generic human intelligence[25]—had been allotted in varying degrees to each "ethnic" and "racial" population group, and that, therefore, these differential degrees could be assessed by measuring the typical cranial shapes and sizes of such groups.

I want to propose here that what is being represented and absolutized by *means* of the *highbrow/lowbrow* totemic figures is the idea or "speculative thought"[26] that the status hierarchies both of the global order and of its national units are as genetically ordered and predetermined as had, ostensibly, been also the hierarchy between the *"taste of reflection"* of the middle class and the *"taste of the sense"* of the lower classes. In effect, these illustrated representations are part of what Levi-Strauss defines as a totemic system, or system of symbolic representations, on whose basis the "speculative thought" of our present global order is as instituted as was that of the traditional orders analyzed (or rather deciphered) by Levi-Strauss.[27]

From the Genesis Narrative of Origin to That of Evolution, From the Leper to the "Captive Population" of the Jobless: On the Paradox of "Criticism"

The proposal here is that these processes of positive/negative marking which enact/inscribe the code of "life" and "death" are always initiated by the *narratives of origin* from which all such codes and, therefore, their "paradigms of value and authority" are brought to "birth." French anthropologist Lucien Scubla's analysis of a traditional myth of origin, as an example of this narratively instituted process, supports this hypothesis.[28] For in this myth, after a woman has committed a crime, is punished, and dies, her husband then picks the leaves of a tobacco plant which grows on the spot where she has died and her blood was shed.[29] The husband then cures the leaves of the plant. By smoking it with his fellow male peers, he becomes, with them, the collective procreator of a new symbolic "birth" whose totem or hyper-sign is the *positively marked* tobacco smoke that rises upwards (i.e., *culture*). The *menstrual blood* of the woman, on the other hand, is negatively marked as the sign of "raw nature" spilling downwards to the earth, the marker of symbolic "death." Here, the myth functions as an order-instituting "narrative of origin" which enacts the "code of life" *(tobacco smoke)* and "death" *(menstrual blood)* on whose basis the mode of the traditional "lineage" subject was "written."

Because this "writing" is only effected by the founding myth's systemic attaching of positively marked opiate-triggering meanings to the iconic emblems of "life," and of negatively marked ones to that of "death," the mythic system of representations is clearly a function of the recoding of

Danielli's IRS, since it is by means of this discursive recoding that the individual subject's libidinal desire to realize "being" is "soldered" to the order's culture-specific criterion of being. At the same time, this criterion bonds the subject to his or her symbolically defined "kin" by serving to induce the specific mode of altruism integrative of the order and, therefore, of its mode of cooperative social cohesion.

Anthony T. de Nicholas points out that humans have never been any one thing or the other since we have no "particular nature" to tie us down "metaphysically." Rather, he insists, we *can* become *human only* because of our ability to turn "theory into flesh" and to regulate ourselves by discourses "whose codings in our 'nervous system' regulate our responses and 'sentiments.'"[30] However, we can become and remain as specific modes of the *human* only to the extent that these *codings* continue to "tie" us down, metaphysically, to a *specific* criterion of being and representation of the human, to Grassi/Winch's governing code of symbolic "life" and "death."

The further hypothesis here, therefore, is that, for the tying down or "soldering" conditioning process to be stably effected, the "life/death" terms of the "codings" *must be* replicated at *all* levels of the social texts of the order, if the *coherence* of the conditioning processes of positive (opiate-triggering) and negative meanings are to be maintained. As a result, wherever the subordinated status of a group category (such as the extreme case of Baldwin's "captive population" in their "high-risk area" from whose rank both films' Underclass protagonists will come) is stably replicated at the level of the socio-economic text, this subordination and the social effectivities that go with it are an imperative function of the enacting of the sociogenic principle of code of "life" and "death" of the specific order, and, therefore, a function of the "cultural imaginary" by means of which the socially cohering behaviors of the order's subjects are induced and motivated, a function, therefore, of the process of "symbolic birth" by means of which both the mode of the subject and its related mode of ASKR are dynamically brought into being.

We can therefore make the following hypotheses with respect to the question, *what does Aesthetics do?* Firstly, each mode of the aesthetic is isomorphic with a specific mode of human being or "form of life." Secondly, both the distributional ratios and the "socio-political" role allocations of each order, while functioning, in the terms of our present order, at proximate levels as the "economic" and the "socio-political," are *ultimately* a rule-governed function of the phenomenon of the Aesthetic I. Thirdly, they are functions of the narratively instituted cultural imaginary (Danielli's "social" program) by means of which each order's altruism-inducing and aggregative "unitary system" of positively (opiate-triggering) and negatively (opiate-blocking) marked meanings are as coherently replicated at the level of empirical social reality, as they are at the levels of (a) the founding narrative of origin, (b) the social text, (c) the disciplinary discourses of Pocock's "public language" systems of knowledge, including that of criticism, and (d) the level of the imaginative discourses and mode of artistic production. Fourthly, each of these levels must function correlatedly with the others, if the order's specific code of "life" and "death" or sociogenic principle is to be regularly brought into being.

Finally, it is only by means of these rule-governed positive/negative correlations at all of these levels that the "conditioning" processes, by which humans are "socialized" as specific modes of the subject and, therefore, as always already altruistically aggregated and symbolically kin-related individuals, can be effected. Processes that are, therefore, those of symbolic speciation or of intra-group bonding which function at the level of human forms of life in a manner that is as discursively rule-governed as are the genetically programmed modes of speciation or of inter-altruistic "kin relatedness" specific to the level of purely organic life.

[In this section of her essay, Sylvia Wynter summarizes the ways in which the correlations between the four levels *a, b, c, d* are effected.—Ed.]

In her book, *Power of Horrors: An Essay on Abjection*,[31] Julia Kristeva makes a seminal point with respect to the functioning of the psycho-affective phenomenon of abjection (or of Lancanian Lack-of-being), in all human societies. This state, which is one of anxiety and is literally experienced as *nausea,* the desire to retch, to expel oneself, is induced by the inscription of a prohibited sign-complex, i.e., the abject. Although common to all orders, all the earlier forms of the abject would come to be subsumed, by the world religion of Judeo-Christianity, under the topos of mankind's enslavement to original sin within the logic of the Christian variant of the Biblical Genesis or narrative of origin. Like all the earlier forms of the abject, however, I then argue, the new topos served the central systemic function of impelling the individual subject of feudal Christian Europe to attach its genetic instinctual desire to realize being to the *specific* criteria defining of the ideal self of the feudal Christian mode of the subject, and, therefore, of a subject who is always already socialized to be conspecific, at the psycho-affective level, with its fellow feudal Christian subjects. I further generalize another seminal point made by Kristeva in order to put forward the major formulation of this section of the essay. Kristeva had pointed out that the scholastic order of knowledge (as the "public language mode of knowledge" of feudal Christian Europe, to use Pocock's terminology) had been elaborated on the pre-analytic premise of the topos of mankind's enslavement to original sin as the now universalized sign-complex of the abject (or Lack-of-being). On the basis of this, I propose that *all* culture-specific modes of "public language" knowledge, including our present one, are necessarily based on the pre-analytic premise of the inscription of the abject and its sign-complex, whether that of Scubla's negatively marked "menstrual blood" or that of original sin. Consequently, in every human order, each such sign-complex of the abject is everywhere empirically embodied in an interned and excluded group category whose role as the pariah figure(s) of the order is indispensable to the verifying of the "regime of truth" orienting of the shared perceptions, and, therefore, of the collective behaviors by means of which each order is brought into being and stably replicated *as such an order.*

I base this generalization on two interrelated points, one made by Jacques Le Golf in his book, *The Medieval Imagination*[32], the other by the ethnologist, Marcel Griaule. In the medieval order, as Le Goff demonstrates, the exclusion and ostracism of the pariah figure of the leper, and of its interned and "captive population" (as, in effect, the embodiment of Kristeva's *abject)* had been legitimated by the "learned discourse" of the scholastic order of knowledge. This discourse had represented leprosy as proof that the leper's parents had breached, with their sexual incontinence and "wicked and lustful desires," the rules of the Church with respect to licit sexual intercourse. Their progeny's leprosy was, therefore, the direct effect of divine or supernatural punishment for the parents' incontinence, as was the leper's prohibited exclusion and ostracized status outside civil society.

As the empirical embodiment of the sign-complex of the abject, the "captive population" of the excluded lepers not only serve to induce and trigger in the individual subject the desire to behave in ways appropriate to a "redeemed-from-original-sin" feudal Christian subject, but also to induce all social categories of the feudal order, including that of the super-exploited peasantry, to accept the roles assigned to them in the social hierarchy. That is, as roles that were as ostensibly supernaturally pre-ordained as was that of the excluded figure of the leper itself within the logic of the "learned discourse" of the order's "public language" mode of knowledge. The existence of that "captive population" and of its pariah figure, the leper, was therefore the empirical verification

of the pre-analytic premise on whose basis the scholarly discourse of the feudal episteme was rigorously elaborated and made to count as true.

In order to put forward the following historical progression, I then make use of Marcel Griaule's insight that all forms of western societies (up to and including our present globally hegemonic one) are still regulated, despite changes in their differing modes of production, by the "ultimate reference point" of the Judeo-Christian symbolic system.[33]

Firstly, that with the cultural and intellectual revolution of civic humanism and the "general upheaval of the Renaissance" the pre-analytic topos of mankind's enslavement to original sin was transumed into that of its represented enslavement to sensory, irrational nature within the logic of the new monarchical political regime and its later variant, the landed gentry. The figure of the leper was, therefore, replaced by the interned and excluded figure of the *mad,* while the place of the "learned discourse" on leprosy was taken by that of the discourse on insanity. At the same time, the "internment" of the indigenous peoples of the New World in a semi-serf relation and of peoples of African descent as slaves on the New World plantation system was also legitimated by the discourse on their Caliban-type irrationality, a discourse which, because it was generated also from the "ground" of the post-feudal "public language" order of knowledge and its classical episteme, elaborated itself within the same terms as the discourse on insanity on whose basis the *mad* had also been interned. Taken together, therefore, all these three "captive populations" were now the empirical embodiment of the pre-analytic premise on whose basis the disciplinary discourses of the classical episteme of the pre-industrial order were elaborated, the condition of its "truth."

Secondly, that with the shift to the industrial order, the intellectual revolution of liberal humanism, together with the rise to hegemony of the new bourgeois mode of the subject and its correlated nation-state mode of symbolic kin-relatedness, the Judeo-Christian topos of enslavement was again reinscribed and transumed. In this shift, the new figure of the *poor and jobless* now displaced the earlier pariah figures. Baldwin's "captive population" of the inner city ghettoes (the world of *Do the Right Thing)* and of the Third World's slums and shantytowns (the world of *The Harder They Come)* now served as the embodiment of liberal humanism's inscription of the abject in new and purely secular terms. These terms were dual. On the one hand, the abject was now inscribed as that of mankind's enslavement to a possibly *evolutionary* regressive and genetically dysselected mode of human nature (as empirically expressed in peoples of Black African descent and, to a lesser extent, in *all* non-white peoples) and, on the other hand, as that of its potential enslavement to the "natural scarcity" of external nature, and, therefore, to the threat of the insufficiency of the earth's resources, as verified by the empirical condition of the new pariah figures of the *poor and jobless.* Consequently, in the place of the "learned discourse" on leprosy and insanity of the earlier two orders, the "learned discourse" of our present order rule-governedly functions to represent *poverty* and *joblessness* as having been caused, *not,* as they are, by the institutional mechanisms of the order, including the behavior-orienting "discourses" of its episteme, but by the *evolutionarily* dysselected genetic incapacity of their bearers, that is, of the "captive population" of the *poor* and *jobless.* Reciprocally, this "learned discourse," like the overall range of the disciplinary discourses of the episteme from which it is generated, also depends on the stable reproduction, in empirical reality, of Baldwin's "captive population" for the "verification" of its "truth," and, therefore, of the "truth" of the overall cultural imaginary in whose logic it functions, just as that of the scholastic disciplinary discourses had depended for their "truth" on the stable reproduction of the excluded and ostracized "captive population" of the lepers.

In the context of the above, the contradictory paradox in which our present disciplinary practice of film criticism necessarily finds itself when approaching films like *The Harder They Come* and *Do The Right Thing*, whose protagonists are now the systemic pariah figures of the Ivans and the Raheems and their respective "captive populations," is clear. As professional academicians and, therefore, as the "normal critics" or observer-knower-subjects of our order who are, like those of the feudal order, accomplices in an "epistemic contract"[34] whose function is to provide the "unitary system of meaning" on whose basis the order is aggregated (with the "captive population" in each case marking a frontier of the inside/outside of the aggregated order), we find ourselves with the imperative of "breaking" this contract when confronted with narrative structures (like those found in *The Harder They Come* and *Do the Right Thing*) whose performative acts of counter-meaning, encoded both in their signifying practices as well as in their Black popular musical forms, can be properly evaluated *only* in the context of the challenge that they make to the cultural imaginary instituting of our present order.

We can now answer the question "what does aesthetics do?" by defining its phenomenon, as instituted by each cultural imaginary, as the imperative enactment of each governing code of subject/abject, of symbolic "life" and "death," and, therefore, of the non-genetic and symbolic modes of psycho-affective altruism aggregating of all human orders up to and including that of our own present nation-state. Consequently, because it is clearly the very condition of existence of all human "forms of life," and of the role-allocating and "cohering principles" aggregative of their modes of conspecific ultra-sociality, the category of the aesthetic is the determinant—in place of the "human nature" of liberal humanism, of the "mode of production" of Marxism, and of the patriarchy of feminism—of the ensemble of collective behaviors by means of which each human order effects its autopoeisis as a living, self-organizing (i.e. cybernetic) system.

However, if this is what aesthetics does, then the paradox of all "criticism" is sited here. For given that, as Bourdieu reveals, the *taste* of reflection is systemically conditioned, as *such a taste*, by the discourse of aesthetics itself and, even more directly, by the "ethico-aesthetic" practices[35] of literary and film criticism themselves, correlated with those of all our disciplinary discourses, then these practices are necessarily a central function of the conditioning of the psycho-affective field of normative sentiments by which we are collectively *induced* to behave in specific *ways* able to bring our present global order and its role allocated hierarchies into being—including that of the "ostracized" and interned high-risk area of the global jobless and lumpen archipelagoes, and their locked in and "captive populations" as the now primary embodied bearers of the antonymic sign-complex of the abject.

Because the plot line of both films is based on the attempt of the two pariah-turned-hero protagonists to break out of the "captive" role imposed upon them (in a now consumer-driven economy, in which the *taste of reflection/taste of sense* opposition is increasingly recoded as that of *brand name* elite consumer taste versus mass taste), and, therefore, to, in the words of Ivan, "get my share/what's mine," whether through the legitimate route of the music industry or through the savage and contraband route of the gunman-cum-drug dealer to which Ivan inevitably turns,[36] it is precisely the normative sentiments of our present mode of the cultural imaginary *against which* their signifying practices are aggressively directed.

As the applied practice of our present mode of the aesthetic, the disciplinary model of film criticism, must, like literary criticism, and in spite of its genial breakthroughs, such as the concept of spectatorship, nevertheless, serve to ensure the stable functioning of the conditioning processes by which the IRS (Internal Reward System) is recoded in the terms of our present code of "life" and

"death." So that in spite of its most radical approaches, its disciplinary paradigm *must* necessarily, in the last instance, function to contain, defuse, and neutralize the counter-signifying practice of *The Harder They Come* and *Do The Right Thing*, within the dynamics of an ongoing "battle of taste" between our present hegemonic cultural Imaginary and that of a still emergent global popular imaginary whose most insistent challenge is carried by the new video-like Black popular musical forms[37] and their counter-poetics of rhythm.

Against our present practice of criticism even in its most deconstructive and "rhetorically" demystifying forms, this paper, therefore, proposes a turn towards a deciphering practice based on a new postulate of causality in place of the "human nature" causality postulate of our present cultural imaginary, in place, also, of its counter-versions,[38] i.e., the "mode of production" causality of Marxism, and the "patriarchy" postulate of causality of feminism. This new postulate is that of the correlated discursive-cum-biochemical causality of our narratively instituted "cultural imaginaries", their modes of the subject, and "forms" or "ways" of life. It is these "Imaginaries," and the modes of altruistic symbolic kin-related-ness (ASKR) they induce, that necessarily set the parameters of possibilities both for the stable replication of the pre-assigned "places" of the group-categories of our order (while allowing the odd individual subject who breaks out of its place to attain to middle-class status and to the maximum of freedom) and for the fictional projection of these group-categories and their role-allocated places at the level of representation,[39] in terms which normatively legitimate the process of role-allocating hierarchies.

A deciphering practice, therefore, sets out to take the image/sound signifying practices of film (and television) as the objects of a new mode of inquiry, one that will and can, in the words of Heinz Pagels, erase the "traditional barriers between the natural sciences and the humanities" in order to make our "narratively constructed worlds" and their behavior-regulating "orders of feeling and beliefs," in other words, our cultural imaginaries, "subject to scientific description in a new way."[40] Such a practice will reveal their rules of functioning rather than merely replicate and perpetuate these rules.

"We will not be," sang Bob Marley from the "captive" high risk area of the Kingston shantytown that is the setting of *The Harder They Come*, "what they want us to be."

We've been treading
On the winepress
Much too long
Rebel, rebel...[41]

PART II — After Criticism, Beyond the Winepress: Towards a Deciphering Turn

Because of the central role they play in our purely secularly instituted systems, the interpretative strategies of all literary critical practice, including the most radical, must necessarily be governed by the "rules of the game", i.e., by the sociogenic principle of "code" that is determining of our present mode of being and "form of life." In this context, the powerful challenge of the Black Aesthetic movement of the 1960s to the normative practice of literary criticism's applied aesthetics, even if aborted,[42] would trigger, within the mainstream itself, new questions which erupted from a growing awareness of this realm of "unfreedom" that haunted critical practice, even if this awareness was translated into terms which enabled it to be "domesticated" in order to "save" the discipline.

In his 1980 study, *Criticism in the Wilderness: A Study of Literature Today*,[43]Geoffrey Hartmann discusses the crucial question raised by philosophical criticism with respect to the rules which

must govern discourse if it is to be intelligible to its readers and hearers. Hartmann points out that the real issue is "not whether we are for, or against the rules" which define the "bounds of intelligibility," given that "we all must live by some rules," but rather the question as to how we are to understand the "rules of language" as the rules of a game "that is partially unknown and that seems to allow the most unusual moves without jeopardizing its formal or Intelligible status." He defends the "separate status of literary criticism" as a "garden in the wilderness," able to both accept and deal with the partial unknowability of the rules of the game during the act of interpretation.[44] For Derrida, more radically, on the other hand, there are no preset rules of the game. Rather, both the textual objects and their interpretations are components of *écriture* or *writing* which function to "set off in the reader an unconstrained or 'creative' play of unlimited significations." Because of their shared assumptions, since both the interpreter of Hartmann and the reader of Derrida are free to autonomously give themselves over to modes of interpretation or to the free play of unlimited significations, both critic-theorists fail to see that, whether as reader or as interpreter, the subject is always already instituted as a specific mode of the always sociogenic subject for whom the rules of the game, whether those determining of all possible interpretations or of the unlimited play of significations that can be set off, are necessarily always already preset and made rigorously *decidable* by the governing sociogenic principle which institutes the reader/interpreter as such a reading/interpreting mode of the subject.

Consequently, the radical approaches of Hartmann and Derrida continue to provide the allegorical exegesis which "saves" the governing "culture to nature" code instituting both of the middle-class mode of the subject, as well as of the post-religious variant of the Judaeo-Christian "cultural Imaginary" that is integrative of our present global order and its hierarchies. As a result, if, as Hartmann points out, "literature is to the modern mind as the Bible was to medieval thought," literary criticism must also necessarily function as a kind of "allegorical exegesis" which, like that which Arnold deconstructed, must function to "save" its premise of the genetic pre-giveness of "man", together with its governing code of "life" to "death," "culture to nature," Greek to Bantu, highbrow to lowbrow, the pure taste of reflection to the impure taste of the sense. Literary criticism must do this despite the "disabling impact of the experience of concrete reality"[45] such as the price paid for the replication of our present form of life and of its processes of symbolic birth by the "throwaway lives" of the Ivans in the "high-risk" ghetto and shantytown archipelagoes of the global system and now, increasingly, by the rapidly deteriorating planetary environment.

What is true of the deconstructionists is no less true of the post-1960s attempts of Marxist and feminist criticism to counter traditional liberal literary criticism with their respective "Ideologies of Otherness." If these have only succeeded in adding the variant figures of proletarian "man" and of "woman" to that of liberalism's "figure of man," the recent attempt by Henry Louis Gates to counter traditional literary theory and its canon by the instituting of the figure of an African American man complete with its own indigenous literary theory and canon[46] has lead instead, as Taylor warned in the parallel case of the Black Aesthetic movement (whose original dazzling eruption was aborted by its being stalled in an ethno-aesthetics), to an ethno-literary criticism and to the reinforcing, therefore, of our present cultural imaginary, together with its still pervasive realm of unfreedom.

Because they are generated from the matrix form of literary criticism, all variants of film criticism function also according to the same "rules of the game" and their heteronomously determined end, i.e., the dynamic bringing into being and stable replication of our present "form of life" and its discursive formation. So that, if Yearwood's observation about the consistent regularity of the hierarchy between white (men and women) and Black (men and women) reveal these practices as belonging to the same archives of communicative acts at the level of lowbrow culture, as the

constancy and regularity between the "taste of reflection" and the "taste of the sense" that is brought into play by the very discriminating practice of literary and, by extension, film criticism, at the level of highbrow culture, then both systems of signifying practices can be recognized as being governed by the pre-analytic code of "culture to nature" instituting of our present comprehension of being and its mode of ultra-sociality. Consequently, even where the founding opposition between the *taste of reflection* and the *taste of the sense* is translated by Marxist/feminist deconstructionist and "African American critics"[47] into the correlated oppositions of *critical theory and scientific truth versus false consciousness*, or *gender-conscious* versus *phallocentrically non-conscious*, or *rhetorically aware deconstructionist practices* versus *rhetorically unaware practices*, or *close reading practices aware of the Black "tradition"* versus *sociological approaches to Black literature or cinema*,[48] together with the cluster of binary oppositions arising from the variants of Bordwell's SLAB theory, the same "rules of the game" are kept in play. This reveals that *it is the* disciplinary practice of criticism itself, not *what* is said or the approach taken, that functions to "save" the premise of our present cultural imaginary, the premise of its "genetic system of justice" in whose context the bid for self-affirmation on the part of Ivan, as of Raheem, must necessarily fall or turn to "contraband and savage ways."

As the literary critic Frank Kermode recently pointed out, film has come to be accommodated in the interpretative system of literary criticism only under the category of "a certain literature" that "the Germans call *Kleinletrateur* or trivial literature."[49] It has therefore been so accommodated only in a sort of "deutero-canonical" sense. Therefore, film criticism has, in general, been necessarily marginalized within the logic of literary criticism proper, even if the occasional "classic" film is allowed to be sacralized as "high art."

Because the praxis of criticism (in its later liberal-humanist form), as part of the book-print culture, is so central to the instituting of the "figure of man" and its related middle class mode of the subject (and to the latter's self-representation as a genetically determined rather than discursively instituted mode of being), the mere "deutero-canonical role" accorded to film as a technology whose medium can potentially break down the barrier between the *highbrow/lowbrow, pure taste/ impure taste* hierarchies instituting of our present "set of perceptual orientations," has been part of a strategy of containment designed to neutralize the challenge of the new technology's non-middle class inclusiveness.

The deutero-canonicity accorded to the genre, therefore, functions, on the one hand, to contain any theoretical approach to film within the terms of the book/print paradigm of literary criticism and the archive of communicative acts to which it belongs and to resolve, on the other hand, a central contradiction between the intended class-exclusive and academic reader of film criticism and the intended popular audience normally imposed on the genre of film, both by its inclusive audiovisual medium and by the "democratic universalism" of its consumer market logic which calls for the greatest possible number of ticket purchases.[50]

The specific danger here, for the "Third World" intelligentsia, is that of falling into a trap parallel to the ethno-aesthetic trap of the Black Aesthetic theorists, as well as the ethno-literary trap into which Gates and his school have fallen. This trap lies in the temptation which confronts the Third World theorist when, in order to attempt to bridge the gap between the class and culture-inclusiveness of academic film criticism and the intended popular audience of Third World filmmakers, she or he should attempt to claim and identify an "ethnic" and cultural-indigenous tradition inherent to these film texts and to repress, thereby, all awareness of the dialectical nature and socio-culturally "countering" aspects of the signifying practices of the films themselves.[51]

Against our present mainstream practices of literary and film criticism, therefore, the turn towards a deciphering practice is posited in a dialectical relation both to these practices and to ethnocriticism, on the one hand, and, on the other, to the "deconstructive turn" in criticism, as itself the summation of Bordwell's SLAB theories of radical criticism.

In his analysis of literary criticism's turn to deconstruction, Christopher Norris argues that "deconstruction bids fair to overthrow the age old prejudice which elevates philosophical truth and reason at the expense of literary feigning."[52] Because, however, a deciphering turn bases itself on the premise that human modes of being are institutable only by means of systems-of-representations and, therefore, of "feigning," it sees the "age old prejudice" as itself a part of the "feigning" specific to the cultural field of western Europe. It therefore defines the binary opposition, *philosophy/truth reason* versus *fiction/literary feigning,* as a meta-truth or governing code from whose pre-analytic matrix, as a founding "paradigm of value and authority," the discourses of "philosophic truth and reason" are *then* rule-governedly and transformatively generated. So that while for a deciphering turn the issue becomes one of revealing the rules of functioning of this process of transformative generation, for the deconstructionists the issue remains tied to a still culture-bound and moralistic imperative—that of using the techniques of rhetorical demystification developed by literary "critics" to reveal the "makedness" or "writing" of "philosophic truth and reason."

Rather than seeking to "rhetorically demystify" (How could one stop at philosophy without also "rhetorically demystifying" the practice of *literary criticism* and its process of rhetorical automystification also?), a deciphering turn seeks to decipher *what* the process of rhetorical mystification *does.* It seeks to identify not what texts and their signifying practices can be interpreted to *mean* but what they can be deciphered to *do,* and it also seeks to evaluate the "illocutionary force" and procedures with which they do what they *do.*

Unlike a critical practice which must seek for the "meanings" of the text in the text alone (as if one should seek for "meaning" of DNA in the DNA code, rather than in the *effects* of its instructions), a deciphering practice will seek to function correlatedly at four levels. The first level investigates the "signifying practices" of the text itself. The second level investigates the specific social environment or cultural dimension specific to the film text as a performative complex of meanings or "symbol-matter information system"[53] which is structured by the terms of the behavior-regulating code that brings it into being as such an environment/dimension. The third level brings the results of the first two levels together in order to correlate those constancies and regularities which replicate each other at the level of the film text, as well as that of the socio-environmental effectivities of its social text, for example, the constancy and regularity of the signifying practices noted by Yearwood at the level of the Hollywood text and the parallel regularity and constancy, noted by researchers in multiple fields, of the differential ratio-proportionality of the distribution of the order's "goods" and "bads," as between the white and Black population groups, as between middle class and non-middle class, working class and jobless, male and female, developed and "underdeveloped" worlds, at both the national and the global levels of the order.

At this third level then, all correlations between the dominant/subordinate, positively/negatively marked roles with respect to the signifying practices of representation and those with respect to the social text's empirically verified distributional ratios of power, wealth, privilege, and social strata, in effect of the "goods" and "bads" of the order, will provide the data from which to deduce *what* the signifying practices, at the level of representation and their performative acts of meaning, are *intended to do*—that is, *what* collective behaviors they are intended to induce and how precisely their practices of signification are enabled to function as, in Rorty's terms, "our present metaphysico-epistemological ways of firming up our habits."[54]

The fourth level is the level on which the proposal of such a practice altogether turns. Such a practice is intended to provide a "separate language" able to deal with how, as humans, we can know the social reality of which we are both agents and always already socio-culturally constituted subjects. This level will, therefore, call for our collaboration—as decipherers of our discursively instituted systems of meaning, or as rhetoricians in the wider sense used by Paolo Valesio[55]—with neuroscientists, on the basis of Danielle's proposed correlated functioning of the orders of discourse of human orders and their rule-governed "production of meaning" with the functioning of the behavior-regulating opiate reward and punishment system of the brain. At this level, the hypothesis, to be tested here, is that there is a rule-governed correlation of the orthodox signifying practices of any order with the status-ordering distributional processes of the "goods" and "bads," as well as of the role allocations of its status hierarchies. It is only by means of such a correlation that each order's "social production of meanings" *can* function to "condition," and, therefore, to "write" (in terms of the specific code of *symbolic life* and *death*) the *biochemical* "reward/punishment" (opiate) system by means of whose "instructions" our behaviors as *human*, rather than as purely "natural organisms," are "programmed," motivated, and oriented and by means of which we ourselves are "written" as specific modes of the human.

The further hypothesis here is that it is precisely against our present orthodox "writing" of the bio-chemical "reward/punishment" (opiate) system that the counter-signifying practices of *The Harder They Come* and *Do The Right Thing* and Black popular reggae and rap are directed; it should be testable and verifiable that these counter-signifying practices induce such a counter-writing and, therefore, such a counter-politics of "feeling" within the context of an emergent new "battle of tastes" between the western middle-class cultural imaginary, whose referent telos is that of the well-being of the middle-class *mode* of the subject, and that the still emergent (and still bitterly contested) global popular imaginary whose referent telos is that of the well-being of the individual human subject and, therefore, of the species.

We Will Not Be What They Want Us to Be: From the Mathematizable to the Decipherable

While referring back to formalism's general theory of aesthetics,[56] our proposed deciphering praxis will follow, in the wake of Clyde Taylor's move toward a meta-aesthetics, one able, in his words, to devise a Nietzschean type genealogy of aesthetics (i.e., of culture-specific psycho-affective sensibilities) on the model of a genealogy of morals. It further proposes that such a genealogy would necessarily take us into the parameters of a new science of human modes of being, their "narratively instituted worlds" (Pageis) and "opiate" orders of discourse (Danielli), able to put an end to the division between the paradigms of the "separate languages" of the natural sciences and those of the "public languages" of our present disciplinary discourses and their archive of communicative acts and unitary systems of meaning by which we have been hitherto instituted as heteronomously governed and, therefore, non-self knowing, subjects.

Here the new horizons opened by the film text's visual medium and its narrationally foregrounded signifying practices directly impact on the new question posed implicitly by Fanon as to how the human subject is itself instituted *as* specific modes of the sociogenic subject by the signifying practices of each culture's order of discourse, in this context, the question raised by David Bordwell as to how films in their "formal and stylistic operations" are able to "solicit story-constructing and story-comprehending activities from spectators" would now be approached in the wider context of our investigation into the dually discursive-cum-biochemical processes by means of which each mode of the human self "writes" itself. So that Bordwell's projected goal-directed

spectator could now be grasped as an always goal-directed spectator on the basis of his/her being a culture-specific mode of the subject. As such, as one who is always already equipped with a schemata for reception that is itself generated from the governing code of "life and death" ("culture to nature") from which the "assumptions" are to be made, the "expectations to be formulated," the "hypothesis to be perfected" are always normally pre-determined, unless and until, of course, that *schemata,* together with its governing code, is directly challenged and called in question by contestatory signifying practices as, for example, with Bahktin's[57] new cultural forms at the end of the European Middle Ages or those of *The Harder They Come* and *Do The Right Thing* at the moment, the ending of the global ours.

The autonomy of human knowledge of physical and organic reality and, therefore, the "separate language" of the natural sciences was won by western thinkers and scientists only on the condition of their continued heteronomy of cognition with respect to the processes by means of which we are instituted as specific modes of being (the subject) and of ultrasociality ("forms of life") or cultures.

This heteronomy was, and is, based on the belief system of ontocentrism—that is, that the human pre-exists the complex of signifying practices and discursive systems by means of which it is instituted as such a subject or mode of being; that, therefore, in effect, the laws which govern human behaviors are the *same* as, rather than *analogous* to, those which govern physical reality (the Cartesian "definitive morality") and organic reality, (the Darwinian "definitive morality").[58]

A deciphering turn necessarily calls ontocentrism into question. Not only does it insist, as the founding premise of its own practice, that the human, because always discursively instituted, is an "outcast" of nature, for whom the laws which govern nature, because only analogous, cannot provide any mode of knowledge which prescribes an *ought* to human behaviors, but it also proposes a new "ground" on whose basis the discursively instituted rules which govern human behaviours can be known. This "ground" also bases itself on a prohibition, one which is directly linked to the counter-signifying practices of *The Harder They Come.* For in the wake of Fanon and of Carter G. Woodson and from the new "lay" or neohumanist perspective of Black Studies,[59] It proposes that the way we "normally" feel about Self, Other, and World should not be taken as any index of the "justness" or legitimacy of the ratios of distribution of power, privilege, and role allocation which lead to the social effectivities both of the throwaway lives of the high-risk areas and the over-consumption of the suburbs.

Rather, a deciphering practice takes the existing inequalities of our order, both as the expressive enactment of the governing code of life and *death* and as the *index* of the "rhetorical mystifications" that must be at work, in order to determine *how* the order should be normatively felt about and known, if the collective behaviors that bring the structuring processes of the order into being are to be dynamically induced and stably replicated.

A deciphering practice proposes, therefore, that the *ways* in which each culture-specific *normal* subject *knows* and *feels about* its social reality (such as the way the entrepreneur Hilton in *The Harder They Come* and Sal the pizzeria owner in *Do The Right Thing* feel about their realities) should in no instance be taken as any *index* of what the empirical reality of our social universe *is.* Rather these *normal* ways of knowing and feeling (together with the signifying practices which induce these "normal ways") should be taken as the index of *how* each such world *must* normally be known and felt about, as the indispensable condition of each such world being brought into existence by the collective behaviors which all such culture-specific normal ways of knowing and feeling about the world, including our own, rule-governedly orient and regulate.

Descartes' rejection of the premise that God had made the physical universe both for the human's sake and with human concerns in mind enabled him not only to reduce the physical world to pure materiality, thereby making it mathematizable, *but also to propose* that such a reality could now be *alterable* and producible in accordance with human purposes, "to the extent that it proves to be inconsiderate for men."[60] Equally, a deciphering practice's rejection of the ontocentric definition of the human and, therefore, of the Cartesian and Darwinian premises of any purposes given to humans by *nature*, rather than by the discursive-cum-neurochemical signalling systems by which we are instituted as a meta-organic form of life, proposes that "human purposes," like the modes of the subject, of sociogeny, of which they are the correlate, are also to be seen as alterable, to the extent that they have proved to be inconsiderate, both for the human species as a whole (witness the ongoing deterioration of the set of conditions of the planetary environment by means of which the species is alone viable) and, most directly, for the concrete individual subject of the jobless archipelagoes, for the Ivans, for the Raheems, for all the Pariahs.

<div style="text-align:center">"We will not be what they want us to be"</div>

The proposal here is that, if we provisionally reduce all our present public language "discourses," epistemic and imaginative, to their function as Danielli's "opium of the people" discourses instituting of our altruistic human orders and modes of being and reduce their variety of genres and types to their function as pure behavior regulating systems of meaning or extra-genetic signalling systems that are complementary to, and regulating of, the signalling systems and IRS of the brain, then we can take the empirical behaviors and social effectivities to which they lead (including their pre-programming of the defeat of Ivan's and Raheem's bid for self-assertion in the context of our present code of "life" and "death") as the data which makes them decipherable and, therefore, as the data which gives insight into the rules which govern the signifying practices by which we are instituted as specific modes of the subject. These modes now, because humanly knowable, are potentially, consciously, and consensually, alterable.

<div style="text-align:center">"We've been treading on the winepress much too long...."</div>

Notes

1. Clyde Taylor, "Black Cinema in a Post-Aesthetic Era," in *Questions of Third Cinema*, Jim Pines and Paul Willeman, ed. (London: British Film Institute, 1989), 90.
2. James Baldwin, *The Evidence of Things Not Seen* (New York: Henry Holt & Co., 1985), 35–36. Baldwin's essay was written both as a report of the trial of Wayne Williams in the Atlanta child murders case and as a reflection on its implications.
3. See Frank Kermode, *The Art of Telling: Essays on Fiction* (Cambridge, Mass.: Harvard University Press, 1983), 181.
4. See Clyde Taylor, "We Don't Need Another Hero: Anti-Theses on Aesthetics," in *Blackframes: Critical Perspectives on Black Independent Cinema*, Mbye B. Cham and Claire Andrade-Watkins, ed. (Cambridge, Mass.: M.I.T. Press, 1988), 80–85, and "Black Cinema in the Post-Aesthetic Era," in *Questions of Third Cinema*, Jim Pines and Paul Willemen, ed. (London: British Film Institute, 1989), 90–110.
5. See the article by Scott Heller, "Once Theoretical Scholarship on Film is Broadened to include History of Movie Industry Practices". In *Chronicle Of Higher Education*, 21 March 1990, A-6. Heller refers to Bordwell's attack in a new book, *Making Meaning: Inference and Rhetoric in the Interpretation of Cinema* (Cambridge, Mass.: Harvard University Press, 1990), as "tweaking" the film studies establishment for "mixing and matching theories without precision" in its canonical approach. Bordwell periodically defines this approach as "SLAB theory" and derives it as an acronym which refers "to the last names of the writers slavishly invoked," the linguist, Ferdinand

de Saussure, the psychoanalyst, Jacques Lacan, the Marxist philosopher, Louis Althusser, and the semiotican, Roland Barthes.

6. For the concept of *speciation* at the levels of organic and of human "forms of life," see Ernst Mayr, *Evolution and the Diversity of Life: Selected Essays* (Cambridge, Mass.: Harvard University Press, 1976) and Erik Ericson (who uses the term *pseudo-speciation) Toys and Reason* (New York: W. W. Norton, 1977). See also my own essay, "On Disenchanting Discourse: Minority Literary Criticism and Beyond" in *The Nature and Context of Minority Discourse II*, no. 7 (Fall 1989): 207–44.

7. See Robert Wright, *Three Scientists and Their Gods: Looking for Meaning in an Age of Information* (New York: Times Books, 1988), 196–98.

8. The concept of a "semantic closure principle" is borrowed from the biologist Howard Partee's description of the integrative functioning of the cell. The proposal is that human orders *should* function according to analogous principles. See Howard H. Partee, "Clues from Molecular Symbol Systems" in *Signed and Spoken Language: Biological Constraints on Linguistic Forms*, U. Bellugi and M. Studdert-Kennedy, ed. (Berlin: Verlag Chemie, 1980), 261–74, and "Laws and Constraints, Symbols and Languages," in *Towards a Theoretical Biology*, C.H. Waddington, ed. (Edinburgh: University of Edinburgh Press, 1972), 248–58. The "semantic closure principle" should therefore be the same phenomenon as that described by Castoriadis as a "unitary system of meanings" whose tenets are "logically unprovable." Castoriadis is cited in note 20 below.

9. The inner-city ghettoes are defined as *favelas* in Brazil, shantytowns in the English-speaking worlds, and by innumerable names in the Third World. The proposal here is that these all together constitute a global "archipelago" which is the analogue for the free market system of the Gulag archipelago for the command system of Marxist-Leninism. Films like *The Harder They Come* and *Do The Right Thing* are, therefore, for the main part, counter-perspectives from these "archipelagoes" as was the *zek* perspective of Solshenitzin and others.

10. See Gladstone L. Yearwood, ed., *Black Cinema Aesthetics: Issues in Independent Black Filmmaking* (Athens, Ohio: Center for Afro-American Studies, Ohio University, 1982).

11. Wittgenstein's concepts of "forms of life" and their "language games" that are therefore necessarily "impervious to philosophical attack" are central to my "rethinking of aesthetics" and therefore of human modes of being. For a recent essay which deals with some of the contemporary implications of these terms, see Samuel C. Wheeler's "Wittgenstein as Conservative Deconstructor," *New Literary History* 19 (Winter 1988).

12. While our present discourse on aesthetics presents itself as *a-cultural*, and, therefore, universal, the argument uses Bertrand Russell's concept of *classes* (such as machinery) and their *members* (such as cranes, tractors, cars, etc.) to redefine our present mode of the aesthetic as a culture-specific *member* of a transcultural *class*.

13. See J.G.A. Pocock, *Politics, Language and Time: Essays on Political Thought and History* (New York: Athenaeum, 1971), 6; and Ernesto Grassi, *Rhetoric and Philosophy: The Humanist Tradition* (University Park and London: Pennsylvania State University Press, 1980).
The proposal here is that each code or *criterion* of being sets the "standard" of what would be called "fit" behaviors at the level of organic life, i.e., those optimal behaviors which best ensure the stable replication of the genome and its genomic principle.

14. Peter Winch, "Understanding A Primitive Society," *American Philosophical Quarterly* (1964): 307–24.

15. Frantz Fanon, *Black Skin, White Mask* (New York: Grove Press, 1964), 10–14.

16. For the Heideggerian concept of the "comprehension of being" instituting of a specific mode of being which then forecloses on any questioning with respect to being itself, see Otto Poggeler, *Martin Heidegger's Path of Thinking*, trans. D. Magurshak and Sigmund Barber (New Jersey: Humanities Press International, 1987), 194.

17. For the concept of tropic matrices, see Tzvetan Todorov, *Theories of the Symbol* (Ithaca, N.Y: Cornell University Press, 1977).

18. See the seminal essay by James F. Danielli, "Altruism and the Internal Reward System of the Opium of the People," *Journal of Social and Biological Structures: Studies in Human Sociobiology* 3 (April 1980): 87–94. See also Jeff Goldberg, *Anatomy of A Scientific Discovery* (Toronto, New York: Bantam Books, 1988), 163–74.

19. See Benedict Anderson, *Imagined Communities: Reflections On The Origin and Spread of Nationalism* (London: Verso, 1983).

20. See Cornelius Castoriadis, "The Imaginary: Creation in the Socio-Historical Domain," In *Disorder and Order Proceedings of the Stanford International Symposium*, Paisley Livingston, ed. (14–18 September 1981, Stanford Literature Studies 1. *Anma Libri): 146–61.

21. Pierre Bourdieu, *Distinction: A Social Critique of the Judgement of Taste,* trans. Richard Nice (Cambridge, Mass.: M.I.T. Press, 1984).

22. See Maria Corti, *An Introduction to Literary Semiotics,* trans. Margareta Bogat and Allen Mandelbaum.

23. Adam Smith's middle-class goal of "bettering one's condition" was the behavior-regulating telos related to the rise of the bourgeoisie to cultural hegemony within the context of the industrial revolution and the free trade legislation which made both possible. It was based on the premise of the human as being a pure natural organism. See Robert L. Hellbronner, *Behind the Veil of Economics: Essays in the Worldly Philosophy* (New York, London: W. W. Norton & Co., 1988), 37.

24. Lawrence W. Levine, *Highbrow/Lowbrow: The Emergence of Cultural Hierarchy in America* (Cambridge, Mass.: Harvard University Press, 1989).

25. See Carter G. Woodson, *The Miseducation of the Negro,* (1933; reprint, New York: A.M.S. Press, 1977).

26. See Lévi-Strauss's deciphering analysis of the phenomenon of toternism in his seminal essay, *Totemism* (Harmondsworth: Penguin, 1969), where he relates traditional totemic systems to the "speculative thought" of their orders.

27. See Marshall Sahlins, *Culture and Practical Reason* (Chicago and London: University of Chicago Press, 1976) for a fuller development of this analogy.

28. See Lucien Scubla, "Contribution à la Theorie du Sacrifice." in *René Girard et le Probleme du Mal,* Michel Deguy and Jean Mariet Dupuy, ed. (Paris: Bernard Grasset, 1982).

29. See the range of work of René Girard where he proposes that all human orders are born out of the spilt blood of sacrificial violence.

30. See Antonio T. de Nicholas, "Notes on the Biology of Religion," *Journal of Social and Biological Structures* 3 (April 1980): 219–26.

31. See Julia Kristeva, *Power of Horror: An Essay on Abjection,* trans. S. Roudiez (New York: Columbia University Press, 1982).

32. See Jacques Le Goff, *The Medieval Imagination,* trans. A. Goldhammer (Chicago: University of Chicago Press, 1983).

33. Cited by V. Y. Mudimbe, *The Invention of Africa: Gnosis, Philosophy and the Order of Knowledge* (Bloomington, Ind.: Indiana University Press, 1988).

34. I have adapted this idea from Manthia Diawara's concept of "aesthetic contract" in which the normative spectator-subject is an accomplice. See his essay, "Black British Cinema: Spectatorship and Identity Formation in Territories" *Public Culture* 3 (Fall 1990): 33–47.

35. See Ian Hunter, *Culture and Government: The Emergence of Literary Education* (London: MacMillan, 1988), 688–95.

36. Recent accounts of hardened Jamaican drug dealers or *posses* operating in New York show the prescience of the 1972 film with respect to the "savage and contraband route" which the Ivans will take, in order to attain the new top consumer ideal of the human.

37. See Nelson George, *The Death of Rhythm and Blues* (New York: E. P. Dutton 1988), 122–24, where he argues that if Melvin Van Peeble's 1970 *Sweet Sweetback's Badass Song* recognized the Black audience's desire for rebellious Black heroes, the rebellion, whatever the blaxploitation nature of the films themselves, was carried by their use of funk-jazz and other forms of Black popular music which fuelled this rebellious thrust creating "moments of music-video-like fascination."

38. I owe this concept to Lemuel Johnson, See his essay, "'A-beng': (Re) calling the Body in(to) Question," In *Out of the Kumbla: Caribbean Women and Literature,* Carole Boyce Davies and Elaine Savory Fido, ed. (Trenton, N.J.: Africa World Press, 1990), 111–42.

39. Neither "reality" nor literature would therefore be a reflection of each other. Both would be generated from the "ground" of their culture-specific imaginaries and their governing code or sociogenic principle.

40. Heinz Pagels, *The Dreams of Reason: The Computer and the Rise of the Sciences of Complexity* (New York: Simon and Schuster, 1988).

41. See Malika Lee Whitney and Dermot Hussey, *Bob Marley: Reggae King of the World* (Kingston, Jamaica: Kingston Publishers, 1989).

42. See Miryam Da Costa's introduction to her collection of essays, *Blacks in Hispanic Literature: Critical Essays* (Port Washington, N.Y.: Kennikat Press, 1977), 6-7.

43. Geoffrey Hartmann, *Criticism in the Wilderness: A Study of Literature Today* (New Haven and London: Yale University Press, 1980).

44. Ibid., 246-49.

45. Ibid., 237.

46. See Henry Louis Gates, Jr., *The Signifying Monkey: A Theory of Afro-American Literary Criticism* (New York/Oxford: Oxford University Press, 1988).
For the concept of Gates's approach as an "Ideology of Otherness," see V. Y. Mudimbe, *The Invention of Africa: Gnosis, Philosophy and the Order of Knowledge* (Bloomington, Ind.: Indiana University Press, 1988).

47. The term "African-American" itself points to the ongoing adoption by Black scholars of the immigrant white-ethnic paradigm. Both "ethnicism" and "feminism" have almost entirely displaced the dynamic and contestatory "Black" socio-cultural thrust of the 1960s.
Also, Anthony Appiah uses the term *"europhone"* (in his essay, "Topologies of Nativism," *Yale Journal of Criticism* 2 [Fall 1988]) to refer to the fact that all members of the global intelligentsia, including the most anti-Western and "Afrocentric" have been educated within the categories of the West's "regime of truth" or episteme—so that even the most rigorous "Afrocentricities," as V. Y. Mudimbe also argues, are themselves generated from the "conceptual systems" and "models of analysis" of our present essentially western-European "epistemological order."

48. See Houston A. Baker, Jr., *Blues, Ideology and Afro-American Literature: A Vernacular Theory* (Chicago and London: University of Chicago Press, 1984), 90ff for a critique of this anti-sociological and "purely literary" approach.

49. Frank Kermode, *The Art of Telling: Essays on Fiction* (Cambridge, Mass.: Harvard University Press, 1983).

50. See Craig Bromberg, *"Forum"* in Omni 12, no. 9: 12–14, for his posing of the ambivalent paradox— it "homogenizes desire"—of this market-consumer universalism.

51. The idea is borrowed from Marx. The *systemic* perspective (i.e. cultural-historical perspective of the Black Underclass) calls in question the "form of life itself," while the "ethnic" perspective seeks a valorized incorporation into the order itself.

52. Christopher Norris, *The Deconstructive Turn: Essays in the Rhetoric of Philosophy* (London and New York: Methuen, 1983), 172.

53. I have adapted this concept from Howard Partee's article, "Cell Physiology: An Evolution-any Approach to the Symbol-Matter Information Problem," In *Cognition and Brain Theory* 5 (1982): 325-41.

54. See Richard Rorty, "Solidarity or Objectivity?" In *Post-Analytic Philosophy*, Rajchman John and Cornel West, ed. (New York: Columbia University Press, 1985), 15.

55. Paolo Valesio, *Nova Antique: Rhetorics as a Contemporary Theory* (Bloomington: Indiana University Press, 1980).

56. Their focus on the *makedness* of literary works provides the "ground" for the concept of the "makedness" through discourse of our modes of "being."

57. See Mikhail Bakhtin, *The Dialogic Imagination: Four Essays by M. M. Bakhtin* (Austin, Texas: University of Texas Press, 1981).

58. Hans Blumenberg, *The Legitimacy of The Modern Age* (Cambridge, Mass.: M.I.T. Press 1983), 209.

59. Neo-humanist in that it *denaturalizes* the human. The parallel between the laity in their relation to the clergy (as *flesh* and *nature* to *Spirit* and *Culture*) and Black scholars as a new "lay" intelligentsia is based on the fact that Blacks are equally to whites within our present cultural model as *nature* (non-evolved) to *culture* (evolved). A Black Studies perspective is therefore like that of the laity in Medieval Europe a *liminal* perspective in Legesse's sense. (See his *GADA: Three Approaches to the Study of an African Society* [New York: Free Press, 1973].) If the first laity de-supernaturalized the human being, and historicized the feudal order's eternal truth, the second laity are compelled to denaturalize being and to culturalize "Objective Truth."

60. See Blumenberg, 209.

Notes on Deconstructing 'The Popular'

Stuart Hall

First, I want to say something about periodisations in the study of popular culture. Difficult problems are posed here by periodisation – I don't offer it to you simply as a sort of gesture to the historians. Are the major breaks largely descriptive? Do they arise largely from within popular culture itself, or from factors which are outside of but impinge on it? With what other movements and periodisations is 'popular culture' most revealingly linked? Then I want to tell you some of the difficulties I have with the term 'popular'. I have almost as many problems with 'popular' as I have with 'culture'. When you put the two terms together, the difficulties can be pretty horrendous.

Throughout the long transition into agrarian capitalism and then in the formation and development of industrial capitalism, there is a more or less continuous struggle over the culture of working people, the labouring classes and the poor. This fact must be the starting point for any study, both of the basis for, and of the transformations of, popular culture. The changing balance and relations of social forces throughout that history reveal themselves, time and again, in struggles over the forms of the culture, traditions and ways of life of the popular classes. Capital had a stake in the culture of the popular classes because the constitution of a whole new social order around capital required a more or less continuous, if intermittent, process of re-education, in the broadest sense. And one of the principal sites of resistance to the forms through which this 'reformation' of the people was pursued lay in popular tradition. That is why popular culture is linked, for so long, to questions of tradition, of traditional forms of life – and why its 'traditionalism' has been so often misinterpreted as a product of a merely conservative impulse, backward looking and anachronistic. Struggle and resistance – but also, of course, appropriation and *ex*-propriation. Time and again, what we are really looking at is the active destruction of particular ways of life, and their transformation into something new. 'Cultural change' is a polite euphemism for the process by which some cultural forms and practices are driven out of the centre of popular life, actively marginalised. Rather than simply 'falling into disuse' through the Long March to modernisation, things are actively pushed aside, so that something else can take their place. The magistrate and the evangelical police have, or ought to have, a more 'honoured' place in the history of popular culture than they have usually been accorded. Even more important than ban and proscription is that subtle and slippery customer – 'reform' (with all the positive and unambiguous overtones it carries today). One way or another, 'the people' are frequently the object of 'reform': often, for their own good, of course – 'in their best interests'. We understand struggle and resistance, nowadays, rather better than we do reform and transformation. Yet 'transformations' are at the heart of the study of popular culture. I mean the active work on existing traditions and activities, their active re-working, so that they come out a different way: they appear to 'persist' – yet, from one period to another, they come to stand in a different relation

Reprinted with permission from *People's History and Socialist Theory*, ed. Raphael Samuel, 227–40 (London: Routledge, 1981).

to the ways working people live and the ways they define their relations to each other, to 'the others' and to their conditions of life. Transformation is the key to the long and protracted process of the 'moralisation' of the labouring classes, and the 'demoralisation' of the poor, and the 're–education' of the people. Popular culture is neither, in a 'pure' sense, the popular traditions of resistance to these processes; nor is it the forms which are superimposed on and over them. It is the ground on which the transformations are worked.

In the study of popular culture, we should always start here: with the double-stake in popular culture, the double movement of containment and resistance, which is always inevitably inside it.

The study of popular culture has tended to oscillate wildly between the two alternative poles of that dialectic – containment/resistance. We have had some striking and marvellous reversals. Think of the really major revolution in historical understanding which has followed as the history of 'polite society' and the Whig aristocracy in eighteenth-century England has been upturned by the addition of the history of the turbulent and ungovernable people. The popular traditions of the eighteenth-century labouring poor, the popular classes and the 'loose and disorderly sort' often, now, appear as virtually independent formations: tolerated in a state of permanently unstable equilibrium in relatively peaceful and prosperous times; subject to arbitrary excursions and expeditions in times of panic and crisis. Yet, though formally these were the cultures of the people 'outside the walls', beyond political society and the triangle of power, they were never, in fact, outside of the larger field of social forces and cultural relations. They not only constantly pressed on 'society'; they were linked and connected with it, by a multitude of traditions and practices. Lines of 'alliance' as well as lines of cleavage. From these cultural bases, often far removed from the dispositions of law, power and authority, 'the people' threatened constantly to erupt: and, when they did so, they break on to the stage of patronage and power with a threatening din and clamour – with fife and drum, cockade and effigy, proclamation and ritual – and, often, with a striking, popular, ritual discipline. Yet never quite overturning the delicate strands of paternalism, deference and terror within which they were constantly if insecurely constrained. In the following century, where the 'labouring' and the 'dangerous' classes lived without benefit of that fine distinction the reformers were so anxious to draw (this was a *cultural* distinction as well as a moral and economic one: and a great deal of legislation and regulation was devised to operate directly on it), some areas preserved for long periods a virtually impenetrable enclave character. It took virtually the whole length of the century before the representatives of 'law and order' – the new police – could acquire anything like a regular and customary foothold within them. Yet, at the same time, the penetration of the cultures of the labouring masses and the urban poor was deeper, more continuous – and more continuously 'educative' and reformatory – in that period than at any time since.

One of the main difficulties standing in the way of a proper periodisation of popular culture is the profound transformation in the culture of the popular classes which occurs between the 1880s and the 1920s. There are whole histories yet to be written about this period. But, although there are probably many things not right about its detail, I do think Gareth Stedman Jones's article on the 'Re-making of the English working class' in this period has drawn our attention to something fundamental and qualitatively different and important about it. It was a period of deep structural change. The more we look at it, the more convinced we become that somewhere in this period lies the matrix of factors and problems from which *our* history – and our peculiar dilemmas – arise. Everything changes – not just a shift in the relations of forces but a reconstitution of the terrain of political struggle itself. It isn't just by chance that so many of the characteristic forms of what we now think of as 'traditional' popular culture either emerge from or emerge in their distinctive

modern form, in that period. What has been done for the 1790s and for the 1840s, and is being done for the eighteenth century, now radically needs to be done for the period of what we might call the 'social imperialist' crisis.

The general point made earlier is true, without qualification, for this period, so far as popular culture is concerned. There is no separate, autonomous, 'authentic' layer of working-class culture to be found. Much of the most immediate forms of popular recreation, for example, are saturated by popular imperialism. Could we expect otherwise? How could we explain, and what would we *do* with the idea of, the culture of a dominated class which, despite its complex interior formations and differentiations, stood in a very particular relation to a major restructuring of capital; which itself stood in a peculiar relation to the rest of the world; a people bound by the most complex ties to a changing set of material relations and conditions; who managed somehow to construct 'a culture' which remained untouched by the most powerful dominant ideology – popular imperialism? Especially when that ideology – belying its name – was directed as much at them as it was at Britain's changing position in a world capitalist expansion?

Think, in relation to the question of popular imperialism, of the history and relations between the people and one of the major means of cultural expression: the press. To go back to displacement and superimposition – we can see clearly how the liberal middle-class press of the mid-nineteenth century was constructed on the back of the active destruction and marginalisation of the indigenous radical and working–class press. But, on top of that process, something qualitatively new occurs towards the end of the nineteenth century and the beginning of the twentieth century in this area: the active, mass insertion of a developed and mature working–class audience into a new kind of *popular,* commercial press. This has had profound cultural consequences: though it isn't in any narrow sense exclusively a 'cultural' question at all. It required the whole reorganisation of the capital basis and structure of the cultural industry; a harnessing of new forms of technology and of labour processes; the establishment of new types of distribution, operating through the new cultural mass markets. But one of its effects was indeed a reconstituting of the cultural and political relations between the dominant and the dominated classes: a change intimately connected with that containment of popular democracy on which 'our democratic way of life' today, appears to be so securely based. Its results are all too palpably with us still, today: a popular press, the more strident and virulent as it gradually shrinks; organised by capital 'for' the working classes; with, nevertheless, deep and influential roots in the culture and language of the 'underdog', of 'Us': with the power to represent the class to itself in its most traditionalist form. This is a slice of the history of 'popular culture' well worth unravelling.

Of course, one could not begin to do so without talking about many things which don't usually figure in the discussion of 'culture' at all. They have to do with the reconstruction of capital and the rise of the collectivisms and the formation of a new kind of 'educative' state as much as with recreation, dance and popular song. As an area of serious historical work, the study of popular culture is like the study of labour history and its institutions. To declare an interest in it is to correct a major imbalance, to mark a significant oversight. But, in the end, it yields most when it is seen in relation to a more general, a wider history.

I select this period – the 1880s–1920s – because it is one of the real test cases for the revived interest in popular culture. Without in any way casting aspersions on the important historical work which has been done and remains to do on earlier periods, I do believe that many of the real difficulties (theoretical as well as empirical) will only be confronted when we begin to examine closely popular culture in a period which begins to resemble our own, which poses the same kind

of interpretive problems as our own, and which is informed by our own sense of contemporary questions. I am dubious about that kind of interest in 'popular culture' which comes to a sudden and unexpected halt at roughly the same point as the decline of Chartism. It isn't by chance that very few of us are working in popular culture in the 1930s. I suspect there is something peculiarly awkward, especially for socialists, in the non–appearance of a militant, radical mature culture of the working class in the 1930s when – to tell you the truth – most of us would have expected it to appear. From the viewpoint of a purely 'heroic' or 'autonomous' popular culture, the 1930s is a pretty barren period. This 'barrenness' – like the earlier unexpected richness and diversity – cannot be explained from *within* popular culture alone.

We have now, to begin to speak, not just about discontinuities and qualitative change, but about a very severe fracture, a deep rupture – especially in popular culture in the postwar period. Here it is not only a matter of a change in cultural relations between the classes, but of the changed relationship between the people and the concentration and expansion of the new cultural apparatuses themselves. But could one seriously now set out to write the history of popular culture without taking into account the monopolisation of the cultural industries, on the back of a profound technological revolution (it goes without saying that no 'profound technological revolution' is ever in any sense 'purely' technical)? To write a history of the culture of the popular classes exclusively from inside those classes, without understanding the ways in which they are constantly held in relation with the institutions of dominant cultural production, is not to live in the twentieth century. The point is clear about the twentieth century. I believe it holds good for the nineteenth and eighteenth centuries as well.

So much for 'some problems of periodisation'.

Next, I want to say something about 'popular'. The term can have a number of different meanings: not all of them useful. Take the most common–sense meaning: the things which are said to be 'popular' because masses of people listen to them, buy them, read them, consume them, and seem to enjoy them to the full. This is the 'market' or commercial definition of the term: the one which brings socialists out in spots. It is quite rightly associated with the manipulation and debasement of the culture of the people. In one sense, it is the direct opposite of the way I have been using the word earlier. I have, though, two reservations about entirely dispensing with this meaning, unsatisfactory as it is.

First, if it is true that, in the twentieth century, vast numbers of people *do* consume and even indeed enjoy the cultural products of our modern cultural industry, then it follows that very substantial numbers of working people must be included within the audiences for such products. Now, if the forms and relationships, on which participation in this sort of commercially provided 'culture' depend, are purely manipulative and debased, then the people who consume and enjoy them must either be themselves debased by these activities or else living in a permanent state of 'false consciousness'. They must be 'cultural dopes' who can't tell that what they are being fed is an up-dated form of the opium of the people. That judgment may make us feel right, decent and self–satisfied about our denunciations of the agents of mass manipulation and deception – the capitalist cultural industries: but I don't know that it is a view which can survive for long as an adequate account of cultural relationships; and even less as a socialist perspective on the culture and nature of the working class. Ultimately, the notion of the people as a purely *passive,* outline force is a deeply unsocialist perspective.

Second, then: can we get around this problem without dropping the inevitable and necessary attention to the manipulative aspect of a great deal of commercial popular culture? There are

a number of strategies for doing so, adopted by radical critics and theorists of popular culture, which, I think, are highly dubious. One is to counterpose to it another, whole, 'alternative' culture – the authentic 'popular culture'; and to suggest that the 'real' working class (whatever that is) isn't taken in by the commercial substitutes. This is a heroic alternative; but not a very convincing one. Basically what is wrong with it is that it neglects the absolutely essential relations of cultural power – of domination and subordination – which is an intrinsic feature of cultural relations. I want to assert on the contrary that there is *no* whole, authentic, autonomous 'popular culture' which lies outside the field of force of the relations of cultural power and domination. Second, it greatly underestimates the power of cultural implantation. This is a tricky point to make, for, as soon as it *is* made, one opens oneself to the charge that one is subscribing to the thesis of cultural incorporation. The study of popular culture keeps shifting between these two, quite unacceptable, poles: pure 'autonomy' or total incapsulation.

Actually, I don't think it is necessary or right to subscribe to either. Since ordinary people are not cultural dopes, they are perfectly capable of recognising the way the realities of working–class life are reorganised, reconstructed and reshaped by the way they are represented (i.e. re-presented) in, say, *Coronation Street*. The cultural industries do have the power constantly to rework and reshape what they represent; and, by repetition and selection, to impose and implant such definitions of ourselves as fit more easily the descriptions of the dominant or preferred culture. That is what the concentration of cultural power – the means of culture-making in the heads of the few –actually means. These definitions don't have the power to occupy our minds; they don't function on us as if we are blank screens. But they do occupy and rework the interior contradictions of feeling and perception in the dominated classes; they *do* find or clear a space of recognition in those who respond to them. Cultural domination has real effects – even if these are neither all-powerful nor all-inclusive. If we were to argue that these imposed forms have no influence, it would be tantamount to arguing that the culture of the people can exist as a separate enclave, outside the distribution of cultural power and the relations of cultural force. I do not believe that. Rather, I think there is a continuous and necessarily uneven and unequal struggle, by the dominant culture, constantly to disorganise and reorganise popular culture; to enclose and confine its definitions and forms within a more inclusive range of dominant forms. There are points of resistance; there are also moments of supersession. This is the dialectic of cultural struggle. In our times, it goes on continuously, in the complex lines of resistance and acceptance, refusal and capitulation, which make the field of culture a sort of constant battlefield. A battlefield where no once-for-all victories are obtained but where there are always strategic positions to be won and lost.

This first definition, then, is not a useful one for our purposes; but it might force us to think more deeply about the complexity of cultural relations, about the reality of cultural power and about the nature of cultural implantation. If the forms of provided commercial popular culture are not purely manipulative, then it is because, alongside the false appeals, the foreshortenings, the trivialisation and shortcircuits, there are also elements of recognition and identification, something approaching a recreation of recognisable experiences and attitudes, to which people are responding. The danger arises because we tend to think of cultural forms as whole and coherent: either wholly corrupt or wholly authentic. Whereas, they are deeply contradictory; they play on contradictions, especially when they function in the domain of the 'popular'. The language of the *Daily Mirror* is neither a pure construction of Fleet Street 'newspeak' nor is it the language which its working-class readers actually speak. It is a highly complex species of linguistic *ventriloquism* in which the debased brutalism of popular journalism is skilfully combined and intricated with

some elements of the directness and vivid particularity of working-class language. It cannot get by without preserving some element of its roots in a real vernacular – in 'the popular'. It wouldn't get very far unless it were capable of reshaping popular elements into a species of canned and neutralised demotic populism.

The second definition of 'popular' is easier to live with. This is the descriptive one. Popular culture is all those things that 'the people' do or have done. This is close to an 'anthropological' definition of the term: the culture, mores, customs and folkways of 'the people'. What defines their 'distinctive way of life'. I have two difficulties with this definition, too.

First, I am suspicious of it precisely because it is too descriptive. This is putting it mildly. Actually, it is based on an infinitely expanding inventory. Virtually *anything* which 'the people' have ever done can fall into the list. Pigeon-fancying and stamp-collecting, flying ducks on the wall and garden gnomes. The problem is how to distinguish this infinite list, in any but a descriptive way, from what popular culture is *not*.

But the second difficulty is more important – and relates to a point made earlier. We can't simply collect into one category all the things which 'the people' do, without observing that the real analytic distinction arises, not from the list itself – an inert category of things and activities – but from the key opposition: the people/not of the people. That is to say, the structuring principle of 'the popular' in this sense is the tensions and oppositions between what belongs to the central domain of elite or dominant culture, and the culture of the 'periphery'. It is this opposition which constantly structures the domain of culture into the 'popular' and the 'non-popular'. But you cannot construct these oppositions in a purely descriptive way. For, from period to period, the *contents* of each category changes. Popular forms become enhanced in cultural value, go up the cultural escalator – and find themselves on the opposite side. Others things cease to have high cultural value, and are appropriated into the popular, becoming transformed in the process. The structuring principle does not consist of the contents of each category – which, I insist, will alter from one period to another. Rather it consists of the forces and relations which sustain the distinction, the difference: roughly, between what, at any time, counts as an elite cultural activity or form, and what does not. These categories remain, though the inventories change. What is more, a whole set of institutions and institutional processes are required to sustain each – and to continually mark the difference between them. The school and the education system is one such institution – distinguishing the valued part of the culture, the cultural heritage, the history to be transmitted, from the 'valueless' part. The literary and scholarly apparatus is another – marking-off certain kinds of valued knowledge from others. The important fact, then, is not a mere descriptive inventory – which may have the negative effect of freezing popular culture into some timeless descriptive mould – but the relations of power which are constantly punctuating and dividing the domain of culture into its preferred and its residual categories.

So I settle for a third definition of 'popular', though it is a rather uneasy one. This looks, in any particular period, at those forms and activities which have their roots in the social and material conditions of particular classes; which have been embodied in popular traditions and practices. In this sense, it retains what is valuable in the descriptive definition. But it goes on to insist that what is essential to the definition of popular culture is the relations which define 'popular culture' in a continuing tension (relationship, influence and antagonism) to the dominant culture. It is a conception of culture which is polarised around this cultural dialectic. It treats the domain of cultural forms and activities as a constantly changing field. Then it looks at the relations which constantly structure this field into dominant and subordinate formations. It looks at the *process* by

which these relations of dominance and subordination are articulated. It treats them as a process: the process by means of which some things are actively preferred so that others can be dethroned. It has at its centre the changing and uneven relations of force which define the field of culture – that is, the question of cultural struggle and its many forms. Its main focus of attention is the relation between culture and questions of hegemony.

What we have to be concerned with, in this definition, is not the question of the 'authenticity' or organic wholeness of popular culture. Actually, it recognises that almost *all* cultural forms will be contradictory in this sense, composed of antagonistic and unstable elements. The meaning of a cultural form and its place or position in the cultural field is *not* inscribed inside its form. Nor is its position fixed once and forever. This year's radical symbol or slogan will be neutralised into next year's fashion; the year after, it will be the object of a profound cultural nostalgia. Today's rebel folksinger ends up, tomorrow, on the cover of *The Observer* colour magazine. The meaning of a cultural symbol is given in part by the social field into which it is incorporated, the practices with which it articulates and is made to resonate. What matters is *not* the intrinsic or historically fixed objects of culture, but the state of play in cultural relations: to put it bluntly and in an over-simplified form – what counts is the class struggle in and over culture.

Almost every fixed inventory will betray us. Is the novel a 'bourgeois' form? The answer can only be historically provisional: when? which novels? for whom? under what conditions?

What that very great Marxist theoretician of language who used the name Volosinov, once said about the sign – the key element of all signifying practices – is true of cultural forms:

> Class does not coincide with the sign community, i.e. with…the totality of users of the same sets of signs for ideological communication. Thus various different classes will use one and the same language. As a result, differently oriented accents intersect in every ideological sign. Sign becomes an arena of class struggle…. By and large it is thanks to this intersecting of accents that a sign maintains its vitality and dynamism and the capacity for further development. A sign that has been withdrawn from the pressure of the social struggle – which so to speak crosses beyond the pale of the social struggle – inevitably loses force, degenerating into an allegory and becoming the object not of live social intelligibility but of philosophical comprehension…. The ruling class strives to impart a supraclass, eternal character to the ideological sign, to extinguish or drive inward the struggle between social value judgements which occurs in it, to make the sign unaccentual. In actual fact, each living ideological sign has two faces, like Janus. Any current curse word can become a word of praise, any current truth must inevitably sound to many people as the greatest lie. This inner dialectic quality of the sign comes out fully in the open only in times of social crisis or revolutionary change.[1]

Cultural struggle, of course, takes many forms: incorporation, distortion, resistance, negotiation, recuperation. Raymond Williams has done us a great deal of service by outlining some of these processes, with his distinction between emergent, residual and incorporated moments. We need to expand and develop this rudimentary schema. The important thing is to look at it dynamically: as an historical process. Emergent forces reappear in ancient historical disguise; emergent forces, pointing to the future, lose their anticipatory power, and become merely backward looking; today's cultural breaks can be recuperated as a support to tomorrow's dominant system of values and meanings. The struggle continues: but it is almost never in the same place, over the same meaning or value. It seems to me that the cultural process – cultural power – in our society depends, in the first instance, on this drawing of the line, always in each period in a different place, as to what is to be incorporated into 'the great tradition' and what is not. Educational and cultural institutions, along with the many positive things they do, also help to discipline and police this boundary.

This should make us think again about that tricky term in popular culture, 'tradition'. Tradition is a vital element in culture; but it has little to do with the mere persistence of old forms. It has much more to do with the way elements have been linked together or articulated. These arrangements in a national-popular culture have no fixed or inscribed position, and certainly no meaning which is carried along, so to speak, in the stream of historical tradition, unchanged. Not only can the elements of 'tradition' be rearranged, so that they articulate with different practices and positions, and take on a new meaning and relevance. It is also often the case that cultural struggle arises in its sharpest form just at the point where different, opposed traditions meet, intersect. They seek to detach a cultural form from its implantation in one tradition, and to give it a new cultural resonance or accent. Traditions are not fixed forever: certainly not in any universal position in relation to a single class. Cultures, conceived not as separate 'ways of life' but as 'ways of struggle' constantly intersect: the pertinent cultural struggles arise at the points of intersection. Think of the ways in the eighteenth century, in which a certain language of legality, of constitutionalism and of 'rights' becomes a battleground, at the point of intersection between two divergent traditions: between the 'tradition' of gentry 'majesty and terror' and the traditions of popular justice. Gramsci, providing a tentative answer to his own question as to how a new 'collective will' arises, and a national-popular culture is transformed, observed that

> What matters is the criticism to which such an ideological complex is subjected by the first representatives of the new historical phase. This criticism makes possible a process of differentiation and change in the relative weight that the elements of old ideologies used to possess. What was previously secondary and subordinate, even incidental, is now taken to be primary – becomes the nucleus of a new ideological and theoretical complex. The old collective will dissolves into its contradictory elements since the subordinate ones develop socially.

This is the terrain of national-popular culture and tradition as a battlefield.

This provides us with a warning against those self-enclosed approaches to popular culture which, valuing 'tradition' for its own sake, and treating it in an a–historical manner, analyse popular cultural forms as if they contained within themselves, from their moment of origin, some fixed and unchanging meaning or value. The relationship between historical position and aesthetic value is an important and difficult question in popular culture. But the attempt to develop some universal popular aesthetic, founded on the moment of origin of cultural forms and practices, is almost certainly profoundly mistaken. What could be more eclectic and random than that assemblage of dead symbols and bric-a-brac, ransacked from yesterday's dressing-up box, in which, just now, many young people have chosen to adorn themselves? These symbols and bits and pieces are profoundly ambiguous. A thousand lost cultural causes could be summoned up through them. Every now and then, amongst the other trinkets, we find that sign which, above all other signs, ought to be fixed – solidified – in its cultural meaning and connotation forever: the swastika. And yet there it dangles, partly – but not entirely – cut loose from its profound cultural reference in twentieth-century history. What does it mean? What is it signifying? Its signification is rich, and richly ambiguous: certainly unstable. This terrifying sign may delimit a range of meanings but it carries no guarantee of a single meaning within itself. The streets are full of kids who are not 'fascist' because they may wear a swastika on a chain. On the other hand, perhaps they *could* be.... . What this sign means will ultimately depend, in the politics of youth culture, less on the intrinsic cultural symbolism of the thing in itself, and more on the balance of forces between, say, the National Front and the Anti-Nazi League, between White Rock and the Two Tone Sound.

Not only is there no intrinsic guarantee within the cultural sign or form itself. There is no guarantee that, because at one time it was linked with a pertinent struggle, that it will always be

the living expression of a class: so that every time you give it an airing it will 'speak the language of socialism'. If cultural expressions register for socialism, it is because they have been linked as the practices, the forms and organisation of a living struggle, which has succeeded in appropriating those symbols and giving them a socialist connotation. Culture is not already permanently inscribed with the conditions of a class before that struggle begins. The struggle consists in the success or failure to give 'the cultural' a socialist accent.

The term 'popular' has very complex relations to the term 'class'. We know this, but are often at pains to forget it. We speak of particular forms of working-class culture; but we use the more inclusive term, 'popular culture' to refer to the general field of enquiry. It's perfectly clear that what I've been saying would make little sense without reference to a class perspective and to class struggle. But it is also clear that there is no one-to-one relationship between a class and a particular cultural form or practice. The terms 'class' and 'popular' are deeply related but they are not absolutely interchangeable. The reason for that is obvious. There are no wholly separate 'cultures' paradigmatically attached, in a relation of historical fixity, to specific 'whole' classes – although there are clearly distinct and variable class-cultural formations. Class cultures tend to intersect and overlap in the same field of struggle. The term 'popular' indicates this somewhat displaced relationship of culture to classes. More accurately, it refers to that alliance of classes and forces which constitute the 'popular classes'. The culture of the oppressed, the excluded classes: this is the area to which the term 'popular' refers us. And the opposite side to that – the side with the cultural power to decide what belongs and what does not – is, by definition, not another 'whole' class, but that other alliance of classes, strata and social forces which constitute what is not 'the people' and not the 'popular classes': the culture of the power-bloc.

The people versus the power-bloc: this, rather than 'class-against-class', is the central line of contradiction around which the terrain of culture is polarised. Popular culture, especially, is organised around the contradiction: the popular forces versus the power-bloc. This gives to the terrain of cultural struggle its own kind of specificity. But the term 'popular', and even more, the collective subject to which it must refer – 'the people' – is highly problematic. It is made problematic by, say, the ability of Mrs. Thatcher to pronounce a sentence like, 'We have to limit the power of the trade unions because that is what the people want'. That suggests to me that, just as there is no fixed content to the category of 'popular culture', so there is no fixed subject to attach to it – 'the people'. 'The people' are not always back there, where they have always been, their culture untouched, their liberties and their instincts intact, still struggling on against the Norman yoke or whatever: as if, if only we can 'discover' them and bring them back on stage, they will always stand up in the right, appointed place and be counted. The capacity to *constitute* classes and individuals as a popular force – that is the nature of political and cultural struggle: to *make* the divided classes and the separated peoples – divided and separated by culture as much as by other factors – *into* a popular-democratic cultural force.

We can be certain that *other* forces also have a stake in defining 'the people' as something else: 'the people' who need to be disciplined more, ruled better, more effectively policed, whose way of life needs to be protected from 'alien cultures', and so on. There is some part of both those alternatives inside each of us. Sometimes we can be constituted as a force against the power-bloc: that is the historical opening in which it is possible to construct a culture which is genuinely popular. But, in our society, if we are not constituted like that, we will be constituted into its opposite: an effective populist force, saying 'Yes' to power. Popular culture is one of the sites where this struggle for and against a culture of the powerful is engaged: it is also the stake to be won or lost *in* that struggle. It

is the arena of consent and resistance. It is partly where hegemony arises, and where it is secured. It is not a sphere where socialism, a socialist culture – already fully formed – might be simply 'expressed'. But it is one of the places where socialism might be constituted. That is why 'popular culture' matters. Otherwise, to tell you the truth, I don't give a damn about it.

Note
1. A. Volosinov, *Marxism and the Philosophy of Language*, New York 1977.

Further Reading
Bailey, Peter, *Leisure and Class in Victorian England 1830–1885*, London 1978.
Hall, Stuart and Whannel, A.D., *The Popular Arts*, London 1964.
Johnson, Richard, 'Three problematics: elements of a theory of working-class culture' in *Working-Class Culture, Studies in History and Theory*, ed. by John Clarke, Charles Chrichter and Richard Johnson, London 1979.
Malcolmson, R.W., *Popular Recreation in English Society, 1700–1850*, Cambridge 1973.
Nowell-Smith, Geoffrey, 'Gramsci and the national-popular', *Screen Education*, Spring 1977.
Stedman Jones, Gareth, 'Working-Class culture and working class politics in London, 1870–1890', *Journal of Social History*, Summer 1974.
Thompson, E.P., 'Patrician society, plebeian culture', *Journal of Social History*, Summer 1974.
Williams, Raymond, 'Radical or popular' in *The Press We Deserve*, ed. by James Curran, London 1970.

The Indigenous Movement

Michael Dash

The first evidence of a radically new sensibility in Haitian writing can be seen in Philippe Thoby-Marcelin's 'Sainement' written in February 1926, in Paris. The poem is more of a *profession de foi*, even a polemical gesture, than a strictly literary exercise:

> J'ai le coeur, ce matin, plein de jeunesse,
>> Tumultueux de violences.
> Ma joue appuyée contre la fraîcheur
>> de l'aube,
> Jurant un eternal dédain aux raffinements européens,
> Je veux désormais vous chanter:
>> révolutions, fusillades, tueries
>
> Bruit de coco-macaque sur des épaules noires,
> Mugissements du lambi, lubricité mystique du vaudou;
> Vous chanter dans un délire trois fois
>> lyrique et religieux
> Me dépouiller de tous oripeaux classiques
>> et me dresser nu, trés sauvage
>> et trés descendant d'esclaves,
> Pour entonner d'une voix nouvelle le de profundis
>> des civilisations pourissantes.[1]

> [This morning my heart is bursting with youth,
>> seething with violence.
> My cheek resting against the freshness
>> of the dawn,
> Swearing an eternal scorn for European refinements,
> I wish henceforth to celebrate.
>> revolutions shootings and massacres,
> the sound of coco-macaque on black shoulders,
> the roar of the lambi, the mystic sensuality of vaudou;
> to celebrate in a delirium three times
>> lyrical and religious
> To strip myself of all classical finery
>> and stand up naked, savage
>> and very much a descendant of slaves,
> To sing with a new voice the 'de profundis'
>> of rotting civilisations.]

Reprinted with permission from *Literature and Ideology in Haiti, 1915–1961* (London and Basingstoke: Macmillan, 1981), 65–97.

The difference in scale and aesthetic values expressed in this poem and those of the earlier poems of the Occupation is striking. No lofty sentiments, no mythological allusions – the poem is in contrast rather informal and prosaic. The irregular typographic arrangement of the poem (which seems to vary with each publication) indicates a departure from regular versification. The title itself contains a note of irony as it is a re-definition of what it means to be sound and judicious.

'Sainement' is the beginning of an anti-rational intellectual tradition in Haitian literature. Terms such as 'plein de jeunesse', 'fraîcheur de l'aube' and 'voix nouvelle' suggest both a youthful exuberance and a strong Utopian impulse that would be characteristic of this generation. This is closely allied to the ever present subjectivity of the artist who is capable of transforming the world. There is a visibly Nietzschean quality in 'le de profundis des civilisations pourissantes'. Along with the absolute *refus* of repressive tradition (whether rigid prosody or social convention) comes the celebration of a hedonistic and uninhibited sensibility. The resulting delirium seems to provide an access to a primordial, authentic sense of self. What is articulated is the need for a complete revolution not only in political terms but also on the level of the psyche.

Marcelin's poem provides a graphic introduction to the iconoclastic spirit of the late twenties and thirties in Haiti. In fact, this period has been traditionally termed Haiti's literary renaissance but this is both a grandiose and misleading title since the past had never witnessed such a sustained and violent burst of literary activity.

It was to some extent a rather negative movement which felt that the past had only left behind the political decadence of the élite as well as dead literary codes. Both of which needed to be subverted and replaced. However, a more positive side to the movement also existed – the concern with creating literary authenticity. The aim of this irreverent generation was to make admissible in literature a range of experience that was once considered unworthy of formal poetic utterance. It was this unity of intention that distinguished this generation of Haitian writers.

The emergence of this radically new politico-literary stand among Haitian writers was facilitated by a number of factors. Naturally one of the most important of these was the Occupation itself. The continued American presence and the colonial nature of this presence, had created a real *crise de conscience* among Haitian writers and intellectuals. This sense of shame and bitterness is obviously reflected by those who were quite young in 1915. The two following statements are typical of the sense of hurt and disorientation felt by this generation:

> The generation which was twenty years old in 1915 was faced with a problem of great importance ...assess the past in order to forge a new future. After a hundred and eleven years of independence all the national institutions had just crumbled in tragic circumstances. What was the reason for this disaster?
>
> (*La Nouvelle Ronde*, no. 2, 1 July 1925, 26)

Carl Brouard is particularly bitter and dramatic in recounting this experience:

> 28 July 1915. The American trampled on our soil. Alas! It was not only on this land conquered at bayonet point that their heavy boots marched, but also on our hearts. Although then in short pants, we understood that we were 'la génération de l'Humanité' and our eyes opened wide with sadness.
>
> (*Les Griots*, vol. 1, no. 1, July–Sept. 1938, 2)

What emerged was a deep distrust of those who, as far as this generation was concerned, favoured the American intervention – the élite. In fact, Jean Price-Mars's collection of essays *La Vocation de l'élite*[2] was published as early as 1919 and it addressed itself to the question of a fragmented ruling

class and the nature of the reform necessary in Haiti. Price-Mars was one of the first to give the term *l'âme nationale* a special value in the context of the Occupation. His point of departure was clearly presented: 'It is indeed an established fact that when a people does not instinctively feel the need to create a national consciousness from the close solidarity of its various social strata... such a people is on the verge of fragmentation' (p. 15). Haiti was simply a perfect example of cultural plurality with no cohesive creolising force to bind together the various disparate groups. In his analysis, responsibility for this situation lay with the élite: 'The fact is that the élite has failed in its social responsibility, that ultimately it has shown itself unworthy of its mission of representation and leadership' (p. 73). This feeling that the élite had effectively renounced its right to lead is echoed in the stereotype of a collaborationist élite found in early protest poetry. It was a conviction that could only reinforce the desire among younger Haitian writers to sever all ties with the past.

The restlessness, already in evidence in the pages of *La Nouvelle Ronde* in 1925, was fed by various external circumstances – not the least of which was the intellectual upheaval in Paris in the 1920s. Paris had become in this post-war period the epicentre of anti-establishment feeling. The disillusion and shock that followed 1918 in France created a profound distrust of traditional values both cultural and moral and led to a deliberate cultivation of absurdity, obscenity, madness and what was termed 'cretinisation'. The nihilism of Dada and Surrealism left an indelible mark on those Haitians who were students in France at the time. Marcelin's 'Sainement' bears the stamp of this absolute *refus* of tradition and the search for truth in the irrational. The liberating experience of the metropolis not only affected Haitians but was primarily responsible for such radical black student movements as *Légitime Défense* (1932). However, for Haitians it meant a violent commitment to rejecting the élite and all it stood for and an equally rigid anti-American stand. Normil Sylvain on his return to Haiti spoke effusively about this experience: 'France made me aware of myself...I had not until then felt my worth as a man, become aware of my existence. It oriented me.'[3]

The effervescence of the twenties is evident in some of the first poems published by these young Haitians on their return home. The apocalyptic voice of the poet evident in 'Sainement' dominates some of the early poems of both Carl Brouard and Jacques Roumain. Art and external reality have become one and their commitment to the nationalist cause was simply part of the poetic ideal of *révolution permanente*. The obvious non-conformist and idealistic spirit of this period can also be explained by the strong attraction that Nietzsche's ideas had for this generation. Roumain makes this very clear in an early interview in 1927: 'I read somewhere that Nietzsche is unbalanced. Quite the contrary. He is anything but ill. No trace of Hegelian melancholy. But a great celebration of life. Of determination. Of the Will to Power. This man has created a religion: that of the Superman.'[4] Roumain's early verse reflects this fiery idealism as in the following poems he presents himself as the vengeful *poète-maudit* resisted by ordinary men but ultimately a superior, destructive force:

Et je rirai:
je rirai à blanches dents
et tout un riant;
je vous crierai:
"Ha, lâches, ha, chiens.
Ha, hommes-aux-yeux-baissés,
Faut-il que la mort
hurle,
faut-il que le feu
brûle,

faut-il que la bouche
crache
pour qu'en foule vous accourriez?...

la mort venue d'au dela des mers
qui hurle des insultes
brûle votre patrimoime
et crache
son mépris blanc
sur vos fronts noirs.[5]

[And I will laugh
I will laugh loudly
and while laughing
I will shout to you
Ha, cowards, ha, dogs
Ha, men with downcast eyes
Must death
scream,
must fire
burn,
must the mouth
spit
for you to become a unified throng?...
death come from across the seas
hurling insults

Burns your patrimony
and spits
its white scorn
on your black brows.]

The allusion to the Occupation is not always apparent but the mention of cowardice and submissiveness is an oblique reference to the lack of resistance among Haitians. This exaltation of the poet's will and superiority did, in fact, have a specific political content. Carl Brouard's equally defiant celebration of rebellion – 'Nous' – offers an image of a dissolute bohemian existence that seems to draw heavily on Rimbaud's ideal of the *poète-voyou* who by a 'dérèglement des sens' attains a superior vision:

Nous
les extravagants, les bohèmes, les fous...
Nous
les écorchés de la vie, les poètes...

Nous
les fous, les poètes...

Nous
qui n'apportons point la paix
mais le poignard triste

de notre plume
et l'encre rouge de notre coeur![6]

[We
the eccentric, the bohemian, the insane...
We
the poets flayed by life...
We
the poets, the insane...
We
who do not bring peace
but the sad dagger
of our pen
and the red ink from our heart!]

Interestingly enough, the bizarre literary experiments and poetic fantasies of Dada and Surrealism never became part of the *prise de position* of this generation. As we shall see they limited themselves to exploiting the freedoms of *vers libre*, to creating a number of short poems constructed around a strong visual image and to the potential of oral poetry. However, they were attracted to one of the effects created by the *refus* of traditional aesthetic values. This was Europe's growing interest in cultures that were non-Western. Such an enlargement of the aesthetic horizon in Europe and particularly the interest in African art and culture found an obvious response among Haitians. *La Nouvelle Ronde* in 1925 in an article which analysed the failure in the past to create a national literature, makes the point that the only way of avoiding an imitative literature or one that simply presents local colour is to pay attention to the interest in black and African culture that existed in France:

It is necessary at this time when exoticism rages in French literature, when Paul Reboux, Maran are studying the black soul, when it is the order of the day to speak of black art, to take pride in black music, it is necessary to analyse the Haitian soul, to strip it bare, to dissect it.[7]

The ultimate aim was a rejection of bland Eurocentric ideals for a more authentic, vital culture. In Europe, Maran's critique of Western civilisation in *Batouala* (1921) and Gide's indictment of the colonial exploitation of the Congo *Voyage au Congo* (1927) represented one area of interest in this prevailing trend. Also the cult of primitivism, in its Rousseauesque thirst for spontaneity and an anti-rational ideal, can be seen in Gauguin's escape to Tahiti and Rimbaud's journey to Abyssinia. Paul Morand's *Magie noire* (1928), for instance, was heavily influenced by this cult of black exoticism. A poem such as Carl Brouard's 'Nostalgie' in 1927 shows how these ideas had already penetrated Haitian writing:

Tambour
quand tu résonnes
mon âme hurle vers l'Afrique
Tantôt
je rêve d'une brousse immense,
baignée de lune
ou s'échevèlent de suantes nudités
Tantôt d'une case immonde
ou je savoure du sang dans des crânes humains.[8]

[Drum
when you resound
my heart screams towards Africa
Sometimes
I dream of a huge jungle
bathed in moonlight
of dishevelled, sweating, naked bodies
Sometimes of a filthy hut
where I revel in blood drunk from human skulls.]

Brouard's fantasy of cannibalism and erotic 'défoulement' is clearly an indication of the nature of the interest in black culture in the twenties.

However, this interest in a racial mystique and African culture did have a more serious side to it. The Haitian desire for cultural authenticity was encouraged by both the mystico-nationalist creed of some French thinkers at this time as well as the growing number of ethnological works on African culture. Charles Maurras and Maurice Barrès in France were responsible for the theory of *enracinement* and the notion that genuine spiritual strength could only be gained from the untainted culture of the provinces. The concept of *l'âme haitienne* that is a collective cultural unconscious which gives some originality to a specific Haitian community seems to originate in the theories of spiritual and racial essences found in Barrès and Maurras. In fact, Dominique Hippolyte's *La route ensoleillée* (1927) begins with the following epigraph from Maurras, 'J'ai tout recu du sol natal...' This is cited with approval in Price-Mars's *Ainsi Parla l'Oncle* (1928) whose work on Haitian folk culture uses as its basic premise the concept of racial essences. Phrases such as 'une certaine sensibilité commune à la race' and 'traits particuliers de notre race' can be frequently found in this work.

This concept of culture as being organic and not conditioned was reinforced by ethnological studies by Europeans done at the time. For instance Lévy-Bruhl's *La mentalité primitive* (1925) is frequently quoted in *Ainsi Parla l'Oncle* to support the theory of congenital racial essences. Indeed Lévy-Bruhl's theories of the differences between African intuition and European reason as well as Gobineau's ideas would later influence Senghor's conception of negritude. The anti-rational impulses celebrated in 'Sainement' were to some extent legitimised by these studies which attempted to demonstrate scientifically the uniqueness of the black soul. These theories, which encouraged Haitian nationalism and anti-assimilationist ideology in the twenties, would unfortunately survive this period to fuel racialist ideologies later on in this century.

There was one other source from which Haitian Indigenism drew inspiration. This was the Harlem Renaissance movement which was created by black American writers. The link between both these movements is a difficult one to trace, however. This is so partly because certain important figures in the Indigenous movement have claimed ignorance of the black American writing until as late as 1929[9] and also because many of the important works by black Americans did not appear until the late twenties and early thirties. The influence of black American writing, especially that of McKay and Langston Hughes, is more visible in the 1930s. Even if widespread awareness of black American writers may have been limited, there must have been at least a strong feeling of solidarity felt by the Haitians. As early as November 1906 the influential Jean Price-Mars, in one of his lectures collected in *La Vocation de l'élite,* drew attention to black American writers: 'Our black brothers have poets, remarkable musicians like Paul Lawrence Dunbar, M. Coles, the Johnson brothers etc' (p. 77).

In fact, from the early 1920s Johnson and Dubois were very active in championing the Haitian nationalist cause in the United States. Not only had the Occupation forged this link with black America but one of the main tenets of the Indigenous movement was to sever the link with French metropolitan literature and make Haitian writers more aware of other literary traditions. In an interview given in 1927 Jacques Roumain declared: 'We have completely ignored that there was in the United States, four days away from us a flourishing black poetry. And original too. Countree Cullins [*sic*] for example. Our literature is wrongly oriented.'[10] The similarities in the themes and aesthetic ideas between Harlem and Haitian writers must have made this sense of solidarity even stronger. The strong anti-bourgeois sentiment, the intense racial feeling and the desire to create an authentic black literary style through the use of folk material were common to both movements. Indeed, in the issue of *La Revue Indigène* which followed Roumain's interview. Dominique Hippolyte published a short piece on Countee Cullen and translated three of the latter's poems. A poem like 'Incident' (1925) would easily have attracted the attention of young Haitian writers:

> Chevauchant une fois dans le vieux Baltimore
> La tête et le coeur pleins de joie
> Je vis un Baltimoréen
> Fixer son regard sur moi...
>
> Ainsi je souris, mais il tira dehors
> Sa langue, et m'appela 'sale nègre'.
> Je vis tout Baltimore
> De mai jusqu'à décembre
> De tout ce que je trouvai là
> C'est tout ce dont je me rappelle.[11]
>
> [Once riding in old Baltimore.
> Heart-filled, head-filled with glee
> I saw a Baltimorean
> Keep looking straight at me...
> And so I smiled, but he poked out
> His tongue and called me 'Nigger'.
> I saw the whole of Baltimore
> From May until December
> Of all the things that happened there
> That's all I remember.]

The prosaic nature of the poem/narrative which almost puts the bitterness of the theme into greater relief is remarkably close to the prevalent style among Indigenous writers. Hippolyte's version accentuates the narrative quality because the rhyme scheme of the original is lost in the translation into French. However, *La Revue Indigène* did not last long enough to cement this link with the Harlem writers but the influence of the latter is evident in the 1930s when Indigenism is left behind.

Early evidence of the new spirit of rebellion can be found in the pages of the shortlived monthly journal called *La Trouée* (July 1927 to December 1927). The very name *La Trouée* (The Breach) indicates the defiance they launched against what they saw as a claustrophobic environment: 'The Breach! Our battle cry... is that of young and ardent souls who are going to pierce through the barricades of ignorance and apathy which stifle us.'[12] They saw themselves as an embattled avant-

garde who, just having returned from Europe, found the complacency of their class inhibiting.

La Trouée devoted itself to literary and cultural matters. Even though theories of an indigenous literature were not elaborated in the journal, its very first issue clearly stated what literature should *not* be: 'It is not the domain of the pedantic and the idle. We will get rid of both of these... It is not this bland pastiche of local colour we find in some, nor the colourless affectations of others.'[13] What literature should be was not yet clearly defined. Yet they stood for what was considered to be an intolerable permissiveness in aesthetic terms. It is in this journal that 'Sainement' is published and in fact is truly characteristic of the self-consciousness and irreverence of these early years.

The poems of *La Trouée* range from the fashionably bohemian themes of Carl Brouard to the more detached experimental poems of Jacques Roumain and Daniel Heurtelou. Brouard's 'Elégie', for instance, deliberately avoids being a lyrical song of lost love. The poem is of a simple prosaic construction and Dolores is not the traditional object of Romantic adoration:

> Dolorès
> te souviens-tu du passé,
> de nos amours clandestines,
> dans une rue calme de la banlieue port-au-princienne...
> Je garderai toujours la nostalgie de ce soir
> de pluie,
> ou tu fus tellement vicieuse.
> Parfois
> j'avais mal à la tete
> et tu me forcais à avaler
> – Dieu sait combien –
> de cachets d'asperine[14]

> [Dolores
> do you remember the past
> our clandestine loves
> in a quiet street of a Port-au-Prince suburb...
> I will always be nostalgic about that evening of rain,
> when you were so depraved.
> Sometimes I had a headache
> and you forced me to swallow
> – God knows many –
> doses of asprin]

The poem seems built around a systematic process of *dégonflage* and irony as sentimental clichés such as 'nostalgie de ce soir' and 'souvenir du passé' degenerate into the erotic and non-poetic 'vicieuse' and 'cachets d'asperine'. This quality of parody evident here was not always present in the treatment of proletarian themes. Marcelin's 'Petite Noire' is a straightforward poem of praise to a black girl:

> Et tu es noire comme tous les péchés. Mais tu souris
> Et c'est une fête des anges
> Douceur de tes regards blancs,
> Candeur de tes dents blanches...
> Je te chanterai, petite noire, c'est bien ton tour.[15]

[And you are black like all sins. But you smile
And it is an angelic spectacle
The sweetness of your white gaze,
The innocence of your white teeth...
I will praise you in my song, little black girl, your time has come.]

Whether in theme or form, *La Trouée* signified a departure from poetic tradition in Haiti.

As far as the question of poetic form is concerned the ornate and earnest poetry of the past was replaced by epigrammatic and sometimes absurd short poems which seem to be no more than chance impressions of landscape. No longer do we see the solemn meditative nature poetry of the nineteenth century but what appears to be nothing more than the quick impersonal glance of a snapshot – remote and trivial:

Chaleur accablante
ou tout semble dormir
Un âne
baigne sa croupe dans la poussière du chemin
...un flamboyant
surgit
la savane
tend
sa lèvre rouge au soleil[16]
[Suffocating heat
when all seems asleep
A donkey
bathes his rump in the dust of the road
...a flamboyante
rises up
the savanna
stretches
its red tongue to the sun.]

Heurtelou's 'Savane desolée' gives a quick impression of heat and lethargy and introduces a dramatic and bizarre note with the image of the red flamboyant tongue stretching towards the sun. Roumain's 'Midi' and 'Apres-midi' similarly use the resources of *vers libre* to present a collage of elliptical visual impressions, snatches of sound and filtered light. The latter shows how effectively Roumain creates a new set of expectations from a rapid enumeration of details of landscape:

Des moucherons bruissent, mandolines
minuscules. Sagaies fines
des palmiers-éventails
immobiles dans le Temps figé.
Le soleil filtre à travers les arbres, en barres
d'or. Un enfant quelque part
crie.
Chaque minute comme un siècle d'ennui
bâilie.[17]

[Flies buzz, tiny
mandolins. Fine spears
of palm trees,
immobile in static Time.
The sun filters through the trees, in bars
of gold. A child somewhere
cries.
Each minute like a century of boredom
yawns.]

More than an attempt to depict heat and motionlessness, this poem can be seen as an attack on the poetic word. Its consciously prosaic and staccato tone seems to be a deliberate attempt to dislocate literary decorum. The resources of *vers libre* became a 'miraculous weapon' in this struggle to reach beyond erudite literary codes and create a new 'space' around words and so restore their original power.

By late 1927 *La Trouée* ceased to exist but it did represent the opening of the breach through which a new wave of creativity would surge. *La Revue Indigène*, which epitomised the new iconoclasm of this generation as well as their actual literary achievements, dominated the Haitian literary scene from the middle of 1927 to early 1928 and can be seen as the prototype of other similar but more strident journals (such as *L'Etudiant Noir* in Paris and *Tropiques* in Martinique) which launched a new phase of ideological ferment and literary experimentation among black writers. It is curious that this journal should have such an impact since it only lasted for six issues and did not represent a thoroughgoing ideological orthodoxy. In fact, it would be more accurate to see it as a loose alliance of partisans of new literary freedoms, so much so that the group was at one point termed *indigeste* instead of *indigene* in order to suggest the diversity of temperaments and talents that it attracted.

Curiously enough, in the midst of the tensions of the Occupation *La Revue Indigène* appears to be noticeably apolitical or at best indirectly political. This note was apparent from the editorial of the very first number where Normil Sylvain asked the question: 'In the turmoil of our daily lives do you not think that we should agree to a moment of calm, a respite...'[18] This journal was to be a literary oasis distinct from the violent political *prise de position* its collaborators had also taken. To the latter cause they devoted their talents as journalists. The political organ of this generation was *Le Petit Impartial* (1927–1931) which outlasted its more precarious and shortlived literary counterpart. This newspaper documents the uncompromising nationalism of the members of the Indigenous movement. There are articles by Jacques Roumain, Carl Brouard and Emile Roumer among others. These constituted violent critiques of American imperialism, the Haitian élite and the Catholic Church. The latter were repeatedly condemned for collaborating in cultural imperialism or what was termed *l'occupation de la pensée*. It was the kind of militant journalism which, encouraging the youth and the masses to revolt, would precipitate the strikes and demonstrations of 1929. The paper, indeed, gives us an insight into the political mind of this generation in all its idealism and contradictions. Its pantheon of heroes, for instance, consists of figures as diverse as Mahatma Gandhi, the prophet of non-violence to Charlemagne Péralte, an open advocate of the tactics of violence. But these various figures all contribute to the ideological effervescence of the times – Gandhi for his closeness to the common man and his mystic anti-materialist philosophy; Price-Mars for his innovative ethnography and Péralte for his aggressive nationalism.

The inconsistencies and disparities in this generation are nowhere more apparent than in their pursuit of *La Muse haitienne* in the pages of *La Revue Indigène*. Their literary efforts ranged

from carefully wrought sonnets to wild explosions of *vers libre*; from formal alexandrines to oral poetry whose form and emphases were determined only by the human voice; from delicate *spleen* poems to the unadorned exclamations of voodoo rituals. However, the members of this disparate group did manage, each in his own way, to convey an undeniable sense of place and for the first time, in an immediate and palpable way the diversity of the Haitian experience. Perhaps it was the combination of heightened sense of place created by their early exile (at school in Europe), as well as the pressures of the Occupation. Whatever the reason, the Indigenous movement brought fresh currency to the desire for cultural authenticity that had been initiated almost a century before in the pages of *L'Union*.

It is difficult to be precise in defining the concept of Indigenism. It is an abstraction which is as amorphous and elusive as the ideology of Négritude and the problem has been further complicated by the term being loosely applied to writers born after the end of the Occupation. Perhaps the best way of seizing the essence of what it stood for is to see the movement as a cluster of ideas and feelings generated by a deep-seated conviction of cultural rootlessness and dislocation felt by this generation. What was desired was more than an infusion of local colour into Haitian writing. They were, consciously or unconsciously, obsessed by the need for cultural wholeness, for the artist to be the voice of a community. Essentially Indigenism was built around this generation's preoccupation with the status of art and ritual in a world of materialism and broken continuities. Their desire was to move away from the contingency of the cultural present, to escape the alienation of the individual artist from his world and, in the process, to explore that repertoire of unconscious responses that constitutes the fabric of one's culture. This network of shared meanings would give identity to the group and be the link between the artist and his community. Sylvain's definition of literary *enracinement* bears this out: 'Literature presents the truest expression of a people's soul...What we are seeking – are the instinctive reactions of our sensibility to certain things.'[19]

Art would be seen in terms of the ideal of a mythical, pastoral culture where the artist was in communion with the spiritual. Sylvain, usually restrained in style, becomes lyrical as he envisages the movement away from the desecrated present to a hallowed past of a serene, whole culture, 'the time when Haitians loved each other, when it was a delight to live in our homeland, a delight enclosed in our serene landscape between our blue hills and the singing sea'.[20] Such a sense of wholeness might be found in the culture of the folk. Poetry was seen as an *instrument de connaissance* which could retrieve this vital contact with a collective authentic culture by using elements of Haitian folk culture. Sylvain's prescription, however, is rather vague:

> It is the sound of the drums announcing the dance from one hillside to another, the call of the conch shell, the hoarse cry of mankind pressed against the wall, it is the vibrant, sensual rhythm of a 'meringue' with wanton melancholy, which must be incorporated in our poetry... Our poems are translated from the Haitian, that is the translation of states of mind which are really our own.[21]

Perhaps this desperate desire for a community, for an ethnic context was already an admission that it was almost impossible to regain such a status for their poetry. However, this desperate urge persists in the work of the major poets of *La Revue Indigène* even after this period. Whether the ideal was the community of the 'damnés de la terre' or the concept of the 'nigritie' of the Haitian soul, essentially the aim was to reinstate the poetic word as the voice of the group or tradition.

Sylvain, who was the only one in this group that one could see as a theoretician, did not elaborate his ideas any further and wrote little poetry. It is therefore difficult to assess the achievements of the diverse talents of *La Revue Indigène* in terms of his criteria. Yet they share a common 'point of departure' which was that poetry should not be used simply as political propaganda but represented

a superior means of perceiving the world, 'a better insight into ourselves... into the mysterious world of the soul'.

However, these speculations were never closely followed in actual practice and their ideas on form and prosody at best appear sketchy. This may have resulted from an absolute refusal to prescribe literary criteria. Indeed, the only rule they all adhered to was the need to do away with any formal orthodoxy. Jacques Roumain indicated this refusal to pay homage to what he considered the sanctified, outmoded styles of the past, in an interview in 1927: 'Give to the poetic word, I ask of you, its fullest meaning... I voluntarily refuse to follow any rules. That bird which we call poetry, dies in captivity.'[22] Poetry must be uncluttered by literary tradition. They expected the poetic word, now set free, to have some kind of magical force. The poet's only guide was his subjectivity and the poem was judged simply by the intensity of the experience conveyed. Roumain in explaining this new aesthetic used the illustration of one of his early poems – 'Cent Metres':

> I want a poem to have the vibrant force which shakes (the reader). A driving force. In '100 Metres' I did not want to paint a picture. I am not a painter. I wanted to bring to life what I had run. The frenzy, the wild impressions ... to show the agonizing drama of this ordinary event.[23]

Their new poetics would not be based on traditional evocations of landscape or the delight in the well-turned phrase. Poetry, whose subject could be chosen at random, must now overwhelm by the violent shock of words or some bizarre fantasy. The poem had become an act of discovery.

Even though the word is never used in *La Revue Indigène* the Surrealist insistence on *délire verbal* and the setting free of the image seem to be at the base of these new demands on poetic form. Indeed. Etienne Lero, an orthodox Surrealist, would later in the pages of *Légitime Défense* make a similar demand on Caribbean poetry. What he called 'the colourful and sensual black imagination'.[24] This cry would also be echoed by Fanon's definition of a new revolutionary art – 'a jerky style full of images...Highly coloured too, bronzed, burnt, violent .'[25] This idea occurs in embryonic form in the pages of *La Revue Indigène*. This meant that the convention in poetry that would be singled out for special attention would be the image. As a Haitian critic said in 1934: 'the image has recaptured its throne... the image simply gives us better insight into reality without losing us in the labyrinth of abstract generalisations.'[26] The strong visual qualities apparent in those short 'nature' poems of La *Trouée* would now become the norm for *La Revue Indigène*. In the process of repossessing and renaming the landscape and reality of Haiti, the startling, evocative, poetic image would imbue the familiar and the commonplace with a sense of wonder. It could destroy both the conventional way of seeing reality as well as subvert traditional literary associations.

Perhaps the best way of identifying these new directions in poetry is in the context of the most introspective of all poetic genres – the *spleen* poems. These frequently occur in the pages of *La Revue Indigène* and reveal a darker side to some of the more violently *engagé* figures of the nationalist movement. For instance, short mood poems such as 'Orage', 'Insomnie', 'Calme', 'Noir' by Jacques Roumain are typical of this kind of writing. Yet these poems do not contain the usual wistful melancholy and sentimental rhetoric. In Roumain's 'Insomnie', for instance, the resources of *vers libre* are combined with concise and dramatic imagery to give a sharp impression of desolation:

> Clarté indécise
> La nuit
> entre dans la chambre, sombre voile
> brodé d'étoiles...
> Nuit interminable. Chaque heure

s'étire monotone comme une litanie.
Je me penche hors de moi
pour écouter une voix
ténue et triste comme un parfum.[27]

[Shadowy light
The night
enters the room, sombre veil
embroidered with stars...
Unending night. Each hour
is drawn out monotonous like a litany.
I strain
to hear a voice
thin and sad like a perfume.]

This kind of mood poetry tended to be closely linked to the bohemian lives of these poets. An atmosphere of eroticism and debauchery is the context for Daniel Heurtelou's 'Douze et Demi'. In this poem the staccato rhythms of *vers libre* suggest the cacophany of the night club and the frank physical imagery heightens the oppressive atmosphere:

Eructation pénible
du saxophone
qui crache
dans le soir lourd
des notes discordantes...

Et dans le coin ombreux
qu'illumine
son sourire de noire,
je tâche d'étouffer
le spleen
qui me tue.[28]

[Painful eructation
of the saxophone
spitting
into the evening heavy
with discordant notes...
And in the shadowy corner
illuminated by
her black girl's smile,
I try to stifle
the melancholy
which is killing me.]

The form has been made far more effective by eliminating the usual clichés of pathos. A Haitian nightclub scene also becomes palpably real in Carl Brouard's 'Bouge'. This fantasy in prose builds up its effects from a montage of apparently random sights and sounds in the bar:

Ce bouge. (Etait-ce un rêve)
Des prostituées mélancoliques dansaient la mérinque,
Songeant à un passé lointain... lointain, et leurs
mules claquaient sur le parquet usé.
Mélancoliques elles tournaient... tournaient comme
dans un rêve, aux sons d'un orchestre étrange; guitare,
grage, triangle, tambour.
Accoudé au comptoir crasseux, un ivrogne braillait
une chanson obscéne.
Ce bouge. (Etait-ce un rêve)[29]

This bar. (Was it a dream)
Melancholy prostitutes danced the meringue,
dreaming of a past far...far away, and their
shoes clicked on the worn floor.
Melancholy they turned...turned
as in a dream, to the sounds of a strange band; guitar,
maracas, triangle, drum.
Leaning on the filthy counter, a drunk roared out an obscene song.
This bar. (Was it a dream)

Even in these short introspective pieces in Haiti, because of the new range of theme and bizarre visual effects, poetry was being shifted away from its traditional moorings. However, the full impact of Indigenism is most obviously seen in the various tableaux of Haitian life that were depicted. The resources of the Haitian landscape would be used to convey that violently expressive style absolutely vital to this new sensibility.

If Price-Mars was the intellectual force behind this generation, Emile Roumer and Philippe Thoby-Marcelin represented the spirit and intuition of these times. The latter indicated their *prise de position* unequivocally in this wry observation: 'your older sister putting you to bed/hums/ the current fox-trot'.[30] Haiti was being lulled to sleep by American civilisation. It was their duty to resist the spread of Western materialism. Their most important literary achievements come from this period and are the best illustrations of how this generation set out to repossess *l'âme haitienne*. There were two ways of restoring the primal innocence they wished for the poetic word. Either innocence could be restored from the 'inside' through the dislocation of traditional literary forms, or 'innocent' non-poetic language could be introduced from the 'outside' and so reshape a literary form. Roumer's desire to retain and subvert the alexandrine puts him in the first category; Marcelin's conscious introduction of the contingency and disharmonies of everyday reality in his work makes him part of the second. It is tempting to see in Marcelin's poetry in particular, the influence of Apollinaire's dictum – 'exalter la vie sous quelque forme qu'elle se présente'. Also we find in much of Marcelin's work an attempt to present raw snatches of life to the extent that rigid perspective or any hint of stylisation are removed. The poem 'Grand rue' presents a collage of impressions and sounds – unrelated but creating a kaleidoscope of movement and colour:

Klaxons
buss
foule
bourrique
paysannes

Sous de grands-chapeaux-de-paille
Le marché et ses bruits colorés
Tohu-bohu
 pêle-mêle
Les maisons neuves sont blanches
Et carrées
Il ne faut pas rêver dans la rue
Les chauffeurs te l'apprennent gentiment à leur manière
compè ou fou?
 Locomotive
 cloche
 HASCO –5
Le convoi beugle
30 wagons de canne-à-sucre
Défilent.[31]

[Horns
buses
crowd
donkey
peasant women
Under huge straw hats
The market and its coloured noises
Hurly-burly pell-mell
The new houses arc white
And square
You must not dream in the street
The drivers gently remind you in their own way
man you mad?
Locomotive bell HASCO –5
The train bellows
30 wagons of sugar cane
file past.]

Marcelin was also very aware of the question of poetic register and how one could combine the visceral tones of Haitian creole with free verse. In 'L'Atlas a menti' he presents the situation of a peasant who looks at an atlas and cannot understand why Haiti is a tiny dot on the map:

Ciel-papier-buvard
L'avion est une vilaine tache
 mobile
qui trace des loopings
Bouqui tresse une natte de latanier
Et Roumer étudie la géographie
 O Bouqui
crache le chique de ton mépris
O chante une 'boula'

> et crève l'assotor
> et danse la chica
> 'Dehie mones gain mones
> Hein?
> Et lan cate-la
> Blancs-yo fait Haiti
> piti
> piti
> con-ça.'[32]

> [Blotting-paper sky
> The airplane is an ugly moving blotch
> making loops
> Bouqui weaves a mat
> And Roumer studies geography
> O Bouqui
> spit out your chew of scorn
> O sing a 'boula'
> and burst the 'assotor'
> and dance the 'chica'

> 'Behind one hill there is always another
> Not so?
> And on the map
> The whites make Haiti
> little
> little
> like that.']

The poem can best be read as a stream of associations almost as naive and arbitrary as those of a primitive painting. It contains allusions to peasant scepticism about the map (ciel-papier-buvard) as well as nonsense rhyme (o chante une boula... danse la chica) and snatches of peasant speech. On the surface a light poem on peasant distrust but it does also extend the range of language possible in poetry and recreate a temperament peculiar to Haiti. Marcelin was one of those who could see how excessive lyricism and stylisation had created many bland representations of Haiti in the past. The rhythms of free verse and the random impressions permissible in this new unrestricted style were manipulated to convey a certain immediacy and deliberately raw texture in his poetry.

Emile Roumer is one of the more enigmatic figures of the Occupation. His insistence on his own idiosyncrasies makes it difficult to see him as a member of any literary or ideological group. Perhaps the loose fraternity of *La Revue Indigène* suited him perfectly. No illustration of his originality is clearer than his poetry at this time. In a period of literary experimentation Roumer chose to retain the alexandrine. He combined this normally formal metric pattern with an enormous range of subjects and vocabulary. Behind it all one always senses an indomitable sense of humour.

Roumer did not need a movement to focus his ideas on creating a Haitian aesthetic in poetry. His most important collection of poetry – *Poèmes d'Haiti et de France* was published in 1925 and so easily predates the appearance of La *Revue Indigène*. Roumer's early poetry, however, gives us little indication of the strength of his poetic talent. His anti-American poetry, for instance, does not go

beyond the earnest but unoriginal *profession de foi* of the twenties. For instance, 'Le Testament' is characteristic of this phase of stately but banal alexandrines:

> J'ai perdu ma jeunesse et le rêve sauvage
> de tomber dans la rue une nuit de carnage
> J'ai perdu tout espoir on cet effort suprême
> de libérer mon sol d'une infâme tutelle[33]

> [I have lost my youth and the savage dream
> of being cut down in the road in a night of carnage
> I have lost all hope in this supreme effort
> to liberate my land from an ignominious yoke]

In fact, whenever Roumer is tempted to fierce *engagement* in his poetry, the verse becomes again a strident but dull declaration of intentions. His more recent *Le Caiman étoilé* (1963) makes us aware of this weakness.

It is in Roumer's apolitical verse that his real strengths as a poet become apparent. Defiantly retaining the alexandrine he set out to create a new lyricism that would be undeniably Haitian. A quick comparison with the use of an old-fashioned lyricism by a few timid poets of the twenties clearly brings out Roumer's originality. For instance, André Liautaud serenades the hills of Kenscoff:

> O Beaux Soirs de Kenscoff! Veillée autour de nattes
> Alors que le brouillard est comme un coutelas[34]

> [O Beautiful evenings in Kenscoff! Vigil around the mats
> While the fog is like a cutlass]

If this is contrasted to Roumer's own evocation of landscape, the latter's inventiveness and control of form are readily apparent. 'Impression d'août' is filled with fleeting sensual imagery and an effective use of synesthesia. This suggestion of colour, sound and smell is sharply disturbed by the last lines which almost undermine the pastoral serenity:

> Un spécial parfum de mangues qui fermentent.
> l'odeur du sol humide et l'arôme des menthes
> sous les manguiers touffus où ronfle le gérant
> près de l'étroit ruisseau dont l'eau clair se rend
> sous les jasmins en fleurs. Des boys à leur marelle
> criaillent dans l'allée; un vol de sauterelle
> met une lueur bleue au rouge des gravois.
> Soudain le type grogne avec un gros renvoi
> de gaz et fait partir de proches libellules
> tandis que les rosiers ont des roses qui brûlent.[35]

> [A special perfume of mangoes fermenting
> the smell of the wet earth and the aroma of mint
> under the dense mango trees where the owner snores
> near to the narrow stream whose clear water passes
> under the jasmine in flower. Boys playing hopscotch
> shout in the alley; a flight of grasshoppers
> places a blue light on the red rubble

Suddenly the man snorts with a great belch
of gas and chases the nearest dragonflies
while the rose bushes have roses that burn]

The shock value of the final lines shows both Roumer's refusal to be too tightly bound by formal prosody as well as his pervasive sense of humour. In fact, Roumer probably went as far as one can go in breaking up the alexandrine into a series of dramatic pauses and random observations. 'Paysage au rhum' in spite of the regular metre is broken by abrupt shifts in perspective:

Les abeilles ont pris, bruissantes, leur vol
doré. Le soleil brûle... Aucun souffle frivole
ne caresse les fleurs à la base des murs
massifs... Repos... [36]

[The bees have taken, noisily, their golden
flight. The sun burns... No frivolous breath
stirs the flowers at the base of their walls
massive... sleep...]

The use of enjambement and the almost elliptical syntax shows how close he is to his contemporary Marcelin, how much Roumer belonged to this time of literary experimentation.

The Indigenist ambition was to create a literature so exclusively and uniquely Haitian as to make it almost inaccessible to others. Roumer made the most sustained attempt in poetry to convey the peculiarities of *l'âme haitienne*. His most successful effort in this regard is the peasant declaration of love – 'Marabout de mon coeur'. The poem can be read on two levels – an irreverent, even gross parody of Petrarchan verse and an equally successful evocation of female sexuality in Haitian terms. Translation of the poem reduces it to nonsense but in its original form it makes fun of the Petrarchan cult of pure, asexual adoration of the beloved. In contrast to the courtly love tradition, Roumer's use of hyperbole is overwhelmingly sexual in its associations. But more importantly, Roumer also exploits a particularly Haitian convention in poetry – the comparison of women to fruits or various dishes (rather than to flowers). Oswald Durand is a precursor in this respect and Roumer fills his lines with the most erotic and savoury dishes that are both an amusing rejection of poetic decorum and wickedly play on the more risqué associations of Haitian creole. In the last line, for example, both 'fesse' and 'victouailles', because of the sibilant sounds suggest the sizzling of hot oil and 'boumba' (which normally means a cauldron) clearly evokes the creole word for the human bottom.[37]

Marabout de mon coeur aux seins de mandarine,
tu m'es plus savoureux que crabe en aubergine,
tu es un afiba dedans mon calalou,
le doumboueil de mon pois, mon thé de z'herbe à clou
Tu es le boeuf salé dont mon coeur est la couane
l'acassan au sirop qui coule dans ma gargane.
Tu es un plat fumant, diondion avec du riz,
des akras croustillants et des thazars bien frits...
Ma fringale d'amour te suit où que tu ailles;
ta fesse est un boumba chargé de victouailles.[38]

[My beloved 'Marabout' with breasts like tangerines
you are more delicious than crab in eggplant,
you are the meat in my *calalou,*
the dumpling in my peas, my aromatic
 herb tea,
You are the salt beef stored in the fat of my heart
the syrup drink that flows down my throat.
You are a steaming dish, mushroom cooked
with rice,
crisp fritters and fried fish...
My hunger for love follows you everywhere,
your bottom is a cauldron stuffed with food.]

Both Roumer and Marcelin, each in his own way, embodies the true spirit of Indigenism as it existed in 1927. Both sought a new poetics to recapture the whole range of the Haitian experience. But Indigenism was never static and consisted of a number of varying, even contradictory patterns. During the Occupation Haitian nationalism, the *raison d'être* of Indigenism, sought various points of orientation. Among the various myths that informed Haitian nationalism were the glorious and untainted pre-Colombian past; the heroic struggle of 1804; the legacy of cultural refinement and literary taste inherited from their Latin culture and the most influential alternative to emerge in the late twenties–Africa. The possibility of seeing Africa as a cultural matrix was promoted in Indigenism because of its interest in the various components of folk culture. It would, however, outlive this early phase to become one of the most dominant ideologies of the twentieth century in Haitian intellectual and cultural life.

Africa was the most attractive of the myths of modern Haitian national feeling because of the lure of cultural authenticity. African survivals were clearly present in the folklore and religion of Haiti's peasantry – Haiti's cultural heartland. Also the emergence of an interest in the African past meant the coming to fruition of Marcelin's 'éternel dédain aux raffinements européens'. It meant the rejection of rationalism and Western culture and the retrieval of an exclusively ethnic world of the senses.

Most of the poets of *La Revue Indigène* tended to gloss over the theme of Africa in their poetry – with one exception. Carl Brouard was the first of this generation openly to celebrate the Africanness of Haitian culture in 1927. The most bohemian and dissolute member of this generation, Brouard saw the emergence of Africa as an attempt to correct the imbalance that existed in Haitian culture. He declared, 'It is ridiculous to play the flute in a country where the national instrument is the powerful assotor drum.'[39] The alien flute against the authentic voodoo drum – Brouard's words were prophetic as this would become in another decade the basis for the ideology of ethnic authenticity.

However, in 1927 Brouard's few poems celebrating Africa are inspired by the sensual, erotic stereotype of his 'Nostalgie'. For instance, the poem 'Ma Muse' puts together similar ideas of Africa and sensuality. She is a somewhat perverse vision of unrestrained emotion:

Ma muse
est une courtisane toucouleur
des dents blanches
une cascade de fous rires
des sanglots profonds jusqu' à l'âme

une tumulte sonore
de bracelets et de verroteries[40]

[My muse
is a Toucouleur prostitute
with white teeth
a cascade of mad laughter
deep heartfelt sobs
a sonorous rattle
of bracelets and glass beads]

As is consistent with Brouard's early Africanist poetry, one senses an everpresent *refus* of the bland, repressed Eurocentric ideal in his evocation of colour, spontaneity and eroticism. In the voodoo religion Brouard found the 'défoulement' that his restless spirit needed. His early 'Hymne à Erzulie' also reflects his preoccupation with female sexuality:

Déese anthropophage de la Volupté
et des richesses
aux robes nuancées des couleurs de l'arc-en-ciel...

O toi
qui tends les désirs comme des cordes! p.93
O dix mille fois dedoublée
qui dans le monde élastique et mol des rêves
chaque nuit de jeudi
Ouvre à tes amants les secrets de tes flancs
et l'odeur de ta chair[41]

[Man-eating goddess of pleasure
and wealth
with robes tinged with the colours of the rainbow...

O you
who stretch desire like cords
O repeated ten thousand times
who in the elastic and soft world of dreams
each Thursday night
opens to your lovers the secrets of your thighs
and the odour of your flesh]

The poem continues as a graphic celebration of the flesh – a sexual 'dérèglement des sens'.

Even though interest in Africa and Haiti's Africanness would later develop into an independent ideological position, Indigenism permitted it to develop because of the fundamental *refus* it entailed as well as its link with the masses of Haiti. In fact, it all comes back to the essential quest for a community to which the Haitian poet could belong. What the members of *La Revue Indigène* had in common was the belief that literature should not be a hermetic and exclusive activity but part of a shared homogeneous culture. The need to democratise literature and the most inaccessible of all the genres – poetry–would be the legacy of Indigenism that permeates much of modern poetry in Haiti.

In another decade the Indigenist school was already outmoded and abandoned. Those who collaborated in this venture either stopped writing completely by the end of the Occupation or took positions in the ideological debate that followed. The debate between those who opted for Marxism as an explanation for Haiti's problems and those who saw national regeneration in terms of ethnic authenticity. If they shared any common feature, it was the dream of a polyvalent literary culture inherited from Indigenism. The Marxists saw themselves as the vanguard of a proletarian culture as opposed to the 'alienated elitist artist'. René Piquion, in his Marxist phase, typifies the sentiments of this group: 'The proletarian writer or artist is above all a fighter. Each day... He must light the way of the proletariat and their leaders.'[41] Brouard, who firmly rejected Marxist ideology, was one of the theoreticians of the Africanist movement in Haiti. He saw the Haitian artist as a 'troubadour' or *griot* perpetually in contact with the people and their culture. He did not explicitly emphasise the revolutionary class struggle but rather the intuition that links artist and community:

> Art in the service of the People has not yet been seriously envisaged, although among us, the only possible, viable Art emerges from them... Sometimes I have the chance to read poems to an illiterate audience. The effect is fascinating. Certainly, they did not understand much, but they perceived the essential beauty... All imaginations are open to the idea of beauty in the Platonic sense. It is not a matter of intelligence but of intuition.[43]

Socialist realism as well as ethnocentric ideology committed the literary word to the same role – not in the service of literary tradition but in the name of accessibility. For instance, Brouard's poem 'Vous' could be seen as the prototype of the new stripped-down literal poetic mode. More than simply being aggressively populist in its appeal, it reinforces the idea of the poem as a collective voice – a product of the new aesthetic democracy:

> Vous
> le gueux
> les immondes
> les puants:
> paysannes qui descendez nos mornes avec un
> gosse dans le ventre...
> Vous
> tous de la plèbe
> debout![44]

> [You
> the destitute
> the filthy
> the stinking
> peasants who descend the mountains
> with a child in your bellies...
> you
> all the people
> stand up]

Later Jacques Roumain, by then a Marxist and ideologically opposed to Brouard, would use a remarkably similar dramatic monologue:

> Eh bien voilà;
> nous autres

les nègres
les niggers
les sales nègres
nous n'acceptons plus
c'est simple
fini
d'être en Afrique
en Amérique
Vos nègres[45]

[Well, here we are
the negroes
the niggers
the dirty niggers
we no longer accept
it is simple
all over
to be in Africa
in America
your niggers]

Indigenism meant a sharp departure from literary convention and the emergence of a new authority and creative effervescence in the arts. It also signified the end of Haiti's isolation in cultural terms. Indigenism never became narrowly provincial. Jacques Roumain, in particular, was forever insistent on the need for opening Haiti's literary horizons: 'I think that our predecessors have been too exclusively preoccupied with a few French writers whose reputation reached them. They were completely uninterested in the happenings in world literature. In the twentieth century one is a citizen of the world.'[46]

Hence it is not surprising that the literary masterpiece that eventually emerged from the movement of Indigenism should have as its hero someone who could embody both the provincial and the cosmopolitan, the traditional and the progressive. Manuel in Roumain's *Gouverneurs de la rosée* epitomises the ideals of Indigenism. These were reinforced in the 1920s by the exhortations of visitors like Paul Morand who could see in the 1920s the beginnings of an international black literary *prise de conscience*. The introduction to his Haitian anthology states the need to link Haiti's problems with those of a world-wide black community: 'aux efforts littéraires de toute votre race, de Chicago à Madagascar'.

The Occupation was a cruel experience for Haiti but without it, it would be difficult to imagine the exuberant and daring spirit of the twenties. It would be difficult to envisage a *crise de conscience* of such proportions and the kind of national feeling created, so different from the tragic sense of belonging of *La Ronde*. It was in many ways a degrading experience, but it created modern Haitian literature.

Notes

1. *La Trouée,* no. 1, 1 July 1927, p. 21.
2. Jean Price-Mars, *La Vocation de l'élite* (Port-au-Prince: Edmond Chenet, 1919). Page numbers quoted from this edition.
3. Normil Sylvain, *La Trouée,* no. 2, 1 Aug. 1927, 55.
4. *La Revue Indigène,* no. 3, Sept. 1927, 105.
5. Jacques Roumain, *Appel* (Port-au-Prince: Pierre-Noel, 1928).
6. *La Revue Indigène,* no. 2, Aug. 1927, 71.
7. *La Nouvelle Ronde,* no. 2, 1 July 1925, 30.
8. *La Trouée,* no. 4, 1 Oct. 1927, 119.
9. Naomi Garret, *The Renaissance of Haitian Poetry* (Paris: Présence Africaine, 1963) p. 77.
10. *La Revue Indigène,* no. 3, Sept. 1927, 103–4.
11. *La Revue Indigène,* no. 4, Oct. 1927, 154.
12. *La Trouée,* no. 1. 1 July 1927, 1.
13. Ibid.
14. *La Trouée,* no. 6, 24 Dec. 1927, 185.
15. *La Trouée,* no. 3, 1 Sept. 1927.
16. Ibid.
17. Ibid.
18. *La Revue Indigène,* no. 1, July 1927, 2.
19. Ibid., pp. 3–4.
20. Ibid.
21. *La Revue Indigène,* no. 2, Aug. 1927, 53.
22. *La Revue Indigène,* no. 3, sept. 1927, 106.
23. Ibid.
24. Etienne Lero, 'Misère d'une poésie', *Légitime Défense,* no. 1, 1932, 12.
25. Frantz Fanon. *The Wretched of the Earth,* (Harmondsworth: Penguin, 1969) p.177.
26. Arthur Bonhomme, 'La nouvelle generation littéraire', *Les tendance, d'une génération* (Port-au-Prince: Collection des Griots, 1934) pp. 152–3.
27. *La Revue Indigène,* no. 3, Sept. 1927, 111.
28. *La Revue Indigène,* no. 4, Oct. 1927, 166.
29. Paul Morand. *Anthologie de la poésie haitienne indigène* (Port-au-Prince: Modèle, 1928) p. 8.
30. Ibid., p. 60.
31. Ibid., p. 62.
32. Ibid., p. 63.
33. Published in a special edition of *Haiti-Journal,* Dec. 1947.
34. Morand, *Anthologie de la poésie.*
35. Emile Roumer. *Poèmes d'Haiti et de France* (Paris: Revue Mondiale, 1925).
36. Ibid.
37. A commentary on this poem is offered by one of Roumain's characters in *La proie et l'Ombre* (Port-au-Prince: La Presse, 1930) p. 19.
38. *Haiti-Journal,* Dec. 1947.
39. *La Revue Indigène,* no. 2, Aug. 1927, 70.
40. Ibid.
41. *La Revue Indigène,* nos. 5–6, Jan.–Feb. 1928, 201.
42. René Piquion, 'Pour une culture prolétarienne', *L'Assaut* (La voix de la génération de l'occupation), Mar. 1936, 86.
43. *Les Griots,* vol. 2, no. 2, Oct.–Dec. 1938. 155.
44. *La Revue Indigène,* no. 2, Aug. 1927, 72.
45. Jacques Roumain, 'Sales nègres', *Bois d'Ebène* (Port-au-Prince: Henri Deschamps, 1945).
46. *La Revue Indigène,* no. 3. Sept. 1927, 103.

Imaginary Dialogue on Folklore

Rogelio Martínez Furé
Translated by Samuel Furé Davis

To my guide Don Fernando: Science, Consciousness, and Patience

Here I am, sitting in the shade of the travelers' palms. The green leaves of these immigrant trees from Madagascar are dancing in the wind. You walk towards me – perhaps you were here before. I proceed with the writing of my book of anonymous Cuban protest songs – since the colonial times to the triumph of the revolution – in the meantime, painful thoughts keep taunting me: the geo-phagous Zionist expansion in Sinai, the everyday assassinations in the streets of Santiago, the endless fratricidal war in Ireland, and Southern Africa always stabbing me, eternally driven like a stake into my heart.

Still putting my book in order – I hope it becomes a testimony of our people's love of freedom. I am still working on it when you suddenly drop your question making me stop the pen in the middle of a word.... You want to know my opinion about folklore. I smile. However, I think your question is right; it is good to set goals, to identify research areas, clarify principles. I am glad to know that you regard this science as a powerful weapon in the struggle for liberation, and that you judge the silent work of folklorists determined to rescue the treasures created by the people. I then get ready to elaborate on each of your questions. Here they are...

Rogelio, how is folklore seen by the bourgeoisie?

I think folklore is the culture of a people, generally transferred by the oral tradition; the habits and customs of any given human group which reflect the experiences, aspirations, concepts of life and death; the construction and decoration of their homes; the oral prose and poetry; the remedies and home-made food; the popular art, beliefs, superstitions and mythology; the music, dances, festivities and traditional costumes; and more... everything that some scholars have called "popular wisdom", while others have called it "traditional popular culture". Folklore is contrary to what is official, bookish or institutional. It is the product of the socio-economic and historic experiences of an entire community; and it reveals the most specific characteristics that define a community as a social entity. Folklore is to the people and for the people. It is anonymous, empiric, collective, and functional.

In the hands of the bourgeoisie, folklore becomes exotic, picturesque, an inferior form of culture worthy of exhibition in festivals or stage shows for leisure tourism, but segregated from the major trends of contemporary civilization. It is a museum-like curiosity, a complement to recreation, a "typical" fossil of an infra-culture unable to reach the so-called *universality* of the great expressions of bourgeois art. At the same time, the social groups which preserve these forms of traditional popular culture are marginalized in this classist society; they are victimized by all kinds of exploitation and prevented from participating in their own technical and scientific progress.

Reprinted with permission from *Díalogos Imaginarios*, trans. Samuel Fure Davis (Havana: Editorial Arte y Literatura, 1979), 257–79.

In most American countries, *folklore* is the word used to refer – somewhat pejoratively – to the survival of Indian, African or Eastern cultures (preserved by some groups by way of cultural resistance and expression of the class struggle in their societies) and the rural culture of European and mixed roots. The ruling capitalist system has placed these real subcultures on the margins, as evils which would be eradicated in the long run from the ethnographic map of their nations when those minority or majority groups finally disappear assimilated into the prevailing exploitation system as wage-earners or as a rough labor force. They have been totally stripped of their culture and have been prevented from adding any true ingredient to the national modern culture. For the oligarchies in power, this act of deculturation is only possible within the framework of western capitalist culture.

And how is it seen within the context of the socialist Revolution? What is the aim of the new society regarding folklore?

Folklore, defined as the most authentic expression of the traditional popular culture as opposed to the culture of the ruling classes or the official culture, is regarded differently within the context of the socialist Revolution. It is primarily seen as the most authentic creation of the people, which safeguarded some of the best examples of the popular resistance to the foreign encroachment and cultural invasions encouraged by the imperialist-driven national oligarchies.

In the new society, the objective is the integration of the best of those traditions. There is a negative side of folklore which should disappear (superstitions, anti-social behavior, ignorance, wrong interpretations of reality, etc.). The positive values should be adopted after a scientific, objective and unbiased criticism; the aim is the creation of a new national culture in combination with those non-capitalist values of contemporary civilization. All those sectors traditionally deprived from knowledge by the interests of the ruling classes would have the right to and take part in the creation of this new culture.

The positive traditions should be shared with the other sectors of the population who usually ignored them as a result of the class differences; their subsequent evolution should also be nurtured because these are living manifestations of a people's culture exposed to processes of change in every society. Folklore is not synonymous to "museum", "frozen culture" or "curious fossil"; we have to promote its organic development in conjunction with the objectives of a socialist system in progress and to improve its practices –for example, in the manufacture of musical instruments, in the scientific analysis of the real properties of the traditional pharmacopoeia, or in the enrichment of indigenous dances. In short, it is all about crossing out poisonous habits and ideas which are opposed to a materialist conception of the world and integrating all that national heritage to the main stream of revolutionary universal culture.

Then, is it possible to encourage the transformation and the development of folklore?

Yes, but that process should not be forced; it should be one of dialectical development. Folklore, the most pristine creation of the entire society, will similarly develop in the same way the whole society renovates itself. That is the reason why there is a present-day folklore and a historical folklore.

It is crucial to examine folklore with deep respect and profound knowledge. We should avoid all kinds of superficial and picturesque appreciations as well as stagnant representations of folkloric culture; these will be the key methods in our victory over ideological diversions. Folklore never disappears, it rather transforms itself; hence, it nurtures our real revolutionary national culture.

And what can you tell me about the artistic, didactic or cultural use of folkloric expressions?

The revolutionary society today should beware of stylish representations that distort the reality of folklore; these actions pretend, from a classist point of view, to turn the "forms of popular art" created by thousands of men and women across many generations into "more artistic expressions". This could be a reflection of bourgeois conceptions about what *art* is, about what *beautiful* is. Popular art has its own laws which do not necessarily have to correspond with the criteria of the academy or the *connoisseur*, used to the artistic expressions of the ruling classes. The popular artists should be encouraged, trained more efficiently in the use of their own techniques, and enriched with the knowledge of all real cultural traditions of humanity; however, they should not be forced to comply with some artistic criteria which, in the majority of our American nations, correspond mostly to cultural conceptions originated in different civilizations.

Have bourgeois influences existed, or do they exist in Cuban folklore?

In a class-divided society, just as Cuba was during the centuries of Spanish colonial rule when the roots of our folklore were planted, it was possible to go through a dialectical process of mutual influences between the European culture of the ruling class and the culture of the working class —mostly Africans and descendants. Since the 16th century, free blacks and mulattos imitated the costumes, habits and dances of the economically and politically powerful classes in the island. These disposed people naïvely believed that they could "ascend" in their social strata to enjoy the same economic well-being and all the privileges granted by the Crown. However, the music, dances and costumes of European origin were gradually modified and assimilated into a new system of values, different from the values held in the European environment where they were created. These elements were becoming *creole* and *mulatto*.

Conversely, the cultural elements originated at the base of the social pyramid were also tailored and surreptitiously *incorporated* to the traditions of the slave owners. It was all about a two-way transculturation movement (up-bottom and bottom-up) made easier by the relations of production and by the slave-based social and political system in which the Cuban culture emerged.

However, the really popular features prevailed during the formation process of our national culture and our folklore: namely, the creation of a distinctive speech form, various musical genres, oral literature, very original and meaningful visual arts, all of which reflected the people's creative ingeniousness. Our people managed to safeguard many of the best traditions of our humble ancestors (some of which were brought by the captive Africans, were "cubanized" and succeeded in the form of rhumbas, *congas*[1], *son*, proverbs, legends, meals, etc.; others were contributed by the underprivileged sectors of Spanish origin, such as the *puntoguajiro*,[2] the *zapateo*,[3] or the children's folklore). Despite the successful confrontation between this traditional popular culture and the foreign habits imported by the slave-holding bourgeoisie, some of our folkloric expressions are indebted to those traditions from the European ballrooms, but, as I said before, our people coopted them and gave them a new meaning and a new role. Let me give you some examples: the costumes and some dance steps of the so-called *tumbafrancesa* remind us of the *rigadoons* and the *quadrilles*; the improvised *décima*[4] used by our countrymen is a refined creation by Espinel; the *bata* used by the Black and mulatto women – a traditional Cuban dress today – is nothing but a folklorized version of the *peignoir* used by the Great House lady; or the so-called *contredanse cycle*, derived from the music and the dances from the ball rooms in Haiti and Louisiana, is the root of all our ballroom music (the Cuban *contradanza*, *danzón*, *danzonete*, etc.)

The most harmful bourgeois influence in our folklore is precisely found in the so-called middle-class ideas about the traditional popular culture: it was considered backward, barbaric, coarse and crude expressions worthy of erasure; these concepts were escalating until the victory of the revolution fortunately stopped the disintegration of our national values. This reactionary attitude allowed the middle class to be participant in the exploitation of the poorest sectors; consequently, they became part and parcel of the bourgeois crew, as second-class members who were unable to understand that they were as exploited as the poor people. This ideology was adopted by some popular – either rural or urban – groups to the point of making them feel ashamed of their parents' traditions and reject them; this reprehensible attitude was similar in many respects to that of the free blacks and mulattos during the colonial period. It was, therefore, impossible for them to admit the existence of any positive values in those traditions.

It is precisely in this regard where the revolution makes one of its greatest efforts; to rescue the positive valuable traditions created by our people, regardless of their roots, for the enjoyment of the new socialist culture in the making. Bringing to the light their proper values contributes to the widespread knowledge of their real ethnic manifestation and to the definitive eradication of ideological traces left over from capitalism or imperialist influences. This would make our cultural heritage tremendously richer and our people would be aware of our inherited traditions. Diversity is a reflection of our countless ethnic origins and the strength of our traditional popular culture. It is a living culture, not fossilized culture. If the Cuban people have been able to preserve it up to this date, it is because it plays a very important social role; otherwise, it would have been labeled as dead or historic folklore.

We must also exterminate the remnants of the diversionist ideas argued by the bourgeois ideologues since the 19th century, who pretended to set the two major roots of our nationality against each other by claiming that they were incompatible, or by acknowledging our cultural expressions of Hispanic origin as the absolute ingredient of being Cuban. Those with a more evident African influence were regarded as nearly foreign. Just as they exist in Cuba today – regardless of their greater of lesser degree of pureness – these two traditions are the results of the historical process that our people has been through and the socio-economic and political relations that have been present in our island for over four hundred years; this has more than once been clearly said by our revolutionary government in speeches and congresses. Our national culture is an *Afro-Hispanic culture in the Caribbean region*. According to our guide Don Fernando Ortiz, the African contribution is not here to graft the existing Cuban culture; on the contrary, *Cubanness* was born out of the alliance between the *Spanish* and the *African* elements, out of the long transculturation process: an unfinished synthesis that we can contribute to accelerate in a revolutionary way.

I can tell you for sure that there is no pure ethnic manifestation in our folklore: it is ethnically mixed in one way or another. This is an effect of the clash of civilizations triggered by the class struggle soon after the arrival of the exploitative Spanish settlers and the exploited Africans, and an result of the various strata established by the slave system in these two major groups by means of complex cultural, social and "racial" crossbreeding among all the social layers in the colony. A process redoubled during the pseudo-republican period had become irreversible with our victorious revolution.

Can you give me some examples of this unfinished "mestization"[5] process?

One example of that *amulatamiento*[6] –constantly present in our culture—is the *puntoguajiro*, which incorporated the *güiro*—a percussion instrument of African origin—more than a century

ago. Today, the bongos and the conga drums also accompany the *puntoguajiro* in many rural areas. Similarly, the Cuban ritual songs of African origin have been exposed to the influences of the Spanish language and music; the *kimbisa* or *chaganí* ritual songs or those used in the *lucumícruzao* can illustrate these influences.

And what about the relation between inertia and development in folklore?

One of the distinguishing features of folklore is *tradition* – which is at the same time one of the static constituents of culture – because it conveys customs, believes and practices of the past to the new generations. Because of *tradition*, new generations sing songs, perform dances, eat food, retell stories or proverbs, etc. created ages before them; sometimes these belong to civilizations with a socio-economic development different from the one in which they survive. These so-called *survivals* are also static elements of culture present in folklore.

Tradition conveys; *survival* secures.

Both prevent the disintegration of a civilization's value or a folklore act with the passing of time. Both are conservative in nature; they tend to freeze the cultural expression in *the same manner the elders used to practice it.* However, as I said before, folklore is a product of society, of the human conglomerate, so it equally develops itself; it is conditioned by all the changing processes which affect the social life. Folklore is a living force and the dynamic elements are dialectically opposed to the inert ones. The former are classified by the specialists into: a) the migration law in the folkloric act, b) the transformation law in the folkloric act, c) the variation law in the folkloric act, and d) the extinction law in the folkloric act.

Thanks to these laws, when the folkloric act is passed on from one generation to another, or from one social stratum to another, or from one region to another, it undergoes variations, adaptations, in which new forms emerge. Ultimately, when it is no longer functional in the community, it transforms itself into another (or other) contemporary act(s). Thus, in Liscano's words, the survivals nor only "survive", they rather revive; in other words, they transform themselves in life experiences, in new cultural forms, with new contents and functions.

Rogelio, sorry if I insist on a particular matter I would like you to elucidate even more/go over a bit further...

Which one?

How can the development of folklore be stimulated?

The development of folklore in a given nation can be stimulated in an intelligent and scientific way. The so-called *negative* folklore can be gradually eliminated (superstitions, taboos without a scientific foundation, idealist notions about supernatural forces that govern human life, the wrongful intrusion of healers in medical practice, coprology, xenophobia, etc.) while enriching and practicing the *positive* folklore. I am referring to all those practices that contribute to the harmonious development of society, to strengthen solidarity relationships, and to highlight the history of struggle against oppression. I also think of the playful folklore, the beneficial empiric pharmacopoeia, and all artistic practices that rose from popular religions and still bear cultural values, regardless of their idealist contents. These practices can be cleansed by giving them a new revolutionary social function–music, dance, visual arts, oral literature, etc. Let us recall some great cultural expressions which in the past emerged grounded on an ideology we today consider negative; however, the best of these cases were permeated by folklore elements of their time, and they have today a positive social function: Juan Sebastian Bach's works, written to be played in the churches and in the great

Russian cathedrals, are now considered treasures of the working people. Quite the opposite, not a single case is known of conversion to Christianity due to the appreciation of the aesthetic values of this music, which today serve the cultural interests of the masses. We can also mention the cases of ballet and opera which, in the past, were the privilege of the ruling classes and a tool for their reactionary ideology; nevertheless, after the October Revolution, these art forms have a new social role which is very far from the elitist nature of their origins. The critical selection, the use and the enrichment of folklore must be made not without a dynamic and profound knowledge of the laws that govern these cultural phenomena and the science that analyzes them. In short, all must be based on a very solid scientific framework – mine is Marxism-Leninism – careful of not killing folklore by implementing wrong criteria which, almost always, are the vestiges of a petit-bourgeois way of thinking about popular culture grounded on a Eurocentric and capitalist understanding of civilization.

According to Mostefa Lacheraf, tradition must be revitalized but must never become a prisoner of the past. Traditions dead or lost should never be artificially revived in the form of pseudo-folklore. This backward policy of inventing folklore has always failed because only authentic folklore – anonymous, collective, functional, traditional, and empiric – will transcend at the end of the day.

Do you remember any case of invention of pseudo-folklore in Cuba?

Of course. Let's recall the unfortunate attempts to create a white *Siboneyista*[7] pseudo-folklore in our country in the 19th century as a way to avoid the real problems of our national culture, as well as the famous Liborio, a character who was claimed to represent the Cuban nationality, also on false grounds. Just as Argeliers León righteously said, "the vernacular theater used to champion a *rough* countryman: Liborio, the non-Cuban type of character used as a representation of the people." Therefore, the African legacy was excluded.

Folklore must be a source of inspiration for new art forms, again citing Lacheraf:

> At the same time, rationally elaborated, explored, and meticulously valued, folklore should enlighten popular culture by disseminating it and become a catalyst for the creative appetite, a reservoir of fresh inspiration for the artist, the writer or the scholar [...]

> [But this will happen in the underdeveloped countries] when education become accessible to all, when a real cultural awareness prevails over the terrible feelings of slowly decaying or painfully agonizing popular traditions, consequently endangered by additional heteroclites, artistic demagogy and disloyalty. [For this reason] it is convenient to be extremely cautious and to set apart two very distinctive levels of analysis:

> - Folklore understood as popular culture in support of the written culture and national aesthetics (high quality craftsmanship, elaborated music, genuine oral literature, a nation of good taste);
> - Folklore understood as spontaneous enjoyment which brings about corrupted inspiration and foreign cultural influences (dubious quality ballets, inauthentic vestments, bad taste exhibitions, refined musical instruments in orchestras, and sweetened songs and chants which betray the most elementary rules of both a simple melodic composition as well as the national and native languages).

There is one last question I would like you to answer...

Yes, of course. Which one?

Are there common elements between Cuban folklore and that of other Caribbean nations?

Definitely. There are significant degrees of coincidence between Cuban folklore and that of other nations in the Caribbean region, since our economic, historic and social development has many points in common. The indigenous Caribbean cultures which spread over most of our islands came from the same geographical areas. Many studies argue that Siboneys, Tainos and Caribs were indigenous from South America, and they moved in consecutive migration waves off the Venezuelan coast. Every new emigration superseded the existing populations and brought in their respective practices. Therefore, agriculture, ceramics, the construction of houses and boats, and working utensils are all similar in most of the insular Caribbean; more developed in some islands than in others, but they belong to the same civilization complex (of Arawak affiliation).

Western European civilizations settled over the remnants of these peoples exterminated by the *conquistadores*. Later, the demand for labor in the exploitation of mines, the quest for gold and the agricultural plantations was satisfied by the import of captives from most corners of the African continent (although the first Blacks who set foot on these lands –we should remember this— arrived with the conquistadores; they were Spanish Blacks, they were rather servants, not slaves).

Centuries later, the expansion of the sugar industry and the lack of work force, brought about the import of Chinese, East Indians, Malaysians, to work in the cane fields; we must not forget that North Americans, Lebanese, Syrians, Hebrews and people of many other nationalities had countless motivations to land in this region. For more than four hundred years, these ancestors settled their various cultural practices in one of the most complex and violent transculturation processes in the world. Numerous cultures in various stages of development melted to produce a new kind of civilization originally based on the plantation economy (sugar cane), African enslaved labor, and a colonial society divided by the so-called *color castes system*.

In the beginning, these territories belonged to Spain, but since the end of 16th and particularly the 17th century and after countless wars many islands, even continental lands, became property of English, French, Dutch or Danish colonizers. Nevertheless, all these Western European cultural traditions adopted the slave-based relations of production. Thus, a new typical life-style emerged in the West Indies: the West Indian style.

Centuries of conflicts between the European powers over the control of the Caribbean Sea and the *Sugar Islands* contributed tremendously to construct the definitive profile of our peoples: Jamaica was discovered by Colombus, but conquered by England in 1655; the Western part of Santo Domingo was also seized from Spanish hands by the French in 1697; Havana, after English rule for almost a year, could only be recovered by Spain in 1793 in exchange for Florida; the island of Trinidad was declared British possession in 1802. Next, the struggles for independence, the conspiracies for freedom, or the victorious revolutions triggered migration waves from one island to another or to the continental seaside territories, whereto they exported much of their cultural elements.

The African-origin substratum, forcibly wrested from their native lands and brought captive to this side of the New World, has a common root. One or another African culture might constitute a majority in some areas (Yoruba here, or Dahomey or Fanti over there), but the prevalence of one ethnic group over another does not exclude background influences from the others. For example, the Ewe-Fon prevailed in the French territories; however, these particular African influences are also found in the former Spanish colonies, such as Cuba, Venezuela or Colombia. Similarly, the Bantu people left their footprints all over the region, as well as the Fanti and the Ashanti, the first choice of the English, but they were also brought to Cuba and Haiti....

Can we speak about a West Indian civilization?

Yes, I think so. This endless process of clash of civilizations, of multiple influences between the West European and African cultures merging themselves over the aboriginal humus – plus the contributions of some Asian civilizations—has created cultural ties visible in dance and musical traditions, popular art, oral literature, culinary practices, religions conceptions and superstitions. As I said before, this process was conditioned by the slave-based relations of production, a dependent economy based on sugar industry, the African bondage, and the colonial regime. This leads us to the point when we can speak of a *West Indian civilization*. It has local variants determined by the dominant culture (Spanish, French, English, etc.) which is not excluded at the level of the popular culture (*folk*) despite the diversity of languages and practices of the *official* culture. Even these languages bear the effect of the West Indian and African languages, so all our islands have some sort of creole languages.

The Cuban *son* has equivalent rhythms in the *calypsos* of Trinidad, Jamaica and the Bahamas, in the *beguines* and the *lagghia* of Martinique, the *plena* of Puerto Rico, the Haitian and Dominican merengues, the round-dances of the Cayman Islands, among others. The dances and the rhythm of the Cuban *tumbafrancesa* are very much present in our folklore (*tahona, cocuyé*); they came from Haiti, but are also found in Martinique and Guadalupe. Even in the so-called Dutch islands, one of their most popular rhythms is known as *tumba*. The solo-chorus pattern of the popular music (of unquestionable African antecedents in the special way we use it) is one of the distinguishing features of most Caribbean musical genres. Additionally, the collective procession-style dances with poly-articulated movements, like our *conga*, are also very common (the *vidée* in Martinique or the *canboulay* in Trinidad, for example). The colonial *caringa* in our country, originated in Congo, is the *calenda* or *calinda* among the slaves in Haiti, Martinique, Trinidad and New Orleans. The Cuban dances of Yoruba ancestry (since the rituals to the contemporary *mozambique, pilón* and *koyudde*) have a perfect match in the *Shango* dances, also from the island of Trinidad.

The Abakua *"diablitos"* can be seen dancing in Cuba, Venezuela, Panama. The sound of the string instruments such as *guitars, tres, cuatros, requintos, mejoraneras* and other instruments of Spanish origin always identify the countrymen in all the West Indies and in the nations along the coasts of the Caribbean Sea. What's more; the marimbas, *maracas*[8], drums, *cencerros*[9], *güiros, quijadas*[10] and many more instruments recreated by the Africans provide the music in this part of the New World with unique features expressed in *rumba, cumbia, bomba, malembe, porro, sangueo, tamborito, limbo, mambo,* and other rhythms. The carnival as a whole and the bands in particular also constitute the most spectacular moment for the exhibition of popular art in our nations; the collective talent is demonstrated in the making of masks, multicolored costumes, body painting, pantomimes, popular street theater, or improvised poetry. Likewise, the sound introduced by the musical genres of French, British and Central European origin –very fashionable since the end of the 18th century— have also left a mark in our ballroom dance styles; this influence has generated *contra dances, quadrilles, lanceros, waltz, rigadoons, polkas* and *mazurkas*, all of them resulted from the melting pot, bringing in a full collection of sounds from the violins, flutes, clarinets, ophicleides, pianos, and cornets, now intrinsically related to West Indian music. The tap dances and the singing style influenced by Semitic music, which arrived via Andalusia and became one of the sources of the *puntoguajiro* and *zapateo* in Cuba, are also found in the Panamamian *mejorana*, in the *puntillo* and *punteocruzado* from the island of Margarita, in the Venezuelan *joropo*, in the *mediatuna, mangulina* and *zapateo* of Santo Domingo, in the Colombian *sanjuanero*, etc. In short, making a list of the common elements, degrees of coincidence among our popular cultures is an endless effort. We

share dishes, proverbs, stories, riddles, prejudices, unfortunate histories, and, most of all, we share a tradition of fighting against exploitation: the concept of the *palenques*[11] founded by the aboriginal peoples, continued by the maroons, nationalized by the *mambises*[12] and now re-taken by the modern revolutionaries symbolizes this tradition.

So, do you think that the more we know of each other, the more aware we'd be of our common history and destiny?

Definitely. As we get to know more of each other, we'll be both aware of the cultural heritage that bring us together and better able to assume our singularity within the context of the Americas. In the same way, it will be a solid barricade against imperialist penetration, and a stimulus for the fight for definitive independence in those territories which still suffer from colonialism and neocolonialism. This West Indian singularity shall not exclude, but reinforce the historical and cultural connections as well as the common revolutionary fights that bring us together and make us an integral part of *our America*.

After this long dialogue –imaginary, perhaps?—you walk away. I go back to my papers, attentive to the latest news about the war in Sinai, at the shade of the travelers-palms which start to blossom.

Havana, October, 1973.

Translator's Notes

1. The word refers to the Cuban dance style of African origin, not the percussion instrument known in English as "conga drums".
2. Cuban rural or country music.
3. Tap dancing.
4. Eight-octameter poetic form.
5. Mixing
6. From "mulatto"; it refers to the cultural mixing process and its result.
7. Siboney: aboriginal or indigenous pre-Colombian people of Cuba
8. Shakers.
9. Cowbells.
10. The lower jaw of the skeleton of a horse.
11. Free settlements.
12. Cuban independence fighters.
13. Sic. This title refers to the set of volumes *Miscelánea de estudios dedicados a Fernando Ortiz*. La Habana, 1955

Bibliography

Acosta Saignes, Miguel: "El poblamiento primitivo de Venezuela", in *Miscelánea de estudios dedicados a Fernando Ortiz*. La Habana, 1955, vol. I.

Aguirre Belthán, Gonzalo: "Comercio de esclavos en México por 1542" in *Afroamérica*, México. D. F., vol. I, nrs. 1 and 2, January and July, 1945.

——. Op. cit., 1916.

——. *Cuijla, esbozo etnográfico de un pueblo negro*. Mexico, D.F. Fondo de Cultura Económica, 1958.

Agulrre, Sergio: Op. cit.

Alegría. Ricardo, E.: "La tradición cultural arcaica antillana" in *Miscelánea...*[13], La Habana, 1955, vol. l.

Alzola. C. T.: Op. cit.

Bastide, Roger: Op. cit.

Bogg. R. S.: "Folklore in literary masterpieces of the world the world" in *Miscelánea...* La Habana, 1955, vol. I.

Cabrera, Lydia: Op. cit., 1948.

——. Op. cit., 1954.

——. Op. cit., 1957.

Castillo Faílde, Osvaldo: Op. cit.

Cepero, Bonilla. Raúl: *Azúcar y abolición*. La Habana, Editorial de Ciencias Sociales, 1971.

Corvein. Robert: Op. cit.

Cortés, Vicenta: *La esclavitud en Valencia durante el reinado de los Reyes Católicos (1479–1516)*. Valencia. Excmo. Ayuntamiento, 1964.

Cruxent, J. M. and Rouse, Lrving: *Arqueología cronológica de Venezuela*. Washington D. C., Unión Panamericana, 1961, vol. I.

Debien, Gabriel: Op. cit. 1961–1964–1965.

——. "Le marronageaux Antilles françaisesau XVII lemesiecle", in *Caribbean Studies*, Río Piedra, Puerto Rico, vol. 6, no. 3, October, 1966.

de Rojas, María Ieresa: Óp. cit., 1950. 3 vol.

——. "Algunos datos sobre los negros esclavos y horros en la Habana del siglo XVI" in *Miscelánea...*, 1956, vol. 3.

de Zárate, Dora: "El poema congo, el gran poema" in *Revista Lotería*. Panamá, nr. 195, February. 1972

Diaz Fabelo, Teodoro: Op. Cit.

Dunham, Katherine: "Las danzas de Haití", in *Acta Antropológica*. Mexico D.F., vol. II, nr. 4, November, 1947.

Escalante, Aquiles: *El negro en Colombia*. Bogotá, Universidad Nacional de Colombia, 1964.

Franco, José Luciano: *Revoluciones y conflictos internacionales en el Caribe* 1789-1854. La Habana, Academia de Ciencias de Cuba, 1965.

——. *Historia de la Revolución de Haití*. La Habana, Academia de Ciencias de Cuba, 1966.

——. Op. cit., 1973.

——. Op. cit., 1974.

——. *La gesta heróica...*1975.

——. *Las minas de Santiago del Prado...*1975.

Historia de Cuba. La Habana, 1967.

Labat, Père Jean BaptistE: *Nouveau voyage auxiles d'Amerique*. Paris. 1741. 8 vols.

Lacheraf, Mostefa: "Le préalable du terrain culturel et socioéconomique et les exigences de la production artistique et économique" in *Présence Africaine*, Paris, nr. 80, 4th quarter, 1971.

Lfaf, EarL: *Isles of Rhythm*. New York, A. X. Barnes, 1948.

León, Argeliers: Op. cit.

Lepkowski, Tadeusz: *Haití*. La Habana, Casa de la Américas, 1968–69, 2 vols.

Linares, María Teresa: *El sucu-sucu de isla de Pinos*. La Habana, Instituto de Etnología y Folklore, Academia de Ciencias de Cuba, 1970.

Lizardo. Fradique: *Danzas y bailes folklóricos dominicanos*. Santo Domingo, R. D., Ed. Fundación García-Arévalo. lnc., 1975.

Liscano, Juan: Op. cit.

Lynn, Smith. T.: "The racial composition of the population of Colombia" in *Journal of Inter-American Studies*. Coral Gables, University of Miami, April, vol. VIII, nr. 2, 1966.

Ortiz, Fernando: Op. cit., 1916.

——. Op. cit., 1924.

——. Op. cit., 1951.

——. Op. cit., 1952–1955. (5 vols.).

——. *La africanía de la música folklórica de Cuba*. La Habana, Editora Universitaria, 1965.

Ortiz Oderigo. Nestor: "El calypso, expresión musical de los negros de Trinidad" in *Miscelánea...* 1956, vol. II.

Pereda Valdés, Ildefonso (Ed.): *Dinámica del Folklore*. Montevideo, 1966.

Pérez de la Riva, Juan: "La situación legal del culí en Cuba" and "Demografía de los culíes chinos en Cuba" (1853-1874)" in *El Barracón y otros ensayos*. La Habana. Editorial de Ciencias Sociales, 1975.

——. Op. cit., 1974.

Pollak-Eltz, Angelina: "The devil dances in Venezuela" in *Caribbean Studies*. Río Piedras, Puerto Rico, vol. 8, nr. 2, July, 1968.

——. "Vestigios africanos en la cultura del pueblo venezolano". Cuernavaca, CIDOC, in *Sondeos*, nr. 76, 1971.

Portuondo, José A.: "Alcance a las relaciones" in *Miscelánea...* 1956, vol. II.

Portuondo del Prado, Fernando: *Historia de Cuba I*. La Habana, Editora. Nacional de Cuba. 1965.

Ramón Y Rivera, Luis Felipe: Op. cit.

Ramos, Arthur: Op. cit.

Rob, Stanley L.: *Hispanic Riddles from Panama*. Berkeley and Los Angeles, University of California Press, 1963.

Sojo, Juan Pablo: Op. cit.

Sherlock, Philip M.:*The aborigines of Jamaica*. Kingston,The Institute of Jamaica, 1939.

Tabio, F. and Rey, E.: *Prehistoria de Cuba*. La Habana, Academia de Ciencias de Cuba, 1966.

Trincado Fontán, Nelsa; Castellanos Castellanos, Nilecta and Sosa Montalvo, Gloria: *Arqueología de Sardinero*. Santiago de Cuba, Instituto Cubano del Libro, 1973.

Vento, Saúl: Op. Cit.

Williams, Eric: "The historical background of race relations in the Caribbean" in *Miscelánea*... 1957, vol. 3.

———. *Capitalismo y esclavitud*. La Habana, Editorial de Ciencias Sociales, 1975.

Zapata Olivella, Delia: "La cumbia" in *Revista Colombiana de folclor*. Bogotá, vol. III, nr. 7, 2nd. period, 1962.

Zapata Olivella, Manuel: "Cantos religiosos de los negros de Palenque" in *Revista Colombiana de folclor*. Bogotá, vol. III, nr. 7, 2nd period, 1962.

Popular Art and Cultural Freedom

Hilary Beckles

Ritualizing Resistance

Magnificently expressive of the anxieties of nationalist consciousness in the twentieth century are the drama, music and literature, both oral and scribal, of the West Indian masses. Nationalist identity and sentiments found eruptive articulation in spectator 'politics' that reveal both the depth and fragility of the new sovereign order. For many colonials this process was entirely surprising. It was not altogether clear at the end of the nineteenth century that within two decades the majority of West Indians would have embraced cricket and promoted it as their principal, popular, nationalist cultural activity.

Much clearer, however, was that traditional promoters of the game wished for no such objective. The intensity of the determination to maintain the heart and soul of the game by white élite participants stimulated the imagination of the excluded majority who understood the principles and ideas at the centre of the contest. By the interwar years cricket had ceased to be a minority game. The masses now saw their own players holding forth and challenging the best. Home-grown heroes were emerging everywhere, and stars were shining in rural villages and urban ghettos in ways hitherto unimaginable. They could now travel overseas as reputable players and engage 'gentlemen' at the highest levels; the status of 'professional' was one they could appropriate and use as a measure, and mirror, of their success.

Like Protestant Christianity, cricket was introduced into West Indian society and defined as part of the ideological armour of an aggressive English cultural imperialism. Neither was intended for the social consumption of the politically disenfranchised and materially impoverished black communities. Both were instruments of empire, imported and imposed upon colonial society by English officials and resident white élite who valued above all the political importance of formally organized social institutions.

The end of the nineteenth century, however, was a significant social moment for advocates of both cricket and Christianity. While nonconformist missionaries in particular traversed the region feverishly seeking a mass (black) membership for their churches, the colonial élite was doing all in its power to insulate cricket culture from the social effects of ideological egalitarianism. Élite whites wished to be satisfied, at least moderately so, that there was still one social institution whose doors remained closed to the lower orders, and in which 'gentlemen' could enjoy exclusively the social pleasures and privileges associated with their oligarchical ownership of private property.

The ideological positions adopted by the Anglo-colonial élite with respect to the politics of Christianity and cricket constitute a discursive context. A sophisticated appreciation of the value system of cricket, élite whites argued, was beyond the intellectual reach of Africans and Asians, whose participation was seen as detrimental to its development. In the ideological sphere, 'high'

Reprinted with permission from *The Development of West Indies Cricket Volume 1: The Age of Nationalism* (Mona, Jamaica: University of the West Indies Press, 1998), 101–116.

moral and aesthetical expression was appropriated and monopolized by the élite, while concepts that denoted crudity and primitivism were levelled against the labouring classes. Eurocentrism and racism, then, functioned as a formidable boundary that separated colonial social groups within the established church as well as on the cricket field.

In the twentieth century, however, West Indians of African and Asian descent confronted the 'imported/imposed' Englishness of the plantation-based cricket world with precise anticolonial, nationalist demands that had the effect of changing forever the social trajectory and meaning of the game.[1] Within this process of cultural domestication and working class aggression, the disenfranchised sculptured unique and distinct methodological and aesthetical forms of the game that reflected and promoted their social identity and concerns. In their varied roles as players, spectators and commentators, the working classes succeeded in determining and defining the popular images, politics and social considerations of cricket in ways that soon gained hegemonic cultural dimensions.[2]

While Englishmen, and their Creole progeny, sought to imitate and fossilize cricketing images and behavioural patterns that originated with the Victorian gentry, the West Indian masses surrounded and infused the game with an aura and ethos derived from their popular struggles and residual cultural norms. Even before 1928, when the West Indies cricket team gained Test status, observers were keen to point out that Africans and Asians brought to the game a unique, dynamic, celebratory, theatrical presence.

With reference to an earlier period, for example, Algernon Aspinall, historian of the English in the nineteenth century West Indies, had commented on the "sheer excitement" and "demonstrative" expressions of "the black spectator". "It is not unusual", he tells us, "to see many of them rush out on the ground and leap and roll about from sheer excitement when a wicket falls on the side which they do not favour, or when a brilliant catch is made." A.F. Somerset, who toured the West Indies in 1895 with the Slade Lucas team, while comparing the participatory 'playing' of the West Indian crowd with its less verbose, more quietly consumerist English counterpart, stated:

> A good ball dealt with brings a shout of 'played!' all around the ground, and to stop a 'yorker' evokes a yell that would not be given for a hit out of the ground in England. When that comes off a large part of the crowd spring on to the ground, throw their hands and umbrellas in the air, perform fantastic dances, and some of them are occasionally arrested by the police.[3]

In the Barbados vs England match of that tour, Somerset stated, the England captain was forced to use a whistle to get the attention of his fieldsmen, so noisy and festive was the crowd.

Performing the Language

This expressive physical and oral appreciation of performance had hardly changed in the years after World War II when West Indians prepared to take the cricket world by storm. In fact, it has been consolidated into that realm of popular recognition generally referred to as custom. Barbadian poet, Edward Brathwaite, captured the nationalist language and sound of the Barbados cricket crowd during a postwar Test against England:

> Clyde [Walcott] back pun de backfoot an' prax!
> Is through extra cover an' four red runs all de way.
> "You see dat shot?" the people was shoutin';
> "Jesus Chrise, man, wanna see dat shot?"
> All over de groun' fellers shakin' hands wid each other
> An' in front o' where I was sittin',

One ball-headed sceptic snatch hat off he head
as if he did crazy
an' pointin' he finger at Wardle [the bowler]
he jump up an' down
Like a sun-shatter daisy an' bawl
out; "B..L..O..O..D, B..I..G.. B..O..Y.
Bring me he B..L..O..O..D".[4]

This tradition of language, performance and sound 'speaks' directly to the variety of issues central to an ontological understanding of what is West Indianness. That the West Indian voice is clearly heard in the sound of the cricket crowd should indicate the basic truth of C.L.R. James' assertion that spectators take with them through the gates of cricket arenas the full weight of their history and visions of the future. This 'sound' of gathered West Indians, like the talking drums of their ancestors, is a secret code which is very easily misconceived and misunderstood by those not perfectly tuned to its transmission. It is a sound that fills the air and unites those whose mission it is to put together fragments of an old world in new, more resistant forms.

The indigenous literature, music, and dance of the West Indian cricket crowd, then, are cultural missiles that emanate from a complex, nationalist command centre within race/class consciousness. The inherent beliefs of the common people with respect to past and current achievements and injustices, as well as everyday fears and expectations, are often displayed at moments of 'play', and in ways which support Brathwaite's and Vidia Naipaul's view that cricket for many constitutes a level of consciousness and existence located somewhere above mundane matters of economics and politics. It is this historically informed matrix of consciousness, actions and ideology that continues to engage the creative art forms of West Indians. Cricket as the popular cultural occupation of the region, therefore, converts spectators into artists in a dialectical and symbiotic way, allowing for some of the finest expressions of music, theatrical performance and oral literature.

The nation language employed by the West Indian voice within the cricket arena, furthermore, is not only authentic, but perhaps more importantly, it is pure in that it remains spontaneous in its creative form and insists upon being uncensored. Its linguistic code is no different in meaning from the drumbeat call to arms by the enslaved on the plantation in an earlier era. At the same time it is also the infrastructure for a sophisticated literary play on the pressing sociopolitical issues "beyond the boundary". All together, as a discursive practice, they constitute a compelling element of an indigenous literary canon that rejects notions of the region as 'other' by the imperial centre and insists upon the existence of plurality in style and genre. The voice of the cricket crowd as heard, and interpreted, to which generations of established artists have responded, is therefore rooted in popular ideology and echoes levels of consciousness within the fragmented West Indian nation.

The oral and scribal text of the West Indian cricket culture, then, constitutes a storehouse of information on the native tongue, sound and senses. In terms of content this text has been fiercely anticolonial, even before the time when such an ideological position had not taken shape in the form of organized political activity. The earliest cricket crowd said as much about English colonialism as more recent political leaders on their soapboxes; working class calypsonians sent as many potent messages to Whitehall in their cricket songs as scholars did in their written texts. The metaphoric cricket poems, songs and prose of the region constitute an innovative literary and artistic style of communication that reinforces the significance of the game within mass society. It is this sporting activity that has given West Indian people as a whole their first mass heroes. While

political or intellectual leaders may attain popularity within single territories, only the following of cricket heroes transcends national, ideological and generational boundaries. This reality provides a unique terrain for artists and intellectuals to speak to the region as one about itself as a unified cultural space.

Such an opportunity was not to be missed by an artist as penetrating and perceptive as Trinidad's Errol John. In his play, *Moon on a Rainbow Shawl*, the quintessential classic of contemporary Caribbean theatre, John speaks of the racial injustices within early twentieth century colonial society that found fertile soil in its cricket fields. In the script, Charlie Adams, who, just by an analysis of his name, is a 'regular' common kind of being – if not the first man in terms of biblical text – has a decidedly promising career ahead of him as a cricketer, possessing in his physical and mental faculties an abundance of skills and power of application. While representing his country on a tour of Jamaica, however, Adams expressed some measure of disgust at the discriminatory treatment meted out to black members of his team by their white hosts. For this social 'indiscretion' his cricketing career came to a cataclysmic end, with the consequence of his being unemployable, abjectly depressed and finally, a convicted, alcoholic criminal. Broken dreams and a shattered life led to Adams' 'social death' in a colonial community that was prepared to offer him 'recognition' on condition of self-negation and denial. What is important about this scenario from our viewpoint is not the written text, but the fact that John's father was himself recognized as a 'potential' who, during the 1930s, had experienced considerable frustration and humiliation at the hands of the 'white' cricketing authorities.[5]

Adams' dream was no different from that of most working class African and Asian West Indian boys from the 1930s to the present; to escape the poverty and racial oppression of their little world aboard the cricket vehicle – the one that took the most passengers from the ghettoes to the suburbs and; beyond. Adams tells his story of hope, struggle and despair, and finally defeat by the 'savannah' colonial upper class of the Queen's Park Cricket Club:

> **Charlie:** In my day, EPF – I use to get my bats second-hand. An' sometimes they had to last me from season to season, but my big talent was with the ball.
>
> I used to trundle down to that wicket – an' send them down red hot! They don't make them that fast these days. The boys don't keep in condition. Today they send down a couple of overs – then they are on their knees. But in my time, John, Old Constantine, Francis, them fellas was fast! Fast! Up in England them so help put the Indies on the map.
>
> **EPF:** I only saw you once on the green, Charlie. Yer was kind of past yer prime. But the ole brain was there! And batsman was seein' trouble! Trouble, man! And I say this to you now, papa – You was class!
>
> **Charlie:** In them days, boy – The Savannah Club crowd was running most everything. People like me either had to lump it or leave it.
>
> **EPF:** It ent much different now, Charlie.
>
> **Charlie:** Is different – a whole lot different. In them times so when we went Barbados or Jamaica to play cricket they used to treat us like hogs, boy. When we went on tours they put we in any ole kind of boarding-house. The best hotels was fer them and the half-scald members of the team – So in twenty-seven when we was on tour in Jamaica I cause a stink, boy. I had had enough of them dirty little boarding-house rooms. I said either they treat me decent or they send me back. The stink I made got into the newspapers. They didn't send me back. But that was the last intercolony series I ever play.
>
> They broke me, boy.

EPF: [quietly] Fer that?

Charlie: I should of known mey place. If I had known mey place, EPF, I'd made the team to England the following year. And in them days, boy – the English County clubs was outbidding each other fer bowlers like me. But the Big Ones here strangled my future, boy.[6]

The collective memory of the cricket 'crowd' has in store cases by the dozen of 'potentials' who dried and died on the cricket vine on account of protesting such social injustices.

Bruce St John, 'nation poet' of Barbados, understood the tragic drama that lurks in the dark corners of the cricket culture. He urges the player, however, to be optimistic and to persevere against all adversity since, in the final instance, the crowd, like Christ of the New Testament, is understanding and sympathetic. Cricket, St John tells us, has assumed quasi-religious proportions for the Barbadian masses:

Le' muh tell yuh somet'ing Boysie boy,
De Lord got somet'ing to do wid cricket.
De wicket does remin' me o' de Trinity
God in de centre of de three,
Holy Ghost pun de lef' and Jesus
Pun de right an' de bails like a crown
Joinin' dem an' mekkin' dem Three in One.
De pitch lika an altar north and south
Wid de sun transfigurin' de scene
And de umpires like two high priests
Wid de groundsmen as de sextons, Yes, Yes...
Cricket is de game o' de Lord
Cricket is de game o' de Master
Play de game right, Boysie boy
An' you stan' a good chance hereafter.[7]

St John's utopian 'hereafter' refers less to the social honour and economic betterment dreamt of by Charlie Adams, and more to a perception that the moral values of the game if properly applied to social life tend towards the making of a Christian character that is readily embraced by the society.

St John's optimism and generosity, however, did not find its way into Edward Brathwaite's use of the cricket metaphor in his clinical (for some cynical) assessment of the West Indian personality. Brathwaite seems to share Wilson Harris's criticism of the West Indian mind as disunited, consumed in apathy and unwilling to be disciplined into taking responsibility for its destiny. In "Rites", the famous poem in which these themes are explored, Brathwaite confronts the question of indiscipline and irresponsibility:

I tole him over an' over
agen: *watch de ball, man,* watch
De ball like it hook to your eye
When you first goes in an' you doan know de pitch.
Uh doan mean to poke
but you jes got to watch what you doin';
this isn't no time for playin'
the fool nor making no sport; this is cricket!
But Gullstone too deaf:

mudder doan clean out de wax in 'e ear!
Firs' ball from Cass an' he fishin':
second ball an' he missin', swishin'
he bat like wishin'
to catch butterfly; though all Gullstone ever could catch
pun this beach was a cole!
But is always the trouble wid we;
Too afraid an' too frighten.
Is all very well when it rosy an' sweet,
but leh murder start an' bruggalungdung!
You cahn fine a man to hole up de side.[8]

On this matter, if not on any other, Brathwaite and Naipaul agree.

For Naipaul, West Indian cricketers, like politicians, lack the kind of mental preparation necessary for the attainment of creative accomplishments. For him, colonials are generally imitators and flippant in manner – nation builders are not. With reference to the 1963 West Indies tour of England, Naipaul places these words in the mouth of his fictional character:

> You know what's wrong with our West Indians? No damn discipline. Look at this business this morning. That Hall and Trueman nonsense, Kya-Kya, very funny. But that is not the way the Aussies won Tests. I tell you, what we need is *conscription*. Put every one of the idlers in the army. Give them discipline.[9]

Music, Melody and Messengers

If Brathwaite saw in cricket characteristic features of an unfit West Indian personality – one not yet ready for serious nationalist concerns – and was therefore unwilling to celebrate and savour the 'highs' of the game on account of the 'lows' that were sure to follow, calypsonians from the earliest days had no such reservations. They composed and performed melodies that captured the essence of historic moments in a way that newspaper reporters could not. In the first West Indies Test match at Lord's, against England, which was played in 1928, Learie Constantine, at age 26, took four wickets and three catches, and was involved in the dismissal of the first four English batsmen. To mark the occasion, Trinidadian calypsonian, Lord Beginner (Egbert Moore) composed the song:

> Joe Small and Griffith was
> excellent
> was magnificent
> And our cricketer, great Wilton St Hill
> Did not do well because he was ill
> He made a name for the West Indies
> Who he was? Learie Constantine
> That old pal of mine.[10]

This calypso, notes Kim Johnson, is the first celebration in song of a West Indies cricket hero.[11]

The 1950 West Indies tour of England was special in many ways. But the most significant feature was that thousands of West Indians had recently emigrated to England and represented for the first time a significant 'home crowd' within the English crowd cheering on the West Indies. The vocal support they offered the West Indies team during Tests strengthened its resolve to the same degree as it disturbed English supporters now faced with a new and novel circumstance. The tensions of race relations in England, and the 'blues' of the migrant communities, meant that the

psychological profiles of West Indian spectators had also been reconfigured. Anti-black racism has long been an endemic feature of West Indian societies, but there was something different and unfamiliar about the English contexts of racism. Perhaps it was the absence of cultural space that prevented West Indian migrants from creating their own world, in spite of racism, that heightened anxieties and produced the besieged consciousness.

The first Test was played at Old Trafford, and England won by 202 runs. The second Test at Lord's, however, produced the long sought after result – West Indies won by 326 runs on account of the brilliance of young mystery spinners Sonny Ramadhin and Alf Valentine. England received a thrashing that broke their resolve, and the West Indies romped home to a 3–1 historic Test victory after winning the third and fourth Tests by 10 wickets and an innings and 56 runs respectively.

The Lord's Test was the scene of the first 'cricket carnival' in England. The ground exploded in dance, song and bacchanal, West Indian style, and signalled the beginning of a process that was to refashion the culture of cricket crowds in England. Lord Kitchener and Lord Beginner were at Lord's for the pivotal Test, and already known as legendary artists, led jubilant West Indians across the field in a procession of improvised singing. The well known photograph of these two Lords of calypso at Lord's, surrounded by chanting melody makers, says more about that moment in the hearts of West Indians than match reports ever could. Kitchener, with guitar in hand, and Beginner leading the vocals, produced for the cricket world the song "Cricket, Lovely Cricket":[12]

> Cricket, lovely cricket
> At Lord's where I saw it
> (repeat)
> Yardley tried his best
> But Goddard won the Test
> They gave the crowd plenty fun
> Second Test and
> West Indies won
> With those two little pals of mine
> Ramadhin and Valentine
> The King was well attired
> So they started with Rae and Stollmeyer
> Stolly was hitting balls around the boundary
> But Wardle stopped him at twenty
> Rae had confidence
> So he put up a strong defence
> He saw the King was waiting
> to see
> So he gave him a century

For West Indians, even those who came of age (in a cricketing sense) after the 1950 Test, this was their redemption song.

Lord Beginner, then, was critical in the establishment of a literary and musical tradition that is, ironically, perhaps more West Indian than the cricket itself. Kitchener, notes Kim Johnson, built upon and deepened this art form in ways that enhanced the standing of cricket for West Indians as "de Lord's game". According to Johnson, Kitchener sang "The Cricket Song" about the 1964 series, telling the story in his beautiful couplets alongside an old-time call-and-response chorus:

(Bowl Griffith) Bowl, don't
stop at all
(Bowl Griffith) Give him back the ball
(Bowl Griffith) Sobers and Hall
(Bowl Griffith) Bring Gibbs and all.

And then in 1967 he sang "Cricket Champions" about the 1966 series in England when West Indies, led by Sobers, won three, drew one and lost one Test:

England must understand
We are the champions
Sobers carray and hit them
potow! potow! – two four
Holford come back and hit
them bodow! bodow! – two more.

But in between these two gems by Kitchener something had changed; Sparrow sang "Sir Garfield Sobers" (1966) about "the greatest cricketer on Earth, or Mars" and the victory over Australia, and narrative ball-by-ball calypso commentaries went out of fashion.

Thereafter, in the 1970s, Relator penned the marvellous 'Gavaskar'. Although this was structured in an old-time narrative mode and made fun of the names of the Indian cricketers, Relator was not only singing humorously about series cricket – not no Chinese match – but also commenting on the first West Indian Test defeat at the hands of India:

and its Gavaskar
We real master
Just like a wall
We couldn't out Gavaskar at all.

Short Shirt sent "Viv Richards" from Antigua in 1975, Maestro gave us "World Cup", and Sparrow sang "Kerry Packer" which in 1978 savagely tore down the final myth of cricketing heroism:

I eh negotiating ah told them
If they got money we can't control them
A West Indian cricketer must always be broke
Is then he does bowl fast and make pretty stroke.[13]

These songs reflect both the celebratory and commemorative values of the wider society, and are rooted in the cultural bedrock of their 'call-and-response', 'praise song' and 'judgemental' oral traditions. They also chronicle the history of West Indies cricket, the successes and failures. But, more importantly, they articulate national political concerns and popular ideologies.

David Rudder's "Rally Round the West Indies" calls for firm support for the West Indies team during the difficult years that followed the retirement of several players from the extraordinarily victorious Clive Lloyd team. But Rudder is also concerned with the wider geopolitical issues involved in West Indies survival when he beckons:

Soon we must take a side or be left in the rubble
In a divided world that don't need islands no more
Are we doomed for ever to be at somebody's mercy
Little keys can open up mighty doors
Rally round the West Indies now and forever.

The West Indies cricket crowd, of course, provides the inspiration and ideological parameters for this musical tradition. It is common indeed for the crowd to call upon known musical talents to take the lead and improvise songs to suit the occasion and mood of the game. What happens in the recording studios is but a refashioning of forms and ideas already ventilated by the cricket crowd. It is the crowd that provides the interpretation of events to which the artist responds, and within the creativity of the moment history is preserved in sound.

A classic 'character' in the musical tradition of the West Indies cricket crowd is the Barbadian calypsonian, Mac Fingall, a schoolteacher by profession, and also popular comedian. He loves cricket as much as he cares for the popular theatre, and blends the two to magical effect much to the delight of spectators at Kensington Oval. Fingall enters the Oval with his trumpet under his arm, and big bass drum around his neck. Soon he is accompanied by persons unknown to himself who arrive with conch shells, kettle drums, flutes, fifes and other instruments. The 'band', somehow, is assembled, the crowd calls the tune, and Fingall's trumpet rings out. By this time, 8,000 people within the stand are rocking, swaying and nodding to the pulsating song.

The music, of course, reflects the mood of the moment. When West Indies batsmen are in trouble, the music ceases. When West Indies batsmen are punishing the opposition's bowlers, the silence erupts into carnival. When, however, West Indies fast bowlers are not making the required impression on the oppositions' batsmen, Fingall puts away the trumpet and seeks to inspire them with a drumming solo that heats the blood, quickens the heartbeat, and energizes the muscles. The quickening rhythmic sound of drums drives the fast bowlers on, unnerves the batsman, and often wickets begin to tumble.

During the recent tours of England and Australia to the West Indies, complaints were lodged to West Indian officials by the tourists with respect to the musical scores of crowds. In response, an attempt was made in Barbados to outlaw the taking of musical instruments, the drum in particular, into the Oval. This resulted in a heated national debate in which spectators vowed to boycott 'matches' unless the 'sounds' were allowed. References were made to the persistent attempts, before and after slavery, by white colonials and their black allies, to criminalize the drum, star of the African musical cosmology. Any attack upon the drum, they said, is an attack upon the "souls of black folks".

Viv Richards, West Indies captain, responded to a decision of the Barbados cricket authorities to ban the drum by stating that it was shortsighted, anti-social and disrespectful of black people whose cricket culture has long been characterized by the presence of sound. The drums, he said in addition, had inspired his bowlers and fieldsmen, and should be treated with respect. The crowd would have none of it. They won this battle, and officials were left to plead for a sound level consistent with the cultural norms of tourists.

Playing Mas' and the Crowd

Familiarity with the display of West Indian social culture, furthermore, would indicate that wherever there is 'sound', there are sights to behold. It is here that we enter the psychological world of the saturnalia, mask, masquerade and make-believe of everyday life. The two 'theatrical' 'crowd' characters of the postcolonial era carry the names King Dyall (Barbados) and Gravey (Antigua). King Dyall, as his alias indicated, was assumed to derive his royal bearing from an ancient pedigree. He was the most well-known member of the Barbados cricket crowd, and announced his arrival at the gates with the waving of his walking cane, the tipping of his derby, and the installation of his pipe. A tailor by trade, he wore brightly coloured three-piece suits, with matching shoes, hat

and gloves, and rode an old bicycle which had been variously painted yellow, white and pink. As a member of the inner city black working class, the 'King' as he was known, had no time for black people and preached at cricket his love for all things white and English. He was not a supporter of the West Indies team, and made much of his preference for the English team. For him, the 'greats' of cricket were Peter May, Colin Cowdrey and Len Hutton. Black spectators around him he described as 'monkey', 'ignorant sheep' and 'primitives'.

The King of the Oval verbally abusing his subjects with language not far removed from that used by Kipling brought tremendous comic relief to spectators during less exciting cricket moments. The King represented the imperial mask that upwardly mobile blacks were forced to wear during the colonial regime. The mask in time became a cultural norm which now stands in a dichotomous relation to the liberating cricket culture. While the King at the Oval was symbolic of the nineteenth century white, colonial gentleman spectator, the tackiness of his attire portrayed his class position, and revealed the self-contemptuousness endemic to the colonized mind. The 'King', therefore, in his masquerade, was a reminder of the values and practices black cricketers fought against, and at the same time his presence represented a confirmation of popular admiration for the pomp and regalia of graceful gait and 'carriage.

Antigua's Gravey is a different kind of cricket character. His is the masquerade associated with dance, song and flamboyant costume. He dresses, more often that not, in women's clothing – wigs, earrings, make-up and handbag included – and dances, some would say immorally, throughout the game in front of amused crowds. The sexual connotations of his dances entertain spectators who call upon him to show them what he can 'do'. His dances and other athletic antics are popular with the Antiguan cricket crowd, which has developed a reputation in the region for its musical character. Gravey's; intention is to mock the ascribed weaknesses and effeminacy of opposing cricketers, and his dance suggests that they are being assaulted by West Indian machismo. It is a dance of triumph and conquest, well understood by the West Indian masses, particularly in terms of the subliminal sexuality of the experience.

The West Indian cricket aesthetic, then, is shaped fundamentally by cultural expression in the form of colour, song and dance, which dictate that cricket looks best if played on a clear bright day. Fielders, of course, ought to be clothed in sparkling white flannels and the field should be green with a pitch Barbadian fans would refer to as "shining like dog stones", meaning flat, shiny and glasslike. This is the perfect setting for the first day of a Test match. The requirements for the spectators are largely visual, in terms of mass and colour, and the pleasures are maximized when moments of tension and tautness are mixed with periods of relaxation.

This is the cricket arena of action, the perfect theatrical environment. The centre of good theatre is conflict and this begins long before the first ball is delivered. The objectives of the opposing teams are clear. Bat must dominate ball or vice versa; and after five days only West Indian cricket can end in the fashion Paul Keens-Douglas describes in his 'performance' poem "Tanti [Auntie] at the Oval":

Islands need seven runs with nine balls to bowl an' one wicket to fall.
Dis time I forget 'bout Tanti Merle,
Excitement in de Oval like you never seen in ya life,
Gore come into bat an' is den de action start
Nine balls seven runs to go...noise in de place
Eight balls six runs to go...Tanti start waving de basket
Seven balls six runs to go...Tanti on top de seat

Six balls five runs to go...Tanti fall off de seat
Five balls five runs to go...Tanti wavin' de parasol
Four balls four runs to go...Police cautionin' Tanti
Three balls three runs to go...I can't see Tanti
Two balls three runs to go...Tanti climbing de fence
One ball three runs to go...Tanti on the field
Gore hit de ball an' Finlay pelt down de wicket for two runs
And is then de bachanal start.'[14]

West Indian masses also demand from cricket what they seek in every form of art – a sense of style. This special quality cannot be defined. It can be perceived by senses well trained for the task, and the sensation is unmistakable. Quality drama must promote high art, and in West Indian society an important cultural residue of the African ancestry is the centrality of style to all ontological expressions. Some batsmen can be very prolific, consistent and reliable, but are never in the West Indies defined as 'great' unless they meet the popular criterion of style. This special quality – essence if you like – is considered endemic to West Indian cricket culture, and does not occupy centre stage in other cultures. As Sobers walked to the wicket, the evidence of this 'thing' is witnessed and celebrated. Something in the way he moved satisfied some spectators who readily confess that they paid to 'see' Sobers, not to watch him score runs.

The question of cricket style, or 'class', has occupied literary aestheticists for some time. V.S. Naipaul in a letter to C.L.R. James indicated that cricket in the West Indies "represents style, grace and other elements of culture in a society which had little else of the kind".[15] This quality which is celebrated and deified by West Indians within the cricket culture is defended in the most uncompromising manner, and is indicative of the popular refusal to be liberal on the matter of 'artistic purity'. C.L.R. James concludes:

> I submit finally that without the intervention of any artist the spectator at cricket extracts the significance of movement and of tactile values. He experiences the heightened sense of capacity. Furthermore, however, the purely human element, the literature, the frustration, in cricket may enhance the purely artistic appeal, the significant form at its most unadulterated is permanently present. It is known, expected, recognized and enjoyed by tens of thousands of spectators. Cricketers call it style.[16]

This visual impression, West Indians would suggest, is expressive of individual confidence that by extension indicates a mastery of form that allows the game to transcend the mundane and to be elevated into the category of art. And, it is this rare quality that occasionally solicits from West Indian crowds another kind of 'sound' – that of stone silence – which indicates a sudden neutralization of the central nervous system. Extreme beauty, they say, can only be understood, experienced and appreciated within the total freedom of a vacuum or the cluttered anarchy of sensual abandonment and madness.

The West Indian cricket crowd, then, has made its distinctive contribution to the artistic tradition in the forms of music, dance, theatre, and oral and scribal literature. It is a special contribution that requires careful attention lest its value be lost within a haze of élitist assumptions about the culture of the 'lower orders'. This, of course can easily happen in the West Indies where such groups who attend cricket matches dressed in jacket and tie in spite of the heat (96° F in the shade) commonly refer to popular culture as expressions of the 'mob' or 'rabble'. The 'sounds' of the crowd, they consider, are the result of a lack of domestic manners and breeding, an attitude that reflects the traditional world view of the colonial white community.

But the redemption 'sounds' of the crowd are indicative of a deeper cultural search for authenticity and nationalist cultural freedom. That you must make your own distinct sound in order to have an independent voice is pretty well understood. What needs to be further understood is the relationship between social life as 'activated' consciousness and the reproduction of the creative process. Understanding how social attitudes and mentalities are translated into performing art – on the field in the case of players – and 'sounds' in the case of the crowd cannot be fully understood in the absence of an indigenous anthropology. What seems clear, furthermore, is the manner in which the cricket crowd continues to be both transmitter and receiver of artistic forms and practices that go to the centre of any definition of the term 'West Indian'.

Notes

1. Aspinall, *The British West Indies: Their History, Resources and Progress,* (London: Pitman, 1912), 153–54.
2. Ibid.
3. Ibid., 154
4. Edward Brathwaite, *The Arrivants: A New World Trilogy* (London: Oxford University Press, 1981), 200.
5. Errol John, *Moon on a Rainbow Shawl* (London: Faber, 1958), 61–62.
6. Ibid.
7. Bruce St John, "Cricket", in *Bumbatuk* 1 (Bridgetown: Cedar Press, 1982), 17, 19.
8. Brathwaite, *The Arrivants,* 198.
9. V.S. Naipaul, "England v. West Indies (1963)", *The Faber Book of Cricket,* edited by M. and S. Davie (London: Faber, 1987), 187.
10. Cited in Kim Johnson, "Calypso cricket", *Sunday Express* (Trinidad and Tobago) 4 April 1993.
11. Johnson, "Calypso Cricket".
12. Ibid.
13. Ibid.
14. Paul Keens-Douglas, "Tanti Merle".
15. Anna Grimshaw (ed.), *C.L.R. James: Cricket* (London: Allison & Busby, 1986), 131.
16. C.L.R. James, *Beyond a Boundary* (London: Hutchinson, 1963), 198.

Erotic Maroonage:
Embodying Emancipation in Jamaican Dancehall Culture

Carolyn Cooper

I deploy the trope "erotic maroonage" to signify an embodied politics of disengagement from the Euro-centric discourses of colonial Jamaica and their pernicious legacies in the contemporary moment. More than two decades ago, I proposed in my exploratory essay, "Slackness Hiding From Culture: Erotic Play in the Dancehall," that the hypersexuality articulated in the lyrics of the DJs, which is conventionally dismissed as pure vulgarity, or "slackness" in the Jamaican vernacular, ought to be retheorised as a decidedly political discourse. I rehearse the earlier arguments here: Slackness, in its invariant coupling with Culture, is not mere sexual looseness – though it certainly is that. Slackness is an ideological revolt against law and order; an undermining of consensual standards of decency. In my revisionist reading, slackness constitutes a radical, underground confrontation with the patriarchal gender ideology and pious morality of fundamentalist Jamaican society.

Encoding subversion, the title of that early essay, taken from the lyrics of DJ Josey Wales – "Slackness in di backyard hiding, hiding from Culture" – celebrates the cunning wiles of slackness.[1] The subtitle, foregrounding the erotic, underscores the ambiguities of disgust and desire in the dancehall imaginary: feminised, seductive Slackness simultaneously resisting and enticing respectable Culture. As Peter Stallybrass and Allon White remind us in *The Politics and Poetics of Transgression*, "disgust always bears the imprint of desire."[2]

The dancehall politics I attempt to recuperate is embodied in the erotic, the signification of which extends beyond the purely sexual domain. I invoke the signifier 'erotic' somewhat duplicitously to define as well a generic, non-sexual bodily pleasure manifested in the desire to live the good life, conceived in unequivocally materialist terms: erotic movement as upward social mobility. This widened meaning of the erotic is encoded in the metamorphosis of Cupid, the Roman equivalent of the Greek Eros, from god of love to demon of lust. The *Oxford English Dictionary* definitions of cupidity are instructive: "1. gen[erally] inordinate longing or lust; covetousness.... 2. spec[ically] inordinate desire to appropriate wealth or possessions." The notorious 'bling' ethos of dancehall culture!

The materialist values of the dancehall have their genesis, I propose, in the embodied folk wisdom of Jamaican popular discourse. For example, the emotive trope of the body as 'soul case' encodes both philosophical and political conceptions of incontestable human worth. The body encases the soul. The spirit is housed in matter. In the words of Damian 'Junior Gong' Marley: "Your body's just a vehicle/Transporting the soul."[3] But Damian's 'just' is not entirely *juste*. For it is precisely because the body transports the soul that one's frame must be protected from exploitation. And the body must be dressed in the blingest of bling.

Most often, the trope of the body as soul case/vehicle is used in the context of the refusal to work out one's soul case for nothing; to be reduced to mere economic tool, especially for someone

else's benefit. Societies like ours that were founded on the exploitation of enslaved labour do continue to bear the burdens of our terrible history. The enslaved, the "emancipated" indentured labourer and the modern, unemployed "worker" alike, all recognise their alienation from the fruits of their own labour. For a stubborn "hard core" of the Jamaican people, work must be seen as yielding reasonable rewards or it will not be done willingly.

Cultural theorist Paul Gilroy selects an apt quotation from Marx's *Grundrisse* as an epigraph to his chapter on "Diaspora, Utopia and the Critique of Capitalism" in his influential book, *There Ain't No Black in the Union Jack: The Cultural Politics of Race and Nation*:

> *The Times* of November 1857 contains an utterly delightful cry of outrage on the part of a West-Indian plantation owner. This advocate analyses with great moral indignation – as a plea for the re-introduction of negro slavery – how the Quashees (the free blacks of Jamaica) content themselves with producing only what is necessary for their own consumption, and, alongside this 'use value' regard loafing (indulgence and idleness) as the real luxury good; how they do not care a damn for the sugar and the fixed capital invested in the plantations, but rather observe the planters' impending bankruptcy with an ironic grin of malicious pleasure, and even exploit their acquired Christianity as an embellishment for this mood of malicious glee and indolence.[4]

There are several Jamaican proverbs that give clues to the origin of what appears to be an entrenched, counter-productive work ethic that is the 'malicious' legacy of slavery: for example, the wry proverb, "bakra wok neva don" [the white man's work is never done]. There is, therefore, no point in even trying. Work is thus understood as fundamentally alienating since the benefits accrue only to the immoral, exploitative "other." 'Bakra,' in the modern context, becomes synonymous with exploiter, whatever the complexion.

Since reward is often not commensurate with effort, very little energy will be expended in non-productive work. Thus: "dog say before him plant yam fi look like mosquito foot, him satisfy fi turn beggar" [dog says that rather than planting yams which will turn out to be no bigger than a mosquito's shank, he will be satisfied to be a beggar]. And, "dog say before him plant potato a pear-tree bottom mek it bear like mosquito shank, him wi sit down look" [dog says that rather than planting potatoes under a pear-tree and having them bear the size of a mosquito's shank, he will sit down and watch]. The most clearly evasive: "dog say him won't work, him wi sit down an look, for him must get a living" [dog says that he won't work, he will sit down and watch, because he must get by].

Conversely, there is a cluster of Jamaican proverbs that advocate the necessity of work, even in situations where the positive outcome of effort is not immediately evident. The proverb "one-one coco full basket" [one by one, one coco at a time, the basket is filled"] validates small increments of effort that ultimately result in the accomplishment of some fully satisfying objective. A similar sentiment is expressed in the proverb, "patient man ride donkey" [a patient man rides on a donkey]. The ride may be slow, but it's sure. A related proverb that advises long-suffering optimism is "every day devil help thief; one day God wi help watchman" [every day the devil helps thieves; one of these days God will help the watchman"]. There is an element of cynicism in this proverb that hints at subversion of its surface optimism. The daily efficiency of the devil seems far more predictable than divine intervention.

The passivity of the proverbial dog that would rather look that work is challenged in the proverb "long foot a sun hot can't pay red herring tax." "Long feet" – an image of idle stretching-out-of-the-body in the heat of the day – cannot earn the income required to live in an economic system where essential goods are taxed. A related proverb is "pound of fret can't pay ounce of debt" [a pound

of fretting can't pay an ounce of debt]. This somewhat ambiguous proverb can be interpreted to mean either a) you had better work to pay your debts; fretting won't help or b) since fretting over debts won't pay them, there's no point in fretting. A rather pointed warning comes in the rhythmic "nonsense" proverb, "Who no vee no vaa, an who no vaa no vee" [whoever does not 'vee' will not 'vaa,' and whoever does not 'vaa' will not 'vee'."] The structure of this proverb allows the substitution of a variety of verbs for the generic "vee" and "vaa": if you don't participate in the process you can't expect to derive any benefits from the system.[5] The echoic structure of this proverb suggests a tradition of verbal play on which contemporary oral performers in Jamaica draw.

A rather "vulgar" proverb highlights the shortsightedness that temporary gratification of basic hungers can induce: "when puss belly full, him say ratta batty bitter" [when the cat's belly is full, he says that the backside of the rat is bitter.] Note, again, the wordplay in "ratta batty bitter;" the meaning of the proverb is reinforced by sound vibes. The identical sentiment is expressed in the following proverb "wen man belly full, him bruck pot" ["when a man's belly is full, he breaks the pot"]. The euphoria of satisfaction in the present can make one forget the cyclical nature of human need.

The competing value systems that are encoded in proverbs articulate the variable wisdom of communal experience. It is not only one proverb that tells the full story. Mutually contradictory proverbs altogether tell the history of a people's struggle to find strategies of survival in contexts where effort is often insufficiently rewarded, and no effort at all can yield surprising results. After all, "puss an dog don't have the same luck" [the cat and the dog don't have the same fortune].

Remarkably, even in circumstances where the worker is self-employed, there is at times still a sense of victimisation, and thus the need to assert one's self unequivocally. For example, in her witty stand-up comic routines, Jamaican poet Louise Bennett gives voice to marginalised working-class women, mostly small-scale higglers, who often resort to verbal abuse of their potential customers as a kind of perverse defense mechanism. For example, "Candy Seller:"

Jamaican:
Come lady buy nice candy mam?
Dem is all wat I meck.
Which kine yuh want mam, pepper-mint?
Tank yuh man. Kiss me neck!
One no mo' farden bump she buy!
Wat a red-kin ooman mean!
Koo har foot eena de wedge-heel boot,
Dem favah submarine.
Ah weh she dah-tun back fah? She
Musa like fe hear me mout
Gwan, all like yuh should'n walk a day,
Yuh clothes fava black-out.
Me kean pick up a big sinting
Like yuh so draw dat blank.
Afta me nohdeh a war, me naw
Colleck no German tank.[6]

English:

Come lady, don't you want to buy nice candy, mam?
I, myself, made all of it
Which kind do you want mam, pepper-mint?
Thank you mam. You could bowl me over!
She's bought only a few cent's worth!
She's so mean for a 'high colour' woman!
Look at her feet in her wedge-heel shoes,
They look like submarines.
I wonder why she's turning back?
She must like to hear me carry on
Get lost, people like you shouldn't come out in daylight,
Your clothes look like a black-out.
I can't pick up an object as big as you
So don't even bother with that one.
After all, I'm not at war
I'm not collecting German tanks

This remarkable sales technique – aggressive verbal intimidation of prospective customers – seems to be a preemptive strike, a self-protective strategy for the vulnerable worker who feels constantly under threat. With the rise of the new breed of internationally travelled female higglers who have far more economic power than their earlier domestic counterparts there is, I would argue, a greater sense of psychological power that comes from reaping the fruits of one's labour. There is thus less of a need to attack customers and sabotage the economic system in which these women now have a vested interest.

The respect that Bennnett commands for her vociferous higglers has its contemporary equivalent in the regard that many male DJs have for their female fans, many of whom represent the new class of productively self-employed higglers. For example, Johnny P's "Gyal Man" celebrates the upward social mobility of enterprising women like those cunning characters Louise Bennett impersonates, who have ambitiously extricated themselves from traditional drudgery: "Hold up yu head, cau yu nah scour people pot/Hold up yu head cau yu have ambition/Jump about cau yu full of protential (sic)" [Hold up your head, because you don't scour other people's pots/ Hold up your head because you have ambition/Jump about because you're full of potential].

In Johnny P's song, the dancehall becomes the stage on which women and men act out rituals of release from historical roles of oppression. The scouring of other people's pots is the sign of entrapment in the exploitative domestic labour market. Working-class women, released from traditional gender roles, are invited by the DJ to "jump about" because their potential can be fulfilled. The error in diction – "protential" for "potential" – is entirely beside the point. Or, more to the point, liberation from the restraints of English correctness is an essential freedom in the process of reclaiming human potential.

Historically, dehumanising Jamaican society made both the use of African languages and the acquisition of literacy (in English) illegal for the enslaved. No wonder that the vast majority of Jamaicans still are not taught English efficiently and their mother tongue is still devalued. Throughout the Caribbean, the Creole languages fashioned by Africans who were forced to acquire the rudiments of English, French, Spanish, Portuguese or Dutch are clear linguistic signs of the proactive human 'protential' to adapt to new material and cultural circumstances.

A classic articulation of the dancehall philosophy of erotic movement conceived as upward social mobility is Buju Banton's commanding "Driver," from the CD, appropriately entitled *Too Bad*. Acknowledging the marijuana trade as an engine of material prosperity, the persona in the song dispatches a compliant Driver to "[d]rop this Arizona round a Albermarle."[7] Trafficking is a hustle that enables many youths to escape the soul-destroying deprivations of ghetto life. It is a bitter irony that Buju Banton is now imprisoned in the US, having been convicted in 2011 for allegedly trafficking in cocaine. The DJ's fans insist that he was framed. His detractors claim that "Driver" is confessional poetry:

Jamaican:

I deh pon a mission, man hustling hard
No ghetto youth should ever suffer an starve
Hustling ability we learn dat a yard

English:

I'm on a mission, and I'm hustling hard
No ghetto youth should ever suffer and starve
The ability to hustle, we've learnt that at home

This hustling mission in the marijuana trade is reminiscent of the trajectory of Ivanhoe Martin in the foundational Jamaican feature film, *The Harder They Come*. In Michael Thelwell's novelisation of the film, the protagonist discovers the true value of the trade in a disturbing exchange with his girlfriend, Elsa:

Jamaican:

"Look, Ivan!"
"Umm wha'? Whe' you a wake me up for?"
"Paper say police in Miami hol' a plane load down wid ganja. Dem say is here is come from too."
Is like ants tek de bed y'know, de way Ivan leap up an' snatch de paper.
"Look yah, street value seven 'undred t'ousan' dollar!" That wake 'im up fully.
He stared at her like a madman. "You hear ah say, seven 'undred t'ousan' dollar to raas? A soon come. Whe' me pants?"[8]

English:

"Look, Ivan!"
"Huh? What? Why did you wake me up?"
"The newspaper says that police in Miami held a plane loaded down with ganja. They also said it came from here."
Ivan jumped up and snatched the paper as if, all of a sudden, there were ants in the bed.
"See this, street value seven hundred thousand dollars!" That woke him up fully.
He stared at her like a madman. "Did you hear what I said, seven hundred thousand dollars? Damn. I'll soon be back. Where are my pants?"

Ivan, rushing out to interrogate Jose, his facilitator in the trade, exclaims incredulously: "Seven hundred t'ousan' dollah! Who a get dat eh? An' we a run from soldier an gunshot every day? Fe what? Small change" ["Seven hundred thousand dollars! Who is getting that eh? And we have to be

running from soldiers and gunshots every day? For what? Small change] (331). In "Driver," Buju, too, acknowledges the scale of the marijuana trade and the fortunes it generates in the line: "A ounce dem a buy when a tons man a ship" [It's being sold by the ounce and shipped by the ton]."In Ivan's terms, he's being paid by the ounce while others are benefitting by the ton. It is his refusal to work out his soul case for small change that makes Ivan uncompromisingly declare, "I'd raddah [rather] be a free man in mah [my] grave/ dan [than] living as a puppet or a slave" (281).

Ivan's apotheosis to outlaw culture hero, like Jimmy Cliff's rise to super stardom as his reincarnation, is the victory of the growling under-dog that dares to bite back. More than three decades later, Ivan's philosophical musings about the meaning of reggae are just as applicable to dancehall:

> It seemed to [Ivan] a sign and a promise, a development he had been waiting for without knowing it. This reggae business – it was the first thing he'd seen that belonged to the youth and to the sufferahs. It was roots music, dread music, their own. It talked about no work, no money, no food, about war an' strife in Babylon, about depression, and lootin' an' shootin', things that were real to him.... He had heard stories of poor boys who were singing this new music, cutting records and becoming star-boys. That excited him as much as the music did. (221–22)

Buju Banton, himself a 'star boy,' chants the aspirations of a whole generation of ghetto youth in "Driver." The DJ's persona identifies two expectations that will be fulfilled with the returns from this particular mission in which all his lifesavings are invested. The first is the satisfaction of the perennial Jamaican ambition to upgrade the infrastructure of one's house: "Mi waan change mi zinc an put up decramastic"[9] [I want to change my zinc roof to decramastic tiles]. Zinc has long been seen as a sign of impoverishment, though in a hierarchical culture of deprivation, zinc is not the lowest rung on the ladder of roofing materials. The traditional thatch roof has a lower social status although it can also signify up-market folksiness in leisure architecture such as the gazebo.

"Decramastic" is the brand name of a stone-coated metal roofing tile manufactured by Decra. But in a familiar pattern of semantic generalisation, it has become the generic name in Jamaica for all metal roofing tiles. A 2007 Decra newspaper advertisement highlights the durability of the tiles in hurricane conditions: "Decra Metal Roofing Tiles have been weathering the storms since 1972. From hurricane Gilbert to Ivan through to Emily they've always come out 'on top'."[10] In the ad, a personified storm threateningly boasts, "Here I come again." The Decra roof coyly retorts, "I'm always prepared!" Just like a good girl guide! Conversely, zinc is particularly vulnerable to hurricane force winds, sometimes faring considerably worse than thatched roofs.

The other motivation for the Driver's drug run fortuitously couples both the narrow, sexual definition of the erotic and my widened application, signaling cupiditous upward social mobility: "A business man a run, mi no inno no 'but' nor 'because'/ My gyal waan wear Victoria Secret drawers" [It's a business I'm running, I don't want any excuses/ My girlfriend wants to wear Victoria's Secret panties."[11] The drawn out vowel sound of Buju's Jamaican Creole pronunciation of the English "drawers" – jraaz – connotes the 'spread out,' erotic body language of the dancehall. It is a far cry from the Victoria's Secret discourse of faux-prudish sexiness.

I visited the Victoria's Secret website to see if I could confirm my recollection of the significance of the brand name: Queen Victoria's improbable secret passion for erotic underwear. No such luck. But I did discover the many ways in which the company is exploiting its brand. It's not just drawers. There's Victoria's Secret Beauty: "For every aspect of beauty care...from sensual fragrance, sexy body care, and hip color cosmetics, to sleek signature pink-on-pink cosmetic cases." Then there's Victoria's Secret Hosiery Boutiques: "An amazing selection of legwear, bodywear, and shapewear.

Choose from the chicest everyday hosiery and slimming bodywear to the sexiest items for evening and beyond." Could 'shapewear' be the old-fashioned, restrictive girdle?

Buju's assertion of his need to be able to keep his girl-friend in the style to which she aspires signals yet another aspect of dancehall philosophy which has its origins in Jamaican folk wisdom. A number of Jamaican proverbs suggest the clear correlation of love, sex and money in folk culture:

1. When money done, love done.
2. Man can't marry if him don't have cashew.
3. When man have coco-head[12] in a barrel, him can go pick wife.
4. When pocket full, and bankra[13] full, woman laugh.
5. Cutacoo[14] full, woman laugh.
6. Woman and wood, and woman and water, and woman and money never quarrel.[15]
7. You must find a place to put your head before you find a hole to put your hood.

In an urban, dancehall updating of this folk wisdom, Shabba Ranks' "Flesh Axe" asserts the woman's desire for both money and sex. Using agricultural, legal and mechanical imagery, Shabba compares the body of woman to valuable property – land that must be cleared, seeded and watered. I know that some will object to the 'commodifying' analogy. But in an agricultural economy that has long deprived small farmers of access to arable land, this earthy metaphor signifies the high value that is placed on the fertile body of woman. Furthermore, the vigorous metaphor of chopping the body land, which may sound disturbingly sadomasochistic to some ears, is a vivid sexual metaphor celebrating the efficiency of the phallic axe as it clears the ground for the planting of the seed. The hard labour of field work is thus transmuted into pleasurable sexual work:

Jamaican:

Flesh axe
Di land pon di body fi chop
Is like money an woman sign a contract
If yu a deal wid a woman fi a natural fact
Is not she dat she a sell her body
Fi run it hot
But every woman need mega cash
Fi buy pretty shoes an pretty frock
Woman love model an dem love fi look hot
She can't go pon di road a look like job lot
Every woman a go call her riff-raff
Look like a old car mash up an crash[16]

English:

Flesh axe
The body-land must be cleared
It's as though money and woman have signed a contract
If you're really going to deal with a woman
It's not that she's actually selling her body
And it's running at high speed
But every woman needs big bucks

To buy pretty shoes and pretty dresses
Women love to show off and they love to look hot
She can't go out on the road looking like job lot goods
Every woman is going to call her riff-raff
Looking like an old car all smashed and crashed

Given the historical context of brutal exploitation of human resources in Jamaica – and dogged resistance – it is quite easy to understand why so many youths now aspire to become DJs. The dancehall is a social and economic space in which effort can be abundantly rewarded. With raw talent and the efficient marketing skills of a sophisticated music industry, spectacular success is, indeed, possible. Those who dismiss the "vulgar" materialism of dancehall culture as regression to a dark past of primitivism need to test the continuing viability of the alternative career options that Jamaican society offers aspiring youth. With limited economic resources to ensure upward social mobility, very few will make it legally. In these circumstances, the international success of so many dancehall DJs is a hard act to parody.

Beyond all reasonable expectations, the globalisation of Jamaican dancehall culture, with its irrepressible bling aesthetics and politics does, indeed, signify the emancipation of its primary agents from historical roles of oppression. Admittedly, raw musical talent is still subject to exploitation, given the capitalist imperatives of the international recording industry in which local practitioners are all implicated. Nevertheless, Jamaican dancehall culture is an exemplary site of contestation in which "maroonage" and its obverse, "accommodation," classic psycho-political responses to the brutality of plantation life, now constitute varying modes of embodied resistance to the manifestations of the far-reaching legacies of slavery in contemporary Jamaica.

Notes

1. Josey Wales, "Culture a Lick," Jammy's, 1988.
2. Peter Stallybrass and Allon White, *The Politics and Poetics of Transgression*, Ithaca, New York: Cornell University Press, 1986, 191.
3. Damien 'Junior Gong' Marley "It Was Written," Track 3, Halfway Tree, Motown Records, 4742-2, 2001.
4. Paul Gilroy, *There Ain't No Black in the Union Jack: The Cultural Politics of Race and Nation*, London: Hutchinson, 1987, 153.
5. Vivien Morris-Brown, *The Jamaica Handbook of Proverbs*, Mandeville, Jamaica: Island Heart Publishers, 1993, 95, interprets the proverb this way: "Those who do not contribute, are not entitled to the ben[e]fits. Or, who does no work does not deserve to eat, or be paid."
6. Louise Bennett, *Jamaica Labrish*, Sangster's: Kingston, Jamaica, 1966; rpt 1975, 28.Subsequent references cited in text.
7. Buju Banton, "Driver A," Track 11, *Too Bad*, GGM004, Gargamel Music, 2006.
8. Michael Thelwell, *The Harder They Come*, New York: Grove Press, 1980, 330. Subsequent references cited in text.
9. Buju Banton, "Driver A," Track 11, *Too Bad*, GGM004, Gargamel Music, 2006.
10. The *Sunday Gleaner*, June 10, 2007, A5.
11. Buju Banton, "Driver A," Track 11, *Too Bad*, GGM004, Gargamel Music, 2006.
12. The rootstock or rhizome of the coco plant as distinct from the tuber, which is a coco." *Dictionary of Jamaican English.*
13. A basket, normally larger than the 'cutacoo.'
14. A field-basket used by hunters and cultivators.
15. Here literal "firewood" which denotes material prosperity becomes a metaphor for the erect penis – 'wood' as 'hood.'
16. Shabba Ranks, "Flesh Axe," Track 7, *As Raw as Ever*, Sony, 468102 2, 1991.

The Calypsonian as Artist:
Freedom and Responsibility

Gordon Rohlehr

If we so-called decent people want to protect ourselves from the jibes of the barefooted let us give them proper example.

–Captain A.A. Cipriani, 1934

In order to contemplate the calypsonian as an artist, one must first consider the nature and evolution of the calypso as an art form. My own approach to this task has been to examine various theories about the evolution of calypso out of a complex of African song forms and via the absorption of varieties of European, West Indian, Latin American, North American and, later, Indian musics. I have found it useful to explore linkages among the content, the social and performance contexts, and the form and function of the music. Of these elements, function is the one that has changed least over time. This is probably because function has always been multifaceted. Calypso music today still performs most of the functions of its ancestor musics: celebration, censure, praise, blame, social control, worship, moralizing, affirmation, confrontation, exhortation, warning, scandal-mongering, ridicule, the generation of laughter, verbal warfare, satire.

Certain basic structures have also survived over time. Of these, the call-and-response structure, the cornerstone of African music, has been replicated in the scores of "party songs" that are composed each year. Group participation remains a major activity with singer or rapper or exhorter, the person in control of the microphone, replacing the chantwel. As in the work song of old, the function of the party song is to induce participation by large groups of people in simultaneous activity. Today's activities are usually spelled out by the exhorter and involve movement of specified parts of the dancer's anatomy in specified directions. Some of this performance style may have been derived from American-styled aerobic exercises. Other aspects of current celebratory performance resemble British punk concerts of the 1980s, with their high levels of physical contact, extreme loudness and dangerous gimmicks such as body-surfing.

One begins with celebration, not only because it is the function that has endured but also because without the music of celebration it is unlikely that most of the other song types would have survived. Moreover, in diasporan African societies there has always been a link between celebration and freedom. The weekend dance assembly should therefore be recognized as the major institution through which African identities were celebrated and renewed both before and after emancipation. These dance assemblies usually took place between Saturday afternoon and Sunday night and constituted a welcome break from the plantation ménage. Enslaved Africans exercised a symbolic or virtual freedom at these assemblies, where they danced "nation dances" – dances that catered for and hence recognized specific ethnic communities.

Festive space was freedom to celebrate identities that were separate and different from the powerfully imposed but by no means absolute plantation identity as chattel, slave, functioning

Reprinted with permission from *Small Axe* 9 (March 2001): 1–26.

and expendable tool. From this festive space one was free to comment on differences between the "nations", and between the diasporan Africans as an undifferentiated mass of people and the Caucasian Other. If the dance assemblies were the context of performed "freedom" before emancipation, Carnival evolved as the grand stage upon which identities were asserted, contested and performed in the post-emancipation period. *Jamette Carnival* of the 1860s to 1880s was the result of the phenomenal inflow of immigrants from the southern and eastern Caribbean into both rural and urban spaces in Trinidad. The impact of such immigration was to increase the degree of conflict, confrontation and contestation among the various Afro-Caribbean ethnic communities, as well as between the stereotyped and undifferentiated mass of immigrants and those white, coloured and black Trinidadians who considered themselves to be the true nationals because of their prior residence in the island.

Naturally, intensified conflict and confrontation were reflected in the festive space of Carnival as well as in performance styles on the streets of Port of Spain. The old French Creole elite retreated from the street parade for nearly eight decades, aghast at the results of freedom. Many voices from among the "decent and respectable" citizenry called for the abolition of Carnival. As for the music, the most essential feature of and catalyst to celebration, this became the target of a consistent clamour that it should be controlled and, if possible, stopped. Citizens who gave evidence before the Hamilton commission of enquiry into the 1881 Canboulay riots complained bitterly not only about the greatly increased riot, disorder, obscenity and indecency of the masked performance but also about the Carnival songs:

> It is common during Carnival for the vilest songs, in which the names of ladies of the island are introduced to be sung in the streets, and the vilest talk to be indulged in while filthy and disgusting scenes are enacted by both sexes, which are beyond description and would be almost beyond belief were it not that they were vouched for by witnesses of unimpeachable credibility.[1]

Thus, if "freedom" in the street songs of Carnival took the form of class aggression performed in a style of scurrility and bawdy picong that deliberately unmasked the real disrespect that the never truly humble underclass felt for their social overlords, responsibility, as defined by the aggrieved elite, would require the vigorous policing of such freedom and include the censorship of street songs and the stilling, wherever possible, of voices from "the Barber-Green".[2] Such censorship proved to be impossible because the songs were, apart from their choruses, improvised by the chantwel and were part of what the Russian intellectual Mikhail Bakhtin, in his seminal study *Rabelais and His World*, termed "festive laughter".

Carnival laughter, festive laughter, is, according to Bakhtin, whose analysis was based on the carnivals of medieval Europe,

> not an individual reaction to some isolated "comic" event. Carnival laughter is the laughter of all the people. Second, it is universal in scope; it is directed at all and everyone, including the carnival's participants. The entire world is seen in its droll aspect, in its gay relativity. Third, this laughter is ambivalent: it is gay, triumphant, and at the same time mocking, deriding, it buries and revives. Such is the laughter of carnival.[3]

Bakhtin goes on to distinguish between such all-inclusive festive laughter and the negative laughter of satire in which the satirist is wholly opposed to and "places himself above the object of his mockery".[4] One thinks right away of the difference between the real life Mighty Spoiler and Derek Walcott's fictional Spoiler, narrator of "The Spoiler's Return". The real-life Spoiler observed life's vagaries, its injustices, strangeness, absurdity, sadness in a humour that was at once corrosive and celebratory; Walcott's Spoiler, a thin mask for Walcott's rage, is literally located above the city,

country and region that he bitterly castigates for its two decades of failed independence and the degeneration of everyone and everything since the end of the colonial period.

The bitterness of Walcott's laughter and the recurrent stance of exile, of alienated detachment that his protagonists, from Crusoe to Spoiler and Shabine, have assumed over the years, are paralleled to the last particular by the increasing acridity of calypsonians' laughter since the mid-1970s, the bitter violence of some of their social commentary in the 1990s, and their occasional assumption of stances above the world that they condemn. This may be partially the result of calypso having become the property of educated middle-class songwriters who may not, in fact, have anything more than a commercial affiliation with the world of the underclass who, in Bakhtin, create the festive laughter that he idealizes. Moreover, in multiethnic societies such as Trinidad and Tobago, where major ethnic groups are locked into grim and wasteful contestations for political and economic power and social visibility, it is a mistake to think of Carnival laughter or any other kind of laughter as "the laughter of *all the people*". Laughter in such societies, is more often than not a weapon to reduce or cut down the "enemy": the stereotypical ethnic Other.

Bakhtin's analysis is truer to our situation when he comments on the role of "corrosive laughter" in an age of radical political change and social upheaval, and commends Rabelais for his ability to "focus the power of laughter"[5] towards an illumination and interpretation of society in his age. Calypsonians have, in their various ways, consistently focused the power of laughter on society in Trinidad and Tobago, and the society has reacted in two ways: it either participated in the play, game and ritual of laughter or retaliated with hostility, lawsuit and the power play of insecure threatened officialdom. Against the freedom claimed by festive convention, threatened officialdom has traditionally placed the sanctions defined by law and power.

Before we illustrate this assertion and trace the history of official retaliation, we need to show how from quite early the calypso "focused the power of laughter" on the society of Trinidad and Tobago, which was in formation in the first five decades after emancipation. The extraordinary case of Dr. Bakewell, an Englishman who was the chief medical officer in Trinidad in 1870, provides an early example of how the calypso focused the power of laughter. Bakewell is described by Bridget Brereton as having been "tarred and feathered in 1870 for insulting a coloured colleague";[6] and with slightly more detail by John Cowley, as having been thus humiliated "on the steps of Government House by three unknown Negroes" for having "clashed with Dr Espinet, 'a well-known and respected coloured Creole', regarding 'the treatment of leprosy' and offended both black and white inhabitants".[7]

Unfortunately for Bakewell, the incident occurred in January at the beginning of the Carnival season and was therefore celebrated in a calypso that was sufficiently famous to have survived in memory right into the mid-twentieth century.[8]

> Bakeway, qui rive (Bakeway, what happen?)
> Qui moon qui fais ça (Who is the person who did this?
> Is two blackman tar poppa (Is two blackman tar papa
> Moen ça garde con you negre (I look like a Negro
> Moen moen blanc mes enfants (Me, I am white, my children
> Is two black man tar poppa (Is two black man tar papa
> Is two black man tar poppa (Is two black man tar papa[9]

If the tarring and feathering – a startling punishment associated with the American post-bellum South – was bad enough, the fact that it took place on the steps of Government House suggests the

complicity of the local elite. How else would three unknown Negroes have, complete with tar and feathers, found themselves at the steps of the governor's residence at the precise moment when, Bakewell appeared and, presumably, no other witnesses were present? Worst of all, though, was the immortalizing of the event in a song that focused the society's malicious laughter on the victim; the verbal tarring and feathering of one who, as chief medical officer, represented high British colonial officialdom.

Like the calypsos vilifying ladies of the elite by attributing to them the same sexuality that respectable society normally associated with the Jamettes, the song immortalizing Bakewell shows the calypso to have shared similar roots to Bakhtin's true Carnival of the unappropriated folk. Its laughter seeks to bring both the Caucasian ladies and Bakewell to a recognition of qualities that they share with the rest of the society: the quality of sexual desire in the case of the ladies and the quality of a common humanity beyond the fiction of a superior white skin in the case of Bakewell. Such corrosive, democratizing laughter was, of course, greeted with officialdom's call via the *Port of Spain Gazette* (9 March 1870) for a recognition of the moral authority of the church to "put an end to the obscene and disgusting buffooner" *(sic)* that characterized Jamette Carnival.[10] Morality, respectability and decency, as defined by an entrenched elite, have always sought to control or even abolish Carnival's festive laughter, particularly such laughter as has been focused on the elite itself to unmask an implied grossness beneath its surface of social superiority.

The history of the calypso for the century and a quarter that separates our time from that of Bakewell displays the same pattern beneath the kaleidoscopic facade of apparent social change. Calypso, and to some extent Carnival, have strived to celebrate and expand a special festive freedom and the scope of festive laughter: the instinct of elitism, respectability and officialdom has continued to be one of defining limits, outlining responsibilities and exercising a patronizing control over the spirit, shape and performance of festivity. This control was manifest in the Musical Ordinance of 1883, which was aimed at the surviving vestiges of African musical instruments and performance style; the Peace Preservation Ordinance of 1884, which was framed in January of that year to tame Jamette Carnival for good and later provided the legal justification for the massacre that came to be known as the Hosein Riots; the employment of sponsorship from small city businessmen after the 1890s as a means of social control of mas bands who lost the support of their patrons if they did not observe proper standards of behaviour; the renewed efforts to have Carnival abolished after the end of World War I and the vigorous response from first the *Argos* and the *Guardian* newspapers, whose committees for the preservation and improvement of Carnival ended in the founding of the parade of bands at the Queen's Park Savannah and at the same time initiated decades of tension between the advocates of downtown J'ouvert-centred, parochial, neighbourhood people's mas and those improved cleaned-up, well-costumed bands at the Savannah.

These developments can all be read as the ongoing attempt by first old then new middle-class elites to circumscribe carnivalesque freedom and festive laughter, whose three traditional features were, according to Bakhtin:
1. "Ritual spectacles", such as pageants and "comic shows of the marketplace";
2. "Comic verbal compositions", such as parodies both oral and written in Latin and in the vernacular; and
3. "Various genres of billingsgate: curses, oaths, popular blazons."[11]

Thus, in 1919, bourgeois caretakership of Carnival and calypso was formalized when Governor Chancellor made the *Argos* and the *Guardian* petitioners, people from the upper and middle classes, responsible for policing the freedom with which mas was celebrated that year. Part of

that responsibility involved the intellectual enhancement of calypso lyrics via the collaboration of the intelligentsia with singers, composers and orchestra leaders. Anyone who thought he knew anything about poetry or calypso music sent in suggestions for calypso improvement to the *Argos* newspaper. *Argos* and *Guardian* committee members visited tents (calypso rehearsals) and made their suggestions regarding improvement. Those were the latter days of M'Zumbo Lazare and the early ones of Courtenay Hannays.

Middle-class cultural caretakership, revealed its political side when, over the next three decades, sectors of the population needing leadership because of the gradually expanding franchise of those days, turned to the middle-class intelligentsia and small business and professional people. In the midst of this emergence of new local leaders, there were strong signals that the old elite was not going to surrender hegemony without a real struggle. The Seditious Publications Ordinance of 1920, along with various smaller bits of legislation aimed at the control of the press and cinemas; the post-1945 Carnival Improvement Committee, with its agenda of purging the Carnival of Dame Lorraine, Pissenlit and rowdyism, and the making the festival safe for locals and tourists alike; and the enthusiastically sponsored Carnival Queen competition all suggested the same heavy hand of elitism, class-based legislation and cultural appropriation.

A brief glimpse at, first, Section 7 of the Seditious Publication Ordinance and, next, the circumstances surrounding the drafting of the Theatres and Dance Halls Ordinance in 1934 is instructive. Section 7 of the bill provided for "the prohibition by the Supreme Court of the issue and circulation of any seditious publication which is shown to the satisfaction of the Court to be likely to lead to unlawful violence or apparently to have the object of promoting feelings of hostility between different classes of the community".[12] "Seditious intention" was elaborately defined under twelve categories, echoes of which have survived to this present time.

The Seditious Publications Ordinance was not, of course, aimed at so small a target as the calypso but was, rather, the effort of the old colonial order to assert its authority in the face of the threat of Garveyism, emergent trade unionism, radical journalism, and what was perceived to be a plot to destroy organized government and to eliminate the white population via an organized boycott of white merchants by the black population and the education of black children in black ethnic consciousness. Between 1921 and 1937, the list of banned socialist or Afrocentric or trade union–oriented pamphlets and books had become extremely long. Although the Seditious Publications Ordinance was not primarily aimed at the calypso, it is significant that when Patrick Jones sang denouncing it as an example of "class legislation", the *Guardian*, which had rapidly rivalled the much older *Port of Spain Gazette* as the mouthpiece for Caucasian upper-class interests and had propagandized the idea of a racist anti-Caucasian plot, wrote an article saying that Jones should be charged with sedition – by the power of the very ordinance that he was denouncing.

The 1934 Theatres and Dance Halls Ordinance was introduced by the inspector general of constabulary, Mavrogordato, to quell the publicizing via calypso or calypso drama of a sexual scandal in which he had been involved at the country club in the previous year. Section 6 of the ordinance codified decades of censorious upper-class opinion since the Hamilton Report of 1881. It prohibited "profane, indecent or obscene songs or ballads"; stage plays or songs that might be "insulting to any individual or section of the community, whether referred to by name or otherwise"; "acting or representation calculated to hold up to public ridicule or contempt any individual or section of the community". It also prohibited "lewd or suggestive dancing" and "violent quarrelsome or disorderly conduct" and advocated decent attire for all performers and dancers.[13]

The Theatres and Dance Halls Ordinance was immediately objected to by Captain Arthur Cipriani on the grounds that laws already existed to cover most of the areas that the Ordinance purported to cover. It would, he said, be virtually impossible to censor calypso innuendo out of existence or to control insult or caricature, particularly if the object of such ridicule was not openly named in the calypso. He supported the calypsonian's right and the general right of the underclass to festive laughter as a tradition or convention that should not be interfered with.

> These people have an extraordinary way, if you like, rightly or wrongly of amusing themselves and singing ballards [sic] and making references to certain people highly or lowly placed in this community, and it is a privilege which they have had for years. It has never been interfered with, and I see no reason why it should be interfered with now.[14]

Cipriani also made the telling point that members of the aristocracy should not be allowed to make laws simply to protect themselves from scrutiny and censure: "If we so-called decent people want to protect ourselves from the jibes of the barefooted man let us give them proper example."[15]

Here, written large and coming to a head, was the clash between the festive laughter of Carnival and calypso and the power of elitist officialdom to pass laws that aimed at limiting the freedom of singers and performers to explore festive space. Law could be manipulated by a class-in-power-and-authority to limit or even annul a freedom that, hard-won, had become convention. Like the Seditious Publications Ordinance of 1920, the Theatres and Dance Halls Ordinance was passed to protect a class and a race in power from the scrutiny of an underclass whose carnival style had permanently entered the area of serious political discourse.

Post–World War II efforts at "Carnival improvement" would, insofar as they applied to calypso, focus on the issue of "cleaner lyrics". The sexual theme had become more pronounced since the Yankee invasion between 1941 and 1945. A decade before Sparrow, the original Young Brigade had begun the unmasking of the ribald, risqué calypso, perhaps to make their meaning crystal clear to the soldiers whose patronage had ushered in a new age of entertainment and revenue.

Forces unleashed during the war would culminate first in the 1950 court case against the Growling Tiger (singer) and Attila the Hun (tent manager) who together had been charged for Tiger's performance of "Daniel Must Go". Tiger's other calypso for the year, "Leggo the Dog, Gemma", was held to be even more scurrilous than "Daniel Must Go". However, since it was impossible, as Cipriani, long dead, had predicted, to prove anything at all against "Leggo the Dog, Gemma", the prosecution based its case on "Daniel Must Go", a calypso that was no more than a fairly accurate description – so the defence argued – of a court case in which the acting director of education, an Englishman, had been charged for drunken driving after a cocktail party. He had driven his car off the road and knocked down a pedestrian. Tiger commented on the country's need for sober people to direct its education. He also expressed dissatisfaction at the acquittal of Daniel by the court on some legal technicality, the type that has always worked to be advantage of the ruling elite. Nothing much came of the case against Tiger and Attila, but the incident does reinforce the point we have been exploring, that elites in power tend to manipulate the law to protect themselves against dissent or satirical scrutiny, or what we have been terming the festive or carnivalesque laughter of the "little black boys" from the underclass.

This brings us to the decade of 1956 to 1966, the age of Sparrow's early dominance. During that decade, calypso freedom was practically rewritten, the boundaries redefined by Sparrow, whose risqué calypsos were more risqué than any had ever been before. His political calypsos, blending raw vitality with pointed commentary (for example, "PAYE", "No Doctor No", "Leave De Dam Doctor", "Solomon Out", "Get to Hell Outa Here") also set new boundaries for incisive criticism at

a time when Dr. Eric Williams held the nation spellbound in the palm of his hand. His gyrations on the stage, the truly grotesque, macabre laughter of something like the "Congo Man", would certainly not have been possible and, if possible, would not have been permitted in the 1930s.

So there was no doubt that calypso freedom had been increased and redefined in every particular. Sparrow was in every way the incarnation of the festive spirit of Carnival. There were the grotesque excesses in sexuality; the assertion of a sort of phallic kingship that was reflected in every movement of his performance. There was the constant head-on confrontation with official values of decency and respectability. There were even the violent physical encounters between Sparrow and a succession of antagonists, some of which led to court cases; and there were, framing and underlying all these, rhythm, life-pulse, celebration, excess, self-assertiveness, the boasting rhetoric of the traditional warrior-hero.

Obviously, this spirit would be confronted by the spirit of censorship; the old spirit of plantation, church, law court that always ruled: or that had always made the rules, defined the values by which the Jamettes must be forced to live, even though the lawmakers had themselves the poorest possible track record for living what they preached. Between 1956 and 1966, the large issue was the denial of airplay to calypsos during the Lenten season. Sparrow was consistently condemned for having "changed" the calypso. It was he, they said with a bitterness that has lasted to this day, who had unmasked its erotic drive. It was he, too, who had transformed its melodic structure, the pace of delivery, the style of performance. He had broken with sacred conventions of structure. He had blended the songs with love ballads and folk songs. He had sung songs composed by ghost writers when everyone knew that true-true calypsonians sang their own compositions. His songs degraded women or focused on women whom life had brought to degradation.

Sparrow's response to his critics was both direct and oblique. A calypso such as "Thanks to the Guardian" (1962) was a direct critique of the establishment press. Sparrow sarcastically commended the newspaper for all the free advertisement it had been giving him, by opening up its pages to so many of his critics. Interestingly, he ended by comparing his situation to that of Premier Eric Williams.

In "Outcast" (1963) he accused "society" in Trinidad of blatant hypocrisy. A class of people who had created nothing that was indigenous, who were even then in the process of appropriating both pan and kaiso as representative national forms, enjoyed the songs and music but were still full of prejudice against the singers and musicians: "And they bracket you in a category so low and mean / Man they leave the impression that your character is unclean." This was as direct and aggressive an attack or defence as one would find in Sparrow; the bulk of his response was quite oblique. The more he was attacked for his "phallic" songs, the more outrageously he would assume the mask of sexual rebel, violator of cherished taboos, or mocker of the respectable, the decent, the moral ethics squad and thought police of the socially conformist. How else can one explain the movement from "Jean and Dinah" (1956) and "May May" (1960) through "Keep the City Clean" (1960) and "Mr Rake and Scrape" (1961) to "The Village Ram" (1964) and "Congo Man" (1965)?

I read the last three as deliberate or unconscious attempts at rebellion by a technique that is common to all proletarian subcultures: that of accepting and according heroic status to the very quality and values that are rejected as antiheroic, antisocial and damnable by "respectable" society. So "Mr Rake and Scrape" presents the phallic hero as a sexual garbage collector. He is the man who rakes and scrapes, who cleans up whatever ends of rubbish and filth remain on the road after the main bulk of it has been placed on the garbage truck, a sexual vulture of the lowest order of *corbeaux*. In "The Village Ram" he is the medieval ram goat of lust, insatiable, efficient and for

hire; or, changing the metaphor, he is the world heavyweight champion capable of lasting and lusting the full fifteen rounds, respected worldwide for the power of his punch. In "Congo Man" he is a veritable cannibal of sexuality, eating his way into the socially forbidden and in his newly independent ex-colonial society, still largely inaccessible white meat. What is this but a thinly veiled and corrosive mockery of a society that had from its very foundation constantly but secretively been breaching the tabooed frontiers between white and black? Sparrow himself had married a white American in 1958 and had complained about the hostile gossip and social ostracism that followed on the marriage in "Everybody Washing They Mouth on Me" (1959).

> Anywhere you go is the same talk
> From the West Indies up to New York
> Anywhere you go is the same talk
> From the West Indies up to New York
>
> Sparrow do this and Sparrow do that
> Sparrow never hit they dog or they cat
> Still for all they would not give me a chance
> They interfering in my private romance
>
> Everybody washing they mouth on me
> I eh do them nothing but they giving they tongue liberty
> They find that ah stupid
> Because ah went and married to Emily
> But ah love me wife and to hell with everybody

"Congo Man", then, attacks the most powerful taboo of colonial society, the taboo that sought to forbid black and white miscegenation, intercourse or love. That taboo was actually reinforced by the racist American Hayes Office Code of film censorship by which the representation in the movies of white and black love, sex or marriage was forbidden. Sparrow's persona crosses the line with a vengeance: he transgresses. Through him, Sparrow implodes the cannibal stereotype by seeming to celebrate it while at the same time turning on and laughing harshly and joyously at his critics, those who had throughout the decade argued for the censorship of his calypsos. "Congo Man", which grew out of news or rumours of Belgian nuns and priests being beaten, raped and killed in the Congo, is a daring, mocking, macabre challenge to the "hypo-critics" of his society. Sparrow's cannibal laughs and giggles triumphantly as he defiles the ultimate symbols of decency and respectability by feasting on them. His is, quite literally, festive laughter!

Other and less obvious oblique attacks on the fortress of respectability are his three calypsos about governors: "Short Little Shorts" (1958), "Popularity Contest" (1963) and "The Governor's Ball" (1967), the last of which came at the end of his first decade as a calypsonian. In "Short Little Shorts" the calypsonian depicts the governor – still British, but increasingly irrelevant – as lusting after a young woman clad in "short little shorts". Respectability is no stranger to common desire. We recognize festive laughter such as had issued from the throats of nineteenth-century chantwels as they baited upper-class ladies about their secret sexual desire.

In "Popularity Contest" the target is the governor general of the short-lived West Indian Federation, Lord Hailes, whose social significance is being measured against that of Dr Williams, the popular, charismatic premier of Trinidad and Tobago, and Sparrow, the phallic hero of the *demimonde,* the people's voice and the medium of their festive laughter. Lord Hailes hardly features in the competition which is reduced to a play-off between the Doc and Sparrow. The Doctor receives

the vote of the father of the family, but Sparrow is chosen by the mother, the sister and the auntie and the big girl. Read now with hindsight, "Popularity Contest" is yet another calypso about the conflict of values in that transitional period. By whose measure and by whose standards would the society now accord social significance? Would the values and rituals of the old colonial order, as symbolized by Lord Hailes, prevail? Would they be replaced by whatever it is Dr Williams represented: the hope of the new black intelligentsia, as yet still nationalist and anti-imperialist?

"Popularity Contest" valorizes neither Hailes nor Williams. Instead, it celebrates the norms and values of the grass roots, what I have been terming the carnivalesque values of naturalness, fertility, unpretentious acceptance of one's sexuality – values of the visceral, the unadorned, the vital. Such values find their fullest expression in excess, comesse, "bacchanal", the erotic, the Dionysian. Hence the women's declaration that they have voted for Sparrow leads to "riot" in the house: "The father get ignorant." His own manhood and patriarchal authority have been challenged. Moreover, when the Doctor is measured against the proletarian hero/antihero Sparrow, he is seen as a little boy "making himself a pappy-show".

> The husband take off like a jet plane through the door
> To meet the Doctor at Piarco
> In no time at all he was out of Port of Spain
> He reach the airport in the rain
> Passing through the crowd he get a shock
> People clapping and I was singing for the Doc
> He say "Who is that boy making himself a pappy-show"
> A fellow say, "I ain't know, but he talking to Sparrow"

I am suggesting that these "governor" calypsos tell us something about the clash of values among the old-time colonial bourgeoisie, the new post-independence nationalistic bourgeoisie and the enduring everlasting proletariat who are destined to live through and beyond both of these absurdities; both the pappy-show of Lord Hailes and the equal and complementary pappy-show of the Doctor's politics of rhetorical nationalism.

In "The Governor's Ball" (1967) a madwoman is drawn by the rhythms of the police band to "storm" a governor general's ball. Since the madhouse and the governor general's residence are in close and perhaps symbolic proximity, the madwoman is able to climb over the wall that separates and protects sanity from insanity, and "invade" the prim propriety of the ball of the new elite. One recognizes in this situation another oblique example of the confrontation between carnivalesque freedom and repressed respectability. The old colonial elite has been replaced by a new elite, but the new elite, which had for decades been waiting in the wings for the death or departure of the old, has shaped itself in the image of its predecessor. Naturally, the new elite of invitees to the now local governor general's ball is as out of step with the pulse, rhythm, energy and spirit of the people's music as was the old stiff-arsed colonial upper crust.

The madwoman, a bacchant driven and filled with the spirit of the music, notices immediately that the fête is dead and tries to enliven first the governor and then the assembled guests.

> ...the woman shake she waist
> In the Governor face
> Telling everybody inside the place
> Shake your baton like Mr Prospect
> Shake it up again, shake it up again, mamayo

> Shake your baton like Mr Prospect
> Calypso! Calypso, maestro!
> Shake your baton like Mr Prospect

The role of the madwoman here would be immediately understood in the 1990s, the age of the "command calypso", where the singer functions as reincarnated chantwel whose chief role is to harangue the audience into enthusiastic performance of the same actions in the same sequence. Carnival, the madwoman knows, is about the loss of individualism in ecstatic communal abandon to the pulse of life, and this is what she tries to achieve with the governor's guests and, indeed, the perhaps too military and rigid police band.

The two men in "authority" at the fête, the bandmaster, Mr Antonio Prospect, and the governor general, Sir Solomon Hochoy, try in their different ways to restore order and propriety. Mr Prospect stops the band and Sir Solomon orders his guard to evict the madwoman. Neither strategy succeeds. The madwoman takes over conducting the band and the fête.

> She said "If you won't conduct
> This band it is your hard luck.
> Now, fellows, One, Two, Three,
> Follow me."
>
> "That is how ah like to hear music play
> Shake your baton like Mr Prospect."
> And if you see how the madwoman break away
> Shake your baton like Mr Prospect

Her response to the governor's attempt to have her evicted is to assume command of the guards as she had previously assumed command of the police band.

> The governor tell the guard
> Put this lunatic outside
> The woman is really mad
> And she should be tied
>
> When the soldier make he move
> She say "Whe you trying to prove?
> I'm only having fun
> Attention!"
>
> "Now behave yourself and do as I say,
> Shake your baton like Mr Prospect.
> About turn!" The soldier turn around and walk away
> Shake your baton like Mr Prospect
> "Listen, soldier boy, leh me stay and enjoy the governor's ball
> Shake your baton like Mr Prospect
> Prospect don't stop at all."

Who is this magical madwoman who can hold the governor, the police band and the military spellbound; who literally and metaphorically takes hold of the phallic baton with which she conducts, controls and subverts the governor's ball by injecting the spirit of revelry and mischievous laughter into the garden party of the respectable cultured? She is the spirit of Carnival itself, the muse of the

Jamette *demi-monde* who, having taken command of the fête, ends as she began with a final attempt to vitalize the terrified Sir Solomon; no easy task.

> She hug up the governor
> Tighter than a rasseler [wrestler]
> "Now, Your Excellency,
> Dance with me!"

Her final command to Sir Solomon is, "Governor, leh we break away." To break away is to abandon oneself to the joy and "madness" of the moment, to break through to and release the repressed "other self". The governor's instinctive command to his guard to "put this lunatic outside" is a clear indication that he will never be able to enter into the spirit that she brings to his ball. When authority cannot break away or even break, it tends to retaliate by seeking to censor the freedom and abandon of those who, in Aimé Césaire's memorable phrase, "give themselves to the essence of things".[16] A great deal of the social history of Trinidad has involved this dance of apparent opposites: "freedom" to the point of total abandon, ecstatic "madness", versus "responsibility" to the point of repression, inhibition and censorship; the madwoman and the governor general; Sparrow and Doctor Williams; "three black man" and Dr Bakewell; the chantwels of the 1880s and the respectable ladies of Port of Spain; the Dionysian and the Apollonian; society and its double.

It was not only in the areas of class relationships and the representation of sexuality that notions of freedom and responsibility needed to be constantly defined and redefined. Many calypsonians also functioned as monitors of political discourse and behaviour. Some, such as Attila and Growling Tiger of the Old Guard or Sparrow and Blakie of the mid-1950s to the mid-1960s and Chalkdust, Valentino, Black Stalin Short Pants and Relator of the 1960s and 1970s, or Delamo, Luta, Cro Cro, Sugar Aloes, David Rudder and many more of the 1980s and 1990s, have been sharp and perceptive critics of the politics of their respective ages. As we have seen, the colonial authorities from the 1920s to the 1940s tried, through measures such as the Seditious Publications Ordinance and the Theatre and Dance Halls Ordinance, to set strict limits on freedom of speech and expression. Such control, we also saw, did not prevent calypsonians, who viewed it as their responsibility, from making critical pronouncements on the politics of their times.

As the state set limits on freedom of speech and conscience, so did the calypsonians from Attila to Chalkdust, from the Growling Tiger to Cro Cro and Sugar Aloes proclaim their responsibility to speak for the underdog. In the process of becoming the people's voice, the calypsonians grew to recognize the necessity for expanding the space within which their voices might be given free play. Freedom of speech could easily become a meaningless empty notion – particularly in the post-plantation society with a history of censorship and repression – if such freedom were not vigorously and consistently exercised. We have identified a few of Sparrow's more critical political calypsos as part of this exercise of freedom, and we now will comment on Chalkdust's important contribution to the maintenance and extension of calypsonians' freedom.

Chalkdust's entry into the People's National Movement "Buy Local" calypso competition in 1966 worried no one. Buy Local calypsos were meant to support an important government economic initiative and were part of what the state liked to hear calypsonians doing: building the nation by encouraging the population to purchase locally produced commodities. Chalkdust's direct criticism in "Brain Drain" (1968) of Dr Williams's condemnation of skilled nationals who had begun to leave Trinidad in search of better opportunities abroad was a different matter altogether. By that time, Chalkdust had begun to appear as a regular performer at the Carnival Development Committee-

sponsored calypso tent. He was also popular, and "Brain Drain" and "Devaluation" won him third place behind Duke and Sniper in the 1968 Calypso Monarch competition.

It was suddenly discovered that Chalkdust was a schoolteacher, a member of the public service and thus subject to regulations that prohibited the public servant from holding more than one job. The real problem, however, lay elsewhere, in the regulations that forbade public servants from making public statements on the political affairs of their country and particularly from offering criticism of the state's public policy. The freedom of the public servant was clearly and narrowly delimited in the regulations; the responsibility, too, it was implied, was to the employer, the state, whose elaborate machinery could, on little provocation, be programmed to work against the uncooperative subject. Chalkdust's great contribution to democratic freedom in Trinidad and Tobago lies in the fact that he challenged the ministry, the regulations and the malignant state machine.

Answering the charge that by singing nightly in a tent he was doing two jobs, he argued that as an employee of the Ministry of Education *and Culture,* he was serving the same master at two different venues, school and tent. In "Reply to the Ministry" (1969), he compiled case after case of public servants, including the director of culture, who were doing more than one job, and had been for years, and yet had not been questioned by their ministries. Chalkdust ventilated the issue via public lectures during the post-Carnival months in 1968 and won great public admiration when he made his deposition in kaiso the following season. (The last time this had happened had been a decade before, with Sparrow's "Ten to One Is Murder".) Holding and defending one's physical or metaphorical ground had always been the duty of chantwel, batonnier, traditional masquerader and calypsonian. Unmasking the real objective of the ministry as being the censorship of dissent, Chalkdust proclaimed his determination to speak out against any category of misdemeanour:

> But the boat they miss
> They should first fix
> All the bobol in the Civil Service
> To tackle me they wrong
> If they want to keep me down
> Tell them to cut out mih tongue

The rest, as they say, is history. Later public servants who sang political calypsos – Short Pants, Penguin, Luta, Watchman, Lady B, Kenny J – would be spared the type of harassment that Chalkdust had to endure in 1968.

The Chalkdust issue of 1968–69 resembles in one seminal respect all the other issues that we have been examining: the call for censorship or control of discourse, once such discourse runs counter to the official line. Censorship has assumed various shapes over the years since emancipation. At one time it has been the banning of drums and other African musical instruments; at another the prohibition of non-Christian religious practices; at another the declaration of radical counter-discourse, sedition. Normally, censorship masks itself under the euphemism of defining or prescribing limits, values and responsibilities; but whatever the mask, censorship is always promoted in the interest of a specific class, ethnic group or political order. The Theatres and Dance Halls Ordinance was, as we have seen, the most blatant example of this truth. There the inspector general of constabulary introduced a most elaborate ordinance in order to protect *himself,* and by extension his class, from the mocking lampoons of a calypsonian.

Since 1968 both the number and the aggressive corrosiveness of political calypsos have increased, as the bards and the politicians each year demarcate their space. The calypsonian's role

in this stickfight has been to extend both his right and his privilege to freedom of dissent as far as and beyond what the system will permit. There were over one hundred and fifty calypsos that commented directly and often critically upon the performance of Eric Williams as political leader and prime minister, and scores more that anatomized politics and social issues over the twenty-five years of Williams's stewardship.[17]

Williams was represented variously as a madman (Chalkdust, "Somebody Mad" [1972]); a devouring shark, Jaws (Chalkdust, in a calypso drama in the Independence Calypso Tent, August 1975); a deaf and vision impaired conductor of a deaf orchestra (Relator, "Deaf Panmen" [1974]); an evil sorcerer with the power of "goat mouth" (Chalkdust, "Goat Mouth Doc" [1972]); an incompetent deejay or proprietor who has lost control of his party (Stalin, "Breakdown Party" [1980]); "a horse that is tired and almost lame" (Relator, "Take a Rest" [1980]); a diseased mangy and headless horse adrift in a cemetery or racing complex (Delamo, "Apocalypse" [1981]); and an envious old voyeur badly afflicted with a hernia (Shorty, "The Doc's Sex Probe" [1975]).

There were, of course, adulatory calypsos that portrayed him as father, founder and lover of the nation (Bomber, "Political Wonder" [1970]); as genius, third or fourth most intelligent being in the galaxy; as godfather and patron not only towards his own people but toward the entire Caribbean (for example, Swallow's "Trinidad: The Caribbean Godfather" [1979]); and as leader and hero marching in the rain against Yankee imperialism (Duke, "Memories of '60" [1961]). But it is true to say that since Blakie's "The Doctor Ent Deh" (1965) and Chalkdust's "Reply to the Ministry" (1969), "Massa Day Must Done" (1970), "Two Sides of a Shilling" (1971), "Somebody Mad" (1972), and many more, calypsonians had extended their freedom considerably, while providing through their focused laughter a measure of the madness and disintegration that they perceived in the society.

The system's role in the national stickfight, performed by whoever is in power for a time or at the time, has been to stress the achievements of the regime in power, to emphasize the dignity and respect due to authority, and to threaten overt or covert reprisal against the irreverent calypsonian. Such reprisal has taken several forms: for example, lawsuit, as was the case with Shorty's "The Art of Making Love" (1974). One school of opinion, supported by Shorty himself, was that Chalkdust was the real target of the lawsuit, not Shorty. A coded warning was being sent out, a word to the wise. Dissenting calypsos were and usually are denied airplay. Radio station managers, fearful for their jobs, took care not to offend the powers that were by pre-censorship of all "offensive" songs. Deejays were served a list containing songs that were not to be played.

Calypsonians of the 1970s – Chalkdust and Stalin, especially – felt that the Calypso Monarch competition regularly discriminated against singers of political dissent. Throughout this period, singers such as Chalkdust were compelled to state and restate their own aesthetic as radical dissenters. (Hence "Juba Doo Bai" [1973]; "Calypso vs Soca" [1978]; "Quacks and Invalids" [1994]; "Why Smut" [1975].) We find Delamo ("Ah Cyan Wine" [1987]), Stalin ("Wait Dorothy" [1985]) and Cro Cro ("Support Social Commentary Calypso" [1996]) making similar defences and definitions of aesthetic in the 1980s and 1990s.

There are, then, and have always been, two sets of players in this ongoing drama of discourse. One party seeks to expand freedom, the other to limit it. Both parties seek their own self-interest. The one clings to convention, the other to law. Convention has always required negotiation, while law involves a constant clarification of limits, an erection of clean, insurmountable boundaries, whose extreme state is censorship, the imprisonment of the word and, if necessary, the assassination of the voice. The freedom that calypsonians habitually claim is based on convention. It is the freedom of traditional festive spaces in which roles are reversed, the powerless play at being powerful and –

if the game is being correctly played – the powerful pretend to be humble and powerless. It is the freedom of the "fool" to criticize and caricature the king; the freedom of the old-time Feast of Fools when the lesser clergy either played or mocked at their betters.

This sort of freedom used to be understood to be transitory. It existed within the special festive space of Carnival but disappeared as Carnival ended and normal time re-established itself. Nothing better illustrates this reality than the calypso – the name I forget – that depicts a masquerader whose socially outrageous behaviour is tolerated throughout the two days of Carnival, but who is charged and sentenced to jail for playing mas on Ash Wednesday. Calypsonians' freedom was expected to be that of the masquerader, a time-limited phenomenon that was tolerated precisely because it was both temporary and confined to the tent's special and festive stage.

The problem was that, over the decades, the calypso tent evolved as a sort of popular equivalent to Parliament: a privileged space that exists not because authority has willingly sanctioned its existence but because it has, decade after decade, era after political era, fiercely asserted and defended its own right to exist as a forum for the public articulation of whatever is officially unspeakable, for the public transgression into what is officially taboo, and for speaking one's mind either openly or behind a mask. In fulfilling these functions the calypso has been seeking a more permanent place in national discourse. It has been trying to extend the privilege of the tent, where one can state the outrageous, into the world of normal, daily discourse where the outrageous may also be the libellous. Gypsy's "Respect the Calypsonian" (1988) is perhaps the clearest statement on this desire among calypsonians to be respected as serious contributors to both celebration and political discourse.

The evolution of the social and political calypso has been similar to that of the Trinidad Carnival which has in all its faces, phases and manifestations been both the theatre and a metaphor of the process through which the still living drama of Trinidad's social history has been both encoded and enacted. Essentially, Carnival, like calypso, has been a celebratory mass/mas theatre of contested social space; a drama of ritualized verbal and violently physical challenge; the domain of the stickfighter, the Wild Indian, the Pierrot, the Midnight Robber, the chantwel, the pan man. The contestation of these carnivalesque figures with rhetoric or blows – often rhetoric and blows – was an enactment of the confrontation that has always been taking place within the social process itself.

It is, therefore, only natural, that the contemporary movement of the Indo-Trinidadian to political and socioeconomic centre stage via the masquerade of politics, should be reflected in the most recent contestations for space on the Carnival stage (see, for example, the efforts that have been made to invent chutney-soca and propel it towards centre stage in the state-sponsored Independence Monarch competition) and in the wider theatre of festivals in Trinidad (note for example, the keen contestation for funding and respectability between emancipation celebrations and Indian Arrival Day).

The calypsonian, master and keeper of all verbal codes within popular "Creole" culture, has assumed the role of decoder and unmasker of the new slogans and codes and masks that each regime of political chantwels has ambiguously employed to inspire society with notions of a desired ideal, and to conceal the distressing truth of our lived reality. Slogans such as the old watchwords enshrined in the national anthem have received a merciless exposure at the hands of calypsonians.[18] New slogans, such as George Chambers's "Productivity" and "Fête Over, Back to Work" or the National Alliance for Reconstruction's "One Love" and "Rainbow Country" or Manning's "World Class" and "Let us go down the road together and get the job done" or Panday's "National Unity", have all been cracked open, laid bare, subjected to the severe scrutiny of the calypsonians' focused

scepticism. "Let us go down the road together," pleads Manning. "How Low?" asks Watchman (Watchman, "How Low" [1994]).

The calypsonian's impulse to unmask the politician as a "mocking pretender" is essentially the same as the impulse that the ancestral chantwel, Midnight Robber, batonnier or Indian chief felt to reveal and demolish any rival who had invaded his space. It is the ancient declaration of territorial rights, the age-old assertion of power-in-discourse projected through the medium of contemporary calypso. There is also the recognition that the present regime, which gained a few thousand votes less than the People's National Movement, came to power through the meretricious process of what Mr Panday termed "One Love on a UNC bed, in the House of the Rising Sun". The choice of imagery was clever but unfortunate; the House of the Rising Sun being, in the famous Nina Simone ballad, a whorehouse in New Orleans! Sugar Aloes in "The Facts" (1996) predicted, accurately enough, that the National Alliance for Reconstruction would be devoured in this second ordeal of "One Love", though Valentino in "To Love Again" (1996) was ecstatic that the nation had, through Robinson's arrangement with Panday, been permitted a second opportunity at national unity.

An aura of illegitimacy – by no means dissipated by the defection of Griffith and Lasse from the People's National Movement to the United National Congress, or the movement of Robinson from political leader of the National Alliance for Reconstruction to the supposedly non-political presidency – has hung around Panday's government, and this has certainly affected how calypsonians have represented the present regime. It has not helped that the prime minister has been trying hard to coerce the public into respecting him, while clinging tenaciously to the verbal register of the hustings. Threats – such as his promise that no one who attacks his "government of national unity" will escape unscathed; reference to striking teachers as "criminals" who should be treated as such for having neglected their charges; frequent attacks on the media; the haranguing of his supporters to "do them", that is the party's "enemies", "first"; and the rank-pulling reference to the harshly dissident calypsonians who have been the plague of his life as "semi-literate social deviants" – have done nothing at all to inspire confidence in his leadership.

In fact, the very opposite has happened, and calypsonians, who have been keepers of all verbal codes within the popular culture, have reacted to this rhetoric of taunt, threat and insult with a similar rhetoric of their own; taunt, threat and insult being, after all, the very substance of the register of the street. The politician, in turn, unable so far to censor the focused laughter and mockery of the calypsonian who relentlessly unmasks the true barrenness of the politician's discourse (see Rudder, "The Madman's Rant" [1996] and "The Savagery" [1998]; Chalkdust, "National Unity" [1996] and "Too Much Parties" [1998]; Pink Panther, "Mistakes" [1998]; Shortpants, "No Comment" [1998]; Sugar Aloes, "Ish" [1998] and "This Stage Is Mine" [1999]; Luta, "Pack Your Bag" [1998]; Penguin, "Criminals" [1997]; Lady B, "Dancing Time" [1999]) – has re-entered the time-honoured masks of insecure authoritarianism under threat. Those masks are censorship; the promise of recrimination; and the employment of state patronage as a form of bribery through which the calypsonian might be induced to compromise the fierceness of his attack or, better still, to remain silent about the discrepancies he observes between proclaimed ideals and the often distressing performance of the politician, or, best of all, to promote the slogans, clichés and agenda of the regime in power in something like the state-sponsored "nation-building" calypso-cum-chutney independence song contest of 1998.

As we have seen, the roles that are being played by both actors, the politician and the calypsonian, are traditional ones. Both players, indeed, seem to be caught up in a pattern of action and

stereotypical reaction, in which the politician's excesses of rhetoric and threat are closely monitored by the calypsonian who then reproduces them in grotesque caricature on the festive stage of the Carnival tent. Watchman's "Mr Panday Needs Glasses" (1997), Sugar Aloes's defiant and insulting "Ah Ready to Go" (1998) and "This Stage Is Mine" (1999), Penguin's "Criminals" (1997) are all calypsos of reaction to one or other of the prime minister's rhetorical excesses, while Luta's "Pack Yuh Bag" (1998) advises the politician to retire in disgrace from the stage of picong, if he "can't take the jamming". Watchman in 1999, back from Africa and the stress of working as a United Nations peace-keeping officer, reacts to Panday's "we must do them first" harangue with the harsh but timely advice that picong and dissenting calypsos are a small price to pay for democracy, in a world where thousands are still dying in bloody struggles for freedom of choice and conscience ("Price of Democracy"; see also "Lessons from Africa" [1999]).

One interesting result of this fierce annual exchange between the prime minister and what he has called "[these] semi-literate social deviants" has been the introduction in March 1998 (just a week or two after the grand post-Carnival furore over Sugar Aloes's "Ah Ready to Go") of a new clause, Clause Seven, hastily appended to the Equal Opportunity Bill. Clause Seven, which is entitled "Offensive Behaviour", reads:

1. A person shall not, otherwise than in private, do any act which:
 (i) is reasonably likely, in all circumstances, to offend, insult, humiliate another person or group of persons; and
 (ii) is done because of the race, origin or religion of the other person, or of some or all of the persons in the group; or
 b. which is done with the intention of inciting racial or religious hatred.
2. For the purposes of sub-section (1) an act is taken not to be done in private if it:
 a. causes words, sounds, images or writing to be communicated to the public;
 b. is done in a public place
 c. is done in the sight and hearing of persons who are in a public place.[19]

According to *Express* journalist Jeff Hackett, one possible outcome of "this dangerous piece of nonsense" would be that

> Writers, artists, calypsonians, show business people, photographers, filmmakers, actors, comedians and people on the whole in the creative field, as well as trade unionists, politician and social activists, should this bill be enacted [would] risk being convicted and jailed for what civilised societies consider harmless activity.[20]

Clause Seven bears a curious resemblance to Section Seven of the Seditious Publications Ordinance of 1920 and the elaborate Theatre and Dance Halls Ordinance of 1934. These three pieces of class legislation share, beneath the euphemism in which they are most righteously clothed, a common end: the control of dissent in the interest of a current ruling class. In 1920 and 1934 that ruling class constituted a deeply embedded oligarchy of British and local whites and off-whites, particularly the rump of French Creole families, who anticipated social turbulence and threat in the nascent labour movement. In 1998 the ruling order is an oligarchy in formation and on the road towards exercising a reciprocal parasitism that is distinguishable from the one that it replaces only through the fact that it is far more blatant.

Politically insecure, but in the process of uniting new money with old and thus securing the necessary economic basis for power, the oligarchy in formation is apprehensive of the probing, often anarchic and aggressive wit of calypsonians. Seeking bourgeois respectability even as it

retains the carnivalesque register of the streets – witness the robber talk, the *sans humanité*–type insults and the mixture of clownishness and gutter violence in certain aspects of its performance – the oligarchy-in-formation is afraid of caricature, the weapon of the society's underclass, of its bards, cartoonists, weekly journalists such as the *Mirror's* Flagsman, lampoonists and comedians. It is afraid of being laughed at.

This confrontation between the street and the balcony, festive laughter and bourgeois propriety, is in fact the old colonial symphony in a new key and at a shriller, more hysterical pitch. For this time, the confrontation involves not a foreign minority versus a local majority seeking its democratic rights but the two large, if internally divided, ethnicities of Afro-Creoles and Indo-Creoles pitted against each other, with a substantial buffer of douglahs, mulattos and other intricately intermixed races, and a more or less detached class of economically powerful Caucasians, Syrian-Lebanese, Chinese and Indian business people who, whatever their internal ethnic quarrels may be, understand the necessity of reconciling old money with new in the mutual interest of class dominance.

The quest for political dominance is a quest to control the decision-making process in the interest of what really matters: economic self-entrenchment on the basis of class if necessary, and/or ethnicity if possible. But since Afro-Creoles and Indo-Creoles are almost equally balanced in terms of electoral strength both groups secretly recognize the need for a rhetoric of national unity and nation building that might attract support from the alienated centre. Hence the oscillation of both major parties between ethnocentric and nationalistic rhetoric, depending on whether they are in opposition or in power.

Calypsonians and other social commentators in this period of flux and transition have needed to come to terms with the great fluidity of values, loyalties and ideological positions manifest, for example, in the phenomenon of "froghopping" — that is, the crossing back and forth of individuals from one political party to another. The politics that amazes Cro Cro, say, in "Look How Man Does Change" (1998) (also called "It's Amazing How People Change") and bewilders Chalkdust in "Too Much Parties" (1998) is a politics of uncommitment, a politics of pure pragmatism, the domain of trickster and opportunist.

What, then, does one demand of the calypsonian in this time of tension between the death of one cycle and the birth of another? What one should demand of every other category of public commentator – the journalist in print or electronic media; the writer of letters to the editor; the member of Parliament, whether speaking under the protection of parliamentary privilege or outside of Parliament; the pundit, the preacher, the prelate pontificating from various pulpits; the politician at the hustings; the caller into radio discussion programmes and the omnipotent hosts of such programmes; the cartoonist; the comedian; the satirist. One demands or should demand

- the courage to state convictions based on verified fact;
- the moral consistency to practise what they preach and to live by the values and standards that they seek to impose on others;
- balance born of the recognition that one's viewpoint may have only partial validity;
- fairness and a democratic spirit that allows the Other – however one defines the Other – the same right to discourse, dissent and dialogue;
- the ability to accept picong, censure, the reductive laughter of the Other in the same spirit of give-and-take of gaiety, of elation and of play as one delivers picong, censure and laughter at other people's doorsteps; and
- a genuine and honest seriousness of social concern.

These qualities – courage of conviction, consistency, balance, fairness, recognition of the Other's right to discourse, a spirit of give-and-take, gaiety and honest social concern – will, if we are sufficiently mature, tolerant and lucky, eventually emerge out of the very process of contestation in which Trinidadians and Tobagonians have been historically engaged. One cannot legislate these qualities, particularly when the would-be legislators display a consistent lack of the very values and standards that they seek to impose on the rest of the population. The society at large recognizes such hypocrisy immediately, and calypsonians focus the power of society's laughter on both the hypocrites and their hypocrisy. The state now seeks to legislate against such laughter, to lock up picong. Caught up in the old colonial masquerade of autocracy, the state has regressed to anachronistic nineteenth- and early twentieth-century class legislation. Equally caught up in the ancient masquerade of resistance, the calypsonian will continue to serve as the channel for people's scepticism, laughter and freedom. Finally, it is the masquerade that plays the masquerader.

Notes

1. R.C.G. Hamilton, "Report on the 1881 Camboulay Riots in Trinidad", reprinted as "The History of Canboulay: The Hamilton Report", *Vanguard*, 8 February 1969, 5.
2. "The Barber-Green" is a phrase coined by comedian Dennis Hall ("Sprangalang") to describe the environment of the urban underclass, Cipriani's "barefoot man".
3. M. Bakhtin, *Rabelais and His World*, trans. H. Iswolsky (Bloomington: Indiana University Press, 1984), 12.
4. Ibid.
5. Ibid., xxii.
6. Bridget Brereton, *Race Relations in Colonial Trinidad 1870–1900* (Cambridge: Cambridge University Press, 1979), 162.
7. J. Cowley, *Carnival, Canboulay and Calypso: Traditions in the Making* (Cambridge: Cambridge University Press, 1996), 67.
8. See, for example, R. Quevedo, *Attila's Kaiso: A Short History of Trinidad Calypso* (Port of Spain: Department of Extra Mural Studies, University of the West Indies 1983), 9–10.
9. Cowley, *Carnival, Canboulay and Calypso*, 68.
10. Ibid., 67.
11. Bakhtin, *Rabelais*, 5.
12. G. Rohlehr, *Calypso and Society in Pre-Independence Trinidad* (Port of Spain, Trinidad: G. Rohlehr, 1990), 104. Quoted from the *Weekly Guardian*, 13 March 1920.
13. Ibid., 290.
14. Ibid., 291.
15. Ibid.
16. Aimé Césaire, *Return to My Native Land*, trans. John Berger and Anna Bostock (Harmondsworth: Penguin, 1969), 75.
17. Louis Regis provides an excellent, detailed and balanced critique of the political calypsos in the first twenty-five years of independence. See Louis Regis, *The Political Calypso: True Opposition in Trinidad and Tobago 1962–1987* (Kingston, Jamaica: University of the West Indies Press, 1999).
18. See G. Rohlehr, "The Culture of Williams: Context, Performance, Legacy", *Calldoo* 20, no. 4 (1998): 849–88.
19. Clause 7 of the Equal Opportunities Bill, as cited in J. Hackett, "Trampling on Equal Opportunity", *Express*, 14 April 1998, 9.
20. Ibid., 8.

Language and Orality

Poetry and Knowledge

Aimé Césaire

Poetic knowledge is born in the great silence of scientific knowledge.

Mankind, once bewildered by sheer facts, finally dominated them through reflection, observation, and experiment. Henceforth mankind knows how to make its way through the forest of phenomena. It knows how to utilize the world.

But it is not the lord of the world on that account.

A view of the world, yes; science affords a view of the world, but a summary and superficial view.

Physics classifies and explains, but the essence of things eludes it. The natural sciences classify, but the *quid proprium* of things eludes them.

As for mathematics, what eludes its abstract and logical activity is reality itself.

In short, scientific knowledge enumerates, measures, classifies, and kills.

But it is not sufficient to state that scientific knowledge is summary. It is necessary to add that it is *poor and half-starved*.

To acquire it mankind has sacrificed everything: desires, fears, feelings, psychological complexes.

To acquire the impersonality of scientific knowledge mankind *depersonalized* itself, *deindividualized* itself.

An impoverished knowledge, I submit, for at its inception—whatever other wealth it may have—there stands an impoverished humanity.

In Aldous Huxley's *Do What You Will* there is a very amusing page. "We all think we know what a lion is. A lion is a desert-colored animal with a mane and claws and an expression like Garibaldi's. But it is also, in Africa, all the neighboring antelopes and zebras, and therefore, indirectly, all the neighboring grass...If there were no antelopes and zebras there would be no lion. When the supply of game runs low, the king of beasts grows thin and mangy; it ceases altogether, and he dies."

It is just the same with knowledge. Scientific knowledge is a lion without antelopes and without zebras. It is gnawed from within. Gnawed by hunger, the hunger of feeling, the hunger of life.

Then dissatisfied mankind sought salvation elsewhere, in the fullness of here and now.

And mankind has gradually become aware that side by side with this half-starved scientific knowledge there is another kind of knowledge. A fulfilling knowledge.

The Ariadne's thread of this discovery: some very simple observations on the faculty that permitted the human whom one must call the primitive scientist to discover the most solid truths without benefit of induction or deduction, as if by flair.

And here we are taken back to the first days of humanity. It is an error to believe that knowledge, to be born, had to await the methodical exercise of thought or the scruples of experimentation.

Reprinted with permission from *Aimé Césaire, Lyric and Dramatic Poetry 1946–1982*, trans. Clayton Eshleman and Annette Smith (Virginia: University of Virginia Press, 1990), xlii–lvi.

I even believe that mankind has never been closer to certain truths than in the first days of the species. At the time when mankind discovered with emotion the first sun, the first rain, the first breath, the first moon. At the time when mankind discovered in fear and rapture the throbbing newness of the world.

Attraction and terror. Trembling and wonderment. Strangeness and intimacy. Only the sacred phenomenon of love can still give us an idea of what that solemn encounter can have been . . .

It is in this state of fear and love, in this climate of emotion and imagination that mankind made its first, most fundamental, and most decisive discoveries.

It was both desirable and inevitable that humanity should accede to greater precision.

It was both desirable and inevitable that humanity should experience nostalgia for greater feeling.

It is that mild autumnal nostalgia that threw mankind back from the clear light of scientific day to the nocturnal forces of poetry.

Poets have always known. All the legends of antiquity attest to it. But in modern times it is only in the nineteenth century, as the Apollonian era draws to a close, that poets dared to claim that they knew.

1850—The revenge of Dionysus upon Apollo.

1850—The great leap into the poetic void.

An extraordinary phenomenon...Until then the French attitude had been one of caution, circumspection, and suspicion. France was dying of prose. Then suddenly there was the great nervous spasm at the prospect of adventure. The prosiest nation, in its most eminent representatives—by the most mountainous routes, the hardest, haughtiest, and most breathtaking, by the only routes I am willing to call sacred and royal—with all weapons and equipment went over to the enemy. I mean to the death's-head army of freedom and imagination.

Prosy France went over to poetry. And everything changed.

Poetry ceased to be a game, even a serious one. Poetry ceased to be an occupation, even an honorable one.

Poetry became an adventure. The most beautiful human adventure. At the end of the road: clairvoyance and knowledge.

And so Baudelaire...

It is significant that much of his poetry relates to the idea of a penetration of the universe.

Happy the man who can with vigorous wings
Mount to those luminous fields serene!

The man whose thoughts, like larks,
Fly liberated to the skies at morning,

—Who hovers o'er life and effortlessly harks
To the language of flowers and voiceless things!

—"Elevation"

And in "Obsession":

But the shadows are themselves canvases
Wherein live, welling up in my eye by thousands,
Beings invisible to the familiar gaze...

And in "Gypsies on the Road":

Cybele, who loves them, increases her green glades,
Makes rock flow and desert bloom
Before these travelers, for whom
Lies open the familiar empire of future shades.

As for Rimbaud, literature is still registering the aftershocks of the incredible seismic tremor of his famous *lettre du voyant* (the seer's letter): "I say that one has to be clairvoyant, to make oneself clairvoyant."

Memorable words, words of distress and of victory…

Henceforth, the field is clear for humanity's most momentous dreams.

There is no longer any possibility of doubt about Mallarmé's enterprise. The clear-eyed boldness of his letter to Verlaine makes of Mallarmé rather more than the poet whose shadow is Paul Valéry. Mallarmé is an especially important engineer of the mind:

Apart from the prose pieces and the poetry of my youth and the aftermath that echoed them…I have always dreamed of and attempted something else…. A book, very simply, a book that would be premeditated and architectonic, and not a collection of chance inspirations, even wondrous ones. I shall go farther; I shall say The Book, persuaded that at bottom there is only one, that every writer, even the genius, was working at unconsciously. The Orphic explanation of the Earth, which is the poet's only duty. And the literary game par excellence…. There you have my vice revealed.

To pass from Mallarmé to Apollinaire is to go from the cold calculator, the strategist of poetry, to the enthusiastic adventurer and ringleader.

Apollinaire—one of the awesome workmen whose advent Rimbaud had predicted—was great because he knew how to remain fundamentally himself in between the popular ballad and the war poem.

You whose mouth is made in the image of God
A mouth that is order itself
Be indulgent when you compare us
To those who were the perfection of order
We who seek adventure everywhere

We are not your enemies
We want to give you vast and strange domains
Where mystery in bloom is offered to whoever would pluck it
New fires are found there, colors yet unseen
A thousand imponderable fantasms
That await the conferral of reality
We want to explore goodness an enormous country where all is silence
Then there is time that you can banish or call back
Pity for us who fight always on the frontiers
Of the limitless and of the future
Pity our errors pity our sins

—"The Pretty Redhead"

I come now, having skipped a few stops, I confess, to André Breton…Surrealism's glory will be in having aligned against it the whole block of admitted and unprofessed enemies of poetry. In having decanted several centuries of poetic experience. In having purged the past, oriented the present, prepared the future.

It was André Breton who wrote: "After all, it is the poets over the centuries who have made it possible to receive, and who have enabled us to expect, the impulses that may once again place humankind at the heart of the universe, abstracting us for a second from our dissolving adventure, reminding us of an indefinitely perfectible place of resolution and echo for every pain and joy exterior to ourselves."

And still more significantly: "Everything leads us to believe that there exists a certain mental point from which life and death, the real and the imaginary, the past and the future, the communicable and the incommunicable, high and low, cease to be perceived contradictorily. And one would search in vain for a motive in surrealist activity other than the determination of that point."

Never in the course of centuries has higher ambition been expressed with greater tranquillity.

This highest ambition is the ambition of poetry itself.

We have only to examine the conditions necessary to satisfy it, and their precise mode.

The ground of poetic knowledge, an astonishing mobilization of all human and cosmic forces.

It is not merely with his whole soul, it is with his entire being that the poet approaches the poem. What presides over the poem is not the most lucid intelligence, or the most acute sensibility, but an entire experience: all the women loved, all the desires experienced, all the dreams dreamed, all the images received or grasped, the whole weight of the body, the whole weight of the mind. All lived experience. All the possibility. Around the poem about to be made, the precious vortex: the ego, the id, the world. And the most extraordinary contacts: all the pasts, all the futures (the anticyclone builds its plateaux, the amoeba loses its pseudopods, vanished vegetations meet). All the flux, all the rays. The body is no longer deaf or blind. Everything has a right, to live. Everything is summoned. Everything awaits. Everything, I say. The individual whole churned up by poetic inspiration. And, in a more disturbing way, the cosmic whole as well.

This is the right occasion to recall that the unconscious that all true poetry calls upon is the receptacle of original relationships that bind us to nature.

Within us, all the ages of mankind. Within us, all humankind. Within us, animal, vegetable, mineral. Mankind is not only mankind. It is *universe*.

Everything happens as though, prior to the secondary scattering of life, there was a knotty primal unity whose gleam poets have homed in on.

Mankind, distracted by its activities, delighted by what is useful, has lost the sense of that fraternity. Here is the superiority of the animal. And the tree's superiority still more than the animal's, because the tree is fixed, attachment, and perseverance to essential nature...

And because the tree is stability, it is also surrender.

Surrender to the vital movement, to the creative élan. Joyous surrender.

And the flower is the sign of that recognition.

The superiority of the tree over mankind, of the tree that says yes over mankind who says no. Superiority of the tree that is consent over mankind who is evasiveness; superiority of the tree, which is rootedness and deepening, over mankind who is agitation and malfeasance.

And that is why mankind does not blossom at all.

Mankind is no tree. Its arms imitate branches, but they are withered branches, which, for having misunderstood their true function (to embrace life), have fallen down along the trunk, have dried up: mankind does not blossom at all.

But one man is the salvation of humanity, one man puts humanity back in the universal concert, one man unites the human flowering with universal flowering; that man is the poet.

But what has he done for that?

Very little, but that little he alone could do. Like the tree, like the animal, he has surrendered to primal life, he has said yes, he has consented to that immense life that transcends him. He has rooted himself in the earth, he has stretched out his arms, he has played with the sun, he has become a tree: he has blossomed, he has sung.

In other words, poetry is full bloom.

The blossoming of mankind to the dimensions of the world—giddy dilation. And it can be said that all true poetry, without ever abandoning its humanity, at the moment of greatest mystery ceases to be strictly human so as to begin to be truly cosmic.

There we see resolved—and by the poetic state—two of the most anguishing antinomies that exist: the antinomy of one and other, the antinomy of Self and World.

"Finally, oh happiness, oh reason, I listened to the azure sky, which is blackness, and I lived, a golden spark in nature's light."

So, pregnant with the world, the poet speaks. "In the beginning was the word..." Never did a man believe it more powerfully than the poet.

And it is on the word, a chip off the world, secret and chaste slice of the world, that he gambles all our possibilities ...Our first and last chance.

More and more the word promises to be an algebraic equation that makes the world intelligible. Just as the new Cartesian algebra permitted the construction of theoretical physics, so too an original handling of the word can make possible at any moment a new theoretical and heedless science that poetry could already give an approximate notion of. Then the time will come again when the study of the word will condition the study of nature. But at this juncture we are still in the shadows. . . .

Let's come back to the poet. Pregnant with the world, the poet speaks.

He speaks and his speech returns language to its purity.

By purity I mean not subject to habit or thought, but only to the cosmic thrust. The poet's word, the primal word: rupestral design in the stuff of sound.

The poet's utterance: primal utterance, the universe played with and copied.

And because in every true poem, the poet plays the game of the world, the true poet hopes to surrender the word to its free associations, certain that in the final analysis that is to surrender it to the will of the universe.

Everything I have just said runs the risk of implying that the poet is defenseless. But that isn't at all correct. If I further specify that in poetic emotion nothing is ever closer to anything than to its opposite, it will be understood that no peacemaker, no plumber of the deep, was ever more rebellious or pugnacious.

Take the old idea of the irritable poet and transfer it to poetry itself. In this sense it is appropriate to speak of poetic violence, of poetic aggressivity, of poetic instability. In this climate of flame and fury that is the climate of poetry, money has no currency, courts pass no judgments, judges do not convict, juries do not acquit. Only the firing squads still know how to ply their trade. The farther one proceeds, the more obvious the signs of the disaster become. Police functions are strangulated. Conventions wear out. The Grammont laws for the protection of mankind, the Locarno agreements for the protection of animals, suddenly and marvelously give up their virtues. A wind of confusion.

...

An agitation that shakes the most solid foundations. At the bloodied far end of mortal avenues an immense disloyal sun sneers. It is the sun of humor. And in the dust of the clouds crows write one name over and over: ISIDORE DUCASSE COUNT OF LAUTREAMONT. Lautréamont, the very first in fact, integrated poetry and humor. He was the first to discover the functional role of humor. The first to make us feel that what love has begun, humor has the power to continue.

Sweeping clean the fields of the mind is not the least important role of humor. To dissolve with its blowtorch the fleeting connections that threaten to build up in our gray matter and harden it. It is humor, first and foremost, that makes Lautréamont sure—in opposition to Pascal, La Rochefoucauld, and so many other moralists—that had Cleopatra's nose been shorter, the face of the world would not have been changed; that death and the sun can look one another in the eye; that mankind is a subject empty of errors . . . that nothing is less strange than the contradictoriness one discovers in mankind. It is humor first and foremost that assures me it is as true to say the thief makes the opportunity as: "opportunity makes the thief..."

Humor alone assures me that the most prodigious turnabouts are legitimate. Humor alone alerts me to the other side of things.

We are now arriving in the crackling fields of metaphor.

One cannot think of the richness of the image without the repercussion suggesting the poverty of judgment.

> Judgment is poor from all the reason in the world.
> The image is rich with all the absurdity in the world.
> Judgment is poor from all the "thought" in the world.
> The image is rich with all the life in the universe.
> Judgment is poor from all the rationality in existence.
> The image is rich with all the irrationality in life.
> Judgment is poor from all immanence.
> The image is rich with all transcendence.

Let me explain...

However much one may strain to reduce analytical judgment to synthetic judgment; or to say that judgment supposes the connecting of two different concepts; or to insist on the idea that there is no judgment without X; that all judgment is a surpassing toward the unknown; that all judgment is transcendence, it is nonetheless true that in all valid judgment the field of trancendence is limited.

The barriers are in place; the law of identity, the law of non-contradiction, the logical principle of the excluded middle.

Precious barriers. But remarkable limitations as well.

It is by means of the image, the revolutionary image, the distant image, the image that overthrows all the laws of thought that mankind finally breaks down the barrier.

> In the image A is no longer A.
> You whose many raspberried laughs
> Are a flock of tame lambs.
> In the image A can be not-A:
> The black focus plate, real strand suns, ah! wells of magic.

In the image every object of thought is not necessarily A or not-A.
The image maintains the possibility of the happy medium.
Another by Rimbaud:

> The carts of silver and copper
> The prows of steel and silver
> Strike the foam
> Raise the bramble roots.

Without taking into consideration the encouraging complicity of the world as it is either *found* or *invented*, which permits us to say *motor* for *sun*, *dynamo* for *mountain*, *carburetor* for *Carib*, etc., ... and to celebrate lyrically the shiny connecting rod of the moons and the tired piston of the stars ... Because the image extends inordinately the field of transcendence and the right of transcendence, poetry is always on the road to truth. And because the image is forever surpassing that which is perceived because the dialectic of the image transcends antinomies, on the whole modern science is perhaps only the pedantic verification of some mad images spewed out by poets...

When the sun of image reaches its zenith, everything becomes possible again...Accursed complexes dissolve, it's the instant of emergence...

What emerges is the individual foundation. The intimate conflicts, the obsessions, the phobias, the fixations. All the codes of the personal message.

It isn't a matter, as in the earlier lyric, of *immortalizing* an hour of pain or joy. Here we are well beyond anecdote, at the very heart of mankind, in the babbling hollow of destiny. My past is there to show and to hide its face from me. My future is there to hold out its hand to me. Rockets flare. It is my childhood in flames. It is my childhood talking and looking for me. And within the person I am now, the person I will be stands on tiptoe.

And what emerges as well is the old ancestral foundation.

Hereditary images that only the poetic atmosphere can bring to light again for ultimate decoding. The buried knowledge of the ages. The legendary cities of knowledge.

In this sense all the mythologies that the poet tumbles about, all the symbols he collects and regilds, are true. And poetry alone takes them seriously. Which goes to make poetry a serious business.

The German philosopher Jung discovers the idea of energy and its conservation in Heraclitus's metaphor of the eternally living fire, in medieval legends related to saintly auras, in theories of metempsychosis. And for his part, Pierre Mabille regrets that the biologist should believe it "dishonorable to describe the evolution of blood corpuscles in terms of the story of the phoenix, or the functions of the spleen through the myth of Saturn engendering children only to devour them."

In other words, myth is repugnant to science, whereas poetry is in accord with myth. Which does not mean that science is superior to poetry. To tell the truth, myth is both inferior and superior to *law*. The inferiority of myth is in the degree of precision. The superiority of myth is in richness and sincerity. Only myth satisfies mankind completely; heart, reason, taste for detail and wholeness, taste for the false and the true, since myth is all that at once. A misty and emotional apprehension, rather than a means of poetic expression...

Thus, love and humor.

Thus, the word, image, and myth...

With the aid of these great powers of synthesis we can at last understand André Breton's words:

"Columbus had to sail with madmen to discover America,"

And look at how that madness has been embodied, and lasted...

It's not fear of madness that will oblige us to furl the flag of imagination.

It's not fear of madness that will oblige us to furl the flag of imagination.

And the poet Lucretius divines the indestructibility of matter, the plurality of worlds, the existence of the infinitely small.

And the poet Seneca in *Medea* sends forth ships on the trail of new worlds: "In centuries to come the Ocean will burst the bonds within which it contains us. A land of infinity shall open before us. The pilot shall discover new countries and Thule will no longer be the ultimate land."

"It's not fear of madness that will oblige us to furl the flag of imagination..." And the painter Rousseau *invented* the vegetation of the tropics. And the painter de Chirico unknowingly painted Apollinaire's future wound on his forehead. And in the year 1924 the poet André Breton associated the number 1939 with the word *war*.

"It's not fear of madness that will oblige us to furl the flag of imagination." And the poet Rimbaud wrote *Illuminations*.

And the result is known to you: strange cities, extraordinary countrysides, worlds twisted, crushed, torn apart, the cosmos given back to chaos, order given back to disorder, being given over to becoming, everywhere the absurd, everywhere the incoherent, the demential. And at the end of all that! What is there? Failure! No, the flashing vision of his own destiny. And the most authentic vision of the world if, as I stubbornly continue to believe, Rimbaud is the first man to have experienced as feeling, as anguish, the modern idea of energetic forces in matter that cunningly wait to ambush our quietude...

No: "It's not fear of madness that will oblige us to furl the flag of imagination..."

And now for a few propositions by way of summation and clarification.

FIRST PROPOSITION

Poetry is that process which through word, image, myth, love, and humor establishes me at the living heart of myself and of the world.

SECOND PROPOSITION

The poetic process is a naturalizing process operating under the demential impulse of imagination.

THIRD PROPOSITION

Poetic knowledge is characterized by humankind splattering the object with all its mobilized richness.

FOURTH PROPOSITION

If affective energy can be endowed with causal power as Freud indicated, it is paradoxical to refuse it power and penetration. It is conceivable that nothing can resist the unheard-of mobilization of forces that poetry necessitates, or the multiplied élan of those forces.

FIFTH PROPOSITION

Marvelous discoveries occur at the equally marvelous contact of inner and outer totality perceived imaginatively and conjointly by, or more precisely within, the poet.

SIXTH PROPOSITION

Scientific truth has as its sign coherence and efficacity. Poetic truth has as its sign beauty.

SEVENTH AND FINAL PROPOSITION

The poetically beautiful is not merely beauty of expression or muscular euphoria. A too Apollonian or gymnastic idea of beauty paradoxically runs the risk of skinning, stuffing, and hardening it.

COROLLARY

The music of poetry cannot be external or formal. The only *acceptable* poetic music comes from a greater distance than sound. To seek to musicalize poetry is the crime against poetic music, which can only be the striking of the mental wave against the rock of the world.

The poet is that very ancient yet new being, at once very complex and very simple, who at the limit of dream and reality, of day and night, between absence and presence, searches for and receives in the sudden triggering of inner cataclysms the password of connivance and power.

History of the Voice: The Development of Nation Language in Anglophone Caribbean Poetry (excerpt)

Kamau Brathwaite

1

What I am going to talk about this morning is language from the Caribbean, the process of using English in a different way from the 'norm'. English in a new sense as I prefer to call it. English in an ancient sense. English in a very traditional sense. And sometimes not English at all, but *language*.

I start my thoughts, taking up from the discussion that developed after Dennis Brutus's[1] very excellent presentation. Without logic, and through instinct, the people who spoke with Dennis from the floor yesterday brought up the question of language. Actually, Dennis's presentation had nothing to do with language. He was speaking about the structural condition of South Africa. But instinctively people recognized that the structural condition described by Dennis had very much to do with language. He didn't concentrate on the language aspect of it because there wasn't enough time and because it was not his main concern. But it was interesting that your instincts, not your logic, moved you toward the question of the relationship between language and culture, language and structure. In his case, it was English as spoken by Africans, and the native languages as spoken by Africans.

We in the Caribbean have a similar kind of plurality: we have English, which is the imposed language on much of the archipelago. It is an imperial language, as are French, Dutch and Spanish. We also have what we call creole English, which is a mixture of English and an adaptation that English took in the new environment of the Caribbean when it became mixed with the other imported languages. We have also what is called *nation language,* which is the kind of English spoken by the people who were brought to the Caribbean, not the official English now, but the language of slaves and labourers, the servants who were brought in by the conquistadors. Finally, we have the remnants of ancestral languages still persisting in the Caribbean. There is Amerindian, which is active in certain parts of Central America but not in the Caribbean because the Amerindians are here a destroyed people, and their languages were practically destroyed. We have Hindi, spoken by some of the more traditional East Indians who live in the Caribbean, and there are also varieties of Chinese.[2] And, miraculously, there are survivals of African languages still persisting in the Caribbean. So we have that spectrum—that prism—of languages similar to the kind of structure that Dennis described for South Africa. Now, I have to give you some kind of background to the development of these languages, the historical development of this plurality, because I can't take it for granted that you know and understand the history of the Caribbean.

The Caribbean is a set of islands stretching out from Florida in a mighty curve. You must know of the Caribbean at least from television, at least now with hurricane David[3] coming right into it. The islands stretch out on an arc of some two thousand miles from Florida through the Atlantic to the South American coast, and they were originally inhabited by Amerindian people: Taino,

Reprinted with permission from *History of the Voice: The Development of Nation Language in Anglophone Caribbean Poetry* (London: New Beacon Books, 1984), 5–17.

Siboney, Carib, Arawak. In 1492 Columbus 'discovered' (as it is said) the Caribbean, and with that discovery came the intrusion of European culture and peoples and a fragmentation of the original Amerindian culture. We had Europe 'nationalizing' itself into Spanish, French, English and Dutch so that people had to start speaking (and *thinking*) four metropolitan languages rather than possibly a single native language. Then with the destruction of the Amerindians, which took place within 30 years of Columbus' discovery (one million dead a year) it was necessary for the Europeans to import new labour bodies into the area. And the most convenient form of labour was the labour on the edge of the *slave* trade winds, the labour on the edge of the hurrican, the labour on the ledge of Africa. And so Ashanti, Congo, Yoruba, all that mighty coast of western Africa was imported into the Caribbean. And we had the arrival in our area of a new language structure. It consisted of many languages but basically they had a common semantic and stylistic form.[4] What these languages had to do, however, was to submerge themselves, because officially the conquering peoples—the Spaniards, the English, the French, and the Dutch—insisted that the language of public discourse and conversation, of obedience, command and conception should be English, French, Spanish or Dutch. They did not wish to hear people speaking Ashanti or any of the Congolese languages. So there was a submergence of this imported language. Its status became one of inferiority. Similarly, its speakers were slaves. They were conceived of as inferiors—non-human, in fact. But this very submergence served an interesting intercultural purpose, because although people continued to speak English as it was spoken in Elizabethan times and on through the Romantic and Victorian ages, that English was, nonetheless, still being influenced by the underground language, the submerged language that the slaves had brought. And that underground language was itself constantly transforming itself into new forms. It was moving from a purely African form to a form which was African but which was adapted to the new environment and adapted to the cultural imperative of the European languages. And it was influencing the way in which the English, French, Dutch, and Spaniards spoke their own languages. So there was a very complex process taking place, which is now beginning to surface in our literature.

Now, as in South Africa (and any area of cultural imperialism for that matter), the educational system of the Caribbean did not recognize the presence of these various languages. What our educational system did was to recognize and maintain the language of the conquistador—the language of the planter, the language of the official, the language of the anglican preacher. It insisted that not only would English be spoken in the anglo-phone Caribbean, but that the educational system would carry the contours of an English heritage. Hence, as Dennis said, Shakespeare, George Eliot, Jane Austen—British literature and literary forms, the models which had very little to do, really, with the environment and the reality of non-Europe—were dominant in the Caribbean educational system. It was a very surprising situation. People were forced to learn things which had no relevance to themselves. Paradoxically, in the Caribbean (as in many other 'cultural disaster' areas), the people educated in this system came to know more, even today, about English kings and queens than they do about our own national heroes, our own slave rebels, the people who helped to build and to destroy our society. We are more excited by their literary models, by the concept of, say, Sherwood Forest and Robin Hood than we are by Nanny of the Maroons,[5] a name some of us didn't even know until a few years ago. And in terms of what we write, our perceptual models, we are more conscious (in terms of sensibility) of the falling of snow, for instance—the models are all there for the falling of the snow—than of the force of the hurricanes which take place every year. In other words, we haven't got the syllables, the syllabic intelligence, to describe the hurricane,[6] which is our own experience, whereas we can describe the imported alien experience of the snowfall. It is that kind of situation that we are in.

The day the first snow fell I floated to my birth
of feathers falling by my window; touched earth
and melted, touched again and left a little touch of light
and everywhere we touched till earth was white.[7]

This is why there were (are?) Caribbean children who, instead of writing in their 'creole' essays 'the snow was falling on the playing fields of Shropshire' (which is what our children literally were writing until a few years ago, below drawings they made of white snowfields and the corn-haired people who inhabited such a landscape), wrote: *the snow was falling on the cane fields*:[8] trying to have both cultures at the same time.

What is even more important, as we develop this business of emergent language in the Caribbean, is the actual rhythm and the syllables, the very software, in a way, of the language. What English has given us as a model for poetry, and to a lesser extent prose (but poetry is the basic tool here), is the pentameter: 'The cúrfew tólls the knéll of párting dáy'. There have, of course, been attempts to break it. And there were other dominant forms like, for example, *Beowulf* (c.750), *The Seafarer* and what Langland (?1332-?1400) had produced:

For trewthe telleth that loue, is triacle of hevene;
May no synne be on him sene, that useth that spise,
And alle his werkes he wrougte, with loue as him liste

or, from *Piers the Plowman* (which does not make it into *Palgrave's Golden Treasury* which we all had to 'do' at school) the haunting prologue:

In a somer seson, whan soft was the sonne
I shope me into shroudes, as I a shepe were

which has recently inspired Derek Walcott with his first major nation language effort:

In idle August, while the sea soft,
and leaves of brown islands stick to the rim
of this Caribbean, I blow out the light
by the dreamless face of Maria Concepcion
to ship as a seaman on the schooner *Flight*.[9]

But by the time we reach Chaucer (1345-1400) the pentameter prevails. Over in the New World, the Americans—Walt Whitman—tried to bridge or to break the pentameter through a cosmic movement, a large movement of sound, Cummings tried to fragment it. And Marianne Moore attacked it with syllabics. But basically the pentameter remained, and it carries with it a certain kind of experience, which is not the experience of a hurricane. The hurricane does not roar in pentameters. And that's the problem: how do you get a rhythm which approximates the *natural* experience, the *environmental* experience?

God talk to de fowl cocks
early dat mornin
he tell dem not to crow
so silence come on
possess ever wing
and fear ever feather

What is dis...

an de quarrelsome shack-shack
tongue tight
an de howlin mile tree
quiet quiet

and de dancin palm tree
hand fold
witholdin duh spirit

Man better take warnin

an dawn
like it smell a rat
cautious bout what comin
like it smell a rat
backin back
like a cat
over house
over tree
backin back under sea

an star an moon
heads covered
turn back to duh beds
an so
jus' so
before grasshopper could blink 'e eye
de whole sky shut up
just so
in terror an
den de news break

> *Hurry man*
> *Hurry chile*
> *Hurry lan'*
> *While you can*
>
> *Hurricane!*

Anthony Hinkson (Barbados) catches, like no-one else I know, the foreboding of the hurricane, but when the hurricane itself comes, when 'leaves collapse' and 'ever man turn owl/ever jack/ eye wide/mout twist in surprise', not even Hinkson can catch all the right syllables:

Sirens
Churchbells
Swells o' panic
bustle
bustle

quick quick to de church
mek fuh de shelter
Oh lawd
oh lawd
as de first branch fall[10]

In 1961, there appeared in *Leewards: writings, past and present about the Leeward Islands*, collected and edited by John Brown, Resident Tutor, Leeward Islands, UCWI, 'Two poems for Anguilla after Hurricane Donna', September 1960 (pp.57-59). One of them, by Anne Nunn (creole? or a visitor? the Hopkins model suggests a visitor), gets to the *effect* of the hurricane:

That hurricane, he came drummed on
My door, bowled the whole shack
Head over heels, cracked
Concrete like biscuit, broke
Bed and bone...[11]

But still no 'proper' *hurricane;* no volcano except Shake Keane's *Volcano Suite* (1979) no earthquake; drought only in Walcott and Brathwaite's *Islands* (1969) and *Black + Blues* (1976), fire in Walcott's 'A city's death by fire' (1948) and (a fuller treatment of the Castries event) in *Another life* (1973 Ch. 13) and (as cannesbrulées) again in Brathwaite's *Islands*...But we have been trying to break out of the entire pentametric model in the Caribbean and to move into a system which more closely and intimately approaches our own experience. So that is what we are talking about now.

It is *nation language* in the Caribbean that, in fact, largely ignores the pentameters. Nation language is the language which is influenced very strongly by the African model, the African aspect of our New World/Caribbean heritage. English it may be in terms of some of its lexical features. But in its contours, its rhythm and timbre, its sound explosions, it is not English, even though the words, as you hear them, might be English to a greater or lesser degree. And this brings us back to the question that some of you raised yesterday: can English be a revolutionary language? And the lovely answer that came back was: *it is not English that is the agent. It is not language, but people, who make revolutions.*

I think, however, that language does really have a role to play here, certainly in the Caribbean. But it is an English which is not the standard, imported, educated English, but that of the submerged, surrealist experience and sensibility, which has always been there and which is now increasingly coming to the surface and influencing the perception of contemporary Caribbean people. It is what I call, as I say, *nation language*. I use the term in contrast to *dialect*. The word 'dialect' has been bandied about for a long time, and it carries very pejorative overtones. Dialect is thought of as 'bad English'. Dialect is 'inferior English'. Dialect is the language used when you want to make fun of someone. Caricature speaks in dialect. Dialect has a long history coming from the plantation where people's dignity is distorted through their language and the descriptions which the dialect gave to them. Nation language, on the other hand, is the *submerged* area of that dialect which is much more closely allied to the African aspect of experience in the Caribbean. It may be in English: but often it is in an English which is like a howl, or a shout or a machine-gun or the wind or a wave. It is also like the blues. And sometimes it is English and African at the same time. I am going to give you some examples. But I should tell you that the reason I have to talk so much is that there has been very little written on this subject. I bring to you the notion of nation language but I can refer you

to very little literature, to very few resources. I cannot refer you to what you call an 'Establishment'. I cannot really refer you to Authorities because there aren't any.[12] One of our urgent tasks now is to try to create our own Authorities. But I will give you a few ideas of what people have tried to do.

The forerunner of all this was of course Dante Alighieri who at the beginning of the fourteenth century argued, in *De vulgari eloquentia* (1304), for the recognition of the (his own) Tuscan vernacular as the nation language to replace Latin as the most natural, complete and accessible means of verbal expression. And the movement was in fact successful throughout Europe with the establishment of national languages and literatures. But these very successful national languages then proceeded to ignore local European colonials such as Basque and Gaelic, for instance, and suppressed overseas colonials wherever they were heard. And it was not until Burns in the 18th century and Rothenberg, Trask, Vansina, Tedlock, Waley, Walton, Whallon, Jahn, Jones, Whiteley, Beckwith, Herskovits, and Ruth Finnegan, among many others in this century, that we have returned, at least, to the *notion* of oral literature. Although I don't need to remind you that oral literature is our oldest form of literature and that it continues richly throughout the world today.[13] In the Caribbean, our novelists have always been conscious of these native resources, but the critics and academics have, as is kinda often the case, lagged far behind. Indeed, until 1970, there was a positive intellectual, almost social, hostility to the concept of 'dialect' as language. But there were some significant studies in linguistics: Beryl Loftman Bailey's *Jamaican creole syntax: a transformational approach* (Cambridge 1966), F. G. Cassidy, *Jamaica talk* (Kingston 1961), Cassidy and R. B. LePage *Dictionary of Jamaican English* (Cambridge 1967); and, still to come, Richard Allsopp's mind-blowing, *Dictionary of Caribbean English*; three glossaries from Frank Collymore in Barbados, and A. J. Seymour and John R. Rickford of Guyana; plus studies on the African presence in Caribbean language by Mervyn Alleyne, Beverley Hall, and Maureen Warner Lewis.[14] In addition, there has been work by Douglas Taylor and Cicely John, among others, on aspects of some of the Amerindian languages; and Dennis Craig, Laurence Carrington, Velma Pollard and several others, at the University of the West Indies' School of Education, on the structure of nation language and its psychosomosis in and for the classroom.

Few of the writers mentioned, however, have gone into nation language as it affects literature.[15] They have set out its grammar, syntax, transformation, structure and all of those things. But they haven't really been able to make any contact between the nation language and its expression in our literature. Recently, a French poet and novelist from Martinique, Edouard Glissant, had a very remarkable article in *Alcheringa*, a 'nation language' journal published at Boston University. The article was called 'Free and Forced Poetics', and in it, for the first time, I feel an effort to describe what nation language really means. For the author of the article it is the language of enslaved persons. For him, nation language is a strategy: the slave is forced to use a certain kind of language in order to disguise himself, to disguise his personality and to retain his culture. And he defines that language as a 'forced poetics' because it is a kind of prison language, if you want to call it that.[16] And then we have another nation language poet, Bruce St John, from Barbados, who has written some informal introductions to his own work which describe the nature of the experiments that he is conducting and the kind of rules that he begins to perceive in the way that he uses his language.[17] I myself have an article called 'Jazz and the West Indian novel', which appeared in a journal called *Bim* in the early 1960s,[18] and there I attempt to show that a very necessary connection to the understanding of nation language is between native musical structures and the native language. That music is, in fact, the surest threshold to the language which comes out of it.[19]

In terms of more formal literary criticism, the pioneers have been H. P. Jacobs (1949) on V. S. Reid, Mervyn Morris (1964) on Louise Bennett and most of Gordon Rohlehr's work, beginning with 'Sparrow and the language of calypso' (1967).

And that is all we have to offer as Authority, which isn't very much, really. But, in fact, one characteristic of nation language is its orality. It is from 'the oral tradition'. And therefore you wouldn't really expect that large, encyclopedic body of learned comment on it that you would expect for a written language and literature.

Notes

1. Dennis Brutus, the South African poet-and-activist-in-exile. His presentation preceded mine at this Conference and was part of a Third World segment: Azanian Caribbean and Navajo.
2. No one, as far as I know, has yet made a study of the influence of Asiatic languages on the contemporary Caribbean, and even the African impact is still in its study's infancy. For aspects of (anglo-phone) Caribbean cultural development relevant to this study, see my *Contradictory omens: cultural diversity and integration in the Caribbean* (Savacou Publications, Mona, 1974). For individual territories, see Baxter (1970), Brathwaite (1979), Nettleford (1978), Seymour (1977). See also Norman E. Whitten & John F. Szwed (eds.), *Afro-American anthropology* (New York & London 1970).
3. This talk was presented at Harvard University, Cambridge, Massachusetts, late in August 1979. Hurricanes ravish the Caribbean and the southern coasts of the United States every summer. David (1979) was followed by Allen (1980) one of the most powerful on record.
4. See Alan Lomax, 'Africanisms in New World Negro music: a canto-metric analysis', *Research and Resources of Haiti* (New York 1969), *The Haitian potential* (New York 1975); Mervyn Alleyne 'The linguistic continuity of Africa in the Caribbean', *Black Academy Review* 1 (4), Winter 1970, pp. 3–16 and *Comparative Afro-American: an historical-comparative study of English-based Afro-American dialects of the New World* (Ann Arbor 1980).
5. The Maroons were Africans /escaped slaves who, throughout Plantation America, set up autonomous societies, as a result of successful runaway and /or rebellion in 'marginal', certainly inaccessible, areas outside European influence. See Richard Price (ed.), *Maroon societies* (New York 1973). Nanny of the Maroons, an ex-Ashanti (?) Queen Mother, is regarded as one of the greatest of the Jamaica freedom fighters. See Brathwaite, *Wars of respect* (Kingston 1977).
6. But see Tony Hinkson's poem, below.
7. Edward Kamau Brathwaite, 'The day the first snow fell'. *Delta* (Cambridge, England [1951]), *Other exiles* (London 1975), p.7.
8. I am indebted to Anne Walmsley, editor of the anthology *The sun's eye* (London 1968) for this example. For experiences of teachers trying to cope with West Indian English in Britain, see Chris Searle, *The forsaken lover: white words and black people* (London 1972) and *Okike* (15 August 1979).
9. Derek Walcott, 'The schooner *Flight', The star-apple kingdom* (New York 1979; London 1980), p.3. Langland's prelude to *Piers* is often 'softened' into 'In somer season, whan soft was the sonne/I shope me in shroudes as I shepe were', which places it closer to Walcott—and to the pentameter.
10. Anthony Hinkson, 'Janet', *Slavation*, unpub. coll. [Bridgetown 1976].
11. Anne Nunn, 'Donna', in John Brown (ed.), *Leewards: writings past and present...* ([Basseterre, St. Kitts] 1961), p.57.
12. But see the paragraphs (and notes) that follow.
13. See for example Finnegan (1970, 1977, 1977), Andrzejewski (1964), Vansina (1961), Babalola (1966), McLuhan (1962), Nketia (1955), Opie (1967), Ogot (1967), Ogotemmeli (1948), Rothenberg (1968), Beier (1970), Tedlock (1972), Egudu & Nwoga (1973), Miss Queenie (1971) and the wonderfully rich literature on Black Culture in the Americas. See Bibliography for details of these and other references.
14. Frank Collymore, *Notes for a glossary of words and phrases of Barbadian dialect* (Bridgetown 1955, with several rev. and expanded editions): A. J. Seymour, *Dictionary of Guyanese folklore* (Georgetown 1975); John R. Rickford (ed.) *A festival of Guyanese words* (U of Guyana 1976, 1978); Mervyn Alleyne, 'The cultural matrix of Caribbean dialects', unpub., paper, UWI, Mona, n.d., 'What is "Jamaican" in our language?' a review of Cassidy/LePage's *Dictionary* in *Sunday Gleaner,*

9 July 1967, *Comparative Afro-American* (Ann Arbor 1980); Maureen Warner Lewis (sometimes as Warner), 'African feasts in Trinidad', *ASAWI Bulletin* 4 (1971), 'Africans in 19th century Trinidad', ibid. 5(1972), 6(1973), 'Trinidad Yoruba — notes on survival' *Caribbean Quarterly* 17:2(1971), *The nkuyu: spirit messengers of the kumina* (Mona 1977), also in *Savacou 13* (1977), *Notes to Masks* [*a study of Edward Kamau Brathwaite's poem*] (Benin City 1977); Edward Kamau Brathwaite, 'Brother Mais [a study of Roger Mais' novel, *Brother Man*]', *Tapia* 27 Oct 1974 and as Introduction (earlier version) to *Brother Man* (London 1974), 'Jazz and the West Indian novel', *Bim* 44-46 (1967–68), 'The African presence in Caribbean literature', *Daedalus* (Spring 1974), reprinted in Sidney Mintz (ed.), *Slavery, colonialism and racism* (New York 1974) and trans. Spanish in Manuel Moreno Fraginals (ed.) *Africa en America Latino* (Paris 1977), 'Kumina: the spirit of African survival in Jamaica', *Jamaica Journal* 42 (Sept 1978) and (earlier version) in *The African Dispersal* (q.v.).

15. A special exception has to be made of the work of Roger D. Abrahams (see *Bibliography*) whose work on Caribbean and New World speech drama is invaluable pioneering. But no one else has (yet) followed and there has (so far) been no connection between Abrahams' sociocultural sense of rhetoric/ imagination and our linguists, socio-linguists, sociologists and literary critics. Nor has the link between Nketia, say, and Abrahams been appreciated; though recent work by Velma Pollard (see especially her 'Dread Talk' in *Bibliography)* feels like its lighting a match...I should also like to invoke J. J. Williams', *Psychic phenomena of Jamaica* (New York 1934). But that is another story. Perhaps another book.

16. *Alcheringa*, New Series 2:2 (1976).

17. See Bruce St John, Introduction to his 'Bumbatuk' poems in *Revista de letras* (U of Puerto Rico en Mayaguez, 1972).

18. See Brathwaite, n.12, above.

19. Extended versions of this lecture attempt to demonstrate the link between music and language structures e.g. Brathwaite and *kaiso, aladura, sookee*, sermon, bop post-bop; Shake Keane on jazz (he is a jazz trumpeter), *cadence, anansesem;* Kwesi Johnson, Oku Onuora and reggae/dub, Michael Smith and ring-game and drumbeat, Malik *kaiso* and worksong, Keens-Douglas and *conte.* Miss Lou folksay and street shout. St John and litany. Recent developments in kaiso (Shadow/Bass man, Short Shirt/*Tourist leggo*, Sparrow/*Music on rhythm: How you jammin so*) suggest even more complex sound shape developments...

Natural Poetics, Forced Poetics

Édouard Glissant

I define as a free or natural poetics any collective yearning for expression that is not opposed to itself either at the level of what it wishes to express or at the level of the language that it puts into practice.

(I call self-expression a shared attitude, in a given community, of confidence or mistrust in the language or languages it uses.)

I define forced or constrained poetics as any collective desire for expression that, when it manifests itself, is negated at the same time because of the *deficiency* that stifles it, not at the level of desire, which never ceases, but at the level of expression, which is never realized.

Natural poetics: Even if the destiny of a community should be a miserable one, or its existence threatened, these poetics are the direct result of activity within the social body. The most daring or the most artificial experiences, the most radical questioning of self-expression, extend, reform, clash with a given poetics. This is because there is no incompatibility here between desire and expression. The most violent challenge to an established order can emerge from a natural poetics, when there is a continuity between the challenged order and the disorder that negates it.

Forced poetics: The issue is not one of attempts at articulation (composite and "voluntary"), through which we test our capacity for self-expression. Forced poetics exist where a need for expression confronts an inability to achieve expression. It can happen that this confrontation is fixed in an opposition between the content to be expressed and the language suggested or imposed.

This is the case in the French Lesser Antilles where the mother tongue, Creole, and the official language, French, produce in the Caribbean mind an unsuspected source of anguish.

A French Caribbean individual who does not experience some inhibition in handling French, since our consciousness is haunted by the deep feeling of being different, would be like someone who swims motionless in the air without suspecting that he could with the same motion move in the water and perhaps discover the unknown. He must cut across one language in order to attain a form of expression that is perhaps not part of the internal logic of this language. A forced poetics is created from the awareness of the opposition between a language that one uses and a form of expression that one needs.

At the same time, Creole, which could have led to a natural poetics (because in it language and expression would correspond perfectly) is being exhausted. It is becoming more French in its daily use; it is becoming vulgarized in the transition from spoken to written. Creole has, however, always resisted this dual deformation. Forced poetics is the result of these deformations and this resistance.

Forced poetics therefore does not generally occur in a traditional culture, even if the latter is threatened. In any traditional culture, that is where the language, the means of expression, and

Reprinted with permission from *Caribbean Discourse: Selected Essays*, trans. Michael Dash (Virginia: University of Virginia Press, 1989), 120–34.

what I call here the form of expression (the collective attitude toward the language used) coincide and reveal no deep *deficiency*, there is no need to resort to this ploy, to this counterpoetics, which I will try to analyze in relation to our Creole language and our use of the French language.

Forced poetics or counterpoetics is instituted by a community whose self-expression does not emerge spontaneously, or result from the autonomous activity of the social body. Self-expression, a casualty of this lack of autonomy, is itself marked by a kind of impotence, a sense of futility. This phenomenon is exacerbated because the communities to which I refer are always primarily oral. The transition from oral to written, until now considered in the context of Western civilization as an inevitable evolution, is still cause for concern. Creole, a not-yet-standardized language, reveals this problem in and through its traditional creativity. That is why I will try to discuss first of all the fundamental situation of Creole: that is, the basis of its orality.

The Situation of the Spoken

1. The written requires nonmovement: the body does not move with the flow of what is said. The body must remain still; therefore the hand wielding the pen (or using the typewriter) does not reflect the movement of the body, but is linked to (an appendage of) the page.

 The oral, on the other hand, is inseparable from the movement of the body. There the spoken is inscribed not only in the posture of the body that makes it possible (squatting for a palaver for instance, or the rhythmic tapping of feet in a circle when we keep time to music), but also in the almost semaphoric signals through which the body implies or emphasizes what is said.[1] Utterance depends on posture, and perhaps is limited by it.

 That which is expressed as a general hypothesis can now perhaps be reinforced by specific illustration. For instance, the alienated body of the slave, in the time of slavery, is in fact deprived, in an attempt at complete dispossession, of speech. Self-expression is not only forbidden, but impossible to envisage. Even in his reproductive function, the slave is not in control of himself. He reproduces, but it is for the master. All pleasure is silent: that is, thwarted, deformed, denied. In such a situation, expression is cautious, reticent, whispered, spun thread by thread in the dark.

 When the body is freed (when day comes) it follows the explosive scream. Caribbean speech is always excited, it ignores silence, softness, sentiment. The body follows suit. It does not know pause, rest, smooth continuity. It is jerked along.

 To move from the oral to the written is to immobilize the body, to take control (to possess it). The creature deprived of his body cannot attain the immobility where writing takes shape. He keeps moving; it can only scream. In this silent world, voice and body pursue desperately an impossible fulfilment.

 Perhaps we will soon enter the world of the nonwritten, where the transition from oral to written, if it takes place, will no longer be seen as promotion or transcendence. For now, speech and body are shaped, in their orality, by the same obsession with past privation. The word in the Caribbean will only survive as such, in a written form, if this earlier loss finds expression.

2. From the outset (that is, from the moment Creole is forged as a medium of communication between slave and master), the spoken imposes on the slave its particular syntax. For Caribbean man, the word is first and foremost sound. Noise is essential to speech. Din is discourse. This must be understood.

It seems that meaning and pitch went together for the uprooted individual, in the unrelenting silence of the world of slavery. It was the intensity of the sound that dictated meaning: the pitch of the sound conferred significance. Ideas were bracketed. One person could make himself understood through the subtle associations of sound, in which the master, so capable of managing "basic Creole" in other situations, got hopelessly lost. Creole spoken by the *békés* was never shouted out loud. Since speech was forbidden, slaves camouflaged the word under the provocative intensity of the scream. No one could translate the meaning of what seemed to be nothing but a shout. It was taken to be nothing but the call of a wild animal.[2] This is how the dispossessed man organized his speech by weaving it into the apparently meaningless texture of extreme noise.

There developed from that point a specialized system of significant insignificance. Creole organizes speech as a blast of sound.

I do not know if this phenomenon is common in threatened languages, dying dialects, languages that suffer from nonproductivity. But it is a constant feature of the popular use of Martinican Creole. Not only in the delivery of folktales and songs, but even and often in daily speech. A requirement is thus introduced into spoken Creole: speed. Not so much speed as a jumbled rush. Perhaps the continuous stream of language that makes speech into one impenetrable block of sound. If it is pitch that confers meaning on a word, rushed and fused sounds shape the meaning of speech. Here again, the use is specific: the *béké* masters, who know Creole even better than the mulattoes, cannot, however, manage this "unstructured" use of language.

In the pace of Creole speech, one can locate the embryonic rhythm of the drum. It is not the semantic structure of the sentence that helps to punctuate it but the breathing of the speaker that dictates the rhythm: a perfect poetic concept and practice.

So the meaning of a sentence is sometimes hidden in the accelerated nonsense created by scrambled sounds. But this nonsense does convey real meaning to which the master's ear cannot have access. Creole is originally a kind of conspiracy that concealed itself by its public and open expression. For example, even if Creole is whispered (for whispering is the shout modified to suit the dark), it is rarely murmured. The whisper is determined by external circumstances; the murmur is a *decision* by the speaker. The murmur allows access to a *confidential* meaning, not to this form of nonsense that could conceal and reveal at the same time a *hidden* meaning.

But if Creole has at its origin this kind of conspiracy to conceal meaning, it should be realized that this initiatic purpose would progressively disappear. Besides, it has to disappear so that the expression of this conspiracy should emerge as an openly accessible language. A language does not require initiation but apprenticeship: it must be accessible to all. All languages created for a secret purpose make the practice of a regular syntax irrelevant and replace it by a "substitute" syntax. So, to attain the status of a language, speech must rid itself of the secretiveness of its "substitute" syntax and open itself to the norms of an adequate stable syntax. In traditional societies this transition is a slow and measured one, from a secret code to a medium open to everyone, even the "outsider." So speech slowly becomes language. No forced poetics is involved, since this new language with its stable syntax is also a form of expression, its syntax agreed to.

The dilemma of Martinican Creole is that the stage of secret code has been passed, but language (as a new opening) has not been attained. The secretiveness of the community is no longer functional, the stage of an open community has not been reached.

3. As in any popular oral literature, the traditional Creole text, folktale or song, is striking in the graphic nature of its images. This is what learned people refer to when they speak of concrete languages subordinate to conceptual languages. By that they mean that there should be a radical transition to the conceptual level, which should be attained once having left (gone beyond) the inherent sensuality of the image.

Now imagery, in what we call expressions of popular wisdom, is deceptive, that is, it can be seen as first and foremost the indication of a conscious strategy. All languages that depend on images (so-called concrete languages) indicate that they have implicitly conceptualized the idea and quietly refused to explain it. Imagery in a language defined as concrete is the deliberate (although collectively unconscious) residue of a certain linguistic potential at a given time. In a process as complete, complex, perfected as its conceptual origins, imaginative expression is secreted in the obscure world of the group unconscious. The original idea is reputed to have been conceived by a god or a particular spirit, in the twilight about which Hegel, for example, speaks.

But the Creole language, in addition, is marked by French—that is, the obsession with the written—as an *internal* transcendence. In the historical circumstances that gave rise to Creole, we can locate a forced poetics that is both an awareness of the restrictive presence of French as a linguistic background and the deliberate attempt to reject French, that is, a conceptual system from which expression can be derived. Thus, imagery, that is, the "concrete" and all its metaphorical associations, is not, in the Creole language, an ordinary feature. It is a deliberate ploy. It is not an implicit slyness but a deliberate craftiness. There is something pathetic in the imaginative ploys of popular Creole maxims. Like a hallmark that imposes limitation.

One could imagine—this is, moreover, a movement that is emerging almost everywhere—a kind of revenge by oral languages over written ones, in the context of a global civilization of the nonwritten. Writing seems linked to the transcendental notion of the individual, which today is threatened by and giving way to a cross-cultural process. In such a context will perhaps appear global systems using imaginative strategies, not conceptual structures, languages that dazzle or shimmer instead of simply "reflecting." Whatever we think of such an eventuality, we must examine from this point on what conditions Creole must satisfy in order to have a place in this new order.

4. Creole was in the islands the language of the plantation system, which was responsible for the cultivation of sugar cane. The system has disappeared, but in Martinique it has not been replaced by another system of production; it degenerated into a circuit of exchange. Martinique is a land in which products manufactured elsewhere are consumed. It is therefore destined to become increasingly a land you pass through. In such a land, whose present organization ensures that nothing will be produced there again, the structure of the mother tongue, deprived of a dynamic hinterland, cannot be reinforced. Creole cannot become the language of shopping malls, nor of luxury hotels. Cane, bananas, pineapples are the last vestiges of the Creole world. With them this language will disappear, if it does not become functional in some other way.

Just as it stopped being a secret code without managing to become the norm and develop as an "open" language, the Creole language slowly stops using the ploy of imagery through which it actively functioned in the world of the plantations, without managing to evolve a more conceptual structure. That reveals a condition of stagnation that makes Creole into a profoundly threatened language.

The role of Creole in the world of the plantations was that of defiance. One could, based on this, define its new mode of structured evolution as "negative" or "reactive," different from the "natural" structural evolution of traditional languages. In this, the Creole language appears to be organically linked to the cross-cultural phenomenon worldwide. It is literally the result of contact between different cultures and did not preexist this contact. It is not a language of a single origin, it is a cross-cultural language.

As long as the system of production in the plantations, despite its unfairness to most of the population, was maintained as an "autonomous" activity, it allowed for a level of symbolic activity, as if to hold the group together, through which the *influential* group, that of the slaves, then the agricultural workers, imposed its form of expression: in their speech, belief, and custom, which are different from the writing, religion, law that are imposed by a *dominant* class.

The Creole folktale is the symbolic strategy through which, in the world of the plantations, the mass of Martinicans developed a forced poetics (which we will also call a counter-poetics) in which were manifested both an inability to liberate oneself totally and an insistence on attempting to do so.

If the plantation system had been replaced by another system of production, it is probable that the Creole language would have been "structured" at an earlier time, that it would have passed "naturally" from secret code to conventional syntax, and perhaps from the diversion of imagery to a conceptual fluency.

Instead of this, we see in Martinique, even today, that one of the extreme consequences of social irresponsibility is this form of verbal delirium that I call habitual, in order to distinguish it from pathological delirium, and which reveals that here no "natural" transition has managed to *extend* the language into a historical dimension. Verbal delirium as the outer edge of speech is one of the most frequent products of the counterpoetics practiced by Creole. Improvisations, drumbeats, acceleration, dense repetitions, slurred syllables, meaning the opposite of what is said, allegory and hidden meanings—there are in the forms of this customary verbal delirium an intense concentration of all the phases of the history of this dramatic language. We can also state, based on our observation of the destructively non-functional situation of Creole, that this language, in its day-to-day application, becomes increasingly a language of neurosis. Screamed speech becomes knotted into contorted speech, into the language of frustration. We can also ask ourselves whether the strategy of delirium has not contributed to maintaining Creole, in spite of the conditions that do not favor its continued existence. We know that delirious speech can be a survival technique.

But it is in the folktale itself, that echo of the plantation, that we can sense the pathetic lucidity of the Creole speaker. An analysis of the folktale reveals the extent to which the *inadequacies* with which the community is afflicted (absence of a hinterland, loss of technical responsibility, isolation from the Caribbean region, etc.) are fixed in terms of popular imagery. What is

remarkable is that this process is always elliptical, quick, camouflaged by derision. That is what we shall see in the folktale. The latter really emanates from a forced poetics: it is a tense discourse that, woven around the inadequacies that afflict it, is committed, in order to deny more defiantly the criteria for transcendence into writing, to constantly refusing to perfect its expression. The Creole folktale includes the ritual of participation but carefully excludes the potential for consecration. It fixes expression in the realm of the derisively aggressive.

Creole and Landscape

1. I do not propose to examine the Creole folktale as a signifying system, nor to isolate its component structures. Synthesis of animal symbolism (African and European), survivals of transplanted tales, keen observation of the master's world by the slave, rejection of the work ethic, cycle of fear, hunger, and misery, containing hope that is invariably unfulfilled; much work has been done on the Creole folktale. My intention is more modest in its attempt to link it to its context.

 What is striking is the emphatic emptiness of the landscape in the Creole folktale; in it landscape is reduced to symbolic space and becomes a pattern of succeeding spaces through which one journeys; the forest and its darkness, the savannah and its daylight, the hill and its fatigue. Really, places you pass through. The importance of walking is amazing. "I walked so much," the tale more or less says, "that I was exhausted and I ended up heel first." The route is reversible. There is, naturally, vegetation along these routes; animals mark the way. But it is important to realize that if the place is indicated, *it is never described*. The description of the landscape is not a feature of the folktale. Neither the joy nor the pleasure of describing are evident in it. This is because the landscape of the folktale is not meant to be inhabited. A place you pass through, it is not yet a country.

2. So this land is never possessed: it is never the subject of the most fundamental protest. There are two dominant characters in the Creole folktales: the King (symbolic of the European it has been said, or is it the *béké*?) and Brer Tiger (symbolic of the *béké* colonizer or simply the black foreman?); the latter, always ridiculed, is often outwitted by the character who is in control, Brer Rabbit (symbolic of the cleverness of the people).[3] But the right to the possession of land by the dominant figures is never questioned. The symbolism of the folktale never goes so far as to eradicate the colonial right to ownership, its moral never involves a final appeal to the suppression of this right. I do not see resignation in this, but a clear instance of the extreme strategy that I mentioned: the pathetic obsession, in these themes—in a word, the inflexible maneuver—through which the Creole folktale indicates that it has *verified* the nature of the system and its structure.

 In such a context, man (the animal who symbolizes him) has with things and trees, creatures and people, nothing like a sustained relationship. The extreme "breathlessness" of the Creole folktale leaves no room for quiet rest. No time to gaze at things. The relationship with one's surroundings is always dramatic and suspicious. The tale is breathless, but it is because it has chosen not to *waste* time. Just as it does not describe, it hardly concerns itself with appreciating the world. There are no soothing shadows or moments of sweet langor. You must run without stopping, from a past order that is rejected to an absurd present. The land that has been suffered is not yet the land that is offered, made accessible. National consciousness is budding in the tale, but it does not burst into bloom.

Another recurring feature is the criterion for assessing the "benefits" that man here recognizes as his own. Where it is a matter of the pleasure of living, or the joy of possessing, the Creole tale recognizes only two conditions, absence or excess. A pathetic lucidity. The benefits are ridiculously small or excessive. Excessive in quantity, when the tale makes up its list of food, for instance; excessive in quality when the tale works out the complicated nature of what is valuable or worth possessing. A "castle" is quickly described (ostentatious, luxurious, comfortable, prestigious) then it is said in one breath, and without any warning, that it has two hundred and ten toilets. Such extravagance is absurd, for "true wealth" is absent from the closed world of the plantation. Excess and absence complement each other in accentuating the same impossible ideal. The tale thus established its decor in an unreal world, either too much or nothing, which exceeds the real country and yet is a precise indication of its structure.

We also observe that there is in the tale no reference to daily techniques of work or creation. Here, the tool is experienced as "remote." The tool, normally man's instrument for dealing with nature, is an impossible reality. Thus, equipment and machinery that are featured in the tale are always associated with an owner whose prestige—that is, who is above the rest—is implicit. It is a matter of "the truck of M. This" or the "sugar mill of M. That." The tool is the other's property; technology remains alien. Man does not (cannot) undertake the transformation of his landscape. He does not even have the luxury of celebrating its beauty, which perhaps seems to him to be a mocking one.

Convergence

1. Where then to locate the will to "endure"? What is the effect of such a "forced" poetics or counterpoetics, which does not spring to life from a fertile past, but, on the contrary, builds its "wall of sticks" against fated destruction, negation, confinement?

 a. This counterpoetics therefore ensures the synthesis of culturally diverse, sometimes distinct, elements.

 b. At least a part of these elements does not predate the process of synthesis, which makes their combination all the more necessary but all the more threatened.

 c. This characteristic contains all the force (energy, drama) of such a forced poetics.

 d. This forced poetics will become worn out if it does not develop into a natural, free, open, cross-cultural poetics.

 The thrust behind this counterpoetics is therefore primarily locked into a defensive strategy—that is, into an unconscious body of knowledge through which the popular consciousness asserts both its rootlessness and its density. We must, however, move from this unconscious awareness to a conscious knowledge of self.

 Here we need perhaps some concluding observations, relating to the link between this situation and what is called today ethnopoetics.

2. First of all, from the perspective of the conflict between Creole and French, in which one has thus far evolved at the expense of the other, we can state that the only possible strategy is to make them *opaque* to each other. To develop everywhere, in defiance of a universalizing and reductive humanism, the theory of specifically opaque structures. In the world of cross-

cultural relationship, which takes over from the homogeneity of the single culture, to accept this opaqueness—that is, the irreducible density of the other—is to truly accomplish, through diversity, a human objective. Humanity is perhaps not the "image of man" but today the evergrowing network of recognized opaque structures.

Second, poetics could not be separated from the functional nature of language. It will not be enough to struggle to write or speak Creole in order to save this language. It will be necessary to transform the conditions of production and release thereby the potential for total, technical control by the Martinican of his country, so that the language may truly develop. In other words, all ethnopoetics, at one time or another must face up to the political situation.

Finally, the previous discussion adequately demonstrates that, if certain communities, oppressed by the historical weight of dominant ideologies, aim at converting their utterance into a scream, thereby rediscovering the innocence of a primitive community, for us it will be a question of transforming a scream (which we once uttered) into a speech that grows from it, thus discovering the expression, perhaps in an intellectual way, of a finally liberated poetics. I think that ethnopoetics can reconcile these very different procedures.

Counterpoetics carried out by Martinicans (in works written in French, the use of the Creole language, the refuge of verbal delirium) therefore records simultaneously both a need for collective expression and a present inability to attain true expression. This contradiction will probably disappear when the Martinican community is able to really speak for itself: that is, choose for itself. Ethnopoetics belongs to the future.

Notes

1. I have always been fascinated by the well-known Italian story, probably invented by the French, of the notice posted in a bus: "Do not speak to the driver. He needs his hands for driving." The motionless body in the act of writing, moreover, favors a neurotic "internalization." The orality that accompanies the "rules of writing" is that of *speaking well* (in seventeenth-century French) which is fixed in a reductive monolingualism. Stendhal says about Italy in the nineteenth century (*De l'amour*, Chapter 49) that there one speaks rarely in order to "speak well"; and also that "Venetian, Neapolitan, Genoese, Piedmontese are almost totally different languages and only spoken by people for whom the printed word can exist only in a common language, the one spoken in Rome." Let us add, by contrast, that such a strategy would not be possible today for Creole. One could not simply decide, for example, to opt unanimously for the Haitian transcriptive model (probably the most elaborate one). The freedom to write is necessary for the Creole language, above and beyond the variations in dialect.
2. The Creole language will call for a noise, a disorder; thus aggravating the ambiguity.
3. We must note that this symbolism is in itself ambiguous. The King, God, the Lion. Where, in fact, is the colonizer? Where is the administrator? Rabbit is the popular ideal, but he is hard on the poor; perhaps he is "mulatto," etc. The proposed ideal is from the outset shaped by a negation of popular "values." One can only escape by ceasing to be oneself, while trying to remain so. The character of Brer Rabbit is therefore also the projection of this individual ingenuity that is sanctioned by a collective absence. ("Bastardizing of the race. Here is the major phenomenon. Individual solutions replace collective ones. Solutions based on craftiness replace solutions based on force." [Aimé Césaire and René Ménil, "Introduction au folklore martiniquais," *Tropiques*, no. 4 (January 1942): 10.]

Joking:
The Training of the Man-of-Words in Talking Broad

Roger Abrahams

One of the dominant features of life in most Afro-American communities is their continuing reliance on oral expression. This means that, among other characteristics, there is still a good deal of social value placed on oral abilities, and these can often be best exhibited in a contest fashion, contests that are waged in creole or street language rather than Standard English. Discussing the role of such verbal abilities in one Washington, D.C., ghetto neighborhood, Ulf Hannerz noted that

> the skill of talking well and easily is widely appreciated among ghetto men; although it is hardly itself a sign of masculinity, it can be very helpful in realizing one's wishes. "Rapping," persuasive speech can be used to manipulate others to one's own advantage. Besides, talking well is useful in cutting losses as well as in making gains. By "jiving" and "shucking," ghetto concepts with the partial denotation of warding off punishment or retribution through tall stories, feigned innocence, demeaning talk about oneself, or other misleading statements, a man may avoid the undesirable consequences of his own misdemeanors.... However, all prestige accrued from being a good talker does not have to do with the strictly utilitarian aspect. A man with good stories well told and with a quick repartee in arguments is certain to be appreciated for his entertainment value, and those men who can talk about the high and mighty, people and places, and the state of the world, may stake claims to a reputation of being "heavy upstairs." (Hannerz 1969, 84–85)

The ability to contend effectively with words is, then, a social skill and highly valued as such. Furthermore, it seems significant that these contests bring black talk (or, as most West Indians refer to it, patois, or bad, broken or broad talk) to a high art. One might hypothesize that the ongoing importance and usefulness of such practices may contribute to the retention of creole speech patterns as the major code for in-group black interactions and entertainments. This argument seems even more plausible as one investigates the crucial place that certain of these verbal contests, like playing the dozens, take in the socialization process of young men in widely scattered black communities.

The importance of these skills in actively contending is amply testified to by many who have grown up in the ghetto environment in the United States, including Malcolm X, Dick Gregory, Claude Brown, Jr., and H. Rap Brown. Brown says of the whole language "problem":

> I learned how to talk in the street, not from reading about Dick and Jane going to the zoo.... The teacher would test our vocabulary each week, but we knew the vocabulary we needed. They'd give us arithmetic to exercise our minds. Hell, we exercised our minds by playing the Dozens.... We played the Dozens for recreation like white folks play Scrabble.... Though, the Dozens is a mean game because what you try to do is totally destroy somebody else with words.... Signifying is more humane. Instead of coming down on somebody's mother, you come down on them. But, before you can signify you got to be able to rap. (Brown 1969, 25–27)

Reprinted with permission from *The Man-of-words in the West Indies: Performance and the Emergence of Creole Culture* (Baltimore: John Hopkins University Press, 1983), 55–76.

Playing the dozens is, as Brown explains here, just one of a number of oral contest traditions that ghetto boys learn and use as the basis of their entertainments. However, this kind of joking activity is not unique to ghetto blacks. The practice of mother-rhyming has also been observed in various other Afro-American communities, as well as in a number of groups in Africa, including the Yoruba, Efik (Simmons, 1962), Dogon (Calame-Griaule 1965), and several Bantu tribes. Peter Rigby, for instance, notes among the Bantu Wagogo that "the abuse between age-mates is of the strongest kind.... Grandparents...may be freely included in the verbal banter, as well as references to each other's 'parents,' particularly 'mothers'.... Completely free conversation, which therefore includes references to sexual matters, is characteristic of relations between age-mates" (Rigby 1968, 150; see also Zahan 1963, 73–77). Philip Mayer similarly reports among the Gusii that "the true measure of the unique unrestraint of pals and the climax of their intimacy is to exchange pornographic references to the other's mother and particularly to impute that he would be prepared for incestuous relations with her" (Mayer 1951, 31–32).

These reports are all but unique because they make a reference to content features as a part of the process of joking. There has been a good deal of discussion concerning the social form and functions of the "joking relationships" in various African groups. But these discussions (other than those noted) focus primarily on who can joke with whom, not how jokes are generated or learned and for what reasons they are employed. Thus, it is difficult to tell how widespread such mother-rhyming is, and what alternatives there are, in joking situations in Africa. We do know that such specially licensed behavior is very widespread on that continent and that it plays an important part in its various speech economies and expressive repertoires.

In the New World, such play is one aspect of a special kind of aggressive joking calling for oral quickness and wit. This highly aggressive joking domain is known by a number of names in the United States, such as rapping or signifying, whereas in the West Indians it is called giving rag, making mock, and giving fatigue. These joking domains, whether in Africa or the New World, are always described in terms of the giving of license because of special relationships or festive occasions. Joking is in this way related to the entire tradition of scandal performances and the various practices of clowning or playing the fool. These scandalizing practices are equally widespread and important in African and Afro-American communities. And we can infer from the range of practices and their importance in community life that when mother-rhyming is practiced by adolescents it is part of the training procedure for adult performances.

Joking at the Crossroads

Peasant and lower-class communities in the West Indies and the United States share this attitude toward effective use of words. The range of this verbal repertory includes the ability to joke aggressively (in some groups this includes riddling), to "make war" with words by insult and scandal pieces, to tell Anansi stories (any kind of folk tale), and to make speeches and toasts appropriate to ceremonial occasions. Community status is designated in the West Indies by making the man-of-words the chairman at wakes, tea meetings, or service of song, and the toastmaster at weddings and other fetes. Few, of course, achieve such distinction.

There tends to be something of a separation made between two kinds of artful word use: one emphasizes joking and license, the other, decorum and formality. The former emphasizes bringing the vernacular creole into stylized use, in the form of wit, repartee, and directed slander. The latter is a demonstration of the speaker's abilities in Standard English, but strictly on the elaborate oratorical level. From this distinction two types of man-of-words have been posited: the broad

talker, who, using license, brings creole into stylized form; and the sweet talker, who emphasizes eloquence and manners through the use of formal Standard English.

Artful broad talk may occur at any time, most commonly in public places; it is not considered appropriate in the yard or the house. This is almost certainly because it involves foolishness or nonsense behavior, which is regarded as a frontal assault on family values. Therefore it occurs on the streets and at places where the men congregate apart from the women. As a rule, only on special occasions like Carnivals or tea meetings is this type of performance carried on in front of women, and, on such occasions, women may involve themselves in the by-play, especially if they are masked in any way. Further, on such occasions there may be a confrontation between such broad-talking performances and ones that call for sweet speechmaking. In such a case, the community dramatically presents the widest range of their performance styles.

Both types of speaking are not only useful for individuals seeking special performance status within the community; they also fit into the system of social control. Speechmaking is an overt articulation of the ideals of the community. The sweet talker achieves his position of moral authority not only by invoking these ideals but also by embodying them in a formal rhetoric. In contrast, the broad talker achieves license to joke because he commonly focuses on behavior of others that is in gross violation of these ideals. His scandalizing therefore acts as something of a moral check on community activities.

The broad talker does a good deal more than this, however, especially on ceremonial occasions. He is licensed to play the fool or the clown and, as such, may enact behaviors that would be regarded as improper on any other occasion. By playing the fool or by describing the antics of the trickster Anansi, the broad talker therefore enacts something of an antiritual for the community; he produces a needed sense of classless liminality and serves as a creative channel for antisocial community motives. Furthermore, by giving him this power, the community provides itself with a set of people who bring a sense of liminality upon the entire participating group, permitting them to forget themselves under special circumstances (like Carnival or Christmas revels) and to enter into the licentious occasion. The importance of this lapsing of the social order for its eventual reorganization is crucial to an understanding not only of the festival but also such licentious ceremonies as wakes.

For both kinds of verbal performer there are, of course, training procedures that have been developed by the community. These differ in their particulars from one Afro-American enclave to another, but some general comments can be made about them. Throughout the West Indies (and, to a certain extent, in the United States), there is an identification of talking sweet with family occasions, especially ceremonial rites of passage. Certainly talking sweet embodies values that focus on the family as the modal institution in which proper, responsible behavior is learned and carried out. But there is also a feeling that parents or grandparents should be responsible for a child learning how to talk sweet. Therefore, if parents or grandparents do not know speeches that they can teach their children for those occasions in which such talking is necessary, they send the child to someone in the community who is an expert in such matters. This person either trains the child orally or, more commonly, writes out a lesson, which the child memorizes. When it is learned, the child returns, recites it, and receives help on his or her delivery.

Learning to talk broad artfully, however, is not developed within the family. Rather, there is an identification of dramatic and stylized broad talk with values that run counter to those of the family and that are associated with public life, the crossroads, rum shops, and markets. Artfully talking

broad is therefore a technique developed apart from the yard and the family environment, as a function of the friendship system on which masculine identity relies. As such, a certain degree of antagonism develops between the values implicit in talking broad and those of the family, because friendships take men (especially young ones) away from the yard. This antagonism is complex and often ambivalent because friendship values in their most important expressions develop from those of the family, especially in the positive valuation and practices of sharing and trust. In a sense, the sharing dimension of friendship actually creates an area of potential conflict because there is just so much to be shared and families and friends therefore vie for what they regard as their due. But the deepest distrust that family people have of friendships arises because drinking is carried on among friends and this often means a breakdown of decorum and the possibility of any number of assaults on family values.

Nevertheless, even the strongest of family people acknowledge, openly or by implication, that both friendships and license are important for the continuing vitality of the group. This is why such value is placed on keeping company and why social pressure is often brought on the selfish (shy) person or the garden man (loner), who are distrusted because of their lack of sociability. Often being selfish is equated with getting on ignorant and means an inability to take a joke and reply in kind. A joking capacity is therefore one of the key behavioral manifestations of group membership extending beyond the family and the yard. The young, especially males, are expected to get out of the yard and the garden and to develop friends, both as a means of broadening the network of people upon whom they can rely in times of need, and as a technique for creating some kind of interlock within the community by which the problems that arise within the family may be taken care of.

The most important of these problems are related to the antagonisms arising from the distribution of power and responsibility within the family. Whether the family is headed by a male or a female, West Indian peasant groups find themselves confronted with the need to maintain an age-based hierarchy and forcing the young into observing continuing respect for their elders. This naturally creates problems with those seeking autonomy, problems that are greatly increased when opportunities that may provide employment for the young exist outside the family. Whether or not these wage-earning positions exist, there is a strong feeling of shared needs and experiences among male peers in these peasant communities, a sharing that results in a mutual and supportive friendship network in the face of common problems. Because the focus of these problems is on the social institution that most constrains them—the family—they tend to channel their performance energies into antifamilistic forms. As a licensed role (or roles) that provides a model of performance for these motives already exists, a number of broad-talking traditions may be observed, mostly joking forms. Appropriate to the peer relationship, these serve both as a training ground for future nonsense performances and as a device by which friendship can be put into action. Thus, as in many groups, joking is an index to the type and intensity of a relationship.

In such situations, learning to be verbally adept is part of the process of maturation. For the adult performer, the man-of-words provides a model of on-going masculine abilities, especially in a contentious and economically marginal world. Consequently, in the practice of the rhyming insult found through this culture area there is an element of masculine role-playing that is one facet of an informal initiation practice. It is, at the same time, a technique by which young men may voice their peer identification and, in so doing, achieve license within that segment of the community to try out their talents. Just such an orientation toward this peer-group joking practice has been exhibited by a number of those commenting on similar practices in Africa. But such

verbal practices do much more, for they permit a trying-on of mature roles in the safety of the peer-group confines while arming the young men with weapons useful in adult life.

The relationship between adolescent practices and adult ones is clear in most cases because of the different subjects and formulas used to embody joking aggressiveness. Thus, in the West Indian community in Panama, the most common subject of adolescent rhyming is the same as that of adult joking—the attribution of homosexuality to the other (a focus probably borrowed from Latin American neighbors), while references to the other's mother—except to start a fight—is prohibited for the most part.

Rhyming On Tobago

Rhyming in Plymouth, Tobago, however, permits this focus on the maternal figure, a focus that is shared with the numerous songs and ring play (singing games played by adults and children) and verbal routines in Tobagonian bongo (wake), as performed by adults in the community. Some of the wake dance songs address this theme, illustrating its intensity and licentious playfulness:

An' de bull take 'e pizzle an' he make his mama whistle,
De bull, de bull, de bull jump 'e mama.

An' de bull, de bull, de bull jumped 'e mother.
De bull, de bull, de bull jump 'e mama.

An' de bull take a whistle and everybody whistle.
De bull, de bull, de bull jump 'e mama.

An' de bull down Carrera with some peas and cassava.
De bull, de bull, de bull in de savannah.

An' de bull jumped 'e mama and he bring forth a heifer,
De bull, de bull, de bull jump 'e mama.

An' de bull jump 'e sister in a open savannah,
De bull, de bull, de bull jump 'e sister.

An' de bull in de savannah, he make your sister partner,
De bull, de bull, de bull in de savannah.

An' de bull take de pizzle an' 'e make your sister whistle,
De bull, de bull, de bull jump 'e mama.
[Repeat ad lib]

Rover dover, roll body over,
Pam palam, knock 'em palam.
T'row way me breakfast an' gi' me de moon-a
Pam palam, knock 'em palam.

A little, little woman carry a big, big moon-a
Pam palam, knock 'em palam.
A big fat woman carry a small, small moon-a
Pam palam, knock 'em palam.

Them small, small woman, bottle neck moon-a,
Pam palam, knock 'em palam.
Them big, big, woman got a small, small moon-a
Pam palam, knock 'em palam.

Dem bottle neck moon got lard at de corner,
Pam palam, knock 'em palam.
Big fat woman serve like a sugar,
Pam palam, knock 'em palam.

This fascination with incest and female genitalia is exhibited in any number of other ways during the bongo. One example that stands out in my memory is a fifteen-minute exercise in metaphor in which a woman's genitalia were compared to a water well, the major point being the pleasures attendant upon digging and finding water.

The practice of adolescent rhyming is more easily understood in the light of these adult performance pieces. For purposes of comparison of content, I shall report one ritual argument, which I heard in November 1965, in a group of six male peers, all of whom were ages fourteen and fifteen. They punctuated each rhyme with punching motions and foot-shiftings. Each rhyme was followed by hilarity and a fight to see who would give the next, so that the underlying impersonality of the invective was even more pronounced than if only two had been trading insults. (This may have occurred because of my presence and because I was recording their contest with a promise of playing it back. They indicated that this often happened when the first assailants ran out of ready rhymes.)

1. *Ten pound iron, ten pound steel,*
 Your mother' vagina is like a steering wheel.

2. *I put your mother to back o' train,*
 When she come back she porky strain.

3. *Christmas comes but once a year,*
 I fuck your mother in a rocking chair.

4. *Ten crapaud was in a pan;*
 The bigger one was your mother' man.

5. *If aeroplane was not flying in the air,*
 Your mother' cyat wouldn't get no hair.

6. *If snake was not crawlin' on the ground*
 Your mother' cyat would not get no tongue.

7. *Beep bop, what is that?*
 A tractor falling a tree in your mother' cyat.

8. *Beep bop, what is that?*
 Thunder roll in your mother' cyat.

9. *Tee-lee-lee, tee-lee-lee, what is that?*
 A tractor stick in your mother' cyat.

10. *Voo, voo, what is that?*
 A blue fly worrying your mother' cyat.

11. *Your mother fucking a old pan,*
 and bring fort' Dan.

12. *A for apple, B for bat,*
 Your mother' cyat like alphabet.

13. *Me and your mother in a pork barrel,*
 And every word a give she porky quarrel.

14. *Me and your mother was digging potato.*
 Spy under she and saw Little Tobago.

15. *Sixty second, one minute,*
 Sixty minute, one hour.
 Twenty-four hour, one day,
 I fucked your mother on Courland Bay.

16. *A little boy with a cocky suit*
 Fuck your mother for a bowl of soup.

17. *Me and your mother was rolling roti;*
 I drop the roti and take she porky.

18. *I put your mother on a electric wire,*
 And every wood I give she, porky send fire.

19. *I put your mother on a bay leaf,*
 And every word I give she was a baby free.

20. *I eat the meat and I t'row away the bone.*
 Your mother' cat like a saxophone.

21. *Forty degrees, the greasy the pole.*
 That was the depth of your mother' porky hole.

22. *Three hundred and sixty-six days, one leap year.*
 I fucked your mother in a rocking chair.

23. *Me and your mother was two friend.*
 I fucked your mother and bring forth Glen.

24. *I fucked your mother on a telephone wire,*
 And every jerk was a blaze of fire.

25. *Me and your mother was cooking rice,*
 And she kill she cat and frighten Chris'.

26. *Up into a cherry tree,*
 Who should come but little me.
 I held the trunk in both my hand
 And I fuck your mother in a frying pan.

27. *Ding-dong bell,*
 Pussy in the well.
 Your mother' pussy like a conk shell.

These rhymes cannot, however, be fully understood only in terms of content features. Rhyming is just one of many contest performances that until recently were very common in Tobagonian festivities, especially Carnival.

In the past two types of performance have been fostered by the community (in line with practices throughout Trinidad and Tobago): performances by the group as a whole or by individuals within it; and performances by individuals addressed to the group, generally while engaged in competition with other individuals. The primary occasions for these are bongo, Carnival, and St. Peter's Day (29 June), which is a special event for Plymouth. Other occasions are christenings, Emancipation Day, and Christmas. All of these occasions present opportunities for both types of performance. For instance, Carnival commonly calls for the town to get together for some Costume mas', a group enterprise in which a theme of decoration is agreed upon and many dress in line with the theme. Then, on Carnival Tuesday, the entire mas', along with the local steel band, goes to Scarborough to jump up together, to show off, in a sense, their community solidarity and strength. A great deal of time and money is expended on this enterprise (so much so that in a bad fishing season such as 1965-66 Tobagonians did not have the resources or spirit to put together a mas').

In the past, Carnival has also offered an opportunity for the individual performer to have his day. There were a number of traditional ways in which he could dress and compete with other such performers. One of these was the Caiso Mas', groups led by a chantwell. Another such competition was Speech Mas', which involved composing boasting and deprecatory speeches of inflated rhetoric and pungent invective. A further activity of this sort was the well-known kalinda stick-fight dance (E.T. Hill 1972).

Lately, in Plymouth, these competitive exercises are being rejected by the younger members of the community and are dying. The young men still admire the good competitors, but not enough to emulate them. The one remaining chantwell in Plymouth no longer performs at Carnival and the one Speech Mas' performer comes from another community and must go to yet another village to find others to form a troupe. It is difficult to understand why this is happening, but one possible explanation is that such competitive expression is no longer as highly valued as the more cooperative performance, or the fully solo activity that takes the calypsonian off the street and places him on the stage.

This retreat from competitive expression is seen in the need for excuses and explanations that is felt by the competitive performers. They self-consciously insist that they are involved in a harmless game of words, though the contest of the speeches, songs, and stick fights is totally aggressive and destructive.

The same rationale has been used by adolescents in their rhyming sessions. Those who play today insist that a nonviolence pact must be made before beginning:

> We made an agreement that we can rhyme on your mother. Then we start. I say, "Go and rhyme."
> He might say, 'Okay' or something like that. Then he first will start. The person who first to ask
> to rhyme, he won't give a rhyme first in case they break the arrangement. (Daniel Dumas, age
> fifteen, Plymouth, Tobago, March 1966; he aided me in gathering the rhyme texts)

Yet the idea is clearly not to play but to hurt as much as possible, to "come back with a hurtful one to make more vex; something like when two persons cursing." The rationale of play arises because the value of this invective contest has been challenged and is to an extent undermined. This defensiveness seems a recent phenomenon, judging by the reminiscences of men in Plymouth.

Whether this development is an indication that rhyming will go the same, say, as Speech Mas' and Caiso Mas' is unclear; it is more important to understand that this self-conscious reaction does

not mean a rejection of all of the licentious and joking traditions that surround these practices. Rhyming is just one technique of exhibiting verbal wit and directing it toward persons outside one's own peer group. There are numerous other such traditions, some of which provide the primary entertainment forms and themes for adolescents. Most important in this regard is a series of short legendary jokes and songs about local happenings, especially those involving ogre-fool figures. These compositions are very much in the scandal-piece tradition, for they focus on activity regarded as foolish and inappropriate. Any kind of action that elicits laughter because it is a disruption of the expectations of the group may become the subject of such scandal pieces among the boys. For instance, when a local boy, Egbert, found a ring in the road, he wore it on his penis and made an exhibition of himself. His father then compounded the indiscretion by giving him a public beating for it, and so the boys sang this song:

Egbert, he busting [he was so happy]
An' he t'ought he get a ring,
But Uncle Darnell
Pitch 'e big wood on him.

Another such song sung by the young is not only a scandal piece but also involves many of the same motives as rhyming. It is a formulaic composition into which can be fit the names of any couple who have recently been caught at illicit lovemaking. Then, however, the song sometimes is performed as a rhyming boast in which the singer becomes the fornicator. Here is an example of such a song:

People, if I hear de fix
Charlie eat up Miss Vaughnie' chicks.
People, if I hear de fix
Charlie eat up Miss Vaughnie' chicks.
Den I [or 'e] gi' she one
She started to run.
When I gi' she two
She buckle she shoe.
When I gi' she three
She cut down tree.
When I gi' she four
She break down door.
When I gi' she five
Now I started to drive.
When I gi' she six
She break up sticks.
When I gi' she seven
She t'ink she was in heaven.
When I gi' she eight
She lay down 'traight.
And I gi' she nine
She started to whine.
When I gi' she ten
Den my cock ben'.

As with rhyming, these songs are similar in content and focus to some of the song games performed at bongo by adults. In the case of the bongo pieces, however, it is assumed that everyone knows the story and therefore many little details, rather than the narrative, are given. Here for instance is the saga of Jean-Louis, a man from the town of Lescoteau [le-ki-to] who made a determined pass at a young girl, who promptly ran away and was said to have bawled out this song:

> *You know Mr. Jean Louis*
> *Tim bam.*
> *Come out a Lescoteau*
> *Tim bam.*
> *You know wha' he hold me for?*
> *Tim bam.*
> *You know Mr. Jean-Louis*
> *Tim bam.*
> *He hold me for pom-pom soir,*
> *Tim bam.*
> *He hold me for pom-pom soir,*
> *Tim bam.*
> *He know me a very long*
> *Tim bam.*
> *You never hear a trus' before,*
> *Tim bam.*
> *Well you know Mr. Jean-Louis*
> *Tim bam.*
> *He come up from Lescoteau,*
> *Tim bam.*
> *He born in Tobago,*
> *Tim bam.*
> *He ain' never call me yet.*

Rhyming on Tobago is, then, one of a number of traditional devices by which adolescents group themselves on a peer-group basis and learn how to perform while joking about their shared problems and perspectives. Although one of these problems certainly is in displaying their masculine identities — which is attempted in part by the combination of boast and taunt in rhyming — this focus on female symbols is not the only means they have of asserting this generational unity and independence from the constrictions of the extended family. License is given them to focus on the generational split as well as the sexual one.

Rhyming on Nevis

On Nevis, rhyming is also practiced and for many of the same reasons, but here the boys rely almost entirely upon the scandal-piece tradition, or they use the closely related techniques of the taunt. As on Tobago, the focus of their joking is on females and on older people, but the rhymes never use the strategy of indirection and impersonality to make their point. Rather, in keeping with the sense of strong interpersonal antagonism, discussed in chapter one, the rhymes are directed at individuals and usually refer to the names of those present. These are primarily formulaic rhymes in which names may be substituted. Others simply make fun of a class of outsiders—for example,

young girls, older men—or make specific reference to an item of gossip. Here is a series of rhymes as performed by a group of fourteen- and fifteen-year-old Nevisian males during the summer of 1962. As explained to me, the idea was to attack some close relative or friend or one boy, to which he might or might not make a bantering reply. Once the rhyming begins, there is apparent license for any rhyme to be performed, whether it happens to be directed at someone's familiars or not, and thus later in the series there are a few rhymes that are scandal pieces about people who live outside the social world of the boys.

1. *Just for the sake of a box of matches,*
 Rose can't put in common patches.

2. *Just for the sake of a banana,*
 Jim knocked Sam from corner to corner.

3. *Twenty boobies on a rock,*
 Sonny catch them by the flock.
 Bobs put them in the pot
 And Mirie eat them piping hot.

4. *The sweetest pumpkin ever born*
 Mirie turn some: in the corn;
 The pumpkin was so sweet
 It knocked out three of Audrey's front teeth.

5. *I went to Dolly' house last night*
 To tell you the truth I didn't sleep all right.
 I got up in the night to make my pee,
 I found bug all over biting me.
 Bug is a t'ing don't have any respect
 It walks from my chin to the back of my neck.
 I bawl, I bawl,
 For the dogs, fleas and all.

6. *I went down to Booby Island*
 I never went to stay.
 I rest my hand on Dinah
 And Dinah went away.

7. *Just for the sake of a root of cassava,*
 That's why some of those young girls don't know their pickny' father.

8. *Young bee meck honey,*
 Old bee meek comb.
 Those young girls get their bellies
 Because they won't stay home.

9. *I went up the lane,*
 I met the parson kissing Jane.
 He gave me a shilling not to tell,
 An' that's why me suit fit me so well.

10. *When I was young and in my prime,*
 I used to jump around those young girls no less and a time
 Now I am old and feeble,
 They call me "Dry Sugar Weehle."

11. *Just for the sake of Mr. Kelly's bell*
 That's why Halstead and Berdicere kisses so well.

12. *Racoon was a curious man,*
 He never walked till dark.
 The only thing could disturb his heart
 Is when he hear old bringle dog bark.

13. *Penny, ha'-penny woman*
 Sit down on a pistol.
 Pistol leggo boom boom
 Knock off Miss Wallace hairy poom poom.

14. *Miss Pemberton has a landing.*
 The landing work with spring.
 The wind blow her petticoat
 And then you see her magazine.

15. *Miss Budgeon has a pepper tree.*
 Jennifer hang she panty dey:
 When the pepper tree begin to bear
 It burn off all of Jennifer' pussy hair.

16. *The longer I live, the more I hear.*
 Bullwiss bite of Rose Pig ear.

17. *When Mr. Clark falls asleep*
 George Baker run with the sheep.

As on Tobago, on Nevis there is a great similarity between these adolescent rhymes and adult entertainments both in content and form. In fact, a number of the same rhymes are used both by adolescents and adults; the latter only use them as part of the licentious clowning performances found in certain Christmas sports and tea meetings. In their adult uses, the rhymes are commonly associated with songs in some way, either as an introduction or within the text spoken between stanzas.

A number of Christmas troupes perform ribald and scandalous inventions, each of which portrays a powerful figure in broad comic terms. Politicians, kings and queens, preachers and schoolteachers, landlords and overseers—none are spared. One of these groups, performing a set of plays called Nigger Business, takes a piece of scandal that has come to its notice, and reenacts it while also performing a song with veiled references to the socially disapproved doings. This group first plays in the yard of the miscreants to see if its members can exact a bribe, but even if they are able to, there is no guarantee that the show will not be given in other yards as well.

Groups such as the Saguas or the Buzzards or the Schoolchildren do not have such a unity to their performance, but rather a series of comic routines that comment on human nature or on

recent noteworthy events heard through gossip. It is this type of group that most performs rhymes and songs that are closely related to those of the adolescent boys.

The idea of the Saguas group is, for instance, for a group to dress up in broadly rendered cutaways and other formal wear and to go from yard to yard at night alternating songs and dances with rhymed speeches. These rhymes are often similar to those of adolescents, although they are performed with a great deal more liberty and are more often centered around an item of scandal. Here are some of the songs and speeches performed by a group of Saguas from the community of Brown Hill.

(Sung)
Monday morning, break a day,
When the old folks got me goin'.
Saturday night when the sun goes down
All those young girls are mine.
[Repeat ad lib]

(Spoken)
Here we are, the higher classes,
Of all the pie asses,
Straight from Missy Wallace, Limited and Company.

(Spoken)
I've got me business organized and planned.
Dis year when de next boat land.
Luther got 'e paddle ready.
Charles Ward got he saw.
Shorty got 'e pickaxe.*
And me, Steel, got me clawhammer.

(Spoken)
One Monday morning, I went up the lane.
I met the parson fixing a Jane.
He shove me six pence, told me not to tell.
That's why me sagua coat fit me so well.

(Sung)
Dollars again, dollars again,
I put me hands on dollars again.
[Repeat ad lib]

(Spoken)
Out of the hollow tree I came,
Calabash is my name.
So long me get me long hungry gut full,
Calabash still remain.

(Spoken)
Hark, hark, the dogs do bark,
Beggars are coming to town.
Some give them white bread,

Some give them brown.
But I just give them a big cut-ass
And send them out of town.

(Spoken)
By golly, you that man Mr. Clifton from Churchground?
He motor bike gi' in' him one fall, land him 'pon ground.
So when get up he say, "That won't be all.
I goin' to collect sufficient money and buy Mr. Abbott' Vauxhall."

Similar alternations of speeches, including rhymes and songs, occur in a number of other licentious Christmas sports, such as the following routines from the Schoolchildren. Here the antisocial content is more pointed.

The setting is a Sunday School, and most of the jokes are directed at specific local Sunday School teachers, who are scorned for their pomposity and mock erudition. The characters are dressed up as scholars in black robe and mortarboard, and they invariably carry a very large book, which they can barely handle but constantly refer to with great mock solemnity. The other characters are dressed as little children or, in the case of Robin (the one who scares all of the bystanders as the group goes from yard to yard—and thus stands in the same position as the Devil does in many other groups) in motley, or Father Christmas in the Mummies (St. George) Play. (Abrahams, 1968, pp. 176-201). These scenes can go in any sequence, and are more or less adlibbed. Between each scene, the fife and drum group plays and everyone dances, including members of the audience. Robin tries to scare some of the children.

Robin. Now here we are, Robin speaking. Yeah!
Christmas come but once a year, yeah heh!
When 'e come, it bring good cheer (I'm glad, you know),
All what I see happ'nin' this year
Is the minister dem a breed off all de young girls dat come in here.
[Music and dancing]

Ward. I'm Godfrey Ward speaking, but I would not like do do anything before the captain reaching, which is Samuel Daniel.
[Music and dancing]

Ward. Hello!

Daniel. Hello, man.

Ward. A book here.

Daniel. I ready to meet you.

Ward. To your exclusion.

Daniel. Damned confusion.
[Music and dancing]

Ward. Madam, come inside here.

Bradshaw [man dressed as woman]. Inside?

Ward. Inside. All you all time out to make confusion.

Bradshaw. Fix me good. [Acting seductive]

Ward. Is all right?

Bradshaw. Sure.

Ward. Dat right? [Goes up next to her]

Bradshaw. Is me, Miss Bradshaw.
[Music and dancing]

Daniel. Well, den, I want fifty thousand men take up a me book of a dictionary. Well yes, fifty thousand men to lif' de book of a dictionary. Tha's right. So now I look [leafing through the book] from the fif' to de six of June, never too late and never too soon, from six o'clock in the afternoon. Blessed assurance after three. One, two, three....

(Song, to the tune of hymn "This Is My Story, This Is My Song")

Send them a pasha dey wouldn't go.

Take up my cat whip and leggo one blow.

Well dem dey reverse back, dey wouldn't go.

Dem dey reverse back, well-a chooka pooh-pooh.
[Let them have it with whip, acted out, scaring children in audience.]

Going on a mountain, no walk with no bread.

I going use potato, dasheen and tania head.

Worser me boy we, de dasheen dems sprout.

I wouldn't buy no tania head to scratch out me mout'.

Daniel. Now look in the back of the hymnbook for them, boy. Four-nine-nine.

All. Four-nine-nine.

Daniel. Last verse, "We going on mountain" after three, One, two, three.
[Repeat "Going on the mountain...."]

Ward. Boys, open your hymn book. Four-nine-two.

All. Four-nine-two.

Ward. Las' time I speakin' to you; not again. I hope everyt'ing will come true. You heard me? De las' time we sang a proper program:
My sister had a penny pork.
She bind them wid a twine.
She po'k 'em in a doving pot.
An' make my water shine.

The joking humor presents nonsense as if it were sense, putting together dialogue and song in a continuous fashion but without the usual logic that determines continuities. Thus, the laughter is directed at the nonsensical aspects of these characters. But this is just one dimension of the

occasion's license, for, in addition, the high are made low and the virtuous revealed as lecherous and dishonest charlatans. The conventions of this kind of humor turn on dramatizing discontinuities and inverting the ascribed characteristics of everyday roles. Laughter arises with the introduction of the unexpected, though in this setting, such introductions are really expected (though their content is not known in advance). The mock-hymn and the rhymes all rely upon the disruption of expectations derived from the usual uses of these specific items (the hymn, the "Christmas comes but once a year" rhyme) to elicit laughter and to add to the irreverent tone. In such a setting, however, as soon as a device is introduced into the performance, an expectation of disruption arises on the part of the audience. This is also true of the adolescent rhymes, which trade both on such humorous conventions and their expectations, and the discontinuities associated with openly attacking others in the protected and licensed confines of peer groupings.

Significantly, the focus of the nonsense is on the symbols of the "sensible" world: school and church. The use of broad talk to confound talking sweet is thus all the more pointed, for nothing represents family-based ideals more fully than teacher and preacher, their books, and their usual manner of formal speech. In these mock speeches then, especially in those of the Schoolchildren, we witness a direct (but licensed) confrontation between family ideals and friendship values in which the latter, for the moment, win the day.

Why Rhyme?

The importance of license is that it permits a playful restructuring of the world. The recognized community order of things, actions, and especially interactions has a deeply felt sense of logic to it, simply because it is ordered and provides comfort and control to those who share this perspective. But everyone at some time feels contradictions or tensions arising from within or without the system. One way of handling this shared problem is for the community to get together ceremonially and reenact or recite in its most basic terms the condition and the genesis of the world's order. Another way is to provide license to community members to impose a new sense of order upon the social and natural environment, an order that is so different from that of the everyday that it produces laughter through manipulating discontinuities and contrasts. Masking is, of course, one of the most extreme examples of this effect, because it permits an overturning of the usual social order and the imposition of new status and power arrangements based upon assumed roles.

Joking is in many ways like masking because of its reorganization of the social order on the basis of different logics. But joking often establishes continuities on only a verbal level, through the use of puns and other *non sequitur* juxtapositions. This is essentially what produces the response to rhymes of children and adolescents on both Nevis and Tobago. Further, in both traditions, the potentially disruptive implications of the *non sequitur* and anti-taboo arguments are rendered harmless not only by insisting that what transpires is only play (and verbal play at that), that there has been a joking about the most discontinuous things by virtue of the most elementary restricted verbal formulas.

This perspective is an extension of Freud's thesis that wit exists as an arbitrary order that permits a freeing of otherwise restrained motives. Or as Mary Douglas expressed it:

> A joke is a play upon form. It brings into relation disparate elements in such a way that one accepted pattern is challenged by the appearance of another which in some way was hidden in the first.... any recognizable joke falls into this joke pattern which needs two elements, the juxtaposition of a control against that which is being controlled, this juxtaposition of being such that the latter triumphs...a successful subversion of one form by another completes or ends the joke for it changes the balance of power.... The joke merely affords opportunity for realizing that

an accepted pattern has no necessity. Its excitement lies in the suggestion that any particular ordering of experience may be arbitrary and subjective. It is frivolous in that it produces no real alternative, only an exhilarating sense of freedom from form in general. (Douglas 1968, 365)

> There is no joking, then, unless there is an order that can be overturned or at least challenged by the establishment of new continuities and relationships. But simply because a joke relies upon this previous social order indicates that it acts in response to certain pressures already existing within that order, tensions that are shared by the group who participates in the joking.

Joking thus helps to give the community the feeling that such situations are under control. But when we look at joking from a performance-centered perspective, we see that the joke seizes on such subjects because they already have tremendous potential to attract attention, for they deal with restricted matters. From this point of view, joking induces everyone's participation, because a potentially embarrassing situation is commonly depicted and drawn upon, but in such a context of social and verbal control that relief rather than embarrassment occurs. Laughter arises in response to the failure of expectations in a patterned situation, but joking occurs only when there has been an assent already given to articulating this failure, this abrogation. Joking uses embarrassment and other social dislocations, but puts the disruptions under a social control by framing them, by conventionalizing the behavior as play.

Social anthropologists argue that joking is essential akin to antiritual because ritual underlines and reenacts social order and cosmology, while joking and clowning challenge this for the purpose of channeling off antisocial tendencies. However, E. R. Leach has suggestively argued that there is an intimate structural relation between rite and antirite masking and that, simply speaking in regard to their occurrence, "they are in practice closely associated. A rite which starts with a formality (e.g. a wedding) is likely to end in masquerade; a rite which starts with masquerade (e.g. New Year's Eve, Carnival) is likely to end in formality" (Leach 1961, 135–136).

Furthermore, as Victor Turner has effectively argued, it is necessary to achieve a "liminal" state for the formal ritual to be effective (Turner 1969). This seems equally true of antirituals. Liminality is the acceptance, by the group and especially the participants, of a sense of communitas in which social distinctions are rejected in favor of a classless state commonly symbolized by the assumption of garb and mien of the lowest social creatures. The costumes of festivals of this sort often "joke" in the same way, combining unusual materials and colors—that is the original meaning of "motley." Joking is similar in almost every sense, given its antisocial thrust and its totally participative strategy in which the joking group coheres on an egalitarian basis.

Joking arises, at least among adolescents, as a ritualistic behavior in which hierarchical order is challenged, and something like liminality occurs in which it becomes possible – in fact necessary – to assert a new order on a peer-group basis. Thus the conventions of joking are crucial not only because they provide a sense of artificial ordering (of words) in the face of disorder (of concepts or themes), but also because the conventions are regarded as the insignia of the peer group, the adolescents' performance is therefore a statement of group solidarity in the face of those who must be considered the common enemy, the actors of hierarchically established roles and relationships within the community. This means that such jokes can be looked to as indications of where adolescents see constraint asserting itself socially. But it does not mean that these jokes focus on all, or even on the most important, of these problems. As I have tried to show, adolescents on Tobago and Nevis are given the cues to what subjects may be discussed licentiously in the content of the songs and rhymes and stories that arise during adult ceremonies of license. The sense of liberation is short-lived, for no real social transformation occurs in such playful occasions. Rather,

a ratification of common feeling occurs in performances, which also enters into the performance preparation for adult nonsense-making.

The success of this system depends on the peers' casting off these ways after a certain period and using their talents for the entertainment of the entire community. On many West Indian islands, however, there are indications that to do so would be an act of incorporation into an extended family system, which the young are not willing to go through. Because of the occasional availability of employment on the island, or the possibility of emigration to places where employment is to be found, the hold that the family exerts on the young has weakened. Consequently, this kind of grouping on a peer-group basis tends to continue, leading the older members of the community to sense that the system is falling apart, a disruption that they attribute to the rudeness of the young. Essentially, this indictment must be read not as a rejection of youthful license but as a charge that the young do not understand the proper occasions on which license is permitted. It would seem that joking has spilled over from the joking relationship into other performances and communications, and this is read by those who have lived with the system as a social disruption.

The elaboration of this kind of rude joking behavior is furthermore paralleled with some loss of respect for other parts of the speaking repertoire – specifically the ceremonial "sweet" speechmaking. Significantly, this kind of ceremony generally discusses overtly the most important features of household values in which the aged (and the ancestors) are given great respect. Thus, in a sense, this gravitation is away from an acceptance of Standard English as well as from a hierarchical, extended-family ideal. Surely this is not the only explanation of why broad-talk creole has persisted in spite of the obvious opportunities for employment and mobility accruing to those who learn Standard English. It is simply to urge that we must more fully understand the relationship between speech acts and events, the varieties used by different segments of the community and the social order that is given articulation through the interactions between and among these segments. For then we can discover why these stigmatized ways of talking have been maintained and used as the basis of linguistic and social experimentation.

Globalization and the Language of Rastafari

Velma Pollard

Rastafari, a New World, twentieth-century socio-religious movement, speaking at first to the Jamaican poor, has in seventy years or so spread not only to the rest of the Caribbean but to North and South America, Europe, Africa, Asia, and the Pacific. Frank Jan van Dijk's article "Chanting Down Babylon Outernational" (1998, 179) gives a comprehensive and enlightening review of Rastafari communities outside of Jamaica. Van Dijk identifies migration and travel as one route by which the philosophy spread but also identifies radio and television as means by which "the message of Jah people, cached in the powerful rhymes and pulsating rhythms of reggae, travels almost without restriction and sweeps 'Rastology' into even the remotest corners of the earth". Pollard (1994, 48) comments on the relationship between the spread of the Rasta philosophy and language and the spread of Reggae music, particularly through the lyrics "on the tongues of its more charismatic proponents". Neil Savishinsky (1994, 259), commenting on the "processes relating to the diffusion and globalization of culture", points to the effect of "low cost/highly sophisticated technologies, widespread transnational corporate expansion, global mediaization" on the spread of the philosophy of the "Jamaican Rastafari Movement". Rastafari, with its call for equal rights and justice, has easily attracted oppressed people everywhere, but it is reggae music that has taken the message far beyond the destinations which would have been possible had the messenger been the traveller or the migrant only.[1]

By the time reggae reached the airwaves of the world, the language of Rastafari had become an integral part of the culture. A code had emerged, custom-made to suit the demands of the philosophy, expressing, *inter alia*, the relationship between the oppressed and the oppressor, brethren and Babylon. Simpson, one of the earliest researchers into Jamaican religion and indeed into Rastafari, comments (1998, 219) that he did not, in the 1950s when he was researching, "encounter the distinctive form of 'Rasta Talk' based on the use of the self-reflective 'I' or 'I-an-I' that is now a widely noted aspect of Rasta culture". He mentions, however, the existence of the term "Babylon", which "was used to refer to the colonial structure". Simpson's comment supports the notion that Dread Talk, a language which evolved in a self-conscious way for a specific purpose, was not born at the same time as the philosophy and way of life that came to be known as Rastafari. Brother W (Pollard 1994, 3) says the code started with the desire of the Brethren to "step-up" with the language and to speak in a way that would not be easily decoded by Babylon. The latter objective got lost or was overtaken as the language became interesting to people outside of Rastafari. Certain processes, however, had been established and the code developed and expanded with the movement. The code has spread with Rastafari to places where neither English nor the English-related (Jamaican) Creole (JC) which spawned Dread Talk is spoken.

Language contact and its effects on the languages involved is an interesting and well-researched aspect of linguistics. The research focuses on how languages are altered in the interactive situation

Reprinted with permission from *Exploring the Boundaries of Caribbean Creole Languages*, ed. Hazel Simmons-McDonald and Ian Robertson, 230–41 (Kingston: University of the West Indies Press, 2006).

in different societies, noting for example which categories of word succumb most easily to change. In "Rastafarian Language in St Lucia and Barbados", Pollard (1994, 45–57) describes the talk of Rastafari adherents in Barbados, where English as well as a version of anglophone Creole are the languages of the society, and in St Lucia, where English shares the linguistic space with both francophone and anglophone Creoles. The essay tries to answer the question of how the language of Rastafari is transformed as it interfaces with languages outside of Jamaica.

This chapter looks at the language of Rastafari as it serves the needs of populations with different linguistic heritages. It does not comment on how the language is used in the interface between itself and languages not necessarily related to English. It examines the body of words available to speakers of such languages who wish to understand, perhaps eventually to use, the words Rastafarians use. To this end, it comments on two dictionaries offered to the global village through the Internet, using the categories established earlier to comment on previous lists. One may regard the dictionaries as consisting of words the Web page creators see as the minimum necessary for an interested reader to have access to lyrics of songs and other pronouncements from within the Rasta community. Far more comprehensive than either of these lists is *Rastafari and Reggae: A Dictionary and Sourcebook* by Rebekah Mulvaney. Included in this book is a ninety-five-page dictionary of words "selected for their direct relationship to Rastafari and reggae and/or for their historical value in offering a broader context from which to better understand these related subject matters" (1990, x). This dictionary includes, *inter alia*, the names of people associated with reggae music. The Web page is preferred for consideration here because it more truly represents the global village: it is immediately accessible all over the world in a way books cannot be. The term these online dictionaries use for Dread Talk is "Rasta Patois".

Rasta Patois Dictionary?

Dread Talk is an adjustment of the lexicon and, to a lesser extent, to the grammar of Patwa (Patois/Jamaican Creole), reflecting the philosophical and religious stance of the Rastafari community, whose members see themselves as oppressed by society (Babylon, the system/shistim). So indeed this version of Jamaican Creole (JC) might justifiably be labelled Rasta Patois. A dictionary of this language might be expected to have words used by the population that speaks Patois as Rastas speak it. The two dictionaries discussed in this chapter are the *Rasta Patois Dictionary*, referred to as D1, and the *Rasta Patois-Russian Dictionary*, referred to as D2. The compilers have used the same thirteen sources, consisting of books, handouts, notes from records and personal information. D2 has an additional three sources. That the sources are numbered identically, with D2 adding another three, suggests that D2 is largely derived from D1.

The dictionaries under discussion both go beyond the expected dictionary function by providing detail on the grammatical functions of some forms. So, for example, there is an entry "a go" in both, described in D1 (p. 2) as "aux w/v 'going to do' as in 'me a go tell him'" and in D2 (p. 1) as "going to do", with the same exemplifying sentence. Both regard the construction as indicating future action. Neither mentions the fact that "a+verb" expresses the continuous aspect in JC so that "me a go home" translates to English "I am/was going home".

The dictionaries include idiomatic utterances with glosses,[2] as in "coo pan, look upon" (D1, 6; D2, 3), "everything cook and curry" (D1, 10; D2, 5), glossed in the former as "all is well taken care of", and "mash it up" (D1, 16, D2, 10), glossed in D1 as "a huge success". The last example illustrates a slight inaccuracy. An imperative sentence is represented, in translation, by a noun phrase. A more accurate translation would be "Do very well!" "We mash it up" would translate "Our act was a huge success".

The vocabulary lists offered in the dictionaries include words which were part of JC long before Rastafari emerged in the 1930s. Some of these words came into the language unchanged from African parent languages. "Bafan", for example, is a form with both adjectival and nominal functions and comes hardly altered from Twi, one of the languages of Ghana. In both lists it is erroneously presented as two words, "bafan" and "bafang", the one identified as noun, the other adjective.

The meanings, however, are accurate. "Bafan", listed as a noun (D1, 3) is the same as in the *Dictionary of Jamaican English* (DJE): "a child who did not learn to walk the first 2–7 years". "Bafang", listed as an adjective meaning "clumsy, awkward", is similar to the DJE's additional meaning: "A useless, clumsy person" (1980, 20). This chapter is concerned less with such words than with those which are identifiably part of the lexicon of Rastafari, those which have been adjusted in one way or other to signal the Rasta point of view or have been created where this has been considered necessary.

van Dijk (1998, 194) observes that "the dissemination of rastafarian ideas and belief to Europe, the Caribbean and the Pacific gave rise to an extremely heterogeneous counterculture". What he sees as constant, however, are the "social, political and cultural ideas associated with the movement". Hepner (1998, 210), also commenting on heterogeneity within a more limited geographical area, notes that the one theme that remains unchanged whether the brethren speak in Jamaica or North America is the "militant rejection of Babylon". The language of Rasta–Dread Talk is used to articulate common sentiments. Hutton and Murrell (1998, 50), restating a point made by Nettleford three decades earlier, comment that the Rastas "In their self-affirmation . . . have gone beyond the use of African names and linguistic adaptation to actual language creation. That is, they have created a language with its own vocabulary, much of which was never encountered before in Jamaica."

Word-Making

All living languages are dynamic. Accordingly, the language used by Rastafari is constantly evolving within identifiable categories. There are four categories resulting from four processes of word formation. A theory informs each process. The process itself, however, once understood, can be applied without a knowledge of the theory. Let us examine first the process generating the I-words (Category III); this is the category most commonly recognized as Rasta words. Behind the strength and importance of these words is the power of the sound /ai/ "I". This is the same sound heard in /aiman/ "I-man", /aianai/ "I-an-I", /diai/ the-"I, all of which represent first and second person pronouns, both singular and plural, and in /ai/"eye", the organ of sight. A pun on "eye" recognizes "fari" (far-eye) in the third and fourth syllables of Rastafari as the "far-seeing eye" so important in Rasta philosophy. Words receive a certain elevation by being brought into this category which has proved easy to manipulate. Schoolboys in the 1970s, for example, anxious to identify with Rasta before they could understand the philosophy, could manipulate this category the way their grandparents manipulated "Pig-Latin/Gypsy" in elementary schools of yesteryear.[3] This ease of manipulation perhaps accounts for the fact that the lists include a relatively small number of these words. Any such list can be extended by simply replacing the initial syllable of a given noun with "I" (so for example "apple" would become "I-ple"). There are some words that begin with the sound associated with the letter "y" rather than "I", such as "yude/food" (Pollard 1994, 37). D2 (p. 16) would include "yod/trod" "yound/sound" and "yunder/thunder" in such a list.[4]

Sound is paramount in Dread Talk. "Wordsound" is a seminal concept. Consistency is also highly valued. Category II consists of English words adjusted to relate sound to meaning. The direction "up", which is usually positive, is required to be consistent in indicating a positive direction. The word "oppress" cannot be allowed its English meaning: the pronunciation of the first syllable indicates upward movement, contradicting the downward movement of the second syllable. So the often-quoted "DOWNpress" replaces OPpress(UPress). Similarly OVERstand replaces UNDERstand.

Certain English words are considered negative by Rastas. Wherever they occur the meaning is negative. "Blind" is one such word. It is in opposition to "see", which is particularly positive because of its relationship to the organ of sight. So "cigarette", which is a negative item, becomes "blindjarete" (Pollard 1994, 6) Equally negative words are "hate" and "dead". These have to be replaced with positive words. So DEADline becomes LIFEline and DEADicate (dedicate) becomes LIVIcate. In order to manipulate this process adequately, however, the speaker needs to be aware of certain pronunciations common in Jamaica, particularly the addition of the "H" before vowels in a random list of words or syllables and its omission in an equally random list. Barbadian Rastas, hearing Jamaicans pronounce "Ital" with an initial "H" – "hightal" – to describe clean, Rasta-approved food, invented the opposite "lotal" to describe unclean food (Pollard 1994, 50), thus introducing a Barbadian Rasta item which would not be generated in Jamaica, where people who say "hightal" automatically write "ital". Dl and D2 both include "Apprecilove" which is what "appreciate" becomes when the negative "hate" in "apreciHATE" is replaced with the positive "love". D2 includes "arguMANT" which replaces "argument" since the form "men", meaning "homosexual" in Dread Talk, must always be avoided in a movement that views homosexuality negatively within a Jamaica that is distinctly homophobic. The avoidance of the term "men" does not become problematic since the Creole plural *man+dem* is an available substitute.

Another category of word represented in the lists is Category I, where known English items are given new meanings. Some of the most important words in the Dread Talk vocabulary fall within this category. "Babylon" has already been mentioned as the term for the establishment and is a term recognized by Simpson as having existed from the earliest days of the movement. "Dread" soon came to mean a person with (dread) locks, a Rasta man, as opposed to "baaled/bald-headed" – a clean-shaven and therefore non-Rasta man. Additional meanings have come to include possible meanings of the word in English. The following are offered in D1 (p. 9), where the word is given as both noun and adjective:

1. a person with dreadlocks

2. a serious idea or thing

3. dangerous situation or person

4. the "dreadful power of the holy"

5. experientially "awesome, fearful confrontation of a people with a primordial but historically denied racial selfhood"

Another word in that category is "red", which is not only a colour but a modifier meaning "very high on herb" (D1, 20). "Herb" is marijuana, sacred to the Rastas as the herb of the sacrament. This plant itself is referred to by a multiplicity of names, one of the more popular being "Collie weed". This term is rendered "Kali/Cooly" in D2 (p. 9). The second spelling here should be avoided since it might lead to the unlikely pronunciation "coolie", which, in Jamaica, is a derogatory label for a

person of East Indian ancestry. There is also "Lambsbread" (D1, 16), which refers to a particularly high quality of marijuana ("Lamb's Bread" in D2, 10), "Sinsemilla; sensie", glossed (D1, 22) as "popular, potent, seedless, unpollinated, female strain of marijuana" (see also D2, 14). Another Category I word is "Chalice", the pipe for smoking marijuana. This might be considered a natural transfer from the Chalice, the cup of the Eucharist in the Christian church. Other names for it – "cutchie (D1, 8; D2, 4) chillum, chalewa" (D2, 3; D1, 5) – all fall within Category IV: "New Items".

The category "New Items" refers to words created by Rasta. "Spliff", the term used for the herb when it is rolled (prepared like a cigarette), falls within this category. (D2, 15; D1, 23) Some others are "Deaders", for meat and its by-products (D1, 8; D2, 4); and "Elizabitch" (D2, 5), which expresses a particular attitude to Queen Elizabeth, the reigning monarch of Great Britain (a person much hated by Jamaican Rastas, second only to the Pope of Rome). "Livity" and "upful" are treated as synonyms in D2, though the former is a noun and the latter an adjective glossed as "positive; encouraging" in D1 (p. 25) and "Niaman: Rasta man" (D1, 17).

Process and Theory

I mentioned earlier the existence of a theory or rationale behind word-making. An example of what happens when the process is used without an understanding of the rationale is the unlikely entry "Niamen" in D2 (p. 11). For reasons explained above, the term "men" is stigmatized. It would be sacrilege to attach it to a word which is an alternative for Rasta man. An American pronunciation of the word "niaman" might have caused the confusion here. Another unlikely creation is "Lovepreciate", which appears in D2, p. 10. Perhaps a "new Rasta" tried to make a word without an understanding of the rationale – eliminating negative sounds. "Aprecilove" is legitimate, "Lovepreciate" is not. This is easily tested by pronouncing it LOVEpreciHATE and noting the inherent contradiction.

Word-Making Revisited or Discourse on Origins

With the spread of reggae lyrics and therefore the language of Rastafari, interest in the theories behind the formation of words has grown and thinkers both inside and outside the movement have applied various levels of logic to the emergence of the different categories of word. Predictably, Category III, the "I-words" – the most distinctive feature of the code – has received the most attention. Here are some recent comments on that feature.

Hepner (1998, 211) quotes Brother Judah, a New York Rasta man and member of the Twelve Tribes of Israel, a "house" (denomination) within the Rastafarian movement, who explains the use of the pronominal "I-an-I" in this way: "we refer to one another [other Rastas] as 'I-an-I' – we don't make no one a second person. We don't say 'I and him' or 'us'. We just say 'I-an-I' because every person is a first person."

Edmonds (1998, 33) reasons as follows: "Since 'I' in Rastafarian thought signifies the divine principle that is in all humanity, 'I-an-I' is an expression of the oneness between two (or more) persons and between the speaker and God (whether Selassie or the god principle that rules in all creation)."

On the preference of the subject pronoun "I" in both subject and object positions where JC uses "me", Edmonds says: "Rastas use 'I-an-I' (as subject even when the sentence calls for an object) to indicate that all people are active, creative agents and not passive objects."

Mulvaney (1990, 39) gives a slightly different explanation for the same phenomenon: "Rastas believe 'me' connotes subservience or objectification of the human individual whereas 'I' is thought

to emphasize the subjective and individual character of a person."

Defining "I and I" Mulvaney writes: "Both singular and plural pronoun in Rasta language. As singular, the speaker chooses I and I to signify the ever presence of Jah. As plural, the choice of I an I signifies the existence of a spirituality and metaphysically intimate relationship among the speaker, other individuals present or spoken of, and Jah."

McFarlane's discourse (1998, 107) on the "Epistemological Significance of 'I-an-I'" describes the form as the "self-reflexive use of the subject pronoun" and sees the "I" words as "the means by which Rastas make all informed utterances related to their principles, cultic practices, and self affirmation". He reaffirms the link identified by earlier researchers, including Yawney, for example (Pollard 1994, 21), between the "I" words and the "I" in "Jah Selassie I, previously known as Ras Tafari" and both to 'the word made flesh' of early Christian theology" and to the early Rastas (punning) reconfiguration of the title as Rasta-for-I. In McFarlane's discourse the "I" that ends Rastafari is the first principle of Rasta life "which reverses the order of things to make the last first and the first last" (1998, 108).

Notably absent from any of these descriptions is the connection between the eye, the organ of sight, and the first person pronoun as well as the effect of that convergence of sound on the power behind the "I" words. This was a point emphasized in the earlier research. Perhaps this omission is a warning that something is changing. What is added to the discourse and what gets lost is unpredictable. It could be that as the research moves further and further away from Jamaica, the locale of the beginnings of the movement and the home of some of the oldest interviewees, emphases change. What is clear is that interest in the culture and so in the language of a movement which speaks to oppressed black people and eventually to the oppressed of all races, is not waning. And perhaps the language has the greatest likelihood of becoming entrenched in new communities, since language is one outlet for defiance which the oppressor is unlikely to succeed in frustrating.

This chapter has commented on word lists offered by the global media as Rasta Patois dictionaries. It does not say anything about the code in its interaction with the languages with which it comes in contact. It would be interesting to note, for example, which words are accepted unchanged into these languages and which are translated. Questions like the acceptance/rejection of the power of word-sound need to be examined in conjunction with the question of the heterogeneity of the culture outside of Jamaica. Dread Talk in the French and Spanish Caribbean and in Latin America immediately offers itself for prospective study. In the 1970s the Rastafari culture spread to Cuba, Jamaica's nearest neighbour, taken there both by travellers and by reggae music. Furé Davis (1999) spoke about Cuban youth and the influence of reggae, hip-hop and other imported lifestyles which, he says, are quickly adapted to the new context. With regard to expression among the youth, he indicated that certain adjustments have had to be made in a situation where, for example, Rastas are using Spanish to discuss an imported topic with a foreign vocabulary. He commented that the process was yielding "something new and different" and used the term *transculturación*.

Indeed *transculturación* is an excellent term to describe the feature to which this chapter drew attention at the beginning – the spread of the culture of Rastafari to all continents and its influence in the new lands. The variation inherent in such a spread (the heterogeneity of which van Dijk and Hepner write) are part of what Furé Davis describes as "something new and different". This is a phrase reminiscent of "something torn and new", which Edward Brathwaite, writing three decades earlier (1969, 113), used to describe the rhythms of the steel pan, a metaphor for the new Caribbean man:

now waking
...making
with their
rhythms some-
thing torn
and new

Perhaps a new Rasta man or several versions of such a man is emerging.[5] Perhaps several versions of the code will emerge to express the new realities.

Acknowledgements

A version of this chapter appears as chapter 6 in the revised edition of Dread Talk, published jointly by Canoe Press and McGill–Queen's University Press 2000.

Notes

1. See also Chevannes (1995, 269), where reference is made to Peter Lee's 1991 tribute to Bob Marley in which the love for Marley's music is seen as "the common bond linking a blues guitarist in Mississippi, a black South African soldier serving in Namibia, a young accordion player in a South African township, and a group of Australians, New Zealanders, and Scotsmen in London."
2. Glosses in D2 are mostly in Russian. Comments here are restricted to those which are also given in English.
3. For a discussion on Gypsy, see Aceto 1995.
4. I have some difficulty recognizing these, especially "yod", since "trod" is a particularly well used item in the Rasta vocabulary.
5. Jan de Cosmo, in a recent presentation, described the Rastafarian community in Bahia, Brazil, and pointed to variations on the Rastafari theology as it interacts with fundamentalist Christian beliefs. See also Neil Savishinsky on Rastafari in the Pacific and South Africa.

References

Aceto, M. 1995. "Variation in a Secret Creole Language of Panama". *Language in Society* 24: 537–60.

Brathwaite, E. 1969. *Islands*. London: Oxford University Press.

Chevannes, B. 1995. *Rastafari: Roots and Ideology*. Kinston, Jamaica: The Press, University of the West Indies.

Cassidy, F., and R. Le Page. 1980. *Dictionary of Jamaican English*, Cambridge: Cambridge University Press.

De Cosmo, J. 1999. "A New Christianity for the Modern World: Rastafari Fundamentalism in Salvador, Bahia, Brazil". Paper presented at the twenty-fourth Annual Conference of the Caribbean Studies Association, Panama City.

Edmonds, E. 1998. "Dread 'I' In-a-Babylon: Ideological Resistance and Cultural Revitalization" In *Chanting Down Babylon*, ed. N. Murrell and A. McFarlane, 23–35. Philadelphia: Temple University Press.

Furé Davis, S. 1999. Paper presented at the Twenty-Fourth Annual Conference of the Caribbean Studies Association, Panama City.

Hepner, R. 1998. "Chanting Down Babylon in the Belly of the Beast: The Rastafarian Movement in the Metropolitan United States". In *Chanting Down Babylon*, ed. N. Murrell and A. McFarlane, 199–216. Philadelphia: Temple University Press.

Hutton, C., and N. Murrell. 1998. "Rastas' Psychology of Blackness". In *Chanting Down Babylon*, ed. N. Murrell and A. McFarlane. Philadelphia: Temple University Press.

McFarlane, A. 1998. "The Epistemological Significance of 'I-an-I' as a Response to Quashie and Anancyism in Jamaican Culture". In *Chanting Down Babylon*, ed. N. Murrell and A. McFarlane. Philadelphia: Temple University Press.

Mulvaney, R. 1990. *Rastafari and Reggae: A Dictionary and Sourcebook*. New York: Greenwood Press.

Pollard, V. 1994. *Dread Talk: The Language of Rastafari*. Kingston: Canoe Press.

Rasta Patois-Russian Dictionary. http://niceup.com/patois.txt

Rasta Patois-Russian Dictionary. http://www.zhurnal.ru/music/rasta/patois.html.

Savishinsky, N. 1994. "Traditional Popular Culture and the Global Spread of the Jamaican Rastafari Movement". *New West Indian Guide* 68, nos. 3 and 4.

———. 1998. "African Dimensions of the Jamaican Rastafari Movement". In *Chanting Down Babylon*, ed. N. Murrell and A. McFarlane. Philadelphia: Temple University Press.

Simpson, G.E. 1998. "Personal Reflections on Rastafari in West Kingston in the Early 1950s". In *Chanting Down Babylon*, ed. N. Murrell and A. McFarlane. Philadelphia: Temple University Press.

van Dijk, F. 1998. "Chanting Down Babylon Outernational: The Rise of Rastafari in Europe, the Caribbean, and the Pacific". In *Chanting Down Babylon*, ed. N. Murrell and A. McFarlane. Philadelphia: Temple University Press.

Discourse on the Logic of Language

Marlene Nourbese Philip

English
is my mother tongue.
A mother tongue is not
not a foreign lan lan lang
language
l/anguish
 anguish
—a foreign anguish.

English is
my father tongue.
A father tongue is
a foreign language,
therefore English is
a foreign language
not a mother tongue.

What is my mother
tongue
my mammy tongue
my mummy tongue
my momsy tongue
my modder tongue
my ma tongue?

I have no mother
tongue
no mother to tongue
no tongue to mother
to mother
tongue
me

I must therefore be tongue
dumb
dumb-tongued
dub-tongued
damn dumb
tongue

Reprinted with permission from *She Tries Her Tongue, Her Silence Softly Breaks* (Charlottetown, Prince Edward Island: Ragweed Press, 1989), 30–33.

EDICT I

Every owner of slaves
shall, wherever possible,
ensure that his slaves
belong to as many ethno-

linguistic groups as
possible. If they can-
not speak to each other,
they cannot then foment
rebellion and revolution.

WHEN IT WAS BORN, THE MOTHER HELD HER NEWBORN CHILD CLOSE: SHE BEGAN THEN TO LICK IT ALL OVER. THE CHILD WHIMPERED A LITTLE, BUT AS THE MOTHER'S TONGUE MOVED FASTER AND STRONGER OVER ITS BODY, IT GREW SILENT – THE MOTHER TURNING IT THIS WAY AND THAT UNDER HER TONGUE UNTIL SHE HAD TONGUED IT CLEAN OF THE CREAMY WHITE SUBSTANCE COVERING ITS BODY.

Those parts of the brain chiefly responsible for speech are named after two learned nineteenth century doctors, the eponymous Doctors Wernicke and Broca respectively.

Dr. Broca believed the size of the brain determined intelligence; he devoted much of his time to 'proving' that white males of the Caucasian race had larger brains than, and were therefore superior to, women, Blacks and other peoples of colour.

Understanding and recognition of the spoken word takes place in Wernicke's area – the left temporal lobe, situated next to the auditory cortex; from there relevant information passes to Broca's area – situated in the left frontal cortex – which then forms the response and passes it on to the motor cortex. The motor cortex controls the muscles of speech.

 but I have
 a dumb tongue
 tongue dumb
 father tongue
 and english is
 my mother tongue
 is
 my father tongue
 is a foreign lan lan lang
 language
 l/anguish
 anguish
 a foreign anguish
 is english—
 another tongue
 my mother
 mammy
 mummy

moder
mater
macer
moder
tongue
mothertongue
tongue mother
tongue me
mothertongue me
mother me
touch me
with the tongue of your
lan lan lang
language
l/anguish
 anguish
english
is a foreign anguish

EDICT II

Every slave caught speaking
his native language
shall be severely punished.
Where necessary,
removal of the tongue is
recommended. The offending
organ, when removed,
should be hung
on high in a central place,
so that all may see and
tremble.

THE MOTHER THEN PUT HER FINGERS INTO HER CHILD'S MOUTH—GENTLY FORCING IT OPEN; SHE TOUCHES HER TONGUE TO THE CHILD'S TONGUE, AND HOLDING THE TINY MOUTH OPEN, SHE BLOWS INTO IT—HARD. SHE WAS BLOWING WORDS—HER WORDS, HER MOTHER'S WORDS, THOSE OF HER MOTHER'S MOTHER, AND ALL THEIR MOTHERS BEFORE—INTO HER DAUGHTER'S MOUTH.

A tapering, blunt-tipped, muscular, soft and fleshy organ describes
(a) the penis.
(b) the tongue.
(c) neither of the above.
(d) both of the above.

In man the tongue is
(a) the principal organ of taste.
(b) the principal organ of articulate speech.
(c) the principal organ of oppression and exploitation.
(d) all of the above.

The tongue
(a) is an interwoven bundle of striated muscle running in three planes.
(b) is fixed to the jawbone.
(c) has an outer covering of a mucous membrane covered with papillae.
(d) contains ten thousand taste buds, none of which is sensitive to the taste of foreign words.

Air is forced out of the lungs up the throat to the larynx where it causes the vocal cords to vibrate and create sound. The metamorphosis from sound to intelligible word requires
(a) the lip, tongue and jaw all working together.
(b) a mother tongue.
(c) the overseer's whip.
(d) all of the above or none.

Me Cyaan Believe It

Michael Smith

Me seh me cyaan believe it
me seh me cyaan believe it

Room dem a rent
me apply widin
but as me go een
cockroach rat an scorpion
also come een

Waan good
nose haffi run
but me naw go siddung pon high wall
like Humpty Dumpty
me a face me reality

One little bwoy come blow im horn
an me look pon im wid scorn
an me realize how me five bwoy-picni
was a victim of de trick
dem call partisan politricks

an me ban me belly
an me bawl
an me ban me belly
an me bawl
Lawd
me cyaan believe it
me seh me cyaan believe it

Me daughter bwoy-frien name Sailor
an im pass through de port like a ship
more gran-picni fi feed
an de whole a we in need
what a night what a plight
an we cyaan get a bite
me life is a stiff fight

Reprinted with permission from *Voiceprint: An Anthology of Oral and Related Poetry from the Caribbean*, ed. Stewart Brown, Mervyn Morris and Gordon Rohlehr, 143–45 (San Juan, Trinidad: Longman Caribbean, 1989).

an me cyaan believe it
me seh me cyaan believe it

Sittin on de corner wid me frien
talking bout tings an time
me hear one voice seh
'Who dat?'
'Me seh 'A who dat?'
'A who a seh who dat
when me a seh who dat?'

When yuh teck a stock
dem lick we dung flat
teet start fly
an big man start cry
me seh me cyaan believe it
me seh me cyaan believe it

De odder day
me a pass one yard pon de hill
When me teck a stock me hear
'Hey, bwoy!'
'Yes, mam?'
'Hey, bwoy!'
'Yes, mam!'
'Yuh clean up de dawg shit?'
'Yes, mam.'

An me cyaan believe it
me seh me cyaan believe it
Doris a modder of four
get a wuk as a domestic
Boss man move een
an bap si kaisico she pregnant again
bap si kaisico she pregnant again
an me cyaan believe it
me seh me cyaan believe it

Deh a yard de odder night
when me hear 'Fire! Fire!'
'Fire, to plate claat!'
Who dead? You dead!
Who dead? Me dead!
Who dead? Harry dead!
Who dead? Eleven dead?

Woeeeeeeee
Orange Street fire
deh pon me head
an me cyaan believe it
me seh me cyaan believe it

Lawd
me see some blackbud
livin inna one buildin
but no rent no pay
so dem cyaan stay
Lawd
de oppress an de dispossess
cyaan get no res

What nex?

Teck a trip from Kingston
to Jamaica
Teck twelve from a dozen
an me see me mumma in heaven
Madhouse! Madhouse!

Me seh me cyaan believe it
Me seh me cyaan believe it

Yuh believe it?
How yuh fi believe it
when yuh laugh
an yuh blind yuh eye to it?
But me know yuh believe it
Lawwwwwwwwd
me know yuh believe it

The Caribbean
Sacred Arts

Thrones of the *Orichas:* Afro-Cuban Altars in New Jersey, New York, and Havana

David H. Brown

To make Santo is to make a king, and kariocha *[initiation]* is a ceremony of kings, like those of the palace of the Oba Lucumí *[Yoruba king].*

(Calixta Morales, priestess Oddedei, in Cabrera 1983b:24 fn.)

[In my work] I favor the Louis XV style . . . in fact, all the Louises.

(priest/throne maker Ramón Esquivél, May 12, 1987)

We can no longer speak of tradition in terms of the approximate identity of some objective thing that changes while remaining the same. Instead, we must understand tradition as a symbolic process that both presupposes past symbolisms and creatively reinterprets them.

(Handler & Linnekin 1984:287)

Thrones of the *orichas*—special altars for Afro-Cuban deities of Yoruba origin—are often huge, stunning installations. Composed of colorful cloth, porcelain vessels, and beadwork objects, they rise above bountiful spreads of fresh fruit, flowers, and plates of prepared foods. Wherever important ritual events take place—in western Cuba, South Florida, New York, New Jersey, California, Puerto Rico, Venezuela—thrones preside as commanding presences in practitioners' homes. Priests (*santeros*) of the religion popularly known as Santería, La Regla de Ocha, or La Regla Lucumí[1] double as artists, or rely upon specialized throne makers, to construct temporary altar installations that please and honor the *orichas,* impress congregations, and play focal roles in sacred performance.

Curiously, these thrones have received little more than a half-dozen pages of superficial description in all the scholarly literature on Afro-Cuban religion combined (Cabrera 1980, 176–79; Brandon 1983, 400–42; Drewal 1989b, 22–25). Only recently has this important art form been given public exposure in several small exhibitions of thrones built by priests and as a series of reflections by contemporary artists.[2] As this is the first article devoted solely to the subject, I will describe and interpret recently documented examples in the United States and Cuba, and then locate the throne form in a broader ethnohistorical context. Reworked transatlantic ritual object types and familiar Yoruba iconography, previously studied in isolation, are seen to crystallize in a uniquely New World altar form that emerged in Cuba, later to be elaborated in the United States among Cuban migrants. Analysis of the throne form reveals much about emergent Diasporic art history and culture and provides fertile ground for a theoretical critique of processes hitherto characterized by the terms "continuity and change," "syncretism," and "creolization."

Thrones are built to honor and formally present one or more deities, interchangeably called *orichas* or *santos,* of the Lucumí pantheon. The *orichas,* deriving ultimately from the major *òrìsà* of Yorubaland, are customarily adorned as powerful royal presences, with splendid clothwork,

David H. Brown, 'Thrones of the Orichas: Afro-Cuban Altars in New Jersey, New York, and Havana', *African Arts* 26:4 (October, 1993), pp. 44–59. © 1993 by Regents of the University of California.

costume, and iconographic attributes. If, as priestess Oddedei declared to Lydia Cabrera in 1954 (Cabrera 1983b:24 fn.), the *kariocha* initiation ritual "is a ceremony of kings" as found in Africa, how is it that it came to be expressed with a system of signs and aesthetic preferences that derive apparently from European aristocracy? How is it that a premier black Cuban altar maker and priest of Obatalá, the late Ramón Esquivél, "favor[ed] the Louis XV style" in his worship of Yoruba-derived deities, and that this style is widely regarded among Cuban practitioners as wholly traditional? More generally, how does one approach the question of the Africanity of Lucumí religion? In an art history of Lucumí religious objects for *orichas* of apparent Yoruba provenance, what weight and attention are placed on Yoruba "origins" in understanding Afro-Cuban iconography and meaning? In short, what are the assumptions behind the notion of "tradition" in general and "Yoruba tradition in the New World" in particular?

As domestic altars, constructed in practitioner's homes which double as "houses of *ocha*" (houses of *oricha* worship),[3] thrones provide a sacred portal for supplicants to approach, salute, praise, communicate with, and make offerings to the *orichas*. Yet thrones are creations distinct from the permanent shrines found in those same homes. Thrones are temporary installations, whose scale often requires reallocation of domestic space, and whose duration as an assemblage is coextensive with particular ritual periods, particularly semipublic events in which the community is invited into the "sacred room" (*cuarto sagrado*, *cuarto de santo*, or *igbodún*[4]) to greet formally presented *orichas*.

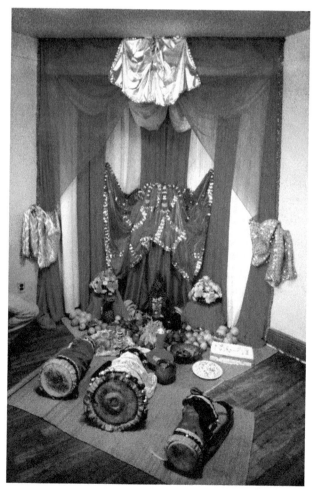

Figure 1. Drumming throne (*trono del tambor*) for the thunder god, Changó, of Adolfo Fernández, designed by the late Ramón Esquivél. Red and white, the colors of Changó, are dominant. Shaped cloth squares (*paños*) represent other deities (*orichas*): at left, Yemayá; at right, Ochún; and above, Obatalá. The cloth covering the centered and elevated vessel of Changó is shaped to form a thunder axe, and the triangles formed by the translucent red curtain panels flanking Obatalá also suggest Changó's thunder axe. Eleguá and the warriors are nestled on the floor. A set of three sacred *bata* drums rest on the mat between segments of the drumming ceremony. New Jersey, 1983. *Photo: David H. Brown*

Thrones employ a basic dominant form: an installation of colorful cloth creating a canopy overhead, a curtain backdrop behind, and symmetrically parted and tied-back curtains in front— either independent hanging curtains or the suggestion of them in swags of cloth stapled to the wall. The throne's canopy may form the hypotenuse of two converging walls, it may project straight out from a long single wall, or it may even span the entirety of one end of a narrow room. The construction recalls a miniature proscenium stage or an elaborately curtained picture window. Yet it recalls more precisely the baldachins[5] of European royal thrones, church and domestic Catholic altars, whose architecture and imagery historically incorporated throne references, and state beds.

The enclosure radiates the identifying colors of the *oricha* of honor. Squares of cloth called *paños,* color coded to a set of companion *orichas,* punctuate the throne enclosure itself in artistically gathered or pinned configurations, or lie draped over elevated *oricha* vessels containing the deity's "secrets," atop which are placed the appropriate iconographic attributes in beadwork and metalwork.

I encountered three main throne configurations keyed to functionally distinct ritual events in houses in New York, New Jersey, Miami, Havana, and Matanzas: thrones built for initiation (*asiento*), for a "saint's birthday" (*cumpleaños*), and for sacred "drummings" (*tambores*).[6]

Initiation Thrones

The initiation throne, or *trono del asiento* (Fig. 2), consists of three basic visible elements: the canopy of cloth, which may be more or less elaborate; a sacred mortar (*pilón* in Spanish, *oddó* in Lucumí) on which the initiate (*iyawó*) may sit; and a reed floormat (*estera*). Completed the night before the initiation, the throne stands for seven days (often Friday to Friday), and is taken down when the newly made priest leaves liminal seclusion for "reincorporation" into the community on the "Day of the Plaza" (Market Day).[7]

The *asiento* is centrally about the creation of a new earthly locus of *oricha* power—that is, the establishment of a shrine – and the parallel birth of a new generation of priesthood to serve and channel that power for human benefit. *Asiento* refers to the "seating" of spiritual power, *aché,* in the material world (*aye*). The ceremony is also called the "coronation," an expression that captures the momentousness of the ritual process of "putting *aché* on the head" (*kariocha* in Lucumí). On the first day (Day of the Asiento), in the *igbodún,* the initiate is seated upon the *pilón* as the *oricha* is "crowned" or "seated" upon the top of the head in a series of secret and guarded procedures. Consistent with the idiom of coronation, the *oricha* is often spoken of as "my crown," a spiritual head that governs, but also confers priestly authority upon, its human servant, a relationship nicely encapsulated by the Lucumí proverb "The head rules the body." Having been crowned atop the *pilón* but outside the throne's domain, the *iyawó* is then installed in the throne and spends that night and the next five nights sleeping under its protective canopy.

The *asiento* throne may be seen to play three metaphorical roles vis-à-vis the initiate, whose name, *iyawó,* translates as "bride of the *oricha*": it is a royal throne for a "new king"; a marriage bed for a new bride and *oricha*; and a container that protects the vulnerable newborn priest from destructive spiritual influences. Not least, the throne plays the symbolic role of "house" or seclusion hut for a week of repose following the initiation.[8]

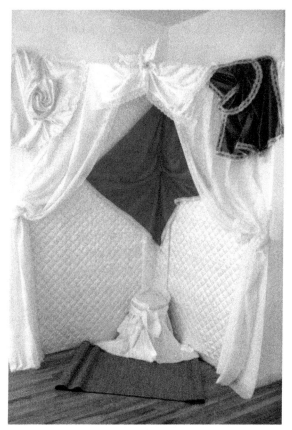

Figure 2. Initiation throne (*trono del asiento*), made by Antonio Queiro for exhibition at the Caribbean Cultural Center, New York, 1984. During initiation into the Lucumí priesthood an oricha is "seated" or "crowned" on the head of the initiate (*iyawó*). Here that oricha is the sky god Obatalá, whose color, white, predominates. The colors of the shaped paños reference other protector orichas received by the initiate.
David H. Brown. Courtesy Of The Caribbean Cultural Center, New York

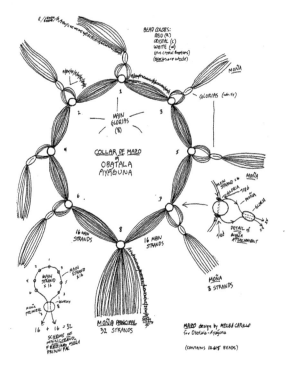

Figure 3. *Collar de mazo* for Obatalá, designed by Melba Carillo. This beaded sash consists of more than 12,000 beads and weighs over three pounds. There are 16 strands of beads, 8 large fastening beads called *glorias*, and 8 tassels called *moñas*. *Collares de mazo* are worn diagonally across the body of the *iyawó* and later draped over the *orichas'* vessels in domestic shrines and on thrones. This drawing is intended to reflect basic construction and does not reflect exact proportions of constituent parts.
Drawing, David H. Brown

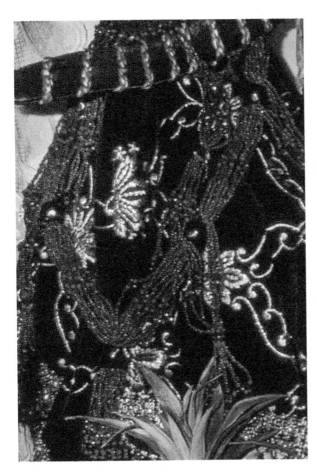

Figure 4. Detail of a birthday throne
(*trono del cumpleaños*) for Obatalá by
Ramón Esquivél. The *paño*-covered vessel
of Oyá has beaded *mazos* by Melba
Carillo, a copper crown, and a tourist
African flywhisk. The decorated seed pod
(*vaina*) is shaken to salute Oyá. Union
City, New Jersey, 1987.
Photo: David H. Brown

The colors of the canopy and the smaller cloth *paños* around it encode the particular configuration of *orichas* fabricated for the initiate – one previously identified through divination as the "owner," or "guardian angel" *(ángel de guarda)*, of the *iyawó's* head, and the others a related basic group of protectors. An *asiento* throne constructed for exhibition purposes at the Caribbean Cultural Center, in New York in 1984 (Fig. 2) is predominantly white, reflecting the central role of Obatalá as the guardian angel. Three draped, shaped, and pinned *paños* punctuate the curtained front, and one the quilted background: yellow for Ochún, blue bordered in white for Yemayá, red for Changó (and probably Oyá),[9] and at top center, white lace adorned with a dove figure with out-spread wings for Obatalá. The maker[10] symmetrically balanced the *paños* for two intimately related female *orichas*, Yemayá and Ochún, and placed the bold red diamond for Changó at rear center – all representing the *orichas* to be "received" by the *iyawó*, in addition to the governing guardian angel Obatalá "made" by the *iyawó*.[11] These lightly floating cloth forms hover about the central space as a kind of supporting cast to the guardian angel's lead.

On the second day in the *igbodún*, the Día del Medio (Middle Day), the initiate is publicly presented in the early after-noon to the community. The *iyawó*, under the immediate influence of the "newly born" *oricha/santo* – referred to as a "new king" or "new queen" – dons elaborate garments called *ropa de santo* (clothes of the saint) or *traje de medio* (suit of the middle day) and appears under the canopied *asiento* throne to receive humble submissions and greetings from family and visitors. The *iyawó* may stand, sit upon the *pilón,* make prone submissions to the floor

to salute elders, or else sit on the mat, as the moment demands. The "secrets," or *fundamentos* (foundation), of the *orichas* made and received the previous day are contained in a variety of covered vessels called *soperas,* arrayed in an orderly line on the floor alongside the throne's mat or elsewhere in the *igbodún.*

Thus, in a real sense, the *asiento* throne as a complete altar consists not only of the canopy and the *pilón* – which has been consecrated like any other sacred *oricha* object – but also the ritually prepared, dressed, and iconographically outfitted body of the *iyawó,* who is nothing less than a living altar.

Formal Garments of the *Orichas*

Initiates who make Obatalá, Yemayá, Oyá, Changó, and Ochún are dressed as crowned palace royalty reposing under lavish cloth thrones of satin, velvet, lamé, and lace (Fig. 6). Their *ropa de santo* ensembles include shimmering pasteboard crowns encrusted with cowries and iconographic details. The warriors (*guerreros*) Eleguá, Ogún, and Ochósi, by contrast, are most frequently figured as dwellers of marginal spaces between town and bush, or of the bush itself: guard or farmer, soldier, and hunter, respectively (Fig. 7).[12] As denizens of the forest (*monte*) or countryside (*campo*), they sport brimmed hats appropriate to their outdoor habitats and stand beneath thrones constructed of natural green leaves, often pine boughs. They sit not upon a lathe-turned wood *pilón* but upon a large, often jagged, heavy stone (*piedra*) brought from their outside domains. Presented on the Día del Medio under the leafy throne in the *igbodún,* each *guerrero* also owns a parallel throne of leaves constructed outside the house (*trono del patio*) where important rituals of the *asiento* were performed. In other words, their particular spiritual power is not wholly containable within the house or the "town."

Formally dressed *iyawós* carry the appropriate dance wand or staff used by their *oricha.* Flywhisks (*rabo*) accompany the outfits of Obatalá and Oyá; fans (*ábanico*) are carried by Yemayá and Ochún; a thunder axe *(hacha)* is held by Changó.[13] Instead of refined implements of palace royalty or aristocracy, the *guerreros* carry rustic and fierce implements of work, war, and hunting: a cutlass (*machete*) for Ogún, a hooked staff (*garabato*) for Eleguá, and a bow and arrow (*arco-y-flecha*) for Ochósi.

Although the form and function of these impressive dance wands and other attributes may be interpreted as Yoruba derived, they have been creatively reworked in an Afro-Cuban idiom. For example, the red and black bead-wrapped hooked staff (*garabato*) of the Afro-Cuban Eleguá reconstitutes the Yoruba Elegba's figurated phallic club (*ogo-elegba*).[14] Fashioned from the guava tree sacred to that deity, the *garabato* is adapted from the rural Cuban field tool used by farmers and herbalists alike for reaching, hooking, and pulling down foliage, herbs, and crops to be cut with a machete of iron.[15]

Beyond their role as "iconographic representations" or "adornments," these attributes are material embodiments at one with the *oricha's* constituted bodily presence in the world. For example, the red and black rooster feathers of Eleguá's hat and the male goat hide used for his bag come from sacrificial animals used to feed the deity (interview, Lourdes López, Feb. 21, 1987). The hat's straw and the guava wood are rooted in the earthly landscape he inhabits. Most important, dance wands, when carried, are extensions of the *orichas'* potential for action—what it is the deities *do*—or more specifically how, when properly invoked, they can transform the world (see Drewal 1989:208, 223–29).

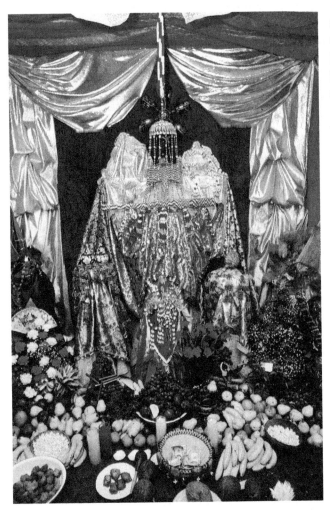

Figure 5. Birthday throne for the Changó of the late priest Adolfo Fernández, designed by Ramón Esquivél in 1985. This throne, composed of lace, satin, velvet, and lamé, celebrates the anniversary of the priest's coronation. Orichas are contained in covered vessels (soperas) on pedestals, draped with luxurious cloth. Obatalá is represented in white double peaks above the red-and-white Changó, the crown of Dadá descends from the canopy, and the cloth-covered soperas of other orichas are arrayed below, from left: Ochún, Agayú with Ibeyis atop him, Changó, Yemayá (Obbá behind in the corner), Oyá. In front are the warrior deities (guerreros) surrounded by a plaza of fruit and food offerings. A calabash for money tributes, coconuts for divination, and a rattle for salutation appear in the foreground. The beaded mazos and attributes were made by priestess Melba Carillo. The maker of the Dadá crown is unknown. Union City, New Jersey, 1985.
Photo: David H. Brown

Complementing the impressively orchestrated textures and colors of expensive-looking fabrics, modeled on aristocratic styles, are Yoruba-derived color-coded bracelets and sashes in metal and beadwork. *Iyawós* wear on the left wrist a multistrand beaded bracelet (*ide*) in the colors of their *ángel de guarda;* and up to four groups of metal bracelets may be divided between the two wrists, depending upon the *oricha* made: silver dedicated to Yemayá and Obatalá, copper to Oyá, and brass to Ochún.[16]

Oricha Beadwork

Beaded necklaces and sashes complete the *iyawó's* Middle Day ensemble. The *iyawó* wears at least five consecrated *oricha* bead necklaces received at an earlier level of initiation. But more prominent, on the occasion of the Middle Day, are the *collares de mazo* (literally bunch or bundle of bead strands), which are saddled around the body (Fig. 3).[17] At least five *mazos* are draped diagonally across the *iyawó's* chest in two directions, forming an X. Each *mazo* can weigh as much as three pounds and consist of over 12,000 glass, ceramic, and plastic beads.[18] The *iyawó* wears one *mazo* for each of the *orichas* made and received. Painstakingly made by hand, *collares de mazo* consist of multiple strands of beads organized on the basis of an *oricha's* oracular number and set of

counterpointed sacred colors. The thick circle is subdivided into equidistant segments by large, decorative fastening beads called *glorias*. In turn, emanating octopus-like, from each main *gloria*, are multistrand tassels called *moñas* (knots/ties), one of which, the *moña principal* (principal knot), is the most worked and elaborate. The number of segments, the number of strands in the bunch making up the segments, the numbered pattern of beads on each strand, and the number of main *glorias* with attached *moñas* are based on the *orichas'* oracular numbers or multiples thereof.[19]

The *mazos*, like crossed bandoliers over the *ropa de santo*, proudly identify the *iyawó* as a newly consecrated living locus of the *orichas' aché*. The beauty and sheer prodigiousness of the *mazo* signifies wealth, prerogative, and divine authority in a way consistent with cascading cowries and beadwork among the Yoruba (Thompson 1970, 8).[20] At the same time, one suspects that the *collar de mazo* was creatively reconstituted in the New World in dialogue with the model of the rosary. The Catholic necklace is mnemonically and numerically organized in segments of ten smaller beads devoted to the *Ave Maria* prayer, punctuated by larger *glorias* and *Padre Nuestros*; it features a depending crucifix whose prominence can be seen to mirror the *moña principal* of the *mazo* (Centra del Rosario n.d; and Brazilian examples in Gleason 1987, 241–43). However, the comparison is limited, as the *mazos* radically differ in scale, weight, complexity, and function.

At another register of meaning, *mazos* in their specific ritual context come to mark boldly and bodily the claims particular *orichas* have made upon the initiate's "head." In their life as objects, *mazos* may be activated as spiritual lassos by ritual elders, and by *orichas* when they possess their priests, to ensnare the bodies of those marked for initiation (a dramatic move called *la prendición*).[21] Finally the *mazos'* physical encirclement delineates and reinforces an envelope of spiritual containment or embodiment. Formally worn in concert with *ropa de santo* on only two occasions in the life of a priest, the Día del Medio and the *presentación al tambor* (presentation to the drums),[22] the *mazos* remain, for the rest of the priest's life, draped around the *orichas' soperas* (Fig. 4) or temporarily upon festival thrones. Thus, the *mazo*-encircled body may be seen as an analog to the vessels containing the *orichas' aché*.[23] And at festival time body and vessels are "dressed" formally with cloth to identify and mark *oricha* presence.

Owing to the architectural role cloth can play, the *trono del asiento* effects a "break" in significant space (to use Mircea Eliade's terms), defining a sphere of the *oricha's* immediate presence and implying the *oricha's* direct influence and claim upon the individual under it. For Eliade it would constitute a "sacred" space carved out of the surrounding "homogenous" "profane" world (1959, 20). Ritually "set apart" by articulated boundaries and prohibitions (see Douglas 1978, chaps. 2, 3), the throne protects the *iyawó* from the potentially dangerous influences carried by disincarnated spirits, *eguns*. At the same time, the uninitiated visitor who intentionally or accidentally crosses the proscenium into the throne's canopied space is subject to the immediate and irrevocable grasp of the *oricha*. That is, the individual must surrender his or her "head" to the *santo*, i.e., the religion: initiation is imminent. The person is encircled immediately with a *collar de mazo* and instructed to get initiated as soon as possible. The seized *mazo*-wearer sooner or later finds him- or herself under the throne on the Día del Medio, dressed in *ropa de santo* and encircled with five *mazos*.

The construction of the throne also effects a break in time, constituting a ritual or festival period, as the appearance of royal cloth registers and heralds the immediate or imminent manifestation of *oricha*. On the same principle, the wearers of *ropa de santo* step into a public ritual role for a defined period as the "mounts" of the deity they serve. "What is important about the dressing of the *orisha* here is the act itself," Robert Friedman has written. "The new dressing signifies that it is an *orisha* who is occupying his mount's body and participating in the event" (Friedman 1982, 194).

Figure 6. Initiate's consecration ensemble (*ropa de santo*) for Yemayá, *oricha* of the sea, by Lourdes López of West New York, New Jersey, exhibited at the Caribbean Cultural Center, New York, 1984. Initiates who "make" Yemayá and most other deities are dressed as royalty wearing pasteboard crowns.
Photo: David H. Brown, Courtesy of the Caribbean Cultural Center, New York

Figure 7. Initiate's *ropa de santo* for Eleguá, trickster and guardian of the crossroads, by Lourdes López, exhibited at the Caribbean Cultural Center, 1984. The costume is in the colonial martial or courtier style, with a straw hat of the countryside, beaded dance wand, and adornments taken from sacrificial animals favored by the deity.
Photo: David H. Brown, Courtesy of the Caribbean Cultural Center, New York

Ropa de santo, and the bolts of cloth and *paños* which comprise the throne, belong exclusively to the *oricha* and may not be worn, displayed, or otherwise used except on ritual occasions.[24] If the cloth is understood to identify or represent iconographically particular *orichas* through a system of color coding, it should also be seen, in more dynamic terms, as actively constitutive of, and materially coextensive in space and time with, embodied *oricha* presence in the world. Indeed, as Ochún priest Ysamur Flores has written, the *ropa de santo* "creates the orisha in the body of the initiate" (Flores 1990, 47). In other words, cloth may evoke *oricha* qualities and serves in the invocation of spiritual power, as Henry Drewal, John Pemberton, and Rowland Abiodun (1989) and Margaret Drewal (1989) understand representation in Yoruba sacred arts. Artistic representations not only "acknowledge supernatural forces and events"; in concert with oral praises, music, and dance, they "more importantly evoke, invoke, and activate diverse forces, to marshal and bring them into the phenomenal world" (Drewal, Pemberton & Abiodun 1989, 16).

Birthday Thrones and Drumming Thrones

While the *trono del asiento* (initiation throne) serves to publicly present and protect the newly crowned *iyawó*, the *trono del cumpleaños* (birthday throne) presents formally, as a dramatic array, all of the priest's *orichas* themselves (Figs. 5, 10), which have remained in covered vessels and confined in their permanent shrine during the year, most often a set of shelves or a closed cabinet (*canastillero*).

The *canastillero* is the historically preferred and probably most convenient form of domestic shrine or altar form developed by Afro-Cuban practitioners of Lucumí religion. It supports covered vessels – the *soperas* – hierarchically ordered on shelves and surrounded by their beaded attributes, accumulated decorative gifts, and, very often, the *ebos* (sacrifices) of ongoing ritual activity in the house (see Fig. 8 and Gonzalez Huguet 1968, 34, 48–49; Cabrera 1983b, plates). The *orichas' soperas*, although adorned with their *mazos* and attributes, are not dressed in cloth *paños* until festival time: drummings (*tambores*) and birthdays (*cumpleaños*).

The *cumpleaños* throne is erected for the annual *oricha's* "birthday," that is, the anniversary of a priest's coronation and the birth of his or her "crown." It is a serious, beautiful petition, weighted with wishes for the well-being of the priest who is entering a new year in ritual age (i.e., seniority).

Each year's birthday throne for active priests registers new additions to the original group of *orichas*, as auxiliary protectors called *addimù-orichas* are incrementally "received."[25] Birthday thrones thus inscribe aesthetically a kind of emergent spiritual biography marking a priest's growth in *santo*. At the same time, active priests regularly create new beaded and cloth objects for their own *orichas* or as gifts to *orichas* of ritual kin, registered annually on the throne in an ever growing accumulation of beautiful attributes. Each time the *orichas* are presented formally their stature and iconographic richness appear more expansive, with new objects that tell stories and reflect not only upon the grandeur of the deity but also upon the well-being of the house, its owner, and the ritual family of "godchildren" (*ahijados*) the latter has initiated.[26]

Modeled on the general outlines of the *trono del asiento*, the birthday throne's canopy is erected over spreading straw mats. The *orichas' soperas* are arranged on pedestals so that the original group of *orichas* made and received in the initiation is usually clustered together centrally, while the *addimú-orichas* arc outward toward the two extremes. Consistent with the ranking of *orichas* in their multishelved *canastilleros*, the houses studied here always placed the arch-divinity Obatalá centrally, in a position of absolute ascendance, followed by the priest's *ángel de guarda* (if it is not already Obatalá), followed by the second parent-*oricha*.[27]

A *trono del tambor* is erected for a drumming celebration *(tambor)*. The main formal difference between a *trono del cumpleaños* and a *trono del tambor* is that the former presents the vessels of all the *orichas* a priest has received, while the latter usually presents only the *oricha* of honor (i.e., the *oricha* to whom the celebration is given) and Eleguá, who, along with his companion *guerreros*, must take part in all ritual events; it is they who "clear the way" for the success of any undertaking. In a throne for a 1983 drumming to Changó, only the envesseled secrets of this deity are elevated at center stage, along with the *guerreros* nestled directly below; however, cloth *paños* representing other key *orichas* – in this case Obatalá, Óchún, and Yemayá – are arranged in an outer constellation of silver, gold, and blue and white respectively (Fig. 1).[28] The *cumpleaños* is held every year on the same date, but drummings can occur at any time during the year, as requested by *orichas* through divination oracles or prophetic (possession) speech, to solve problems, fulfill obligations, bring about health, and so forth.[29]

In both the birthday throne and drumming throne the *orichas* are decked out in their finest festive cloth, metal-work crowns, *collares de mazo,* and beaded staffs. They receive a sumptuous spread of fruit and sweets, and special tributes *(derechos)* of coconuts, candles, and money, from godchildren who gather in the house of their godfather *(padrino)* or godmother *(madrina)* to celebrate.

Figure 8. Typical domestic oricha shrine room (*igbodún*) with a *canastillero*, a cabinet that hierarchically organizes soperas of the deities. Atop it is the green sopera for Orunmila, followed by Obatalá's and Ochún's. Staffs (*osun*) and twin vessels for the Ibeyis also appear atop the cabinet. On the floor are Yemayá's painted clay vessels with encrusted shells and swan, blue vessels for Olokun, spray-painted multicolored vessels for Oyá, and a raised red wood vessel (*batea*) for Changó. The painting represents St. Lázarus/Babalú Ayé. Marianao, Havana, Cuba, 1989.

Bolts of cloth of silk brocade, sequins, velvet, lace, lamé, satin, and chiffon, carefully selected for the colors, textures, and patterns associated with particular *orichas*, are purchased in wholesale textile stores (in Manhattan, for example, in the Garment District and on Delancy Street). Cut and fitted with sparkling contrasting borders of silver and gold braid, and often adorned with cowrie shells, they become *paños* to dress and cover the *orichas' soperas*. The most desirable fabrics have printed or brocaded floral sprays with flecks or threads of metallic silver or gold, or else they are densely sequined.

Over the *paño* the *oricha's mazo* can be doubled to encircle the now-covered *sopera*, or draped sash-style. Crowns (a nine-pointed copper one for Oyá, a five-pointed brass one for Ochún[30]) are then placed on top, their dangling attributes radiating out from the center.[31] In order "to make it beautiful," says Josie García, the top of the *paño* is carefully coaxed up through the crown, or pinched and tied if there is no crown, to form a puffy navel or head that she likens to a "bun" (interview, May 21, 1988)(Figs. 9–11). Finally the appropriate beaded or painted staffs, dance wands, or other symbolically resonant attributes owned by the *oricha* are placed on top or slipped through the *mazo*, or nestled nearby against the wall (Fig. 11).[32] The result poses the finely dressed *orichas* like a glorious assembled theatrical cast at a curtain call or, more precisely, like royalty sitting in state.

Offerings for the Orichas

Orichas mounted on birthday and drumming thrones, as well as those newly born orichas reposing on the floor of the *igbodún* on the final day of the initiation period, find a selection of cool (*fresco*) and sweet (*dulce*) fruits and foods arranged before them. This array is called *plaza*, a term which here simply means a bountiful "spread" of food, but which, in a related context, refers to an open-air marketplace (interviews, Melba Carillo and Beatriz Morales, Sept. 9, 1993). The *plaza* is said to refresh (*refrescar*) them before they are addressed through divination with four shards of coconut meat (*obi*). That which is cool, refreshing, and sweet should produce a disposition conducive to positive divinatory responses and is metaphorically consistent with the desired result: tranquility, advancement, health, and well-being.

The aesthetic choices of the *plaza* are guided by *oricha* categories and characteristics, in which shape, color, texture, and even taste are taken into account.[33] Creative throne makers engage in a kind of intimate landscaping. Ochún, for example, receives fruits of her characteristic color and sweetness: mangos, oranges, and grapefruits, as well as "Spanish pumpkins" *(calabazas)*, which suggest the contours of the female abdomen. Changó receives bananas and plantains (for their phallic shape), and strawberries and apples (for their red and white color); Obatalá receives Anjou pears, whose light exterior and white interior correspond to his color, while their shape approximates the conical mountain where he lives. Other matches are not as easily explained but are nevertheless traditional: Oyá receives eggplants (*berenjenas*), whose dark color appears to reproduce the shades of the robes of St. Theresa and Our Lady of Candlemas with whom Oyá is associated; Eleguá, Ogún, and Ochósi prefer sugar cane (*caña de azúcar*), perhaps because of its association with the "outside" (the fields) and the aggressive cane-cutting/ground-clearing wielders of machetes (Ogún in particular).[34]

Particular kinds of fruits are placed before or near particular *orichas*, often creatively distributed in symbolically significant configurations and eye-popping alternations of color echoing the counterpoint of *oricha* beadwork. For a 1986 birthday throne to her Ochún (Fig. 10), Josie García of the Bronx spread a central circle of five pineapples (the number five being sacred to Ochún) alternated with four small *calabazas*, in the middle of which rested a large *calabaza*.

Figure 9. Detail of a birthday throne by Ramón Esquivél. A *paño*-covered vessel of Ochún, draped with beaded *mazos* made by Melba Carillo, has a "bun" or head of cloth pulled up through the deity's brass crown. The paper fan and peacock feathers are attributes of the deity. Union City, New Jersey, 1987.
Photo David H. Brown

These pumpkins were doused with honey and sprinkled with sweet, multicolored jimmies. In a 1983 throne for Changó (Fig. 1), Ramón Esquivél arranged delicious apples on the mat into the shape of the deity's double thunder axe, whose twin points sprouted from a bunch of bananas.

Elaborate *plazas* also feature a host of home-prepared and purchased desserts and snacks. Eleguá loves hard candies (*caramelas*) and popcorn (*rositas de maiz*). Ochún gets *dulces finos* (syrup-soaked yellow cakes) and *natilla con canela* (sweet egg custard with cinnamon). Obatalá takes *arroz con leche* (rice pudding, but unsweetened), white rolls and *merengues* (swirled puffs of white sugar) in multiples of eight and a large, conical "tower" (*torre*) of *merengue* that represents the white, heavenly mountain upon which he lives. Yemayá likes *coco dulce,* made of grated coconut with brown sugar and *melao* (molasses or dark cane syrup), and also often receives *mala-rabia* and *boniatillo,* sweet potatoes (*boniato*) blended to be chunky and smooth, respectively. Oyá receives a dish of chocolate pudding, really a custard of the same base as Ochún's *natilla* with chocolate added. Changó is served *amalá-ilá* (cornmeal and okra) (interviews, Melba Carillo, 1987 and Aug. 1993). The prize of the prepared sweets is a large frosted birthday cake featuring the *oricha* of honor's name. After a period of time on the mat as offerings to the *oricha,* pieces of the cake and the rest of the throne's fruits are distributed back to birthday guests.

Oricha Thronescapes[35]

Throne makers like the masterful Ramón Esquivél employ cloth as a plastic medium to create thrones that dramatically announce *oricha* presence through their signature colors, that reference architecture and the sacralized natural landscape, and that inscribe a hierarchical model of the cosmos. The *oricha* of honor customarily is elevated and centralized, fronted by Eleguá upon the mat and transcended by Obatalá above. Eleguá is always placed on the floor in the center, near where priests make their prone salutations *(moforibale)* and deposit a monetary tribute *(derecho)* in the calabash *(jícara)* on the mat (Figs. 1, 5, 10). He is the *guardiero* (guardian) of crossroads, thresholds, marketplace, and house; the diminutive "messenger" who ferries communications and sacrifices to other *orichas;* the *oricha* addressed, fed, and assuaged before all others. He thus stands guard with the other *guerreros* before the *orichas* elevated behind him, at a kind of threshold or crossroads that links them with the throne's human supplicants.

Fruits and foods as products of the earth distributed on mats of straw find direct vertical opposition in the rising celestial canopy, often made of sheer white fabric, lace or crepe, suggesting clouds in the sky and rising mountains (Fig. 5). This is the sphere of Obatalá, sky *oricha* and pure "King of the White Cloth." In a 1983 drumming throne for Changó (Fig. 1), behind the sheer red curtains joined at the apex by the silver lamé "shield" of Obatalá, white mountain peaks rise above the horizontal bar spanning the two converging walls, while bunted lace "clouds" depend below. Beneath this firmament in cloth, the striking *paños* and the covered, elevated vessel of Changó are set against the blazon-like dominant background of alternating vertical pillars of red and white bolts of cloth, forming the counterpointed signature colors of Changó, the *oricha* of honor.

In a 1985 birthday throne for Changó (Fig. 5), Ramón Esquivél shaped the silver and white brocade *paños* covering the *soperas* of two Obatalás to form double peaks, referencing the deity's mythological residence, the "hill of Oke," that towers above all of the other *orichas* (interview, Ramón Esquivél, Aug. 17, 1986). Oke is Obatalá's faithful companion *oricha,* his rock-solid support or "staff" *(bastón)* (interview, Melba Carillo, Nov. 14, 1987; see also Angarica n.d:21). Thus Esquivél rendered in his thronescape not only a hierarchicalized landscape of sky and earth but also an understanding of Obatalá—who, by rights, is "higher" than the other deities presented—as the spiritual "head of all the *orichas.*" Obatalá crowned atop the "hill" bridges and mediates "sky" and "earth," playing the *axis mundi* role to which Eliade refers (1959, 36–37).

In a marvelous instance of cultural bricolage, Esquivél mounted on the wall an elaborate golden spoked metal lamp in the form of the monstrance of the Host, the Christian God's Holy Sacrament *(Santíssimo Sacramento).* The lamp, with bulbs of different colors, rises just above and behind the twin peaks of Obatalá. A priest fleshed out the sense of this striking juxtaposition in an explanation to me of an Obatalá drumming throne that Esquivél made for him. The throne's central upward-aspiring white and silver *paño* was an "airplane going to heaven... you know, *height!,* like something that looks toward the sky. Because Obatalá, is, you know, God's son. Like Jesus, Obatalá is like Jesus. It's like something [going] to his father, very symbolic...to open the ways to Heaven from Earth" (interview, Idalberto Cardenas, Nov. 29, 1986).

Thus the spiritual landscape as inscribed in throne architecture suggests something of a reconciliation of Yoruba and Western Christian cosmology based, undoubtedly, in a historically emergent Cuban and Latino popular religious conception. Yet though the throne presents an image structured by a Western spirit-matter hierarchy of "heaven" and "earth," heaven is not at all a distant or otherworldly one as in certain Christian conceptions. Reflecting its foundation as an African-derived shrine, the throne-as-altar embodies spiritual power in envesseled earthly material

objects, a power manifested in an immediate, intimate, and voluptuous way, right here, amid an otherwise mundane domestic domain.

These same canopies that structure vertical mediations between "sky" and "earth" provide the dramatic stage for some of Esquivél's most powerful and large-scale evocations of the thunder god Changó and his *oricha* "sister" Dadá, who is known in Cuba as the "crown of the Saints" (Angarica n.d., 45–49). In the 1985 birthday throne Esquivél built for Changó (Fig. 5), the magnificent beaded and cowrie-encrusted crown of Dadá descends from the canopy on clustered strands of red and white beads and cowries.[36] Hovering above the covered vessel and pedestal of Changó, its twelve long cowrie-studded fringes dangle beneath it and encircle a red and gold floral *paño*, atop which are arranged Changó's beaded thunder axe *(oché)*, beaded baseball bat *(bate)*,[37] and *collares de mazo*. In Yorubaland the prototype of the New World version of the crown is worn by special priests of Shàngó called to pay homage to their thunder god when houses are struck by lightning (Abraham 1946:121, 622).[38] Here the descending crown of Dadá appears as the very embodiment of Changó's lightning (his *aché*) arcing from sky to ground, condensing in the beaded attributes of Changó and the covered vessel that contains his thunderstones *(edun ará)*. Esquivél echoed lightning's descent with the vertical chevron pattern of sequins embroidered across the surface of the *paño* itself. As if that were not enough, Esquivél shaped the *paño* further by draping and tacking its upper edge in the form of zigzagged horns, evocations of lightning and of the ox horns that represent Changó's companion-*oricha* Oggue. In a stunning repeat performance in 1987 (Fig. 12), Esquivél shaped the same red and gold *paño* into repeating diamond-shaped lightning bolts falling downward beside the uncovered vessel *(batea)* and pedestal *(pilón)* of Changó, Having seen, in 1986, photographs of decoratively painted Changó vessels and pedestals on display in a Havana museum, he decided to reconstitute this tradition in the United States.[39]

Numerous other possibilities exist for employing throne curtains and *paños* iconographically. Esquivél and other throne makers shape cloth creatively as flowers and butterflies for the feminine water *orichas* Yemayá and Ochún (Figs. 2, 10) and thunder axes for Changó (Fig. 10). Esquivél's 1983 drumming throne for Changó (Fig. 1) features a fiery red *paño* crackling with gold sequins, shaped to the form of the *oricha's* double thunder axe at the center of the throne. Most dramatically, the front curtains are parted sharply so that the two opposing triangular areas of sheer red cloth appear to compose a huge overarching double thunder axe.

The 1986 birthday throne built by Josie García for her Ochún expands the possibilities of rendering cosmology in cloth, as it reorients a more strictly hierarchicalized sky/earth landscape into underwaterscape (Fig. 10). And it suggests a fluid reinscription of aesthetic emphases around the values of the cult of Ochún. While Obatalá still sits ascendant, he is dominated by Ochún's colors; there is no sky or mountain range rendered in puffy white lace or crepe. The canopy was, in fact, conceived by Josie García as a running river's surface as seen from below, for the throne maker understands her particular manifestation, or "road," of Ochún as having "lived in a river in a cave." The dominant colors are "honey" and gold, representing all of Ochún's "sweet things," especially the "sweet water" of the river she "owns." The canopy's lacy gold border glistens and bubbles; its gold dimpled ceiling suggests running rapids; its pleated vertical drapes at left and right are like water lapping riverbanks. The gentle curves of the central butterfly shape – a beautiful avatar of the female *oricha* Ochún – double as a figure of emanating, concentric "waves," as its maker explained (interview, Josie García, May 16, 1986). Peacock feathers, from one of Ochún's central avatars, adorn the outer drapes as well as Ochún's central *paño*. Layered in with these references to Ochún's sweet things are the counterpointed bead colors of this Ochún: the alternating vertical

bars of amber and green. (This road of Ochún employs green because of her intimate association with Orunmila, whose colors are yellow and green.)

The meaning of the throne and its objects is not exhausted by an account of its iconography, not least because most of its constituents are quite abstract. How is one to understand, for example, the rising, moundlike figures in lavish cloth beneath the throne's canopy (Figs. 4, 9)? A hierarchy and differentiation of aesthetic density – the lavishness of cloth, decorative embellishment, and concentration of gathered objects – throws into relief the *paño*-covered *oricha* vessels against the dominant areas of the throne itself. It is certainly the *paños*, with their rich gold and silver fabrics, that appear most expensive. Clearly density of design and apparent value index and localize the presence of each *oricha*.[40] Yet, in a visual paradox, the apparent invitation to knowledge of this display – especially given the open curtains which promote the experience of revelation – is at the same time precisely about containment and concealment of the secret. The effect echoes Judith Gleason's observations of Yoruba Egungun masquerades and suggests something of a transatlantic tradition of sacred clothwork. The masquerades use "a dramatizing of the surfaces in order to stress the depth of what is thereby concealed. The delighted eye teases the mind to contemplation of the unseen force behind the apparition" (Gleason 1987, 102).

Figure 10. Birthday throne for the Ochún of priestess Josie García, made by García for her fifth *cumpleaños*. The golds and "honey" colors identify this oricha of "sweet water" (the river). Obatalá is above Ochún in the center. To Ochún's left are Olokun, Kofá de Orula, and Yemayá, with the twins Ibeyi (represented by dolls). Warrior *orichas* appear in front. To the right of Ochún are Agayú, Oyá, and Changó. At the top, a red *paño* is shaped like Changó's thunder axe. The beaded *mazos* were made by Melba Carillo. New York, 1986.
Photo By David H. Brown

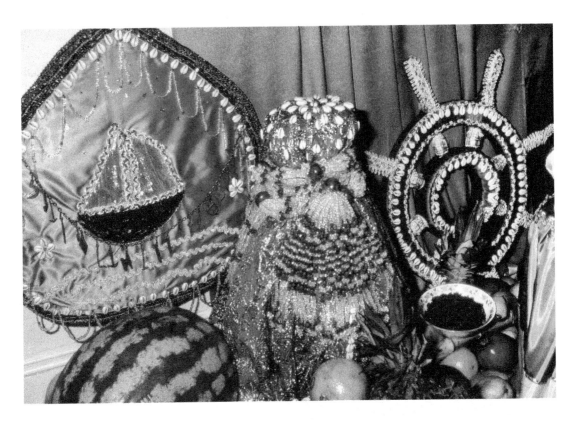

Figure 11. Detail of the birthday throne in Figure 10, showing various *oricha* attributes: a fan and a cowrie-encrusted ship's wheel for Yemayá, multistrand bead sashes (*mazos*) over the vessel for Olokun, which is draped with cowrie-encrusted cloth.
Photo By David H. Brown

The crowns and globe-like gatherings of cloth rise like heads atop a conical body draped with beads. Dance wands or other hand-held attributes sprout atop them. The assemblage is at once readable as hierarchical and anthropomorphic on the one hand, and as a discontinuous, additive, metonymic clustering of forms on the other. Robert Plant Armstrong has referred to this latter additive aesthetic formation as a process of "syndesis," in which the intentional addition and piling up of forms, including material objects, songs, praises, and sacrifices, serve to invoke and sustain "presence" – in this case *oricha* power, *aché* – for particular ritual applications and passages (Armstrong 1981).[41] If the mound is a kind of body, a "grammatically animate" (Jackson 1989, 144) body that "stores" *aché* (Apter 1987, 246–47), diacritically distinguished by its attributes from its neighbor, it is both similar to and distinct from the more clearly hierarchically organized, kinetically animate body of the priest whose body may be possessed and danced by the *oricha*.[42]

Finally, while the throne is accessible in this extended moment for visual contemplation, an effect heightened by its objectification in a photograph, the process of the accumulation of its objects is masked or internalized. And the "meaning" of the throne is certainly not reduceable to the results of a single static iconographic "decoding operation" (Bourdieu 1977:1). Its constituents accumulate prior to the throne's construction in an additive way, unsystematically over time, in numerous exchanges and encounters – a field of actions and moves that could be encapsulated by the term "practice" – between individuals, within ritual families, and in the setting of modern

urban culture. Many of these moments of addition gain their significance in the context of promises made, obligations fulfilled, and personal struggles and desires as mediated by the *orichas'* involvement in priests' daily experience. Thus an important level of "meaning" must be identified in what Richard and Sally Price call "social meaning" (1980, 188–93), that which is embedded in the micro-exchanges of everyday life – in this case as marked ritual exchanges.

Exchange and the Ritualized Circulation of Objects

As a special festival altar, the throne structures communication – drummed and chanted praises rendered, and divinatory dialogue conducted, through *obi* divination (the coconuts) – between two worlds, and witnesses a wealth of gift exchanges between *orichas* and followers. Upon their arrival at houses celebrating an *oricha's* birthday, priests immediately "throw themselves to the throne" *(moforibale)* to show respect for the *oricha* of honor, salute the *oricha* musically with a shaker or bell, and deposit monetary tributes in a calabash *(jícara)* or basket on the floor. The birthday thrones of godparents who have large ritual families become, in the course of a day, veritable groves of coconuts and candles which their godchildren must bring as a special tribute, and whose *jícaras* overflow with money.

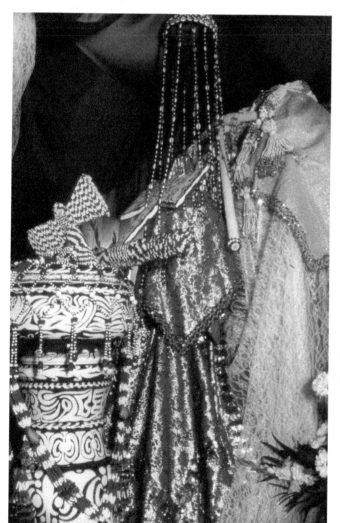

Figure 12. A crown of Dadá hangs from the canopy of a birthday throne for the Changó of Adolfo Fernández. The throne design and painted pedestal and vessel of Changó are by Ramón Esquivél. The *mazos*, beaded thunder axe and baseball bat for Changó, and white beaded cane for Obatalá are by Melba Carillo. The maker of the Dadá crown is unknown. Union City, New Jersey, 1987.

Photo By David H. Brown

The spread of the basic *plaza* arranged by the throne maker grows in proportion to the arrival of the gift-bearing faithful to the house, and ebbs as the cornucopia is later distributed and consumed. Just about "everything sweet is given out to the people" (interview, Melba Carillo, Mar. 20, 1987). Gifts initially made to the *oricha* cycle back to refresh the givers anew with food that has absorbed the *orichas' aché*. The cutting and serving of the *oricha's* birthday cake happily borrow a secular form in dramatizing the distribution of sweet blessings. By the end of the evening the mat of the throne is virtually defoliated. Within thirty-six hours its contents have traveled from supermarket bins to the throne – from actual *plaza* (market) to the throne's *plaza;* have been presented to the *orichas* and then reciprocated, to be eaten immediately or taken home, often in the same shopping plastic or brown paper bags used to purchase the fruit in the first place. The fruit taken home is eaten by the guests' family and friends in an exponential spreading of the *oricha's* blessing.

Finally, the gift cycle includes many constituents of the throne itself. New additions of cloth and beaded objects make for considerable variation in throne design from year to year. Whereas some objects are purchased or made for one's own *orichas,* others come to the house as gifts from godchildren and, in fact, from other *orichas.* When *orichas* "come down" at drummings, they often give away the *paños* and even the very *ropa de santo* in which they have been dressed. The *paños* may soon appear upon the blessed recipient's own enthroned *orichas.* Thus, the composition of a throne and its attendant meanings are produced collectively through the circulation of status gifts, some of which do not remain for long in the same house, suggesting an informal and fluid inner-city gift-exchange network, which interfaces with the mass marketplace of commodities.[43]

Thrones of *Oricha* Royalty in Afro-Cuban Cultural History

Lydia Cabrera in 1954 remarked upon the royal protocol—a set of gestures and images—evident in everyday Afro-Cuban Lucumí religious practice and most powerfully in the *asiento* or *kariocha* (initiation) of priests and priestesses. The elder priestess Oddedei (Calixta Morales) explained to her that "to make Santo is to make a king, and *kariocha* is a ceremony of kings, like those of the palace of the Oba Lucumí" (Yoruba king).[44] And, she stated, the priests and priestesses of Afro-Cuban Lucumí religion, "the babalao, and the mamalochas, formed a court like the one there" (in Africa) (Cabrera 1983b, 24 fn.). The pageantry of the Día del Medio existed, Cabrera was told by her informants, "for the simple reason, 'that the Orichas were kings'" (Cabrera 1980, 179).

Though we might want to qualify Oddedei's allusion by distinguishing ethnographically between the ritual enthroning of Yoruba divine rulers on the one hand and the initiation of cult members on the other, she in fact invokes a mythico-historical understanding common to the Yoruba themselves: that the *òrìsà* were "princes of the royal family" of Oduduwa, founder and first Oni of Ifé, princes "who traveled away from their home in all directions to found new kingdoms and dynasties" (Smith 1969, 19–20). As Obas – new kings of their respective domains – each of them bore a crown as a sign of their rightful office. Today, the possession of such a crown and genealogical links to Oduduwa legitimate the authority of Yoruba kings. In effect, kings are officially the descendants of certain *òrìsà.*[45] It is no less significant that Yoruba cult members, the *aworo,* are considered not only as the "kings" *(aládé,* crown wearers) of their ritual domains—their shrines – but also the "kingmakers," for the king who wears the beaded crown is dependent upon them to "safeguard the crown and revitalize its powers," his *ashe,* in annual festivals (Apter 1992, 103–5).

While all agree that West African Yoruba ritual is the *ultimate* source of Lucumí practice, many have observed that African traditions were creatively reworked and reorganized in the Americas (e.g.,

Mintz & Price 1976; Bastide 1978; Thompson 1983:18). In late eighteenth- and nineteenth-century Cuba, the important *proximate,* contextual source for the emergence of Lucumí royal religious symbolism is to be found in stylistic traditions elaborated during and after the colonial period within Afro-Cuban religious brotherhoods called *cabildos* (Bastide 1972:95; Brandon 1983:61–94; Palmié 1989). The "focus" of African-derived religious practice – what William Bascom defined as "stones, herbs, and blood" (Bascom 1950) along with African patterns of divination, sacred music, spirit possession, and structures of leadership – was reembedded in a set of expressions congruent with the island's distinctive cultural history. The authority and splendor of elected or hereditary *cabildo* officeholders – kings, queens, courtiers, and military aides – were encoded in symbols creatively borrowed from Spanish or colonial Cuban iconography of the eighteenth and nineteenth centuries. European aristocratic styles were endlessly copied and revived in colonial Cuba by an emerging bourgeoisie of merchants and planters: lavishly draped and layered floral cloths, gold-gilt adornment, porcelain, and faience. Appropriated, in turn, by Afro-Cubans, these objects and styles became traditionalized as status objects in the presentation of Lucumí *orichas.* That is, Afro-Cubans brilliantly reinvested colonial Cuban forms with new significance in constructing the "royal" setting for initiatory and ceremonial practice.

Change occurred not through a single agentless encounter between "Spanish" and "African" traditions, but through a dynamic socio-cultural history in which Africans and creoles built institutions and actively engaged in constructing and presenting themselves in relation to their changing surroundings. This involved both the preservation of Yoruba ritual patterns precisely through a conscientious reworking of them, and the borrowing, copying, or appropriating of available symbolic elements and whole stylistic systems for enjoyment and empowerment. The kinds of transformations that historically occur in creole settings, Karl Reisman insists, involve "not merely the passive results of history" (1970, 131).

Cultural borrowing does not necessarily represent dilution, loss, or corruption, as implied in recent Yoruba Reversionist writing seeking to "purify" the tradition of foreign elements (see Mason 1985). To my mind, "copying" and "imitation" remain uncomfortable concepts only if one acquiesces to the hegemonic conceit that people easily succumb to assimilating pressures; we should look for creative behavior, practical and tactical processes of resistance through transformation, or what recent theorists have called "critical revision" (Gates 1988; Apter 1992).

A deemphasis of "origins" as primary and determinant in cultural investigation is in order, for the processes and products of cultural change defy the teasing out of "pure" strands or elements as essences organically continuous with some putative point of origin in the past. If we follow recent work by Handler and Linnekin, moreover, we are forced to relinquish the formalist, essentialist, or natural science point of view, which "identifies the essential attributes of culture traits rather than to understand our own and our subjects' interpretive models" (Handler & Linnekin 1984, 274).

Lydia Cabrera suggested, probably based upon readings of Fernando Ortiz (1921), that the Afro-Cuban religious brotherhoods *(cabildos)* during the colonial period carried on traditions of kingship that appeared to mirror those of Africa. The "royal honors" that were rendered to *cabildo* kings and queens, perhaps as late as the 1880s, were reflected in certain "courtly reminders," that is, an "etiquette shown by junior priests toward their most distinguished elders," that she observed in the 1950s and were reported to her by her elderly informant Oddedei (Cabrera 1983b, 24 fn.).

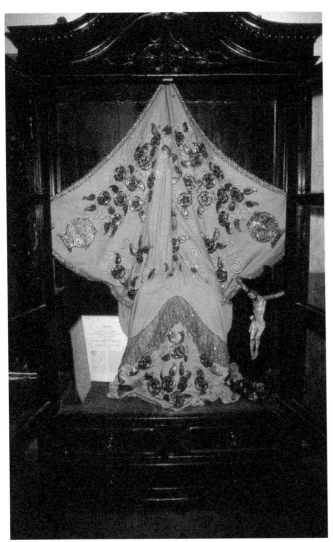

Figure 13. Mantle (*manto*) of the Virgin of Regla, displayed in its cabinet. The statue of the Virgin, the Catholic counterpart of the *oricha* Yemayá, is dressed in this *manto* when it is taken out of the church for a procession on her feast day, September 7. The *paños* covering enthroned orichas were modeled after the mantles draping figures of Catholic saints. Church of the Virgin of Regla, Havana, Cuba, 1989. *Photo By David H. Brown*

In 1853 the Swedish traveler Frederika Bremer visited a wealthy, well-appointed and well-staffed Lucumí *cabildo* in a black barrio just outside the walled city now known as Old Havana. She described its elegant king and queen as possessed of "a throne with a canopy over it," under which stood their seats and near which was a crown painted on the wall. Greeted by the king and queen, she watched festive drumming and dancing proceed before the throne in what may be read as a religious celebration complete with spirit possession. A conscientious observer of customs, Bremer made a tribute of money to a male dancer apparently possessed by the deity Changó as well as to the society's coffers (Bremer 1853, vol. 2, 380–81).

In journalistic reports of the first half of the nineteenth century, observers of Carnival on the January 6th Day of Kings described *cabildo* queens as they emerged

> in dress the style of the whites, covered with fine Spanish lace, sash of precious stones, belt and scepter of gold, pendant earrings and necklace of pearls Each queen had her court of young slaves, in imitation of her aristocratic mistresses [female masters], decked out luxuriously.

(Ortiz 1921, 6–9)

One *cabildo* king was described as wearing "a genuine costume of a king of the Middle Ages, a very proper red, close coat, velvet vest and a magnificent gilt paper crown" (Aimes 1905, 20–21). Other officers such as the Mayor de Plaza (Chief of Ceremonies) wore "long military coats, starched shirts...flamboyant doublepeaked hats, gold braid...swords on the belt...[etc.].... All of these adornments," noted Ortiz, "were taken principally from the Spanish Army" (1921, 6–9).

Many observers regarded such formal expressions of *cabildo* courtly hierarchy as grotesque and humorous "imitations" of "the adornments and dress of the whites." I suggest, following Roger Abrahams (1983, 26), that *cabildo* processions in stylized court and military dress artfully presented subversive public models of royal wealth, order, power, and alternative authority. The presentations were strategically masked by the ambiguity of the signs and thus were "safe": these were just slaves and of course it was just entertaining – "slavish" – imitation.

Karl Reisman suggests that the symbolic technique of "taking on" dominant cultural forms and "remodeling" them has characterized the emergence of creole cultures in the Caribbean. In a range of practices, Caribbean people "reshap[e] the forms of symbols to resemble as closely as possible both the historical source and the forms current in the environment" (Reisman 1970). The case of Yoruba kings and *cabildo* kingship seems to be a good example of this. While Oddedei's reference is to the "palace of the Oba Lucumí" "there" in Africa, this is not necessarily the same Yoruba king that the contemporary ethnographer knows. Her language is reoriented to, and shaped by, the uniquely and historically Cuban ethnic nomenclature for the Yoruba – "Lucumí" – the nearest ("emic") rather than the more remote ("etic") term.

How might the creation of Afro-Cuban royalty be understood in terms of the creolization model? First off, a new language or system of signs is not created through the simple synthesis, blend, or reconciliation of two different languages – in other words on the popular A + B=C syncretism model or the binary "tourist-guide" model (Decamp 1971, 21–22). The process requires at least three languages and an available pidgin grammatical system; it might involve, for example, two or more minority groups under colonization or conquest, establishing a new common language by drawing lexical items into the pidgin grammar from the third language – the tongue of the colonizer – as well as usable terms from their respective mother tongues (a process known as "relexification") (Decamp 1971).

In the Lucumí context, it is Africans and their descendants of diverse Yoruba ethnicities and related regional peoples who occupied subordinate status in the slave society and its aftermath, constructing an emergent Afro-Cuban culture in relation to, and against, the dominant Spanish-Cuban system of signs.[46] In the religious domain, the core ritual patterns were reworked, having been wrenched from their "wealth of institutional and ritual detail" (Bascom 1950:68) in Africa and reembedded in new socio-ritual and aesthetic frameworks in the New World (Bastide 1978). The fundamentals of stones, herbs, blood, and patterns of divination, drumming, and spirit possession were not lost but reworked and critically differentiated from dominant Catholic practice at the same time that they borrowed aesthetic ideas and even structural patterns from it. A "creole" – uniquely New World – "mother tongue," religiously speaking, emerged, through relexification and elaboration, ritually and aesthetically. African stones and shells – the *fundamento* of the *orichas* – came to be fed in prestige copies of rococo porcelain soup tureens, initiations consummated under grand canopied thrones, and initiates presented in the royal or quasi-military garments on the models of those described to us by nineteenth-century *cabildo* observers.

Using the terminology of historical linguistics, Roger Abrahams and John Szwed suggest that many borrowed performance elements – the equivalent of lexical items – are "loan translations"

or "calques" incorporated according to the "ethical and esthetic demands of a conceptual system shared by Africans and Afro-Americans....Many of these features (such as the oratorical variety of Standard English) were introduced into ceremonial proceedings as a substitution for similar prestige varieties used for oratory in West Africa" (Abrahams & Szwed 1983:36). In short, *cabildo* kings, queens, and their courts may be seen as Afro-Cuban creolizations of African structures of authority and centers of power (see Aimes 1905). With historical changes like the suppression of the *cabildos* and emancipation in the 1880s, Afro-Cubans continued to transform themselves and their religions (Ortiz 1921; Scott 1985). The framework of popular religion among Cubans and Afro-Cubans, which included African religion and "folk" Catholicism – a Catholicism that Cubans say they practice "in my own way" *(en mi manera)* – was and remains one such local or regional "conceptual system."

Whereas the eighteenth- and nineteenth-century *cabildo* leaders called kings and queens possessed a formalized administrative role and political relationship (as official "ambassadors") to the colonial power, in the late nineteenth and early twentieth centuries specifically religious houses of the *oricha* (houses of *ocha*) emerged from the institutional base of the extinct old-style *cabildos*. When the politico-administrative structure fell away and *oricha* houses split off and went underground, powerful priests and priestesses remained as leaders, notably the emerging ritual specialist-administrator within the house of *ocha* called the *obá-oriaté* (king or head of ritual proceedings and divination). *Babalawos* – Ifá diviners – within their own organizations ranked themselves with nomenclature that derived from Yoruba titles, including that of *obá* (king). This history lends suggestive context to Oddedei's remark that the *"babalao,* [and] the *mamalochas* formed a court, just like there" (in Africa) (Cabrera 1983b, 24 fn.).

At the same time, it seems, the glorious symbolic styles from the period of the old-style *cabildo* royalty have remained to this day as the distinctive adornment of the *orichas* themselves who are seen as "kings" and "queens." When Oddedei located the origin of ritual coronation in African royal traditions, she was correct; yet the materials and styles in which their royalty was figured – thrones, formal festive costume, crowns – in great part were elaborations upon models derived from the proximate source of the *cabildo* hierarchy of kings and queens, combined, of course, with reworked Yoruba-derived models of beadwork and *oricha* iconography.

Royal canopied thrones and garments of specifically religious initiation were modeled after, or emerged historically in tandem with, *cabildo* royal styles, which themselves were imitations or appropriations of colonial Cuban models. In speaking about the religious throne and costuming tradition, it is historically erroneous, if not insensitive, to refer to it as "Spanish" or "European." What I have called its proximate source – *cabildo* material culture – was *already* Afro-Cubanized and traditionalized within the institution of *cabildo* kingship. New Jersey priestess and seamstress of ritual garments Lourdes López was taken aback when I suggested that her designs were European in style; she responded that they were Cuban, as taught to her by her godmother in *ocha* (interview, Feb. 21, 1987). What is Cuban is complexly creole and emergent in ways that defy formalistic readings that focus upon putative ultimate origins, leapfrogging a whole cultural process of contextually embedded choices by creative New World people.

If emergent *oricha* thrones and garment styles were nourished by the material culture of the rising Cuban bourgeoisie in the nineteenth century, throne makers drew also from Catholic forms of sacred presentation. For example, the draping of cloth upon altars (the dossal) and over the saints (their mantles, or *mantos),* and the symmetrical, cosmically soaring architecture and gold-gilt ornamentation of church and domestic altars (see Fig. 14) offered visual inspiration. Such discrete propitiatory media as candles, flowers, and ex-votos came to serve the needs of the *orichas.*

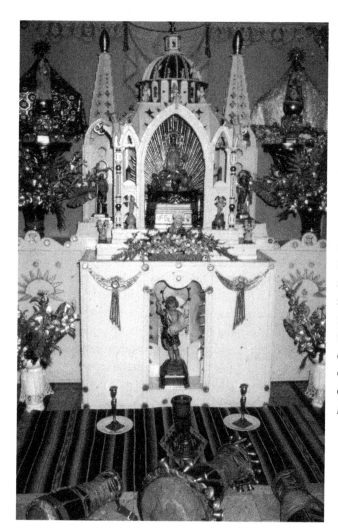

Figure 14. Domestic shrine for Our Lady of Charity (*Caridad de Cobre*), who is associated with Ochún, in the house of the late Ochún priest Rigoberto Rodríguez. The house is now an ethnographic museum maintained by the priest's widow, Fredesvinda Rosell. The Catholic shrine's cosmic organization, symmetry, and flatness probably provided one model for aspects of Lucumí throne organization. The *batá* drums belong to the National Folklore Group of Cuba. Madruga, Havana, Cuba, 1989.

Photo By David H. Brown

The *paños* covering enthroned *orichas* were undoubtedly modeled after the style of draping statues of Catholic saints. These statues are dressed in lavish, sparkling, brocaded *mantos* or *paños* that fall cape-like over the shoulders and back, often combined with a *mantilla* that covers the head. Ornamental gold crowns (and halos) grace their heads. For example, as displayed in its own *canastillero*-like cabinet in the chapel behind the main altar of her church, the capacious sea-blue *manto* of the Virgin of Regla, bordered in silver braid and surfaced with silver floral patterns (Fig. 13), looks to be the inspiration of a common *paño* type hung upon an *oricha* throne.[47] The Virgin is specially dressed in the *manto* on her feast day, September 7, when she heads a procession through the streets of the town of Regla. Lourdes López, in fact, has used the saints' garments and accessories "as a model" when she makes crowns and *ropa de santo*. She pointed to the large statue of La Virgen de las Mercedes (The Virgin of Mercy) atop her antique white *canastillero*, comparing the saint's crown to one she had recently made for Obatalá, the significant difference being one of detail (interview, Lourdes López, Feb. 21, 1987). Yet far from being "Catholic elements," the clothes and accessories of the saints are artfully recontextualized signs of prestige for the greater glory of Lucumí *orichas*.

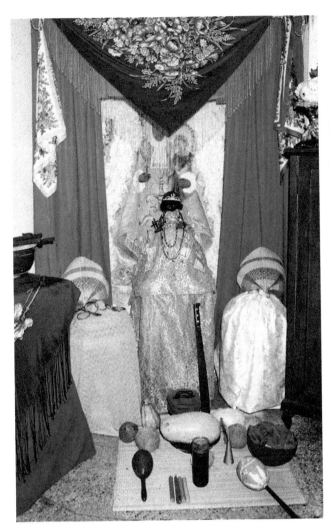

Figure 15. Throne for Yemayá, incorporating a tapestry of her Catholic counterpart, the Virgin of Regla. The skirt of a doll representing the Virgin covers Yemayá's sacred vessel. House of the "Sons of San Lazaro" of Enriquito Hernández Almenteros, La Hata, Guanabacoa, Havana, Cuba, 1989.

The flat, symmetrical, soaring architecture of church and domestic Catholic altars, in which the saint of honor is centered and supported by a constellation of angels and companion saints who also wear brocaded *mantos*, suggests itself as one important model for Lucumí thronework (Fig. 14).[48] Yet the means of throne construction are wholly different, employing cloth as opposed to stone or wood architecture.

At the same time, the Yoruba brought definite patterns of altar making to Cuba, whose organization was not inimical to Catholic forms. John Pemberton studied shrines for Eshu in Ila-Orangun, Nigeria:

> Some are large chambers which open upon a main corridor, with raised altars that can be seen through an entrance resembling a proscenium arch.... the pedestal is called *ijoko* Eshu ("seat of Eshu") and the calabash is simply referred to as *igba* Eshu ("calabash of Eshu").... Cloths of appropriate colors, dance vestments with long strands of cowrie shells, and dance wands hang on the wall behind the calabash, enhancing the importance of the central symbol just as a dossal frames the cross on a Christian altar.

(Pemberton 1975, 20–22)

Eshu's shrine is at once altar and throne, whose presentational form reminded Pemberton of something Western. Africans in the New World apparently found something in the material culture of the Cuban church and state which reminded them of something African.[49]

Recently documented examples of thrones in Cuba dramatically combine the foregoing sensibilities. In one a dossal bearing the image of the Virgin of Regla frames the elevated vessel of Yemayá covered by the protective, embracing blue skirts of a black doll that may be read multivocally as the Virgin herself (she carries a crucifix and the Christ child) and as a spirit doll representing a servant of Yemayá (Fig. 15). Bascom observed this up-down configuration of saint over *oricha*:

> While chromolithographs and plaster images of the Catholic saints are prominently displayed in the shrines and houses of the santeros, they are regarded as empty ornaments or decorations, which may be dispensed with. The real power of the *santos* resides in the stones, hidden behind a curtain in the lower part of the altar, without which no santería shrine could exist.

(Bascom 1950, 65)

The concealing of *orichas* with cloth of the saints may have been historically a strategy of defensive masking (Reisman 1970; Bastide 1978, 260; Metraux 1972: chap. 6; Thompson 1983, 18)—and still may represent a safely ambiguous front where persecution has not abated. But it has at the same time become traditionalized as a cherished mode of presentation in what emerged as a popular religion that located saints and *orichas* in distinct, sometimes parallel and sometimes hierarchical registers of spiritual being (see Murphy 1988, chap. 11; Wafer 1991, 14–15).

Figure 16. Decorative soup tureens (*soperas*) in a range of styles, available for sale in a U.S. *botánica*. The *soperas* are used to contain *oricha* secrets. Botánica Nena, Miami, Florida, 1984. *Photo By David H. Brown*

In some of the most "traditional" houses of *ocha* in Cuba, saint statues are highly prized. I dare anyone to try to take them away from their owners. Yet variant traditions do exist: some houses and ritual lineages emphasize the saints while others do not. Thrones I observed in New York, New Jersey, Miami, and some houses in Havana do dispense with the saints, resulting in far more abstract tableaux.

Historically, while individual creative choices were important in the emerging throne art of the nineteenth and twentieth centuries, these must be seen in the larger context of class and the international marketplace. What circle of options affected or constrained the rising style? To begin with, we see the vigorous nineteenth-century trade in mass-produced export-porcelain and luxury objects for the consumption of the emergent Cuban urban bourgeoisie made rich between 1820 and 1860 by slave-produced sugar (Faniel 1957; Thomas 1971). The versions of royal styles that this class copied from France and Spain (Thomas 1971, 142–48; Faniel 1957, 38)[50] became available for appropriation by Afro-Cubans because of an expanding marketplace.

The *sopera* (soup tureen), for example, became a prized object in Cuban homes of all classes, saturated with the meanings of domestic family nurture, well-being, and status. The *sopera* styles that became traditionalized in Afro-Cuban religion were the most popular oval and octagonal forms of the Chinese export trade and European-centered manufacture in the eighteenth and nineteenth centuries, mass-manufactured and shipped throughout the world increasingly in the first half of the nineteenth century. Copies of copies of the "original" styles remain universally popular (Fig. 16) (Fay-Halle & Mundt 1983, 11–12; Palmer 1976; Godden 1979).

In the nineteenth century also, the most lavish thrones and ritual garments appear to have utilized an extraordinary array of African adornments that were being imported in the "lucrative trade carried on by Canary Islanders who plied the West Coast of Africa to supply themselves with goods to sell to priests of the Lucumí cult and other African cults in Cuba" (Cabrera 1980, 176). Combining adornments such as African animal skins, horns, beads, cloths, rugs, and cowries, as well as European-derived luxuries, the thrones and garments of these late-nineteenth-century houses of *ocha* must have appeared as remarkably creative bricolaged assemblages. The logical extension of this international trading and marketing phenomenon in the twentieth century is the extraordinary specialized market for ritual goods, called the *botánica*, found in most major U.S. cities (Fig. 16).

With such a trade in mind we can revise the acculturative stereotype of irreversible dilution from some primordially pure state. Perhaps, bereft of African materials as a result of the Middle Passage, ritual assemblages were re-Africanized over the course of the nineteenth century (see Bastide 1978, 66, 165) even as they appropriated styles from the Cuban bourgeoisie. Urban ethnic culture can thus be renewed thanks to the marketplace rather than withering in the face of it (see Kirshenblatt-Gimblett 1983).

While it is clear that only the wealthiest houses of *ocha* could afford the most expensive trade objects, they may have set stylistic trends that were copied in budget media by the less fortunate. Cheaper objects nevertheless sent similar messages of prestige. Cabrera's informants reported that in nineteenth-century houses of *ocha* that initiated light-skinned creole women who were kept by wealthy Spanish gentlemen, the thrones were astonishing in their extravagance; while those in poorer houses were "nothing of luxury!," consisting of white sheets hung from the wall, often painted with floral designs (Cabrera 1980, 176–77). Shrines in more impoverished houses have relied upon brightly painted clay vessels *(tinajas)* (Fig. 8) or *chumbas* consisting of two bowls, one inverted as a lid (Ortiz 1973, 79), adding the highly prized *soperas* when possible. On the other hand,

certain orthodox houses may have have resisted creolizing trends by falling back on more "purely" African models, retaining, for example, the use of lidded natural calabashes instead of porcelain *soperas* (González Huguet 1968, 34).

What appears to us in this history—not forgetting, of course, powerful preservations of core practices—is a great chain of imitations, appropriations, borrowings, importations, and renovations across space, time, and class, given the largest context of global changes. It culminates, in our moment, with Lucumí thrones and garments made all the more luxurious by Cubans in the United States in the last three decades.

If these traditions have resulted from the process of Caribbean creolization and migration, it does not mean that other agents might not subject them to further shifts according to their own aesthetic and ethical demands. I have in mind the ideological agenda of Black Nationalism in the United States. The first black Americans initiated by Cubans in Matanzas in 1959 inaugurated a movement of black American Yoruba which has sought to "purify" the religion of European and Catholic elements, a strategy later called "Yoruba Reversionism" (Mason 1985, iv–v). Their wearing of Yoruba clothes and rejection of saint statues contributed to a split with New York Cuban priests (Hunt 1979, 27). Their changes can be seen as self-conscious relexifications in an ethical and ideological context in which elements of the Cuban creole tradition are seen as irrelevant or antagonistic to black American identity. Thus they decisively reworked their practice as a "neo-Yoruba" religion (Omari 1991), which departs radically from an aesthetic and cultural history that Cubans and other Latinos share.

Notes

This article is dedicated to the memory of the late Ramón Esquivél's masterful throne making. He died in the spring of 1993.

The work presented here represents a rewriting and rethinking of parts of chapters 1 and 7 of my Ph.D. dissertation in American Studies, directed by Robert Farris Thompson (D. Brown 1989). It derives in part from dissertation research conducted in New Jersey, New York, and Miami with the support of a pre-doctoral research grant by the Wenner Gren Foundation for Anthropological Research in 1987, from dissertation writing with support from the Charlotte Newcombe Fellowship (Woodrow Wilson Fellowship Foundation) in 1987–1988, and from research in Cuba in 1989 as part of a post-doctoral fellowship at the Office of Folklife Programs of the Smithsonian Institution.

I cannot thank enough the following priests and priestesses for their patience, cooperation, and generosity: Luís Castillo, Melba Carillo, Idalberto Cardenas, Lourdes López, Luís Bauzó, Ernesto Pichardo, Zenaida Villanueva Justíz, Hermes. Valera Ramírez, and the late Adolfo Fernández. I would also like to thank Judith Bettelheim and Donald Cosentino for encouraging me to seek publication of this material in *African Arts*, Michael A. Mason for reading and commenting upon a draft of this manuscript, and Ysamur Flores for giving me the opportunity to present the conference paper that contained the working version of my cultural history argument (the final section here) at his American Folklore Society panel in October 1992.

1. Santería means "the way of the saints." La Regla de Ocha means the "order of the o[ri]cha," *ocha* being a contraction of the Yoruba-derived word for deity. (A note on orthography: throughout I use the Spanish form *oricha* in Cuban contexts, which is how it is spelled and pronounced there, as well as the Spanish names for the deities—Ochún, Changó, etc.) Members of various Yoruba ethnic subgroups, brought to Cuba as slaves in the greatest numbers between the last decade of the eighteenth century and about 1865, were known as the Lucumí (or Lukumi) (Lachatañeré 1961:3). For data on numbers of Yoruba slaves that were taken to Cuba see Curtin 1969.

 The religion of the Lukumí, always ensconced and secret within the colonial period's *cabildos* (religious brotherhoods) and later houses of *ocha*, has been intermittently persecuted or ignored

until quite recently. From the 1940s to 1980 hundreds of thousands of Cubans emigrated to the United States in four major waves, the greatest numbers arriving following the installation of the current Cuban revolutionary government in 1959. Priest/throne maker Ramón Esquivél was one of those who arrived from Havana with the 1980 Mariel Exodus. More than one million Cubans now live in the United States (Clarke 1981; Dixon 1983, 1986). La Regla de Ocha has been established in New York, New Jersey, Miami, and California, as well as Puerto Rico, Venezuela, and Mexico.

2. Including Caribbean Cultural Center 1984; Miralda & Mason 1985; Abramson & Rodríguez 1985; Boza 1986; López & Keiro 1987; Lindsay 1992. Some of the constituent ritual objects (vessels, dance wands, clothwork and other Yoruba-derived iconography) have been studied and exhibited individually or documented in related domestic altar configurations, yet apart from their most dramatic presentation within thrones themselves (Cabrera 1983b; "Orichas" 1964; González Huguet 1968; Dombach 1977; Gómez Abreu 1982; Center for African Studies 1982; Thompson 1983; Bolívar Aróstegui 1990; Flores 1990).

3. However, I did much work in one house of *ocha* (also *casa de santo* or *ilé-ocha*) that was not a practitioner's home but a house exclusively dedicated to *ocha* ritual work.

4. *Igbodún* means "sacred grove of the festival" as translated from the Yoruba, a place for the receiving of spiritual power (see Brown 1989:272, fn. 30 for a developed etymology).

5. *Baldachins* were of silk and gold thread, rich brocade, suspended from the roof, supported on columns, or projected from walls.

6. I say "three main" configurations or types, yet the throne form has influenced other functionally distinct rituals. The throne form was used by Ramón Esquivél to fete a Palo Monte (Kongo-Cuban) spirit. At the same time, a throne is not always erected for a birthday, where economic means and other factors may be at play.

7. See Turner 1967 and 1969 for the theoretical and ethnographic use of these terms which form the tripartite moments of the "rite-of-passage" model: separation, liminality, reincorporation. In Lucumí religion, the initiate's ritual at the "river" the night before the main initiation rites might be seen to mark the beginning of his/her "separation"; entering the room, the formal commencement of his/her "liminality"; and the trip out of the house to the market, the moment of "reincorporation." While the term *asiento* can refer generally to the whole weeklong period/process of initiation, it more strictly refers to the key ritual events of the initiate's first full day in the room, the Day of the Asiento or "coronation," followed by the Día del Medio (Middle Day) and the Día del Itá, a day of intensive divination. See D. Brown 1989:chaps. 3, 4, 7 for more detailed description, as well as Cabrera 1980, Brandon 1983, Murphy 1988.

8. I am indebted to Brandon (1983:388) for a way to describe these proceedings in terms of the controlling metaphors of bride, king, and infant. *Iyawó* is a surviving Yoruba ritual metaphor which in Africa situates the structurally feminized body of the initiate as subject to the penetration of the structurally male and ruling *òrìsà* (see Matory 1986; 1991:pt. 3, chap. 11, app. 6).

9. Traditionally, Oyá is "received" along with Yemayá, Changó, and Ochún when Obatalá is "made." She may or may not be represented with her own *paño* on an *asiento* throne. In any case, the four colors—white, blue, red, yellow—not only represent particular *orichas* but also can signify groups of like temperament. For example, red can stand for, evoke, and invoke warriors and generally "hot" *orichas* such as Eleguá, Ogún, Changó, Agayú, Oyá; blue may do so for Yemayá and Ochósi, as in the ceremony of painting the head during the *asiento* (see Ecun 1985:210, 66; Angarica n.d.:72–73).

10. The maker was Antonio Queiro (also spelled Keiro), according to exhibition brochures (Caribbean Cultural Center 1984, López & Keiro 1987).

11. In the Cuban-Lucumí ritual idiom the guardian angel is said to be "made," while the others are "received." The identity of the *oricha* to be made determines which are received. Most *iyawós* emerge with Obatalá, Yemayá, Changó, and Ochún, and some, additionally, with Oyá or Agayú. All have already received their Eleguá, Ogún, and Ochósi in prior rituals, and possibly other *orichas* like Olokun and St. Lazarus (Babalú Ayé). See Brown 1989, chaps. 3, 7; and Ecun 1985.

12. See Barnes (1989) for discussion of these roles in Africa as played by Ogún; Thompson (1983:18–33, 52–60) on relationships between Elegba, Ogun, and Oshosi; Karen Brown (1989) on Ogun's military history in Haiti; Murphy (1988:70–73) on these three "warriors."

13. In Lucumí they are called *iruke* (flywhisk), *abebé* (fan), *oché-changó* (thunder axe), *adá-ogún* (sword of Ogún). There are nuances and exceptions to these characterizations that are too extensive to

be covered here. For example, Changó is also seen as a *guerrero;* there are younger and more aggressive roads of Obatalá that carry swords; and Oyá can fight carrying a machete.

14. See discussions of the West African Yoruba *ogo-elegba* in Wescott 1962, Pemberton 1975, and Thompson 1976; and its manifestation as an Afro-Cuban hooked staff in Thompson 1983:32.

15. *Garabato* and machete in concert evoke concretely one of the ways Eleguá and Ogún may be seen to "work" together. The hook permits Eleguá, the trickster and glutton, to trip up unsuspecting travelers and grab what he wants. The traditional Afro-Cuban *campesino's* straw hat (*yaréy*) and the rustic sidebag (*cartera*) of goat hide (*chivo*) mark this Eleguá as a rural-dweller from outside the "town." Ochósi, the Hunter, carries a sidebag of deer hide.

16. There is one silver bracelet for Obatalá, and then nine copper for Oyá, seven silver for Yemayá, and five brass for Ochún. The system of bracelet coding/wearing is too complex to elaborate upon here. However, it can be said that Oyá's bracelets and Yemayá's are never worn on the same wrist as they are antagonists. Obatalá's is always worn on the left wrist. People who make male *orichas* do not wear the bracelets under the throne. People who make female *orichas* do wear the bracelets, but of them only the women wear them later, on the street.

17. *Mazos* are not always available or affordable, as in contemporary Cuba; for example, *mazos* are not seen in Figure 8 over the *soperas.* They are sold, in abundance, at *botánicas* in U.S. cities, at prices ranging from $65 to over $100. Beadworker and priestess Melba Carillo understands the *mazo* as the descendant of the cascades of cowrie shells worn by priests/deities "in Africa" which she has seen in photographs. Examples of cascading cowries are seen in the art of Eshu-Elegba (see Pemberton 1975) and Oshumare (Verger 1954). With respect to clusters of beads, William Bascom notes that priests of certain orisha wear "large bunches of beads ("ìdíleke") around their waists, walk up and down until they are possessed by the deity" (1944:35).

18. I arrived at the approximation of three pounds by picking up several examples and comparing their weights against my three-pound Nikon F2 camera. The number 12,000 comes from a study of one example in which I counted its constituent beads. It actually had 12,615 beads (see Fig. 3).

19. The term *moña* was taught to me by beadworker and Obatalá priestess Melba Carillo of New York. The *moña principal* is formed when the two extremes of a length of beaded strands is brought together and threaded through a *gloria*—sometimes a triad of *glorias.* A *mazo* for Ochún, which is based on fifteen strands (her number 5 × 3), results in a *moña principal* of thirty strands. This *mazo* will have five main segments junctioned by five main *glorias.* With the *moña principal* already formed by the joining of the circle, each of the remaining four *moñas* is then tied to the main circle at each of the four junctions, so that each appears to emanate from one of the large main *glorias.* A *collar de mazo* for Obatalá-Ayáguna (Fig. 3), whose colors are white punctuated by red and whose basic number is 8 (and related multiples 16, 24, 32), is comprised of a main circle of sixteen strands with eight main *glorias* and eight *moña.* Its *moña principal* has thirty-two strands. A *mazo* for Yemayá would have seven *moñas* and bead-strand clusters/patterns in multiples of the number 7; Changó, six and its multiples, in red and white; Ochún, five, beaded in yellow and amber with punctuations of red or green; Oyá, nine, in brown or caramel beads with black and white stripes; Elegua, three, in red and black.

20. Robert Farris Thompson writes: "The gods of the Yoruba long ago chose beaded strands as emblems.... Indeed the prerogative of beaded objects is restricted to those who represent the gods, kings and priests; and those with whom the gods communicate, kings, priests, diviners, and native doctors" (Thompson 1970:8).

21. In a pre-initiatory ritual called the "first *prendición,*" according to Cabrera, the neophyte, when "distracted" and "least expecting it," is snared with the white *mazo* of Obatalá (Cabrera 1980:146–47). Obatalá's *mazo* is used because he is the arch-divinity who has authority over, or "owns all" heads.

22. *La presentación at tambor* is a procession of the *iyawó* entailing the initiate's delivery of a tribute (*derecho*) to the sacred *bata* drums (*tambores de añá* or *de fundamento*), a ritual submission to the drums and ritual elders, and finally, the initiate's dancing for the first time before the drums. All this is dedicated to authorizing the *iyawó* to actively participate in drumming rituals that can involve spirit possession (for those destined to become possessed). Only two *mazos* are worn of the oricha-mother and -father, crisscrossed over the chest for the *presentación al tambor.*

23. See Matory 1986 and 1991 for brilliant discussions of the role of bodies and vessels as structurally homologous forms of containment of spiritual power.

24. However, exceptions have been made here and in Cuba for exhibitions and folkloric performances by cultural institutions. The former is, of course, the source of Figures 2, 6, 7.

25. *Addimú-orichas* received may include Olokun, St. Lazarus, the Ibeyi (twins), Oricha-Oko, Obba, Odúa (Oduduwa), and Dadá, among others (see Brown 1989, chap. 3).

26. This continues the tradition Karin Barber documents in Yorubaland: "Each devotee concentrates on her own *òrìsà* and tries to enhance its glory through her attentions. This involves not only making offerings and chanting *oriki*, but also spending money as lavishly as possible on their day to give the feast. In return, the *òrìsà* is asked to give blessings and protection.... Personal magnificence enhances reputation: it is the outward sign of greatness, and is described in images of riches, sumptuous garments, beads, beauty, elegance, graceful dancing, and so on." With these visual and verbal praises, the devotee's "concern is...to elevate and enhance her own [*òrìsà*] so that it will be able to bless and protect her... . [I]t is the devotees who spend conspicuously to increase the prestige of their *òrìsà*. Indeed, the devotee seems here to be combining the roles of supporter and Big Man. He adulates his *òrìsà*. and by doing so increases his own stature" (Barber 1981:735–37).

27. If a male *ángel de guarda* was made, the initiate "received" a female *oricha* as second parent or "mother" from the original group. If the *ángel de guarda* was female, the initiate received a *male* second parent or "father"—as determined by divination.

28. In the case of sacred *bata* drums, which are considered to embody an *oricha* in their own right (the spirit Añá), the drums, in effect, become an altar/part of the throne-as-altar. Drummings may variously, as the occasion demands, employ the goblet-shaped, double-headed sacred *bata* drums called *fundamentos;* unconsecrated *bata* drums called *aberinkulá;* a *güiro* ensemble of gourd shakers called *chekere* or *güiros*, conga, and bell; or even a violin ensemble to play sweet romantic music for Ochún *(las violinas para Ochún)*. For detail and analysis of Lucumí drumming celebrations, see Robert Alan Friedman's fine study of drumming, drummers, and ritual performance in Lucumí religion (Friedman 1982).

29. I have encountered cases of drummings added to birthday festivities where drumming proceeds before the birthday throne type.

30. Oyá and Ochún are the only two *orichas* that wear metalwork crowns, apparently because they are the two, sometimes competing, wives and queens of Changó. There are, however, examples of silver crowns for Yemayá in Cuban ethnographic collections (The Fernando Ortiz Collection of the Casa de Africa in Havana). The program of brass (Ochún), copper (Oyá) and silver (Yemayá) crowns for these three female *orichas* is identical to that found in the Brazilian Candomblé (see Carybé 1980).

31. Oyá's crown bears the tools of Ogún's forge, in copper, while Ochún's has five brass depending oars or bracelets.

32. *Oricha* objects are produced in a substantial cottage industry that draws on the Garment District for bulk beads and cloth of startling variety, and on *botánicas* and specialty stores for the objects used by the *orichas*. Tourist-industry figurated flywhisks, carved statues, and Asian masks are drawn from specialty importers of African and Oriental objects. The metalwork *(herramientas)* in brass, copper, and iron, such as the bracelets of Oyá, Yemayá, and Ochún, the tools of Ogún, and the crowns of Oyá and Ochún, is forged in small workshops and apparently then sold to larger outlets such as Almacenes Shangó ("Shango's Warehouse") on Madison at 111th Street in Manhattan.

33. It is interesting to note that in the U.S. more commonly available fruits combine with more specialized tropical fruits that ethnically diversifying supermarkets are increasingly carrying, which were more traditionally used in Cuba. See Angarica (n.d.:87–89) for a list of fruits and foods traditional for the *orichas* prior to 1955 in Cuba, many of which are not found or used in the United States.

34. For developed studies of *oricha* food, see Edwards & Mason 1981 and Miralda & Mason 1985.

35. I coined the term "thronescape."

36. The crown of Dadá is composed of alternated concentric bands of cowries and beads—four bands of cowries with one in the center at the very top, four bands of rows of beads. From widest band to center: A) cowries; B) four rows of red and white beads in the pattern 2W/4R/2W/4R, etc.; C) five rows of red and white in the pattern 2W/2R/2W/2R, etc.; D) cowries; E) four rows of red and white in the pattern 2W/4R/2W/4R, etc.; F) cowries; G) four rows of 2W/4R/2W/4R, etc.; H) finally a single cowrie at its zenith. Each "leg" of fringe consists of twelve cowries divided by units of red and white beads in the pattern 2R/2W/2R/2W/2R/2W/2R/2W, twelve units in all.

37. The bat, an emblem of phallic shape and great force, is used by Changó to enforce justice and defend his children, as he often also does with a whip (interview, Melba Carillo, Aug. 17, 1985).

38. In Cuba Dadá is called La Corona de los Santos ("The Crown of the Saints") and La Hermana de Changó ("Changó's Sister") in La Regla de Ocha. The relatively rare Afro-Cuban Dadá is the last of a series of auxiliary *orichas* received by senior priests. She is often called Bañaní inter-changeably. In Yorubaland the crown, called *baàyòn:nì*, is worn only by priests of Shango, while in Lucumí Afro-Cuban religion, priests of any *oricha* can receive the crown if necessary.

39. I am inspired here by Thompson's discussion of artistic representations of the descent of Shango's lightning (Thompson 1983:84–97). I went to Cuba for the first time in 1986 and took photographs of examples of Changó mortars and vessels in the collection of Fredesvinda Rosell, which were on exhibit at the Museum of Fine Arts in Havana and in her own small ethnographic museum in Madruga, east of Havana. Esquivél saw these photographs following my return during that summer. In the spring of 1986 he painted the vessel and pedestal, which were then unveiled on his friend's birthday throne of August 17, 1987, in Union City, New Jersey.

40. I am grateful to my colleague Alice Jarrard for these observations.

41. My thoughts here emerged in conversations with my colleague Michael A. Mason, who originally suggested the Armstrong text to me.

42. "Grammatically animate" means to me a *subject* of discourse, a spiritual interlocutor endowed with independent agency to effect change and mount bodies in order to act, heal, speak, and so forth.

43. My thoughts on the circulation and exchange of objects have been shaped by Appadurai 1986.

44. As an example of royal etiquette, Cabrera reported that following the coronation ceremony, "[around] [t]he *iyawó*, now installed on the *apotí* [mortar], with barefeet, the Iyalochas sit on the mat, also barefoot, and there [the *iyawó*] remains like a king surrounded by his court, until sundown, receiving homage from those who come to salute him and deposit, in a calabash placed before him on the ground, a tribute of money" (Cabrera 1980:177).

45. Conjoined here are two distinct but related notions, one the "royalty" of the gods as founder-kings, and the other the divinity of Yoruba kings themselves; the former is an earthly metaphor that images divinity, and the latter a heavenly metaphor that officially authorizes the king's power.

46. Mintz and Price argue that syncretism or creolization occurred between African peoples in the New World as much as it ever did, if at all, between Africans and Europeans (Mintz & Price 1976).

47. One wonders if it always was displayed in this way or if the church (re)appropriated this manner of display as a strategy of cooptation to draw *santeros* into the church and stress the primacy of the Virgin over Yemayá.

48. The elaborate domestic shrine for Our Lady of Charity (Caridad de Cobre) (Fig. 14) in an eclectic but predominantly neoclassical style occupies the front room, facing the street, in the house of a famous deceased *santero*, Rigoberto Rodríguez, in Madruga, outside Havana.

49. The Yoruba conception of altar clearly bears the double reference of place of sacrifice and throne of dignified authority. The Yoruba term for "sacrificial altar"—the place in the shrine where offerings are made—is *ojú ebó* (literally "face" [*ojú*] + "sacrifice" [*ebo*]). *Ojú* can mean "face," "eye," "mouth," "presence," "surface," "edge" in different contexts, all relevant considerations for the nature of an altar as a mediating threshold, a place of encountering a deity in relation to whom "speaking," and "eating" are potent metaphors. See Abraham 1946:460–62, and Thompson 1983:58. Thompson, inspired by the meanings of *ojú ebó*, has taught Yale Seminars in Yoruba Art called "Face of the Gods," which I was privileged to take. Yoruba linguist Michael Oladejo Afolayan translates *ojú* as "throne" in this fragment of praise poetry collected by Apter: "Bí Olókun lé mi legbee / ó ye yín yeye lójú òdee" ("Walking with self-composed dignity like Olokun/ It befits you and befits the *throne* in the open place") (Apter 1987:261).

50. To express their new elevation the Cuban bourgeoisie bought royal titles for tens of thousands of dollars, were "'indolently fond of rich and gaudy furniture and apparel'" and spent "great sums... on houses, fountains, renaissance ceilings, marble staircases, and baths.... Next to the [Moorish] palaces of the 16th and 17th centuries, and baroque adaptations of the 18th, there now arose classical palaces inspired by the French Revolution" (Thomas 1971, 142,146–48).

References cited

Abraham, R. C. 1946. *Dictionary of Modern Yoruba.* London, Sydney, Auckland, Toronto: Hodder & Stoughton.

Abrahams, Roger. 1983. *The Man-of-Words in the West Indies: Performance and the Emergence of Creole Culture.* Johns Hopkins Studies in Atlantic History and Culture. Baltimore, London: The Johns Hopkins University Press.

Abrahams, Roger D. and John F. Szwed. 1983. *After Africa: Extracts from British Travel Accounts and Journals...* New Haven: Yale University Press.

Abramson, Charles and Jorge Rodríguez (artists). 1985. "Orisha/Santos: An Artistic Interpretation of the Seven African Powers." Exhibition. Writers: Leval Torruella, Susana, Cynthia Turner, and Robert Farris Thompson. New York: Museum of Contemporary Hispanic Art (MOCHA).

Aimes, Huber H. S. 1905. "African Institutions in America," *Journal of American Folklore* 8:15–32.

Angarica, Nicolas Valentin. N.d. [1955]. *Manual de Orihate: Relígión Lucumí.* Havana.

Appadurai, Arjun. 1986. "Introduction: Commodities and the Politics of Value," in *The Social Life of Things: Commodities in Cultural Perspective,* ed. Arjun Appadurai. Cambridge, MA: Cambridge University Press.

Apter, Andrew. 1992. *Black Critics and Kings: The Hermeneutics of Power in Yoruba Society.* Chicago: University of Chicago Press.

Apter, Andrew. 1987. "Rituals of Power: The Politics of Orisha Worship in Yoruba Society." Ph.D. dissertation, Yale University.

Armstrong, Robert Plant. 1981. *The Powers of Presence: Consciousness, Myth, and Affecting Presence.* Philadelphia: University of Pennsylvania Press.

Barber, Karin. 1981. "How Man Makes God in West Africa," *Africa* 5, 3:724–44.

Barnes, Sandra (ed). 1989. *Africa's Ogun: Old World and New.* African Systems of Thought. Bloomington: Indiana University Press.

Bascom, William. 1980. *Sixteen Cowries: Yoruba Divination from Africa to the New World.* Bloomington: Indiana University Press.

Bascom, William. 1952. "Two Forms of Afro-Cuban Divination," in *Acculturation in the Americas,* ed. Sol Tax. 3 vols. Proceedings and Selected Papers of the XXIX International Congress of Americanists, vol. 2. Chicago: University of Chicago Press.

Bascom, William. 1950. "The Focus of the Cuban Santeria," *Southwestern Journal of Anthropology* 6,1:64–68.

Bascom, William. 1944. *The Sociological Role of the Yoruba Cult Group.* Titles in the Memoir Series of the American Anthropological Association, no. 63. Menasha, WI: American Anthropological Association.

Bastide, Roger. 1978. *The African Religions of Brazil: Toward a Sociology of the Interpenetration of Civilizations,* trans. Helen Sebba. Johns Hopkins Studies in Atlantic History and Culture. Baltimore: Johns Hopkins University Press.

Bastide, Roger. 1972. *African Civilizations in the New World,* trans. Peter Green. New York: Harper & Row, Harper Torchbooks.

Bolívar Aróstegui, Natalia. 1990. *Los orichas en Cuba.* Havana: Ediciones Unión, Unión de Escritores y Artistas de Cuba.

Bourdieu, Pierre. 1977. *Outline of a Theory of Practice,* trans. Richard Nice. Cambridge Studies in Social Anthropology, vol. 16. Cambridge: Cambridge University Press.

Boza, Juan (artist). 1986. "Afro-Cuban Altars by Juan Boza." Exhibition, Oct. New York: Caribbean Cultural Center.

Brandon, George E. 1983. " 'The Dead Sell Memories': An Anthropological Study of Santería in New York City." Ph.D. dissertation, Rutgers University.

Bremer, Fredrika. 1853. *The Homes of the New World: Impressions of America,* trans. Mary Howitt. 2 vols. New York: Harper Bros.

Brown, David. 1989. "Garden in the Machine: Afro-Cuban Sacred Art and Performance in Urban New Jersey and New York." Ph.D. dissertation, Yale University.

Brown, Karen McCarthy. 1989. "Systematic Remembering, Systematic Forgetting: Ogou in Haiti," in *Africa's Ogun: Old World and New,* ed. Sandra Barnes, pp. 65–89. African Systems of Thought. Bloomington: Indiana University Press.

Burgess-Polcyn, Yvette. 1986. "Dobale: Respect Gesture as Greeting Ritual." Paper Presented at the Third International Conference on Orisha Tradition. New York.

Cabrera, Lydia. 1983a. *Anagó: Vocabulario Lucumí (el Yoruba que se habla en Cuba)*. Miami: Ediciones Universal.

Cabrera, Lydia. 1983b [1954]. *El monte: Igbo-finda ewe orishavititi nfinda; notas sobre las religiones, la magia, las superstitiones, y el folklore de los Negros criollos y el pueblo de Cuba*. Miami: Colección del Chicherekú en el Exilo.

Cabrera, Lydia. 1980. *Yemayá y Ochún*. New York: C. R. Publishers.

Caribbean Cultural Center. 1984. "Orisa/Orixa/Orisha// Africa/Brazil/New York: An Exhibition on the Survival of African Belief Systems among Yoruba Descendants in the Americas." Exhibition. Comp. Marta Moreno. New York: Caribbean Cultural Center.

Carybé. 1980. *Iconografía dos Deuses Africanos no Candomblé da Bahia*. Salvador, Bahia, Brazil: Fundação Cultural do E. da Bahia, Institute Nacional do Livro Universidade Federal da Bahia.

Center for African Studies. 1982. *Thunder over Miami: Ritual Objects of Nigerian and Afro-Cuban Religion*. Center for African Studies, University of Florida.

Centro del Rosario. N.d. *Modo de rezar el rosario*.

Clarke, Juan M. 1981. *The 1980 Mariel Exodus: An Assessment and Prospect: A Special Report*. Washington, DC: Council for Interamerican Security.

Curtin, Philip D. 1969. *The Atlantic Slave Trade: A Census*. Madison: University of Wisconsin Press.

Decamp, David. 1971. "Introduction: The Study of Pidgin and Creole Languages," in *Conference on Pidginization and Creolization*, ed. Dell Hymes, pp. 13–39. Cambridge: Cambridge University Press.

Dixon, Heriberto. 1986. "The Cuban-American Counterpoint: Black Cubans in the United States." Unpublished paper delivered at the International Symposium on the Cultural Expression of Hispanics in the United States. Paris.

Dixon, Heriberto. 1983. "An Overview of the Black Cubans among the Mariel Entrants." ERIC Documents (ED 233104).

Dornbach, Maria. 1977. "Gods in Earthenware Vessels," *Acta Ethnographica Scientiarum Hungaricae* 26, 3–4:285–308.

Douglas, Mary. 1978 [1969]. *Purity and Danger: An Analysis of Concepts of Pollution and Taboo*. London: Routledge & Kegan Paul.

Drewal, Henry John, John Pemberton III, and Rowland Abiodun. 1989. *Yoruba: Nine Centuries of African Art and Thought*. New York: Center for African Art in association with Harry N. Abrams, Inc.

Drewal, Margaret. 1989a. "Dancing for Ogun in Yorubaland and Brazil," in *Africa's Ogun: Old World and New*, ed. Sandra Barnes, pp. 199–234. African Systems of Thought. Bloomington: Indiana University Press.

Drewal, Margaret. 1989b. "Yoruba Reversionism in New York." Conference paper presented at Cultural Vibrations: Transformations and Continuities in the Yoruba Diaspora, Gainesville, FL, April 27–28. 54 leaves. Collection of Warren Robbins Library, National Museum of African Art, Washington, DC.

Ecun, Oba (Cecilio Pérez). 1989. *Ita: Mythology of the Yoruba Religion*. Miami: Obaecun Books.

Ecun, Oba (Cecilio Pérez). 1985. *Oricha: Metodologia de la religion Yoruba*. Miami: Editorial Sibi.

Edwards, Gary, and John Mason. 1985. *Black Gods: Orisa Studies in the New World*. Brooklyn, New York: Yoruba Theological Archministry.

Edwards, Gary and John Mason. 1981. *Onje fun orisa (Food for the gods)*. New York: Yoruba Theological Archministry.

Eliade, Mircea. 1959 [1957]. *The Sacred and the Profane: The Nature of Religion*, trans. Willard R. Trask. New York: Harcourt Brace.

Elizondo, Carlos. N.d. [1934]. *Manual de la religion Lucumí*. New Jersey.

Faniel, Stephane. 1957. *French Art of the Eighteenth Century*. New York: Simon & Schuster.

Fay-Halle, Antoinette and Barbara Mundt. 1983. *Porcelain of the Nineteenth Century*. New York: Rizzoli.

Flores, Ysamur M. 1990. " 'Fit for a Queen': Analysis of a Consecration Outfit in the Cult of Yemaya," *Folklore Forum* 1, 2:47–56.

Friedman, Robert Alan. 1982. "Making an Abstract World Concrete: Knowledge. Competence, and Structural Dimensions of Performance among Bata Drummers in Santería." Ph.D. dissertation, Indiana University.

Gates, Henry Louis, Jr. 1988. "The Signifying Monkey and the Language of Signifyin(g): Rhetorical Difference and the Orders of Meaning" (chap. 1), in *The Signifying Monkey: A Theory of African-American Literary Criticism*, 44–88. New York: Oxford University Press.

Gleason, Judith. 1987. *Oya: in Praise of the Goddess.* Boston: Shambhala.

Godden, Geoffrey A. 1979. *Oriental Export Market Porcelain and Its Influence on European Wares.* London, New York: Granada.

Gómez Abreu, Nerys. 1982. "Estudio de una Casa Templo de Cultura Yoruba: El Ile-Ocha Tula," *Islas* 71:113–38.

González Huguet, Lydia. 1968. "La Casa-templo en la Regla de Ocha," *Etnologia y Folklore* 5 (Jan.-June): 33–57.

González Wippler, Migene. 1982. *The Santería Experience.* New York: Original Publications.

Handler, Richard and Jocelyn Linnekin. 1984. "Tradition, Genuine or Spurious," *Journal of American Folklore* 97, 385:273–90.

Hunt, Carl. 1979. *Oyotunji Village: The Yoruba Movement in America.* Washington, DC: University Press of America.

Idowu, E. Bolaji. 1963. *Olodumare: God in Yoruba Belief.* New York: Frederick A. Praeger.

Jackson, Michael. 1989. *Paths toward a Clearing: Radical Empiricism and Ethnographic Inquiry.* Bloomington, Indianapolis: Indiana University Press.

Kirshenblatt-Gimblett, Barbara. 1983. "The Future of Folklore Studies in America: The Urban Frontier," *Folklore Forum* 16 (winter):185–234.

Lachatañeré, Romulo. 1961. "Nota Historica sobre los Lucumí," *Actas del folklore* 1 (Feb.):3–12.

Lindsay, Arturo (artist). 1992. "New Work by Arturo Lindsay: Las Siete Potencias: Mestizaje and the Aesthetics of Santería." Exhibition, July-Sept. Atlanta: Chastain Gallery.

López, Lourdes and Antonio Keiro (artists). 1987. "Ritual Dress of Initiation Designed and Constructed by Lourdes López and Antonio Keiro." Exhibition, May 8–June 13. New York: Caribbean Cultural Center.

Mason, John. 1985. *Four New World Yoruba Rituals.* Brooklyn, NY: Yoruba Theological Archministry

Matory, James Lorand. 1991. "Sex and the Empire That Is No More: A Ritual History of Women's Power among the Oyo-Yoruba." Ph.D. dissertation, The University of Chicago, Dept. of Anthropology. 2 vols.

Matory, James Lorand. 1986. "Vessels of Power: The Dialectical Symbolism of Power in Yoruba Religion and Polity." M.A. thesis, The University of Chicago, Dept. of Anthropology.

Metraux, Alfred. 1972 [1959]. *Voodoo in Haiti,* trans. Hugo Charteris. New York: Schocken Books.

Mintz, Sidney W. and Richard Price. 1976. *An Anthropological Approach to the Afro-American Past: A Caribbean Perspective.* ISHI, Occasional Papers in Social Change, no. 2. Philadelphia: Institute for the Study of Human Issues.

Miralda, Antonio (artist) and John Mason (writer). 1985. *Santa comida/holy food.* Exhibition catalogue, in collaboration with John Mason. New York: El Museo del Barrio.

Murphy, Joseph. 1988. *Santería: An African Religion in America.* Boston: Beacon Press.

Ornari, Mikelle Smith. 1991. "Completing the Circle: Notes on African Art, Society, and Religion in Oyotunji, South Carolina," *African Arts* 24 (July):66–75, 96.

Orichas de Cuba. 1964. *Cuba: Revista mensual* Nov: 34–45.

Ortiz, Fernando. 1973 [1906]. *Los Negros Brujos: Apuntes para un estudio de etnología criminal.* Miami: Ediciones Universal.

Ortiz, Fernando. 1952. *Los instrumentas de la música Afrocubana.* Havana: Publicaciones de la Dirección de la Cultura del Ministerio de Educación.

Ortiz, Fernando. 1921. "Los cabildos Afrocubanos," *Revista Bimestre Cubana* 16 (Jan.-Feb.):5–39.

Palmer, Arlene. 1976. *A Winterthur Guide to Chinese Export Porcelain.* New York: Winterthur/Rutledge.

Palmie, Stephan. 1989. "Ethnogenetic Processes and Cultural Transfer in Afro-American Slave Populations." Unpublished Conference Paper.

Pemberton, John. 1975. "Eshu-Elegba: The Yoruba Trickster God," *African Arts* 9, 1 (Oct.):20–27, 66–70, 90–92.

Price, Sally and Richard Price. 1980. *Afro-American Arts of the Suriname Rain Forest.* Los Angeles: Museum of Cultural History/University of California Press.

Reisman, Karl. 1970. "Cultural and Linguistic Ambiguity in a West Indian Village," in *Afro-American Anthropology: Contemporary Perspectives,* eds. John F. Szwed and Norman Whitten. New York: The Free Press.

Scott, Rebecca Jarvis. 1985. *Slave Emancipation in Cuba: The Transition to Free Labor. 1860-1899.* Princeton: Princeton University Press.

Smith, Robert S. 1969. *Kingdoms of the Yoruba.* Great Britain: Methuen & Co.

Thomas, Hugh. 1971. *Cuba: The Pursuit of Freedom.* New York: Harper & Row.

Thompson, Robert Farris. 1983. *Flash of the Spirit: African and Afro-American Art and Philosophy.* New York: Random House.

Thompson, Robert Farris. 1976 [1971]. *Black Gods and Kings: Yoruba Art at UCLA.* Bloomington: Indiana University Press.

Thompson, Robert Farris. 1970. "The Sign of the Divine King," *African Arts* 3, 3:8–17, 74–80.

Turner, Victor. 1967. "Betwixt and Between: The Liminal Period in *Rites de Passage,*" in *The Forest of Symbols: Aspects of Ndembu Ritual,* pp. 93–111. Ithaca, London: Cornell University Press.

Turner, Victor. 1969. *The Ritual Process: Structure and Anti-structure.* Symbol, Myth, and Ritual Series. Ithaca: Cornell University Press.

Verger, Pierre. 1954. *Dieux d'Afrique culte des orishas et vodouns à l' ancienne Côte des Esclaves en Afrique et a Bahia, la Baie de tous les saints au Bresil.* Paris: Paul Hartmann Editeur.

Wafer, Jim. 1991. *The Taste of Blood: Spirit Possession in the Brazilian Candomblé.* Philadelphia: University of Pennsylvania Press.

Wescott, Joan. 1962. "The Sculpture and Myths of Eshu-Elegba, the Yoraba Trickster," pp. 336–54.

Without One Ritual Note:
Folklore Performance and the Haitian State, 1935–1946

Kate Ramscy

During a roundtable discussion focused on the early history of Haitian staged folklore performance that took place in Port-au-Prince in April 1997, one panelist noted that the so-called *mouvement folklorique* had "really begun" under the post–U.S. occupation presidency of Elie Lescot (1941–46). Another then observed that "paradoxically, you also had under Lescot the *kanpay rejete*," the Roman Catholic Church's violent crusade against "superstition," which the state backed in 1941–42 with military force.[1] This article focuses on the logic of that historical conjunction, examining official cultural nationalist policy in Haiti during the late 1930s and early 1940s in relation to the postoccupation legal regime against *les pratiques superstitieuses* (superstitious practices).

The latter was a new penal category instituted by Lescot's predecessor, Sténio Vincent, a year after the end of the nineteen-year U.S. military occupation of Haiti in the summer of 1934. Repealing the longstanding legal prohibition against *les sortilèges* (spells), Vincent's government tightened the official interdiction of particular forms of popular ritual, but also, for the first time, affirmed the right of peasants to organize "popular dances." The article explores the implications of that legal formulation through a close study of the Haitian state's initial civil and military support for the Roman Catholic Church's so-called *campagne anti-superstitieuse* (antisuperstition campaign), while it annexed "folklore," and particularly choreographic constuctions of ritual dance, as official national signs.

Throughout the article, I will also consider how practitioners of the Vodou religion negotiated their own participation in the codification and performance of folklore at a moment when popular ritual practices were subject to repression on the part of both state authorities and the Catholic Church in Haiti.[2] My research on what became collectively known as the *mouvement folklorique* in the early 1940s suggests that a number of *sèvitè* ("servitors" of the spirits) were instrumentally involved in the construction of the folk, whether working as informants to ethnologists and theater directors, drumming for official presentations of music and dance folklore, or performing in independent folklore events in Port-au-Prince. How certain *sèvitè* may have used their involvement in the production of folklore to protest persecution by the church and state during these years will be a key focus of the pages that follow.

"Better Than the Laws Which Can Only Be Borrowed Finery"

Imperial myths of peasant ritualism had never been so highly charged as on the eve of the U.S. military departure from Haiti in August 1934. However, neither had Haitian popular cultures ever been so forcefully figured as the matrix for Haitian national identity. During the occupation, an intense nationalist concern for the ethnological study and literary representation of the folk developed in Haiti among young urban intellectuals and writers.[3] Carl Brouard, a poet and one of

Reprinted with permission from *Radical History Review* 84 (Fall 2002): 7–42.

the cofounders of the short-lived landmark literary journal, *La Revue indigène*, later characterized the iconoclastic "new school" as having been a reaction against the "too servile imitation" of European models that, he and others charged, had stunted the development of Haitian arts and letters up until that time.[4] The proponents of what became known as *indigénisme* defined their break with the past by figuring popular cultures as the proper source and subject for the building of a national literature. Michel Buteau notes that while there had been earlier efforts to establish a national literary school based on popular themes, most significantly that advanced by Pierre Nau in the 1830s, none of these initiatives exerted the political force that *indigénisme* would, particularly on state policy. "Above all," Buteau writes, "*indigénisme* changed the terms of the debate."[5]

No one was more influential in the project of reevaluating Haitian popular cultures toward national ends than Jean Price-Mars, medical doctor, teacher, statesman, and founder of what became the Haitian school of ethnology. Born in 1876 at Grande Rivière du Nord, Price-Mars was a generation older than most of the self-identified *indigénistes* and not himself a poet. But he galvanized the movement through his persistent public critique of the Haitian elite's failure to unite the country. In 1928, a number of his lectures were published as *Ainsi parla l'oncle* [So spoke the uncle], Price-Mars's classic study of Haitian folklore and popular traditions.[6] In this enormously influential work, which a group of his students later called "the basic book of our folklore," Price-Mars attacked the elite's cultural identification with France and the West more generally at the expense of "all that is authentically indigenous—language, customs, sentiments, beliefs."[7] He charged that the persistence of this *"bovarysme collectif"* precluded the possibility of national unity, and had weakened the state to such a degree that Haiti was left vulnerable to U.S. takeover in July 1915.[8] "Our only chance to be ourselves," he wrote, "is to not repudiate part of our ancestral heritage. And...as for this heritage, eight-tenths of it is a gift from Africa" (290).

Thus Price-Mars called for the reevaluation of Haitian culture through the intensive study of folklore, a concept that he defined, after the French folklorist Paul Sébillot, as the "oral traditions of a people," encompassing the inventory of "legends, tales, songs, riddles, customs, observances, ceremonies, and beliefs which are its own, or which it has assimilated in a way that gives them a personal imprint" (51).[9] Above all, it was "the religious sentiment of the rural masses," objectified, not unproblematically in Price-Mars's view, as "Vaudou" (according to one orthography) that, he argued, should be recognized as the wellspring of Haitian folklore and primary source of the nation's cultural particularity.[10] Marshaling French sociological theory (and particularly Emile Durkheim's *Les formes élémentaires de la vie religieuse* [Elementary forms of religious life]), Price-Mars set out to refute the colonial construction of peasant belief and ritual as "sorcery" and to argue methodically for their status as a religion, albeit a "very primitive" one, "formed in part by beliefs in the almighty Power of spiritual beings—gods, demons, disembodied souls—in part by beliefs in sorcery and magic" (88–89).

The implications of this reclassification were not simply academic in his view, given that such practices were then subject to demonization by Catholic and Protestant clergies in Haiti, criminalization in Haitian penal law, and repression at the hands of the marines and U.S.-trained gendarmes. While Price-Mars justified his focus on popular religious belief and practice in *Ainsi parla l'oncle* with reference to the primacy of the spirits in peasant life and culture, he also points throughout his book to the way in which "Vaudou" functioned as a sign, encapsulating, as he put it, "the undesirable legacy of a shameful past" (232). Price-Mars's recognition of the ways in which the longstanding prohibition of *les sortilèges* in the Haitian *Code penal* served as a pretext for the peasantry's continued subjugation shaped the political stakes of *Ainsi parla l'oncle* and much of his subsequent work.

At one point in *Ainsi parla l'oncle*, Price-Mars makes explicit his call for a shift away from earlier elite-centered, Western-identified nationalist models and toward the construction of popular tradition as a commonly held, uniquely Haitian cultural endowment:

> Better than the stories of great battles, better than the relation of the great deeds of official history..., better than the theatrical poses of statesmen in attitudes of command, better than the laws which can only be borrowed finery ill fitted to our social state, in which short-lived holders of power condense their hatred, their prejudices, their dreams or their hopes, better than all these things which are most often...adopted by only one part of the nation—tales, songs, legends, proverbs, beliefs are works or products spontaneously sprung up, at a given moment, from an inspired mind, adopted by all. (253–54)

It is not incidental that Price-Mars singles out law in this inventory for particular critique. As he suggests, Haiti's legal codes served the state as both a sign of modernity and a space for the repudiation of the "primitive," most particularly through the penal prohibition of "spells."[11] *Ainsi parla l'oncle* is an extended rebuke of the Haitian elite for having disavowed and repressed precisely what they ought to have claimed and constructed as the repository of Haitian national identity, or as Price-Mars, after Herder, terms it, the "national soul."

For Price-Mars, the reevaluation of popular cultures as folklore held the promise of national unification. The political force of this argument stemmed from its basis in an anti-imperial assertion of difference. However, the premises of this project were also shaped by nineteenth-century European Romantic nationalism, and the increasingly ubiquitous way in which folklore was being promoted internationally as the cultural basis for state nationalist claims. This was the legacy of *indigénisme* for official cultural politics in Haiti during the late 1930s and early 1940s. With the restoration of Haitian sovereignty in 1934, the postoccupation state constructed popular practices, and particularly ritual dance, as indices of official Haitian identity and modernity, but at times framed such performances internationally as revivals of a transcended cultural past.

Popular Dances versus Superstitious Practices

Coming so soon on the heels of the restoration of Haitian sovereignty, the law that President Sténio Vincent signed in September 1935 against *les pratiques superstitieuses* was welcomed as a kind of signature legislation in certain quarters.[12] While only a few months earlier, the Port-au-Prince daily *Le Matin* had been antagonistic to Vincent's government and its increasingly absolutist tendencies, the newspaper hailed this new law as representing "a turning point in national life," and one that would heighten the nation's prestige, given that, "the most frequent subject of denigration of our country is...*our* superstitious practices."[13]

It seems circumstantially notable in this regard that the law against "superstitious practices" was promulgated only a few days after notices of the latest imperial travelogue had appeared in Port-au-Prince newspapers. This was a book entitled *Voodoo Fire in Haiti*, written and illustrated with lurid woodcuts by an Austrian artist named Richard Loederer, which circulated widely in translation across Europe and North America in 1935.[14] Purportedly an account of the author's travels in Haiti, *Voodoo Fire in Haiti* was so replete with hallucinatory scenes of, in Loederer's words, "wild dances" and "frenzied ceremonies," that one reviewer, H.P. Davis, an American living in Haiti at the time, characterized it as being "not simply another sensational book on Haiti," but rather, "we sincerely hope, the extreme limit of this genre."[15] Loederer wrote on the heels of the rash of voyeuristic firsthand accounts of "voodoo" ritual that had proliferated over the course of the U.S. occupation, and he was clearly himself an aficionado of this genre. *Voodoo Fire in Haiti* reads like a compendium of tropes taken from previously published texts. It features a particularly frequent

return to primitivized and sexualized images of dance, which inspire his most derivative prose.[16] In *Ainsi parla l'oncle*, Jean Price-Mars describes such passages as constituting a kind of imperial plagiarism, whereby "accounts...[can be] made of the cultic ceremonies of 'Vodou' by writers who have not even had the opportunity to observe them."[17]

I do not mean to suggest that the publication of Loederer's book, in itself, prompted the Vincent government to pass new legislation against *les pratiques superstitieuses* in September 1935. Rather, I want to argue that *Voodoo Fire in Haiti* was emblematic of an occupation-era literature that, in constructing "voodoo" or "vaudoux" (or any number of cognates) as the sign of either a felicitous primitivism or an abiding barbarism on the part of Haitians, played a compelling role in the perpetuation and tightening of this penal regime after the restoration of Haitian sovereignty. In fact, the pressure that such representations exerted on the early postoccupation state was written into the prologue of Vincent's 1935 legislation as its primary justification. Specifically in the name of preventing "the accomplishment of all acts, practices, etc., liable to foster superstitious beliefs harmful to the good name of the country," the new law doubled the minimum prison sentence for such offenses, which it now defined, principally, as "ceremonies, rites, dances, and meetings during the course of which sacrifices of livestock or fowl are performed in offering to so-called divinities."[18] This was the first time in the history of Haitian penal discourses against popular ritual that such offerings were made a legal litmus test of prohibition.[19]

Yet if this legislation was compelled, in part, by the force of imperial sensationalism around "voodoo" just after the occupation, it also reflected, I want to argue, the influence of cultural nationalist discourse and politics in Haiti at this time. After asserting the responsibility of the state to eradicate practices potentially damaging to the reputation of Haiti, the prologue to the 1935 law conceded that, in the past, there had been an "exaggerated application" of the former penal code articles against *les sortilèges*. In an apparent softening of the penal regime toward peasant communities, this prologue then affirmed "the right of citizens, particularly country dwellers, to enjoy themselves and organize dances according to local customs," making such dances, for the first time in Haitian juridical history, explicit exceptions to the category of "superstitious practice."

One might assume that the acknowledgment of prior excesses in the application of the law against *les sortilèges* referred to the rigor with which these articles of the *Code pénal* had been enforced by marines and the Haitian gendarmes under their command during the U.S. occupation.[20] However, there is also evidence to suggest that such an "exaggerated application" of these laws had continued under Vincent's governance. In April 1935, three months prior to the abrogation of the laws against "spells," Northwestern University anthropologist Melville J. Herskovits, who had conducted fieldwork in central Haiti during the prior summer, wrote to a contact at the U.S. legation in Port-au-Prince on behalf of Katherine Dunham, then a young student of anthropology at the University of Chicago, who was preparing, under his tutelage, to undertake research on dance in the Caribbean. "Knowing the charm with which the Haitians care for visitors," Herskovits wrote, "I had no hesitancy two or three months ago when the plans were laid out, in indicating Haiti as the logical place for her to work. Recent reports of the political situation, however, especially as these bear on the prohibition of dancing—this I get from my friends at Mirebalais with whom I am in correspondence—lead me to wonder how much work she will be able to do in Haiti." A representative of the legation wrote back that Dunham "would probably have little difficulty in finding opportunities to study native dances, since they occur almost nightly throughout the island, and attendance at any one of them could probably be arranged. The much discussed religious ceremonies, or voodoo dances, are banned by law, however, as you probably know."[21]

Whether the law's reference was to the occupation or a more recent episode of enforcement, the concession that there had been past "exaggerated applications" of the statute against *sortilèges* does not transparently explain the unprecedented legal affirmation of popular dances that followed. How do we account for the anomalous exemption of popular dances from the tightening of this penal regime? Given the centrality of dance to rituals of serving the *lwa* (spirits), sociologist Laënnec Hurbon has interpreted the preamble to the 1935 law as a kind of juridical wink, signifying the tacit forbearance of the government toward the ritual practices the law apparently forbids: "As if surreptitiously they must tolerate Vodou, but without saying so, or rather while stating its prohibition."[22] Hurbon's analysis is particularly persuasive in light of reports of the way peasants in certain parts of Haiti were already negotiating the local regulation of their spiritual traditions. Indeed, there is some evidence to suggest that the law might have been, in the sense that Hurbon suggests, a kind of official endorsement of a customary or informal legal status quo then in practice in some parts of the country. George Eaton Simpson, an American anthropologist who spent 1937 in northern Haiti on a Social Science Research Council (SSRC) postdoctoral fellowship, wrote that, according to his informants, the so-called "dance without sacrifices" had been popularly "invented" in the late occupation period "to circumvent the law." Of the several ethnographers who visited Haiti from the United States during the 1930s, Simpson was one of the few to acknowledge in his published work that these practices were officially prohibited, and was, to my knowledge, the only to consider seriously how local regulation shaped the ways in which different communities served the spirits.[23] The fallacy of earlier anthropological displacement of such questions is that the legal status of these practices has been, at different historical moments, constitutive of how they were performed. Describing the regulatory regime in Plaisance and elsewhere following the promulgation of the 1935 law, Simpson wrote: "Sometimes members of a family held their ceremony in the privacy of a bedroom while a dance was in progress in the courtyard."[24]

Hurbon's interpretation of the 1935 law, against its apparent grain, as signaling the state's surreptitious tolerance for that which it seemed to prohibit, suggests that perhaps the new law was meant to keep a kind of public secret. He writes, "If the foreigner, in reading this text, does not discern all its implications, no one is fooled in the very interior of the country."[25] In his *Defacement: Public Secrecy and the Labor of the Negative*, Michael Taussig writes of the "margin of fiction separating the laws of the state from their actual observance, in which not only the law but also the system of community values is largely honored in the breach."[26] Similarly, Joseph Roach, in his *Cities of the Dead: Circum-Atlantic Performance*, discusses how in seeking to regulate New Orleans Mardi Gras, Louisiana law "has deliberately created in its interstices a space for easily overlooked transgression."[27] Such readings of the 1935 law against *les pratiques superstitieuses* are persuasive in light of the paradoxical political situation whereby, as Hurbon writes, "the tolerance of Vodou [was] necessary to the general functioning of society. But its penalization, no less so."[28]

I want to suggest another way to think about the state's sudden defense of rural pastimes, and, in particular, the unprecedented insistence on the distinction between popular dances and superstitious practices, notably set apart here by the performance of sacrifice. It seems to me that the penal revisions of September 1935 mark the moment when it became politically desirable, given the force of postoccupation cultural nationalism in Haiti, and epistemologically possible, given the turn toward national folklore, for the state to distinguish popular dances from prohibited ritual.[29] The latter then became more subject to penalization under the law as superstitious practice, while this excised construct—popular dance—was figured in ensuing years as national culture.

In interpreting the 1935 law's validation of the right of peasants to hold popular dances as a concession to *indigénisme*, I also want to propose that the social scientific logic of folklore, separating a unified national culture into an inventory of discrete cultural traits and forms—tales, songs, dances, superstitious beliefs, proverbs, and so on—influenced the formulation of this law as well. As appropriated by the Haitian state under Vincent and his successor, Elie Lescot, the concept of national folklore seemed both to politically *compel* and logically *enable* the constitutive separation on which the 1935 legislation was premised. In a sense, by legalizing what had never before been expressly prohibited, the law annexed the figure of popular dance to the state and laid a juridical groundwork for the subsequent promotion of this construct as an official national sign. My interest here, then, is studying the connection between how the Haitian state constructed and, in conjunction with the Catholic Church, policed so-called superstitious practices during the early postoccupation years, and how it constructed—and also policed—representations of Haitian national identity and culture through the performance of folklore during those years.

Staging Folklore and *Bon Voisinage*

While the occupation-era *indigénisme* movement had been primarily literary in scope, what came to be collectively nominated in the 1940s as the *mouvement folklorique* in Port-au-Prince encompassed an array of overlapping disciplinary projects.[30] Jean Price-Mars later wrote of the "variety and originality of productions of all orders" that were sparked by his *Ainsi parla l'oncle*, and the *indigéniste* movement more generally: "Novels, poems, linguistic, archaeological, and psychiatric studies....And pictorial art, sculpture, music, dance, for the first time...found application for their techniques in Haitian material."[31] From the beginning, the *mouvement folklorique* was as heterogeneous ideologically as it was generically. There was Jacques Roumain, *indigéniste* poet, novelist, and cofounder of the Haitian Communist Party who based his critique of elite hegemony and peasant subjugation in a historical materialist analysis. Roumain regarded Haitian color politics as an idiom of the class struggle and took a dim view of those who, in his view, cynically privileged the problem of color in public discourse to obscure the economic basis of inequality in Haiti. If overtly directed at elite politicians, Roumain's critique also implicated members of the so-called Groupe des Griots, named after the traditional storyteller musicians of West Africa, whose most prominent members were the collaborators Lorimer Denis and François Duvalier. In 1938, the group founded the journal *Les Griots* which became the principal mouthpiece of the postoccupation political movement of *noirisme*, positioning Denis and Duvalier as its foremost ideologues. Ethnology, they maintained in articles throughout the late 1930s and 1940s, scientifically corroborated the central *noiriste* political doctrine that Haiti's social structure and political institutions should reflect the African biological and psychological "nature" of its masses. State power, consolidated throughout Haitian history in the hands of the *mulâtre* (mulatto) elite, ought instead be held by representatives of the *petite bourgeoisie noire*, or *authentiques*, who, Duvalier and Denis argued, shared the interests of the peasants and were uniquely capable of acting on their behalf.

As ideologically divergent as Roumain's politics were from those of the Griots, their mutual investment in the study of ethnology was linked to an expressed solidarity with the peasantry and an advocacy for the redistribution of economic and political power in Haiti.[32] There was another prominent sector of the self-identified *mouvement folklorique* in the late 1930s and early 1940s that expressed little of this populism, nor a particular interest in social transformation. They were primarily elite folk song collectors, arrangers, and composers such as Valério Canez, a violinist, and Werner A. Jaegerhuber, a music professor and pianist of German-Haitian descent, who, in the tradition of Brahms and Liszt, sought to locate the Haitian "national character" through the

distillation of popular musical themes.[33] Their collective efforts were encouraged by the international success and popularity during these years of so-called American Negro spirituals, harmonized and arranged for piano or orchestra. Canez felt particularly strongly, as he explained in an article in *Haïti-Journal*, that in order for its national character to be realized, Haitian musical folklore, "with its beautiful melodies and its unique rhythms must be known, executed in all parts of the world." To this end, Canez advocated that Haitian popular songs, including those that were ritually dedicated to the spirits, be "harmonized, purified, and presented in a universal musical form, a classical musical form, rendering them accessible to all, and extricating from them all primitive form, while preserving their national character." In response to those who argued that it was necessary to use drums "to give the really typical, local character to our folklore," Canez replied that conical Haitian drums were, categorically, "not musical instruments," and that their rhythms could be adequately replicated on the piano, or, in orchestral performances, by the kettledrum.[34]

I quote Canez's article at some length here not only to highlight the divergent political projects encompassed by the early 1940s under the heading of the *mouvement folklorique*, but also to point to the particular contestation that surrounded the representation of performed genres of folklore as these were being codified for the first time. There are two reasons why I think the emergence of "staged folklore" is crucial for understanding the complex field of cultural politics around the folk in early postoccupation Haiti. First, from the late 1930s on, the performance of folklore was a highly prominent, even privileged aspect of the *mouvement folklorique*.[35] Independent music and dance troupes were beginning to form, such as that organized in 1939 among a group of secondary school students from predominantly elite families by Lina Fussman-Mathon, a Port-au-Prince pianist and music teacher, who many credit with first codifying and theatrically presenting a Haitian folklore dance idiom.[36]

Figure 1. Lina Fussman-Mathon, second from right, watching an informal performance at her home in the mid-1940s.
Photograph by Earl Leaf. Michael Ochs Archives, Getty Images.

In 1940, Clément Benoit, a teacher and writer, assembled his own small troupe and created a weekly radio program called *L'Heure de l'Art Haïtien* [The Haitian art hour] which, judging both from press reports at the time and the memories of Benoit's younger contemporaries who listened to the program, became an important catalyst in popularizing musical folklore among middle-class and, to a lesser extent, elite audiences in Port-au-Prince during the early and mid-1940s.[37]

With the founding of the Haitian Bureau d'Ethnologie as a state agency for ethnological study and archaeological preservation, and the Institut d'Ethnologie as an independent higher education faculty for ethnological training in 1941, the staging of folklore came to have a formalized place in Haitian ethnographic research and pedagogy.[38] At a time when North American anthropologists often avoided studying dance on the grounds that it resisted objectivist methodologies, the integration of such performances into the Institut d'Ethnologie's curriculum is notable.[39] Jean-Léon Destiné, who later became one of Haiti's premier folklore performers, was a student at the Institute in the early 1940s and recalls that classes sometimes featured demonstrations of ritual dances and rhythms performed by practitioners: "That is how we learned....As they danced in front of us, we would...analyze the steps, trying to see what they meant, trying to see the background, and the interpenetration of the songs and rhythms. Naturally we also learned from books, but we got to associate what we read with what we saw."[40]

Such was the priority that the Bureau d'Ethnologie accorded to performance in its early years that nearly all of its public lectures were illustrated with demonstrations of popular music, dance, and ritual. These were performed by the Bureau's own troupe, called Mater Dolorosa, whose members were drawn from its pool of informants and directed by Saint Erlonge Abraham, an *oungan* (male priest), who worked closely with ethnologists.[41] Billed as Haiti's first "popular folklore choir," signaling that its performers came from the peasantry rather than, more typically, the urban middle class or bourgeoisie, the members of Mater Dolorosa, as both performers and informants, played a key role in the ethnological interpretation and codification of ritual performance as folklore in the early and mid-1940s.[42]

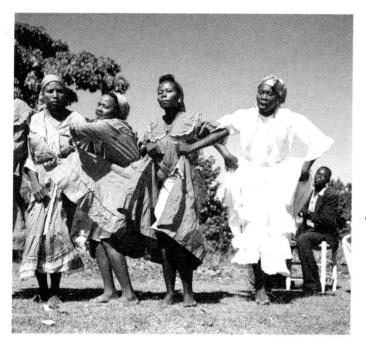

Figure 2. Members of the troupe Mater Dolorosa performing in Pétion-Ville, Haiti, 1945.
Photo by Earl Leaf. Michael Ochs Archives, Getty Images.

The second reason, I would suggest, that the performance of folklore is particularly critical to an analysis of postoccupation cultural politics in Haiti is that, from the early 1940s on, the Haitian state was highly invested in constructing new images of Haitian national culture and identity through dance and music folklore. This should be understood in the context of Washington's policies of pan-Americanism and Good Neighborliness during World War II, when U.S. efforts to foster a sense of collective hemispheric identity through cultural means converged with the efforts of some Latin American and Caribbean states to construct traditional cultures as the repository of national particularity. Franklin Delano Roosevelt's goodwill visit to the northern city of Cap-Haïtien in July 1934 to announce that the last marines would depart from Haiti by August 15 was symbolically weighted to mark the end of an age of repeated U.S. military aggressions in the Caribbean and Latin America, and the beginning of an era of *bon voisinage* (good neighborliness).[43] Of course, the withdrawal of American troops did not alter the fundamentally neocolonial nature of U.S. involvement in Haitian affairs.[44] However, in keeping with the mandate of pan-Americanism, the U.S. legation in Port-au-Prince focused a spotlight on Haitian and U.S. cultural relations, which it sought to promote among the elite and middle classes through a wide array of programs, sponsorships, collaborations, and exchanges.

One of the earliest high-profile occasions for such an exchange of inter-American folk performance was the eighth annual National Folk Festival, which took place in Washington, DC, in early May 1941, sponsored by the *Washington Post* Folk Festival Association. Up to that point, this annual festival had been national in scope, with each featured group representing a particular state or territory. That year, however, as director Sarah Gertrude Knott explained in a January 1941 letter to Melville Herskovits, the organizers had decided to explore the possibility of "inviting guest groups from Canada, Mexico, one South American country and some of the Islands." She went on, "We feel that there has never been a time when the need was so obvious for better understanding, more tolerance and a stronger National Unity. We believe the use and interchange of folk traditions will help to bring this about."[45] Knott was writing to solicit Herskovits's advice about inviting folklore groups from Peru and Haiti to perform at the festival in May. She was clearly also hoping that he would authoritatively intervene in a dispute she was having with the Haitian minister to the United States over what sort of group should be presented. This minister was Elie Lescot, who would succeed Sténio Vincent as president of Haiti four months later, and become known, thereafter, for his efforts to further consolidate the hegemony of the country's light-skinned elite. Knott explained the nature of their disagreement:

> The Minister from Haiti is interested in sending a small group demonstrating the Voodoo. It seems to me that this is the thing that we would have to handle especially careful [*sic*], isn't it? He too, had an idea of bringing a group of the natives who had been sort of polished off. I feel that it would be much better to have the genuine thing or nothing. What do you think?...We shall appreciate any information which might help us to secure the most genuine representation.

Herskovits obliged with a strongly worded reply against the kind of group that Lescot had proposed. Stating that he would consider it "very unfortunate if anything but a group of peasants were brought to do this," he recommended that "singers and drummers be obtained from the southern peninsula of the island, particularly Miragoane or Leogane." He further specified: "This group should be headed by a *hungan*, or native priest, and the group should be brought with the idea of performing a *vodun bamboche*, which means that they would drum the vodun rhythm and sing the accepted songs without spirit possession ensuing, since this might be a little embarrassing. If it did happen, the *hungan* could take care of it."[46]

Two weeks before the festival was to begin, Knott again wrote to Herskovits, hoping that he would agree to vet the program notes prepared for the Haitian dances, and, announcing, rather apologetically, that these would be performed by the type of group that Lescot had originally recommended. She explained: "A number of people, including the Minister, told me that if we brought the type of group we were thinking of at first we could not depend on what would happen. In the first place, they might decide not to dance or if they got under the power we might not be able to stop them." The group that had been invited in the end was the student troupe of Lina Fussman-Mathon. "Of course," she wrote, "the type of group in which we both were interested at first would be of more interest to Anthropologists, but in our Festival we are showing things as they are done today and I am absolutely convinced that this is a true group of its kind."[47]

If Elie Lescot was already invested, as his initiative suggests here, in fashioning new images of Haitian national culture and identity through folklore performance, he seems to have recognized that such a project was not without risks. On the one hand, constructions of dance and music folklore had become a ubiquitous vehicle for representing modern nationhood. On the other hand, the Haitian popular forms on which these might be based had long been sensationally constructed in the West as evidence of Haiti's primitivism. Lescot convinced Knott that it would be folly to invite a group of *sèvitè* to perform at the festival who, as initiates, might lose control of themselves and, in their performances, exceed the domain of representation,. The control actually at stake here, of course, was that which the state sought to exercise over the construction of ritual dance as an exemplary sign of Haitian national culture. A group of peasants, who themselves served the spirits, could not perform the nation's modernity. This is the implication of the argument that Knott recounted to Herskovits in defense of the festival's decision to invite Fussman-Mathon's "polished off" troupe. While the performance of a group of *sèvitè* might be of academic interest to an anthropologist, Fussman-Mathon's company was modern, up-to-date, and would, as Knott put it, "be able to show things as they are done today." One hears in her words the echo of evolutionary anthropology's denial of coevality to the cultures it studied, ironically rehearsed back to Herskovits, an advocate of anthropological relativism. Significantly as well, the anachronism of ritual practice is contrasted with the modernity of folkloric constructions based on that practice.

In fact, the invitation to perform at the National Folk Festival required Lina Fussman-Mathon to make certain overnight changes to her young troupe's repertory. While up to that point, they had been performing popular songs she had collected and harmonized with her collaborator Werner A. Jaegerhuber, Lescot specifically wanted to send a dance troupe. Jean-Léon Destiné, then a young member of the company emphasized this point during a 1997 panel in Port-au-Prince: "We did not begin with the dance, we were singers. There was no dance. It was when we were going to Washington to do the show that we began to study seriously, with a young woman or a young man who came to the home of Mme. Fussman-Mathon to teach us a few steps. But Mme. Mathon danced herself too. She taught us the *petwo*, the *juba*—a society woman dancing Vodou!"[48]

For the most part, the troupe was coached in ritual dances such as the *kongo, yanvalou* and *banda* in Fussman-Mathon's home by *sèvitè* she had met through her own research. Destiné related, however, that one Saturday, with the intent to "expose us to the very source of the folklore," Mme. Fussman-Mathon took several members of the troupe, all young men, to attend a *sèvis* on the outskirts of the capital. Destiné recalls this experience vividly, for the excitement and distress that it produced in him and his friends at the time. "What adventure! What anxiety!" he wrote in a 1994 tribute to his former teacher. "The mambo, highly respected in her community, graciously received us. Her assistant showed us the ritual forms to observe, which we would perform to the letter, but not without a certain fear."[49]

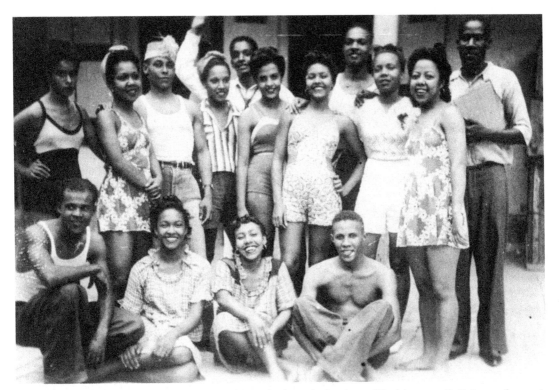

Figure 3: The troupe of Lina Fussman-Mathon before their trip to Washington, D.C. to perform at the 1941 National Folk Festival. Jean-Léon Destiné is standing fourth from the right.
Courtesy of Jean-Léon Destiné.

This was a fear, Destiné specifies, cultivated by clerical diabolism of these practices, which had recently intensified with the *campagne anti-superstitieuse* that the Catholic Church had been waging against *"le mélange"*—the "mixture" of Catholicism with popular belief and ritual—since 1940. This had become a crusade on the part of some French priests, who conducted raids on *ounfò* (temples) and other suspected sites of "superstition," confiscating donkey-loads of drums and other sacred objects that were burned in bonfires behind local presbyteries. Those who voluntarily gave up ritual objects in their possession were called *rejetés* (rejectors) and were issued a ticket that made them eligible to take an anti-superstitious oath.[50] Any parishioner over the age of fourteen who failed or refused to comply with the campaign was forbidden from receiving communion, marriage and burial rites, or any other sacrament. *Oungan, manbo* (female priests), and those found guilty of participating in a Vodou ceremony were subject not only to ecclesiastical punishments, but also, at the direction of the church, to penalization under the recently tightened proscription in the Haitian criminal code.

These were the circumstances under which, perhaps somewhat surprisingly, Fussman-Mathon led her students on their visit to the *ounfò*. Destiné continues: "Drums, dances, songs, all of this mounted in my head and, timidly, in movements hardly sketched, I imitated the participants. Conscious of the terror that the 'forbidden fruit' inspired in me, I already saw myself at the confessional of the 'bon père' [Catholic priest], admitting my sin of having attended a Vaudou meeting." It may have been such a *bon père* who, hearing drums that day, dispatched the gendarme who broke up the *sèvis* Fussman-Mathon and her troupe members were attending, and as Destiné writes, "arrested us all and conducted us to the nearest police station."

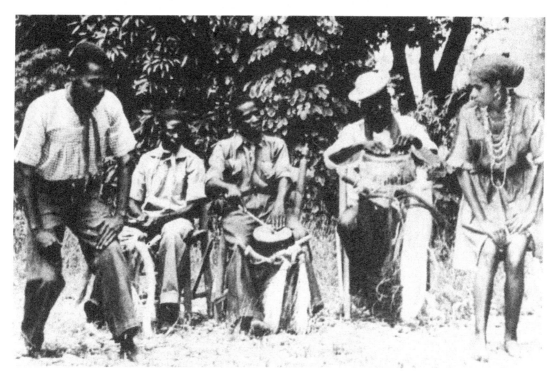

Figure 4: Jean-Léon Destiné and Gladys Hyppolite rehearsing in preparation for their performances at the National Folk Festival in Washington, D.C. The drummers are, *left to right:* Jonas, Léandre Lunique, and André Janvier.
Courtesy of Jean-Léon Destiné.

There as Fussman-Mathon secured their release, her students were lectured by a sergeant who admonished them "that such 'diabolical ceremonies' were legally interdicted, and to no longer participate in them."[51]

The other major change in the group's repertory that followed the invitation to perform in Washington was that, from then on, their performances would be accompanied by drums. In part, this was a function of the shift to performing dances, in addition to harmonized arrangements of traditional songs. However, it also seems likely that the Folk Festival, invested in the presentation of indigenous forms of instrumentation, exerted some pressure on this decision. In soliciting Herskovits's intervention in another case (the proposal on the part of a diplomat from Peru that Peruvian songs be performed by "some white people...using the piano"), for example, Knott specified, "we have never used the piano accompaniment."[52] At the same moment, then, that *sèvitè* in the countryside were forced to conceal drums to preserve them from antisuperstitious raids, two peasant drummers were added to the twelve-member student troupe who were to represent Haiti in Washington.

These "ambassadeurs de l'art populaire haïtien," as one article called them, left Port-au-Prince aboard the *America* on April 18, 1941, accompanied by Fussman-Mathon and Antoine Bervin, Haitian commissioner of tourism, who served as the group's spokesperson and, as Destiné remembers, master of ceremonies.[53] The official national status of the company had been magnified three days earlier with Elie Lescot's election to the presidency by the Assemblée Nationale.[54] This identification intensified once they arrived in Washington, where Lescot was still stationed. While

Destiné recalls that Fussman-Mathon had given the troupe the name Haïti Chante et Danse, the *Washington Post* referred to them simply as "the troupe of Elie Lescot, President-elect of Haiti."[55]

As part of the Folk Festival, the group gave six performances over a three day engagement at Constitution Hall, breaking the color bar where two years earlier the Daughters of the American Revolution had refused to allow Marian Anderson to sing.[56] They also gave performances at Howard University, Washington's International House, and at venues in Wilmington, Delaware and Boston. The Port-au-Prince dailies followed their travels closely, reporting the warm reception that the group received from audiences in Washington, as well as in the pages of the festival's sponsor, the *Washington Post*. *Le Nouvelliste* printed excerpts from a review that appeared in the April 29 edition of that newspaper praising the troupe's performance at a lavish banquet organized by Lescot at the Hotel Carlton prior to the opening of the festival. Attended by Washington's political elite, including the U.S Undersecretary of State Benjamin Sumner Welles, the Mexican ambassador to the United States, and "numerous representatives" of the diplomatic corps from Latin America, the event reflected Lescot's deft ability, even at this earliest moment of his presidency, to exploit the nationalist opportunities of pan-Americanism. The *Washington Post* article reported that at some point during this reception, which featured the young company performing choreography based on the ritual dance of *yanvalou*, including stylized representations of spirit embodiment, "it was explained that the Haitians didn't believe in Voodooism. It's just an old dance they like to break out occasionally."[57]

We have no access to what was actually said, but one hears in this rendering of those remarks an official sense that if choreographic constructions of ritual dances were to become internationally legible signs of Haiti's postoccupation modernity, they had to be framed as folkloric revivals of a vanishing or already extinguished cultural past. Lescot's presentation of Fussman-Mathon's student troupe at this reception marked the first time that folklore dance, based on ritual performance, was constructed as officially representative of Haitian cultural identity. This disclaimer makes clear, however, that such dances, or such scenes of spirit embodiment, could only be indexed as national if they were simultaneously figured as transcended. It seems that through these folkloric constructions Lescot sought to negate the contemporary reality of the popular practices that served as their referents, while also thereby negating imperialist representations of an enduring, atavistic "voodoo" that held all of Haiti, including the state, in its thrall. The primitivizing optic of the *Washington Post* article itself, in which the young male performers are described as "wild-eyed" and the girls "writhe" as they dance, suggests both the high stakes and risks of this project.

Such representations point to the imperative for controlling performed representations of folklore, at the same time as they cast doubt on how effective such efforts could be. There was, on the one hand, the mimetic relation of these folkloric choreographies to contemporary ritual practices. There was, on the other hand, the possibility, or even likelihood that foreign audiences would mistake such representations for precisely what they were meant to disavow. One witnesses, for example, a slippage in the *Washington Post's* review of the students' performance at the reception, which first describes their entrance as performers, "in native costume," but then goes on to depict one of the dancers as "falling on the floor palpably voodooed" and having to be revived on stage. In parts of the review that were notably not excerpted in *Le Nouvelliste*, the author observed that the performers "weren't professionals but boys and girls from the bush," and that on mounting the stage, "they didn't look at the audience nor seem to care whether they had one. Somehow back among the dishes and soup spoons they must have worked themselves into incipient jungle fever because they had it when they arrived on the party floor."[58]

Along with the clearly justified concern that these constructions would themselves be willfully mistaken for actual ritual by such audiences, came the shadow of a doubt that such performances might not always be purely representational. There was, in a sense, a suspicion that the signified (the choreographed ritual dance) could overwhelm and seep into the signifier (the dancer) like spirit embodiment itself.[59] Jean-Léon Destiné recalls that it was once Lina Fussman-Mathon's young troupe began learning and performing choreography based on ritual, as opposed to simply singing harmonized folksongs, that they began to be stigmatized by some of their peers from bourgeois families. During a panel in Port-au-Prince in 1997, he remembered:

> I didn't want to tell my friends that I was studying folklore....Everyone knew that young men and women were dancing [folklore with Mme. Fussman-Mathon] and they began to speak badly about us. Once, there was a little dance, and when I arrived no one wanted to dance with me. The young women of my generation said, oh-oh, he's a Vaudou man—that was enough to discourage anyone to quit. What happened was, I had gone to...a ritual gathering where people were dancing, and it seemed that while the dance was going on someone was possessed. They always associate Vaudou with orgies or black magic. When they heard that I went out to a Vaudou ceremony they believed that I could contaminate them.[60]

If there was a sense that performers could be "contaminated"—and then contaminate others—by their bodily mimesis of ritual forms, there also seemed to be some official uneasiness around the participation of popular religious practitioners in folklore representations, at first primarily as drummers, but increasingly in independent productions, as dancers and singers. Destiné remembers that in the course of another reception Lescot held for the troupe in Washington, following their performances at Constitution Hall, lead drummer André Janvier was moved to ask Fussman-Mathon's permission to address the gathering. Lescot had just finished praising the company's performances at the Folk Festival, and for these accolades the drummer thanked the president-elect. Then, according to Destiné, Janvier asked Lescot for a memento or souvenir to prove on his return to Haiti that drummers who were "so unappreciated in our country, were recognized as great artists abroad." With this intervention, it seems to me, as Destiné recounts it, Janvier effectively insisted that the new president acknowledge the contemporaneity of ritual practices in Haiti, and their immediate relation to the representations the troupe had staged as national folklore. What's more, in asking for a memento, Janvier made the president-elect confront the discrepancy between his acclaim for the troupe's theatrical staging of ritual performance and the persecution to which ritual ways of serving the spirits were then increasingly subject in Haiti. It might seem like a particularly significant reversal that Janvier requested a physical token of state legitimation from Lescot at a moment when the church was systematically confiscating and performatively destroying ritual objects in the Haitian countryside. That night, as Destiné recalls, "in the face of such aplomb," the president-elect offered Janvier "a medallion, under the sustained applause of the guests."[61]

A month later, in one of his earliest presidential acts, Lescot officially endorsed the Catholic Church's ongoing campaign in the Haitian countryside by issuing a presidential letter directing the Haitian civil and military authorities "to give their most complete assistance," to the church's "mission...to combat fetishism and superstition," specifying that "no violence [should be] used against those who exercise superstitious and fetishistic practices."[62] Thereafter, priests were joined on their antisuperstitious raids not only by groups of rejetés, who aided in the destruction of sacred objects and sites. They were also accompanied by members of the U.S.-trained Haitian Garde (guard) and/or local chefs de section (section chiefs), who, no doubt often in spite of their own beliefs

and customary protocols, enforced the church's campaign by applying the 1935 *décret-loi* against superstitious practices.[63]

In September 1942, the U.S. cultural attaché to Haiti, J.C. White, sent a memorandum to U.S. secretary of state Cordell Hull concerning what he perceived to be a changing attitude toward "voodoo" on the part of the elite, suggesting that the "reported success" of Fussman-Mathon's group in Washington, "may be partially responsible for the awakening of Haitian interest in their folklore." However, he noted that there appeared "to be two conflicting attitudes toward voodoo among the intellectuals of Haiti":

> One group believes that the songs and dances of the voodoo ceremonies should be developed systematically as Haiti's folklore, and exhibited at home and abroad largely in order to interest and attract tourists; whereas the other group believes that they should be ignored or denied, if not actually stamped out, as an unfortunate and debasing heritage from the dark days of slavery in the French colony, declaring that it is not a part of the life of the independent nation of Haiti.[64]

What is signaled, however, by the disclaimer apparently made at the reception in Washington, no less than by Lescot's presidential letter a month later backing the church's crusade against "superstition" with civil and military force, is that for the elite state there was not necessarily a conflict between exploiting folklore "to interest and attract tourists," and ignoring, denying, or even "stamping out" the practices on which such folkloric forms were based. This was consistent with the logic of the 1935 legislation against *les pratiques superstitieuses*, in which the figure of popular dance, once divorced from the category of superstition, lent itself to a tightening regime of popular control at home, as much as to a renovated image of national culture abroad.

I want to suggest, however, that the early 1940s are a particularly interesting and complex moment in the history of the staged representation of popular performance in Haiti, if only because the state had no monopoly on such productions. While there were prominent artists and arrangers whose vision closely corresponded to government aspirations for the international circulation of Haitian music and dance folklore in nationally representative forms, there were also numerous practitioners in the early 1940s who seemed to regard the staging of popular performance, and especially ritual, in terms of a very different set of possibilities. Thus my concern in the pages that follow is not simply with how the Lescot government constructed popular performance, including codified versions of ritual dances, as national culture. It is also with how the state policed unofficial and even antiofficial representations of folklore, and ultimately banned the theatrical depiction of prohibited ritual practices on stage, with reference to the terms of the 1935 law against *les pratiques superstitieuses*.

"Without the Inclusion of One Ritual Note"

During the early 1940s, the independent staging of folklore seems to have been far more subject to state surveillance and censorship than other forms of folkloric representation. As folklore performance became an increasingly primary space for the official elaboration of national particularity, the stakes rose for controlling the ways in which ritual dance could be theatrically represented. It may seem like a deceptively simple point, but while there were numerous ethnographic accounts of *sèvis* in publications of the Bureau d'Ethnologie, frequent literary representations of ritual in the so-called peasant novel genre, and even radio broadcasts of simulated ceremonies, there was far greater imperative on the part of Lescot's government to police representations of ritual practice by independent dance and theater artists.

Interestingly, it was the radio producer Clément Benoit, creator of the popular weekly program *L'Heure de l'Art Haïtien*, who first brought this issue to a head, when, in September 1942, his ensemble mounted its first theatrical performance on the stage of the Rex Theatre. By this point Benoit was a well-known producer whose broadcasts of ritual drumming and songs, storytelling, and comedies of local manners were widely acclaimed, and even endorsed by president Lescot, under whose high patronage the program's first anniversary was celebrated in May 1941.[65] Well-publicized in advance by the Port-au-Prince dailies, "Gabélus," as Benoit entitled his group's first theatrical venture, was advertised as being "a *gala folklorique* without precedent."[66] On the evening of the performance, before the curtain rose, Benoit addressed the capacity audience with a short *manifeste* (manifesto) that was published, several days later, in the newspaper *Haïti-Journal*.[67] He began by expressing his satisfaction at the flight of interest in folklore since the founding of *L'Heure de l'Art Haïtien*, and what he sensed was a new openness in public discourse around the subjects of "Vaudou, *loas* [spirits], *houngans*, etc." He attributed this candor to a growing recognition of "the value that the people have always had in the life of a nation, and therefore the value of their practices in the domain of Art." He continued: "If we present today religious ceremonies of the peasant cult, it is without doubt because we are certain that Haitian art cannot be found elsewhere —and that in large measure, the art of the people in Haiti can only be the most integral expression of a life truly Haitian and national....Thus, we present for you, without great pretensions, some scenes of peasant life which deal with their religious customs."

The performance began with the company staging a piece that Benoit introduced in his remarks as dramatizing "the antagonism between peasants rooted to their land, to their customs and traditions," and those forced by circumstances to leave for the cities. Such migrations had been going on for years, and intensified during the occupation, as U.S. agricultural and industrial companies won concessions to take over government lands formerly under peasant cultivation. Most recently, beginning in 1941, large tracts of farmland had been seized for U.S. wartime rubber production in a debacle known by the acronym SHADA (La Société Haïtiano-Américaine de Développement Agricole).[68] Benoit may have had these displacements in mind in so thematizing the piece, but its focus was not primarily on the protest of such policies. Rather, in structuring the scenes around the staging of a ritual offering, Benoit and his collaborators aimed, according to his precurtain statement, to affirm the legitimacy of such rituals as both religion and source for artistic representation.

The well-known singer Marthe Augustin, who performed as a soloist on the *L'Heure de l'Art Haïtien*'s radio broadcasts, and, on occasion, with the Bureau d'Ethnologie's troupe Mater Dolorosa, played the figure of the *manbo*, supported by a cast of *ounsi* (initiates), played by a group identified in newspaper reviews of the production only as "peasants." Jean-Léon Destiné remembers that Benoit worked with *sèvitè* in this production, not as the usual behind-the-scenes choreographic consultants, but as performers themselves, who were also meant, in some sense, it seems, to perform themselves. In the course of this dramatization, the figure of the *manbo*, Marthe Augustin, sacrificed a *kòk*, or rooster, on the stage of the theater as an offering to the spirits. The reviewer in *Le Nouvelliste* recounted the scene thus:

> It would be necessary to be an initiate, or a 'specialist,' in order to explain...the sense and meaning of these attitudes and movements, these abrupt and jerky gestures, these steps of the Mambo... the sincerity of a rite older than a thousand years....The sacrifice of the victim: a rooster. The public, breathless, stifled, followed the brief, quick and expert movements of the mambo, twisting, tearing off the neck of the victim and drinking its blood.[69]

This offering was followed by a cycle of ritual dances—the *vaudou*, *kongo*, and *makaya*—and the production closed with a popular love song, the eponymous "Gabélus," around which, as *Le Nouvelliste* described, Benoit had "embroidered a little scenario" of peasant life and customs.

The major Port-au-Prince dailies highly praised Marthe Augustin's performance of "Gabélus," the final sketch. They were sternly critical, even scathing, however, about Benoit's inclusion of the ritual offering on the program. Discounting his precurtain claim that this enactment of ritual held the status of art, both reviews argued that Benoit had betrayed what he intended to honor through the production. *Le Nouvelliste* contended that the performance had transformed what was "a pious and clearly religious ceremony" into a ridiculous spectacle, and that such a reconstruction, "with all the realism of its rites, but without the atmosphere which is indispensable to it, is very exactly the opposite of an artistic performance."[70] Two days following the performance, *Haïti-Journal*, for which Benoit sometimes wrote, published a thinly veiled rebuke, without naming their colleague, of artists who, whether "intentionally or unconsciously, render popular art ridiculous," describing this as "a crime against...the masses," and a betrayal of the cause of revolutionary art.[71] The public debate incited by the performance in late September 1942 was such that it motivated the U.S. cultural attaché J.C. White to send his memorandum to the U.S. secretary of state a few days later, describing Benoit's production as "probably the most important of its kind yet given in Haiti." White read the contestation surrounding it as "evidence that opinion is divided as to whether Haitian folklore composed of voodoo ceremonies, songs and dances shall be recognized and presented to the world, or denied like an illegitimate child."[72]

Decades later, Benoit's contemporaries, folklore performers and ethnologists of his generation, still discussed the September 1942 performance as representing a decisive marker in the history of Haitian folklore performance. However, their interpretations of the controversy complicate that offered by White. On the subject of this performance during the 1997 conference in Port-au-Prince on the history of Haitian folklore dance, some participants remained critical, maintaining that Benoit had an artistic responsibility to further translate the *manje lezanj* rite for the stage. "We must remember," Destiné said in this context, "that there is a difference between what the peasant does under the *peristil* and that which is done in the theater....The end of theater is not to reproduce but to communicate, and in our case, to adapt the raw material [*la matière brute*] in the best way possible, with taste, integrity, and the greatest artistic ability." In staging the ritual offering, Benoit had marked, in crossing, what his colleagues thereafter identified as the limit of folkloric representation. Pierre Desrameaux, a former folklore performer and well-known folklore dance teacher in Port-au-Prince, emphasized, in discussing the protocols of staging ritual more generally, that in representing sacred acts and performances onstage, whether sacrificial offerings or spirit embodiments, "you must mime them [*fòk ou 'mime' yo*]," otherwise "you are not in the theater anymore."[73]

In Discussing "Gabélus" in a 1997 interview, ethnologist Michel Lamartinière Honorat likewise noted, as others had, that Benoit was not a "person of the theater." However, he set aside the question of whether or not the staged reenactment of this ritual was art in order to emphasize the opprobrium that the performance generated among the bourgeois public.[74] There are many questions that one might want to ask about this section of Benoit's production, which raises, of course, a host of ethical issues. What I would like to focus on here, taking Honorat's cue, is how socially and politically confrontational the performance was at that moment. It presented as "folklore" precisely the act by which *pratiques superstitieuses* were principally defined and prohibited in the 1935 law; and it did so as the state claimed folklore performance as an official national sign.

The production was arguably a good deal more challenging to the 1935 legal redefinition and prohibition of "superstitious practices" as, specifically, any dance, ceremony, or meeting involving animal sacrifice, than most foreign anthropological and Haitian ethnological writings at this time. Published calls for the decriminalization of popular ritual were surprisingly few and far between, given that the tightening of the legal regime occurred at the same moment that ethnological studies were being inaugurated in Haiti. There were a few notable exceptions to this general silence. Jean Price-Mars, in asserting the status of Vodou as a religion in *Ainsi parla l'oncle*, had implicitly challenged the construction and interdiction of these practices as *sortilèges* in legal discourses.[75] That same year, the esotericist Arthur Holly had gone further in his *Dra-Po*, calling for the extention of "the constitutional provisions relating to the liberty of worship...to the practice of divine and orthodox Mysteries of the Voudo religion."[76] A decade later, Kléber Georges-Jacob, a lawyer and associate of the Griots group, critiqued the regime of penalization against Vodou as part of his more general *noiriste* argument against the liberal republican political institutions that Haiti had "borrowed" from Europe after independence, "with which," he wrote in his 1941 anthology *L'ethnie haïtienne*, "we have nothing in common."[77]

Outside of Price-Mars's, Holly's, and Georges-Jacob's work, amidst the proliferation of close ethnographic studies of Vodou in the early to mid-1940s, most notably those published by Lorimer Denis and François Duvalier, few ethnological writings contested, or even acknowledged, this legal regime. By contrast, Benoit's performance directly violated the 1935 law against *les pratiques superstitieuses*, defined in part by the act of sacrifice. Certainly, he and his company members did not suffer what were, at that time, the official penalties for such a transgression—six months imprisonment and fines equivalent to $80. Yet Benoit's contemporaries emphasize that his representation of a prohibited ritual had its own repercussions. Lamartinière Honorat associates the departure of Benoit's star performer, Marthe Augustin, from the group shortly thereafter with the negative publicity surrounding the production, and he remembers that other members left at that point as well.[78] While *L'Heure de l'Art Haïtien*'s radio broadcasts continued through the mid-1940s, Benoit seems not to have returned to the stage until the late 1940s, when he founded another folklore troupe called "Pierre Damballah."

What is interesting is that, in spite of, or perhaps more likely because of the scandal it generated, Benoit's *gala folklorique* in September 1942 seemed to catalyze a new trend in folklore performance and popular theater in Port-au-Prince. Whether motivated by political protest in solidarity with the peasantry, theatrical provocation in a surrealist vein, and/or the strong box office receipts that burlesque comedies of popular manners frequently yielded, for nearly ten months thereafter performances of prohibited ritual continued to take place on the stages of the city's concert halls.

By early 1943 *Haïti-Journal* was denouncing, as Pierre Mayard, a writer and popular theater actor himself, put it in one article, "the great vogue, these last months, of theatrical performances: I dare not say of Haitian theater!! The theater is something honest and clean."[79] In favorably reviewing a lecture by ethnologist Lorimer Denis a few months later, another critic wrote of the importance of distinguishing "between the serious work of a scholar [like Denis] and the grotesque exhibitions to which imbecilic parvenus have attempted, as of late, to accustom a public too weak to boo and stone them as it should."[80] A few days later an editorial warned the authors, directors, and players of local *comédies de moeurs* that "the public...is beginning to complain of these grotesque comedies in which, in the guise of theater, they are offered buffooneries of a clearly bad taste, augmented by licentious subjects that are no longer even amusing."[81]

Such protests did not deter the director René Rosemond from staging his three-act *comédie folklorique* entitled "Mambo-Chérie" at the Rex Theatre on June 2, 1943. Taking the stage before the curtain rose, as Clément Benoit had done the prior September, Rosemond announced that with this performance what had formerly been a *mouvement folklorique*, would henceforth become a "*révolution folklorique*."[82] In the newspapers the next day, there appeared categorical denunciations of Rosemond's production. *Le Nouvelliste* was particularly critical, rebuking Rosemond for his failure to recognize "the necessity of showing the beauty of our folklore" and for not bringing "a more refined sense, a more delicate taste to the national theater."[83] Beyond such pronouncements, however, there was little in the way of description to give a sense of what kind of folkloric revolution "Mambo-Chérie" had augured.

This might be better gauged by the official response to the show—and one senses its genre—which came two days later. On June 5, 1943, a new ordinance was issued by the office of the wartime governmental censor, the Bureau d'Information à la Presse (BIP), forbidding the staged representation of prohibited rituals. As printed in both *Haïti-Journal* and *Le Nouvelliste* (in the latter case, under the headline, "An Excellent Decision"), it began: "For some time now, authors have been presenting to the public, under the pretext of folkloric exhibitions, scenes that are rather only imitations of prohibited ritual ceremonies. This practice, which has no artistic character whatsoever, can only throw Haitian customs into disrepute. Consequently, these sorts of performance are henceforth formally interdicted."[84] Up until that time, the BIP was charged, in general terms, with censoring "theater plays and other publications judged to be contrary to the foreign policy of the Government of the Republic, and harmful to national defense and domestic peace." Two months earlier, in the midst of this wave of objectionable folklore productions, the government had issued a warning to theaters advising that because the BIP "only practices political censorship," it was "up to them [the theaters themselves] to interdict the performance of plays liable to ridicule Haitian intellectualism."[85] The new BIP ordinance, however, was specifically addressed to folklore performance. In banning the staging of prohibited rituals, it further specified that, from then on, "folkloric performances must be limited to the presentation of popular dances and songs without, under any circumstances, the inclusion of one ritual note."[86] An editorial in *Le Nouvelliste* commended the government for putting a stop to the "trend of transporting prohibited practices to the stage," adding, "[w]e have been vindicated in our call for the end of this genre of folklore."[87]

The BIP ordinance was, in one sense, typical of what historians have characterized as President Lescot's inclination, whenever possible, to exploit the situation of wartime as an alibi to further curtail civil liberties in Haiti. Yet what seems most striking about this law is its reiteration of the constitutive split between prohibited ritual and popular dance that, I have argued, structured both the 1935 legislation against *les pratiques superstitieuses* as well as official cultural nationalist policy in early postoccupation Haiti. Whatever their diverse motives in staging interdicted rituals on the stage of the Rex Theatre, Clément Benoit and the popular theater artists who followed his lead could scarcely have chosen a more politically provocative object of folkloric representation in the early 1940s. The 1935 law made animal sacrifice the definitive mark of "superstitious practice," and, thus, the legal litmus test distinguishing prohibited ritual from the newly protected category of popular dance. I have examined how these two categories were mutually constitutive and particularly how the legal negation of prohibited ritual served as a kind of juridical groundwork for the state's annexation of popular dance as national folklore in the early 1940s.

The official stakes for policing performed folklore were particularly high in the early postoccupation moment, given the frequency with which the ritual practices of Vodou continued

to be construed by foreigners as evidence of Haiti's primitivism, whether this was deemed a cause for celebration or censure. The fact that the need to protect the reputation of Haitian customs from negative associations with "superstition" was written into both the 1935 legislation and the 1943 ordinance as their justificatory rationale, draws attention to the way in which representation was principally at stake in both laws. Because it was to a great extent concern over the depiction of Haitian popular cultures that propelled the passage of the antisuperstition statute in 1935, folklore performers and popular theater artists who transgressed that prohibition through the staging of banned rituals in the early 1940s became subject to the same interdiction, if not, certainly, the same penalties.

However, to point to the representational stakes of the 1935 law against *les pratiques superstitieuses*, promulgated by the Haitian state at a moment when Euro-American literary and cinematic sensationalism around "voodoo" was reaching new heights, is not to propose that this law had no material consequence for communities of *sèvitè*. Jacques Derrida's caveat in his essay on legal authority that there is "no such thing as a law...that doesn't imply *in itself*...the possibility of being 'enforced,'" was borne out repeatedly in Haiti's juridical history, regardless of the "customary" ways in which officially interdicted practices were locally regulated much of the time.[88] Most notably, U.S. military officials made the strict application of Haitian laws against *les sortilèges* both a hallmark of official policy and, in the early years of the occupation, a frequent point of self-congratulation. After the departure of the marines from Haiti, the latent force of Sténio Vincent's new law against superstitious practices was soon realized in the Catholic Church's *campagne anti-superstitieuse*, backed by the Haitian military and police as of June 1941. Even outside of such episodes of strict enforcement, in criminalizing a primary way in which Vodouyizan ensured mutually beneficial relations with the spirits, the 1935 legislation played a key role, as its antecedents had, in perpetuating the political marginalization, social stigmatization, and everyday economic exploitation of the subaltern majority in Haiti. It joined the battery of laws regulating peasant life through which, as Laënnec Hurbon has written, the elite state sought to maintain "a peasant society closed in on itself, based on its own traditions, and effectively constituting another country...in the interior of Haiti."[89]

Yet, in some sense, both the 1935 law against *les pratiques superstitieuses* and the 1943 ordinance exposed their own impossibility in attempting to legislate an absolute distinction between prohibited ritual and popular dance. This is why Hurbon interprets the 1935 law's validation of rural dancing as a kind of juridical wink, tacitly acknowledging the impossibility of establishing a strict separation between popular dance and ritual practice, even while seeming to attempt to legally enforce one. The 1943 ordinance against the staging of prohibited rituals aspired to another impossible detachment in restricting folklore performance to the presentation of popular dance and songs, "without, under any circumstances, the inclusion of one ritual note." Much like the law against superstitious practices, the ritual dances that Lescot presented as national folklore in 1941 were intended to perform a labor of negation. Yet also like the law, they were subject to misreading, as when the author of the *Washington Post* review willfully refused to see the dances performed by Fussman-Mathon's students as choreographic representations and instead depicted them as effective rituals that overwhelmed several of the performers.

The stakes for officially policing independent folklore performances were high, then, not merely because staged folklore was a primary space in which the post-occupation Haitian state articulated national identity during the 1940s. The "embodiedness" of these representations affiliated them with the ritual practices that the official figure of popular dance, constructed in legal discourse as well as in national culture formations, was meant to repudiate and supplant. As the government's

censorship of the folkloric *comédiens* in 1942-43 drove home, these staged representations of ritual were at least as threatening to state authorities as the "real" ones they indexed, if not more so for being publicly performed in the capital. Yet, it seems to me that even state-sponsored folklore bore witness to the spiritual practices performed on the other side of official sanction. Was this not the drummer Janvier's point when, after listening to Lescot's accolades in Washington, DC, he requested that the president-elect provide him with a tangible memento to mark the Haitian state's appreciation abroad for practices then subject to violent repression in Haiti?

Barbara Kirshenblatt-Gimblett has characterized "folkloricization" as a mode of cultural production through which "errors" are converted into "archaisms," a process transvaluing "the repudiated...as heritage."[90] It seems to me that this is a helpful way to think about the penal and performative processes that I have analyzed in early post-occupation Haiti.[91] Over the course of the article, I have been concerned with examining the interconnections between the post-occupation Haitian state's legal construction of fundamental ways of serving the spirits as "prohibited ritual," and its elevation and international presentation of "popular dance" as an official national sign. This has meant thinking about the relationship between state nationalist rhetoric that, at times, constructed folklore performance as reviving a transcended past, and the penal and ecclesiastical regimes that seemed designed to relegate forms of popular ritualism to the past. Yet Janvier's confrontation of Lescot, and, perhaps as well, the performances of those credited only as peasants in Benoit's transgressive theater piece, suggest that the "folkloricization" of ritual practice became itself, at times, the occasion for popular political challenges to the law's repressive regime.

Notes

I am very grateful to Yanique Hume and Aaron Kamugisha for the opportunity to publish this article in *Caribbean Popular Cultures: Power, Politics and Performance*, and to Tricia Herman, Lesvie Archer and Margaret Harris for their meticulous transcription of the text. An earlier version of this article appears in *Radical History Review* 84 (Fall 2002): 7-42. This was a Special Issue on "The Uses of the Folk" co-edited by Karl Hagstrom Miller and Ellen Noonan. An extended version of the article appears as a chapter entitled "Cultural Nationalist Policy and the Pursuit of 'Superstition' in Post-Occupation Haiti," in my book *The Spirits and the Law: Vodou and Power in Haiti* (Chicago: The University of Chicago Press, 2011).

For their valuable input and support during the research and writing of this article, I would like to thank Jean Coulanges, Yanick Guiteau Dandin, J. Michael Dash, Pierre Desrameaux, Jean-Léon Destiné, Lina Mathon-Blanchet, Michel Lamartinière Honorat, Laënnec Hurbon, Alphonse Jean, Louines Louinis, Michael Taussig, Tim Watson, the participants in the 1997 conference "La Danse Haïtienne: Histoire et Traditions" in Port-au-Prince, in the 1999 seminar "Race and Representation in Dance" at the University of California, Riverside, and in the 2001 working group on "Performances of Culture/Cultures of Performance" at the Ohio State University.

I would also like to thank Frère Ernest Even at the Bibliothèque des Frères de l'Instruction Chrétienne; Ephèle Milce and Sabrina Réveil at the Bibliothèque Haïtienne des Pères du Saint Esprit; and Eleanor Snare at the Institut Haïtiano-Américain, all in Port-au-Prince; and the staff of the Melville J. Herskovits Library of African Studies at Northwestern University. I am grateful to have received funding from Columbia University and the Institute for Collaborative Research and Public Humanities at the Ohio State University.

I dedicate this article to Jean-Léon Destiné (March 26, 1918–January 22, 2013).

1. Remarks made by Maritou Moscoso and Deíta (Mercédes Foucard Guignard) during the panel "Les Débuts des Danses Folkloriques Haïtiennes sur Scène Théâtrale," at the conference La Danse Haïtienne: Histoire et Traditions, April 3, 1997, Port-au-Prince, Haiti. Videotapes of this conference are available at the Performing Arts Library, Lincoln Center, New York Public Library, New York. My spelling of Haitian Kreyòl words in this text will generally follow the orthography standardized by the Haitian government since 1979. However, in quoting other writers I will preserve their choice of spelling. All translations of French and Kreyòl are mine, unless otherwise noted.

2. In Haiti, Vodou has traditionally referred to a particular rite within the Rada religious repertory, and, more recently, has been used to gloss all of the rituals serving this principal *nanchon* (nation) of spirits, believed to derive from Ginen, or Africa. It has generally not been figured as an inclusive term for the entire range of spiritual practices pursued individually and through relationships with male and female "priests," called, respectively, *oungan* and *manbo*.

3. If catalyzed by the shock of imperial domination, the poetics of what became known as *indigénisme* in Haiti emerged in dialogue with a confluence of other post–World War I literary and political currents. A number of the self-identified *indigénistes*, most of whom were from elite families, had recently returned from study in Europe.

4. Carl Brouard, "Doctrine de la Nouvelle Ecole," *Conjonction: Revue franco-haïtien de l'Institut Français d'Haïti* 198 (1993): 39.

5. Pierre Buteau, "Une problématique de l'identité," *Conjonction* 198 (1993): 25. See literary scholar J. Michael Dash's discussion of how nineteenth-century Haitian nationalist discourses privileged "official" revolutionary histories (the leadership of Toussaint Louverture, for example, over that of the maroon rebel Boukman), and embraced republican institutions and enlightenment values in positing the elite as "the avant-garde that would rehabilitate the black race." J. Michael Dash, *The Other America: Caribbean Literature in a New World Context* (Charlottesville: University of Virginia Press, 1998), 45. Laënnec Hurbon makes a similar argument: "[The elite] soon would take itself for the entire black race which it would defend and exemplify to the West." Laënnec Hurbon, *Le barbare imaginaire* (Port-au-Prince, Haiti: Editions Henri Deschamps, 1987), 53.

6. Jean Price-Mars, *Ainsi parla l'oncle* (1928; reprint, Ottawa: Editions Leméac, 1973).

7. Jacques Oriol, Léonce Viaud, and Michel Aubourg, *Le mouvement folklorique en Haïti* (Port-au-Prince, Haiti: Imprimerie de l'Etat, 1952), 20. Price-Mars, *Ainsi parla l'oncle*, 45.

8. "A singularly dangerous course if this society, weighted with impedimenta, stumbles in the ruts of dull and slavish imitations, because then it does not appear to bring any tribute to the complex play of human progress and will serve sooner or later as the surest pretext for nations impatient for territorial expansion, ambitious for hegemony, to erase the society from the map of the world." Price-Mars, *Ainsi parla l'oncle*, 44.

9. Price-Mars notes that Paul Sébillot derives the definition of *folklore* in his *Le folk-lore: Littérature orale et ethnographie traditionnelle* (Paris: O. Doin et fils, 1913), from the work of English antiquarian William J. Thoms (1803–85). Interestingly, Price-Mars quotes Thoms (from Sébillot) as proposing that folklore "holds a position in the history of a people corresponding exactly to that which the famous unwritten law occupies in regard to codified law." Quoted in Price-Mars, *Ainsi parla l'oncle*, 49.

10. Price-Mars, *Ainsi parla l'oncle*, 170. Price-Mars problematizes the word "Vaudou" and its variants in discussing its etymology: "To our mind the term Vaudou carries an ambiguity that should be dissipated forthwith. Nowhere have we found it to signify a body of beliefs with codified formulas and dogmas" (90–91).

11. In a 1917 lecture, "La domination économique et politique de l'élite," which was later compiled in his 1919 *La vocation de l'élite*, Price-Mars critiques the Haitian *Code rural* (rural code) for establishing "a category of individuals whose social and economic role merited being defined by special laws in order to demonstrate more accurately that they do not resemble us and that we are able to dispose of their goods, of their liberty and even of their life at will!" He argued that these laws were proof of "the arbitrary nature and the abomination of the legal regime to which we subject our peasants," and noted that it was on the basis of this code that U.S. marines justified the forced conscription of Haitian peasants into *corvées* (work crews) to build roads during the occupation. Quoted in (and translated by) Magdaline Shannon, *Jean Price-Mars, the Haitian Elite and the American Occupation, 1915–35* (New York: St. Martin's, 1996), 42.

12. When this law was passed just a little over a year after the U.S. occupation of Haiti had ended, the popular practices formerly legally classified as *sortilèges* had been officially prohibited by the Haitian *Code pénal* for precisely a century. Article 405 of the original 1835 *Code pénal* prohibited the making of "*ouangas, caprelatas, vaudoux, donpèdre, macandals* and other spells." In 1864, under president Fabre Nicolas Geffrard, the law was revised, its penalties reinforced, and its scope expanded so that, "all dances and any other practices of the nature to keep alive in the populations the spirit of fetishism and superstition will be considered spells and punished by the same sentences." The 1864 *Code pénal* was in effect during the U.S. occupation, and article 405,

in particular, was enforced by U.S. military officials with extreme severity during the early years of the nineteen-year intervention, when it both served as a pretext for the repression of peasant rebels and enabled U.S. officials to justify that counterinsurgency before the 1921–22 U.S. Senate committee investigating the occupations of Haiti and the Dominican Republic as a "civilizing" mission.

13. The article went on to affirm that this "Presidential Act will have considerable repercussions for the prestige of the nation," because Vincent "included in his reform of the state this reform of our customs, this reform of our mentality, banishing from our habits these shameful vestiges of Africa which have always made us considered a strange people, backward, withdrawn from the great lights of civilization and presenting the paradoxical characteristic of appropriating the most refined elements of civilization while preserving in secret beliefs and practices of barbarous peoples." "La réforme de l'état, les décrets-loi," *Le Matin*, October 11, 1935. On the former hostility of *Le Matin* to Vincent's policies, see Shannon, *Jean Price-Mars*, 143, 151.

14. Richard A. Loederer, *Voodoo Fire in Haiti*, trans. Desmond Ivo Vesey (New York: Literary Guild, 1935).

15. Once head of the American Chamber of Commerce in Haiti and author of the historical account *Black Democracy: The Story of Haiti* (1928), Davis continued, "After a first quick read, I turned, completely bewildered, to page 99 and, after having re-read these sentences: 'The fetid air clogged my lungs. My breath came in thick, short gasps. A fit of vomiting seized me . . .' I was grateful to the author of the book for having found an adequate expression for translating the effect that this work will produce on readers who really know Haiti and Haitians." H. P. Davis, "La fumée s'élève des feux du vaudou," *Haïti-Journal*, November 6, 1935.

16. Transparently threatened by the education, wealth, and cosmopolitanism of elite Haitians, white American and European writers during the occupation and thereafter frequently sought to identify such essential "racial traits" that would, as Loederer put it in one case, force the "primitive African [to] break through the shell of civilized convention." Loederer, *Voodoo Fire in Haiti*, 4.

17. Price-Mars, *Ainsi parla l'oncle*, 173.

18. "Art. 1er.— Sont considérées comme pratiques superstitieuses: 1) les cérémonies, rites, danses et réunions au cours desquels se pratiquent, en offrande à des prétendues divinités, des sacrifices de bétail ou de volaille." *Décret-loi sur les pratiques superstitieuses*, République d'Haïti, September 5, 1935.

19. Interestingly, in his 1910 portrait of Haiti, *La République d'Haïti: Telle qu'elle est*, Vincent anticipates his legislation of this specific prohibition in quoting from his "eminent compatriot" Dr. Léon Audain's book *Le mal d'Haïti* on the subject of "*la danse du* Vaudou": "It is necessary to purify the dance of Vaudou of all that which can take the mind back to the barbarism of past times, to suppress the ceremony that precedes the sacrifice, to prohibit the public bloodshed of animals, to check the tafiatic [rum-induced] passion of initiates, to reduce, in a word, Vaudou to a simple popular dance, joyful and decent." Quoted in Sténio Vincent, *La République d'Haïti: Telle qu'elle est* (Bruxelles: Société Anonyme Belge d'Imprimerie, 1910), 284.

20. Alphonse Jean, an elderly *oungan* (male priest) in an area of Tabarre, on the outskirts of Port-au-Prince, known as Kazo, emphasized in a 1997 conversation that during the occupation, "we could not do anything." Alphonse Jean, interview by the author, Tabarre, Haiti, June 15, 1997. My thanks to Yanick Guiteau Dandin and Etienne Germain for introducing me to Jean.

21. Melville J. Herskovits to Norman Armour, American Legation, Port-au-Prince, Haiti, April 12, 1935, Haiti Field Trip file, box 8, folder 22, Melville J. Herskovits Papers, Northwestern University Library, Evanston, IL.

22. Hurbon, *Le barbare imaginaire*, 124.

23. George Eaton Simpson, "The Belief System of Haitian Vodun," in *Religious Cults of the Caribbean: Trinidad, Jamaica, and Haiti* (Rio Piedras, Puerto Rico: Institute of Caribbean Studies, 1970), 255. The end of the occupation in August 1934 ushered in a moment of intense ethnographic interest in Haiti on the parts of American anthropologists and folklorists. Elsie Clews Parsons had visited in 1926. Harold Courlander made his first trip in 1932 and would spend much of the next decade in residence in Port-au-Prince. Melville Herskovits arrived with his wife and collaborator, Frances, for a three-month stay in the summer of 1934 as U.S. military forces were preparing to leave. In 1935–36, under Herskovits's direction, Katherine Dunham spent nine months in Haiti researching social and ritual dances. Remarkably, in the early months of 1937, Harold Courlander, Alan Lomax,

Zora Neale Hurston, Lydia Parrish, and George Eaton Simpson were all simultaneously conducting research in Haiti.

24. Simpson, *Religious Cults of the Caribbean*, 255.

25. Hurbon, *Le barbare imaginaire*, 124–25.

26. Michael Taussig, *Defacement: Public Secrecy and the Labor of the Negative* (Stanford, CA: Stanford University Press, 1999), 61.

27. Joseph Roach, *Cities of the Dead: Circum-Atlantic Performance* (New York: Columbia University Press, 1996), 243.

28. Hurbon, *Le barbare imaginaire*, 92.

29. In discussing Vincent's *décret-loi*, Leon-Francois Hoffmann makes a similar point. He also sees "the influence of Jean Price-Mars and his disciples, who pleaded for the conservation and study of national folklore," but detects this in the new law's provision for the confiscation of *objets cabalistiques*, rather than also their destruction, as article 407 of the 1864 *Code pénal* had prescribed. Léon-François Hoffmann, *Haïti: Couleurs, croyances, créole* (Port-au-Prince, Haiti: Editions Henri Deschamps et Les Editions du CIDIHCA, 1990), 138.

30. References to the *mouvement folklorique* as such appear in the Port-au-Prince daily *Haïti-Journal* as early as April 1941.

31. Jean Price-Mars, *Folklore et patriotisme: Conférence prononcée sous les auspices de l'Alliance Française le 24 novembre 1951* (Port-au-Prince, Haiti: Les Presses Libres, 1951), 11–12.

32. As David Nicholls argues, the romantic populism of the Griots school was "to some extent shared by Roumain." See David Nicholls, *From Dessalines to Duvalier: Race, Colour, and National Independence in Haiti*, rev. ed. (New Brunswick, NJ: Rutgers University Press, 1996), 176.

33. See Jean Coulanges, untitled essay, *Conjonction* 198 (1993): 85. Coulanges discusses the work of Jaegerhuber, Justin Elie, Ludovic Lamothe, Lina Mathon, and Frantz Casséus, among others: "Certain Haitian artists and foreign artists (living in Haiti), following the example of a Béla Bartok, for Hungary, of a Hector Villa Lobos for Brazil, of a Manuel de Falla for Spain, utilized their technique and talent to make classical, concert, recital, salon, chamber work, from Haitian popular themes" (85).

34. Valério Canez, "Notre folk-lore musical," *Haïti-Journal*, November 26, 1942; and Valério Canez, "A propos de notre folk-lore musical," *Haïti-Journal*, December 23, 1942.

35. One indication of this prioritization of performance comes in a 1947 article by ethnologist Michel Aubourg in *Haïti-Journal*, which summarizes the course and scope of the *mouvement folklorique* up to that point. Interestingly, almost all of the figures and groups he mentions were performers. Michel Aubourg, "Le mouvement folklorique d'aujourd'hui," *Haïti-Journal*, August 8, 1947.

36. Jean-Léon Destiné, one of Fussman-Mathon's original company members, who went on to have an international career as a teacher, choreographer, and performer of Haitian dance, remembers that they would rehearse in Fussman-Mathon's home. To begin with, according to Destiné, they concentrated on learning popular songs that Fussman-Mathon had arranged, occasionally offering performances at elite social clubs, or illustrating lectures given by Jean Price-Mars. Remarks made during the roundtable, "Les Débuts des Danses Folkloriques Haïtiennes sur Scène Théâtrale."

37. Ethnologist Michel Lamartinière Honorat remembers as a young person having to listen to *L'Heure de l'Art Haïtien* surreptitiously, as his father did not approve of it. He recalls that the program remained on the air until approximately 1946. Interview by the author, Pétion-Ville, Haiti, June 4, 1997.

38. The Bureau d'Ethnologie de la République d'Haïti was founded by Jacques Roumain on October 31, 1941. The Lescot government issued a lengthy *décret-loi* instituting the Bureau as a state agency and identifying as its mission the collection, classification, and conservation of "archaeological and ethnological pieces found in Haitian territory." Quoted in "Création d'un bureau d'ethnologie: Un important décret-loi instituant ce bureau vient d'être promulgué," *Haïti-Journal*, November 11, 1941. A week after the Bureau's institutionalization, the Port-au-Prince daily newspapers announced that a group of scholars, headed by Jean Price-Mars, had created the Institut d'Ethnologie. See "Un institut d'ethnologie: Il vient d'être créé à Port-au-Prince par un groupe d'intellectuels. Le premier cours sera fait le 17 novembre," *Haïti-Journal*, November 8, 1941.

39. See, for example, Melville J. Herskovits's regret in *The Myth of the Negro Past* (1941; reprint, Boston: Beacon Hill, 1958), that "no method has as yet been evolved to permit objective study of the dance" (269).

40. Jean-Léon Destiné, interview by the author, New York City, January 21, 1992.
41. Louines Louinis, interview by the author, Brooklyn, NY, July 19, 1998. Michel Lamartinière Honorat recalls that Lorimer Denis was instrumental in forming Mater Dolorosa and gave the troupe its name.
42. Marie Noël, a particularly respected informant and member of the troupe, was memorialized on her death in a 1947 issue of the *Bulletin du Bureau d'Ethnologie*: "The Afro-Haitian Ethnography Section to which Marie-Noel was attached...owes to her the greatest part of its documentation on popular culture." The tribute goes on: "At the head of the choir 'Mater Dolorosa,' supervised by M. Saint Erlonge Abraham, she interpreted sacred hymns and popular songs....Marie Noël participated, in a way, in the very life of the Bureau: illustrating its lectures on the subject of the culture of the Haitian masses, collaborating with it in the collection of proverbs, tales and legends." See Regnor C. Bérnard, "Hommage à Marie-Noël," [sic] *Bulletin du Bureau d'Ethnologie* (1947): 27.
43. The Roosevelt administration considered the ongoing occupation of Haiti, scheduled to continue according to the terms of the 1915 Haitian-American Treaty until May 1936, to be a serious political liability to efforts to recruit the alliance of neighboring states through the rhetoric of pan-Americanism. Reporting on talks held between Vincent and Roosevelt in Washington in April 1934 to work out the terms of an early departure of U.S. troops from Haiti, H. P. Davis commented that "the complete restoration of Haitian sovereignty...coincident with the withdrawal of the armed forces of the United States, unquestionably would be accepted throughout Latin America as a proof of the sincerity of Mr. Roosevelt's new 'good neighbor' policy." H. P. Davis, "Haiti and the 'Good Neighbor' Policy," *Literary Digest* 117, no. 17 (1934): 8.
44. Haiti remained under U.S. financial control for thirteen years thereafter, with a U.S. fiscal representative rigidly enforcing the country's debt repayments to American bondholders on a 1922 loan, amounting by 1934 to approximately $11 million.
45. Sarah Gertrude Knott to Melville Herskovits, January 28, 1941, National Folk Festival file, box 14, folder 11, Melville J. Herskovits Papers, Northwestern University Library, Evanston, IL. Interestingly, a March 1938 letter from Charles S. Johnson of Fisk University to Katherine Dunham suggests that the festival's interest in presenting Haitian material was more long-standing. As part of his response to her query about venues that might be interested in her dance company, Johnson wrote: "You know, I suppose, of Miss Gertrude Knott's Folk Festival. This is the third year, I believe. I have just had an inquiry from her about Zora Hurston, who wants to present a Haitian voodoo ritual." Hurston had returned from her Guggenheim-funded research in Jamaica and Haiti several months earlier and was then in the process of completing her ethnography *Tell My Horse*. Charles S. Johnson to Katherine Dunham, March 1, 1938, correspondence folder 20–7–F1, 1/6, Katherine Mary Dunham Papers, Special Collections/Morris Library, Southern Illinois University, Carbondale.
46. Herskovits also asked Knott to "transmit to the Minister from Haiti my considered opinion that the music and dances of these people, as they perform these in their *vodun* rites, is artistically the equivalent of any folk music and many music art forms. The drumming is magnificent; I know of no Negro society where drumming has been perfected to a higher degree, and I would not exclude West Africa itself in this." Melville Herskovits to Sarah Gertrude Knott, January 31, 1941, National Folk Festival file, box 14, folder 11, Melville J. Herskovits Papers, Northwestern University Library, Evanston, IL.
47. Sarah Gertrude Knott to Melville Herskovits, April 17, 1941, National Folk Festival file, box 14, folder 11, Melville J. Herskovits Papers, Northwestern University Library, Evanston, IL.
48. Remarks made by Jean-Léon Destiné during the panel "Les Débuts des Danses Folkloriques Haïtiennes sur Scène Théâtrale." According to another member of this panel, Maritou Moscoso, Fussman-Mathon "often frequented the *peristil* [Vodou temple]," and in Port-au-Prince consulted with the well-known *manbo* Lorgina and her assistant Cicéron St. Aude, who was widely recognized as an extraordinary dancer. Lorgina also had close ties to members of the Troupe Folklorique Nationale, founded in 1949. When I asked if he had known Lorgina, Louines Louinis laughed and replied, "You could not be part of the national troupe and not know Lorgina." Louines Louinis, interview by the author.
49. Jean-Léon Destiné, "Hommage à Lina Mathon-Blanchet," *Haïti-Observateur*, May 18–25, 1994.

50. In studying the literature produced by the church for its so-called *campagne antisuperstitieuse*, it becomes evident that the missions institutionalized between 1939–42 need to be understood, in part, as an effort to check the growing postoccupation influence and prestige of Protestantism in Haiti. A church declaration from early in the campaign, for instance, cites, as a cause for alarm and action, a persistent rumor that "one must become a Protestant in order to extricate oneself from the obligations of superstition." One of the antisuperstitious oaths, in fact, required Catholics to swear both that they were "completely finished with superstitions," and that they would never become Protestants. *Campagne anti-superstitieuse: Documentation* (n.p.: n.p., 1941), 7, 91. Collected at the Bibliothèque Haïtienne des Pères du Saint Esprit, Port-au-Prince, Haiti.

51. Destiné, "Hommage à Lina Mathon-Blanchet."

52. Sarah Gertrude Knott to Melville J. Herskovits, January 28, 1941.

53. The young members of this troupe, according to Jean-Léon Destiné, were: Max, Denise, and Marie-Thérèse Roy, Carline Duré, Léon Walker, Carmen Dalencourt, Martial Day, Jacqueline Déjean, Gladys Hyppolite, Chaton Duplessis, and Léon Destiné. An article in *Le Nouvelliste* on the eve of their departure lists the drummers as André Janvier and Léandre Lunique; Destiné remembers a third drummer named Jonas. See Destiné's remarks during the panel "Les Débuts des Danses Folkloriques Haïtiennes sur Scène Théâtrale." Also see, "Départ du groupe folklorique de Madame Fussman-Mathon," *Le Nouvelliste*, April 17, 1941.

54. "L'Assemblée Nationale en sa séance de ce matin a élu le citoyen Elie Lescot président de la république," *Haïti-Journal*, April 15, 1941.

55. "Haitians Sing to Voodoo Gods As Jungle Drums Beat at Party," *Washington Post*, April 29, 1941. Quoted in "Le groupe folklorique haïtien aux États-Unis," *Le Nouvelliste*, May 8, 1941.

56. Lina Mathon-Blanchet, interview by the author, Port-au-Prince, Haiti, June 25, 1991. Jean-Léon Destiné writes that the members of her group were "the first blacks to be admitted there." Destiné, "Hommage à Lina Mathon-Blanchet."

57. "Haitians Sing to Voodoo Gods As Jungle Drums Beat at Party" in "Le groupe folklorique haïtien aux États-Unis," *Le Nouvelliste*, May 8, 1941. Interestingly, the paragraph in *Le Nouvelliste* that introduces the excerpts from the *Washington Post* article makes a point of describing the "janvalou" (*yanvalou*), which Destiné and Gladys Hyppolite were performing in the photograph that accompanied the article, as a "vaudouesque dance that is *currently* practiced in our countrysides" (emphasis added).

58. "Haitians Sing to Voodoo Gods As Jungle Drums Beat at Party."

59. See Rosalind C. Morris, *In the Place of Origins: Modernity and Its Mediums in Northern Thailand* (Durham, NC: Duke University Press, 2000), 84.

60. Remarks made by Destiné during the 1997 panel "Les Débuts des Danses Folkloriques Haïtiennes sur Scène Théâtrale."

61. Ibid.

62. *Campagne anti-superstitieuse: Documentation*, 112.

63. While lauded by the elite and backed by the force of civil and military authorities when battling *le mélange* in the countryside, the church lost this support in February 1942, when it attempted to install the antisuperstitious missions in Port-au-Prince and administer them across the capital's social classes. The establishment press and government then accused the church of providing fodder, through its campaign, for those in the West who desired to represent or view Haiti as "the most superstitious country in the world." "La campagne anti-superstitieuse dégénère en manifestations de haine et de discorde," *Haïti-Journal*, February 23, 1942. Ultimately the persecution of *sèvitè* by church and state authorities seemed only to intensify such associations. Elie Lescot, who, in his 1974 memoir, accused the Roman Catholic hierarchy of attempting to destabilize his government through the *campagne anti-superstitieuse*, regretted, too, that "all this din in our poor country in 1941 and 1942, under the fallacious pretext of converting our rural masses, constituted, abroad, the most deplorable publicity for Haiti." Given his initial backing for the campaign when it was focused in the countryside, such a statement might seem rather revisionary. Elie Lescot, *Avant l'oubli: Christianisme et paganisme en Haïti et autres lieux* (Port-au-Prince, Haiti: H. Deschamps, 1974), 360.

64. J. C. White to the Secretary of State, "Change in Attitude towards Voodoo on the Part of the Intellectual Classes in Haiti As Evidenced by Development of Expressions of Interest in Folklore,"

September 24, 1942, U.S. Department of State decimal file 838.404/85, U. S. National Archives, College Park, MD.

65. *Haïti-Journal* announced this event several weeks earlier: "This will be the occasion of a great artistic and society event under the high patronage of the new chief of state, S.E.M. Elie Lescot." *Haïti-Journal*, April 21, 1941.

66. "Ce soir au Rex Marthe Augustin dans 'Gabélus': Un gala folk-lorique sans précédent," advertisement, *Haïti-Journal*, September 21, 1942.

67. "Au gala folk-lorique au Rex, l'allocution du directeur de 'L'Heure de l'Art Haïtien,' notre collaborateur Clément Benoit," *Haïti-Journal*, September 24, 1942.

68. In cooperating on SHADA, Haiti and the United States took over massive tracts of land to cultivate a latex-producing plant called cryptostegia, resulting in serious food shortages in the affected regions during the following year. When the U.S. government abandoned the project in 1944, it provided no financial or other assistance for the resettlement of peasants on the confiscated land.

69. "Le Gala Folklorique de l'Heure de l'Art Haïtien," *Le Nouvelliste*, September 22, 1942.

70. Ibid.

71. Roussan Camille, "Regards," *Haïti-Journal*, September 23, 1942.

72. J.C. White to the Secretary of State, "Change in Attitude towards Voodoo."

73. Pierre Desrameaux, interview by the author, Port-au-Prince, Haiti, May 27, 1997.

74. Michael Lamartinière Honorat, interview by the author, Pétion-Ville, Haiti, June 4, 1997.

75. Later on, in his 1951 lecture, "Folklore et Patriotisme," probably his strongest published statement against the legal prohibition of *les pratiques superstitieuses*, Price-Mars built on this earlier redefinition in arguing against the injustice of the law's failure "to disassociate archaic and old-fashioned religious practices from crimes of sorcery and magic." Addressing his auditors (and subsequent readers) in the confrontational tone that was his frequent rhetorical mode, Price-Mars analyzes the stakes of the governing elite's reliance on this prohibition: "Ah! You don't want to hear Vodou spoken of...you feel only shame and scorn for this form of barbarity and it is the *Code pénal* for which you call to help to put an end to this scandal which contrasts so strongly with the degree of civilization that you boast of having attained." Price-Mars, *Folklore et patriotisme*, 17-18.

76. Her-Ra-Ma-El [Arthur Holly], *Dra-Po: Étude ésotérique de* égrégore *africain, traditionnel, social et national de Haïti.* (Port-au-Prince: Imprimerie Nemours Telhomme, 1928), 359.

77. Kléber Georges-Jacob, *L'ethnie haïtienne* (Port-au-Prince, Haiti: Imprimerie de l'Etat, 1941), 65. In this work, Georges-Jacob made Price-Mars's reclassification the basis of a legal argument against Vodou's interdiction, with reference to the Haitian Constitution's protection of religious freedom. He reasoned that if these were practices of a religious nature, as Price-Mars had demonstrated, and if, constitutionally, each citizen had the right to profess his religion as long as it did not disturb the public order, then the prohibition should be lifted, as such family-based rites "constitute neither an immediate nor indirect danger for society" (74).

78. It seems that Augustin may have formed her own company of performers soon thereafter. In May 1943, an advertisement in *Haïti-Journal* read: "This evening at the Rex, the Great National Star Marthe Augustin and her troupe in a Great Folkloric Gala." *Haïti-Journal*, May 12, 1943. By the late 1940s, when folklore performance, as Oriol et al. write, had "reached its apogee" under the officializing cultural policies of president Dumarsais Estimé and the boom in tourism in Haiti, Marthe Augustin seems to have stopped performing. Oriol, Viaud, and Aubourg, *Le mouvement folklorique en Haïti*, 75. She was only vaguely remembered by the participants in the panel "Les Débuts des Danses Folkloriques sur Scène Théâtrale," at the 1997 conference in Port-au-Prince. Michel Lamartinière Honorat recalled that some of Benoit's other former performers became founding members of the folklore company La Troupe Macaya, directed by André Narcisse. Interview by the author.

79. Pierre Mayard, "Raccourcis," *Haïti-Journal*, February 17, 1943.

80. Roussan Camille, "Lorimer Denis et le folklore haïtien," *Haïti-Journal*, May 3, 1943.

81. "Dans le théâtre: Nos auteurs chôment...faute de public," *Haïti-Journal*, May 7, 1943.

82. Quoted in "'Mambo-Chérie' est 'Malade,'" *Le Nouvelliste*, June 3-4, 1943.

83. "'Mambo-Chérie' est 'Malade.'"

84. Quoted in "Une excellente décision," *Le Nouvelliste*, June 5, 1943; "Au théâtre: Les imitations des cérémonies rituelles sont désormais interdites," *Haïti-Journal*, June 5, 1943.

85. "Le B.I.P. ne pratique que la censure politique," *Haïti-Journal*, April 16, 1943.

86. Authors and directors of this genre of folklore who had already had their works approved by the BIP were required to present them again to the undersecretary of state for information and the general police to be reexamined in light of this new ordinance. To be mounted onstage, productions would require an official "visa" issued once a government representative had attended, and approved, a dress rehearsal. "Une excellente décision." Georges Corvington, author of a multivolume history of the city of Port-au-Prince, was certain that this ordinance was applied to theatrical folklore productions during the remaining three years of Lescot's presidency. Interview by the author, Port-au-Prince, Haiti, June 8, 1997. See his *Port-au-Prince au cours des ans: La ville contemporaine, 1934–1950* (Port-au-Prince, Haiti: Henri Deschamps, 1991), 233 for another case of BIP censorship "in the interest of morality and good customs."

87. "L'incident est clos; Clos est le folklore...," *Le Nouvelliste*, June 7, 1943.

88. Derrida writes: "The word 'enforceability' reminds us that there is no such thing as law (*droit*) that doesn't imply *in itself, a priori, in the analytic structure of its concept*, the possibility of being 'enforced', applied by force. There are, to be sure, laws that are not enforced, but there is no law without enforceability, and no applicability or enforceability of the law without force, whether this force be direct or indirect, physical or symbolic, exterior or interior, brutal or subtly discursive and hermeneutic, coercive or regulative, and so forth." Jacques Derrida, "Force of Law: The 'Mystical Foundation of Authority,'" trans. Mary Quaintance, *Cardozo Law Review* 11, no. 5-6 (1990): 925-27.

89. Hurbon continues: "The specific task of the state—and...the service expected from the penalization of Vodou—consists first of all in producing the marginalization of the peasantry." Hurbon, *Le barbare imaginaire*, 143.

90. Barbara Kirshenblatt-Gimblett, *Destination Culture: Tourism, Museums, and Heritage* (Berkeley and Los Angeles: University of California Press, 1998), 161.

91. Perhaps this analysis points to a series of larger questions about the relationship between prohibition and performance in the staging of official national and postcolonial modernities: Given the persistent and global force of colonial ascriptions of backwardness and barbarism, have not the stakes for transvaluing "error into archaism" been particularly high for modernizing postcolonial and post-occupation states? What roles have law and theater played in such conversions in other postcolonial contexts? Finally, when governments have claimed the legitimacy of the "folk" by nationalizing popular performance cultures, what have been the consequences for populations who have regarded such cultures neither as errors nor as archaisms, nor as in need of such transvaluation?

Atis Rezistans:
Gede and the Art of Vagabondaj

Katherine Smith

This chapter begins on the Grand Rue, the main street of Port-au-Prince, Haiti. The Grand Rue stretches from the sprawling slums of Cité Soleil in the north to the city's lively necropolis in the south, a place inhabited by both spirits and transients. To the west lies the city's shoreline, a repository of history, spirit, and human waste. From the east side of the street, downtown distends toward the hills recalled in Haiti's popular proverb "Beyond the mountains, more mountains."[1] Amid the sensual dissonance of downtown, at a spot where mechanics ply their trade street-side, there is a courtyard where the artist André Eugene lives and shares a workspace with Frantz (Guyodo) Jacques and Jean-Hérard Céleur. These three artists form the core of a collective called Atis Rezistans, or Artists of Resistance. While the artists all have workshops of their own, Eugene describes this courtyard as a museum, and in practice it functions as much more.

Eugene's courtyard would be unremarkable if not for the proliferation of Vodou-inspired sculpture that inhabits it. For most of the neighbors that share the space, and for the artist himself, it is still an urban *lakou*, or compound. Meals are still cooked there, dominoes are played, children turn plastic bags into kites, and in an unoccupied corner someone has planted a small patch of beans and corn. Yet the industrial waste, the car parts and other First World debris that clog the rest of the city have been transformed into images of Vodou's cosmic recycler of life and death, the spirit Gede. There are other spirits represented as well, but it is Gede – master of all aspects of life's beginning and end, from ancestors and future progeny to sex and death – who takes center stage in Eugene's courtyard. Just beyond the shadows of the love hotels of the Grand Rue, with the cemetery over the horizon, there is a statue of Gede that looms taller than the other buildings on the block. Named after the chief of the Gede family, the statue titled *Bawon*[2] stands near the entrance of the lakou (figures 1 and 2). The body is made of welded pieces of recovered metal, with a head made of a large muffler. The *Bawon* smokes a pipe, as the spirit himself characteristically does upon "mounting" a bodily host. The statue features a wooden phallus attached to its steel frame by a shock coil, effectively rendering the appendage kinetic. On days when the neighboring women do the wash in the shadow of this towering monument to tumescence, the phallus is draped in clothes hung to dry. The statue has been there since 2002, and it no longer garners much attention from the neighbors unless an outsider is actively engaging the piece. But even this happens frequently enough that it attracts little attention.

Reprinted with permission from *Obeah and Other Powers: The Politics of Caribbean Religion and Healing* (Durham and London: Duke University Press, 2012), 121–48.

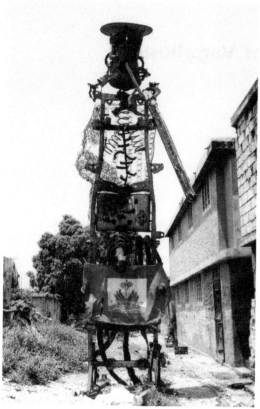

Figure 1. This sculpture of Bawon, who is closely related to Gede, stands just outside André Eugene's courtyard.
Photo by the author, 2005.

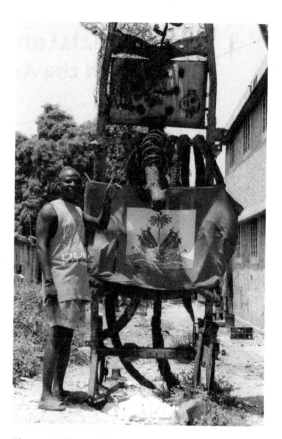

Figure 2. The artist André Eugene with *Bawon.*
Photo by the author, 2005.

Sometimes, when the artist sees fit, *Bawon* wears a Haitian flag, but rather than obscuring Gede's genitals, the flag is draped just below and behind them as if to serve as a backdrop for the impressive appendage. The *Bawon's* salute to Haitian nationalism is more than ironic, though humor is always relevant to a discussion of Gede. Eugene is demonstrating that Gede is the spirit closest to the Haitian people. But the question of how this spirit of *pèp la* (the people) is imagined is complex, at the very least because of Gede's overwhelming phallocentrism. In this chapter, I present my reading of Eugene's answer to this question. I assert that what emerges from his work is an idea of Gede that expresses an incarnation of masculinity that may be best described as the urban *vagabon*, or vagabond. I situate this transgressive masculinity historically, and trace two more sculptures of Gede. I begin, however, with introductions, first to the Atis Rezistans, then to Gede.

Atis Rezistans: An Urban Art Collective

While Guyodo, Eugene, and Céleur are the core members of the Atis Rezistans collective, some neighbors have begun making sculpture as well. Eugene has encouraged this by teaching children the art of painting and assemblage in a group he calls Ti Moun Rezistans or Children's Resistance. Eugene and Céleur began their careers as artisans who worked in wood to create tourist souvenirs and kitchen goods for the domestic market. Céleur was the first in the area to begin carving pieces that parted from the conventions of the trade. Eugene joined him shortly thereafter. Guyodo, the

youngest of the three, began training as an artist under the tutelage of Céleur.[3] Before Guyodo joined, the two artists had collaborated with Nasson and Mario Benjamin, two established Haitian artists who helped Atis Rezistans gain recognition. Barbara Prézeau-Stephenson, founder of the organization AfricAmerica, who arranged their first international exhibition, also promoted their work.[4]

It is important to understand the artists and their works as a collective because they live and work in close proximity to one another. This is a conscious choice on their part, and an effort that they see as part of a movement based in their community. The three artists have traveled and exhibited internationally, and in 2007 they were commissioned to create a piece for the International Slavery Museum in Liverpool. Despite this success, the artists choose to remain in their neighborhood. And I have heard repeatedly from the neighbors that their work is good because it brings in money and foreigners. The Atis Rezistans are taking garbage and making it live again, as each of them phrased it. In doing so, they are transforming their neighborhood. Guyodo envisions the place as a "garden of artists."[5]

While I stress that it is important to understand the artists as a collective, I will be focusing on the work of André Eugene in particular because his courtyard is an important hub of neighborhood activity and creative work. Also, while all the artists make images of Gede, Eugene has been dedicated to the spirit since he was born.[6] While he serves all the spirits, he clearly has a close affinity for Gede: "I like to work with Gede because no one can hide anything from him. When Gede appears, he exposes the truth."[7] It is not surprising, then, that the images he creates of Gede are poignant and prolific. Eugene's affinity for seditious tricksters extends to the human realm as well. The walls of his home feature photographs and news clippings of Karl Marx, Osama bin Laden, and Charlemagne Péralte, leader of the guerilla fighters who resisted the first United States occupation (1915–34).[8] Eugene, in fact, styles his carefully angled haircut after the latter. There is also a picture of the signing of the United States Constitution printed on velveteen. Eugene identifies all these images as influences, as portrayals of men who had a vision for the future and who broke laws to accomplish their goals.

Eugene was born in 1959 and, like the other two artists, he grew up in an area of the Grand Rue known as Ghetto Leanne. His home is modest in scale, but the ambiance and décor of the simple concrete structure can only be described as Gede baroque. He almost constantly hosts an assortment of neighbors, friends, children, artists, art collectors from uptown, foreign journalists, "adventure tourists," international art marketers, culture brokers, ethnographers, photographers, NGO workers and more. Everyone who enters must at some point bend, bow, or otherwise negotiate the protuberance of a phallus, a doll's head, a skull, or some other carefully placed aberrance. The sheer abundance of sculptures – all with faces of marble, plastic, or nails, eyes that glint from just beyond the ebb of the light – effects a dissonance of the senses. This orchestrated excess reflects the conditions of life itself in the city. But excess also describes Gede's dual appetite for death and fornication. Ultimately, Eugene presents an image of Gede that embodies the city in all its vivacity and decrepitude. As Céleur has said, "We are an artist collective, but we are artists of the city, too."[9]

Figures for the population of Haiti are usually given around 8.5 to 9 million, with an estimated one-fourth of the population residing in the capital, Port-au-Prince.[10] More than half of the city's population arrived in the last two decades, though its infrastructure was designed for a population of 200,000. But statistics are specious in a place where the nature of urban survival is peripatetic. As a friend once said of the city, "Not even God knows how many people live in Port-au-Prince."

The layout of Port-au-Prince is defined both by the grid of major boulevards and by the maze of makeshift homes and passageways between them. The city is a palimpsest of decay and development; rebar rusts at the unfinished ends of buildings whose concrete skins begin to crumble long before completion. But completion is a fallacious lens for viewing a city that is so clearly improvised – or, better put, *improvising*. Daily its denizens increase, expanding into the narrowing gangways, precariously piling cement on cement, and mounting labyrinths of corrugated tin up into the hills. Yet if there is more life here, then there is also more death. Eugene has said of his space, "This is an art museum, but it is also a cemetery in its own way."[11] Sometimes Port-au-Prince has the same feel. In a place crowded with so much life and death, it seems only fitting to speak of Gede as a spirit at home in the city.

Who Is Gede?

The images of Gede presented by Eugene in *Bawon* and other works may be shocking, but they are culturally intelligible. The sculpture employs a lexicon of symbols that most Haitians would recognize as referencing Gede. The artist has said, "For me, Gede symbolizes life and death."[12] Gede is commonly represented by the phallus, the skull, and the cross—the cross being a tomb, but also more generally the place where the world of the dead finds a place in the world of the living. In Vodou cosmology, these worlds are always coeval, suspended in mirrored communion above and below the ancestral waters. Maya Deren describes the immanent presence of the spiritual world in Vodou, "the metaphysical world of *les Invisibles* is not a vague, mystical notion; it is as a world within a cosmic mirror, peopled by the immortal reflections of all those, who had ever confronted it."[13] Eugene made a similar point describing another sculpture: "Everything in the world below is the same as the world above."[14] That includes, of course, sex.

For Gede, the world begins and ends in the realm of the corporeal. He embodies a resolution to those seemingly intractable oppositions that power so much human creativity: sex and death, consumption and excretion. He is the nexus between the sexual reproduction of the individual body and the regeneration of the social body. By this I mean that in him lies the realization that the most base and pungent physical aspects of sexual reproduction are also the most fecund semantic generators. This is graphically performed when Gede possesses someone. As Eugene explains, "When Gede arrives he immediately pulls out his dick and shows you the symbol of life." Yet as the spirit who is best able to contravene the boundaries of the social and physical body, he is also a healer employed in the direst of circumstances. As Marilyn Houlberg has said, "Gede is the special guardian of infant children and the *lwa* (spirit) best able to help human beings avoid death."[15]

It is difficult to overstate the prominence Gede enjoys in Vodou, and more generally in Haitian popular culture. Gede is the most ubiquitous spirit of the pantheon because he is common to everyone. A temple may serve any combination of spirits, but it will always have a tomb for Gede, usually outside the peristyle. Likewise, every individual has a spirit that "rules" his or her head, but additionally, as the esteemed priestess Mama Lola said, "Some people got Ogou. Some got Papa Danbala...not everybody. But everybody got Gede. Everybody."[16] Or as another associate of Atis Rezistans, Claude Sentius, stated, "We are all Gede spirits. I am a Gede. It's a Gede that is speaking to you. I've already died, I just haven't been buried yet. When I die I will be a Gede and dance inside someone's head."[17]

Gede is a spirit associated with the family and ancestors, and by extension, the rural family compound, or lakou. The lakou is the locus of ritual service for Gede, with the family tomb (often more elaborate than the homes of the living) serving as an altar. But urbanization marks a radical

restructuring of the lakou.[18] In the city, one may share the same space with other families, and the space may be rented rather than inherited.[19] Impermanent as it is, the urban lakou is hardly a fit repository for ancestors.

Instead, urban necropolises have become sites of devotion, prayer, magic, and partying. Fet Gede has become a holiday celebrated in public on a massive scale, rather than a private, family affair. In 2007 at Fet Gede in Port-au-Prince, I saw families quietly attending to their tombs; delegations of devotees from temples passing out coffee and bread; street children asking for alms; pilgrims on their own mystical missions; foreign and local photographers, videographers, and journalists vying for the best vantage point to observe the spectacle; market women selling libations, candles and cigarettes; showmen who eat glass, pierce their skin with needles, or hold burning embers; marauding bands of adherents possessed by Gede; and the onlookers who follow the spirit. Finally, there were bands of young men (although there are occasionally women, too) who sang lewd songs and generally *fe dezòd* (misbehaved). I saw one young man pounding on the tombs yelling, "Leve bouzen! Leve!" (Get up, whore! Get up!). Outside the cemetery, the streets filled with *bands à pieds*, and even the most dormant temples enlivened to celebrate and sacrifice goats and offer food to the poor.

Guyodo explained to me that the scene in the cemetery was "normal" for Gede: "Well, the reason why people call Gede a vagabon is because of the way he is when he arrives [when he possesses a person]. When Gede first comes he acts boldly, and some of them [Gedes] might go as far as hitting someone on the leg with a stick or even putting hot pepper in someone's eye. You can sometimes see in Carnival someone will be possessed with Gede. You will see this in the Raras [popular street bands],[20] that they become possessed with Gede. That is why they call it the 'Vagabon religion.' "[21] Guyodo is describing a behavior of Gede that is direct and provocative. It is significant, however, that he labels Vodou as "the vagabon religion." On the one hand, the phrase would frame Vodou as almost carnivalesque. Yet this also acknowledges that the most public face of Vodou is Gede, and that the image presented is masculine and transgressive. In the following section, I examine another sculpture by Eugene that manifestly references the uniform of Duvalierist agents, but also reveals a historically situated and gendered concept of *vagabondaj* – a Creole term for vagrancy, but also more generally for misbehaving.

Chef Seksyon

In André Eugene's home and courtyard, the statues of Gede and his Vodou compatriots come and go. If a piece is not sold, or if Eugene tires of it, it is taken apart and turned into something else. One of the pieces that has remained in its place since I first met the artist in 2003 is a sculpture titled *Chef Seksyon* (Section chief; figures 3a and 3b). Upon entering Eugene's home, one is greeted by *Chef Seksyon*, who stands opposite the front door. The piece takes its name from the paramilitary force popularly known as the Tonton Makout under the two Duvalier dictatorships. Eugene is making an analogy between Bawon and the Makout: "Chef Seksyon under the Duvaliers was someone who was a chief of their community....If you wanted to do something in that zone, you have to pass him. It's the same with Bawon Samdi in the cemetery, he's the chief." Bawon Samdi is the master of the dead, and therefore the spirit marshal of *zonbis*. Eugene is suggesting that negotiating with Bawon is a kind of clientelistic relationship with the dead. He signifies this linkage visually with a steel pan from the underside of a car, positioned on the *Chef*'s head to resemble a military officer's hat. The *Chef* also dons a scarf around his neck, which, as Eugene pointed out, resembles the uniforms of the Tonton Makout.

Gede and the state have been engaged in a mimetic pas de deux since at least the early twentieth century.[22] The intertwining of masculinity and Vodou reached its zenith, however, under the rule of François Duvalier (1957–71). The infamous "president for life" cultivated an image of father of the nation, thus earning the epithet "Papa Doc."[23] But his paternal image was complex and subtly employed the mythography of Vodou toward political ends.[24] That his dress and nasal voice bore a striking resemblance to Bawon Samdi was not lost on the majority of Haitians. While the Bawon is the head of the Gede family, he is not a vagabon. Chief arbitrator of zonbis, the Bawon can inspire dread. Duvalier, likely taking cues from the Bawon, created a paramilitary force that appeared to raid Vodou's closet.[25] Regarding their standard-issue sunglasses, it is said that "the Tonton Macoutes took to wearing sunglasses in order to make peasants think they were zombies."[26] The implication was that Papa Doc was the controlling agent behind the Makout. But their dress had other Vodou associations as well. Their denim suits and neck scarves resembled the spirit Kouzin Zaka, who resides over agriculture. Zaka is closely related to Gede, and is the only other spirit who is said to be a vagabon. Certainly many Macoutes were engaged in vagabondaj. Yet the dress of the Tonton Makout also resembled a boogeyman of Haitian folklore, who was said to kidnap disobedient children and carry their diced remains in his knapsack (*makout*). Be they zonbis, boogeymen, or vagabons, the Makout enforced a regime of violence that was, in most respects, unprecedented in Haitian history for its intensity, duration, and penetration of civil society.

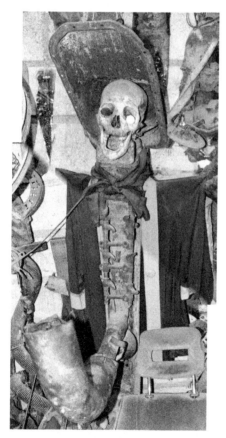

Figure 3a. *Chef Seksyon* by André Eugene is an image of Gede that recalls, and recasts, the Duvalier era Tonton Macoutes.

Photo by the author, 2005.

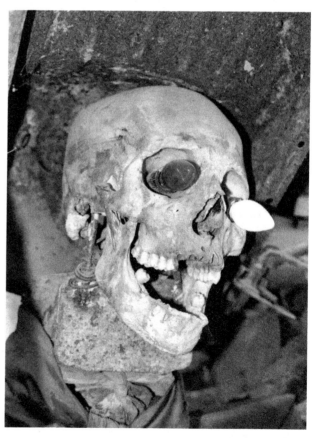

Figure 3b. Detail of *Chef Seksyon* by André Eugene.

Photo by the author, 2005.

Jean-Claude Duvalier demonstrated similar totalitarian tendencies as his father, but he did not hold the same serious persona in the popular imagination. For example, it was rumored among the people that he was *masisi*, or gay, a term that is generally used pejoratively. In Vodou, masisi are associated with the lwa Ezili Freda, who is as stridently feminine as Gede is thoroughly boyish. Like Gede, Freda's hyper-gendered identity is not biologically determined. Freda is recognized by her stereotypical feminine proclivities, namely an insatiable appetite for fineries. In that sense, the younger Duvalier and his avaricious wife, Michèle Bennett, lived the Ezili lifestyle. It was not that corruption and graft were new, but that the spectacle of gratuitous consumption had reached a new level.[27] At a moment before the AIDS epidemic, when tourism was at its height, Haiti appeared to be a land of cocaine and champagne. It was an era of Ezili Freda—or at least it was for some.

For the vast majority of Haitians, little changed in the shadows of such resplendence. The graft did begin to take its toll on the economy, and in February 1986 the masses, emboldened by hunger, took to the streets and helped to topple the dynasty. Out of Duvalier's overthrow came a galvanized popular movement unlike anything seen since the early twentieth century, perhaps even the revolution. Yet this was only half the story. The old guard of Papa Doc's regime was not satisfied with the younger Duvalier's marriage or the lifestyle it entailed. As the historian and anthropologist Michel-Rolph Trouillot asserts, "What Haitians witnessed on February 7, 1986, was not the disorderly escape of an "entire leadership" pushed out by popular pressure...but a transmission of power, orchestrated with absolute order—albeit against a backdrop of popular uprising."[28] The expulsion of Baby Doc was, in part, devised by Duvalierists, and so the era leading up to elections in 1990 came to be cynically referred to as "Duvalierism without the Duvaliers."[29]

Yet this era was not all *plus ça change*. Duvalierism was irreversibly destabilized, just not immediately. In Eugene's imaging of *Chef Seksyon*, then, the "military hat" is atop a human skull and a spine made of a camshaft, but the seriousness of bones and steel fortifiers is undermined by the Christmas tree lights in the eye sockets of the skull. One light is slightly askew and the jaw is disjointed, giving him an expression of grinning madness. The artist said of the piece, "It's a real skull. I put two lights in his eyes so he can see. He isn't dead though, he is in life, that's the reason he has the big *zozo*. He gives life always." In Creole, *zo* means "bone," and while words are often repeated for extra emphasis, in this case, *zozo* becomes slang for an erect penis. Eugene is referring to the industrial-sized exhaust pipe that juts three feet out from *Chef's* body, a phallus that marries abundance and absurdity in its scale.

The phallus of *Chef* also has a lived presence in Eugene's home. First, there is the fact that it occupies a central, even awkward, position in what serves as the artist's living room. Every living body that enters the space must accommodate it. As an active part of the home, the phallus wears an ever-changing assortment of accessories. These appurtenances generate narratives of a certain lifestyle that may be described as vagabondaj. When I interviewed Eugene about the *Chef*, he leaned on the exhaust pipe, which was at the time bound with a rope, and explained:

> The zozo is tied with a rope because it gives too many problems...This part is tied, but he may also use a condom. I can put a plastic sack on it for a condom. Sometimes I take it off and sometimes I tie it, and sometimes I untie it. An artist's oeuvre is never done for him. He is always improvising on things. Depends how I feel because a piece of work for an artist is never done. With the same materials [the artist] can create different things, he can create a diverse oeuvre with the same philosophy.

It should be noted that Eugene was laughing when he described the problems of the zozo and his attempts to rein it in. Yet he is also clearly making a link with the expressive and creative quality of the zozo and his role as an artist.

I asked Eugene why *Chef* was not wearing a condom, and he replied, "Now's the time for having sex *ann dezòd* (recklessly). Time to make children. When he doesn't make children he wears a condom. When the zozo stays hard though he has to tie it, to chain it." The term "ann dezòd" is significant because it is commonly used to describe the behavior of both Gede and vagabons. But Eugene pushes the humor and metaphor further when describing the singular, metal testicle of *Chef*: "You see Monsieur also has only one testicle [*grenn*],³⁰ a testicle that is like a grenade.... It's the same when you blow your load [ejaculate], there is a lot of small stuff that disperses." Eugene's analogy describes Gede's explosive sexuality in terms of a procreative bomb. The latent duality of creation and destruction in this analogy is particularly apposite, considering the population boom that stifles the city under so much vitality. Yet the image is also masculine and chaotic. There is a performative aspect to Eugene's description that demands a deeper reading. Specifically, with the image of *Chef* and his explanation of it, Eugene is making plain the linkage between Gede and the average man—or more to the point, the average vagabon.

Vagabondaj: Haitian Discourses On Misbehaving

Sitting outside a barbershop one afternoon, a friend explained to me, "Everyone engages in vagabondaj sometimes. Sometimes you feel good, maybe you have a little money and you get a friend and go out on the street and look for women." When he said this he was smiling broadly and leaning back with arms open wide, as if to suggest he was ready to *banbouche*, or party.³¹ Often it seems that "vagabon" permeates every aspect of public discourse: from Carnival songs like "Vagabond 4 Life" to political commentary in *Le Nouvelliste*, the word has become ubiquitous. Young men are lauded as vagabons when dancing suggestively behind a Rara band, but the word is also spray painted on walls to deride a local politician or "big shot." Friends would use the word when discussing current events, especially the urban gangs that have flourished in the past decade.

It is clear that there is a deep uncertainty in the term. Its usage can be playful and sexual, but also menacing and derogatory. The vagabon is celebrated for flaunting authority in a country saddled with a long history of authoritarianism, yet the same disregard for social norms makes the vagabon an object of fear. The vagabon's transgressions may be humorous and liberating, or they may be violent and destructive. Haitians put it best with the proverb "Se ton an ki bay signifikasyon" (It's the tone that gives meaning). The word may be spat at a passing car, whispered under the breath when discussing a recent kidnapping, or used to cajole a disobedient child, but the tenor of its meaning is always contextual.

Despite the wide range of possible targets for the term, there are two defining characteristics of the vagabon. First, the vagabon does not respect the order of things. The word was repeatedly defined with the phrase "Li pa respekte prensip la" (He has no respect for etiquette, or literally, he doesn't respect the principle). The idea of "the principle" is best summed up with the exchange performed outside the rural family compound or lakou. When an outsider approaches, he or she says, "Honor," and the host responds, "Respect."³² This exchange exemplifies the dignified behavior that is considered normative, or at least ideal, in most of Haitian society. This is precisely what Eugene meant when he described the *Chef*'s unsafe sex practices as "reckless" or literally as "making disorder." He was indicating that Gede acts on his antisocial desires.

The second characteristic of the vagabon is his unambiguous masculinity. There is an aspect of public spectacle that marks the vagabon as male: most often one earns the moniker for doing in public what should be hidden in private. Public space may be gendered male and domestic space female, but in practice, of course, women engage in vagabondaj as well. But a woman is a *fanm*

vagabon, or a woman vagabon; the term "vagabon" is therefore unmarked as male. The vagabon's aggressive sexuality is also something that would be accepted with a winking disapproval, as he would only be pushing normative gender roles to a playful extreme. I have only ever heard fanm vagabon used pejoratively, however, as synonymous with *bouzen* (whore) or *manman chyen* (bitch). The point is that the term, by being marked and unambiguously derogatory, demonstrates the inherently masculine quality of the vagabon. And this inherent characteristic is reflected in the Gede-Bawon family, in which the only female spirit, Gran Brijit, is secondary, elderly, and devoid of sexuality.

The Haitian vagabon is part of a larger identity matrix of African-Atlantic transgressive masculinities. The vagabon shares a polythetic resemblance to a host of labels applied to men who are generally poor, disenfranchised, and perform a sort of irreverence as resistance to propriety and respectability.[33] Thus in the vagabon one recognizes the style of the *malandro* (Brazil),[34] the trickiness and slackness of the rude boy (Jamaica),[35] the menace and envied coolness of the gangsta (United States),[36] the phallocentric braggadocio of the Trinidadian stickman,[37] the cunning of the Martiniquan *débrouillard*,[38] and the virility of *tíguere* street culture (Dominican Republic and Puerto Rico).[39] Even in the northern regions of the Atlantic, at the Boston Massacre of 1770, Crispus Attucks's compatriots were described as a "motley rabble of saucy boys, negroes and mulattoes, Irish Teagues, and outlandish Jack tars."[40] The point is that the vagabon is only one permutation of a broader complex of masculine identities that are intimately connected with the structures and strictures that both revile and define them. But the vagabon and his cohort are revered as antiheroes because they flaunt their exclusion.

In this sense, the identity matrix that I have described parallels the religious and spiritual complex of Afro-Atlantic tricksters. The category is broad and diverse, but it may be defined by a common marginality vis-à-vis mythical and social hierarchy. Tricksters, like the vagabon and his ilk, are defined by their position outside and against established order. Gede, for example, acts as an intermediary between life and death, but can do so only by going outside the prescribed role of respectability.[41] According to Robert Pelton, the trickster mediates the center to periphery by "means of a lie that is really a truth, a deception that is in fact a revelation and a conspiracy that should have been no secret."[42] In other words, the trickster's lies always undermine the discourse in which they are couched, in order to reveal a deeper, underlying truth. In societies where the state's "truth" and its constitutive silences have been maintained with violence and terror, the trickster can be revolutionary—hence the trickster is widely embraced as liberator and the vagabon is given more leeway than the average lout.

What, then, do the vagabon and the trickster reveal with lies and trickery? One answer could be found in unraveling the history in which they are bound. As E. Antonio de Moya has remarked on the *tíguere*, "The origins of this mostly transgressive culture in the Dominican Republic are probably related to a history of slavery, oppression and political instability, but few studies have been conducted in this regard."[43] Vagabondaj, in the sense of vagrancy, was, like the Trinidadian stickman, a form of "refusing to be the grist for the mill of colonial machinery."[44] The vagabon social type is common throughout the Afro-Atlantic in part because under the system of slavery, idleness was theft. Like the lie that reveals artifice, this act of theft undermined the tenets of slavery through the assertion of willfulness. The efficacy of vagrancy as a means of resistance was not lost on the colonial powers. Kate Ramsey notes that in Haiti, the legal regulation of Vodou and vagabondaj have often worked in tandem. As an example, she cites the 1931 memoir of Faustin Wirkus, *The White King of La Gonave*, who openly admitted that "whenever he needed manual labor for construction projects he would make arrests on charges of 'vagrancy' or 'spellmaking.' "[45]

The vagabon and his band of Afro-Caribbean rogues have therefore always been in opposition to officialdom, seeking power instead from acts of subversion and from the corroboration of pèp la.[46] It is my contention here, however, that the current age is characterized by a troubling of center-to-periphery modalities of power, especially when describing the relation of the state to the people. In the next section, I will begin with a sculpture by Eugene that is a departure from both *Bawon* and *Chef Seksyon* in its portrayal of Gede's phallus. The phallus here is used to comment on the state of the country in a moment of extreme political, social, and economic upheaval. In doing so, it troubles the distinction between social and semantic reproduction.

Dr. Zozo

In 2005, André Eugene created a sculpture titled *Dr. Zozo* (Dr. Boner; figures 4a and 4b).[47] It was a figurative piece that stood approximately five feet tall in the artist's courtyard. *Dr. Zozo's* arching body was constructed of metal scrap: part of a car chassis for a spine, shock coils for ribs, with mattress springs clinging to his metal bones like veins. Eugene had dressed *Dr. Zozo* in used clothes of red and blue, the colors of the Haitian flag. Atop these scraps was a human skull covered in resin, made to resemble bones not yet cleaned by time. *Dr. Zozo's* mouth was agape, seemingly grinning. He wore a stethoscope that extended from his skull to the head of a large wooden phallus. The phallus erected from the base of the sculpture, which was a child-sized coffin. Here was the namesake of the piece, an absurd, exaggerated penis that was being examined for a pulse. It appeared a sentient abnormality on the steel-boned corpse. The penis was further complicated by spikes that protruded from the underside of its head. This was Gede—vulgar, irreverent, grotesque, bawdy—but the addition of spikes negated the purpose of his regenerative font. It was an unprecedented image in Vodou, but for a brief time it became a recurrent theme in the work of the Atis Rezistans.

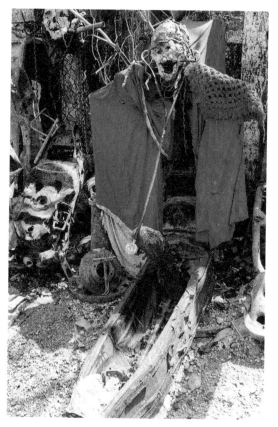

Figure 4a. André Eugene created *Dr. Zozo*, a deeply ambivalent image of Gede, at a moment of heighted political instability. *Photo by the author, 2005.*

Figure 4b. Detail of *Dr. Zozo* by André Eugene. *Photo by the author, 2005.*

Speaking about nails in the penis of another piece, Eugene explained, "It is a zozo with power, with nails. The zozo has a power inside, it's the force it uses to create. If the zozo isn't hard, it can't create, it can't enter into the vagina. The nails have a force, too, that's why I put them there. It intensifies the sensation." While it is a graphic image, it is describing a concept of power that is accumulative.[48] The hardness of the penis is fortified in the strength of the nails. It is a concept of power that is essentially amoral, echoed in the proverb "Zozo a pa gen zorey" (The zozo doesn't have ears).

With the sculpture *Dr. Zozo*, however, the spikes take on another layer of meaning specific to the time when it was created. As Eugene explained to me in 2005, there were rumors that certain gangsters, mostly from Cité Soleil, were implanting spikes in their penises. This was at the peak of the kidnapping crisis, when Haitians of all socioeconomic strata were in terror of the newly established industry. The kidnappers were not common thugs, but a new breed of *djab* (devils). People perceived them to be criminal deportees returning from the United States. They were said to be implanting the spikes in order to facilitate in the transmission of HIV when they raped a woman. When I reacted to Eugene's story with some surprise, he said, "They learned it in the United States. They do that there, don't you know that?" With that very direct coda, the onus of vagabondaj, in its most malevolent and absurd form, was turned on the United States.

The Age of Vagabondaj

The most dramatic transformation between the Duvalier era and the present one is that then the state used to have a monopoly on violence, whereas now it does not. While this democratization of violence has led a minority of Haitians to lament the days of dictatorship, it seems that the difference is not as much in the volume of violence as it is in the unpredictability of its source. When Haitians protest the conditions of insecurity afflicting the capital, they may be just as easily decrying the crimes of the police, the United Nations, gangs, or petty criminals.

Today, however, the faces behind the guns are typically younger than they were during the Duvalier era.[49] Many of these urban youth have ascended the ranks of power in their own right through ties to the drug trade or illicit alliances with state and elitist interests. For youth born in an era that is both post-factory and post-field, leaving the country presents the most viable alternative to survival by illicit means. The median age in Haiti is 18.5, meaning that most Haitians were actually born after the fall of Duvalier.[50] Haiti is a young nation, and Gede is a spirit closely associated with youth.

The phrase "age of vagabondaj" describes a shift in political significance of urban male youth of the popular class in the post-Aristide era. I realize that even the phrase "post-Aristide" is controversial, as the former president remains a divisive yet influential figure in Haitian politics. What seems less contentious is that when Aristide returned at the end of the coup in 1994, he was not the revolutionary who had been swept into office on a tide of radical democracy in 1990.[51] But it is beyond the scope of this chapter to debate whether Aristide became a demagogue or remained a radical reformer, victimized by imperial interests and duplicity.[52] Such approaches are not productive in that they focus on the personage to the exclusion of more systemic problems.

What is relevant, however, is the role of young men from urban centers in Haiti's turbulent struggle for democracy. Young, disenfranchised men have always been important to Aristide's power, as well as to the popular movement more generally.[53] Part of Aristide's initial popularity, and credibility, as the champion of the poor came from his work with the legions of street children of Port-au-Prince, most of them male.[54] These youths came to be known as "Aristide's boys," and

they accompanied Aristide at nearly all of his public appearances leading up to the coup in 1991. In a move that had profound symbolic impact—appalling many of the elites and inspiring the disenfranchised majority—Aristide's boys were invited into the National Palace to sing at his first inauguration. Effectively, the most marginalized segment of society was ushered into the center of power to participate in a ceremony that would establish Haiti's first democratically elected leader. It would prove to be a moment as ephemeral as it was elated.

What Aristide accomplished in his two truncated terms was a very limited political enfranchisement of some members of this group. But this political re-centering was problematic in many ways, especially after his first term in office. While the performance at Aristide's inauguration was a profound symbolic gesture, Aristide, when confronted with the dual mechanisms of class and politics in Haiti and the interests and influences of the international community, ultimately capitalized on this power base by arming it. In the end, this strategy failed, not just for Aristide, but more devastatingly for the young men who were killed or imprisoned in the political crossfire. Under circumstances that may never be fully elucidated, Aristide left office on February 29, 2004, on a private plane contracted by American officials.[55] With the fallout of Aristide's demise begins what I term the "age of vagabondaj."

It must be stressed that this term is not pro-Aristide or anti-Aristide, as such thinking does not reflect the realities of how most people survive under conditions of extraordinary violence—not just the dramatic violence of guns and machetes, but also the more banal "structural violence" that casts a broader net.[56] All factions are guilty of what may be termed "vagabondaj" when used pejoratively. "Chimè" (chimera) became a buzzword to describe the pro-Aristide gangsters, but I have chosen to avoid the term because of its partisan associations. J. Christopher Kovats-Berat, for example, describes the vagabondaj of the two leaders of the anti-Aristide militia that took control of the north of the country in 2004: "Chamblain drank rum and danced in the streets that day with Guy Philippe."[57] In the end, the majority of people celebrated neither the demise of Aristide nor the victory of his opponents: "The people may not have embraced the opposition and rebel forces that ousted Aristide, but many of them did not believe that he was worth rescuing either—not because they no longer believed in what he once stood for, but because they could see that he had betrayed their trust and their interests to serve his own and his cronies."[58] The age of vagabondaj is characterized by such ambivalence.

While disillusionment and ambivalence characterize the attitude of pèp la toward the state, it is not necessarily a totalizing view. The notorious gangsters of Cité Soleil may be *vagabons extraordinaires*, but my visits there revealed that in addition to all the signs of chaos—such as United Nations tanks and bullet-pocked walls—small gardens had been planted in any available space.[59] These are small patches, often just a row of beans and a few stalks of corn, like the garden in the corner of Eugene's courtyard, but they highlight the fact that the young men who are blamed for so much of the current crisis are not without history. They are neither spatially nor temporally far removed from the mountains, but rather part of a larger trend of domestic diaspora, a segment of the population expelled from the ecological crisis afflicting the countryside.

The age of vagabondaj was preceded by the creation of ecological refugees and urbanization without industrialization, and it is marked by the mobilization of urban young men toward political ends and a popular disillusionment with democracy. All these tectonic social ruptures make the body vulnerable to both malnutrition and the ravages of infectious diseases. At the intersection of all these phenomena – the land, youth, masculinity, the body – one finds Gede.

Gede and the Age of Vagabondaj

The role of young men in urban Haiti has always been one of contradiction: they are socially marginalized yet symbolically central.[60] Gede embodies this symbolic prominence as the spirit who is not only ubiquitous, but also perpetually young and unabashedly male. Yet, to a significant extent, the label "vagabon" has served to disenfranchise urban young men, blaming their lack of productivity on character and lifestyle rather than a class system built on their exclusion and exploitation. As Yelvington says of racial tensions in Trinidad, "The symbolization process was and is, in large part, monopolized by those who have had access to the 'symbolic capital' to perpetrate 'symbolic violence' against less-endowed groups."[61] In a perverse way, the myth of the vagabon's danger and virility exists in reverse proportion to their economic and political impotence. In the past two decades, the symbolic and economic positions of the "vagabon demographic" have only grown more extreme.

Given the current semantic and political terrain of masculinity, it becomes necessary to ask, what will become of Gede? André Eugene offers his perspective:

> When technology advances, things begin to change, too. A long time ago in the Bible, it said not to come on the ground [to "waste your seed"] because there weren't many people. Now there's lots of people, so you have to wear a condom. You have to protect yourself against sickness, but also so you don't have too many children, because children can bring misery. In this neighborhood, people who have too many children have more misery. If Gede is the Chef Seksyon, he has to be able to check out these things. If technology advances, he goes that way, too.[62]

Yet the image that Eugene offers of a Gede who is au courant is profoundly dystopian. In *Chef Seksyon*, a condom may offer protection, but in *Dr. Zozo*, Gede comes to embody disease. It is a grotesque embodiment though, a contagion that is menacing and dangerous. Here technology is represented as the "spikes," but also as the stethoscope. His role as a doctor may also promise a cure.

Spirits are as subject to the vagaries of history as are their human counterparts, however, and it would be disingenuous to conclude by facilely pinning abstract hopes for the nation on Gede's regenerative potential. Gede is the embodiment of youth and masculinity, holding the promise of virility and renewal, but "young men" has proved a social and historical category that has been tenuously balanced in the crosshairs of both domestic and international powers in the Afro-Atlantic. And never more so than today, when "vagabon" has become an umbrella term for a tremendous segment of the population. The word's ubiquity is rivaled only by its ambiguity; it is in one moment embraced as freedom and in another shunned as threat.

Dr. Zozo is a shocking image of Gede, and I hasten to add that it is not a common one. The rumors about deportees and young men from Cité Soleil are not rumors about Gede, but they do represent a disturbing transformation in how the body is imagined. Where the rumors and Gede overlap is in the concept of vagabondaj, which I have argued is deeply ambivalent. We see this ambivalence in *Dr. Zozo* as the embodied disease, but also as the potential cure. In his portrayal of Gede, Eugene offers an indicator of what the grounds and means of survival will be. Undoubtedly vagabons will be agents of those means, but as *Dr. Zozo* demonstrates, vagabondaj is no longer merely a domestic affair, and likely never was.

Perhaps part of the message embodied in *Dr. Zozo* holds another kind of potential. What I have described as the festering abundance of urban Haiti has made for a fertile urban art scene. For the Atis Rezistans, trash has become the means of reflecting, critiquing, and re-imagining what I have described as the age of vagabondaj. But they are not alone in their creative endeavor. In Cité Soleil

there are murals now for the first time since the late nineties. The traditional sequined flags, which had their genesis in Vodou temples, are experiencing a kind of renaissance. Their subjects, variety, and styles have expanded exponentially since the late nineties. There are also, for the first time, prominent women flag artists.[63]

While the international market consumes most of these artistic forms, other forms thrive in the domestic market. The affordability of digital media has resulted in a burgeoning of Haitian cinema. Most of the films are sold by young men who wander the streets and intersections of Port-au-Prince selling three-dollar DVDs from their backpacks. And while American hip-hop has always been popular in Haiti, it is now being produced locally in Creole by groups like Barikad Crew and Rock Fam.[64] Their lyrics can be obscene, and sometimes violent, but they are sung enthusiastically by youth all over the country and its diaspora. These lyrics become the anthem for an imperfect world.

The same can be said for the work of Atis Rezistans. The work is not pretty, but as the Creole expression has it, "Pito nou led, nou la" (Hey, we're ugly, but we're here). Haiti has survived slavery, revolutions, foreign occupations, military coups, insidious aid programs, and neoliberal structural adjustments. If its future at times appears implausible, it is no more so than its past. The courtyard of André Eugene is a small corner of a vast city, but it is a crossroads. Like the cemetery, it is a place where the dead cohabitate with the living. The image of Gede one finds there is an urban amalgamation that embodies a troubled history. It is, nonetheless, a sign of life.

Notes

Support for fieldwork cited in this chapter came from the UCLA International Institute and the UCLA Fowler Museum Arnold Rubin Award. The chapter was written before the earthquake of January 2010. One member of the collective, Destimare Piene Isnèl (a.k.a. Louko), was killed in the earthquake and others were temporarily displaced. The collective continues to make politically charged art that draws on Vodou imagery.

1. "Dèyè mòn, gen mòn."
2. The Bawon is the head of the Gede family, though there are a number of different manifestations of him, such as Bawon Samdi (Baron Saturday), Bawon Lakwa (Baron of the Cross), and Bawon Simityè (Baron of the Cemetery). He is always ritually located in the cemetery at the tomb of the first man said to be buried there. His wife, Gran Brijit, is always situated at the first woman's tomb.
3. Guyodo left the collective in 2009, though he is still working in the neighborhood.
4. Barbara Prézeau-Stephenson, "Contemporary Art as Cultural Production in the Context of Haiti," *Small Axe* 27 (2008): 94–104.
5. *Atis Rezistans: Sculptors of the Grand Rue*, directed by Leah Gordon (London: Haiti Support Group, 2008), DVD (hereafter cited as *Atis Rezistans*).
6. Eugene stated that he was baptized in the hospital when he was born, but that it was Gede who really baptized him: "Gede came home with me from the hospital." André Eugene, interview with the author, July 5, 2007. Unless otherwise stated, quotations from André Eugene are from this interview.
7. *Atis Rezistans*.
8. For more on Charlemagne Péralte and the armed resistance to the United States occupation, see David Nicholls, *From Dessalines to Duvalier: Race, Colour and National Independence in Haiti* (New York: Cambridge University Press, 1979), 148–52.
9. *Atis Rezistans*.
10. Central Intelligence Agency, "CIA World Fact Book: Haiti," https://www.cia.gov/library/publications/the-world-factbook/geos/ha.html.
11. *Atis Rezistans*.
12. André Eugene, interview with the author, January 23, 2008.
13. Maya Deren, *Divine Horsemen: The Living Gods of Haiti* (New York: McPherson, 1953). For a structural interpretation of symmetry in Vodou cosmography, see Karen McCarthy Brown, "The

'Veve' of Haitian Vodou: A Structural Analysis of Visual Imagery" (Ph.D. diss., Temple University, 1976).

14. André Eugene, interview with the author, July 5, 2007.

15. Marilyn Houlberg, "Magique Marasa: The Ritual Cosmos of Twins and Other Sacred Children," in *The Sacred Arts of Haitian Vodou*, ed. Donald J. Cosentino (Los Angeles: UCLA Fowler Museum of Cultural History, 1995), 280. Gede is described as a healer in most modern ethnographic literature on Vodou, though Maya Deren and then Karen McCarthy Brown recorded two remarkable examples. Deren described a ceremony where Gede is called on to heal a sick child. Using "seminal ejaculation" that he brings forth from the body of the woman he possessed, he cures a child, who miraculously survives. See Deren, *Divine Horsemen*, 114. Forty years later, Brown recalls that it was Gede who possessed Mama Lola when the daughter of the priestess was in the midst of a difficult childbirth. See Karen McCarthy Brown, *Mama Lola: A Vodou Priestess in Brooklyn* (Berkeley: University of California Press, 1991), 372. These examples demonstrate not only Gede's association with healing but also his special affinity for children.

16. Brown, *Mama Lola*, 362.

17. *Atis Rezistans*.

18. In *Mama Lola*, Karen McCarthy Brown describes the transformations of the family lakou in the context of an immigrant community. She likens Mama Lola's Brooklyn home and *ounfò* (Vodou temple) to a community center where recently arrived immigrants find information and resources. Yet, she notes, "participating in ceremonies in her Brooklyn home ironically brought me close to a form of Vodou older than the form I had seen studying urban Haiti. It brought me closer to the family-style Vodou of the countryside where the patriarch of the extended family functions as priest and all those who serve the spirits under his tutelage are either blood kin or honorary members of the family" (9–10). See also Serge Larose, "The Haitian Lakou, Land, Family, and Ritual," in *Family and Kinship in Middle America and the Caribbean*, ed. Arnaud F. Marks and Rene A. Romer (Leiden: Royal Institute of Linguistics and Anthropology, 1975), 482–512.

19. The lakou is similar to the "yard" in Jamaica. Barry Chevannes describes the living space of the yard thus: "By 'yard' people refer to the space behind a fence and a gate, hidden and protected from public view where people are domiciled; where they cook, eat, sleep, relieve themselves, wash, bathe, and so on." *Learning to Be a Man* (Mona: University of the West Indies Press, 2001), 169.

20. Elizabeth McAlister, *Rara! Vodou, Power, and Performance in Haiti and Its Diaspora* (Berkeley: University of California Press, 2002). Discussing obscenity in popular discourse, McAlister perceptively observes that "when you are not permitted to say anything else, at least you can swear, drink, and sing vulgar songs" (61).

21. Frantz (Guyodo) Jacques, interview with the author, September 27, 2007.

22. Maya Deren (*Divine Horsemen*, 106) relates that during the Borno administration (1922–30), a group of Carnival revelers became possessed by Gede Nibo and marched through the gates of the National Palace to demand money. The scene caused such an embarrassment that the president is said to have paid them. Gede's triumph is remembered in the following song, which is still sung in Haiti today: "Papa Gede is a handsome guy / Gede Nibo is a guy / He is dressed all in black, / He is going up to the palace."

23. Elizabeth Abbott, *Haiti: The Duvaliers and Their Legacy* (New York: Touchstone, 1988), 59.

24. Michel Laguerre states that Francois Duvalier, like a few historical figures, became part of the Vodou pantheon. He notes a ceremony he witnessed in 1976: "I was surprised to see the priest dressed up to resemble Francois Duvalier—in a dark suit and black hat, wearing heavy reading glasses and holding a pistol in his right hand. He spoke with a nasal voice, imitating Francois Duvalier's speech." Laguerre goes on to explain that this is "*loa 22 os*," the mystical name given to the deified and deceased dictator. I have not found other examples that corroborate this, but the dress and manner of speech of "*loa 22 os*" also describes Gede's possession performance. Unfortunately, Laguerre does not identify the family of this "*loa 22 os*." Michel Laguerre, *Voodoo and Politics in Haiti* (Houndmills, United Kingdom: Macmillan, 1989), 118.

25. The Tonton Makout, as they were popularly called, were thugs who did Duvalier's bidding from the earliest phase of his regime. By 1958 they had gone from clandestine force to secret police, trading in their hoods for dark sunglasses. In 1962 Duvalier created a civil militia, the Volontaires de la Sécurité Nationale (VSN), which he presented as an official version of the feared Macoutes.

Thereafter VSN and Macoutes came to be used synonymously, at least in common parlance. See Michel-Rolph Trouillot, *Haiti: State against Nation* (New York: Monthly Review Press, 1990), 190.

26. Amy Wilentz, *The Rainy Season: Haiti since Duvalier* (New York: Simon and Schuster, 1990), 175.

27. As one example of the display made of consumption under the junior Duvalier, for his wedding Baby Doc spent a reported $7 million (much of it on the installation of televisions throughout the country so that the masses could witness the event). See ibid., 84–85.

28. Trouillot, *Haiti*, 225.

29. Ibid.

30. André Eugene is playing on words here. The Creole word for testicle is *grenn*, which sounds like *grennad*, or grenade. He pushes the jokes further by describing the moment of ejaculation as an "explosion." Interview with author, July 5, 2007.

31. Georges René, interview with the author, November 2007. The gesture he performed was reminiscent of the song and dance that was popular in Carnival in 2006, "Ouvri le Kò" (Open the body) by Raram. The song was massively popular during the protests against the stalled elections that were happening at the time. Flooding the streets with their bodies, people were calling for the interim government and the United Nations peacekeeping mission to open the way for the democratic election of René Préval.

32. Donald Cosentino references Gede's relationship to *l'honneur* when he writes, "Just as every character—political, military, or celestial—stripped of his pretenses is an avatar of Gede, so finally every motive, every action is reducible to *zozo*. Not *l'amooooour...*or *la vie...*or even *l'honneur*—only *zozo*." See "Envoi: The Gedes and Bawon Samdi," in Cosentino, *The Sacred Arts of Haitian Vodou*, 413.

33. I am borrowing from Sandra Barnes's use of the word "polythetic" to describe the inclusive principle that defines the Afro-Atlantic spirit Ogun. In the technical sense of the term, a polythetic definition is one that is not based on a single characteristic, but rather on a series of traits that may be combined differently. See *Africa's Ogun: Old World and New* (Bloomington: Indiana University Press, 1997), 13–14.

34. Bryan McCann, *Hello, Hello Brazil: Popular Music in the Making of Modern Brazil* (Durham: Duke University Press, 2004), 52–54.

35. On rude boy culture, see Obika Gray, *Radicalism and Social Change in Jamaica, 1960–1972* (Knoxville: University of Tennessee Press, 1991); Norman C. Stolzoff, *Wake the Town and Tell the People: Dancehall Culture in Jamaica* (Durham: Duke University Press, 2000); Garth White, "Rudie, Oh Rudie," *Caribbean Quarterly* 13, no. 3 (1967): 39–44. On "slackness" in Jamaican popular culture, see Carolyn Cooper, *Noises in the Blood: Orality, Gender, and the "Vulgar" Body of Jamaican Popular Culture* (London: Macmillan, 1993).

36. Tricia Rose, *Black Noise: Rap Music and Black Culture in Contemporary America* (Hanover, Conn.: Wesleyan University Press, 1994).

37. Gordon Rohlehr, "I Lawa: The Construction of Masculinity in Trinidad and Tobago Calypso," in *Interrogating Caribbean Masculinities: Theoretical and Empirical Analyses*, ed. Rhoda E. Reddock (Mona: University of the West Indies Press, 2004). 326–403.

38. Katherine E. Browne, *Creole Economics: Caribbean Cunning under the French Flag* (Austin: University of Texas Press, 2004).

39. E. Antonio de Moya, "Power Games and Masculinity in the Dominican Republic," in Reddock, *Interrogating Caribbean Masculinities*, 68–102; Lauren Derby, *The Dictator's Seduction: Politics and the Popular Imagination in the Dominican Republic in the Era of Trujillo* (Durham: Duke University Press, 2009).

40. Crispus Attucks, an African American, was the first person killed in the American Revolution. John Adams quoted in Peter Linebaugh, "All the Atlantic Mountains Shook." *Labour/Le Travail* 10 (Autumn 1982): 112.

41. For more on the relative position of the hero-trickster, see Donald J. Cosentino, "Midnight Charters: Musa Wo and Mende Myths of Chaos," in *Creativity of Power: Cosmology and Action in African Societies*, ed. W. Arens and Ivan Karp (Washington. D.C.: Smithsonian Institution Press, 1989), 30.

42. Robert Pelton, *The Trickster in West Africa: A Study in Mythic Ironies and Sacred Delights* (Berkeley: University of California Press), 79.

43. De Moya, "Power Games and Totalitarian Masculinity in the Dominican Republic," 79.

44. Kenneth Ramchand, "Calling All Dragons: The Crumbling of Caribbean Masculinity," in Reddock, *Interrogating Caribbean Masculinities*, 316.

45. Kate Ramsey, "Penalizing and Promoting 'Voodoo' in U.S.-Occupied Haiti, 1915–1934" (paper presented at the Obeah and Other Powers: The Politics of Caribbean Religion conference, Newcastle, United Kingdom, June 16–18, 2008).

46. Derby, *The Dictator's Seduction*, 292–94.

47. *Dr. Zozo* was created in 2005, but it did not last for long. By the time I returned the following year, André Eugene had dismantled it and used the pieces in new sculptures.

48. For comparative concepts about power and the aesthetics of assemblage among the Fon of Benin, see Susan Preston Blier, *African Vodun: Art, Psychology, and Power* (Chicago: University of Chicago Press, 1995).

49. Michel-Rolph Trouillot notes that in the weeks leading up to and immediately following his election, François Duvalier began using lumpen youth to intimidate political opposition. Many of these individuals would go onto the Tonton Makout. As Trouillot also argues, however, "the most original characteristic of Duvalierist violence, even before the taking of power, was the *extent of its social base.*" *Haiti*, 153.

50. Central Intelligence Agency, "CIA World Fact Book: Haiti," https://www.cia.gov/library/publications/the-world-factbook/geos/ha.html.

51. Aristide was still extremely popular when he returned to office in 1994; however, the "Paris Plan," the Clinton administration's agreement to return Aristide to Haiti, compromised his radical political program and guaranteed amnesty to those behind the coup. Peter Hallward rightly contends that Aristide had little choice in these concessions, and that while the plan itself was moderate in many aspects, the international community respected none of its provisions intended to protect the Haitian economy. See *Damming the Flood: Haiti, Aristide, and the Politics of Containment* (London: Verso, 2007), 55–58.

52. I am referring here to the spate of at least seven books published between 2000 and 2007 about Aristide and his political party, Fanmi Lavalas. These vary as widely in their intellectual merit as they do in their political positions. One pole in this debate about Aristide's fate may be represented by Michael Deibert's *Notes from the Last Testament: The Struggle for Haiti* (New York: Seven Stories Press, 2005), which argues, often speciously, that Aristide held onto power through increasingly brutal and dictatorial means. Conversely, Hallward, in the more academically rigorous *Damming the Flood*, argues that Aristide remained a popular and radical leader targeted and sabotaged by elitist and imperialist interests.

53. Alex Dupuy describes the role of "professional and political organizations, workers' associations and trade unions, women's groups, religious and lay community organizations, neighborhood committees, and peasant organizations" in the movement for democracy following the fall of Duvalier in his book *The Prophet and the Power: Jean-Bertrand Aristide, the International Community, and Haiti* (Lanham, Md.: Rowman and Littlefield, 2007), 57–72.

54. Aristide's charitable works include the establishment of a large orphanage in Port-au-Prince, Lafanmi Selavi (The family is life). The orphanage was set on fire by Duvalierist militants in 1991, killing four young inhabitants, but was later reopened. See Christopher J. Kovats-Bernat, *Sleeping Rough in Port-au-Prince: An Ethnography of Street Children and Violence in Haiti* (Gainesville: University of Florida Press, 2008), chap. 5.

55. It is strongly held by Aristide and his supporters that he was kidnapped by the United States government. Officially, however, it was maintained by the interim government that he left office of his own volition on the eve of the impending fall of the capital to rebel groups, who had already taken control of the north of the country. Aristide returned to Haiti from exile in South Africa in March 2011.

56. Paul Farmer, *Pathologies of Power: Health, Human Rights, and the New War on the Poor* (Berkeley: University of California Press, 2003).

57. J. Christopher Kovats-Bernat, "Factional Terror, Paramilitarism and Civil War in Haiti: The View from Port-au-Prince, 1994–2004," *Anthropologica* 48, no. 1 (2006): 134.

58. Dupuy, *The Prophet and the Power*, 169. Hallward correctly argues that Aristide was, even in the turbulence of 2004, the most popular leader in Haitian politics (*Damming the Flood*, 200–77). What he does not fully acknowledge, however, is the larger trend of disillusionment and ambivalence toward all state politics. Hallward cites the 2006 election of the former Aristide

protégé René Préval as evidence of this enduring popularity. Based on my own experience in Haiti at the time, however, I would offer the counterargument that Préval's popularity at that time was based on opposition to the interim government and the United Nations occupying mission, and on the memory of his first administration (1996–2001) as a time of relative calm. For example, during Carnival in 2005 and 2006, I recorded no songs, performances, music videos, or visual manifestations that would indicate support for Aristide. The popular political discourse of those years was characterized instead by resistance to the interim government and the United Nations.

59. For many Haitians and foreigners, Cité Soleil is seen as the epicenter of the gang violence that has gripped the country over the past decade, despite the fact that crime exists in all levels of Haitian society.

60. Peter Stallybrass and Allon White, *The Politics and Poetics of Transgression* (Ithaca: Cornell University Press, 1986), 20.

61. Kevin Yelvington, "Introduction: Trinidad Ethnicity," *Trinidad Ethnicity*, edited by K. Yelvington (London: Macmillan, 1993), 10.

62. Interview with author, July 5, 2007.

63. Among the most prominent of these is Myrlande Constant, who pioneered the technique of solid beading. She says she learned this method in the wedding dress factory where she worked. When she was laid off in the early 1990s, she opened a workshop to create flags. She has since had several women apprentices who have gone on to become esteemed flag artists in their own right.

64. The obvious exception here is the hip-hop artist Wyclef Jean, who gained international acclaim as part of the group the Fugees. Later he started rapping in Creole on his first solo album, *The Carnival* (1997). In 2010, Jean attempted to run for president, but was disqualified by the electoral council due to his citizenship status.

From the Stage to the Grave:
Exploring Celebrity Funerals in Dancehall Culture

Donna P. Hope

Funerals in Jamaica

The social role of funerals in contemporary Jamaica is linked to the historical specificities of plantation slavery and the culture of the enslaved Africans, particularly those from West Africa, who were brought to the Americas. Religious-cultural, survival mechanisms of the slaves included the West African derived funeral rites that many slaves believed would smooth the passage home to Africa (Pigou, 1987: 24). Though many of these rites were transformed with the impact of slavery, migration and Christian missionary activities, a number of African forms of religious worship were maintained, and those related to death are still the most prevalent. In this regard, Pigou identified several traceable West African/Afro-Jamaican beliefs associated with death and its rituals, which included the fact that the individual is made up of three components – the body, spirit/soul and the duppy. Second, that death is perceived as an extended event which marks the end of mortal life and the passage to immortality, and also that, at death, the spirit undertakes a journey to return to the Supreme God and join other spirits. Additionally, there is the belief that the duppy, or shadow, wanders for several days, after which it must be laid to rest by special rites. If these rites are not conducted the belief is that it can result in the indefinite wandering of the duppy, who may be capable of carrying out evil acts. Thus the purpose of funeral rites is to secure the safe journey of the spirit and to placate the duppy (Pigou, 1987, 24).[1]

In his work on death and the culture of death in Jamaican slave society, Brown notes that: 'during funerals, enslaved blacks created a shared moral universe: they recovered their common humanity, they assumed and affirmed meaningful social roles, and they rendered communal values sacred by associating them with the dead' (2008, 65). Funerals were a relatively constant ceremonial process in this era. Common perceptions of relations with the dead formed the basic elements of a moral discourse that Africans and their descendants used in an effort to regulate their interactions with one another and oppose the tenets of their masters (Brown, 2008: 65). While they were divided along the lines of language, regional identification, gender or occupation, Brown notes that enslaved Africans held several common assumptions about death, which reflected the similar cosmological orientations shared in their West African homelands. This included basic practices having to do with relations between the living and the dead. For example, most Atlantic Africans recognized a supernatural hierarchy, from a high god to lesser territorial deities and down to ancestors and the spirits of the dead. They maintained active social relations with these other-worldly beings, especially the dead (Brown 2008, 65).

In a related vein, Patrick Bryan explores some of the particularities of Afro-Jamaican death rituals in late 18th-century Jamaica, which obviously differed from European customs and practices (2000: 36–8). The community-oriented nature of death rituals and the special ceremonies that accompanied this final rite of passage were based on fraternizing, gossip and feasting and, in one

Reprinted with permission from *International Journal of Cultural Studies* 13, no. 3 (May 2010): 254–70.

account quoted by Bryan, there was storytelling, games and wrestling until morning at a Ninth Night ceremony (2000, 37). The Ninth Night or 'nine night' is technically the period of mourning after death that culminates in ceremonies involving food and dancing on the ninth night after death. Following Christian custom, the soul's ascent to heaven is emphasized, while West African traditions call for more emphasis to be placed on placating the spirit of the dead person. Religious ceremonies are usually staged first so as to ensure that the dead person understands that it is time to leave the place formerly identified as home. If this is not done, the spirit is said to haunt the living (Senior 2003, 353).[2] Jamaican 'nine nights' are celebratory in nature and stress the continuity of life in death. Death rituals of this nature are strong manifestations of the community-generating West African belief system that unites the practitioner of the rituals to his people, gods, ancestors and the unborn. Thus, while ushering the deceased into the great beyond, Afro-Jamaican funerals and their associated rituals also provide various opportunities for the coming together of families and friends in a sober moment of communal, celebratory camaraderie.

In contemporary Jamaica, funerals employ various strategies to showcase the financial and social status of the deceased and close relatives to a wider audience (Tortello, n.d.). In line with traditional rites around the deceased, these strategies include the variety and type of food offerings and general level of hospitality on display at the home of the deceased (or 'dead yard') during the period of bereavement and, more particularly, at the 'set-up'[3] or wake or at the 'nine night'. In many contemporary working-class and inner-city settings, these Christian and West African customs are now also intertwined with post-millennial popular cultural rituals. Consequently, African drumming and chants, Christian hymns and prayers, and dancehall music, deejay clash and dance all battle for space at the 'nine night' or set-up.

In Jamaica a well-attended, harmonious funeral is considered a positive symbol of the deceased's life. Consequently, the presentation of the deceased at the funeral ceremony must suggest that, regardless of the deceased's status in life, this particular individual 'died well'. As a result, many families go to great pains to ensure that the casket in which the deceased takes their final repose is visibly expensive and many insist that the funeral programs must be glossy, and filled with family photos and photos of the deceased. Members of the deceased's immediate family usually go to great pains to look and dress their best at the funeral ceremony. The foregoing facets all work in concert to underwrite and project the preferred aura that the deceased has lived (and done) well.

Thus, the traditional and prescribed *mores* for funerals in Jamaica have historically been somewhere between the often negated, emotive, African-influenced ethos of the masses and the socially sanctioned, staid and sober Eurocentric values of the upper and middle classes, operating in concert with Christian religious rites. These prescribe the accepted religious rites and mode of operation at funerals in Jamaica. However, in concert with the celebratory ethos of the current manifestation of Jamaica's lower- and working-class popular culture, dancehall culture,[4] what now pervades wakes or 'nine nights' is the extreme emphasis on status-generating components. This has become a primary social and cultural component of the contemporary funeral arena in Jamaican culture, particularly for working-class and poor individuals. The discursive value that these celebratory funerals hold for ordinary, working-class Afro-Jamaicans lies within the historical manifestation of Jamaica's class structure.

Class and status in Jamaica

According to Waters (1985, 26): 'Jamaica's class structure today reflects its history as a colonial plantation society and its beginnings of industrial development.' Carl Stone's Marxist-influenced work of the mid to late 1970s on Jamaica's class structure stands as the only broad-based, scientific

investigation into the political economy of class and the distinct class groupings in postcolonial Jamaica to date. Stone outlines the particularities of Jamaica's class structure and system and identifies three key components. First, he notes that there are power domains which define a hierarchy of power or determine which classes have what degree of power over each other. Second, there is a dominant ideological system reinforcing and rationalizing the hierarchy of class power. Third, he identifies a reward system that supports the power hierarchy and is in line with the dominant ideological system (Stone, 1980, 14).

Stone identified three status and seven class groupings, with the class groupings fitting into the status groups thus: capitalists and administrative classes in the upper/upper middle class, independent property owners/middle-level capitalists and labor aristocracy in the lower middle class, and own-account workers/petty capitalists, working class and long-term or indefinitely unemployed in the lower class (Stone, 1980, 20–1). According to Stone, Jamaica's upper and middle classes accounted for 1 percent of the population, with the lower middle class accounting for 23 percent, and the largest percentage, 76 percent, in the lower class at the time of his study.

However, Stone does not clearly demarcate the then existing differences in lifestyles, attitudes and behaviors that existed between rural and urban workers and rural and urban poor. In this regard, Hope notes that:

> ...despite the emphasis placed on income and wealth in the definitions given for class positioning and status by Stone, class structure in Jamaica remains perceived in terms of a rigid continuum of class rankings that subsume other factors. Occupational and educational prestige remain very important in defining one's class and status positioning, and education as a means of social and economic mobility continues to hold value for members of the rural working class and the rural poor. (2006, 6)

Additionally:

> ...though race and/or color may play a role in defining status and personhood, the discontinuities based on class far supersede those that may be predicated on race and/or color. A residual color and racial differentiation remains as a part of Jamaica's plantation slavery history. Race is still correlated with class because the greater percentage of ethnic minorities (whites, Jews, and light colored Chinese and Lebanese) either own property or are located at the highest levels of Jamaica's class/status hierarchy in a society where more than 97% of the society is Afro-Jamaican or black. The visibility of this small percentage of lighter-skinned, upper and middle class individuals create race/color tensions that often operate simultaneously with the class divisions...the greater percentage of Jamaica's very poor and chronically under-employed and/or unemployed is darker-skinned or black. (Hope 2006, 6)

The primary creators and adherents of dancehall music and culture come from among this group. Stone refers to this class/popular culture dialogue in his discussions about the transformations in the class system and the social practices that govern it. For him, this includes the growing lack of deference among classes and the rise of egalitarianism, coupled with the increased confidence of lower- and working-class Jamaicans (1980, 19–20). Stone's identification of the role of music culture in asserting lower-class culture and social struggles, alongside a popular militancy (1980: 20), referred particularly to reggae music of the 1970s. However, in its present manifestation, as the popular culture of the day, Jamaican dancehall music culture holds its place as a site of assertion of black, lower-class values and attitudes in social contestation against traditional, and often Eurocentric hegemonies that deny status and personhood to many ordinary, working-class, Afro-Jamaicans. Bling/dancehall funerals are located at this nexus as a status-generating and class transgressive facet of the lives of Jamaica's underclasses.

Conceptualizing bling

In line with current social and political tensions in Jamaica, celebratory working-class funerals have earned the title bling and/or dancehall. Bling is a derivative of the term 'bling bling'. The MSN Encarta Online Dictionary defines 'bling-bling' as an adjective that means: 'rich: having or displaying ostentatious material wealth (slang) [Probably an imitation of the sound of a cash register]'. Colloquially, Jamaicans identify the ringing up of the cash register as a chi-ching sound, not bling-bling.

On the other hand, the Merriam-Webster Online Dictionary suggests that the term is a noun that dates back to 1999 and here 'bling' is defined as 'flashy jewelry worn especially as an indication of wealth; *broadly*: expensive and ostentatious possessions'. This is reflective of the type of bling that circulated within Jamaican dancehall and American hip hop culture in the 1980s and 1990s. This late-20th-century bling featured large flashy gold chains with heavy pendants for men and large, heavy gold earrings for women, complemented with huge gold rings and bracelets for both men and women. These conspicuous modes of adornment reflected the movement towards the overt signaling of wealth and its corresponding prestige that held sway in that era.

The term 'bling-bling' (which entered the *Oxford English Dictionary* in 2003) encapsulates the aura of the 'ghetto fabulous' in the USA, where it is idealized in concert with the music and culture of hip hop. Throughout this article, the term is mainly adjectival and captures the essence of post-millennial, ostentatious aesthetics and conspicuous consumption that works itself across the bodies of ordinary, often poor individuals, in the form of expensive, brand-name clothing, hairstyles, shoes, jewelry, cars and other methods of accessorizing and enhancing the body, including expensive cellular phones and the public consumption of expensive liquors. The significant element of 'blinging' or 'to bling' is the public nature of this ostentatious aesthetic – it must be made visible; it must be visualized by onlookers to generate and validate status for its bearer.

In Jamaica, the term 'bling-bling' or 'bling' is also intertwined with ideas of the flashy and pervasive urban, working-class popular music culture of the day – dancehall. Thus, the terms 'bling-bling', 'bling' and 'dancehall' are often used synonymously in Jamaica. If it is bling, it is dancehall and if it is dancehall it is bling-bling. Accordingly, bling funerals are understood to exist particularly within the spaces of Jamaican dancehall culture and to be intertwined with identities of Afro-Jamaican men and women who hail from the urban inner cities and rural working classes who are the primary fans, supporters and creators of dancehall culture.

Constructing celebrity through bling/dancehall funerals

Bling/dancehall funerals entered the stage of Jamaican reality with the first truly bling/dancehall funeral held on Tuesday 8 May 2001 at the National Arena in Kingston. William Augustus Moore, aka Willie Haggart, leader of the iconic Black Roses Crew,[5] dancehall dancer, a man reputed to be involved in illegal drug and gun activities, and a Don,[6] hailing from the tough, inner-city community of Arnett Gardens in St Andrew, was ushered on and off the bling/dancehall stage with an ostentatious, royal ceremony. The funeral had been preceded by the traditional wake and viewing in Haggart's community of origin, Arnett Gardens, where thousands of friends, relatives, fans and supporters paid their respects ('Thousands View "Don's" Body...', 2001). The newsworthiness, entertainment value and popular hype around this funeral as a celebrity event was reflected in the throngs of reporters, journalists, video-graphers and cameramen in the jam-packed National Arena.[7]

In line with traditional modes of funeral attire, black was the predominant colour, but the fanciful, daring and erotic costumes and hairstyles associated with dancehall culture, parties and riotous celebration, ruptured the sobriety and mourning associated with traditional funeral rites. The funeral ceremony was conducted in the traditional Christian fashion with Catholic priest the Rt Revd Kenneth Mock Yen officiating over the conventional Christian hymns, prayers and other funeral rites. The time-honored African ritual of passing the youngest child over her father's casket to secure the deceased's good wishes added to the montage.[8] Underlying and overlapping these rituals was the buzz and hype that made Haggart's funeral event a spectacular celebration of a life and a lifestyle. Here, the catalytic ethos of Brite Lite Funeral Service, under the stewardship of the astute Tommy Thompson, set the standard for all subsequent bling/dancehall funerals as fantastic celebrations of life. Haggart was conveyed to his final resting place in a glass house hearse drawn by a special black Benz hearse specially imported into Jamaica. The funeral reputedly cost several million Jamaican dollars.[9]

In the wake of Haggart's opulent send-off, bling/dancehall funerals joined the ranks of official modes of mourning and funeral rites in 21st-century Jamaica. While traditional and more staid and sober methods of mourning and burial continue in Jamaica, the preponderance of these bling celebrations of life continues to grow among Jamaica's underclasses, and many ordinary individuals have been granted the final opulence of a grandiose bling/dancehall funeral. However, prominent dancehall actors, dons, area leaders, gang leaders and other figures of the underworld are the central figures whose bodies dominate/d the stage of bling/dancehall funerals. These include the funeral of Kenroy 'Trinity' Edwards of the British Link Up Crew in 2002.[10] As a member of the British Link Up Crew, a group noted for holding annual dances and its conspicuous display of ostentatious costumes and lifestyles,[11] Trinity, like Haggart of Black Roses, was positioned squarely as a working-class icon within the realm of dancehall and the Jamaican underworld, and was also reputedly involved in illegal drug-related activities. Like Haggart, Trinity had been murdered in a drive-by shooting. In August 2004, Oliver 'Bubba' Smith, leader of the notorious One Order Gang from Spanish Town was treated to a similar, spectacular send-off under the auspices of Maddens Funeral Supplies.[12] Other spectacular celebrations of life included the funeral of Franklyn 'Chubby Dread', Area Leader[13] of Southside in downtown Kingston in 2005.

In constructing the arguments here, the funeral of Bogle, another popular underworld icon whose activities spanned the dancehall and Kingston's inner cities is examined. Gerald 'Bogle' Levy, member of Haggart's Black Roses Crew and dancehall's popular Master Dancer, was also treated to a spectacular, bling/dancehall send-off celebration on Sunday 6 February 2005. Like Haggart, Bogle lay in state at the Black Roses Corner in the Arnett Gardens community and was viewed by thousands of friends, relatives, fans and media personnel. His funeral was another riotous celebration of life and, like Haggart's, was attended by political elites, academic elites, media elites, dancehall superstars and a host of family, friends and fans. Costumes ranged from sober funeral garb, through high fashion to dancehall erotica and the casual wear of curious passers-by. However, unlike the more controlled, traditional funeral ceremony that unfolded at Haggart's final rites, the celebration of life in dancehall style was given full on at Bogle's funeral. The Kencot Seventh Day Adventist Church, which consented to host Bogle's final staging, was transformed into a dancehall stage as dancehall actors paid tribute in song and dance at the altar. The police and large numbers of vendors provided the backdrop that blended with the song, dance and celebratory mood to paint a true portrait of an unbridled and celebratory dancehall event that celebrated the continuity of life in death.

The construction of celebrity and status for Jamaica's underclasses, through the discursive pathways created by the phenomena of bling/dancehall funerals is based on several important constitutive elements. The first is the seminal role of modern undertakers and funeral homes (e.g. Brite Lite Funeral Services and House of Tranquility), which have played midwife to the incarnation of these spectacular events and overseen the production of post-millennial bling/dancehall funerals in Jamaica since Brite Lite's first staging of Haggart's final rites in 2001.[14] The particularities of these events establish them as extra-funeral and create standards which suggest alternative methods of mourning that incorporate contemporary materialistic and popular culture approaches. These include the large sums of money spent on the event,[15] the riotous celebratory mood of the large crowds who gather, the erotic, often revealing costumes of the women and the flashy, expensive garb of the men. The magical aura that is created utilizes various methods including fairy-tale glass coffins, glass chariots to transport the bodies to the cemetery, and the use of late-model brand-name vehicles such as stretch limousines, SUVs, Benzes, Lexus, Ford F150s and Hummers to pull these chariots, or as part of the funeral procession. In addition (as in the case of Bogle's funeral), the merging of dancehall aesthetics and dance as a part of the actual funeral ceremony transforms these funerals from sober, private and mournful to riotous, communal and celebratory events. Efforts to commemorate the deceased go beyond the printing of funeral programs of an earlier era and include the use of bumper stickers, colored T-shirts, buttons, helium balloons, bookmarks and flyers bearing the name and picture of the deceased as part of the overall package to celebrate and immortalize the deceased as an individual of merit and worth.

The culture of fandom and celebrity that coalesces around these events underscores the seminal role these events play in the creation of superstars from below. Haggart's funeral was attended by over 5000 individuals, many of whom had no personal acquaintance with the deceased but were motivated to share in his final rites by a convergence of factors. These included the obvious hype of the event, the expectations of media coverage, the opportunity to fraternize with members of idolized and idealized sectors of the society, the opportunity to showcase fantastic and erotic costumes, and also the opportunity to engage in participant research on Jamaican life and culture. Massive crowds thronged to funerals such as Bogle's for similar reasons. The convergence of contemporary capitalist impulses with the popular hype and entertainment of dancehall and media culture around these events constructs them as hyper-real moments of celebration that form part of an ideal calendar of activities. The body of the deceased and the surrounding aura of celebration and celebrity project a siren-like call to those who desire this type of revelry, and they heed its call.

Consequently, the massive crowds that often converge on many of these funerals are reflective of the community spirit that has governed the funeral rites of black people in the Americas since plantation slavery. In its current high-tech manifestation, the event is recorded for posterity and transmitted beyond its temporal and temporary staging via the print and electronic media and by the use of digital computer technology, including the internet and DVDs, to an ever-widening but perpetually interrelated community, including Jamaicans in the diaspora and international fans of Jamaican culture.[16] The popular attention paid to these funerals and the media treatment of them as high-profile (dancehall) events worthy of much debate, highlights their importance in the discursive constitution of fame and its attendant status on the dancehall body. The convergence of entertainment, media and culture opens a discursive pathway that points to the elaborate superstardom that many ordinary individuals crave.

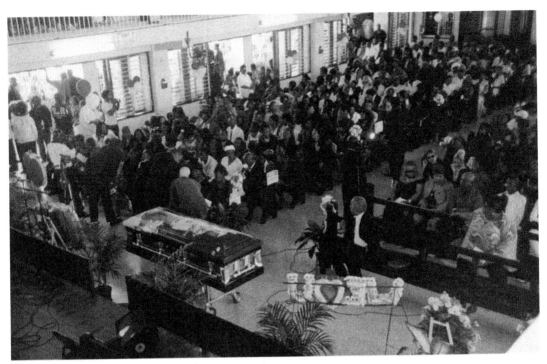

Figure 1. A section of the Kencot SDA church at Bogle's funeral. *Source: © Donna P. Hope*

Thus, the media is another constitutive element that opens the pathways to celebrity and status for members of Jamaica's underclasses at these bling/dancehall funerals. The print and electronic media frenzy generated around the first national bling/dancehall funeral of William 'Willie Haggart' Moore's ostentatious and non-traditional funeral sealed his celebrity status in the eyes of his/dancehall's public, while simultaneously documenting his passing for posterity, and catapulted Haggart and others of his ilk to a level of celebrity and status far beyond his ascribed status in Jamaican life. Radio and television talk shows, news programs and call-in programs, along with headline and opinion articles in the prominent daily newspapers, underscored the popular attention that Haggart received from the underground media and fused the entertainment and popular cultural status into an explosive discursive pathway to true celebrity. Bogle's funeral ceremony was also treated to a massive round of media attention, and the controversial rupture between secular dancehall celebration and sober religious mourning at the church provided additional grist for the mill. The insistence of the media's agenda setters and other authority figures on this artificial rupture between sacred and the secular underscored the notion that funerals of this nature are squarely positioned in the centre of popular culture and are circumscribed by the ethics and *mores* of the dancehall. Yet, the persistent denunciation of these funerals as secular dancehall events continues to fuel the notion that bling/dancehall funerals are indeed legitimate stages from which members of Jamaica's underclasses can project a celebrated notion of self from below.

In Jamaica, public and media debates about the lack of morals, growing levels of anarchy and chaos, and the overall 'disrespect to God' involved in the activities at bling/dancehall funerals increased, particularly after Bogle's funeral in 2005 and the spectacular events that unfolded in the Christian sanctuary of the Kencot Seventh Day Adventist Church. While Christianity was seemingly able to mediate some consensus with the often elaborate African funeral rituals that form part of Jamaican life, the contemporary capitalist materialism and popular culture rites of celebration

in bling/dancehall funerals have not yet gained full social acceptance. As a consequence, in the wake of the controversy surrounding Bogle's funeral, members of the Seventh Day Adventist (SDA) denomination decided to withhold final rites from individuals who were 'not worthy' of these services and summarily issued a list of guidelines for funeral services.[17] These included the 'establishment of a code of conduct for the conduct of funerals', which would be communicated to the family of the deceased and efforts made by the SDA church 'to determine the lifestyle of the deceased (thus determining if the church will accommodate the funeral)'. In a direct stab at the materialistic, flashy aesthetics of bling/dancehall funerals, the final item of this 'code of conduct' stated: 'All participants in the funeral service will be asked to adhere to the SDA standards of dress, which should be communicated to them at the time the programme is being prepared' (see *Sunday Observer* articles cited in note 17).

Bling/dancehall funerals are celebrations of life in death that breach the currently accepted codes of conservative mourning that elite, traditional and Eurocentric social convention insists should accompany final rites in Jamaica. Unlike the sober, grief-filled, mournful, black-garbed religious rites associated with the upper and middle classes and practiced by many from the rural working classes, the bling/dancehall funerals of a growing segment of Jamaica's working and lower classes are youthful, riotous, party-like secular/spiritual celebrations of life, with mourners in fabulous colorful, party costumes, dancehall dress and high fashion and style, often with a costly price tag. Many of the mourners are associated with urban life and survival in tough inner-city conditions. These bling/dancehall funerals create an attractive Utopian fantasy that projects ideas of a fabulous and celebrated self in life and death across the body of its adherents.

In this regard, bling/dancehall funerals temporarily suspend social boundaries and momentarily rotate the distinctions between those defined as heroes and anti-heroes in Jamaican culture.[18] Heroes of Jamaica's underworld are granted a final, grandiose public staging of a constructed image that is projected as idealized identity. Willie Haggart was eulogized as a 'hero of the ghetto', 'a cultural phenomenon unrecognized by mainstream Jamaican society', and Bogle was eulogized as a 'cultural icon and a dancehall superstar, and a wonderful entertainer'.[19] The ambivalence of these moments breathe life into these distinctive descriptions and immortalize these men as powerful and worthy, thereby validating their existence within the realms of the inner cities, dancehall culture and Jamaica. The intense media attention, fandom and publicity render Haggart and other members of Jamaica's underworld as heroes of the ghetto. Yet one must note the paradox that can be created in this transgressive moment of celebration. Though celebrating members of the underworld through funeral identity-rites can transgress the status quo by commemorating and reifying individuals identified as or suspected to be criminals, this practice can simultaneously maintain the status quo by reinforcing the link that is often crafted between the inner cities, the underworld, and crime and violence.

Nonetheless, in the final analysis, bling/dancehall funerals do tamper with the ideas of self in a rigidly bounded society like Jamaica. If funeral rites showcase the financial and social status of the deceased and the immediate family, then, in a truly ambivalent turn, the high levels of financial expenditure exposed at bling/dancehall funerals elevate the body of the black, Jamaican underclasses to the greatest possible heights of financial and social status and create a dialectic of personhood that returns to the bling dancehall and its adherents. The ingenuity of men like Brite Lite's Tommy Thompson creates aesthetics that capture the underpinnings of a capitalist-influenced society where money and power are made synonymous and where the body, as bearer of status, bestows its modicum of personhood on those who revel in its ostentatious shadow.

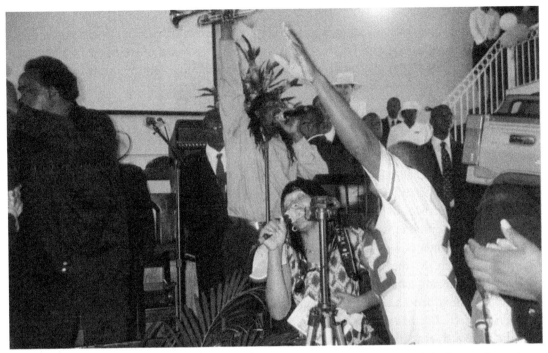

Figure 2. Musicians, dancehall dancer Mad Michelle and an artiste appropriate the podium at Bogle's funeral. *Source: © Donna P. Hope*

Figure 3. Some of the vendors who converged on the streets outside the Kencot Seventh Day Adventist Church as a part of the activities surrounding Bogle's funeral. *Source: © Donna P. Hope*

These riotous celebrations have secured a place among Jamaica's cultural and social happenings, and bling/dancehall funerals are firmly established among the ranks of contemporary Jamaican funeral rituals, operating at one extreme of an almost see-saw-like continuum, with traditional, sober funeral rituals at the opposing pole.

Conclusion

Bling/dancehall funerals are preferred identity-rites that play a seminal role in the production and maintenance of celebrated dancehall identities which become standards of status and personhood for dancehall adherents and members of Jamaica's underclasses. Bling/dancehall funerals are celebrations of life that combine media, material culture and the creative arts of music, fashion, dance and style. Using dancehall culture's creativity and innovation that is concretized in this discussion on bling/dancehall funerals, Jamaica's underclasses transgress the status quo by demonstrating their power and worth through collective living expression. The dancehall body resurrects and recreates these celebrated identities which operate beyond the grave as important standards in the maintenance of a spectrum of relevant and accessible identity-types for Jamaica's underclasses. Bling/dancehall funerals operate socially and culturally as celebrated identity-spaces that offer preferred standards from which dancehall adherents select patterns of personhood, and simultaneously reap a sense of communal camaraderie and socio-political legitimacy on the dancehall stage and beyond.

As a consequence, the stage is the grave and the grave is the stage. At this blurred nexus revolves a paradoxical site of identity-negotiation and status-generation whose rituals play into and beyond the African/European retentions of a postcolonial society and wade into the mire of capitalist consumption that infuses contemporary popular Jamaican culture. The ostentatious aesthetics of the staged grave and the grave that is a stage projects its ideas of status and personhood across the dancehall body. The fantasy created by bling/dancehall funerals elevates ordinary individuals to extraordinary heights of celebrity and superstardom, unmatched by their officially designated social, political and economic positions in Jamaica. Thus, bling/dancehall funerals operate a kind of hegemony from below, where ordinary bodies are used in the making and bestowing of ideas of status upon the body of Jamaica's underclasses. These moments in time project immortal fantasies of personhood across the deceased body into the minds of the funeral revelers, and these fantasies tamper with the socio-economic and socio-political strictures that work to maintain the status quo in Jamaica. And from the grave, the bling is returned to the stage and the stage returns to the grave. It is a glorious fantasy dance with the socio-cultural self. And so the dance continues. It is indeed a 'jiggy time again.'[20]

Notes
1. During the interval between clinical death and the time the duppy is laid to rest, the individual is not considered fully dead (Pigou, 1987: 24).
2. Jamaican 'nine nights', which are performed to accompany the deceased spirit's final departure, combine several African as well as Christian elements. For example, to safeguard the spirit's journey, nine-night ceremonies are held by family and friends of the deceased in order to remember and entertain the dead spirit. Food is offered and sermons, hymns and songs given in order to smooth the passage from this into the other world (Pigou, 1987: 26).
3. The 'set-up' is a gathering of people that is traditionally hosted on the eve of the funeral. At this event individuals sing traditional religious hymns and also dance and pay their respects to the deceased and members of the immediate family. Food is offered to visitors and, in most rural areas, visitors typically bestow gifts of food, money or white rum to the deceased's family to assist with the nine-night or set-up rites, or to offset the funeral costs.

4. Dancehall culture draws significantly from other indigenous forms of black popular celebration and worship that form part of Jamaica's history and culture. Scholars like L'Antoinette Stines (2008) document the positive relationship between contemporary dancehall and other forms of Afro-Jamaican religious and celebratory expression like Kumina, Bruckins and Nyabinghi.

5. In the dancehall, groups, sects and crews act as collective embodiments of overlapping and competing discourses, e.g. Black Roses Crew, Higglers Crew, Ouch Crew, Scare Dem Crew, Diplomat Crew and British Link Up Crew (Hope, 2004: 109). The Black Roses Crew is an all-male group that has been noted for the dance prowess of its members (e.g. Willie Haggart, Bogle and Ice – all now deceased). The group has also reputedly been involved with illegal drug and gun activities.

6. 'Don' is a title of distinction afforded to men who are considered to be of high social, political and economic status in Jamaica. It is particularly used to denote status among men from the lower socio-economic levels and in the inner-city context and is commonly used in inner-city and dancehall slang. The Jamaican definition of 'Don' draws significantly from the distinctive label given to Mafia overlords of the kind immortalized in the movie *The Godfather*; however it is oriented around indigenous symbols of the 'ghetto gunman', who may sometimes have political and/or narco-political linkages. Political Dons are affiliated to one of the two major political parties in Jamaica (the People's National Party or the Jamaica Labor Party) and generally oversee the running of garrison communities in Jamaica. Many practicing Dons have been accused of illegal or extra-legal activities in Jamaica (Hope, 2006: 91–2).

7. Representatives from every media house in Jamaica were present, with the cameras from CVM TV, Mediamix and Sowah Productions holding centre-stage at the front of the National Arena.

8. Babies or young children are usually crossed over the coffin twice so that the spirit of the deceased will not lure away their spirits and will offer them good wishes and protection.

9. The precedent for Haggart's ostentatious send-off had been set as early as 1975, when reports show that a huge crowd of approximately 25,000 persons converged on the funeral of Winston 'Burry Boy' Blake. This funeral was attended by then Prime Minister, the late Michael Manley, who was the Member of Parliament for 'Burry Boy's' constituency. The huge crowds resulted in chaos at the event (see Cooke, 2006).

10. This was another bling/dancehall production of Brite Lite Funeral Services.

11. See Hope (2004) for analysis and discussion of the British Link Up Crew.

12. Of interest is the fact that Maddens, a long-standing and highly traditional funeral service in Jamaica, had been co-opted into the bling/dancehall ethic which was considered appropriate for an individual of Bubba's underworld 'hero' status.

13. The Area Leader is hierarchically related to the Don. He/she becomes prominent in the community based on hard work and respect engendered from facilitating community development. The Area Leader may eventually acquire enough social, political and economic resources to accede to the higher position of a Don. It is important to note that while some women become Area Leaders there are no female Dons in Jamaica and also that not all Area Leaders become Dons (Hope, 2006: 92).

14. Arguably, the prominence and success of these funerals has encouraged traditional and long-standing funeral homes like Maddens Funeral Supplies to follow suit.

15. The average cost for such an event was set at approximately J$1.2 million in 2007.

16. For example, see online links to video of Bogle's funeral rites at: http://video.google.com/videop lay?docid=-5121426271934431145 or at: www.truveo.com/boglefuneral/id/1054410592
 Several internet sites also offer DVDs of Bogle's funeral for sale, for example: www.bigupradio. com/videoDetail.jsp?vid=393 or www.reggaecd.com/store/mcart.php?ID=13544

17. See for example: 'Adventists Won't Bury Lawbreakers: Will Do Background Checks of the Dead', 'Other Church Groups Support SDA Decision' and 'New SDA Guidelines for Funeral Services', all in the *Sunday Observer* (19 June 2005).
 See also an article from the Public Theology Forum, in the *Sunday Gleaner* ('Funeral Rites and Popular Culture', 2007) and a letter to the editor from Dudley McFarlane ('Church's "Anti-bling" Stance Long Overdue', 2005).

18. For example, present at both Willie Haggart and Bogle's funerals were prominent members of Jamaica's political elite, academic elite and media elite rubbing shoulders with individuals whose reputed illegal activities made them ideal candidates for state sanctions.

19. From personal notes recorded at both events.
20. From a popular song by the late Gerald 'Bogle' Levy which was performed at his wake and also at his funeral.

References

Brown, Vincent (2008) *The Reaper's Garden: Death and Power in the World of Atlantic Slavery.* Cambridge, MA: Harvard University Press.

Bryan, Patrick (2000) *The Jamaican People – 1880–1902.* Kingston: UWI Press.

'Church's Anti-bling Stance Long Overdue' (2005) Letter to the Editor, *Sunday Gleaner* 3 April.

Cooke, Mel (2006) 'Short History on the Warrior Cause', *The Gleaner* 8 November.

'Funeral Rites and Popular Culture' (2007) *Sunday Gleaner* 29 April.

Hope, Donna P. (2004) 'The British Link Up Crew – Consumption Masquerading as Masculinity in the Dancehall', *Interventions: International Journal of Postcolonial Studies* 6(1): 101–17.

Hope, Donna P. (2006) *Inna di Dancehall: Popular Culture and the Politics of Identity in Jamaica.* Kingston: UWI Press.

Pigou, Elizabeth (1987) 'A Note on Afro-Jamaican Beliefs and Rituals', *Jamaica Journal* 20(2): 23–6.

Senior, Olive (2003) *The Encyclopedia of the Jamaican Heritage.* Kingston: Twin Guinep Publishers.

Stines, L'Antoinette (2008) 'The Body as the Storehouse of Cultural Memory', paper presented at the Inaugural Global Reggae Studies Conference, University of the West Indies, Mona, Jamaica, 18–24 February.

Stone, Carl (1980) *Democracy and Clientelism in Jamaica.* New Brunswick, NJ: Transaction Books.

'Thousands View "Don's" Body in Arnett Gardens' (2001) *Jamaica Gleaner* 8 May, URL (consulted August 2009): www.jamaica-gleaner.com/gleaner/20010508/news/news2.html

Tortello, Rebecca (n.d.) 'A Time to Die: Death Rituals', *Jamaica Gleaner,* URL (consulted January 2010): www.jamaica-gleaner.com/pages/history/story0080.html

Turner, Graeme (2006) *Understanding Celebrity.* London: Sage.

Waters, Anita (1985) *Race, Class and Political Symbols: Rastafari and Reggae in Jamaican Politics.* New Brunswick, NJ: Transaction Books.

Muñecas and Memoryscapes:
Negotiating Identity and Understanding History in Cuban Espiritismo

Carrie Viarnés

Every September by the docks of Regla, a small industrial district across the bay from Havana, thousands of Cubans await the procession of the Black Virgin at the Church of Our Lady of Regla, patroness of the sea and of the great city of Havana. Devotees of the Virgin board the ferry to Regla with flowers and candles intended for her. Ferry passengers cross themselves with coins, tossing the shiny offerings into the bay as they whisper appeals to the *oricha* (deity) of the ocean, Yemayá. Some also carry black *muñecas* (dolls, hereafter "spirit dolls") dressed in blue and white—key symbols that refer to the Virgin as well as to her Yoruba (Yemayá) and Congo (Madre Agua) counterparts. Procession participants and other devotees tell me that these dolls represent their spirit guides: former enslaved people who were once practitioners of Palo (Congo-based Cuban religion), Ocha (Yoruba-based Cuban religion, commonly known as Santería or Lucumí), Espiritismo, or some combination of these. While each spirit is different and has its own "spirit biography," they are most commonly described, as one espiritista eloquently stated, as "African spirit[s]... brought from Africa and taken to the plantations...during the Spanish colonial period." Some espiritistas suggest that the spirits of the formerly enslaved help them to "understand what the lives of the blacks brought from Africa were like."[1] Espiritistas rarely broach the topic of slavery in everyday speech, but it is not uncommon for them to do so when discussing their spirits and the dolls that contain them. The memory of slavery is very much alive in these reimaginings of the dead: espiritistas invoke the memories of formerly enslaved peoples through dreams and trance possession to determine how to prepare and adorn their spirit dolls to reflect the appropriate history.

Figure 1. A recent Ocha initiate (iyawó, or "bride of the secret") carries her spirit doll in procession for the Virgin of Regla in Havana, September 2005. She agreed to be photographed but only if the doll covered her, as it is considered bad luck to be photographed during the initiation year (iyaworaje).
Photo by author.

Historical memory is a rather nebulous term that scholars use to talk about things we cannot quite articulate. I take it to refer to the ways in which people reconstruct the past through image and ritual in meaningful, if abstract, ways that are significant to the present. So the question here becomes: What exactly is being remembered when a practitioner makes and uses a spirit doll? A spirit doll is evidence of an attempt to embody multiple identities that correspond to various Afro-Cuban religious practices. Put simply, people remember who they are by making spirit dolls; they remember their ritual and blood ancestors (who were often practitioners of different religions) in order to make sense of a complex and traumatic past, and to establish control over their present and future. Significantly, a spirit doll represents a practitioner's specific spirit guide that belongs only to them and at the same time embodies the ritual knowledge transmitted by these spiritual ancestors over generations. The dolls embody a historical memory that is at once personal and collective. Whereas agents of the slave trade attempted to render all African-descended people atomized individuals, spirit dolls give a name and a face to the ancestors and thus represent lineages unbroken, at least in the spiritual imaginary, by slavery.

Often referred to as "Mama Francisca" (specifically if the spirit shared a relationship with a female ocean deity) or, more generally, as "Africanas" or "Congas," spirit dolls are adorned with accoutrements that signal an amalgam of religious symbolisms and thus indicate a *cruzado* (crossed) practice: *garabatos* (forked sticks used in Palo Monte), blue-and-white gingham dresses, and beaded necklaces signifying initiation into the Regla de Ocha. They have names like Francisca Siete Sallas (frequently referred to as Mama Francisca) that imply a connection to the female water spirits in Palo.[2] Their most important function is to stand in for ritual ancestors; that is, they embody the historical memory of lineages of Palo and Ocha priestesses. It is no coincidence that these blue-and-white robed black female dolls are called "Mama." In the case of Mama Francisca and other maternal "African" water spirits, spirit dolls tell a *her*story. They are icons of motherhood, and thus "countermyths" to the colonial images of seductive and hypersexualized black women whom Aline Helg so aptly calls "icons of fear" (1995, 17–18). Black mothers, matriarchs, and leaders of lineages are reproduced in spirit dolls. They are also symbolic representations of the critical role that African and African-descended women have played as spiritual leaders in Cuba. The valuable work of these women in passing on African religious heritage and establishing and maintaining networks of relationships with both other practitioners and supernatural entities is what some scholars have called the spiritual "work of kinship" (see Turner and Seriff 1993, diLeonardo 1984).[3] In this way, these embodying symbols also provide models *of* ancestors, deities, mothers, and spirits as well as models *for* devotion to and interaction with these entities "by inducing in the worshipper a certain distinctive set of dispositions...which lend a chronic character to the flow of his activity and the quality of his experience" (Geertz 1973, 95). They are also models for living a spiritually "developed" life, the central goal of most espiritistas.

In some cases, spirit dolls are "born from" other dolls. In such instances, each doll is a member of a ritual lineage of other dolls just as the client or spiritual godchild of the doll maker becomes a member of his or her spiritual lineage. Like the spirit itself, the spirit doll becomes a member of one's family. Xiomara, an Espiritista from Guantanamo Province, says of her dolls, "I tell my *muertos* (spirits of the dead), 'you are my children, my parents.' I love them like a second family because they have helped me through so much, so many hard things."[4] In Cuba, for those who believe, spirits are integral members of the family and the community. Dolls are then material markers of very important relationships. To some extent the spirit and its representation serve as a means by which we can understand the medium and the relationships that structure their world(s)

(Wehmeyer 2002, 71). As spirit mediums relay their knowledge and reproduce their spiritual ancestors during the ritual that imbues a doll with its spiritual essence, memory is crystallized in the image of the spirit doll. Through this rite of ritual reproduction, key spiritual concepts—ideas about ritual kinship and spiritual transformation, to name a few—are remembered, performed, and communicated. In this sense, spirit dolls are memory maps; they summarize an entire universe of supernatural and human relationships and the ritual logic that emerges from these relationships. Espiritistas' experiences of their spirit dolls concretely address the fact that "people ordinarily do not long for a lost 'cultural heritage' in the abstract, but for the immediately experienced personal relationships" (Mintz and Price [1976] 1992, 47).

But how do dolls come to embody historical memory in the first place? In this chapter I examine the process through which dolls become inhabited by spirits to discern the ways in which the ritual consecration of a spirit doll is a mode of memory production that condenses a multiplicity of African spiritual logics. Spirit dolls, through a process of ritual accumulation, are charged with diverse spiritual powers that draw from a variety of historical memories we might call "creole." They are material markers of distinct yet interconnected modes of performance, spiritual discourse, and systems of belief. Espiritistas build on their identities in the same way the dolls acquire accoutrements and ingredients: just as dressing a doll with multireferential symbols and filling it with ritually charged materials that draw from the various Afro-Cuban religious traditions are accumulative processes, so is the process of constructing historically conscious identities. The ritual construction of spirit dolls suggests that the spirit and the spirit medium accumulate power through modes of remembering, representing, and re-enacting the past, and through the complex subject-object relationship between espiritistas and their spirit objects. It articulates a vision of Cubanness and identity as both African and Creole.

Dolls express an artistic and spiritual ethos of accumulation that owes as much to traditionally inclusive and dynamic African spiritual practices as it does to the similarly open system of Espiritismo and the process of creolization that transformed them both. African modes of thought and performative traditions have had a profound impact on the Caribbean and on the Atlantic world in general. African notions of multireligiosity, innovative ritual, festive performance, and the relationship between the spirit world and human world impacted the ways in which European and American Spiritist practices were incorporated into African-derived religious practices and authenticated as Afro-Cuban. I suggest that shared understandings and hybrid modes of spirit-knowing and spirit-making among enslaved Africans in the New World were foundational to the religious forms that emerged later in Cuba. In doll making rituals, these systems of knowledge converge and memories of Africa are condensed into small, portable, and significant personal symbols that chronicle religious innovations and recreations.

The process of creating, adorning, interacting with, and publicly using the dolls is one of the ways that practitioners reclaim history by representing their ancestors and spirit guides, negotiate identity via the logic of *"trascendencia"* (transcendence), which I discuss below, and reinvent religious praxis, as Cubans say, "a mi manera" (in my own way). Doll making is a subtle method of achieving such feats, yet it speaks volumes about the importance of the past and those who lived it. The dolls in the hands of practitioners represent "a move back from text to life," or in other words, a way of literally remembering, re-"dressing," and reinscribing history to make it accessible and meaningful to practitioners (Palmié 2001, 207). It is certain, at least, that the dolls are creole art forms that embody distinct practices and divergent identities in many ways. They are vessels of personal, cultural, and historical negotiation, much like the bodies of practitioners are vessels for

the spirits and the identities they represent, and "bodies" onto which "genealogies of performance" (Roach's phrase) – whether performances of doll making rituals, *misas espirituales* (séances), or Catholic processions – have been inscribed. These inhabited dolls as embodied spirits, witnesses, and intermediaries of history are the public faces of the ancestral dead that legitimize collective memory. Juxtaposed against the hegemonic symbol of the Virgin, now publicly stripped of her once formal association with African cabildos and goddesses in the procession, spirit dolls are powerful objects of countermemory in public performances of multireligiosity. As Joseph Roach (1996, 25–26) contends:

> genealogies of performance document – and suspect – the historical transmission and dissemination of cultural practices through collective representations... [and they] also attend to 'counter-memories,' or the disparities between history as it is discursively transmitted and memory as it is publicly enacted by the bodies that bear its consequences.

In the procession, in ritual, and on altars, the spirit doll is one of the alternative "archives" that fills this disjuncture in memory.

The procession is just one of the performative contexts, the "stages," so to speak, on which spirit dolls perform the task of activating the past. Just as these dolls are fundamentally connected with Catholic, Spiritist, Yoruba- and Congo-derived practices, they, along with the public and private ritual performances associated with them, are also manifestations of what the Yoruba call "deep knowledge" that "safeguards a space opposing hegemony...[and] by definition opposes public discourse" (Apter 1992, 256). Perhaps the public exhibition of the dolls in processions speaks to a "hidden transcript" (see Harris 2003) of sorts that seeks to give voice to the narratives of the ancestors in the midst of public festival, a remembrance of cabildo queens and religious forebears. For instance, the dolls as they are paraded in the procession for the Virgin of Regla suggest several interpretations. First, the gesture of raising up the doll so that it "dances" above the crowd recalls the *anaquille* (the female figure atop a pole that was used in cabildo processions during colonial times) and "raising up" is a critical ritual action in sacred Yoruba practices. Second, the raising of the doll in the air during the procession puts the spirit of the dead, and in some cases the oricha associated with it, on the same spatial plane as the Catholic saint. The dolls and the traditions associated with them are physically and publicly vying for attention on the holy feast day of a venerated Virgin.

The dolls, particularly in terms of their ritual preparation, also speak to the problematic distinctions between diverse religious traditions in Cuba – distinctions that many practitioners staunchly defend even though these religions are based on similar ideas about the natural world and the relationship between the living and the spiritual forces that guide them, and despite the fact that there is significant blurring of the lines between Afro-Cuban religions by practitioners themselves. Instituting hybrid ideologies in the aesthetic and internal construction of the doll illustrates this. For example, by naming the entity that animates it after the spirit of an *nganga* (e.g., Francisca Siete Sallas) and characterizing it as having a *transcendencia* of Yemayá, practitioners are demonstrating the intimate relationship between Palo and Ocha, spirits and orichas.[5] Spirit dolls illustrate that spirits and orichas, and the processes by which they are made, do not fit into discrete categories. As Lydia Cabrera's informants declared decades ago:

> Ocha or Palo...doesn't it come to the same thing? Spirits, that's all! Doesn't one fall [into a state of possession] the same with the oricha as with the dead? In religion everything is a thing of the dead. The dead became saints" (1975, 30).

The dolls not only mediate between this world and the other world, between orichas and spirits, and between the identities of espiritistas, Catholics, and priest/esses of Palo and Ocha, but also challenge these boundaries and the way they are remembered and memorialized in doll form. Spirit dolls acknowledge and embody the fact that practitioners often identify with multiple spiritual practices of European and African origins. This kind of popular spiritual practice also allows uninitiated practitioners to "trespass" on the sacred worlds of Ocha and Palo, a tactic that is considered necessary by some who find initiation a financially unattainable goal.

Spirit dolls embody collective memory in the same sense that effigies do. I use this problematic term specifically because of its root meanings: effigy derives from the Latin *effingere*, meaning to *fingere* (to form, to shape). The emphasis here is not on effigy as a noun, but as an action or process we might liken in modern English to the act of "memorializing" a person or thing. The distinction is significant because, as Roach (1996, 36) observes, "when effigy appears as a verb...it means to evoke an absence, to body something forth, especially something from the distant past." Espiritistas attempt to memorialize their ancestors and the experiences they lived through, which suggests that there is some part of history they feel the need to document, to represent, and to recall on a daily basis in both public processionals and on their home altars. Jennifer Cole's (2001) discussion of memory is significant here because it provides a link between history and (ancestral) memory and suggests that remembering is a form of agency – it is *intentional*. I agree with her assertion of "constructions of the past as intentional memory" and see the practice of doll making as evidence that, as Cole suggests of memory more generally, "historical consciousness emerges from people's efforts to connect with ancestors" (ibid., 133). Another nuanced modifier of memory is also useful. "Cultural memory," writes Diana Taylor (2003, 82), is "a practice, an act of imagination and interconnection...a lifeline between past and future." Taylor's perspective situates memory in the realm of a specific social and regional reality, and emphasizes performative agency: memory is a cultural "*act*." The doll maker, through this ritualized and *intentional act* of shaping, making, and evoking "the distant past," creates a spirit object that embodies ("bodies forth") historical memories expressed through specific ritual idioms.

Whereas some objects retain obvious references to memories of slavery, like the chains and other binding instruments found in an nganga, the doll is a more subtle and portable "memoryscape." I take memoryscapes to include both spirit objects and "the broad spectrum of commemorative practices" like ritual and procession, "through which people rehearse certain memories critical to their personal dreams of who they think they are, what they want the world to be like, and their attempts to make life come out that way" (Cole 2001, 290). By attending the procession with these personal emblems or building altars intended for semipublic ceremonies, devotees publicly perform their Creole identities and spiritualities. They are African and Cuban; they practice Ocha, Espiritismo, Palo, and Catholicism, each products of a contentious history of mixture. The dolls are symbolic of this cultural assemblage. They embody, indeed "miniaturize," memories not only of slavery but also of the cultural-religious practices and social processes of creolization that were recreated within that institution, processes that continue to the present day.

Espiritismo and Spiritual Development

During the first weeks of my second trip to Cuba in the summer of 2005, I attended three misas espirituales in Havana. The mediums at these three ceremonies informed me that I owed tremendous reverence to Yemayá, without whose help, they said, I never would have set foot on the island. Each espiritista also suggested I dedicate a doll to a spirit they said was very attached to

me – an African spirit with a trascendencia of Yemayá. Maternal water spirits are almost always described as having a trascendencia of Yemayá, meaning that they share a spiritual relationship with the oricha and have acquired some of the extraordinary powers associated with the deity. Spirit dolls with a trascendencia of Yemayá embody the "spiritual aspects" of the Yoruba oricha Yemayá, the Palo spirit of Madre Agua, and the Virgin of Regla, as well as the common spirits of ritually powerful women and formerly enslaved individuals who were her devotees during their lifetime. Thus trascendencia connects earthly and ritual motherhood to supernatural maternity as well as links divergent religious practices. One espiritista describes "trascendencia" as a "mythological connection to the water goddesses of the world."[6] Mama Francisca, then, condenses and incorporates both universal principles and more culturally specific ideas about maternal water spirits. Yet spirit dolls also condense the essence of the individual: some of the devotee's own traits, talents, or habits are attributed to the presence of this particular spirit in their *cuadro espiritual* (personal spirit pantheon).

Making a doll for Mama Francisca will give me the stability I lack, the espiritistas insist, particularly since I have not received Olokún or my oricha. Obtaining a relatively accurate representation of her and attending to her as a central part of my practice, they advised, would not only draw her closer to me, but would also help me achieve balance in my life and accelerate my own process of *desarrollo* (spiritual development). Attending to her, they tell me, includes establishing a home altar where I can nourish her with "spiritual food" – offerings of water, perfume, candles, flowers, food, coffee, rum, new accoutrements, and custom-made dresses. These acts of devotion, including the ritual preparation of a "spirit-receptacle" (Argyriadis 2005, 91), would help me address their concerns about my spiritual welfare and mark my commitment to lead a more spiritually upright life. "You can't keep running from house to house," I was advised by one of these embodied spirits during a ceremony. "You have to be more religious, associate yourself with one (religious) house and stay there."[7] The spirit doll will allow me to generate and maintain reciprocal relationships with my spirit guide, on the one hand, and to link myself ritually to a particular lineage of practitioners, on the other. This loyalty to one family and thus one spiritual philosophy, it seems, is key to beginning the process of desarrollo.

In compliance with these suggestions, I chose a trusted friend with a solid background in a variety of Afro-Cuban religious practices to prepare a spirit doll for me. It should be noted here that anyone can make a doll for his or her guardian spirit(s), and some devotees simply dress a doll and dedicate it to their spirit without any formal ritual preparation. Regardless of the method of preparation, this is not an arbitrary act of creative expression; it signifies a pact with the spirit. It not only acknowledges the spirit and its worthiness of representation, but it also constitutes a promise to attend to that spirit in a very concrete and tangible way in exchange for protection, guidance, and presence. Much like receiving an nganga or an oricha is a very serious spiritually binding act, making a doll and promising to care for it is essentially a contractual agreement to be entered into with the utmost care. For this reason, it is best to select a "responsible" espiritista to do this work, or better still, one who will assist the client (if they are uninitiated or, in the case of Espiritismo "spiritually undeveloped") in the process as opposed to preparing the doll for them in their absence. The devotee should be present because the spirit that is to be installed in the doll is the client's guide, and therefore he or she should observe and participate in what is being done on his or her behalf. The ritual is both a means of incorporating spiritual godchildren into the lineage of their elders and is central to one's own spiritual training, a more or less exact repetition of the godparent's experience of making their own doll. In the section that follows, I sketch the step-by-

step process of the ritual to illustrate the ways in which ritual knowledge and religious philosophies from Ocha and Palo as well as Espiritismo are condensed in the doll. The spirit doll, in the end, embodies what Rosalind Shaw (2002) calls "palimpsest memories" because, while I can discern Yoruba and Congo correlates, at times it is difficult to separate out these ritual rememberings, for they share similar ritual logics and have become even further intertwined through the historical realities of syncretic practice in Cuba.

I refer to the man who worked with me in the preparation of my spirit doll as "Rafael" or, alternately, as "Padrino" throughout this text to convey the respect due him as my spiritual godfather as well as to conceal his identity.[8] Rafael was born in Havana, Cuba on November 13, 1971, to a family of religious practitioners. His mother is a priestess of Ochún, his father a member of the Abakúa society, and both sides of his family descend from long lineages of *nganguleros* (priests of Palo Monte). He was initiated into Palo Monte at the age of seven and consecrated as a priest of Ogún in 2003.[9] He considers himself an espiritista, a santero, and an ngangulero (but not a palero, he insists), although he admits to engaging in unorthodox practices:

> I believe that word [palero] is...employed incorrectly. Really we who practice the religion Palo Monte are either nganguleros or we are mayomberos. I consider myself a ngangulero, but I'm kind of a strange ngangulero in the sense that I am very spiritual and I combine Palo Monte with the spiritual a lot, to the point where I sit down in front of my *fundamentos* [nganga] and I read prayers because the *muertos* [dead] that live inside are spirits and I read them prayers. There are people who criticize me, but in any case they are spirits and they have to attach themselves to a spiritual altar...I use perfume on my *fundamento*; there are people who criticize me for that, too.[10]

Rafael's explanation is indicative not only of proper Bantú terminology for Palo priests, but also of the kind of philosophy that generates hybridized practices associated with what scholars refer to as Espiritismo Cruzado (Crossed Spiritism). He suggests an equivalence between the spirits of the nganga and the spirits of the *boveda* (Espiritismo altar): they can be approached using similar techniques, including Catholic or Spiritist prayers. His comments illustrate the fact that despite the attempts of many orthodox religious houses to maintain the divisions between Palo, Ocha, and Espiritismo, practitioners "have blended and borrowed attributes from among the several systems, leading to highly syncretic or 'crossed' (cruzado) practices" (D. Brown 1999, 160). These creative recombinations make the religion(s) work for the people who practice them and follow a long-standing tradition of inventive spiritual strategies. For instance, filling a seemingly innocuous doll with magical elements culled from Palo and Ocha practices mirrors the mid-nineteenth-century actions of Andrés Facundo de los Dolores Petít who, in search of protective talismans that would not invoke the wrath of the church, filled crucifixes with Congo *nkisi* medicines for the members of his syncretic Abakúa society, La Regla Kimbisa del Santo Cristo del Buen Viaje (ibid.).

Spirit dolls are typically associated with Espiritismo, a Cuban version of a spiritual practice popularized in 1852 by the Fox sisters of New York, the first recognized spirit mediums, and by the writings of Allan Kardec (born Hippolyte Léon Dénizard Rivail), a French philosopher who published widely on the subject beginning in 1857 (Bermúdez 1967, 7).[11] Among the key elements of the Spiritist doctrine according to Kardec ([1857] 1989) are a belief in the immortality of the soul, a concept of death and subsequent good works as a mechanism for the evolution of the soul, and the assertion that it is possible to communicate with spirits through mediums. Kardec theorized the character of spirits, which he ranked from "inferior" to "superior" on an evolutionary scale and concerned himself with the role of the spirits in the lives of the living (ibid., 34–36). While Kardec was not a medium himself, his spiritual philosophy was dictated to him by the spirits

through "writing mediums" (ibid., 2–13). His books and the Spiritist doctrine he set forth became wildly popular in Europe and were almost immediately available in translation, inspiring the establishment of Spiritist centers in many different countries.

Espiritismo was especially well-received in Europe and the Americas, where it became popular among the European and Latin American elite. In Cuba it was promoted by national heroes and prominent scholars like José Martí and Fernando Ortiz who applauded it as a solution to the "problem of witchcraft" (Lago Vieito 2002, 42–48). Ortiz (1919) believed Espiritismo represented a "rational" spiritual philosophy, firmly rooted in scientific empiricism and cultural evolutionary theory that would advance the newly independent country's image as a modern nation. After 1902 (i.e. post-independence) the doctrine flourished and Spiritist centers proliferated across the island (Lago Vieito 2002, 39–40). As Espiritismo filtered down to the masses, it acquired several distinct popular forms and reflected the local areas in which it flourished and the diverging beliefs of different espiritistas. By 1963 most centers had dissolved, having failed to unify the "diverse tendencies" of believers (ibid.), or, in many cases, due to government repression (see Juncker 2006; Warden 2006). House temples eventually became the loci of ritual activity for espiritistas, much as they had for practitioners of Ocha and Palo six decades before when the cabildos were disbanded in the wake of the Independence wars and the racial tensions that followed them. Most important, however, Espiritismo became the most popular and widespread means of embodying the ancestors through séances and possession. Today it is the primary means through which the dead are remembered, represented, and made manifest in increasingly innovative ways that incorporate other established forms of religiosity in Cuba.

Spirit dolls, necessarily imbued with multiple sacred meanings, signify a popular idiom, *a mi manera* (in my own way), used by Cuban people to describe the way they practice religion. They are one material example of deeply embedded processes of creolization that show the importance of historical memory; they reflect how "the past is remembered...in images and nondiscursive practical forms that go beyond words" (Shaw 2002, 4). Specifically, the ways in which the dolls are used and prepared, like the phrase "a mi manera," reflect a highly syncretic and personalized logic. They are just one element of a variety of Cuban Espiritismo that scholars (and some orthodox practitioners) call Espiritismo Cruzado, which incorporates elements of Catholicism, Kardecian Spiritism, and the Reglas of Palo and Ocha into *el ajiaco completo* (the all-inclusive stew), a description used by Orozco and Bolívar Aróstegui (1998:283), following Ortiz.[12]

The term "Espiritismo Cruzado" is problematic at best, since it implies that a "pure" form of Espiritismo exists and contradicts recent scholarly debates about cultural purity and authenticity expressed in the use of such terms as syncretism, creolization, hybridity, and most recently, cruzado (e.g., Shaw and Stewart 1994, Mintz and Price [1976] 1992). More significant is the fact that espiritistas and priests of Palo and Ocha generally resent the term cruzado, which means mixed, crossed, or crossbred, and is distinct from the concept of syncretism.[13] For them, the term cruzado is pejorative in ways that syncretism is not. In Cuban vernacular Spanish, the phrase *esto está cruzado* (this is crossed) indicates that something has been done incorrectly, an impolite way of saying that something is terribly wrong. More orthodox practitioners sometimes use the term to express contempt for the practices of others and, consequently, to categorize their own methods as authentic in comparison. To many practitioners, cruzado seems to indicate the mixing of practices as a result of confusion and ignorance, whereas syncretism connotes *intentional* parallels that derive from the historical reality of slavery and the conscious decisions made by the enslaved and their descendants to ensure the survival of their religious beliefs (D. Brown 2003:5–6). For my

collaborators, syncretism is not necessarily "a contentious term, often taken to imply 'inauthenticity' or 'contamination'" (Shaw and Stewart 1994, 1). Cruzado, on the other hand, does imply these kinds of derogatory judgments, while more widely accepted scholarly terms like creolization are absent from the vernacular vocabulary. Rafael, for example, expressed confusion when questioned about the term: "I've heard of it, but I don't know what they call 'Espiritismo Cruzado' because everybody uses it. Yes, syncretisms exist, but the practices are not 'crossed.' One thing takes you to another – it's like a ladder (*escalera*)."[14] Others take extreme offense to the term, saying in defense of their practices, "Nothing is crossed here!"

While many practitioners insist that each of these belief systems remains distinct from one another despite some surface syncretisms, it is evident that Cuban espiritistas often borrow symbols and ritual practices from Catholicism and the Reglas, while priests of both Reglas have incorporated Espiritismo rituals in their own practices (see Castañeda Mache and Hodge Limonta 2003). Indeed, in many religious houses, one if not several misas espirituales are required prior to initiation, particularly into the Regla de Ocha. Likewise, an ngangulero or mayombero's decision to pursue initiation in Palo Monte ("rayarse") is sometimes the result of advice obtained by an espiritista during a misa (although the individual would then consult with an ngangulero). Isabel and Jorge Castellanos (1992, 194) term this kind of Espiritismo "popular" instead of Cruzado. I prefer this term because it both echoes the concerns of practitioners and serves the equally important function of distinguishing between what Ileana Hodge Limonta and Minerva Rodríguez Delgado (1997, 23) call "classic" and "contextualized" forms of Espiritismo. Classic Espiritismo practices—also referred to as "mesa blanca" (white table), "scientifico" (scientific), and "kardecista" (kardecist)—resemble most closely their European forebears in theory. Practitioners primarily concern themselves with philosophical questions and follow early Spiritist teachings, including Kardec's Spiritist doctrine, which tends to be less ritual-oriented (Bermúdez 1967, 5). While Catholic prayers and songs are utilized, they do not reflect the influence of other popular Cuban religious practices (Hodge Limonta and Rodríguez Delgado 1997, 24, 27). Practitioners of the more widespread "contextualized" Espiritismo, on the other hand, deal with everyday concerns such as healing physical, social, and spiritual ailments. While most of them own Kardec's *Collection of Selected Prayers* (1975), some espiritistas do not know who Allan Kardec is, having learned prayers and practices from their parents, mentors, or fellow practitioners.[15] The various "contextualized" forms of Espiritismo, of which Espiritismo Cruzado is one, have, like other religious practices in Cuba, acquired a distinctly popular and syncretic character.[16] Still, framing the discussion on Espiritismo in terms such as "classic" or "European" echoes a hierarchical structure that prioritizes "high" culture and the pursuit of philosophical enlightenment as somehow more significant than the daily struggles of practitioners of "popular" or "Cruzado." I use "popular Espiritismo" throughout this paper to refer to the so-called "cruzado" spiritual practice that is the focus of my research, primarily because it is, if nothing else, extremely popular. I refrain, however, from inventing a new scholarly prefix to define it out of respect for practitioners and their quotidian terminology.

My Francisca, Rafael explained, would be born at the foot of his doll, which represents Madre Agua and constitutes a part of his collection of nkisi. It is significant that the doll is "born" of another doll, particularly an nkisi object from the fundaments of an initiated priest. Like a human child, this spirit doll has a "parent" from which it emerges, an ancestor who connects the doll to a spiritual lineage that encompasses very specific (albeit often overdetermined) religious philosophies, spiritual practices, and aesthetic traditions. Casting this act of creation in terms of human reproduction speaks volumes about the importance of the doll as a marker of ancestry and

spiritual continuity. Lineage is central to Afro-Cuban religious practices, although it refers not only to bloodlines, but also to ritually adopted "godchildren." As such, the process of consecrating my doll was punctuated at various moments with narratives about Padrino's own spirits and his ritual and biological ancestors, that is, the people who make up his earthly and supernatural lineage.

Spirit from the Watery Depths: Making Mama Francisca

In Cuba, due to the lack of affordable new dolls, old ones are often reconstructed or repaired either by those who operate doll shops in the informal economy, or less commonly, by practitioners with extra doll parts on hand. These surrogate arms, torsos, and heads are fragments of different epochs of history, resignified objects of memory from previous lives, palimpsest appendages attached in a ritual re-membering of the body. Thus a doll destined to house a spirit must be ritually bathed, purified, and prepared– just as a devotee's body must be anointed to receive an oricha – to erase the potentially harmful energies of her former owners or existences. The first order of business, then, was to cleanse the doll and ritually "baptize" her, so to speak, with a new identity.

Baptism is a useful metaphor in this particular instance for many reasons, but primarily because it is significant to discussions of historical memory in the New World. The baptism of enslaved Africans in the New World was not conducted solely for the "humanitarian" purpose of saving souls in the name of Christ. It was also done with the intention of giving recently arrived Africans new Spanish identities and names. Obviously, the goal of conversion was not only or even primarily a religious one; rather baptism was a soul-stripping function of the colonial machine of mass production. Although in this case baptism has the opposite function – to invoke and celebrate the spirit and to give the object a soul and a name – the naming practices of espiritistas necessarily reflect the legacy of slavery, since many spirit dolls are representations of enslaved Africans or their descendants. Rafael explains that:

> the name [of the spirit doll] is a *shield*. There are thousands of espiritistas who have a spirit called Francisca. In the old days, when they brought the slaves, the masters didn't care what your name was – they gave [the slave] the name they wanted. But the muerto has its *real* name.

Historical memories of slavery are articulated through spirit naming practices and crystallized in ritual. "Francisca" is a stereotypical name often associated with the spirits of once-enslaved individuals, and the suffix "Siete Sallas," which is frequently appended to the name, identifies this spirit with a specific type of nganga (Palmié 2002, 176). Many spirit dolls dressed in blue and white use "Francisca Siete Sallas" as their generic name, a ruse, as Rafael suggests, to hide their *nombre de pila* (literally, a fountain, faucet, or battery) or *nombre de nación* (ethnically specific African name), their secret, original name known only to the devotee that is used to call the spirit in times of need.[17] While these terms refer to origins or sources – a battery is a source of power and nación refers to ethnic origins – they also contain allusions to water.[18]

Water is spiritually significant in Catholicism, Espiritismo, Ocha, Palo, and many other religions. In Catholic practices, holy water blessed by the priest is valued for its healing, soothing, and protective qualities. In Ocha, spirits inhabit the river where the dead often make their appearances in this world (Cabrera and Hiriart 1980, 22). Cabrera (1979, 75) also notes the practice of putting a glass of water by the bed or behind the door to quench the thirst of the dead so they might not torment the living. In Congo belief, water separates the land of the living from the land of the dead: it is both a threshold and a life giving force, thought to have magical and cleansing properties (Jacobson-Widding 1979, 334–35, 342). Water also separates good spirits from evil ones that "live on the other side of the water." Categorized as a "red" and thus an unpredictable element, water is ambiguous and linked with birth and the future (ibid.). Palo priests in Cuba use a glass of water or

a mirror to tell the future (Castellanos and Castellanos 1992:153, 155); water is used to "refresh" the coconut pieces used for divination. In Palo practices, new initiates must bathe in ritually prepared *omiero* (infusion) and consume some of the substance to "cleanse themselves within" (ibid., 151). Cleansing the body as well as ritual objects with omiero is similarly central to many Ocha rituals and initiations. In Kardec's Espiritismo, one's lifelong spirit guide joins the individual with the first breath as a newborn baby emerging from the amniotic fluid (see Kardec [1857] 1989). In Cuban Espiritismo rituals such as misas espirituales and *cajon para los muertos*, water is a spiritual conduit: it is the consistent element on every Espiritismo altar, serving as a focal point for communicating with the spirits.[19]

Water is also used for spiritual cleansing. In some houses, a bowl of perfumed water with flower petals and *cascarilla* (a white chalk-like substance) used for cleansing and protection is placed at the doorway; participants dip their hands in the bowl and wipe the back of their necks with the fragrant water as they cross the threshold into the house where a misa espiritual or cajon is being performed. This is also a customary way to enter a Palo temple during a ritual (Castellanos and Castellanos 1992, 151). A similarly prepared bowl of water sits at the foot of the boveda during a misa or cajon. During the opening prayers, participants approach the boveda one at a time and cleanse themselves with the water by passing their dampened hands over their head, arms, and body as they pray. They subsequently make a *despojo* (cleansing movement) to shake the excess water off their hands toward the boveda in a final act of cleansing before stepping away. In Regla de Ocha ceremonies such as the *tambor de fundamento*, an initiate of Yemayá dances a bucket of water out of the house and dumps it in the street at the end of the ritual, a symbolic cleansing of the sacred space of all of the energies brought into it by participants. Thus in all of these traditions water is essential for cleansing and is a primary conductor of spiritual energy. It is a multireferential symbol of both victimization and agency that evokes memories of forced baptisms and migrations as well as those of ritual cleansing and purification. The doll too must undergo a watery transformation and cleansing so that she can be "reborn" as my spirit guide.

As I set out fresh water, a Francisca-sized gingham dress from Padrino's impressive collection, and all of the items we will use in the preparation of the doll, Padrino draws *firmas* (Kongo cosmograms) for the spirit of his nganga, Madre Agua, and arranges the Eleggúas on the floor in front of his shrine. He explains that we must pay homage to the *egun* (spirits of the dead) and to Eleggúa before beginning the work; he recites the names of his own ancestors and orders me to do the same. This act of naming one's ancestors, both ritual and biological, is common to Ocha and Palo, and is often done prior to the start of a misa espiritual as well. This common gesture of respectful memory suggests how central the dead are to these spiritual traditions.

The doll, too, has "ancestors" worth mentioning. In his work on festive traditions in colonial Cuba, Fernando Ortiz identified dolls called *anaquille*, the term historically used for "idols," carried in processions for the Día de los Reyes (Day of Kings or Epiphany) in colonial Havana (Ortiz [1921] 1992, 61). At the time, anaquille also referred to a kind of toy doll manipulated with strings and made to dance like a puppet, and to amulets or other talismans thought to bring good luck (Ortiz [1951] 1981, 536). Ortiz asserts that the anaquille, which he describes as an "idol or figure for African rites," placed atop a staff and "carried by the blacks in some of their ceremonial or religious dances," have possible African roots. He posits their origins in the festive traditions of Dahomey and Old Calabar, where revelers carried doll-like representations of the dead (called *nabikém* in Calabar); he also suggests that Lucumí dancewands as possible prototypes (Ortiz [1921] 1992, 61). The first to hypothesize a connection between the dolls and the spirits of the dead, he noted that it was the cabildo queens who carried these small, dressed effigies (his term) in the

Day of Kings processions (see also Bettelheim 1988).[20] Following Ortiz's early observations, David H. Brown (2003, 49) sees the dolls as offshoots of sacred handheld items used by African kings and possession priests to signify the orichas (cf. M. Drewal 1997). The dolls, as representations of spirits with a trascendencia of Yemayá, certainly share the functions of Lucumí dancewands and other handheld devices insofar as they can be "embodiments of each oricha's aché [spiritual power]" and serve to "evoke, invoke, and activate" the power and presence of the orichas in their "spiritual" form (D. Brown 2003, 182–85). The spirit doll's contemporary connection to the dead suggests the extent to which the notion of trascendencia has permeated the concept of the oricha/spirit interconnection.

The festive context for the anaquille is significant: spirit dolls are still part of the memory-infused symbolic language of public procession. They are embedded with historical memories of Día de los Reyes celebrations when African cabildos were officially recognized and supported by the Catholic Church and their leaders paraded the streets in the sartorial signifiers of royalty. They remember a narrative history of the imposition of the Catholic faith and the space this created for the reconstitution of African religions through the culture building efforts of Afro-Cubans. The dress of the spirit doll reflects this by recoding colonial representations in a way that "remembers" both nineteenth-century European philosophies and African ideologies, as well as Cuban creole traditions and historical experience (Palmié 2002, 113). Practitioners dress their spirit dolls in rich fabrics and crowns, much like the cabildo queens who carried them appropriated signifiers of colonial authority or aristocratic social status by dressing in the finery associated with the elite. The dolls are just as often dressed in costly, extravagant styles as they are in gingham and their devotees often switch out their clothing as the spirit moves them.

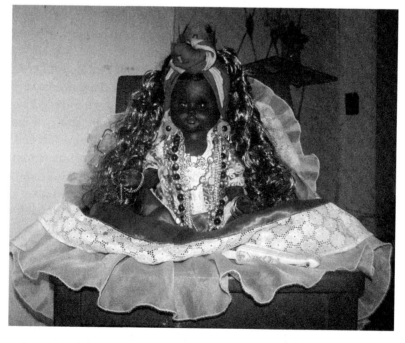

Figure 2: Mama Juana, an inherited spirit doll belonging to Marcos. Note that while Mama Juana is dressed in rich blue-and-white fabrics and wears the silver bracelets normally associated with Yemayá, her hair extensions identify her as a mulatta and she wears the crown of Ochún. This suggests the extent to which dolls and the spirits they represent are extremely diverse and very personal, reflecting the particular tastes of the devotee and the understandings they have of their spirits. *Photo by author.*

Nearly every spirit doll has a gingham dress. Gingham fabric began to be imported into Cuba in the nineteenth century, a bit earlier than the arrival of Espiritismo and large numbers of enslaved Yoruba people (D. Brown 2003, 354). Clothing made from gingham fabric is associated with stereotypical representations of enslaved people in Cuba. Significantly, it is also the fabric used for the "lunch suit," an outfit worn by initiates of Regla de Ocha during the portion of the Dia del Medio ceremony when the initiate transitions from being a newborn to a representative of the royal oricha or "bride" of the deity (ibid., 198). Moreover, gingham aprons are the official attire of the *santeras* (priestesses) when they are working as assistants to reproduce initiates in Ocha rituals. The *íremes* (spirit masquerades) or *diablitos* (little devils) of the Abakúa, which represent ancestral spirits, also wear a similar check pattern when they dance. While it is beyond the scope of this paper to engage in a deeper analysis of the fabric, it is interesting that it is often associated with liminal moments, like carnival, initiation, and representations of ancestors. Essentially, the aesthetic and actual history of the mass-produced doll and the clothing she often wears chart a temporally and culturally specific "sacred geography" – a history of enslaved Africans imported to the Caribbean (i.e., the ancestors), fabric that signifies historical and religious identity, and the meeting of various spiritual practices in Espiritismo. This brief analysis of gingham fabric reveals one of the many ways in which "the penetration of Western forms of capitalism and cultural hegemony have been – paradoxically – both subverted and promoted through syncretism" (Shaw and Stewart 1994, 21).

Immediately after I set out Francisca's clothing, Padrino instructs me to prepare the omiero for the cleansing, so we can begin. Omiero is prepared with special water, herbs, and other substances, sometimes even the blood of sacrificial animals, and is used for ritual cleansing in Ocha, Palo, and popular Espiritismo. As one of Cabrera's informants describes it, omiero consists of:

> 'water from the sky' – from rain, ollouro, – from the river and the sea...the powers of plants, the sap of herbs, are concentrated in this very sacred liquid...with which we purify and invigorate... everything is washed and sanctified with omiero: the otán, the necklaces, the shells, the relics (1975, 106).

For this Francisca, the omiero includes a secret combination of several herbs including *siempre viva* (literally, always alive) torn by hand into a mixture of tap water, riverwater, rainwater, seawater, fragrant white flowers, cascarilla, and other substances. In Wexler's account (2001, 97), Quintana elaborates on this process, stating that what is contained inside the doll is central to its function because one uses:

> ingredients that have been used throughout the years – herbs and things that to us are secret and that are used to call the spirit or Oricha. So we use those things and we add them up in a specific place to give them life; it's like a battery...something that's going to give them life.

Note that not only does the "battery" function to "call" the spirit and thus facilitate communication with historical ancestors, but the components are herbs and other ingredients that also have a temporal element: they "have been used throughout the years." Thus the internal elements of the doll function as devices that "recall" ritual procedures and more literally, ancestors and other spirit guides.

Padrino sings incantations and blows tobacco (cigar) smoke over the omiero, supervising me as I scrub the herbs together briskly, as one might wash clothes by hand, so that their essences infuse the water evenly. I begin this task, but Padrino, who has done this kind of ritual work for many years, loses his patience with my slow and clumsy novice hands and takes the bowl from me. He sits barefoot on a low bench in front of the bowl and sings songs in Bantú as he finishes making the omiero, insisting that this is how enslaved nganguleros before him conducted their rituals.

Tobacco is ubiquitous in Afro-Cuban religious work. Cigars are often smoked by participants in misas espirituales to attract the spirits. Once a spirit mounts its medium, it generally asks for *sunga* (tobacco in Bantú as spoken in Cuba). Many spirits smoke profusely while they are present, but the tobacco smoke serves a specific ritual purpose. During a *cajon*, an embodied spirit will sometimes offer their cigar to a participant and invite him or her to dance: it is a moment in which the participant revels in the presence of the spirit. More commonly, the embodied spirit will invert the cigar, placing the lit end in his or her mouth, and blow the smoke onto an individual for the purposes of healing and spiritual cleansing. Ocha practitioners use the same technique when approaching Eleggúa with offerings of tobacco, "the offering most appreciated by the masculine divinities" (Cabrera 1975, 547). In Palo funerary rites, the corpse is cleansed with omiero and tobacco smoke prior to burial (Castellanos and Castellanos 1992, 169). These modes of propitiation and spiritual cleansing in both Congo and Yoruba traditions are reenacted in the doll-making ritual.

Ortiz argues ([1947] 1995, 114–19) that among Native Americans and Africans tobacco smoke was used for healing the sick who were "fumigated with it or made to inhale it." *Behiques* (indigenous Cuban shamans) used tobacco to facilitate communication with the *cemíes* (deities) during divination and healing rituals and to induce states of trance after they conveyed the messages of the cemíes to their clients or peers. Ortiz insists that enslaved Africans learned of tobacco from whites, although there are clearly similarities between its use in Afro-Cuban religion and its historical use among the Taino. While most scholars, including Ortiz, argue that Cuba's indigenous peoples had been killed off by 1550, new ethnographic research shows that Indian-descended families were being forced from their land as late as the nineteenth century in eastern Cuba and that indigenous traditions have survived to the present day. José Barreiro (2003, 31, 34) points to the possibility that the ritual use of tobacco, while "not exclusive to the Indo-Cuban folks in the region," is just one of "many elements [that] certainly appear to have originated in indigenous culture and become diffused in the transculturation of the Cuban people." Among practitioners of Afro-Cuban religions, it is also common to feed the spirits with *ajiaco* (a traditional Taino stew) (ibid., 29). These possible cultural borrowings point to new directions for future research, but for the purposes of this paper I argue that the ceremonial use of native foods and tobacco to open the doors between the worlds is common in rites concerning the spirits of the dead in contemporary Cuba. Still these borrowings are another example of the ways in which historical memory is performed in ritual.

Performing Spiritual Power: Speaking *Aché* and Drawing *Firmas*

The songs Padrino sings are for Madre Agua. They are a method of communicating with the spirit. He explains, "I have to prepare it in omiero, say prayers and sing invocations so that the spirit will know that it is her representation." Yet the significance of these incantations goes far beyond words in all Afro-Cuban religious practices because "words are susceptible to transposition into spirit-invoking and predictive experiences" and emit spiritual power, what the Yoruba call *àse* (aché in Cuba), which "literally means 'So be it,' 'May it happen'" (Thompson 1983, 7). The notion that speech acts are potentially sacred and permit contact with the divine is not unique to the Yoruba. Correlates exist in many other faiths, including Espiritismo, Congo-derived religions, Catholicism – indeed in the Christian Bible words have tremendous agency, for the word of God is the agent of creation itself. Emile Durkheim (1995, 309) recognized the sacred and powerful nature of utterances more generally:

> Speech is another means of coming into contact with persons or things. The exhaled breath establishes contact, since it is a part of ourselves that spreads outside us...In addition to the things that are sacred, there are words and sounds that have the same quality.

Durkheim's concept of speech includes breath; among the Yoruba breath is the soul. The aché of a person verbalized and orally emitted is that which gives actualization and animation to human life. Accompanied by the oricha that rules over the devotee's head, breath makes up the spiritual aspect of the individual. According to anthropologist William Bascom (1969, 71):

> Each individual is believed to have at least two souls...The second is the breath (emi) which resides in the lungs and chest and has the nostrils to serve it like the two openings in a Yoruba blacksmith's bellows. The breath is the vital force which makes man work and gives him life.

Aché, then, can be found in and transmitted via the breath and, by extension, word and sound. The Yoruba-derived concept of aché has been adopted into non-Yoruba practices and is central to any discussion of religion in Cuba; aché has also become a common term in Cuban vernacular speech, used to convey well wishes or admiration. Cabrera (1957, 25) defines aché as the "attributes and objects that pertain to the Orichas" and also as "soul, blessing, grace, virtue" and interestingly enough, "*word*" (my emphasis). Joseph Murphy (1993:8) defines it as "the blood of cosmic life...a divine current that finds many conductors of greater or lesser receptivity." Margaret and Henry Drewal (1990:5) insist that:

> àse is absolute power and potential present in all things—rocks, hills, streams, mountains, leaves, animals, sculpture, ancestors, and gods—and in utterances—prayers, songs, curses, and even everyday speech. Utterances, as expressions of the spiritual inner self of an individual, possess àse, the power to bring things into actual existence.

Aché resonates with the power to manifest reality – indeed in certain *diloggun* divinations by Ocha initiates a client may be advised, as I once was, to be careful what they say and to speak the truth as often as possible, as any lies they verbalize could come to pass. When verbalized, as Thompson (1983:9) infers, aché is at the heart of Afro-Cuban religions, which find their center in "prophecy and predictive grace." Ritual incantation "is profound because the Yoruba conceive of their religious discourse as such. Ritual language is *jinlè* (deep) and stylized, and it possesses àse – the capacity to invoke powers, appropriate fundamental essences, and influence the future" (Apter 1992, 117). Aché in Cuba is all these things: it is generative and effective spiritual power emitted in ritual, in speech, and by every element of the natural and supernatural world. But not all people possess the same amount of aché. Padrino's breath and utterances are especially powerful given his multiple initiations and long years of practice: aché (ritual potency) is cumulative and a result of memory passed on through lineages of ritual elders. According to Margaret Drewal (1992, 27):

> Àse is the power of transformation. Humans possess this generative force and through education, initiation, and experience learn to manipulate it to enhance their own lives and the lives of those around them.... This is the real 'work' of a ritual performer; indeed, it is in essence what the act of representation is all about. There is no ritual specialist among the Yoruba who does not possess àse, the proto-concept of...the aché of Cuban Santería.

As a ritual specialist, Padrino enters into dialogue with the spirit on my behalf, since as a novice I have not yet learned how to direct my energies as effectively as he has. Verbally emitting spiritual power or "speaking" aché, he calls Mama Francisca and engages her spirit in conversation. She communicates her wishes to Padrino in a dialogic exchange that results in the creation of a charged object imbued with the spirit that has been called (or recalled) by virtue of this spoken energy.

Yoruba healing rituals provide a context for further understanding the connections between consciousness and the power of words. Herbs are used in healing rituals for a variety of physical and spiritual ailments, yet there is often a very pragmatic aspect to the verbal portion of ritual because

aché in its spoken form can activate other forms of aché. Yoruba healers utilize this relationship between various forms of cosmic power in rituals designed to prepare herbs:

> When the powers of the ingredients are not apparent in nature, the herbalist himself must reveal their hidden power. This he does usually by chanting an incantation...there is the same combined cleavage between that which is revealed and that which is hidden (Buckley 1985, 146).

Buckley maintains that incantation in the aforementioned ritual is necessary to attain a desired result; it provides the spoken component of the connection between consciousness and life force. The speech act occupies a vital space in the process of healing because the herbalist's words are themselves a means of weaving a path for the healing power of the orichas to reach the patient. Furthermore, he suggests, incantation serves as a bridge between what is medically possible, given the properties of the herbs, and the desired outcome of the ritual.

Prior to singing incantations, Padrino first drew the firmas pertaining to Madre Agua on the floor. The *nfumbe* spirits of Palo all have corresponding firmas that serve to both identify and call the spirit. Firmas are essential for all kinds of ritual work in Palo, including the mounting of *prendas* (nganga) and spirit dolls because "without the firma there is no *brujería* [witchcraft]."[21] Padrino drew the firma to begin the work; it was necessary to open the doors to the other world.[22] The firma performs an important function in ceremonies dedicated to the spirit and corresponds to the notion of the spiritual power of orality discussed above, a concept actualized in this ritual which combines action—in this case, the drawing of symbols—with incantation. In essence, these firmas in their performative context are historical memories of the Kongo ritual *yimbila ye sona* (singing and drawing [a point]), intended to provide a space in which the spiritual and material worlds come into contact with one another:

> They [the Bakongo] believe that the combined force of singing Ki-Kongo words and tracing in appropriate media the ritually designated "point" or "mark" of contact between the worlds will result in the descent of God's power upon that very point:

sikulu dya nene	a mighty noise
dyakulumukina	causing to descend
Na Nzambi a Mpungu	Lord God Almighty

> The cosmogram of Kongo emerged in the Americas precisely as *singing and drawing points of contact between the worlds*... One of the major functions of the cosmogram of Kongo, to validate a space on which to stand a person or a charm, remains in force in certain Afro-Cuban religious circles... Songs (mambos) are chanted, as in Kongo, to persuade this concentration of power upon the designated point (Thompson 1983, 110–11, emphasis in original).

As Thompson points out, the original function of *yimbila ye sona* was retained in Afro-Cuban spiritual practices. By drawing the firmas and singing, Padrino was creating a sacred space – indeed performing it into existence – but also calling Madre Agua to inhabit the space and enticing her to empower this spiritual "charm," my Mama Francisca.

This tradition of "drawing and singing the point" is also incorporated into homages to one's spirit guide(s) as practiced in contemporary Cuban Espiritismo. In this context the firma is drawn before special occasions, like a cajon para los muertos, specifically conducted as homage to the spirit, but also with the goal of cleansing and healing the community. These ceremonies, which always include prayer and song, are performed to invoke the presence of and initiate a conversation with a deceased ancestor or protector spirit. In this case the firma serves a second function as a

protective device. When musicians arrive at a practitioner's home to play a cajon, a firma, often in the form of a semicircle with nine rays radiating from its curving line, is drawn in chalk around a glass of water which is placed behind the musicians to protect them from potentially harmful spiritual influences. Because they are calling the spirits to heal the community, the musicians are always exposed to the negative energies that are washed away during such celebrations. The water attracts these forces and the firma traps them there until the glass is removed at the end of the ceremony and the water is thrown in the street.[23]

In the case of doll making, the spirit must be asked if it requires a firma. An ngangulero birthing a doll at the foot of his own prenda performs divination with the *chamalongo* (shells) used to communicate with the spirits of an nganga, as Padrino did for Francisca. My doll will be born from his material doll for Madre Agua (see Figure 11–3), not from the prenda (nganga) itself and is thus a spiritual doll based on material elements minus earth and the bone of the dead. Still, spirits who in the past were practitioners of Congo-derived religions will often require a firma, regardless of whether or not the doll itself is material. If a client's guardian spirit was the owner of an nganga in life, that person might also obtain what Padrino refers to as a spiritual prenda, which is essentially an nganga that allows the devotee to perform some limited spiritual work involving Palo healing practices without actually being *rayado* (cut) in the Palo initiation ceremony. This last statement is an extremely significant point that deserves elaboration.

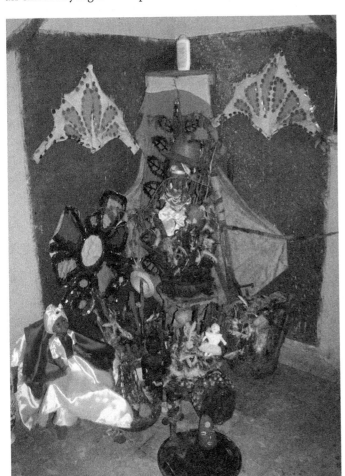

Figure 3. Padrino's nganga. At center is his Sarabanda, front center is Eleggúa, atop the painted tray and to the right of the cross. At far left is Madre Agua, the spiritual parent of my Mama Francisca. At far right, although not visible, is Padrino's spiritual boveda.
Photo by author.

Xiomara's practices provide a good example of Padrino's distinction between the material and spiritual and are worth a short digression. Although she is not initiated into Ocha or Palo, she utilizes symbols, philosophies, and rituals associated with both religions. For instance, she takes it upon herself to sacrifice animals to the orichas by propitiating their "spiritual side" using Catholic statues or spirit dolls. For orthodox practitioners, the sacrifice of an animal requires that an individual be initiated into Ocha and undergo another ceremony in which he or she receives the *pinaldo* (knife) (D. Brown 2003, 333). Xiomara explains the function of her Congo spirits in her practice: "My spirits were paleros, but me, no...I like to work spiritually...I am not a palera, but I can work with sticks and nganga, the spirit shows me how." Spirit mediums, in other words, can utilize the healing, herbs, and magical practices of Palo without enduring the social stigma that sometimes accompanies the visible cuts of initiation. Xiomara's philosophy emphasizes both her natural ability to communicate with the spirits who guide her in these actions and her economic inability to become initiated.[24] Her unorthodox practices are one example of the extent to which popular Espiritismo incorporates elements of African-derived practices. Her use of dolls and the way she conceptualizes her spirits further illustrate how these spiritual practices sometimes provide access to "material" practices that have historically been shunned as witchcraft and as *cosa de negros* (a black thing), allowing the uninitiated to trespass, so to speak, on terrain often seen as the work of specific kinds of priests/priestesses. While Rafael might take issue with Xiomara's acts of sacrifice, her notion of the "spiritual side" of the orichas and her "spiritual" use of Palo techniques is nonetheless revealing of the distinction he makes between the spiritual and the material.

After Eleggúa has been propitiated, the firmas drawn, and the omiero prepared, it is time to strip Mama Francisca of her old clothing and former self, a process common in both Palo and Ocha initiation rites. Padrino tells me to ritually bathe her in the sacred liquid as I meditate on the purpose of this action, reciting personal prayers that inform the spirit of the desires and intentions that underlie the preparation of the doll. Once this is accomplished he sits Francisca down in front of his Madre Agua doll on a wooden disc, similar in size and appearance to the divining tray of a *babalao* [high priest], onto which a firma for Padrino's muerto has been permanently emblazoned. His is a mulatta doll, dressed in fine blue-and-white satin with a skirt of seven colors (a reference to her other name, Siete Sallas), her head topped with a straw hat that is unraveling around the edges, betraying both its age and her true purpose – to work hard for my Padrino. Her eyes are big, connoting vigilance and alertness.

The eyes are an important feature of the doll that must not be overlooked. Spirit dolls, unlike ngangas or the *soperas* of the orichas, generally occupy the public areas of the home and thus function as protective "observers." Azucena, a Cuban espiritista and priestess of Ochún, explains that "Santos [orichas] – because they represent your head – are kept in the back [room of the house]. She [Francisca] is my spirit, she stays out here [in the living room]. *She likes to be vigilant, to watch and to be seen.*"[25] The gaze of the spirit doll is critical – for Azucena, it is protective. Devotees who attend the procession for the Virgin of Regla bring their spirit dolls to "witness" the event; others bring them to "see" the ocean and behold the aché of Yemayá. Espiritistas reason that by performing these visual acts, the spirit gains strength and effectiveness by virtue of her connection with the ocean, Yemayá, and the Virgin of Regla. Celia, an espiritista and priestess of Yemayá from Santiago de Cuba, takes her Conga, Tomasa Siete Sallas, to Regla "because it makes her stronger."[26] The sea, in turn, gets its ritual charge from the spirits who reside there. It is a repository of ancestral memory.

While the doll is many things – a representation, a container, an nkisi, an *agbona* (see discussion about this term below) – it is also akin to an idol, at least from an etymological perspective. The terms "image" and "idol" come from the Greek *eîdos* (*weid-es*) meaning shape or form (Flexner 1987, 951). More important, these terms, as well as "wisdom" and "guide," are derived from the common Indo-European root *weid* meaning "to see," a reflection of the true function of the spirit. They are also related to the participle form *weid-to*, from which "voyeur," "vision," and "clairvoyant" are derived (Pickett 2000). While the primary purpose of making a spirit doll is to establish a relationship between a person and their spirit by giving the entity a shape or form, it is also an important step in the overall spiritual *desarrollo* of the individual. This lifelong process begins with a spiritual awakening of sorts (that is, beginning to "see" in a new way) and continues with the development of one's own gifts of (in)sight, (fore)knowledge, and otherworldly vision. Under the watchful eyes of Madre Agua, I begin to fill Mama Francisca's body cavity with care and intention as Padrino recounts the making of his own doll.

Francisca, particularly because she is a spirit associated with the sea, is filled with ocean water and other objects associated with the ocean, such as shells and powdered smoked fish. "All of the things we put in there are so that the doll [spirit] takes ahold of the positive energies of those things," Padrino explains. His explanation reflects the basic rationale behind many Palo practices (e.g., Barnet [2001] 2006, 93). Sacred stones, seeds, shells, and other secret substances are also added, some of them in sets of seven, the number associated with Yemayá.

Cowrie shells are one of the many ingredients used to charge various spirit-imbued containers, among them spirit dolls and the orichas. Their maritime origins recall the Middle Passage and connect them to ancestral African spirits who converge in watery domains (Cabrera and Hiriart 1980, Jacobson-Widding 1979, Shaw 2002). Espiritistas sometimes tell their clients' futures with tarot cards, often using a syncretized system that corresponds numerically to the diloggun (cowrie shell) divination of the Regla de Ocha. The diloggun, in turn, is an adaptation of Ifá divination practices, which some scholars believe have their origins in thirteenth-century Muslim foretelling techniques (Shaw 2002, 85). And the cowries themselves are multireferential objects of memory: they became the currency of the slave trade after Europeans brought them to West Africa from the Indian Ocean (ibid., 43). Cowrie shells are just one of the multilayered sites of memory embedded within the spirit doll.

The *piedra de iman* (magnet) is another of these sacred memory-infused ingredients. For Rafael, all of these elements, their spiritual forces, and the sacred acts that accompany them follow an obvious system of logic. He tries to teach me this logic by inviting me to answer my own questions. For example, when I ask him why he uses a magnet in the doll, he looks at me as if I should know and responds with a question: "What are magnets used for?" I remain silent, wanting to hear his interpretation before giving my own. I explain to him that as both an ethnographer and a novice my answers are not as important as his. "To attract things!" he exclaims, a bit frustrated by my reluctance. He explains that this stone has a long and significant history for the descendants of enslaved peoples in Cuba. For practitioners of Afro-Cuban religions, the magnet holds tremendous potentiality, and, once prepared, contains a spirit all its own. It is an essential component in the preparation of Palo prendas and Lucumí orichas. The stone itself is also used as a protective amulet and can be prepared in a variety of ways for both beneficent and morally ambiguous ends; if properly propitiated "its virtue is so great that with its protection one can achieve all that one wants" (Cabrera 1975, 139–141). Citing biblical references to the origins of the stone, an informant

of Cabrera's states that "it is not an African stone. It came to the earth when Jesus was born, so that all of us, black and white, would adore it and use it to attract luck" (ibid.). We include this stone among the many elements of Mama Francisca's constitution to bring me, as Padrino says, "*todas las cosas buenas de la vida*" (all of the good things in life) and, by extension, to attract the spirit with its magnetism.

Next Padrino prepares a vial of mercury, which he fills with omiero and seals with wax. He shakes up the vial to make sure the life elements are combined with the mercury that, he explains, gives her a heart and thus life. Then he secures the tiny vial inside her while I preoccupy myself with more secular concerns, like whether or not the mercury will set off metal detectors or create a situation when I take her through post-9/11 U.S. customs (I will return to the significance of mercury later). After that padrino chooses specific types and quantities of sticks, feathers, and other elements from his prenda to add to Mama Francisca's unique composition.[27] One of the feathers he adds is from a turkey vulture, a bird sacred in both Ocha and Palo mythology and belief. Padrino explains that "the turkey vulture is always flying. It is the bird that flies most, it is the messenger of Olofi. You use it so that all of your [ritual] works will go as high as possible." As he prepares these sacred ingredients, he takes the opportunity to recount sacred stories brought to the island by enslaved Africans and handed down to him by his own ritual ancestors, explaining the role they play in the structure of this ritual. The feathers of the bird, he says, ensure that any pleas I make at the foot of my doll will be heard, and the work that my spirit (and my padrino) does on my behalf will be successful. Finally, he hands me a rather blunt, rusty knife and instructs me to cut off a sliver of each of the sticks from his prenda. Once all of the sticks are prepared, they are added to the rest of the ingredients, topped off by several feathers inserted upright into Francisca's body cavity. His prenda, or at least the natural elements within it, is literally reconstructed in the body of my doll.

Ritual Logics: Yoruba and Congo Philosophies in Miniature

I have already discussed the significance of water in European and African-derived beliefs, but I return to it briefly here. Aside from the omiero in which Francisca was "baptized," ocean water was placed inside the doll: her very heart floats in a vial of the omiero. Obviously, water ties Mama Francisca to the ocean. She is a spirit of the sea not only by virtue of the Congo belief in "good" ancestors that reside beneath the water, but also because of her correlation with Madre Agua and Yemayá. Water shares the reflective properties of other substances, namely mercury. It also "gives life" to the object, just as water and Yemayá – as a mother goddess – are life-bringers. Additionally, it serves as a mirror of sorts, one that moves, constantly shifting like the ocean. Each of these qualities facilitates vision by virtue of their reflective nature; like mirrors, they can be associated with revelation and prophecy (Thompson 1983, 125). Ultimately the reflective nature of these elements contained by the doll encourage the practitioner to reflect on himself or herself and actively incorporate the positive aspects of Francisca's "personality" traits into his or her life, thus assimilating the wisdom of ritual ancestors and spiritual elders. In this way the practitioner hopes to develop vision and self-reflexive tendencies that will make them a better, more spiritually evolved person.

The use of mercury and other elements with which we prepared Mama Francisca are grounded primarily in Congo-derived philosophies that merit discussion. However, it may also be worth mentioning that mercury has long been thought to possess healing and magical properties, was at the heart of European alchemy from the time of the Roman Empire, and was later used as a cure

for various illnesses in Europe and the Americas. For nganguleros mercury has another set of meanings and applications entirely. An nkisi-maker and informant of Cabrera (1975, 123) explains the logic behind the construction of his own prenda as follows:

> one places to the side a piece of sugarcane filled with seawater, sand and mercury, stoppered with wax, so that the nkisi will always have life, like the flow of quicksilver, so that it will be swift and moving, like the waters of the ocean, so that the spirit in the charm can merge with the sea and travel far away...[with] sticks...and leaves and herbs also added.

The idea here is that the spirit of the prenda – and of Mama Francisca – will be more effective if imbued with the forces of nature, and quicker to arrive if it contains fast-moving elements. Cabrera (1979, 145) argues that mercury is used in Palo "amulets" because of its "extraordinary vitality... because of its mobility, [the ngangulero says] it acts in ngangas as a heart that continuously beats." Clearly the items with which the doll is constructed and adorned correspond to the functions the spirit is expected to serve. Mercury combined with water from the ocean gives Mama Francisca life and movement, the facility to travel, and a heart made from the very heart of the planet – mercury from its bowels and water from the mysterious depths of the ocean, the source of calm, serenity, and stability in Lucumí theology (i.e. Olokún).

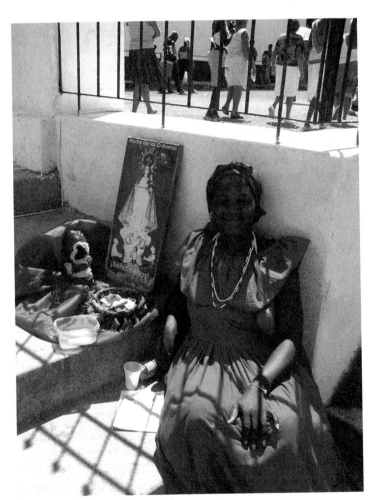

Figure 4. Virgin of Regla devotee with her spirit doll asking for alms outside the Church at Regla on procession day. Note the container of water at the foot of the doll, suggesting the importance of water even in a portable altar, and the way in which the woman's attire mirrors that of her spirit guide, alluding to an intimate connection between spirit and practitioner.
Photo by author.

In addition, Mama Francisca contains feathers, slid in upright to connect the lower stratum of the body with the head. Possibly these share with mercury the function of swiftness or the "flight" of the spirit from the other world to the body of the doll. In Congo belief systems, however, they "connote ceaseless growth as well as plenitude. So if the earth within the charm affirms the presence of a spirit from the dead – from the underworld – the feathers capping the charm suggest connection with the upper half of the Kongo cosmogram, which represents the world of the living, and the empyrean habitat of God" (Thompson 1983, 121). Establishing a connection between the world of the living and the world of the dead is a primary concern of the doll maker. This means facilitating communication, often by means of sympathetic magic. Ngangas often contain a human skull, that is, the part of the body associated with speech. The Osain of the Lucumí similarly contains human teeth "so it will speak" (Cabrera 1975, 103). Some dolls, even if they are spiritual and do not contain human remains, are prepared with similar components of animals, that is, those associated with speech. The idea here is that the spirit must speak, and therefore must be provided the means by which she can have a voice in this world. Herein lies a conceptual tie between the doll and the act of possession which is at the very heart of Palo, Ocha, and Espiritismo practices because it is the means by which the spirits communicate with their congregation.

Finally, the doll, like an nganga, is not only a representation, but a small-scale universe. Much like myth is a condensation in narrative form that allows us to grasp the world, the doll is an anthropomorphic container for a condensed version of the world and all of its elements as Cabrera (cited in Thompson 1983, 123) observes in the case of the prenda:

> The prenda is like the entire world in miniature, a means of domination. The ritual expert places in the kettle all manner of spiritualizing forces: there he keeps the cemetery and the forest, there he keeps the river and the sea, the lightning-bolt, the whirlwind, the sun, the moon, the stars – forces in concentration.

The creative principle in the making of the doll is very similar: she is the container for forces from the earth and the sea; from animals, fish, shells, stones, and minerals; from human remains or the hair of the living; from feathers, blood, bone, cascarilla, honey, omiero, fresh and ocean water, herbs, prayers, song, and incantation. The prenda and the doll are internally structured in the same way; dolls, much like ngangas and *paquets congo* (discussed below) can be "interpreted cosmogrammatically" (Thompson 1983, 127). One important distinction, as espiritista Celia points out, is that the doll is like a *façade* (front) that hides these concentrated and intense powers away from prying eyes, while the nganga is a bit more conspicuous. It is also critical to acknowledge that the similarities between Francisca's inner makeup and that of an nganga have a practical reason. Her maker has practiced Palo Monte longer than either Ocha or Espiritismo, so in many ways it constitutes his strongest foundation, for Francisca is the spiritual "daughter" of his own material doll representing Madre Agua. The contents of spirit dolls vary widely depending on the practitioner and the tradition(s) to which they pertain. While "Francisca (Siete Sallas)" refers to a specific type of spirit that is rather ubiquitous, each spirit doll that represents her has its own unique composition much like each spirit has a secret name known only to the devotee, and certainly not every "Francisca" shares a relationship with a Palo spirit.

"You can't put any of that [rum] in there," my padrino, motioning to Francisca's head, said after we had finished filling the doll's body cavity with numerous objects. "What do you use your head for? To think! The head must be cool, so that your head is always cool and so your spirit guide is cool-headed also." What that means, he explained to me, is that nothing "hot"– rum, stones, blood, bones, feathers, or other remnants of once-living creatures – can go in the doll's head. Only items

categorized as "cool" – cascarilla, perfume, holy water, prayers, incantations written on paper, and so on – belong in that part. If a doll is fed with a blood sacrifice before being handed over to the client, then the head is put on afterwards so that it is not exposed to this "hot" aspect of the ceremony.

This theology of spiritual "temperature" suggests a particular logic. It indicates that Mama Francisca is governed by both Yoruba concepts of coolness and by the kind of ritual logic expressed in the making of Congo-derived *paquets congo*, small packages that provide protection and guard against illness and evil spirits. According to Thompson paquets congo are "capable of exciting and heating up the deities in favor of their owners. Deprived of such "points," the deities lose their force" (1983, 127). Heat, then, is what motivates spirits to work for their earthly charges, while coolness tempers the spirits' sometimes unpredictable personalities.

The dolls, as I have already argued, serve a similar protective function for their owners. As my padrino explains to me, while dolls are not necessary, they provide a focal point for offerings and are a payment of gratitude to the spirit, a plea for its assistance, and a material marker of an ephemeral emotion: "It's so the spirit *sees* what one is feeling for him," he says. They, like paquets congo and *pwen* (points), are a locus of communicative potentiality and a means of enticing the spirit to protect and work for the benefit of their owner. Aesthetically, paquets congo resemble dolls in that they have a "head." The creole versions of paquets congo are also governed by the logic of "cool-headedness" (Thompson 1983). In these, a crucifix is implanted in the base of the paquet congo to form its top or "head." Similarly, Francisca's head contains holy water and Catholic and Spiritist prayers written on paper, but has her foundation firmly rooted in African-derived philosophies. She contains the text inside her, maintaining it in secrecy where the power of its words are unknown, silent, but pregnant with potential and aché. In some ways this structure mimics the present day initiatory procedures of practitioners who chose to work both Palo and Ocha. The body may be marked with firmas, cut for bloodletting that connects Palo initiates with their "hot" (read: potentially malevolent and unpredictable) guardians, but the head, the semidivine part of the human body, belongs to "cool" practices associated with what have been traditionally viewed as less morally ambiguous forms of spiritual labor (i.e. Ocha).[28]

From a Yoruba perspective, *itutu* (coolness) is a mystical principle having to do with morality and tranquility. As Thompson's (1983, 13) Yoruba informants stated, "Coolness or gentleness of character is so important in our lives. Coolness is the correct way you represent yourself to a human being." Moreover, it also has aesthetic implications for religious art:

> to tame or pacify is to "cool the face" (tu l'oju). Thus, providing the non-figurative symbol of an orisha with sculptured face facilitates the pacification of that orisha, for what has a face is controllable (Lawal 1976, cited in Thompson 1983, 2).

This conceptual framework is central to understanding why these dolls are created in the first place. By giving the spirit a (doll) face – that is, by giving the spirit a means of expression and identification through recognizable human features—the practitioner gains some power over the spirit. In preparing the doll's head, Padrino clearly demonstrates how the spirit shares an affective relationship with both the doll and the practitioner. Logically, then, by making and attending to a doll, one must also be able to gain control over both the spirit and some aspect of his or her own life, for "the making and existence of the artifact that portrays something gives one power over that which is portrayed" (Taussig 1993, 13). In my case, the doll was recommended to establish a relationship with my spirit guide and ultimately to achieve spiritual balance in my life. Ysamur Flores-Peña, a priest and scholar of Lucumí religion, and co-author Roberta J. Evanchuk (1994,

25) further define coolness as "keeping balance in all things." From their perspective, coolness is as much a theory of aesthetics as it is a concept to live by: "Its achievement in worship and in life becomes our aim...an altar that does not achieve tension as well as a calm nobility is not 'cool' or effective." The doll is governed by these concepts in her dress, accoutrements, ingredients, and in the purposeful nature of her construction. Padrino insists that I not only understand these concepts handed down to him by his ritual godparents and reenacted for me in this ceremony, but also that I remember them always and apply them to my own life.

"Coolness" as an ideal is linked to the Yoruba concept of the head as paramount to human and spiritual existence. As Padrino implies and Thompson (1983, 11) explains, a "good head" suggests a "good character" as well. Many rites and rituals in Lucumí religion focus on the head with the ultimate goal of calming and spiritually cooling an individual. Probably the most common of such rituals is the *rogación de cabeza* (purification of the head), during which the person's head is covered with "cooling" agents like coconut and cotton and wrapped in a clean white cloth overnight. This ritual is believed to be periodically necessary for most people, preventive medicine for the mind and "cool" food for the hot-headed. The rogación encourages spiritual tranquility and quiets the client's mind so they can think clearly and make good decisions.

In Cuba's Lucumí religion, each person's *ori* (head) is owned by an oricha who assumes responsibility for or "defends" the devotee. A new initiate of the religion is "crowned" in the kariocha ceremony, during which the oricha's herbal and spiritual essence is inserted into an incision in the head. After this rite, the deity is said to be "seated" in the head of the priest or priestess (this ceremony is also referred to as the *asiento* [seat]). When the oricha descends to visit the community by "mounting" or possessing the initiate, the process often begins with an itching sensation at the crown of the head. It is no coincidence that the ori is the only spirit that travels with an individual to the next world.[29] Bascom (1969, 71) elaborates on this idea, explaining that in Yoruba thought, "each individual is believed to have at least two souls. The most important is the *eleda or iponri* (ancestral guardian soul), which is associated with his head, his destiny, and with the belief in reincarnation." Thus the ori is the primary element of stability and permanence in the liminal spaces between worlds, an aspect of the human soul through which spiritual continuity is expressed. Therefore, a doll that represents an individual's primary spirit guide – a parallel, perhaps, to the ancestral guardian soul – serves the dual function of memorializing the spirit and embodying a spiritual ideal (e.g., good character or coolness) for which the devotee should strive. The doll, the spirit, and the ori of the practitioner are inextricably linked, so it is crucial that the head of the doll contain elements associated with coolness. From this perspective, the doll might also be considered a kind of shrine to the ori. In this sense, Mama Francisca embodies or memorializes a particular Yoruba ethos. At the same time, the structural similarity to paquets congo belies her connection to Congo-derived religious practices in the New World.

Containing the Spirit: Representing the Dead in Other Hybrid Traditions

My padrino's method is not the only way to make a spirit doll. There is no Bible or instruction book for constructing a spirit doll. This particular account is significant, however, because it illustrates the mixing of philosophical and religious concepts from a range of African and European historicocultural sources and how these new synergies combine in the process of making an object that is both tangible and ephemeral. My Mama Francisca is a product of a spiritual philosophy that scholars and some orthodox practitioners call cruzado, as mentioned earlier; more specifically,

she is a product of one practitioner's distinctive way of incorporating the belief systems in which he has been raised in the making of a spirit object. The doll making process is one of the rituals in which he constructs an image of historical memory as well as a salient symbol of the present. The beauty of the spirit doll is precisely that she contains layers of contemporary and historical ritual knowledge, which allows us to witness contemporary creolization on the ground and modern recombinations in the making. Essentially, in these religious practices, art cannot be disconnected from the action and creative forces from which it is born—it is, and cannot be anything but, historical consciousness and ritual "knowledge in action" (Nooter 1993, 33).

Popular Espiritismo has not enjoyed the same kind of scholarly attention as other, presumably more "African," Cuban religious practices. Contemporary ethnographies in English are especially absent from the available literature, although these spiritual practices have been addressed by several Cuban scholars (e.g., Castellanos and Castellanos 1992, Millet 1993, Castañeda Mache and Hodge Limonta 1997, Hodge Limonta and Rodríguez Delgado 2003). Still less attention has been paid to spirit dolls as an element of Espiritismo. Cabrera documents Palo practices that involve the transference of witchcraft-inflicted illnesses from a patient to a ritually prepared cloth doll (Fernández Olmos 2001, 37–38). The doll essentially "switches lives" with the patient. In Ocha practices there is a similar ritual that is intended to "confuse Ikú [death]...so that 'the appetite becomes heavy and she forgets whom she was coming for'" (ibid., 40). In this case, dolls are used to heal patients facing potentially life-threatening illnesses. In another example, Cabrera publishes photographs of chichirekú (wooden dolls representing the orichas) in her seminal work *El Monte* (1975), in which she details the preparation of a doll containing the oricha Osain, the divine herbalist. She explains that various kinds of plant and animal matter and human remains, including parts of the body that correspond to sight and speech, are inserted into the doll to infuse it with natural and spiritual forces (ibid., 103). Cabrera's work is significant to this study for two reasons. First, her short description of the Osain doll details the method and logic that underlies the doll-making process in Ocha practices, which roughly parallel those discussed above. Second, her work on healing rituals sheds light on the intimate connection between the doll, the dead, and the client, complicating the subject-object relationship in much the same way as do spirit guides and spirit dolls.

On the other hand, Ana Wexler (2001) writes about spirit dolls as representations of ancestors or spirit guides in Espiritismo. Her interview with Ocha priest and espiritista Steve Quintana reveals the importance of dolls as indicators of respect for the dead and as focal points for attending to the spirits with offerings of food, water, flowers, and coffee (ibid., 92–93). She distinguishes between "the dolls for deceased family members and other spirit guides" and "those that represent the major deities of Santería," although she acknowledges that "both kinds of dolls may be used if a given priest or santero/santera also incorporates spiritualism into his or her religious practice" (ibid.:90). While Wexler is correct in differentiating between different kinds of dolls, the fact that dolls often represent former initiates is key, since the orichas themselves are aggregate beings, "part ancestor, part Big Man or cultural hero, and part nature spirit" (Apter 1992, 152). This suggests that the spirits represented by dolls share a close relationship with, perhaps even form a part of, the oricha. For espiritistas, this relationship between spirit and oricha is often summed up by the concept of trascendencia, which blurs the boundaries between entities and thus bridges practices derisively described as "crossed" by those who idealize them as completely distinct categories.

Art historian Judith Bettelheim, referring to Wexler's statement, argues that "it is precisely such a cruzado practice that produces beliefs and altar iconography incorporating Indian spirit

guides and Indian imagery," which allows for the conflation of powerful spiritual forces like the Indian and the Congo on the Espiritismo altars she studies (2005, 314). To be certain, dolls, like other elements of Espiritismo iconography and practice, "correspond with an ideology, a faith, or a personally developed belief system already in place" and are thus based on other older religious practices (ibid., 313). I agree with Bettelheim's analysis that the process of creolization has deeply impacted the concept and material expressions of spiritual "others" in popular or cruzado forms of Afro-Caribbean religions. While this is a central argument in this chapter, I wish to take this a step further by suggesting that the internal composition of the doll and the method of her preparation invites similar conclusions. This is why I narrate the *process* of making a spirit doll in an effort to explore the ways in which ritual knowledge from Ocha and Palo – and thus historical memories of Africa congealed in ritual practices – is implemented into the logic of doll making. Yet, because some of these practices are not unique to New World Yoruba- and Congo-derived religions, it is necessary to discuss possible correlates of spirit dolls in European, African, and other creole cultures to acknowledge several beliefs that may have contributed to, or at least mirror, their complex function.

Although it shares commonalities with other spirit containers, the spirit doll is a distinctly "creole invention" (to borrow David Brown's terminology): this is the key to understanding the importance of dolls as religious objects in the New World. The plastic, mass-produced doll used to make these spirit containers did not initially hold the same religious "charge" as the image of a Catholic saint or the Kongo nganga or nkisi object or the *otan* (stones that embody the orichas) of the Yoruba orichas.[30] It was essentially an object devoid of any clear spiritual or religious meaning, a body onto which spiritual values could be inscribed, and thus an opportunity for the construction of a distinctly Afro-Cuban image of the divine. Significantly, these dolls became widely available in the colonies at a rather auspicious moment, particularly in Cuba where, especially in the nineteenth century, diverse religious practices were being constituted as new and meaningful wholes via the choices of conscious social actors (see D. Brown 2003). The dolls can thus be said to chronicle religious innovations – for instance, the incorporation of "the extremely syncretic rite called misa espiritual as a preamble of the Asiento [Ocha initiation ceremony]" (Castellanos 1996, 48). The fusion of Ocha and Espiritismo practices likely occurred in the late nineteenth century, about the same time that increasing numbers of enslaved Yoruba people were being brought to the Caribbean. This shift in the ethnic demography of the enslaved population in the New World began to have an impact on the religious topography of Cuba, particularly the western part of the island, "marking the increasing displacement of older – ethnographically unknown – Afro-Cuban religious cultures" (Palmié 2001:192). The kind of dolls now widely used as spirit dolls resemble the mass-produced German variety that began to circulate throughout Europe in the nineteenth century. According to Fawcett (1964, 7, 58), "innovation in manufacture made fancy dolls, previously owned only by royalty and the wealthy, available to the rising [European] middle class." While the mass-production of the dolls democratized the European market (and most likely the market in the colonies as well), it may have had an even greater impact on religious culture in Cuba and on the ways in which practitioners were able to visualize or imagine spirits and ancestors in their own image. The doll is the creation of industrial Europe on the outside, but inside contains elements that recall African religious practices; the mass-produced shell was resignified as a spirit object.

Some Ocha priests refer to spirit dolls as *agbona*.[31] Although the term "agbona" does not appear in Yoruba dictionaries, words that appear to be related are suggestive. The word "*àgbo*", which is defined as "medicine brewed from leaves and barks of trees" (Fakinlede 2003, 483), echoes the

palos, or various sticks and branches of trees, that are a key component of spirit dolls. The word "*agbòn*" can be translated as "vibrating (object)," "wavelength," or "basket" (ibid., 484). Vibration is akin to the Cuban term "*corriente,*" which is used in Espiritismo to describe the "current" of energy that signals the presence of the spirit. "Wavelength" (at least in English vernacular) conveys the kind of mutual understanding a person shares with their spirit guide; a "basket" is, among other things, a container, which is precisely what these dolls are: containers for personal spirit guides.

Spirit dolls also bear a strong resemblance to Yoruba *ibeji* (twins) statues. The ibeji share the function of the dolls as earthly residences for deceased spirits and generally receive similar kinds of ritual "activation" and attention (Cameron 1996, 32, 68–70). The ibeji are rubbed and adorned for empowerment; this is a call to the spirit memorialized in the statue. Similarly, dolls are ritually bathed, prepared, and dressed, and this ritual process occurs with the intention of establishing communication with the spirit. Although the ibeji in Cuba are no longer represented by figures carved from wood, their New World counterparts, the twin oricha children of Yemayá and Changó, reside in the same mass-produced plastic dolls from which contemporary spirit dolls are made. The records of Rafael Roche y Monteagudo (1908, 81), a detective devoted to seeking out and punishing "witches" in early twentieth-century Cuba, indicate that the ibeji were represented in doll form as early as 1906 and contained "human remains, horns, earth, roots, stones, and all sorts of filth soaked in blood." The contents of these ibeji dolls, which were subsequently confiscated by Roche, as recorded a century ago, mirror those of the spirit doll I prepared with my padrino.

The preparation of these early twentieth-century ibeji dolls also suggests a parallel with the contents of Palo spirit containers like nganga or other nkisi objects, which I discussed above in greater detail. While nganga in the Lower Kongo region refers to a priest or owner of an nkisi, the word "nkisi" usually "refers to a certain object, into which an nkisi spirit (or rather a reflexion of an nkisi spirit) has been incorporated" (Jacobson-Widding 1979, 135). These objects contain "medicinal herbs and leaves, seeds and kernels...stones, feathers, claws, teeth, hair, etc." (ibid.:140). In Cuba, nganga and nkisi both refer to a receptacle into which the spirit is placed and are made with similar components. As Cabrera (1979, 127) notes, these spirits can live in almost any kind of vessel including *kini-kini* (statues) or dolls that resemble the wooden chicherekú used in Ocha practices. Sometimes these spirit containers are constructed using contents from the nganga of the initiating priest. Because an nganga or nkisi object is made with animal and plant matter, minerals, stones, and human remains, it represents a microcosm "in [which] are the condensed forces and spirits of all the kingdoms of nature" (ibid.). Because these sacred objects are constructed from the nganga of elders, they are "microcosms" that condense historical memory expressed through modes of ritual production handed down through the generations.

While spirit dolls certainly share many commonalities with the aforementioned objects, there are still other noteworthy correlates. According to Susan Blier (1998, 218), the Bwende of northern Kongo enshrined the remains of important people in funerary mannequins called *niombo,* which were capable of interacting with the living, sometimes to reveal something about how the person died. Essentially, the niombo are mummified corpses (Jacobson-Widding 1979, 170) and thus share few similarities with Cuban spirit dolls. They are analogous in the sense that the spirits contained in spirit dolls are similarly active: they communicate with, and are capable of, affecting the world of the living. Their biographies inevitably contain the details of their earthly demise.

The Baule of Côte d'Ivoire have a doll-making tradition that is strikingly similar to that of Afro-Cuban vernacular artists:

one or a pair of asie usu will establish a connection with a living person, giving him or her the ability to be a possession diviner. When this happens, a figure is carved to honor the asie usu and receive sacrifices for them...the spirit is perceived as an active person who volitionally initiates contact with a specific human being and demands recognition in a formal relationship... They [the Baule] insisted on the fundamental personhood of the figure (Cameron 1994, 35).

In Cuba, a spirit guide makes itself known to the devotee through dreams, misas espirituales, or divination. Often the spirit demands to be represented in a doll, as was the case for me, and the practitioner will subsequently attend to the spirit (doll) with offerings of candles, perfume, food, water, and other more compelling libations (rum, *aguardiente*, champagne, or sweet wine, depending on the spirit). The devotee develops his or her spiritual faculties and vision, which often include the ability to become possessed by the spirit and to see into the future, by establishing and maintaining a relationship with the spirit in the doll. The doll, while it is not considered a person, has a name and is treated and attended to as a living being complete with its own space, such as a chair or altar always reserved specifically for it.

The use of dolls in ritual and religious art in other parts of the Caribbean warrants mention as well. As Cosentino (1998, 15) argues concerning dolls used in Haitian vodou art, they are akin to action figures in the sense that they do work. Both the Haitian and the Cuban variety can effect change in the real world; both can serve as messengers between worlds. For artist-sculptor Pierrot Barra, his doll-encrusted "vodou things" protect their owners (ibid.:23), much like Afro-Cuban dolls provide protection and vigilance over the home once they have been properly prepared with the essence of the spirit. Dolls in both traditions undergo what amounts to a "divine makeover" that prepares them for the supernatural work they will be expected to perform (ibid., 17). This ensures that the doll will not be "just" a doll, but an extraordinary spirit object. As Haitian vodou priest Georges René explains:

> anything can do mystique if you believe in it...you have to turn it into mystic. You baptize it. You make a ceremony. You put the food the lwa [spirit] eats...after that you can work with it. It gets a soul. You can put it on an altar (ibid., 21).

Cuban altars often contain such soul-filled spiritual dolls, items representing the orichas and statues depicting the Catholic saints. These anthropomorphic figures and their corresponding entities, as discussed above, are all fundamentally related. And these altars "are made up of individual parts relating to multiple worlds, each part having its own life and history" (Cameron 1996, 38). Together, these "individual parts," along with their corresponding meanings and values, quite literally map an entire universe of supernatural and human relationships. On the altar, the doll is much like the tiny foot peeking out from the funky bricolage of one of Pierrot Barra's Haitian "vodou things." It is a pwen (a point of spiritual concentration) whose striking aesthetic attracts the attention of both earthly and supernatural beings (Cosentino 1998). As Flores-Peña and Evanchuk (1994, 31) observe about thrones and altars built to honor the orichas, dolls serve a communicative function. They convey a particular aesthetic and tell a story using key symbols. The fabrics and elements used in their construction allow the artist to tell stories about the spirits and/or the orichas from their own perspective, interjecting their personal theology and devotion (ibid., 16–17). Similarly, the personal touches employed in the preparation of the doll and the altar on which it resides allow each practitioner to represent their spirit guide faithfully, utilizing their creative inclinations to construct meaningful narratives through key symbols. Key symbols, and the spirit dolls that form a cluster of these summarizing symbols, are alternative, nonverbal modes of discussing and representing the past, and thus depend on historical memory.

Spirit dolls and the altars on which they reside are fundamentally related to Iberian folk Catholic traditions as well. In medieval Spain, shrines were the Grand Central Station of the spirit world; they were the divine horizon connecting the earthly and heavenly domains (Hamilton 1986, 129). Although European shrines may not necessarily have contained dolls, the making of idols for spiritual and magical purposes may have been an element of popular religion at the time. Hermetic texts (specifically the *Asclepius*) widely available in Europe during the middle ages "gave instructions about how to animate idols by drawing demons" and angels into them (ibid., 169). "Idols" were prepared with herbs and other substances to enable them to speak and perform divination. In medieval Spain, making an icon was a gesture of gratitude or a vow to the saint in whose image the representation was created (Christian 1981, 57). Some images of the saints were considered more active or more miraculous than others, so active that they literally came alive. Christian notes that "the images that wept and bled, or that changed complexion and blinked, or whose eyes were seen to become brilliant and move, were participating in the tribulations of the people, and suffered for them, in the same way that the people participated vicariously in the Passion of Christ and the Sorrows of Mary" (ibid., 198).[32] The Virgin of Regla provides one example of such an animated local image. The nineteenth-century black *beatas* (lay holy women) who tended to her shrine believed that at night the Virgin would leave the sanctuary to swim in the bay, where she was once spotted by a ñáñigo (Abakúa member) fisherman (Cabrera and Hiriart 1980, 16). According to Cabrera's informant, chicherekú dolls similarly left their altars at night, as did the dolls representing the twins (ibeji), and would "go out at night to get fresh air and would often wake [him] up because they would get into [his] bed" (1975, 493). The statues of the saints are mystical, capable of magic (or miracles), and brimming with the same life force attributed to the chicherekú and spirit dolls in Cuba, which are likewise believed to express the emotions of their owners.

While images of folk saints bear some resemblance to dolls, early ideas about the saints are similarly relevant. Cosentino (1998, 19) establishes a key parallel between dolls in Haitian art and relics of the saints in Catholic churches, arguing that:

> both contain the debris of sanctity…[and] compel us to meditate on the hidden sources of divine power irradiating the tangible world. Each forces us to acknowledge the real presence of the spirit in the basest of materials.

The parallel between dolls and relics, and thus the cult of the saints, is particularly relevant to spirit dolls. "Material" dolls are those made with bones of the dead (i.e., relics), while "spiritual" dolls are not. Spiritual dolls contain "the debris of sanctity" only in a metaphorical sense – that is, they contain no actual human remains. Yet they still represent a very real connection with the dead because of the sacredness of their contents, the love, devotion, and faith with which they are made, and because they are such important cultural markers of historical and spiritual ancestors. No less important is the philosophical contribution of the cult of the saints because it "designated dead human beings as the recipients of unalloyed reverence, and it linked these dead and invisible figures in no uncertain manner…to precise living representations" (P. Brown 1981, 21). In other words, the cult of the saints allowed for public devotion and representation of the "high profile" dead (ibid., 23). Early Christian philosophies paved the way for the sanctioning of saints' processions and, by extension, the parading of spirit dolls alongside the Virgin in popular Cuban Catholicism. Thus, contemporary public memorialization of the common dead (spirit guides might even be called "personal saints") in Cuba extends the holiness of canonized saints to former practitioners of Palo and Ocha, enslaved Africans, and other historically silenced Others and promotes their ability to function as role models even (or especially) from beyond the grave.

Epilogue: A Trip to the Sea

While European, Haitian, and West and Central African spirit containers may or may not be the historical predecessors or cultural correlates of Afro-Cuban spirit dolls, the philosophy that guides the interaction between the dead and the living as seen in these doll-like figures is strikingly similar. Spirit dolls emerge as creole icons ("countericons of fear") of spiritual power and historical memory that assert, by symbolic association, the cognate powers and practices found in these regions and their emergent diasporas. The preparation and propitiation of spirit dolls also suggests shared ideas about the role of natural elements (feathers, earth, bones, seeds, etc.) and the logic of ritual sacrifice in cementing and maintaining relationships with the spirit world. Via these shared systems of knowledge and ritual performance, spirits, dolls, and mediums accumulate power. In this sense, spirit dolls are vibrant contemporary examples of the "cultural systems" that crystallized in the Americas as a result of the "fundamental assumptions" common to West and Central African belief systems, particularly those about the relationship between the living and the dead (Mintz and Price 1992, 44–45). Similarly, they encapsulate "theoretically irreconcilable" systems of meaning, revealing the extent to which "cruzado" practices are increasingly becoming normalized (D. Brown 1999, 215). While I am not the first to suggest this, I assert that by deconstructing the spirit doll we see a close-up snapshot of how the process of creolization is enacted by one particular practitioner in contemporary Cuba. Yet, we also gain a sense of what these processes may have looked like decades or perhaps even centuries ago. The concrete acts of creative recombination, the influence of an individual's ritual and familial lineage on their religious identity and ritual practice, the personal decisions to, say, recite Spiritist prayers to nfumbe spirits as my Padrino does, despite the criticism of his peers, all give us a glimpse into what "syncretism" really means to people who are (or were) living in the midst of this cultural-historical process. Spirit dolls are memory maps of increasingly complex networks of ritual kin, markers of spiritual lineages that no longer strictly mark relationships based on initiation, but these functions all ultimately reinforce the fact that the spirit doll makes these "theoretically irreconcilable" systems coexist inside her and, by extension, inside the devotee. On this deep structural level, spirit dolls embody historical memory and, in turn, reflect how devotees internalize it.

A local vocabulary has emerged around the dolls to articulate this process of reconciling divergent belief systems by articulating the similar characteristics or powers of deities and spirits: trascendencia. I have come to view these as "aché-types," spiritual energies or natural forces that are easily translatable from one Afro-Cuban belief system to another. The concept of trascendencia functions as a bridge between spirits, saints, and orichas. The term "aché-types" is more apt than its Jungian counterpart, "archetypes," because it incorporates the universal connotation of the latter term and adds the culturally specific concept of aché. The term "aché-types" suggests the kind of affective power these spirit dolls contain and acknowledges the natural forces or elements associated with a specific deity or spirit type, thus creating a mode of understanding the multiple connectives that make up the core of the dolls. Through the logic of shared aché—trascendencia or aché-types—composite "deities" are made and cruzado practices are reconciled. This is not to say that the orichas are not similarly composite, but simply reflects the flexibility of Espiritismo as a spiritual practice and the fluid nature of deities and spirits in Afro-Cuban religion.

I have not addressed the life stories of the spirit guides of my collaborators here; although their biographies merit significant analysis, they are beyond the scope of this chapter. As Palmié (2001, 4) suggests, such a study would have to examine seriously the "spirit histories" told by spirit mediums and embodied by the dolls I discuss here. Is it yet permissible to think of these

narratives and the dolls that represent them as a discourse on history—an "other" history, told by the spirits of those who speak to "the myth of the negro past" as conceived by Herskovits ([1941] 1990)? I insist that it is. To my mind, the life stories of spirits are reminders that there is a part of Cuban history that is beyond archival recovery, accessible only through memory preserved in spirit biographies, in the body (i.e. possession performances), and in ritual reenactment and ritual objects (e.g., Connerton 1989; Stoller 1995; Roberts et al 1996 and Shaw 2002). Spirit dolls and the way practitioners interact with them, including the ways they extract spirit biographies from the guides these dolls represent, indicate a living dialogue with history illuminated only by the insight of practitioners whose perceptions of history are inestimably relevant. The dolls are representations that, as Karin Barber (1991, 15) suggests of oriki poetry, posit and embody "a living relationship with the past [as it] is daily apprehended and reconstituted in the present...the past in the present." By acknowledging their role as markers of historical memory, on the one hand, and "receptacles" that reflect an attempt to embody multiple identities, on the other, we begin to see how these spirit objects generate, negotiate, and represent popular and personal notions of history and memory, self and other, spirituality and religion. A close analysis of the "spirit biographies" of practitioners' spirit guides that takes into account both history and contemporary theories of memory would be a rich and meaningful contribution to the growing body of research on Afro-Cuban religions.

These biographies play a key role in connecting the novice to their ritual family. Dressing, preparing, and "initiating" the doll is the beginning of another, longer process that involves the biographical reconstruction of the spirit. Inevitably, this process mirrors the spiritual development of the spiritual godchild. In fact, the process of coming to know the true identity of the spirit, its history, and its purpose in the life of the devotee is a lifelong journey. Only through ongoing interactions in misas espirituales and other ceremonies during which spirits communicate with the community are these mysteries revealed. In this way, spirit dolls link ritual families together long after the ritual knowledge itself has been passed down. Palmié (2002, 6) suggests that "as soon...as we think about how to represent the past, we already begin to intervene in its content." Thus mediums as doll makers and diviners have been intervening in histories for generations, for these dolls and the spirits they house are, among many other things, deliberate representations of the past (and passed). Mediums generate sacred narratives about spirits they regard as very real historical actors, creating contexts for ongoing ritual kinship while playing an active role in constructing collective historical memory in their communities.[33]

Although the account I give here reflects the experience of a knowledgeable priest, one need not undertake any kind of religious initiation to make one's own doll. Espiritistas generally consider a person's preferences – everything from personal adornment to, at times, sexual preference – to be the expression of the spirits' desires. Dreams are also one of the important media through which these desires may be transmitted. This renders the making of a spirit doll a very private, highly individualized process of creation. Even if one is directed by a professional medium, the creative aspect of the belief system is a channel through which artistry can be expressed. Everyone has the capacity to participate in the dressing and preparation of their own doll, which communicates beliefs in an abstract yet tangible way that text cannot. Dolls are flexible symbols – not because they have moving body parts – but because they are hollow receptacles in which meanings are created and entities are theorized. Additional case studies would provide a more complete picture of this doll making tradition and the ways in which spirit dolls reflect increasingly "cruzado" belief systems, yet remain specific to each individual and their personalized practices.

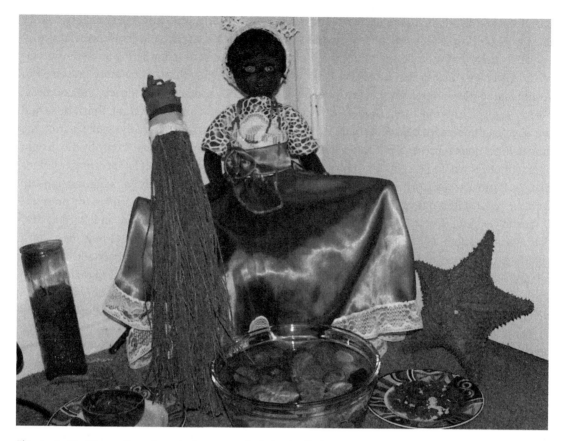

Figure 5. My Mama Francisca, in her own chair in the living room facing the door according to the teachings of my espiritista collaborators and friends. Her accoutrements and offerings include (clockwise from left) a blue candle, a handmade broom (a gift from a friend and priestess of Ochún), a blue and white satin and lace dress designed by me and executed by a seamstress in Havana, a starfish, a plate of food, a bowl with shells and stones collected from Cuban beaches, and a plate with a cigar and a coconut shell filled with rum. *Photo by author.*

The themes I touch upon in this essay deserve further development and exploration. More research is needed concerning the use of dolls in spiritual practices throughout Afro-Atlantic societies at large. Dolls are used as spirit containers, as representations of or gifts to spirits, as objects of sympathetic magic, or as objects carried in procession or carnival in many countries. One tradition that deserves particular attention is the Brazilian maracatú, a dance in which the participants carry dolls they call "Mama Kalunga" (Ortiz [1951] 1981).[34] Another subject that requires reassessment is the use of dolls in hoodoo traditions in Louisiana or among vodouists in Haiti, particularly because dolls in these two areas have long been associated with the stereotypical "voodoo doll" of Hollywood films that stigmatize African-derived religious traditions. A more accurate picture of what these dolls actually do would clarify their evolution and role in diasporan culture and begin to repair the cultural damage done by these kinds of stereotypes. In Cuba, at least, these lovingly constructed dolls are powerful personal and collective symbols that condense systems of meaning, demand devotion, and embody the memory of enslaved priests and priestesses, honoring the rich legacy of diverse modes of ritual knowledge they left behind.

Notes

1. Directly quoted from interview with Marcos, Havana, August 2005.
2. Siete Sallas is another name for Madre Agua.
3. While the quoted term was coined by Micaela DiLeonardo (1984) and later utilized by Kay Turner and Suzanne Seriff (1993) to describe the work of women in maintaining relationships with both earthly and supernatural family members, the important addition of "spiritual" to the phrase is the innovation of Kerry Noonan.
4. Interview with Dulce [Xiomara] August 2005.
5. An nganga, also referred to as a "prenda," is a cauldron used to house a spirit or "nfumbe." The nganga is the primary ritual tool of the ngangulero (also palero, mayombero), a practitioner of Palo Monte, a religion of Congo derivation and influence. I wish to clarify here that not all practitioners' spirit guides or spirit dolls share connections to spirits of *nganga* and/or the oricha, although these certainly emerged as the most common kinds of spirits throughout the course of my research from 2004-2010.
6. Interview with "La China," September 2006.
7. Although these three espiritistas did not know each other and gave their advice independently of one another and, to some extent, out of genuine concern for my spiritual well being, it should be noted here that such suggestions of fealty to a single house may also reflect other motivations. For example, in Cuba it is generally accepted that religious practitioners belong to a house – that is, they have a primary godparent in Ocha and another in Palo, if they practice it, to whom they owe allegiance. At times practitioners also have allegiances to espiritistas or have left their original "houses" for complicated personal reasons or philosophical differences, but the ideal is to be loyal to one or two spiritual godparents. I am aware that as a researcher it is possible, even probable, that this kind of spiritual recommendation was given to me in the hopes of securing my loyalty to the house of the espiritista dispensing the advice. However, it has been my approach throughout my research in Cuba to work with several different houses, with the goal of providing a broader picture of religious practices on the island.
8. Although I leave out critical information in the making of the doll to keep some key elements secret, I have decided not to use my padrino's real name so as not to disclose too much about his ritual logic and methodology, because I reveal so much about the process of Francisca's preparation. In addition, there is the factor of Institutional Review Board regulations for the protection of human research "subjects."
9. Ogún is the oricha of iron, a hot-tempered oricha of the forest and mountain, Ogún is a foundational deity responsible for labor and construction, technology, metalwork. Initiated priests of any oricha are referred to as babalocha (father of the oricha) or iyalocha (mother of the oricha) or, more commonly, as "santeros."
10. This and all subsequent quotes from Rafael were taken from a series of interviews conducted in September 2005 and September 2006.
11. While this information is widely available, I cite Bermúdez because he is one of the few scholars who argues that the practice was brought to Cuba via the United States, a point that requires future research. Espiritismo, or Spiritism, became quite popular throughout Europe and the Americas in the mid- to late nineteenth century. It has retained its popularity in Cuba and other Latin American and Caribbean countries, where it exists in a variety of localized forms and is arguably the most widespread spiritual practice.
12. Ajiaco is a stew of indigenous Taino origin (Barreria 2003).
13. I use the terms "syncretic" and "syncretism" not out of any allegiance to a particular stance on the processes of cultural blending in the Caribbean, but because the practitioners I work with favor the term and use it frequently to describe the existence of mixture in the religions they practice. Therefore I consider it a more local (and thus politically correct) term than, say, "hybridity" or "creolization," terms favored in contemporary scholarship.
14. Interview with Rafael, September 2006.
15. Although the Collection of Selected Prayers (1975) is credited to Allan Kardec, it was in fact complied and written by several unnamed authors. Only some of the prayers were derived from Kardec's The Gospel According to the Spiritist Doctrine, originally published in 1864.
16. Espiritismo de Cruce and Espiritismo de Cordón are two other varieties generally found in eastern Cuba.

17. Interview with Romero, July 2005.
18. These names perhaps also speak to the kind of double consciousness (Dubois 1903) that was born in the Middle Passage and emerged from the Black experience of immoral, unjust, and brutal enslavement of millions of human beings.
19. A cajon para los muertos is a ceremony performed in gratitude towards a spirit or in order to appease or evoke a favor from the spirit. Like a misa spiritual, a cajon begins with opening prayers culled from Kardec's *Collection of Selected Prayers* (1975), but what follows is a distinctly Cuban celebration during which hired musicians play drums and sing songs in call and response fashion. Some of the songs are plegarias from misas espirituales, while others are songs for Palo spirits, but all are performed with the intention of inducing possession in the mediums present at the ceremony – that is, with the intent of calling down the spirits to communicate with their devotees. Participants sing and dance, and often drink rum and smoke cigars; many will receive important messages from the spirits, while others will fall into trance. After the ceremony is completed, *caldoza*, a traditional stew, is often served, followed by sweets and coffee. The cajon is particularly noteworthy because it is, in my experience, the signature ceremony of Espiritismo "cruzado" in the sense that neither participants nor scholars locate its roots in Ocha, Palo, or so called "classic" Espiritismo practices. For more on the cajon, see Warden 2006.
20. Ortiz ([1951] 1981) also notes the existence of other "doll dances" or performative festive traditions involving the use of dolls in Brazil and Venezuela. Of particular interest is the use of *kalunga* dolls in Congo-derived *maracatú* traditions in Brazil. While these possible correlates are beyond the scope of this paper, I will address them in future work.
21. Quoted in a pamphlet entitled "Regla de Palo," author unknown, which is in popular circulation in Cuban botanicas (yerberos).
22. The term "brujeria" literally means witchcraft. Cubans use this word interchangeably with *"trabajo"* (literally: work, but in this case spiritual-magical work). However, when uttered by practitioners, "brujo/a" and "brujeria" are terms used with great pride. In recent years, if not before, these words have undergone a process of resignification and revalorization.
23. Personal communication with Los Gemelos, a cajon group popular in Havana.
24. Xiomara's practices also very much reflect her origins in Guantanamo Province, where Ocha initiates are somewhat scarce and the religious landscape is dominated by popular Espiritismo and Palo.
25. Interview with Azucena, February 26, 2005, emphasis mine.
26. Interview with Celia, September 2005.
27. I will not to go into detail about these elements out of respect for my padrino's nganga, as its secrets are his alone to reveal.
28. This is not to say that Ocha practices are any more or less morally ambiguous than Palo ones. See Palmié 2002 for an in-depth discussion of the perceived moral superiority of Ocha vs. Palo practices.
29. Interview with John Mason, April 11, 2006.
30. Because I conducted my research among Spanish speakers, I primarily use Spanish spellings for words like oricha or Congo. I use "Kongo," when referring specifically to the region in West Central Africa. Similarly, when I refer to the predecessors of Afro-Cuban creole traditions, I use the spellings acceptable in those areas, for example orisa (instead of oricha) when referring to Yoruba religion.
31. Personal communication with Manuel, a priest of Changó and recent Cuban immigrant to Los Angeles. Manuel, like many other babalocha and iyalocha (Ocha priests and priestesses), has some knowledge of ritual Yoruba as it is spoken in Cuba but no formal training in modern Yoruba language. It is perhaps worth mentioning that the reference to a doll as "agbona" is the only one I have found in written or oral histories or in any scholarship.
32. There were an assortment of explanations for the blackness of these effigies that "changed complexion." Some, like the Virgin of Regla, were carved from dark wood, thus blackness was dismissed as a symptom of locally available materials. Others were said to "turn" black from age or the soot of candles left as offerings by devotees, but the church would not readily admit that the saints themselves were African (Begg 1996).
33. Some practitioners go so far as to travel to other Cuban provinces where their spirits claim to have resided during their lifetimes, often in search of *pruebas* (evidence) of their former existence.

At times they succeed in their research, obtaining oral histories from local residents or other proof that their spirit has, in fact, given them their true name and details of their earthly life. Again, beyond the scope of this paper, but very compelling and suggestive of the ways in which practitioners contribute to constructing historical memory in communities whose religious and spiritual history has yet to be thoroughly investigated.

34. The "Kalunga line" is the horizon that separates the realm of the living from the watery depths of the land of the dead in Congo cosmology.

References

Apter, Andrew. 1992. *Black critics and kings: The hermeneutics of power in Yoruba society*. Chicago: University of Chicago Press.

Argyriadis, Kali. 2005. *Religión de indígenas, religión de científicos: Construcción de la cubanidad y Santería*. Desacatos. Centro de Investigaciones y Estudios Superiores en Antropología Social 17:85–106.

Barber, Karin. 1991. *I could speak until tomorrow: Oríkì, women, and the past in a Yoruba town*. Washington, D.C.: Smithsonian Institution Press.

Barnet, Miguel. 2001. *Afro-Cuban religions*. Trs. Christine Renata Ayorinde. Princeton, NJ: Markus Wiener Publishers.

Barreiro, José. 2003. Survival stories. In *The Cuba reader: History, culture, politics*, ed. Aviva Chomsky, Barry Carr, and Pamela María Smorkaloff, 44–57. Durham: Duke University Press.

Bascom, William. 1969. *The Yoruba of southwestern Nigeria*. New York: Holt, Rinehart and Winston.

Begg, Ean Cochrane Macinnes. 1996. *The cult of the Black Virgin*. London: Arkana.

Bermúdez, Armando Andrés. 1968. Notas para la historia del Espiritismo en Cuba. *Etnología y Folklore* 4:5–22.

Bettelhiem, Judith. 1988. Jonkonnu and other Christmas masquerades. In *Caribbean festival arts: Each and every bit of difference*, ed. J. W. Nunley and J. Bettleheim, 39–83. [Saint Louis]: Saint Louis Art Museum; Seattle: University of Washington Press.

———. 2005. Caribbean Espiritismo (Spiritist) altars: The Indian and the Congo. *Art Bulletin*. 87:312–30.

Blier, Suzanne Preston. 1998. *The royal arts of Africa: The majesty of form*. New York: H. N. Abrams; London: Laurence King.

Brown, David H. 1999. Altared spaces, Afro-Cuban religions and the urban landscape in Cuba and the United States. In *Gods of the city: Religion and the American urban landscape*, ed. Robert A. Orsi, 155–230. Bloomington: Indiana University Press.

———. 2003. *Santería enthroned: Art, ritual, and innovation in an Afro-Cuban religion*. Chicago: University of Chicago Press.

Brown, Peter R. L. 1981. *The cult of the saints: Its rise and function in Latin Christianity*. Chicago: University of Chicago Press.

Buckley, Anthony D. 1985. *Yoruba medicine*. New York: Oxford University Press.

Cabrera, Lydia. 1957. *Anagó: Vocabulario Lucumí (el Yoruba que se habla en Cuba)*. Habana: Ediciones C.R.

———. 1975. *El monte: Igbo, finda, Ewe orisha, vititi nfinda: Notas sobre las religiones, la magia, las supersticiones y el folklore de los negros criollos y el pueblo de Cuba*. Miami: Ediciones Universal.

———. [1979] 1986. *Reglas de Congo: Mayombe Palo Monte*. Miami: Ediciones Universal. First published Miami: Peninsular Print.

Cabrera, Lydia, and Rosario Hiriart. 1980. *Yemayá y Ochún*. Eastchester, NY: distributed by E. Torres CR.

Cameron, Elisabeth Lynn. 1996. *Isn't s/he a doll? Play and ritual in African sculpture*. Los Angeles: Fowler Museum of Cultural History, UCLA.

Castañeda Mache, Yalexy, and Ileana Hodge Limonta. 2003. Escenario simbólico en el ritual del espiritismo cruzado. In *Rito y representación: Los sistemas mágico-religiosos en la cultura cubana contemporánea*, ed. Yana Elsa Brugal and Beatriz J. Rizk. Colección Nexos y diferencias, no. 6. Madrid: Iberoamericana.

Castellanos, Isabel. 1996. From Ulukumí to Lucumí: A historical overview of religious acculturation in Cuba. In *Santería aesthetics in contemporary Latin American art*, ed. Arturo Lindsay. Washington: Smithsonian Institution Press.

Castellanos, Jorge, and Castellanos, Isabel. 1992. *Cultura Afrocubana*. Vol.3: *Las religiones y las lenguas*. Miami: Ediciones Universal.

Christian, Jr. William A. 1981. *Local religion in sixteenth-century Spain*. Princeton, NJ: Princeton University Press.

Cole, Jennifer. 2001. *Forget colonialism? Sacrifice and the art of memory in Madagascar*. Berkeley: University of California Press.

Connerton, Paul. 1989. *How societies remember*. Cambridge: Cambridge University Press.

Cosentino, Donald J. 1998. *Vodou things: The art of Pierrot Barra and Marie Cassaise*. Jackson, MS: University Press of Mississippi.

DiLeonardo, Micaela. 1984. *The varieties of ethnic experience: Kinship, class and gender among California Italian-Americans*. Ithaca: Cornell University Press.

Drewal, Margaret Thompson. 1997. Dancing for Ogun in Yorubaland and in Brazil. In *Africa's Ogun*, ed. Sandra Barnes, 199–234. Bloomington: Indiana University Press.

———. 1992. *Yoruba ritual: Performers, play, agency*. Bloomington: Indiana University Press.

Drewal, Margaret Thompson, and Henry John Drewal. 1983. *Gelede: Art and female power among the Yoruba*. Bloomington: Indiana University Press.

DuBois, W.E.B. [1903] 1995. *The Souls of Black Folk*. New York: Penguin Putnam.

Durkheim, Émile. 1995. *The elementary forms of religious life*. Trs. Karen E. Fields. New York: Simon and Schuster.

Fakinlede, Kayode J. 2003. *English-Yoruba/Yoruba-English modern practical dictionary*. New York and London: Hippocrene.

Fawcett, Clara Hallard. 1964. *Dolls: A new guide for collectors*. Boston: C. T. Branford Co.

Fernandez Olmos, Margarite. 2001. Black arts: African folk wisdom and popular medicine in Cuba, a translation of Lydia Cabrera. In *Healing cultures: Art and religion as curative practices in the Caribbean and its diaspora*, 29–42. New York: Palgrave.

Fernández Olmos, Margarite, and Lizabeth Paravisini-Gebert. 2003. *Creole religions of the Caribbean: An introduction from Vodou and Santería to Obeah and Espiritismo*. New York: New York University Press.

Flexner, Stuart Berg, ed. 1987. *The Random House dictionary of the English language*. New York: Random House.

Flores-Peña, Ysamur, and Roberta J. Evanchuk. 1994. *Santería garments and altars: Speaking without a voice*. Jackson: University Press of Mississippi.

Geertz, Clifford. 1973. *The interpretation of cultures: Selected essays*. New York: Basic Books.

Hamilton, Bernard. [1986] 1997. *Religion in the medieval West*. New York: Arnold/St. Martin's Press. First published London and Baltimore, MD: E. Arnold.

Harris, Max. 2003. *Carnival and other Christian festivals folk theology and folk performance*. Austin: University of Texas Press.

Helg, Aline. 1995. *Our rightful share: The Afro-Cuban struggle for equality, 1886–1912*. Chapel Hill: University of North Carolina Press.

Herskovits, Melville Jean. [1941] 1990. *The myth of the Negro past*. Boston: Beacon Press. First published New York: Harper.

Hodge Limonta, Ileana, and Minerva Rodríguez Delgado. 1997. *El espiritismo en Cuba: Percepción y exteriorización*. La Habana: Editorial Academia.

Jacobson-Widding, Anita. 1979. *Red—white—black as a mode of thought: A study of triadic classification by colours in the ritual symbolism and cognitive thought of the peoples of the Lower Congo*. Uppsala, Sweden: Almqvist and Wiksell.

Juncker, Kristine. 2006. *Honey at the Crossroads: Four Women and Afro-Cuban Ritual Arts, 1899-1969*. New York: Columbia University Press.

Kardec, Allan [Hippolyte Léon Denizard Rivail]. [1857] 1989. *The spirits' book: Containing the principles of spiritist doctrine on the immortality of the soul; the nature of spirits and their relations with men; the moral law; the present life, the future life, and the destiny of the human race*. Albuquerque, NM: Brotherhood of Life. First published in France.

———. [1966] 1990. *Colección de oraciones escogidas de Allan Kardec y otros autores*. Bronx, NY: De Pablo International. First published México: Editora Latino Americana.

———. 1975. *Collection of selected prayers*. New York: Studium.

Lago Vieito, Angel. 2002. *Fernando Ortiz y sus estudios acerca del espiritismo en Cuba*. La Habana: Centro de Investigación y Desarrollo de la Cultura Cubana Juan Marinello.

Lawal, Babatunde. 1976. The significance of Yoruba sculpture. Paper presented at the conference on Yoruba Civilization, University of Ife, Ile-Ife, July 26-31.

Millet, José. 1993. *Del mundo terrenal: Hablan los espiritistas cubanos*. Mexico, D.F.: Editorial Travesía.

Mintz, Sidney, and Richard Price. [1976] 1992. *The birth of African-American culture: An anthropological perspective*. Boston: Beacon Press. First published Philadelphia: Institute for the Study of Human Issues.

Murphy, Joseph M. 1993. *Santería: African spirits in America*. Boston: Beacon Press.

Nooter [Roberts], Mary H., ed. 1993. *Secrecy: African art that conceals and reveals*. New York: Museum for African Art.

Orozco, Román, and Natalia Bolívar Aróstegui. 1998. *Cuba Santa: Comunistas, santeros y cristianos en la isla de Fidel Castro*. Madrid: El País Aguilar.

Ortiz, Fernando. 1919. *Las fases de la evolucion religiosa*. Conferencia de vulgarización sociológica pronunciada en el Teatro Payret de la Habana, el día 7 de abril de 1919, a petición de la Sociedad Espiritista de Cuba. La Habana: Tipografía Moderno.

———. [1921] 1992. *Los cabildos y la fiesta afrocubanos del Día de Reyes*. La Habana: Editorial de Ciencias Sociales.

———. [1947] 1995. *Cuban counterpoint: Tobacco and sugar*. Durham, NC: Duke University Press. Trs. Harriet de Onís. First American edition New York: A. A. Knopf.

———. [1951] 1981. *Los bailes y el teatro de los negros en el folklore de Cuba*. La Habana: Ed. Letras Cubanas. First published La Habana: Cardenas y Cia.

Palmié, Stephan. 2001. Of pharisees and snark hunters: Afro-Cuban religions as an object of knowledge. *Culture and Religion* 2:3–19.

———. 2002. *Wizards and scientists: Explorations in Afro-Cuban modernity and tradition*. Durham, NC: Duke University Press.

Pickett, Joseph P. 2000. *The American heritage dictionary of the English language*. 4th ed. Boston: Houghton Mifflin. http://bartelby.com/61/a0.html.

Roach, Joseph R. 1996. *Cities of the dead: Circum-Atlantic performance*. New York: Columbia University Press.

Roberts, Mary Nooter, Allen F. Roberts, and S. Terry Childs. 1996. *Memory: Luba art and the making of history*. New York: Museum for African Art.

Roche y Monteagudo, Rafael. 1908. *La policia y sus misterios; adicionada con "La policia judicial", procedimientos, formularios, leyes, reglamentos, ordenanzas, y disposiciones que conciernen a los cuerpos de seguridad publica*. La Habana: Imprementa La Prueba.

Shaw, Rosalind. 2002. *Memories of the slave trade: Ritual and the historical imagination in Sierra Leone*. Chicago: University of Chicago Press.

Shaw, Rosalind, and Charles Stewart. 1994. Introduction. Problematizing syncretism. In *Syncretism/antisyncretism: The politics of religious synthesis*, ed. Charles Stewart and Rosalind Shaw, 1–24. London: Taylor and Francis; New York, Routledge.

Stoller, Paul. 1995. *Embodying colonial memories: Spirit possession, power, and the Hauka in West Africa*. New York: Routledge.

Taussig, Michael T. 1993. *Mimesis and alterity: A particular history of the senses*. New York: Routledge.

Taylor, Diana. 2003. *The archive and the repertoire: Cultural memory and performance in the Americas*. Durham, NC and London: Duke University Press.

Thompson, Robert Farris. 1983. *Flash of the spirit: African and Afro-American art and philosophy*. New York: Random House.

Turner, Kay, and Suzanne Seriff. 1993. "Giving an altar to St. Joseph": A feminist prospective on a patronal feast. In *Feminist theory and the study of folklore*, ed. Susan Tower Hollis, Linda Pershing, and M. Jane Young, 89–117. Urbana: University of Illinois Press.

Warden, Nolan. 2006. Cajon pa' los Muertos: Transculturation and Emergent Tradition in Afro-Cuban Ritual Drumming and song. MA thesis. Tufts University, Medford, MA.

Wehmeyer, Stephen C. 2002. Red mysteries: "Indian" spirits and the sacred landscape of American Spiritualism. PhD dissertation, University of California, Los Angeles.

Wexler, Anna. 2001. Dolls and healing in a Santeria house. In *Healing cultures: Art and religion as curative practices in the Caribbean and its diaspora*, ed. Margarite Fernandez Olmos and Lizabeth Paravisini-Gebert, 89–113. London: Palgrave.

From Bush to Stage:
The Shifting Performing Geography of Haitian Rara and Cuban Gagá

Yanique Hume

Introduction

It started as a faint rumble in the far distance, but with each advance the multilayered sonic tapestry grew more intense, ushering the arrival of one of Cuba's oldest Rara/Gagá bands,[1] *Grupo Barranca*. The animated cast of characters with bodies donning brilliantly colored fabric strips and bedecked with ritual beads as spiritual armor, descended upon the crowd of dignitaries assembled to welcome then Haitian president Jean Bertrand Aristide during his visit to Cuba in June 2000. With each crack of the whip and sounding of the *lanbi* (conch shell), the melodious cadence of the *baccines* (bamboo trumpet) and *tambourin* (portable drum head) increased in tempo. The descendants of Haitian field laborers stomped their feet and danced joyously to the rapid *petwo-kongo* rhythms for the delighted mass of spectators. As they marched through the lobby of one of Santiago de Cuba's premier hotels, brandishing the ritual flags of their *lwa* (spirits) and native homeland, they chanted, *"Aysien Nou Ye"* (We Are Haitians), thus proclaiming their sense of belonging to a place they have never seen, but one that has shaped their existence and sensibilities for generations. In response, the Haitian president looked overwhelmed by what unfolded in front of him, with a smile on his face that bespoke the tone of such a momentous encounter.

Removed from the locality of the Haitian countryside and urban thoroughfares to the Cuban *bateyes* (agricultural outposts) and then to the city streets and stages of Santiago de Cuba, Gagá is one of the myriad cultural forms that now participates in several symbolic systems and performative contexts. Gagá became part of the performance geography of Oriente (eastern Cuba) with the influx of labor migrants to Cuba during the early twentieth-century.[2] Initially cloaked in secrecy and maintained exclusively by *Vodú sociétés*,[3] Gagá remained relatively invisible as a national cultural form. Its initial marginality in many ways historically mirrored the placement of Haitians and their descendants in both the spatial and social landscapes of eastern Cuba.[4] However, since the mid 1970s, there have been concerted efforts by state officials to unearth and exhibit popular subaltern expressions.[5] *Casa del Caribe*, one of the leading cultural institution in Cuba dedicated to researching the traditions and historical connections between Cuba and the Caribbean, has through its programming been pivotal in popularizing and disseminating knowledge about the Haitian presence on the island. In turn, Gagá has become increasingly enrolled in state-sponsored folkloric spectacles for locals and tourists alike and is the latest signifier of Santiago's distinctive pluri-cultural identity and pan-Caribbean heritage.

What makes Grupo Barranca's performance significant for our current consideration is not so much that Gagá is chosen as the emblematic icon of Haitian identity in Cuba, or placed in a context that seemingly reduces or at best neutralizes its oppositional potentialities. Instead, its importance lies in the fact that, for generations of displaced Haitians living in Cuba, cultural performances like Gagá provided a tangible link to an identity that had been devalued within the society. In the once insular rural environments of Oriente, festive traditions like Gagá served as a

Reprinted with permission from *E-misférica: Journal of the Hemispheric Institute for Performance and Politics, Caribbean Rasanblaj* 12, issue 1 (2015), ed. Gina Athena Ulysse.

marker distinguishing the diverse communities of Antillean immigrant laborers and, in the words of a Barranca resident, "joined us over here [in Cuba] with those over there [in Haiti] as one Haitian people."[6] More poignantly, the overt carnivalesque facade of Gagá also provided a suitable cloak for the more demonized ritual practices associated with Vodú.[7] Today, the expanding performance networks and contexts provide venues for the "performance of visibility" (Thompson 2007) beyond the confines of the bateyes. They also provide an opportunity for those of Haitian descent to proclaim publicly an ethnic identity that is often denied within prevailing understandings of *cubanidad* (Cubanness).

Sonjah Stanley Niaah (2008) utilizes the term *performance geography* to elaborate on the intersections of cultural geography and performance studies in order to trace the shared spatialities and "common genealogy" of Black Atlantic performance cultures. Beyond examining the continuities of African diasporic musical and performance genres, Stanley Niaah explores "the way people, living in particular locations, give meaning [to their social worlds] through performance practices" (344). I am likewise invested in mapping the contours of performances as they traverse geographical locales and social/spatial contexts. However, unlike the majority of scholarship on migration and cultural displacement across the Black Atlantic, which focuses on metropolitan urban spaces (see Gilroy 1993; Hall 1995; Ho and Nurse 2005), this essay examines the circulation of culture in hybrid rural locations that exist on the peripheries of global capitalism. Moreover, by using a reconstituted peasant ritual as a lens to analyse contemporary cultural politics at both the level of the state and local subaltern communities, this essay examines how Haitian forms are situated in Cuba's folkloric imaginary, and also assesses the motivating factors and agendas that animate such cultural productions.

Haitian Rara: The Socio-Cultural Roots of Gagá Cubano

Rara is one of the most subversive popular expressions practiced by the economically deprived peasant and urban classes of Haiti. During the Lenten period, ritual activities are suspended in the Vodou temples and diverted to the Rara bands, which enact rites in auspicious sites along their nocturnal pilgrimages. Structured as a public ritual, Rara processions, with their casts of characters,[8] navigate the Haitian landscape, enveloping all within their reach. They provide public platforms for the honoring of the spirits and for the powerless masses to broadcast coded and symbolically potent messages about their social realities. As a festive form, Rara marries religious rituals, politics, exuberant dances, songs, and music, in a six-week Lenten street festival that begins on Ash Wednesday in Vodou temples across the country and culminates the week of Easter.[9] The celebrations climaxed with the burning of an effigy, known locally as a *jwif* (Jew) or devil, but this practice was banned in Haiti in the mid-1970s.[10] The aesthetic, ritual, and socio-political features work together to give Rara its complex multidimensionality as a cultural performance that merges the festival and sacred arts. Within the context of Haiti, Rara is used as an oppositional force that counters the Catholic orthodoxy and social inequities of Haiti in its reclamation of public space for the display of Vodou rites and carnivalesque revelry (McAlister 2002). Through its spectacular performance of oral dexterity, which oscillates between secular and sacred registers, Rara becomes a critical platform for the materially and socially disadvantaged to negotiate their place within asymmetrical structures of power. Thus within this festive form revelers express an emancipatory ethos, albeit in the temporality of its enactment.

According to Micheal Largey (2000), "Rara bands follow a pattern in their nightly parades resembling the 19th-century insurrection/coup d'etat. Like the regional armies of aspiring Haitian generals, Rara bands move through the streets looking to pick up supporters for their musical

'platform'" (244). These songs, and specifically the particular soundscape, go beyond their immediate local environment, however, for in many ways they become the aural, or what Elizabeth McAlister (2002) has called the "sonic flags" (247), linking the multiple communities of Haitians on the island with those who celebrate this festive form in diverse diasporic communities. As Rara migrates with the flows of Haitians that settle in neighboring Cuba, the cultural practices, iconography, and aesthetic principles of the form are transplanted, reconfigured, and represented as a means not only to recuperate the past, but also to serve as a key agent in the collective assertion of a Haitian identity on Cuban soil, and later operating within an increasingly expansive folkloric economy.

The Early Formation of Gagá Societies in Rural Cuba

In their 1988 study of the Haitian settlement Caidije, a batey in the old provincial area of Camagüey, Cuban ethnographers Jesus Guanche and Denis Moreno contend that Gagá bands were started fairly soon after a population of Haitian migrants settled in the batey. As an example, in 1926, three years after the community of Caidije was founded, the primarily male residents created a Gagá society that has been performing this celebratory and communal rite consistently for over eighty years.

The organizational structure of the Gagá ensemble resembles the Haitian *société*, or spiritual collectivity, connected to an *ounfó*, or religious house/temple. In her explication of the importance and interdependency of the société to the *oungan/mambo* (Vodou priest or priestess) and the religious structure of Vodou, Maya Deren (1953) maintains that:

> The term refers to all the people connected with a specific *hounfor* and defines them as a communal entity. While the hounfor itself is referred to in the name of the *houngan*, it is understood as being under the sponsorship of the société, which has a separate name. The société may even include members who live in town and attend only the most important ceremonies, but upon whose assistance the priest can rely should he need to raise money for an expensive ceremony, to arrange transportation, to be advised on building, etc. As a collective unit at the base of the religious structure, the société is represented by two heavily embroidered ceremonial flags. Carried by two flag bearers, these banners are used to salute the loa and as a mark of respect to any distinguished guest at ceremonies. When one arrives at a ceremony, the accepted greeting is: *Bonjour, la société* (154).

Following an analogous structure, the sociétés that developed in Oriente mirror the system of reciprocity and exchange found in their Haitian counterpart. While the social networks created out of these collective units are considerably smaller, they function in a similar fashion as they helped to define and solidify the community of Haitians and their descendants. They also were a centralizing force, bringing disparate communities of Haitians together under the banner of Vodú (i.e. the Cuban version of Haitian Vodou). By extension, they have historically helped these displaced migrants reconstitute, develop, and reformulate their religious and socio-cultural worlds, while serving as a catalyst for the maintenance of a Haitian sensibility and consciousness that was routinely activated through collective ritualizing.[11]

Initially "a hermetic and laborious brotherhood that few manage[d] to penetrate" (Montero 1992, 9), Gagá societies were further fortified by their links to the Masonic Order, which functioned as a meeting ground for oungans and served as a practical cloak to the more vilified rites associated with Vodú.[12] Fraternal organizations, like the Lodge, were legitimate and established institutions in the socio-cultural and political scene of Santiago from as early as the late 1700s, after they were founded by the French émigrés class.[13] That Haitian migrants in the 20th century joined the

Masonic Orders soon after settling in Cuba bespeaks the continuation of a cultural practice, but more so, it reveals the strategy employed by oungans to shield their religion and to acquire power and legitimacy among their kinsmen and Cubans alike. Through the ritual guise of the Masonic rites and salutations, these mobile processions created a space for Haitian migrants to conduct mystical negotiations and fulfill sacred contracts as they paraded the countryside year after year or until the *promesas* (sacred pledges or promises made to the spirits) were satisfied.

Over time Gagá became imbricated into the social life of the bateyes and functioned as a source of community identification and solidarity from as early as 1915.[14] As an annual commemorative rite, Gagá functioned as a central feature of the liturgical calendar, thus punctuating the otherwise monotonous flow of agricultural labor. Like many traditional masquerade forms found in the Afro-Atlantic world, Gagá functioned as a collective ceremonial reprieve from an otherwise arduous work schedule. In fact the shortened time frame of the festival correlated with the one-week respite laborers were given during Holy Week or *Semana Santa*, which also coincided with the height of the *zafra*, or harvest period. Symbolically, Gagá became enveloped within a liberatory ethos, as performers bracketed the realities of life in the bateyes through releasing into the communal spirit of celebration, ancestral veneration, and social detachment. Yet Gagá bands not only followed prescribed Vodú rites, they also mirrored the structures of power and social hierarchy in the Cuban batey. Similar to the Dominican Republic, where Gagá bands are also found, these community-centered associations, as June Rosenberg (1979) argues, "offer[ed] an identity which [was] far removed from the possibilities of these individuals...as the structure of the group reflect[ed] the values of the larger society" (203). As an example, in Cuba, as in the Dominican Republic, the maximum leader of the band was on occasion called a *dueño/a* meaning "master." The term was used to designate the sugar boss, and hence the locus of power and prestige in the bateyes. With the appropriation of the title, the name came also to refer to a Vodú priest (*oungan* or *manbo*) of great repute who was a spiritual director of the *serviteurs* (devotees) and revelers and a proprietor of his/her own Gagá society and band. Even with the adoption of a Spanish title, the sacred dimensions of the form and the primacy of the Haitian god of war, Papa Ogou, remained evident.

One event I witnessed in March 2003, which throws the hybrid cultural world of Gagá in stark relief, involved the mock battle between bands and feasting/feting of Ogou in the community of Barranca. A group of drummers and family members from Santiago de Cuba with ties to the batey came to participate in the opening rites of offering foods to the ancestors [*Fig. 1*] and rehearsing songs and dances in preparation for the climactic procession, which was to take place on the day before Easter Sunday.[15] On the night of the journey, the band wove its way through fields of cane before approaching train tracks off in the distance. Train tracks are auspicious sites because they are deemed to manifest the greatness of Ogou's power as owner of metal and protector of those who work with or manipulate metal implements. They also stand as a symbol of the transshipment of sugar cane from the bateyes to the town, and hence function as a figurative condensation of the livelihood of these field laborers cum performers. As the band danced towards the tracks, another band made its way toward them, waving ritual flags or banners of affiliations to the revered Haitian *lwa*, Ogou. With their heads and waist tied in his sacred red cloth, both bands flanked either side of the train tracks. With the pulsating sounds of whistles, which initiated the building of a bonfire, revelers began their magnificent display of skill and mastery of the swords, rendering the cold glistening steel brilliantly and fluidly as they hurled them through the air. The spectacle soon turned into a possession-performance as the assembled congregants/revelers were taken over by the powerful warrior spirit. They threw jabs at each other and sliced through the sky as if clearing bush.

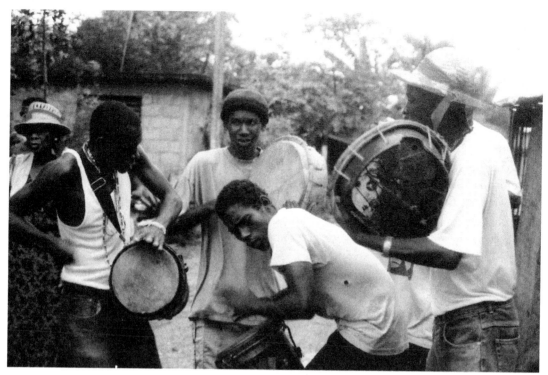

Figure 1. Ritual Ochan or Drum Salute in front of residence of Gagá Queen, Palma Sorriano, March 2003. *Photo by author.*

The revelers charged through the cane fields that run along either side of the track, slashing cane trash before returning to the center of the ritual space where they slapped their machetes onto the metal rail lines before turning the tip of their blades against themselves. The *majó*[16] machetes (machete twirlers) took turns at passing the blades across their tongues, faces, abdomens, and arms. The frenzied movement climaxed to a crescendo as they engaged in mock battle around the blazing bonfire. To mark the end of the rite, the *baterí* (musical ensemble)[17] stopped playing and the majó machetes responded by turning their blades face down into the earth along the length of the train track. Each majó poured libations of rum where their blades pierce the earth and to the cardinal points. As the collective circled the line of sabers, they were sprayed with rum from the pierced lips of the band leaders, and then proceeded on with their journey, stomping their feet and swaying their hips before disappearing into the night.

Within this ritual, multiple narratives converged, along with diverse spiritual worlds, thus throwing into relief the inherent dynamism of this festive form. Outside of the geographic territory of Haiti, Gagá performers systematically borrow and draw on the rich spiritual world of their adopted home, incorporating some of the symbols associated with other sacred complexes. The inherent syncretic nature thus points to what scholar Margarite Fernández Olmos (2000) has identified as "a secondary type of syncretism, one between (ex) colonized peoples" (273). Foregrounded in the rite around the train tracks is the pivotal place in which Ogun is situated within the ritual landscape of Cuba, where the boundaries of his spiritual identity bleed across Vodú and the Yoruba-derived Santería/Lucumí tradition. As a powerful African warrior who brandishes a machete as his spiritual tool and creative devise, Ogou/Ogun initiates war and clears the fields to usher into being civilization and modern industry. In this way, Ogun becomes linked both to positive and negative

deeds. As such, he represents the African ideal of complementarity, whereby a destroyer-creator binary operates within a broader imaginary of social transformation.[18] The iconographic emblems of the machete and sacred banners that are ritually *mises en activite* (put into action) also point to Ogou's metaphorical link between religion and the military, which gave rise to the birth of the Haitian nation. Religion scholar Karen McCarthy Brown (1989) writes that "[t]he military-political complex has provided the primary niche for Ogou in Haiti" (71). Within the diasporic enclaves, this embodied memory of Haiti becomes activated through rites for Ogou, which references these two interlocking forces. Repeatedly, younger and older men spoke of their affinity to Ogou's revolutionary and transformative power. According to one performer, "Papa Ogou is our most important spirit. He brought freedom to our ancestors in Haiti and he fights for our freedom in Cuba...he lives in all of us, he is in our blood."[19] After probing this comment further with other performers, it became apparent that Gagá in the bateys became in some ways a festive ode to this god of war. In collectively embodying the gestures and agile movements of this divine warrior, the remembrance of Haiti and the revolutionary struggle for freedom is repeatedly brought to memory as an on-going process. Ogou's transformative power is continually recalled and harnessed in the collective bodily labor of the performers, as they, too, in their performance and everyday lives toil for a greater sense of self-actualization.

The communal efforts of the *majó machete* with the accompaniment of the ritual chorus of queens and mobile orchestra ignite Ogou's energy through their collective spiritual work and discipline. The flags and sabers become condensed symbols of potent power, or what is known in Haiti as *pwen* (power point). As mnemonic devices, they call to the fore this history and serve as the channels through which they cleanse and recharge the earth at the very place where Ogou's power is concentrated (i.e. a railroad track), a numinous site in Cuba where diverse spiritual worlds collide. Through their highly choreographed performance, they reclaim the land that has historically been the source of not only their labor but also their oppression and, in turn, recast it as the sacred domain of the lwa. By extension, they harness the might and authority of Ogou to enact a power that they do not ordinarily have.

The *haitiano-cubano* (Haitian-Cuban) communities, mostly dispersed across the eastern provinces from Camaguey to Holguin, are unlike their Haitian diasporic counterparts residing in metropolitan centers, who are embedded in well-established transnational networks and social fields.[20] While the recent relaxation of travel restrictions for Cuban nationals may shift this reality, the prohibitive socio-economic climate makes the continuous circulation of cultural products, peoples and ideas between the two Caribbean nations relatively minimal.[21] Thus the diasporic subjectivity constructed in Cuba has been articulated and sustained primarily through collective memory, guarded traditions, and cultural inventions, as opposed to an identity forged through consistent transnational flows. As a case in point, the repetitious sequencing of events that mark Gagá festivities, including the feasting of ancestral kin, days of rehearsing songs and dances for the journey across the bateyes, the conducting of ceremonial offerings at auspicious sites and within the family compound, and the final act of burning an effigy and ingesting the ashes in a scared alcoholic brew, became part of the naturalized rhythm that defined this seasonal festive form [*Fig. 2*]. There has been a maintenance, amplification and creation of some characters, most notably the *majó table*, which is no longer part of the repertoire in Haiti. Similarly, the formidable skills of the *majó machete* —a competency honed over generations of cutting cane—have usurped the primacy placed on the traditional Haitian *majó jonc*, or baton twirlers. Meanwhile, the *majó rua diable*, with his multilayered strips of cloth reminiscent of a traditional *egugun*-like masquerade, has been added in as the spiritual protectors of the band, who deflects negative energies with his twirling cloth [*Fig. 3*].

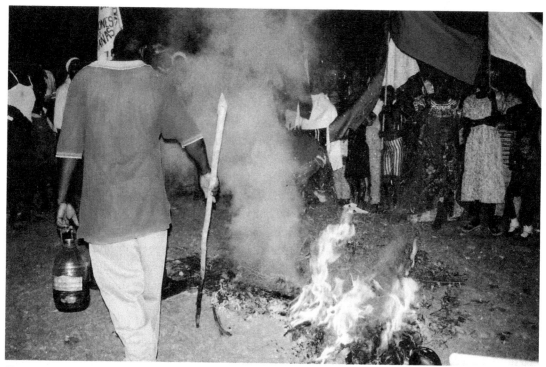

Figure 2. Burning of Dyab to close Gagá celebrations in Barranca. 2003. *Photo by author.*

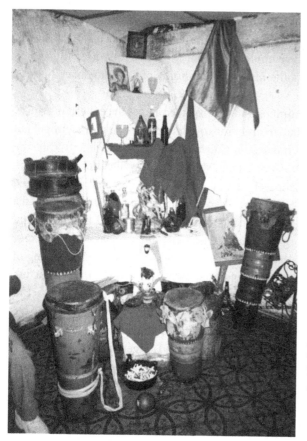

Figure 3. Madame Sylvia Gardes three-tiered domestic altar features the ritual flags and Dahomean-styled Vodú ritual drums where they are housed until they are needed for ceremonies. To the left, partly covered by a white flag, is a framed image of the Haitian coat of arms and in the upper left is a small Haitian flag. The altar also features an image of a deceased family member with a small ceramic image of La Caridad de Cobre (Patron Saint of Cuba. Ochun within Yoruba derived practices and Ezile Freda amongst Vodú practitioners). Just below is a statue of Santa Barbara or Chango, on the main tier are reproduced images of Sen Jak (the Patron Saint of Santiago de Cuba and of the Haitian-Cuban population). At the base stands a statue of St. Lazarus, who is popularly regarded as Papa Legba. Santiago de Cuba, Cuba. Photo by author. *Photo by author.*

Although deviation from the cultural script concerning the sequencing of the ritual events would occasion criticism, the inherent hybridity of the form manifests itself nonetheless. This is perhaps most evident in the local lingua franca used in the ceremony, as in everyday life, which slips seamlessly between Kreyol and Spanish. It is further expressed in the worshiping of divinities beyond those found in the Vodou pantheon, and indeed feasting their *lwas* on either the same days or seasons dedicated to honoring those associated with the more popular religious traditions found in Cuba. Further illuminating this confluence of cultures is the fact that most *voduisants* and ritual leaders are usually adept in *Espiritismo* (Spiritism), as well, and have created altar spaces in their domestic and ritual environments to represent their expansive sacred universe [*Fig. 3*]. The intercultural participation and collapsing of diverse spiritual worlds is also evident in the rural drum-dance fetes, known locally as *bembé de sao,* which are a central feature of the social and ritual lives of these communities formed by descendants of Haitians and Cuban peasants.

Vodou and, by extension, the rites associated with Gagá proved particularly adaptive to the Cuban socio-religious environment. Haitiano-cubanos were able to reconstruct their sacred expressions and practices in part because of the isolation and, hence, protection the forested rural regions afforded them. More poignantly, the similar vegetation and fortification provided by the physical environment was further enhanced by the familiar spiritual topography of eastern Cuba. Vodú and Gagá were also able to thrive because they were not institutionalized practices requiring a fixed structure, priesthood, codified practice, or geographical center (see Mintz and Trouillot 1995). Instead, they were able to take root in Cuba because individual priests established religious family networks in the communities they settled and re-established their practices. Gagá leaders collapsed and re-blended the ritual accouterments of several ritual systems, which then served as the sacred armory used by the oungans and other participants to mediate between the gods, the Cuban state, and their new environment. I now turn to the adaptations of the form to the concert stage as part of the annual Festival of Fire, where it has taken on a renewed vibrancy.

Festive Forms and Their Shifting Performance Context

In his assessment of the shifts in the last few decades within the scholarship on ritual and festive traditions, anthropologist David Guss (2000) maintains that there has been a move away from examining these forms in terms of their discrete place-based cultural specificity and function to that of "relocating festive practice in the sociopolitical reality" of the post-modern era (3–7). The realm of the popular is seen, therefore, not as an uncontaminated sphere of cultural production, but in fact one that participates in ever-expanding semantic fields. Popular cultural expressions are not static constructs, but are informed by processes such as urbanization, migration, tourism, and the global flows and circuits of culture within market-driven economies (García Canclini 1995; Yúdice 2003; Ho and Nurse 2005). Following this logic, cultural performances are therefore ripe arenas not only to map the ambiguous and contradictory processes through which meaning is made and remade, but likewise to see how identities are refashioned within and across distinct performance frames.

From as early as the 1960s, Haitian expressive forms began to enter the repertoire of professional folkloric troupes in Santiago de Cuba and later gained more visibility through public events such as Carnival[22] and the Festival of Caribbean Culture (*Fiesta del Fuego*). With the formation of the *Conjunto Folklórico de Oriente* (founded in 1959) and its offshoot, *Ballet Folklórico Cutumba* (founded in 1960), formal channels for the inclusion of Afro-Franco and Haitian expressive forms (e.g. ritual/social dances and music traditions) were institutionalized. However, a much longer history

of cross-cultural entanglements with the Afro-Cuban population in eastern Cuba existed and thus reveals how the cultural influences of Saint Domingue and, later, Haiti were intimately interwoven into the cultural tapestry of Santiago de Cuba and Oriente more generally (see Bettelheim 1998, 2001). As an example, the creolized music and dance tradition, Tumba Francesa and Tajona, was forged in the cafetales (coffee plantations) during the late eighteenth and early nineteenth centuries and embodies one of the oldest tangible links to the Afro-FrancoHaitian heritage of Cuba's eastern provinces. During Carnival processions in Santiago de Cuba, members of the only remaining tumba society, Santa Catalina de Rici (founded in 1902), or Pompadour, as they are known locally, parade with stately and aristocratic finesse in front of local and foreign spectators. Outside of this heightened festive environment, society members present the imitative French court dances merged with African syncopated drum rhythms to more modest tourist audiences who visit their cultural center in Guantánamo.

Gagá on the Concert Stage

While the linear structure of creolized tumba dances [24] was translatable to the concert stage, the incorporation of Gagá within the folkloric repertoire involved a greater investment in making the dances more theatrically accessible. According to former director of the Conjunto Folklórico de Oriente, Antonio "Toni" Pérez Martínez:

> The dances we witnessed in our trips to the Haitian communities were wild and energetic. We went as a team to see how the dances are performed in the bateyes and to learn directly from the source....These people were not professional dancers....They were field hands who danced as part of their lives. They worked hard, and when they danced, it was as if there was something in them they were trying to release. What we witnessed was raw almost primal energy and strong movements. They were strong rhythms and dances, but they lacked the sophistication needed for the stage....We had to clean it and make it art. [25]

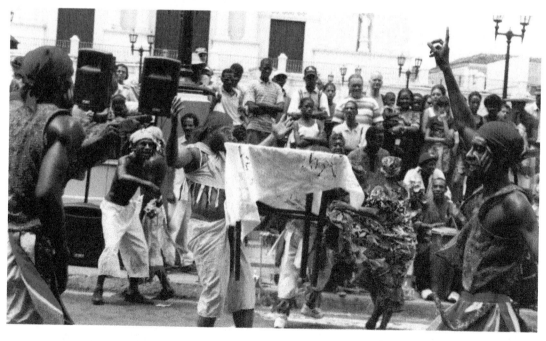

Figure 4. Majo Table peforming in folkloric spectacle. Grupo Abureyé Performance in Santiago de Cuba, June 2004. *Photo by author.*

In the process of staging Gagá as art, the sacred context and ritual grammars that give meaning to the festive form are reduced to key symbolic identity markers of *hatianidad* (Haitian-ness). The flags, batons, and machetes are no longer amulets of sacred power or linked to specific divinities. Instead, these objects, along with some key characters (e.g. *majo table* and *majo jonc/macete*) [*Fig. 4*] become props that distinguish the folkloric form from the more popularized Afro-Cuban religio-dance traditions that have had a much longer history of public staging.[26] Often structured around a linear processional formation, dancers crisscross the stage with the signature wide-legged stomping action that characterizes the grounded earth-bound quality of the dance. While the movements of the legs, sinuous swaying or rotation of the hips, and pulsating arms in an alternating downward pattern remain true to the dance, the spatial demarcations that separate dancers/revelers from the stationary groupings of musicians and chorus belie the original integrative form of the mobile procession. The presentation of performers into distinct areas on the stage, the dominant frontal positioning of the cast of characters, and more linear configuration of their placement creates a clearly defined boundary between spectator/performer—a distinction, which in its original aesthetic context, remains blurred.

One of the most characteristic features is displaying the athletic virtuosity of the male dancers. However, in the staged presentation, these feats of athleticism tend to dwarf the women, who are marginalized within the overall composition of the choreography. Moreover, the confidence that is inscribed onto the bodies of the traditional queens through their carriage and long, layered garments, reminiscent of the sacred vestment typically worn by servieurs, are replaced with outfits that reveal, rather than conceal. To this end, the female body is not positioned as a locus of feminine and spiritual strength, but instead reduced to a sign of the exotic to be observed.[27] The sacred knowledge that women are deemed to embody within Gagá bands finds no tangible expression on the concert stage. Instead, her sexualized posture is subject to an external gaze that trivializes the primacy of queens within the traditional hierarchy of Gagá bands. Despite the limited numbers of Haitian women migrating to Cuba, the significance of and reverence to the queens was maintained. The sharing of spiritual work between the genders that one witnesses in traditional Gagá performances mirrors the sacred pairing that undergirds the overarching cosmological orientation towards balance in the Vodou religion.[28] The queen's power is thus always in relationship with that of her male counterparts, the *prezidan* (president) and *kolonèl* (colonel), who then assist with the execution of the rites. The title of "queen" bespeaks her *konesans,* or intuitive knowledge and spiritual power. In many respects, the queens of Gagá invoke a regal lineage in the likeness of those linked to the Tajona and Tumba Francesa societies. However, in the staged version of the form she is marked as sexual 'other,' marginalized in the physical space and stripped of any reference to her significant status within the community of ritual adherents.

Further compounding the process of turning sacred rites into spectacle are the elisions that inevitably follow. In many ways the repertoire of Conjunto Folklorico and Cutumba kinesthetically and aurally embody the *ajiaco* stew that Fernando Ortiz offered as a culinary metaphor of *cubanidad* (1949). At the same time, the contextual framework of these forms, as well as the history and socio-cultural and political positioning of Haitian culture in Cuba, are erased. The historical marginalization of Haitians and their descendants are also absent from the corporeal narrative of *cubanidad.* Indeed, the repertoire of Haitian materials presents a visual and performative history of the migratory waves of Franco and Afro-Haitians and the significant cultural contributions made by the distinct groups that entered the island. The issues concerning their social and political marginalization, however, are glossed over with a smile. Certainly, there is a growing appreciation

of the diversity of Cuba and, by extension, a disruption of the mulatto imagery that has long identified Cuban culture and national identity. For many state officials in Santiago, including a former anthropologist with Casa del Caribe, José Millet, the cultural traditions in the east of the island are diverse and express "the uniqueness of Santiago as the cultural soul of Cuba." There is also an acknowledgement that "Haiti is central to this history, and we are proud to demonstrate it in our programming."[29] However, while some haitiano-cubanos are thrilled to be gaining greater exposure, others remain ambiguous about questions concerning cultural ownership and the representation of their traditions. As Sylvia Gardes, director of Mysterie d' Vodu states, "We have to be careful and make sure that our traditions are represented as they should be....That's why as Haitians we have to also be on stage presenting who we are."[30] While Haitian heritage communities are interested in validating their cultural forms and showcasing the different aspects of their customs publically, they are also concerned that they have had to struggle to maintain their identities in a hostile environment for several decades and hence want to have a say in how their cultural expressions become enveloped in national folkloric spectacles. Gagá is not solely a symbol of haitianidad, it is a lived cultural expression with sacred roots, a fact that many haitiano-cubanos are keen to guard through their own renditions at more intimate local events that they are developing, as well as in national celebrations.

I am reminded of Barbara Kirshenblatt-Gimblett's (1998) astute critique of national folkloric companies and the tendency to reclassify ritual as art, while at the same time raising questions concerning cultural ownership and difference:

> ...the proprietary rights to the material [folkloric repertoire performed by national companies] have been transferred from local areas to the "nation," where regional forms are declared national heritage. National troupes typically perform traditions from across the land, no matter what the personal histories of the performers. Since everyone can perform everything and everything belongs to everyone, *differences do not differentiate*. Polygot programs, besides offering variety, generally represent an "imagined community" in which diversity is harmoniously integrated. Difference is reduced to style and decoration, to spice of life. Cultural difference is then praised for the variety and color it adds to an otherwise bland scene. (65; emphasis added)

The question of difference, which folkloric companies attempt to produce through their diverse program, actually serves to dilute its oppositional potential. While I am cognizant of the various implications and dangers of the increased folklorization of Haitian forms, the results are more ambivalent and complex than what is often discussed. Indeed, there are risks in celebrating the superficial harmonious tapestry of cultural differences as they are presented in folkloric performances. Moreover, "valorizing an aesthetic of marginalization" (Ibid., 76) only serves to uphold the status quo and normative readings of culture. It further endorses frivolity, as opposed to encouraging critique and action. But, to dismiss these staged presentations as somehow aberrant and inherently lacking reduces their complex communicative power, as they do more than entertain. For the audiences that view them, these performances also have multiple meanings and speak to them in a multiplicity of ways. There is a tendency to leave the concerns of the actors and audience out of the equation, when in fact these are the people who will counter this very claim of superficiality.

Casa del Caribe & the Reframing of Cuba's Folkloric Paradigm

Defining Cuba's "national character" has been a pivotal feature of the discursive practice of the state and its shifting cultural politics. From the advent of tourism campaigns of the 1920s and the ensuing polemic surrounding the revolution of signs in the 1930s, Afro-Cuban cultural expressions

were reevaluated as official national signifiers. Moreover, African-derived religions emerged as the identifying marker of Cuba's cultural distinctiveness. Acclaimed Cuban ethnographer Fernando Ortiz reevaluated the maligned image of Cuba's African-derived religions and expressive forms as unique emblems of national cultural distinction.[31] Not to be relegated to the margins, religious expressions were to be reformulated as viable sources of Cuban folklore and popular culture.

Given the turbulent history of the systematic repression of Afro-Cuban religions (Matibag 1996; Ayorinde 2004), the radical shift from the overt displays of public hostility and, later, ambivalence toward black forms of worship and spirituality to the contemporary preponderance of representations of ritual performances in the streets and on the stage may occasion surprise. However, the consistent appropriation of Afro-Cuban religions, or what Carlos Moore (1988) has identified as "the repository of Cuba's most powerful cultural distinctiveness" (98), reveals the manner in which these popular forms are fully imbricated within the structure of state power (Routon 2010). With the formation of Cuba's national folkloric company, a template was set for the future secularization, commoditization, and folklorization of sacred and popular forms.

As a means of combating this trend of de-contextualization, Casa del Caribe inaugurated an alternative approach that attempts to retrieve the teachings, sacred arts, and ritual practice associated with African-derived religions from the margins of "folk practice" to a more central position within intellectual discourse. Through its annual Festival of Caribbean Culture with its attendant program of events, including symposia on popular culture and religion and the staging of rituals in curated presentations, Casa attempts to re-contextualize Cuba's diverse religious worlds. According to one of the Institute's founding scholars and previous director, Joel James Figarola, "Religion provides a window through which to examine the complex multidimensionality of an individual and collective sense of identity. It also helps us locate Cuba's pervasive African-ness."[32] Religion thus becomes a key lens through which to examine the lived experience of marginal communities. It also serves as a critical vehicle for examining the processes of intercultural exchange while at the same time celebrating the cultural expressiveness of Cuba's diverse religious landscape.

For its part, Casa del Caribe has grounded its official endeavors in a process of affirming and legitimating an array of ritual practices, as well as the practitioners (*portadores,* or tradition bearers) of African derived religions. This particular emphasis on the practice as preserved within families and communities has led to a focus on the moral authority of devotees (*creyentes*) and leaders (*santeros/as, paleros/as, manbos, houngans, espiritistas*) selected by senior cultural researchers working in Casa del Caribe. The center of authority for granting legitimacy to haitiano-cubano expressive forms has come through the efforts of this regional institution. Today, there is hardly a Haitian-Cuban community untouched by Casa's reach. Interestingly, while state intervention has grown to a certain degree in tandem with community initiatives, Casa's investment in exposing subaltern expressions has resulted in a hierarchy among folkloric troupes and, likewise, the popularity of certain communities and troupes over others. Over time, ritual specialists supported by cultural researchers at Casa del Caribe have gained greater spiritual capital and are benefitting from their access to broader, more expansive networks.

FROM STAGE to STREET Gagá in the Festival Circuit

One such performance space that is creating a new arena for communal gathering is the *Gran Gagá,* which has been part of the program of events in the annual Fiesta del Fuego sponsored by Casa del Caribe. Concerned that Gagá as a cultural practice is disappearing, I spoke to several Gagá performers in the summer of 2009 about the fate of the form:

Gagá will never die and it is not dying. We have just moved it from the bateyes to the streets and stages. We don't all live in the bateyes anymore and we don't all cut cane. Our foreparents did and they kept the Gagá alive in the bateyes because that was where they lived and worked, where they shared with one another....But we have other celebrations where we come together, like the Festival of Fire, and we have our own community celebrations in Ramon, San German, Cueto, and we dance Gagá then. The old people are tired of walking, but we will keep the tradition alive in our own way, in the streets, where we don't just sing to ourselves anymore but to everyone.... Now everyone wants to learn Kreyol in Cuba and learn our dances. It's even on the national stage.[33]

As a case in point, the Gran Gagá, which has been part of the festival program since 1994, presents an occasion where approximately ten to fifteen groups comprised of first-, second-, and third-generation Haitians take to the city streets of Santiago in a celebratory procession and performance. Those who assemble each year have extended their contractual agreements with the *lwa* to make this annual pilgrimage.

Lifted out of its Lenten season and outside of the forested environs, it may appear to be a more secular public spectacle, but I would argue that beneath the public transcript of playful festivity operates the seriousness of communal work [*Fig. 5*]. In this context the gods are not feasted in the exposed environment, but there exists the collective labor of fostering community and a shared identity through performance. Unlike its rural counterpart, the Gran Gagá presents an opportunity for several Gagá bands/sociétés and Haitian-Cuban communities to meet and celebrate. With many of the community members getting older, the trek through the countryside is growing more difficult. As a result, Gagá celebrations in the bateyes have been radically reduced to accommodate the inability of members to make the journey to neighboring bateyes.[34]

Today, the meeting of different Gagá bands in this annual street festival is reviving the sense of community, which was fostered by decades of marching through the cane fields. The occasion is therefore filled with excitement, as community elders reconnect with the extended family of Haitian descendants living across Cuba. Those who migrated to Havana and other parts of the island use the Gran Gagá as an opportunity to reestablish ties, foster new ones, and, in a sense, mold their own imagined communities outside the confines of the batey. No longer banished to their communities where they performed in insulated isolation for decades, by claiming the public space of the streets afforded them for that one day, disparate Haitian-Cuban communities assemble under one national flag and dance to one rhythm, regardless of their diverse experiences in Cuba. They are able to use their traditional festive form to celebrate their ethnic and cultural identity and in turn lay claim to their shared historical legacy and sense of belonging to Haiti, as well as the Cuban national space.

The Gran Gagá functions as its own discrete festival within the overall structure of events featured in the Festival of Fire. As such, it has its own internal logic and by extension operates somewhat outside of the template established by the Festival of Fire. As an example, festival organizers or researchers do not mediate the event. Moreover, because of its distance from the city center, it does not attract large crowds of tourists. One may conclude that the marginality of these communities and Haitians more generally is replicated in the placement of the event in the overall Festival structure. It is my contention, however, that this particular spatialization of the Gran Gagá has encouraged the transference of the integrity of the ritual structure within the overall festive frame. The performers thus view the Gran Gagá not as a performance for spectators, but for each other. As one *majó yonc* mentioned, "We dance for our ancestors in the batey and they look over us here in the city where we dance amongst our friends." [*Fig. 6*]

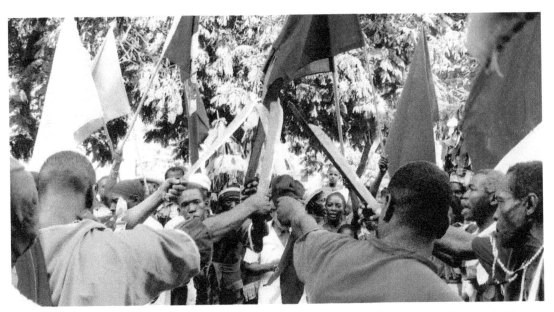

Figure 5. Majo Machetes performing in the Gran Gaga. July 2003. Santiago de Cuba. *Photo by author.*

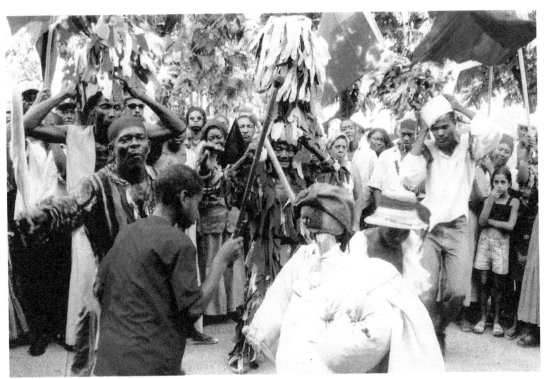

Figure 6. Gran Gagá celebrants - majo joncs dancing around dyab before setting it ablaze. Encircled by rua diable maskers protecting band and community members. With his multilayered strips of cloth reminiscent of a traditional egugun-like masquerade, the majo rua diable have been added in as the spiritual protectors of the band deflecting negative energies with their twirling cloth. *Photo by author.*

Gagá, as a traditional ritual and festive form, finds itself in ever-changing performance contexts. According to Nestor García Canclini, it is "doubly enrolled" in a *historical* (i.e. a process that gives identity to ethnic groups) and a *structural* (i.e. within the present logic of dependent capitalism)" paradigm (1988, 486; 1993, 45). However, in respect to the latter, Gagá's integration into this structural enrollment to which García Canclíni refers is tempered by Cuba's rather peripheral socio-political and economic positioning in the global economy. To this end, Gagá is yet to be inscribed within a strictly consumerist framework[35] in that it is not underwritten by multinational companies, corporations, or firms, but indeed still operates under the patronage of the gods, community members, and, to a growing degree, state institutions.

The argument here is that, despite the challenges of commercialization and folkorization, for popular cultural forms and identities deemed invisible and unworthy, their exposure can also be interpreted as a challenge to conventional notions of nation and identity. These twin processes (folklorization and commodification) also serve as a vehicle for giving expression and a space for alternative identities to be projected. While not immune to the dangers Barbara Kirshenblatt-Gimblett warns against, the theatrical spectacle has also proven to stimulate an indigenization process in the communities in which the forms emerged. What has become apparent is that, as these cultural expressions become more folklorized, they also enter a process whereby they are further traditionalized, forming what David Coplan (1994) has identified as a "dynamic of persistence" (19) amidst the changing realities and shifting performative contexts in which they are now operating. In other words, the folklorization process has encouraged the Haitian-Cuban field laborer, who also dances and drums in his/her ethnic enclaves to perform across wider performance circuits and in turn to reassess, reconfigure, and adapt what has been guarded as a traditional form. In publicly staging once private cultural forms, the descendants of Haitians are using their sacred traditions as a way of articulating their distinct identity. These staged events also serve as a catalyst for stimulating interest in maintaining these cultural performances so that they are not reduced to folly, but upheld as icons of a collective identity and as a marker of history. The cultural imperative to perform in today's Cuba also extends beyond the politics of national recognition. Through staging their rites for tourist consumption, haitiano-cubanos are using their traditions to make a viable living and gain much needed material resources to meet their needs. Dancing to their gods to the applause of foreigners is not simply the enactment of a quaint pastime, but an essential part of making a living in today's rapidly changing Cuba.

The staging of Vodú rituals for popular consumption goes beyond mere folkloric spectacle and entertainment to that of redefining and expanding the contours of Cuba's late socialist cultural patrimony and national identity. The new public spaces for expression that have opened up in the aftermath of Cuba's Special Period[36] have become critical for understanding contemporary cultural politics. State-sanctioned performances allow for an examination of inclusionary policies that focus on the exploitation of culture as a pivotal democratizing resource[37]. These also offer an opportunity to explore the agency of ordinary Cubans of Haitian descent as they express their ethnic heritage and social identities and in turn further nuance prevailing discourses on race, culture, and citizenship. As noted haitiano-cubano percussionist Yesel Espret notes in an interview conducted in 2009, "Today everyone wants to be Haitian, talk Haitian, dance Haitian and even you are here to study what it is like to be Haitian."[38] The once isolated mountain cultures of Oriente are thus part of an ever-expanding national identity adding another exotic mix to Cuba's multicultural folkloric imaginary. This increased public presence stands as an example of Cuba's protracted history of incorporating marginal citizens through the staging of folklore.[39] However, the late socialist context

presents an interesting moment for assessing how regional institutions interpret and galvanize the cultures of Cuba's marginal folk. It simultaneously asks us to consider the implications of the descendants of field hands becoming increasingly enrolled in folk tourism projects.

Conclusion

The increased public staging of Haitian-Cuban cultural expressions, like other black cultural performances endorsed by the Cuban state, have evoked contradictory reactions from the wider Cuban community, in particular those who do not share the same ethnic heritage. Many of the performers, as well as Haitian-Cuban community members, view the public re-enactments as a celebration of Cuba's cultural diversity and as a means of preserving and reclaiming marginal expressions through performance. For others Haitian forms have no place in the national folkloric repertoire because they do not coincide with the normative understandings of Cubanness. This particular tension speaks to the dynamic migratory history that has come to define Oriente as a culturally distinctive space from Havana, thus revealing the lack of a homogenous cultural sphere in Cuba.

This essay has also argued that each performance of Gagá brings its own localized and spatialized meanings, thus it calls into question any view of a universal Gagá in terms of form and functions. Gagá is inherently malleable, and for that reason is subject to repeated appropriations, not only by national companies, but also by descendants of Haitians wanting to reconnect with their historical experience and commemorate their collective identity and sense of community through their own local celebrations. As Dolores Yonker (1988) reminds us, "Rara [Gagá] emphasizes movement in space rather than observances at fixed locations" (151). To this end, the process of deterritorialization and subsequent reterritorialization across geographical locales and spaces is indicative of the inherent migratory and dialogical structure that governs the form. I caution that if we deny the creative agency of its performers to resignify their practices as they traverse different contexts, we miss the dynamic logic that is at the ontological root of Gagá. Gagá is at its core about crossings, passages, and journeys, linking the sacred and secular realms of existence with the communities and territories they pass through, solidifying the identities of those in the immediate space of its enactment and also reaching across to those who exist in different environments.

In this vein, Gagá evokes a transnational performance geography that bespeaks the foundational role of Vodou in the diasporic experience of Haitian migrants. Its presence in Cuba attests to the ways Haitians have historically used their popular cultural forms to create expansive "social fields" that allow them to re-root themselves in the diverse spaces they call home, while maintaining a connection to the homeland, either literally or figuratively (Basch, Schiller, and Blanc 1994; McCarthy Brown 1997; McAlister 2002). The argument here is that the facilitation of this diasporic cultural formation and the subsequent fashioning of diasporic subjectivities emerge out of this process of dislocation and relocation (Alleyne-Dettmers 2005).

Haitiano-cubano expressive culture is a hybrid form that configures a distinct ethnic/cultural identity that in fact embodies the plurality of contemporary cubanidad. At the same time, the expansive networks and diverse social contexts of cultural performance have been instrumental in satisfying the contemporary integrationist polices of the Cuban state. In the countryside, Gagá and other Haitian expressive forms have served to articulate a sense of belonging for the descendants of displaced migrants and a corporeal diasporic consciousness. As Gagá moves to the stage, it increasingly becomes an emblem of Cuba's diverse heritage. What Gagá reveals is the manner in which cultural forms are reconstituted over time, thus taking on new and expansive meanings and socio-cultural functions in and through varying social and national contexts.

Notes

This article first appeared in e-misférica 12.1 Caribbean Rasanblaj. This was a special double issue for the NYU hemispheric Institute of Performance and Politics edited by Gina Athena Ulysses, 2015. Ethnographic and archival research for this essay grew out of my dissertation fieldwork, which was funded by The Social Science Research Council and the Wenner Gren Foundation for Anthropological Research.

1. Throughout this essay readers will encounter the terms "Rara" and "Gagá" used interchangeably, in part because, in Cuba, both are used to reference this Haitian festival tradition. For clarity, I will use "rara" when specifically speaking of the festival form in its Haitian context and "gagá" or "ban rara" when speaking of the Cuban context. This article grows out of a larger manuscript entitled *Haiti in Cuba's Folkloric Imaginary,* which examines the dynamic interplay of cultural performances and identity formation among Cubans of Haitian descent. The Social Science Research Council and the Wenner-Gren Foundation for Anthropological Research supported ethnographic and archival research conducted in summer 2000 and 2001-2004 The Graduate Institute of the Liberal Arts and the Institute of African Studies, Emory University provided additional funding.

2. Cuba received two significant migratory flows from Haiti, the first in the late eighteenth and early-nineteenth century period of the French *emigres* class and their enslaved domestics. This group, called the *francesas,* developed the famed Tumba Francesa mutual aid societies. The second and more substantial migration was centered around the first three decades of the twentieth century, with numbers ranging from 200,000 to 600,000. See Pérez de la Riva (1979); Alvarez Estévez (1988); Carr (1998).

3. I utilize the Cuban spelling "Vodú" in reference to the hybrid religious tradition observed in Cuba, which is derived from the Haitian cosmological universe. The spelling speaks to the process of syncretic transformations the religion underwent upon being brought to Cuba by Haitians and maintained by their descendants. I use "Vodou" in reference to discussing Haitian and not Haitian-Cuban practices.

4. For more on the placement of Haitians in eastern Cuba, see Yanique Hume, 2011, "On the Margins: The Emergence of a Diasporic Enclave in Eastern Cuba," in Regine O. Jackson (ed) *Geographies of the Haitian Diaspora* (NY: Routledge).

5. Most notable among these institutions is Casa del Caribe, which was founded in 1981 in the eastern city of Santiago de Cuba.

6. Interview with Barranca resident, Berta Armiñan, March 16th, 2003. All interviews and personal communications cited were conducted in Spanish or Cuban Kreyol and translated by the author.

7. The peak periods of Antillean labor migration to Cuba (1906-1933) also coincided with the rampant anti-*brujería* campaigns to eradicate Cuba of atavistic practices. Afro-Cubans and Haitians, in particular, often fell prey to the accusation of Rural Guards declaring that they were stealing children to perform human sacrifices. See Helg (1997). Throughout this essay I will utilize the spelling Vodú when referencing the hybrid religious form that developed in Cuba as a derivative of its Haitian counterpart, Vodou. This distinction is important for while the cosmological structure remains intact, Cuban Vodú developed under specific socio-cultural conditions and in relation to a diverse array of religious expressions found in Cuba.

8. Characters are composed of a hierarchy of ritual specialists, musicians, dancer queens (both dancers and keepers of the ritual knowledge), flag-bearers, and baton-twirlers. Each plays their specialized tasks including clearing a path for the safe passage of bands, conducting rites, dictating the pace of the musical arrangement and singing of songs, soliciting monetary contributions. Rara/Gagá bands are also comprised of revelers who move in and out of the procession, blurring the lines between performer and spectator.

9. Verna Gillis and Gage Averill (1991), however, note that while Rara is associated with Lent, it is not bounded exclusively to a specific season, but instead is performed as needed. As a grassroots cultural expression, Rara is used by political leaders as well as the people to voice particular concerns, thus, "despite its seasonal association, rara can take place at any time of the year and animates political rallies, demonstrations, and celebrations of all types" (3). See also Michael Largey (2000).

10. The burning of an effigy is a popular subversive act in most carnival traditions of the Circum-Atlantic. Within the specific case of Rara in Haiti, the image of the Jew or jwif is collapsed into that of Judas, who was blamed for the killing of Christ. For McAlister (2000), the Jew in Haiti is a central

referent for the "other," difference, and an anti-Christian force. In Cuba the jwif does not evoke religious sentiment, nor is it identified with a specific ethnic or religious community. Instead, the burning of the jwif/dyab represents the purging of negativity and/or forces of oppression.

11. Haitian heritage communities spanning across Camagüey, Las Tunas, Ciego de Avila, Santiago de Cuba, Guantanamo, and Holguin, routinely come together in ritual feasts that are parties for the lwa. The height of the ritual season is in June, around Ogou's feast day, and December, where Gran Bwa and other divinities are honored. These occasions for ceremonial gathering haves expanded into a rather elaborate festive terrain of community events initiated by members of these longstanding communities.

12. The rampant brujería [witchcraft] scare in Cuba during the early twentieth century coincided in great part with the increased numbers of Antillean immigrants entering the island at first seasonally and later on a more permanent basis. These Black Caribbean laborers were imagined to be not only socially and culturally other, but indeed a threat to the social fabric of Cuba. Haitians in particular were consistently vilified and feared because of their perceived moral degeneracy and proclivity for witchcraft. For more on the treatment of Haiti in the nineteenth and early-twentieth century, see Helg (1997); Carr (1998); and McLeod (1998).

13. In his 1983 publication *Procesos Ethnoculturales de Cuba*, Cuban historian Jesus Guanche notes that *La Persévérance* and *La Concorde* are reported to be first Masonic Lodges founded in Cuba by the French immigrant class fleeing the turmoil of the revolution in Haiti. Approximately three years later in 1792, the first *Sociedades de Tumba Francesa* (French Drum Societies) were founded by enslaved and free Black franceses as mutual aid organizations that provided a social forum that proved critical to the maintenance and development of cultural expressions, like the creolized contradance (Tumba Francesa), which shares the same name as the fraternal organization.

14. For more on Gagá in the rural environs of eastern Cuba, see Jorge Berenguer Cala, *El Gagá de Barranca* (2006); Jesús Guanche and Dennos Moreno, *Cadije* (1988); and Alberto Pedro, "La Semana Santa Haitiano-Cubana" (1967).

15. Rehearsals have long been a feature of Gagá whereby the normative six weeks of parading the streets are placed into six days of feasting and practicing in the compound of the owner of a Gagá band. The community would prepare their arrangements to the music of accompanying percussive instruments, including the now defunct *caolina*, or what Harold Courlander in his 1960, *The Drum and the Hoe*, identified as the *tambor maringouin* (mosquito drum). The days of rehearsals culminate in a procession through the cane fields on the Saturday just before Easter Sunday.

16. The term *majó* means "major," or a title of authority and knowledge bestowed onto those who master a particular performance skill, such as baton or sword twirling. The use of military or aristocratic titles in Caribbean festive forms is quite abundant. For more, see David H. Brown, *Santeria Enthroned* (2003).

17. Critical to the success of the rites performed by the Gagá ensemble is the mobile orchestra that provides the necessary musical accompaniment and songs to invoke the spirits. While there is no set template for the configuration of the orchestra, the instrumental ensemble is loosely structured around several lines of musicians playing a wide range of percussive instruments. Among the instruments featured are the carved conical Petwo drums, *gwo baka* and *ti baka*, *tambourin*, which is known as the *basse* in Haiti. This hand-held bass drum head is played in a similar fashion as a tambourine. However, unlike the shrill sound of a tambourine, the *tambourin* produces sounds that are relatively low in register. Accompanying the drums is a *samba* (known as an *ogan* in Haiti), a hoe blade that is played with a piece of metal to keep time. The *lanbi*, or conch shell trumpet, is a common signaling device that is used to set the tempo and mark any shift in the velocity of the drum rhythms. The *baccine* (vaksin) are the instruments most readily associated with Rara/Gagá music. They are hollowed pieces of bamboo of varying lengths that are used as a flute to produce either high or low tones. The bamboo or plastic (PVC pipe) *baccine* are also joined by the *klewon*, a foot-long handmade metal trumpet that flares at the end. Together these instruments create the syncopated and melodious soundscape that collectivizes the crowd in communal ritual action and liberates them to gyrate to the bawdy and robust reverberations. For more on these instruments and Haitian music in general, see Gage Averill (1997) and Averill and Yih (2000).

18. For more on the multidimensionality of Ogun, see Sandra Barnes (1988).

19. Interview with drummer Emilio Milanes, Palma Sorriano, Cuba, July 8, 2009.

20. For more on Haitian transmigrants, see Laguerre (1998); Glick-Schiller and Fouron (2001).
21. The continuous transnational flow of Haitian students enrolled in tertiary institutions is the most sustained contact between the two countries. When I first started conducting research in these communities fifteen years ago, the degree of social interaction with Cuba's Haitian heritage communities was quite minimal, if existent at all. However this reality is shifting.
22. In 1963 and 1964 the famous Conga Los Hoyos, under the direction of Juan Esparraguerra, included Gagá choreographic sequences for the first time in their Carnival procession. In contemporary Carnival processions, Gagá dances are not as visible; instead the annual Festival of Caribbean Culture (Fiesta del Fuego) is the event where Gagá and other Haitian-Cuban dances are most predominantly exhibited.
23. *Sociedades de Tumba Francesa*, as Rafael Brea and José Millet (2001) suggest, "are social clubs and mutual aid societ[ies] founded by Black and French-Haitian mestizos, self-named 'franceses'... Its festivities were under the protection of virgin and saints whose images are hung on the walls, next to photographs of Cuban patriots, some of whom participated in the festivities before going to the War of Independence" (204). In 2003, UNESCO declared the Sociedad de Tumba Francesa and Tajona Masterpieces of the Oral and Intangible Heritage of Humanity.
24. The *contradanse* sets performed by Tumba associations and within the folkloric repertoires include *mason, yubá*, and *frenté*. Each of these forms expresses a corporeal confluence of European and African aesthetic features, including an upright carriage of the torso juxtaposed against a more relaxed waistline and pelvic girdle. In the case of frenté, the more African component is expressed in the improvisational skills that showcase intricate polyrhythmic footwork.
25. Interview with Antonio Perez, Santiago de Cuba, 3 June 2001.
26. For more on the staging of Afro-Cuban sacred forms, see Katherine Hagerdorn (2001).
27. For more on women in Vodou see Joan Dayan (1994) and McCarthy Brown (1997).
28. This mystical totality within Vodou cosmology is represented in the androgynous divinities Legba and Gede, and also manifested in the cosmic couples Dambala and Ayida Wedo, Agwe and La Siren, as well as the sacred twins, Marassa.
29. Interview with José Millet conducted in Casa del Caribe, Santiago de Cuba, 18 July 2002.
30. Interview with Sylvia Gardes, 15 July 2009.
31. The writings of Fernando Ortiz have been pivotal to the formation of Afro-Cuban Studies. For more on the shifts in his perspectives concerning the location of blackness within the study of Cuba, see Robin Moore (1994).
32. Personal communication, Joel James Figarola, Santiago de Cuba, 10 July 2000
33. Informal interviews and conversation with Gagá performers in Santiago de Cuba, 2009. The discussion was recorded on a bus ride back to the hotel where rural Haitian-Cuban bands were staying during the weeklong Festival activities.
34. The aging population of *haitiano-cubano* batey residents and the increased migration of Cubans of Haitian descent to neighboring towns and urban centers has borne witness to a radical decline, since the early 1990s, in the customary annual spring Gagá processions. Thus, only two or three communities observe a scaled down version of the rites in local bateyes, and their celebrations are not always observed during the annual Holy Week. The communities that still observe the events during Semana Santa (Holy Week) include Cadije, Barranca, and La Caridad.
35. In their work on the intersections of festivals and cultural politics in Puerto Rico and Venezuela, respectively, both Arlene Davila (1997) and David Guss (2000) interrogate the role of multinational companies and their sponsorship of community and state-sanctioned public festivals. This trend is, however, notably absent from Cuba's socialist context.
36. Cuba's "Special Period" roughly corresponds to the decade of the 1990s following the demise of the Socialist Bloc where Cuba entered a period of austere economic restructuring and increased socio-economic deprivation. In the wake of this period of insecurity, Cuba witnessed the emergence of diverse cultural practices and increased cultural production with alternate formulations and critique of cultural identity.
37. For more on the uses of culture as resource, see Yúdice (2003). For an elaboration of contemporary Cuban cultural politics and ideology, see Hernandez-Reguant (2009).
38. Telephone interview with Haitian-Cuban percussionist, Yesel Espret. 15 May 2009.
39. See for example Hagerdorn (2001), Knauer (2009), and for contemporary discussion on "folklore," see Hernandez-Reguant (2009) and Viddal (2012).

Work Cited

Alleyne-Dettmers, Patricia. 2005. "The Relocation of Trinidad Carnival in Notting Hill, London and the politics of Diasporisation." In *Globalisation, Diaspora and Caribbean Popular Culture*, eds. Christine G. T. Ho and Keith Nurse. Kingston: Ian Randle Press.

Alvarez Estevez, Rolando. 1988. *Azúcar e inmigración 1900-1940*. Havana: Editorial Ciencias.

Averil, Gage and Verna Gillis. 1991. *Caribbean Revels: Haitian Rara and Dominican Gagá* CD Liner Notes. Washington: Smithsonian Folkways (orig. Record Album No. FE 4531 (1978)).

Averil, Gage. 1997. *A Day for the Hunter a day for the Prey: Popular Music and Power in Haiti*. Chicago: University of Chicago Press.

Averill, Gage, and David Yih. 2000. "Militarism in Haitian Music." In *The African Diaspora: A Musical Perspective*, ed. Ingrid Monson, 267-93. New York: Garland.

Ayorinde, Christine. 2005. *Afro-Cuban Religiosity, Revolution, and National Identity*. Gainesville: University Press of Florida.

Basch, Linda, Schiller Nina and Blanc, Christina. 1994. *Transnational Projects, Postcolonial Predicaments and Deterritorialized Nation-States*. New York: Routledge.

Barnes, Sandra. 1997. *Africa's Ogun: Old World and New (African Systems)*. Bloomington: Indiana University Press.

Berenguer Cala, Jorge. 2006. *El Gagá de Barrancas*. Santiago de Cuba: Ediciones Santiago.

Bettelheim, Judith. 1994. "Ethnicity, Gender and Power: Carnaval in Santiago de Cuba. In *Negotiating Power: Gender, Sexuality and Thetricality in Latin/o America*, eds. Diana Taylor and Juan Villegas, 176-212. Durham: Duke University Press.

—— (ed.) 2001. "The Tumba Francesa and Tajona Societies of Santiago de Cuba." In *Cuban Festivals: A Century of Afro-Cuban Culture*, ed. Judith Bettelheim, 141-153. Kingston: Ian Randle Publishers.

Carr, Barry. 1998. "Identity, Class, and Nation: Black Immigrant Workers, Cuban Communism, and the Sugar Insurgency 1925-1934." *Hispanic American Historical Review* 78(1) (Feb. 1998): 83–116.

Coplan, David. 1994. *In the Time of Cannibals: Word Music of South Africa's Basotho Migrants*. Chicago and Johannesburg: University of Chicago and Witwatersrand University Presses

Davila, Arlene. 1997. *Sponsored Identities: Cultural Politics in Puerto Rico*. Philadelphia: Temple University Press.

Dayan, Joan. 1994. "Erzulie: A Woman's History of Haiti." *Research in African Literatures* 25(2) (Summer): 5–30.

Deren, Maya. 1953. *Divine Horseman: The Living Gods of Haiti*

García Canclini, Néstor. 1988. "Culture and Power: The State of Research." *Media, Culture and Society* 10: 467-497.

——. 1995. *Hybrid Cultures: Strategies for Entering and Leaving Modernity*. Minneapolis: University of Minnesota Press.

Gilroy, Paul. 1993. *The Black Atlantic: Modernity and Double Consciousness*. London: Verso.

Glick-Schiller, Nina and Georges Eugene Fouron. 2001. *George Woke Up Laughing: Long Distance Nationalism and the Search for Home*. Durham: Duke University Press.

Guanche, Jesus. 1983. *Procesos Ethnoculturales de Cuba*. Havana: Letras Cubanas.

Guanche, Jesús and Dennos Moreno. 1988. *Cadije*. Santiago de Cuba. Editorial Oriente.

Guss, David. 2000. *The Festive State: Race, Ethnicity, and Nationalism as Cultural Performance*. Berkeley: University of California Press.

Hagerdorn, Katherine. 2001. *Divine Utterances: The Performance of Afro-Cuban Santiería*. Washington D.C.: Smithsonian Institution Press.

Hall, Stuart. 1990. "Cultural Identity and Diaspora." In *Identity: Community, Culture, Difference*, ed. Jonathan Rutherford, 222-237. London: Lawrence and Wishart Ltd.

Helg, Aline. 1995. *Our Rightful Share: The Afro-Cuban Struggle for Equality 1886–1912*. Chapel Hill: University of North Carolina Press.

Hernandez-Reguant, Ariana, ed. 2009. *Cuba in the Special Period: Culture and Ideology in the 1990s*. New York: Palgrave Macmillan

Ho, Christine G.T. and Keith Nurse, eds. 2005. *Globalisation, Diaspora and Caribbean Popular Culture*. Kingston: Ian Randle Press.

Hume, Yanique. 2011. "On the Margins: The Emergence of a Diasporic Enclave in Eastern Cuba." In *Geographies of the Haitian Diaspora*, ed. Regine O. Jackson, 71-90. London: Routledge.

Kirshenblatt-Gimblett, Barbara. 1998. *Destination Culture: Tourism, Museums, and Heritage.* Berkeley: University of California Press.

Knauer, Lisa. 2009. "Afrocuban Religion, Museums and the Cuban Nation." In *Contested Histories in Public Space: Memory, Race and Nation,* eds. Daniel Walkowitz and Lisa Maya Knauer, 280–310. Durham, NC: Duke University Press.

Laguerre, Michel. 1998. *Diasporic Citizenship: Haitian Americans in Transnational America.* Basingstoke: Macmillan Press Ltd.

Largey, Michael. 2000. "Politics on the Pavement: Haitian Rara as Traditionalizing Process," *Journal of American Folklore* 113(449): 239–254.

Matibag, Eugenio. 1996. *Afro-Cuban Religious Experience: Cultural Reflections in Narrative.* Gainesville: University Press of Florida.

Montero Myara. 1992. *Del roja de su sombra.* Barcelona: Tusquets Editores.

Moore, Robin. 1994. "Representations of Afrocuban Expressive Culture in the Writings of Fernando Ortiz." *Latin American Music Review* 15(1) (Spring/Summer 1994): 32–54.

Moore, Carlos. 1988. *Castro, the Blacks, and Africa.* Los Angeles: Center for Afro-American Studies.

McAlister, Elizabeth. 2000. "'The Jew' in the Haitian Imagination: Pre-Modern Anti-Judaism in the Postmodern Caribbean." In *Black Zion: African American Religious Encounters with Judaism,* eds. Yvonne Chireau and Nathanial Deutsch, 203-228. New York: Oxford University Press.

——. 2002. *Rara! Vodou, Power, and Performance in Haiti and Its Diaspora.* Berkeley: University of California Press, Ltd.

McCarthy Brown, Karen. 1997. "The Power to Heal: Haitian Women in Vodou." In *Daughters of Caliban: Caribbean Women in the Twentieth Century,* ed. C. L. Springfield, 123-142. Bloomington: Indiana University Press.

Ortiz, Fernando. 1940. "Actas de la Sociedad del Folklore Cubano." *Archivos del Folklore Cubano* 1(1): 76–90.

——. 1949. "Los Factores humandos de la cubanidad." *Revista Bimestre Cubana.* 14(3): 161–86.

Pedro, Alberto. 1967. "La Semana Santa Haitiano-Cubana." *Etnologia y Folklore* 4 (Julio-Diciembre): 49-78.

Ramsay, Kate. 1997. "Vodou, Nationalism, and Performance: The Staging of Folklore in Mid-Twentieth-Century Haiti." In *Meaning in Motion: New Cultural Studies of Dance,* ed. Jane Desmond, 29–54. Durham: Duke University Press.

——. 2002. "Without One Ritual Note: Folklore Performance and the Haitian State, 1935-1946." *Radical History Review* 84 (Fall): 7–42.

——. 2011. *The Spirits and the Law: Vodou and Power in Haiti.* Chicago: University of Chicago Press.

Routon, Kenneth. 2011. *Hidden Powers of State in the Cuban Imagination.* Gainesville: University Press of Florida.

Stanley-Niaah, Sonjah. 2008. "Performance Geographies From Slave Ship to Ghetto." *Space and Culture* 11(4): 343-360.

Thompson, Krista. 2007. "Performing Visibility: Freaknic and the Spatial Politics of Sexuality, Race, and Class in Atlanta." *TDR: The Drama Review* 51:4 (Winter): 24–46.

Viddal, Grete. 2012. "Vodú Chic: Haitian Religion and the Folkloric Imaginary in Socialist Cuba." *New West Indian Guide* 86(3-4): 205–36

Puri, Shalini. 2003. *Marginal Migrations: The Circulation of Cultures within the Caribbean.* Oxford: Macmillan Caribbean.

Yonker, Dolores. 1988. "Rara in Haiti." In *Caribbean Festival Arts: Each and Every Bit of Difference,* eds. John Nunley and Judith Bettelheim, 147–55. Seattle: Washington University Press.

Yúdice, George. 2003. *The Expediency of Culture: Uses of Culture in the Global Era.* Durham, NC: Duke University Press.

Visuality and the
Caribbean Imaginary

The Evidence of Things Not Photographed:
Slavery and Historical Memory in the British West Indies

Krista Thompson

Slavery and the period of apprenticeship came to an end in the British West Indies in 1838, the year photography was developed.[1] The twilight of slavery occurred as the new medium literally came to light. Superficially, the two moments would seem unrelated: they would seem to be two events falling in separate historical forests. Slavery's occurrence outside the purview of photography would, however, profoundly inform how the pre-emancipation era in the British Empire was reproduced, remembered, or willfully forgotten. If, as photography historian Alan Trachtenberg postulates, "historical knowledge declares its true value by its photographability," what impact would photography's development at the end of slavery have on the production of history in the African diaspora within the British West Indies specifically?[2] How would the fact of slavery in Britain's colonies accrue its historical valence without photography as firsthand witness?

Despite this absence of photographs dating from the pre-emancipation era, and perhaps because of the intimate relationship between the camera and the production of modern forms of historical knowledge, some historians of the Anglophone Caribbean have drawn on photographs – albeit images from the late nineteenth century – to give slavery historical form in their accounts. It is this use of photographic archives to represent slavery in the West Indies in popular and scholarly accounts that I investigate in this essay. How does the employment of photographs that date from almost a century after emancipation dramatically transform the visual imagination of slavery in the Anglophone Caribbean? How does photography cloud or bring into focus the memory of slavery? While the use of late nineteenth-century photographs may obstruct from view aspects of the history of slavery, this occlusion may in fact be revelatory. The reproduction of these photographic images may bring to the fore ways of remembering and ways of reconfiguring photographic representation, memory, and history in the African diaspora. Indeed, the transposition of accounts of slavery and photographs from the late nineteenth century in some historical accounts may aptly capture what Toni Morrison characterizes as "rememory" among enslaved Africans and their descendants – the ruptures in space and time and the ever-presentness of the past that are intrinsic to the memory of slavery and to the formation of the African diaspora more generally.[3] The presentation of late nineteenth-century photographs as the pictorial face of slavery might precisely visualize the continuities between the period of slavery and post-emancipation, the ghostly and all too real reappearance of forms of unfreedom past. As such the reproduction of photographs in contemporary historical accounts may highlight new ways of reading photographic archives from the perspective of African diasporic subjects and alternate ways of bringing to light the histories of the enslaved and their descendants.

The complexities of creating histories of slavery in the Anglophone Caribbean through the lens of photography can be seen in the volume *Slavery, Abolition, and Emancipation: Black Slaves and the British Empire*, a book that is symptomatic of the problem of the photographic in studies

Reprinted with permission from *Representations* 113 (Winter 2011): 39–71. Published with the permission of University of California Press Journals.

of slavery in the British West Indies.[4] Three eminent and prolific historians of the Anglophone Caribbean, Michael Craton, James Walvin, and David Wright, produced the collection of essays and primary documents in 1976. In it, they set out to present what they describe as a reexamination of slavery in the face of the unbalanced focus on the abolitionist movement in historical scholarship. To provide a more holistic consideration of black slaves, they place equal weight on six periods, whose chapter titles are "African Slave Trade," "Plantation Slavery," "Slavery and the Law," "Anti-Slavery," "Abolition," and "Emancipation." The period of apprenticeship in 1838 bookends the publication's historical coverage, and photographs appear as illustrations throughout the book. Coincidentally, 1838 is the same year that Frenchman Louis Jacques Mandé Daguerre announced the invention of a photographic process he called the daguerreotype, which fixed the impressions of light as created in the camera obscura on a metal plate, creating a nonduplicatable, laterally reversed, monochrome picture. Immediately following his pronouncement, numerous persons working in a variety of locations, including England, Germany, and Brazil, came forward to show how they too had been working on the idea of making permanent photographic images from nature. Perhaps the most recognized of these was the Englishman William Henry Fox Talbot.[5] He created "photogenic drawings" in 1833 and eventually patented a paper-based negative-positive system in 1841.[6] While Talbot, and before him the Englishmen Henry Brougham (working in 1795), Tom Wedgwood and Humphry Davy (1802), the Americans Samuel Morse (1821–1823), James Miles Wattles (circa 1828), Frenchman A. H. E. (Eugène) Hubert (the 1820s), and French-born Brazilian Hercules Florence (the 1830s), among others, all worked on photographic and protophotographic processes, it was Daguerre's photography method that gained the greatest global currency in the 1840s and 1850s.[7] Indeed, by the early 1840s, a photographer in Jamaica, Adolphe Duperly, opened the first daguerreotype studio in Kingston, but this came after the period of apprenticeship.[8] It is the presence of photographs in the Craton, Walvin, and Wright text on the slavery and the immediate post-emancipation period – an era that predates the earliest uses of photography in Jamaica – that will serve as a point of departure in this consideration.

The frontispiece of *Slavery, Abolition, and Emancipation* reproduces two photographs of black laborers standing amid sharp blades of sugarcane (fig. 1). In the bottom image, four male figures (and one cut off by the frame) turn toward the camera. The two central figures hold up machetes, proffering the tools as photographic props. Just above the image of the men, in a shape oddly incongruous with that of its neighbor, another photograph pictures several women, all of whom also address the camera. Two of them appear to chew on the fruits of their labor, while the central figure rests her head in her hand in a gesture that seems to suggest both tired repose and self-aware pose. Not only do the figures appear in their dual group portraits in the frontispiece, but their individually framed countenances also stare out from the book jacket and at the beginning of each chapter. Since the photographs appear with no information about their producer, without titles or dates, they come to bear the representational weight of the chapters they introduce (figs. 2, 3, 4). As the subjects of the only images in the book, the bodies of these laborers, shown at work and at photographic rest, serve as visual proxies for the black experience of slavery in the British Empire.

The images, although enlisted in a certain historical recounting of slavery, however, do not date from the era of enforced labor at all, but from the end of the nineteenth century. They were also not created as two separate representations, but as a single photograph entitled *Cane Cutters, Jamaica*, taken on the island by an agent of the Scottish photo-publishing firm James Valentine and Sons in the early 1890s (fig. 5). The company, which advertised itself as "photographers to the Queen," came to the British crown colony on the invitation of the governor in 1891.[9] If the photograph can be

seen as representative of transitions of labor at all (as suggested by the placement of the images at the opening of each period-focused chapter), it is Jamaica's transition to a tourism economy and its closely related fruit trade in the late nineteenth century that informs the photograph's production.

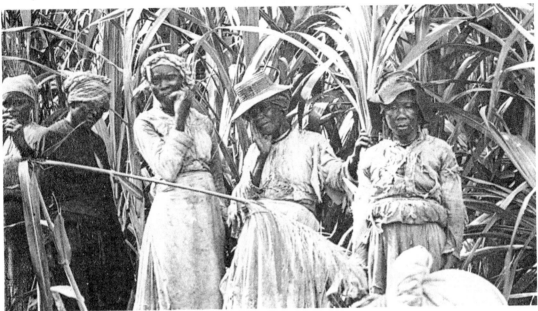

Figure 1. Frontispiece to Michael Craton, James Walvin, and David Wright, *Slavery, Abolition, and Emancipation: Black Slaves and the British Empire* (London, 1976). *Reproduced by permission of Pearson Education.*

Figures 2, 3, 4. (*left, center, right*). Opening images, chapters 1, 2, and 4, in Craton, Walvin, and Wright, *Slavery, Abolition, and Emancipation. Reproduced by permission of Pearson Education.*

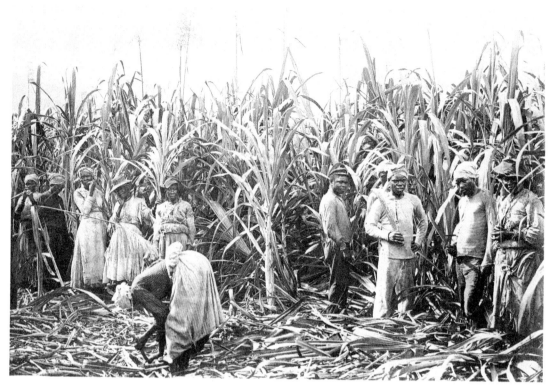

Figure 5. James Valentine and Sons, *Cane Cutters*, Jamaica, 1891. *Reproduced by permission of Onyx: The David Boxer Collection of Jamaican Photography.*

Figure 6. Photographer unknown, *The Great Exposition, Jamaica*, 1891. *Collection of the author.*

Tropical Modernity: Photography and Developing the New Jamaica

Starting in 1889, Jamaica's British crown government, the white mercantile elite, and their British and American corporate bedfellows aimed to promote a new ideal of the colony for the purposes of promoting tourism and a new fruit trade, particularly in bananas. Toward this end, tourism and fruit industry advocates in Jamaica organized an international exhibition in 1891 that they hoped would bring new visibility to what they deemed "the New Jamaica" as an "unequal health resort and as a profitable field of settlement for would-be British Colonists or United States citizens" (fig. 6).[10] The American United Fruit Company and the British Elder, Dempster, and Company – both of which transported tourists and bananas on their steamships – were doubly invested in refashioning the island. After the rapid decline of the colony's once crowning sugar industry in the early nineteenth century, the island's ruling classes complained that Jamaica could "hang only on the skirts of modern civilization."[11] Through tourism and new commerce, however, they prophesied that the New Jamaica, in the words of one hopeful resident, would "be 'discovered' in the modern sense, and if we succeed in pleasing the fastidious taste of the class [of tourists]...we may also in the modern sense be 'made.'"[12] Photographs, like the one Valentine and Sons created, were central to the formation and propagation of these ideals.

To bring about "the New Jamaica," promoters discerned that they had to create images to dispel widespread fears of the tropics as a place of death and disease, and, more specifically, they had to debunk concerns that Jamaica had been "ruined" by emancipation. As a contemporaneous newspaper editor put it in 1892, "The popular idea of Jamaica at home [in Britain] is of an island ruined by emancipation, a region of derelict estates with a scattered population of negro squatters, paying no rent, living in squalid huts, supporting life on yams and bananas."[13] Crafters of Jamaica's new image enlisted British, American, and local photographers to produce, perpetuate, and project a new vision of the post-emancipation era in the British colony. Their images often circulated as lantern slides, illuminating the faces of audiences; as photographs at colonial exhibitions, offering inhabitable vistas for international audiences; as representations in illustrated guides, providing visual testimony in texts; as stereographs, presenting privately experienced three-dimensional views of the island and its inhabitants; and as postcards, providing miniature and portable souvenirs of the colony. *Cane Cutters*, in particular, formed part of a series that imagers of the New Jamaica enlarged to 21 by 15 inches and used at the Jamaica pavilion at the Columbian Exposition in Chicago in 1893. The photographs, as the Kingston *Daily Gleaner* reported, served to "give the passing visitor an instant idea of the beautiful scenes to be found on our sunny Caribbean island."[14] The Valentine and Sons images were also offered for sale as visual mementos in local shops in Kingston and, starting in 1903, circulated as picture postcards.[15] *Cane Cutters* then formed part of a schematic effort to advertise Jamaica, as one member of the Legislative Council in Jamaica recognized in 1904, "more than she had ever been advertised in her social history in every way."[16]

Promoters of the New Jamaica often sought to advertise the island's landscape as tropical and bountiful, appealing to travelers' tastes for picturesque scenes and appetites for new fruits. This may explain why in Valentine and Sons' *Cane Cutters* sugarcane commands the focal point of the image. Nature is not simply the stage on which the scene is set, but its main actor. Indeed, the centrally positioned stalk of sugarcane assumes a dominating and almost figural presence in the image, and the cane fields generally subsume the laborers in the photograph.

The fecundity of nature is further emphasized through the three figures posed as if consuming cane, an act that likely sought to communicate, in part, the idea that the island's black inhabitants could sustain themselves on the fruit of the land.[17] The repetition of this trope in other contemporaneous

photographs gives some indication of the significance of this performance of tropicality. In a postcard by the local photography firm A. Duperly and Sons, for instance, several laborers in a cane field, namely those who pose on the ground, hold sugarcane up to their mouths (fig. 7). They do this even as their lounging positions make it physically awkward to do so. They partake in the cane as a white male figure in a hat and suit, whose presence I will return to, poses on the right of the image. Yet paradoxically, in reality laborers during the slavery and post-emancipation eras would have been discouraged from consuming the agricultural products they had reaped, especially so flagrantly under the eye of an overseer. Under the auspices of the New Jamaica, however, the feasting figures helped to perpetuate the touristic Edenic myth that the island's residents inhabited a veritable Garden of Eden.

At the same time that members of the island's black population appear in many late nineteenth-century photographs lounging on the ground eating cane, they are also often presented as industrious and disciplined laborers – qualities that would appeal to new business investors (and potential new white residents).[18] Valentine and Sons' *Cane Cutters* thus also portrays the colony's inhabitants as ardent workers in the geographic context of their labor, in some instances holding tools. The woman bending over in the foreground of the photograph in particular appears engaged in back-bending labor. Her pose indeed recalls the postures of laborers monumentalized in the canvases of French realist painters like Jean François Millet. In Millet's *The Gleaners*, 1857 (fig. 8), three women with bowed backs and downcast eyes direct their attention to their physically demanding task in the same way that the foreground figure in the Valentine and Sons *Cane Cutters* bends to her work.

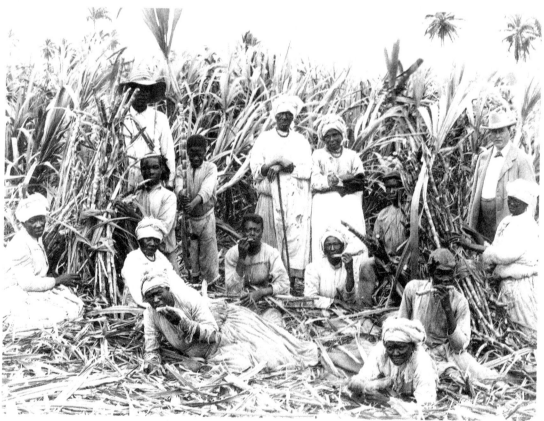

Figure 7. A. Duperly and Sons, *Cutting Sugar Cane*, postmarked 1904. Postcard, 3.5 x 5.5 in.
Collection of author.

It is possible that the monumental Valentine and Sons photograph similarly sought to ennoble black Jamaicans as steadfast laborers, to quote a visual language capable of representing free blacks as industrious and civilized subjects. The centrality of this enactment of labor is demonstrated in another version of the photograph in which the woman appears in the same pose, while her peers take up different positions (fig. 9). That she remains immutable in the dual stagings of the image suggests that the photographer explicitly aimed to spotlight the laboring black female body. Such photographs of disciplined black workers (displayed in the context of the Columbian Exposition, a celebration of industry and imperial ingenuity) not only encouraged new commerce in agriculture but also bore witness to the successes of British colonial rule after emancipation more generally. *Cane Cutters*, created in the context of these representational demands for images of leisure and labor, of tropicality and industry, provides a snapshot of a common visual formula in touristic and fruit industry–oriented photographs from late nineteenth-century Jamaica. Many images simultaneously conveyed tropical languor and colonial discipline, portraying the island's inhabitants as ardent workers in a landscape that did not need labor.

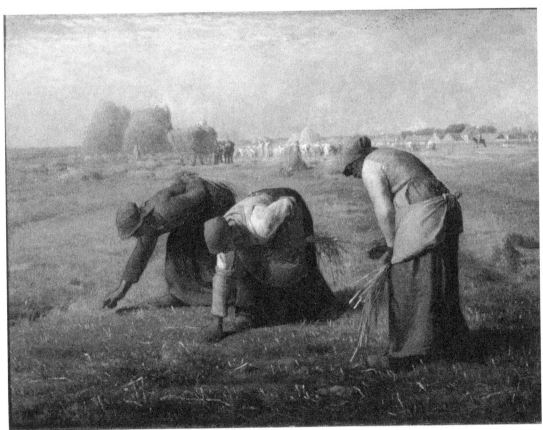

Figure 8. Jean François Millet, *The Gleaners*, 1857. Oil on Canvas, 32.9 × 43.7 in. RF 592, Musée d'Orsay, Paris. Photo by Jean Schormans.
Photo credit: Réunion des Musées Nationaux/Art Resource, New York.

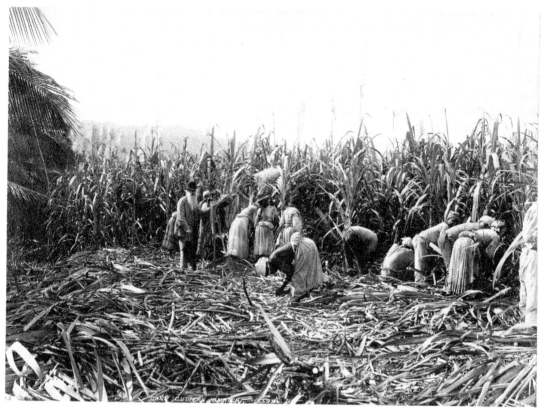

Figure 9. James Valentine and Sons, *Cane Cutters*, 1891.
Reproduced by permission of Onyx: The David Boxer Collection of Jamaican Photography.

The complexities and contradictions of the photographic image-world of the New Jamaica are evident in another photograph of black Jamaicans consuming native products, this one a postcard from the early twentieth century captioned Jamaica Peasantry (fig. 10). In this image by the local firm Cleary and Elliott, in an improbable roadside scene, a line of local inhabitants hold fruit up to their mouths, readying it for eating. As if this scene of communal feasting were not sufficient to demonstrate the island's tropical abundance, a comparison of the postcard with an earlier version of the image shows how the card's producer colored and enlarged the original image to make the fruit appear fuller, perhaps more succulent and tropical (fig. 11). But perhaps more telling than what the later image makes visible is what it hides from view. The postcard's producers removed electrical lines – a sign of modernization – from the later photograph, subsuming them in lush green foliage. The image's overpainting offers a further glimpse at the scope of the New Jamaica initiatives and the role photography played not only in portraying but also in producing these ideals. Through photographic manipulation, tourism promoters and fruit companies presented the island as untouched by the modern world – despite the fact that the island was modernized precisely through plantation slavery and before industrialization took place in Europe. While the architects of the New Jamaica viewed the tourism and banana trades as blueprints for the island's ascension to modernity and future development, they often engaged in practices that may be described as tropical modernization, a fashioning of Jamaica as a tropical land that was in many respects premodern, a vision of modernity constructed on an armature of the past.

Figure 10. Cleary and Elliott, *Jamaica Peasantry*, 1907–14. Postcard, 3.5 × 5.5 in.
Collection of the author.

Figure 11. E. Wells Elliott, *Types of Jamaica Peasantry*, 1907–14. Postcard, 3.5 × 5.5 in.
Collection of the author.

Writing the New Jamaica and Framing the Slave Past

What is particularly pertinent here is that modern progress in the New Jamaica also entailed a return to the slave past, a desire for the former glory and prosperity that existed under slavery. A local visitor to one pavilion of Jamaica's international exhibition, for instance, lauded the perceived parallels between representations of cultivated lands from the "palmy days" of slavery and those of the New Jamaica, and encouraged exposition viewers to do the same. "When the public look at the diagram exhibited by the Jamaica Institute, showing the cane lands cultivated in 1790, the chief of the so-called 'palmy days' of old, and turn to the companion diagram showing the cane-fields cultivated to-day, they will see some reason for writing of a *new* Jamaica."[19] In other words, Jamaica's newness, its modernity, could be seen through the contemporary landscape's acquiescence to slavery's past.

Moreover, crafters of the New Jamaica believed that the island's former slave plantation society held prestige in tourists' imaginations. This is likely why images of workers within the representational landscape of cane would remain a constant theme of late nineteenth-century photographs like *Cane Cutters*, although sugar production had declined to 11 percent of the agricultural product by this period. In an effort to support the notion that the islands had not declined since emancipation, some tourism promoters suggested in promotional literature that the landscape and those that labored on the land had not changed since the days of slavery. American promoters in particular propagated this view. In the United Fruit Company magazine, *The Golden Caribbean*, published in 1904, for instance, writer A. M. Kellogg remarked on "the stationary civilization of the black population" in Jamaica.[20] He maintained, "They [the black population] are no longer slaves, but they remain much as they were at the time of their emancipation in 1834....The truth is that the languor that seizes at once on us when we land has permanently affected them, and they have become constitutionally lazy."[21] The same periodical reproduced a text from 1790 from the planter William Beckford and assured readers that "this charming island has not changed in the least in over one hundred years."[22] The United Fruit Company also reproduced photographs of their own plantations in the same *Golden Caribbean* publication and in contemporaneous promotional literature (fig. 12).[23] In such images they replace the sugar crops of old with newly transplanted banana plants. In other words, tourism promoters framed the period of slavery as an ideal era in Jamaica's history – a time when the potential of the land and its inhabitants were realized – and quite literally framed, through photographs, their own plantations as continuing the slave-owners' legacy.

This return to the slave past as a development scheme in the New Jamaica performed two historical erasures at once. First, it presented the island's slave-maintained plantations as naturally occurring and aesthetically ideal landscapes, even though much of the island's geography had been dramatically transformed through what art historian Jill Casid calls "colonial relandscaping," the discursive and material production of the ideals of the "tropical landscape" in the island.[24] Jamaica, like many islands in the West Indies, had undergone extensive relandscaping with the first plantations in the Americas.[25] In fact, many parts of the island were completely razed to the ground and recreated through the introduction of botanical grafts from around the British Empire. Second, the literal late nineteenth-century focus on the slave-maintained sugar plantation also effectively erased and idealized the subsequent dramatic transformations of the landscape inaugurated by the new fruit industry. The United Fruit Company dramatically transformed both the landscape and labor relations on the island through its transnational conglomeration of their fruit plantations.

Figure 12. Photographer unknown, *Golden Vale*, in *Jamaica via the Great White Fleet: United Fruit Company Steamship Service* (Boston, 1913), 29.

Figure 13. C. H. (Carleton H.) Graves, *Our Observation Car, Golden Grove R. R., Jamaica*, 1899. Stereograph, 3.5 × 7 in. (in mount).Reproduced by permission of the Schomburg Center for Research in Black Culture/Photographs and Prints Division.

By claiming that nothing had changed since slavery, the United Fruit Company erased, naturalized, and aestheticized their recent transplantation of the island, encouraging visitors and locals alike to see these transformations not as changes at all but as somehow a naturally occurring, seamless extension of and return to slavery's natural order.

The fruit companies and other authors of the New Jamaica, while promoting the immutable nature of Jamaica's landscape, did help to inaugurate a change in the way visitors viewed the island: they encouraged travelers to recognize value in the colony's picturesque scenery and its inhabitants. As an editorial entitled "The New Jamaica" outlined, "There is another new thing connected with Jamaica. The character of its scenery is not new. So far from that, it is as old as the hills. But the recognition of it and of the character of the climate is new."[26] Through the efforts of promoters, gazing at and photographing the island's scenery became a new form of commodity in the island. Tourism industry supporters encouraged visitors to travel to its contemporary plantations, in particular to view the landscape and those who labored on it. The United Fruit Company indeed installed railcars on their plantations that they used for this purpose. A rare stereograph, dating from 1890 and taken by the photographer C. H. Graves pictures one such observation car bearing well-dressed white male and female passengers in the process of sightseeing on the plantation (fig. 13).[27] "Everyone who goes to Jamaica wants to see bananas growing, and guests are always welcome at the immense plantation of the United Fruit Company at Golden Vale," one early guidebook crowed.[28] The Graves and Valentine and Sons photographs capture this particular and peculiar moment when the plantation and black laborers became objects of touristic leisure; when, as photography historian Peter Osborne puts it, the "overseeing stare of the planter with time and space in his hands" metamorphosed into "the ludic, pleasuring gaze of the tourists with time and space *on* their hands."[29]

It is precisely this image pool, filled with photographs produced precisely when the needs of the agricultural industry intersected with the demands of touristic leisure in the late nineteenth century, that some late twentieth-century historians – like Craton, Walvin, and Wright – dip into to reflect on slavery. Given that tourism and fruit industry promoters created images like the *Cane Cutters* that picture laboring and lounging black workers to reframe the new fruit plantations through the lens of slavery, to both bring about and disguise modernity, what view of slavery in the British Empire can they offer? And how is slavery reconfigured in the process? I do not want to dwell on the obvious historical incongruities and temporal warps produced when a late nineteenth-century image is presented as representative of slavery – on the way the details of the image, such as the figures' dress, if understood as set in the era of slavery, would be a misrepresentation of the period. Indeed, the very engagement with the camera evident in the image captures a particular historically specific understanding of what it means to be represented as a photographic subject.

Rather, what I find more pertinent epistemologically is the publication's recasting of the late nineteenth-century image as representative of the slave era, which inadvertently replays precisely the narrative of the New Jamaica that the fruit companies and ruling classes were projecting through photographs in the last decade of the nineteenth century: the narrative that nothing had changed since the end of slavery, that the landscape and ethnoscape remained unchanged since the sun set on that peculiar institution. Perhaps to enhance the case that the late nineteenth-century image represents the slave past, in *Slavery, Abolition, and Emancipation*, the book's designers appear to have altered the photograph to seem older, more antique, and to bear the visual traces of age. In the process, the image becomes a mirage, representing any desired time or place through its shadowy new form. The presentation of the image in *Slavery, Abolition, and Emancipation* threatens

to enact in the register of the visual precisely the forms of historical erasure that became central to the production of certain touristic narratives of the New Jamaica. In a book purporting to offer a temporally accurate textual account of slavery, the image erases a certain temporal passage by reproducing a photograph that was designed precisely to occlude a sense of history and historicity. Post-production manipulation of the photograph further creates the sense of temporal erasure (fig. 1). The reproduction of *Cane Cutters* in the Craton, Walton, and Wright volume conjures the dreamwork of tourism, which is itself based on a creative reimagining of slavery, on giving the slave past visual substance.

The use of a photograph that aimed to aestheticize black labor to represent slavery in the book also runs the risk of historicizing a benign and even romantic sense of the period of forced labor. The image of picturesque blacks cannot begin to convey the daily negotiations of life on the plantation or the spectacular forms of bodily violence that governed black labor in the pre-emancipation period. As Saidiya Hartman reminds us, it is difficult to recover the experience of slavery through any image, photographic or literary, since attempts to empathize with or figure the slave often result in the occlusion or displacement of his or her subjectivity.[30] The representational slippery allusiveness of slavery through photographic representation in the Anglophone Caribbean seems especially evident in *Slavery, Abolition, and Emancipation*. Indeed, in a publication about black slave labor, it is notable that the only figure in the *Cane Cutters* photograph who explicitly appears engaged in agricultural work is erased. The black woman, who bends over with axe in hand, is removed from the frontispiece. The odd shape of the top photograph seems to stem from efforts to crop the figure out of the image altogether. Like the post-development manipulation of nineteenth-century photographs, the book's creators engage in their own form of visual excision. Only the barest traces of the figure, a crescent moon–shaped sliver of her back, remain visible in the image. In the process, the photograph originally enlisted to signify slavery in the end resists showing black subjects performing agricultural work, presenting instead figures who participate in a form of labor new to the late nineteenth century: working as a photographic subject.

The absented figure is revealing not only for the labor she performs, but for what her image refuses. She does not appear to offer her body readily as a visual commodity. Her "*Gleaneresque*" pose does not yield to the camera, as do those of her counterparts, who uniformly turn their eyes, faces, and bodies toward the photographer. Indeed, her steadfast attention to her labor and stooping position result in the least camera-friendly position one can imagine. This is not to attribute intentionality to the figure, since her appearance in the same position in two photographs makes it clear that she posed at the urging of the photographer, holding the posture for the time required to secure the photographic images and retaining it perhaps as the photographer reorganized the other figures. Irrespective of the conditions and purposes of the image's creation, the resulting posture of the woman denies visual consumption. Indeed, the very opacity of the figure, her anomalous presence within the photograph's production, is visualized in her exclusion from the subsequent reproduction of the photograph. In other words, it is precisely because she is not made available to the viewer in the typical ways that photographers required black subjects to address the camera in Jamaican tourism-oriented photographs that she is likely excised from the subsequent reproduction. The woman's erasure, I want to suggest, highlights how we might and should read absences in images for what they make present, how we might read photographs against the grain to assess certain histories and historiographies of African diasporic subjects. What does the exclusion of the figure render legible about possibilities and the impossibilities of certain forms of knowledge through the photographic archive? What does the figure's disqualification from the production of

history reveal about visual ideals of slavery specifically? What ways of remembering slavery does the photographic archive of tourism conveniently offer and occlude?

Although I have concentrated primarily on Craton, Walvin, and Wright's book, their use of photography is not unique. Their book simply provides a catalyst for a conversation about a widespread practice. Several recent histories on Jamaica also use late nineteenth-century photographs as illustrations of slavery. Philip Sherlock and Hazel Bennett in *The Story of the Jamaican People* (1998), for instance, use another Valentine and Sons photograph of two young black women taken in Cherry Gardens in a chapter on pens, provision grounds, and higglers during slavery. Steeve O. Buckridge's *The Language of Dress: Resistance and Accommodation in Jamaica, 1760–1890* (2004), reproduces two early twentieth-century postcards by tourism promoter and bookseller Astley Smith in a section on "the colour and fabric of plantation dress."[31] Thomas Holt, in *The Problem of Freedom* (1992), also reproduces photographs by the Duperly firm, *A Peasant's Hut* and *Falmouth Market*, as images of the immediate post-emancipation period.[32] Even more enigmatically, Werner Zips, in *Black Rebels: African-Caribbean Freedom Fighters in Jamaica* (1999), reproduces a mid-nineteenth-century photograph from the United States to signify "the politics of intimidation by mutilation and torture" in Jamaica.[33] I do not have the space here to describe in detail how these different photographs occupy or ornament these individual texts. Indeed, it is not clear whether in each case it is the authors, publishers, or designers who are responsible for the inclusion of the photographs in the books.[34] This visual roll call simply aims to make the case that there is a broader use of the photographic archive to cast historical light on slavery, and that, regardless of how and why these photographs came to be in these accounts, they inform and frame the presentation of historical knowledge about the region.

I suspect that many authors of books pertaining to slavery, as well as their publishers and designers, use photographs to render slavery more legible, the unrepresentable more imaginable, the unrecorded more truthful, the past more present. They lay claim to the ontology of the photographic image and its indexicality to substantiate their narrative accounting of slavery. For a historical period that has often been shrouded by what Marcus Wood refers to as "blind memory," photographs may appear to offer an unblinking witness to the institutional practices of slavery.[35] Photography historian Jens Ruchatz points out that photographs are intrinsic to the externalization of memory for many social groups.[36] Photography is a technology through which memory can be materialized and stored outside the body, and in the process transmitted across generations over time. The books' creators may use the photographs to give slavery material form, substantiating and consolidating memory and history in the process.

By using photographs to represent slavery, book producers and authors also place the experience of slavery within a genealogy of other traumatic world events that have become ingrained in popular memory through photography. Alan Trachtenberg suggests that the impact of photography on the production of historical knowledge was first felt in the mid-nineteenth century, at the time of the American Civil War.[37] Strikingly, despite the history-transforming presence of the camera in the era, slavery remained a blind spot in early Civil War histories.[38] The photographic production of history perhaps reached its apogee in the Second World War. Photographs taken by Allied forces at the end of the war became widely representative of the horrors of concentration camps during Nazi rule.[39] Interestingly, according to Siegfried Kracauer, not only did photographs offer a visual record of events, but photography's seeming ability to reconstruct a "series of events in their temporal succession without any gaps" also reproduced the temporal unfolding of historical narratives.[40] What Kracauer describes as "the photography of time" provided a technological ally to historicist reconstructions of the past.[41] The impulse to use photographs in histories of slavery in

the British West Indies may respond to this photographic colonization of the imagination, and even temporality, of modern history over the last century and a half.

Recent historical accounts of slavery in the British West Indies that use photographs from the late nineteenth century as illustrations, however, inadvertently present what might be described as a nonhistoricist sense of temporal unfolding as outlined by Kracauer. By publishing photographs that date from a time period that does not coincide with slavery but purports to represent it, the publications juxtapose and commingle different eras, resulting in a distinctly nonlinear sense of time and history. Rather than interpret the reproduction of the late nineteenth-century photographs simply as incongruous, might we consider such reconfigurations of temporality to have their own historical value, particularly when it comes to histories of slavery? In other words, might the kinds of ruptures and repetitions of time facilitated by photographs in these accounts in fact be fitting within historical narratives of slavery and its legacy in the Anglophone Caribbean?

This atemporal use of photography, as it is used in these accounts, provocatively recalls Nobel laureate Toni Morrison's concept of rememory, her characterization of the way the traumatic experiences of the past maintain a living presence with the world of slaves and their descendants.[42] More specifically, in the case of historical accounts in the Anglophone Caribbean, such photographs may encourage reflection on how the specter of slavery maintained a living presence in the New Jamaica. Many historians and post-colonial critics observe that the late nineteenth century and the era of slavery are linked by more than touristic nostalgia for the palmy days of the slave-maintained plantation. They point to the constitutive relationship between tourism and slavery. Frank Taylor, for one, insists on casting tourism as it developed in the late nineteenth century as "intrinsically ...a neoplantation enterprise" built on and extending some of the socio-economic relations and hierarchies that existed under slavery.[43] While being careful not to collapse the experiences of oppression in the era of plantation slavery with those that governed the tourism trade in the Anglophone Caribbean, literary scholar Ian Strachan also maintains that, in the English-speaking Caribbean, "in a number of crucial ways, tourism has grown out of and sustains the [slave and post-emancipation] plantation economy."[44] Intriguingly, Walvin, Craton, and Wright make a related argument about the connection between slavery and subsequent plantation systems in the very publication that features the Valentine and Sons photograph of the sugar plantation. They argue: "As long as plantations lasted, so did all the socio-economic effects usually ascribed solely to slavery days."[45] In other words, the commingling of photographs from the New Jamaica with descriptions of slavery results in a reconfiguration of temporality, which in turn calls attention to the way plantation slavery informed the structure of the tourism and fruit trades, how it shaped the socio-economic horizons of post-emancipation Jamaica. This use of such photographs projects and presents slavery not as a thing of the past but as an enduring presence in late nineteenth-century Jamaica.

Present-day historians and critics are not the only ones to telescope between slavery and the era of tourism as inaugurated by the New Jamaica. In the late nineteenth and early twentieth century, residents in Jamaica were quick to characterize the Elder, Dempster, and Company's; the United Fruit Company's; and the crown government's labor practices as they related to black Jamaicans and indentured Indian laborers on the fruit plantations as constitutive of a "new slavery," to use a term blazoned across the front page of one local newspaper in the early twentieth century.[46] In many cases, those who most insisted on drawing parallels between the New Jamaica and the old plantation system vehemently opposed the new system of Indian indentureship because it undermined wage-based black labor.[47]

Crucially, late nineteenth-century newspaper reports suggest that many black Jamaicans saw more than metaphorical links between the slave past and the celebrated New Jamaica period. Indeed, although organizers of the island's great exhibition hoped the event would draw local as well as international audiences, many blacks steered clear of the exhibition site because they believed it was part of a plot to re-enslave them. As the local *Gleaner* recounted: "The story goes that Captain L. D. Baker [head of the United Fruit Company] has been actively engaged in the importation of shackles in casks in large quantities for the purposes of entrapping the people when they got to the Exhibition and making them slaves again.... The Exhibition is a trap."[48] Another newspaper article ridiculed the popular idea that "the Exhibition would...cause a going back to Slavery in any form." It berated "the people [who were] not yet seeming sufficiently intelligent to see the difference between entering into voluntary agreements to work for certain parties or properties and the old time bondage of slavery."[49] The descriptions of the exhibition as a trap reveal that, although the island's governing classes saw the event as inaugurating a New Jamaica, some of the formerly enslaved and their descendants thought it held the power to return them to the condition, if not the time, of slavery. The prevalence of this belief suggests that some black Jamaicans, even sixty years after emancipation, conceived of their freedom as something so fragile and alterable that it could be taken away at any moment. That they believed the shackles of slavery awaited them confirms a point made by scholars like Saidiya Hartman and Diana Paton that the lines between freedom and unfreedom were not indelibly marked by the proclamation of emancipation.[50] It appears that the memory of slavery – the bodily experience of being enslaved in casks – had a lived presence in late nineteenth-century Jamaica. For some blacks, the New Jamaica seemed a clear picture of the days of old. In provocative ways, then, the historical accounts that juxtapose the tourism-oriented photographs with the history of slavery draw the same parallels as did the suspicious black residents between the New Jamaica and the period of slavery.

The photographs of the late nineteenth century may provide an even more interesting linchpin between slavery and the New Jamaica. In the last decade of the nineteenth century and into the early twentieth, photography served precisely to manage what historian Thomas Holt describes as "the problem of freedom," the colonial authorities' efforts to govern black Jamaicans outside the structures of subjection that maintained the slave plantation.[51] Specifically, the colonial authorities faced the challenge of transforming slaves into voluntary wage-based workers without using the techniques of surveillance, discipline, and punishment that ordered and produced black labor before emancipation. The camera would play a role in these new phases of social regulation and labor structures introduced by colonial authorities in the post-emancipation era.

The regulatory purposes of photography at the turn of the twentieth century are evident in a tourism-oriented photograph of prison laborers taken by the minister-turned-tourism-promoter James Johnston in 1903 (fig. 14). Like Valentine and Sons, Johnston worked as part of the colonial government's and the fruit companies' tourism and trade efforts. The photograph, titled *"Hard Labour,"* appeared as an illustration in Johnston's tourist guide and in his global lantern lectures promoting tourism.[52] The image pictures chained black male prisoners breaking stones in a desolate stone quarry. Several cast a wary eye toward the photographer, while others turn away from the camera entirely. One prisoner wears the word "penitence" or "penitentiary" across his back. His counterparts literally wear the terms of their sentences on their uniforms. The photograph pictures a form of social discipline and punishment that was a central component of Jamaica's penal system in the post-emancipation era and gives visual support to the belief in the redemptive and reformative potential of coerced prison labor.[53]

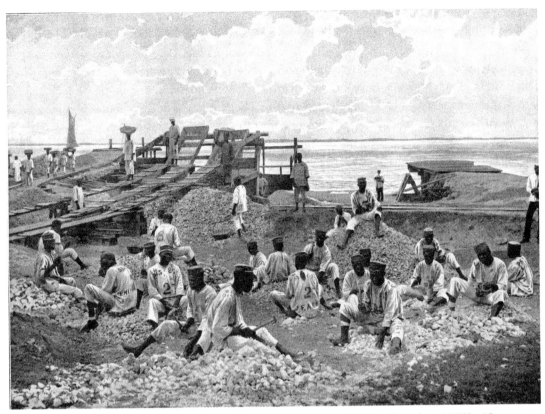

Figure 14. James Johnston, *"Hard Labour,"* in *Jamaica, the New Riviera* (London, 1903), 49.

The *"Hard Labour"* photograph highlights the intersecting forms of social control in late nineteenth-century Jamaica and the visual economy of the tourist trade, and it calls attention to the blurred lines between slavery and freedom in the post-emancipation era. As historian Diana Paton details, although the crown government transformed the Jamaican penal system after emancipation, the state contradictorily relied on hard labor – and, after 1850, corporal punishment – as a form of rehabilitation, so that inmates would willingly accept labor contracts upon their release.[54] In other words, in the post-emancipation period the state managed wage workers by using a form of coerced labor reminiscent of the practices employed during slavery. No wonder that the critic of local blacks who refused to go to Jamaica's international exhibition accused them of not knowing the difference between "voluntary agreements to work" and "old time bondage."[55] Even judges at the time recognized the similarities between prison labor and slavery. One member of the judiciary, in the course of sentencing a man to a three-year term, explicitly admonished him: "While there you will have to labour like a slave."[56] Throughout the post-emancipation period, as Paton details, the colonial state depended heavily, in some parishes entirely, on unpaid prison labor for the maintenance of post-emancipation infrastructure. The stone quarry pictured in the Johnston photograph was but one of the places Jamaican prisoners labored in the post-emancipation era in colonial efforts to turn them into hard-working citizens. The photograph in this way pictures a site in which contradictory forms of freedom, as identified by the authorities and black residents alike, coexisted in post-emancipation Jamaica.

The *"Hard Labour"* photograph also provocatively calls attention to processes of surveillance that were intrinsic to the island's post-emancipation penal system. Paton points out that authorities in

Jamaica created new, modern penal facilities in the 1860s. The new prisons, like those designed by English social reformer Jeremy Bentham, were designed with a "hall of inspections" to facilitate the surveillance of prisoners.[57] Since prisoners spent substantial time on public works projects, surveillance was often carried out in public spaces by overseers and by the public more generally.[58] This process of public and institutional surveillance, so central to governance in post-emancipation Jamaica, intersected with tourism-oriented uses of photography. The connection is hinted at in the *"Hard Labour"* photograph, which not only pictures penitence and presents it as a touristic sight but also positions and presents the camera, literally and figuratively, as a central surveilling presence in the scene of black penitence. The photographer's part in producing disciplined black laboring subjects is evident. This is suggested in the positioning of, and even redefinition of, the overseer in the image. A uniformed officer occupies the margins of the quarry, barely visible on the right side of the photograph. More centrally positioned, and assuming the primary role of overseer, is the photographer himself (and subsequent observers of the scene), whom the prisoners acknowledge through their gaze. The camera's overseeing presence extended from prisons to the cane fields, from explicit scenes of discipline like the stone quarry to the touristic surveillance of black wage earners on the plantation. The photographers' gaze, whether directed through the tourists' viewfinder or through the eyes of plantation visitors or tourist promoters, played a role in managing black labor in the New Jamaica era. At the very least, the importance of photographing black laborers in the new visual economies of tourism resulted in the constant possibility of inspection for many Jamaican laborers. One laborer at the turn of the twentieth century complained precisely about the intrusion of camera-toting tourists during the workday, remarking, "An when de tourists come up de country and see we working in de ground, dem is not going to do anything fa we, but take picta and laugh at we."[59]

Not only would laborers have been conscious of their possible inspection by tourists, but in the late nineteenth century they would also have been acquainted with the subtle and not so subtle forms of bodily discipline required of them before its lens. The men and women who acknowledge the camera in the Valentine and Sons photograph offer some insight into how much laborers were accustomed to the presence of the camera and to the new work of being a photographic subject. Bodily performance for the camera is perhaps most explicit in the posture of the woman who poses with her head tilted to the side and hand on her chin. Like the stooping woman, she is the only figure to appear in both versions of the image, and, of all the women pictured, she seems most aware of posing for the camera, most attentive to the bodily ideals of the picturesque subject (figs. 5 and 9).[60] In another photograph produced by the local A. Duperly and Son, the bodily labor of the photographic subject is also emphasized (fig. 15). The women, especially at the far right and in the middle of the image, contort their bodies, leaning in uncomfortable poses, fulfilling the bodily demands of the picturesque photograph. This awareness of how one should behave for the camera, I want to suggest, had broader implications. The presence (or even suggestion) of a photographer elicited certain behaviors, a phenomenon that itself constituted a way of overseeing, managing, and revaluing new forms of labor in the New Jamaica era.

That the island's black inhabitants could be photographed, that they were willing to submit to the camera, that they performed the kind of bodily discipline necessary for capture and consumption by photography implicitly constituted a selling point for the promoters of tourism. Tellingly, when local residents refused to be photographed or when they demanded money for posing, travelers framed these incidents as acts of black indiscipline or evidence of the corrupting influence of American capitalism on the British colony.[61] The assumption that the natives were photographable

was the visual equivalent of saying the natives were friendly, an important mantra when trying to market travel to a majority black island to white British and North American tourists in the late nineteenth century.

It is worth pointing out too that black photographic subjects were not the only ones framed by the disciplining lens of photography. The tourists themselves were also subject to the lessons of photography – from the other end of the camera. Through plantation tours, photographs, and stereographs (to recall the stereograph of the plantation tour, fig. 13), tourism promoters aimed to indoctrinate tourists into a new vision of post-emancipation Jamaica, encouraging them to see value in British and American civilizing missions more generally.

While tourism promoters' photographs aimed to picture and produce black discipline, these ambitions were never realized, either in photographs or on plantations. Black Jamaicans sometimes refused to inhabit photographs or inhabited them in ways that sometimes simultaneously confirmed and confounded ideals of the island's residents as "civilized subjects" or docile photographic ones. In Valentine and Sons' *Cane Cutters*, for instance, two of the men in the photograph hold up their machetes, one turning his blade in such a way that its sharp edge flashes in the sun. The image communicates threat as much as thrift. The figures speak to the ambivalences within both tourism's visual script and local responses to its photographic demands.

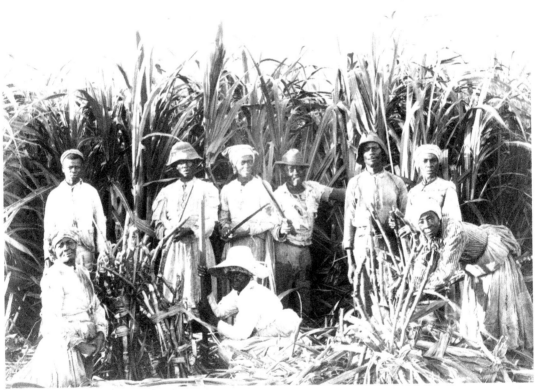

Figure 15. A. Duperly and Son, *Cane Cutters*, circa 1900. Reproduced by permission of the National Gallery of Jamaica.

The historical accounts that use photographs from the late nineteenth century to represent slavery ultimately transpose the period of slavery and tourism in ways that might enable a more complicated historical window precisely into relationship between these eras, a connection that the formerly enslaved may have ultimately recognized. It is possible that some of the blacks who were subject to touristic forms of social overseeing in the late nineteenth century associated it with structures of governance under slavery. This may explain in part why some black Jamaicans were so certain that their re-enslavement lay just around the exhibition's corner. The forms of social control employed to manage blacks in the late nineteenth century may have recalled types of surveillance and discipline that former slaves and their descendents associated with slavery. The use of photographs in contemporary historical accounts do not simply posit connections between the slavery days of old and the purported New Jamaica, but highlight the very medium through which a contiguity was maintained, the means through which a social overseeing and bodily regulation of blacks would continue to be carried out: the medium of photography itself.

While the use of the photographic images in historical accounts like *Slavery, Abolition, and Emancipation* offers the possibility of new histories of slavery, post-emancipation, and photography, the very compulsion to mine the photographic archive for representational traces of slavery may leave certain expectations about the evidentiary nature of photography intact. Such interpretative lenses reinforce notions of the historical value of certain forms of representation. I would argue that slavery in the Anglophone Caribbean, and perhaps in the African diaspora more generally, demands a more radical reformulation of the "evidence of things unseen" and unphotographed. Absences in the photographic record should be viewed not as a lack for which compensation is necessary, but as an intrinsic part of, and even representation of, the history of slavery and post-emancipation in the region.[62]

I want to conclude by exploring the representational and historical possibilities of absence in the Anglophone Caribbean as they relate to photography, through a consideration of a photographic series by Andrea Chung, a contemporary artist of Jamaican and Trinidadian descent. Starting in 2008, Chung began producing a series of approximately thirty cutouts entitled *May Day*, in which she took touristic photographs from late nineteenth-century Jamaica and cut out all the black laborers that had inhabited the images. In the resulting photographs, sugarcane stalks still bear the weight of the workers (fig. 16), bananas remain upheld on litter-strewn docks (fig. 17), and baskets tilt in mid-air (fig. 18), but only vacated white silhouettes, blank spaces, remain within the excisions where laborers once appeared. In cutouts like *'Im hole 'im cahner* (fig. 16), she left only the white male figure in place, casting a light on "the overseer" figure in late nineteenth-century photographs.[63] Chung's reading of the hatted white male as an overseer (fig. 7; as it happens, he is Armand Duperly, a photographer in the A. Duperly and Son photography firm), brings into further focus the surveilling role of the photographer in the spaces of black labor during the period.

Interestingly, Chung creates her cutouts from reproductions of the photographs as they appear in historical accounts or online, rather than from archival originals. Often she enlarges the images in ways that emphasize the "visual texture" of their reproduction history – highlighting the pixels, grain, and lines. By extracting the workers from the photographs, she allows them to take reprieve from their labor, to take a May Day, a day without work. She wants them to escape the confines, the spatiotemporality, of the photograph. The absented figures thus disrupt the indexicality or temporality of photography, its signification of a particular space in time. The missing persons, the black laborers, are precisely not represented; they are only hinted at by their absence.

Figure 16. Andrea Chung, *'Im hole 'im cahner*, 2008. Photo cutout, 24 × 17 in. Courtesy of the artist.

Figure 17 (*left*). Andrea Chung, *Daylight cum an' mi waan guh home*, 2008. Photo cutout, 13.5 × 15 in. Courtesy of the artist.

Figure 18 (*center*). Andrea Chung, *Yuh nuh see it?* 2009. Photo cutout, 12 × 16 in. Courtesy of the artist.

Ultimately Chung's vacant silhouettes not only produce and call attention to photographic absence but also give absence figurative form. Hans Belting argues that an "image makes present that which is absent." It replaces absence through an iconic presence or "visible absence" by material means.[64] The late nineteenth-century archive that Chung mines, photographs previously used to make slavery present despite the absence of photographs from the pre-emancipation period, may be seen to mark a doubly visible absence. The artist describes how she emphasizes this quality by mounting the photographs on top of Plexiglas so the work is raised enough to cast a slight shadow, one that gives the absented figure three-dimensional depth. Some of her titles also taunt the viewer with what can't be seen: "Yuh nuh see it?" one image queries (fig. 18).

An example of the representational possibilities of absence is discernible in figure 16, *'Im hole 'im cahner* (He holds his camera). Coincidentally, Chung chooses for her cutout the A. Duperly photograph *Cutting Sugar Cane*, in which several of the black figures located at the bottom of the photograph appear to chomp on sugarcane. Chung's version of the image brings visibility to figures barely discernible in the Duperly photograph, like the man kneeling, largely concealed by cane, on the right near the overseer (figs. 19, 20).[65] One wonders how he came so ambivalently to appear in the photograph, when in many other tourism-oriented images by A. Duperly and Son the photographers seemed so intent on making all the photographed subjects fully visually accessible to the camera. Intriguingly, a similar figure can be made out in the Valentine and Sons photograph of cane cutters (fig. 21). Close inspection reveals a man just to the left of the men with the machetes. The man's face seems almost an eclipse of the face in front of him. He is barely detectable in the original photograph and almost invisible in reproductions (fig. 22). The most visible thing about him is the way light catches his one-eyed stare, a gaze that does not meet the photographer's. How might we understand these almost-hidden figures and their near disappearance in the photographs themselves and in the visual textures of their reproduction? How do Chung's cutouts, her production of and playing with absence in the photographic archive, create new types of representational presence? It is tempting to interpret these men as engaged in a photographic refusal, as not wanting to be seen or inscribed in the representational apparatus of tourism even as they appear, if only barely, in the image. My interest here is not to speculate on the intentions of these two, or to expound on their complex figuration in the photographs. Instead, I am concerned with suggesting that the figures' absent presence opens an alternate way of seeing, interpreting, and assessing the history of the African diasporic subject through the photographic image.

This reading of the representational spaces of absence involves more than seeking that which inhabits the edge of visibility or invisibility in photographs, as the male figures in the Duperly and Son and the Valentine and Sons photographs do. It tries to take seriously Toni Morrison's prescient observation that "invisible things are not necessarily 'not there'.... Certain absences are so stressed, so ornate, so planned, they call attention to themselves."[66] It pays attention to these planned absences, like the one evident in the frontispiece where the female figure was erased. In some respects, the woman's absence called so much attention to itself that this essay has been an attempt to understand the meaning of her disappearance and what it reveals about the work of photography in representing (and vanquishing) slavery, post-emancipation, tourism, labor, and their histories. Moreover, the absence of a photographic archive pertaining to slavery can be seen as yet another, and even more ornate, absence. The challenge is to recognize and value the historically specific forms that image, memory, and history-making take in the space of the absence of the photographic archive of slavery, to see that absence as productive and generative of its own types of representation, meanings, histories, and subjectivities.

Figure 19 (*left*). Andrea Chung, *'Im hole 'im cahner* (detail). Courtesy of the artist.

Figure 20 (*right*). Duperly and Son, *Cutting Sugar Cane* (detail), postmarked 1904. Postcard 3.5 x 5.5 in. Collection of author.

Figure 21 (*left*). James Valentine and Sons, *Cane Cutters, Jamaica* (detail), 1891. Reproduced by permission of Onyx: The David Boxer Collection of Jamaican Photography.

Figure 22 (*right*). Frontispiece to Craton, Walvin, and Wright, *Slavery, Abolition, and Emancipation* (detail). Reproduced by permission of Pearson Education.

Notes

I want to thank my co-editors, Huey Copeland and Darcy Grimaldo Grigsby, as well as the editorial board of *Representations* and Associate Editor Jean Day for their keen insights on the essay. Thanks also to Stephen Best, David Boxer, Andrea Chung, Christopher Cozier, Wayne Modest, Harvey Neptune, Richard Rosa, David Scott, and attendees of the conference "Archaeologies of Black Memory" (organized by the journal *Small Axe* and the Caribbean Literary Studies program at the University of Miami) for adding new and invaluable perspectives on the work.

1. Apprenticeship was the four-year transitional period following slavery during which ex-slaves trained, without pay, with their former masters.
2. Alan Trachtenberg, "Albums of War: On Reading Civil War Photographs," *Representations* 9 (Winter 1985): 1.
3. Toni Morrison, *Beloved: A Novel* (New York, 1987), 35.
4. Michael Craton, James Walvin, and David Wright, *Slavery, Abolition, and Emancipation: Black Slaves and the British Empire: A Thematic Documentary* (London, 1976).
5. For a discussion of the idea and desire for photography as well as a careful and nuanced examination of different thinkers in early protophotographic and photographic practices, see Geoffrey Batchen, *Burning with Desire: The Conception of Photography* (Cambridge, MA, 1997), 24–102.
6. Naomi Rosenblum, *A World History of Photography* (New York, 2007), 29.
7. For an examination of these photographers, see Batchen, *Burning with Desire*, 24–53. On the global circulation of the daguerreotype, consult Rosenblum, *World History of Photography*, 14–17, and for its circulation in Latin America and for more on Hercules Florence, someone not discussed in some histories of photography, see Boris Kossoy, "Photography in Nineteenth-Century Latin America," in Wendy Watriss and Lois Parkinson Zamora, eds., *Image and Memory: Latin American Photography, 1865–1994* (Austin, TX, 1998), 19–54.
8. David Boxer, "The Duperlys of Jamaica," in *Duperly: An Exhibition of Works by Adolphe Duperly, His Sons, and Grandsons Mounted in Commemoration of the Bicentenary of His Birth*, ed. National Gallery of Jamaica (Kingston, Jamaica, 2001), 6.
9. As art historian David Boxer notes, "The photographers were in Jamaica at the invitation of the Governor to prepare a series of photographs for exhibition at the Chicago Columbian Exhibition in 1892"; ibid., 20. For newspaper articles on the photography of Valentine and Sons in Jamaica, see *Daily Gleaner*, May 2, 1891; February 15, 1893; April 12, 1900, January 10, 1903.
10. C. J. Ward, *World's Fair: Jamaica at Chicago: An Account Descriptive of the Colony of Jamaica with Historical and Other Appendices* (New York, 1893), preface; Edgar Mayhew Bacon and Eugene Murray-Aaron, *The New Jamaica; Describing the Island, Explaining Its Conditions of Life and Growth and Discussing Its Mercantile Relations and Potential Importance; Adding Somewhat in Relation to Those Matters Which Directly Interest the Tourist and the Health Seeker* (New York, 1890).

11. *Daily Gleaner*, September 28, 1889.
12. *Daily Gleaner*, January 9, 1893.
13. *Daily Gleaner*, February 2, 1892.
14. *Daily Gleaner*, February 15, 1893.
15. *Daily Gleaner*, November 21, 1902.
16. *Daily Gleaner*, December 8, 1904.
17. For a more expansive examination of the importance and purposes of such representations of tropical abundance, see my discussion in Krista A. Thompson, *An Eye for the Tropics* (Durham, NC, 2006), 74–78.
18. Ibid., 29, 67–70.
19. *Daily Gleaner*, January 29, 1891.
20. Kellogg's article from *The Golden Caribbean* was reprinted in *Daily Gleaner*, January 26, 1904.
21. Ibid.
22. The editors of *The Golden Caribbean* framed William Beckford's statements with this quote: "We accidentally picked up an old volume published in England, about 1790, by William Bickford [*sic*], an old time English painter"; *The Golden Caribbean* 1, no. 1 (Nov. 1903): 4.
23. Ibid., 3, 5.
24. Jill H. Casid, *Sowing Empire: Landscape and Colonization* (Minneapolis, 2005), 1–14.
25. Ibid., 14–24.
26. *Daily Gleaner*, January 29, 1891.
27. The stereograph is rare in that it makes the tourists, the consumers of Jamaica's newly recognized scenery and laborers, the subject of the photograph, in a reversal of the typical scenarios in which tourists observed and photographed local laborers.
28. Mortimer C. DeSouza, *A Tourist's Guide to the Parishes of Jamaica: Together with an Account Descriptive of the Jamaica Exhibition, 1891, Being a Supplement to Desouza's . . . Jamaica Commercial Almanack* (Kingston, Jamaica, 1891), 69.
29. Peter D. Osborne, *Travelling Light: Photography, Travel, and Visual Culture* (Manchester, England, 2000), 113.
30. Saidiya V. Hartman, *Scenes of Subjection: Terror, Slavery, and Self-Making in Nineteenth-Century America* (New York, 1997).
31. Steeve O. Buckridge, *The Language of Dress: Resistance and Accommodation in Jamaica, 1760–1890* (Kingston, Jamaica, 2004), 53.
32. Philip Manderson Sherlock and Hazel Bennett, *The Story of the Jamaican People* (Kingston, Jamaica, 1998), 172; Thomas C. Holt, *The Problem of Freedom: Race, Labor, and Politics in Jamaica and Britain, 1832–1938* (Baltimore, 1992); Werner Zips and Shelley L. Frisch, *Black Rebels: African-Caribbean Freedom Fighters in Jamaica* (Princeton, 1999), 102, Buckridge, *The Language of Dress*, 53.
33. Zips and Frisch, *Black Rebels*, 102.
34. Photographs come to populate historical texts as illustrations, as covers, and as frontispieces through processes that involve many people – including the authors, publishers, designers, and marketing specialists. The publishers' involvement in such decisions is hinted at in the *Slavery, Abolition, and Emancipation* frontispiece. Longman's insignia, a stylized merchant ship (an ironic accompaniment to a book on slavery), appears wedged between both photographs. In this publication the Valentine and Sons photograph continues its work as a marketing tool serving, like all book covers and frontispieces, to heighten the book's desirability as a commodity. As anthropologist Corrine Kratz points out, regardless of how and why a particular photograph comes to occupy a text, readers and reviewers often attempt to tell a book by its cover, understanding it as revelatory of the identity or genre of the book or as allegorical of the text and its interpretation. Photographs used on covers and as internal illustrations frame literally and figuratively the content of the text and, I would suggest in the case of history texts, function as part of the historical narrative; Corinne A. Kratz, "On Telling/Selling a Book by Its Cover," *Cultural Anthropology* 9, no. 2 (May 1994).
35. Wood, *Blind Memory: Visual Representations of Slavery in England and America* (New York, 2000).
36. Jens Ruchatz, "The Photograph as Externalization and Trace," in *Cultural Memory Studies: An International and Interdisciplinary Handbook*, ed. Astrid Erll (Berlin, 2008), 8:337.
37. Trachtenberg, "Albums of War."

38. Ibid. See also Wood's observation that few photographs of slavery existed prior to the Civil War; Wood, *Blind Memory*, 268.
39. Although, as Frances Guerin and Roger Hallas suggest, as early as the 1950s some scholars, survivors, and critics had questioned the "representability" of the photographic archive; photographs became central to historical imagination of and transmission of the Holocaust and other traumatic events, as well as truth claims about those events. Frances Guerin and Roger Hallas, introduction to *The Image and the Witness: Trauma, Memory, and Visual Culture*, ed. Frances Guerin and Roger Hallas (New York, 2007), 6.
40. Siegfried Kracauer and Thomas Y. Levin, "Photography," *Critical Inquiry* 19, no. 3 (Spring 1993): 425.
41. Ibid., 426.
42. Morrison, *Beloved*, 35.
43. Frank Taylor, *To Hell with Paradise: A History of the Jamaican Tourist Industry* (Pittsburgh, 1993), 175.
44. Ian G. Strachan, *Paradise and Plantation: Tourism and Culture in the Anglophone Caribbean* (Charlottesville, VA, 2002), 9.
45. Craton, Walvin, and Wright, *Slavery, Abolition, and Emancipation*, xi.
46. *Daily Gleaner*, January 27, 1910.
47. Thompson, *An Eye for the Tropics*, 78–80.
48. *Daily Gleaner*, November 7, 1890.
49. Ibid.
50. Hartman, *Scenes of Subjection*; Diana Paton, *No Bond but the Law: Punishment, Race, and Gender in Jamaican State Formation, 1780–1870* (Durham, NC, 2004).
51. Holt, *The Problem of Freedom*.
52. James Johnston, *Jamaica, the New Riviera: A Pictorial Description of the Island and Its Attractions* (London, 1903); James Johnston, *Optical Lantern Lectures on Jamaica, "The New Riviera"* (Bristol, UK, 1903).
53. Paton, *No Bond but the Law*, 90.
54. Ibid.
55. *Daily Gleaner*, November 7, 1890.
56. Paton, *No Bond but the Law*, 137.
57. Ibid., 128.
58. Ibid., 135.
59. Quoted in Bessie Pullen-Burry, *Ethiopia in Exile: Jamaica Revisited* (London, 1905), 30.
60. In one image she appears in the same position under the shelter of a makeshift parasol held by an older white or brown Jamaican male. "Brown," a term used locally, describes a class of mixed-race Jamaicans who, within colonial hierarchies, ranked higher than Jamaicans of primarily African descent but lower than the British colonials, the former planter class, and the white mercantile elite.
61. This was evident in geographer and naturalist Harry Johnston's account of his travels throughout the Caribbean, *The Negro in the New World* (1910). Johnston was disarmed when members of the Maroon community in Jamaica demanded monetary compensation when he aimed a camera in their direction or at the surrounding scenery. A faithful believer in the virtues of the British civilizing mission in the West Indies, Johnston attributed such behavior to the corrupting forces of the Americans; Harry Johnston, *The Negro in the New World* (London, 1910), 279.
62. James Baldwin, *The Evidence of Things Not Seen*, 1st ed. (New York, 1985).
63. Andrea Chung, telephone interview with author, February 3, 2009.
64. Hans Belting, *Likeness and Presence: A History of the Image Before the Era of Art*, trans. Edmund Jephcott (Chicago, 1994), 11.
65. Conversely, many of the figures in the photograph, especially those in the group in the middle, become most indistinguishable and unrecognizable.
66. Toni Morrison, "Unspeakable Things Unspoken: The Afro-American Presence in American Literature," *Michigan Quarterly Review* 28, no. 1 (Winter 1989): 11.

Curating Carnival?
Performance in Contemporary Caribbean Art and the Paradox of Performance Art in Contemporary Art

Claire Tancons

Every first Monday of September since 1969, Caribbean Carnival celebrations have turned Labor Day observances into leisurely pageantry on Brooklyn's Eastern Parkway, its main parading venue. Having first moved from the ballrooms of the Harlem Renaissance to the streets of the old New Negro neighborhood before migrating to Crown Heights post-Civil Rights Movement, the history of Carnival was never any less complicated in the United States than it was in the Caribbean. Nor is its place within the arts, complex at home and abroad, as exemplified by the relationship between the West Indian American Day Parade, as it is now known, and the Brooklyn Museum of Art, to which it was only ever granted but limited access in four decades spent at its doorsteps.

Carnival made a prominent debut at the Brooklyn Museum in 1990 with the exhibition 'Caribbean Festival Arts,' organized by John Nunley and Judith Bettelheim. That exhibition's discourse and display, however, were largely anthropological, presenting Carnival, along with Hosay and Junkanoo, as folkloric emanations of historical diasporic cultures more so than vibrant artistic manifestations of contemporary global networks.[1] Carnival made a promising re-entry at the Brooklyn Museum in 1999, under the form of a lecture, "Minshall and the Mas," and a performance "The Dance of the Cloth," presented by legendary Trinidadian artist Peter Minshall, a formidable proponent of the recognition of the artistic status of Carnival.

Nearly ten years later, the exhibition 'Infinite Island: Contemporary Caribbean Art' organized by Tumelo Mosaka for the Brooklyn Museum though dedicated to "Carlos Lezama (1923-2007), founder of the Brooklyn's West-Indian American Day Carnival and Parade, a champion of Caribbean Culture," left Carnival at the door once again. The warning Annie Paul issued in her essay for the exhibition catalogue was not followed: "Caribbean visual art cannot model itself on narrow modernist concepts and tropes without risking extinction"[2] she wrote, lamenting the reductive Western modernist framework within which Caribbean art is confined. Drawing from notions of the modern, the vernacular and the cosmopolitan, articulated by Homi K. Bhabha as "vernacular cosmopolitanism"[3] and by Kobena Mercer as "cosmopolitan modernism,"[4] the Kingston-based cultural critic envisions Jamaican Dancehall as "represent[ing] a *vernacular modern* or *vernacular cosmopolitanism* in fundamental opposition to the delicately constructed high modernism of its art world"[5] (my emphasis). She could have just as well spoken of the Trinidad Carnival, another vernacular modern, in these terms.

That Carnival, let alone Dancehall, should enter the museum is debatable. The question was posed regularly, if ambiguously in most major contemporary Caribbean art exhibitions organized in the United States over the last two decades. The main challenge this question sought to meet was the artistic validation of Carnival, a task traditionally assigned to that great artistic standard-bearer, the museum. The other more fundamental questions about whether or not Carnival

Reprinted with permission from *Curating in the Caribbean*, ed. David A. Bailey, Alissandra Cummins, Axel Lapp and Allison Thompson, 37–62 (Berlin: The Green Box, 2012).

should be curated at all and if so whether or not it should or could be curated outside of the museum context and the exhibitionary complex remained largely unanswered.

Taking inspiration from the notion of vernacular modernism as a possible way out of accepted ideas of artistic value and of curatorial principles, artists and curators have yet to articulate questions and make propositions that break away from the dichotomic view of that which can be curated and that which can not, of that which belongs in or out of the museum. "Curating Carnival" presents past and present efforts to address Carnival as an artistic and curatorial object, discusses attending discourses that supported these efforts and offers this author's own contribution to the debate and practice of Carnival.

I

By and large, Carnival has been marginalized at best, left out at worst in contemporary Caribbean art exhibitions in the United States and the United Kingdom, where most such exhibitions are organized. It is virtually absent from all non-Caribbean contemporary art exhibitions as it is from contemporary art exhibitions in the Caribbean. Following is a sample of two decades of contemporary Caribbean art exhibitions in the US and the UK and of Carnival therein. A similar exercise could be done about Carnival in Brazil but I will restrict my argument to Carnival in the Caribbean within the frame of this essay. As we will see, the Trinidad Carnival, the Caribbean's most famous carnival is also the most represented.

'Caribbean Visions: Contemporary Painting and Sculpture' (1995) organized by Art Services International for a number of American museums including the Center for Fine Arts in Miami and the New Orleans Museum of Art clearly indicated its focus on the traditional media of painting and sculpture in its title, and did not feature Carnival. However, and somewhat paradoxically, the catalogue included two essays celebrating the importance of Carnival in Caribbean art and culture: "Trinidad Carnival. History and Meaning"[6] by Errol Hill, the great professor of Drama and Oratory at Dartmouth College and author of *The Trinidad Carnival. Mandate for a National Theatre* (1972), and "Carnival and Its Place in Caribbean Culture and Art"[7] by Peter Minshall, Trinidad's acclaimed contemporary carnival designer and self-styled masman.

In contrast, in 'Caribe Insular. Exclusión, Fragmentación, Paraíso' (1998) organized by Antonio Zaya and Maria Lluisa Borras for the Museo Extremeno e Iberoamericano de Arte Contemporaneo in Badajoz and Casa de América in Madrid in 1998, Peter Minshall's carnival band of the same year, RED, not only figured on the catalogue cover but was also included in the exhibition. The catalogue also featured several written pieces about Carnival in Trinidad: an artist statement by Peter Minshall and a text about RED from the Callaloo Company, Minshall's Carnival production company, as well as an essay by Trinidadian artist, art critic and curator Christopher Cozier,[8] a section of which, "'Roadworks' Searching for a Starting Point?" is devoted to the importance and relevance of Carnival to contemporary Caribbean culture.

Significantly, 'Rockstone and Bootheel: Contemporary West Indian Art' (2010) an exhibition focusing on works from the English-speaking Caribbean countries of The Bahamas, Barbados, Jamaica and Trinidad & Tobago, curated by Kristina Newman-Scott and Yona Backer for Real Art Ways, in Hartford, Connecticut, was accompanied by two exhibitions exposing Caribbean performance traditions, one, the 'Trinidad Carnival,' with Zak Ové's *Blue Devils* and the other, 'Jamaican Dancehall,' with a presentation of posters by Maxine Walters. Indeed, the very title of the exhibition, 'Rockstone and Bootheel', was borrowed from a Jamaican dub-metal song by Gibby. However, both exhibitions, the former of Carnival photographs and the latter of Dancehall posters,

kept the performative within the traditional realm of representation rather than enactment. "That is Mas" an incisive essay by literary critic Nicholas Laughlin is that exhibition's greatest contribution to the understanding of the importance Carnival "as a resource for our artists as they play themselves on the world stage."⁹ Cozier's own exhibition, 'Wrestling with the Image: Caribbean Interventions' which he co-curated for the Art Museum of the Americas in Washington (2011), dealt with performance in much the same way as 'Rockstone and Bootheel' did with performative representations in the works of artists such as Ebony Patterson and Marlon Griffith. Time will tell how the planned Carnival section in the upcoming pan-Caribbean exhibition 'Caribbean: Crossroads of the World' (2012) organized jointly by The Queens Museum of Art, The Studio Museum in Harlem, and El Museo del Barrio will be handled.

In the United Kingdom, even the current re-examination of modern art practices within the expanded context of the Black Atlantic failed to re-centre Carnival away from the margins to which it is being relegated. In 'Afro Modern: Journeys through the Black Atlantic' (Tate Liverpool, 2010), Carnival only appeared as a footnote to the exhibition's grand narrative through the screening of the seminal *Orfeu Negro* (1959) set during the Rio Carnival. In 2000, the Hayward Gallery mounted the exhibition 'Carnivalesque,' largely based on Mikhail Bakhtin's eponymous theory, to celebrate an important movement within the cultural life of Great Britain and Europe. Looking beyond Bakhtin and European carnival traditions and at its own postcolonial diasporic carnival, two exhibitions were organized about the Notting Hill Carnival, no doubt a result of its hard-won recognition following the infamous riots: one, 'Masquerading: The Art of the Notting Hill Carnival' by the Arts Council of England in 1986 at the height of the multicultural discourse, and, more recently, 'Midnight Robbers, The Artists of Notting Hill Carnival', in 2007 at London City Hall and later in American university art galleries (Ohio State University and University of Memphis).

That Carnival is centrally marginal is no less oxymoronic a semantic proposition than is the idea of an exhibition on painting and sculpture devoting two essays to Carnival and that of another one dedicated to the memory of Carnival's founder, yet blatantly excluding it from its content. Perhaps, wisely, these exhibitions' curators sensed the inadequacy of the exhibition format and the museum framework for Carnival. The scarcity of critical writing on Carnival suggests instead that Carnival was not within their purview of the artistic and the curatorial. When it was, it could only be within the anthropological or representational traditions, by way of displays of props or photographs rather than of the actual performative action itself. Yet, what more propitious a time could there be for the advancement of the debate on the place of, not just Carnival but of performance in general within contemporary Caribbean art practice when so-called performance art dominates the mainstream contemporary art discourse?

In the United States, the discourse about performance art is largely dominated by the terms set by curator and art historian RoseLee Goldberg. As a theoretical construct that emerged in the late 1970s, it follows closely her art historical account enshrined in *Performance: Live Art, 1909 to the Present* (1979) seen by some as "the Bible" and in *Performance: Live Art since the 60s* (1998).¹⁰ As a field of curatorial practice performance art finds its largest incarnation in the Performa biennial, since 2005 New York's biennial of "new visual art performance" organized by Performa, Goldberg's non-profit organization "committed to the research, development and presentation of performance by visual artists from around the world."¹¹ While the performance art narrative is set mainly in North America, Europe and Japan, its canonical representations are staged within the white cube gallery and the black box theatre, both of which are inappropriate to the display of street-based urban artistic practices such as Carnival. A notable exception was Arto Lindsay's *Something I Heard*

for Performa 09, a single-file procession inspired by his experience of the Bahia Carnival, held at night in Times Square.[12]

Performance art's positioning within the mainstream Euro-American canon behooves me to ask the following questions: Is performance the last bastion of Eurocentrism in contemporary art discourse and practice? Or, in other words, is performance art a Eurocentric concept? Could Carnival only find its way in the sanctum of performance art by way of Lindsay's deft deconstruction of the form? And, specifically as regards contemporary Caribbean art: How relevant are terminologies such as "visual art performance" or even simply "performance art" to contemporary Caribbean art anyway? Can Caribbean art offer a platform from which to investigate anew the supposed epistemological difference between the performing arts and performance art?

II

The quasi-total absence of Carnival within contemporary Caribbean art exhibitions is matched by its near-oblivion from contemporary Caribbean art history manuals. As an example, *Caribbean Art*[13] by Veerle Poupeye does devote a chapter to Carnival; however, it is the thinnest. There are scores of books about various Caribbean carnivals, chief amongst which in terms of numbers of publications, the Trinidad Carnival, followed by the Carnival of French Guyane. For the most part however, the region's carnivals still need proper historical accounts of their own. More often than not, when considered in scholarly publications, it is within the disciplines of history or anthropology, seldom art history or even visual studies. An exception is *Carnival: Culture in Action – The Trinidad Experience*[14] edited by Milla Riggio with a foreword by Richard Schechner, founder and head of the Performance Studies department at New York University, who ushered Carnival into the academic field he created, which might combine approaches from the above-mentioned disciplines, and more.

In the decades following Independence in the British Caribbean colonies, Caribbean artistic performance practices were discussed by academics such as Trinidadian Errol Hill (1921–2003), and Jamaican Rex Nettleford (1933–2010), Vice-Chancellor Emeritus at the University of the West Indies (UWI), choreographer and founder of the National Dance Theater Company of Jamaica, within the context of the Performing Arts, mainly Theatre for the former and Dance for the latter, against the backdrop of their countries' blossoming national discourse. Carnival, according to Hill, was to be Trinidad's National Theatre and, for Nettleford, Jamaica had to have a National Dance Theatre Company. The path to recognition for vernacular forms of expression, artistic or otherwise, was through academic legitimization within known Western disciplines. The exercise often entailed including vernacular content into standard Western form, or using a vernacular form to interpret classical European or American pop music as continues to be the case in steel pan, Trinidad's vernacular musical instrument. Surely, this was considered an improvement from not simply integrating the vernacular into the theatre, dance or music repertoire at all, as would have been the case during the colonial era.

Fast-forward to the 1990s and back to Carnival. From the mid-1990s onwards, Peter Minshall along with Todd Gulick, Callaloo Company's production manager, began shifting the discourse on Carnival from the Performing Arts and into the field of the Visual Arts, though Minshall came from the theatre, having studied Theatre Design at Central St Martins School of Art and Design in London in the mid-1960s.[15] Specifically, Minshall and Gulick steered Carnival towards performance art, aided by the concept of mas' which they helped shape. Mas', short for masquerade, is the vernacular for Carnival in Trinidad and other English-speaking Caribbean countries where taking

part in Carnival is to "play mas'" as it is to "rush" in Junkanoo in the Bahamas or to "courir le vidé" in Guadeloupe and Martinique. The word mas' was certainly not invented by Minshall but he appropriated it to refer to "the most visual" Carnival form and, by extension, to his own work, having defined or helped refine mas' as an artistic genre. Minshall's 1999 lecture at the Brooklyn Museum was indeed called "Minshall and the Mas" and he is fond of calling himself and being called a 'masman', the title of a recent documentary on his work (*Masman Peter Minshall* by Dalton Narine, 2010). In "Carnival and its Place in Caribbean Culture and Art," his essay for Caribbean Visions, he writes:

> To evaluate the place of the Carnival in Caribbean culture and art, it is helpful to realize that Carnival incorporates a broad range of forms and activities. Carnival in Trinidad includes: lyrical songs (calypso and soca), instrumental music (steel bands and brass orchestras), and costumed masquerade along with the dance and movement by which it is presented (mas'). [...] *The most visual of these forms is what we call mas'*: the tradition of costumed masquerade in the Trinidad Carnival. [16] (my emphasis)

Minshall goes on, specifically referring to mas' as "a performance art," then as "performance" or "performance art:"

> Mas is *a performance art*. It is not merely visual; a mas costume displayed on a mannequin is not mas. [...] *Though it is performance, mas does not easily fit into the mold of any one of the more conventional performing arts*. It is theatrical, but it is necessarily broader of stroke, more symbolic, simpler than conventional narrative theater. It involves dance, but this dance is often more spontaneous than choreographed; or, it is dance that is aimed at articulating the mas that is worn, more than the body that is wearing it. *It is most akin to what has become known as simply "performance" or "performance art,"* yet the mas had these characteristics, naively and unselfconsciously, long before the term "performance art" was coined. [17] (my emphasis)

In a footnote, he goes on to quote directly the following passage from RoseLee Goldberg's *Performance: Live Art to the Present*:

> Many of the things that have been said about 'performance' as an avant-garde discipline apply in equal terms to mas [Minshall wrote:]
>
> [Goldberg quote starts] 'Performance has been a way of appealing directly to a large public, as well as shocking audiences into reassessing their own notions of art and its relationship to culture...
>
> [B]y its very nature, performance defies precise or easy definition beyond the simple declaration that it is live art by artists...For performance draws freely on a number of references—literature, theatre, drama, music, architecture, poetry, film and fantasy, deploying them in any combination.
>
> No other artistic form of expression can be said to have such a boundless manifesto...The manifestos accompanying much of this work establish a framework and a utopian vision for an all-inclusive art that no painting, sculpture, or architectural monument can hope to achieve in itself.' [18]

Minshall does however recognize that performance art and mas' are not entirely identical and that there are many ways in which mas' is not performance art. In the same essay he writes:

> The field of art 'performance' has been described as a natural searching in response to the growing irrelevance of conventional object-oriented art to the dynamic modern world. Mas can offer the same opportunity to transcend the object in favor of the experience, yet in a manner that is not elite and inaccessible, but by its nature popular and participatory. [19]

I would add that another main difference between mas' and performance art, in addition to the fact that it is "popular and participatory" is that mas' is also collective on a massive scale in a way that little performance art is.

Ten years later, artist and art critic Luis Camnitzer reprised the argument about mas' as performance art in "The Keeper of the Lens," his essay for 'Looking at the Spirits: Peter Minshall's Carnival drawings' (2005), an exhibition he co-curated with Gulick at the Drawing Center:

> Carnival in Trinidad, or more precisely *mas*—a derivation from *masquerade* and used as in 'playing mas'—*features practically all the dynamics of cutting-edge performance art and installation* while predating those forms by over a century.[20]

The argument was also used by random art commentators such as one William Dunlap, "Special to the Washington Post", who wrote of *The Dance of the Cloth*, Minshall's adaptation of Mancrab—the King of one of the bands in his trilogy of bands *River*—for the 7th Havana Biennial (2000):

> Any piece of performance art would be hard-pressed to compete with Havana's lively street musicians, costumed señoritas, jugglers, fire-eaters, Obispo barrel rollers, Cohiba-smoking tarot card readers and vintage Detroit rolling stock. One work, however, was triumphant and made the whole trip worthwhile.[21]

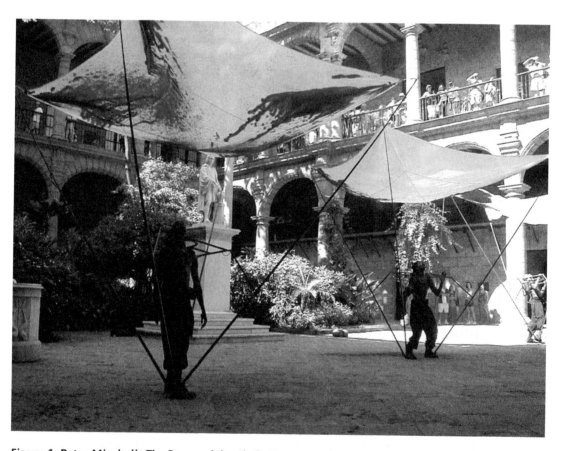

Figure 1. Peter Minshall, *The Dance of the Cloth*, Havana, Palacio Municipal, 7th Biennial of Havana, 2000. *Photo: Charlotte Elias. Courtesy the Callaloo Company, Chaguaramas, Trinidad. **The Dance of the Cloth** was performed by members of the Callaloo Company.*

The Dance of the Cloth, however, might have rightfully belonged as performance art, or indeed, as the closest version of mas' to performance art, as presented through Mancrab, a reprise from the main costume of the masband River, Mancrab, in a performance in the courtyard of the Palacio Municipal. It was characterized as such by Gulick: "Outside of the context of Carnival, this type of performance could be referred to as mas-theatre, a type of performance art."[22]

Like Minshall and Gulick before him, Camnitzer also utilized some of the arguments about Carnival's lack of recognition in the mainstream art world and wrote:

> Because it belongs to a different history, it is considered a local, vernacular, and popular expression, lacking significance for any speculation about 'high art'.[23]

Both Minshall and Camnitzer along with Cozier and Dunlap also conveyed the opinion that if mas' was to be produced outside of Trinidad, in the by now shifting centers of the mainstream contemporary art world, it would create an unprecedented stir. Cozier writes:

> If something like it were to happen in one of the alleged power locations for art theory there would be miles of text. So far it is perceived to be a mere folk or street festival the subject for more renderings of culture by local artists and foreign anthropological case studies.[24]

However, Cozier's greatest contribution to the debate about the place of Carnival in contemporary art discourse, indeed about Carnival as an art form, was to define Minshall's mas as "contemporary theatrical and visual art strategies to give new shape and meaning to traditional carnival and folk characterizations" and use the notions of moments and monuments , echoing Pierre Nora's concept of *lieu de mémoire* or site of memory, to define mas. In a text entitled "Mancrab", Cozier wrote:

> Through his work, Minshall often proposes an *alternative critical understanding of the "monumental"* in opposition to what is asserted in conventional art history books. He prods us to *rethink the vernacular and the ephemeral; to consider the way actions or "a moment" can also live through memory and discourse.*[25] (my emphasis)

and in his essay for the 'Caribe Insular' catalogue:

> Outside of geological phenomena, there are no monuments in the Caribbean islands such as pyramids, domes or towers but we have our people; their particular stories as defined by their language, gestures and vision.[26]

One may argue that there are monuments in the Caribbean, if in the Greater Antilles more so than in the Lesser Antilles and that Carnival is no less vibrant throughout Brazil whose architecture from the Baroque to the Modern eras gives meaning to the very notion of the monumental (not least among which is Oscar Niemeyer's Sambódromo or Carnival stadium in Rio de Janeiro). However, Cozier's intention with this statement is less to imply that there is a direct relationship between the absence of monuments and the existence of Carnival, as it is to create a critical vocabulary within the specifics of the vernacular while remaining fully aware of the larger global art context. In an earlier version of the same essay, Cozier proposes the term roadwork to refer to Peter Minshall's work: "Since many of the activities surrounding our lives are street activities I thought it interesting to replace the word art with road."[27] In the published version in *Caribe Insular* he writes: "His [Peter Minshall's] artworks or rather roadworks as I'd like to call them, as they are used in street performance [...]"[28]

How might the epistemological shift articulated by Cozier from artwork to roadwork affect the way in which Carnival is conceived of and, by extension curated?

III

It should be noted that three of the most influential critics and theoreticians of Carnival, Camnitzer and above all Minshall and Cozier are artists. So have two practicing Carnival artists, Minshall and Marlon Griffith, most advanced the curation of Carnival. It might also be worth mentioning that both Minshall (born 1941) and Griffith (born 1976) received a Guggenheim fellowship, the former in 1982 in Carnival Design and Kinetics and the latter in 2010 in Fine Arts, facts which, in addition to the specificity of the artists' practice, might indicate the growing appreciation—or co-optation—of Carnival within the realm of the visual arts.

From the mid 1980s through to 2000, Minshall's work was repeatedly featured in British art institutions and twice in international art biennials.[29] In each instance, Minshall's role was paramount in the choice and display of the work. According to Gulick who often wrote the catalogues' texts, Minshall "confronted the difficulty of trying to convey a dynamic performative work of art in a static gallery space, and in answer to this selected a work whose mas costume forms are especially sculptural even when static [...]; and to include a video and sound."[30] This statement, which applied to Minshall's choice of the masband Callaloo (1984) for his first invitation to present an exhibition of his work called 'Callaloo by Minshall' in an art gallery, the Arnolfini in Bristol and the Riverside Studios in London (1986), an exhibition later reprised for the 19th São Paulo Biennale (1987), could have applied to the masband RED which he chose to exhibit in the 7th Havana Biennale (2000) and later at the Drawing Center exhibition mentioned previously (2005). In both cases, the choice of a single masband for exhibition reflected Minshall's desire to "convey the integrity and coherence of a single (albeit multi-faceted) work of art."[31]

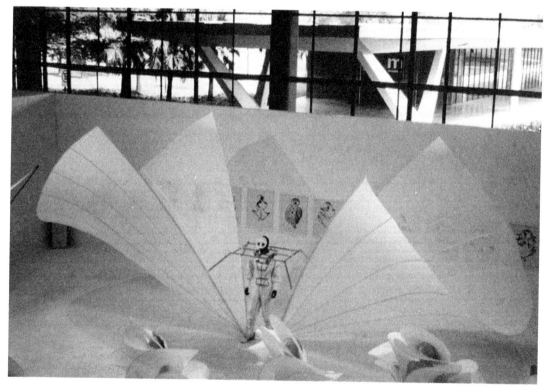

Figure 2. Peter Minshall, *Peter Minshall: Callaloo, an Exhibition of Works from the Carnival of Trinidad,* 19th International Biennial of São Paulo, 1987.
Photo: Todd Gulick; courtesy the Callaloo Company, Chaguaramas, Trinidad.

And while Callaloo was indeed "especially sculptural", RED was particularly visual and both masbands illustrate Minshall's ongoing dialogue with the visual arts. But Minshall's exhibition displays in gallery spaces seemed rather traditional, if masterful: drawings of costumes were hung on the wall and costumes displayed on mannequins; even in these perhaps novel features for the times: ambient sound and videos; and details, in which Minshall's part could be found: mannequins painted black and a sophisticated multi-channel video display.

His curatorial experiments within his own medium, mas' proved more innovative. If with 'Carnival is Color' (1987), Minshall killed two birds with one stone, poking fun at the narrow-mindedness of small-island people who, by saying that "carnival is color" meant that carnival should be fun rather than serious, while also castigating the highbrow pretentiousness of the artworld with section titles such as "Horizontal Primaries," "Tangerine Expanding" and "Uncomposed Red Lines in Space," with 'Tantana' (1990), he devised an entire section as "a group exhibition as a public art event, conceived, commissioned and curated by [himself.]"[32] Taking the seven foot square of appliquéd cloth, an important design medium, as a premise, Minshall invited about fifteen fine artists, among whom at least one also doubled as a masman, Carlysle Chang, along with Lisa Henry Choo Foon, LeRoy Clarke and others, to contribute designs sewn up by Callaloo company craftsmen which taken together, formed the section called "Artists Squares."

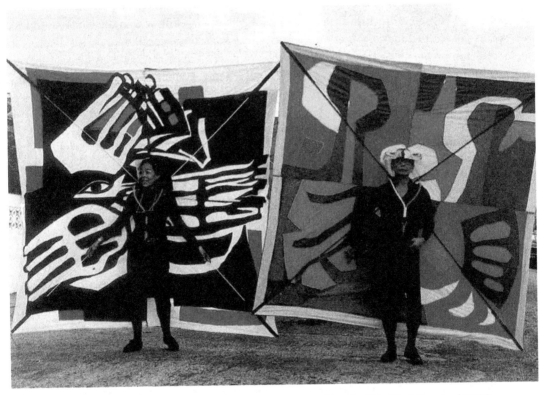

Figure 3. Peter Minshall, *Artists Squares* in *Tantana*, Port of Spain, Trinidad Carnival 1999.
Photo: Noel Norton. Courtesy the Callaloo Company, Chaguaramas, Trinidad Featured on the photograph are Artists Squares by, on the right Carlysle Chang, played by him; on the left Lisa Henry Choo-Foon, played by Carol Aqui.

As Chris Cozier, who declined the invitation to participate in the "Artists Squares" anticipated, this "exhibition of 'dancing paintings'" in Minshall's words, squares of appliquéd clothes totted on the back of the masqueraders as if kites (whose rods they used for reinforcement) lacking wind or speed to take to the sky and fly, was somewhat awkward.[33] More promising maybe, and less tied to the sacrosanct medium of painting which Minshall for all his irreverence against it, deeply respected, was yet another section of that decidedly unbridled Tantana band, a section for children, Bacchacs (the vernacular for a local leaf-carrying ant) designed by fine artist and maswoman Kathryn Chan who, rather than trying to replicate her own paintings onto an appliquéd canvas, used mas' as an artistic medium.

In keeping with his preoccupation to legitimize Carnival by way of a comparison with performance art, Minshall sought ways to translate masbands into performance art pieces within the context of the art gallery or biennial. If for the installation of 'Callaloo by Minshall' at the Arnolfini in Bristol Minshall created an original masband, *Drums and Colours*, to accompany the exhibition, a year later, for the São Paulo Biennial, in the days preceded the opening, he gave into an improvised performance of *The Dance of the Cloth* to a percussive soundtrack, before an audience of a hundred or so spectators. *The Dance of the Cloth* was later reprised in 1999 at the Brooklyn Museum to accompany his lecture and in 2000 at the 7th Havana Biennale. In this last instance, over a decade apart from the first, Minshall was no longer the sole improvising performer, or a performer at all, but rather several members of the Callaloo Company presented a rehearsed performance in the courtyard of the Palacio Municipal. But, as was the case with painting within the context of mas', wasn't Minshall too tied to the concept of performance art in these contemporary art displays to which, for better or worse, he tried to adapt? Cozier, who saw the performance twice, said that "it had something to it..."[34] Unfortunately, a planned retrospective exhibition designed by Chan, and a publication edited by Cozier and other faithful followers such as editor and writer Patricia Ganase, both of which could have granted Minshall the recognition from the mainstream art world he so desired, were aborted in 2006.

Figure 4. Marlon Griffith, *Symbiosis*, CAGE Gallery, Edna Manley College, Kingston, Jamaica, 2007, curated by Veerle Poupeye. *Photo: courtesy the artist.*

Marlon Griffith, a disciple of Cozier, with whom he perfected his drawing and graphic skills, even more so than of Minshall's, in whose mascamp he apprenticed, seems to be headed in a different direction. When featuring his work in an art gallery context, Griffith has, for the most part, resisted trying to recreate a masband physically in the gallery space by way of mannequins but rather has attempted to recreate phenomenologically the feeling of being immersed in a masband. In 'Lighting the Shadow: Trinidad in and out of Light' (CCA7, Port of Spain, 2004, curated by this author), Griffith, appropriated the technique used to cast molds for carnival costumes, to create clear-plastic prints of carnival characters reflected as shadows onto the gallery wall through light projection. With these he said that he was attempting to evoke the emotions of Jouvé, the nocturnal Carnival Sunday purifying ritual, as did Kathryn Chan who also contributed a mas-inspired installation to the exhibition. In various other instances, with 'Symbiosis' (CAGE Gallery, Edna Manley College, Kingston, Jamaica, 2007, curated by Veerle Poupeye) and *Trapped in a Memory* (in 'Mas': From Process to Procession', BRIC's Rotunda Gallery, Brooklyn, New York, 2007, curated by this author) Griffith created organic environments in the cut-out technique that has become his hallmark, using light to reflect shifting motives and, in so doing allowed shadows to fragment the image even as they also became an embodiment of the work and a reminder of the transient and ephemeral quality of mas'. When incorporating mannequins, at the Mino Paper Art Village (2005) {Marlon Griffith Artist in Residence Exhibition, Mino Paper Art Village, Mono Japan, 2005} and in 'South-South: Interruptions and Encounter' (Barnicke Gallery, University of Toronto, 2009, curated by Tejpal Ajji and Jon Sonske) Griffith designed his work specifically for the gallery space rather than using past design as props. When using past designs, he resorted to suspending the work, rather than displaying it on mannequins, in another attempt to respect the irrevocability of the spatio-temporal dimension.

Figure 5. Marlon Griffith Artist in Residence Exhibition, Mino Paper Art Village, Mono Japan, 2005.

Figure 6. 'Spring,' 90-minute procession with 200 participants curated by Claire Tancons, 7th Gwangju Biennale5 Septembe 2008, May 18 Democratic Plaza. Clockwise from left: Jarbas Lopes, Demolition Now (after the second float has been destroyed in front of the Former Provincial Office); Karyn Oliver, Grey Hope; Mario Benjamin, The Banquet; Marlon Griffith, Runaway/ Reaction; Map Office, The Final Battle (before the wagons are set on fire).

Space, it has been suggested, not the artwork, is the material of curators, and their instrument the exhibition.[35] When space is the street, the artwork becomes roadwork, the exhibition a procession, a parade, a march. It is with this understanding of space that with 'Spring' (September 5, 2008), the group procession I organized for the 7th Gwangju Biennale, as a project curator under Okwui Enwezor's artistic directorship, I offered Griffith the opportunity for his first "full-scale street production"[36]

Having written and spoken extensively about 'Spring', I will turn to Cozier, that expert mas' commentator.[37] According to Cozier, "*Spring* proposed and implemented a trans-cultural, collaborative street procession involving artists from Trinidad, Haiti, Brazil, France and Germany. Through the process of this collaboration, various moments—historical and cultural—were interwoven [...]. Tancons has tried to shift the dialogue from anthropological culturalism to comparative discussions with other places (and moments), where similar street actions take place. As a curator of the project, she also entered into the process as imaginer/instigator of the "band" in Gwangju. The line between curator and creative producer became blurred in a transient exhibition space, one without walls and in the public domain. Utilizing the impulse of Carnival, Tancons is advocating another way or mode of curatorship."[38]

I initially apprehended my role as the organizer of 'Spring' and of 'A Walk Into the Night' (2 May 2009) for CAPE 09, the second Cape Town biennial, no differently than I did other curatorial projects, having started to mull over the idea of the procession as a curatorial format at least since

'Mas': From Process to Procession', which was to be accompanied by a procession, if not since 'Lighting The Shadow: Trinidad in and Out of Light', both exhibitions mentioned earlier which I organized and in which Griffith's work was featured. Griffith, the main artist in 'A Walk Into the Night' went on to organize a procession of his own, *Stuffed Swan* (2010), as part of Junkanoo in Nassau. Growing up in Guadeloupe, I had run the vidé in Pointe-à-Pitre through childhood and adolescence. During research trips, I participated in Jouvé in Port-of-Spain a couple of times since 2005, rushed in Junkanoo in Nassau in 2008 with fellow art historian and curator Krista Thompson, had gone up and down Arto Lindsay's trio elétrico in Bahia and paraded with artist Jarbas Lopes and the Mangueira Samba School in Rio de Janeiro's Sambódromo in 2009. I researched artistic practices and observed the cultural milieu out of which they developed and set out to design a methodology best suited to produce works outside of their original context of creation. I was aided in this pursuit by ongoing conversations with Gulick and it was made possible to a great extent by Anthony 'Sam' Mollineau, one of the last recruits of the Callaloo Company who was workshop and parade manager of 'Spring.' For both my procession projects, I started by organizing what could be seen as a mascamp, barracón or shack, that is workshops during which artists would create works with assistants.[39] I then proceeded to curate a procession, a parade, a march, taking a measure of space unbounded by walls, reaching back in times immemorial of popular festivals and tuning into a future of globalized mass movements.

Enwezor, who back in 2008 told me that as a Nigerian he knew what a masquerade was, where I was coming from and where I was going, was first to refer to me as a producer in my role as organizer of a procession. At a recent conference, Brazilian art historian Roberto Conduru, responded to my presentation of 'Spring' by saying that Carnival already had its curators, the carnavalescos. In turn, Brazilian curator and architecture historian Paola Berenstein Jacques, ventured to say that I was a carnavalesca.[40] In Trinidad they would have said maswoman. While the Trinidad Carnival can be seen as having generated not just a new artistic lingua franca, under the form of mas', but also reinvented an old performative exhibitionary model specially suited for the public ceremonial culture of the Caribbean streets, the procession or parade, the Rio Carnival created its own museum-stadium to Carnival, the Sambódromo.

The truth is, I never set out to be a producer, a carnavalesca or a maswoman and the proposition of "Curating Carnival" remains a risky one. Yet to the extent that carnavalescos in Brazil, masmen in Trinidad, Junkanoo-makers in the Bahamas and Crop-Over designers in Barbados continue to make daring contemporary artistic interventions, and artists and audiences throughout the Americas create and participate in Carnival, it remains a necessary one. As contemporary Caribbean art integrates more fully the global contemporary art world and its performance tradition is recognized as being central to it, it becomes an urgent one.

Notes

1. See: John Nunley and Judith Bettleheim (eds.), *Caribbean Festival Arts*, Seattle: the University of Washington Press and St Louis: St Louis Art Museum, 1988. The exhibition opened at the St Louis Art Museum in 1988. Though the organizers of the exhibition and authors of the catalogue might disagree with the characterization of their approach to Carnival as folkloric, such statements as "The ingredients [of the festivals], like the people, are distinctive yet together they create a sweet, pungent pan-Caribbean aesthetic" on the flap cover makes it also exotic and suspect of the kind of essentialism that Eurocentric views of non-European cultures promulgate.

2. Annie Paul, "Visualizing Art in the Caribbean," in: Tumelo Mosaka (ed.), *Infinite Island: Contemporary Caribbean Art*, Brooklyn: Brooklyn Museum and London: Philip Wilson Publishers, 2007, p. 32.

3. Homi K. Bhabha, "Unsatisfied: notes on vernacular cosmopolitanism," in: Laura Garcia-Moreno and Peter C. Pfeiffer (eds.), *Text and Nation: Cross-Disciplinary Essays on Cultural and National Identities*, Columbia: Camden House, 1996, pp. 191-207.
4. Kobena Mercer (ed.), *Cosmopolitan Modernism*, Boston: MIT Press and London: inIVA, 2008.
5. Paul, op. cit., p. 30.
6. Errol Hill, "Trinidad Carnival. History and Meaning," in: *Caribbean Visions: Contemporary Painting and Sculpture*, Alexandria, Va: Art Services International, 1995, pp. 43-7.
7. Peter Minshall, "Carnival and Its Place in Caribbean Culture and Art," in: *Caribbean Visions: Contemporary Painting and Sculpture*, Alexandria: Art Services International, 1995, pp. 49-57.
8. Christopher Cozier, "Trinidad: Questions about Contemporary Histories," in: *Caribe insular: exclusion, fragmentación, y paraíso*, Badajoz: Mejac and Madrid: Casa de América, 1998, pp. 348-9.
9. Nicholas Laughlin, "That is mas," in: Yona Backer and Kristina Newman-Scott (eds.), *Rockstone and Bootheel, Contemporary West Indian Art*, Hartford, Ct: Real Art Ways, 2010, pp. 22-7. By "our artists" Laughlin refers to Trinidadian and possibly Caribbean artists at large. Laughlin also quotes this author in a passage from the essay "The Greatest Free Show on Earth. Carnival from Trinidad to Brazil, Cape Town to New Orleans," in: Dan Cameron (ed.), *Prospect. 1 New Orleans*, Brooklyn, PICTUREBOX, 2008, p. 52.
10. RoseLee Goldberg's *Performance: Live Art 1909 to the present* was first edited by Abrams in 1979, re-edited by Thames and Hudson in 1988, revised, expanded upon and re-edited in 2001 as *Performance Art: From Futurism to the present* by the same publisher. Her second book on performance art, *Performance: Live Art since the 60s* was published, also by Thames and Hudson, in 1998 and 2004.
11. http://www.performa-arts.org (10 July 2011).
12. Inspired by his experience of the Bahia Carnival, for which he usually performs on a *trio elétrico*, Lindsay, a musician of the Tropicália generation and participant in the noise avant-garde in New York, has been organizing parades in collaboration with artists such as Matthew Barney and Rikrit Tiravanija in Brazil, Europe and the United States since 2004.
13. Veerle Poupeye, *Caribbean Art*, New York: Thames & Hudson, 1998.
14. Milla Riggio (ed.), *Carnival: Culture in Action - The Trinidad Experience* New York and London: Routledge, 2004.
15. Among many other theatre projects, Minshall created set designs for Hill's *Man Better Man* at Dartmouth College in 1975.
16. Minshall, *Caribbean Visions*, op. cit., p. 50.
17. Minshall, *Caribbean Visions*, op. cit., p. 51.
18. Minshall, *Caribbean Visions*, op. cit., pp. 56-7.
19. Minshall, *Caribbean Visions*, op. cit., p. 50.
20. Luis Camnitzer, "The Keeper of the Lens," in: *Looking at the Spirits: Peter Minshall's Carnival Drawings*, New York: The Drawing Center, 2005, p. 5.
21. William Dunlap, "The Island of Reflected Images. Two-month festival brought out the best of Havana's contemporary art scene," *The Washington Post*, 18 February 2001, p. G4.
22. Todd Gulick, explanatory notes to the typescript of William Dunlap, The Peter Minshall Archives, Callaloo Company, Chaguaramas, Trinidad and Tobago, W. I.
23. Camnitzer, op. cit., p. 5.
24. Cozier, *Caribe Insular*, op. cit., p. 349.
25. Christopher Cozier, "Mancrab," typescript, p. 2.
26. Cozier, *Caribe Insular*, op. cit., p. 348.
27. Christopher Cozier, typescript of talk given in 1998, p. 2. A revised version of this essay was published in *Caribe Insular*. The sentence, in italics in the typescript, as if to suggest a mental note, does not feature in the final published version.
28. Cozier, *Caribe Insular*, op. cit., p. 348.
29. Other art exhibitions of Minshall's work in Great Britain, in addition to those mentioned in the text, include: 'The Dancing Mobile', an exhibition of work from the mas' by Minshall (Leicestershire Museum & Art Gallery, Leicester, England, 1990) and an important section of Minshall's work in the Trinidad Carnival and the Barcelona Olympic Opening Ceremony in 'The Power of the Mask' (National Museums of Scotland, Edinburgh, Scotland, 1993).
30. Todd Gulick, 24 February 2011, 2:15pm, email correspondence with the author.

31. Gulick, 24 February 2011, 2:15pm, email correspondence with the author.

32. Gulick, 24 February 2011, 2:17pm, email correspondence with the author.

33. Christopher Cozier, 07 April 2011, 2:44am, email correspondence with the author. "For *Tantana*, I opted to be a regular foot soldier. I bought a costume and played with the band, which I have done for years when I could. [...] I wanted to just play mas - anonymously - and had a better time out in the regular band with a flowing parangole like cloth with my posse getting on - not walking around on display with a static image stuck to my back."

34. Cozier, 07 April 2011, 4:39am, email correspondence with the author.

35. See Carson Chan, "Measures of an Exhibition," in: *Fillip*, Issue no.3, Spring 2011, pp. 28-37.

36. Christopher Cozier, "Shifting Signs and Transitional Moments," in: *South-South: Interruptions and Encounters*, Toronto: The Justina M. Barnicke Gallery, 2009, p. 49.

37. For my writings about *Spring* see: Claire Tancons, "Spring," in: *The 7th Gwangju Biennale. Annual Report: A Year in Exhibitions*, Gwangju: Gwangju Biennale Foundation, 2008, pp. 334-63; Claire Tancons and Jesse McKee, "On Carnival and Contractual Curating," in: *Fillip*, Issue No.13, Spring 2011, pp. 74-79; Claire Tancons, "Carnival as Counter-Curatorial Intervention," in *Viz.Inter-Arts* (UC Santa Cruz), upcoming in 2011. For writings about *Spring* by others see: Anna Schneider "Architectures of Spectacle. Facets of the exhibition boom in South Korea and China in the context of the strategy of globalism" in: *Springerin*, Issue 1/09, January 2009 (http://www.springerin.at/dyn/heft.php?id=58&pos=1&textid=2167&lang=en); Anna Daneri, "The Carnival of Art" in: *Mousse*, December-January 2009, pp. 81-83; Jesse McKee, "Mythographies, Archeologies, Circuitries. Other Ways of Curating" in: *BorderCrossings*, Vol. 29 No. 2 (#114), February 2010, pp. 66-67.

38. Cozier, *South-South*, op. cit., p. 50.

39. The 'mascamp,' 'barracón' and 'shack' are the names of the workshop-like, basic production units of the Trinidad and Rio carnivals and Bahamian Junkanoo respectively.

40. On the occasion of the reading of my paper "Carnaval do Sublime" at the 'Contemporary Art in the South Atlantic? Images and Strategies' panel in the 'Terceira Metade/Third Half' conference, Museu de Arte Moderna, Rio de Janeiro, 29-31 March 2011.

From Mythologies to Realities:
The Iconography of Ras Daniel Heartman

Ama

Introduction

Patricia Mohammed's "The Emergence of Caribbean Iconography in the Evolution of Identity" is a compelling review of early Caribbean art history. The chapter chronicles the colonial imagination of the itinerant and Creole artists that laid the foundation for what would formally be considered Caribbean art through a survey of paintings from the fifteenth to the nineteenth century. But distinct from the pastoral, idyllic imagery of the early colonies which focused on the vastness of the land, and a wild, untamed nature where people would come to feature mainly as the market woman and banana man, Mohammed also discerns "a new invention of the black Caribbean male removed from slavery and metaphorically reinvented....The reshaping of the image of masculinity damaged by the enslavement of African peoples outside of the African continent."[1] She uses a single image, "Rastaman Lion" by Ras Clarence "Guilty" Williams, to illustrate that new invention. The essay does not delve into the history embodied in Ras Clarence's piece which represents both the intuitive and specifically Rastafarian tradition in Caribbean art, and is used as a device to illuminate an alternative trajectory in the emergence of Caribbean iconography. Instead, Mohammed outlines a "methodology of enquiry" for looking at, uncovering, and rediscovering both the preferred and alternative roots of Caribbean art. She merely points to rather than explores the parameters of this other tradition but suggests that to trace the roots of Caribbean iconography we must consider the genesis of a native, indigenous identity and expression, which the formalised art of Creole society only captures in part. This forces a consideration of the multiple perspectives wrought by class, race, gender, and colour within the Caribbean mosaic.

> Colonization did not facilitate or encourage the indigenous art forms, which were largely eradicated, making way for the European lens through which the societies were looked at and, consequently, the way in which the immigrant groups who comprised the society began to look at themselves. *The truth is also that these layers are to be uncovered* in the cultural graveyards of the societies from which many contemporary Caribbean peoples have themselves been derived.[2]

It is not coincidental that Mohammed invokes the trope of the Conquering Lion to counterpoise the classical tradition of Western expansionism and colonial identity. Even within the black nationalist tradition, it is perhaps not until the advent of Rastafari that a truly alternative discourse of the sovereignty and integrity of the black subject can take place, because Rastafari proffers a new language that is at once metaphorical and figurative. The (re)discovery of the black subject in Jamaican and Caribbean iconography takes place in the interstices of alternate and overlapping spaces in the contest for identity born of class struggle. But it is also a spiritual mission to approach the image in Jamaican iconography, because it is an expression of who we (think we) are in the image of God.

Reprinted with permission from *Small Axe* 23 (2007): 66–87. The images of Ras Heartman's work are reproduced with the permission of his son, Ato Roberts.

Rastafari insists first of all on the image of the black God, but equally important on the *a priori* existence of God within man. In contradistinction to the Christian projection of God in both the conscious and subconscious mind of the Caribbean person, the Rastafari worldview presents its own pantheon of symbols by which to express this alternative relationship. The colour trinity of red, gold, and green, locks, the Conquering Lion, the holy herb, as well as the personage of the Emperor Haile Selassie are the main visual cues around which the fellowship of Rastafari has been built since the 1930s. These images are consciously reproduced in Rastafari artmaking which, alongside its distinct and ever-evolving language, forms a unique lexicon that informs and challenges Jamaican, Caribbean, and black diasporan identity.

Mohammed continues:

> How a shift begins to take place in the way Caribbean people have defined themselves and how they have been defined by others needs to be systematically examined through the plethora of iconographic images that have emerged over the last two centuries. There is much scope for examining these images at comparative and differential levels across the territories in order to arrive at the icons of identity that they produce for the Region.[3]

Amid "the layers of indigenous art-making" in the modern Caribbean, the contributions of Rastafari are an undeniable force – as a worldview, a metaphysical and symbolic conceptual system, and a social, cultural, spiritual, and political presence. Yet Rastafari artists are largely unknown and scarcely acknowledged within the canon of Jamaican and Caribbean *visual* art. There are several images of Rasta such as those created by Osmond Watson, Karl Parboosingh, Christopher Gonzalez, or even Carl Abrahams. Some of them have been sympathetic portrayals, and often they take different stances in relation to the saintly or mystical characterization of Rastafari. But all these artists have created an outsiders' view of Rastafari; as a source of inspiration, yes, but few speaking from the authentic voice of Rastafari themselves. Indeed there are few recognized works of art of Rasta by Rasta. As we look at the progression of Jamaican art history, this omission belies the important contribution of Rastafari to the production of art and image-making, particularly in the 1960s, 1970s, and 1980s. This omission would seem to suggest that the Rasta contribution to Jamaican and Caribbean art has been on a relatively small scale, confined primarily to reggae music and craft production. But the outsider view when taken *en masse* also has the effect of mythologizing rather than representing, which in the contestation for truths and rights often overshadows with Othering.

From among the cultural archaeology, then, is the need to reclaim important artists and imagery that may have been discarded according to the cultural priorities of the past, so that the process of writing and rewriting our (art) history is supported by a fair assessment of our values, our heroes and icons. In this essay we take a look at the life and work of a Rastafarian artist whose art is perhaps the most internationally known, and perhaps the most widely pirated of Jamaican artists.

Approaching Ras Daniel

Ras Daniel Heartman was born Lloyd George Roberts on 18 January 1942 in Kingston. He was an accomplished artist, who earned his living both as a tailor and as a portrait artist from the late 1950s until the end of the 1980s when he left Jamaica to reside in Tanzania. He died on 31 May 1990.

Few Jamaican visual artists have been able to capture the quintessence of Jamaican identity in the way that Ras Daniel Heartman did. Best known for the images he produced in the 1960s and early 1970s, Ras Daniel achieved an astounding level of popularity generated around a profound

identification with his work by people all over the world. And yet there is virtually no written record of Ras Daniel in Jamaica. While there are a few scant instances in which his work was published, these are rarely accompanied by either critical or biographical notes. What follows, therefore, is a sketch compiled from the living memories of a few individuals who knew him well. Daniel's eldest son, Mani, who resides in West Kingston just a few doors away from the yard in which he grew up with his father, was an important source in helping to understand the persona of this self-taught artist and powerful Rastaman. He spoke from the intimate distance that is accorded to family, distinct from the perspective of friends and supporters who came to know Daniel in the early 1970s.[4]

Photograph of Ras Daniel,
courtesy of Richard Frankson

Brian and Beverly Morgan, who have an unparalleled collection of original works by Ras Daniel Heartman, also provided critical insight borne out of their friendship with Daniel over more than a decade. The Morgans' collection reflects a body of work far more extensive than can be represented in this brief sketch, speaking to a breadth of both style and subject that surprises and challenges us to respect the evolution of genius. Indeed, one of the striking things shared by all the informants was the way in which Daniel's memory, his philosophy and his humanity, are closely guarded by those who knew him well. There is an insistence that Ras Daniel is approached with respect, in keeping with the very circumspect nature of the man himself, and in the unfolding of this effort I wish to also honour that intent.

Church Triumphant

Coming of age at the end of the 1950s, in the urban expanse that defined the black underclass of Kingston, young Daniel was like many youths who "sight up" Rasta from an early age as a medium through which to explore and affirm a positive grounding in the post-plantation, but avowedly still *colonial* present. Within the promasculine fold of the movement was a sense in which each was encouraged to nurture the talents and innate abilities within, and to culture oneself around a sense of the divine inspiration that could be seen as both a source and a guide to righteous living. Ras Malachi Wilson recalled that even at that time Daniel already showed an impressive ability to draw what he saw, and was able to channel this talent productively from early on. He began painting signboards, dance posters, and so on at the age of sixteen or seventeen, and at eighteen, around the time of his son's birth, started drawing seriously. Daniel worked primarily in pencil, sometimes in pen and ink, and dabbled in painting, although he is less well known for the latter (his first oil painting, *The Black Rose*, was done around 1963).

Ras Daniel's early inculcation into Rastafari saw him emerge as a central figure among an influential group of Rastamen who would gather and reason in and around West Kingston. The group, which featured Ras Shadrach and others, was known as Church Triumphant and held gatherings on Spanish Town Road in the early 1960s until they were moved by the police. They then congregated for a time at Bull Bay, and could be found also in the Papine-Gordon Town area. Daniel was known for his sharp reasoning and respected for his artistic ability by many who came in contact with him. He appeared to have a penetrating ability to read people that could both amaze and disturb; having begun to make a name for himself by the age of twenty, he was a man of incredible presence and spiritual depth who was treated as an elder by many.

Identities...are continuously constructed through the mental and visual images we conceive and produce. We either reinforce recurrent imagery, if it is representative of common perceptions or beliefs, or we reconfigure it to suit the political and social moment. An understanding of identity creation, through any medium, forces an interrogation of oneself in relation to how one is perceived by others, consequently sharpening the lens of how one defines oneself.[5]

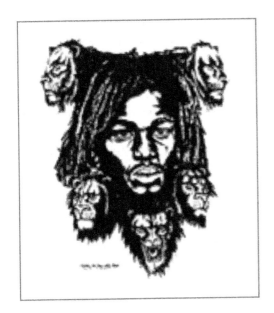

Daniel in the Lion's Den c. 1963

Daniel in the Lion's Den was one of his first prints sold as a reproduction by popular demand. This self-portrait reflects the symbolic alignment of Rastafari manifesting the power and majesty of a leonine energy that is all at once ferocious and watchful, contemplative and subdued. Each head of the lion, five in all, emerges from the mighty locks and beard of Daniel at the centre, extensions of the inner man poised as sentinels to the outer world. The composition evokes its ancestral origins in Africa, from where Daniel's visage emerges from the deep, dark centre to confront us, unafraid. *Daniel in the Lion's Den* struck a chord with its unabashed display of sovereignty and dominion in the newly independent Jamaica, tapping into the popular imagination of the time. Widely circulated as a print and appropriated for the cover of a John Holt LP, it travelled the diaspora over the next decade or so to appear as a signature for the new black ascendancy.[6]

In contrast, *Not Far Away* is a later self-portrait that reflects the depth and complexity of a more mature artist. Here, the central figure looks back and away, somewhat removed from the gaze of the viewer. With nothing but pencil on paper Daniel achieves a series of levels in this piece that alternate between the corporeal and the supreme, the here and the hereafter.

Not Far Away c. 1975?

In contrast, *Not Far Away* is a later self-portrait that reflects the depth and complexity of a more mature artist. Here, the central figure looks back and away, somewhat removed from the gaze of the viewer. With nothing but pencil on paper Daniel achieves a series of levels in this piece that alternate between the corporeal and the supreme, the here and the hereafter. A flattened lock of hair from the central figure tumbles down like a stairway, joining with the lion's mane below the image of Daniel as a familiar to his master. The lion in the foreground is more rooted and earthly than the projection of the figure above it, which appears to float through the heavens, timeless and mighty. As both Daniel and the lion look off into the distance, to the East, as it were, we follow the gaze of his furrowed brow to try to catch a glimpse of what he sees before him, somewhere beyond the cloud of what we know now.

One has to study the drawing closely to see the intricate detail of what appears in the background. On the first level one will admire the way the central figures are rendered in graphite to achieve incredible texture and emotion with such confidence and precision. Even at a passing glance, *Not Far Away* distinguishes itself as a masterpiece because we are able to recognize the intensity with which the artist has brought the inner man to the surface. However the work cannot be read fully outside its spiritual context as a contemplation, reflecting also an impatience for Repatriation. Travelling back in the distance from the first lion is another, bearing the flag of the ites (red), green, and gold. These are two distinctly different, though clearly related creatures: where the first appears somewhat subdued compared to the erect and stately bearing of the Conquering Lion figure in the distance, this lion guards and patrols an exquisitely rendered depiction of the Royal Palace of Ethiopia even further into the distance. The striking detail of the imperial palace impresses with its miniature scale, and unlocks the yearning discerned above and behind the eyes in the foreground. *Not Far Away* traverses the boundaries between realism and symbolism, interweaving Rastafari cosmology with i-sight – the virtuoso, inborn ability to bring forward the spiritual and make manifest in the here and now. That inner-sight is also referenced by the appearance of the herb stalk to the lower right of the work. In contrast, the plant is rendered faintly, as a motif rather than a central element, but it adds to the body of symbolic representation that defines the work as being by and about Rasta.

This is the artist at a distinctly different stage of the journey, and there is some variance of opinion about when this piece was actually created. According to Mani, this was the very last print that Daniel reproduced; it originated, he says, in the early 1980s, just a short while before Daniel actually left Jamaica. From this standpoint the piece certainly hearkens to Daniel's eventual repatriation to Tanzania in 1988, the title prophetically calling, chanting for both the spiritual and physical reward that would soon come. However other persons believe the drawing was first done as early as 1974. What is clear is that by this time Daniel had broken with the Church Triumphant group that was such a seminal part of his foundation in Rastafari. As an independent, he remained influential in the movement and was sought after for advice as a man of great discernment and *overstanding*. He continued to sign many of his works "Ras Daniel Heartman – Church Triumphant," which may reflect a more generalized use of the Church Triumphant concept that suggests the holy sanctuary or inner temple of the Most High. "Heartman" was a name he had given himself, according to Mani, as both a play on the Creole pronunciation of "art" and "heart," and a signal to the source of his talent.

From Mythologies:
Ras Daniel Heartman and the Reggae Aesthetic

I begin by rooting Daniel quite deliberately within the devout tradition of the spectrum of Rastafari, having certain churchical precepts that must be approached with consideration if one is to fully appreciate both the symbolic and the artistic historical significance of his iconography. In a review of the book *Rastafarian Art* edited by Wolfgang Bender, Annie Paul writes:

> [Ras Daniel Heartman's] life-like pencil drawings were the first to depict the Rastafarian subject in all his dreadness, capturing what literary scholar Gordon Rohlehr aptly described as the "fierce energy, resolve, and an underlying sense of the tragic" that characterised the quality of "dread" associated with Rastafari...[Heartman's work] betrays the fact that not every Rasta artist is congenitally wedded to naïve or spontaneous modes of expression.[7]

Heartman's arresting realism is the vehicle for an exploration of some important facets of Jamaican identity through portraiture, particularly during the period of the 1960s and 1970s. In the search for a critical language with which to frame my own estimation of the impact of Ras Daniel's work, I was struck by Kwame Dawes's *Natural Mysticism* and his notion of the reggae aesthetic. Navigating the space between the spiritual and the popular, it becomes important to note the outsider status of Rastafari within the Jamaican social order, even as the popular culture of the time becomes infused with its ethos in the contest for a new national identity. Approaching a definition of the reggae aesthetic, Dawes states "I know that it is a way of seeing the world which arises from the conflicts in our social order."[8] He continues:

> [The] focus on history and on race within the Rastafarian ethos is another important shaper of the reggae aesthetic. It has enabled history not only to become accessible to, but defining for the working-class Caribbean person. The embrace of history, particularly in using it to define the present, is central to reggae and it offers a crucial aesthetic direction... The very act of retelling history is also important because it brings to the fore the nature of the artists role, her/his philosophical position in society.[9]

For the generation that came of age around and immediately after independence, Ras Daniel provided a new vocabulary of the black subject, presenting powerful images of Rastafari that are unequalled in any genre, and recognizably Jamaican the world over. In much the same way that the movement in music from ska to reggae provided a soundtrack to the conscious struggle for self-determination, Ras Daniel Heartman's iconographic work parallels that evolution in the visual arts. For me, nowhere is this seen more starkly than in his portraits of children.

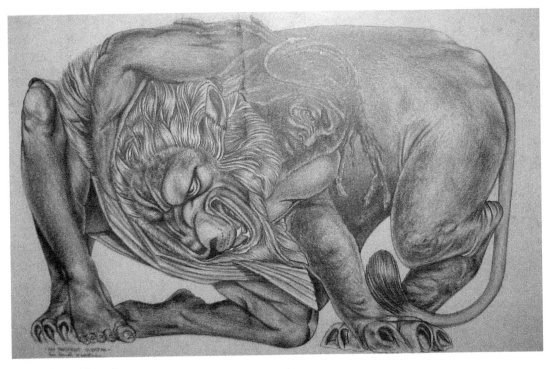

An Ancient Olympian

The portrait of Prince Emanuel, commonly called "Rasta Baby," is one of the most widely copied of Ras Daniel Heartman's works. I grew up seeing this image around me, in just about every black-conscious home of my youth, and for me it is the seminal work by Ras Daniel in terms of portraiture. Once again the pencil deftly delineates every lock on the head of the young Ras, capturing the regal quality of the skin – an inexorably solarized melanin where other black visual artists of the time still wrestled with how to present black skin in realistic shades as against the flat black that was the norm in the earlier era of visual representation. Prince Emanuel was an age mate of Daniel's own son, Mani, who also features in several of these early portraits.

Prince Emanuel
c. 1966–67

What is striking to the viewer is the facial expression, showing an unrestrained dignity and defiance that arrests our perception of what we are seeing: it is not easy to discern the age of the child who stares back at you as the intensity of the subject's gaze challenges in his *mannish* stance. There are several portraits of girl children, as well as mother and child images that originate from the same period, and the need for a more detailed treatment of the body of Daniel's work does not permit me to contrast them here. However his depictions of children are fascinating as they reveal the side of Rastafari that nurtures and expands the scope of what was perceived as a mainly male-centred, rebel movement. These portraits bring attention to the development of family within the movement and signify the evolution of a culture, as against the "cult" status Rastafari had been accorded.

When I interviewed computer science lecturer Dr. Ashley Hamilton-Taylor, who grew up in a Rastafarian family and knew Ras Heartman from an early age as a brethren of his parents, he spoke about the attitudes of Jamaican society towards Rastafari, and Rasta children in particular during that period of the 1960s. "Of course Rastafarian children were heavily discriminated against and Ras Daniel's portraits were the first popular representation," he said. "Because of the poverty Rastafarians were kept in, not everyone had the ability to represent their children as healthy and intelligent."[10] In school, if they were allowed to attend, and in the society at large, they were treated as second class, and there was the notion that they couldn't possibly be intelligent, clean, and well-spoken. "Ras Daniel's imagery helped to break the stigma," Hamilton-Taylor stated, and placed the artist at the forefront of the fight towards acceptance.

Prince Mani
c. 1966–67

Prince Emanuel (detail)

What emerges from these portraits is a new sense of masculinity, of personhood and humanhood that reflect the philosophy and teaching of Rastafari. They reveal the inborn concept from the tradition of Marcus Garvey to the era of Black Power. Ras Daniel's powerful imagery challenges colonial notions of race and class position, causes us to confront gender too as Daniel the father is revealed eloquently and unmistakably in his own hand. Mani tells that on seeing a particular piece of his father's work at the time, one person

remarked that Daniel had the ability to use his pencil like a camera. Able to capture distinct personalities, moods, and moments, his enduring legacy is indeed etched into the visual fabric of Jamaica's era of Independence, even if the Jamaican art movement failed to embrace the true magnitude of his contribution.

> I present an image of the reggae artist that is both *of* the community and speaking *for* and *to* it and who is also a prophetic figure who sometimes challenges the community from a position of isolation—the isolation of the prophet with an uncomfortable message to give. As such the reggae artist has a role which is at once public and private.[11]

With painterly care and precision, Heartman brings the humanity of Rastafari (and by extension, black people) forward from the margins of the postcolonial underclass to confront the mainstream. He succeeds in creating an opening for an intimate conversation among ourselves that transcends the hallowed spaces of traditional iconography. We are now the viewer and the viewed, free to express the strength and beauty of our common character in a brand new blackness. Sacred and ancestral spirits stare back through the lens of modernity, daring us to be what too many have only dreamed about.

Art historian Petrine Archer-Straw engages the idea of nationalism and the notion that one could create and reflect a nation through image-making. Speaking in Mary Wells's video project, Archer-Straw posits that "there is a case to be made for representation in Jamaica" adding that among younger artists there is a trend to go beyond realism.[12] In this vein, Rastafari iconography and the work of Ras Daniel Heartman in particular, are central to the making and promulgation of the Rastafari nation, culture, and worldview. Heartman transcends, reinscribes, and goes beyond the mythologizing tendency in many artists' interpretation of Rasta to give us a new depiction of the Jamaican with whom he is himself at odds, who can be found increasingly in communities in Britain and North America, beyond the Caribbean into Africa.

It is important to note, however, that Daniel's own evolution trends toward greater symbolism in his later work. It may be fair to say that he moved just as other Jamaicans and artists worldwide moved to embrace symbolism more generally at the end of the 1960s. But both Ashley

Rasta Boy
Published in the Jamaica Journal December 1967
(Vol1 No. 1)

Untitled *(2 youths)*
From the collection of Brian & Beverley Morgan

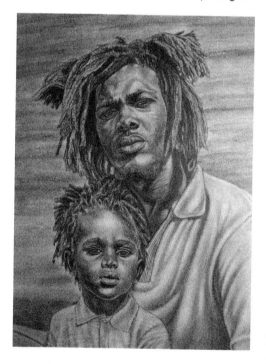

Ras Daniel & Prince Mani, c. 1964
from the collection of the Research Institute for the Study of Man

Hamilton-Taylor and artist Buona Swaby, a close friend of Daniel during the 1970s, agree that the transition was also about having expressed himself fully in the style of portraiture for which he had achieved renown by the early 1970s.

David Boxer differentiates between Rastafarian artists who comfortably fall within the "intuitive" category and those, like Heartman, who he categorises as "essentially academic artists." The implication is that the latter, while extremely popular, are inherently lacking in aesthetic virtue, and thus not worth collecting or taking note of. Heartman, however, far from being the product of any academy, was actually a self-taught draughtsman and craftsman, who was equally creative in designing and producing items of Rastafarian clothing such as hats and tams.[13]

Notwithstanding (or perhaps even because of) the immense popularity and social resonance of his work, Heartman was not embraced by the Jamaican art establishment. His marginalization is evident in the ease with which his personage, if not the faintly recurring persistence of his imagery, has been all but erased from Jamaican art history just one generation later, occupying a tenuous position in the folkloric, mostly oral tradition of cultural history. Mani tells how as a child he and his uncle would travel by bicycle to sell Daniel's drawings in the craft markets of Kingston and Spanish Town, occasionally Ocho Rios and elsewhere. Daniel had plates made of his most popular work, and would sell prints for about $3 per copy in the late 1960s. However, the same printery might run additional copies of the work, and there are examples of other "entrepreneurs" who distributed unauthorized prints through their own connections overseas. Daniel received no compensation for the vast majority of his artwork, unable to exercise much control over its reproduction and distribution like many other popular "reggae" artists. Nonetheless he was apparently unbothered by the situation. In any case, to many of his friends and family (like his son Mani), he was primarily an ace tailor who certain people would check for a special outfit.

Ras Malachi Wilson first met Daniel when the artist was about the age of fifteen and noted that as a boy Daniel loved comics. The "Action Man" comics of the time appeared in black and white, and Daniel (Lloydie as he was then known) had a fascination for depicting the action he saw around him in the same imagistic style. Malachi reveals that at about fifteen or sixteen, Daniel apprenticed to a Master Ossie, described as a great painter who specialized in skirts and painted fabrics for the Tourist Board. Malachi also recounts that Ossie felt that Daniel was already very talented when they began working together. Although Daniel did not study tailoring, and stayed in the apprenticeship for just over a year, he was known to be able to cut a suit or a style "by sight," bringing the same flair and precision to fabric as we see in his works on paper. Most who knew him in the latter period, however, note him for making high-quality peaked caps sewn from leatherette rather than garments, though Mani insists that Daniel created entire outfits for those who sought him out. At the height of his popularity, he said, international stars like Marvin Gaye, Jermaine Jackson, Calvin Lockhart, and countless others passed through the gates at Olympic Way in West Kingston.

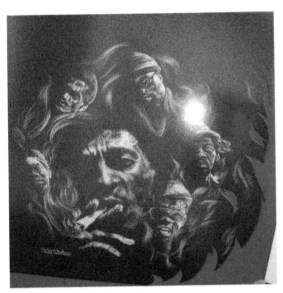

Catch a Fire
Commissioned LP design, c. 1974
From the collection of Dr. Brian Morgan

Daniel felt that the art establishment was a clique that did not give his work the respect it deserved. As a pencil artist he was unparalleled in Jamaica. Ashley Hamilton-Taylor points to the portraits of J. McDonald Henry, who also featured Jamaican portraits and may have followed a similar approach to poster distribution. However, Daniel's work carries no hint of the kitsch that traces its way through that of the celebrated Henry. Ras Daniel, on the other hand, breaks new ground in his representations of Rastafari as Outsider in the truest sense. Reflecting a sophisticated, highly developed intellectual and spiritual tradition, his dexterity goes against the grain of the naive, and against the Judeo-Christian values espoused by revival, Pentecostalism, and other spiritual movements that have gained ascendancy in national and folk historiography. Mani tells the story of an art competition Daniel entered in 1973 or 1974 and his annoyance at being beaten by "Kapo's Oranges."[14] Ras Daniel was not boastful or envious, but definitely possessed the "self assured sense of mission" that characterized other reggae artists.[15]

Foundation Rastaman Malachi Wilson reflects that when "Rastafari is employed to do a *specific* work, no experience can divert you."[16] He draws parallels with other celebrated artist-leaders such as Mortimer Planno, who had a knack, Wilson felt, for capturing a person's countenance in his drawing. In 1966 Ras Daniel presented a rare painting to H. I. M. Haile Selassie on his visit to Jamaica, for which Daniel was honoured with a Gold Medal at King's House (the official residence of the Governor-General), along with Sam Brown and Mortimer Planno. It is said to be a portrait of the Emperor riding a chariot, rendered, as related by Heartman to Ashley Hamilton-Taylor, in a pointillist style comprised of tiny red, green, gold and black dots. Stressing the divine inspiration at the heart of their abilities, Ras Malachi reasoned that there were significant similarities between

Daniel and Bob Marley, the difference being that perhaps "Bob was able to attract more people to help in his development."[17]

An excellent dancer, left-handed Heartman was the quintessential, enigmatic artist who excelled in many areas. Though often serious, he is noted among friends for having a brilliant sense of humour and, Hamilton-Taylor recalls, for being an excellent cook. So in the early 1970s when Perry Henzell was making the film *The Harder They Come*, Daniel was a natural choice to bring this already-popular persona to the screen. Memorable for his appearance in this first Jamaican-made feature that incidentally also includes his son Mani in the Hellshire Beach scene, it is perhaps ironic that in internet terms Daniel is distinguished for his supporting role in the "reggae film" far more than he is as a visual artist in his own right.[18] Yet by 1974 Heartman was piqued that the film had not produced the expected financial return.

Around the same period, Daniel was commissioned to create an album cover for Bob Marley and the Wailers' *Catch a Fire*. When the record company would not pay the fee he requested, offering instead to pay in royalties which Heartman refused, the deal went sour. Heartman felt cheated. Although they did not pay Ras Daniel for his work, it is clear that Heartman's design (see page 371), masterfully created in the negative using white crayon on black paper, was the inspiration for the cover of follow-up album, *Burning*, where a different artist would perhaps have been paid a more nominal fee.

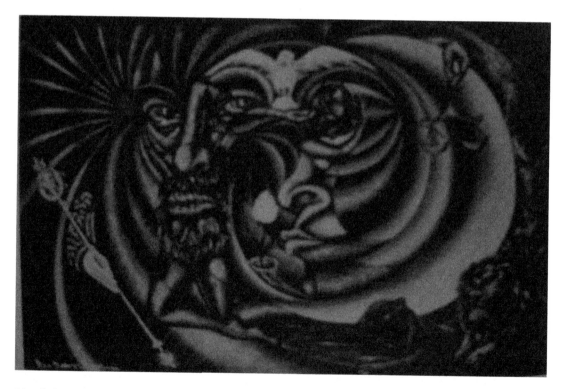

Mystic Presence
Entry in the All-Island Painting Competition, published in Jamaica Journal 1970 (vol 4 no 1 pg. 30)

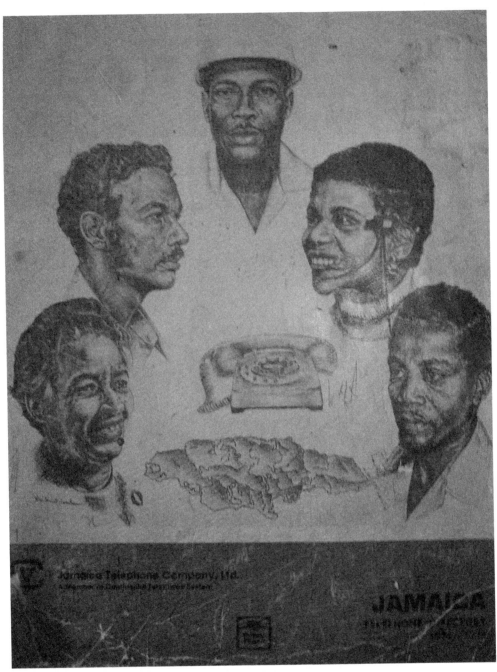

Jamaica Telephone Directory, 1974-1975
Commissioned by Jamaica Telephone Company Ltd.
From the collection of Ireko Baker

Textile Artist Ireko Baker indicated to me that Ras Daniel was the first Jamaican artist commissioned to do an illustrative cover of the National Telephone Directory, which appeared in 1974.[19] This piece crowned my search for Ras Heartman's images because it demonstrates the place Heartman occupied within the mainstream of popular consciousness in Jamaica by the mid-1970s. Five figures are shown as head and shoulders arranged around a central telephone and

contour map of the island. Each character is distinctively detailed to show recognizably Jamaican individuality—a buck-toothed, jovial character; a skilled and experienced worker; the willing smile of the telephone operator whose earring gleams beneath the suitably-wired headset (see page 373). Again, Heartman is able to depict characters without caricature. Buona Swaby suggests that prior to the early 1970s Daniel would have been reluctant to take on a strictly commercial assignment such as this, though he continued to be sought after to do portraits.

By this time, however, Daniel had grown weary of people stealing his work and was shifting from the classic early portraits towards increasingly symbolic compositions. He moved from West Kingston out to Bull Bay in 1977 after a brief stay in Gordon Town, but it became difficult to settle in the divisively charged climate of the time. In 1980 he was attacked by political interests and narrowly escaped death after refusing to join either camp, both of which had tried to court his influence. In the period that followed he relied on the support of a network of family and close friends, moving frequently. At one stage he stopped drawing completely, though he resumed in the 1980s. Brian Morgan was Heartman's dentist in the early 1970s, and became close to him over the years. Both Brian and Beverly Morgan speak lovingly of their friend as generous and easygoing, despite disappointing experiences.

Heartman lived at the home of Ashley Hamilton-Taylor for about two years between 1984 and 1986 when the latter was a student at the University of the West Indies. During this later period before he left Jamaica, Daniel would deal almost exclusively with more representational aspects of art. He became immersed in the search for a symbolic expression of his metaphysical concepts, linked inextricably to his critique of church and state as Rasta, an understanding of the global currents at work in the local political context, and his own sense of personal development. Hamilton-Taylor recounts that Ras Daniel began to utilize ideas from Egyptian art in his later work, taught himself hieroglyphics, and had begun to learn Amharic. When Ireko Baker told me that Heartman's drawings had come to be concerned with "the cellular structure of humanity," I could not fathom what that would mean visually until I was privileged to view some of the Morgans' extensive collection.[20]

The final piece in this paper, which carries no title, demonstrates elements of this evolution, and may be a good point on which to pause this brief look at Ras Daniel's contribution to Jamaican iconography in the context of myth-making and representation. It depicts the body of a man, ancient but invigorated, seated at the centre of a pyramid, eight rays emanating from this power centre with a different Egyptian deity represented at the end of each one (see final image below). The man carries a rod and staff. In the foreground are potted plants of different types arranged in a circle, and all around is an intricate, visceral background which Morgan points out resembles brain matter and the internal organs of the body. The lower ground appears as a sinewy abyss, while across the top is a spectrum of hieroglyphic characters. The drawing may most definitely be "read" through its placement of the Egyptian symbols. Experts in metaphysics (here, specifically Kemetic) would observe that the central tableau is held suspended by the two major deities at the lower extremes of the pyramid. I found Heartman's inner journey to the cellular, fleshy insides of the body quite fascinating.[21] That Heartman broke new ground through his own enduring "natural mysticism" is without question.

"In the era of Thatcher, Reagan, Seaga and Bush Senior," one key informant pointed out, "post-liberation conservatism" and the wars across Africa mirrored to Heartman the spiritual fight between good and evil. He felt that Jamaica had gone beyond repair because of the politicians and the people's unwillingness to take a real stand. Though he had had many invitations to travel

abroad over the years, he had been reluctant to travel to anywhere but Africa. In 1988 at age forty-four he repatriated with his younger son, Ato, to Tanzania. He died a few years later at age forty-seven, struck down by anaemia.

Throughout the 1980s Ras Daniel's work continued to appear in posters, prints, t-shirts and other popular cultural media. As mentioned earlier, although many do not know the name, much of Heartman's work is instantly recognizable across the Caribbean diaspora. Within his short lifetime Daniel produced hundreds of drawings; I look forward to a time when Jamaican art history will properly embrace Heartman's aesthetic contribution to what may be considered fine art, acknowledging that this means on some level being able to embrace his commercial popularity. Wherever fine art hits the street there is an uncomfortable silence from the academy, as the credentials of the artist are weighed against the tyranny of the popular. No, it perhaps does not happen often, this level of public esteem (even if the "public" is not necessarily the mainstream), and yet it is what every artist dreams of, somewhere in the recesses of their own creative impulse. Ras Daniel was a cultural icon whose body of work should be preserved as an important part of the history from which he emerged.

Untitled c. 1985

Acknowledgments

The search for Ras Daniel Heartman and his work has been an extraordinary journey for me, for which I have to thank a few people who guided me to first-hand sources over the research period in October and November 2006. These include cultural critic Annie Paul; textile artist Ireko Baker and his friend, Buona Swaby; and cultural historian and Rastafari scholar Arthur Newland. In the process of doing this research I received access to a wealth of information about Ras Daniel, and met other scholars who will advance our understanding and appreciation of Heartman's body of effort. May his unique contributions to Jamaican art continue to illuminate and inspire us all.

Notes

1. Patricia Mohammed, "The Emergence of a Caribbean Iconography in the Evolution of Identity" in *New Caribbean Thought: A Reader,* ed. Brian Meeks and Folke Lindahl (Kingston: University of the West Indies Press, 2001), 234.
2. Ibid., 237, emphasis added.
3. Ibid., 260–61.
4. Junior Roberts / Ras Mani, interview with author, 12 and 18 November 2006, Kingston.
5. Mohammed, "The Emergence of Caribbean Iconography," 236.
6. Cultural historian Herbie Miller featured the work in a 2005 exhibition of album art. It is credited as *Vision of Africa* by Errol Holt and was released in the mid-1970s. Miller points out that Ras Daniel Heartman also produced a portrait of Che Guevara on another Holt LP entitled *Revolutionaries.*
7. Annie Paul, "The Art of Ital," a review of Wolfgang Bender's *Rastafarian Art* in *Caribbean Review of Books* 1, no. 4 (May 2005). Available at: http://www.ianrandlepublishers.com/review35.htm, accessed 13 October 2006.
8. Kwame Dawes, *Natural Mysticism: Towards a New Reggae Aesthetic in Caribbean Writing* (London: Peepal Tree Press, 1999), 90.
9. Ibid., 99.
10. Ashley Hamilton-Taylor, interview with author, 25 November 2006, Kingston.
11. Dawes, *Natural Mysticism,* 100.
12. *Redefining Images, Space: Contemporary Art Jamaica,* dir. Mary Wells, The Video Archive Project, University of Technology Caribbean School of Art and Architecture, Jamaica, 2004.
13. Paul, "The Art of Ital," 26.
14. The piece *Mystic Presence,* came second in the All-Island Painting Competition and appears in the *Jamaica Journal* 4, no.1 (1970), where Mallica "Kapo" Reynolds' *Sweet Oranges* is also featured as the prize-winning painting.
15. In Dawes, *Natural Mysticism,* 103.
16. Ras Malachi Wilson, personal communication with author, 26 November 2006.
17. Ibid.
18. Dawes notes that *"The Harder They Come* was a 'reggae film', not simply because of the use of reggae music as part of the soundtrack, but because it constructed a narrative line out of reggae archetypes and motif.... Henzell's film shifted the dialogue by demonstrating that a new creative force was operating in the Caribbean, a force that emerged from the working class milieu with a coherent, dynamic vision centred on the Jamaican imagination." See Dawes, *Natural Mysticism,* 27.
19. Ireko Baker, personal communication with author, 26 November 2006.
20. Ibid.
21. I then recently discovered that the Department of Art History at the University of Chicago offers a course in "Neuronal Aesthetics," which purports to explore "how the internal circuitry of brain architecture, neurology, optical technology and media intersect with aesthetics in a new domain." See http://humanities.uchicago.edu/depts/art/courses (ARTH45500), accessed January 2007.

Intuitive Art as a Canon

Veerle Poupeye

In the summer of 2006, the National Gallery of Jamaica staged *Intuitives III*, a survey exhibition of what it has called Intuitive art, the work of self-taught popular artists of Jamaica. It was an important exhibition, not only in its own right but also in terms of the Gallery's institutional history and the debates that have surrounded it. The focus of this essay is on the latter.

Articulating a Narrative

Intuitives III was the National Gallery of Jamaica's third survey exhibition of Intuitive art. The first one, *The Intuitive Eye*, was held in 1979 and the second, *Fifteen Intuitives*, was shown in 1987. The Gallery has thus far also presented four retrospectives of Intuitive artists: John Dunkley in 1976, Sidney McLaren in 1978 (although this one was, in actuality, shown at the St Thomas Parish Library), Mallica "Kapo" Reynolds in 1983, and Everald Brown in 2004. All but the latter, which I curated, were the work of David Boxer, the Gallery's chief curator, who is the one who coined and most vigorously promoted the Intuitives concept. Kapo has had a gallery dedicated exclusively to his work in the National Gallery's permanent collection since 1983 and was the first Jamaican artist to be so honored. This gallery houses the collection of the American owner of the Stony Hill Hotel, Larry Wirth, which was acquired after his death with the help of Kapo's most prominent patron, the then prime minister Edward Seaga.

The Intuitives have also been well represented in the rest of the Gallery's permanent collection and many of its other exhibitions, such as the National Biennial (formerly the Annual National).

The Intuitive Eye exhibition in 1979 launched the concept and the term "Intuitive", as a noun and an adjective and an alternative to more obviously problematic terms such as "Primitive" and "Naïve" (although it had, strictly spoken, already been used as such in the Gallery's *The Formative Years* catalogue in 1978). *The Intuitive Eye* exhibition was part of a number of landmark exhibitions, *The Formative Years* included, that served to articulate the National

Figure 1. Byron Johnson, *The Snake* (2000),
courtesy of Hi-Qo Galleries, Kingston.

Reprinted with permission from *Small Axe* 11, no. 3 (2007): 73–82.

Gallery's narratives on Jamaican art. This articulation process was a necessary part of the early work of the National Gallery, which opened in 1974 and was mandated to document a national (and nationalist) Jamaican art history.[1]

This process had started with *Five Centuries of Art in Jamaica* (1975), David Boxer's first major exhibition and the Gallery's first survey, which provided an overview of art in Jamaica from the start of the Spanish period to the 1970s. It culminated with *Jamaican Art 1922–1982*, a survey of modern Jamaican art which, from 1983 to 1985 was toured in the United States, Canada and Haiti by the Smithsonian Institution Traveling Exhibition Service. The Intuitives concept played a major role in the articulation of the National Gallery's narratives and had started with the Dunkley retrospective in 1976, which consecrated this then near-forgotten artist as one of the masters of Jamaican art. Some of the artists who were thus labeled as Intuitives—John Dunkley, David Miller Sr and Jr, Sidney McLaren, Gaston Tabois, Mallica "Kapo" Reynolds, and Everald and Clinton Brown—had already received some national and international acclaim as Jamaican Primitives. Their position in the Jamaican artistic hierarchies was, however, ambivalent, especially vis-à-vis highly educated artists such as Barrington Watson, who actively claimed recognition as professionals and modern masters and left little doubt that they considered themselves at the apex of the Jamaican art world.

In what was then a revolutionary counter-canonical move, David Boxer not only granted collective and individual recognition to the self-taught artists he labeled as Intuitives, but placed them at the epicenter of the national canons. He defined them as follows in his catalogue essay for *The Intuitive Eye*:

Figure 2. Roy Reid, *A Pig is Nothing but a Pig* (1986), *collection: Herman van Asbroeck, Kingston.*

Figure 3. Leonard Daley, *John Crow* (2000),
private collection, Kingston.

These artists paint, or sculpt, intuitively. They are not guided by fashion. Their vision is pure and sincere, untarnished by art theories and philosophies, principles and movements.... Their visions, (and many are true visionaries) as released through paint or wood, are unmediated expressions of the world around them – and the worlds within. Some of them... reveal as well a capacity for reaching into the depths of the subconscious to rekindle century old traditions, and to pluck out images as elemental and vital as those of their African fathers.[2]

Boxer seemed to imply that mainstream artists were somehow "tarnished" by "art theories and philosophies, principles and movements" and therefore, it could be construed, inferior to the Intuitives. Rex Nettleford, in his contribution to the same publication, wisely avoided suggesting that the Intuitives were necessarily the better artists but contended that their work provided a model for autonomous and relevant postcolonial cultural production. According to him, the Intuitives "must be closely observed as guides to that aesthetic certitude which must be rooted in our own creative potential if the world is to take us seriously as creators rather than as imitators."[3]

A Jamaican Culture War

Controversy had already started with the *Intuitive Eye* exhibition when the Gleaner art critic, Andrew Hope, stated in his otherwise appreciative review that the artists would benefit from training, which resulted in a war of words between himself and Boxer.[4] The debate escalated when *Jamaican Art 1922–1982* was touring in North America. This exhibition earned its most positive critical feedback for the work of the Intuitives, which comprised nearly forty percent of the exhibition. John Bentley Mays of the *Globe and Mail* of Toronto, for instance, wrote: "The most intriguing paintings and sculptures here, however, are not the polished Euro-Jamaican descendents of [Edna Manley's] the *Beadseller*, but the home-spun, punchy pictures of the self-taught Intuitives."[5] Such critical responses derived, at least in part, from (white) North American preconceptions about (black) Caribbean art, as necessarily separate from the Western mainstream—a reductive, Primitivist view that must, as such, be questioned—but the Intuitive works in the exhibition undeniably made

compelling, original aesthetic and cultural statements that overshadowed many of their mainstream counterparts.

The Intuitives were thus positioned as a threat to the Jamaican art establishment and those mainstream artists who felt most targeted responded by questioning their legitimacy and David Boxer's professional judgment. This campaign was spearheaded by Barrington Watson and Andrew Hope, who devoted a significant portion of his biweekly columns to Boxer and the Intuitives in the mid 1980s. The following comments on the final showing of *Jamaican Art 1922–1982* at the National Gallery of Jamaica in 1986, is typical and also shows how this critic pointedly refused to use the term Intuitive: "Judging from what we've seen, the exhibition lacks a guiding intelligence and seems to have been thrown together with the objective of demonstrating that our primitives are superior to those painters and sculptors who have received formal training and were 'contaminated' by European influences."[6] Local class prejudices also played a role in this debate, not surprisingly since most of the Intuitives were poor, scarcely educated rural and urban black Jamaicans. In 1988, for instance, Andrew Hope bluntly dismissed them as "a group of elderly rustics" who were presumably incapable of producing high art or representing Jamaica internationally in any respectable manner.[7] This protracted polemic did not dampen the enthusiasm of the Intuitives' supporters but actually bolstered them, as it united them in the conviction that they were the ones "in the know" who, furthermore, had a cause to defend. This resulted in, among other things, the organization of the *Crisis in Criticism* symposium in 1988, in which the National Gallery launched a scathing counterattack on Andrew Hope and questioned the quality and relevance of newspaper criticism in Jamaica. I had organizational responsibility for this symposium and was among the defenders of the Intuitives cause at the time.[8]

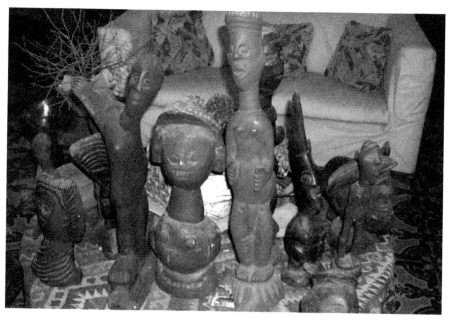

Figure 4. A group of William "Woody" Joseph carvings in a Kingston private collection. Woody was one of the Intuitives included in *Jamaican Art 1922–1982,* where his work was shown alongside that of mainstream artists such as Edna Manley and Barrington Watson.

The debate about the National Gallery's promotion of the Intuitives was perhaps the main polarizing force in the Jamaican art world of the 1980s and concealed underlying divisive issues such as personal and political rivalries. It was independent Jamaica's first full-fledged culture war: a struggle for control over the production of the dominant canons and narratives which erupted at a moment when the local artistic community was well aware of the National Gallery's political vulnerabilities as a perceived "Manley" institution, and despite Seaga's support of Kapo. While it is regrettable that this polemic prevented some from appreciating the undeniable value of much of what was labeled as Intuitive art, there are genuine problems with the concept that require more critical attention than they have thus far received.

Not all critical responses were as extreme as Andrew Hope's. Many in the Jamaican art community argued, as Nettleford had done, that reliance on intuition was evident in all good art, irrespective of the artist's background, education or the type of art produced, and objected that the term Intuitive suggested that this was an exclusive characteristic of self-taught, popular artists. Despite these reservations, the term is now fairly well established in Jamaica. The term has also gained broader usage and is now also used outside of Jamaica, often alongside or interchangeably with Outsider art. A noted specialized gallery in Chicago is named *Intuit: the Center for Intuitive and Outsider Art*, for instance, while the Anglo-American periodical, *Raw Vision*, which was founded in 1989, states that it is dedicated to "outsider art, art brut, contemporary folk art, intuitive & visionary art from around the world." The association with Outsider art sits uneasily, however, with the local definition of the Jamaican Intuitives as the ultimate cultural *insiders* but this tension provides a useful point of entry into the contradictoriness of the concept, which should, in my view, be the real focus of the critical debate.

Figure 5. Everald Brown, *The Rainbow Valley: House of Gabriel* **(1960?),** *private collection, Kingston. This panel was part of the religious paintings in Brother Brown's church along Spanish Town Road in West Kingston.*

Figure 6. Everald Brown, *Duppy Tree* **(1994),**
collection: National Gallery of Jamaica. This work is
representative of Brown's later work, as a recognized Intuitive
artist.

Intuitive Art as a Canon

One notion that needs to be challenged is that Intuitive art is a genre that emerges spontaneously from collective and individual popular creativity, passively waiting to be discovered, nurtured and consumed by knowing patrons. Most of what has been "discovered" as Intuitive art was originally created to promote religious or ideological beliefs or commercial services, or in response to a genuine inner compulsion. Once its maker was recognized, however, much of it started to be created as art in active response to the standards set and the demand created by local and overseas cultural institutions, patrons and markets. The earliest works of Everald Brown, a religious Rastafarian who had established a self-appointed mission of the Ethiopian Orthodox Church, were made as religious wall paintings for his small church, but once recognized as an artist in the late 1960s, he started consciously producing "proper paintings" for his local and overseas patrons although these continued to explore the same mystical-religious beliefs.

The notion of Intuitive art is therefore best understood as a canon that holds a special and highly contested position in the broader artistic and cultural canons that are being negotiated in Jamaica and not just as a politically correct synonym for Primitive, Naïve, or Outsider. Recognizing the canonical nature of the category usefully reveals its main internal contradictions. While the concept has certainly elevated the status of the Intuitive artists and their work, decisions about what qualifies as Intuitive art are made by a small corps of specialized scholars, curators, dealers and patrons and are usually based on narrow criteria of purity and authenticity—it is an artifact of the sort of exclusive connoisseurship that was previously associated with the concept of Primitive art. No other area of Jamaican art has been policed with such strict and moralized standards. David Boxer often cites examples of artists who were "spoiled" by thoughtless exposure. For example:

> An artist like Roy Reid, more knowing than others, has occasionally been *sidetracked* into an *alien* form of expression—as was [William] Rhule who naively took the advice of a well wisher who showed him paintings by [Albert] Huie and implored him to start painting like the Jamaican master. The results were ghastly. Rhule stopped painting and slipped into oblivion for nearly five years.[9] (Emphasis added)

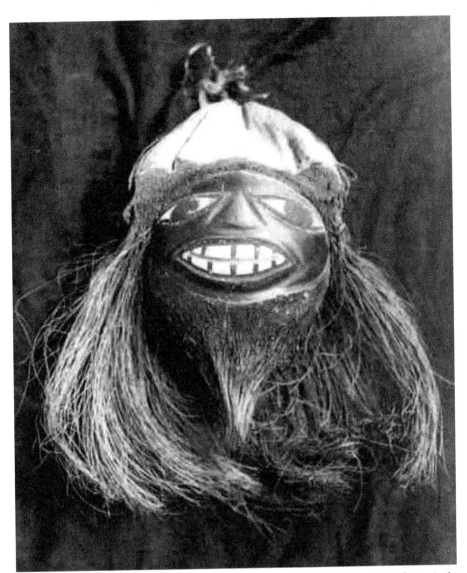

Figure 7. Photograph of an *Obeah Head,* **possibly by David Miller Sr. or Jr., from Astley Clerk manuscript on Jamaican art, c1939.** *Private collection, Kingston. This example is representative of the sort of items the Millers sold to tourists.*

The Intuitives concept may have represented a genuine attempt to remove the stigmas and marginalization from Jamaica's Primitive artists but it has unwittingly perpetuated some of the premises on which the notion of Primitive art was based. The status of the Intuitive artists thus remains ambivalent, located in a no-man's land between high and low culture, in which they are not empowered to take control of their representation which remains dependent on the artistic establishment.

The criteria of purity and authenticity that shape the definition of Intuitive art are, furthermore, untenable and insufficiently consider its exposure to various influences. Most of what has been labeled as Intuitive art is hybrid rather than pure, and this hybridity is part of what makes the work so appealing. Insufficient attention has, for instance, been paid to the role of market forces in the development of Intuitive art. Several key Intuitives, carvers David Miller Sr and David Miller Jr, and

painter Gaston Tabois, chief among them, started their career in the tourist market, which helped to shape the form and content of their work without compromising its quality.

The Millers had started out as curio carvers and vendors in the 1920s but continued making and selling such items, which contributed greatly to the family income, after they had been recognized as artists and were producing more ambitious "art" carvings. Gaston Tabois had his first exhibition at the Hills Gallery on Harbour Street in Kingston in 1955. This gallery, which was located near the famous Myrtle Bank Hotel, targeted tourist and local buyers alike and its clients included celebrity visitors such as Elizabeth Taylor. In a telling illustration of the Primitivist foundations of the Intuitives concept, concerns about contamination were already part of the debate when the Intuitives were still labeled as Primitives. The art critic Norman Rae wrote in 1965: "The tourist temptation has sometimes proved calamitous for some promising painters. Gaston Tabois once charmed with his fresh, naïve, gaily primitive vignettes of country and city life, but he found it hard to recover after Elizabeth Taylor had bought some of his work."[10] Tabois seems to have survived his brush with celebrity patronage, however, and continues to produce compelling paintings, although his work has inevitably evolved over time and at least partly in response to patronage.

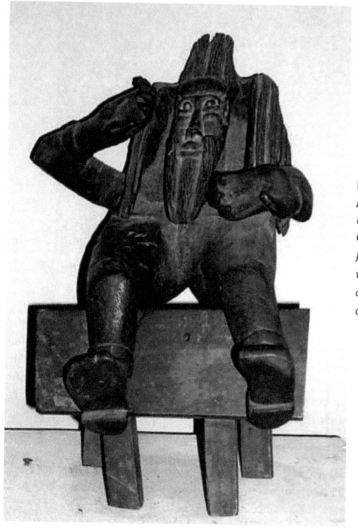

Figure 8. David Miller Sr.,
John the Baptist: Do Not Touch the
***Lord's Annointed,* c1964.**
Collection: National Gallery of Jamaica. One of the more ambitious works produced by the Millers, after they were recognized as major artists.

The rigidity and narrowness of the definition has also led to the exclusion of artists such as the sculptor, Hylton Nembhard, who briefly attended the Jamaica School of Art, and the painter and assemblagist, David Marchand, who attended the Art Students League when he lived in New York City, although their work and social marginalization closely relate to the Intuitives and are probably better understood in that context. The question thus arises as to what is achieved by insisting on such strict, dogmatic delineations, which contrast strikingly with the very relaxed and open-ended definitions that shape the rest of Jamaican art.

Reflection and Evaluation

The war over the Intuitives gradually subsided during the 1990s and was replaced by new polemics, such as the National Gallery's perceived over-promotion of contemporary art. There also seemed to be a loss of interest in the Intuitives' course on the part of the National Gallery's curators, perhaps as a result of understandable battle fatigue. The recent Everald Brown retrospective and *Intuitives III* exhibition represented a return to the subject but the tenor of these new exhibitions has been quite different from before. *Intuitives III* was the largest and most inclusive Intuitives show thus far and was less dogmatic than the previous ones. It even included two artists, Llewellyn "Bongo" Johnson and Ralph Cameron, who work primarily in the tourism industry. Cameron is a producer and vendor of the notorious "Big Bamboo" carvings in Fern Gully near Ocho Rios— phallic carvings of Rastafarian figures that many in Jamaica find offensive—although at the show he was represented by a safe carving of a horse and carriage instead. The public reception of the *Intuitives III* exhibition was surprisingly positive and there were no controversies in the press this time around. This suggests that the Intuitives debate has entered a new phase in which more even-handed, self-reflexive and, hopefully, productive discussion has finally become possible and I wrote this essay to contribute to this process. It may also suggest that narrow, dogmatic canons such as the Intuitives canon have an inherently limited lifespan, as the product of a particular moment and debate.

While the conceptual weaknesses and contentiousness of the Intuitives concept need to be acknowledged and critiqued, its effects on Jamaican art production have not necessarily been detrimental. The canonization of the Intuitives has, in fact, created opportunities for the creation and exposure of often-amazing art that would otherwise never have existed and from which the artists have certainly benefited. Everald Brown, for instance, would probably never have made his spectacular "Instrument for Four People" (1985)—a large, intricately painted and carved combination of a guitar, harp, rumba box and drum incorporated into the overall, symbolic shape of a dove—if he had not been emboldened by the recognition and support he received from the National Gallery and specialized dealers and patrons. In turn, he would not have made at least five more versions of it, some of them even more beautiful than the original, were it not for the market demand and his need to make a living for his family. That is no mean achievement and the cultural and aesthetic significance of such work should be recognized, no matter what position one takes on the categorizations.

Notes

1. The 1974 articles of association of the National Gallery of Jamaica more specifically mandated it to concern itself with the art that came out of the ferment of 1938. This narrow focus was challenged by Boxer, who joined the staff as director/curator in 1975, when he insisted on adding pre-twentieth century art and modern art from 1922 onwards to the narratives.

2. David Boxer, "Foreword" in *The Intuitive Eye* (Kingston: National Gallery of Jamaica, 1979), 2.

3. Rex Nettleford, "Introduction" in *The Intuitive Eye*, 5.

4. See Andrew Hope, "Art View: The Intuitive Eye," *Daily Gleaner*, 26 August 1979, 7; and The Anonymous Eye, "Intuitive Eye," Letter to the Editor, *Daily Gleaner*, 11 November 1979, 11.

5. As quoted in Rosalie Smith McCrea, *Jamaican Art 1922–1982 Returns* (Kingston: National Gallery of Jamaica, 1986), 11.

6. Andrew Hope, "Gallery Guide," *Daily Gleaner*, 31 March 1986, 16.

7. Andrew Hope, "The Crisis in Leadership (Part 2)," *Daily Gleaner*, 28 February 1988.

8. This event took place on 2 February 1988 and the speakers were Rex Nettleford, Sonia Jones, Pamela O'Gorman, David Boxer and Gloria Escoffery. Andrew Hope's "Crisis in Leadership" columns, which appeared in three installments, were written in response.

9. David Boxer, *Fifteen Intuitives* (Kingston: National Gallery of Jamaica, 1987), 4.

10. Norman Rae, "Contemporary Jamaican Art" in *Ian Fleming Introduces Jamaica* (London: Andre Deutsch, 1965), 169.

Africa, the West and the Analogy of Culture: The Cinematic Text after Man

Sylvia Wynter

Introduction

My proposed title, 'Africa, the West and the Analogy of Culture: The Cinematic Text after Man' differs in two respects from the one listed in the conference programme ('Africa, the West and Cultural Analogy: Film after Mankind'). With respect to the first, not 'Cultural Analogy' but 'the Analogy of Culture'; to the second, not 'after Mankind' but 'after Man' – that is, 'The Cinematic Text after Man'. The two are linked, and I thought that I would make use of this fortunate error to explain my title.

Why 'Man'?, to take the second first. 'Man' is not the human, although it represents itself as if it were. It is a specific, local-cultural conception of the human, that of the Judaeo-Christian West, in its now purely secularised form.[1] Its 'Other' therefore is not *woman,* as I hope to show. Rather because *Man* conceives of itself, through its Origin narrative or 'official creation story' of Evolution,[2] as having been bio-evolutionarily selected, its 'Other' and 'Others' are necessarily those categories of humans who are projected, in the terms of the same Origin narrative, as having been bio-evolutionarily dysselected – i.e. all *native* peoples, and most extremely, to the ultimately zero degree, all peoples of African descent, wholly or partly (i.e. *negroes*), who are negatively marked as *defective humans* within the terms of Man's self-conception, and its related understanding of what it is to *be* human.[3]

Whatever our culture or religions of origin, all of us in this room, because educated in the Western episteme or order of knowledge which is based on the *a priori* of this conception of the human, *Man,* must normally know the world, even when most radically and oppositionally so, from this perspective. It is because of the shared nature of this perspective, one that, as Michel Foucault pointed out, is founding to all our contemporary disciplines,[4] that we can all understand each other – that is, as long as we remain within the terms of this conception, and the field of meanings to which it gives rise. But what if we were to move outside this field? Outside its perspective or reference frame?

The idea behind the phrase and the title 'after Man' is to suggest that the function of the cinematic text for the twenty-first century will be to move outside this field, this conception, in order to redefine what it is to *be* human. In addition, because *Man* further defines itself as *homo oeconomicus,* in the reoccupied place of its pre-nineteenth-century conception of itself as *homo politicus* (political man), as well as in that of its originally matrix feudal-Christian conception of itself as *homo religious* (religious man), its' *Other',* or signifier of alterity to this sub-definition (and therefore the analogue, at the level of the economic system, of *natives/negroes* at the overall level of our present cultural order, and its societal 'form of life'), is the category of the *Poor,* i.e. the jobless and semi-jobless; as well as, in terms of the global system as a whole, the so-called 'underdeveloped' countries of the world. While because economic *Man* is optimally defined as the

Reprinted with permission from *Symbolic Narratives/African Cinema: Audiences, Theory and the Moving Image,* ed. June Givanni, 25–76 (London: British Film Institute, 2000).

Breadwinner (with the working classes thereby being defined as the secondary Breadwinners to the middle classes, specifically to their investor upper class),[5] the *'Other'* to this definition is, logically, the category of the *jobless, semi-jobless Poor,* together with that of the underdeveloped countries, both of which are made to actualise the negative alterity status of *defective Breadwinners.*

The central thrust of the 'after Man' of my title is therefore to propose, given the role of *defective Otherness* analogically imposed upon the peoples and countries of Africa and the black diaspora by the representational apparatus of our Western world system, central to which is that of its cinematic text, that the challenge to be met by the black African, and indeed black diasporic, cinema for the twenty-first century will be that of deconstructing the present conception of the human, *Man,* together with its corollary definition as *homo oeconomicus;* to deconstruct with both, the order of consciousness and mode of the aesthetic to which this conception leads and through which we normally think, feel and behave. This cinema will therefore be compelled, as it has already begun to do, if still tentatively so, to reinscribe, in Clyde Taylor's phrase,[6] and thereby redefine, the human on the basis of a new iconography. One that will take its point of departure from the First Emergence of *fully* human forms of life, as an Emergence that was to be later attested to by, inter alia, the convergent explosion at multiple sites of the rock paintings of some 30,000 years ago, including that of the Grotto Apollo of Namibia;[7] as an explosion whose dynamic moving images bear witness to the presence of the representational apparatus inscripting of their 'forms of life', of their culture-specific modes or poeses of being human[8]. This hypothesis, as one which places our origins in *Representation* rather than in *Evolution,* and thereby redefines the human outside the terms of its present hegemonic Western-bourgeois conception as a purely bio-economic being which pre-exists the event of culture, would, of course, call for a new poetics. This poetics, I propose, would be that of the human as *homo culturans/culturata,* that is, as the auto-instituting because self-inscripting mode of being, which is, in turn, reciprocally enculturated by the conception of itself which it has created; the poetics, in effect, of a hybrid *nature-culture, bios/logos* form of life bio-evolutionarily preprogrammed to institute, inscript itself, (by means of its invented origin narratives up to and including our contemporary half-scientific, half-mythic origin narrative of *Evolution*), as this or that *culture-centric* (and, as also, in our case, *class-centric*) genre of being human.

Why, 'The Analogy of Culture'? I have adapted the concept from Isaac Newton. As Amos Funkenstein points out, in the wake of the fifteenth-century voyages of the Portuguese around the hitherto believed to be unroundable bulge of West Africa and of their landing on the shores of Senegal in 1444, as well as of that of Columbus across the hitherto believed to be non-navigable Atlantic Ocean, and of his landing on a Caribbean island in 1492; as well, too, in the wake of the 1543 publication of Copernicus' 'Of the Revolution of the Spheres,'[9] Newton, like all scientists of the seventeenth-century, found himself empowered to make a new demand on the basis of the new image of the Earth and conception of the cosmos to which both the empirical voyages and Copernicus' astronomy had led.[10] In place of the traditional acceptance of an Earth ostensibly divided into habitable and inhabitable regions (as it had been held to be in the orthodox geography of Europe before the voyages), or of a universe divided by an ostensibly ontological difference of substance between the incorruptible perfection of a celestial realm which moved in harmoniously ordered circles, and its Other, the degraded, fallen realm of an Earth fixed and motionless at the centre of the universe as its dregs, (as it had been held to be in pre-Copernican astronomy),[11] the new demand was that all nature should now be seen as being homogenous, uniform and symmetrical. For the same laws of Nature, Newton had argued, could now be seen to apply to heaven and earth alike, and in Europe as in America. So that on this premise, a new order of knowledge based on the

gradual acceptance that the same kind of matter built all parts of the universe as it built all parts of the earth, as well as that all matter was indeed governed by the same causes or forces, could now be elaborated; one that could now permit human observers to extrapolate, from the constant qualities of bodies that are found to be within the reach of our experiments, to all bodies whatsoever, seeing that the analogy of Nature is always consonant with itself.[12]

The point of the phrase 'the analogy of culture' is, therefore, the following: that, in the same way as Newton had argued, on the basis of the premise of laws of Nature, that one could extrapolate from knowledge of the processes of functioning of the bodies nearest to us, in order to infer what had to be those of the bodies furthest from us, we too could now, on the basis of a projected new premise of laws of culture which function equally for the contemporary culture of the West as they have done for all human cultures hitherto, make use of the analogy of culture in order to gain insight into 'the basic principles of understanding' of the Western cultural body.[13] That is, of the body of which we are all, as Western educated subjects, necessarily always already socialised, and therefore, in Fanonian terms, sociogenetic subjects.[14] Further, that we should be able to gain such insight into these principles on the specific basis of the analogy of the processes of functioning of the cultures of traditional Africa, as the cultures which alone exist in a continuous line of descent with the Event of the First Emergence of the human out of the animal kingdom.[15] And therefore, out of, as Ernesto Grassi proposes, the purely organic level of existence where behaviours are induced by genetic programmes, to a new and third level of existence, which is that of our uniquely human forms of life; as one whose behaviours are instead primarily motivated by the Word, whether that of the Sacred Word (as in the case of the Dogon's *Nommo*,[16] that of Judaeo-Christianity, that of Islam) or that of the objective Word of *Man*. In effect, by what Grassi further defines as the linguistically inscribed governing codes, which when neurophysiologically implemented can alone enable us to *experience*, be conscious of ourselves as, *human* subjects.[17] Further, that these codes do so by the enacting of correlated clusters of meanings/representations able to mediate and govern – ('Meaning', David Bohm points out, 'affects matter'[18]) – if in always culturally relative terms, the biochemical reward and punishment system of the brain which functions in the case of purely organic forms of life, to directly motivate and demotivate the ensemble of behaviours[19] that are of adaptive advantage to each species.[20] Yet how exactly, in the case of humans, does the mediation by the verbal governing codes and their clusters of meaning, their recoding of the behaviour-motivational biochemical reward and punishment system specific to purely organic forms of life, take place? What are the laws that govern their mediating and recoding function?

My proposal here will be that the traditional (i.e. pre-Islamic, pre-Christian) cultures of Africa are the 'cultural bodies' best able to provide us with insights into what the laws that govern this mediation, and, thereby, our behaviours, *must necessarily be*. Specifically, in the case of our contemporary Western world system, to decipher what must be the governing code and its related, representation system (including centrally that of the iconography of the Western cinematic text), which now functions to induce our present global collective ensemble of behaviours – doing so on the basis of the analogy of culture premised to be, like the analogy of nature, always consonant with itself.

The Argument

The cinema and its new iconographic language made their first appearance on 28 December, 1895, some one hundred years ago. On that day, the brothers Lumière showed their first film in Paris. A decade or so before, in 1884, and in the wake of a meeting by the dominant Western

powers in Berlin, the scramble for Africa by western European nation-states began in the context of an accelerated process of colonisation. This process was to fully incorporate the peoples of black Africa, and indeed of Africa, as a whole, into the industrial era as an appendage to, and mere logistical extension of, the Western techno-industrial world system.

By 1897, as Ukadike points out in a recent book, the film titles of succeeding Lumière films had begun to define the role that the representation of an Africa, stigmatised with exoticism as the backdrop landscape for innumerable Tarzan figures confronting African 'natives' and African primates that were indistinguishable from each other, was to play in the modern Western cinematic text.[21] For the new medium of cinema was itself to play a, if at that time still limited, role in the legitimation of the incorporation of Africa into the Western imperial system in post-slave trade terms. New, because this was not the first encounter of Africa and an expanding West. Some four and a half centuries before the birth of the cinema, in the early decades of the fifteenth-century, what was to become the Western world system had been first put in place in the wake of two voyages. These voyages were to transform the history of the species. The first was that of the Portuguese ships and their eventual rounding of what had been for Europeans the hitherto believed to be unroundable Cape Bojador on the bulge of West Africa, followed by the Portuguese landing, in 1444, on the shores of Senegal. Their, at first, forcible initiation of a trade both in gold and in slaves was to be at the origin of today's black African diaspora. The second voyage was that of Columbus across a hitherto also believed to be non-navigable Atlantic Ocean and his landing on an island in the Caribbean in 1492. This voyage was followed by the West's expropriation of the lands of the Caribbean and the Americas. The accelerated slave trade out of Africa by several European countries provided the forced labour for the West's development of large-scale commercial agriculture in these newly expropriated lands.

The Western world system was therefore to be initiated on the basis of the bringing together of three hitherto separate worlds, their peoples and their cultural spheres: that of Europe, that of Africa, and that of the indigenous populations of the Western hemisphere. It was out of this bringing together that today's Caribbean and the Americas, like modernity itself, were to be born.[22]

In his recent book *The Idea of Africa*, V. Y. Mudimbe makes a seminal point which allows us to correlate these three dates, that of 1444, that of 1884, and that of 1895 – that is to say, the landing on the shores of Senegal, the scramble for Africa, the birth of the cinema – and to do this within a reconceptualisation of the past from a world systemic perspective that is central to the argument I want to make here.[23]

His new book *The Idea of Africa*, Mudimbe tells us, is both the product and continuation of his by now classic *The Invention of Africa*.[24] This is so in two ways. First, *The Idea of Africa* asserts that there are natural features, cultural characteristics and probable values specific to the reality of Africa as a continent, which serve to constitute it as a totally different civilisation from those of, say, Asia and Europe. Secondly, *The Idea of Africa* goes on to analyse the ways in which Africa, as well as Asia and Europe, have been represented in Western scholarship by fantasies and constructs made up by scholars and writers since Greek times. 'From Herodotus onwards', Mudimbe writes,

> the West's self-representations have always included images of peoples situated outside of its cultural and imaginary frontiers. The paradox is that, if indeed these outsiders were understood as localised and far away geographically, they were none the less imagined and projected as the intimate and other side of the European thinking subject ... In any case, since the 15th century, the idea of Africa has mingled together new scientific and ideological interpretations with the semantic fields of concepts such as primitivism and savagery. The geographic expansion of Europe and its

civilisation was then a holy saga of mythic proportions. The only problem – and it is a big one – is that, as this civilisation developed, it submitted the world to its memory.[25]

This latter point is the central thesis that I want to put forward in this paper. There are, therefore, two central proposals here. The first is that if, as Mudimbe suggests, with the development of its post-medieval civilisation, the West seemed to be sanctioned by, and to produce, terrible evils that only a mad person could have imagined, including 'three remarkable monstrosities – the slave trade, colonialism and imperialism at the end of the eighteenth, and throughout the nineteenth fascism and Nazism in the twentieth',[26] this is so because the West was to be itself submitted to the same memory to which it would submit the rest of the world. It was to be that same memory that would lead, on the other side of the equation, to equally unimaginable achievements in many fields. These achievements included, centrally, the field of technology out of which the cinema was to emerge. It would include also Western Man's and, by proxy, the humans', first footfall on the Moon, together with the audiovisual communications revolution and, today, the computer-driven information systems that now circle the globe. The paradox here is that all of these technological revolutions have increasingly served to more totally submit mankind to the single Western and, in Clifford Geertz's term, 'local culture' memory that has made it all possible; that in effect has made our gathering here today, with all of us in this room, being able to understand each other, conceivable. Unimaginable evil, therefore, side by side, with the dazzling scientific, technological and other triumphs.

The second proposal is that if no other medium was to be more effective than that of the cinema in ensuring the continued submission to its single memory of the peoples whom the West has subordinated in the course of its rise to world hegemony, no other medium is so potentially equipped to effect our common human emancipation from this memory, from, therefore, in Nietzsche's terms, the prison walls of its world perception,[27] or, in Marx's, from its ideology;[28] or in mine, from the culture-specific order of consciousness or mode of mind of which this memory is a centrally instituting function.[29] This memory, I shall propose here, is the memory of the 'Man' of my title; that, therefore, of a specific conception of the human, the first secular or degodded (i.e. detached from its earlier millennial anchoring in the realm of the supernatural) conception of the human in history. The memory, therefore, of a mode of being human that had been unknown, as Foucault points out, before its invention by European culture in the sixteenth century, if in a then still partly religious form.[30] In the nineteenth century, however, as he also shows, this conception was to be inscripted in a purely secular, because biologised, form by the then new, 'fundamental arrangements of knowledge' put in place by the matrix disciplines of economics, biology, philology. By, therefore, the arrangements that we have inherited, along with, in Mudimbe's terms, their ground or epistemological locus and conceptual modes of analysis or paradigms,[31] as the model/ paradigms through which, as Western or Western-educated filmmakers and scholars, we normally know, and represent, even where oppositionally so, the social reality of our contemporary world.[32]

The central problem here is that if, as Foucault noted, *Man* was invented in the terms of a specific culture, that of sixteenth-century Europe, the anthropologist Jacob Pandian also reminds us that this new mode of identity was to be a direct transformation of the identity of *Christian,* that is, of the matrix identity of medieval Latin Christian Europe.[33] Now, the implication of the fact that the identity of Man is a transform of *Christian,* is not normally graspable within the terms of our disciplines, through whose reference frames we know and represent reality. This is so because, while the medieval public identity of *Christian* was easily identifiable as belonging to a specific religious creed and system of belief, and therefore to what Lyotard calls a 'Grand Narrative of

Emancipation',[34] the parallel linkage is not normally seeable in the case of *Man* as the now purely secularised variant of *Christian*. Rather, instead of the reality of Man's existence being recognised as a culture-specific mode of identity which functions within the terms of a secular belief system or Grand Narrative of Emancipation, that is itself the transformed analogue of the religious belief system and Origin Narrative of feudal-Christian Europe, *Man* is conceived of as an *acultural* mode of being. As one, therefore, whose ostensible pre-given and biologically determined 'human nature' is supposed to determine the behaviours that collectively lead to a social reality that is then represented as *the way things are in* themselves, the way they *will have to be*, with this representation then serving a teleological purpose. For how can one fly in the face of a reality, even where one is condemned by, and in, it?

The Dealt Cards, the Paradox of the Appeal of Mass Commercial Cinema and the Conference Organisers' Question

In the 1987 film *Saaraba* by Amadou Saalum Seck of Senegal, a group of disillusioned youngsters argue amongst themselves. 'The White man', says one, 'points out the direction and others must follow.' 'Don't you know', says another resignedly, 'that the cards have already been dealt?'[35] While although it might indeed be suspected that these dealt cards were from decks that were always already stacked, given that we are always already inserted in this reality, the problem we confront is that *Man* and the all-pervasive nature of what Heidegger defines as the understanding of the human's humanity that it embodies, so engulfs us, that we are unable to question this reality. Since it is precisely our present understanding of our humanity, the way we conceive ourselves to be human, that induces us to bring this reality into being by means of the collective behaviours that this understanding motivates; in effect, behaviours induced in the terms of the specific order of consciousness and mode of memory to which such an understanding and conception leads.

So how are we to contradict this reality? Call in question its always already dealt cards, its stacked deck? If we are to do so, we must first understand that it is because of this ontological dilemma that the commercial cinema of Hollywood and India has had such spectacular success with mass audiences in Africa and the diaspora. In that the global reach and mass appeal of the cinematic dream factories of Hollywood's commercial cinema, in particular, directly derive from their ability both to provide an illusory escape from our present mode of reality, and at the same time to reinforce it. For they provide the escape in the very terms of the memory and understanding that gave rise to this reality in the first place; terms in which its celluloid heroes and heroines are shown, in the end, to succeed, against all odds, in mastering our contemporary reality. The paradox here is that it was, and continues to be, the systemically negative experiencing of this empirical reality by the vast majority of the individual spectators whose real lives are prescriptively lived according to ways in which the cards are dealt, that then makes the escapist fantasies of Hollywood into a necessity rather than a luxury. In that, it is because the experience of their real-life reality is such a persistently harsh and unfulfilled one for the cinema's mass audiences, that the fantasy of escaping from it becomes an urgent consumer need. This is so, given that in the wake of the West's secularisation of *Christian* as *Man*, and with the world system that it would bring into existence, being based on this transformation, an increasing loss of the guarantees that had been provided for, in all earlier 'forms of life', by the realm of the sacred, of the supernatural, would come to be experienced. Hence, as Heidegger noted, the emergence of the intensified form of insecurity that characterises and motivates the modern human and that now continually brings individuals and groups into conflict with their fellows[36] since all of us are driven, because of the unceasing

competition to which this insecurity has led, to manipulate both nature and each other in order to ensure our own certainty and well-being. Such behaviours should *not,* however, as Heidegger further points out, be interpreted in the usual terms: that is, as being due to the political and personal ambition of individuals as Machiavelli would have had it, or to the universal desire for biological self-preservation, as Hobbes would have interpreted. Rather, these behaviours should be seen as being directly caused by our present understanding of mankind's humanity, and the subsequent attempt of all men, all women, of all of us, to realise it; the attempt of all of us, to realise being in the terms of contemporary modernity and of its techno-industrial mode of reality, to in effect, *be* modern, *be* Man.[37]

The mass appeal of contemporary commercial cinema is therefore due to the formulaic way in which Hollywood's dream factories reinforce the desire for being in the terms of Man's modernity, and therefore in the terms of our present understanding of mankind's humanity, with their middle class heroes – and, now increasingly, heroines – attaining to this quest in the face of great odds, thereby enabling the mass spectators to participate vicariously in their celluloid triumph, however illusory this triumph must necessarily remain for them. Hence the paradox that while at the level of empirical reality we all remain submitted to a memory, that of Western bourgeois *Man,* and to the logic of its stacked deck and dealt cards which dictates that any such concrete realisation on the part of the masses, and thereby, on the part also of the majority of the peoples of Africa, must continue to be thwarted, at the same time, these very masses are being drawn by means of cinematic fantasies and their plot-lines, into the consumer-producer network of contemporary techno-industrial civilisation. That is, into the civilisation that is increasingly bringing to an end the long agrarian era of mankind in which African civilisations, for example, had grown and flourished. In consequence, since it is through these Hollywood model cinematic texts that all the world's peoples are being induced to aspire to realise being, however vicariously, in Westernised terms, to be *Man,* and to be modern, the success of commercial cinema with its up-to-the-minute re-enacting of the ideal techno-industrial lifestyle and optimum behaviours defining of the human within the terms of our present understanding of our humanity is ensured.

This widespread success of mass commercial cinema, and the paradox that it poses for an emergent African cinema, is one of the major issues that the organisers of this conference have posed. How, they ask, are the filmmakers of black Africa to confront and deal with the dichotomy which seems to definitely separate the possibilities of a commercialised mass appreciation of African cinema, and of African cinema as a valued cultural art form? What if, as they further suggest, the either/or choice of commercial mass success, on the one hand, or of seeking to produce a cinema of aesthetic force and cultural integrity on the other hand – what if this would call for the elaboration of a new conceptual ground?[38] Would such a new ground not have to be one which, in my own terms, moves outside the parameters of the memory of *Man,* as the memory to which we are at present submitted? Outside its understanding of our humanity?

The Birth of a Nation, Resisting Spectators, and the Issue of Consciousness/Memory as an Issue-in-itself: The Cinema and World Outlooks

To address this issue, I shall bring in two other significant dates from the early history of the cinema, and of the Western cinematic text. The first date is that of 1915, the year in which D. W. Griffith's *Birth of a Nation* was first screened. This year also saw the emergence of black Americans as, in the terms of Manthia Diawara, a 'group of resisting spectators'.[39] The paradox here was that

Griffith's innovations, as far as the art of cinema was concerned, were far-reaching, and would set the pattern for many techniques of cinema that were to follow. Indeed, the aesthetic force and power of Griffith's technical innovations would lead filmmakers of the stature of an Eisenstein not only to hail him as one of the genuine masters of the American cinema – i.e. 'a magician of tempo and montage'[40] – but to be also deeply influenced by the new techniques in the series of masterpieces that Eisenstein was himself to conceive and direct. In terms of content, however, while the film *Birth of a Nation* provided a symbolic charter that not only unified North and South after the Civil War, but laid the basis of the eventual integration of Anglo-Americans with the diverse immigrant European ethnic groups, it did so on the basis of a *racial* identity that could only be sustained by the symbolic, conceptual and empirical exclusion of *black* Americans, as a people of African descent, whether unmixed or mixed. The integration of North/South Immigrant/Anglo-America was therefore to be effected by means of the creation of a powerful new stereotype, that of the black American male. This stereotype was that of the violent, sensual, 'big black buck' bent on assaulting white men and raping white women;[41] and thereby of 'miscegenating' the 'racial purity' of the hegemonic population group of European hereditary descent.

As a result, if, as Michelle Wallace points out, the film had set out to justify the emergence of the Ku Klux Klan by giving a tailored version of Reconstruction's impact on the South,[42] its screening was also to be a watershed in what might be called the history of consciousness of black America.[43] For its screening set off the process by which black Americans, like black peoples everywhere, would gradually come to recognise that the issue of consciousness, although a secondary and epiphenomenal issue for all forms of Western thought (including the oppositional thought of Marxism and feminism), was to be the issue specific, as Aimé Césaire was to write in 1956, to the uniqueness of the problem of black people; as an issue and a problem that could not therefore be made into a subordinate part of any other issue or problem.[44] Here Manthia Diawara's analysis of the narrational units of the film, including those in which the brutal black character Gus attempts to rape the white Little Sister, who jumps off the cliff to escape him, later dying in her brother's, the Little Colonel's, arms (with the Little Colonel thereby *justly* punishing Gus, by organising his vigilante execution by the Ku Klux Klan), reveals why this film was to evoke such deep outrage on the part of black American viewers, and to make them into one of the earliest groups of actively resisting spectators.[45]

As Diawara further comments, the black spectator, confronted with such a scene, is placed in an impossible position. Drawn by the storyline to, on the one hand, identify with the white Little Sister as victim, feel grief for her, as well as desire vengeance against Gus, on the other, the black spectator was also compelled to resist the thematic representation of the black man as a dangerous, atavistic threat. The film's systemic negative marking of the black male (played in blackface by a white actor), would therefore, Diawara writes, lead black Americans not only to 'lobby for laws banning racial slandering, but also to begin the production of their long line of movies called "race movies" '. For in this context, the name 'race movies' signified not only that black Americans had recognised the need to fight their battle against racial subordination in the new language of the cinema itself. It also signified the widespread recognition that Griffith's film had confronted black Americans with an issue *specific* to them as a group, one that would have to be fought in the terms of a counter-iconography to that of Griffith's. Above all, that this would have to be done not as an *'ethnic'* group,[46] but rather as a group that had been conceptually and aesthetically constituted, within the terms of the now globally hegemonic culture of the West, as the signifier of alterity or Otherness, both to post-abolition America as it now reinvented itself in the terms of its being a *white*

nation, as well as, at a global scale, together with all peoples of African descent, as *Other* to *Man*;[47] a group whose members are thereby made to experience themselves as the deviant Other to being human within the terms of *Man*, within the terms of the memory, and order of consciousness therefore to which they/we were, and are still now, submitted.

This takes us to the cinema of black Africa. For although, as Ukadike points out, France had banned the showing of Griffith's film, *Birth of a Nation* in order not to offend its black colonial troops and the elite of its African colonies,[48] the same issue that had been raised by black America's response was to be raised by black African filmmakers in the wake of political independence, as an issue also experienced as being urgently specific to them. This issue, even where it remained as a subtext of their films, had to do with the reality of a hegemonic Western memory and its order of consciousness, as one to which, even after political independence had been won by social and military struggles, they still found themselves, as an educated elite, submitted; perhaps, even more so, after independence.[49] For in the same way as the black American, in order to identify himself/ herself as a middle class *American*, post-abolition, had been compelled to negate not only his/ her physiognomy, but the stigma of any African cultural characteristics that had been brought in on the slave ships across the Middle Passage, equally, post-independence filmmakers of black Africa found that in order to identify themselves as middle class men or women, they too had to deny, to be aversive to, the reality of their original cultural reality as a reality negatively marked and represented as *backward, primitive and savage*. They too found that, as in the case of *Birth of a Nation*, no other medium would so blatantly force them to a choice of options as would the new medium of cinema, as deployed by the formulaic stock fare of the Western cinematic text; nor so forcibly remind them not only that after the struggles by which political independence had been won, the issue with which they were and are still confronted is that of the Sisyphean issue of the memory of *Man*, of the prison walls of its world perception or order of consciousness, but also that 'independence' went and goes beyond the 'political', beyond even the economic in order to touch upon the question of representation, the representational apparatus, and of the culture-specific memory and mode of consciousness which it institutes.[50]

The second date is memorable in the above context. In 1925, after having absorbed the influence of Griffith's, the Russian filmmaker Sergei Eisenstein screened a film that is still recognised as one of the dozen or so best films ever made. That film was *Battleship Potemkin*.[51] Combining aesthetic force with a mass appeal to its Russian audience, the film, because it was made in the context of the still creative dynamism that had followed in the wake of the 1917 Russian Revolution, and therefore in the context of the projection of a new counter-identity to that of *Man*, that of the *proletarian*, could now count upon a new kind of spectator.[52] Indeed the film was to be one of the central means of the ongoing transformation of memory, and therefore of consciousness, on whose basis post-revolutionary Russia was being put in place. Further, a central part of the film's aesthetic power and effectivity came from the fact that Eisenstein, as a Marxist, former engineer and now filmmaker, was fully aware of the potential power of the cinema and of cinematic techniques to either further enslave humankind or emancipate it from the dictatorship of memory, orders of consciousness or, in Marxian terms, of ideology, that have hitherto induced all subordinated groups to acquiesce in their, in our, own subordination; of the power of the cinema and of cinematic techniques, in effect, to engage spectators on one side or the other of the battle now being waged in the central intellectual cum aesthetic frontier and war zone of our times. That is, the battle, on the one hand, for our continued enslavement, as humans, in however seductive a guise, to our hitherto, heteronomously instituted orders of consciousness, and on the other, for the full emancipation,

and therefore autonomy, of our always, culturally relative and symbolically coded modes of mind:[53] the autonomy, therefore, of the phenomenon of consciousness by means of which alone we can subjectively experience ourselves *as* human.[54]

In 1946, in the wake of the eagerly awaited ending of World War II, Eisenstein wrote:

> The cinema is 50 years old. It has vast possibilities that must be used, just as in the age of modern physics the atom must be used for peaceful purposes. But how immeasurably little the world aesthetics has achieved in mastering the means and potentialities of the cinema.[55]

At the height of the war, he continued, 'his dream and hope had been that when peace came, a victorious humanity would use its liberated energies to create new aesthetic values, to attain new summits of culture'. With peace, however, not only had the splitting of the atom and the use of the nuclear bomb which followed it brought new problems for mankind, but the cinema itself had failed to realise its potential promise. Why had this been? 'It was not', he writes, 'only because of a lack of skill, of enthusiasm. It was because of striking conservatism, routine, aesthetic escapism, in the face of the new problems set by every new phase in the rapid development of cinematography.' And the central issue here was that, while we have no reason to doubt our capacity to solve these problems, 'we should always bear in mind that it is the profound ideological meaning of subject and content that is, and will always be, the true basis of aesthetics and that will ensure our mastery of the new techniques'. So that, in 'this context, the means of expression would serve the medium for a more perfect embodiment of more lofty forms of world outlook ...'[56]

For Eisenstein, writing just after the war and caught up in the enthusiasm which had followed on Soviet Russia's heroic part in the defeat of Hitler's Germany, and therefore of the fascist threat that his victory would have entailed, such a new and lofty world outlook could only have been that of Communism. Yet, Eisenstein himself had already, since the 1930s, as has been now revealed, begun to find himself *persona non grata* with Stalin; and even though partly rehabilitated after one of his films had been banned in 1935, he still found himself outside the innermost party circles. Other filmmakers who were in ideologically correct grace with the party leadership had therefore begun to preside over what was to be the decline of the Soviet cinema from the ideo-aesthetic standard set by Eisenstein.[57]

From our 1990s' hindsight perspective, and in the wake of the total collapse of the Soviet Union and of its satellite spheres (including those African states whose variant one-party states had also been loosely based on the theoretical framework of a Stalinist Marxism), it is clear that Eisenstein's wished-for 'lofty world outlook' was not to be that of Communism.[58] Instead with the defeat of the Marxist theoretical challenge, and its postulate of a *'proletarian'* counter-identity, the outlook of *Man* remains intact. While given the disappearance of the Soviet Union and, with it, that of its alternative memory, that of *Man* is now all-pervasive as it penetrates every nook and cranny of a world that has been recently defined by one writer as a 'Mac world' – Macintosh and McDonalds.[59]

What has remained constant is the position of Africa. Although no longer militarily and politically colonised, Africa, nevertheless, as the projected continent of origin as the extreme form of the 'native Other' to *Man*, retains its position as the bottom-most world, the one plagued most extremely by the contradictions that are inseparable from *Man's* bourgeois conception of being human. Given that under the weight of the consciousness, memory and world outlook to which this conception gives rise, no other continent must as prescriptively find itself enslaved to the unending global production of poverty which is the necessary underside of the this-worldly goal of *Material Redemption* from *Natural Scarcity,* and therefore, of the no less unending production of wealth that is the correlate of Man's optimal self-definition as *homo oeconomicus,* and Breadwinner. In that if

we see our present this-worldly goal of *Material Redemption* as the secular form of the other-worldly goal of *Spiritual Redemption* that had been central to the Grand Narrative of Emancipation founding to the religion of Judaeo-Christianity, and therefore to the civilisation of Western Europe, in the same way that the matrix goal of *Spiritual Redemption* had been generated from that narrative's inscripting of the human as a being enslaved to Adamic Original Sin, with his/her redemption only therefore made possible by adherence to the behaviours prescribed by the Church, as the only behaviours able to realise the hope of Eternal Salvation in the Augustinian City of God, then our present biocentric and optimally economic conception of the human can also be recognised as having its historical origin in the intellectual revolution of lay humanism. That is, in the latter's invention of the identity of *Man* in the place of the identity of *Christian*, if at first only in a hybridly religious and political form that at the end of the eighteenth century was to be reinvented in a now purely secular, because biologised, form.[60] This, at the same time as this ongoing secularisation of identity, the matrix behaviour-motivational other-worldly goal of *Spiritual Redemption*, would also be transumed into this-worldly ones, the first, political, the second, from the end of the eighteenth century on, economic.[61]

This may, at first, seem startling. Yet once we recognise that the 'cultural field' in which we all now find ourselves is that of "Clifford Geertz's 'local cultural' of the West" and, therefore, that of the Judaeo-Christian culture for which the behaviour-motivating schema and Narrative of Emancipation as originally formulated by St Augustine continues to function,[62] if in a now purely secular and transumed form, two consequences can be seen to follow. The first is that our present behaviour-motivating systemic goal of economic growth, development, i.e. or of *Material Redemption*, can now be identified as a logical transformation of the original matrix Judaeo-Christian goal of *Spiritual Redemption*. While the founding Augustinian postulate of the source of evil as being sited in mankind's enslavement to *Original Sin* can also be seen to have taken new form in the discourses of Malthus and of Ricardo (where it became translated into that of our enslavement to *Natural Scarcity*),[63] as well as in the new cosmogonic schema of Darwinism, in the reoccupied place of the Biblical Genesis and of its Adamic Fall. In these latter discourses and cosmogonic schema, the source of evil now came to be sited in humankind's postulated enslavement, not now to *Original Sin*, but rather to the random and arbitrary processes of bioevolutionary Natural 'selection' and 'dysselection'[64] – with all peoples of African descent wholly or partly thereby being, in consequence, lawlikely inscribed as the ultimate boundary marker of non-evolved, dysselected, and therefore barely human, being. This, in the same way as in the medieval order of Europe, the unroundable Cape Bojador had marked the limits of Christian being, and had thereby functioned as the boundary marker of the *habitable* regions of the earth enclosed in God's providential Grace, so that beyond its limits, the then believed to be non-habitable regions of the Torrid Zone (i.e. the zone which included today's sub-Saharan Africa) could be made to attest to the chaos that ostensibly threatened all those areas of the earth supposed to be outside that Grace;[65] and that analogically threatened any Christian whose behaviours moved outside the prescribed pathways laid down by the Church. In the same way, therefore, as within the terms of the Malthusian/Ricardo order of discourse, both the nation-state categories of the jobless or semi-jobless Poor, together with the global category of the 'underdeveloped' countries of the Western world system, (with their most extreme marker being the nations of Africa as well as other black nations such as Haiti), are logically postulated as being outside the 'grace' of Natural Selection because intended by Evolution to be expendable;[66] with their condemned fate threatening all those who move outside the behavioural pathways prescribed by the Western bourgeois order of words and of things.

The issue of consciousness or memory, the issue of Eisenstein's world outlook, can here be seen to take on a central significance, in the context of the related issue of the representational apparatus of the West, including centrally that of its cinematic text. Since what becomes clear is that although behaviour-motivational postulates such as *Original Sin, Natural Scarcity* and *Genetic dysselection,* or *dysgenesis,*[67] and the system of representations to which they give rise, are 'true' within the terms of this field, and are, as such, 'facts' for our present *order of consciousness,* outside the terms of our present secular cultural field they no more exist than the ritual practices of circumcision/ clitoridectomy of traditional non-monotheistic Africa existed as desirable marks of honour *outside* the religio-*cultural fields* to which they belonged–and in residual cases, still belong.[68]

The proposal here, therefore, is that outside of the terms of our contemporary culture, neither *Natural Scarcity* nor *Original Sin* (nor indeed *natural abundance*) exist, seeing that since these are conceptions that are 'true' only within the terms of what is the now purely secularised culture of the Judaeo-Christian West, as the field that prescribes, inter alia, the role of Africa both within the scholarly and cinematic texts, as well as within the socioeconomic structures of our present world system. So that, if within the logic of the matrix medieval Grand Narrative of Emancipation of Christianity and its system of representation, it had been the category of the *leper* with its leprosy which, proscribed outside the gates of the medieval town as the ostensibly actualised icon of his/ her parents' sexual lust,[69] and thereby as proof of mankind's represented enslavement to *Original Sin,* that had legitimated the call for freedom to be conceived in terms of *Spiritual Redemption,* it is now the poor and jobless category – Marx's *lumpen proletariat,* Fanon's *Les damnes de la terre*[70] –who must remain proscribed in the ghetto and shanty town archipelagos of the First, Third and Fourth Worlds, and in the ultimate world of Africa. Since it is this category that now serves, within the terms of *Man's* secular Narrative of Emancipation, as the actualised icon, of humankind's threatened enslavement to *Natural Scarcity* in the reoccupied place of its post-Adamic enslavement to *Original Sin.* Given that it is the dually represented and concretely produced presence of the categories of the *jobless Poor* and of the *'underdeveloped'* peoples, as signifiers of genetically dysselected humans, who as *defective Breadwinners* are unable to master *Natural Scarcity,* which imperatively prescribes that freedom be imagined in terms of *Material Redemption.* With the new telos or goal of 'economic growth' and 'development' and its metaphysics of productivity thereby coming to orient the behaviours of subjects socialised to experience freedom as freedom from enslavement to *material,* rather than as earlier to *spiritual* want.[71] In consequence, in the same way as in the matrix narrative of the Judaeo-Christian West, freedom, and the behaviours necessary to achieve it, had been represented within the terms of the theocentric identity of *Christian* as that of attaining to *Eternal Salvation* in the other-worldly City of God, or *civitas Dei,* so freedom for us, and the behaviours to secure it, have come to be imagined within the terms of the biocentric identity of *Man,* as that of attaining to the American Dream in the *civitas materialis* (the Material City) of the suburbs of the global bourgeoisie; within the terms, therefore, of our present world outlook, as enacted inter alia, in the Western cinematic text.

If all this seems too sweeping, let me refer you to the near-home example of the successful manipulation of our present cultural systemic goal of *Material Redemption* by the highly successful policies of Margaret Thatcher. To cite Stuart Hall's 1988 analysis of this phenomenon: 'Thatcherism', he wrote,

> has put in place a range of different social and economic strategies. But it has never for a moment neglected the ideological dimension. Privatisation, for example, has many economic and social payoffs. But it is never advanced by Thatcherism without being constructed ideologically ('Sid',

the 'share-owning democracy' etc.). There is no point in giving people tax cuts unless you also sell it to them as part of the 'freedom' package.[72]

Thatcher's 'freedom package' would not have sold, however, if it had not been couched within the deep-structure terms of our present 'cultural field' and its Grand Narrative of Emancipation, as in Saussurian terms the *parole* of a *langue* in whose logic the ideal of mastering *Natural Scarcity* can only be made to function as a behaviour-motivating ideal, if its Lack, the failure to master *Natural Scarcity,* continues to be actualised in the systemically produced global categories of the Jobless/Homeless Poor, as well as of the 'underdeveloped worlds'. This in the same way as in the medieval order of western Europe, the ideal of *Spiritual Redemption* and of Divine Election to *Eternal Salvation* had depended for its performative urgency on the actualised example of the failure on the part of the leper's parents to master their enslavement to the carnal lust of Adamic Original Sin; as the sign of this failure, of its 'disease of the soul' was embodied in the condemned figure of the leper proscribed outside the gates of the medieval towns.

Black African Cinema, the Untheorised Thematic of Poverty, the Issue of Consciousness, and the 'Freedom Package'

From the earliest films of post-independence Africa, beginning with Ousmane Sembène's *Borom Sarret* in 1963, the theme of poverty, as portrayed in the sharply coded contrast between urban poor and urban rich, divided, in Fanon's terms, between both the settlers' towns and the towns of the new African elites, on the one hand, and the natives' towns and the towns of the postcolonial poor,[73] on the other, has remained as a pervasive horizon text of black African cinema. While in spite of the fact that the thematic of poverty, unlike the thematics of labour proper as well as of gender, has not been theorised, its portrayal in black African cinema has consistently drawn attention to the reality that the global production of poverty is no less a constant of our contemporary world system than is the production of wealth, even where the implications of their dialectical relation have not been explored.[74] For as Zygmunt Bauman has noted, contemporary intellectuals, whether liberal-capitalist or Marxist, have remained incapable of theorising the issue of the category of *Jobless Poor,* as well as that of the category of the New Poor (i.e. people stuck in low-wage and temporary, casual jobs). This in spite of the fact that the latter category, (whose members are called 'temps' in the USA) is now a rapidly increasing one given the spread of technological automatisation, and the subsequent transformation of a large number of lifetime jobs complete with seniority status and benefit packages into part-time benefitless ones.[75]

The persistence of the joblessness/poverty thematic not only in black African cinema, but as centrally in that of the black diaspora–in the by now classic films, *The Harder They Come* (1972, Perry Henzell) as well as Spike Lee's *Do the Right Thing* (1989)–has nevertheless begun to make it clear that the systemic reproduction both of the increasingly endemically jobless category, as well as that of the temporary labour category of the New Poor, is the lawlike consequence of the accelerated automatisation of the 'high-tech'/consumer stage of capitalism as the enforcer of the, now fully globalised, *Material Redemption* notion of human freedom; of the globalisation, therefore, of the this-worldly goal of Thatcher's 'freedom package'. A useful analogy here is provided by C. L. R. James's 1948 analysis of the widespread phenomenon of the Gulags or forced labour camps that had been put in place in the Soviet Union, as well as in its satellite spheres in eastern Europe. James's parallel point here was that the phenomenon of the forced labour archipelagos was the lawlike consequence of the Soviet New Class bureaucracy's notion of human freedom.[76] In that once the Party bureaucracy or *Nomenklatura* had come to install itself as a new ruling class, it had

been able to legitimate this only by redefining socialism's notion of human emancipation and autonomy, in terms that made it isomorphic with the nationalisation of the means of production, under the total control of the Party: as a notion of freedom that had then functioned to legitimate the dictatorship of the New Class bureaucracy *over* the real-life proletariat or working classes in whose name they had seized power.

James's point that it was the notion of freedom[77] as redefined by the New Class or Party *Nomenklatura* that was a central determinant of the institution of the Gulag, and of the internment in these forced labour archipelagos, of any or all groups or individuals suspected of being recalcitrant to, or of sabotaging of, the overriding goal of accelerated production based on collectivised agriculture, processes of industrialisation directly controlled by the Party and an overall centralised command economy, can be applied to our own notion of freedom or 'freedom package',[78] in terms of the telos or supra-ordinate goal of *Material Redemption*. Since it is the imperative of this overriding goal that has led, for example, to the situation in which, with the dismantling of the barriers of racial apartheid that had for so long existed in South Africa (as well as some 30 years before, with the dismantling of the US form of racial apartheid), a new form of now purely economic apartheid has come to reoccupy the earlier socially segregated form.[79] With this shift, because it was linked to widespread processes of automatisation, having led lawlikely to the accelerating expansion in South Africa, in the USA, in Britain, Brazil and indeed all over the world, of the category of endemically jobless inner-city ghettoes, favelas, jobless shantytown archipelagos, together with the prison-industrial complex that is their extension, as the criminalisation and incarceration of the poor and jobless, and, centrally, that of the young black male, now rapidly expands.[80] At the same time as their systemic 'damnation' was to become a central thematic of the black African and black diaspora cinematic text.

Here again, the issue of consciousness or memory and, with them, the imperative of redefining the notion of freedom emerges. In South Africa, for example, Stephen Biko, had he still been alive, would not have been surprised by the shift from a primarily socio-racial system of apartheid to a primarily socio-economic one. This is because the notion of freedom for him had not been either the issue of free market capitalist 'development', as the path to *Material Redemption*, or, as for the then neo-Marxist ANC, that of the path of socialism defined by an economy based on the nationalisation of the means of production. Rather, for Biko, the issue had been centrally one of consciousness, and therefore of the imperative need of any subordinated group to first of all secure its autonomy *from* the memory or normative consciousness in whose terms its members are both socialised and at the same time, prescriptively subordinated;[81] of whose putting and keeping in place, the subordinated are thereby always in the long run accomplices, and with the ending of their subordination, therefore, necessarily calling for an end to be put to all such forms of complicity, for an uprising against their/our 'normal' order of consciousness.

Since Biko's death, and the parallel domesticating of the Black Consciousness Movement, both that of South Africa as well as that of the US in the 1960s, the issue of consciousness as a central issue – that is, the issue of *black*, indeed, of *native* consciousness, as a potentially alternative consciousness to that of *Man*'s – has been marginalised.[82] The difficulty here has to do with the conception of consciousness that underlies the dominant Western theories of our time, whether those of the status quo or those which are radically oppositional.[83] In the paradigm of liberal humanism, for example, which is based on what an African scholar, I. B. Sow, has identified as the 'theoretical fiction' of a purely biological and therefore non-changing human nature,[84] the mind *is* the brain.[85] Indeed, consciousness has also been defined within the logic of our present

understanding of what it is to be human, by the DNA discoverer and Nobel Prize winner Crick, as being merely 'a pack of neurons.'[86] While for the counter-discourse of Marxism, consciousness, because labelled as *ideology,* and as such, as a merely superstructural or epiphenomenal effect of the *economic mode* of production, cannot be recognised as an issue in its own terms, any more than the correlated issues of *race* or of *poverty* and *Joblessness* can be seen as issues in their own.

Here Mudimbe's point, that all oppositional movements, including that of the most extreme Afrocentrism, and indeed that of Marxism and of feminism, must necessarily think themselves within the 'ground' of the contemporary epistemological locus of the West and its conceptual models of analysis, even where they contest some of its surface structure premises,[87] enables us to see why our present understanding of *Man* and its biologised conception of being human must lawlikely block recognition of the issue of memory, of consciousness, as being *the* primary issue of our times. Rather, so powerfully pervasive is the 'theoretical fiction' of our fixed biological human nature that, although, as Antonio de Nicolas points out, it is clear, given the diversity of human religions, as well as of human cultures, that men and women have 'never been any one particular thing or had any particular nature to tie them down metaphysically', and that, instead, we become human only by means of the conceptions (i.e. theories) of being human that are specific to each culture,[88] there is stubborn resistance to the recognition that it is these conceptions that encode, as the anthropologist John Davis points out, each culture's criterion of 'what it is to be a good man and woman of one's kind',[89] as the criteria of optimal being that motivate us to attain to the representation of symbolic life that they encode, and which is the only life that humans live.[90] It is here, therefore, that the centrality to human orders of representational apparatuses, including that of the cinematic text to our contemporary own, becomes apparent. For if, as Antonio de Nicolas points out, we are enabled to *live* and actualise these conceptions of being human, and therefore to be *conscious* of, to *experience* being in their culture-specific terms, only because of our capacity to turn theory into flesh, and into 'codings in the nervous system', this process of transmutation can be effected only by means of the system of representations in whose terms we are socialised as subjects, since it is these that function to 'tie us down metaphysically' to each culture's criterion of what it is to *be* human. Hence the paradox that our present purely biologised conception of being human, that is, its 'presentation' of the human on the model of the *natural organism* (as this model is elaborated, Foucault shows, by our present 'fundamental arrangements of knowledge' and their disciplinary paradigms),[91] does indeed so serve to 'tie us down' metaphysically to its 'theoretical fiction' of 'human nature'. At the same time as its biocentric strategy of identity, its representation of the human as a purely biological being who *pre-exists* culture, the Word, has come to both reoccupy and displace, at the global public level of a now *economically* rather than religiously organised reality, the formerly dominant theocentric strategies of monotheistic identity,[92] whether that of Judaism, Judaeo-Christianity or of Islam. And, to effect, thereby, the ongoing displacement or the politicising of these religious identities as, in its time, Islam – as Sembène chronicles one instance of in his film *Ceddo* (1976),[93] – had displaced and reoccupied the traditional religions of Africa and their then local polytheistic and essentially agrarian strategies of identity, self-conception and therefore consciousness.[94]

In the film *Ceddo,* Sembène visualises the clash that took place between the polytheistic strategies of the indigenous religions, and the monotheistic strategies of a then incoming Islam. In the battle of consciousness and thereby of being that had then ensued, Sembène portrays how the 'people of Ceddo', defined in terms of alterity as people from 'outside the spiritual circles of Mohammed', had fought and resisted the Muslims who attempted to convert them, doing so in order to remain

faithful to their traditional mode of being, their millennial memory and mode of consciousness. As Sembène wrote in his synopsis of the film:

> At the beginning of the Islamic expansion, the people who hesitated to accept the new religion were called 'Ced-do,' that is 'people from outside,' outside the spiritual circles of Mohammed. They were the last holders of African spiritualism before it became tinged with Islam or Christianity. The Ceddo from Pakao resisted the Muslims who wanted to convert them, with a suicidal opposition. Their wives and children drowned themselves in springs in order to remain faithful to their African spirituality.[95]

However, while Sembène canonises the struggle in *Ceddo* in epic terms, he also shows, in other films, that all such orders of consciousness, world outlooks and the memories of different traditions and cultures can also outlive their usefulness. At the end of another film, *Emitai* (1971), (the god of thunder), for example, he also suggests that the consciousness and memory of such traditional religions may also have outlived their usefulness; that they too must give way to a new consciousness. Consequently, in an episode of the film, he shows how, in the wake of the Diola villagers' defeat by the French, a defeat that leads them to begin to question the old religion, the Spirits threaten the chief that if he ceases to continue to believe in them, he will die. Yes, Sembène has the chief answer, he will die, but they too will die with him.[96] Sembène's point here is that the Spirits exist because of the chief's and the Diola villagers' collective belief in them, in the same way as, in my own terms, *'Man'* (and its purely biologised self-conception) exists because of ours.

My major proposal therefore parallels that of Sembène's *Emitai* – that is, that a new conceptual ground for African cinema will call for our putting an end to our present conception of being human. In that, in the same ways as in *Emitai*, the Spirits had existed only as a function of that traditional Agrarian conception of being, and therefore because of the collective *belief* held by the people and chief of the village in that conception, so our present Western bourgeois or ethno-class, techno-industrial conception of being *Man* exists only because of our collective belief in, and faithful adherence to, its now purely secular or desupernaturalised/degodded criterion of what it is to be good man or woman of our kind.[97] Only because, in other words, of our continued subordination to the memory and order of consciousness to which this conception/criterion gives rise; to, in effect, its notion of the 'freedom package' as *Material Redemption,* rather than as freedom *from* the mode of memory and world outlook which induces us to conceive of freedom in the terms of *Man's* conception of being. How then shall we reimagine freedom as emancipation from our present ethno-class or Western-bourgeois conception of freedom? And therefore, in *human,* rather than as now, *Man's,* terms?

The fundamental question then becomes: can a new conception of freedom, defined as that of attaining to the autonomy of consciousness and, thereby, of autonomy with respect to the always culture-specific self-conception in the terms of whose governing codes of symbolic life and death and their respective criteria we are alone enabled to realise ourselves as specific modes of the human, provide us with the new ground called for by the conference organisers? And, thereby, with a new post-liberal and post-Marxian 'lofty world outlook' able, as Eisenstein noted, to provide the 'profound ideological meaning of subject and content' as the true basis of an aesthetics able to transcend the opposition between the consumer escapism of the mass commercial cinema, on the one hand, and on the other African cinema's realisation as a culturally valid art form of force and power? As one, however, based on a new conception of freedom able to move us not only beyond that of Man's 'freedom package', but also beyond those of Man's oppositional sub-versions,– that of Marxism's *proletariat,* that of feminism's *woman* (gender rights), and that of our multiple

muiticulturalisms and/or centric cultural nationalisms (minority rights), to that of gay liberation (homosexual rights), but also as a conception of freedom able to draw them all together in a new synthesis?[98] One in which the 'rights' of the Poor/jobless and increasingly criminalised category to escape the dealt cards of their systemic condemnation will no longer have to be excluded?

These questions take me to the crux of my proposal with respect to Africa, the West, and the analogy of culture; with what could be, therefore, the role of African cinema both in the deconstruction of our present memory of *Man*, its order of consciousness, and their reconstruction in the ecumenical terms of the planetary human. This is the new ground to which I've given the name of 'the Second Emergence'. My further proposal here is that it was with the challenge of this new ground with which black African cinema was, like black American cinema earlier, but even more comprehensively so, confronted from its inception.

The 'Colonial' or the 'Ontological' Rationale? The 'Gallery of Mirrors' of the Western Text and African Cinema towards the Second Emergence

'We've had enough', Pfaff cites Sembène as saying 'of feathers and tom-toms'.[99] The central impulse behind the beginning of filmmaking in post-independence Africa was indeed, as Ukadike points out in his recent book on black African cinema, the common concern of the filmmakers 'to provide a more realistic image of Africa as opposed to the distorted artistic and ideological expressions of the dominant film medium reflecting (to borrow from Erik Barnouw's terminology) the attitudes that made up the colonial rationale'.[100] For the exoticised and 'primitive' celluloid stereotypes of Africa which had been coterminous with the birth of the medium of film (specifically colonial films such as *Congorilla* (Martin Johnson) in 1932, an ostensible documentary, seen from an explorer-cum-anthropological perspective, as well as *Sanders of the River* (Zoltan Korda) in 1935 and in 1937) had consistently provided a distorted view of 'natives', portraying them as 'ingenuous, outlandish, somewhat mysterious beings who were nevertheless loyal and grateful to the Europeans for coming to guide and protect them'.[101] This had, therefore, been a world outlook which, in spite of the presence of Paul Robeson who played the role of Bosambo, that of an 'enlightened' native chief subservient to Sanders the powerful representative of the British government, had 'served to portray all the peoples of Africa in *terms which legitimated* the colonising redemptive mission of the Europeans'; in secular redemptive terms, therefore, rather than, as in the earlier case of the missionaries, Christian redemptive terms, in which the polytheistic 'natives' had been primarily seen as *heathens, pagans,* and *practitioners of idolatry,* waiting to be brought into the only true because monotheistic path of spiritual salvation.[102]

A key point emerges here – that of the constancy of the representation. For although the term *postcolonial* is now widely used to indicate an Africa in which the anti-colonial struggles waged during the 1950s and 1960s have resulted in political independence for Africa, with an end being put (except for South Africa, until very recently) to the political supremacy both of the colonial powers as well as of their settler-colonisers, in spite of the fact, also, that a wide range of films by post-independence African, filmmakers have been produced, the representational role of Africa in the basic plot line, iconography and matrix narrational units of the Western cinematic text, although modernised and updated, and, in the case of the film *Congo* (1995, Frank Marshall), even gone high tech, remains the same. In all such films these representations of Africa, whether as an exotic backdrop against whose landscape of indistinguishable wild game, primates and African natives, Europeans work out their destinies as the central characters of a love triangle (as in *Out of*

Africa (1985, Sydney Pollack)), or as the backdrop for American adventurers and speculators who seek the industrial diamond mines of a vanished civilisation guarded by terrifying and specially-bred intelligent grey-skinned gorillas, at the same time as an American linguist having taught a young gorilla to speak and use sign language has nevertheless come all the way to return her to her native wilds and to her own kind (*Congo*),[103] rearticulate themselves. In these films, we therefore see revisualised, if now in partly feminist guise (for example, in *Out of Africa* the Scandinavian baroness heroine copes with her ne'er-do-well aristocratic husband as well as with a white hunter lover, manages her coffee-farm single-handedly, and builds a school to teach the native children to read having convinced the native chief (shades of Bosambo!) that reading is a good thing!) the same constants. In effect, from *Sanders of the River* to *Out of Africa*, and from *King Solomon's Mines* (1937, Robert Stevenson) to *Congo*, the reality of the African continent and of its varied peoples is made to conform to a lawlikely prescribed pattern. What is more, it is made to do so both *before* political independence and *after* political independence; both before the emergence of an independent black African cinema, and *after* the emergence of such a cinema; both *during* the colonial era and *after* the colonial era. Can we therefore speak here, as does Barnouw, of merely a *colonial rationale* as the causal factor which determines the lawlike production of these representations?

What if we are here dealing, more profoundly, with a kind of *rationale* that can be no more seen to exist as an 'object of knowledge' within the terms of our present mainstream order of knowledge (which as Foucault points out was put in place at the end of the eighteenth and during the nineteenth century by Western thinkers), than, as he also points out, in the earlier pre-nineteenth-century classical order of knowledge, the concept of *'life'* as a biological phenomenon could have been seen to exist within the logic of the then discipline of *natural history*? What if this rationale, which I shall tentatively title the *ontological rationale* or the *rationale of the symbolic code*, is a rationale that opens us onto the issue of consciousness as an issue in its own terms? One therefore that opens up to a new 'ground' beyond the ground of *'Man'*, beyond its purely biologised conception of being human, of human being?

The proposal here is that the systemic nature of the negatively marked (mis)representations of Africa, Africans, as well as of all diasporic peoples of African descent (indeed of all the non-white, non-Western, and therefore 'native' Others), by the signifying practices not only of the cinematic texts of the West, from the exoticised Africa of the Lumière Brothers in 1896 to Black Gus in *Birth of a Nation*, from the explorer ethnographic documentary *Congorilla* to the 'Third World' ethnographic film *Reassemblage* (1983) by Trinh T. Minh-Ha,[104] from the backdrop of Africa in *Sanders of the River* to that in *Out of Africa*, the Africa of *King Solomon's Mines* and of Tarzan to that of the nauseous sentimentality of *Gorillas in the Mist* (1988, Michael Apted), to that of the recent *Congo*, should be seen as being due, not to a colonial rationale, but more far-reachingly to an ontological rationale, of which the colonial rationale is but one variant expression. That, further, this ontological rationale is that of the governing code of symbolic life and death, together with the related understanding of Man's humanity that is specific to the 'local culture' of the Judaeo-Christian West in its now purely secularised and bourgeois variant; in effect the code of *Man*, and therefore of the human in its Western bourgeois, or ethno-class expression.

In addition, the further proposal here is that if it is the rules generated by this code that govern the representations of Africa and peoples of African descent as well as of all other 'native' non-white peoples, doing so *outside* the conscious awareness of their Western and Westernised filmmakers, these are the same rules that have led Western as well as African and other non-Western scholars trained in the methodologies of the social sciences and the related disciplines of our present order

of knowledge (or Foucauldian episteme) to systemically know and 'represent' Africa by means of parallel symbolically coded discourses that were first identified by Aimé Césaire in his *Discourse on Colonialism*,[105] and later by Edward Said in his book *Orientalism*.[106] To thereby know and 'represent' Africa through what is, as K. C. Anyanyu cites Roger Bastide, 'an immense gallery of mirrors which only reflect the image of our (Western and Westernised) selves, our *desires or our passions* ... [through] mirrors which deform'.[107] While, if as Mudimbe proposed in *The Invention of Africa*, both the world view of autocentric Africa and that of 'African traditional systems of thought' rather than being known and represented 'in the framework of their own rationality', have hitherto been known and represented, by both Western and Western-educated African analysts, 'by means of ... conceptual systems which depend on a Western epistemological locus', it would suggest that not even we ourselves, as African and black diaspora critics and filmmakers can, in the normal course of things, be entirely freed from the functioning of these rules; and, therefore, from knowing and representing the 'cultural universe of Africa' through the same Western 'gallery of mirrors' which deform – even where this deformation is effected in the most radically oppositional terms which seek to challenge rather than to reinforce the deformation.

How then can we free ourselves from our own subordination to the ontological rationale of *Man*, to its symbolically coded 'gallery of mirrors' and distorted yet rule-governed representations? In 1976, K. C. Anyanyu proposed that we can be enabled to break the academic (and by extrapolation, the cinematic) mirrors that systematically misrepresent the reality of the African cultural universe, only if we seek to cognitively grasp 'the basic principles of understanding of both African and Western cultures'.[108] Yet given that, as Mudimbe reminds us, it is precisely in the terms of the 'mirror' of this latter culture, and therefore of its 'epistemological locus',[109] that whatever our cultures of origin, we have been educated as academic, filmmaker and critic subjects, how can we cognitively grasp the 'basic principles of understanding' through which we now normally know and represent not only the African 'cultural universe', but also our own Westernised 'cultural universe', *outside* the terms of these basic principles of understanding themselves? How can we come to know what these 'basic principles of understanding' *are* outside the terms of their own self-representation? Would this not call for the effecting of a radical discontinuity not only with the deepest levels of Western thought (as Foucault argues Marxism has been unable to do),[110] but with *all* human thought hitherto – including that of traditional African 'cultural universes' within the framework of their own rationality? Doing so in order to ensure the effecting of a transculturally applicable mode of discontinuity which I have defined as that of the Second Emergence?

This is the point of my attaching to my paper a photograph of a rock painting from Namibia in southern Africa discovered in a cave,[111] and which has been dated approximately some 28,000 years before the present. It is the same time-frame (i.e. some 30,000 years ago), therefore, that John Pfeiffer identifies as the time-frame of the 'creative explosion' of the human species when an extraordinary series of rock paintings convergently blossomed at multiple sites throughout the world.[112] In this context, and with respect to the rock painting from Namibia, I want to emphasise a central suggestion that was put forward at a 1987 FESPAC Conference by the African scholar Théophile Obenga. In referring to the intellectual revolution of Renaissance humanism by which the lay intelligentsia of fifteenth- and sixteenth-century Europe had laid the conceptual basis of the West's five centuries of global expansion, triumph and conquest, leading to the single history of secular modernity that we all now live, if severely unequally so, Obenga argues that they had been able to do so only on the basis of a central and fundamental strategy. This strategy had enabled them to move outside the limits of their then hegemonically religious medieval-Christian

world, in effect, outside the limits of its 'epistemological locus', and order of consciousness, in order to reconceptualise their past in new terms. These terms had been afforded the Renaissance intellectuals by their strategic return to their pagan Greco-Roman intellectual heritage, as well as their revalorisation of a heritage whose system of thought had been either domesticated by the theology of medieval Christianity or stigmatised by it. It had therefore been on the basis of their new reinterpretation of their past that they had been enabled to effect the intellectual revolution of humanism, and to thereby give rise to the new image of the earth and conception of the cosmos that were to be indispensable to the emergence and gradual development of the natural sciences, as a new mode of human cognition.[113] And as centrally, to also give rise to an epochally new, because secularising, conception of being, *Man,* as a post-religious and gradually desupernaturalised or degodded mode of the subject, at the public level of identity of the then emergent modern European state.[114]

On the basis of this analogy, Obenga had then proposed that if the intelligentsia of Africa are to bring an end to the ongoing agony of the continent, they also will find themselves compelled to reconceptualise the history of Africa, as outside the terms of our present 'epistemological locus' and its 'cultural universe'; and to do so by going back to the First Emergence of the human out of the animal kingdom, and then to the full flowering of the consequence of this First Emergence in the Egypt of the Pharaohs.[115] However, while the tendency hitherto, given the 'great civilisation' syndrome of contemporary bourgeois scholarship, has been to focus on the latter aspect of this reconceptualisation of the history of Africa, I should like us to focus instead on its earlier and most dazzling, its most extraordinary, phase, that is, the phase of *auto-hominisation,* as a phase in which the history of Africa uniquely converges with the origin of the human; and thereby with the origin of its history as a uniquely hybrid (because *nature/culture*) form of life. Ernesto Grassi further identifies this phase as that of the moment in which a specific species effected the rupture that brought to an end the earlier subordination of its behaviours to the genetically-coded 'directive signs', and therefore to the subordination characteristic of purely organic life; and entered instead into the realm of the sacred Logos or Word, where its primary behaviours as a social being were now to be oriented, instead, by the 'directive signs' of a specifically human code, that – in my own – terms, of the governing code of symbolic life and death, specific to each culture.[116]

Grassi's thesis here is that the emergence of the human *out* of the animal kingdom, its rupture with the closed circles of purely biological life, had been impelled by the fact that the genetically coded 'directive signs' ordering of the behaviours of purely organic species were no longer sufficient to necessitate the new behaviours that were indispensable to the survival and reproduction of our uniquely human, because verbally *inscripted,* mode(s) of being. One can add here that because it was for these now verbally inscripted beings – ones therefore transformed from being purely biological *males/females* into hybridly biological and cultural *men/women, husbands/wives, fathers/ mothers, sons/daughters, brothers/sisters, uncles/nephews, aunts/nieces* and so on – that the genetically coded 'directive signs' of purely organic forms of life would have proved insufficient, it was for them that the rupture of the First Emergence, that is, from total subordination to the hegemony of the genetically coded directive signs that necessitate the behaviours of purely organic life, would have become imperative. 'The insufficiency of the pre-verbal code', Grassi wrote in this context,

> is the immediate presupposition of the function of language, for here we are confronted with the distinctly human phenomenon of *the absence of an immediate code.* This absence of an 'immediate code' therefore not only points to the insufficiency of the biological code for this new language-capacitied form of life, but also reveals something else. This is the entry of a power that dissolves

the unity of life, a power whose hidden and yet effective strength is that *upon which the origin of a new 'code' —the human code – and world depend*. While with this entry of 'human spirituality' life receives a completely different meaning compared to the biological world.[117]

Both the absence of an immediate code and the new behaviours for which genetic codes could no longer provide the appropriately motivating 'directive signs', are due to the paradoxical nature of the evolutionary route taken by our species. For humans, who normally should have lived like other primates in the very small closed *societies for which they are genetically programmed*, found that because of the prolonged period of helplessness of the human infant after birth, they needed larger societies based, like those of the social insects, on a division of tasks, which could enable them to co-operate as insects did, as an indispensable requirement for their species survival and reproduction.[118] If, in the case of the social insects, however, the kind of kin-recognising altruism needed for this co-operation was ensured by the evolutionary route that the insects had taken, one in which the necessary degrees of co-operative eusociality had been determined by what biologists define as their high degree of *genetic kin relatedness*, this had not been so in the case of humans, and of the evolutionary route that they/we had taken.[119] Since humans, as members of the primate family, are genetically programmed to be competitive rather than co-operative, and to normally display altruism only towards a small group of more or less immediate kin. In consequence, if they were to be able to display the behaviours needed to live in large complex societies, and to transcend the narrow limits of their genetically programmed kin-recognising behaviours (given that, as biologists argue, the intra-species' socially cohering modes of eusocial altruism displayed by all forms of organic life is primarily dependent on the *sharing* of genes, i.e. I'm altruistic to you because you share the same genes with me, and if I help you, even at the expense of my own life, this is because the genes that you pass on will be the same as mine, thereby fulfilling my own reproductive imperative),[120] some other mechanism would have to be called into play. Human forms of life, therefore, if they were to be enabled to display a more generalised and inclusive level of kin-recognising altruism, would both have to effect a break with the purely genetic determining of altruistic behaviours, and to replace this with a new culturally motivated mode of altruism based on *symbolic*, rather than on purely genetic, degrees of conspecificity or of kinship. This would therefore have to be a new mode of cultural kinship, and of intra-group altruism, one now induced and necessitated by the Word, by the Sacred Logos, and by the overall religio-cultural field to which the 'directive signs' of the Word, and its governing code of symbolic life, give rise. In effect, therefore, the life that we call *human,* as one which 'receives a completely different meaning' compared to the one that organic species receive from the biological world,[121] *cannot pre-exist* what Grassi calls the 'human code' (one that I have defined as being, on the basis of a proposal by Peter Winch that symbolic forms of life are the only lives that humans live, the governing code of symbolic life and death).

I use the term 'inscription' here, in the context of Derrida's proposed grammatology, but in the extended sense, going beyond Derrida's itself, of our always self-instituting or self-inscripting, and therefore culture-specific, modes of being, of experiencing ourselves as, human. In this context both the rock paintings of Namibia and the 'creative explosion' identified by Pfeiffer as having taken place in multiple sites of the world, both African and extra-African, could themselves be seen as an even later phase of the *initial* forms of writing or of hominising self-inscription (Nietzsche's 'tremendous labor of man upon himself')[122] by means of which Grassi's rupture was effected – ones of which that writing on the flesh, which is the rite of initiation and of circumcision, would have been an early and central form.

Anne Solomon notes in this context, in a 1996 *Scientific American* essay entitled 'Rock Art in Southern Africa', that 'rock paintings' which are found all over southern Africa and which were made by the ancestors of today's San peoples 'not only attest by their wide range to the vast areas once occupied by the ancient San', but also 'encode the history and culture of a society thousands of years old'. To accompany her essay, Solomon published a photograph of the contemporary San engaged in a dance, side by side with the rock painting of what is probably a portrayal of the initiation rite, as it attained to women. Indeed, as she further notes, the rock paintings on one of her research sites consisted 'overwhelmingly of images of women'. While this 'unusual prevalence', she goes on, 'not only suggests that some locations may have been ritual sites used only by women perhaps in connection with female initiation', it also proves that it can no longer be assumed, as has commonly been done, that 'art' (and the self-instituting self-inscripting processes of that, the 'tremendous labor' of the human upon itself), that 'art', like ritual, enacts, was 'solely a male, preserve'.[123]

I would like, in this context, to bring the 'analogy of culture' proposal of my title together with Obenga's proposal that we return conceptually to the origins of human life in Africa, to its emergence out of the animal kingdom, doing so in order to reconceptualise the history of Africa, in terms outside those of our present order of knowledge. For if, as Grassi proposes, the question that confronts us with respect to the human code is the question of how exactly it is structured,[124] then Newton's concept of the analogy of nature always consonant with itself suggests a way in which it can be done. In that it enables us to extrapolate to the idea of the analogy of culture always consonant with itself so that by inverting the terms of Newton's argument that given that the laws of nature function in the same way for all parts of the universe in the same way, we can therefore be able to infer from our knowledge of the 'bodies' nearest to us what the processes of functioning of the bodies furthest from us must *necessarily be*,[125] we could postulate the following: that it is precisely those 'cultural bodies' whose institutions are far older than ours and therefore the furthest in time, as are the traditional cultures of Africa, that can provide us with two central insights, one general, one specific. The first insight is with respect to the question as to *how* the code is structured; the second is with respect to the rules which govern the functioning of the code in our contemporary case, as well as to the nature of the terms of this code – to the terms of its *ontological rationale*, and, therefore, of the 'basic principles of understanding' that such a rationale generates.

To develop both of these I make use of a further insight provided by a traditional African culture, that of the Sara of Chad, as discussed by the ethnologist Lucien Scubla in the context of his hypothesis with respect to the central role of the imagery of *spilt blood,* as the analogue of that *of menstrual blood* in the ritual ceremony of initiation or of symbolic birth, of traditional Africa. For the Sara, Scubla points out, the meaning of the ritual of initiation is based on a binary opposition between two kinds of 'birth', i.e. 'natural' birth of which the women are the bearers, and 'cultural' birth of which only the men can be the 'procreators'. Because, for them, it is only through the second birth that full humanhood can be attained, the function of the ritual is to transform beings who are 'animals with a human vocation' into humans. So that where, for the cultural belief system of the Judaeo-Christian West in its now purely secularised form, degrees of 'true' humanhood are equated with one's ostensible degrees of bio-evolutionary selectedness, with the scale of humanness therefore being based on the binary code of *eugenicity/dysgenicity,* for the Sara, true humanhood is attained to through the processes of cultural socialisation. One of the high points of this process, the ritual of initiation, is therefore represented as analogous to the transformative process of cooking. Where in the latter process, the men who are hunters give the

'raw meat' that they have killed to the women who then render it edible for human consumption, in the transformative process of initiation or of symbolic birth as it pertains to males, the women hand over the 'raw' male adolescents to the men so that they can be ritually killed and 'engorged' by the ancestors in order to be mimetically reborn, through a series of ritual ordeals, as *members of the clan*.[126] Central to this transformative process, therefore, is a value-principle which is drawn by the Sara between the positively marked blood spilt by the male either as hunter (the blood of the hunt) or as sacrificer (the blood of sacrifice), and its founding, yet binary analogue, the menstrual blood of the female. This is therefore a value-principle that is central, in my own terms, to the enacting of Grassi's governing code. Both of the former, i.e. the blood spilt by the hunter and the spilt blood of sacrifice in the religious rites presided over by the men, are therefore positively marked as signs of *symbolic life-giving* activity. They are thereby valorised as 'cooked' or 'true' life as contrasted with the 'raw' or 'uncooked' life given birth to by the women. And although Scubla does not discuss this aspect, the ceremony of female initiation presided over by older women should function according to the same principle of value-transformation.

My proposal here is that the institution of initiation or of *symbolic birth* should be seen in the terms of the Sara's conception, as one of the matrix social inventions founding to all human 'forms of life', to, therefore, their poesis of being, and correlated modes of symbolically coded, rather than genetically programmed, eusociality;[127] the invention, therefore of their conspecific identity as, in the case of the Sara, 'members of the clan' rather than as members of a biological species or sub-species. In this context, the institution of initiation based on the semantic charter[128] or morphogenetic fantasy[129] of the binary code of symbolic life/biological life, and the value-principle enacted by its positive/negative series of representations, can therefore be recognised as a central hominising mechanism by means of which what Antonio de Nicholas defines as the transmutation of *genetic* into *symbolic* identity, of theory (the conception of being human) into *flesh*, is effected.[130] By means of which, therefore, the now initiated young male adolescent is enabled to phenomenologically experience himself as the symbolic conspecific of those initiated and socialised with him in the terms of the same code; with this new experiencing of the self thereby inducing him to display altruistic co-identifying behaviours towards his age-group peers, within the terms of a mode of eusociality, that is, that of the *clan*, as a mode of eusociality which, like that of our contemporary nation-state mode of conspecificity, is culture-systemically, rather than genetically, ordered.[131]

In other words, the order of the social, as Scubla further points out, is itself 'born' from the *spilt blood* of the religious sacrificial rites presided over by the men. Since it is this rite which marks the passage from the order of purely biological life, negatively marked as the sign of 'sterile' disorder in the Origin myths of traditional societies (as in the case of a Dinka Origin myth as well as of an Amerindian myth of the origin of tobacco that Scubla gives as examples), to the order of human societies that is founding to our uniquely symbolic 'forms of life'. While, as he further shows, an indispensable condition of this 'founding' is that the negative/positive binary opposition pointed to by the Sara of Chad between, on the one hand, the biological or 'natural' life given by the women (whose signifier is that of the image of *menstrual blood*) and, on the other, the 'cultural life' or symbolic birth given to by the men (whose analogical macro-signifiers are the blood spilt by the hunter and, even more centrally, by the spilt blood of the religious rite of sacrifice), must be lawlikely kept in place and maintained at all levels of the specific social order and 'form of life'; as is also the case, therefore, with respect to the systemic nature of the *negatively marked representation of black Africa and of the peoples of black African descent, by the scholarly, cinematic, and social texts of the contemporary West.*

This symbolic coding imperative is clear in the two examples that are given by Scubla, that of the Dinka origin narrative and that of the tobacco origin myth of the Tereno Arawaks, but perhaps at its most transparent in the latter. In the latter's plotline, as Scubla shows, a woman who is a sorceress, attempts to poison her husband with her *menstrual blood* (the symbol of biological life/ birth). Warned by his son, the husband goes in search of honey, mixes it with the embryos of a pregnant snake which he has killed, and gives it to the woman to eat. Eating it, she is transformed into a man-eating ogress. While chasing her husband to devour him, she falls into a pit and dies. Where she dies and spills her blood, a hitherto unknown plant, the tobacco plant, sprouts up from the ground. Her husband collects the leaves, cures them, then ritually smokes them in the company of his male peers (who are collectively, in the terms of the myth, the procreators of 'true' symbolic life as against the 'mere' biological life given birth to by the women). As they ritually smoke, the smoke ascends as incense to the gods. The constant here is that the plotline of the narrative can be seen to pivot on the same system of *negatively/positively* marked representations, whose binary evil/ good oppositions will be performatively enacted as the passage of disorder to order in the ceremony of *symbolic birth* that is founding to traditional societies. 'The woman', Scubla writes,

> is accused of poisoning her husband with her menstrual blood. The myth then leads from menstrual blood *which flows downwards* – a natural privilege of women but a privilege marked negatively, to the tobacco smoke *which rises upward* as the cultural privilege of the men which is marked positively; that is to say from the *signifier of procreation to the signifier of religion.*[132]

The transformative passage in both narrative and ritual ceremony is therefore one *from* the signifier of the procreation of biological life (in whose terms behaviours of bonding altruism are restricted to their *genetic* limits), *to* the signifier of the cultural 'procreation' of symbolic life (in which degrees of bonding altruism will be induced and motivated by the new 'directive signs' of the narratively inscribed code). Here the representation system of the myth, together with the *cooked/ raw, tobacco smoke/menstrual blood* code of symbolic life and death that it enacts, functions, as the parallel drawn by the Sara reveals, according to the same negative/positive opposition on whose basis the ceremony of *symbolic birth* presided over by the male 'procreators' is effected. Since it is by means of both that the subjects of the order are induced to experience their biological being in symbolically coded terms, and to thereby transfer allegiance and kinship loyalty *from* their genetic *to* their culturally instituted conspecifics: from the siblings of the 'womb' to those of the clan. In our own case, to those of the class, of the nation-state, of the ethno-religious group, the 'race'.

From here the imperative nature of the way in which the *representation* of biological identity must be *negatively marked* at all levels, since it is this negative marking that induces the aversive behavioural response on the part of the subjects of each order, to the otherwise overriding imperative of their genetic identity.[133] This, at the same time as the positively marked representation of their 'artificial' identity serves to induce desire for, and allegiance to, the culture-specific criterion of being which it encodes. For the Sara of Chad, therefore, the category of the life to which the women give rise had to be as negatively marked (i.e. as 'brute' or 'raw' life) as was the sign of *menstrual blood* of which the woman is the bearer in the Tereno myth, given that both must now function as signifiers of *symbolic death;* of 'sterility' to the 'fecundity' of symbolic life.

Looked at transculturally, the image of *menstrual blood* can be identified as the image enacting of the Origin model of *Procreation* that is specific to societies of the agrarian era whose polytheistic religions had divinised Nature and the natural forces. Its macro-image of Origin was,[134] however, to be increasingly displaced by the rise of the monotheistic religions whose new Origin model of *Creation* would, by its degodding or de-divinising of nature, replace the *menstrual blood* Origin

signifier with those of the macrotextual signifiers – as in the case of *Original Sin* – of their respective faiths. As Scubla's analysis of the Tereno myth therefore makes clear, the binary value opposition between order/full being, and the lack of full being (i.e. the positively marked *tobacco smoke* rising upwards) and disorder (i.e. the negatively marked *menstrual blood* flowing downwards), enacts the ontological rationale of a code in which the category of *women* are the bearer/signifiers of 'raw' biological life, and that of *men*, the procreators/creators of 'cooked' symbolic life, or culture. This, however, should not be seen as an effect of what we have come to define as 'patriarchy', and thereby interpreted in terms of the feminist paradigm as an empirical opposition between 'men' and 'women'. Rather, what is at issue here is an opposition that makes use of the *physiological* difference between the two sexes in order to inscript and enact Grassi's governing code in agrarian polytheistic terms.[135] This in the same way as, I shall propose here, in our contemporary industrial order, and thereby in the terms of the now purely secularised variant of the Judaeo-Christian culture of the West, the *physiognomically* different categories of two population groups, that of, on the one hand, the Indo-Europeans, and of, on the other, the Bantu-Africans, are deployed as the central means of the enacting of the governing code instituting of our present conception of the human, *Man*. With Africa thereby having to be represented in the terms of this code, by both the cinematic and scholarly texts of the West, as the abode and origin of the *Human Other*. This, at the same time as all peoples of African descent must be negatively represented, within the logic of our present conception of being, *Man*, as 'brute' or 'uncooked' life, as contrasted with the 'cooked' or symbolic life signified by the West, and embodied in all peoples of Indo-European descent, who must therefore be canonised as such by means of a positively marked system of representation.

Whether within the terms of the pre-Industrial Origin narratives of Africa, as well as in that of the Amerindian myth of the origin of tobacco, or in that of the Origin model of Evolution or 'Official Creation Story'[136] of the contemporary techno-industrial culture of the West, the negatively marked categories – that of the *Woman* of the first two, and that of the peoples of African descent of the third – are imperative to the process by means of which the governing code of symbolic life, and its verbally inscripted 'directive signs', can be made to override the directive signs of the biological aspect of human 'forms of life' and modes of being. That is, as an aspect which, although the indispensable condition of our experiencing ourselves in culture-specific terms of this or that mode of the human, must itself be systemically devalued, by being negatively *marked*. Given that if, as the linguist Lieberman points out, the human is defined by two levels of conspecific altruism – that of the organic level determined by our degrees of genetic kinship, and that of a 'more generalised level'[137] determined by our culturally instituted modes of symbolic identity, it is only by the latter's overriding of the 'directive signs' of the former that our experience of being human both as symbolic I and as a *we* based on symbolic, and therefore artificial, modes of kinship, can be enabled.

An example: soldiers who fight today's national wars and who must be prepared to die in defence of the flag might very well be tempted, as individuals, by the genetic imperative to save themselves. Yet given the enculturation process of school and home, and the social order in general, the genetic imperative is so automatically overridden that it can scarcely be heard. When, in addition, Bosnian Serbs fight and kill Bosnian Muslims or vice versa, or when Tutsis kill Hutus or vice versa,[138] therefore, they do so as subjects enculturated in the terms of their specific group identities. It does not matter that, as in the case of the Tutsis and Hutus, they all speak the *same language;* – the positivism of linguistic identity is not the issue here. Rather, the issue is that of narrative representations, of the symbolic identities to which they give rise, and of the systems of domination and counter-domination to which their respective group narcissism impels them.[139] Given that such

identities and modes of *symbolic kinship/non-kinship* are experienced by their socialised subjects in no less cognitively and affectively closed, and therefore narcissistic, a manner, than are the purely *genetically determined* modes of conspecificity of organic species.

The fundamental hypothesis of our proposed new conceptual ground and world outlook, therefore, is that if the ritual ceremony of symbolic birth as conceptualised by the Sara of Chad enables us to grasp the mechanisms by which Grassi's governing code was and is structured and inscripted as the condition of the First Emergence (and thereby of the instituting of human 'forms of life' as a hybridly *bios/logos, nature/culture* level of existence), it also enables us to understand the nature of the price that had to be paid for the rupture effected by such 'forms of life' with the *genetically* determined 'directive signs' that motivate and necessitate the behaviours of purely organic life. This price, one that explains, inter alia, the lawlike nature of the 'gallery of mirrors'/ representation of Africa and of all peoples of African descent in the scholarly and cinematic texts of the West, is that of our having to remain hitherto subordinated to the 'directive signs' generated from the narratively inscribed codes of symbolic life and death, signs which now function to motivate and necessitate our *human* behaviours in the terms of culture-specific fields defined by the self-referentiality of the code; and, thereby, by the cognitive and affective closure to which this self-referentiality leads.

How, nevertheless, is this motivation of behaviours by the negative/positive representations and/or 'directive signs' of Grassi's code concretely effected? The answer lies in the recent discovery by biologists and neuroscientists of what they identify as the opiate biochemical reward-and-punishment system of the brain; and of the ways in which this system functions as the centrally directive mechanism which serves to both motivate and necessitate the behaviours of all organic species. As Avram Goldstein explains in a recent book, for all forms of organic life, a species-specific opioid system functions to *signal reward* on the one hand, and *punishment* on the other. In all cases, the *feel-good* reward signal is effected by the euphoria-inducing chemical event which, as Goldstein argues, is an event that is probably defined by the activating of *beta-endorphins*, while the *feel-bad* punishment signal is induced by the activating of *dynorphins*. 'We can therefore speculate', he continues,

> that the reward systems function to drive adaptive behaviors the following way: They signal 'good' when food is found and eaten by a hungry animal, when water is found and drunk by a thirsty animal, when sexual activity is promised and consummated, when a threatening situation is averted. They signal 'bad' when harmful behavior is engaged in or when pain is experienced. These signals become associated with the situations in which they are generated, and they are remembered.[140]

Here we approach the central role played by negatively/positively marked representations, as in the case of the *menstrual blood/tobacco smoke* representations of the Chadian narrative, or as in that of the Africa/Europe binarily opposed iconography of Western cinematic texts, in the artificial motivation systems that drive human behaviours. For if the reward system is central to the genetic motivation system (or GMS), by which the animal 'learns to seek what is beneficial and to avoid what is harmful', and, therefore, by means of which, the behaviours *appropriate* to each species are lawlikely induced – 'This delicately regulated system', Goldstein continues, 'was perfected by evolution over millions of years to serve the survival of all species, and to let us humans experience pleasure and satisfaction *from the biologically appropriate behaviors and situations of daily life*'[141] – nevertheless, as the biologist Danielli proposes, in contradiction to Goldstein in this respect, there is a fundamental difference in the case of the humans. For not only are the behaviours to

be induced here intended to be *culturally* rather than *biologically appropriate* behaviours, but in the case of the humans, Danielli suggests, where the *altruistic* behaviours essential to social cohesion must be verbally semantically induced, it is discursive processes (i.e. Origin narratives, ideology or belief systems) and their respective systems of negatively/positively marked representations which serve to activate, in *culturally relative and receded terms,* the functioning of the human biochemical reward and punishment mechanism, thereby motivating our always culture-specific ensemble of behaviours.[142] With the consequence that the kind of 'generalised altruism' needed as the integrating mechanism of each social order must be as consistently 'rewarded' through the mediation of positively marked representations as must be the *criterion* of *symbolic life,* whose no less positive marking functions to induce in the order's subjects the desire to realise being in the terms which also makes possible the display of kin-recognising behaviours towards those socialised into subjectivity in the same terms as themselves; those with whom each *I* constitutes a symbolic *We.*

Each such criterion of the normal subject can itself be realised and experienced as a value-criterion, however, only through the mediating presence of the negatively marked category which is made to embody the signifier of *symbolic death,* in terms that are the antithesis of those of normal being; as the category, therefore of deviant *Otherness* or of Difference from which the bonding principle of *Sameness* or 'fake' similarity is generated. If, therefore, every human mode of being and its 'form of life' is instituted about a governing code or representation of symbolic life (the TSRU) and death (the MBFD), which then functions to regulate in verbally recoded terms the functioning of the opiate reward and punishment systems of the brain, thereby enabling our human behaviours to be governed by the learned or *acquired motivation system (AMS)* specific to each 'local culture', then the behaviours so induced are everywhere behaviours *appropriate to the specific code* instituted by each cultural system and its founding Origin narrative. In consequence, where for all purely organic species, it is the *biochemical event* of reward and punishment which directly motivates and is causal of each species' ensemble behaviours, the fundamental distinction for human forms of life is that it is the *culture-representational event* which motivates and is causal of (by means of the functioning of the opiate reward/punishment system which it verbally recodes) *our uniquely human* behaviours.[143]

The issue of the systemically negative representation of Africa in both the Western cinematic text as well as in the scholarly text can therefore be recognised as a function of the enacting of the governing code of symbolic life and death, which is instituting of our present criterion/conception of being *Man,* and thereby of the basic principles of understanding of our contemporary global culture – that of the West in its bourgeois and biocentric conception. While, since in the case of all human forms of life, it is the representational event (as in the case of those given rise to by the Western cinematic text) which gives rise to the biochemical event (whether to that of the beta-endorphin event activated by the *positively marked* representation of *Man* as iconised in the signifier of the Indo-European physiognomy, or that of the dynorphin event activated by the *negatively marked* representation of Man's Human Other,[144] as iconised by the Bantu-type physiognomy of peoples of African descent),[145] then the calling into question and countering, by the African cinematic text, from Sembène onwards, of these dynorphin-activating representations of Africa and of the peoples of African descent *is a calling into question of the governing symbolic code enacting of Man;* and therefore of our present ethno-class conception of the human, *Man,* itself. Yet, however, a calling into question that has necessarily remained tentative and provisional, since having to be carried out within the terms of our present 'epistemological locus'; and thereby, outside as yet a conceptual

ground in whose reference frame or world outlook human 'forms of life', together with their respective governing codes of symbolic life and thereby of symbolic kinship and eusociality, will be able to exist as 'objects of knowledge', and to be thereby fully theorisable.[146] This in very much the same way as biological life itself would only come to exist as an 'object of knowledge' and be thereby theorisable, as Foucault points out, only within the then new conceptual ground elaborated by the 'fundamental rearrangements of knowledge' that took place at the end of the eighteenth century and during the nineteenth; as a rearrangement which provided the new episteme or order of knowledge needed to inscribe our present 'figure of Man', together with the ethno-class conception of the human as an evolutionarily selected and purely biologised being which, ostensibly, pre-exists the culture and governing code that can alone inscript and enact it as such a mode of being human.

We can therefore put forward the following hypotheses: that ruling groups in all human cultures, including our own, are ruling groups to the extent that they embody their respective cultures' optimal criterion of being, or code of symbolic life; that therefore the great transformations in history are always transformations of the code, of what it means to *be* human, and, therefore, of the poesis of being and mode of symbolic conspecificity, of which the code is the organising principle; a transformation, therefore, of the always symbolically coded modes of consciousness integrating of our human orders and their forms of life. In this context if, as Jacob Pandian notes, with the West's *reinvention*, beginning in the sixteenth century, of its matrix religious identity, *Christian*, in two variant forms of *Man* (the first hybridly religio-secular, the other purely secular), it was to be the population group of African descent who were to be made into the physical referent of the *Human Other* to its second and purely secular because biocentric form, then the systemic negatively marked representations of this population group and of its continent of origin, Africa, can now be recognised as ones that are a lawlike function of the enacting of our present conception of being human, of its governing code and ontological rationale. That, therefore, the 'gallery of mirrors' representations of Africa and of African-descended peoples as signifiers of *Genetic Dysselection/ Defectivity*, and thereby of symbolic death in the cinematic and scholarly texts of the West, are, as lawlikely a function of our enacting of our present evolutionarily selected conception of being human, *Man*, as the negatively marked representation of the *Woman* (as the bearer of the macro-signifier of *menstrual blood* or of symbolic death), was a function of the enacting of one variant of the 'lineage' conception of being human of traditional polytheistic Africa.

Further, on the basis of the related hypothesis that there are laws of culture which function for our contemporary order as they have functioned for all human 'forms of life' hitherto, we can now postulate that the systematically negative misrepresentations of Africa made by the Western cinematic text is the lawlike effect of the fact that, within the terms of our present governing code of *Man*, Africa and all peoples of African descent, wholly or partly, have been made to take the signifying place of the *Woman*, and thereby made to *actualise* the code of symbolic death – of the 'menstrual blood always flowing downwards', the MBFD, if in the new and secular terms of *Genetic Dysselection/Defectivity*.[147] Here too, Scubla's point adapted from René Girard, that traditional orders see themselves as being born from ritual sacrifice[148] – with the blood of sacrifice being a re-enactment of the image of the *menstrual blood* – enables us not only to note that it is from the 'sacrifice' of the woman's death from which the tobacco plant grows, but also to recognise the imperative nature of the keeping in place, by all cultures and their modes of being human, of a value hierarchy between the representation of symbolic life (TSRU), on the one hand, and of death (MBFD), on the other; this as the condition of the subject being motivated to desire to realise him/ herself in the terms of his/her *symbolic* rather than *biological* identity.[149]

Here, Pandian's observation with respect to the way in which our present identity, that of *Man*, is a transumed variant of *Christian*,[150] enables us to identify an analogical parallel. This is that the systemic misrepresentation of Africa and of peoples of African descent, by both the Western cinematic text and the 'gallery of mirrors' of contemporary scholarship, is as lawlikely effected as, in the scholarship and religio-aesthetic system of Latin Christian Europe, the category of the *laity*, and therefore of the lay intelligentsia, had been negatively marked as the embodiment of symbolic death, i.e. of mankind's postulated enslavement to *Original Sin*, as contrasted with the positively represented category of the clergy as the embodiment of the *Redeemed Spirit*. In that, while in the terms of the Christian Origin Story, and its correlated Grand Narrative of Emancipation, the clergy had freed themselves by means of their voluntary celibacy from their negative legacy of Original Sin (as a legacy represented as having been transmitted in the wake of Adam's Fall, through the processes of genital procreation), the category of the laity had not. The intelligentsia of the latter were, therefore, because of the nature of their *fallen flesh*, represented as incapable of attaining to any certain knowledge of reality except through the mediation of the theological paradigms of which the clergy were the guardians. In consequence, given that these paradigms were themselves tautologically based upon the founding premise which legitimated the ontological and therefore the knowledge-hegemony of the clergy–i.e. the premise of mankind's enslavement to Original Sin from whose negative consequences only the voluntarily celibate clergy had been freed – the cognitive closure to which they gave rise was a closure that was to be brought to an end only by the intellectual revolution of humanism. By, that is, the reciprocally ontological and epistemological revolution effected by the lay intelligentsia of Renaissance Europe against the then hegemonic medieval-Christian and theocentric conception of being, and thereby against their own negatively marked representation as bearers of the fallen flesh (MBFD) enslaved to Original Sin. As a conception of being that they were to deconstruct, only by means of their revalorised reconception of lay status, and their narrativisation and invention (beginning with Pico della Mirandola's *Oration on the Dignity of Man*) of 'Man' and its Origin.[151]

If we note that at the end of the eighteenth and during the nineteenth century the Origin of *Man* was again renarrativised, this time in the cosmogonic terms of evolution, as that of a bio-evolutionarily selected being on the model of a natural organism in the reoccupied place of Christianity's divinely created being in the image of God, a central recognition can be made with respect to the 'epistemological locus' which came into existence *pari passu* with this renarrativised Origin and its biocentric conception of being; as the locus that we have inherited. This recognition, one hinted at by Foucault at the end of his *The Order of Things*, is that our present disciplinary discourses and their respective systems of positively/negatively marked representations are the very practices by means of which our contemporary Western bourgeois criterion of being human, together with its nation-state mode of symbolic conspecificity, as well as the global order or world system which is the indispensable condition of their reciprocal existence, are produced and reproduced. Here the biologist Danielli's proposal that Marx's statement that religion (and therefore religious discourse) is 'the opium of the people' is a statement that needs to be taken *literally*, and indeed, is one that can be extended to the secular belief system or ideology,[152] specific to our contemporary order, leads to the following conclusions. First, that the struggles waged with respect to the issue of representation (whether by Diawara's 'resisting spectators' of black America or by filmmakers of Africa who from Sembène onwards set out to counter and challenge the West's representations of Africa, in the immediate wake of political independence) can be recognised as struggles over the modes of consciousness to which our contemporary secular belief system or

ideology gives rise. Second, that the role of all such orders or modes of consciousness generated from belief systems, religious or secular, is to *integrate human orders*, at the same time as they also serve to legitimate the social hierarchies, role allocations and the distributional ratios of the goods and the bads ('the way the cards are dealt'), the structuring of each such order, as well as the imperative of social cohesion. 'When Marx', Danielli wrote,

> said that 'religion is the opiate of the people,' he spoke with greater accuracy than he realised. The ...decline of religion...[has]...tended to transform society so that we could now say that 'Ideology is the opium of the people.' What none of us has realised until the last few years is that...unless society provides mechanisms for the release of endogenous opiates, i.e., for activating the IRS (the internal biochemical reward and punishment system internal to the brain)...*social cohesion* is lost and collapse...may be imminent.[153]

Danielli's seminal point here is that because all human societies as well as their structuring hierarchies are primarily held together by the discursive practices of culture-specific theologies/ideologies able to induce cohesion in the terms needed by each order for its stable reproduction (in effect by the discursive practices which institute each order's field of consciousness), it is only by means of such practices, ones able to make the inequalities of each order seem just and legitimate, and as the way things are and *have to be* to their subjects, that the social cohesion of each such order can be maintained. Seeing that, without such discourses, together with their positively/negatively marked, and thereby symbolically coded system of representations (whether that of the Origin narrative of Chad or that of our own Origin narrative of evolution as enacted in the Europe/African binary representations of the Western cinematic and scholarly texts,)[154] human forms of life as the culturally instituted, and sociosymbolic systems that they are, *cannot* be brought into existence and stably replicated. In effect, our modes of being human cannot pre-exist the Word, and thereby, the meanings/representations which the Word generates, given that it is by the latter's activation of the reward and punishment system of the brain in the terms of each culture's governing code of symbolic life and death, that we alone can experience ourselves *as* human. In effect, that we can come to exist in our respective phenomenological universes which function as parallel languaging universes to those of the purely biological, doing so in the terms of each such universe's culturally instituted mode of memory, of consciousness, of mind.

It is, therefore, only in relation to these phenomenological universes of our human 'forms of life' (as universes that cannot paradoxically exist as 'objects of knowledge' within the terms of our present episteme, its purely biologised conception of being, and the specific universe to which this biocentric conception gives rise) that we can be enabled to grasp the dimensions of the inventiveness of institutions such as that of initiation/symbolic birth, as well as of the foundational narratives and their complex religious belief systems; the inventiveness, therefore, of their respective Words, whether in the case of the millennially existent polytheistic religions such as that of the Dogon peoples, where the Word (*Nommo*) is conceived of as 'the beginning of all things',[155] or in the far later monotheistic religions, from Judaism's Single Text, to Judaeo-Christianity's Catholic ritual of transubstantiation effected by the priest's utterance of words, to the sculpted word of the Islamic Koran. That in addition, we can be also enabled to grasp the no lesser degree of inventiveness that was at work in the West's forging of the secular belief systems or ideologies, beginning with that of the discourse of civic humanism elaborated by the lay revolution of the Renaissance civic humanism, and re-enacted as that of a new form of biological and/or economic humanism, in the nineteenth century; both as the ideologies by means of which the West, as a function of its epochal 'killing' of God, was to replace and/or marginalise all earlier Words, together with their religious

conceptions of being human, with its single increasingly homogenising and secular or degodded conception, that of *Man*. As a conception, however, in the logic of whose Word, or governing code, its positive/negative system of representations, and thereby of the memory, and order of consciousness which they inscript and institute, the continued subordination and impoverishment of Africa and its peoples, as well as of the peoples of its diaspora, is always already prescribed – the cards as dealt within the terms of its 'official creation story', of evolution, as they would have been dealt for the category who embodied the negatively marked category of biological or 'raw' life (the MBFD),[156] within the terms of the traditional 'official creation story' (on the model of *Procreation* rather than of evolution) of Chad – of its Word, its mode of memory, of consciousness, of being human.

Conclusion

Mudimbe's thesis as to the way in which the West, since the fifteenth century, has submitted the rest of the world to its memory, when linked to the hypothesis of the existence of laws of culture, and thereby of the analogy of culture always consonant with itself, reveals that the phenomenon that Marx and indeed Danielli identify as *ideology*,[157] is a phenomenon of the same order as the phenomenon described by Evans-Pritchard in the case of the Azande, a traditional people of Africa's Sudan, when he encountered them during the first decades of the twentieth century. What Evans-Pritchard says of the Azande, and of the cognitively closed nature of their culture-systemic memory and order of consciousness, can therefore be seen to apply, if in different terms, to the culture-specific memory and order of consciousness of *Man*, and to the nature of the symbolically coded systems of representations by which this memory/consciousness is inscribed. 'I have attempted', he wrote,

> to show how all their beliefs hang together, and were the Azande to give up faith in witchdoctorhood, he would have to surrender equally his faith in witchcraft and the oracles. In this web of belief, every strand depends upon every other strand. An Azande cannot get out of the meshes because it is the only world he knows. This web is not an external structure in which he is enclosed: it is the very texture of his thought, and he cannot think that his thought is wrong.[158]

This leads us therefore to the conclusion that there is, today, no misery being experienced by contemporary black Africa and its peoples, nor by the peoples of its diaspora, nor by the peoples who belong to the global and transnational category of the jobless and semi-jobless inner-city ghettos and shanty-town archipelagos, together with their prison-extensions, that is *not* due (as is also the ongoing pollution and degradation of the planetary environment)[159] to the following causal factor: that the way we collectively behave on our present reality, doing so in the terms of a world outlook based on our belief in the purely biological nature of the human, constitutes the very texture of our own thought, and that, like the Azande, we too cannot, normally, think our thought wrong. More precisely, think that our thought is true *only* within the terms of the local but now globalised and purely secular variant culture of the Western bourgeoisie, in the cognitive closure of whose symbolically coded system of representations and order of consciousness we are as enclosed, as the condition of the enacting of our present poesis of being, *Man*, as were the Azande, as the condition of the enacting of theirs; as would have been, and still residually are, the subjects of the traditional order of Chad, as the condition too, of the enacting of their own.

On the basis of the analogy of culture always consonant with itself, we can therefore put forward the following hypothesis: that if the governing code of symbolic life and death is a transcultural constant, then all our behaviours, including that of our contemporary order (and specifically those

of the systemic and negatively marked representing of black Africa, its human hereditary variation, and indigenous cultural systems, by the Western cinematic and scholarly texts), must be as relative to it as, at the physical level of reality, time and distance are relative to the constant of the speed of light. Further, that because as observers of our social realities we are always already socialised as subjects in the terms of the governing code which prescribes the collective behaviours instituting of the reality that we observe, then the predicament in which we, like the Azande, find ourselves (i.e. that we cannot normally think that our thought is wrong, and must necessarily remain, normally, 'trapped in the circularity of a self-referential paradox')[160] is a culturally lawlike predicament.[161]

This Azande-type predicament was the unstated question that shadowed a 1992 symposium which dealt with the issue of the relation between mind and brain, consciousness and neurobiology. Against the view of mainstream neuroscientists that the *mind is the brain,* Jonathan Miller proposed that *mind* or consciousness, while implemented by the neurobiological processes of the *brain,* is *not* itself a property of these processes; that we cannot therefore use the same methods by which we have become acquainted with the brain (i.e. the neurosciences), to become acquainted with consciousness, with the mind. And therefore, with the 'vernacular languages of belief and desire' through which alone we can, as human, *know* what it's *like to be us* (an I, a we);[162] in effect, through which alone we can phenomenologically *be* in the terms of each order's mode of symbolic birth. If, therefore, we define consciousness as a property of the correlation between the governing code of symbolic life and death (as inscribed by the Origin narratives founding to each human 'form of life') and, therefore, between its positive/negative marked system of representations and the opiate or biochemical reward-and-punishment system of the brain, with the former, the code, *always* determinant of the states of the latter, then finding a method by which to get acquainted with consciousness would call for the event of a Second Emergence. That is, for a rupture with the cognitive closure and circular self-referentiality of our symbolically coded orders of consciousness whose culture-specific 'directive signs' now function to induce our, thereby still heteronomously ordered, behaviours. Seeing that it is only by means of such a new rupture that we can, as a species, be empowered to govern the governing codes of symbolic life and death which have hitherto governed and still govern us, thereby necessitating our behaviours in pre-determined and code-specific ways. This, in the same way, therefore, as with the singularity of the First Emergence, we had, as a condition of our realisation as a new form of life, effected that initial rupture with the directive signs of the genetic codes that necessitate the behaviours of purely organic life; with this initial rupture then determining that as humans we were to experience ourselves in *symbolically coded* terms – even where, as in our own case, we verbally define ourselves on the model of a natural organism, and are thereby induced to experience ourselves as the purely biological beings that we inscript,[163] define ourselves to be.

The ethnologist Asmarom Legesse proposed in 1973 that it is only the liminal categories of human orders (i.e. categories made to embody the signifier of deviant alterity and, thereby, of *symbolic death* to the criterion of being, of each culture's 'normal' mode of being), who, in attempting to free themselves from their systemic role of ontological negation, can free us all from the prescriptive categories of the circularly self-referential modes of memory or orders of consciousness, whose function is to integrate human orders,[164] on the basis of the represented *symbolically*, rather than *genetically,* determined conspecificity of their subjects. If, in consequence, the West's intellectual revolution of humanism as spearheaded by the then liminal category of the laity, with its revalorising conception of the human in the secular terms of *Man,* over against its theologically defined hopelessly fallen status, to make possible, on the basis of its new and correlated premise

of autonomously functioning laws of nature, the rise of the natural sciences and, thereby, human knowledge of its physical and organic levels of reality *in their objective existence,* this new mode of cognition was, however, to remain an incomplete and half-fulfilled one. This given that, as Aimé Césaire pointed out, it remains unable to make our human worlds, as worlds instituted by the Word, by Origin narratives and representations, intelligible,[165] and therefore to provide knowledge of our phenomenological universes as a third level of reality, *outside* the symbolically coded terms of their order-enacting cognitive closure and circular self-referentiality.

This, I propose, is where our liminal status, as filmmakers and intellectuals, provides us with a cognitive advantage, which parallels, in new terms, that of the lay intelligentsia of Renaissance Europe. In that any sustained attempt to free ourselves from the negatively marked representations imposed upon us, as the embodied signifiers of Man's most extreme Human Others, by the 'gallery of mirrors' of the Western cinematic and scholarly texts, will necessarily impel us towards the realisation of Aimé Césaire's proposed new science of the Word, as one that, he argued in 1946, was imperatively needed to complete the natural sciences. If, that is, we are to gain knowledge of our human worlds, specifically of the contemporary global order of reality in which we all now find ourselves, *as it is;*[166] rather than in the behaviour-motivating terms in which it must be known by its subjects, as the indispensable condition of its own stable reproduction as such an order of reality. Knowledge, therefore, of the governing codes of symbolic life and death and their basic principles of understanding which lawlikely prescribe the ensemble of behaviours, cognitive, imaginative and actional, by means of which all human orders, including our own, are brought into existence as living systems; codes which therefore determine, through the cards they deal, the overall effects, both good and ill, to which each such ensemble of behaviours will lead.

The concluding thesis here, therefore, is that it is only such a projected new science (one that Heinz Pagels was also to call for in 1988 in his book *The Dream of Reason: The Computer and the Sciences of Complexity,*[167] when he suggested that we should now set out to breach the barriers between the natural sciences and the humanities in order to put our 'narratively constructed world and their orders of feeling and beliefs under scientific description in a new way')[168] that can provide us with a method by which to get acquainted with the functioning of our symbolically coded orders of consciousness, of mind, as the neuroscientists have found a natural-scientific method by which to become acquainted with the processes of functioning of the brain. That can thereby make accessible to us the basic 'principles of understanding' of the contemporary culture in which we find ourselves, as principles that determine our own 'gallery of mirrors' representation in the circularly self-referentiality of the Western cinematic and scholarly texts: our representation, within the terms of our present culture's conception of the human, as the Human Other to *Man* and the actualisation of this negated role of alterity at the level of empirical reality, as well as at the level of our always already socialised consciousness.[169]

Meaning, the physicist David Bohm pointed out, is *being.*[170] Because *meaning,* which is able to regulate *matter* (including, centrally, the biochemical opiate reward-and-punishment system of the brain), is that which defines us as *humans,* any fundamental change in our affairs calls for a profound change in meaning and thereby in the order of consciousness which it structures;[171] cinematically speaking, a profound change in representations, iconographies. One that can move us towards the transformation of our present *purely* biologised understanding of what it means to be human, and towards the redefining of the human as the uniquely cultural and thereby *bios/ logos* mode of being that it is. With such a redefining being made possible only by the proposed reconception of Africa's history as a history inseparable from the Event of the First Emergence,

and thereby from the origin of being/behaving *human*, not in evolution, which gave rise only to the biological condition of our being able to *experience* ourselves as this or that mode of the human through the mediation of our self-instituting inscription;[172] this latter as witnessed to both by the initiation iconography of the San rock paintings, as well as by the 'creative explosion' of some 30,000 years ago that took place convergently throughout the world.[173] While it is this challenge to our present culture's biocentric Origin narrative of Evolution and the reimagining of human origin in the terms of its autopoesis or of its self-instituting as this is effected in the inscripted modes of being human to which each culture gives rise, that, I suggest, alone can provide a 'loftier' because transculturally applicable 'world outlook', able to serve as the basis for a fully realised black African cinema in the new millennium; and, thereby, as the new conceptual ground called for by the organisers of this conference.[174]

If the novelistic text and its medium, print, was the quintessential genre/medium by which Western *Man* and its then epochally new, because secularising, Renaissance 'understanding of man's humanity' was to be inscribed and enacted,[175] the cinematic text, conceptualised in terms outside those of our present biocentric understanding, will be the quintessential genre of our now de-biologised conception of the human; the medium, I propose, of a new form of 'writing' which reconnects with the 'writing' of the rock paintings of Apollo Namibia, some 30,000 years ago, and beyond that, with the origin of the human in that first governing code of symbolic 'life' and 'death', about which, in the wake of the species' rupture with purely organic life, all other human forms of life were to enact their/our poeses of being, together with the self-organising social systems to which each such poesis gives rise. In the place of print, therefore, the cinematic text, and its audiovisual spin-off, the texts of TV/video, as *the* medium of the new iconography of *homo culturans* as a self-instituting mode of being, in the reoccupied ground of *homo oeconomicus*, and therefore, of the human represented and culturally instituted, in ethno-class or Western-bourgeois terms, on the model of a natural organism.

Black African cinema, by the unique nature of the imperative which it confronts of having to interface and grapple both with the fundamentally Neolithic nature of its traditional indigenous cultures and their founding mythical narratives as well as with that of the global techno-industrial culture of the contemporary West together with its founding Grand Narrative,[176] has already prefigured this mutation of the Second Emergence in many of the elements of its iconography, of its thematics. To take one example. In Amadou Saluum Seck's *Saaraba* (1988),[177] the narrational units show the hero of the film, newly returned to Senegal from his university education in the metropolitan centre, France, having to come to grips with a central dilemma. This dilemma is that none of the three cultural systems and their respective belief systems or creeds (two religious, one secular) that have come to coexist in a now postcolonial reality are capable of resolving the pressing problems of contemporary Senegal. These three are that of the indigenous, once autocentric, polytheistic religious system of neolithic agrarian Africa, that of the still theocentric monotheism of Islam, and that of the West as the biocentric secular creed in whose order of knowledge the hero has been formally educated. The inability of all three to resolve the ongoing crisis situation are shown in a series of episodes. In one episode, one of the characters, a herdsman, finding his livelihood threatened by the drought which kills off his cows one by one, turns to the local witchdoctor for help. The drought continues, in spite of the witchdoctor's efforts; the cows still die. The ultimate remedy then proposed by the witchdoctor, that he ritually sacrifice his daughter, is only averted by the character Demba, who stops the herdsman just in time by enabling him to recognise the futility and unthinkability of such a remedy.[178] In the central sequence of episodes, the hero who,

as a Muslim has returned from his studies in Europe in order to find his 'roots' and to turn his back on the machine civilisation of the West, is shown as everywhere encountering the chaos that the secular Western 'remedy', i.e. its policies of economic development, has brought to Senegal. Beset on all sides by the crowd of beggars, and traumatised by the spectacle of the large numbers of the jobless poor on the margins of the wealth and luxury of a now increasingly materialistic urban elite, the hero is shown as having to recognise that his 'roots' are not the answer, that the 'remedy' cannot be found there either. For the traditional answers of Islamic theology cannot tell him how to deal with an increasingly degodded world, nor how to escape the pervasive technological tentacles of the West, together with its remorseless displacement of all other 'forms of life', its ongoing homogenisation of belief, desire, consciousness.

Nor, however, can the secular creed of the West, with its reasons-of-the-economy ethic, any more solve the problems of Senegal's swarm of beggars as well as of its endemically jobless, educated young people who turn to drugs to alleviate their despair, than can the religious belief cum ethical systems of traditional Africa or of Islam. Instead the plotline of the film suggests that it is the very programme of industrial development (as spearheaded by the bribe-taking politician and by the hero's wealthy businessman uncle), intended as the 'cure' for Senegal's ills, that, by its very dynamic, leads to the rapid expansion of the archipelagos of the jobless, filled with peasants violently *uprooted* from the land, the village and from their millennial agrarian way of life. The very dynamics therefore of the secular Western creed's understanding of man's humanity and, therefore, of a remedy based on a specific notion of freedom, one imagined as *Material Redemption* from *Natural Scarcity* in the reoccupied place of the matrix Judaeo-Christian behaviour-motivating notion of human freedom as that of *Spiritual Redemption* from *Original Sin*.

The only way out of a no-win situation therefore seems to the hero to lie in the utopian challenge to the creeds of all three, a challenge which is carried in the film by the semi-mad mechanic Demba. In the same way as the disillusioned jobless young people of the hero's generation listen to the messianic utopianism of Bob Marley's reggae – its musical form returned, via technology and reversing the Middle Passage to Africa from the also jobless shanty-towns of the diaspora[179] – the hero goes off with Demba, riding on the back of his motorbike, in quest of the utopian place of traditional Wolof culture called Saaraba; as a place sung about in traditional songs and imagined as a place, free from misery, full of plenty, where people celebrate every day. Demba is shown, at first, imagining Saaraba in technological terms as a land where machines do all the work as he has heard happens in Europe: the bright glittering lights of the city at night seen from the top of a hill seem to him to be its very epitome. However, a car crash wrecks the bike and injures him severely. Unable to accept that this is the end of his quest, Demba at first angrily turns on the hero, knocking him over a cliff, where he barely hangs from the edge. In saving his friend's life at risk to his own, the now dying Demba reimagines Saaraba, in terms of a new ethic that moves beyond the limits of all three creeds (two religious, one secular), their particularistic inscriptions of being human, and respective 'truths'; beyond *Man*, and the dystopic world, made, (because represented) in its image.[180]

'The human', he tells his friend, 'needs his fellow human. If you fight for that, you'll *find Saaraba'/Utopia.*[181]

Notes

1. See Clifford Geertz's book of essays *Local Knowledge* for the definition of contemporary Western culture as a 'local culture', '*one* of the forms that life has locally taken' (p. 16). Luc de Heusch had earlier defined this culture as one which, whatever the changes in its mode of production and social systems, continues to be governed by the 'reference point' of the Judaeo-Christian religion and symbology. See for this Luc de Heusch, *Sacrifice in Africa*, p. 206. For the definition of contemporary Western culture as the purely secularised form of the matrix Judaeo-Christian religious culture of feudal-Christian Europe, see Sylvia Wynter, '1492: A New World View'. See also her essay, 'Columbus'.

2. See for this term Philip Johnson, *Darwin on Trial*.

3. In his book *Hegel, Heidegger, and the Ground of History*, pp. 126–7. M. G. Gillespie cites Heidegger's point that our contemporary behaviours are driven by our present understanding of man's humanity and our attempt to realise ourselves in the terms of this understanding.

4. Michel Foucault, in his *The Order of Things*.

5. While J. G. A. Pocock shows the way in which the Renaissance discourse of civic humanism redefined the originally religious subject of medieval Europe as optimally *homo politicus* or political citizen (see his essay 'Civic Humanism and Its Role in Anglo-American Thought' in this collection of essays, *Politics, Language, and Time*. pp. 80–103, as well as his later book *The Machiavellian Moment*), he nevertheless oversees the way in which the new nineteenth-century discourse of liberal or economic humanism was to redefine the political citizen as *homo oeconomicus* and optimally *Breadwinner* (with woman's complementary role being that of *homemaker*).

6. See Clyde Taylor's essays, 'We Don't Need Another Hero' and 'Black Cinema'.

7. See, for a general analysis of the rock paintings of Namibia, Harold Pager, *Rock Paintings*. See specifically pp. 25–31 for a discussion on the relation of the rock paintings to 'intensive ritual activities'.

8. The term is used to emphasise the 'made' or constructed nature of the criterion of being that is enacting of the code of *symbolic life* in a binary opposition with the negatively marked anti-criterion of *symbolic death*.

9. The Latin title was *De orbis Revolutionibus*.

10. See, for this, Amos Funkenstein, *Theology and the Scientific Imagination*, n. 22, p. 29. Contemporary interpretations of the significance of the Copernican thesis with respect to the position of the earth unfailingly interpret it in modern terms, laying the emphasis on the decentring of earth and therefore of the human. Taken in its own Renaissance humanist terms, however, Copernicus' feat lay in the fact that he broke down the binary opposition between the heavens as the realm of *Redeemed Perfection*, and the earth as *the sinful abode of fallen man*, thereby revalorising the latter, and asserting the homogeneity of substance between the two realms on whose basis the hypothesis of laws of nature was made possible. See, for this, Kurt Hubner, *The Critique of Scientific Reason*.

11. Ferdinand Hallyn, *The Poetic Structure of the World* and Sylvia Wynter, 'Columbus'.

12. Funkenstein, *Theology*, p. 29, n. 22 and p. 91.

13. See, for this, K. C. Anyanyu, *The Studies of African Religions*.

14. In *Black Skins, White Masks*, Fanon made the proposal that the reflex behavioural aversive responses of his black patients could not be an *individual* problem, that besides the ontogenetic unfolding of the human individual there are also the processes of socialisation (or sociogeny) by which he or she is enculturated as a subject. The response was therefore due to the terms in which the black is socialised as a subject of the cultural order of the West.

15. See Théophile Obenga's essay, 'Sous-Thème', in which he defines the history of Africa as coterminous with the emergence of the human *out* of the animal kingdom.

16. Marcel Griaule, *Conversations with Ogotemmeli*.

17. The central thesis is that we realise ourselves as specific modes of the subject, and therefore of the human, *only* through the always culturally instituted field of meanings/representations, by means of which we are enabled to experience what *it is like to be* a specific subject; that is, through the mode of subjectivity into which we are socialised to *be* human. Hence the paradox that while our being human is implemented by the physiological processes of the body, the *experience of being human* is both a property of, and relative to, the criteria of being that are instituted and enacted by each cultural system or 'form of life'.

18. See David Bohm's interview with *Omni* magazine, January 1987 p. 74.
19. See, for this, Avram Goldstein, *Addiction: From Biology to Drug Policy.*
20. In his book *Neural Darwinism*, Gerald Edelman proposes that organic species classify and know their environment in the terms of the behaviours that are of adaptive advantage to each species.
21. See Nwachukwu Frank Ukadike, *Black African Cinema*, p. 32. This indistinguishability of Africans and primates in Africa in the representational apparatus of the Western cinematic text was, and is, generalised from the premise that the human exists in a pure continuity with organic species, and that Africans mark the dividing line, as the least evolved humans, between primates and the 'normal' because highly evolved human, as this normalcy is embodied in Indo-europeans.
22. See, for this Sylvia Wynter, '1492'.
23. See Immanuel Wallerstein, *The Modern World System* and Wynter, '1492'.
24. See Mudimbe, *The Idea of Africa*, p. xiv. See also his *The Invention of Africa.*
25. *The Idea of Africa*, p. xv.
26. *Ibid.*, pp. xi–xii. Nietzsche's 'On Truth and Falsity', p. 83.
27. See, for this, Nietzsche's 'On Truth and Falsity', p. 83.
28. See, for a discussion of Marx's concept of ideology in this context, Paul Ricœur's essay 'Ideology and Utopia'. Ricœur's extension of the concept of *ideology* beyond that of *false consciousness* to that of a 'shared horizon of understanding' which functions as, so to speak, the template of social oiganisation, when linked to Nietzsche's concept of world perception as the rule-governed way by means of which humans know their reality, according to a specific standard of perception (as a bird, for example, knows its reality according to a species-specific standard), is crucial to the hypothesis that I put forward here. That is, that the phenomenon of consciousness, of Mudimbe's 'memory', which still remains undiscovered by neuroscientists, should be seen in the terms of Marx's concept of *ideology* redefined in Ricœur's terms.
29. Since I shall be arguing that all human orders are born from a founding Origin narrative, memories, whether mythic, theological or historical, all take their point of departure from the conception of a *shared origin*. This origin then serves to structure the consciousness or mode of mind integrating of the specific order.
30. See his *Order of Things*, p. 386. See also Wynter, '1492'.
31. See *The Invention of Africa*, p. x.
32. *Ibid.*, p, ix.
33. See, for this, Jacob Pandian, *Anthropology and the Western Tradition*, pp. 2–11.
34. See Jean François Lyotard, *The Postmodern Condition.*
35. The film *Saaraba* was made in Senegal by one of the younger generation of directors.
36. Cited by Gillespie, *Hegel*, p. 127.
37. *Ibid.*, pp. 126–7.
38. See the statement of purpose that was sent out to participants by conference organisers. 'In that sense' they wrote 'it will be an explanation of new ground rather than the proposal of hard and fast conclusions, and an opening up of debate rather than an exercise in making African cinema.' Letter of 6 July, p. 2.
39. See his essay 'Black Spectatorship: Problems of Identification and Resistance', in Diawara, *Black American Cinema*, pp. 211–20.
40. See Herbert Marshall's Introduction to Sergei Eisenstein's *Immoral Memories*, p. ix.
41. See Michelle Wallace in her essay 'Race, Gender and Psychoanalysis', p. 257.
42. *Ibid.*, p. 260.
43. For Marxism, the issue of consciousness is a superstructural effect of the mode of production; for feminism it is an effect of patriarchy.
44. See his open letter to Maurice Thorez – *Lettre à Maurice Thorez.*
45. Diawara, *Black American Cinema*, pp. 212–14.
46. *Ibid.*, p. 213. Where as Diawara makes clear the black-faced villain Gus is *racially* defined as Other to the white hero and heroine.
47. See, for this, Pandian, *Anthropology and the Western Tradition*, pp. 1–3.
48. Ukadike, *Black African Cinema*, p. 32.
49. The term 'neo-colonialism' was the attempt to come to terms with this fact – if in neo-Marxist, and thereby still culturally Western, terms – by radical politicians/thinkers such as Nkrumah.

50. This issue of consciousness and of its 'prison walls' has also been raised in the film *Sankofa* (1993) by Haile Gerima, but in cultural nationalist terms. *Cultural nationalist* because Gerima sees the issue as that of a *false consciousness*, which needs to be corrected, rather than of a *culture systemic consciousness*, which because it is the condition of all our present 'form of life' needs to be transformed, together with the overall system and mode of subjectivity (one in which we are all enculturated and socialised) that gives rise to this consciousness.

51. See, for this, David Mayer, *Eisenstein's Potemkin*.

52. As Eisenstein wrote in his autobiography, *Immoral Memories*, 'The boy from Riga became famous at twenty seven. Douglas Fairbanks and Mary Pickford came to Moscow to shake by the hand the boy from Riga who had made *Battleship Potemkin*' (p. 8). Eisenstein tells in his autobiography also of how powerfully the film *Battleship Potemkin* resonated with members of the working classes (i.e. of the proletariat) all over the world (p. 65):
 And then to reap the fruits of your fame: To be invited to Buenos Aires for a series of lectures. To be suddenly recognised in the remote silver mines of the Sierra Madre, where the film was shown to the Mexican workers. To be embraced by unknown, wonderful people in the workers' district of Liège, where they screened the film in secret. To hear Alvarez del Vayo's account of how, back in the time of the monarchy, he himself had sneaked a print of *Potemkin* into Spain for a showing in Madrid. Suddenly to learn in some Parisian café, where you happen to share a little marble table with two dark-skinned Sorbonne students from the East, that 'your name is very well known to us in ... Java'! Or, on leaving some little garish roadhouse, to receive a warm handshake from a Negro waiter in recognition of what you have done in films.

53. In a recent essay by David Chalmers, 'The Puzzle of Conscious Experience'.

54. The proposal here is that it is only through our symbolically coded, and thereby culturally instituted, orders of consciousness that we can experience ourselves as *human*, i.e. as hybridly bios and logos, gene and word, organic and meta organic. See, for the thematisation of this premise, Sylvia Wynter, 'The Pope Must Have Been Drunk'.

55. See his *Notes of a Film Director*, p. 7.

56. *Ibid.*, p. 7.

57. The collapse of Communism, at the end of the 1980s, was inseparably linked to the formulaic degeneration of the aesthetics of social realism under the weight of the ideological imperatives of the New Class or *Nomenklatura*. In a longer version of 'The Pope Must Have Been Drunk' essay I draw the parallels between the belief system of *witchcraft* in traditional agrarian societies and that of *Natural Scarcity* in our contemporary techno-industrial own. The central parallel or *law* is that both *witchcraft* and *Natural Scarcity* (or for that matter the earlier Judaeo-Christian construct of *Original Sin*) function as 'socially significant causes' (see Evans-Pritchard, *Witchcraft, Oracles and Magic*) which calls for a specific kind of intervention to be made (i.e. witchcraft to be cured by ritual practices, *Natural Scarcity* to be cured by economic policies or remedies): interventions that thereby *prescribe* the behavioural pathways that are to be followed by the order as the condition of its own stable replication as a 'form of life').
 As Ukadike points out, a central problem with African firms of the 1980s which deal with traditional African ritual practices and beliefs such as witchcraft (i.e. films such as Idrissa Ouedraogo's *Yaaba* (1989)) is that while it can be said that these films are now penetrating the world market, 'there seems to be a movement away from the political use of the film medium, which addresses and relates to authentic cultures and histories, toward a concern with film as an object of anthropological interest'; in effect, a tendency to 'employ the same Western ethnographic conventions that have historically worked to emit the understanding of Africa's sociocultural formations' (Ukadike, *Black African Cinema* p. 248). The proposal of a new *conceptual ground* which sees practices like ethnomedicine, witchcraft and clitoridectomy (a ritual practice centrally portrayed by Sissoko in *Finzan* (1990)) as behaviour-regulating practices that function according to the same laws as does, for example, the ethno-discipline of economics and its 'socially significant cause' of *Natural Scarcity* (in the reoccupied places of *Original Sin*), to motivate our contemporary ensemble of behaviours, would enable African filmmakers to deal with those issues without any risk of their being received by mass spectators as 'exotic' ethnographic material relevant only to the West's Others; would therefore avoid the dangerous trap of *magical realism* into which Latin American fiction fell.

58. In his autobiography, Eisenstein makes it clear that for him the 'world outlook' of Communism was the world outlook alone able to achieve what he called the 'single idea, single theme, and

single subject' of his work – that of the 'achievement of (human) unity', *Immoral Memories*, p. 259. The collapse and disintegration of the Soviet Union was, however, to disprove this hope.

59. Benjamin Barber, *Jihad vs. McWorld* (New York: Random House/Times Books, 1995).
60. My central proposal in the address is that although our biological makeup is the 'condition' of our being human (and therefore the nature or bios aspect of our being) we experience ourselves as human only in the verbally inscribed part of our cultures, whether religious or secular. We are theoretic hybrids, both gene and word, nature and culture.
61. See Pocock, *The Machiavellian Moment*, p. 552.
62. See Peter Brown, *The Cult of the Saints*.
63. See, for this, Hans Blumenberg's *The Legitimacy of the Modern Age*, pp. 127–36, 220–5. See also Gary Gutting's *Michel Foucault's Archaeology* and his analysis of Foucault's deconstruction of Ricardo's and Marx's belief-construct of *Natural Scarcity*.
64. The use of the concept 'dysgenic pressure' by Richard Herrnstein and Charles Murray in their recent book *The Bell Curve* is a contemporary expression of the neo-Augustinian premise of mankind's enslavement, not now to *Original Sin*, but rather to hereditary dysselection for low IQ.
65. For Zygmunt Bauman's concept of *Conceptual Otherness*, see his *Modernity and the Holocaust*.
66. See, for a further development of this concept, my essay 'Is Development a Purely Empirical Concept?'
67. See Herrnstein and Murray, *The Bell Curve*, pp. 348–68
68. Within the ideological terms of feminist theory, which sees *gender* as an *acultural* concept, it cannot be recognised that clitoridectomy is one form of the *construction* of *gender*, just as the keeping of middle-class white women to the role of *homemaker* (until the revolt of feminism) is the contemporary bourgeois form of this construction of gender, of being. Hence the paradox of Sissoko's otherwise excellent film *Finzan* which remains, in this respect, entrapped in feminist ideology which defines clitoridectomy in terms of feminist culture as 'genital mutilation'. This is not a plea for the continuation of this practice now that we live in quite another world; rather both clitoridectomy and the contemporary feminist description of it as 'genital mutilation' should be seen as belonging to culture-specific fields and only 'true' and 'meaningful' within their respective fields. See also Ukadike, *Black African Cinema*, pp. 271–5 for a discussion of this issue.
69. See Jacques Le Goff, *The Medieval Imagination*.
70. See the title and theme of his *The Wretched of the Earth*.
71. Blumenberg, *The Legitimacy of the Modern Age*, p. 221, points out that while before the West's institution of the modern age, human beings had always known material want, this want had never before this been 'generalised to reality as a whole'. This generalisation was to be fully realised, of course, with Ricardo's construct of *Natural Scarcity* on whose rhetorical a priori the discipline of economics was to be based.
72. In his essay 'The Toad in the Garden', p. 274.
73. In *The Wretched of the Earth*, p. 274.
74. Marxism of course saw poverty only as an *effect* of the exploitation of the labour-power of the working classes, and therefore consistently defined the Poor as the liminal or Other category to the working classes, thereby accepting the bourgeois criterion of optimal being/behaving as that of breadwinner/breadwinning. Other recent -isms, feminisms, muiticulturalisms, gay liberationism, ignore the issue both of the poor and of the social *subordination* of the working class. Only liberation theology theory with its preferential option for the poor thesis and Fanon's polemic on behalf of the *lumpen* i.e. the rural/shanty-town afro proletariat of the Third World, have attempted to deal with poverty as an issue in itself.
75. See Bauman's *Legislators and Interpreters*.
76. In his prescient and prophetic series of lectures published as *Notes on the Dialectics*, pp. 129–36, 211–23.
77. *Ibid.*, pp. 129–36.
78. The point here is that the conception of the 'freedom package' of *Material Redemption* then functions, in the terms of artificial intelligence theorists, as the supraordinate goal about which our contemporary behaviours are motivated. See Jaime Carbonell, *Subjective Understanding*. See also Sylvia Wynter, '1492'.
79. The ongoing explosion of black 'crime' in South Africa (see the *New York Times*, 12 Dec. 1995) testifies to the new form of *economic apartheid* which has incorporated the black South African

middle classes into the horizon of expectation of white middle-class privilege, with the large majority of the expendable jobless having to resort to crime as *their* avenue of 'advancement'. The prison system has therefore reoccupied the *outsider* place of the earlier segregated black world.

80. A global pattern has begun to emerge, whether in the case of the death squads in Brazil in the case of street children (see Gilberto Dimenstein's *War on Children*), or in the USA with the high rate of intra-black male violence and murder, as well as the high rate of police brutality resulting in the death of suspects taken into custody.

81. See his *I Write What I Like*.

82. That is the consciousness of *alterity* to Man as a conception of being, and 'form of life', as that of the working class is, in the Marxian paradigm, that of *alterity* to the employer and investor class within the terms of an economic mode of production as the determinant factor. Here the conception of being, in a sense the politics of being, replaces the mode of production as the *determinant* factor. Since ruling groups are legitimated *as* ruling groups to the extent that they embody their respective social order's criterion of being – and therefore of *behaving*. This then legitimates their control of the means of material production.

83. See Jonathan Miller's summary of this position in his brief essay 'Trouble in Mind'.

84. Cited by Mudimbe in his *The Invention of Africa*, p. 168. As Sow states,
We are not persuaded that when looked at carefully the specific object of social sciences is the study of one universal human nature given a *priori*, because we do not know if such a human nature exists concretely somewhere. It may be that human nature (of human being in general, natural human being, etc.) is a theoretical fiction of general philosophy, or then, the activist generalisation of a limited concrete experience.
Mudimbe gives the citation as *Psychiatrie dynamique Africaine* (Paris: Payol, 1977), pp. 250–5.

85. Miller, 'Trouble in Mind' and Chalmers, 'The Puzzle'.

86. In *The Astonishing Hypothesis*.

87. In his *The Invention of Africa*, p. x.

88. See Antonio T. de Nicholas, 'Notes on the Biology of Religion'.

89. See his book *Exchange: Concepts in Social Thought* (Minneapolis, MN: University of Minnesota Press, 1992).

90. The concept that the only life that humans live is our represented symbolic life is Peter Winch's. See his essay 'Understanding a Primitive Society'.

91. Foucault, *The Order of Things*.

92. Hans Blumenberg analyses the implication of these theocentric strategies, i.e. strategies based on the premise of an Aristotelianised Unmoved Mover God, who had created the world and mankind purely for the sake of His own Glory, rather than with any special consideration for man. This God could therefore arbitrarily intervene to alter his creation, ensuring that humans could not depend upon the regularities of functioning of nature in order to know the rules according to which nature functions. The intellectual revolution of humanism was to challenge and change this conception of God and of his non-caring relation to an ostensibly contingent/mankind. See his *The Legitimacy*. See also Wynter, 'Columbus'.

93. *Ceddo* was made in 1976.

94. The premise here is that 'consciousness' is generated from each order's governing self-conception or governing code. See, for a conception of the specificity of the reflexive thought of the agrarian era of mankind as distinct from our techno-industrial order, Harold Morowitz, 'Balancing Species Preservation'.

95. Cited by Francoise Pfaff in *The Cinema of Ousmane Sembène*, p. 166. See also Ukadike's discussion of *Ceddo* in *Black African Cinema*, pp. 182–5.

96. See Pfaff, *The Cinema of Ousmane Sembène*, p. 147.

97. An identity, that of the West's 'Man', that unlike the earlier matrix identity, 'Christian', and indeed like all earlier cultural identities, hitherto, had not been guaranteed by being mapped onto the realm of the gods, or the supernatural, i.e. a secular identity.

98. The strategic manoeuvre by each group of their isolated *-ism* in their group-interest has confined the intellectual revolution of the 1960s to a reformist, and still hegemonically middle-class, role. I have adapted the pun, *sub/version*, from Lemuel Johnson's essay, 'A-beng: (Re)Calling the Body in(to) Question'.

99. Pfaff, *The Cinema*, p. 43.

100. Ukadike, *Black African Cinema*, p. 3.
101. *Ibid.*
102. See Mudimbe, *The Invention of Africa*.
103. Here again the indistinguishability of apes and African natives is subtly yet systemically insisted upon.
104. Made in 1982. See, for a discussion of this, Ukadike, *Black African Cinema*, pp. 54–7.
105. Published by Monthly Review Press, New York, 1972, trans. Joan Pinkham.
106. Published by Pantheon Books, 1978.
107. See Anyanyu, *The Studies of African Religions*.
108. *Ibid.*
109. See Mudimbe, *The Invention of Africa*.
110. See his *The Order of Things*. See also, for this, Gary Gutting's *Michel Foucault's Archaeology*.
111. In Obenga, unpublished paper.
112. See his *The Creative Explosion*.
113. In Obenga, unpublished paper.
114. That is, of the optimal subject as *political citizen* whose first loyalty is to the state in its post-medieval conception. See, for this, Pocock, 'Civic Humanism in Anglo-American Thought' in his *Politics, Language, and Time*, pp. 85–95.
115. In Obenga, unpublished paper.
116. In his book *Rhetoric as Philosophy*, pp. 104–10.
117. *Ibid.*, p. 110.
118. See Donald T. Campbell, 'On the Genetics of Altruism' and 'The Two Distinct Routes beyond Kin Selection to Ultra-sociality: Implications for the Humanities and Social Sciences', in *The Nature of Pro-Social Development: Interdisciplinary Theories and Strategies*, ed. Diane L. Bridgman (New York: Academic Press, 1982).
119. See for this Campbell. See also Philip Wright, *Three Scientists*.
120. Campbell, pp. 133–7.
121. Grassi, *Rhetoric as Philosophy*, p. 110.
122. See Nietzsche, *The Basic Writings of Nietzsche*, p. 495.
123. See Anne Solomon, 'Rock Art'. See also Sylvia Wynter, 'Genital Mutilation'.
124. Grassi, op. cit, p. 108.
125. See Funkenstein, *Theology*, n. 22, p. 29 and p. 91.
126. See his 'Contribution'.
127. The term is used by biologists and applied to species like the bees who are able to coexist and collaborate on the basis of their genetically programmed degrees of kinship.
128. See, for a definition of the term, Pierre Maranda, 'The Dialectic of Metaphor'.
129. Gregory Bateson uses this construct in his *Of Mind and Nature*.
130. De Nicholas, 'Notes'.
131. With culture rather than biology therefore being the 'ground' of human being/being human. See, for a further discussion of this, Sylvia Wynter, 'The Pope Must Have Been Drunk'.
132. Scubla, 'Contribution', p. 120.
133. The etiology of the reflex self-aversion displayed by Fanon's patients which led him to the hypothesis that human subjects are always socialised (sociogenetic) rather than purely ontogenetic or biological subjects, is to be found here. See his *Black Skins, White Masks*.
134. A recent book by Judy Grahn, *Blood, Bread, and Roses*, bears out this hypothesis with respect to the central role of the macro-representation of *menstrual blood* in human cultures.
135. Harold Morowitz, in his essay, 'Balancing Species Preservation'.
136. The term is from Phillip Johnson's *Darwin on Trial*.
137. Lieberman, *Uniquely Human*.
138. See, for a discussion of both the traditional and the contemporary identity systems of Rwanda and Burundi, by means of which the Tutsis have asserted their dominance over the Hutus, René Lemarchand, *Rwanda and Burundi*.
139. See *ibid.*, p. 155, for his discussion of the role of the *Karinga* drum in the assertion of the traditional dominance of the Tutsis over the Hutus.
140. Goldstein, *Addiction*.
141. *Ibid.*
142. In his essay, 'Altruism'.

143. See in this context the book by Wade Davis, *Passage of Darkness*. Davis's analysis of the functioning of zombification as a sanction system by the Bizerta secret society of Vodun, and his discovery of the chemical substances used by the houngans to effect zombification, provides a scientific rather than ideo-ethnographic insight into the traditional cultures and religions of Africa from which Vodun is derived. Not only does it bear out Basil Davidson's thesis that African religions should be seen as the embodiment of the behavioural norms which had facilitated the expansion of black peoples across the African continent but he makes a critical point that enables us to identify the parallel function of the systemically negatively marked representations in the cinematic and scholarly texts of the West – this point is that it is *not* the chemical event which gives rise to the phenomenon of zombification but the cultural belief system (in effect the representation Event) which activates the functioning of the biochemical event (pp. 244–62).

144. Note that the *Other* here is not simply black men or women, but the line of hereditary descent of which they are the expression. Since it is the latter's negative marking as a dysselected line of hereditary descent that enables the self-representations of the bourgeoisie as a ruling class, with their right to rule being based on their *eugenic* (rather than as in the case of the aristocracy of its *noble*) line of descent. See in this context Daniel Kelves, *In the Name of Eugenics*.

145. See, for illustrations bearing out this point, George Mosse, *The Final Solution*.

146. See, for this concept, Foucault's 'The Order of Discourse'.

147. As the laity had been made to signify the *Fallen Flesh* to the *Redeemed Spirit* of the clergy. This belief system has been given contemporary expression in Herrnstein and Murray's *The Bell Curve*.

148. Scubla, 'Contribution', pp. 105, 134.

149. Grassi, *Rhetoric as Philosophy*, pp. 108.

150. Pandian, *Anthropology*, pp. 2–3.

151. See the edition translated by Charles Glenn Wallis and published by Bobbs-Merrill, Indianapolis, New York, 1965.

152. James F. Danielli, 'Altruism'.

153. *Ibid.*, pp. 91–2.

154. These representations can therefore be recognised as symbolically coded ones as had been those of the pre-Copernican representations of the earth as fixed and motionless at the centre of the universe as its dregs, *because* it was the abode of fallen mankind.

155. See Marcel Griaule, *Conversations*.

156. The terms of course were first widely used in scholarship by Lévi-Strauss and refer to the distinction between the being of culture (the *cooked*) and the being of nature (the *raw*); the socialised vs. the unsocialised. The concept of the *ritual cooking* or socialisation of the child is common to many African cultures. See, in this respect, Eugenia W. Herbert, *Iron, Gender and Power*.

157. See also Paul Ricœur's further development of the Marxian concept of ideology in his essay 'Ideology'.

158. In *Witchcraft, Oracles and Magic*.

159. See, for this, A.J. Michael, *Planetary Overload*.

160. See, for a discussion of this, Fernández Amesto, *The Millennium: A History of the Last Thousand Years* (New York: Scribner, 1995).

161. See, for this hypothesis, Sylvia Wynter, 'The Pope'.

162. See his essay 'Trouble in Mind'.

163. See Foucault, *The Order of Things*.

164. See his book *Gada*.

165. In his essay *Poetry and Knowledge*.

166. See Nicholas Humphrey, *A History of the Mind*.

167. Published by Simon & Schuster, 1988.

168. *Ibid.*, p. 319.

169. The central point here is that because the role of *alterity* must be expressed at the level of empirical reality, the distribution of the bads and goods of the order must function so as to replicate its signifying role at the level of the social system – i.e. it must be expressed in the dominance structure and status hierarchy of the order.

170. In his interview with *Omni*, January 1987, p. 74.

171. *Ibid.*, p. 74.

172. See John Pfeiffer, *The Creative Explosion*, pp. 11–15. The point here is that human being is defined by a specific *ensemble of behaviours* that are unique to the properly human species. As Brenda

Fowler points out in a recent *New York Times* review of James Shreeve, *The Neanderthal Enigma*, some 40,000 years ago the archaeological record shows a sudden marked change:

> A wealth of new tools appear, as do, for the first time, examples of symbolic expression, in the form of the Venus figurines and cave-paintings. It is here, most paleoanthropologists now agree, that we first recognise human beings as they are today.

Fowler also cites a major point made by Shreeve in which he argues that it was the ability of the Cro-Magnon peoples to 'mate outside the immediate social group resulting in alliances that laid the ground for cultural innovations' and that defined the latter as properly human. My argument stands his on its head. It was the 'cultural innovations' that enabled the human transcendence of the limits of genetic kinship, defining of being human. See Fowler's review, p. 21.

173. See Pfeiffer, *The Creative Explosion*, pp. 11–13, 119–33.

174. In this new 'world outlook' what we humans 'produce' would be recognised as being *not* primarily our economic systems, but rather our 'forms of life', our respective modes of subjectivity and of sociality. What Marx defined as 'social relations of production' and saw as a function of economic production would therefore be turned on its head. Instead economic production would be seen as a function of the production of the social structure of relations by means of which we are instituted and integrated as *culture-specific and* always symbolically coded subjects.

175. See Elizabeth L. Eisenstein, *Print Culture*.

176. If, as Mudimbe cites Claude Lévi-Strauss, 'the most important scientific discoveries on which we are still living – the invention of agriculture, the domestication of animals and the mastering of edible plants and their integration in human cultures – took place during periods dominated by mythical narratives' (see Mudimbe, *Parables of Fables: Exegesis Textuality, and Politics in Central Africa* (Madison, WI: University of Wisconsin Press, 1991), p. 97), my proposal here is that the techno-industrial civilisation of the West and its discoveries were brought about within the context of the secular Origin Narrative of Evolution.

177. *Saaraba* was produced in Senegal in 1987–8. A video version of the film has been put out by the Library of African Cinema. The languages used are Wolof and French, with English subtitles.

178. Given that the cultural reality in which these agrarian behaviour-motivating beliefs had been viable had now deserted both the herdsman and the witchdoctor. One that, in another epoch, as Basil Davidson notes, had served to motivate the behaviours needed for the expansion across and settlement of African peoples. See his *Black Man's Burden*.
Here again a new conceptual ground that would have enabled the herdsman's proposed sacrifice of his child (within the terms of the traditional African belief system in which nature is still divinzed and the 'drought' can be cured by the sacrifice of what the herdsman most loves, his child), to be seen as paralleling the 'sacrifice' of the uprooted jobless masses in the West's secular belief system, one in which being is *biologised*, would have further de-exoticised traditional African ritual practices by identifying them as *one* form of the culture-systemic belief systems by means of whose 'programming languages' our human behaviours are lawlikely induced/motivated. See, for this, Wynter, 'The Pope'.

179. The popular messianic religion of Rastafarianism had its origins from the 1930s onwards in the endemically jobless shanty-towns of Kingston, Jamaica. See Malika Lee Whitney and Dermot Hussey, *Bob Marley*.

180. The proposal here is (i) that the earlier political ethic which had had its origin in Machiavelli's *reasons of state* was replaced during the nineteenth century with a new economic ethic, i.e. *reasons of the economy*, which functioned in the same absolute terms as the earlier reasons of slate ethic had done; (ii) that all human cultures are instituted about the reasons of a specific ethical imperative encoded by their founding narratives or belief systems.

181. In this context, Heidegger's concept of our present understanding of the human, as one in which each man must be brought into conflict with his fellows, causes the closing narrational unit of the film – in which Demba, after first attacking the hero in his disillusionment, in the wake of an accident, and pushing him over a cliff, holds on to him, and desperately grapples to save him, dying as he does so – to be in a direct challenge to this understanding and therefore to its bourgeois *notion of freedom* or 'freedom package', as being *Material Redemption* from *Natural Scarcity*. This is the notion of freedom from which we shall have to emancipate ourselves.

References

Films
Griffith, D. W. *The Birth of a Nation* (1915; Film Preservation Associates, 1992).
Seck, Amadou Saalum. *Saaraba* (Senegal, 1987–8).

Anyanyu, K. Chukwulozie. *The Studies of African Religions*, (Dakar: OMNA, 1976).
Bateson, Gregory. *Of Mind and Nature: A Necessary Unity* (New York: E. B. Dutton, 1974).
Bauman, Zygmunt *Legislators and Interpreters: On Modernity, Post-Modernity, and Intellectuals* (Cambridge: Polity Press, 1987).
——. *Modernity and the Holocaust* (Ithaca, NY: Cornell University Press, 1989).
Biko, Stephen. *I Write What I Like*, selection edited by Alfred Stubbs (Oxford: Heinemann International, 1978).
Blumenberg, Hans. *The Legitimacy of the Modern Age*, trans. B.W. Wallace (Cambridge, MA: MIT Press, 1983).
Bohm, David. Interview with *Omni*, January 1987.
Brown, Peter. *The Cult of the Saints: Its Rise and Function in Latin Christianity* (Chicago and London: University of Chicago Press, 1981).
Campbell, D. T. 'On the Genetics of Altruism and the Counter-Hedonic Components in Human Culture', *Journal of Social Issues*, vol. 28, no. 3, 1972: 21–37.
Carbonell, Jaime. *Subjective Understanding: Computer Models of Belief* (Ann Arbor, MI: University of Michigan Press, 1981).
Césaire, Aimé. *Lettre à Maurice Thorez*, 3rd edn. (Paris: Présence Africaine, n.d.).
——. *Poetry and Knowledge*, trans. James Arnold, in *Lyric and Dramatic Poetry 1946–82 by Aimé Césaire*, ed. and trans. Clayton Eshelman and Annette Smith (Charlottesville, VA: University Press of Virginia, Caraf Books, 1990).
Chalmers, David. 'The Puzzle of Conscious Experience', *Scientific American*, Dec. 1995: 80–7.
Crick, Francis. *The Astonishing Hypothesis: The Scientific Search for the Soul* (New York: Scribners, 1994).
Danielli, James F. 'Altruism and the Internal Reward System or The Opium of the People', *Journal of Social and Biological Sciences*, vol. 3, no. 2, 1980: 87–94.
Davidson, Basil, *The Black Man's Burden: Africa and the Curse of the Nation-State* (New York: Times Books, 1992).
Davis, Wade, *Passage of Darkness: The Ethnobiology of the Haitian Zombie* (Chapel Hill and London: University of North Carolina Press, 1988).
Diawara, Manthia. *Black American Cinema* (New York; Routledge, 1993).
Dimenstein, Gilberto. *War on Children* (London: The Latin-American Bureau, 1995).
Dixon, Thomas Jr. *The Clansman: An Historical Romance of the Ku Klux Klan* (Lexington, KY: University Press of Kentucky, 1970).
Edelman, Gerald. *Neural Darwinism: The Theory of Neuronal Group Selection* (New York: Basic Books, 1987).
Eisenstein, Elizabeth. *Print Culture and Enlightenment Thought* (Hanes Foundation, Chapel Hill: University of North Carolina, 1986).
Eisenstein, Sergei M. *Immoral Memories: An Autobiography*, trans. H. Marshall (Boston, MA: Houghton Mifflin, 1983).
——. *Notes of a Film Director* (New York: Dover Publications, 1970).
——. *Potemkin* (New York: Grossman Publishers, 1972).
Evans-Pritchard, Edward. *Witchcraft, Oracles and Magic in among the Azande* (Oxford: Clarendon Press, 1937).
Fanon, Frantz. *Black Skins, White Masks* (New York: Grove Press, 1967).
——. *The Wretched of the Earth*, preface by Jean-Paul Sartre, trans. Constance Farrington (New York: Grove Press, 1963).
Foucault, Michel. 'The Order of Discourse' [1971], trans. Ian McLeod, in *Untying the Text: A Post-Structuralist Reader*, ed. Robert Young (London: Routledge & Kegan Paul, 1981).
——. *The Order of Things: An Archaeology of the Human Sciences* (New York: Random House, 1973).
Fowler, Brenda. Review of James Shreeve *The Neanderthal Enigma: Solving the Mystery of Modern Human Origins*, Sunday *New York Times* Review of Books, 17 Dec. 1995, p. 21.

Funkenstein, Amos. *Theology and the Scientific Imagination from the Middle Ages to the Seventeenth Century* (Princeton, NJ: Princeton University Press, 1986).

Geertz, Clifford. *Local Knowledge: Further Essays in Interpretive Anthropology* (New York: Basic Books, 1983).

Gillespie, Michael. *Hegel, Heidegger, and the Ground of History* (Chicago, IL: University of Chicago Press, 1984).

Godelier, Maurice. *The Mental and the Material: Thought, Economy, and Society* (London: Verso, 1986).

Goldstein, Avram. *Addiction: From Biology to Drug Policy* (New York: W. H. Freeman, 1994).

Grahn, Judy. *Blood, Bread, and Roses: How Menstruation Created the World*, with foreword by Charlene Spretnak (Boston, MA: Beacon Press, 1993).

Grassi, Ernesto, *Rhetoric as Philosophy: The Humanist Tradition* (University Park and London: Penn State University Press, 1982).

Griaule, Marcel. *Conversations with Ogotemmeli* (Oxford: Oxford University Press, 1965).

Gutting, Gary. *Michel Foucault's Archaeology of Scientific Reason* (Cambridge: Cambridge University Press, 1989).

Hall, Stewart. 'The Toad in the Garden: Thatcherism among the Theorists', in *Marxism and the Interpretation of Culture*, ed. Nelson cary and Lawrence Grossberg (London: Macmillan, 1988).

Hallyn, Ferdinand. *The Poetic Structure of the World: Copernicus and Kepler* (New York: Zone Books, 1990).

Herbert, Eugenia W. *Iron, Gender and Power: Rituals of Transformation in African Societies* (Bloomington, IN: Indiana University Press 1993).

Herrnstein, Richard and Charles Murray. *The Bell Curve: Intelligence and Class Structure in American Life* (New York: The Free Press, 1994).

Heusch, Luc de. *Sacrifice in Africa: A Structuralist Approach* (Manchester: Manchester University Press, 1985).

Hubner, Kurt. *The Critique of Scientific Reason* (Chicago, IL: University of Chicago Press, 1983).

Humphrey, Nicholas. *A History of the Mind: Evolution and the Birth of Consciousness* (New York: Simon & Schuster, 1992).

James, C. L. R. *Notes on the Dialectics: Hegel, Marx, Lenin* (Westport, CT: Lawrence Hill, 1980).

Johnson, Lemuel. 'Abeng: (Re)Calling the Body in(to) Question' in *Out of the Kumbla: Caribbean Women and Literature*, ed. Carole Boyce Davies and Elaine Savory Fido (Trenton, NJ: Africa World Press, 1990).

Johnson, Phillip. *Darwin on Trial* (Downers Grove, IL: Intervarsity Press, 1993).

Kelves, Daniel. *In the Name of Eugenics: Genetics and the Uses of Human Heredity* (Berkeley and Los Angeles, CA: University of California Press, 1984).

Legesse, Asmarom. *Gada: Three Approaches to the Study of African Society* (New York: The Free Press, 1973).

Le Goff, Jacques. *The Medieval Imagination*, trans. A. Goldhammer (Chicago, IL: University of Chicago Press, 1983).

Lemarchand, René. *Rwanda and Burundi* (London: Pall Mall Press, 1970).

Lieberman, Philip. *Uniquely Human: The Evolution of Speech, Thought, and Selfless Behavior* (Cambridge, MA: Harvard University Press, 1991).

Lyotard, Jean François. *The Postmodern Condition: A Report on Knowledge*, trans. G. Bennington and B. Massumi, foreword by F. Jameson (Minneapolis, MN: University of Minnesota Press, 1984).

Madsen, Roy Paul. *The Impact of Film: How Ideas Are Communicated through Cinema and Television* (New York: Macmillan, 1973).

Maranda, Pierre. 'The Dialectic of Metaphor: An Anthropological Essay on Hermeneutics', in *The Reader in the Text: Essays on Audience and Interpretation*, ed. S. R. Suleiman and I. Crosman (Princeton, NJ: Princeton University Press, 1980).

Mayer, David. *Eisenstein's Potemkin: A Shot by Shot Presentation* (New York: Grossman Publishers, 1972).

Michael, A. J. *Planetary Overload: Global Environmental Change and the Health of the Human Species*. (Cambridge: Cambridge University Press, 1993).

Miers, Suzanne and Igor Kapytoff, (eds) *Slavery in Africa: Historical and Anthropological Perspectives* (Madison, WI: University of Wisconsin Press, 1977).

Miller, Jonathan. 'Trouble in Mind', *Scientific American*, Sept. 1992: 180.

Mirandola, Pico della. *On the Dignity of Man and Other Essays*, trans. J. W. Miller (Indianapolis, New York, Kansas City: Bobbs-Merrill, 1940).

Morowitz, Harold. 'Balancing Species Preservation and Economic Consideration,' *Science*, vol. 253, AAAS, 16 August 1991.

Mosse, George. *The Final Solution: A History of European Racism* (New York: Howard Fertig, 1976).

Mudimbe, V. Y. *The Idea of Africa* (Bloomington and Indianapolis, IN: Indiana University Press, 1994).

——. *The Invention of Africa: Gnosis, Philosophy and the Order of Knowledge* (Bloomington, IN: Indiana University Press, 1988).

Nicholas, Antonio T. de. 'Notes on the Biology of Religion', *Journal of Social and Biological Structures*, vol. 3, April 1980: 219–26.

Nietzsche, Friedrich. *The Basic Writings of Nietzsche*, trans, and ed. William Kaufman (New York: The Modern Library, 1968).

——. 'On Truth and Falsity in the Ultra-Moral Sense', trans. A. Muge, in *The Existential Tradition*, ed. Nino Languilli (New York: Doubleday & Co., Anchor Books, 1971).

Obenga, Théophile. 'Sous-Thème: La Pensée africaine et la philosophie dans une perspective de renouvellement', unpublished paper presented at a symposium organised by FESPAC, Dakar, 15–19 Dec. 1987.

Pagden, Anthony. *The Fall of Natural Man: The American Indian and the Origin of Comparative Ethnology* (New York: Cambridge University Press, 1982).

Pager, Harald. *The Rock Paintings of the Upper Brandenberg*, in Africa Praehistorica series: monographs of African Archaeology and Environment, compiled by Tilman Lenssen-Erz, ed. Rudolph Kuber, Part 1, Vol. 1 (Köln: Heinrich-Barth Institut, 1993).

Pandian, Jacob. *Anthropology and the Western Tradition: Towards an Authentic Anthropology* (Prospect Heights, IL: Waveland Press, 1985).

Pfaff, Françoise. *The Cinema of Ousmane Sembène: A Pioneer of African Film* (Westport, CT: Greenwood Press, 1984).

Pfeiffer, John E. *The Creative Explosion: An Inquiry into the Origins of Art and Religion* (New York: Harper & Row, 1982).

Pocock, J. G. A. *Politics, Language, and Time: Essays on Political Thought and History* (1960; Chicago and London: University of Chicago Press, 1989).

——. *The Machiavellian Moment: Florentine Political Thought and the Atlantic Political Tradition*. (Princeton, NJ: Princeton University Press, 1975).

Ricoeur, Paul. 'Ideology and Utopia as Cultural Imagination', in *Being Human in a Technological Age*, ed. D. M. Borchert and D. Stewart (Athens, OH: Ohio University Press, 1979), pp. 107–25.

Scubla, Lucien. 'Contribution á la théorie du sacrifice', in *René Girard et le problème du mal*, ed. M. Deguy and Jean-Pierre Dupuy (Paris: Bernard Grasset, 1982).

Solomon, Anne. 'Rock Art in Southern Africa', *Scientific American*, Nov. 1996:106–12.

Taussig, Michael. *Shamanism, Colonialism, and the Wild Man: A Study in Terror and Healing* (Chicago, IL: The University of Chicago Press, 1987).

Taviani, Paolo Emilio. *Columbus, the Great Adventure: His Life, His Times, and His Voyages* (New York: Orion Books, 1991).

Taylor, Clyde 'Black Cinema in a Post-Aesthetic Era', in *Questions of Third Cinema*, ed. Jim Pines and Paul Willemen. (London: BFI, 1989), p. 90.

——. 'We Don't Need Another Hero: AntiThesis on Aesthetics', in *Blackframes: Critical Perspectives on Black Independent Cinema*, ed. Mbye B. Cham and Claire Andrade-Watkins (Cambridge, MA: MIT Press, 1988), pp. 80–5.

Thompson, Robert Farris. *Flash of the Spirit: African and Afro-American Art and Philosophy* (New York: Random House, 1984).

Ukadike, Nwachukwu Frank. *Black African Cinema* (Berkeley, CA: University of California Press, 1994).

Wallace, Michele. 'Race, Gender and Psychoanalysis in Forties Film: *Lost Boundaries, Home of the Brave, The Quiet One*', in *Black American Cinema*, ed. M. Diawara (New York: Routledge, 1993).

Wallerstein, Immanuel. *The Modern World System: Capitalist Agriculture and the Origins of the World Economy in the Sixteenth Century* (London: Academic Press, 1974).

Whitney, M. L. and Dermott Hussey. *Bob Marley: Reggae King of the World* (Kingston, Jamaica: Kingston Publishers, 1989).

Winch, Peter. 'Understanding a Primitive Society', *American Philosophical Quarterly*, vol. I: 307–24. No further details available.

Wright, Philip. *Three Scientists and Their Gods: Looking for Meaning in an Age of Information* (New York: Times Books, 1988).

Wynter, Sylvia. 'Columbus and the Poetics of the Propter Nos', in *Discovering Columbus*, ed. D. Kadir, *Annals of Scholarship; An International Quarterly in the Humanities and Sciences*, vol. 8, no. 2 (Detroit, IL: Wayne State University Press, 1992).

——. '1492: A New World View', in *Race, Discourse, and the Origins of the Americas*, ed. V. L. Hyatt *et al* (Washington: Smithsonian Press, 1995).

——. '"Genital Mutilaton" or "Symbolic Birth"? Female Circumcision, Lost Origins, and the Aculturalism of Feminist/Western Thought', in *Colloquium; Bridging Society, Culture and Law* in *Case Western Law Review*, vol. 47, no. 2, winter 1997: 501–52.

——. 'Is Development a Purely Empirical Concept? Or Is It also Teleological? A Perspective from "we the underdeveloped"', in *Prospects for Recovery and Sustainable Development in Africa*, ed. A. Y. Yansane (Westport, CT: Greenwood Press, 1996).

——. 'The Pope Must Have Been Drunk, The King of Castile a Madman: Culture as Actuality and the Caribbean Rethinking Modernity', in *The Reordering of Culture: Latin America, the Caribbean, and Canada in the Hood*, ed. Alvina Ruprecht and Cecilia Taiana (Ottawa, Ontario: Carleton University Press, 1995).

——. 'Rethinking "Aesthetics": Notes towards a Deciphering Practice', in *Ex-iles. Essays on Caribbean Cinema*, ed. Mbye Cham (Trenton, NJ: African World Press, 1992).

Caribbean Masquerade and Festival Politics

The Invention of Traditional Mas and the Politics of Gender

Pamela R. Franco

Since the 1960s, women's participation in Trinidad's pre-Lenten Carnival has steadily increased.[1] By 2005, however, the festival came to a crossroads. For the first time in its recorded history, women are very visible in the historically male enclaves of calypso and steelband, and are also the numerical majority in the street parade on Carnival Monday and Tuesday. Women's dominance of the street parade has resulted in significant changes to the overall aesthetic of the festival. In performance, for example, women prefer the highly sexualized dance, *wining*,[2] instead of the traditional characterization or playing someone other than themselves, a hallmark of performance theory and masquerade systems. In dress, they generally opt for costumes that emphasize and display their semiclad bodies.[3] Without moorings or "roots" to which one could anchor this novel masquerade style, critics, culture brokers, and scholars turned in the late 1980s to the familiar, the male-centered traditional mas,[4] hoping that it would help them to make sense of this new phenomenon.

Thus in 1988, there was a concerted effort to revive and reposition traditional mas characters. Two new events, Viey la Cou (the old yard) and the Ole Time mas parade, were added to the schedule of Carnival activities. Almost immediately, the use of traditional characters was enveloped in a cultural nationalist discourse. "We don't want to lose our rich Carnival heritage [the traditional characters] which is being denied us with every passing Carnival more and more," declared a writer in *Express* (February 5, 1988). The fact was that with "every passing Carnival" there was a steady increase of female maskers; at the same time, the number of traditional characters was decreasing. Consequently, the former was at the center of the festival, and the latter was relegated to its margins. Interpreting this sequence of events as a case of cause and effect, the organizers of the new performances sought to rectify what they perceived to be a problem. They presented Viey la Cou and the Ole Time mas parade as effective solutions. Selecting "*authentic* characters . . . play[ed] by the actual persons who performed years ago" (*Express*, February 5, 1988), they hoped to reinscribe the festival with its "roots," its authentic self. To accomplish this goal, the organizers tacitly valorized such mas characters as the Midnight Robber, the Moko Jumbie, and the *Jab Jab*[5] by re-presenting them as the standard or canon of mas. Instead of clarifying the extant situation of female dominance, this strategy of reclamation, coupled with cultural nationalist rhetoric, created a dichotomous situation, pitting the male-dominated traditional characters on one side and the contemporary women's mas on the opposite side.

Today this binary continues to be at the center of many popular debates, specifically those on authenticity in mas. The model of authenticity that is often invoked is heavily indebted to the 1956 *Caribbean Quarterly* (*CQ*) special issue that was dedicated to Trinidad Carnival. The brainchild of British anthropologist Andrew Pearse and Trinidadian folklorist Andrew Carr, it was the first scholarly analysis of Carnival. The titles of its articles included "Carnival in Nineteenth-Century Trinidad," "Traditional Masques in Trinidad Carnival," "Carnival in New Orleans," and "The

Reprinted with permission from *Trinidad Carnival: The Cultural Politics of a Transnational Festival*, ed. Garth L. Green and Philip W. Scher, 25–47 (Bloomington and Indianapolis: Indiana University Press, 2007).

Changing Attitude of the Coloured Middle Class towards Carnival." Additional essays on three male characters, the Midnight Robber, the Dragon, and the Pierrot Grenade, as well as Mitto Sampson's "Calypso Legends of the Nineteenth Century" completed the special issue. The uncritical repetition (Hill 1972; Stewart 1984) of the content and assertions of these articles helped to establish certain mas characters as traditional and their performance styles as standard. In addition, they facilitated the construction of a mas hierarchy in which the traditional characters are elevated to the level of the "real" or "authentic." But the equating of the traditional with the authentic is problematic. As constructed, the category of traditional mas is a highly gendered and racialized conceptualization of Carnival. It does not totally represent the reality and breadth of the festival. Instead, it indicates the authors' applied methodologies and the political climate of the 1950s, which the late Daniel Crowley posited as a critical trajectory in selecting the characters that would eventually comprise the category of traditional mas. He explained, "Nationalism, it was all around us...You couldn't miss it."[6] Not only is this statement very illuminating, but it also makes sense. Many qualities of the 1950s anticolonial–nationalist movement are echoed in Crowley's imagining of the traditional characters. Both sought to reconceptualize and reposition blacks, or Afro-Trinidadians, in the island's cultural and political landscapes. In sum, the cultural and political were intertwined.

In the late twentieth century, the revival of male-centered traditional characters does not help us "make sense" of the contemporary mas. Instead, it has created significant problems for female maskers. They include the positing of femininity as a sign of inauthenticity, the evaluation of women's mas through their reproductive role as mothers, and the interpretation of women's mas style as a form of "emasculation." In this chapter, I discuss how the specific methodologies that were applied in a 1950s nationalist climate aided the construction of the traditional mas as male-centered. I will also examine the consequences of this gendered construction on the contemporary mas. The aim is twofold: (1) to show that the category of the traditional mas, as created by Daniel Crowley, privileges gender (male) and race (African), and (2) to illustrate its inadequacy as an explanatory paradigm for "making sense" of the female-dominated contemporary Carnival.

Invention of Traditional Mas

The 1956 special issue of the CQ in 1956 presented the first scholarly analysis of Trinidad's premier festival. Diverse topics provided the reader with a history of Carnival's origins, its principal characters, and performance styles. However, it is the first two articles, Andrew Pearse's "Carnival in Nineteenth-Century Trinidad" and Daniel Crowley's "Traditional Masques of Trinidad Carnival,"[7] that are critical to our understanding of how the category of traditional mas was invented or constructed. New traditions are invented through conscious selection of symbols that are connected to a reinterpreted past, and are used to serve contemporary goals or situations (Hobsbawm 1983). New traditions are most likely to be created "in response to novel situations... [or] when a rapid transformation of society weakens or destroys the social patterns for which 'old' traditions had been designed" (Hobsbawm 1983, 2–4). In essence, new situations require new traditions. In the twentieth century, nation building and nationalist movements have necessitated the creation of new traditions as a way of defining the nation as an "imagined community" and to give "permanence and solidity to a [new] political form" (Brennan 1993, 47–49). In similar fashion, in 1950s Trinidad, the nationalist movement required cultural icons that expressed not only the changes and new face of the nation but also represented the cohesiveness of the national community. Carnival, as the most prominent of all cultural forms, quickly became the icon par excellence because, presumably, it was a very public display of nationalist ideology. It was in this

nationalist climate that the traditional characters were imagined and created. So, to fully understand the rationale behind their construction there are three major elements, essential to the process of inventing new traditions, to be considered: (1) the characters' connections to a historical past, real or fictitious, (2) the privileging of a specific community or group, and (3) the period in which the new tradition was constructed. The following discussion will reveal the intertextual link between the traditional mas and the new nation.

In his article, Andrew Pearse located the origins of the public or street festival in the dynamic and racialized politics of slavery, as well as in the resistance of the black underclass to the Victorian code of moral ethics. He categorized his article around a tripartite slavery–emancipation model: (1) pre-emancipation (1783–1833), (2) post-emancipation (ca. 1834–1860), and (3) the Jamette Carnival (ca. 1860–1890).[8] In the pre-emancipation Carnival, whites, primarily the English and French, were the dominant participants.[9] The French organized "concerts, balls, dinners, hunting parties, and fetes champetres[10] [during] the Carnival season, which lasted from Christmas to Ash Wednesday" (Pearse 1956, 7). For the English, Christmas was the season "of rowdy merrymaking and licence" (Pearse 1956, 13), and at Carnival, they organized "fancy dress" balls under the patronage of the governor. The "coloured middle class"[11] also celebrated the season by hosting private masquerade balls. Until 1826, however, they were required to obtain permission to host any evening activity that included music and dancing (Pearse 1956, 11).[12] In all three cases, there was some form of public or street processioning, with many whites opting for participation within the confines of their carriages. At Christmas, slaves had "considerable freedom for dancing, pageantry, parades and traditional good strife between plantation bands" (Pearse 1956, 11). They performed under the master's watchful gaze. Slaves, however, rarely paraded in the street Carnival. Thus, in Pearse's pre-emancipation Carnival, the principal event was the private masquerade ball. Although freed citizens of different ethnic groups hosted this event, they did so in their separate spheres.

In the post-emancipation Carnival, the former slaves' participation increased, resulting in significant changes to both the festival's structure and its contents.[13] After 1838, many ex-slaves fled the plantations and relocated to the capital city of Port of Spain. In Carnival, they introduced an "Africanized" style of performance – a multimedia affair that included singing, dancing, mime, theatrical reenactments, and a percussive style of music. They also introduced the *Canboulay*,[14] which Trinidadian playwright Errol Hill (1972, 23–31) would later identify as the festival's "ritual beginning." In Pearse's post-emancipation Carnival, the premier disguises were the all-male characters: the Highlander, the Pulchinello, Pirates, Turks, and Death (Day 1852). Presumably, a growing black presence in the streets, combined with a loud, percussive musical performance forced "the white elite of the society to with[draw] from public participation" (Pearse 1956, 21). This action cleared the path for blacks to introduce their masquerade style. For Pearse, it is the black (male) presence in the streets coupled with the multimedia, percussive performance style that precipitated the changes that would eventually lead to the restructuring of the festival.

The Jamette Carnival, which highlighted such mas characters as the *Pissenlit*[15] and Stickfighter, shifted the focus away from the private masquerade balls to the public or street festival. Allegedly, these masquerades did not permit "our mothers, wives, and sisters to walk the streets and promenades without having their senses shocked by sights and sound in the fullest sense of the word 'disgusting'" (Pearse 1956, 31). Although newspapers described the jamette mas as "disgusting," Pearse reinterpreted it as oppositional to the established values and norms of the superstructure, which he defined as "the interwoven, administrative, legal, economic and religious institutions stemming from the colonising power" (Pearse 1956, 39). In all probability, nineteenth-

century, working-class blacks, the chief participants of Jamette Carnival, also may have perceived their performances to be oppositional, or in direct contrast, to the Victorian code of moral ethics. Unlike the colored middle class, they were less inclined to aspire to the white community's sense of morality and to adopt their cultural practices (Brereton 1979, 152–175). Black's unwillingness to adhere to the mainstream value system resulted in frequent misunderstandings and confrontations with the local authorities, finally culminating in the 1881 Canboulay Riots.[16] In the Jamette Carnival, Pearse crystallized an image of blacks as racialized protagonists.

By pinpointing a specific historical moment or event, in this case slavery–emancipation, Pearse effectively established a new origin for the modern festival, one that overshadowed the French Creole's claim of introducing the pre-Lenten festival to the island in the late eighteenth century. To legitimize this new claim, Pearse needed to identify "a past with which it [the modern festival] [was] continuous and in whose terms it [was] explicable" (Toren 1988, 697). His slavery–emancipation frame was most effective because not only did it connect the contemporary festival to a major historical event in the past, but it also positioned blacks at the center of the activities. But, as Paul Gilroy (1992, 198) notes, when and where "new beginnings have been identified...new modes of recollection are...necessary." In other words, Pearse's relocation of Carnival's origins in a slavery–emancipation paradigm required a new episteme, one in which blacks were reconstituted as protagonists. Thus, his rewriting of the extant slavery narrative privileged the instrumentality of black males in the post-emancipation shift from the private masquerade balls (white/Europe/elite) to the street or public festival (black/Africa/folk). By doing this, Pearse, in 1956, effectively marginalized the European's (i.e., colonial's) and, to a lesser degree, black women's contributions to Trinidad Carnival.

While Andrew Pearse located the origins of the festival in slavery and represented black males as the festival's principal maskers, North American anthropologist Daniel Crowley, in his article "Traditional Masques of Carnival," identified and foregrounded those characters that best exemplified Pearse's originary model of black male agency. Crowley organized his article in a typological fashion, using such categories as "Rare and Extinct," "Sailor and Military," "Indians and Other Warriors," "Historical," and "Clowns," to name a few. In the "Rare and Extinct" category, for example, he brought together a group of disparate characters who had once been popular but either were absent or at the periphery of the 1955 Carnival, when he conducted his research. They included Negre Jardin or "Garden Nigger," the Stickfighter, the Pissenlit or "bedwetter," and Jamet bands, all subscribed to, almost exclusively, by black male maskers. Their performance styles varied from the combative Stickfighter to the sexual play of the Pissenlit.

A brief review of Crowley's cast of traditional mas reveals a gender focus and a performance aesthetic based on a combination of stylized choreography, eloquent speeches, and dramatic reenactments. For example, the disguises of the male-dominated Sailor and Military bands extended from the very simple to the fancy sailor. Their performances ranged from throwing powder on each other and on spectators to mock militaristic maneuvers. Their dances, which were determined by each character's "occupation," emphasized stylized, intricate footwork.[17] Similarly, the Indian mas (more accurately Hollywood-inspired representations of Native Americans) was also categorized in two genres, the Wild and the Fancy. The former generally meant representations of such "warlike" groups as the Apaches, Seminoles, and Sioux, and the latter was an elaborate depiction of Native American costume. In performance, the Indians spoke an invented Indian language. Likewise, the Midnight Robber recited boastful and self-aggrandizing speeches. The most sumptuous costumes were found in the Historical, Fancy Dress, and Original bands. Generally, their themes were

adaptations of events and stories, culled from European or Middle and Far Eastern history, Greek mythology, and the Bible. They showcased beautiful, voluminous costumes, pageantry and a non-percussive musical style.[18] Perormances were dramatic reenactments of carefully chosen historical events that were acted out in front of the judges. Although the membership of these bands was heterogeneous, men constituted at least two-thirds of the maskers and held the principal roles. Finally, such characters as the Clown, Burroquite or Sumari,[19] and Maypole dancers[20] completed Crowley's list of "traditional masques." Unlike the mas of previously mentioned categories, many of these characters were prominent at Carnivals in outlying towns and villages. With the exception of Sumari, black male maskers were the principal performers. In sum, Crowley's overall emphasis on certain Carnival characters inscribed a model of traditional mas in which black male maskers were the preeminent actors, and stylized dance, orality, and theatrical dramas were the preferred performance aesthetics.

The foregrounding of male maskers and their performance styles was not arbitrary. Pearse and Crowley's imagining of the origin of the festival and the traditional mas is indebted to three major factors: (1) the authors' knowledge of and dependence on Melville Herskovits's theory of acculturation,[21] (2) the application of a West African masquerade model, and (3) the political climate in which the CQ special issue was conceived and published. As I will demonstrate, these factors together determined the gender and racial profiles of the traditional or Ole Time mas.

Briefly, Herskovits (Pearse 1956, 10) defined acculturation as the study of "those phenomenon which result when groups of individuals having different cultures come into continuous first-hand contact, with subsequent changes in the original cultural patterns of either or both groups." Among Africans in the New World, the degree of acculturation was determined by many variables, including the demographic ratio of one cultural group to another, climate and topography, the frequency and points of contact or interaction with Europeans, and whether or not these contacts took place in a rural or urban setting (Pearse 1956, 10). Herskovits termed the new forms that resulted from acculturation *Africanisms* because, despite varying degrees of transformation, many of the cultural elements were "traceable to an African origin" (Holloway 1991, ix). In the 1950s, Crowley, Herskovits's student, and Pearse, a visiting colleague at Northwestern University, would have understood *Africanism* in a very similar manner, as an endpoint or product that, at some level, revealed specific elements that were traceable to Africa.

In Carnival, Africanisms were realized in the syncretic mas forms that either showed recognizable signs of the cultures in contact or, in a more covert manner, made reference to shared philosophies. For example, in his account of the nineteenth-century Carnival, Pearse (1956, 24) acknowledged the syncretic nature of the early masquerades when he wrote that "we can distinguish the persisting elements of both Europe and Creole provenance." Creole, here, is a synonym for black or African. Similarly, Crowley also foregrounded the characters whose costumes and/or performances were illustrative of acculturation. The Moko Jumbie, or West African stilt walker, was a perfect example of this process. He "wore a long full skirt and a jacket or 'eton' of brightly-coloured satin or velvet... his hat was fashioned into an 'Admiral's' hat with long peaks in front and back" (Crowley 1956, 50). Here was a West African masquerade figure dressed in a sumptuous European-styled costume and wearing an admiral's hat!

The Historical band, with its European themes and costumes, illustrated a less overt form of syncretism. "This hierarchy [Kings, Queens, High Priests, High Priestess, etc.] not only provides a masque for every taste and pocketbook, but also faithfully reflects the African and the Crown Colony [England] societies" (Crowley 1956, 84). While the external trappings and themes of the

Historical mas overtly indexes European history, the underlying content of court tradition makes reference to parallelism in African and European social structure. In this example, shared social ideologies, experienced by two different cultural groups, underpin the European costume and historical referents.

While Crowley's choice of Carnival characters underscored the syncretic nature of much of the traditional mas, it was the application of a West African system of masquerading that facilitated the privileging of a multimedia performance style and the foregrounding of male maskers. Briefly, in West Africa, with rare exception, masquerades are performed almost exclusively by men.[22] For example, the Yoruba ancestral mask, Egungun, and Gelede, a mask to honor women, are performed by initiated adult males. In the latter, using layers of cloth, men transform their bodies into that of a pregnant female, revealing the fact that, if or when necessary, they would cross-dress to play female roles. Varying combinations of singing, miming, virtuosity in dancing, and the percussive rhythms of the drums enhance maskers' performances. Women, children, and foreigners constitute the audience. Despite their marginalization, women are essential to the overall performance "since the efficaciousness of the mask requires its legitimation by those supposedly unaware that it is an illusion and who accept their own exclusion from the secret of its meaning" (Kasfir 1998, 18). In other words, the success of a West African masquerade is dependent on the audience's willingness to "believe" and play along with the illusion of transformation. Similarly, the success of the traditional mas performances was due, in part, to the audience's very active participation and their acceptance of the character on its own terms. Also, the ole time characters were performed, almost exclusively, by male maskers; their disguises were of a persona other than themselves; their performances often consisting of a combination of dance, mime, song, and verbal virtuosity. When necessary, they cross-dressed. Crowley's academic training with Africanist scholars William Bascom and Melville Herskovits insured that Africa would be a principal trajectory for his analysis. Thus, it is feasible to suggest that the masquerade model that informed his construction of traditional mas was a West African one.[23]

The emphasis on Africa – acculturation, Africanisms, African masquerading systems – was complemented by the political climate in which the special issue was written and published. It was during a period of intense political upheaval in Trinidad and Tobago, the region, and the world. For example, in 1955, the Reverend Martin Luther King, then leader of the Montgomery Improvement Association, led the Montgomery Bus Boycott, which catapulted the North American Civil Rights movement into high gear. In 1957, Ghana, led by Dr. Kwame Nkrumah, was the first African nation to attain its independence from Britain. In that same year, Haitians elected François "Papa Doc" Duvalier, as President. And in 1959, Fidel Castro carried out a successful revolution in Cuba. In the post–World War II West Indies, leaders sought to mobilize citizens in attempts to establish regional unity. The creation of the West Indies Federation, and later independence, would create a novel nationalist environment for which many of the "old" (colonial) traditions were no longer applicable or relevant. This shift necessitated the construction of new traditions that were appropriate to the presiding political climate.

One such tradition was Eric Williams's program to educate the masses in Trinidad and Tobago. However, in true du Boisian style, Williams believed that people had to be led by the intellectual class.[24] He thus created the University of Woodford Square, actually a park in the center of the commercial district, and installed himself as its sole "professor." It was here that Williams "lectured" to his "students," mainly the black working class, on the legacy of slavery and colonialism. He linked the inferior status of blacks to these two phenomena (Oxaal 1968).

Reportedly, his first "lecture" on June 21, 1955 drew a crowd of 20,000 "students" (Cudjoe 1993, 58). These public lectures garnered name recognition and a substantial following for Williams. In October 1956, his political party, the People's National Movement (PNM), won the general election, giving Trinidad and Tobago its first-elected black Chief Minister and government. In 1957, on the heels of this auspicious event, Williams, through his minister of education and culture, announced the appointment of a committee to consider the future development of Carnival "along national lines" (*Trinidad Guardian*, January 3, 1957) with the government as its new patron.

But Carnival in the 1950s was a dichotomous affair. The majority of its participants were black. However, their portrayals or themes were overwhelmingly based on non-African and non-Caribbean historical narratives. In 1957, the first Carnival following the PNM's victory, the festival's organizers introduced a new competition category. The Band of the Year award was a very public acknowledgment of the superiority of one mas band over all others. This award also bestowed prestige on the winner. That year, George Bailey won the coveted prize with his band's portrayal *Back to Africa*, a title that conjured up an image of Africa as the ancestral land. Prior to 1957, Carnival representations of Africa had frequently been based on a spurious Western and Hollywood perception of the African continent as primitive and uncivilized. For example, some of the popular mas bands had been *Ju-Ju Warriors, South African Zulus, African Congo Warriors,* and *Heroes of the Dark Continent*.[25] In 1947, the winners of the Best Warriors Carnival competition category were (1) Uganda, (2) Tanganyika, and (3) Tribal Ju-Ju (Anthony 1989, 181). These early depictions reinforced the Western imagining of a savage and wild continent. A decade later, Bailey attempted to counter the pejorative visualization of Africa. Historian Michael Anthony (1989, 263) described the band's impact.

> Bailey's band *Back to Africa* made a stunning and immediate impact, and straightaway changed the then current viewpoint towards African masquerade. People had been accustomed to seeing the fierce-looking Zulu, the prancing Warusi, and the crocodile-loving Zambesi. They had never seen an elaborate, elegant, dignified, and at the same time wondrously colourful display of African masquerade, and they had never dreamt that any African masquerade could reach such heights of splendour so as to challenge the classic styles of Greece and Rome.

To reclaim Africa, Bailey framed the continent in the visual and structural idiom of the historical mas bands. The maskers were organized around a hierarchy of principal characters, and many costumes showcased European-style capes and trains made from velvet and satin. For example, "the King of the Band...Oba Adele the First was a magnificently-dressed character, with a cape about fifteen yards long, held up by maidens, and with burnished rhinestones studding his crown (Anthony 1989, 264)." Compare this description with the king of Harold Saldenha's *Imperial Rome* (1955): "The King of this band, Valman Jones, was spectacular as Nero Caesar. Dressed in royal purple and gold, he was wearing a cape about fifteen yards long" (Anthony 1989, 248). Overall, Bailey's depiction of Africa veered somewhat from the stereotypical images of "the fierce-looking Zulu, the prancing Watusi, and the crocodile-loving Zambesi" to include a novel view of Africa as "elegant and dignified." He achieved this by historicizing the African continent alongside the great European civilizations of Greece and Rome, two popular Carnival themes.[26] As a matter of fact, in 1957 Harold Saldenha's mas band, *The Glory That was Greece*, was favored to win the Band-of-the-Year title. Some Carnival aficionados interpreted Bailey's triumph over Saldenha as Africa's triumph over Europe (colonialism). Bailey's very bold step of re-presenting Africa, albeit as a historical mas, publicly validated the continent and made it worthy for blacks to reclaim it as the ancestral homeland.[27]

Similarly, Williams sought to reevaluate and reposition the island's African descendants and their cultural practices. For example, in his foreword to Errol Hill's play *Ping Pong* (Williams in Hill 1955, 6), he stated,

> These [ordinary people] are the creators of our Caribbean music, the characters of our Caribbean drama, the voters of our Caribbean democracy. It is people like these from whom the Caribbean cultural movement derives its principal inspiration.

In this statement, Williams acknowledged the political potential of the black community, who, incidentally, would later become his constituents. Having received full suffrage in 1946, "the voters of our Caribbean democracy," now had a "consanguine" candidate who selected them as the chosen ones, the culture bearers of the new nation.[28] Williams' political agenda was clear. He was building the nation from the bottom up, from a black working-class constituency. However, this black–Creole nation would be fashioned and led by a fraternity of men; women would be its loyal supporters (Reddock 1994).

This mode of (en)gendering the new nation is very typical of nationalist movements (Enloe 1990; McClintock 1995; Reddock 1996; McClintock et al. 1997). As Cynthia Enloe (1990, 44) explains, "nationalism typically has sprung from masculinized memory, masculinized humiliation and masculinized hope." In other words, men's need to regain what, presumably, was lost during previous political regimes – their manhood/masculinity, their pride, and their reputation – is a primary impetus of nationalist movements. Therefore, nationhood has to be imag[in]ed through the male. Eric Williams's immediate foray into the political arena on the heels of his termination from the Caribbean Commission in 1955, seems to illustrate this idea. Frustrated and angry at the commission's policies regarding the region, Williams may have felt insulted and humiliated by the body's action. Reportedly, they offered him a job "requiring [him] to work in a subordinate capacity to one of the very men who sat down in secret session in Puerto Rico and decided unanimously not to renew [his] contract with the Commission" (Cudjoe 1993, 164). In a subsequent address, regarding his tenure at the Commission, he claimed a need "to clear my name and reputation from any imputations of inefficiency or failure" (Cudjoe 1993, 160). Applying Enloe's theory, it could be said that Williams's entrance into local politics was, in part, a strategy to reclaim what he viewed as having lost, his "reputation," a signifier of his manhood. Paul Gilroy's discussion of the imagining of racial communities through black masculinity also resonates here. As he notes (Gilroy 1992, 194), "the integrity of the race [nation] is...interchangeable with the integrity of black masculinity, which [had to] be regenerated at all costs." With a paucity of relevant popular visual images, Carnival became the source par excellence that would provide iconic representations of the black male. Recast in Crowley's traditional mas model, maleness or masculinity was defined as black militancy (Sailor, Indian, Midnight Robber), elegance (Historical bands), and wit (Pierrot Grenade).[29] In this very public and politicized space, black males/men and nationhood became inextricably linked. However, the 1950s imag[in]ing of Carnival and traditional mas has serious implications for the significance of race and ethnicity, class and gender in the codification and authentication of mas. For the remainder of this chapter, I will address briefly what I consider to be three major implications of the costume and performance aesthetics of traditional mas on gender relations in contemporary Carnival. This discussion will illustrate the inadequacy of the traditional mas paradigm to valorize, interpret, and "make sense" of the contemporary mas.

Woman/Female as Inauthentic

In the late 1980s Carnival, the unprecedented dominance of female maskers and their preferred costume and performance styles resulted in a gendered framing of the festival. According to Desa Philippi (1987, 41), "gender operates as a system of signs, the sign woman [or man] is only meaningful within the system of signification in which it is produced." Thus the significance of Woman is dependent on the role(s) that society sets for her. In Trinidad and Tobago, as it is in most parts of the world, a pervasive image of Woman projects her as the moral and ethical arm of society. She tends to symbolize the virtuous and also the goodness in society. However, as Philippi (1987, 41) goes on to explain, "Woman [also] occupies a dual position, negatively inscribed in that the phallic function rests on exception (absence) and at the same time as the category of absolute otherness that acts as the guarantee in the logic of the sign." In other words, with man posited as the "norm," Woman, as sign, is representative of the abnormal, deviant, and nonstandard. However, Woman, as other, is necessary to the concept of man. In Carnival, a self-reflexive event, these ideas of gender obtain. They are underscored in the contemporary festival, resulting in analysis based on sex and gender and not on aesthetics and style.

Local journalism proves this point. Since the 1980s, newspaper reports on the event have been fixated on the female image. Such headlines as "Carnival Is Woman" or "Reign of Carnival Women" have become popular fare. Principally, they acknowledge the dominance of female maskers in modifying the festival. The headlines also underscore what Sue Best (1995, 185) describes as "the 'metaphoric' transfer of the attributes of woman to space." In other words, stereotypical "female characteristics" – shapely, sensual, coquette – are employed either to describe the festival or to signify its inherent quality. In conjunction with the headlines, newspaper reports that describe the contemporary Carnival as women "celebrating their femaleness in coquettish, sensual fabrics and designs" (*Trinidad Guardian Carnival Magazine* 1992, 52) or, their disguises as "beautiful and shapely Arawaks and Caribs" (*Trinidad Guardian Carnival Magazine* 1992, 1) affirm the festival's gender focus. They also insinuate "woman" as an anomaly. Throughout the recorded history of the festival, "Carnival is Man/Male" has not been a concept that requires vocalization because, in large part, maleness/masculinity, as exemplified in the traditional characters, tends to represent or signify the norm or the canon. Hence, there is rarely a need to articulate the obvious. However, deviance and difference require articulation and visualization to alert us to their exception from the norm.

The public display of women's bodies and their performances, specifically *wining*, now is disturbing to many citizens. Letters to newspaper editors reveal the populace's evaluation of women's mas. For example,

> This year's celebration, particularly Carnival Tuesday's presentation, has been noted as the most vulgar and immoral display ever witnessed on the Savannah stage. Women, particularly, no sooner spotted cameramen than they began their lewd dance, which brought the bile up in most men's stomachs.[30]

A newspaper editorial (*Trinidad Express*, February 22, 1988) shared a similar assessment.

> In 1988, the spectacle had very little to do with the parade of costumed bands but with the disgusting behavior of hundreds of women who made an obscene spectacle of themselves.... In skimpy outfits which apparently some of them still found to be too cumbersome, they gyrated with and against one another and occasionally with men.

While women's "lewd dance" is defined as "vulgar and immoral display" and "obscene spectacle," similar performances by male maskers are not singled out.[31] This biased evaluation and reporting of women's Carnival performance stems from a tacitly sexist framing of women's mas in their biological and social roles as mothers and wives, respectively. As one resident explained, "Women are the cradle of civilisation...they remain the bedrock of family life" (*Trinidad Express*, February 22, 1988). Thus, their public behavior should be in keeping with their socially prescribed symbolic roles. "The scandalous and lewd cavorting of...women, many of whom took the pains to simulate the sex act in full view of their audience" (*Trinidad Guardian*, April 3, 1988) was unacceptable. Curiously, this author's isolation of women "simulating the sex act" absented and absolved men of any egregious participation. If men were not participants, then women were the sole performers of the "act." Was the author's criticism aimed at the homoerotic nature of the women's performance? Maybe. Her articulated concern, however, was on the effect of the women's performance on young impressionable children. "Let us not forget that many of the viewers are small children?" (*Trinidad Guardian*, April 3, 1988). Another letter also underscored this concern: "I think it is downright shameful and even frightful to see how the *mothers* and *mothers-to-be* of our nation 'wine' and expose their bodies to all and sundry. What signals are we sending to the next generation?" [emphasis added] (*Trinidad Guardian*, February 12, 1988). Traditional mas is never framed in a discourse on paternity. This public and ontological assessment of female maskers clearly illustrates women's Carnival behavior is too often "read" or interpreted primarily in relationship to their biological role as mothers.

The Aesthetics of Motherhood

Motherhood epitomizes the good and virtuous woman. As feminist writer Elaine Savory Fido (1992, 283) explains, in the Caribbean "motherhood is still viewed as a most important role for women by both men and women." Janice Lee Liddell (1990, 321), writing on the representations of mothers in Caribbean literature, underscores Fido's observations: "The image of mother – giver and nurturer of life: teacher and instiller of values and mores – has indeed become the most persistent of Caribbean archetypes." Liddell (1990, 322) also notes that the concept of motherhood is often paradoxical: mothers are strong "pillar[s] of fortitude" while being "self-sacrificing, self-effacing wom[e]n-parent[s]." Lord Pretender, in his calypso *Mother Love* (1937), identifies the characteristics of a good mother.

> The zenith of a woman's ambition in life
> Should be to be a loving mother and a pleasing wife
> For thus they are by nature intended
> Not as overlords or slaves but to man subjected
> To join with him in love and connubial unity
> In generating humanity. (Rohlehr 1990, 225)

In this calypso, Pretender presents motherhood, within the sanctity of marriage where women are subordinate to their husbands, as women's natural role. Throughout local history, the upper classes, both white and colored, have frequently used the single-mother status as a sign of the inferiority and immorality of working-class women, making poverty and immorality interchangeable conditions. However, the poor mother could be "saved" or "redeemed," *if* she were self-sacrificing. The "self-sacrificing" characteristic is spelled out in the Mighty Caresser's "A Warning to Men, Women and Children about their Parents" (1937):

A good Mother always does things constructive
To help her children is her objective
No matter *how poor* she happens to be
Her duty she'll perform assiduously
Without the shadow of a single doubt
They'll feed you, clothe you and remain without
Send you to school to be educated
So that in days to come you'll be respected,
[emphasis added] (Rohlehr 1990, 225)

Literary critic Gordon Rohlehr (1990, 224–226) presents motherhood as "part of an ideology of control":

> Veneration of woman's role as wife, mother and helpmate was part of an ideology of control which was designed to deny women the possibility of successful movement beyond the home and family...and to deny them the sexual or social freedom which the men themselves enjoyed and cherished.

In other words, motherhood as ideology could present a confining and limiting role for women. It reaffirms the old adage that a woman's place is in the home and also sanctions the containment of women's sexual expression. Some contemporary writers of women's history have reinterpreted motherhood as a metaphor for women's selfhood or their rebirth. In "On Becoming One's Mother," poet Lorna Goodison suggests that "in some essential sense one has to become one's own mother, that is one has to create or produce oneself" (Baugh 1997, 212). In sum, motherhood is a polyvalent image and concept. It is the raison d'etre of women's lives; it can bring a modicum of respect to poor mothers; it limits women's social and sexual movement, and it can be a trope for women's selfhood and self-representation. In Carnival, however, it is motherhood as ideal (respectability) and ideology (confinement and control) that has become the unspoken aesthetic in the evaluation of women's mas.

Motherhood, thus, becomes the primary hermeneutic frame for women's Carnival costume and performance, which are judged *not* for their aesthetic value but, instead, for their adherence to societal standards of good, respectable, public dress and conduct for mothers. In contrast, traditional characters are never judged for their adherence to good, public behavior standards for fathers. Because of this prejudicial assessment, women's mas cannot be appraised solely in terms of transformation or inversion, the anthropological and sociological hallmarks of festival theory. Neither can it be evaluated fully nor be valorized through the aesthetic lens of traditional mas, which is heavily invested in fully-clothed body and stylized oral and choreographic performances. In reality, women's mas requires a new paradigm, one that offers gender as a principal unit of analysis.

"Emasculation" of Men

As self-reflexive, women's mas style resonates with their changing status in the larger society, as seen in their seemingly nonreliance on men. Journalist Terry Joseph (*Trinidad Express*, February 2, 1988) intimates this as a cause and effect of women's mas:

> There is the aspect of an albeit licentious form of liberation among women, which sees hordes of females feeling enough of a sense of security to venture into the mas band on carnival days *without any promise of male protection*. In fact, so secure are they that they seem to spend much of the time *taunting males who failed to perform* [emphasis added].

Joseph's observation is echoed in social scientist Ramesh Deosaran's evaluation of gender affairs in the larger society (*Trinidad Guardian*, February 14, 1993):

> In Trinidad, we are being faced with a crisis of masculinity...While our young girls are pumping iron, studying harder and pushing forward, we now have young men ambivalent about their very roles in society and worse yet, confused about their sexuality. Even many of our women are finding it difficult to find satisfaction with the attitudes and performance of our young males. In fact, the very ideal of sexual equality is being threatened.

In their remarks, Joseph and Deosaran posit the idea that women's public behavior, including their Carnival performance, is reflective or illustrative of a larger societal problem, the "emasculation" of men. According to these authors, women's sense of liberation and security (Joseph) and their academic achievement (Deosaran) bear a direct correlation to men's inadequacy, both financial and sexual. For Joseph, women's feeling of liberation and security allow them to publicly taunt men "who failed to perform." Sexual impotency is also implied here. For Deosaran, women's academic and professional achievements result in their dissatisfaction "with the attitudes and performance of our young men." This perceived "emasculation" of men may explain, in large part, why many believe there is a need to publicly counteract the increasing "feminization" of the national festival with strong and assertive images of masculinity.

However, the group of traditional characters selected as a counternarrative to the "female" Carnival is problematic. Among the now sacralized traditional characters are the boastful Midnight Robber, the "savage" and violent Indian, and the elegantly dressed but equally violent Pierrot and Stickfighter. Presumably, these characters evoke a time when men were men or, as journalist David Chase (*Trinidad Express*, January 24, 1997) wrote in 1997, "when Carnival was Carnival." Judging from the choice of traditional characters, when Carnival was "real" or "authentic," masculinity was located in ethnicity (black men), physical violence (Indian, Pierrot, Stickfighter), self-aggrandizement (Midnight Robber), and male reputation (Stickfighter, Pierrot, and Midnight Robber). In this model, nonblack and nonviolent males are not "real" men. In a society that is currently struggling to come to grips with the alarming increase of domestic violence and sexual assault against women, at Carnival and throughout the year, the indirect and unbalanced celebration of male violence and aggressive behavior is unsettling, even in play.[32] The elevation or sacralization of violence and aggression sends a subliminal message that, under certain circumstances (i.e., Carnival), aggressive behavior is acceptable. While many residents may feel the need or urgency for a more balanced representation of gender in mas, there is also an obligation to select a more diverse array of traditional characters.[33] This may be difficult in light of the extant dependency on Crowley's cast of "traditional masques."

In their articles, Pearse and Crowley tacitly molded our perception and understanding of the origins of the modern Carnival and the costume and performative traditions of its principal characters. Applying Herskovits's theory of acculturation and a West African model of masquerade, they constructed a particular image of Carnival in which black men were the preeminent performers. In costuming, there was a marked aesthetic preference for syncretism and voluminous dress. The hallmarks of performance were a combination of aggression (Stickfighter, Pierrot), stylized movements (Dragon, Bats), verbal artistry (Pierrot Grenade, Midnight Robber), and theatrical reenactments (Historical Bands). The combined styles of these categories – men, fully covered bodies, aggression, verbal artistry, stylized movements, reenactments, and inversion – now constitute the hallmarks of canonical or authentic mas. This particular construction of the authentic in mas is heavily indebted to the 1950s political climate, which required efficacious images of blacks that paralleled the imaginings of a new nation.

More recent scholarship has begun to challenge the focus on the male maskers (Miller 1991; Franco 1998; Davies 1998). Molly Ahye (1991), in her analysis of the polymorphic nature of Carnival, proffered gender as an effective analytical tool. She noted that women experienced Carnival differently from men, and vice versa. For example, men play mas "with a strong commitment to some cause or other...some use it to socialize...[or] to stalk, snare and consume their prey" (Ahye 1991, 403–404). By contrast, Carnival allows women who "are plagued by the stress of life, stymied by tradition...[to] reach the grand climax...to explode with galvanic energy" (Ahye 1991, 407). Despite the very sexual and reductionist connotations, Ahye veers from the well-worn, and often inaccurate, authentic–inauthentic paradigm. Her approach allows analysis of distinct women and men's mas, gender construction in mas, sexuality, and the complementarity of male and female styles of masking. While I agree with Ahye's call for a gendered lens of analysis, one must be careful not to flip the coin from a male-centered to a female-centered mas paradigm. Neither addresses the complexity or polyvalence of the festival.

In sum, the nationalist climate of the 1950s greatly affected the particular patterning of the traditional or authentic in Carnival. However, it did not facilitate the type of analysis that would have revealed a distinct women's style that was markedly different from men's. The image or representation of women had to be symbolic or subsumed into a master narrative. Crowley and Pearse were men of their time and their convictions. The *CQ* special issue is a testimony to their training, vision, and political consciousness. But times have changed and at the dawn of the twenty-first century, their post-World War II imag[in]ing of mas is inadequate as the sole or primary model to evaluate or contextualize women's mas. We need a new paradigm to evaluate the contemporary mas; one that would allow for a more panoramic and democratic view of the festival, one that would value the contributions of *all* participants, irrespective of race, class or gender.

Notes

1. The twin-island state is Trinidad and Tobago. In this chapter, when I use the term *Trinidad Carnival*, I am referring specifically to Port of Spain, the main Carnival venue. Therefore, Trinidad Carnival, here, is actually Port of Spain Carnival.
2. Wining refers to gyrating pelvic movements.
3. The aesthetic of contemporary mas is realized in the skimpy and sexy costuming of such bands as Barbarossa, Legends, and Harts, the Younger Generation. When I mention the contemporary women's mas, I am referring specifically to the skimpy and sexily dressed female maskers.
4. *Mas* is an abbreviation for masquerade. It is the popular term used in Trinidad and Tobago to describe the costumed performers who parade on Carnival Monday and Tuesday.
5. *Jab Jab* is a creolized version of the French *diable* or devil.
6. This quotation was taken from an interview I conducted with Crowley in 1984.
7. This article, "Traditional Masques of Trinidad Carnival," may have been initially conceived by Andrew Pearse. In his unpublished notes and papers, housed at the University of the West Indies, St. Augustine, I found a very detailed outline of this article. It is possible that Pearse created the outline and Crowley completed the analysis.
8. Jamette is a creolization of the French *diametre*. The term describes those at the periphery of society. In nineteenth-century Trinidad, the jamette class defined working-class blacks who lived in urban areas and, reportedly, indulged in criminal or dubious activities.
9. The French migrated to Spanish Trinidad in the late eighteenth century. Many were royalists fleeing the French Revolution or the economic downturn in the French colonies. They quickly created a very distinct French society. In 1797, the island was capitulated to the English.
10. The term *Fetes champetres* translates as country or open-air party or celebration.
11. The "coloured middle class," in this context, are free men and women of mixed European and African ancestry generally with fair or light complexion. By 1810, they were the second-largest ethnic and cultural group, after the slaves. They valued European culture but were also

race conscious. Historian Bridget Brereton in *Race Relations in Colonial Trinidad* explained that the colored middle class "stressed racial consciousness...to 'disprove' the theory of the innate mental infirmity of the African race" (1979, 6). In a somewhat twisted logic, the colored middle class believed that by acquiring European values and cultural practices they were negating the Eurocentric perception of African inferiority.

12. After the capitulation of the island to the British in 1797, the free coloreds lost many of the privileges that they had previously enjoyed under Spanish law. The British under Governor Picton introduced barbarous legislation as a way to keep the coloreds in a subordinate place. One example was the right to flog a colored man or woman, free or enslaved, for any crime she or he may have committed. They were required to pay $16 for a permit to host musical events in the privacy of their homes. In 1824, a prominent colored man, Jean Baptiste Philip, presented a scathing report to Secretary of State Balthurst in London. Titled *The Free Mulatto Speaks*, the report presented the abuses that the free colored community in Trinidad suffered under British governance. The British Parliament, on the basis of Baptiste's report, finally ordered the repeal of the new discriminatory legislation. After 1826, free coloreds were no longer required to obtain a permit to host musical events in their homes.

13. The Emancipation Proclamation was effective on August 1, 1834. However, planters complained about their impending losses if the slaves abandoned the plantations. A six year apprenticeship period was permitted. In 1838, slavery was abolished in the Anglophone Caribbean.

14. Canboulay is a creolized form of *cannes brulees* or burnt cane. After emancipation, freed blacks opened Carnival, midnight on Carnival Sunday, with the Canboulay performance, a reenactment of estate procedures to quell fires.

15. The Pissenlit or bedwetter wore a transparent nightgown and carried a "menstrual cloth." It was actually a white cloth dyed or painted red.

16. In an attempt to remove the fighting and violence from the nineteenth-century Carnival, local authorities tried to outlaw the carrying of sticks during the festival. In 1880, under the leadership of Captain Baker, the police were successful in getting the maskers to parade without their sticks. However, in 1881, the maskers refused to abide by the proclamation, which prohibited the carrying of sticks in the streets during Carnival. A confrontation ensued between the maskers and the police, resulting in casualties on both sides. Eventually, groups or bands of stickfighters were banned from the street Carnival.

17. The military characters were based on personnel on board ship. Hence, the Stoker danced incorporated elements of his occupation of stoking the fire.

18. This type of costume was popularly known as cloth mas. This term made reference to the large quantity of cloth used to fabricate the costume.

19. Sumari was performed by East Indian males.

20. At one point, boys and girls danced the Maypole. Now, mostly girls participate in the dance.

21. In the early 1950s, Andrew Pearse was a visiting professor at Northwestern University, where he met and worked with Melville Herskovits. At this time, Daniel Crowley was a graduate student of African art under the tutelage of Bascom and Herskovits.

22. The Sande or Bundu society, among such groups as the Mende, Temne, and Vai, is the only female society in which women wear and dance with wooden masks.

23. As a student of African art under the tutelage of William Bascom, Crowley was very familiar with West African masking practices.

24. Williams is drawing on W. E. B. du Bois's concept of the Talented Tenth. Du Bois believed that the duty of the 10 percent of African-Americans who constituted the intellectual elite was to educate and lead the less fortunate masses. See his *Dusk at Dawn* (New York: Shocken Books, 1940).

25. This Carnival portrayal was judged in the Indian (Native American) or Warrior categories. *Heroes of the Dark Continent* depicted Africa as wild and uncivilized.

26. By using the structure and costume aesthetic of the historical mas genre, Baily cleverly re-presented Africa as having a history that was worthy of portrayal. The sumptuous quality of many of the costumes also placed the band, and Africa, in the pretty mas category.

27. The concept of homeland was important to Eric Williams. Prior to the 1950s, Africa was not valued as an acceptable homeland. By 1962, the year of independence, Williams would put forth Trinidad and Tobago, the newly independent nation, as the new motherland. In a famous speech,

he declared, "There'll be no mother Europe, mother India, or mother Africa, only mother Trinidad and Tobago."

28. Williams's particular imagining of the new nation had its parallel in the visual arts. Black artists began to look to Trinidad's landscape, its people, and their folk practices for inspiration and subject matter. For example, such artists as Boscoe Holder and Dermot Louison painted the local landscapes as serene and timeless. Noel Vaucrosson's *Bele* (1957) depicted the popular drum dance that eventually became one of the national dances. Alfred Codallo's *Kalinda* (1957) and *Wake* (1957) also made reference to the cultural practices of the black folk. Dancer and choreographer Beryl McBurnie would include such folk dances as Bele and Dongo in her company's dance repertoire. The cultural and political visualizations of the new nation were intertwined and, also, heavily invested in the black folk and their practices.

29. Black militancy was a mixed bag. While the Military and Indian mas may have symbolized some degree of subjectivity and agency, these portrayals were popular among the nascent steelbands. With the exception of 1954, fighting among steelbands occurred every year of the 1950s.

30. *Trinidad Guardian*, February 22, 1988. In 1988, in the first live television broadcast of Carnival, many women maskers used the media to perform exaggerated versions of wining.

31. Some newspaper articles inadvertently included men when they mentioned the behavior of adults. However, none of them singled out men for their Carnival behavior. Only women were, and are, repeatedly singled out for their "obscene" behavior.

32. I use the word *indirect* because I know that the supporters of the traditional mas characters will say that they are not supporting violence and aggressive behavior. The point that they are missing, however, is that a character's costume and his performance are inextricably linked, and we can't have one without the other. For example, the Midnight Robber is not a Midnight Robber until he gives his boastful speeches. A Midnight Robber who does not recite boastful speeches is generally dismissed; he is an imposter. So when we lavish praise on a Robber or Stickfighter, we are also praising his unique performance, be it boasting or fighting.

33. While many lament the absence of men in contemporary mas, this does not present an accurate picture. There are many men who play mas, and there is also a large contingent of men who are the musicians providing music for Carnival bands. Men also provide security for many of the bands with large numbers of women dressed in sexy costumes. Men are also involved in the behind-the-scenes organization. Therefore, men are very active in mas, both in front and behind the scene. They are just not the numerical majority.

Rara in New York City:
Transnational Popular Culture

Elizabeth McAlister

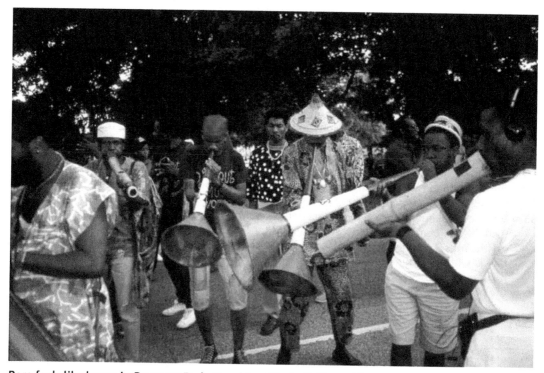

Rara feels like home in Prospect Park, Brooklyn *(Photo © Chantal Regnault)*

Woy Woy Woy
Why Why Why
That's right, That's right
The police can't stand to see Black [people]

Woy Woy Woy
Why Why Why
Se sa, se sa

La polis pa vle wè nwa

Rara Djakout, Prospect Park, Brooklyn,
August 1994

Reprinted with permission from *Rara!: Vodou, Power and Performance in Haiti and Its Diaspora* (Berkeley: University of California Press, 2002), 183–207.

"Let's talk in Prospect Park, Ti-Madame," suggested Chiko, a Haitian musician I wanted to interview on immigrant religion. That summer of 1990 I was studying Afro-Haitian religious practice, analyzing the ways that oungan *and* manbo *must reconfigure ritual to adapt to the commodification of space and time in the New York setting. When we arrived in Brooklyn's largest park for the interview, we abruptly came face to face with the slapping drum rhythms and loud songs of hundreds of Haitian people dancing and singing. "This is Rara," shouted a pleased Chiko. I recognized some of the faces in the crowd from Brooklyn's vibrant Vodou ceremonies. A flag bearer headed the procession, followed by a line of drummers. Directly behind them was a row of young men blowing bocketed notes on* banbou *and* klewon. *My tape recorder stayed inside my pack, and the interview was abandoned. What was this festival? Where did it come from? What was it doing here?*

The dancing crowds numbered in the hundreds. Young Haitian women stood by, wondering how far to get into singing the betiz *that were starting to fly. Older ladies wheeled babies in strollers alongside the parade. This event was free, outdoors, and easy to find. I could tell that for them it felt, smelled, and sounded like home.*

There was a lot going on – it looked like Carnival, but it also felt like Vodou. Speaking to the people present, I learned that many did not know a great deal about the history of this parade or its relationship to Vodou, but they nevertheless valued it enormously. The musicians were more knowledgeable – they told me it was a mystical festival, a dangerous festival, and, in Haiti, an old festival.

This encounter, minutes from my apartment in Brooklyn's Park Slope, was my first experience of Rara. Before that moment, I had barely heard of the festival. As I began to mill around and get a sense of the scene, I saw that this festival, and the experience of immersing themselves in it in New York, was a precious, emotionally charged celebration for the young men who were its performers. They were throwing themselves into the music and losing themselves, as in a Vodou dance. It seemed like a sense of community solidarity took form in the bodily experience of performing Rara in New York. Seeing all this led me to Haiti to research the present study on the meanings and uses of Rara.

Though there has been a significant Haitian population in New York for the last thirty years, an organized Rara had never been celebrated before 1990.[1] There had been moments of spontaneous Rara performance during political confrontations. Bursts of Rara singing and music erupted in Miami and New York at demonstrations against the Duvalier regime in the early 1980s and also during strikes involving Haitian labor groups. But the summer of 1990 saw something new: a full-blown Rara every Sunday, the same people returning each week to socialize, dance, and augment the singing. Only five years later, in 1995, four separate Rara bands assembled in Brooklyn's Prospect Park and Manhattan's Central Park to play each summer weekend. Like the Raras in Haiti, the New York scene was dominated by men, but unlike Haiti, there were no queens, and the women on the scene were mostly relegated to the sidelines. Lifted from its Lenten context to fit the summer weather, Rara in the United States is a secular affair, and the *lwa* have not (yet) demanded libations, trips to the cemetery, or mystical seven-year contracts.

The people who gather each week have extended Haiti's grassroots popular culture onto their local U.S. terrain. The bands created entirely new lyrics to speak of the New York experience, and these new songs were carried to families and circulated in neighborhoods after the Rara. Today, Rara in New York has come to express a point of view about the Haitian immigrant predicament.

The Rara in New York is not a local phenomenon, however. The movements, ideologies, and economic transactions of Rara actors in the United States mirror the more complex realities of Haitian immigrants whom social scientists are now defining as "transmigrants." Transmigrants sustain social relations that link together their societies of origin and settlement. They may support

houses in Haiti with jobs in New York. They may keep their children in Haiti. Transmigrants live, operate, and "develop subjectivities and identities embedded in networks of relationships that connect them simultaneously to two or more nation-states."[2] Indeed, when I began to walk in the Raras of Port-au-Prince, Léogâne, and even the more remote Artibonite Valley, I encountered young men from Brooklyn who were home for vacation or, more profoundly, who had returned to walk in pilgrimage in a family Rara.

Rara performance, with its roots firmly in Haiti, now has a role in a wider transnational Black Atlantic popular culture. Performance and attendance at Rara festivals took place as Haitian people moved back and forth between home villages in Haiti and points in the United States. A song created in Léogâne could be sung in Brooklyn a week later, creating a deterritorialized popular Haitian discourse that allowed traditional knowledge rooted in peasant culture, now inflected with the diaspora experience, to circulate internationally throughout many Haitian social spheres. Rara music and performance are in dialogue with the Haitian branches of dancehall and hip-hop culture (that include Wyclef Jean, Bigga Haitian, King Posse, and Original Rap Stars). But as a particularly Haitian genre that large groups parade in public, Rara occupies a singular space that has unique possibilities for communication and performance.

Rara performance has been widely deployed as a political weapon in mass demonstrations. In Haiti, Raras protested the 1991 attempted coup d'étar against Aristide by Roger Lafontant. One Rara member explained, "When they uprooted Lafontant that's what they used. They used *vaksin*, drums, and tree branches. Because when you beat the drums the spirits are ready to come. They know the call."[3] After Aristide was ousted later in 1991, musicians and their singing followers played for weeks on end at the United Nations and in rallies at Washington's Capitol Hill. Rara's combined religious and military ethos lent force to these moments, when the ritualized Rara "battalions" performed their opposition to the coup. Rara bands also gathered more recently in New York to sing and protest during demonstrations against the New York police's brutality in three cases involving African and Haitian men: Abner Louima, Amadou Diallo, and Patrick Dorismond.

Rara songs have made their way onto record albums by *mizik rasin* groups that have flourished since the fall of Duvalier, but the Rara activity I describe that is taking place throughout the diaspora consists of social organization, songwriting, and musical performances that are community-produced and noncommercial. The folk societies, "imagined governments" that dispatch Rara armies in Haiti, are replaced in New York by transmigrants who sculpt an imagined national terrain on the popular level in New York. Within this Brooklyn-based "nationscape." Rara members in locations in the diaspora can *chante pwen* to the Haitian military, to Haitian presidential candidates, to the New York police force, and to other ethnic groups in Brooklyn.[4]

Though the literature on transnationalism has tended to focus on leaders and the politics of the nation-state, transmigrants at the grassroots level use popular culture to reterritorialize both their practices and their identities. The weekend festivities in Brooklyn have made room for an unprecedented social sphere in which youth from a plurality of classes learn peasant culture in order to be viewed as authentic Haitians among their peers. In consciously performing peasant culture, Haitians are contesting both Haitian middle-class values and dominant Euro-American values. By rediscovering and embracing their African roots and their specific history through Rara, Haitians are privileging an identity that is distinct from whiteness yet is unique among other African-American groups. In creating this specific Haitian identity, Haitian transmigrants are rejecting U.S. racial categorizations.

Transnationalism and the Raraman

Theoretical work by Linda Basch, Nina Glick Schiller, and Cristina Szanton Blanc that analyzes transnationalism builds on Immanuel Wallerstein's "world systems" framework, in which geographic regions perform different and unequal functions in a global division of labor. "Core" areas control and dominate production, while the natural resources and labor of the "periphery" are exploited.[5] Those who have augmented Wallerstein's work characterize the past several decades in terms of new levels of capital penetrations into "Third World" economies, the development of export processing, and the increased migration of people from the peripheries to the centers.[6] What is important for the discussion here is that economic conditions – the international division of labor and the new transnational forms of accumulation of capital – are affecting both the flows of transmigrant activities and "the manner in which they come to understand who they are and what they are doing."[7]

Transmigrants use their international ties to make strategic economic decisions in their best interests. Many people work in the United States but leave small children with family in Haiti, or collect rent on property in New York while retiring in Haiti. Basch, Glick Schiller, and Szanton Blanc see immigrants' building transnational social fields as a form of resistance against national hegemonies; however, they also see these strategies as paradoxically perpetuating their economic exploitation within the international division of labor.

My discussion of Rara as transnational popular culture focuses on theoretical inclusion of the social, cultural, and political dimensions of immigrant experiences. The Rara *ti nèg* who dances and sings in the street bands of New York may have migrated from Haiti to seek employment, or he may have been raised in New York. Most likely, however, the Rara *ti nèg* is carving out an identity as a "Raraman" in Prospect Park because of the time he has on his hands as a member of the classic "reserve army of labor," the sector of the working class that capital cannot employ – or the sector that is underemployed.

Migrant workers like the Raraman now form the basis of the modern industrial reserve army.[8] As Stuart Hall notes about Black people in Britain, the strategies for dealing with unemployment that these men develop must be seen as doubly positioned within their colonial history and their present underemployment.[9] Indeed, I suggest that the subjectivities of young Haitian men must be viewed as multiply positioned within their original colonial history, their class positions in contemporary Haitian society, and their newly found predicament as "racial minorities" in the United States.

This last point is particularly significant: racializations and racisms are processes in historical evolution and are both historically and culturally specific. The ways in which the Francophone and Anglophone West Indies developed racialized societies have resulted in particular configurations, ones that differ from contemporary U.S. racial codes.[10] Haitian-Americans' identity and subjective positions of racialization must be seen as being superimposed onto their new experience of U.S. constructions of race. Part of the challenge facing new Haitian immigrants is in assessing and renegotiating their newly found racial states in the United States.

One side of this strategy on the part of young Haitian men has been to cultivate styles and philosophies within a popular movement based on peasant tropes and quintessentially Haitian activities such as Rara. As a public, festive occasion when people can fashion and perform identities, exchange information, and create reputations, Rara has become a central form of activity in the emerging *rasin* movement.

Secular Raras in Diasporic *Rasin* *Culture*

The first Rara to form in New York in the summer of 1990 was created by musicians who were part of the recent *mizik rasin* movement that became viable in Haiti after the fall of Duvalier. Although there had been commercial music based on Vodou and Rara drumming in earlier periods of Haitian history – Voodoo Jazz of the 1940s and 1950s and the kilti libète (freedom culture) of the early 1970s – this music was thwarted by Haiti's Eurocentric codes and by the dictatorship itself.[11] In the late 1970s during the rule of Jean-Claude Duvalier, musical groups began to form that were influenced by the nationalisms of the U.S. Civil Rights struggle and Black Power movements, the rock music of Carlos Santana and Jimi Hendrix, the reggae of Bob Marley and the Wailers, and other musical styles of the African diaspora. Called Gwoup Sa, Moun Ife, then Sanba-Yo and Foula, these 1970s collectives developed musical styles that crossed the indigenous Vodou and Rara-based music with the codes of commercial pop music.[12] The groups were formed and re-formed by young men – and fewer women – who desired to be known as professional *sanba*.

After the dictatorship collapsed in 1986, a small cultural space opened up allowing this traditionalized music to emerge in the public sphere. Musicians were able to rehearse, carry their instruments in public, and book time in recording studios. *Mizik rasin* groups Sanba-Yo and Foula performed at the Port-au-Prince Rex Theatre and even Haiti's space for high culture, the Institute Française. The group Sanba-Yo recorded a song called "Vaksinen" (Vaccinate) as a radio public service announcement encouraging parents to vaccinate their children. Its catchy, upbeat melody broadcasting its lively message was sung on the breath of anyone with a radio – the majority of people in Port-au-Prince.[13]

Duvalier's *makoutes* had responded to long hair on men with arrests and beatings. After Duvalier, the musicians in these groups began to wear their hair in long locks and to self-consciously adopt peasant styles of dress – straw *djakout* shoulder-bags, leather sandals, and pants rolled up at the cuffs (signifying fieldwork and also, in a second sense, spirit possession). By embracing the negative connotations of Rara, the *ti nèg* transformed himself into a stylish "drummer-hero," the Raraman who, by spinning traditional lyrics into new, politically relevant music, expressed his verbal exhibitionism as a classic man-of-words.[14]

A group of men who had been involved in these early bands were now transmigrants. Some of these *rasin* musicians were funded by white, Black, and Japanese-American women whom they had married or lived with in New York. Using their charisma as *sanba* and artists, some left their Haitian wives for American women. In so doing they attained the prized "green card," or permanent resident status: this crucial legal standing allowed them to travel back to Haiti. In some cases, the men had public relationships with American women but maintained hidden relationships with their Haitian wives, who were often the mothers of their children. Haitian women lost relationships, resources, and status in this equation, which shows how sexuality, race, and national status are interrelated within issues of migration and this Caribbean popular movement.

Part of the *rasin* musicians' impetus for forming the Rara in New York was a perceived snub they received from other local drummers. During a particularly bad heat wave in 1990, they were escaping their apartments in Prospect Park, listening to the rhythms emanating from a large drumming collective of African-American and West Indian people near the Parkside entrance. According to Fito Vivien, "I saw a bunch of Jamaicans or Africans who were playing drums. We asked if we could play their drums and they said no – they looked at us funny for asking. I said to myself, OK, I'll come back and show you!"[15] The *rasin* musicians disappeared into the home of a friend they knew who had drums, then came back the next day playing Rara and walked past the

stationary drumming circle. Soon enough, the forces of *teledjol* (word of mouth; literally, "tele-mouth") brought out hundreds of other young people with free time and the inclination to sing. These other Haitians joined in the Rara and walked, danced, and "threw" songs, making each Sunday evening a community event.[16]

After spending the summer documenting the emergence of Rara in New York, I decided to visit Haiti during the next Lenten Rara season to trace the "historical source" of the New York Rara. I was operating under a premise that in tracing the festival back to Haiti I would find a more archaic, original practice. However, the currents of transnational popular culture had short-circuited my assumption. When I arrived in Port-au-Prince, the best-attended Rara was founded by some of the very same people who had formed Rara Djakout in New York.

Rara Nou Vodoule was a Rara whose headquarters near the main cemetery in Port-au-Prince became a gathering place for thousands of urban youth. Their song "Pa Vle Zenglendo" (Don't want criminals) was well-known by most downtown residents. It was a secular Rara, unsanctioned by the *lwa*, that took advantage of the decrease in violence under Aristide to dance in the streets and *pran plezi* (have fun). It was founded by members of Sanba-Yo and Foula, some of whom were raised in Protestant (Baptist and Seventh-Day Adventist) churches. The connection to literacy and the church gave these men's families an upwardly mobile status. They were now "returning to roots" and engaging in the project of consciously traditionalizing their own musical practice. Forming a Rara and taking it to the streets in direct competition with other Rara bands in the neighborhoods headed by sorcerers and Vodou societies was a way to popularize their own music, establish reputations as *gwo nèg*, and interact directly with the *pép-la* (common people).

Just as Haitian transmigrants move back and forth from Haiti to New York, creating a continuous sphere of social relations, so they have created a single popular culture in both countries through Rara music and performance. People in both the Rara Djakout in New York and Rara Nou Vodoule in Port-au-Prince spoke to me about what they called the *mouvman Rara* (Rara movement). Said one man called Yanba Ye, "The real revolution is our culture. This is the only solution possible for us, in the situation we're living in. It's a roots revolution."

The leaders of this *rasin* movement are the *sanba* who use their personal charisma, songwriting talent, and roles in *mizik rasin* bands to enhance their reputations and move into *gwo nèg* status. In the Rara movement, the role of the *sanba* becomes enlarged into a role of moral leadership. Said Yanba, "You can't do things that are not good for society and call yourself a *sanba*. You have to be straight." One of the ways a *sanba* is recognizable to others is through a system of style-signs with which he dresses. This is a style Haitians call "roots," and it is constructed with elements of Haitian peasant dress adopted in a direct refutation of European styles. Leather sandals are worn instead of tennis shoes; leather or seashell jewelry is worn instead of gold. Some people wear their hair locked, making a double religious and political statement. Not called dreadlocks as in the tradition of Rastafari, their locked hair is called *cheve Simbi* (Simbi's hair) and refers to its wearer's identification with the *lwa* called Simbi who is associated with water and sometimes snakes. Politically, long locks celebrate the newly won freedom from the Duvalier regime, when men with hair longer than a few inches were arrested. Some women cut their hair short or lock it in opposition to the ubiquitous permanent weaves most Haitian women wear in order to achieve French hairstyles. Some men wear Haitian straw hats and burlap shirts.

Style is a form of cultural bricolage, the reordering of objects to create fresh meanings within a total system of significances.[17] *Rasin* stylistic commentary contests the rigid, French-identified codes of Haitian society. In this sense Haitian men and women use bodily adornment to announce

their politics with respect to French cultural hegemony, their own African histories, and their pro-peasant positions within Haitian cultural politics. People responding to the *rasin* movement wear these styles in the Haitian provinces, in the streets of Port-au-Prince, and in southern Florida, Miami, New York, Boston, Chicago, Canada, and Paris. They mix *rasin* styles with local fashion and with the ever-changing styles of hip-hop culture.

The Haitian bourgeoisie has cultivated its French Creole national culture and French-based style partly in response to their wish to establish their equality with white people and to distance themselves from the international image of Haiti as a subordinate, primitive culture.[18] *Rasin* movement members, though some are from the bourgeoisie, wish to turn that image on its head and embrace it for its positive wisdom and history. The values of "acting bad" and "acting African," which in Haiti are associated with the "play" values of Rara, with Kreyòl, and with the popular classes, are reworked in this second diaspora. African values are enacted in a positive way, where they are validated and privileged.

A parallel process occurs among Jamaican young people who leave the island for school. "In Jamaica the middle class is increasingly being used as a negative referent. It is a move on the part of young persons...to adopt a more folksy working-class orientation."[19] They, too, sometimes cultivate a more obviously "natural" African image.[20] In fact, Haitian *rasin* styles have been developed through a broad cultural conversation with the Jamaican Rastafari movement, which made its way to Haiti through the reggae on the radio and through the interactions between Haitian and Jamaican migrant workers in southern Florida.

Rasin and Rastafari: Transnational Youth Roots Culture

The ideologies and styles of the Haitian *rasin* movement have without a doubt been influenced by the reggae music and the religiosity of Jamaica's Rastafari movement. Rastafari is the Jamaican religious movement whose members interpret the Bible to cast African people as the true Israelites who must return to Zion. The goal of the members of this millenarian movement is to be repatriated to Ethiopia, the nation that was ruled earlier in this century by the man they believe to be the second incarnation of Christ, Emperor Haile Selassie I. It is his precoronation name that the movement takes as its own: Ras Tafari.[21]

Although most Haitians have not embraced the worship of Haile Selassie as the messiah, some Haitian men have been influenced by Rasta "reasoning," the talent of oral philosophizing and debate. Haitian men appreciate Rastas' casting African people as central historical actors, their creative reinterpretations of biblical scripture, and their ideology of male supremacy. It is important to remember that Rastafari is not a fixed culture bur rather a cultural constellation that has moved through several stages; it is a social movement in historical process. By the same token, individuals move through Rasta "careers" and take different positions to the movement. The point here is that Haitians have encountered and befriended Rastas of various stripes and have embraced many of the fundamental tenets of what has itself become a transnational Rasta culture. Haitian women may be sympathetic to Rastafari, though for a variety of reasons fewer women lock their hair and adopt explicit Rasta-affiliated identities.

Some Haitians, especially those who have lived in Florida, wear locked hair under Rasta tams woven in the combined colors of the Ethiopian and Garveyite nationalist flags: red, gold, green, and black. They share Rasta values of simple, non-violent living and the Ital vegetarian diet. The English they learned in Florida is Jamaican English. *Roots* is a word in Iyaric (Dread Talk), the Rasta inner-language, connoting that which is chemical-free and natural, African-based, or non-exploitative.[22]

Although it is impossible to document, the term *rasin* probably originated with this Rasta usage.

An early grassroots band that formed in Miami in the late 1970s was called Rasta Sanba Ginen. Mixing Rasta styles with Vodou references, the band members played Vodou rhythms along with the *nyahbinghi* drumming of Rasta meditative music and called their gatherings *binghis*, the Jamaican term for an all-night ritual drumming and chanting circle. The group was a cultural beacon for youth interested in the communal values of Haitian country living, formed by men who were political exiles and could not return to Haiti.[23]

When Duvalier fell in 1986 and a cultural space opened up for the emergence of the *rasin* movement, some of these young men and their wives moved from Florida to Haiti or to New York and refashioned their cultural identities. They abandoned part of their Rasta ideology and reformed their thinking based on the symbols and rituals of Vodou. One example of this rethinking involves the use of salt: the Ital diet of the Rasta excludes salt, but the figure who does not eat salt in Haiti is the *zonbi*, the person whose soul has been stolen. Haitians shifting from Rasta to *rasin* moved to reincorporate salt and meat into their diets. Similarly, they had grown long hair that they called dreadlocks in South Florida. In New York they began calling their hair *cheve Simbi* and referred to themselves as *zing*.[24] In rural Haiti, when children are born with locked hair (or a caul over their face) they are considered to be under the special protection of the *lwa* Simbi. A *zing* is a person who wears locked hair from birth and cannot bathe in rivers and streams for fear of being swallowed up by the spirit. Haitians who had organized their diet and grown their hair in the context of Rastafari philosophy moved to traditionalize their practices in the context of this new Haitian *rasin* movement.[25] Their movement away from Rasta and into *rasin* coincides with the right-leaning political shifts in Jamaica that accompanied the ousting of Manley by Seaga. This period of Reaganism and Thatcherism was a difficult time for Rastas. Reggae culture itself shifted at this time toward "slackness," or sexualizing vulgarity.

On 11 May 1995, the fourteen-year anniversary of the death of reggae superstar Bob Marley, an organization was founded in Haiti called Mouvman Rasta Faray Ayisyen (Haitian Rastafari Movement). This was a group of young men who had made their way back from Florida to Haiti in the years following Duvalier. "The Fari movement has already taken hold. There can be no democracy without the Rastafarians. We walk to the rhythm of love, justice, freedom and equality for every person," said their spokesperson to the Haitian press.[26] Being Rasta within Haiti becomes a mark of distinction, another position from which to make vocal demands of the present government.

Both Rara and the Jamaican reggae music enjoyed by Haitians is rivaled and cross-fertilized by the growing diasporic hip-hop and dancehall cultures. Haitians in Haiti and its outpost in New York have been involved in hip-hop culture from early on, and young Haitians were part of the earliest formulations of hip-hop that were produced by youth in the Bronx in the late 1970s. Haitian immigrants were among the "crews" of young African American, Latino, and Caribbean artists who threw outdoor competitions of break-dancing, DJ-ing and rapping. While Jean-Michel Basquiat (the graffiti artist of Haitian descent) rose to fame in fine art circles, young Haitian rappers like "Jamerican and Sha" and DJ Frankie spun records in Roberto Clemente Park in the Bronx. They looked up to the more successful Bigga Haitian, who made LPs in which he rapped and toasted in both Jamaican English and Kreyòl.[27]

In the early 1990s, groups in Haiti like King Posse and Original Raps Stars made albums and music videos that combined dancehall raggamuffin and hip-hop styles, and their songs and their accompanying dances made their way into Carnival and Rara performance.[28] Wyclef Jean, himself a Haitian immigrant, rose to stardom with the group The Fugees and began recording raps in Kreyòl,

which he released independently to Haitian radio in Port-au-Prince. He performed in Haiti several times, both with The Fugees and solo, as part of the Bouyon Rasin music festival in 1995. When he released his 1997 solo album, *Wyclef Jean Presents the Carnival,* he used Kreyòl in several songs, announcing and displaying his Haitian identity. The critical acclaim and high sales of the album gave Kreyòl language and Haitian participation in hip-hop new visibility. A track on his next album, *The Eclectic,* featured the well-known Slogan constantly recycled in Carnival and Rara (and recorded in Boukman Eksperyans' best-known Carnival song, "*Ke'm Pa Sote*" (My heart doesn't leap / I am not afraid): "Grenn zaboka sevi zòriye anba l'acha'w – aswè-a m'p'ap dòmi – Yas! – yas Maman!" (A rough translation of this slogan would be: An avocado seed will be your pillow tonight – I won't be sleeping – Hey – Hey Mama!) This clear sonic *pwen* signaled to Haitian fans throughout hip-hop culture that the Haitian popular culture of Carnival and Rara was indeed part of hip-hop.[29]

Apart from the strong political and aesthetic influence that Rastafari and hip-hop have had on *rasin* culture, the profound effects of zouk music on all Haitian music, including *rasin* music, should not be underestimated. The mid-eighties saw the spectacular rise of zouk with the band Kassav, comprised of members from Guadeloupe and Martinique who now live in Paris. Kassav made over twenty albums from 1985 to 1990, some of which went gold. Their music was imported and consumed enthusiastically by transnational Francophone youth culture in Dominica, Saint Lucia, Haiti, the United States, Canada, Paris, Belgium, Switzerland, and West Africa.

The heavy use of brass instruments and the dancehall quality of zouk gave it an association with *konpa direk,* the Haitian dance music based on merengue rhythms. However, zouk lyrics were more politically substantive, preaching messages of emancipation, social harmony, and cultural consciousness. In addition zouk is sung in Creole, giving voice to the tribulations and celebrations of Creole West Indian identity and implicitly resisting French cultural hegemony still active in the island *départements* of France.[30]

While zouk music buttressed *rasin* music in certain ways, the influences of zouk on *rasin* are limited. Zouk musicians, from the relatively prosperous French islands, have not cultivated a "rootsy" style of adornment, or an engaged activism. In many ways, the classic image of the "downpressed" Rasta with long dreadlocks and a walking staff who calls thunder and brimstone down on Jamaican society as he negotiates the slums of Kingston is a more powerful source of identification for the Haitian Raraman.

Rara and **Rasin** *as Cultural Creolizations*

Both Rastafari and *rasin* are marginalized, poor people's movements led by Third World men who build community in performative gatherings called *binghis* and Raras; these performances give way to the commodified forms of Reggae music and *mizik rasin.* We can place the emergence of these various roots movements in broad historical context. As Hall notes in his essay on Black popular culture, three factors coutribute to the emergence of contemporary constellations of Black popular expressions and the current scholarly work around them. First is the displacement of European models of culture and of Europeans as universal subjects. Second is the present dominance of the United States as the center of global cultural production and circulation. Third is the decolonization of the Third World and the construction of decolonized sensibilities and subjectivities.[31] These factors are giving way not only to forms of Black grassroots popular culture (which, of course, have existed since Black peoples arrived in the Atlantic world) but also to a new kind of self-consciousness about this culture on the part of its makers and its audiences.

In the New York setting, Rara gatherings create an in-between world that is not the Haitian countryside but is also not typical of metropolitan New York. The gatherings are not quite traditional,

though they are not wholesale inventions. In seeking to establish social cohesion through reference to tradition in the midst of rapid social change, Rara in New York displays many of the characteristics of "invented tradition" in the way E. J. Hobsbawm and T. O. Ranger define them: "a set of practices, normally governed by overtly or tacitly accepted rules and of a ritual or symbolic nature, which seek to inculcate certain values and norms of behavior by repetition, which automatically implies continuity with the past."[32] But in a real way, Rara was not absent from people's lives long enough to be "invented" or revived. Writing on similar issues in the history of Yoruba religion in Cuba, David H. Brown maintains that "the issue of self-conscious rediscovery of 'African roots' encourages a more open and responsive notion of 'tradition,' one in which 'reafricanization' is as sensible as 'African survivals.'"[33] Rara in New York is a conscious and cooperative project that occurs as a process of change, with continuities and discontinuities.

When young Raramen make circular journeys playing Rara in a home village in February and in Brooklyn in June, new cultural relationships are created out of old "center" and "periphery" arenas. Ulf Hannerz has stressed that with respect to the domains of popular culture, center-periphery relationships must be seen as a continuously emergent historical structure, with a new kind of polycentricity in this transnational era. It is true that Haitians still travel to the French centers of Paris and Belgium for education in the centers of previous empires, or, more commonly, to the current centers of the United States and Francophone Canada for school and work. But the popular interest in Rara has altered the logic of the center-periphery flow. Roots-identified Haitian New Yorkers turn their gaze to Port-au-Prince and the *moun deyo* (people outside) in the rural provinces often to the consternation of their parents. What is more, their attraction to Rastafari has given Haitians another cultural center – Kingston and its countryside. With little direct movement between Port-au-Prince and Kingston, these two peripheries have become centers of popular culture bridged by the original centers of New York and Miami. Likewise, in the case of zouk music, Haitians in Port-au-Prince sing along with Martiniquain in Fort de-France via the connecting center of Paris. Thus the traditional center is still important to "structure access to the global cultural inventory," as culture tends not to flow straight from one periphery to another. These peripheries are themselves centers of knowledge and cultural activity.[34] The spatialization of cross-dialogue within populations in the African diaspora helps form an understanding of the patterns of creolization that are taking place among diverse and sometimes far-flung groups in the Black diaspora.

It is only by shifting our perspective that we can understand the ways in which "minority" cultures are formed and influenced by one another. Diasporic groups construct themselves not only with reference to the dominant culture of their own nation-state, but also with respect to other Black groups both near and far. It thus becomes clear that the process of identity building is coproduced with other minority communities, and not just against hegemonic groups. Identities are influenced in their processes of formation and redefinition by both local and distant forces.

The Cultural Politics of Transnationalism: Roots Identity in New York City

Rara Nou Vodoule *ekzésis* in Port-au-Prince, Rara Djakout gatherings in New York, and the Rasta Sanba Ginen Bingis in Miami carve out an alternative social space for Haitians to develop new peasant-identified, re-Africanized identities. Because the spaces are linked by continuous interactions of people traveling back and forth within them, the forces of transnational migration have generated *rasin* culture, like its Rasta counterpart, as a deterritorialized popular culture. No longer linked just to Port-au-Prince, this space is created any place in the Haitian diaspora that a *sanba* manifests his or her philosophy and style.

As I have mentioned, the Haitian roots identity is produced out of earlier *indègenisme* and *négritude* movements within Haiti, as well as U.S. Black Power ideologies and Jamaican Rastafari. In a sense, then, the philosophical base of the movement was already transnationalized, with roots in both Pan-Caribbean and U.S. antiracist struggles. Being openly roots-identified, however, is a relatively new option for Haitians inside Haiti.

Theories of a fixed ethnic identity are now giving way to questions about the processes of identity formation, the manipulation of identity, and the situational variability of identity.[35] Fredrik Barth in 1969 was the first to argue that ethnicity is the product of social ascriptions, developed out of the view one has of oneself as well as the views held by others – the result of a dialectical process involving internal and external identifications and designations.[36] Current theoretical work explores the subjectivities and struggles that are now constituted around race, nationhood, gender, sexuality, and transnational political economy. Gage Averill has noted that "the effort to create a roots music culture in Haiti after the fall of the dictatorship is a musical corollary to populist political movements and represents a musical discourse that has the potential to cross class and geographical lines in Haiti."[37] The social position of the roots-identified *sanba*, although it implies downward mobility, nonetheless gives Haitian youth a status based on distinctiveness and personal creativity; some have even parlayed this status into celebrity in *mizik rasin* bands. This identity, and the community it implies, is a unique product of the post-Duvalier era. Not only is it a new phenomenon in the Haitian community, but the "Haitian community" itself did not always exist in New York, despite a large Haitian population. Transnational politics and a revived Haitian nationalism all played a part in the construction of Haitian roots identity in the 1990s.

Glick Schiller and a team of social scientists have conducted extensive research on Haitian organizations to chart the emergence of the Haitian-American community and the construction of Haitian ethnicity in the United States.[38] Her convincing conclusion is that the concept of a Haitian ethnic community was taught by representatives of American institutions to members of the Haitian immigrant population. These institutions have included the Democratic Party, the Ford Foundation, the Center for Human Services, and various church groups. Glick Schiller sees the construction of Haitian-American ethnicity as a move on the part of hegemonic interests to create constituencies and interest groups that could be manipulated for various political reasons. Her work focuses mainly on Haitian leadership and the "higher" levels of Haitian politics. I suggest **that** the sense of ethnic community created by U.S. groups in turn spawned a public popular culture that has since leveled powerful and effective critiques at U.S. domestic and foreign policy and become a factor in U.S. policymaking decisions.

Although it is impossible here to present a detailed history of the Haitian population in New York and its construction as an ethnic community, it is necessary to stress several points about Haitian immigration to the northeastern United States. There has been a significant Haitian presence in New York since the 1950s. But a historic downward spiral of economic and political devastation in Haiti, added to the abuses of the Duvalier regime, forced hundreds of thousands of Haitians into exile, and huge Haitian enclaves grew outside Haiti. Now an estimated four hundred thousand Haitians live in the New York metropolitan area alone. These numbers are impossible to verify, both because the U.S. Census Bureau does not distinguish between African-American and West Indian ethnicities, and because many Haitian immigrants are undocumented.[39] In any case, estimates suggest that the Haitian presence is large and that it is growing: already Haitian Kreyòl is the second most common foreign language after Spanish in the New York City public schools.[40]

A common perception among North Americans is that Haitians are poor and uneducated. The reality is that most Haitians who immigrate are not from the lowest social classes. In fact, people of

all class backgrounds have immigrated. Some 80 percent have had previous work experience, and 50 percent own their own homes in Haiti. Immigrating to New York eases the effect of poverty for the lower classes, but the upper classes experience a loss of status when they arrive in New York.[41]

Perhaps the most salient point about Haitian-American identity is the fact that the social cleavages that exist in Haiti are played out in the Haitian population in New York. Class, color, gender, religious, regional, and language differences have tended to divide Haitians and thwart their attempts at organization.[42] Despite this fact, outside events have forced to some extent the consolidation of a Haitian community and sense of Haitian ethnicity. During the tragedy of the *bòt pipol* (boat people) in the late 1970s, when many people lost their lives attempting to flee Duvalier, Haitians in the United States faced rejection based on associations with this stigmatized group. This stigma precipitated the construction of a Haitian community by Haitians themselves as they began organizing large political demonstrations against U.S. refugee policy.[43]

Then in 1990 the Food and Drug Administration (FDA) issued a ruling that banned Haitians from donating blood, declaring them transmitters of AIDS.[44] Again, Haitians held massive demonstrations in New York, Miami, Boston, Chicago, and even at the U.S. Embassy in Port-au-Prince.[45] Rara musicians played drums at the demonstrations, and songs were "thrown" critiquing the discriminatory practices of the FDA. In an event unprecedented in Haitian history, sixty thousand Haitians and their supporters walked across the Brooklyn Bridge in New York on 20 April 1990 and forced the entire city to become aware of the racism in the AIDS issue. Later that day Father Aristide delivered "electrical antiphonal oratory," casting the anger of the crowd into transnational perspective. Karen Richman writes that Aristide painted a picture in which Haitians'

> continued insecurity in the United States was an inevitable product of the unholy union between Home and Host states. Aristide's speech elaborated a triadic pun based on the rhyming Kreyòl words of SIDA (AIDS in French or Kreyòl) with siga, or cigar and the well-known idiom, "*men siga ou,*" literally, "here is your cigar," meaning, "surprise!" or "it will never happen the way you intended."...Haitians had become a bold cigar lit at both ends to resist the machinations of its imperialist smoker and the "pimps" and "house boys" campaigning in the upcoming elections back Home.[46]

With the entry of Aristide into the political arena, the popular classes in Haiti felt they had found a viable political representative. Aristide's use of Haitian Kreyòl and his policies for land reform and peasants' rights posed a real challenge to Euro-Haitian hegemony. These combined events in Haiti and the United States further opened the cultural space for the *rasin* movement.

Haitian Rara drummers were snubbed by Jamaican musicians in Prospect Park in 1990, just two months after they halted traffic in New York at the massive, exhilarating antiracism demonstration. Their creation of a parading Rara band was the moment in which Haitians girded themselves for an ongoing public display of their ethnic strength and national pride. Throughout that summer and each summer since, the Haitian Rara gatherings became an interpretive community that articulated a clear position with regard to the cultural politics in which they found themselves enmeshed. A popular politics emerged that was multiply positioned and that took a stance in relation to various historical processes.

The Raraman took up an ideological position with relationship to the War of Haitian Independence against the French (and by extension, all of Europe), the ruling Catholic Haitian elite, the hegemonic forces of "white" America, and other Black groups (Jamaicans, Trinidadians, and African Americans) in New York. The positions of the Raramen were often contradictory (or sometimes partial) truths and often obfuscated depressing realities, such as links between the *makoutes* and Vodou priests.

Definitions of Blackness in Haitian *Rasin* Culture

Seen as a subculture, the Raras can be analyzed in terms of a double articulation of relationship – first to the "parent culture" (Haiti), and second to the dominant culture (the United States).[47] Opposition to dominant America was implicit in the "rootsy" peasant dress styles and the activity of public Rara parading itself. It took the same form of physicality that it took in Haiti: hundreds of Haitian people (Black bodies) walking along the park road and singing. The potential of the Rara for political disruption was not lost on the New York City Police Department. On several occasions they arrived in squad cars with their lights flashing and attempted to direct the Rara off the park road and onto the grass to let traffic through the park. The reaction of some young men in the crowd, although incomprehensible to the officers, was a show of performative opposition. They formed a ring and danced in a circle, singing an improvised song:

Your mother's clitoris!
The police have come to "crash" the Rara

Kou langet manman-ou –
Polis vim pou kraze rara

The police were perceived as an oppositional force that was inherently racist. The refrain of one of the original songs composed by Rara Neg Gran Bwa in Prospect Park was "*La polis pa vle wè nwa*" (The police can't stand to see Black [people]). This feeling grew from the group's experiences in Crown Heights and Bedford Styvesant neighborhoods, where community-police relations are marred by police corruption and brutality.

Yet as the work of Carolle Charles shows, Haitians in the United States have tended to disaffiliate with Black Americans. Haitian immigrants are aware that Black people represent "the bottom" of U.S. society. Haitians self-identify as Black, but they link their Blackness to Haitian history through Africa and not through the United States. Haitians reject U.S.-specific racializations, sometimes saying, "I don't want to be Black twice." Previously the most common Haitian-American tactic was to self-identify as French. People who were Kreyòl-speaking and fully Haitian would present themselves socially as French by speaking the French language. Charles writes of high-school children who camouflaged their identity as Jamaican so as not to be known as Haitian; she also notes others' willingness to be called "Frenchies" in their efforts to disaffiliate themselves with African Americans.[48]

The *sanbas* and Raramen of the Haitian *rasin* movement have created a second alternative to the dilemma of Black identity for Haitian Americans. Rather than playing on their French roots, they can perform, through style and bodily adornment, a specifically Afro-Haitian identity. In this way Haitians express solidarity with other Black groups while nevertheless maintaining and privileging their Haitianness. By virtue of the early independence revolution in Haiti, this construction of Haitianness is felt to be implicitly closer to Africa and more in touch with its Blackness than some other African American groups.

Social class and year of migration from Haiti affect people's relationship to the Rara gatherings in New York. For example, recent immigrants from the Port-au-Prince slums, having performed Rara in Haiti, arrived in Brooklyn in 1990 and found Rara waiting for them. They picked up where they left off, so to speak, and found that their "authentic" talent in "throwing" songs was prized by their Americanized colleagues. The older bourgeois gentleman who left Haiti thirty years ago and sees Rara for the first time in decades reacts to the scene with ambivalence: nationalist nostalgia

mixed with class-based distaste. For the young Haitian American born and raised in New York, Rara may provide a key to the problem of identity and a milieu in which he can "learn" to be Haitian.

Tensions between the newly arrived Haitian and the established Haitian American play out in the Rara. The recent arrival, while most likely broke, not fluent in English, and possibly undocumented, may nevertheless be an accomplished drummer or a talented *sanba* who understands the process of songwriting and knows the codes of *voye pwen*. He can therefore present himself as the authentic Haitian, to the envy of the Haitian American raised in New York. The American Haitian, meanwhile, is envied by the new immigrant: he is literate, more likely to be established in a job, and able to navigate American culture. Rivalry and competition play out between the "Kongo" (someone who is too "country" or loud-talking) and the *biznisman* (an American Haitian who is too interested in money). At the same time, each desperately needs the other: the one for help in settling in as an immigrant, and the other to confirm a sense of Haitianness and culture.

Haitian Nationalism and the *Rasin* Movement

Haiti had the first and only successful slave revolution in Western history, a revolution fought by slaves with the inspiration of Vodou spirituality and magical weapons. Every Haitian is acutely aware of this chapter in history, citing the pivotal moment when Boukman, a maroon religious leader, held a ceremony in which he asked the Vodou *lwa* for assistance in the fight. This moment sealed the subsequent bond between religion and politics in Haiti. If Haitians have faced nothing but economic misery ever since, at least, they maintain, they have held their freedom. This has resulted in a fierce Haitian nationalism: a pride and an awareness that no other Afro-Atlantic country shares their achievement of revolutionary success. Haitians combat their status as one of the lowest groups on the economic ladder in New York by reiterating these symbols of independence.[49]

Nationalist tropes have assumed mythical status both in Haiti and in the diaspora, and early liberation fighters – Boukman, Makandal, and Dessalines – are constantly invoked in calls to unity among Haitians. But these same tropes also serve to distort other historical realities, like the continued downward spiral of the Haitian economy, the lack of a civil society that can support basic human needs like education and health care, and the dismal record of political despotism and foreign domination across Haitian history.

Because there are more economic opportunities in the United States than at home, Haitians in America can concentrate on working, on sending money back to Haiti, and on imagining a future where they will return to the island to live. They thus escape theorizing about U.S. racism because they consider themselves, as foreigners, outside racial conflicts.[50] By parading Rara – the strongly African, quintessential Haitian cultural form – they underscore to themselves and to other groups of African descent that their identity is fully realized through its own cultural roots. No longer one group against other Rara groups in local battle, the Brooklyn celebrations are first and foremost conceptualized as Haitians against everybody else, a cultural show of Haitian nationalism with respect to both whites and Black people in America.

While the Brooklyn Rara is a statement of Haitian ethnic distinctiveness from all other groups, the Rara is also, paradoxically, an affirmation of Afrocentric identity and Pan-Africanism. Because the celebration takes place in a country where Haitians become part of a Black minority, Rara members see links between themselves and other African peoples. One strong indication of this general African nationalism is in the style of dress of Rara members. In addition to traditional Haitian peasant clothing, Rara members sport Malcolm X shirts, Nelson Mandela buttons, leather medallions of Africa, kente cloth articles, and Spike Lee t-shirts.

Paul Gilroy draws attention to the way that "Africanness," signaled by such things as Malcolm X shirts, "operates transnationally and interculturally through the symbolic projection of 'race' as kinship.[51] The discourse of Black brotherhood and sisterhood, which of course stems from the Black Protestant tradition of seeing all people as "God's children," was perhaps strongest during the Black Power era but still operates in arenas as varied as the Nation of Islam and the voguing balls of Black gay culture.

Haitian tropes of nationalism centered on the concept of the people as army operate quite differently from the rhetoric of the family. A central concept in *rasin* culture currently is the aspiration to continue the "revolution" that Aristide's Lavalas movement began and, by extension, to continue the original slave revolt against Europe. Says Djames, a leader of Rara Nèg Gran Bwa in Brooklyn: "You take Rara, you take your drum, you go outside, and you start to make your revolution. Even if you only have a machete in your hand, the other guy has guns, you feel like you are ten thousand men. That's the kind of feeling that comes over us even though the struggle against the high classes has not yet been won."[52]

This militarized sense of Haitian nationalism came vividly to life in the events surrounding the coup d'état against President Aristide. Some of the Raramen in Brooklyn had appointed themselves Aristide's unofficial musical entourage, acting as a kind of signal drumming corps for his public speaking engagements in the United States. They welcomed him with the hocketing tones of the *banbou* at Kennedy Airport when he visited New York in October 1991, and they embellished his arrival and departure at the Cathedral of Saint John the Divine when he spoke there. When the coup d'état against Aristide was announced, they mobilized immediately to become a presence in the subsequent vigils and marches. With the active participation of the crowds that gathered around them, the Rara and demonstrators created new songs to express their political voice. The core members of Nèg Gran Bwa Rara played at the rallies at the United Nations, in Washington, and in the large New York demonstrations that outnumbered even the famous anti-FDA demonstration. Gone were the summer's songs, *"La Polis pa vle wè nwa"* (The police don't want to see Black [people]). New songs instead expressed the Rara's collective sentiment regarding the Cedras coup.

During these Rara protest demonstrations, Rara bands took on the militarized identity of an army of invasion, and members spoke of forming a Haitian "Bay of pigs" force to restore Aristide. The songs at the protest Raras after the coup did not follow the same logic as the statements given by Wilson Desir, the Haitian consul to New York, or even the statements given by Aristide himself. For example, many of the songs made reference to *Pè Lebrun* (necklacing) in a supportive light. *"Brule yo, brule yo"* (Burn them, burn them) were the lyrics of one of the more popular songs. Some Vodou songs were sung, substituting Aristide's name for the *lwa*.

Most people in the demonstrations seemed to support the presence of the Rara, despite a wide variety of class backgrounds. Even those people who informed me that they were unaccustomed to going to Rara in Haiti were supportive. They were of the opinion that, because this was a Haitian political demonstration, the Rara was appropriate and not a spiritual or political threat. I was told by many that plenty of the people dancing in the Rara would not have been doing so if they had been in Haiti. Their original class affiliations had become modified by their status in New York and by their solidarity with Lavalas.

The Rara gatherings in New York and elsewhere in the United States did not form an official organization. But Rara gatherings became a place where popular Haitian culture was enacted and a poly-vocal politics emerged, based on Rara performance principles of *voye pwen*, personal charisma, and songwriting talent. Rara can be seen as an attempt to solve problems in the social structure that

are created by contradictions and tensions in the larger society. The Rara solves, in an imaginary way, problems that at the material level remain unresolved.[53]

Haitian people performing Rara in New York are continuing an old historical tradition in order to consolidate their community, solidify their vision of ethnic identity, and further a political movement. The Rara wins symbolic and actual space for the Haitian community in the United States. It wins real time for Haitians to enter a liminal, healing mode of performance and to experience – or create – the form in which they traditionally take pleasure in their culture, to be in their "deep skin."[54] In this sense, Rara is an answer to the alienation and oppression many Haitians face in U.S. culture.

Rara in New York maintains its basic spiritual principles, but it is also a new entity with a new vocabulary and philosophy of progressive Haitian politics, a position allied with Pan-Africanism, with peasants' rights in Haiti, and against dominant America and the Haitian elite. Through the Rara, members of the Haitian community are choosing values of community, resistance, nationalist and ethnic pride, and racial solidarity in the performative mode of song, dance, and celebration.

Notes

1. Afro-Haitian religious rituals have been (and are) performed by Haitians in New York, but only in very private circles. See Karen McCarthy Brown, *Mama Lola*.
2. Basch, Glick Schiller, and Szanton Blanc, *Nations Unbound*, 7. See also Glick Schiller, Basch, and Szanton Blanc, *Towards a Transnational Perspective on Migration*.
3. Anderson, interview, Léogâne, 26 March 1991. Tree branches were carried by anti-Duvalier demonstrators as a visual pun on their intent to uproot him from Haitian soil.
4. See Benedict R. Anderson, *Imagined Communities: Reflections on the Origin and Spread of Nationalism*, rev. ed. (London: Verso, 1983).
5. Immanuel Maurice Wallerstein, *The Modern World-System* (New York: Academic Press, 1974), 229–31.
6. June Nash, "The Impact of the Changing International Division of Labor on Different Sectors of the Labor Force," in *Women, Men, and the International Division of Labor*, ed. June Nash and Patricia Fernandez-Kelly (Albany: SUNY Press, 1983). Also see Roy Bryce-Laporte, *Sourcebook on the New Immigrants* (New Jersey: Transaction Books, 1980).
7. Basch, Glick Schiller, and Szanton Blanc, *Nations Unbound*, 12.
8. See Richman, "They Will Remember Me in the House."
9. Stuart Hall, *Policing the Crisis: Mugging, the State, and Law and Order* (New York: Holmes and Meier, 1978), 381.
10. United States racial codes, also in process, are different from North to South: this work focuses on the particularities of New York in the 1990s.
11. The history of these groups is outside the scope of this discussion, but Gage Averill has outlined it well in Gage Averill, " 'Se Kreyòl Nou Ye'/'We're Creole': Musical Discourse on Haitian Identities," in *Music and Black Ethnicity: The Caribbean and South America*, ed. Gerard Behague (New Jersey: Transaction Press, 1994).
12. These pioneers of *rasin* music included Sanba Zawo, Sanbaje, Azouke (Gregory Sanon), Aiyzan (Harry Sanon), Godo (Patrick Pascale), Aboudja (Ronald Derencourt), Chiko (Yves Boyer), Tido, (Wilfred Laveaud), Bonga (Gaston), Lòlò (Theodore Beaubrun, Jr.), and many others. Women in the movement include Manze (Mimerose Beaubrun) and Sò An (Annette August).
13. This song was chosen in 1989 by filmmaker Jonathan Demme for a compilation album of Haitian music on a major United States label: *Konbit: Burning Rhythms of Haiti*, A&M 75021–5281–2 (1989). You can hear a song of Foula called. "Sovè" on *Global Gatherings: Authentic Music from Joyous Festivals around the World*, Roslyn, N.Y.: Ellipsis Arts, CD 3234.
14. Abrahams, *The Man-of-Words in the West Indies*.
15. Fito Vivien, interview, Brooklyn, 3 March 1991.
16. See Elizabeth McAlister, "Rara: Haitians Make Some Noise in Brooklyn," *The Beat Magazine* (summer 1991).

17. Claude Lévi-Strauss, *The Savage Mind* (Chicago: University of Chicago Press, 1966). Cited in Dick Hebdige, *Subculture, the Meaning of Style* (London: Methuen, 1979), 177.

18. Charles, "A Transnational Dialectic of Race, Class, and Ethnicity," 96.

19. Randal L. Hepner, "Chanting Down Babylon in the Belly of the Beast: The Rastafari Movement in Metropolitan U.S.A.," in *Chanting Down Babylon: A Rastafari Reader*, ed. Samuel Murrell (Philadelphia: Temple University Press).

20. Hebdige, *Subculture, the Meaning of Style*, 44–45.

21. For standard works on Rastafari in Jamaica, see Leonard E. Barrett, *The Rastafarians: Sounds of Cultural Dissonance*, rev. and updated ed. (Boston: Beacon Press, 1988). See also Barry Chevannes, *Rastafari: Roots and Ideology*, Utopianism and Communitarianism series (Syracuse, N.Y.: Syracuse University Press, 1995), and Horace Campbell, *Rasta and Resistance: From Marcus Garvey to Walter Rodney*, 1st American ed. (Trenton, N.J.: Africa World Press, 1987).

22. See Velma Pollard, "Dread Talk: The Speech of the Rastafarians in Jamaica," *Caribbean Quarterly* 26, no. 4, and Velma Pollard, "The Social History of Dread Talk," *Caribbean Quarterly* 28, no. 4.

23. *Sanba* Wowo, interview, New York, July 1995.

24. This information comes from interviews with Sanba Yanba Ye, Sanba Djames, and Sanba Wowo, New York City, 1993. For an informative discussion of the origin of dreadlocks among Jamaican Rastafarians, see Barry Chevannes, "The Origins of the Dreadlock," in *Institute of Social Studies* (The Hague: N.p., 1989).

25. See Paul Gilroy, *'There Ain't No Black in the Union Jack': The Cultural Politics of Race and Nation* (London: Routledge, 1992), 186.

26. Gerard Michel quoted in *Libète*, no. 138, 17 May 1995, p. 6.

27. DJ Frankie, interview, Bronx, 2000. Bigga Haitian, a.k.a. Charles Dorismond, is the son of Andre Dorismond, lead vocalist with the famous Webert Sico Group. Bigga Haitian is also the brother of Patrick Dorismond, who was tragically slain by police in Brooklyn in the notorious police brutality event of 2000. See Bigga Haitian, *I Am Back*, A Royal Productions/Jomino/Roots International, 1997.

28. King Posse, "Retounen" (Comeback), track on *Putomayo Presents: Carnival 2001*, New York: Putomayo Recordings, 2001; Original Rap Staff, *Kè Pò Pòz*, France: Declic AMCD 77120, 1996. Also see Various artists, *Haiti Rap and Ragga: Match la Red*, France: Declic Communications 319–2, 1994, and Black Leaders, *Tout Moun Jwen*, Krazy Staff Productions/Cross Over Records KS-BL001, 1997.

29. Various artists, *Bouyon Rasin: First International Haitian Roots Music Festival*, notes by Claus Schreiner and Gage Averill, Global Beat Records 9601, 1996; Wyclef Jean, *The Eclectic: 2 Sides II a Book*, Sony Columbia, 2000; and Wyclef Jean, *Wyclef Jean Presents the Carnival*, Sony Columbia, 1997. *Mizik rasin*, ragga, and hip-hop artists are also in conversation, across national boundaries. For example, Boukman Eksperyans recorded most of their 1998 album, *Revolution*, in The Refugee Camp, The Fugees's original basement recording studio, in a home that Wyclef Jean owns. That album features Jerry du Plexis, The Fugees writer and bass player.

30. Jocelyne Guilbault, "On Interpreting Popular Music: Zouk in the West Indies," in *Caribbean Popular Culture*, ed. John A. Lent (Bowling Green, Ohio: Bowling Green State University Press, 1990), 93. See also Jocelyne Guilbault, *Zouk: World Music in the West Indies* (Chicago: University of Chicago Press, 1993).

31. Stuart Hall, "What Is This 'Black' in Black Popular Culture?" in *Black Popular Culture*, ed. Gina Dent (Seattle: Bay Press, 1992), 22.

32. E. J. Hobsbawm and T. O. Ranger, *The Invention of Tradition* (Cambridge: Cambridge University Press, 1983), 1.

33. D. Brown, "Garden in the Machine," 93.

34. Ulf Hannerz, "Cities, Culture and Center-Periphery Relationships" (paper presented at the American Anthropological Association, Atlanta, 1994). Hannerz speaks of Sansone's work on young Black Surinamese who move from Paramibo to the old metropole of Amsterdam, become Rasta, trade goods for *ganja* with other Rastas in London, and look to Kingston as a cultural center. Livio Sansone, "From Creole to Black: Leisure Time, Style and the New Ethnicity of Lower-Class Young Blacks of Surinamese Origin in Amsterdam: 1975–1991," unpublished manuscript, 1991.

35. For a literature review on ethnic identity, see Joane Nagel, "Constructing Ethnicity: Creating and Recreating Ethnic Identity and Culture," *Social Problems* 41, no. 1 (1994).

36. Fredrik Barth and Universitetet i Bergen, *Ethnic Groups and Boundaries: The Social Organization of Culture Difference* (Prospect Heights, Ill.: Waveland Press, 1998).

37. Averill, " 'Se Kreyòl Nou Ye'/'We're Creole,' " 178.

38. For a recapitulation of her extensive research, see chapter 6 of Basch, Glick Schiller, and Szanton Blanc, *Nations Unbound*, 201–7.

39. As of 1980, the U.S. Bureau of the Census reported 92,400 Haitian-born persons in the United States, whereas the newspaper *Haiti Obsevateur* claimed an estimate of 400,000 in New York, based on circulation statistics of the paper. In Lois Wilcken, "Vodou Music among Haitian Living in New York" (master's thesis, Hunter College, 1986), 26.

40. Michel S. Laguerre, *American Odyssey: Haitians in New York City* (Ithaca, N.Y.: Cornell University Press, 1984), 30.

41. Carolle Charles, "Distinct Meanings of Blackness: Haitian Migrants in New York City," *Cimarron* 2, no. 3 (1990): 130.

42. Charles, "A Transnational Dialectic of Race, Class, and Ethnicity."

43. Nina Glick Schiller, "All in the Same Boat? Unity and Diversity in Haitian Organizing in New York," in *Caribbean Life in New York City: Sociocultural Dimensions*, ed. Constance Sutton and Elsa Chaney (New York: Center for Migration Studies, 1987), 193.

44. AIDS became known in Haitian circles as *les quatres H's:* Homosexuals, Hemophiliacs, Heroin addicts, and Haitians. For further analysis of the link between AIDS and Haiti, see Farmer, *Aids and Accusation*.

45. *Haiti Progrès* (April 25–May 1) 1990, cited in Richman, "'A Lavalas at Home/a Lavalas for Home.'"

46. Richman, " 'A Lavalas at Home/a Lavalas for Home,' " 193.

47. Stuart Hall, Tony Jefferson, and University of Birmingham Center for Contemporary Cultural Studies, *Resistance through Rituals: Youth Subcultures in Post-War Britain* (London: Hutchinson, 1976).

48. Charles, "A Transnational Dialectic of Race, Class, and Ethnicity." David H. Brown reports that Haitians who fled to Cuba after the independence revolution also pretended to a socially superior rank by calling themselves "French." D. Brown, "Garden in the Machine," 33.

49. Charles, "A Transnational Dialectic of Race, Class, and Ethnicity," 243–44.

50. Ibid., 252–53.

51. Paul Gilroy, "It's a Family Affair." in *Black Popular Culture*, ed. Gina Dent (Seattle: Bay Press, 1995), 306.

52. Sanba James, interview, Brooklyn, 7 December 1991.

53. Hall, Jefferson, and University of Birmingham, *Resistance through Rituals*, 29–39.

54. Sanba Yanba, interview, New York, 1992.

Performing Religion:
Folklore Performance, Carnaval and Festival in Cuba
Judith Bettelheim

Introduction

I perceive the relationship of performances of Afro-Cuban religions to Cuban national policy as basically a form of "cultural preservation." An explication of cultural preservation highlights the racialized dimensions of the policy and teases out the connotations of what is termed in Cuba as the "national rescuing process." This is the thread that weaves together my observations. At the core of the national concern with the "rescuing process" is the tension that exists between rescuing something perceived as *static,* such as Afro-Cuban religion and its accoutrements, and something *innovating,* which is usually deemed as modern, or non-religious.

It is important to realize that the politics of a "rescuing process" began in the pre-revolutionary period (prior to 1959), although the revolutionary government has forcefully enabled this process to continue. (I will give detailed examples below.) The perpetuation of a platform that calls for "the rescuing" of certain cultural manifestations relegates these same manifestations to the periphery, forever having to be rescued. As the official rhetoric contends that Afro-Cuban cultural performances continue to need rescuing, they will always remain marginalized in order that national cultural forces can exert control over their visibility.

Aesthetic innovation within cultural performances presents a special kind of challenge for the performer, because "tradition" and "future" are perceived as oppositions, predicated on an understanding that they represent fixed positions. Tradition has to do with roots, which in the case of Cuba is its Afro-Cuban heritage. And *now* signifies contemporary innovation. In the case of the folklore performances I discuss, the *now* seems to have produced a peculiar predicament, where performers are caught between wanting to honor tradition and simultaneously innovate. I wonder if innovation needs to obscure that which has made certain folklore performances unique? In the examples I present, it is particular performed Afro-Cuban cultural elements that have come under scrutiny or criticism. Ticio Escobar articulates this dilemma regarding popular culture as follows:

> Popular creativity is perfectly capable of assimilating new challenges and formulating answers and solutions according to its own needs and at its own speed. According to the creators themselves, popular art can preserve centuries-old elements or incorporate new ones. The only real condition of authenticity is that traditional or innovatory choices are made in response to internal cultural demands and that they be generated by the dynamics of this culture.[1]

The key phrase here is "internal cultural demands," for according to the evidence I present, I question if certain innovations are in fact motivated internally. In using the phrase "internally" I refer to the core participants in Afro-Cuban religions, not Cuban cultural and governmental organizations.

Although there were precedents in the patronage of Afro-Cuban cultural manifestations prior to the 1959 Revolution, the immediate implementation of a national policy and mechanisms for study of these traditions provided the opportunity to work within and thus regulate aspects of these same traditions. It is obvious that the revolutionary government was well aware of the social control and authority embedded in Afro-Cuban cultural and religious organizations, and made an effort to recognize and work with them, and subsequently appropriate them into a national policy.[2]

It is also important to understand the continued use of the term "folklore," as in "folklore performance," by all Cubans-from intellectuals to scholars to practitioners. The ethnomusicologist Katherine Hagedorn discusses of the often-troubling term 'folklore' and the implications of its use since the Revolution.[3] And historian Elizabeth Kiddy, who has worked in Brazil, states, " The field of folklore no longer recognizes an opposition between folklore and religion..." Yet she notes that in Brazil the "rubric of folklore [is presented] as oppositional to religion."[4] Today in Cuba the use of the term 'folklore' automatically implies Afro-based religion, music, dance, etc. In this way Cubans officially avoid what has become a very controversial term, *Afro-Cuban*, which I insist on using.[5] In fact, during my research and visits to Cuba, especially in the 2000s, some officials and scholars criticized my emphatic use of the term Afro-Cuban during seminars and lectures. The term is controversial because the Cuban national transcript insists that **all** Cubans are Afro-Cubans, following Fidel's assertion that every Cuban has a drop of black blood. It is very difficult to admit that racial inequality exists if the contemporary nation is constructed as a multicultural nation, understood as concomitant with racial equality. Consequently this has produced a national transcript of racial democracy, what some may call the myth of racial democracy. I ask: what is implied when the state attempts to eradicate difference? On the street, as it were, does this amalgamating philosophy hold true? No. Racial and social divisions persist and are embedded in the cultural and religious performances presented below.

The folklore performances I discuss, including aspects of Carnaval performances, are not really "integrating" as Bakhtin imagined for European Carnival. In fact I see Cuban Carnaval as a counter to Bakhtin's model, which "unmasks" through reversals.[6] Much of Bakhtinian-derived analysis is dependent on the inversion of high culture that produces topsy-turvy conditions. This is not the case in Cuba, or in the greater Caribbean. Carnaval performances in Cuba present an opportunity for remembering and acting out present realities, thus providing a public forum for "truths" according to the performers. As Victor Turner suggests, a public performance is part of an ongoing social process when people themselves are conscious of the texture and style of their own lives.

Performance is the means of becoming and remaining visible. By choosing to represent oneself or one's culture in Carnaval, different cultural groups chose to remain visible within the history and fabric of contemporary Cuban society. But there is also a dilemma, an irony if you will, that is developing around contemporary Carnaval performances. As in Bahia, Brazil, since the mid 1970s, and in Cuba since the mid 1990s, the perceived exoticness of Afro-Cuban culture is being marketed for tourist dollars. Thus, while Afro-Cubans are achieving increased representation in state supported arts and cultural institutions, and this is especially true in Havana, that recognition goes hand in hand with a "commercialization" of these practices. Toward the end of this paper I will turn to the topic of commercialization and attempt to elucidate how it has impacted certain folkloric practices themselves.

In the next section I introduce the cultural agencies and organizations that have been central in the national recognition of Afro-Cuban religions and through their policies have been part of a campaign centering on a rescuing process.

Background

The precedent for certain cultural agencies was established well before Fidel Castro's Revolution. Although the Sociedad de Folklore Cubano was founded in 1923, it concentrated on Hispanicisms in Cuban culture.[7] The extraordinary, and unfortunately under-recognized, Afro-Cuban researcher Rómulo Lachatañeré published important pieces on Afro-Cuban religion and culture in the late 1930s and early 1940s. In 1933 the Afro-Cuban musicologist Odilio Urfé featured the presentation of an Abakuá lodge[8] at the Primer Festival Musical Folklórico, in Havana. The sacred *bata* drums of Santería were first heard in a public, secular setting in May 1936, at an ethnographic conference organized by Fernando Ortiz.[9] By the late 1940s Radio Cadena Suaritos began weekly programs devoted to Afro-Cuban based compositions, and Afro-Cuban performers like Celia Cruz and Mercedita Valdés performed. By the early 1950s Cruz and Valdés recorded sacred Santería chants in "Yoruba dialect" for the newly formed record label Panart.[10]

During the 1940s and 50s, the Havana nightclub scene flourished. Many initiated musicians introduced sacred rhythms into compositions played at the clubs. Francisco Aguabella moved from Matanzas to Havana in 1947 and a few years later joined the nightclub orchestra at the Sans Souci restaurant. He then moved to the USA in 1957 and settled in Los Angeles.[11] Aguabella was initiated in Santería, was a member of an Abakuá lodge, and is still considered a master of all sacred Afro-Cuban musical styles. As Raul Fernandez indicates, "Francisco played every form of Afro-Cuban drumming..."[12] Certainly there were other musicians who integrated sacred rhythms into a popular context. So by the 1960s, after the Triumph of the Revolution, state mechanisms were set in place to embrace these traditions and appropriate them into an official state policy.

Immediately after the 1959 Revolution, the Teatro Nacional was founded. Under the umbrella of the Teatro Nacional, other departments were established. Ramiro Guerra, who had earned a reputation as both a performer and choreographer, and used material from several Afro-Cuban religions in his work, directed the Department of Modern Dance. By the mid 1960s, the Teatro Nacional was divided into five departments, of which the Department of Folklore and its offshoot, the Conjunto Folklórico, are central to my discussion.

By the mid 1960s, Argeliers León directed the Department of Folklore.[13] León was a protégé of Fernando Ortiz, and from October 1960 through May of 1961, León organized a series of seminars on the analysis and interpretation of folklore. In 1961, under the auspices of the Department of Folklore, he published a succession of articles in the journal *Actas del Folklore*. Later in 1961, the Institute of Ethnology and Folklore, directed by León, was founded as part of the Consejo de Cultura, a branch of the Ministry of Education. León included extensive explanatory notes in the programs for his productions. John DuMoulin, who was in Havana during the early critical 1960-61 period, published one of the first analyses of these performances. He states: " León brought to the National Theatre his production Yímbula, featuring *paleros* from the Briyumba house of Palo[14].... It is the first in which there has been an attempt to reconstruct most of a religious fiesta in all its aspects."[15] DuMoulin also comments that León was seriously interested in overcoming "the common prejudices of the general public who views 'folk-art as exotic or even savage.'" In early 1962 Rogelio Martínez Furé, an Afro-Cuban, founded the Conjunto Folklórico. Martínez Furé was an alumnus of the Teatro Nacional seminars.[16] In March 1964 El Concierto Música Abakuá, directed by León, was presented at the Biblioteca Nacional, as David Brown says, "on a state-sanctioned stage."[17] It is instructive to quote what León wrote about this production in the program notes.

The musical expression of the Abakuá, completely isolatable from the hold that ritual has on them, and their rhythmic and melodic value, are what the Department of Music of the José Martí National Library presents today, as an effort to **rescue** [emphasis mine] the cultural expressions of our people.[18]

According to María Teresa Vélez this proved more controversial than any previously staged performance, especially among Abakuá members.[19] Hagadorn uses the phrase "remarkable" to describe the same performance.[20] It is interesting to compare reports of this and a similar, later performance. Reflecting back to 1964, Argeliers León explained to Hagedorn in a 1990 interview,

The *toques* [rhythms] were the same, the songs were the same [as they would be in a ritual context] ...because the public that attended understood these songs. This created a very interesting effect, which was that in the middle of a song or a presentation, there was a dialogue between the 'officient' performer and the audience members who were believers....In the *plante* [Abakwá initiation ceremony], there were blacks who participated in this performance as if it were real... In fact, the Abakwá performance at the Biblioteca Nacional was perhaps the best we ever did.[21]

Hagedorn comments that this performance "sparked a few fistfights between those religious practitioners in the audience who felt that the informants gave away too many secrets and those (usually family members) who defended the informants' rights to limited fame and fortune."[22] Although León and Hagedorn are reflecting on a performance that occurred a good thirty years prior to their interviews, it is important to note the introduction, as early as the 1960s, of the importance of monetary compensation into this discussion. I will return to that point below.

María Teresa Vélez spent many years interviewing Felipe García Villamil, a noted Afro-Cuban percussionist now living in Los Angeles.[23] García Villamil is initiated in three major Afro-Cuban religions: Santería, Palo Monte, and Abakuá.[24] In 1970 in Matanzas he organized the folkloric group Emikeké, which performed until he left for the USA in 1980 as part of the Mariel boatlift.[25] A practitioner, performer and director, his commentary, recorded about thirty years after the events described above, is elucidating. García Villamil states:

Then the revolution came and they took our things to the theater. Initially the *santeros* [26]didn't look at it favorable, you see. Because they thought it was like doing profane things. The older *santeros* were really bothered...Then other people began to develop a consciousness. They realized that with these presentations they were making these traditions international, that their culture was gaining recognition. So they loosened up a little...In Matanzas it was never easy to present the religious things in public. But slowly things have changed, people began to change their mind. People also had to change because they had to look for a way to survive, and those concerts for people were a job, they were work.[27]

García Villamil continues this discussion with a lengthy explanation of his attempts to incorporate Abakuá music and chants into Emikeké's performances. He also defends his position by stating, "When I started in Cultura it was a job, like many of the other jobs I had."[28] (Again, note the commentary about being paid to perform.) And García Villamil was conscious of the historical precedent set by Argeliers León in 1964. He states:

When I began to prepare for the Abakuá concert in Matanzas, many of the Abakuá were fuming. People were telling me: 'Hey, look, be careful 'cause they are going to kill you.' I said: 'But to kill me they would have to have to kill the people of Folklórico Nacional first.'[29]

Villamil's case is interesting, for he is a practitioner who decided to work with Cultura, and his folkloric group performed pieces from all of Cuba's African-based religions.

The Ministry of Culture was not founded until the late 1960s. As Vélez explains,

> Following the founding and systematic organization of the CFNC [Conjunto Folklórico Nacional de Cuba], other folkloric groups around the country developed and were supported by local cultural organizations, such as the Casas de la Cultura and the Movimiento de Aficionados [Amateur Artists Movement], in researching and staging the folkloric traditions. Workshops were organized and contests, annual festivals, and competitions were instituted.[30]

In 1962 when Rogelio Martínez Furé took over the direction of the Conjunto Folklórico, dancers and singers who were not initiated joined the performance troupe. These same performers were used for all the dramatizations of the religious rituals. This led to the development of schools that taught the dances and songs of the religious traditions out of context, in a classroom. Thus developed a core group of performers, adept and professional. And today every Cultura organization boasts a folkloric troupe. What is especially important to realize is that as these troupes developed post-Revolution, the revolutionary government simultaneously instituted a crack down on the practice of these same African based religions and traditions. Although aspects of these traditions were performed in public nationally and internationally, their practice in Cuba went (back) underground. This dichotomy must be appreciated. Performers earned wages for their public interpretations of religious rituals, but in order to be initiated and practice these same rituals they had to participate in their own ceremonies secretly. Here I use the word "secret" with caution, for even though the Communist Party prohibited membership to religious practitioners, and membership was often necessary to secure jobs and housing, there were party members who were also practitioners, and there were performers who had been initiated. Also, certain scholars were able to study religious ceremonies, especially foreign scholars. The situation was/is very complex.

During the 1970s, official policy toward religion fluctuated. There were arrests and interrogations, and by 1975 there was a government backlash against Afro-Cuban study groups that had been established to resemble Soviet-style informal cells. Yet in 1976, the Cuban constitution guaranteed religious freedom, although it was not until 1984 that an Office of Religious Affairs, attached to the Central Committee of the Communist Party, was established. By the mid 1980s, FolkCuba, a workshop designed by and under the auspices of the Conjunto Folklórico, was established for the express purpose of teaching Afro-Cuban performance traditions to non-Cubans. By the end of the 1980s a more open policy toward religious practice was evident, and by 1991 the Communist Party Congress opened the Party to religious practitioners. By 1992, the new constitution declared Cuba a secular, rather than atheist state. In January 1998 Pope John Paul ll delivered mass in Revolution Plaza, Havana. Fourteen years later in March 2012 Pope Benedict XVI also delivered mass in Revolution Plaza, as did Pope Francis on September 20, 2015.

Performance: From Día de Reyes to Carnaval and Festival

Ever since the 1959 Triumph of the Revolution, Carnaval in Cuba's principal cities has been held during the last two weeks of July, with the most important parade being held on the anniversary of the July 26 assault on the Moncada barracks.[31] By 2000, in Havana, neighboring Matanzas, and Santiago de Cuba, Carnaval is celebrated from the 18th to the 27th of July, with the final complete Carnaval parade held on the 26th.

Most documentation on Cuban Carnavals is based on observations from central and western Cuba, and more particularly from Havana. The Afro-Cuban poet and cultural critic Pedro Pérez Sarduy recalls his participation in his hometown Carnaval in Santa Clara in central Cuba, in the mid 1950s.

> There were 48 couples in our group, all young blacks and mulattoes, of similar class background, though there were always some exceptions. I was one of a small group of high school students... The great moment came when I finally stood in front of the mirror and contemplated my street graduation. I was laughing inside as my aunts helped me to do my sideburns, thin moustache and pointed beard. Our costume was a Panama-type hat, brown jacket, ...long-sleeved pink shirt, and bow tie...The baggy white trousers were made out of flour sacking...[32]

Pérez Sarduy stated that there were never any religious references in the Carnaval productions he remembers from his youth. Although not part of a public presentation, he recalls that it was well known that the "old black founder of our masquerade group," Don Macana, "was a *mayombero* [a practitioner of the religion Palo Monte, and the branch Mayombe] with a militant worker tradition."[33] In this case, and certainly in many others, the practice of religion did not receive a corresponding enactment in public festivals. For example, the multi-talented percussionist Francisco Aguabella, discussed earlier, moved to Havana in 1947 and immediately joined the famous Havana Carnaval group, Los Dandys de Belén. Although Aguabella excelled at sacred music, he also established a strong reputation for Carnaval music and led the rhythm ensemble of Los Dandys.[34]

Yet, a mini case study presented by Pérez Sarduy underscores the difficulty of establishing a historical perspective on performing religion within the Carnaval context. Pérez Sarduy writes about the Havana Carnaval group El Alacrán (the Scorpion), which still performs today. The group originates in the predominantly Afro-Cuban central Havana barrio of El Cerro. In the very early 20th century there were whites in the group who paraded in blackface, but the role of an African in the danced narrative was played by a citizen of Havana born in Africa, Gerónimo, who played himself. By the 1930s with an increase in tourism, blackface performers became so unpopular with foreign visitors that they no longer appeared in public presentations. Demanding "authenticity," Afro-Cubans took over performance roles.

Pérez Sarduy is writing from his own experience, personal interviews and knowledge gained from oral history as he states the following:

> The fact that El Alacrán arose in El Cerro is not fortuitous...The diverse expressions of African culture, their gods, their costumes, their rhythms and their dances, that during the year remain hidden in *casa-templos*, are brought out into the streets during Carnival. Carnival performances recreate mythology and blend the ritual with the profane. From the beginning, this tradition has been present in El Alacrán, which, according to those who saw it in early 1900s, was associated with Yemayá, the *oricha* associated with the sea in the Afro-Cuban religion la Regla de Ocha or Santería. For this reason, El Alacrán participants dress in blue, reflecting the sea.[35]

The Afro-Cuban filmmaker Gloria Rolando produced a documentary about El Alacrán, which pays tribute to the 60-year history of the group, and filmed it in El Cerro.[36] The director of the group, son of the original director, and his mother are interviewed in the 1999 film. Both discuss the group's Afro-Cuban past, and their struggle to keep the group together during the vicissitudes of government regulations. There are also other, older commentaries available. A detailed report of the March 1952 Havana Carnaval was published in Holiday magazine.[37] Against the background of a military coup and the presence of armed guards at every corner, Carnaval participants paraded in full force.[38]

The author, a travel writer from the USA, reserved his most detailed description for the performance of El Alacrán. About 100 men and women of "darkish complexion" were dressed in costumes reminiscent of the cane cutters of Cuba. What attracted the writer's attention most was the powerful narrative danced performance with its live musical accompaniment. Mistakenly, but appropriately sensationalized, he referred to the performance as a "voodoo ceremony" directed by

a "voodoo high priest." One can only imagine which dance sequences, related to which religious rituals, were being performed. For, as established in an earlier section of this paper, by the 1950s aspects of Afro-Cuban religions were performed on stage, live performances of religious chants were heard over the airwaves, and scholars attended religious rituals to document a misunderstood and maligned aspect of Cuban culture.

What is important in the above commentary, in the comments of Pérez Sarduy, and in Rolando's documentary film, is the fact that indeed religions, or religious rituals, have been part of Carnaval performances since the early 20th century. It is apparent that visitors to Cuba, and even many Cubans themselves, did not recognize the references embodied in these Carnival performances. One may not see something if one does not understand or recognize what is performed. But that does not mean that the Afro-Cuban participants were not engaged in publicly performing aspects of their own culture.

Beginning in 1985 during my own fieldwork in Cuba, I have had ample opportunities to witness the various ways in which religious rituals and references are incorporated into festivals and Carnavals. In the July 1989 Carnaval parade in Santiago de Cuba the crowds in the stands responded enthusiastically to the float sponsored by Cubanacan, the national tourist agency. As the float pulled by a truck moved slowly down the parade route the crowd rose and applauded as the dancers performed to recorded pop music and scantily clad gyrating women threw paper serpentines at the onlookers. And this same crowd applauded equally heartily when the *oricha* (a deity or spirit) Babalú Ayé, from the *paseo* La Placita, was held aloft by three other male dancers (fig. 1).

during Carnaval, Santiago de Cuba, July 1989.
Photo: Judith Bettelheim

Babalú Ayé was especially convincing. His choreographed performance included a limp, a deformed arm, drools and trance-like dancing. This choreographic formula derives from Babalú's domain, as he is the patron of the poor he is always dressed in burlap. He is the owner of infectious diseases, especially skin diseases, and deformities, and is a specialist in the realm of the dead. Practitioners pay homage to him in hopes of a cure, or at least some relief. La Placita's artistic director explained this Carnaval group's commitment to a two- sided reality, the sacred and the secular, in the following way:

> In our themes we bring out our cultural ancestry as well as the modern side of Cuba. We pay attention to the *rescuing* [emphasis mine] of folkloric values; that is why there are religious, ritual elements within the *paseo*. There are people in our *paseo* who belong to folkloric groups and know these dances; so we learn from these people. All these kinds of groups have been created by

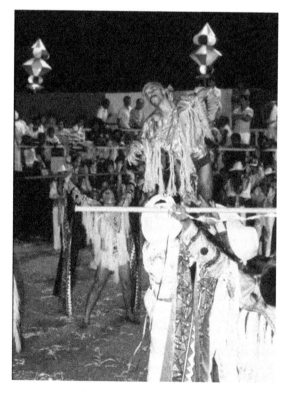

Figure 1. A Babalú Ayé impersonator performing

our government in order to *preserve* [emphasis mine] the Afro-Cuban culture. So, anyway, there is always the modern, the Tropicana-style as we call it, and there is the folkloric.[39]

Note the recurrent use of the phrase "rescuing," twenty-five years after it was used by Argeliers León to describe an important motivation for his own productions.

Most Carnaval organizers agree with this assessment, that Afro-Cuban culture needed and still needs rescuing, and that in post- revolutionary Cuba this rescuing process is part of the official work of cultural institutions. In fact, according to the national cultural agenda, they have needed rescuing since the beginning of the Revolution. These performances can be linked to national and regional governments' appropriation of Afro-Cuban culture for national stability. Official cultural institutions are the patrons, and these patrons control the public visibility of the performances. What does this indicate about the status and appreciation of Cuba's African heritage? Why are the country's African roots seemingly in a constant state of "disappearing?" I revisit this question below.

1990 and beyond

Faced with a dire economic decline, since the beginning of the "Special Period" in 1990,[40] Cuba has become a frequent destination for religious tourism, supported by national government and regional offices. Tourism offices work with religious houses that invite paying foreigners to performances and offer initiation and ritual training for much needed funds. Religion has become a tourist commodity. In an article from 2004 Martin Holbraad wrote the following:

> On the one hand, since the collapse of the Soviet bloc in 1989-90, Cubans have experienced a dramatic and generalized drop in their standard of living and well nigh universally consider this period as one of relative poverty. On the other hand, this same period has seen a veritable explosion of Afro-Cuban cult activity...accompanied by an extraordinary price hike in fees...[41]

Even for Cubans, prices for initiation have risen substantially. Yet, today, all over Cuba, and especially in the major cities, initiates openly wear their ritual necklaces and bracelets. One often sees first year initiates, dressed all in white, going about day-to-day business. Cubans prefer to live for the moment, rather than plan for an unknown future. Even before the onset of the Special Period, if one could accumulate the resources, lavish dinners were prepared for every birthday, even if the same foods may not have been available two weeks later. In the 1990s and 2000s, Afro-Cuban religions have become more and more visible. A long-term study states that devotees' participation in the annual pilgrimage to the sanctuary of San Lázaro,[42] located about 25 kilometers outside of Havana, on December 16 and 17 has risen steadily since 1983, from 34,444 in that year to 94,109 in 1995, although participation dropped to 83,776 in 1998.[43]

Holbraad marks the public appearance of religious accessories as a corollary to the collapse of the Soviet Union and the 1989-90 Special Period with its economic reforms. He establishes a parallel between the public display of initiation insignia and comparable street credibility in the USA, like "gold accessories or cool Nike gear."[44] I agree with this assessment and add that in Cuba what used to be prohibited is now flaunted in public, and performing religion in public venues is also a way of going public with one's heritage and beliefs.

I now summarize what I consider one of the most profound changes in Carnaval with a description of a particular Carnaval-related performance that I saw during a pre-Carnaval Festival in summer 1998. Festival is the official name for the yearly celebrations organized by the Casa del Caribe in Santiago de Cuba. Festival originated in a specific state project of the 1980s. By 1986, during the Communist Party National Congress, an official policy of *rectificación de errores* was

begun. The government became more open toward certain previously marginalized social groups, such as the practitioners of African-based religions. And as discussed above, concomitant with these changes came a push to organize national cultural tourism, and slowly both African-based religions and certain cultural performance groups were enveloped in cultural tourism, and the yearly Festival celebrations in Santiago de Cuba are part of this project.

The performance I describe took place in central downtown Santiago de Cuba, in Cespedes Park in front of the old but newly restored Grand Hotel. One dancer, impersonating the *oricha* Ochún, was part of a cultural group that was funded by the Department of Municipal Culture. During the performance, the Ochún impersonator took off layers of her costume (scarves, skirt, etc.), and ended up wearing a tight white tee shirt and yellow tights (figs. 2, 3, 4).

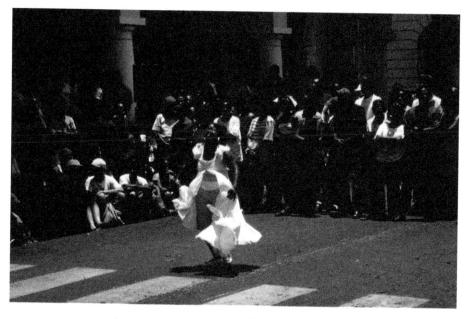

Figures 2, 3, 4. An Ochún impersonator performing during a pre-Carnaval Festival in Santiago de Cuba, summer 1998.

Photos: Judith Bettelheim

Figure 5. An Ochún impersonator performing during Carnaval, Santiago de Cuba, July 1989.

Photo: Judith Bettelheim

Ochún is a sexy, flirtatious *oricha*, but her *oricha* clothes, during religious services, folkloric performances, and even previous Carnavals, are most often frilly, layered, and discreet (fig. 5).

She is usually clothed in fine "feminine" dresses, in her colors, yellow and white. By ending this performance in a white tight-fitting shirt and yellow tights, this *oricha* impersonator may have been asserting her own personality, that of a contemporary liberated woman. It is quite possible to read this performance as a personal, yet public, affirmation of a certain type of female power in Cuba today.

Indeed, this performer was voicing a present truth about contemporary life in Cuba, where the sensual woman is a powerful, albeit controversial, social and economic force. This dancer performed a version of a current cultural experience. Perhaps she was also implying that her persona paralleled that of Ochún's. For Ochún is not just a beautiful woman; she is an enchanting seductress. Whatever the impetus, and there are probably many, this newly configured Ochún impersonator presented the spectators, both Cubans and tourists, with a performance that challenged previous performance norms while confronting established conventions of *oricha* representation. Here is a performance that speaks to the complexities of honoring tradition while simultaneously innovating.

As religious institutions themselves are becoming more and more easily accessible to both Cubans and foreign visitors, there is less necessity to conform to strict and agreed-upon norms of public performance. Folklore spectacles can be seen at tourist hotels, big restaurants, in museum courtyards, and at certain religious houses where tour busses stop. The new open policy of accessibility outlined above and in the previous section may negate the need or desire to perform religion within Carnaval celebrations. When I compare the Santiago de Cuba Carnavals I attended between 1987 and 1998, I note that in 1998 no Carnaval group incorporated religious references or performances in their repertoires,

perhaps because public, religious performances happen elsewhere, more and more on a stage as part of a larger folkloric presentation. Or perhaps, as tour buses visit particular religious houses, religious performances are part of the staged events. Staged performances by many different types of religious groups and heritage festivals are now evident all over Cuba. Anthropologist Grete Viddal first visited Cuba in 1998 and has returned annually since. She notes a significant growth in the number of folkloric groups and heritage festivals focusing on Cuba's Haitian heritage.[45] Ironically Haitian-Cuban communities remain mostly rural and poor. Yet theses communities continually assert their presence and importance, increasingly through public performances. Most often they receive some type of support from local government institutions.

Public display often diffuses the power of an image or an event, especially if that image was once restricted in its use and potential for symbolic interpretation. Since the Triumph of the Revolution religious imagery (and I am including Abakuá references in this) frequently is used in a secular public context.[46] For many of the individuals involved, this complicated negotiation of performing religion is a way to honor Afro-Cuba. But, I ask: have national cultural institutions appropriated this imagery as a means to perpetuate/confirm the demise of these religions as a social force? (This may be especially relevant when discussing Haitian-Cuban performances, as these communities have long been viewed as particularly potent centers of social unrest.) Certainly, by incorporating the performance of Abakuá *ireme* dancers or performances by a costumed Changó or Ochún into Carnaval, expressions of Afro-Cuban ethnicity achieve a public face.

Where does one draw the line between proud public expressions of ethnicity and "folkloric propaganda?" Cuban Carnaval performances present common emblems that can be interpreted in multiple ways, reflecting the existence of multiple realities that are mediated through performance and exhibition, often employed against their original intent. These images are doubly coded. For many Afro-Cubans they are powerful messages, reminders of an ongoing rich and powerful reality. Most of the dancers performing in folkloric presentations are confident that their participation is helping to keep an aspect of Afro-Cuban culture vibrant. According to official culture these performances are indicators of the new status, an elevated status of Afro-Cuban culture in post-revolutionary Cuba. Yet, references to the "rescuing" of Afro-Cuban cultural traditions are frequent, and have been for over forty years. And in performance, the power, or potential power, of the institutions behind these images are appropriated into a national agenda. There are many examples of the state institutionalizing critical art into a national platform. The revolutionary government has been doing this with Afro-Cuban religions since 1960.

Notes

1. Ticio Escobar, "Issues in Popular Art" in Gerardo Mosquera, ed. Beyond the Fantastic: Contemporary Art Criticism from Latin America (London: Institute of International Visual Arts, 1995), 92.
2. It is important to remember that a substantial majority of Cuba's African- descended population fought for and supported the Revolution, which presents a complicated arena when analyzing the relationship between Afro-Cuban cultural organizations and national policy.
3. Katherine J. Hagedorn, Divine Utterances, The Performance of Afro-Cuban Santería (Washington and London: Smithsonian Institution Press, 2001). See especially Chapter 5 and notes 9 and 10. A brilliant ethnomusicologist, Hagedorn succumbed to cancer in 2013.
4. Elizabeth Kiddy, Blacks of the Rosary, Memory and History in Minas Gerais, Brazil (University Park, PA.: The Pennsylvania State University Press, 2005), 208.
5. In his numerous publications Cuban-American Alejandro de la Fuente, now a history professor at Harvard University, has helped to underscore the importance of using this term, especially in regards to a growing cultural movement spearheaded by a core group of Afro-Cuban artists. See

Alejandro de la Fuente, Queloides: Race and Racism in Contemporary Cuban Art (Pittsburgh, PA.: University of Pittsburgh Press, 2011) and Judith Bettelheim, AfroCuba: Works on Paper, 1968-2003 (San Francisco: International Center for the Arts, San Francisco State University, 2005). See also de la Fuente's most recent publication: Grupo Antillano: The Art of Afro-Cuba, 2013, and in particular his essay "Drapetomania: Grupo Antillano and Cultural Cimarronaje."

6. Krystyna Pomorska, Rabelais and his World, Mikhail Bakhtin (Bloomington: University of Indiana Press, 1984), x.

7. Robin D. Moore, Nationalizing Blackness, Afro-Cubanismo and Aesthetic Revolution in Havana, 1920-1940 (Pittsburgh, PA.: University of Pittsburgh Press, 1997), 125.

8. This fraternal order is one of the most misunderstood and sensationalized in all of Cuba. In order to put into perspective subsequent discussions of Abakuá, I present the following.: (Note: *ñáñigo* is an older nomenclature used to name the individual spirits of an Abakuá brotherhood. Individual spirits today are called *ireme* In the mid 1950s, through the efforts of folklorist-anthropologist Lydia Cabrera, who had gained an "insider status" with several Abakuá groups, the pejorative nomenclatures *ñáñigo* and *diablito* were slowly replaced by Abakuá and *ireme* respectively.) As Aline Helg reports, in August 1896, the killing of a notorious *ñáñigo* in a settling of scores between *juegos* [a group of thirteen initiated men] caused the roundup of 92 suspects, of which 30 were later released and the rest deported. During November 1896, 104 alleged *ñáñigos* were arrested in Havana alone, and 74 of them were selected for deportation...More than 580 supposed *ñáñigos* were deported ..." Helg demonstrates that Afro-Cubans in general were negatively written about and persecuted during the tumultuous period (1880s-1912) that included two Wars of Independence, including the race war of 1912. Aline Helg, Our Rightful Share, The Afro-Cuban Struggle for Equality, 1886-1912 (Chapel Hill: University of North Carolina Press, 1995), 83.

9. According to Hagedorn, p.141, these were unconsecrated *bata* drums commissioned by Ortiz. Fernando Ortiz, 1881-1969, considered Cuba's most erudite and prolific scholar, and a national hero, developed the concept of "transculturation," as opposed to "acculturation," a one-way process. He contends that transculturation results in hybrid forms of new cultural innovation. Author of over 100 books and articles, only one book and one article have been translated into English. See Judith Bettelheim (ed.), Cuban Festivals, A Century of Afro-Cuban Culture (Kingston: Ian Randle Publishers, 2001) for an introduction to his work and a translation of his Day of Kings article, originally published in 1960 in Cuba.

10. Robin D. Moore, 223-4. Mercedita Valdés worked with Fernando Ortiz from the 1940s until his death in 1962. Her nickname *"La Pequeña Aché"* underscores her strong relationship with the Yoruba-based Santería religion and the power of her performances. *Aché* is a Yoruba word connoting ritual performance power, or the power to make things happen.

11. Francisco Aguabella died at his home in Los Angeles on May 9, 2010.

12. Raul A. Fernandez, From Afro-Cuban Rhythms to Latin Jazz. (Berkeley: University of California Press, 2006) 119. Fernandez's book is a vital reference for understanding the role of Afro-Cuban based music at the inception of Latin Jazz.

13. Argeliers León worked in the field of Afro-Cuban folklore, music and ritual until his death in 1991. He also traveled to Africa and wrote about African sculpture.

14. A *palero*, of the religion Palo Monte, is a leader who has the ability to initiate others. Briyumba is actually one branch (house/*rama*) of the religion.

15. John DuMoulin, "The Participative Art of Afrocuban Religions." *Abhandlungen und Berichte des Staatlichen Museums fur Volkerkunde Dresden.* 21, (1962): 68.
DuMoulin illustrates this very early article with photographs of the performances of what he calls "the folklore group of the National Theatre."

16. This material is summarized from Hagedorn, 138-140, and Vélez, 76-77, 82.

17. David. H. Brown, The Light Inside, Abakuá Society Arts and Cuban Cultural History. (Washington and London: Smithsonian Institution Press, 2003), 199.

18. Ibid., 200. I will comment further on the recurring theme "rescuing" below.

19. María Teresa Vélez, Drumming for the Gods, The Life and Times of Felipe García Villamil (Philadelphia, PA.: Temple University Press, 2000), 83.

20. Hagadorn, 141.

21. Ibid., 142.

22. Ibid.

23. I was at a conference at UCLA in 2010 and García Villamil was in attendance. He was quite frail, but still able to insert some commentary into our discussion. He is still a revered member of the Afro-Cuban community in Los Angeles.

24. I realize that it is controversial to regard Abakuá as a religion. I do that now for simplicity and clarity, and follow the lead of David H. Brown who has written extensively about the Abakuá.

25. From April to June 1980, at least 125,000 Cubans left Cuba from Mariel, a small port outside of Havana, and landed in Florida.

26. A priest of Santería.

27. Vélez, 80.

28. Ibid., 82.

29. Ibid.

30. Ibid., 76.

31. In Santiago de Cuba, where the Moncada barracks are located, Fidel timed his July 26, 1953 attack to coincide with the celebration of both Saint Santiago and Carnaval, falsely assuming that the army would be preoccupied. Although this attack failed, the revolutionary movement became known as "the 26 of July" movement and July Carnaval thus also honors the Revolution.

32. Sarduy Pérez, Pedro. "Flashback on Carnival: A Personal Memoir," in Bettelheim, Judith (ed.) Cuban Festivals, A Century of Afro-Cuban Culture (Kingston, Jamaica: Ian Randle Publishers, 2001),158.

33. Ibid., 160.

34. Fernandez, 119. See the chapter on Aguabella for a fascinating discussion of his career and performances of sacred music in a secular setting.

35. Sarduy Pérez, 168. Oricha is the generic name for all deities of the religion Santería.

36. Gloria Rolando. "El Alacrán," Producción Freddy Moros, (La Habana, Cuba: Televisión Latina 1999)

37. Hamilton Basso, "Havana," *Holiday*, 12 #6 (December 1952): 140.

38. On March 10, 1952, a military coup established army control and returned Fulgencio Batista to power.

39. Bettelheim interview, March 10, 1990, Santiago de Cuba.

40. The Special Period was marked by the collapse of the Soviet Union, and the establishment of new laws to counter the effects of a lack of trade and economic Soviet support. By the turn of the twenty-first century, tourism has become the most important agent in Cuba's economic survival.

41. Martin Holbraad, "Religious 'Speculation', The Rise of Ifá Cults and Consumption in Post-Soviet Cuba," *Journal of Latin American Studies*. 36 (2004): 643. Here he is referring to the cost of initiation and its associated rituals, including animal sacrifice and foods.

42. San Lázaro, a Christian saint, is dedicated to helping and healing the poor and the afflicted. For many believers he is cross-referenced with Babalú Ayé, whose Carnaval performance was discussed earlier. Thus the devotees simultaneously honor the Christian saint and an *oricha* of the Afro-Cuban religion Santería.

43. Ibid., 653. I would like to point out that the 1994 *balsero* (rafters) exodus consisted of a large portion of Afro-Cubans, many of them practitioners, otherwise the 1995 statistic may have been even higher. This was the second wave of practitioners to land in the USA, or attempt to, since 1980.

44. Ibid., 661.

45. See Grete Vidal, 2012.

46. All over the cultural Caribbean similar tensions play out. In a lecture at the UC Berkeley Art Museum, during the *Face of the Gods* exhibition in 1993, Henry Drewal presented an example from Bahia that I use for comparison. Sometime in the late 1980s, the Bahian city government wanted to display flags with *orixas* images all over town, as part of the advertisements for carnival season. The outcry among the Candomblé houses was so strong, that the flags were never used. Another example: An article from the *Trinidad Express*, Feb. 8, 2001, indicates that the Council of Orisha Elders "has warned that the vengeance of Orisha will fall on anybody who dares to play an Orisha mas." The lengthy article explains that the orisha community elders were willing to go to court to prevent a particular Carnival band from "portraying some of the most powerful Orisha deities," during the Mardi Gras parades.

Bibliography

Basso, Hamilton. 1952. "Havana," *Holiday*, 12 #6. pp. 65-68, 70, 138, 140-144.

Bettelheim, Judith ed. *AfroCuba: Works on Paper, 1968-2003*. San Francisco: International Center for the Arts, San Francisco State University, 2005.

Bettelheim, Judith (ed.). *Cuban Festivals, A Century of Afro-Cuban Culture*. Kingston, Jamaica: Ian Randle Publishers, 2001.

Brown, David H. *The Light Inside, Abakuá Society Arts and Cuban Cultural History*. Washington and London: Smithsonian Institution Press, 2003.

de la Fuente, Alejandro. *Queloides: Race and Racism in Contemporary Cuban Art*. Pittsburgh, PA: University of Pittsburgh Press, 2011.

de la Fuente, Alejandro. *Grupo Antillano: The Art of Afro-Cuba*. Pittsburg, PA: Caguayo Foundation, 2013.

DuMoulin, John. 1962. "The Participative Art of Afrocuban Religions." *Abhandlungen und Berichte des Staatlichen Museums fur Volkerkunde Dresden*. 21, pp. 63-77.

Escobar, Ticio. "Issues in Popular Art" in Gerardo Mosquera, ed. *Beyond the Fantastic: Contemporary Art Criticism from Latin America*. London: Institute of International Visual Arts, 1995. pp. 90–113.

Fernandez, Raul A. *From Afro-Cuban Rhythms to Latin Jazz*. Berkeley: University of California Press, 2006.

Hagedorn, Katherine J. Divine Utterances, The Performance of Afro-Cuban Santería. Washington and London: Smithsonian Institution Press, 2001.

Helg, Aline. *Our Rightful Share, The Afro-Cuban Struggle for Equality, 1886–1912*. Chapel Hill: University of North Carolina Press, 1995.

Holbraad, Martin. "Religious 'Speculation', The Rise of Ifá Cults and Consumption in Post-Soviet Cuba." *Journal of Latin American Studies*, 2004, 36, pp. 643-663.

Kiddy, Elizabeth. *Blacks of the Rosary, Memory and History in Minas Gerais, Brazil*. University Park, PA: The Pennsylvania State University Press, 2005.

León, Argeliers. *Del Tiempo y el Canto*. La Habana: Editorial Letras Cubanas, 2004.

Moore, Robin D. *Nationalizing Blackness, Afro-Cubanismo and Aesthetic Revolution in Havana, 1920-1940*. Pittsburgh, PA: University of Pittsburgh Press, 1997.

Pomorska, Krystyna. *Rabelais and his World, Mikhail Bakhtin*. Bloomington: University of Indiana Press, 1984.

Pérez Sarduy, Pedro. "Flashback on Carnival: A Personal Memoir," in Bettelheim, Judith (ed.). *Cuban Festivals, A Century of Afro-Cuban Culture*. Kingston: Ian Randle Publishers, 2001. pp. 154-165.

Vélez, María Teresa. *Drumming for the Gods, The Life and Times of Felipe García Villamil*. Philadelphia, PA: Temple University Press, 2000.

Viddal, Grete. "Vodú Chic: Haitian Religion and the Folkloric Imaginary in Socialist Cuba." *New West Indian Guide*, 2012, v.86 no. 3-4, pp. 215-236.

Muharram Moves West:
Exploring the Absent-Present

Aisha Khan

"Popular culture" is a term that is deceptively simple. It is a label that identifies the cultural activities and tastes of the general masses of ordinary people, as opposed to the educated elite.[1] It is also, as Hume and Kamugisha (this volume) note, multilayered: a social field of power, performance, and creativity. Rather than approaching "popular culture" as something that points to an imagined opposition between "ordinary" peoples' behaviors and values and those of "elites," popular culture is best conceptualized as consisting of diverse arenas in which ordinary people have room to express themselves as they engage with the expectations, values, and confinements that are imposed (or attempted to be imposed) on their lifeworlds by those holding the various forms of power to do so. Popular culture may be "what *the people* do," but they do it always in terms of an unequally empowered dialogue with others located throughout a given social structure. Together, these constituencies and relations among them comprise the social context in which popular culture is expressed and contested.

This chapter considers these issues through the example of Hosay in Trinidad, the region's version of Muharram as it is known in the Old World, a ritual commemoration brought to the Americas by indentured Indian laborers entering the Caribbean through Britain's indenture project, which began in 1838 and continued until 1917. An annual ritual of mourning, Hosay is a public recital that memorializes the historic Battle of Kerbala (located in present-day Iraq) in 680 C.E, during the wars of succession following the death of the Prophet Mohammed. Although involving sacred elements reserved for observant Muslims, Hosay is not a tradition of engagement with other-worldly entities or "ethereal agents" (Khan 2004). Hosay is this-worldly in orientation, a public expression of passion (Muharram is often referred to as a kind of "passion play") and defiance, an adamantly visual and audible popular historiography of glory and loss. Bereavement and ritual reenactment are key to Hosay. They concern the martyrdom of Hussein (of which "Hosay" is a transliteration), grandson of the Prophet, who died in battle. Involving Muslims in its sacred aspects, Hindus in its ritual aspects, Afro-Trinidadians in its secular aspects, and everyone else in Trinidadian society in its mission to convey its particular message of presence, Trinidad's Hosay nuances the way we understand popular culture: it is simultaneously a major religious event, a freighted political statement, an embattled heritage claim, and a multicultural symbol, variously crafted and disciplined by numerous vested interests. The blunt visibility of Hosay belies the absences that it has endured both as a practice of the disfranchised "popular masses" in the colonial period, and as a kind of conceptualized "thing" (Heidegger 1968); that is, as legitimately amenable "religion" or as illegitimately non-compliant "superstition."

The absent-present

"History is written by the victors," a pithy pronouncement made famous by Winston Churchill (www.thinkexist.com/quotation), can be read as an admission about the phenomenon of power,

about its unequal relations within and between groups. That the victorious tend to exercise their prerogatives of representation is no surprise: accounts, reports, explanations, and memorials privilege certain interests, agendas, and points of view, and truncate or eliminate others. This tendency is vivid in the histories of colonized peoples, written subjectively, as they have largely been, by colonizers. Even in much of the ostensibly objective scholarship produced by academia until well into the twentieth century we can see this tendency toward certain elisions, scholars being another sort of victor in contests over representation. As Walter Mignolo points out, for example, knowledge is geo-politically situated, and the "blindness toward histories and experiences lying outside the local history of Western Christianity,...has been and continues to be a trademark of intellectual history and its ethical, political, and economic consequences" (Mignolo 2005, 8). Without the draw of material reward or much personal power in most cases, scholars nonetheless possess the means and voice to make their narratives, configured in particular ways, heard by broad constituencies, thereby helping to shape, through corroboration or disputation, conventional wisdom's ways of knowing.

This chapter inquires into the prerogatives of representation (privileging, truncating, eliding) by considering how diverse means of naming, or the production of symbols of difference, can create the "absent present." What I mean by "absent-present" is the relationship between the invisible and the visible in the ways scholars, communities, nation-states, leaders, and ordinary people conceptualize the cultures and histories of populations of the Americas. What is emphasized, valued, derogated, or hidden generally recapitulates in some fashion the vantage points of the victors. Something more imposing than deliberate strategizing is, however, involved in situating vantage points, whether dominant or marginalized. Conceptualizations of one's own and others' cultures and histories are a consequence of something more imposing: the relationship between the evidentiary materials available and collected (what the archives hold of documents, arts, accounts, recordings, narratives of both living and deceased) and the *Zeitgeist*, the spirit of the times or, more particularly in this context, the ideological climate in which certain materials are deemed worthy of being gathered and the ways in which they are received (interpreted).

The idea is not simply, however, that unearthing and exhibiting presences rectifies absences. Most important is that the relationship between absences and presences is what allows both to be meaningful. In other words, absence makes presence possible, and presence calls up questions about what is being erased or sidelined–and why. Because absence and presence are necessarily relational, things are never "not there"; they are perhaps better understood to be latent, pregnant, suspended, arrested–where silence can be deafening rather than un-hearable or inarticulate. If things in relation create each other, and meaning depends on the character of the relationship, then the question of visibility, its creation and its meanings, arises. In our quest for new and unflinching, equitable ways of knowing, how ought we to make absence visible and presence meaningful, and what actors are involved in doing so?

When we embark on this exploration, we encounter an irony. There is no absolute template for rectifying historical gaps and ideological agendas, because disfranchised peoples' lived experience gives rise to vested interests, idiosyncratic interpretation, and competitive objectives as much as in the everyday lives of the powerful, although those of the latter are far more apt to be "present"—that is, visible and memorialized. Lest it seem that I wish to end on a note of stalemate, however, let me draw attention to another of Winston Churchill's *bon mots* that I think helps clarify what the problem is that faces us and how we might grapple with absent-presences. "We are the masters of the unsaid words, but slaves of those we let slip out," Churchill remarked (www.thinkexist.com/

quotation). While he surely had no intention of juxtaposing this observation with his comment about victors writing history, I take the liberty of doing so in the context of this discussion. In modifying his first comment, this second one underscores the idea of the vulnerability, if not fragility, of ownership—of history, of representation—and that being in control, as "masters," also means being in thrall, as "slaves." When things are kept silent or mysterious, the keepers of those silences and mysteries may not be held accountable but they are also subject to the effects of their ideas and words. Like traps, ideas and words subject us to them as they are voiced, because they function in a particular Zeitgeist of diverse listeners. Thus, here, Churchill's polemic can be read as problematizing the term "victors." Certain groups make their interpretation of their presences, and their critiques of their absences known (that is, heard and accepted) but, "victory" is not necessarily synonymous with "vanquished." That is, power has many forms. Disempowered groups, too, have forms of power that, although not hegemonic, are asserted and demonstrated through everyday practice, as, for example, in "hidden transcripts" (Scott 1985) if not through institutional structures and organized collectivities.

This not only complicates the binary of "absence-presence," but it also raises the question, as I noted earlier, of boundaries: how absence is made visible and presence meaningful; which constituencies (communities, groups) get omitted or sidelined as others appear; what criteria determine the proper or appropriate forms of representation and ways of knowing histories, identities, cultural practices? Multiple perspectives, interests, and forms of consciousness reflect and engender multiple relations of power. The challenge is to explore ways to claim a space for the histories, memories, and subjectivities of the uncharted and undervalued, or explore the ways in which they can themselves make claims—without seeking or validating "true" essences, without anesthetizing the protean and context-contingent boundaries that distinguish peoples in the places within which they situate themselves.

These questions have been taken up by a number of scholars, from different, if complementary angles. For example, pointing to the gendered "paradox" of "a being whose existence and specificity are simultaneously asserted and denied, negated and controlled," Teresa De Lauretis analyzes what she calls the "non-being of woman" (De Lauretis 1990, 115). This rubric is meant to highlight what "is at once captive and absent in discourse, constantly spoken of but of itself inaudible or inexpressible, displayed as spectacle and still unrepresented or unrepresentable, invisible yet constituted as the object and the guarantee of vision" (1990, 115). We see a comparable concern with objectification and perceptibility in Dianne Stewart's (2005) argument about African diasporic religions. She rejects the notion of "syncretism" that conventionally has been employed to describe the cultural encounters between Africans and Europeans in the Caribbean, which emphasizes implicitly or otherwise the dominance of European influence, and the "subdued" or "disintegrated" (2005, 222) presence of African cultures in these processes. Instead, Stewart promotes the idea of "antibodies" (2005, 213) borrowed from African philosopher Eboussi Boulaga. Concurring with Boulaga, she posits that African diasporic religions are living organisms with innate dynamism and antibodies—codes and symbols—which allow practitioners of African diasporic religions in the Caribbean to resist external (Euro-colonial) assault.

Provoked by the elision of the Indo-Caribbean in Afro-Caribbean arts and art criticism despite their "almost two centuries of living together," Gita Rajan (2006) offers the metaphor "chutney" to explore Afro-Asian encounters: Indo-Caribbeans' "hybridized, uneasy syncretistic fusion of words, secular and sacred symbols, and folk and popular cultural mythologies gleaned from memories of home and adapted to [Afro-Creole] Caribbean contexts" (2006, 129). In her discussion of the

unequal relationship between Indo-Caribbean and Afro-Caribbean fine arts, Rajan observes that, given Afro-Caribbean art's articulation and spearheading by Caribbean intelligentsia, it "fused high culture with pop cultural mores," bringing together "transcontinental and cosmopolitan tastes with an indigeneity presumed to be inherent in island cultures..." (2006, 126). With Indo-Caribbeans' post-independence environment being one of Afro-Caribbean hegemony (rather than a Euro-colonial one), Asian influences in Caribbean art, Rajan argues, remain "consciously or unconsciously, on the sidelines" (2006, 126). She goes on to point out that this omission is particularly curious since Caribbean artists have been credited by art critics, among others, with the propensity for cultural borrowing, for example from Mexican muralism and Amerindian and African American cultural codes (2006, 126). An alternative metaphor for making presences out of absences is a focus on "dialogue." J. Lorand Matory's (2006) interest in a dialogic approach emphasizes what he calls "live dialogue" (2006, 171), which he argues allows escape from such conventional concepts in diaspora studies as "collective memory." Live, enduring dialogue represents "diverse diasporic locales not as divergent streams but as interlocutors in supraregional conversations" where there is "mutual transformation over time" (2006, 183). The usefulness of this metaphor's corrective is to remind scholars that collective memory and other forms of commemoration are always strategic in what is selected and excluded, and how these selections and exclusions are interpreted (see also, for example, Williams 1977; Trouillot 1998). For Matory, the concept of live dialogue works against the tendency that the conventional notion of "memory" possesses: to hide rather than highlight struggles over meaning–of words, monuments, gestures, and recollections. What "memory" implies is "the organic unity of the collective 'rememberer'," rather than the fluid heterogeneity of social life, where the power struggle among diverse rivals over unequal resources is paramount (2006, 163).

A crucial consequence is that in the process, the metaphor of memory suggests "a certain passivity, involuntariness, absence of strategy, and political guilelessness and neutrality" that are actually quite the opposite of the processes that have shaped African and African American—and, I would add, all other diaspora—cultures (Matory 2006, 164). For issues of absent-presence, the consequence is the implication of involuntariness and neutrality that Matory points out are contained in static categories like "memory." The relationship between the invisible and the visible (what is emphasized, what is valued, what is derogated, what is hidden), is rendered less rather than more a matter of unequal relations of power, and more rather than less homogeneous—simply a matter of multiple and competing interests. In other words, there is a flattening out of the absent-presence problematic, where "dialogue," which is necessarily in the plural and often highly charged, becomes primarily a matter of reductive, binary images of the "powerful" versus the "powerless."

Whether it is a matter of revealing obfuscated relationships and deconstructing complex discourses with analytical metaphors like "non-being," "antibodies," "chutney" and "live dialogue," there is still the equally complex matter of how to construe the visible: what is emphasized, what is valued, what is derogated, what is hidden, and according to whose gaze?

Considering the case of *Hosay*, the Caribbean name for *Muharram*, as it is practiced in the Republic of Trinidad and Tobago (hereafter Trinidad), I argue in this chapter that rectifying the problem of absent-presence cannot entail uniform political visions or homogeneous solutions. Necessarily localized, absent-presences are continuously unfolding and multilayered. They are also, however, imperative indicators of the necessity of understanding visibility and meaning in terms of the tension between the discursive constructions of culture and history and their manifestation

in everyday life. Hosay, another good example of the problematic of "absent-presences," is where a cacophony of the visible and invisible are variously hewn into ostensibly more orderly, manageable parts by local practitioners as well as by those who oppose them.

What is in a name?

The category "religion" in the Caribbean has had a paradoxical history. It has been, on the one hand, a trademark of scholarship in the region, an undisputed and recurring motif in an anthropological climate that, as Sidney Mintz famously observed, deemed the Caribbean neither sufficiently "primitive," nor "modern" enough to be of much interest otherwise, but where Vodou, for example, has held abiding fascination (Ghani 1998). And despite the differences in perspective that anthropologist Melville Herskovits and sociologist E. Franklin Frazier had with each other about cultural continuities between Africa and the New World, the domain of religion was not among them. Instead, Frazier concurred with Herskovits's position that African religious "retentions" existed among Afro-Caribbean (and Afro-Latin American) peoples (Frazier 1939, 5-6, in Yelvington 2001, 232). Yet on the other hand, if significantly defining the region, Caribbean religions have long troubled the definition of "religion" itself, notably in terms of the emergence of "syncretic" religions from Caribbean "creole" societies—that combination of elements from two or more different traditions (e.g., Stewart 1999) which gives rise to new formations of cosmology and theology and presents innovative or unfamiliar official and popular versions, notions of orthodoxy, interpretations of hegemony, connections and relationships between so-called "natural" and "supernatural" beings and worlds, and degrees of correspondence between "agency" and "resistance."

One way to approach the implications of these questions is to think in terms of the process of *naming*, the categories and their classificatory boundaries that define, establish, and disturb modes of understanding. In other words, categories not only identify what seems empirically obvious, they also create empirical phenomena by specifying particularities out of generalities. We think through categories in order to interpret and understand our experiences; these categories work in part by accentuating certain phenomena or features of something (rendering them present) and lessening other phenomena or features (rendering them marginal or absent). The point is that these processes of present-ing and absent-ing are inevitable but not random or accidental; rather, they follow broader epistemological and ideological structures.

As Mintz, Herskovits, and Frazier each suggested in their own fashion, religion has demarcated the Caribbean as a particular kind of place, and so-called syncretic religions blur the boundaries around ostensibly uniform religions. This raises the crucial question of what, then, is "religion"? To paraphrase an observation Eric Wolf (1984) made over a quarter of a century ago, it is almost as if the more that is recorded about what religion *does*, the less has been certain about what religion *is*. Wolf identifies one likely reason for this being our inability to employ "culture-free constructs" to replace notions of "religious 'common sense'" that are drawn from observers' own religious traditions (1984, 1–2). In other words, we may never be able to get at what religion *is* because religion has no "true" nature and because we are not able to think outside the boundaries of our own categories (cultural constructs). Thus, the "does" and the "is" slide into each other—in practice as well as in conceptualization—as each implies or anticipates the other. At stake here are two important issues. One is conceptualization—how to use prefigured categories, or representations, that define "religion" in particular ways. The other is approach—how to employ categories that identify and explain on-the-ground, empirically observable experience, where what often ensues

are, essentially, tensions between, on the one hand, conversations about categories and, on the other hand, portrayals of lived experience through ethnographic detail. This is, in short, really a problematic of theory-building and its relationship to the collecting and marshaling of data. Or, to put it another way, it is a problem of categories and their use. I am not suggesting that other parts of the world do not also involve these concerns, that the Caribbean is unique or exceptional in this regard. But as a region that simultaneously has been defined by religious traditions and that troubles the conceptualization of and approach to "religion," the Caribbean illustrates the issues quite distinctly.

The obvious question that arises from this is exploring *when* something is "religion," and according to whom, a richer and more promising point of departure than starting with the premise that something *is* "religion" and then investigating what *type* it is. Ultimately the question becomes: what utility and significance does the category "religion" have altogether (and, by extension, what do all categories have), and what would the methods and politics of religion's analysis and practice look like without such an identifying name? Getting to this point of scrutinizing *when* a phenomenon is "religion" has required concerted efforts by early and mid-20th century scholars to establish the legitimacy and respectability of Caribbean religions—"creole," "syncretic," and otherwise. Most scholars of Caribbean religions today do not spend much time deliberating about where, or whether, these forms of veneration of and engagement with other-worldly dimensions belong within the category "religion." Instead, the rich array of expressions and variations found are what tend to be of interest, with the assumption that they do indeed constitute "religion," which is one way to legitimate them as important forms of cultural production worthy of scholarly interest and popular respect.

Other kinds of stakeholders, notably religious practitioners and policy and law makers, have other kinds of vested interests in the question of how to categorize (define, explain) religion. What I offer in the remainder of this chapter is the example of Hosay in Trinidad. Historically and today, Hosay is perceived by observers and practitioners alike as consummately Caribbean, a creole variation of Islam subjected to galloping, rather than creeping, syncretism. Hosay's emphasis on performance and public spaces makes it a useful case for thinking about the question of boundary creation, patterns, systems, religion's definitional criteria, and, ultimately, what kinds of authenticating and legitimizing practices the latter might be useful for.

Hosay may appear an opposite contrast to other Caribbean "creole" or "syncretic" religions, not the least reasons being the centrality of *public* performance (at the same time that the Muslim preparatory rituals connected to its culminating procession are considered sacred and hence restricted to observant Muslims); its possessing a *name* (it is one ritual situated within a recognized religion, Islam); its capacity to have *participants* who are not necessarily *practitioners*; and its written documentation in colonial Caribbean history, which has been more consistent than other religious traditions whose histories are significantly, or at times entirely, based on oral historiographies.

Hosay in Trinidad

As Satnarine Balkaransingh rightly observes, "Trinidad Hosay is one of the major annual events on the cultural calendar…" (Balkaransingh 2010, 247). Originally practiced throughout the British West Indies, Hosay is now observed on a large scale only in Trinidad. In other parts of the region, for example, Jamaica, it is commemorated on a much smaller scale, and Hosay ceased to be practiced in Guyana by the early 20th century. Although still a vibrant annual event in Trinidad, in the last few years a narrative among its practitioners about its diminution has arisen, an expression of concern

about the ability to secure support in the form of public and private funding and the ability to keep intact Hosay's traditional organizational structure and forms of knowledge, which historically in Trinidad have been family-based and generationally passed down. As of the current moment, however, Trinidad's Hosay remains an energetic and meaningful island-wide public ritual.

Hosay derives some of its form and substance from the peoples in India who have long engaged in its practice, and from the Indian laborers who brought it with them in diaspora during the official period of Trinidad's indenture system, 1845–1917, to work on post-emancipation sugar plantations. Hosay was first observed in Trinidad in 1847 (Samaroo 2008), on the Philippine sugar estate (Wood 1968, 152). Because there already are other treatments of Hosay that provide more detail than space presently allows (e.g., Singh 1988; Balkaransingh 2010; Samaroo 2008; Korom 2003), I will limit my description to broad strokes. Hosay in Trinidad occurs as an annual procession in the first month of the Islamic lunar calendar ("Muharram"). Its two principle sites historically were, and remain, the town of St. James to the north and the town of Cedros in the southern part of the island. Hosay involves a month of ritual fasting and prayers, the construction of *taziyahs*—in Trinidad, "*tadjahs*"—massive replicas of the tombs of Hussein and Hassan, and, finally, the main public procession of the tombs by mourners–and others–on Ashura, the 10th day of Muharram.

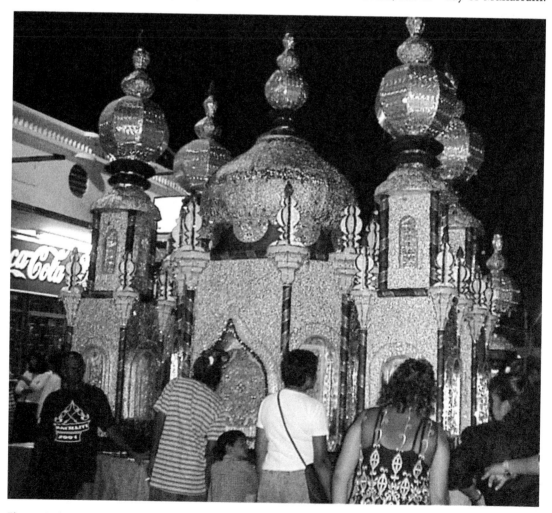

Figure 1. St. James Hosay procession November 2012. *Photo by Patricia Mohammed*

The tadjahs are built in yards, called "*imambaras*," typically located adjacent to the private homes of certain family participants, and construction generally is organized into extended family and neighbor work groups of Muslims, Hindus, and Afro-Trinidadians. During the three days before Ashura smaller processions are held, including "Little Hosay Night," a parade of small replicas of the tadjahs, called "Little Hosays," along with the insistent and rhythmically complex drumming that signals Muharram's martial history. On the 9th day of Muharram, "Big Hosay Night," the full size tadjahs are brought out for public viewing, to the accompaniment of drummers and two flag-bearers who carry standards in the shape of half-moons representing Hussein and his brother, Hassan. On the 10th day of Muharram the tadjahs are marched to a special site called the Karbala (the site of Hussain's death, located in present day Iraq), where the procession gathers and funeral prayers are read. On the 13th day of Muharram the tadjahs are taken to the sea, dismantled, and set afloat. Some charge that this latter practice reflects the influence of Hindu custom. Hosay historically has enjoyed the considerable involvement of Hindus and people of African descent, the latter having traditionally played a significant role as drummers, stick fighters, and bearers of the tadjahs in procession. Hindus assist in the building of tadjahs, accompanying the processions of mourners, and historically have participated in stickfighting performances. Still today Hindus sometimes make vows and offerings during Hosay.

Also present at the procession are non-Muslim on-lookers as well as non-observant Muslims, locally termed "Muslims in name only." These groups tend to stand along the sidelines and watch the tadjahs, drummers, and flag bearers march by, theirs being a secular orientation that might be associated with a parade. Some among them may consume alcohol or dance to the rhythms of the drums. In the 19th century, ganja smoking and stick fighting were also a part of this event. Importantly for our purposes, Hosay remains today decried as "un-Islamic" by some orthodox Muslims, who have periodically, over time, made formal and informal attempts to curb it. Others treat the procession as a site for their own expressions of piety, such as the Hindus I have observed (most recently, during St. James's Hosay in November 2012), who follow the tadjahs and toss flowers and rice in supplication of Hindu deities.

Although Muharram historically is a Shi'a Muslim tradition, in India, from whence it came to Trinidad, its observance has long involved Sunni Muslims as well as Hindus. In diaspora this religious and cultural diversity includes other locals, notably people of African descent who are predominantly Christian; at the same time, in diaspora Hosay's Shi'a heritage was not emphasized, the more encompassing identity category "Muslim" being salient in British West Indian (and other British) colonies. Muslims in Trinidad were not distinctly grouped into "Shi'a" and "Sunni" partly because there were likely more Sunnis among the indentured immigrants (the majority of Indo-Caribbean Muslims self-identify as Sunni) and partly because even if these distinctions were salient in parts of India at the time, they ceased to be so in diasporic contexts that did not depend upon or derive particular benefit from such parsing. Identity is always and necessarily context-contingent. Moreover, the Hindu indentured laborers from India far outnumbered those who were not Hindu, and, seemingly unperturbed by Hosay's Islamic origins, the majority of Hosay participants in Trinidad have been Hindu—both because the majority of indentured laborers were Hindu and because there was not a distinct boundary delimiting their participation in India.

Today there is among Hosay practitioners a self-reflexive awareness of the Shi'a genealogy of Muharram/Hosay, but this took generations to become a meaningful part of religious discourse and consciousness. The most likely reasons for this include the general post-independence climate in Trinidad, where identity boundaries were becoming increasingly differentiated within a socio-

political milieu created by the communal politics produced in large part by the implementation of voting in Trinidad, where "the most important, visible, and salient dimension of political cleavage is race" (Hintzen 1989:20). By the 1950s in Trinidad, the appeal to race was a principal aspect of mass political mobilization, given that majority rule required aspiring leaders to amass the support of the largest voting blocs (Hintzen 1989, 3, 39). I am not at all suggesting a simplistic link between racial thinking and intra-Muslim group distinctions; rather, I am placing the buttressing of difference that Trinidadians (both Indo and Afro) have been describing to me since my work began in the mid-1980s (see, for example, Khan 2004) into a broader historical and social context. The gradual transformation from the 19th century British umbrella category "Hindoo" indicating Caribbean Indians in general, to later classifications of "Hindoo" and "Mahometan Hindoo," to the post-independence preponderance of the terms "Hindu" and "Muslim" ("Hindoo" and "Mahometan Hindoo" having dwindled in the vernacular), and increasing intra-Hindu and intra-Muslim differentiations (for example, "Sanatanist," "Arya Samaj," "Sunni," "Shi'a," etc.) belong to an emphasis on the dividing and subdividing of identity boundaries that became a focus (and tool) of post-independence Trinidadian society, and which continued to be heightened as the late 20th century moved toward the 21st.

A probable catalyst for the more recent focus on, or at least heightened interest in expressly Shi'a foundations of Hosay echo my earlier comment about scholarship, heard and configured in particular ways by broad local constituencies, helping to shape, through corroboration or disputation, popular wisdom's ways of knowing. There are more synergies between "popular" and "high" or "erudite" culture than the conventional binary model between them might allow us to anticipate. For example, during my last field research on Hosay, in November 2012, I was shown by members of one of the St. James yards a book on Muharram (*Ta'ziyeh*) in Iran, written by a North American author. These men ardently consulted this text for explanations and guidance as they strove to sustain Hosay in what is for them the most accurate, sacred, and meaningful way possible. For my part, it was an interesting example of the present tutoring the past, and one kind of retroactive ascription of the significance of Shi'a to Trinidad's Hosay.

As the decades of the 19th century passed, Hosay became well-established on the sugar estates, and by this means institutionalized into Trinidadian colonial society. Competition developed among the sugar estates over building the biggest and most elaborate tadjahs, and joining Muslims and Hindus in donating funds for their construction were Afro-Trinidadians and Chinese, who were either working on, or located near to the estates. Of salient interest to the rivals was the size and magnificence of the tadjahs, the numbers of people in each procession, and the dexterity and stamina—the "sweetness"—of the drumming that was a necessary element of the procession (Thaiss 1994). This historical heterogeneity of interested parties as well as participants, along with the flexibility of objectives associated with Hosay, raised three key questions, still relevant to practitioners and policymakers today, involving the question of how to be *present* and whether or not to be *absent*: (i) what exactly *is* Hosay (in its connections to labor diasporas); (ii) what are the consequences of choosing an identity, a name, and thus an explanation for it, and (iii) what is the connection between its religious "thing-ness" (identity) and its implications for other, perhaps more pressing social, political, and analytical concerns? Throughout the last almost two centuries, there have been periodic calls to curb or prohibit Hosay. These have come from numerous parties and historical moments: 19th century colonial authorities concerned about breaks in sugar production and the potential growth of labor solidarity; 20th and 21st century orthodox religious leadership, both Muslim and Hindu, who decry Hosay as either "un-Islamic" and therefore inappropriate activity

for Muslims, or as too Islamic and therefore inappropriate activity for Hindus; and late 20th and 21st century upwardly mobile, younger generation Trinidadians who deem it insufficiently modern (Thaiss 1994). All speak in some way to the problem of categorizing "religion" as such, and the problem of how to know/understand it.

A key 19th century colonial weapon against Hosay was a form of what Ronald Richardson (1987) calls, in his discussion of obeah, "psychological warfare," the objective of which was to cast doubt on the legitimacy of alien practices of the colonized *as religion*. As just one example, when a visiting Englishman observed his first public procession of Hosay, in 1847 in the southern town of San Fernando, he reported that he "saw their heathen temple [i.e., tadjah] carried on men's shoulders, heard their yelling, witnessed their dancing, gestures and other things connected to their pagan ceremonies; but here I could not refrain from shedding a sympathetic tear over the moral degradation of this benighted race of beings" (quoted in Balkaransingh 2010, 248). Such words as "heathen," "yelling," and "pagan" together convey a message of denigration of what was being practiced (the acts themselves) and denial of what those practices could claim to be a part of (i.e., a religious tradition).

Labor stoppage, crowd control, and worker solidarity always presented a problem for planters, as well as being issues for indentured immigrants and their fellow laborers. In October of 1884 the infamous "Hosay Massacre" occurred in southern Trinidad, when four to five thousand participants refused to obey a colonial order to curtail their procession and stay within agricultural districts away from more densely populated areas (see Singh 1988). A demonstration of resistance on the part of Hosay participants and of discipline on the part of colonial authority, thirteen marchers were killed by the barrage of colonial bullets that were trained their way, and ninety-three people were injured (some of whom may have later died). This particular year, 1884, Hosay became even more overtly a vehicle for determining the difference between "genuine" and "spurious" religion, as colonial authorities attempted to defend their own rash and extreme actions. Not being counted as genuine "religion" also held another advantage for colonial authority. "Religion" by definition connoted an organized body of belief, a standardized structure; "popular" refers to the masses, who represented disorder, unruliness, and unpredictability. Hosay was amorphous: although it consists of an organized procession based on the historiography and religious knowledge of its adherents, it was not rigorously self-disciplined except in its sacred dimensions, nor was it restricted; on the contrary, it presented entry points for any number of groups—Indos, Afros, Chinese, Hindu, Muslim, Christian, etc. Hosay was also viewed by the colonial gaze to be potentially ferocious: the throngs of people, the uncertain combination of participants and practitioners, the stick-fighting, the resolute rhythms of the drumming, perhaps the ganja, the passion of bereavement—martyrs made, a battle lost—and the passion of solidarities formed in procession, whether in protest or in revelry. In this context, the "popular culture" of which Hosay was a part may have represented a liminal space of creativity, but it was not the kind of creativity that regimes tend to feel comfortable with.

Historian Prabhu Mohapatra (2002) tells us, for example, that Sir Henry Norman, Governor of Jamaica, produced in 1885 a "Report on Coolie Disturbances on Muharram in Trinidad," in which he claimed that Hosay was not religious and thus the government was not interfering in religious freedom. Like obeah, Hosay was being denied the boundaries of protection provided by a religious identity. Governor Norman "argued that Hosay could not be a religious festival" because it is purely a Muslim concern yet most of those involved with it are Hindus; "the whole celebration in Trinidad," he concluded, "has long since ceased to have a religious significance" (Mohapatra 2002,196). Not possessing "religious significance"—that is, not being counted as a religion—

enabled the authorities to circumvent the post-emancipation British colonial policy, advanced by Queen Victoria herself, that the religions of the colonized, although not meriting respect, should not be interfered with. Colonial officer Norman was appealing to canons of orthodoxy to support his defense of the government's actions; two years before the massacre, in 1882, for example, when the governor of Trinidad first sought Colonial Office permission to regulate Hosay, he did not include Hindu participation in Hosay as among the reasons. To the majority of planters and officials, Hosay was "plain and simple 'Coolie Religion'," and a day of amusement for them, which should be tolerated (Mohapatra 2002, 197). Intolerance came to a head primarily with increasing labor unrest and was justified, it seems, by taking what was an amorphous, vaguely delimited, generic "Coolie Religion," and parsing this seemingly unstructured whole into separate parts of truth (genuine "religion") and falsehood (perversions or misappropriations of "religion"). This leads one to consider whether "Coolie Religion" can be viewed at least somewhat akin to obeah– imagined as amorphous, syncretic, with seemingly undisciplined (uncertain) boundaries. (A key difference, of course, is that "Coolie religion" was understood to be *collectively* oriented while obeah is typically understood to be *individually* oriented.)

In a March 1884 article in the *Port of Spain Gazette* newspaper, titled "The Coolie Hosein" (Hosay), the author called for curbing, "with a firm hand," the "Coolie Hosein," due to the increasing "abuses which have gradually crept into what was, formerly, a simple religious rite." He continued: "We are bound not to interfere with the religion of the Indian immigrants introduced here by the Government. This forms part of our contract with them. [But]...it is our duty carefully to ascertain where the purely religious rite ends, and abuses begin. There can be no difficulty in fixing the limits within which coolies should be kept. It is utterly absurd to pretend that the monster processions which...inundate our principal towns with thousands of fanatical and drunken coolies can form any necessary part of their religious ceremonies" (National Archives, Republic of Trinidad and Tobago). To close out the 19th century, an 1877 article in Trinidad's *New Era* newspaper decried the tendency of the "lower orders" ("grassroots" Afro-Trinidadians) to participate in the "heathen ceremony"—the Hosay commemoration—and labeled this tendency "strange and contradictory to our character of a strictly Christian community" (quoted in Moore 1995, 182).

With the help of the Canadian Presbyterian Mission (CPM), which had been exerting enormous influence in Trinidad since its arrival there from Nova Scotia in 1868, the colonial government began to distinguish Hosay's religious *rites* from, as it was phrased, the "irreligious" *procession*. This is not surprising given that rites can be contained in space and time more effectively than mobility can—for example, leaving the sugar estates, or marching. A few genuinely "religious" aspects of Hosay were identified and permitted: prayer, gathering sacred earth and placing it in the sacred tomb, and burying the tomb–"genuine" because they were deemed exclusive to Muslims and which did not require leaving the estate (Mohapatra 2002,198). Attempting to prohibit Hindus from participating accomplished a number of objectives: shoring up the idea that only "real" religion could be permitted, that only Muslims (and certain ones at that)–along with colonial clerical authority–could lend religious credibility, and that since the majority of the Indian population, along with non-Indian participants, were not Muslim, the actual numbers of sanctioned Hosay marchers should be significantly diminished.

Concerned about the Mission's getting positive results, the Reverend John Morton, who with his wife Sarah, founded the CPM in Trinidad, records in 1869, the second year of their work, that among those indentured laborers attending church services, "more correct notions of God and duty are coming to be entertained, and that often there is exhibited an interest in the Saviour's love and

mercy. But none have come forward to give up their system of error, and while we see a certain restraining influence to some extent at work, we cannot see that any have been constrained by Divine grace to turn heartily from their wicked ways" (Morton 1916, 78). Also a ready contributor to the print media of his day, Reverend Morton wrote a letter to the *Trinidad Chronicle* newspaper in 1871, claiming that there is "enough evidence to show that Hindus in Trinidad had a strong religious commitment to the Hosay" (Mohapatra 2002, 200). For example, "they seemed to have believed that Hassan and Hussain were reincarnated every year during the Hosay and regarded them as benevolent spirits" (Mohapatra 2002, 200). Another observer (a Mr. A. Weed) wrote in 1883 to the *San Fernando Gazette* that sites where fowls were sacrificed to Hassan and Hosein were located throughout the country" (cited in Mohapatra 2002, 200, fn.25, fn.26). Given what we saw of Morton's view askance of indentured Indians' religious traditions in his *Gazette* remark about Indian's multiple religious commitments, he was likely addressing broader problems with what he perceived to be indentured laborers' errant ways; ambiguities in Indian cosmology were only one aspect. For him, as for many others, firm demarcations among beliefs into identifiable, recognizable "systems," and the practices linked to them, required a watchful eye, and, in this case, (Christian) correction.

Ninety-one years later, anthropologists Arthur and Juanita Niehoff came to the conclusion about their ethnographic fieldwork among rural communities in Trinidad that Indo-Trinidadians' "folk religion," as they called it, "borrowed heavily from their Negro neighbors. Almost all the traditional spirits derived from Negro culture" (1960, 168, 182). In the following decade, Patricia Hale, the first Mrs. V.S. Naipaul, made a diary entry (in 1971) that Naipaul had watched "the 'delicate and glistening' tazias paraded at the Hosay festival...[she continued]: 'Vidia allows himself to be carried away[,] as this is Indian drums and drumming. I dart out into the road and grab him as he is following happily'" (quoted in French 2008, 295). Even dyspectic, Trinidad-phobic, and self-consciously Brahmin Hindu V.S. Naipaul, found himself drawn to revel in the "Indian" (not "African") drumming. Unlike the missionary Mortons, neither the Niehoffs, who were academics, nor the Naipauls, who were Global North observers, had a stake in the project of religious conversion. Yet their comments similarly reveal the historical narratives of any cultural practice and the variegated and unanticipated ways they can be experienced.

As Mohapatra, among others, observes, Hosay was "about representation of collectivities dramatically staged in public space...[transgressing] the bounded space in which Indians were placed, i.e., the plantations" (Mohapatra 2002, 223). Similarly, Vijay Prashad (2001) interprets the "Hosay Massacre," and Hosay in general, as representing the empirical absence of racial antinomies and cultural xenophobia between Indo and Afro, where subalterns sought to hold the Hosay commemoration as they saw fit, according to both Muslim doctrine and local patterns of social relationships. From this vantage point, one can argue that the colonial dividing lines of "race," "culture," and "religion" meant little to people united by a stronger sense of affinities deriving from the relations of production and the perceptions of a class "for itself." Given the historical record there is no reason to doubt this perspective, but it does complicate the ways we ascertain (identify, interpret) diverse forms of presence and absence, and ascribe boundary divisions among them. This process seems similar, if in reverse, to obeah, where what is feared about it lies in the realm of the private and the unseen. As opposed to Hosay practitioners' insistence on self-assertive empowerment by being seen, obeah threatens because of what is not visible; obeah arguably acts most powerfully on rumor. Yet what remains in common is the play of boundaries–ones that arguably float more questions than secure answers.

These issues of authority, authenticity, and legitimacy—and the presences and absences they create—have not been limited to the Caribbean. In writing about Muharram observances in colonial Natal (South Africa), historian Goolam Vahed (2002) notes that Indianness was "a complex construction, constituted through struggles among disparate Indians, and between them and whites and Africans..." (2002, 77). While Muharram mourned the deaths of Muslim martyrs, the joint participation of Hindus and Muslims, along with the fusion of Hindu and Muslim traditions, made it a "pan-Indian festival"—"Coolie Christmas," as it was locally called (2002, 80). Like their indentured counterparts in the Caribbean, Indians in Natal practiced Muharram, in part, as a moment to gather together socially, to dance, drink, smoke "Indian hemp" (ganja), play music (including drumming, or "tom-tomming"), and generally "make merry" (Vahed 2002, 81). Unlike in Trinidadian Hosay, however, but worth mentioning because of the significance of this practice as a multiple crossroads of peoples and popular cultural practices, Natal commemorations included dancers known as "tigers." These dancers were local champion wrestlers who wore skimpy costumes, masks, and plentiful face paint to resemble tigers. They lead the tadjahs and charged the worshippers as if they were real beasts (Vahed 2002, 84-85), adding some extra thrill and perhaps even gaiety to the occasion. Local newspapers of the day reported that at the commemoration Hindu men and women wore abundant jewelry and gaudy costumes that "defied description" (Vahed 2002:86)–all amid "religious grief, large crowds...and tazzias [sic] jostling for public space..." (Vahed 2002, 86).

Contributing to this variegation, if not to say unruly heterodoxy, is an 1889 newspaper report which covered the story of a crime that had been committed (apparently unrelated to the commemoration), noted by Vahed (2002). In giving evidence, one man testified that he had not been present at the Muharram festival but had made it to "the pig killing at 2 o'clock" (Vahed 2002, 85)! Whether or not Vahed is correct in his speculation about the reason for this practice occurring in a Muharram context being due to "deeply entrenched" ideas among Indians about blood's curative powers and the connection between blood sacrifice and identity (Vahed 2002, 86), pig killing at a Muslim event is, at the least, a pretty good indication of the interpellated boundaries of the Natal Muharram observance, where clearly very old cultural practices were put into commemorative play. In this context of multiple traditions (which holds for Trinidad as well as Natal), where does "Indian" end and "African" begin? When does "Indian" no longer become perceptible and when does "African" come into view? How are genuine "religion" and spurious "superstition" or "heathenry" differentiated? And, of course, lying within all of these questions is the issue of what is present and what becomes absented as they get answered?

By the turn of the 20th century in Natal, as in the Caribbean, police and government pressure worked to restrain Muharram as a way of maintaining social order. Some Hindus and religious leaders also worked to curb Hindus' participation in Muharram; there was considerable concern with the alleged propensity of the Hindu masses for superstition and idolatry. This class- and religion-based position was also resonant in the Caribbean but on the part of participating Hindus only quite recently, after independence in 1962, with the rise of "orthodox" interpretations of Hinduism. Much more among Muslims there, Hosay has been a contested tradition. Yet similar themes persist: what are the appropriate (correct, orthodox) interpretations of Islam, which kinds of authority (religious, political) should confirm these interpretations, and who should be legitimate contributors to this annual commemoration as well as who should be silenced or absented from recognition of their presence?

From the contemporary perspective of cultural politics and nation-building, Hosay is a metaphor, and a case in point, for the tensions of a self-described "creole" society attempting to forge a "callaloo nation" (Khan 2004): one united body that can embrace, and justly represent, the racial and religious and cultural diversity that is Trinidad's historical legacy. Mid-20th century pre- and post-independence nationalist ideology organized universal suffrage into racially-based voting blocs *made visible and tangible* by selected cultural traditions that represented the callaloo nation largely through public performance. Within the context of these developments, the issue of *authenticity* became paramount. That is, how are given selected cultural emblems, such as, for example, Divali for Hindus, calypso for Afro-Trinidadians, and Hosay (ostensibly) for Muslims, to be defined, presented, and authorized? These tensions and debates are not simply academic exercises; they are the basis upon which groups vie for state patronage (and receive it, often in terms of funding of "cultural" programs and activities, building of denominational schools, etc.). A deliberately public and visible occupation of space was being, and continues to be, in a sense, privatized; that is, made increasingly esoteric and specified in the sense of stipulated rites that can more easily become ideologically associated with a delimited group and enclosed within the defense system of sacredness. But in public performance, even when staged, and certainly when not staged, controlling an event's participants and its meaning is a highly charged challenge. Through the consistent participation of non-Indians and non-Muslims in Hosay, as well as changes in Indo-Caribbean Muslims' intra-community interpretations of the beliefs and practices of Islam (a much longer story), concern over the authenticity of Hosay and its "carnivalization" (or, in Jamaica, its "jollification" [Mansingh and Mansingh 1976]) fuels heated public discourse every year about the religiously incorrect or secular, and thus inappropriate, consequences of treating this mourning rite as an occasion for revelry, with drinking, drumming, and dancing moving across the borders of ritual sacrality and religious exclusivity.

Writing about these issues in Trinidad, Gustav Thaiss (1994) contends that, "Clearly, the Shi'a are aware that they are losing control of being able to define the meaning of the public performances of the Muharram rituals" (1994, 48). But, as I noted, I would argue that in addition to Shi'a not historically constituting a distinctly aggregated group in the Indo-Caribbean, to speak in terms of "losing control" implies that "control" was possessed to be lost. Since "control" connotes boundaries (control over *what*), it was never possible, since Hosay has always been a continuous process—even if organized public visibility gives the suggestion of a *thing*, confirmed and stable. Attempting to authorize certain meanings of Hosay and its practice is on-going, although certainly exacerbated in the climate of post-independence nationalism. Even today, Muslims' intra-community debates about religious authenticity and legitimacy revolve around whether Hosay should be observed altogether, given the terms of the Hadith (the words and deeds of the Prophet Mohammed), and specifically, in terms of managing its diverse population of participants. As we saw, the control that was foremost in the minds of sugar estate workers in the late 19th century was directed outward toward colonial authority, concerned with the right to some form of sovereignty: exercising spatial mobility and asserting customary traditions for all to see.

With respect to generational divisions over Trinidad's Hosay, Thaiss (1994) reported that "Members of the older generation believe that if they do not continue to construct the *ta'ziyah* and organize processions some evil or illness will befall the family" (1994, 49). The younger generation rejects this and moreover, "does not accept the stories that are told of miraculous cures which occurred when promises were made to support the Hosay by building the *ta'ziyah* or by making

financial contributions for its continuing success or the strong belief among many of the old timers that Imam Husein will reward, in this world, those who actively sustain the Hosay. Vows are made by individuals–Shi'a as well as non-Muslim Hindus and Afro-Trinidadians–that if a desired request is fulfilled, they will make a promise to support the Hosay in some way. The younger, more educated generation view these explanations and practices as 'superstitions'..." (1994, 49). However, such practices as avoiding negative consequences, making promises in exchange for divine intervention, and so on, are common among all Trinidadians and are virtually always linked to any kind of supplication or self-protection that involves other-worldly entities or processes. Also, older and younger generations and their respective relationship to so-called "superstition" is complicated by class: that is, grassroots people irrespective of age will be more likely to feel socially and physically vulnerable or feel the need to take diverse palliative measures, seeking "whatever works." Thus there is no neat and tidy distinction to be made that divides Hosay opinions into two camps.

Finally, a number of observers (scholars and otherwise) contend that Afro-Trinidadian participation has turned Hosay into a *fete* (e.g., Thaiss 1994, 55). But this assumes either that Afro-Trinidadians are not aware of, or do not understand or appreciate the religious significance of Hosay, or that there is a litmus test for what that "religious significance" is. A great number of non-Muslims present at Hosay (as well as those not there)—Afro-Trinidadians, Chinese, Syrian-Lebanese, French Creole—would be able, if asked, to supply at least a basic description of Hosay and its significance. This is possible because of the multiple exposure through, for example, neighbors' religious activities, school instruction, and the print media, which has long been, especially since independence, keen on supplying editorials and reportage intended to be edifying tutorials. Non-Muslims may, in fact, tell the same narratives about Hosay as do Muslim adherents, who are also tutored about it largely in these ways. These discourses have their origins long preceding contemporary expression. As Kelvin Singh (1988, 4) observes about early Trinidadian Hosay, it was the only significant element in the Indian cultural repertoire that provided a social bridge to the rest of nineteenth century Trinidadian society. We must be careful, therefore, not to essentialize the congruence between *a* religion and its ostensible practitioners. Religious traditions are multi-stranded narratives (and not dissonant for being so) which grasp and tumble orthodox and heterodox, permissible and unallowable, legitimate and illegitimate, present and absent ways of knowing, putting all into play simultaneously—where "religion" emerges only contingently and under debate.

Pathways Possible

Taken from ancestral, subcontinental forms of cultural authenticity, the emblems of Hosay have been claimed as the special property of constituencies who would protect Hosay from what they perceive as the taint of irreligious or sacrilegious influences. These stewards tend to come from the local Muslim–Indo or Afro–religious leadership (recall Natal's Hindu leadership), or are lay practitioners who reject "innovations" and deviations from "correct" modes of practice. Speaking from the vantage point of orthodoxy as a way to safeguard Hosay's authenticity and purity, every year during the Hosay period representatives of orthodox modes present both learned and anecdotal objections to the way that Hosay is carried out. These objections stimulate lively debates locally about the practice of Islam, the role of "culture" in "religion," and the tension between, on the one hand, the idealized embrace of national unity and equal representation, and, on the other hand, the reality of Indo-Trinidadians' absent-presence from the Afro-Euro foundational ancestral axis, and their struggles to be equally represented by state patronage based on "racial" constituencies of voters whose competitive arsenal relies on the visual ascertainment of boundary

marking cultural emblems – such as tadjahs themselves, virtually always; such as multicultural participation, sometimes, depending.

Demographics and adherents both complicate the importance of genealogical descent as a mode of imagining boundaries and claiming religious membership and authority. Yet if we seek to make absence present in all areas of human experience and from all gazes–subordinate, dominant, and those not so well-defined as either–local discourses about Hosay's religious authenticity (how much it diverges from "correct," Old World practice), about its proximity to South Asian cultural traditions (the infusion of which, from various orthodox perspectives, would render it illegitimate), and about its rightful representatives (whose claims rest largely on diverse and competing interpretations of Muslim identity and religious doctrine) must be accounted for. If we do not wish to be left simply with a check-listed survey smorgasbord of these-people-do-this and those-people-do-that, then we need to understand power and its unequal relations in more nuanced and fine-grained ways.

Participants not defined as practitioners may participate in Hosay, to the great reluctance or resentment of some, but they may not own Hosay; that is, claim it as a legitimate part of their identity. The logic goes that the resulting dilution, impersonation, or acquisition of this flagship of Trinidadian practice blurs the boundaries distinguishing "Trinidadian" (representing the nation), "popular" (representing the masses), "Indian" (representing the "racial" or ethnic group, irrespective of religion), and "Muslim" (exclusively representing Islam, and a specific interpretation of Islam, at that). From this orthodox stance, the egalitarian call of multicultural tolerance is not the issue; heterogeneity is undesirable in itself since it jeopardizes the purity and authenticity of certain practices – in this case, religious ones. It is not simply that unearthing and exhibiting presences rectifies absences; in everyday life, neither operates empirically as an ideal-type binary of dominants versus subordinates. Most important is that relations of power are what allow absence and presence to be meaningful. As we have seen in the preceding discussion, absence makes presence possible, and presence calls up questions about what is being elided or sidelined–and why. Power is concentrated in particular moments and spaces, but it is also contingent on the struggles at hand, on the particular perspectives involved, and on the restiveness, and thus unpredictability, of vested interests. The challenge is to be able to ascertain—in "popular" as well as all culture—the present in what is missing, and the absent in what is in front of our eyes.

Acknowledgements

Versions of this chapter were presented in 2007 at the "Conference on Diasporic Counterpoint: Africans, Asians, and the Americas." Center for African American History and Program in Asian American Studies, Northwestern University, Evanston, IL (April), in 2009 at the "International Symposium on Sensitive Territories: Difference, Agency, and Transgression." National Museum, Rio de Janeiro, Brazil (June), and in Khan (2007).

Note

1. See, for example, Oxforddictionaries.com/us, and Dictionary.com.

References

Balkaransingh, Satnarine. 2010. Trinidad Space Speaking Through Indo-Trinidadian Ritual and Festivals, 1990–2009. Ph.D. thesis, School of Post Graduate Studies, Research and Development. University of Trinidad and Tobago, Trinidad.

De Lauretis, Teresa. 1990. Eccentric Subjects: Feminist Theory and Historical Consciousness. *Feminist Studies* 16(1): 115–50.

Frazier, E. Franklin. 1939. *The Negro Family in the United States*. Chicago: University of Chicago Press.

French, Patrick. 2008. *The World Is What It Is: The Authorized Biography of V.S. Naipaul*. New York: Alfred A. Knopf.

Ghani, Ashraf. 1998. Routes to the Caribbean: An Interview with Sidney W. Mintz. *Plantation Society in the Americas* 5(1): 103–34.

Hall, Stuart. 1980. Race, Articulation, and Societies Structured in Dominance. *Sociological Theories: Race and Colonialism*. Paris: UNESCO.

Heidegger, Martin. 1968. *What Is A Thing?* Chicago: H. Regnery Co.

Hiltebeitel, Alf. 1991. *The Cult of Draupadi: On Hindu Ritual and the Goddess, Vol. II*. Chicago: University of Chicago Press.

Hintzen, Percy. 1989. *The Costs of Regime Survival: Racial Mobilization, Elite Domination and Control of the State in Guyana and Trinidad*. Cambridge: Cambridge University Press.

Khan, Aisha. 2007. Mixing Matters: *Callaloo Nation* Revisited. *Callaloo* 30(1): 51–67.

———. 2004 *Callaloo Nation: Metaphors of Race and Religious Identity among South Asians in Trinidad*. Durham: Duke University Press.

Korom, Frank. 2003. *Hosay Trinidad*. Philadelphia: University of Pennsylvania Press.

Mansingh, Ajai and Lakshmi Mansingh. 1976. Indian Heritage in Jamaica. *Jamaica Journal* 10(2–4): 10–19.

Matory, L. Randall. 2006. The "New World" Surrounds an Ocean: Theorizing the Live Dialogue Between African and African American Cultures. In *Afro-Atlantic Dialogues*, edited by Kevin Yelvington, 151–92. Santa Fe: School of American Research.

Mignolo, Walter. 2005. *The Idea of Latin America*. Oxford: Blackwell.

Mohapatra, Prabhu. 2002. The Hosay Massacre of 1884: Class and Community among Indian Labourers in Trinidad. In *Work and Social Change in South Asia Festschrift volume for Professor Jan Breman*, eds. Marcel van der Linden and Arvind N. Das, 187–230. New Delhi: Manohar-CSH.

Moore, Dennison. 1995. *Origins and Development of Racial Ideology in Trinidad*. Tunapuna, Trinidad: Chakra.

Morton, Sarah. 1916. *John Morton of Trinidad*. Toronto: Westminster Company.

Niehoff, Arthur and Juanita Niehoff. 1960. *East Indians in the West Indies*. Publications in Anthropology, vol 6. Milwaukee: Milwaukee Public Museum.

Prashad, Vijay. 2001. *Everybody Was Kung Fu Fighting: Afro-Asian Connections and the Myth of Cultural Purity*. Boston: Beacon Press.

Price, Richard. 2008. *Travels With Tooy*. Chicago: University of Chicago Press.

Rajan, Gita. 2006. Chutney, Metissage, and Other Mixed Metaphors: Reading Indo Caribbean Art in Afro Caribbean Contexts. In *AfroAsian Encounters: Culture, History, Politics*, eds. Heike Raphael-Hernandez and Shannon Steen, 124–45. New York: NYU Press.

Richardson, Ronald Kent. 1987. *Moral Imperium: Afro-Caribbeans and the Transformations of British Rule, 1776–1838*. New York: Greenwood Press.

Samaroo, Brinsley. 2008. The First Hosay, 1847. Paper presented at Hosay/Muharram and Cultural Space, an International Conference on Hosay/Muharram, March 7–8, University of Trinidad and Tobago, Trinidad.

Scott, James. 1985. *Weapons of the Weak*. New Haven: Yale University Press.

Singh, Kelvin. 1988. *Bloodstained Tombs*. London: Macmillan.

Stewart, Charles. 1999. Syncretism and its Synonyms: Reflections on Cultural Mixture. *Diacritics* 29: 40–62.

Stewart, Dianne. 2005. *Three Eyes for the Journey*. New York: Oxford University Press.

Thaiss, Gustav. 1994. Contested Meanings and the Politics of Authenticity. In *Islam, Globalization, and Postmodernity*, eds. A.S. Ahmad and H. Donnan, 38–62. London: Routledge.

Trouillot, Michel-Rolph. 1998. Culture on the Edges: Creolization in the Plantation Context. *Plantation Society in the Americas* 5(1): 8–28.

Vahed, Goolam. 2002. Constructions of Community and Identity among Indians in Colonial Natal, 1860–1910: The Role of the Muharram Festival. *Journal of African History* 43: 77–93.

Williams, Raymond. 1977. *Marxism and Literature*. Oxford: Oxford University Press.

Wolf, Eric R. 1984. Introduction. In Religion, Power, and Protest in Local Communities, ed. Eric R. Wolf, 1–14. Amsterdam: Mouton.

Wood, Donald. 1968. *Trinidad in Transition*. London: Oxford University Press.

Yelvington, Kevin. 2001. The Anthropology of Afro-Latin America. *Annual Review of Anthropology* 30: 227–60.

Surviving Secularization:
Masking The Spirit in the Jankunu (John Canoe) Festivals of the Caribbean
Kenneth Bilby

In certain parts of the Americas colonized by the English and built with the labor of Africans and their descendants, the holiday season at the end of the year was once – and in some areas still is – celebrated by parading bands of masqueraders whose danced processions created an ambiguous, highly charged space of their own.[1] These outdoor performances by enslaved Africans amused, mystified, and discomfited the Europeans who observed and wrote about them during the nineteenth century. The loud drumming and singing, "wild" dancing, and "extravagant" costumes topped with horned animal masks and towering headdresses overloaded the senses of these white onlookers, and suggested to them something inscrutably and dangerously African, even when certain European elements could be recognized within the unfamiliar mix. Unlike the pre-Lenten Catholic carnivals that were appropriated and refashioned by Africans in several parts of the Americas, this was a festival created by the enslaved themselves. Over time it was accepted by the ruling whites, who came to view it as a necessary evil – a kind of safety valve through which the simmering tensions on slave plantations could be periodically released and kept from exploding. In certain parts of the Caribbean and Central America, variants of this enigmatic festival are still practiced.

Indeed, this Christmas and New Year's festival, known as Jankunu (John Canoe, Jonkonnu, Junkanoo, John Kuner) has, for some, become a powerful symbol of a surviving African "spirit" in the English-speaking Americas.[2] In the words of the renowned Caribbean poet and historian Kamau Brathwaite (1990, 90-91), "the [jon]konnus that we know throughout Plantation America are the visible publicly permitted survival ikons of African religious culture." Yet Jankunu today is characterized by most local commentators, including the majority of practitioners themselves, as a fundamentally "secular" tradition.

How could a tradition almost universally perceived as "secular," and said by participants themselves to be devoid of spiritual significance, be interpreted by a leading scholar and cultural "insider" as an iconic embodiment of religiosity? What might explain this apparent contradiction? In this essay I offer some possible answers to this question and examine its broader implications.

In my view, Brathwaite is correct. His representation of Jankunu, I believe, captures a profound historical truth – one that can be clearly apprehended and verified only through a genuinely diachronic perspective that moves beyond one-sided modes of historiography that depend exclusively on written forms of documentation. Only by employing contemporary ethnography to overcome the limitations of written sources and help us bridge past and present in a more balanced way, I would argue, can we really arrive at such a perspective, enabling us to recover a crucial but previously inaccessible dimension in the history of an important, but poorly understood, Afro-Atlantic performance complex.

Reprinted with permission from *New West Indian Guide* 84, nos. 3–4 (2010): 179–223.

Absence or Presence of "Spirit" in Jankunu: Varying Perspectives

In my very first interview with a Jamaican Jankunu practitioner, in 1974, when I gingerly raised the question of a possible spiritual dimension to his tradition, I was told flatly, "no man! ... Jankunu is only a pleasure."[3] Three decades later, when I began comparative fieldwork on Jankunu in various other parts of the Caribbean, I heard many similar statements. A respected cultural authority in the Bahamas, who had himself experienced a local version of the Jankunu masquerade every Christmas season while growing up in a small village on Cat Island, told me that "Jankanu was totally separate from religion," and insisted that there was "not a scintilla of spirituality in it."[4] Some weeks later, in Belize, a Garifuna cultural activist and museum director used the term "secular" to describe to me the local version of Jankunu practiced by his own people.[5] Such characterizations remain the norm almost everywhere that variants of the tradition continue to be found (in Jamaica, the Bahamas, and along the Atlantic coast of Central America).

It is hardly surprising, then, that most scholars who have had actual experience with contemporary performances and practitioners tend to represent Jankunu as being devoid of religious significance. In what remains probably the most comprehensive study of Jankunu as a pan-Caribbean phenomenon to date, the art historian Judith Bettelheim (1979, 227) concludes that this tradition is "fundamentally secular in nature." In a later publication, she maintains this position, arguing that "the evidence suggests ... that Jonkonnu is a secular festival. To say a festival is secular," she continues, "means, above all, that it does not systematically address gods or spirits in a uniform or codified manner" (Bettelheim 1988, 40).[6] In another extensive overview, the historian Michael Craton (1995, 14) similarly concludes that all the "differently named variants" of the Jankunu festival, like the Bahamian version, are "essentially secular." Viewing the tradition from a Bahamian perspective, the ethnomusicologist Clement Bethel (1991, 12-14) goes even further, denying not only any spiritual significance in the present, but also the possibility of a religious connection in the past. "However attractive the theory that John Canoe was the relic of some deeply religious African ritual," he argues, "it must be discounted...[The] suggestion of a religious origin of John Canoe must be laid aside."[7]

Religious origins had earlier been suggested by a number of scholars whose understandings had been shaped primarily, if not exclusively, by historical accounts of Jankunu during the slavery era, viewed alongside written accounts of West African festival traditions that provided evidence of striking parallels. For a scholar interested in long-term historical processes unfolding over time, statements made by present-day Jankunu practitioners, although not to be dismissed, need not carry much weight in attempts to determine what the tradition might have meant to participants during its heyday in the eighteenth and nineteenth centuries. Meanings that held sway centuries ago could easily have been replaced by others in more recent times; original religious or spiritual meanings could have been lost or become submerged over time through a process of cultural erosion supported by hegemonic colonial ideologies that powerfully stigmatized any visible traces of the African past.

Given what was known of festival traditions in various parts of West Africa – which often included similar combinations of drumming, processional music, costuming, and masked dance – the hypothesis of a religious origin for Jankunu was bound to arise. Both masking and dance were pervaded by spiritual meanings across West Africa, where the European bifurcation of public life into separate "secular" and "religious" domains did not exist. Pointing out the similarities between Jamaican Jankunu and African masked dances, Orlando Patterson (1969, 244–47) proposed that the origins of the Jamaican tradition could be found in three "clusters" of West African

festival traditions: the yam festival of the Mmo secret society of the Igbo peoples; the Egungun masquerades of the Yoruba; and the Homowo yam festival of the Ga people. All three of these are filled with spiritual purpose and closely tied to rites venerating ancestors. Following Patterson's lead, a number of other scholars working on Jamaican Jankunu, including Sylvia Wynter (1970, 37-45), Sheila Barnett (1979, 25-28), and Cheryl Ryman (1984), have similarly argued that its origins lie in West African harvest festivals or other religious rites. While pointing to a variety of possible sources, these authors have tended to privilege the Yoruba Egungun festival and/or the masked dances of the Poro societies spread across a large part of the region from which the enslaved were drawn. Discussing the cognate John Kuner festival of North Carolina, which is attested in several locations in that state during the nineteenth century but appears to have died out early in the twentieth century, Sterling Stuckey (1987, 67–73) also notes very suggestive similarities with Yoruba Egungun observances, and concludes that such parallels clearly indicate that this North American version of Jankunu represented an African-derived religious expression of reverence for ancestors.

Far from being purely academic exercises, these investigations of possible origins may be seen as part of a larger search for meaning. They constitute, at least in part, attempts to recover deeper meanings that have presumably been lost, or only vaguely retained, among present-day Jankunu practitioners. In the context of larger societies where Jankunu has gradually come to be seen as an important cultural legacy and a symbol of identity, such research into origins often takes on an aspect of soul-searching. Bridging past and present in the pursuit of answers to these kinds of experiential questions, however, is no easy matter. In the absence of reliable oral evidence in the present speaking directly to this question, how are we to arrive at a historically grounded understanding of what Jankunu meant to practitioners when it flourished on slave plantations in the Caribbean and parts of the United States? The contemporaneous written accounts left by European and white American observers are decidedly inadequate in this regard. As the Jamaican musicologist Laura Murray (1972, 109) noted in passing, when researching Jankunu as part of a larger study of "cult music" in Jamaica, "it is impossible to judge from early records whether the festivity had any religious significance in the negroes' mind. So far as records go it was a mere social festivity without reference to the exorcising of evil spirits or care for the spirits of the dead."

Murray's passing remark brings us face to face with a perennial historiographical and epistemological dilemma – one familiar to all who have a stake in the interpretation of the past in places where plantation slavery reigned. How is one to access such pasts? Given that the vast majority of contemporaneous written documentation, particularly in the Anglophone Caribbean, was produced by authors who were not only hostile to the cultural worlds that interest us, but largely ignorant of them, where do we turn for our evidence? If we, like Michael Craton (1995, 15), wish to reach "beyond the scarce and often purblind accounts of contemporary whites in an attempt to understand quite what Junkanoo was like and what it meant to British West Indian slaves," what can we do, other than rely on our imaginations? As Erna Brodber (1983, 7) asks, where "will we find the admissible data on the behaviour of people who left no memoirs?" And if we wish to extend our vision beyond observable behavior to the complex interior world of cultural meaning, by what means might we be able to (re)construct deeper "knowledge" of such people and the lives they created? Theorizing about the historical origins and possible spiritual foundations of Jankunu brings us squarely into this largely uncharted epistemological terrain.[8]

When we turn to the Bahamas, we are confronted with yet another apparent variation on this theme – in this case, one containing certain ironies. Of all the present-day outposts of Jankunu, the

Bahamas is surely the society where the tradition (officially spelled "Junkanoo") is most visible, most vigorous, and most ubiquitous; in short, this is where, in some respects, the tradition seems most alive. At the same time, it is here that the tradition appears to have strayed farthest from its historical roots, departing in startling ways from older forms while developing rapidly in new directions. In the Bahamas today, Junkanoo is an enormous national festival rivaling in energy and scale the famous pre-Lenten carnival of Trinidad and the numerous Eastern Caribbean festivals patterned after it, as well as a primary symbol of Bahamian identity. Associated with a complex structure of official and commercial patronage, codified and governed by a strict set of regulations, featuring ever more elaborate costumes and thematic displays designed and constructed by competing Junkanoo bands with hundreds of members, this Bahamian festival mobilizes thousands of people and receives a great deal of media coverage. It has also become one of the main tourist attractions of the Bahamas and is by far the most commercialized of the surviving variants of Jankunu.[9]

Though undoubtedly a vibrant and deeply meaningful expression of identity for many Bahamians, Junkanoo could easily be seen as the least "spiritual," and the most evidently "secular," existing form of the tradition. The degree of commodification, the close links with tourism, the cooptation by the state, and the decreasing grassroots control characterizing the contemporary tradition all work against a sense of sacredness. Although this appearance of "secularity" may have become particularly glaring in Bahamian Junkanoo of late, the idea that Junkanoo is devoid of religious meaning is not new there. Like their counterparts in Jamaica, most Bahamian practitioners in the 1970s – and probably their predecessors going back several decades – would likely have reacted negatively to the suggestion that their tradition might have religious or spiritual significance. Yet, as with the blues and jazz in the United States (Reed 2003; Stuckey 1995), there is evidence that at a deeply intuitive level many Bahamians have sensed, and continue to sense, something that could only be called "spiritual" in the music, dance, and costuming of Junkanoo.

In popular writings on Junkanoo produced for both local and tourist consumption, generalized invocations of "spirit" and "spirituality" are common, often in conjunction with references to the African past, the ancestral experience of slavery, and the deep and ineffable sense of shared identity many Bahamians feel when participating in the festival. In one such publication, Junkanoo is described as "a motivation to become one with the inner spirit," and a "spirit touching experience" (Chipman 2001, 26). "Junkanoo is tightly plaited into the Bahamian psyche," according to another such publication, "yet seldom do we dwell on its roots, that have been within us since we first became aware of ourselves." When Bahamians do take the time to listen to the stories of their elders, continues this author, "we are borne back through the years to understand the drum that beats always within us: the drum that is the spirit of our ancestors ... [whose] voices call out to us across the centuries" (Nash Ferguson 2000, 3). Such statements suggest a tendency in the Bahamas, when expressing the symbolic associations of Junkanoo, to conflate a racialized national identity with vague notions of a surviving "African spirituality." In the words of one anthropological observer, Junkanoo "allows [the Bahamian people] to gather pride and strength from their heritage and their spiritual roots in Africa" (DeCosmo 2003, 254).

One outspoken local commentator, Patrick Rahming, writing at a time of noticeably mounting government involvement and intensifying institutionalization of Junknaoo, clearly captured both the general uncertainty as to Junkanoo's beginnings and original meanings, and the coexisting sense that it constituted an ancestral vehicle for deep feelings of a spiritual kind, the sanctity of which was threatened by increasing rationalization, routinization, and commercialization. At one point, he raises the soul-searching question, "what is Junkanoo?... what is the essence of this thing?" (Rahming 1992, 31). He goes on to complain that

the experience of junkanoo is not one that can be easily filed into spectator-performer categories. The performers are not minstrels and acrobats providing entertainment for an audience. They are participants in a therapeutic ritual with important personal and natural implications. The fact that the cultural memory is so vague that the "original" basis for the ritual is foggy is no reason to disrespect the yearnings expressed. In other words, at least for the time being there is still validity in the spiritual "roots" aspect of the festival/ritual. (Rahming 1992, 32)

Particularly noteworthy here are the allusion to "cultural memory" (an idea to which we will return in the last section of this essay) and the explicit acknowledgement of a "spiritual aspect" associated with the "roots" of Junkanoo. This ostensible spiritual dimension is made yet more explicit in another passage by the same author suggesting that the attempt to formulate an intellectualized, standardized aesthetic of Junkanoo for the purpose of judging performances in official, state-sponsored contests may constitute a kind of "sacrilege" (a passage that, it is worth noting, would likely resonate with many performers in the black American musical tradition as well):

Successful junkanoo evokes strong emotional response, which cannot be replaced by intellectual rationale, even concerning so-called "artistic excellence." The judgement of strong emotional response is not easy ... If the commitment to judgement is made, then a concurrent commitment must be made to find a way to judge emotional response. "It scared the hell out of me" is a more successful response than "It was nice" or "I'm so excited I can't breathe" is a higher score than "The costumes were very well done." I query the need to judge in the first place. (Imagine determining the best church service every Sunday, and awarding prizes for "having the spirit".) (Rahming 1992, 32)

By the following decade, Rahming's misgivings were apparently shared by many in the larger society, including some of the festival's most prominent exponents and a number of public intellectuals interested in the question of cultural meaning in Junkanoo. In 2002 – partly, one suspects, in response to the growing recognition that Junkanoo was at risk of becoming permanently detached from its cultural moorings and losing its deeper meanings – a major symposium on "Junkanoo and Religion" was organized at the College of the Bahamas in Nassau. The resulting publication (Minnis 2003) contains eighteen contributions by scholars and Junkanoo practitioners sympathetically examining the possible religious or spiritual dimensions of the tradition. One might find some irony in the fact that the subtitle of this volume is "Christianity and Cultural Identity in the Bahamas," given that agents of Christianity (perhaps detecting an underlying African religiosity in Junkanoo) have been among the most ardent opponents of the festival, both in the Bahamas and other parts of the Caribbean. Even today, there is considerable opposition to Junkanoo from some Christians in the Bahamas. Vivian Wood (1995, 333) notes that "in 1994 religious leaders and Christians continued to denounce the Junkanoo parade and its music as being sensual and 'of the devil.'" In response to these attacks, "listeners to Christian radio shows spent hours calling in for on-air discussions of the immorality of Junkanoo, Junkanoo music, and Showtime dancing."

Despite this sometimes virulent opposition, other Bahamian Christians have in recent years enthusiastically embraced the festival, introducing Christian music and themes into the annual parades and incorporating elements of Junkanoo into church services (Wood 1995, 332-35). The 2002 symposium on "Junkanoo and Religion" – clearly an example of the kind of scholarly soul-searching alluded to above – no doubt came about partly in response to this growing phenomenon. Several of the papers presented at the symposium raised the issue of Junkanoo's compatibility with Christianity; some explored the implications of this controversial question in greater depth, and a few touted the festival's positive potential as a means of indigenizing Christian theological praxis

in the Bahamas. Breaking faith with the traditional Christian denigration of African religiosity, even some of the most committed Christians among the participants in the symposium were able to take the position that Junkanoo represents a surviving expression of a fundamentally African mode of worship, and should be welcomed as such. Kirkley Sands (2003a, 10), an Anglican priest and canon of Nassau's Christ Church Cathedral, for example, asserted that "the original life setting of Bahamian Junkanoo is Bahamian slave religiosity, i.e. the spirituality and religious culture of Bahamian slaves." It is clear, in his view, that "Junkanoo is a New World slave religious cultural celebration whose antecedents are rooted in West African religious culture" (Sands 2003a, 13). Indeed, Sands (2003a, 15) contends, this cultural celebration "embodied the slaves' prophetic voice," and "constituted a demand for dialogue with their ancestral faith." Junkanoo, he concludes, is "deeply rooted in Bahamian slave spirituality" and "West African religiosity" (Sands 2003a, 17). In another paper delivered at the same symposium Sands (2003b, 73) suggests that, even today, Junkanoo is "more than a secular cultural celebration. It is a unique embodiment of Bahamian slave spirituality which is itself Junkanoo's immediate life setting." A number of other authors represented in the collection express similar views. Yet, in the foreword to the volume, the historian Gail Saunders injects a note of uncertainty. While agreeing that "the spirit of Junkanoo is truly the soul of the Bahamian people," she seems to require further proof of its religious pedigree, not to mention its impact on the development of Bahamian forms of spirituality. "Have we come any further in pinpointing the origins of Junkanoo in the Bahamas?" she asks, after having reviewed the collected papers. And "how much did early Junkanoo and slave spirituality affect the Christian Church in the Bahamas?" (Saunders 2003, 4).

It was just this kind of unresolved ambiguity regarding origins, and the associated lack of consensus on the question of "secularity" versus "spirituality," that some years earlier in Jamaica had led me to wonder whether the inherent difficulties of investigating this essentially historiographical problem might be addressed, and perhaps partly overcome, through ethnography. Could there be older forms of Jankunu or related festival traditions still existing in Jamaica – forms retaining more from the past than any of the varieties yet documented – whose living practitioners might speak more clearly to the question of spiritual meaning? In the absence of firm evidence one way or the other, I was not prepared to discount the intuitions of the many in Jamaica who seemed able to divine a surviving undercurrent of spirituality in the professedly secular "fun" of Jankunu. In 1991, relying in part on intuitions of my own, I found some answers to these questions in the rural parish of St. Elizabeth.[10]

Coker, St. Elizabeth, Jamaica

In the country "district" of Coker, nestled in the Nassau Mountains of western Jamaica, public celebrations of Christmas have traditionally been held in and around two particular areas named after the community's nineteenth-century founders. These sections of the community, known as Rhoden Town and Brown Town, are inhabited by Coker's "old people." So old are some of these members of the community that they require special care: Rhoden Town and Brown Town, in fact, are cemeteries. Here lie not only the original founders and apical ancestors of Coker, Benjamin Rhoden and Bob Brown, but many of their descendants as well, who are also remembered by name.

Near each of these ancestral "towns" is a sacred clearing consisting of a traditional "danceground" and a "healing ground." Known as Big Yard and Brown Yard, these cleared areas have for generations served as sites for community ceremonies revolving around *myal* – a term of unknown derivation referring to possession by spirits, including those of departed ancestors.[11] The ancestors of Coker, honored by their descendants, have on the whole shown benevolence toward the living.

Until recently, they have returned regularly in the bodies of living dancers, known as *myal man* and *myal woman*, and in this form have used their knowledge of herbs and their special powers to tend to the needs of the living, healing spiritual afflictions and offering solutions to other problems. Throughout the years, as the need arises, they have continued to be drawn into the cares and concerns of their living descendants by the rhythms of the *gumbe* drum and the special *myal sing* (spirit-invoking songs) they have taught them, and in this way have remained a part of daily life.

In such a setting, how could the ancestors *not* be a part of the major holiday to which the entire community looks forward as every year draws to an end? After all, the single most important local celebration of the Christmas season, centering on the unveiling of the house headdress itself known as Jankunu and the accompanying music and dance, was passed on from these older people themselves. In addition to being myal specialists, Benjamin Rhoden and Bob Brown were also "masters," or builders, of the Jankunu headdress, and renowned Jankunu dancers. They are revered as founders not only of the community of Coker, but of its Jankunu tradition as well. Buried alongside them are several of the successors they taught, most of whom also once served as spirit mediums in the local tradition, and who are remembered today as outstanding Jankunu builders, dancers, drummers, and singers in their own right.

The Coker variant of Jankunu performance differs conspicuously from the "standard" forms found elsewhere in Jamaica today. (The Coker version, for instance, has retained several characteristic features mentioned in eighteenth- and nineteenth-century descriptions of Jamaican Jankunu that appear to have been lost almost everywhere else, such as the square or rectangular gumbe drum played with the hands, a leading dancer who wears a house headdress, and female singers who play a prominent role.)[12] But it also displays important similarities. For one thing, like other varieties, it occurs in the context of street parades or processions. Yet, there is a significant difference here as well. For these processions, in the Coker tradition, represent but the tip of an iceberg, as it were. Traditionally, only after the break of day on Christmas did the Jankunu performers of Coker leave the ancestral confines of Big Yard and the immediate surrounding area to begin their procession through the wider community; and only after completing this circuit of their own community did they carry the festivities out to neighboring communities, entertaining crowds and soliciting donations as they went. Preceding these highly visible "Christmas sports" in outside locations was a series of "private" rites performed at home by the Coker celebrants for themselves and their ancestors. Few of the spectators amused by their exuberant "antics" as they paraded through towns and villages in this part of St. Elizabeth were aware of this hidden "back stage"; for this reason, most of those from other communities who witnessed the Jankunu bands of Coker – which continued to go outside to perform at Christmas throughout most of the twentieth century – would never gain a clear idea of the spiritual meanings the festival held for the participants themselves.

For those trained in the tradition, these deeper meanings are clear as day, flowing as they do from their "immediate life experience" (to borrow Kirkley Sands's evocative phrase). Virtually every aspect of the Jankunu tradition in Coker is permeated with explicit spiritual meanings, from the building of the house headdress to the songs, dancing, and offerings of food and rum to the ancestors on Christmas and New Year's Day. This seasonal tradition, after all, is part and parcel of the larger ancestor-focused community religion practiced year-round by the gumbe drummers and myal dancers of Coker.

The briefest account of a portion of the Christmas rites typically observed in Coker until very recently will leave no doubt as to the fundamentally spiritual nature of the local variant of the Jankunu festival that has survived here. Early on Christmas Eve, the entire community is summoned to a major "gumbe play" (myal dance) by the blowing of a conch shell. As one long-time

participant told me, "you see, the conch shell deh, them blow it that everybody know seh them a go play tonight. From them hear it blow, they know seh them a go have the met [public gathering, dance] tonight. The living hear, and the dead hear."[13] As the night wears on, the time comes for the Jankunu headdress to "turn out" – to be unveiled and brought out for public display after weeks of concealment in a specially constructed shack guarded over by the watchful spirits of the ancestors. Down at the two main family graveyards of Rhoden Town and Brown Town, the ancestors are fed with white rice, the blood of a chicken, and a specially prepared concoction known as "egg punch" (a drink that was closely associated with Christmas festivities in Jamaica during the nineteenth century). Back up at the neighboring dancing ground, the myal man and his assistants remove the sheet that has up to this point covered the Jankunu (as the house headdress itself is known), and carry the beautifully decorated object out into the open for all to see, placing it on a bench in the central performing space in Big Yard, known as the "ring." Songs such as the following are sung to greet the arriving Jankunu and all who have come to join in the celebration:

> You tek me out a house
> And you put me out a open parade
> Chorus: Mornin maam-oh
> Mornin to you all-oh
> Mornin, Grand Queen-oh [the name of one such Jankunu house headdress]
> Mornin to you all-oh

The ancestors, too, are welcomed and honored with songs of their own. One might hear, for instance,

> Oy-oh, eh-de-oy, eh-de
> Roll de band a yard
> Det a grong a me fren [literally, "the ancestral dead in the earth/cemetery are my friends"][14]
> Seh duppy a me fren ["the spirits are my friends"]
> Seh duppy a me fren
> Roll de band a yard
> Det a grong a me fren

Shortly before dawn, the leading myal man and Jankunu builder, with the help of his assistants, hoists the house headdress onto his head and proceeds down to the cemeteries of Rhoden Town and Brown Town, where he dances and displays his creation, so that its beauty can be enjoyed by the entire community of ancestors. In the words of one practitioner:

> Christmas night, before day, them have fe dance, and carry it [the house headdress] to all of the cemetery dem. Kompini [the assembled people] tek off sheet off of it, and carry it to all of the cemetery, and lean it [toward the individual graves], show it to all spirit ... [letting them see] how beautiful it be. Them [the ancestors] see it still [i.e. have already seen it], you know, for them go and come weh-paat it a build [to the place where it is built]. But, you know, that is just a old-time original thing – them have fe carry it to the cemetery.[15]

After daybreak, the crowd moves out onto the road, marching along with the musicians and leading Jankunu dancer through the different sections of the community while singing yet other songs. Only after December 25 is the Jankunu ensemble allowed to venture out to perform in other communities. Finally, some time in January, when the Christmas spirit has begun to fade away, the ancestors provide indications that the time has come to "mash up" (destroy) the Jankunu. A last gumbe play is called and the "master" of the Jankunu – the myal man who built it – places the

headdress on his head and carries it down to Rhoden Town and Brown Town, where he performs a final dance for the ancestors. Before daylight, the spirits of ancestors enter the bodies of younger dancers, who then tear the headdress to pieces, thus bringing the annual cycle to its proper end. Thoughts of the Jankunu need not occupy the community's attention again until the next Christmas season approaches.

As I was later to find out, Coker is not the only place in Jamaica where ancestors regularly take part in the Christmas celebrations of the living, or have done so within living memory. I know of at least three different rural communities in other parts of St. Elizabeth and in the neighboring parish of Manchester where related Jankunu traditions tied to ancestral myal rites and family burial grounds have either survived in attenuated form, or are clearly remembered by older people. In yet another parish, St. Catherine, very similar, and still vibrant, rites for community ancestors take place in the context of the local *Buru* festival – a Christmas masquerade historically related to Jankunu, which today, in this particular community, still features African-derived drumming, dancing, singing, offerings of food and rum to the "ol' sumaadi" (old people), and non-stop parading from dawn to dusk along a route carefully chosen by these same ancestors (Bilby 2005a). Nor am I the only researcher to have encountered Christmas festivities in Jamaica in which unambiguously spiritual gestures and meanings – clear expressions of African religiosity – remain alive. At least one other writer, Honor Ford-Smith, mentions the existence of similar rituals on the other side of the island in the parish of St. Thomas, where certain Jankunu performers still pay homage to the spirits of their predecessors by making offerings to them before appearing in public processions. "With its roots in the secret society rituals, *Jonkonnu* still invokes spirits and aims at social control," she states. "In St. Thomas, for example, performers sometimes sprinkle rum on the graves of ancestors before going out on to the streets" (Ford-Smith 1995, 153-54).

And what does this story of "masked spirituality" in Jamaican Jankunu – spirituality that has been submerged in "private" family contexts and rendered mostly invisible to the larger Jamaican public – tell us of the various traditions bearing the same name in other parts of the Caribbean? If we accept that all the far-flung Christmas festivals known by the name "Jankunu" (those, that is, whose practitioners did not recently borrow the name but have used it since time immemorial to refer to what they do) share common roots, or at least are historically related – as I believe the evidence suggests – then these revelations of an undeniable, actively maintained ancestral presence in the oldest surviving forms of Jamaican Jankunu gain in significance.[16] Might traces of similar spiritual meanings be found in the Jankunu tradition across large stretches of time and space? As in the Jamaican case, the historical writings that describe cognate forms in the Bahamas and Belize are of little help in searching out the deeper cultural meanings that interest us. Once again, if we wish to achieve greater insight into this question, we must depend on the recollections of living practitioners, as well as the cultural "memories" passed on from previous generations "off the record."

Cat Island, Bahamas

Of the forty or so inhabited islands of the Bahamas, Cat Island has the reputation of being the one that has retained the strongest African cultural heritage. Tourist guides single it out as the island in which, more than any other, African-derived bush medicine and obeah have continued to thrive (Baker 2001, 361; Dold, Folster & Vaitilingam 2003, 277). Ironically, as I found shortly after arriving, the indigenous Jankunu festival of Cat Island died out several decades ago. Tourists who encountered "Junkanoo" performances there in the late 1990s had no way of knowing it,

but what they were witnessing was a calculated attempt to "revive" the festival on the island; the colorful, competitive parades staged during this period, performed mostly by younger people who had never experienced the older varieties that had once flourished on Cat Island, were based on the contemporary Nassau model and were supported in part by the Bahamian government. Perhaps because this glossy, commercialized Nassau version was perceived to some extent as a "foreign" implant, it failed to take root, and after a few years was abandoned.[17]

In seeking after knowledge of "old-time" Jankunu on Cat Island – which appears to have faded away in the 1950s or early 1960s – one quickly discovers that there was a remarkable amount of variation for an island with a population that has probably never exceeded a few thousand.[18] But there were also many commonalities from village to village. One thing that seems to have been shared from one end of the island to the other is that local forms of Jankunu were everywhere linked with religious spheres and activities through overlapping memberships and closely intertwined celebrations of the Christmas and New Year's holidays. Yet, at the same time, actual Jankunu performance was carefully kept separate from formal (i.e. Christian) religious contexts – in theory, if not always in practice. As for connections with African-derived religious ideas, hints of some possible past relationship with spirits of the dead do exist here and there in vestigial elements of folklore that may represent "witnesses in spite of themselves" (Bloch 1953). In the community of Dumfries, for instance, children until relatively recently (1930s or 1940s) would annually take to the streets shortly after Christmas to join in play processions mimicking the "serious" Jankunu masquerading they had seen adults perform during the holiday season; the masks fashioned by these children from cardboard, with large holes for eyes, resembled human skulls. While imitating the performances of their elders, they sang songs such as the following:

Sperrit [spirit] walking on wire

Jook [poke] he foot in the fire[19]

To the north, in Orange Creek, instead of donning actual masks, Jankunu revelers would sometimes coat their faces with white powder[20] – a widespread practice in Central and West Africa, as well as among the Maroon peoples of the Guianas, where it symbolizes, among other things, the ancestral dead and the spiritual power emanating from them.[21]

Nonetheless, I was unable to find any evidence of an explicit ancestral presence in the accounts of "old-time" Jankunu given by Cat Island elders. Certainly nothing like the close, interactive relationship between living and dead that characterizes the older Jamaican variants of Jankunu discussed above, exemplified by institutionalized spirit possession and offerings to specific ancestors, can be gleaned from their recountings. Rather, what I found is a complex duality suggestive of a history of resistance and accommodation – a separation of performance contexts into two symbolic domains, one thought of as "inside" and explicitly "religious" or "spiritual," and the other as "outside" and "worldly."[22] This division clearly reflects the impact, on an island with a long history of intensive Christian missionization, of Western theological principles. For those with whom I discussed "old-time" Jankunu festivities, music and dance performed "inside" the church is, by definition, "sacred"; in contrast, those varieties performed "outside" in street processions, such as Jankunu, are, by definition, not. As such, they should be kept apart. Yet, in these elders' accounts, the boundaries between these opposed symbolic domains and the distinct physical spaces associated with them were revealed to be permeable in practice. Such was the degree of overlap in performance modes, musical qualities, movement style, and actual contexts and performers during Christmas and New Year's celebrations that a strict division between the "sacred" and the "secular" could not always be sustained.

The underlying vision that is suggested by this interpenetration of opposed symbolic domains is a familiar one to those who have viewed diasporic arts from an African perspective. As Marta Moreno Vega (1999, 48) – among a great many others – points out, "African Diasporan creative expressions continue to blend the boundaries between the sacred and secular, connecting divine aesthetic knowledge to worldly artistic endeavors." For those African descendants in the West who share this profoundly holistic vision, the opposed categories denoted by the terms "secular" and "sacred," even if firmly embedded in thought at the level of ordinary discourse, are regularly overruled in ritual contexts by the deep structures of an experiential universe in which spirituality and the sacred are omnipresent and inseparable from the "mundane." There is much evidence (of the kind adduced by Brennan 2008, Reed 2003, Stuckey 1995, and Turner 2009 in connection with the blues, jazz, and other diasporic musics) to suggest that these experiential deep structures have survived in music, dance, and other aesthetic practices throughout the African diaspora, whether or not these are explicitly tied to "religious" contexts.[23] The "old-time" Jankunu of Cat Island would seem to represent yet another example of the subsuming over time of imposed theological dichotomies separating the "spiritual" from the "material" within a larger, indivisible sense of the "sacred" – a process greatly favored by the inextricability, in much of the diaspora as in Africa, of musical sound and movement and the spiritual charge they carry. This process has also been helped along by the general tendency toward fluidity characterizing the musical cultures of Africa and the diaspora, leading to a constant flow of aesthetic forms and stylistic features across genres and contexts.

Let us briefly consider the manifestation of these tendencies in the case of Cat Island and its Jankunu tradition. The first thing that strikes one is a close connection between the forms of movement characterizing "secular" Jankunu performance and those associated with "spiritual" church music: in both traditions, Christmas and New Year's were celebrated with processions. Although these occurred "outside" on the streets in the case of Jankunu and "inside," within the walls of a house of worship, in the case of the church processions, the two varieties, tellingly, were referred to by the same term: "rushing."[24] People remember the two kinds of rushing as being stylistically distinct: rushing in church featured only vocals and handclapping, and was generally done at a faster tempo, while Jankunu rushing was accompanied by the rhythms of the "goatskin drums," scraped saws, rattles, and occasionally other instruments such as the banjo. Some of the elders with whom I spoke made a distinction between "marching" and "dancing"; reflecting the traditional European Christian antagonism toward "dance" in sacred contexts, they categorized the sacred shuffling dance of those who rushed in church (a dance closely resembling the ring shout of the U.S. coastal Sea Islands to the north) as "marching" in opposition to the sometimes very similar "dancing" of those who rushed in Jankunu processions.[25] The two processions were of necessity also quite different in terms of their use of space; rushing in the restricted "inside" space of the church involved lines of dancers moving up, down, and across aisles (or in some cases, I was told, in circles, when there was sufficient space inside the church); Jankunu processions, in contrast, traveled along streets and lanes, following linear paths and circuits that took them through whole villages or from one community to another, with periodic stops to perform at the gates of residents along the way. But despite these differences, there was a good deal of aesthetic and kinetic overlap between the two kinds of rushing. For example, according to a musician and singer who used to participate in both church rushing and Jankunu rushing, the two kinds of performances, despite the absence of drums in the former, sometimes used "the same beat – the same beat, but only singing different songs."[26]

This is not at all surprising, since many individuals participated in both settings. Both, after all, were linked to the same seasonal calendar, and occurred at roughly the same time, in celebration of the same holidays. As might be expected, there was a considerable amount of movement back and forth between the two contexts. Indeed, the Christmas and New Year's church services with rushing and the Jankunu festivities might be seen as complementary facets of a single, larger community celebration. According to one elder who participated in these parallel observances in the community of New Bight in her younger days, "when you got tired of rushing in the church," you could simply go out onto the street and "dance" Jankunu.[27] Another former practitioner of both traditions describes this overlap as she experienced it in the community of Orange Creek:

> Before-time [in the past], [at] Christmas time, you [go to church] like ten o'clock [at night] ... then you'll march from twelve o'clock till high sun next morning. Till high sun. Big morning you coming home, sleepy and dragging on the side there. And you singing, rush out now. They'd rush, they'd rush. And see Christmas? When you come out Christmas morning out of the church, you rush right into the Jankanu.[28] You go right into the Jankanu. You're drumming out there, beating! Beating! Faithful must join them! [The Jankanu performers were] waiting, waiting for you to come out of the church! When you come out of the church, you go into the Jankanu, into the Jankanu rush. There used to be some good times those days.[29]

At another point, the same individual elaborated on this seamless movement of joint participants between "inside" and "outside" contexts:

> You hear what I tell you? The Jankanu, when the Christmas, as morning's getting on the eve of breaking, the Jankanus who are leading up the Jankanu, they're gearing up, for just how the church come out. Yeah, they're gearing up for just how the church out, they join with the Jankanu, you know. Some of them [Jankanu leaders] was in church before. They go out in time to get ready for that Jankanu. That's right. Well, they go, some of them get the drums heated, and get ready for that Jankanu, get dressed up, white up with skin powder and stuff.[30]

The boundaries between the "secular" and the "sacred" appear to have been particularly frangible during the "rolling out" of the old year (as it was called) and the passage into the new – a liminal time of heightened spiritual sensitivity. The "Watch Night" services of New Year's Eve, with rushing and prayer that continued through the night and into the following morning, were held for the express purpose of "pushing out" the old year (again, as participants referred to it) and ushering the community safely into the new year, thus completing and rebirthing the annual cycle of ritual observances that mirrored the sacred cycle of life and death itself. Just before midnight, inside the church, the celebrants would go around shaking one another's hands while singing a spiritual song:

Jesus spare we another year
Oh Lord, thank God
Jesus spare we another year
Oh Lord, thank God
For my Jesus love his children
Spare me another year, oh Lord
Bless my soul this morning[31]

At midnight the ringer would toll the church bell, and gun shots would be fired outside.[32] "Glad to get over in another year" (in the words of one elder), the celebrants would begin rushing to "anthems," some of them, such as the following, alluding to the thin line dividing life from death – and thus, the living from the dead:

Next year by this time
I may be gone
Into the lonesome graveyard
Oh Lord, I'm gone
Next year by this time
We may be gone
Into the lonesome graveyard
We may be gone[33]

Like the church services before and on Christmas Day, those on New Year's Eve coincided with parallel Jankunu festivities held outside, and there was frequent movement by "the faithful" from the "sacred" setting to the "worldly" one. In fact, a number of older people recall that the flow could go in either direction, though the movement from "outside" to "inside" was not always entirely smooth. One elder, a member since childhood of the Zion Baptist church in the southern community of Old Bight, remembers that when she was younger the Jankunu performers would sometimes rush right into the church – in full costume, some with masks on – where they would join in the rushing already going on inside (although they would not play the drums or sing Jankunu songs in the church). Some members of the church were displeased by this, complaining that they should not "carry what they dance on the street in the church, because the church is a holy place."[34] When I touched on this question again a few days later, the same veteran churchgoer confirmed her earlier account, stating that "when they [costumed Jankunu performers] come in the church, we used to rush, and the preacher used to say, 'now, you all go out! You all go out!' The Jankunu – they didn't want them in the church."[35] Nonetheless, others in the church – according to this elder and a number of others – did not mind their presence; the masqueraders would remain for a while in the line, rushing, singing the same spiritual "anthems," and clapping along with the others.

Nor was this musical interpenetration limited to the season with which Jankunu was normally associated. Another common performance context on Cat Island was that of the "society anniversary." Each community had its "burial societies" – cooperative associations that helped members to pool their economic resources for various purposes, and in the event of a death, to ensure a dignified burial. These societies, which were linked through cross-cutting memberships to both local churches and networks of Jankunu performers, were clearly based partly on African models.[36] At different points throughout the year, each society would host its own anniversary celebration commemorating the date of its founding, to which the general public was invited. These celebrations often included "outside" street processions in which "spiritual" songs were sung; these were backed by the same rhythms used in Jankunu rushing, played on the same goatskin drums. The burial societies would usually have to hire Jankunu drummers for these anniversary processions. Thus, in this "outside" setting, "sacred" songs normally restricted to "inside" (i.e. church) contexts were combined with the African-based style of Jankunu drumming customarily excluded from "sacred" contexts, temporarily clouding, once again, the dichotomy between "spiritual" and "worldly." A certain amount of "mixing up" could not be avoided in such circumstances. And, as a former participant remembers, sometimes even Jankunu songs made their way into the mix:

> [In society street processions] they would sing spiritual songs – spiritual songs with those same goatskin drums. Now, the society would mix up the songs while down the road there. Right? You see, on the road, you had to get these men [Jankunu drummers] to beat these things, to beat these drums, most of the time, for the society and things. And they would sing, they would play what

they wanted to play, you know? Well, that's how they [the burial societies] got mixed up with the Jankanu dance. They [the Jankanu drummers] would play to make *them* [themselves] feel good, playing *their* music.[37]

But the ties between the burial societies and Jankunu went deeper than this, extending into the actual "proper" domain and season for Jankunu – Christmas. For it was the custom to cap off the last Jankunu procession of the Christmas season with a final "feast" sponsored by these very same burial societies as an offering for the Jankunu performers and the general public. These communal gatherings, which featured traditional Cat Island foods and refreshments such as flour cakes, johnny cakes, and drinks made from the logwood and braziletto trees, symbolized community ideals of sharing and reciprocity.[38]

We are confronted here with an ambiguously dual world – a world in which spatial and cosmological dichotomies imposed in the distant past (and constantly reinforced in the present by ongoing evangelical activity by both local and foreign religious organizations) are repeatedly collapsed by communal performances bringing together and mixing older and newer permutations of music and dance embodying a common African aesthetic and spiritual energy. In such a layered world, it would be difficult to cordon off the "sacred" from the "profane" in any definitive way. Cat Island Jankunu was an integral part of this social and cultural world and its ambiguous dualism. As such, it was, in the final analysis, neither more "secular" nor more "sacred" than any other part – which is to say that it too, at a deep level, constituted a reflection, alongside Cat Island's Afro-Bahamian recastings of Christianity, of irreducible and indivisible spirituality. In this sense, perhaps, it masked, even while contributing to, the enduring presence of the ancestors.

Dangriga, Belize

The Garifuna (also known as Black Caribs) are famous for their Jankunu (usually rendered as *John Canoe* in English and *Yancunú* in Spanish, and known as *Wanáragua* in their own language).[39] Scattered along the Atlantic coast of Central America, from Belize to Nicaragua, the Garifuna emerged through a remarkable history of struggle against various European colonial powers that culminated in their displacement from their original homeland on the Caribbean island of St. Vincent to the Honduran coast in 1797. Of mixed Amerindian and African descent, they have maintained a unique culture that represents a thoroughgoing fusion of elements from both sides of their ancestral past, but which has been strongly influenced as well by the cultures of the colonial societies with which they have interacted since their beginnings as a people (Gonzalez 1988). While their distinctive language is an Amerindian one, belonging to the Arawakan group (Cayetano 1997: 86; Taylor 1977, 14-15), much of their expressive culture, and especially their music, is clearly derived in part from African sources.

In the literature on the Garifuna, there seems to be the same uncertainty regarding Jankunu's origins and its spiritual significance (or lack thereof) that one finds in the accounts of Jankunu in Jamaica and the Bahamas.[40] This ambiguity about both past and present meanings appears, for instance, in one of the first studies of Garifuna music. According to this work, "the dances of the Carib's John Canoe festival are ... devoid of religious significance; in fact the Caribs themselves have no knowledge of their origin or significance" (Whipple 1971, 114). Yet, earlier in the same study, we read that "lyrics for the John Canoe are characteristically 'spooky' in nature favoring supernatural themes" (Whipple 1971, 48). As an example, the author provides the following Jankunu song, translated into English by the performer:

Nighttime catches me.
Nighttime catches me my dear.

I saw a spirit open its wings: In front of me, my dear, at midnight.

Joy, joy, they shouted.

I saw a spirit open its wings.

In front of me, my dear, at midnight. (Whipple 1971, 48)

Despite the suggestion of deeper meanings in such songs, most studies of Garifuna Jankunu, like those of the Jamaican and Bahamian versions, indicate that the performers themselves think of what they are doing as a mere form of amusement or entertainment with no deeper significance. As Dirks (1979a, 103) noted, "none of the Caribs that I have talked to about John Canoe are willing to interpret its meaning. It is simply good fun."

I know of only two or three published accounts of Jankunu in Central America contradicting this view. But these accounts speak so clearly of religious meaning and linkages with spiritually charged contexts that they would seem to suggest that the common representation of Jankunu in this part of the world, as in Jamaica and the Bahamas, as an unambiguously "secular" tradition needs to be reevaluated and researched further. In one of these sources, a prominent Garifuna Jankunu performer from Belize, discussing what he calls "the Wanáragua cycle," says that in the view of the previous Jankunu leader who trained him and a number of other leading performers in the art, "*wanaragua* [Jankunu] had a very deep religious significance" (Valentine 2002, 42). Another author states that on the Miskito Coast – an area spanning eastern Honduras and northern Nicaragua, known for a long history of social and cultural mixing between Garifunas, Afro-Amerindian Miskitos, and immigrants from Jamaica and other parts of the Anglophone Caribbean – "*jaangkunu* was formerly a dance performed at a memorial feast for the dead, later at Christmas" (Holm 1978, 212, cited in Holm & Shilling 1982, 117). There is also a nineteenth-century account – likely the original source on which the foregoing reference is based – in which a traditional feast "in memory of the departed" among Miskito Indians is depicted as including "John-Canoe, a particular kind of dance" (Young 1842, 30-31, cited in Bettelheim 1979, 241).

Clearly, the social conditions under which Jankunu took root and evolved in Central America were highly complex and fluid, involving much interethnic contact and cultural exchange.[41] As a result, there is a good deal of variation in the Jankunu performed in this area today, with significant differences, for instance, between Belizean Garifuna and Honduran Garifuna versions (and internal variations within each of these as well). The country with the largest Garifuna population by far is Honduras, where local variants of Jankunu have received very little scholarly attention and remain largely undocumented. Further work in that country promises to lead to many new revelations. It should be borne in mind, therefore, that the Belizean variant discussed below represents but a small part of the larger picture of Garifuna Jankunu in Central America.

In the Belizean Garifuna capital of Dangriga, as I learned soon after arriving, Jankunu was traditionally directed by a number of trained specialists or "leaders" known as *ábuti* (a general term in the Garifuna language for "chief" or "person in charge"). Specialized knowledge of the tradition was passed on from one generation to the next by these leaders, who carefully selected younger individuals to follow in their footsteps. There were three main days on which Jankunu was performed each year (with scattered performances on some of the days in between): Christmas, New Year's Day, and "Dia-Rey" (i.e. El Día de Reyes, "Day of the Kings" or Epiphany [January 6]).[42] Each individual leader was given responsibility for one (or sometimes more) of these days. The three recognized leaders of the current generation were all trained by a single individual named Max Garcia, now deceased, who is revered as one of the last great authorities and truly knowledgeable practitioners of Wanáragua (Jankunu) in Belize. All of his three primary trainees acknowledge

that the teaching they received from him differed individually, since each was assigned different responsibilities – as was normal in the Jankunu tradition. It would not be surprising, therefore, if their viewpoints on the question of Jankunu's spiritual significance varied to some extent. And this, indeed, is what I found.

One of Garcia's apprentices expressed a view similar to those of a number of other Garifuna with whom I had spoken about Jankunu, stating outright that the tradition had no religious or spiritual meaning (even while describing certain aspects suggesting spiritual significance, such as the wearing of black arm bands during particular segments of Jankunu performances as signs of "mourning" for deceased Jankunu practitioners of the past).[43] A full understanding of the view expressed by this individual, however, may require a brief digression. After speaking with several others about the question of a possible spiritual dimension, I was led to wonder whether this man's response, and similar ones, were as much as anything reflections of an implicit assumption that the only traditional Garifuna cultural practice properly deserving of the term "religious" or "spiritual" is the institution known as *dügü* (defined in *The People's Garifuna Dictionary* as "the most important of the propitiation rites" held for Garifuna ancestors [Cayetano 1993, 38]). The *dügü* – which is similar in many ways to the ancestor-focused neo-African religions found in various parts of the Caribbean, but also has much in common with circum-Caribbean Amerindian religions – is an institution of central importance in traditional Garifuna society.[44] Having survived the challenges of Catholic and Methodist missionaries for nearly two centuries, it now exists within a fractured theological zone in which "religion" has to some extent become compartmentalized, and what may "properly" be considered "religious" somewhat rigidly defined. Linguistic categories are also part of the problem I faced in trying to look under the surface of Garifuna Jankunu. Since all conversations and formal interviews took place in English, responses may have been influenced by the limitations imposed by English vocabulary and conceptual categories, which do not always fit neatly with those in the Garifuna language. (It may be significant that the only bilingual Garifuna-English dictionary includes no entries for "religion," "religious," or "spiritual" – although it does have "spirit," "spirit-double," "spiritualism," and "spiritualist" [Cayetano 1993, 148].) I began to sense that for some of the Garifuna with whom I spoke, any aspect of Garifuna culture that did not form an integral part of either the institution of the *dügü* or one of the recognized Christian churches in the area could not properly be represented (in English) as "religious" or "spiritual." And, as I was repeatedly told, Wanáragua has no direct connection with the *dügü* (and certainly none with any of the established churches).

This linguistic ambiguity may well help to account for the differences in the views expressed by the three Jankunu leaders I interviewed. These differences of opinion, in any case, were very significant. While the somewhat ambiguous responses of the first leader, suggesting an absence of spiritual meaning, made me wonder why the ancestors who remain so important in traditional Garifuna life would never take an interest in Jankunu, the responses of the other two left no room for doubt. According to both of them, the spirits of ancestors *were* very much concerned with, and involved in, Jankunu performances.

One of these Jankunu leaders (now "retired" from this position), recognized by many as the single most knowledgeable practitioner of his generation, explained that his teacher, Max Garcia, and other elders in the Jankunu tradition thought of the purpose of Wanáragua or Jankunu as being "to lift up the world" (*lurahon ubóu*, in Garifuna). Garcia would sometimes tell him, when speaking of the deeper meaning of the tradition, that in performing Jankunu "we are lifting up the world" (*lurahon niwa*).[45] What he meant by this was that the performers were "lifting up" or

"raising up" the "spirits" of all those around them, helping to spread through the entire community a feeling of celebration and happiness. Nor was this celebration meant only for the living. As previous generations thought of it, according to this former Jankunu leader, the "spirits" that were "lifted" by these ritual performances most definitely included the *áfurugu*, or spirits, of the Garifuna ancestors, who were very much present at such times.[46] For this reason, and others, this Jankunu *ábuti*, like Max Garcia before him, has always considered Jankunu performances to be fundamentally "sacred."[47]

The third of the Jankunu leaders with whom I spoke was also quite clear about what he saw as Jankunu's spiritual dimension. Here is an excerpt from what he had to say on this question:

> Before Christmas, maybe a week, or maybe three days before Christmas, the spirit would appear and tell me that we are going to perform Jankunu … [the spirit] would say I must [perform]. So I believe then that it is spiritual. Then you can go a little farther. Amongst the other dances [outside the context of the *dügü*] that Garinagu [Garifuna] people do, Wanáragua is one of the number one where spirit can transfer into you. The spirit will transfer into you. While celebrating, dancing Jankunu, spirits of your ancestors can come and transfer into you. It happens [even] to ladies, to woman, that the spirit of the ancestors borrow their body, transfer into them, and she will jump up. And you know that is something natural, that she is not the one that [is] doing that, that there is spirit in it.[48]

According to this Jankunu *ábuti*, the ancestors were traditionally *expected* to attend the major dance performances on Christmas Day and New Year's Day, and to participate in them along with the living. For this reason, at the appropriate point in the ritual cycle an offering would be left for them in the "ring," the central space where dancing took place. This ritual gesture would be made right at the outset of the festivities, during the more "private" part that took place at the yard of the presiding *ábuti*, where the participants would assemble early in the morning and dance in preparation for their journey out into the more public spaces of the town:

> With our ancestors, before the Jankunu would start to move house to house, out there, [at] the yard where they are assembling – generally it's the yard of the boss [i.e. the *ábuti*] – that's why they always take that white bottle, white bottle of rum, place it in the middle of the ring. Because Jankunu use ring, they dance in ring. [They] place it in the middle of that circle. And they started to play and sing. That's for the spirit of our ancestors. Because we know and we believe that they will come and dance. So we do that first.[49]

For one who had traveled the particular research route that I had, seeking clues that might lead me to "masked" forms of spirit presence in a performance tradition long represented as essentially "African" yet somehow also essentially devoid of religious or spiritual meaning, such clearly stated revelations seemed almost "too good to be true." And I began to wonder whether, in fact, they *were* true – that is, whether they truly were what they appeared to be. Could such explicitly spiritual associations, today expressed by only a handful of Garifuna elders formerly apprenticed to older "experts," actually reflect accurately an understanding of Jankunu that had once been more broadly shared among participants and perhaps others in the wider community – an understanding that had begun to fade away only in more recent times? According to the two Jankunu leaders who speak of a spiritual presence above, the answer is yes. Both explained the disjuncture between past and present in the same terms – as the result of a breakdown of "discipline," and a lack of respect among younger participants and the larger community. According to both leaders, Jankunu had always been not only "entertainment," not just a "joke," but a "serious" tradition, based on certain "rules," and requiring "discipline." Faced with an increasing lack of commitment and respect, the older leaders had begun to withdraw, and to withhold much of their knowledge from those

of younger generations. As a result, the tradition had lost, or only vaguely retained, some of its most important original meanings. As Jerris Valentine – the *ábuti* chosen by Max Garcia to be his primary successor – lamented, "you have to understand what Wanáragua has become. Wanáragua has become something you laugh at. Wanáragua has lost its sacredness – its value. So it has no meaning, especially for the young people."[50] The fact that the famous statue of a Jankunu performer that once stood as a proud icon of Garifuna identity near the entrance to Dangriga's main street is now gone would seem to bear out his assertion; repeatedly defaced by local vandals, the statue was finally torn down and removed a few decades ago, and is now remembered only by middle-aged or older people.

Masking the Spirit and surviving Secularization through Sacred Sounds

In a recent study of religion in Jamaica, Dianne Stewart uses the masquerading of Jankunu as a metaphor for the defensive cloaking of African modes of religiosity that made possible their survival in new guises. "The institution of masquerading," she writes,

> provided enslaved Africans in Jamaica with an aesthetic mode of concealment and protection that allowed them to preserve Obeah, Myal, and other African-derived religious traditions in variegated forms masked as Christian traditions. By the same token, Myal was also preserved literally within the Jonkunnu masking tradition. African religious practitioners who instituted the Native Baptist and Revival Zion traditions made a Jonkunnu out of Christianity – a performance mask that they could wear and control in their efforts to safeguard African religious culture. (Stewart 2005, 221)

As she suggests, this masking metaphor can be applied to the Jankunu tradition itself, in which, as the present-day Jamaican community of Coker shows, the living ancestral presence could, under the right circumstances, be literally preserved through the practice of myal, or spirit possession, in the context of Christmas celebrations involving both material and aesthetic offerings and exchanges between the living and the dead.

But such literal preservation of the bond with ancestral spirits, in the case of Jankunu performances, most likely required a particular kind of disguise of its own. In order to survive as a clearly understood (among practitioners) expression of African religiosity in the context of plantation slavery, and especially in the period of continuing colonial domination and intense Christian missionization that followed, the Jankunu tradition had to mask (that is, pose) in public not as a form of Christianity (which would have been impossible given the centrality of African-style masked dance to it), but rather, as Christianity's harmless opposite – a "secular" form of "play." In this recontextualized, ostensibly "secular" form, it was given periodic license to roam the streets and spread holiday cheer precisely because it was perceived (or hoped) to be "mere fun" rather than an uncontrollable expression of a genuinely alternative worldview, or a still viable remnant of what the agents of colonialism thought of as a "savage" variety of religion (Christianity's "opposite" in a different, and ontologically much more threatening, sense).[51] The more African forms of masking and dancing associated with what was originally known as Jankunu were simply too far removed from what European Christians and their converts considered appropriate modes of behavior and appearance in "religious" contexts to be assimilated to them as such – that is, to take on certain aspects of a "Christian" appearance (as did some of the Native Baptist churches), or to "mask" as a form of Christianity, and then continue as before in this new guise. What most likely happened, rather, was that the practitioners of Jankunu, as part of the ongoing process of creolization, adapted to the harsh repression of visible or overt expressions of non-Christian religiosity by "masking"

in a double sense, depending on context. In "outside" contexts, when parading in costume and "making capers" before a larger public in the streets of towns, or performing in the environs of the plantation great house, they "masked the spirit" in the sense of disguising its presence from crowds made up largely of uncomprehending spectators; in "inside" contexts, when performing only among family, co-religionists, and the ancestors themselves, they "masked the spirit" in the common African sense of *embodying* it.[52]

Just such a bifurcation of Christmas performances into "public" and "private," "outside" and "inside," contexts and spaces appears to have allowed Coker, and a few other relatively isolated rural communities in Jamaica, to maintain into the twenty-first century a Jankunu tradition that remains explicitly connected to the community's ancestors and the religion practiced by the latter while they were alive. (And the division of "old-time" Christmas celebrations in the Bahamas into "outside/secular" and "inside/sacred" spheres, the former given over to Jankunu processions and the latter to Christian church services, might be seen as a related permutation that resulted from a somewhat similar process of adaptation – one that, in the past, served in a similar way to enable Jankunu to survive through [apparent] "secularization," even as it remained linked, at least during liminal periods, to the sacred.) Most of those who witnessed the "public face" of Coker's Jankunu performers when they "paraded" their masquerade, music, and dancing "outside" in other communities remained unaware of the inner meanings preserved in the "inside" spaces inhabited year-round by the performers and their ancestors. For the larger public, these bands of masqueraders were no more than what they appeared to be – amusing, even exciting, forms of "Christmas sport," perhaps tinged with a vaguely alluring air of mystery (and, for children, fear), but essentially devoid of deeper meanings, and because of this, welcome during the holiday season for the contribution they made to the general merriment that was seen as appropriate to this special time of year. By doing nothing to overturn this "public face" – to "unmask" the private significance of Jankunu when performing it "outside" – the performers forestalled a clash of worldviews in which the balance of power (both material and ideological) was clearly not in their favor. Such a clash finally became unavoidable in the latter half of the twentieth century, when a number of Christian evangelical churches (and, more importantly, their local proxies) penetrated the "inside" spaces of Coker and became active right in the heart of the community, where the ancestral presence surviving under the "mask" of Jankunu could not be concealed. Although the final outcome of this contentious encounter is not yet known, it has created a situation in which the continuing existence of Coker's Jankunu tradition is likely to depend on its increasing "secularization" via the ongoing incorporation of younger performers into touristic performance venues outside the community, official government-sponsored festivals, and the like – a process that has already begun. This process may be seen as a recapitulation of the actual "secularization" (or partial "secularization") that gradually overtook Jankunu elsewhere in Jamaica as it adapted to a number of changes in the larger society that favored the dissimulation of an absence of spirit (a kind of "masking" in the sense of concealment) and, at the same time, made the actual embodying of spirit ("masking" in the other, more profound sense) increasingly untenable. Whether, and how, the kinds of spiritual meanings embodied in the ancestors' version of Jankunu will survive this process in Coker remains to be seen.

Indeed, one may pose the question of whether, and how, similar spiritual meanings – meanings known only to the maskers themselves (or perhaps "sensed" by them at a subliminal rather than fully conscious level) – have been able to survive under the secular "mask" of the mainstream or "official" forms of Jankunu that now dominate in Jamaica, the Bahamas, and Belize. I would

argue that even if the modern-day transformations effected by tourism, commercialization, nationalization, folklorization, festivalization, and other such processes have left the better-known contemporary varieties of Jankunu (e.g., Nassau Junkanoo) with a purely "secular" appearance, we cannot discount the vague (if powerful) sense of the "spiritual" such modern "secular" performances seem to arouse in some participants. Nor can we deny the possibility that such perceptions might be rooted in "memories" of an actual cultural past that have been carried forth in various ways to the present.[53] For the concept of "cultural memory" involves complexities and subtleties that have yet to be apprehended fully and may apply to a broader range of phenomena than previously thought. Particularly useful in thinking about Jankunu is the phenomenon that has been termed "nondiscursive memory." One interesting example is provided in Rosalind Shaw's recent study of previously unacknowledged memories of the slave trade among the Temne of Sierra Leone, which discusses the existence of nondiscursive forms of social memory that encode seemingly "forgotten" histories in ritual practices and sedimented "memoryscapes" rather than verbal narratives. Shaw (2002, 22) characterizes these forms of cultural memory as histories of "moral imagination" that are "told primarily in the language of practical memory through places and practices, images and visions, rituals and rumors." Another form of nondiscursive "memory" – one that is particularly relevant in discussions of Africa and the diaspora – is encoded in what Connerton (1989, 74) refers to as a "mnemonics of the body." By this he means a repository of performative symbols ritually expressed through kinetic practices such as dance. Such bodily practices may play an important role in the reproduction and transmission of a community's cultural memory. In my own study of cultural memory in the Maroon communities of Jamaica, I found that such nondiscursive, performative forms of "memory," concentrated in the ceremony known as Kromanti Play or Kromanti Dance, were crucial to the process of social "remembering," complementing and lending a powerful affective charge to the verbal narratives through which consciousness of the past is transmitted across generations (Bilby 2005b). I also found that among Jamaican Maroons, as among many others in the African diaspora, musical sound serves as a particularly important and effective medium for nondiscursive "memories."

It is precisely music (not to be separated from dance) that appears to have been key to the survival of a sense of spirituality in all variants of Jankunu – even those most thoroughly transformed by the process of "secularization." In the Jankunu of Coker, Jamaica, which is the least secularized variety of this festival known to exist anywhere in the Americas today, ancestral spirits are literally summoned into the heads of mediums by the rhythms of the gumbe drum (struck in a special spirit-drawing manner known as *myal box*), and there is also a special category of songs for this purpose known as *myal sing* ("spirit invocation songs") (Bilby 1999, 56). On Cat Island in the Bahamas, as we have seen, the underlying spiritually charged commonalities in "sacred" and "secular" music and dance allowed Africanized Christian churches and the Jankunu masquerade temporarily to merge (in a sense, to "reunite") at least once a year in common celebration of a sacred rite of transition and renewal. For at least some Garifuna Jankunu practitioners in Belize, not only the explicitly religious drumming and chanting of *dügü* spirit -possession ceremonies, but also the performance of Jankunu itself, has the power to attract the spirits of ancestors; for when it is done properly, in the words of the Jankunu leader cited above, "we know and we believe that they will come and dance." This close connection between music and spirit, in fact, is present throughout the African diaspora, where generations of scholars working in different areas have repeatedly encountered "music, song, dances, and legends that have the power to attract, convey, dispel, honor, and celebrate the sacred energies of nature and the spirit world" (Vega 1999, 49).

It is with this background in mind that one should interpret comments such as the following, about the present-day "secular" Junkanoo festival of Nassau:

> everyone knows that the music is the soul of Junkanoo. If the music is right, the costumes look better, and the performance becomes totally animated. Without the music, there is no emotional response from the public or the judges. The music must be able to make the body move involuntarily. It is the music that is the essence of the parade. (Nash Ferguson 2000, 32)

The very "magic" and mysterious power that still resides in this contemporary national festival is often expressed through metaphors of musical sound and motion, as when this same author states that "the mere mention of the word 'Junkanoo' evokes strange and inexplicable emotions and compulsions. At the very core of your being, your 'Bahamianness,' the rhythm of a drum begins to pulsate, the beat vibrating through every pore of your body. A feeling of intense excitement slowly fills your soul" (Nash Ferguson 2000, 2). The state of mind evoked by this passage resembles the transcendent experience that some performers call "running hot," when the music locks into a groove that triggers a powerful, if brief, altered state of consciousness. As Vivian Wood (1995, 410) describes it, "when the Junkanooer runs hot she/he enters a very brief, trance-like state in which she/he experiences a feeling of ecstasy and intensity." "In the *run hot* stage," she continues, "the Junkanooer's performance is heightened and becomes more intense, and the Junkanooer has a sense of being outside the realm of the event" (Wood 1995, 411). Michael P. Smith (1992, 106), writing of the ostensibly "secular" performances of the Mardi Gras Indians in New Orleans, speaks in a comparable way of "the use of native African/West Indian rhythms and percussion to establish the spirit." During the more intense segments of their practices, according to Smith (1992, 93), "the rhythm and energy gradually build into a transcendent, throbbing, primal spiritual presence." As Daniel Avorgbedor (2003, 30) points out, this ability of musical sound (and movement) to summon and channel the divine is not entirely dependent on sensory stimulation or the physiological reactions music may trigger (though these can certainly play a critical role), for spirit possession and trance also often occur in the absence of music and dance; rather, in a much deeper sense, this perception of music as spiritually potent must be seen as a cultural principle – a cognitive predisposition transmitted, sometimes at an unconscious level, across generations – that is widely shared across Africa and the diaspora, and constitutes yet another form of "cultural memory."[54]

The understanding that this inherently sacred quality of music links the living with an ancestral past would also seem to be widely shared in the cultural memory of people of African descent in the Americas. It is among what Samuel Floyd (1995, 9) calls the "imperatives of the cultural memory" to which black musicians have always been highly sensitive. Indeed, in confirming that the lingering spiritual presence in all varieties of Jankunu almost certainly reflects, however indirectly, an actual and not just a mythic or recently reimagined past, the present study would seem to bear out Floyd's observation, following Jason Berry (1988), that "the musical retentions and performance practices of African-American music helped and still help to preserve this [cultural] memory, recalling the mysteries of myth and the trappings of ritual long after they are no longer functional" (Floyd 1995, 9). It also lends support to the insights of Rosita Sands, when she generalizes from Bahamian Junkanoo and the Mardi Gras Indians to other African-derived forms of masking and processional music and dance, noting that

> these celebrations speak to the deep spirituality embedded in the wearing of a mask and the assuming of another character, perhaps an ancestor or a person or people revered and admired. These are aspects of African thinking and qualities of African life, strong enough to have survived in the memories of the people and important enough to have served as the inspiration for the

carnival celebrations created by peoples of African descent in their New World environments. (Sands 1991, 91)[55]

In closing, I return to the observation by Kamau Brathwaite (1990, 90-91) with which I opened this essay: "the [jon]konnus that we know throughout Plantation America are the visible publicly permitted survival ikons of African religious culture." This summation neatly, and I believe accurately, encapsulates both the historical reality of Jankunu, and what it has become. Jankunu emerged in the Americas as an aspect of African religious culture that survived, remained visible, and was publicly permitted only because it succeeded in "masking" the African spiritual presence it embodied with an appearance of secularity; eventually overtaken by a gradual process of actual secularization (or partial secularization), it then survived as an "icon" of the African spirituality it had once both embodied and concealed.[56] With historically grounded poetic imagination, Brathwaite (1990, 101) goes on to sketch out, in his inimitable way, the outlines of this historical process: "since these forms [of Afro-Caribbean festival behavior] ... were from another world, as it were; they under pressure of the State & Princes of the Church (the old process of seasoning/cultural brain washing & buying or bribing out) began to lose their old African [jon]*konnu* connection, materializing & – successfully – secularizing themselves." This took place in somewhat different ways in Jamaica, the Bahamas, and Belize, different colonial settings and varying cultural input giving a unique stamp to Jankunu in each place; but gradual secularization appears to have occurred in all three places.

Yet, as we have seen, this complex process of secularization, whether in Jankunu or other originally sacred arts of the African diaspora, is far from definitive, and traces of the spirit remain alive today in an almost infinite variety of new "secular" expressions. Viewed from this perspective, we can better understand how practitioners of certain music and dance traditions might speak (and at some level, think) of their performances as "secular" – indeed, might firmly insist on such a characterization – and at the same time might feel (and, at another level of thought, intuit and recognize) something profoundly (or, in Brathwaite's terms, iconically) "spiritual" in these same performances. The apparent contradiction vanishes – or rather, becomes transparent – once we allow for the continuing operation of forms of consciousness, of cultural memory, embodying long histories of ideological struggle, cultural suppression, and cultural reassertion. Not only were the outcomes of the confrontations and conflicts over meaning and morality that typified the process of creolization in the Caribbean extremely complex, but they were never truly conclusive; and in the end, even where Eurocentric cultural hegemony appears to have been strongest, they left powerful, though often submerged and sometimes "masked," traces of an African worldview in which the "sacred" and the "secular" were indivisible, and spirits of ancestors and other manifestations of the divine were ever present.

In the case of Jankunu, it is still possible, by using ethnographic methods to circumvent the limitations of the written record, to follow the traces of "spirit" even now present in ostensibly "secular" performances back to an undeniably religious (or "spiritual") foundation (in which spirits of ancestors once actively and openly participated, and were explicitly acknowledged through material and symbolic exchanges). This endeavor has value not only because it allows us to enrich our understanding of one of the most important and widespread cultural institutions created by enslaved Africans in the English-speaking Americas (Burton 1997, 65; Fabre 1994, 55), but also because it reminds us that for its creators and early practitioners Jankunu was not simply the temporary "rite of rebellion" it appears (to present-day scholars who filter the past solely through historical documents written by uncomprehending European observers) to have been; more important than this, it was an expression of an alternative worldview maintained through an

ongoing dialogue with the ancestors. Such evidence of relative cultural and existential autonomy among the enslaved says much more about the ways they were able to resist the condition imposed upon them than does the "rebellious" playacting sporadically observed by European writers (who understood and sanctioned this behavior as an aspect of their own custom of "Saturnalia") in public spaces during the period of ritual license with which Jankunu performances coincided. The continuing presence of an underlying sense of spirituality in Jankunu even today suggests that what the enslaved kept "behind the mask" of this "Black Saturnalia" (Dirks 1987) was far more significant than what was displayed for all to see. Today, in the transformed Jankunu that has survived and is still with us, there is still more than meets the eye, encoded and carried down to us in "secular" yet sacred sounds to which, "masked" as ever, the spirit still dances.

Notes

1. This article is based on comparative fieldwork and library research supported by a Rockefeller Fellowship at the Center for Black Music Research in Chicago and the Alton Augustus Adams Music Research Institute in St. Thomas, U.S. Virgin Islands (2003-4), as well as a subsequent Fellowship at the Virginia Foundation for the Humanities in Charlottesville (2006). I am most grateful to these institutions. I would like to express special appreciation to Olivia Bowles, Sebastian Cayetano, Jerome Handler, John Mariano, Eris Moncur, Alson Titus, and Jerris Valentine for their contributions to the larger, ongoing project on Jankunu of which this research is a part. I would also like to thank Samuel Floyd for urging me to write this article in the first place, and Shannon Dudley for his insightful comments on an earlier draft. Lastly, I would like to acknowledge the thoughtful comments and criticisms of an anonymous reviewer for this journal, which, owing to limitations of space, I am unable adequately to address herein, but which I intend to take up in future writings on the topic.

2. To suggest common origins and the continuing relatedness of all the traditions going by variants of this same name, I use a single spelling, "Jankunu," throughout this essay. This spelling more accurately reflects the pronunciation of the word that I have heard practitioners almost everywhere use (/jángkunu/) than do the usual spellings of John Canoe, Jonkonnu, Junkanoo, etc. (see Cassidy 1966:47-51). (The exception is the Bahamas, where I most often heard /jángkanu/.) In quoted passages I retain the original spellings unless otherwise noted. I also use "Junkanoo" when referring specifically to the "official" version of the Bahamian festival that reigns in Nassau.

3. Interview with Simon Augustus Lewis, seventy-four-year-old leader of a Jankunu troupe, St. Ann's Bay, Jamaica, January 26, 1974. It is of course possible that at least some such statements may represent attempts to protect insider understandings from outside scrutiny, or forms of subterfuge motivated by the speaker's discomfort with the idea of publicly admitting adherence to stigmatized African-derived religious concepts. However, subsequent conversations with Mr. Lewis and many other practitioners, as well as similar comments frequently encountered in the contemporary literature on Jankunu in Jamaica, eventually persuaded me that such statements usually represent candid expressions of the speaker's actual views. When Martha Beckwith inquired into the possible religious significance of the tradition while carrying out fieldwork in Jamaica in the early 1920s, she was likewise told by most of the practitioners she encountered that "John Canoe was simply 'to make fun'" (Beckwith 1928:11).

4. Interview with Eris Moncur, District Superintendent of the Ministry of Education and Training, Knowles, Cat Island, Bahamas, March 19, 2004.

5. Interview with Sebastian Cayetano, Belize City, May 8, 2004. Mr. Cayetano, however, remained open to the possibility that Jankunu might have certain esoteric spiritual meanings for "leaders" in the tradition, of which casual participants and other Garifuna observers might not be aware; and he was strongly supportive of the idea of investigating this question further.

6. Bettelheims's succinct statement about what is meant by "secular" in this context raises a number of important theoretical questions that are not directly treated in the present paper. What, after all, do "secular" and "religious" mean precisely? Is the dichotomous opposition between these terms not inherently problematic? Does this dichotomy, long embedded in Western thought, not in itself replicate structured relations of power (and fundamental assumptions associated with them) that ought continually to be thrown into question? Certain recent contributions to the

study of religious life in the Caribbean (e.g., Khan 1999; 2004:24-25, 101-20; Paton 2009) stress the need to question such basic categories as "religion" and "religious," showing how they have served to structure "reality" in ways that favor the projects of some (e.g., the agents of colonialism) and overrule those of others. Other than repeatedly pointing out the inapplicability of the secular/religious dichotomy to contexts in which broadly shared "African" cosmological concepts and understandings prevail, I do not interrogate here such problematic terms as "secular," "religious," or "spiritual." Rather, I use them – advisedly – in somewhat loose and "commonsensical" ways that reflect the usages and discursive practices of both those I interviewed for this study and the literature to which I am responding. I invite readers to keep the problematic nature of these largely unexamined terms in mind, while at the same time keeping in focus the central argument of this paper. It is an argument not so much about semantic categories and how they came to be (for instance, what is the difference between "religion" and "superstition," and who decides what to place in which category?) as about recovering some of the fundamental meanings and understandings – what Palmié (2010:91) characterizes as "minimal assumptions about the workings of the world" – that may once have lain behind practices poorly understood by outside observers, based on previously unavailable ethnographic evidence of various kinds. In fact, by uncovering deeper "spiritual" meanings in supposedly "secular" practices, and relating these to broadly shared African conceptualizations that fall outside Western categories of thought, such a project, I believe, by its very nature challenges the standard religious/secular dichotomy, and suggests how, in the Caribbean setting, it became fundamentally intertwined with – and, indeed, continues today to support – ideologies and structural relations of power that date back to the colonial era.

7. The anthropologist Janet DeCosmo, writing specifically about Bahamian Junkanoo, disagrees with Bethel's conclusion and acknowledges the African "religious roots of what is now a secular observance." Though providing no documentation to back up her claim, she states that "in the early stage (1800-1899) Junkanoo still held close affinities to African religious ritual" (DeCosmo 2003:246, 248).

8. This epistemological terrain has been explored in innovative ways in the work of Richard Price on the Saramaka Maroons of Suriname (e.g., Price 1983, 1990, 2008) – whose influence on my own thinking will be apparent here – and has also been a primary area of concern in some of my own work on Jamaican Maroons (e.g., Bilby 1995, 1997, 2005b).

9. A good discussion of how the Junkanoo festival of Nassau has entered Bahamian popular culture, spawned new genres of local popular music, and been integrated into nationalist discourse may be found in Rommen 1999.

10. The ethnographic "clues" that led me to the "discovery" of the surviving older variant of Jamaican Jankunu described below are discussed in Bilby (1999), which includes additional ethnographic background on this tradition, only a sketch of which is provided in the present essay. See also Bilby 2007.

11. Maureen Warner-Lewis (2003:190) suggests a derivation from Kikongo *mayaala*, meaning "the physical representations of power." The term *myal* is frequently mentioned in eighteenth- and nineteenth-century accounts of Jamaica in connection with spiritual beliefs and practices of the enslaved and their descendants, though never explicitly in connection with "John Canoe." Warner-Lewis also proposes a new etymology for the word *Jankunu* – one which, in view of what is now known about older variants such as the one in Coker, I find more persuasive than any of those previously proposed. The derivation she suggests is from Kikongo *nza a nkunu*, which she glosses as "world of the ancestral spirits" (Warner-Lewis 2003:224).

12. Craton (1995:31) notes that "among the few features of [Jankunu] that were common [to all variants in previous centuries] and therefore essential were the gumbey drum music" and "the mysterious masked and fantastically head-dressed central figure."

13. Interview with gumbe drummer Percel Titus, Coker, January 11, 1991.

14. In Coker, the term det (derived from English, "death") is synonymous with the Jamaican Creole term *duppy*, used throughout the island to refer to the spirit of a deceased human being.

15. Interview with Percel Titus, Coker, October 30, 1991.

16. My thesis that the varieties of Jankunu that exist today in Jamaica, the Bahamas, and Central America (and once existed in the southern United States) are cognate forms that spring from a common root tradition, which was originally practiced on eighteenth-century Jamaican slave

plantations, cannot be further elaborated here but will be supported and discussed at length in a book I am in the process of writing. In this respect, I am in agreement with the two scholars who have conducted the most extensive pan-Caribbean surveys of Jankunu to date, Bettelheim (1979) and Craton (1995:34), who both see "Jamaica as a central crucible of the [Jankunu] complex."

17. Interview with Eris Moncur, Knowles, Cat Island, March 19, 2004; and conversations with Bradley Russell, New Bight, Cat Island, March 16, 2004, and Jason Russell, New Bight, March 20, 2004. The increasing influence of the newer evangelical Christian churches on Cat Island, most of which are opposed to dancing of any kind outside of church, also played a role in the demise of this recent version of Junkanoo imported from Nassau.

18. Eris Moncur (personal communication, March 19, 2004) estimates that the present population is around 1,600. Though the island is only one to four miles wide for most of its length, it is roughly forty-eight miles long. The population is widely scattered in a number of small villages spread across the entire length of the western coast. People living in the "North" (for example, in Orange Creek or Arthur's Town) often speak of those in the "South" (say, McQueens or Old Bight) – and vice versa – as if they were noticeably different, with unfamiliar "customs" of their own.

19. Interview with Eris Moncur, Knowles, Cat Island, March 19, 2004.

20. Interview with Olivia Bowles, Orange Creek, Cat Island, March 16, 2004.

21. See Thompson (1984; 1993) for numerous mentions of the use of sacred white clay (kaolin) in the altars, artwork, and rituals of a number of peoples in Africa, as well as among African descendants in several different parts of the Americas. In Central Africa, and in Western hemisphere contexts influenced by Kongo culture, such use of powdered white clay (*mpemba* in Kikongo, *pemba* in the languages of the eastern Guianese [Ndyuka, Aluku, and Paramaka] Maroons) represents, among other things, "the powers of 'the white realm,' the kaolin-tinted world of the dead" (Thompson 1984:134). Similar meanings are attached to the use of *hyire* (white clay) among the Akan-speaking peoples of Ghana and Côte d'Ivoire (Thompson 1993:120). During my fieldwork among the Aluku Maroons of French Guiana and Suriname during the 1980s, I very frequently saw spirit mediums in a variety of religious contexts with faces coated in *pemba doti* (powdered white clay). (For a photograph of Ndyuka Maroon spirit mediums covered with *pemba doti* during a *Papa Gadu* rite in Suriname, see Price & Price 1980:176.) The use of "whiteface" masks in Jankunu and other Caribbean festivals, noted in a number of historical accounts from Jamaica and other parts of the region, has often been interpreted, with good reason, as a ritualistic form of "mockery" aimed at the European oppressors – in keeping with the larger significance of such festivals as "rites of rebellion." (In some present-day versions of the Jankunu tradition, as among Garifuna performers in Belize and Honduras, wire-mesh masks – which are a relatively recent introduction – are painted white or pink and are explicitly thought of in this way, sometimes being given additional features, such as mustaches and goatees, meant to show that they represent "Europeans.") By pointing out that African-derived spiritual meanings might have once underlay the whitening of the face (or the wearing of white masks) in Jankunu, I do not mean to contradict such interpretations. There is every reason to believe that Jankunu performances in the past, as in the present, contained complex, multiple layers of meaning; and both of the meanings suggested here could have come into play at different points and in different contexts, or even simultaneously.

22. See, for an interesting comparison, the discussion by Morton Marks (1974:67-75) of Brazilian carnival, which similarly "has a dual nature, indoor and outdoor, white and black" (Marks 1974).

23. See, in this connection, Morton Marks's groundbreaking study (1974) of underlying "ritual structures," code-switching and style-switching in Afro-American music.

24. This dual sense exists more widely in the Bahamas, as noted in the *Dictionary of Bahamian English*, which gives two definitions for the verb *to rush*: "1. to participate in a Junkanoo parade; 2. to march or strut up and down the aisle of a church to a lively spiritual, singing or clapping in rhythm" (Holm & Shilling 1982:173).

25. Rushing in Bahamian church services, both on Christmas Eve and New Year's Eve, is briefly described in Hedrick & Stephens (1976:23-24). See also Parsons (1928:455-56). Joyce Marie Jackson (2006:96-101) describes an "updated" form of rushing, backed by an electric gospel band, she witnessed in a Pentecostal church on Andros Island in 1996.

26. Interview with Olivia Bowles, Orange Creek, Cat Island, March 16, 2004. After witnessing both Junkanoo rushing in Nassau and church rushing on Andros Island in 1996, Jackson (2006:98)

noted the similarities between the two: "the traditional movement [used in Junkanoo rushing] is a basic slide step in which the right foot slides up and the right hip goes down, the left hip goes up and out simultaneously. This is the exact movement used in the sacred Rushin' ritual [on Andros Island] and it is the performance practice that connects one ritual to the other."

27. Conversation with Rita Russell, New Bight, Cat Island, March 16, 2004. Similarly, a church elder on Andros Island, reminiscing in 1996, told Joyce Marie Jackson (2006:90) that "rushin' was done in the church before the streets." Some older people remember a similar overlap between church services and Junkanoo rushing on the streets of Nassau in the old days (before the main Christmas parade was changed from December 25 to Boxing Day [December 26]). For instance, a Nassau resident reminiscing about the 1930s says, "when I was growing up, Junkanoo was just cowbells and drums, no saxophones and stuff, not the modern stuff ... It used to be Christmas Day. You go out there after church. After church you go to Bay Street [the site of the main Junkanoo parade]" (Jenkins 2000:90-91).

28. In this and other passages directly quoting Bahamian speakers referring to older, non-official (i.e. pre-Junkanoo) forms, I use this slightly different spelling (Jankanu), since it more accurately reflects their pronunciation (/jángkanu/) than does "Jankunu."

29. Interview with Olivia Bowles, Orange Creek, Cat Island, March 16, 2004.

30. Interview with Olivia Bowles, Orange Creek, Cat Island, March 16, 2004.

31. Interview with Matrid Armbrister, McQueens, Cat Island, March 20, 2004. Interestingly enough, this same song is still often heard in the Junkanoo festival of Nassau, where it is one of the very few spiritual songs thought to have been introduced to the festival in the distant past by the "forefathers" (as opposed to religious songs that have entered the Nassau tradition more recently as a result of the growing impact of Christianity over the last few years). It belongs to a handful of Junkanoo songs considered to be old-time "classics" in Nassau (Nash Ferguson 2000:9).

32. See Parsons (1928:456) for an interesting description of a New Year's Eve "rushin' meetin'" on Rum Cay in the Bahamas in 1927, which includes most of the features described here for Cat Island.

33. Interviews with Matrid Armbrister, McQueens, Cat Island, March 17 and March 20, 2004. A version of this song, recorded in Old Bight in 1935 by Alan Lomax and Mary Elizabeth Barnicle, may be heard on the compact disc *Deep River of Song: Bahamas 1935* (Cambridge MA: Rounder Records, Rounder 11661-1822-2, 1999). The CD notes describe this anthem as "a favorite rushing song in Cat Island ... traditionally sung on New Year's Eve to accompany 'rushin'' in Baptist churches. After the evening service, the people of a settlement will march or 'rush' through the aisle of the church, clapping their hands and stomping their feet sometimes until daybreak" (Lomax, Droussart & Lomax Chairetakis 1999:23).

34. Interview with Matrid Armbrister, McQueens, Cat Island, March 17, 2004.

35. Interview with Matrid Armbrister, McQueens, Cat Island, March 20, 2004.

36. These cooperative associations, found in various parts of the Bahamas, are said to have been established by ex-slaves and/or indentured African immigrants shortly after the abolition of slavery, and closely resemble credit institutions and cooperative savings groups in various parts of West Africa and the Caribbean. That African-born individuals were among the founding members of these organizations on Cat Island is strongly suggested by the fact that one of the most prominent of the burial societies still existing in the northern part of the island is known as Congo No. 2. There are, to my knowledge, no in-depth studies of these institutions on Cat Island. For additional background on contemporary burial societies in the Bahamas (also known as "friendly societies," and in some areas, as asues), see Jenkins (2000:83-86). For historical background, see Johnson (1991).

37. Interview with Olivia Bowles, Orange Creek, Cat Island, March 16, 2004. In the same interview, Mistress Bowles revealed that genre boundaries could be crossed in the other direction as well, with Jankunu drummers and singers sometimes choosing to perform the occasional "spiritual" anthem during their own Jankunu processions as well. Furthermore, Jankunu crossed over to a number of other performance contexts; for instance, Jankunu music and dance became an integral part of celebrations of Guy Fawkes Day (a British holiday observed in several parts of the Bahamas on November 5), including those in Nassau (Jenkins 2000:94) and Cat Island (Olivia Bowles, March 16, 2004). See also Crowley (1958).

38. Interview with Olivia Bowles, Orange Creek, Cat Island, March 16, 2004.

39. In their own language, *Garifuna* is a singular form, and *Garinagu* is the corresponding plural. In this paper, I follow the common convention in English-language publications of using the first form for all contexts, to denote either singular or plural.

40. Among scholars, as among the Garifuna themselves, there is no consensus regarding the origins of Garifuna Jankunu (Wanáragua). Some suggest that it was originally practiced by the Carib Indian ancestors of the Garifuna, and was indigenous to the island of St. Vincent. Others hypothesize that it reached the Garifuna directly from African sources. My own position is that it represents a complex amalgam that has drawn on various sources, but that its earliest forms were adopted by Garifuna who came into contact with immigrants from Jamaica (or others who had adopted the tradition after such contact themselves) some time after their arrival at Roatan off the coast of Honduras in 1797. Thus, in my view, Garifuna Jankunu must be considerd a cognate of both Jamaican and Bahamian Jankunu. The same view is succinctly expressed by Dirks (1979b:487), who writes: "one might say [Garifuna] John Canoe was born and raised on eighteenth century Jamaican plantations."

41. It is clear that some of this interethnic contact and exchange took place in the context of joint Christmas celebrations. Greene (2005:208), for instance, points to "Young's [1842] account of Christmas at Fort Wellington on the Mosquitia coast of Honduras, in which Spanish, British, Mosquito, Caribs [Garifuna/Garinagu], Poyer and Wankee [local Amerindians] assemble, play skin drums and other percussive instruments, and dance wildly."

42. There were also three somewhat distinct segments of Jankunu performed at different points during the Wanáragua cycle: Wárini (or Wárin, an opening and closing rite done on December 24 and January 6); Wanáragua "proper" (done on Christmas Day, New Year's Day, and at various other points); and Chárikanári (related to an older dance called Pia Manadi, done on Boxing Day [December 26] and at various other points). There is not sufficient space to discuss these distinct segments further here, but they will be treated in more depth in a book on Jankunu in the Caribbean and the southern United States that I am currently preparing. See also Greene (2005:210-18) for further background on all three.

43. Interview with John Miguel, Dangriga, Belize, May 25, 2004.

44. For further background on *dügü*, see Jenkins 1983, Gonzalez 1988:83-97, Foster 1994, and Valentine 2002; and on the music of *dügü*, Greene 1998 and 1999.

45. These renderings of Garifuna phrases (*lurahon ubóu* and *lurahon niwa*), as well as their English glosses, were provided by the speaker, Jerris Valentine.

46. In the Garifuna-English dictionary (Cayetano 1993:12, 40, 148), *áfurugu* is glossed as "spirit, ghost," or "spirit-double," while *gubida* (the term usually used in anthropological accounts to mean "ancestor spirit") has a narrower sense: "spirit of deceased relatives." Jerris Valentine (interview of May 24, 2004) explained that, for the Garifuna, every individual has both a physical body, and a "spirit" that can also be "seen." One may know or recognize an individual not only by his physical body, but also his spiritual "body," known as *áfurugu*, which constitutes something like what would be called his "personality" in English. After death, the *áfurugu* remains among the living, as an ancestor. As Valentine (2002:23) writes, "since the *áfurugu* continues to live after the body is dead, the Garifuna has no problem in offering food to the *áfurugu* of the dead."

47. Interview with Jerris Valentine, Dangriga, Belize, May 24, 2004. In addition to being Max Garcia's protégé, Rev. Valentine, a Garifuna who was born in Dangriga, is an Anglican priest. He is also known as a staunch defender of the right of his people to maintain their ancestral culture. It is he who authored the statement cited above regarding Max Garcia's feeling that Jankunu "had a very deep religious significance."

48. Interview with John Mariano, Dangriga, Belize, May 20, 2004. In addition to being a Jankunu *ábuti*, John Mariano is one of the most respected *buyei* (Garifuna shamans) in Belize, and regularly conducts healing services in the context of the *dügü*.

49. Interview with John Mariano, Dangriga, Belize, May 20, 2004.

50. Interview with Jerris Valentine, Dangriga, Belize, May 24, 2004.

51. Even when understood as a "secular" form of "play," Jankunu performances represented a potential threat to white authority during the slavery era — as did any large gathering of slaves — and the temporary period of "ritual license" typifying the Christmas holidays made them seem even more dangerous. This led the authorities to take extra precautions over the holidays — for instance, by placing the colonial militia on alert. After the final abolition of slavery in 1838, some

authorities still viewed Jankunu processions, especially those in urban areas, as a dangerous form of public disorder, while others saw them as "degrading" throwbacks to "savagery," and periodic attempts were made to suppress them. Attempts by the authorities to ban Jankunu performances in Kingston in the 1840s led to riots (Wilmot 1990). One can imagine how much more difficult it would have been for Jankunu performers throughout this period if they had regularly and overtly manifested unmistakable indications of African religiosity in public spaces (for instance, with spirit possession, sacrifices and offerings to ancestors, etc.). This would have been especially true from the 1840s on, when the presence and influence of Christian missions began to increase rapidly.

52. This is not to suggest, of course, that in the "public" world, including the spaces most clearly dominated by Europeans, they did not also embody the spirits at the same time that they concealed them from unknowledgeable onlookers; the two kinds of "masking" could conceivably occur simultaneously in "outside" contexts.

53. What I am suggesting here – that the vague and ineffable (but powerfully felt) sense of "spirit" often associated with ostensibly "secular" performances in the African diaspora may constitute the present-day reflection, or trace, of specific forms of (non-Christian) African religiosity or spirituality actually practiced in the past – seems also to be borne out in the case of the steelband (pan) tradition of Trinidad and Tobago. In his recent study, for instance, Shannon Dudley (2008:14-16, 44-45, 55) points out that there are good historical reasons for the common Trinidadian saying that "pan is a jumbie" (a spirit that possesses people). Dudley points to research by the Trinidadian playwright and scholar Rawle Gibbons showing that there was extensive overlap between the Orisha (then known as Shango) religious community and the steelband community at the very time when pan was coming into being, and that some of the early panmen (steelband players) "were also Orisha men ... who brought to the steelband their drumming techniques, their song repertoire, and their understanding of music as a vehicle for the manifestation of divine power" (Dudley 2008:15). This helps to account for the fact that today, as Gibbons points out, "the pan is regarded by African-Trinidadians in particular as an instrument of 'spirit'" – this despite the fact that the majority of present-day Trinidadians, including many pan performers themselves, seem to regard steelband music as essentially "secular" (except perhaps when Christian tunes are performed on the instrument). Using oral sources, Amon Saba Saakana (Sebastian Clarke) also documents the significant input Orisha drummers had in the development of steelband music in Trinidad (Saakana 2005:85-86).

54. Spencer (1996:44-45) takes a position very close to this when he asserts that "black music itself is, from an Afro-conceptual viewpoint, theological sound," going on to suggest that "perhaps what music is from such an Afro-conceptual viewpoint is sound (rhythm) that is unconsciously perceived of as being religious."

55. Interesting for comparison with the case of Jankunu (as well as the celebrations of the New Orleans Mardi Gras Indians cited by Sands) is another Afro-Caribbean festival tradition in which masking plays a prominent role – the festival of Santiago Apóstol in Loíza, Puerto Rico. For some interesting recent writings on this tradition that touch on a number of issues related to those at the center of the present paper (e.g., forms of cultural memory, and hidden expressions of "African spirituality"), see Fiet (2006-7; 2007).

56. This notion of surviving "iconicity" in the aftermath of secularization invites further analysis along the lines of Gerard Aching's examination of both real and figurative masks as "devices [that may] maintain forms of (self)-knowledge in abeyance," and his exploration of masking as a process that sometimes "does not conceal the 'truth' but embodies ... 'ideological distortion.'" Building upon the work of Fanon (1967) and others, Aching discusses masking practices in the context of postcolonial Caribbean carnivals not as techniques for hiding or disguising reality, but rather, as oppositional forms of "identity reaffirmation" that sometimes force viewers (through exaggeration, provocative juxtaposition, and the like) to "see" uncomfortable social, economic, and political "truths" that normally remain "invisible" (Aching 2002:4-5, 19-31). If, as Brathwaite suggests, Jankunu masquerades, despite their ostensible secularity, are still widely understood or sensed by those who view such performances today as "survival ikons of African religious culture," it is not difficult to see how, as symbolic embodiments of something supposedly gone yet still visibly present, they might operate in a similar oppositional fashion in a society such as Jamaica, where surviving expressions of African spirituality coexist uneasily with dominant forms of Christianity and, though they remain important to many, continue to be stigmatized, suppressed, and concealed.

References

Aching, Gerard, 2002. *Masking and Power: Carnival and Popular Culture in the Caribbean*. Minneapolis: University of Minnesota Press.

Avorgbedor, Daniel K., 2003. A *Sound* Idea: Belief and the Production of Musical Spaces. *In* Daniel K. Avorgbedor (ed.), *The Interrelatedness of Music, Religion, and Ritual in African Performance Practice*. Lewiston NY: Edwin Mellen Press, pp. 15–36.

Baker, Christopher P., 2001. *Bahamas, Turks & Caicos*. Melbourne: Lonely Planet Publications. [Orig. 1998.]

Barnett, Sheila, 1979. Jonkonnu Pitchy Patchy. *Jamaica Journal* 43:19-32.

Beckwith, Martha Warren, 1928. *Christmas Mummings in Jamaica*. New York: American Folk-Lore Society.

Berry, Jason, 1988. African Cultural Memory in New Orleans Music. *Black Music Research Journal* 8(1):3-12.

Bethel, E. Clement, 1991. *Junkanoo: Festival of the Bahamas*. London: Macmillan.

Bettelheim, Judith, 1979. The Afro-Jamaican Jonkonnu Festival: Playing the Forces and Operating the Cloth. Ph.D. thesis, Yale University, New Haven CT.

——. 1988. Jonkonnu and other Christmas Masquerades. *In* John W. Nunley & Judith Bettelheim (eds.), *Caribbean Festival Arts*. Seattle: University of Washington Press, pp. 39-83.

Bilby, Kenneth, 1995. Oral Traditions in Two Maroon Societies: The Windward Maroons of Jamaica and the Aluku Maroons of French Guiana and Suriname. *In* Wim Hoogbergen (ed.), *Born Out of Resistance: On Caribbean Cultural Creativity*. Utrecht: ISOR, pp. 169–80.

——. 1997. Swearing by the Past, Swearing to the Future: Sacred Oaths, Alliances, and Treaties among the Guianese and Jamaican Maroons. *Ethnohistory* 44:655–89.

——. 1999. Gumbay, Myal, and the Great House: New Evidence on the Religious Background of Jonkonnu in Jamaica. *ACIJ Research Review* (African Caribbean Institute of Jamaica) 4:47–70.

——. 2005a. Christmas with the Ancestors: Jonkonnu and Related Festivities in Jamaica. *Cariso!* [Newsletter of the Alton Augustus Adams Music Research Institute] Winter:1–5, 9.

——. 2005b. *True-born Maroons*. Gainesville: University Press of Florida.

——. 2007. More than Met the Eye: African-Jamaican Festivities in the time of Belisario. *In* Timothy Barringer, Gillian Forrester & Barbaro Martinez-Ruiz (eds.), *Art and Emancipation in Jamaica*. New Haven CT: Yale University Press, pp. 120-35.

Bloch, Marc, 1953. *The Historian's Craft*. Translated by Peter Putnam. New York: Vintage Books.

Brathwaite, Kamau, 1990. Ala(r)ms of God – Konnu and Carnival in the Caribbean. *Caribbean Quarterly* 36(3&4):77–107.

Brennan, Timothy, 2008. *Secular Devotion: Afro-Latin Music and Imperial Jazz*. London: Verso.

Brodber, Erna, 1983. Oral Sources and the Creation of a Social History of the Caribbean. *Jamaica Journal* 16(4):2–11.

Burton, Richard D.E., 1997. *Afro-Creole: Power, Opposition, and Play in the Caribbean*. Ithaca NY: Cornell University Press.

Cassidy, Frederic G., 1966. "Hipsaw" and "John Canoe." *American Speech* 41(1):45–51.

Cayetano, E. Roy, 1993. *The People's Garifuna Dictionary*. Dangriga, Belize: National Garifuna Council.

Cayetano, Sebastian, 1997. *Garifuna History, Language and Culture*. Dangriga, Belize: National Garifuna Council. [Orig. 1993.]

Chipman, Donna L.M., 2001. *Bahamian Cultural Dynasty*. Nassau, Bahamas: PMT Atlantean.

Connerton, Paul, 1989. *How Societies Remember*. Cambridge: Cambridge University Press.

Craton, Michael, 1995. Decoding Pitchy-Patchy: The Roots, Branches and Essence of Junkanoo. *Slavery and Abolition* 16:14-44.

Crowley, Daniel J., 1958. Guy Fawkes Day at Fresh Creek, Andros Island, Bahamas. *Man* 58:114–15.

Decosmo, Janet L., 2003. Junkanoo: The African Cultural Connection in Nassau, Bahamas. *Western Journal of Black Studies* 27(4):246–57.

Dirks, Robert, 1979a. The Evolution of a Playful Ritual: The Garifuna's John Canoe in Comparative Perspective. *In* Edward Norbeck & Claire R. Farrer (eds.), *The Forms of Play of Native North Americans*. St. Paul MN: West Publishing Company, pp. 89-109.

——. 1979b. John Canoe: Ethnohistorical and Comparative Analysis of a Carib Dance. *Actes du XLIIe Congrès International des Américanistes* 6:487–501.

——. 1987. *The Black Saturnalia: Conflict and its Ritual Expression on British West Indian Slave Plantations*. Gainesville: University Presses of Florida.

Dold, Gaylord, Natalie Folster & Adam Vaitlingam, 2003. *Rough Guide to the Bahamas*. London: Rough Guides.

Dudley, Shannon, 2008. *Music from Behind the Bridge: Steelband Spirit and Politics in Trinidad and Tobago*. New York: Oxford University Press.

Faber, Geneviève, 1994. Festive Moments in Antebellum African American Culture. *In* Werner Sollors & Maria Diedrich (eds.), *The Black Columbiad: Defining Moments in African American Literature and Culture*. Cambridge MA: Harvard University Press, pp. 52–63.

Fanon, Frantz, 1967. *Black Skin, White Masks*. Translated by Charles Lam Markmann. New York: Grove Press.

Fiet, Lowell, 2006-7. "The Vejigante [Trickster/Diablo] Is Painted/Green, Yellow, and Red..." (El vejigante está pintao/Verde, amarillo y colorao...). *Sargasso* 2:81–96.

———. 2007. *Caballeros, vejigantes, locas, y viejos: Santiago Apóstol y los performeros afropuertorriqueños*. San Juan: Terranova Editores.

Floyd, Samuel A., 1995. *The Power of Black Music*. New York: Oxford University Press.

Ford-Smith, Honor, 1995. An Experiment in Popular Theatre and Women's History: *Ida Revolt inna Jonkonnu Stylee*. *In* Saskia Wieringa (ed.), *Subversive Women: Historical Experiences of Gender and Resistance*. London: Zed Books, pp. 147-64.

Foster, Byron, 1994. *Heart Drum: Spirit Possession in the Garifuna Communities of Belize*. Benque Viejo del Carmen., Belize: Cubola. [Orig. 1986.]

Gonzalez, Nancie L., 1988. *Sojourners of the Caribbean: Ethnogenesis and Ethnohistory of the Garifuna*. Urbana: University of Illinois Press.

Greene, Oliver N., 1998. The *Dügü* Ritual of the Garinagu of Belize: Reinforcing Values of Society through Music and Spirit Possession. *Black Music Research Journal* 18(1&2):167–81.

———. 1999. "*Aura buni, amürü nuni*", "I Am for You, You Are for Me": Reinforcing Garifuna Cultural Values through Music and Ancestor Spirit Possession. Ph.D. thesis, Florida State University, Tallahassee.

———. 2005. Music Behind the Mask: Men, Social Commentary, and Identity in *Wanáragua* (John Canoe). *In* Joseph O. Palacio (ed.), *The Garifuna: A Nation Across Borders: Essays in Social Anthropology*. Benque Viejo del Carmen, Belize: Cubola, pp. 196–229.

Hedrick, Basil C. & Jeanette E. Stephens, 1976. *In the Days of Yesterday and in the Days of Today: An Overview of Bahamian Folkmusic*. Carbondale: University Museum, Southern Illinois University.

Holm, John A., 1978. The Creole English of Nicaragua's Miskito Coast: Its Sociolinguistic History and a Comparative Study of its Lexicon and Syntax. Ph.D. thesis, University of London.

Holm, John A. & Alison W. Shilling, 1982. *Dictionary of Bahamian English*. Cold Spring NY: Lexik House.

Jackson, Joyce Marie, 2006. Rockin' and Rushin' for Christ: Hidden Transcripts in Diasporic Ritual Performance. *In* Helen A. Regis (ed.), *Caribbean and Southern: Transnational Perspectives on the U.S. South*. Athens: University of Georgia Press, pp. 89–123.

Jenkins, Carol L., 1983. Ritual and Resource Flow: The Garifuna "Dugu." *American Ethnologist* 10:429–42.

Jenkins, Olga Culmer, 2000. *Bahamian Memories: Island Voices of the Twentieth Century*. Gainesville: University Press of Florida.

Johnson, Howard, 1991. Friendly Societies in the Bahamas 1834-1910. *Slavery and Abolition* 12:183-99.

Khan, Aisha, 1999. On the "Right Path": Interpolating Religion in Trinidad. *In* John W. Pulis (ed.), *Religion, Diaspora, and Cultural Identity: A Reader in the Anglophone Caribbean*. Amsterdam: Gordon and Breach, pp. 247–75.

———. 2004. *Callaloo Nation*. Durham NC: Duke University Press.

Lomax, Alan, Guy Droussart & Anna Lomax Chairetakis (eds.), 1999. *Deep River of Song: Bahamas 1935*. Cambridge MA: Rounder Records (Rounder 11661-1822-2).

Marks, Morton, 1974. Uncovering Ritual Structures in Afro-American Music. *In* Irving I. Zaretsky & Mark P. Leone (eds.), *Religious Movements in Contemporary America*. Princeton: Princeton University Press, pp. 60-134.

Minnis, Jessica (ed.), 2003. *Junkanoo and Religion: Christianity and Cultural Identity in the Bahamas*. Nassau, Bahamas: Media Enterprises.

Murray, Laura Bernice, 1972. The Folk and Cult Music of Jamaica, W.I., Ph.D. thesis, Indiana University, Bloomington.

Nash Ferguson, Arlene, 2000. *I Come to Get Me!: An Inside Look at the Junkanoo Festival*. Nassau, Bahamas: Doongalik Studios.

Palmié, Stephan, 2010. Now You See It, Now You Don't: Santería, Anthropology, and the Semiotics of "Belief" in Santiago de Cuba. *New West Indian Guide* 84:87–95.

Parsons, Elsie Clews, 1928. Spirituals and Other Folklore from the Bahamas. *Journal of American Folklore* 41:453–524.

Paton, Diana, 2009. Obeah Acts: Producing and Policing the Boundaries of Religion in the Caribbean. *Small Axe* 13(1):1–18.

Patterson, Orlando, 1969. *The Sociology of Slavery: An Analysis of the Origins, Development and Structure of Negro Slave Society in Jamaica*. Rutherford NJ: Fairleigh Dickinson University Press. [Orig. 1967.]

Price, Richard, 1983. *First-Time: The Historical Vision of an Afro-American People*. Baltimore MD: Johns Hopkins University Press.

——. 1990. *Alabi's World*. Baltimore MD: Johns Hopkins University Press.

——. 2008. *Travels with Tooy: History, Memory, and the African American Imagination*. Chicago: University of Chicago Press.

Price, Sally & Richard Price, 1980. *Afro-American Arts of the Suriname Rain Forest*. Los Angeles: Museum of Cultural History and University of California Press.

Rahming, Patrick, 1992. *The Naïve Agenda: Social and Political Issues for the Bahamas*. Nassau, Bahamas: Patrick Rahming.

Reed, Teresa L., 2003. *The Holy Profane: Religion in Black Popular Music*. Lexington: University Press of Kentucky.

Rommen, Timothy, 1999. Home Sweet Home: Junkanoo as National Discourse in the Bahamas. *Black Music Research Journal* 19(1):71-92.

Ryman, Cheryl, 1984. Jonkonnu: A Neo-African Form. *Jamaica Journal* 17(1):13–23; 17(2):50–61.

Saakana, Amon Saba, 2005. Africanity and Continuum in Sacred and Popular Trinidadian Musical Forms. *In* Timothy J. Reiss (ed.), *Music, Writing, and Cultural Unity in the Caribbean*. Trenton NJ: African World Press, pp. 75-89.

Sands, Kirkley, 2003a. Junkanoo in Historical Perspective. *In* Jessica Minnis (ed.), *Junkanoo and Religion: Christianity and Cultural Identity in the Bahamas*. Nassau, Bahamas: Media Enterprises, pp. 10-19.

——. 2003b. Theological Implications of Junkanoo. *In* Jessica Minnis (ed.), *Junkanoo and Religion: Christianity and Cultural Identity in the Bahamas*. Nassau, Bahamas: Media Enterprises, pp. 69–74.

Sands, Rosita M., 1991. Carnival Celebrations in Africa and the New World: Junkanoo and the Black Indians of Mardi Gras. *Black Music Research Journal* 11(1):75–92.

Saunders, D. Gail, 2003. "Foreword." *In* Jessica Minnis (ed.), *Junkanoo and Religion: Christianity and Cultural Identity in the Bahamas*. Nassau: Media Enterprises, p. 4.

Shaw, Rosalind, 2002. *Memories of the Slave Trade: Ritual and Historical Imagination in Sierra Leone*. Chicago: University of Chicago Press.

Smith, Michael P., 1992. *Spirit World: Pattern in the Expressive Folk Culture of African-American New Orleans*. Gretna LA: Pelican Publishing Company.

Spencer, Jon Michael, 1996. *Re-Searching Black Music*. Knoxville: University of Tennessee Press.

Stewart, Dianne M., 2005. *Three Eyes for the Journey: African Dimensions of the Jamaican Religious Experience*. Oxford: Oxford University Press.

Stuckey, Sterling, 1987. *Slave Culture: Nationalist Theory and the Foundations of Black America*. New York: Oxford University Press.

——. 1995. The Music that is in One's Soul: On the Sacred Origins of Jazz and the Blues. *Lenox Avenue* 1:73-88.

Taylor, Douglas, 1977. *Languages of the West Indies*. Baltimore MD: Johns Hopkins University Press.

Thompson, Robert Farris, 1984. *Flash of the Spirit*. New York: Vintage Books.

——. 1993. *Faces of the Gods*. New York: Museum for African Art.

Turner, Richard Brent, 2009. *Jazz Religion, the Second Line, and Black New Orleans*. Bloomington: Indiana University Press.

Valentine, Rev. Fr. Jerris J., 2002. *Garifuna Understanding of Death*. Dangriga, Belize: National Garifuna Council.

Vega, Marta Moreno, 1999. The Ancestral Sacred Creative Impulse of Africa and the African Diaspora: *Àse*, the Nexus of the Black Global Aesthetic. *Lenox Avenue* 5:45–57.

Warner-Lewis, Maureen, 2003. *Central Africa in the Caribbean: Transcending Time, Transforming Cultures*. Kingston, Jamaica: University of the West Indies Press.

Whipple, Emory Clark, 1971. Music of the Black Caribs of British Honduras. M.A. thesis, University of Texas, Austin.

Wilmot, Swithin, 1990. The Politics of Protest in Free Jamaica – The Kingston John Canoe Christmas Riots, 1840 and 1841. *Caribbean Quarterly* 36(3&4):65–75.

Wood, Vivian Nina Michele, 1995. Rushin' Hard and Runnin' Hot: Experiencing the Music of the Junkanoo Parade in Nassau, Bahamas. Ph.D. thesis, Indiana University, Bloomington.

Wynter, Sylvia, 1970. Jonkonnu in Jamaica: Towards the Interpretation of Folk Dance as a Cultural Process. *Jamaica Journal* 4(2): 34–48.

Young, Thomas, 1842. *Narrative of a Residence on the Mosquito Shore during the Years 1839, 1840, and 1841.* London: Smith, Elder, and Co.

The Carriacou Mas' as "Syncretic Artifact"

Joan Fayer and Joan F. McMurray

Carnival celebration in Carriacou, the largest of the Grenadine islands, includes street performances of speeches from Shakespeare's *Julius Caesar* at the crossroads of villages and in the main street of Hillsborough, the largest town. The Shakespeare Mas', as the performances are called, is a type of verbal dueling between two players to determine who can recite the most speeches in a competitive exchange. These all-male performances begin early on Shrove Tuesday morning when Shakespeare Mas' players wearing traditional Pierrot-like costumes "jump out" to join others in the first of several "clashes" at hilltop villages in the northern part of the island. One player announces his readiness for the mas' when he jumps out by saying, "Ladies and gentlemen, do you admire my garment?" He then joins his group of mas' men who will challenge players from another village to recite passages from *Julius Caesar*. A player who recites poorly or inaccurately is hit with a whip by his opponent. People from each village gather to cheer the players on, and, after several verbal and nonverbal challenges, the mas' players go to the next village for "combat" with the players there. The audience increases at each village and follows the players to the next crossroads. These performances culminate in less structured presentations in the town when other carnival activities begin. Although there were once similar folk performances of Shakespeare throughout the Anglophone Caribbean, today the Carriacou Shakespeare Mas' is unique. This article examines this particular example of verbal dueling in the larger context of African Caribbean carnival traditions.

Although the mas' has had a long history on the island, little documentation exists before the 1950s. Older people recall fathers and grandfathers who participated year after year in this event, which now distinguishes Carriacou's carnival from other similar activities in the Anglophone West Indies. One of the oldest residents remembers mas' performances at the end of the last century. Over the years changes have taken place in the texts used, the costumes, and the type of fighting. Although similar folk dramas were common on islands such as Grenada, Trinidad, St. Kitts, Nevis, and Jamaica (see Abrahams 1967, 1973; Bettelheim 1979; Carr 1956; Mills, Jones-Hendrickson, and Eugene 1984; Nunley 1988; Payne 1990), it is only on Carriacou that this folk drama continues as part of carnival. Several factors have contributed to the survival of the Shakespeare Mas' in Carriacou. The early mas' performers were slaves, and in Carriacou slaves were a high percentage of the population. In 1833, just before emancipation, there were 3,200 slaves in the total population of about four thousand (*St. George's Chronicle and Grenada Gazette* 1833:273). After emancipation, European planters departed, and the ex-slaves were able to develop "their society and culture in splendid isolation [while] new racial and cultural elements were being introduced to larger possessions nearby" (Smith 1962:2). Other factors that made it possible for events such as the Shakespeare Mas' to survive are the small size of the island and its relative isolation.

Reprinted with permission from *The Journal of American Folklore* 112, no. 443 (1999): 58–73.

The Shakespeare Mas' combines European and African traditions; but as Antonio Benítez-Rojo explained in his recent study of the Caribbean, "the combination throughout the islands is not one of synthesis but a 'syncretic artifact...made of differences'" (1996, 21). He explained:

> In the case of the Caribbean, it is easy to see that what we call traditional culture refers to an interplay of supersyncretic signifiers whose principal "centers" are localized in preindustrial Europe, in the sub-Saharan regions of Africa, and in certain island and coastal zones of southern Asia. [I]t could be said that, in the Caribbean, the "foreign" interacts with the "tradition" like a ray of light with a prism; that is, they produce phenomena of reflection, refraction, and decomposition. But the light keeps on being light; furthermore, the eye's camera comes out the winner, since spectacular optical performances unfold which almost always induce pleasure, or at least curiosity. [1996, 21]

Benítez-Rojo's syncretic artifacts are dramatically present in Carriacou carnival celebrations but in particular in the Shakespeare Mas', which brings together European pre-Lenten celebrations, the British mummers' performances at Christmas, and West African masquerading traditions. These signifiers are combined in the Shakespeare Mas' where English literary text, verbal combat, costumes, and dance-like movements interact to create a Caribbean creole artifact. Opinions vary as to the relative strength of West African and Western European components, but the influences of both are dramatically illustrated in the performances from 1994 to 1997 that serve as the basis for this analysis.

One of the sources of the Shakespeare Mas' is the English mummers' plays, in particular the "Hero-Combat Plays," and another is West African festivals. The European carnival Pierrot, which is found in other Caribbean carnival speech bands, provides still another influence. In Carriacou, Shakespeare appears to have been the most popular provider of the literary text; however, portions of the biography of Queen Victoria and descriptions of historical events such as the Battle of Waterloo were recited in the past. The only speeches in the mas' today are from *Julius Caesar*. John Bunyan's *Pilgrim's Progress* and the biblical plays of Hannah More have also been utilized in popular performances elsewhere in the British West Indies. Tea meetings in Nevis, St. Vincent, and Jamaica also have competitive recitations, but these are usually of original texts composed by the performers.

The earliest references to folk performances of Shakespeare in the Anglophone West Indies are found in the 18th- and 19th-century accounts of Jonkonnu in Jamaica. Although there is no evidence of extensive contact between Jamaica and Carriacou, there are similarities in the sociocultural histories of the islands. Neither of the initial settlements were English. The first European settlements in Jamaica were Spanish, and in Carriacou, French. In 1655 Britain attacked Jamaica and began settlement. France lost control of Carriacou to the British during the American War of Independence. Slavery and plantation society dominated both cultures until emancipation in 1834. However, there are important differences that are due not just to size and location. Smith noted that Carriacou "[s]ince its colonisation...has remained a dependency with very little to say in its own governments" and added "there is no local elite, class stratification, or cultural plurality" (1962:4). Nevertheless, the mixture of African and British populations and plantation economies served to produce creole societies in the Caribbean that share similar folk cultures.

Because there are no historical data on the origins of the Shakespeare Mas' in Carriacou, evidence from other islands, such as Jamaica, that had similar performances can provide insights.[1] All the early accounts of Jamaican folk performances were written by Europeans traveling or residing there or by upper-class Jamaicans; there are none by the performers themselves. One of these performances, the Jamaican Jonkonnu Christmas festivities, is related in important ways to the

Shakespeare Mas' in Carriacou. During the period of slavery in the Caribbean, slaves were given several days off work at Christmas and New Year's. At this time, they received their clothing and food allotments and were allowed to participate in special meals and dancing in the master's house or yard. They often performed in masquerades and other theatrical activities. In early accounts the masquerades are described as "African" and the dramatic performances as "English" (De La Beche 1825; Marly 1828, 294).

Though scholars differ as to the origins of Jonkonnu, all agree that it has its roots in West Africa. Orlando Patterson (1967) described three possible sources—one in the Yam Festivals of the Ibo, another in the harvest festivals of the Ga, and a third in the festival honoring ancestors of the Yoruba. The Yoruba celebrations had processions and plays that included pantomime as well as singing and dancing. Each of the Yoruba Egungun groups put on a play: "There could be much rivalry, even fighting, between the different Egungun groups. This feature was continued in the rivalry between the different Jonkonnus [in Jamaica]" (Wynter 1970, 38).

These Yoruba Egungun masquerades honoring ancestors, which still continue in West Africa today, can be of several types using pantomime, music, and dance. The participants wear elaborate costumes, including masks that depict both human and animal characters. Furthermore, "*Egungun* are the creations of social relationships. They reflect the continuing relationships of living to the deceased, as well as the relations of the living members of a family to one another" (Drewel, Pemberton, and Abiodun 1989, 183).

The influence of the Egungun masquerade tradition, with its elaborate, colorful costumes, is found in the early recognition of the African origin of Jonkonnu noted by 18th-century writer Edward Long: "In 1769, several masques appeared; the Ebos, the Pawpaws, etc. having their respective Connus, male and female, who were dressed in very laughable style" (1828, 425). The early distinctions among the masques of various West African groups no longer remain.

The most likely source of the name "Jonkonnu" is Africa. The earliest account of its origin is by Long, who in 1774 wrote,

> In the towns [of Jamaica], during Christmas holidays, they have several tall robust fellows dressed up in grotesque habits, and a pair of ox horns on their head, sprouting from the top of a horrid sort of vizor, or mask, which about the mouth is rendered very terrific with large boar-tusks. The masquerader, carrying a wooden sword in his hand, is followed with a numerous crowd of drunken women, who refresh him frequently with a cup of aniseed-water, whilst he dances at every door, bellowing out "John Connu!" with great vehemence; so that, what with the liquor and the exercise, most of them are thrown into dangerous fevers; and some examples have happened of their dying. This dance is probably an honourable memorial of John Conny, a celebrated cabocero at *Tres Puntas* in *Axim*, on the Guiney Coast; who flourished about the year 1720. He bore great authority among the Negroes of that district. When the Prussians deserted Fort Brandenburgh, they left it to his charge; and he gallantly held it for a long time against the Dutch, to whom it was afterwards ceded by the Prussian monarch. He is mentioned with encomium by several of our voyage-writers. [1828, 424–425]

Judith Bettelheim (1978, 10) noted that it is not clear just how Jonkonnu came to be associated with the celebrations in Jamaica. However, a plausible explanation is that the fame of this African who stood up to white invaders on the coast was transmitted throughout the Ashanti Empire and arrived in the Caribbean via the Gold Coast slaves sold throughout the area. As the first specific reference to the use of the term *Jonkonnu* in Jamaica says that the name was shouted out, in all likelihood it was a coded cry of solidarity exclaimed in public and even in front of the "Great Houses."

Scholars, linguists, and early writers propose other explanations for both the name and its spelling. Isaac Belisario stated that the term "has had many derivations applied to it, amongst others, that it has arisen from the circumstance of negroes having formerly carried a house in a boat, or canoe" (1837, 5). Frederic Cassidy suggested the Ewe terms *dzono* ("sorcerer") and *kunu* ("something that causes death") as the source (1961, 259). Although the derivation from John Conny, the African trader, seems most plausible, it is also possible that there are multiple etymologies for the term.

Other descriptions of Jonkonnu followed Long's. Matthew Lewis arrived in Jamaica on 1 January 1815, just in time to be charmed by the celebration:

> [T]he sudden sounds of the drum and banjee, called our attention to a procession of "John-Canoe," which was proceeding to celebrate the opening of the new year at the town of Black River. The John-Canoe is a Merry Andrew dressed in a striped doublet, and bearing upon his head a kind of pasteboard house-boat, filled with puppets, representing, some sailors, others soldiers, others again slaves at work on a plantation, &c. The negroes are allowed three days for the holidays at Christmas, and also New-year's day, which being the last is always reckoned by them as the festival of the greatest importance. [1929, 52–53]

The first account of the inclusion of drama in Jonkonnu is in Lady Nugent's 1801 diary:

> Rise early, and the whole town and house bore the appearance of a masquerade. After Church, amuse myself very much with the strange processions, and figures called Johnny Canoes. All dance, leap and play a thousand anticks. Then there are groups of dancing men and women. They had a leader or superior at their head, who sang a sort of recitative, and seemed to regulate all their proceedings; the rest joining at intervals in the air and the chorus....Then there was a part of actors. —Then a little child was introduced, supposed to be a king, who stabbed all the rest. They told me that some of the children who appeared were to represent Tippoo Saib's children, and the man was Henry the 4th of France. —What a "melange!" All were dressed very finely, and, many of the blacks had really gold and silver fringe on their robes. After the tragedy, they all began dancing with the greatest glee. [1966, 66]

The earliest reference to the inclusion of folk performances of parts of Shakespeare's plays in Jamaica in Christmas and Easter celebrations is in H. T. De La Beche's 1825 account:

> Some of the negroes go about at Christmas and Easter attended by drums, &c., and perform much in the same manner as our Mummers. I was much amused by a party which came to my house from a neighboring property, consisting of musicians and a couple of personages fantastically dressed to represent kings or warriors; one of them wore a white mask on his face, and part of the representation had evidently some reference to play of Richard the Third; for the man in the white mask exclaimed, "A horse, a horse, my kingdom for a horse!" The piece however terminated by Richard killing his antagonist, and then fighting in a sword dance with him. [1825, 42–43]

Isaac Belisario's *Sketches of Character, in Illustration of the Habits, Occupation, and Costume of the Negro Population in the Island of Jamaica* (1837) includes both sketches and descriptions of the Christmas festivities and provides a vivid account of these festivities. Although previously "John-Canoe" through pantomime had asked for food, Belisario noted the changes that had occurred: "At each request, an attendant chorus repeated 'Koo-Koo,' this was intended in imitation of the rumbling sound of the bowels, when in a hungry state" (1837, 5). This request has a clear parallel in the *quete* or collection of a reward by the British mummers (Chambers 1933, 70). The name "Koo-Koo," or "Actor Boys," came from this sound and request. According to Belisario there were several companies of Actor Boys that were

self-styled Performers, envious of each other's abilities [who] strolled through the streets, habited in varied costumes considered by them however, as having been in strict accordance with the characters they were called upon to sustain—for be it known, they dared to perpetrate "murder most foul" even on the plays of Shakespeare. [1837, 5]

While dramatic performances of Shakespeare or historical events were being introduced into Jonkonnu in cities and plantations, in rural areas the African influences continued. In an account published in 1828, Jonkonnu and his wife, "metamorphosed into the appearance of a gigantic female, only by the whimsical dress," were described as "of true African extraction" (Marly 1828, 294). According to Bettelheim,

an African theatrical element was slowly replaced by a European one. The original Jonkonnu with his ox horned and boar tusked mask was replaced by a performer in a white face mask, half military, half mountebank costume. At the same time, the increased white patronage of able and creative black performers assisted the organization of the groups known as Actor Boys who performed British dramas. [1979, 19]

The last recorded Shakespeare performances of the Actor Boys in Jamaica was on Christmas day, 1945, at the Imperial Theatre in Savanna la Mar.[2] Actor Boys also appeared after cricket matches and at tea meetings, and the last leader of a group remembered the roles of footman, doctor, messenger, queen, king, Warwick, Canteberry, Westmoreland, and Exeter in his group's performances.

Today portions of Shakespeare are no longer part of Jonkonnu celebrations in Jamaica, although elements from British mummers' plays are still evident. In Jamaica from the 18th until the 20th century, black males were the actors. In the years following the first references, the influence of British mummers' plays and historical dramas became more apparent in the texts and costumes. Data from other islands, while not as extensive, provide evidence of the performances of Shakespearean plays other than *Richard III* cited above. The written accounts of the origin and development of Jonkonnu in Jamaica and Shakespeare Mas' on other islands provide a diachronic dimension not available for Carriacou. However, in Carriacou the Shakespeare Mas' continues to be performed for enthusiastic audiences during carnival. As in Jonkonnu, the performers are only males. *Julius Caesar* is the only text used now. The costumes, the whip fighting, and the rhetoric all seem to have strong African influences. Whether the Carriacou mas' developed in a way similar to the performances in Jamaica cannot be determined. It may have been brought to the island in the pre-emancipation period by either British planters or their slaves in a form that already included the performance of Shakespeare. It can be said, however, that it is only in Carriacou that a performance similar to those that existed on many Caribbean islands still continues, probably because of sociohistorical factors and lack of contact with other islands.

As mentioned above, in addition to the strong African influences on these performances, there was also an important impact from British mummers' plays—Christmas folk plays that were common in the 16th century and earlier. Originally they were pantomimes performed by groups of men which evolved into three types: "Hero-Combat Plays," "Sword Plays," and "Wooing Plays" (Brody 1970, 5). In Ireland these performances continued until the middle of the 20th century (Glassie 1975). The Hero-Combat Play is the type most directly related to the Shakespeare Mas' in Carriacou. The battle between the mas' players and the fighting that ensues are similar to the action in these plays.

William Archer gave the following description of the fighting that could occur between groups of mummers:

Sometimes a large village would furnish forth two sets of mummers. They would go to the farmhouse round between Christmas and Twelfth Night doing some four or five performances each evening, and getting ale and money at every house. Sometimes the mummers of one village would encroach on the traditional sphere of influence of another village and there would be a battle in earnest. [1904, 35]

Like the English mummers, Carriacou mas' players move from village to village for competitive performances; however, the time is not Christmas but, rather, before the beginning of Lent. For two periods in the 18th century Carriacou was a French possession. This early French influence is found in the French patois that continued to be spoken by many on the island until recently, and French place-names are common. It is this French Catholic heritage that is the source of the pre-Lenten carnival celebration in Carriacou as it is in other areas that have a similar heritage. In other Caribbean islands that had less Catholic influence the folk celebrations are often held at Christmas, crop over (celebrations at the end of the sugar cane harvest), or more recently on the anniversary of independence.

Assigning a specific date to the beginning of what is now called the Shakespeare Mas' in Carriacou may be impossible. Contemporary informants have widely different views not just about the dates but also about the content of the speeches, the use of the whip, and the traditions related to the costumes. The oldest island resident, who was born in 1892, remembers seeing some version of the speech mas' as early as 1897. Another remembers what he calls the Shakespeare Mas' when he was a boy of seven or eight in 1915. He recalls a famous conflict between the players from the north and the south of the island, the Heroes and the Banroys. In this mas', the recitations ended not in one but two general battles between players from the two parts of the island—one in the morning and the other in the afternoon. There were at least thirty men in the Banroy group. As a result of this violence, participants were forbidden the use of brass knuckles and knives and had to fight with their fists. Today the fighting is between a pair of players rather than area groups.

One veteran performer thinks that historical texts (that is, recitations about William the Conqueror, Napoleon, Queen Victoria, and so on) were no longer used after the 1940s, and *Julius Caesar* became the only source for the mas' recitations.

Other parts of the Carriacou carnival—Queen Show, Dimanche Gras, Big Drum performances, Calypso Finals, J'ouvert Morning, Old Mas', Mas' Band Competitions, and Street Parade of Bands also have important places in the island celebrations. However, the Shakespeare Mas' is unique in that it derives from an English literary source and combines that source with West African costumes, whip fighting, and rhythmic body movements, as well as British mummers' plays and European carnival traditions, in an example of what Benítez-Rojo calls "a signifier made of differences" (1996, 21).

Preparations for the mas' begin months before carnival is to take place; players from the individual villages—Top Hill, Mt. Royal, Belmont, Six Roads (Tief), Brunswick, Windward, Mt. Pleasant, Belair—gather under streetlights on the open roads to learn or in most cases relearn their speeches from *Julius Caesar*. This all-male group will represent the village in street competitions with other village groups and will be judged according to the ability of individual members to recite with accuracy and appropriateness passages from Shakespeare's play. During the rehearsal period the group selects a king and peacemaker or peacemakers; the king is generally an experienced mas' player who has won the admiration of other players in previous years, and the peacemaker is another performer who knows the speeches as well as the "unwritten" rules of performance. He is able to control the players on the frequent occasions when players from both sides get out of hand.

Preparation for the mas' not only includes getting ready to recite Shakespeare's "book"—which means *Julius Caesar* and not the complete canon—but also requires readying the costumes, which differ from player to player. A typical costume consists of a headpiece or crown made from colorful fabric pasted on cement bags which extends down the back of the player. The base of the crown is a cotta, woven from the fibrous air roots of a ficus tree, which supports the crown and is tied around the head and under the chin. A mask, made from screen wire and painted white, also gives some protection. The white mask shows the influence of the Pierrot character from European carnival traditions who became a carnival figure on Trinidad, Grenada, and other West Indian islands. One experienced mas' player said that the masks used to be "pretty" but now are "Grenadian" screen wire painted with crude drawings of human or animal faces.

A player wears baggy trousers, a petticoat, tennis shoes or leather boots, and a loose-fitting, colorful shirt that has overlapping rows of fabric cut in triangles with a large black heart and mirrors on the front; he also carries a whip. Some players wear gloves and carry a bell. Trousers are tucked into the tops of socks. The designs and colors of the fabric of the shirt and crown are different for each player, and the brilliant clashing colors enable spectators to recognize the individual players from the different villages, such as Mt. Royal, Brunswick, or Hillsborough.

An island seamstress and mas' costume maker described the colorful designs and the history of the costumes. In the past, after carnival, part of the costume was cut up and made into clothing for family members, and part was given to the costume maker to repay her for her work. Costume making is a tradition in the seamstress's family; her mother made costumes in the early 1930s. Now the same costume can be worn from year to year.

According to the costume maker, red and black are common colors, but she says that the heart on the shirt "should be black...just to tantalize." Several performers noted that the reason the heart should be black is that it provides strong contrast to the many other colors of the costume. According to Thompson (1983), both red and black have special significance in many West African cultures. These are the colors of Eshu, the Yoruba deity (Thompson 1983, 276); in Dahomean myth, the color of the night is black, and twilight is red (Thompson 1983, 176). While there are many aspects of culture in Carriacou that can be traced to African sources, the significance of red and black in mas' costumes does not seem to have any links with African deities or myths. What is a more likely source is that for centuries in West Africa there has been the use of high-affect colors in fabric "in willful, percusively contrastive, bold arrangements" (Thompson 1983, 209). The multicolored fabric of mas' costumes emblazoned with black hearts represent this clash of colors.

Players use their whips, made out of telephone or electrical cable wrapped in plastic, both to challenge their opponents and to hit them on the backs of their crowns when they fail to respond. Hard blows are delivered, and the fighting frequently becomes fierce. As Abrahams noted, a whip is "a symbol of masculine power" (1967, 475). Recently, when an ex-player was asked what he liked best about the Shakespeare Mas', he answered without hesitation, "the whipping." Abrahams also noted the appeal of fighting and its integration in folk performances, saying, "Nothing is enjoyed by participants and audiences so much as a fight, and if the fight is physical, interest and hilarity are highest" (1967, 475).

Local school principal and folklorist Christine David said that in the 1950s the generalized fighting was prohibited by the local government because it became too violent when the Shakespeare Mas' players from the northern and southern parts of the island met for the final battle. At this now-famous event, women joined in by supplying boiling water and stones for the attack (David

1985, 49). While the fighting now is between individual players and is less violent, it continues to be one of the more popular parts of the mas'.

The Shakespeare Mas', like every other event in the Carriacou carnival, has a schedule, but the schedule changes to conform to the unpredictable conditions of the moment. The theoretical schedule, which was formulated through reading and later modified by actual experience, begins with an early morning "warm-up" mas' at Top Hill and another in Bogles. These mas' players then proceed to the first major encounter in Mt. Royal, a second in Six Roads, a third in Brunswick, and a final, more relaxed one in the major town of Hillsborough. At each location the players fight a series of verbal and physical battles that test their virtuosity and memory; one village appears to be recognized champion, and the king leads his group to the second site where the newly crowned victors face challengers from that village. Verbal and physical battles are again fought, winners are unofficially declared, and the crowd moves to the next location. The series of performances finally ends with the informal declaration of that year's champion village and king. Then the players and the crowd move on to Hillsborough for freer, less structured recitations—simply for the fun of it—and much drinking of beer and Jack Iron, a very strong rum.

The coming together of groups from contending villages has the appearance of preparation for battle. Players walk down the hills and roads in loosely formed lines; they wave their whips in response to the encouraging crowd until they reach a wide section in the road where they will engage in verbal warfare, whipping and fighting with players from a different village.

All performances revolve around a challenge and response format. In a series of interviews, the mas' players summarized the following order for each encounter: A player initiates his first recitation by asking his opponent to relate a specific speech from the play, for instance, "Will you relate to me Mark Antony's speech over Caesar's dead body?" His opponent responds, "Go back and relate," which tells the first player that he is free to recite the passage he mentioned in his question. After the first player finishes his speech, the second player is free to initiate a speech he wishes to recite with the same question, for example, "Will you please relate the speech about Caesar's will?" If properly prepared, he will recite the passage; and the first player will prepare for his second turn. If, however, either player fails to come forward with the speech he himself has cited in his question, the opponent will threaten to use his whip with the words "Break for your crown," and the failing player must raise his own extended whip above his head in preparation for the blow. The victor then taps the loser's whip—or in most cases strikes the crown or back of the cape; the loser withdraws, and the winning player readies himself for a new opponent. In the performances we observed, the noise level was so intense and the crowd so large that it was not always possible to hear the question "Will you please relate...?" Nor were the sentences "Go back and relate" and "Break for your crown" always audible. In addition, the tapping of the extended whip or crown was seldom honored but became instead a vigorous whipping action that was saved from becoming a melee through the intervention of the peacemakers and other males in the crowd. The reason for the differences in the descriptions given by the players and what happens in actual performances may be attributed to the excitement that is generated as the mas' progresses. The physical fighting increases in the encounters at each crossroad and can result in cuts if a player's mask is not in place. In the last encounters in Hillsborough, the players do not wear their crowns and masks, and there is no whipping.

Spectators take active roles in the performances by cheering their village players on with words like "Brave," "Tell him," "Go on," "That's right," and "Yeah, yeah" or shouting out the mistakes of the opposition: "He got the *will* wrong." At one lively moment in a 1995 recitation a Mt. Royal

player, overwhelmed by the spirit of performance and Jack Iron, inserted an obscenity in his speech; the delighted crowd recognized the player's invention and shouted almost as a chorus their correction—"Ain't no *F* words in Shakespeare!" Peacemakers frequently have to intervene to prevent overly zealous spectators from interrupting performances and contributing to the constant threat of violence.

The number of pairs in a given performance depends on the number of players. Recently Mt. Royal has been the most active community, with eight players and a large group of enthusiastic village spectators, many of whom appeared to know by memory the lines from "Shakespeare's book." It seems that 1995 was the year of revival for the Shakespeare Mas', which in previous years had been fading; the small village of Six Roads alone produced perhaps as many as six new players.

As noted, people in Carriacou refer to *Julius Caesar* as Shakespeare's book and boast about grandfathers, great grandfathers, and famous players in the 1940s and 1950s who knew the whole book by heart. The first question asked of all local informants was "Why Shakespeare?," but this question was never answered adequately. The process of re-evaluating Shakespeare and trying to decide why he, instead of other equally prolific European writers of the 16th and 17th centuries, holds the highest and most "privileged" position in world literature is being undertaken by such scholars as Gary Taylor (1991). The question was not asked, however, to raise matters related to Carriacou's intellectual history but, rather, to stimulate memories of studying Shakespeare in primary school and suggest that this introduction to the play had inspired local villages to use it for the competitive performance.

The next question was "Why *Julius Caesar*?" We received two responses. One was given by a former mas' player who is now chairman of the Carriacou Carnival Committee. He believes that because the historical date of the play is close to the birth of Christ, *Julius Caesar* is appropriate for the pre-Lenten carnival celebration. The other answer for the selection of *Julius Caesar*—which might seem more believable but which is even more doubtful than the first—is that the political uncertainties, cycles, and philosophies developed by Shakespeare in *Julius Caesar* have parallels in Carriacou's 20th-century history and are therefore topically relevant. The political and economic upheavals of the 19th and 20th centuries in Grenada and Carriacou (Grenada's sister island and dependency) do in fact have many analogues in *Julius Caesar* and for that matter in all of Shakespeare's plays that deal with Roman or English history; but research has not as yet uncovered any information that indicates that the play is popular because of its political philosophy or relevance.

The historical reason for the survival of *Julius Caesar* in this lively form is probably to be found in books and examinations used in the educational system from the late 19th century through the 1950s. The school readers used throughout the British West Indies well into the 20th century were *The Royal Readers*; selections from Shakespeare appear regularly beginning with book 4. Two different editions in the series contain condensed versions of Shakespeare's *King John and Julius Caesar* with a selection of passages in the original language, vocabulary lists, topics for discussion, and sample questions. What seems likely is that, if the play was studied and selections memorized by schoolchildren, it would have logically found its way into the speech mas'. The influence of the reading materials from *The Royal Readers* on the older population in Carriacou is still great. During interviews with various residents, there were impromptu recitations from the biographies of Napoleon, William Tell, William the Conqueror, Queen Victoria, and Henry V. The passages were recited with pride. Even with a limited familiarity with the series, the sources can be identified in the readers. The only Shakespeare now available in the Carriacou school supply store was the New Swan Shakespeare 1983 edition of *Julius Caesar*.

While it has not been possible to determine when *Julius Caesar* became a school text in Carriacou, Shakespeare is presently taught in the schools, though there is more emphasis given to more contemporary literature. The syllabus issued by the Caribbean Examinations Council (CXC) effective May 1993 includes *Julius Caesar* in the list of non–West Indian plays for third-year students. Additional plays for third-year students are *Macbeth, Merchant of Venice, As You Like It,* and *A Midsummer Night's Dream.* For the fourth year the list includes *Henry IV, Part I, Richard III, Henry V,* and *Othello* (CXC 1992).

In addition to the importance of *Julius Caesar* as a reading and examination text in Carriacou's educational system, the language of Shakespeare's poetry is equally responsible for his continued popularity in performance. One player in describing the tradition of speech mas' claimed that the histories of William the Conqueror and Queen Victoria had been used in the past but that Shakespeare was better, or in his words "sweeter," and he recited Antony's familiar oration—"O pardon me, thou bleeding piece of earth," which indeed is an example of their sweetness.

Julius Caesar, in particular, is appropriate for the type of verbal combat that takes place in the carnival performance, in that it is built around rhetorical structures that allow characters to exchange passages of debate in set speeches. A dialectic text written in dialogue is a "natural" vehicle for competitive verbal activity in which characters "throw one speech against another." This is the phrase that was used by a former player who took part in the Shakespeare Mas' as a young man. He believes that Shakespeare, which he learned to love as a boy, is both unique and important in Carriacou's culture and thinks that local people should get together and insist that more Shakespeare be taught in the schools. The fact that Elizabethan drama "flourished" and still flourishes as "an art of contest, dialogue and debate, agreement and disagreement" has long been recognized by scholars of Renaissance literature such as Hardin Craig, who appropriately praises Shakespeare for his "ability to see both sides of a question, and a sympathy with all sorts and conditions of men" (Craig 1936, 157).

In an interchange at the Shakespeare Mas' of 15 February 1994, two players recited a total of six passages from *Julius Caesar.* Player one recited, player two responded in an appropriate manner, player one took his second turn, player two responded, and so on. However, the players were not in fact following the chronology of Shakespeare's play. Recitation one, by player one, was Calphurnia's plea to Caesar to not go to the Senate House; recitation two, by player two, leapt ahead to Mark Antony's funeral oration and also included lines Shakespeare wrote for the plebeians. Player one's response returned to the beginning of the play when two enemies of Caesar drive the plebeians from the streets of Rome; player two responded with Antony's soliloquy over the recently murdered body of Caesar—"O pardon me, thou bleeding piece of earth." Player one's response moved forward to act 4 when Cassius begs for Brutus's forgiveness—"Cassius is aweary of the world"; player two's final speech consisted of lines Shakespeare gave to the crowd, Antony, and three plebeians which come at the end of the funeral oration. Player one retired at this point, and another player took his place. Although no two interchanges between the players are the same, in general older, more experienced players can recite more passages than younger players. There are common passages that many players have learned, but there are no set passages that must be memorized.

A comparison between this performance and Shakespeare's text allows several broad generalizations to be drawn about the Carriacou Shakespeare Mas' and speculations on how that text relates to the performance. First, as is clear from the summarized performance, the recitations are a dialogue between two performers, but the passages recited do not follow the order in Shakespeare's play, nor are passages related thematically. Furthermore, the performers do not

restrict themselves to the speeches of a single character but take over lines assigned to two or more characters in the original.

A general observation seems appropriate at this point. Some of the information given in interviews with the players and spectators about the speeches in the interchanges is different from what was actually observed during the mas'. In reporting on the content of the verbal exchanges one of the players insisted that the contenders were not allowed to recite the lines of more than one character, and he corrected an opponent for making this mistake during a performance. However, when this same performer recited "typical" passages after the mas', he included multiple characters' speeches in his recitation. What players say should be recited and what is recited in an interview are not always the same.

The recitation of extended passages in this manner is not done to fulfill some previously agreed on numerical or quantitative requirement, for lines recited in all the performances observed vary in length from 52 (the longest) to four (the shortest). Only occasionally does a player take on the identity of the character whose lines he recites. Some passages selected for the Carriacou mas' fit in the category of famous speeches from Shakespeare and thus can probably be found in books of famous quotations from English literature; this fact would suggest that the players memorize only well-known speeches such as those found in *The Royal Readers*. However, the speeches by Cassius and Calphurnia are relatively obscure and do not fit in this category, and their inclusion could serve as evidence that the performer has memorized at least the major speeches in the play.

Information from players refutes the idea that the performers memorize the entire play; without exception they speak of *Julius Caesar* in terms of speeches and claim to know a certain number—30 was the highest and three the lowest. The younger players believe that with every year's performance they will acquire more speeches; this is a natural supposition clearly illustrated by the fact that the man claiming 30 was a senior member of his group whereas the one claiming three was performing for the first time.

The second generalization has to do with the other components of the performance; and while the verbal activity is dominant, it is mixed with rhythmic dance motions before and during the recitations, actions and gestures with the whip, and movements that call attention to the elaborate costumes. These components are in fact the details that make the Shakespeare Mas' an example of Benítez-Rojo's syncretic artifact. Each component—the procession, the verbal challenge-response format, body movements, and whipping—is related to but nonetheless different from folk traditions in West Africa and Europe.

The verbal exchanges themselves are in the English of Shakespeare, but the delivery and the noise of the crowd make many of the passages difficult for English-speaking outsiders to understand—especially those in the back of the very large crowd. Although the complete speeches may not be audible or intelligible to everyone, this is not to say that they are not "impressive," for they are indeed delivered with feeling and extraordinary energy and generate feeling and energy in the audience.

The performances can be placed in the tradition of West Indian verbal dueling meant in fun and play, popular on other islands in the Anglophone Caribbean. However, the earnestness that characterizes the majority of the performances suggests a seriousness that goes beyond carnival festivities. In this creolized condition, the recitations have unique beauty or "sweetness," as one player contends. This is due at least in part to the rhetorical features of Shakespeare's poetry which are responsible for the survival of *Julius Caesar* in this popular form. The aesthetics of Shakespeare's rhetoric are best understood through the classical figures and tropes he acquired in the process

of learning Latin and used in his English plays; however, Shakespeare's power of invention is far greater than any of the figures, devices, grammatical patterns, or ornaments he was forced to commit to memory as a schoolboy. But the methods of persuasion conveyed by the sounds, images, rhythms, and even the thoughts in the individual passages have lasting appeal and relevance. Their effectiveness strike the ear repeatedly in the recitations and contribute to the pleasure, sweetness, and "impressiveness" of the Carriacou performances. Because this example of a folk play that derives from Shakespeare does not follow the plot, the individual speeches are the most important aspect of Shakespeare's original work to these folk performers.

In the 19th century there were other carnival bands in the Caribbean which also used speeches from Shakespeare, British literature, and European history. The Pierrot Grenades in Trinidad wore shirts similar to those of the Carriacou mas' players and also carried whips. When encountering another Pierrot, "[t]he boastful speeches of victories and counter speeches came into play. Questions and counter-questions were put....Pierrots were also always strong, sturdy, adventurous men, and a fight was usually inevitable" (Carr 1956, 282). By 1896, the fighting became so fierce that it was necessary to get a special license, and soon the Pierrots were no longer part of carnival. The similarities between the Pierrot in Trinidad and Carriacou both in costume and performance are many.

Pierrots also performed in Grenada, but these spoke in French patois mixed with Creole English. Their speeches, which were often satiric, were about farming, political and social events, and so on and were recited in a type of spelling by syllable game (Carr 1956, 284). As the number of Grenadians who understood French patois declined, so did the number of Pierrots in carnival. The Midnight Robbers in Trinidad carnival also took their speeches from literary and historical sources. They went around in pairs carrying guns or daggers to threaten the spectators and collect money from them. Originally the costumes were based on American cowboy attire, but then there were variations such as Hunting Robbers, Railroad Robbers, and so forth. According to Crowley, "the victim is threatened in a long and elaborate speech full of horrendous phrases to give up all your hidden treasures" and "choose what death you will die" (1956, 263).

There are other Caribbean folk performances that do have plots based on literary texts. In Nevis, performances of Giant Despair continued at Christmas in yards and along the roads and now are a part of Culturama, an August celebration. In Giant Despair performances, a group of male performers recite a set text taken from *Pilgrim's Progress*. The plot is the Christians' journey to the Celestial City and concludes with the mock death of Despair. The players then threaten and chase the spectators, especially the children. A string band accompanies the performers, announcing their arrival and playing during the performance (McMurray and Fayer 1996).

There are similarities as well as contrasts in many of these Caribbean carnival performances. Some follow a plot, whereas others consist of the recitation of speeches from literary sources. In some performers threaten the spectators and request money, and in others the performers whip each other. Varieties of Pierrot costumes are worn in some, and in others the performers wear costumes resembling the characters they portray. In each distinctive creole setting, the supersyncretic signifiers that they all share have produced folk performances that enrich carnival celebrations. In describing this hybridity Abrahams said,

> In bringing together these two vital traditions in a world alien to both, each was drawn upon at those places where it came closest to the other: the process of "syncretism." European forms and subjects were adopted in which African patterns of performance and technique could be practiced, African forms and subjects persisted where they were enjoyed by the masters. Out of the newly-

created world of the plantation grew the traditions and aesthetic which drew upon major Old World cultural expressions and adapted them to their new situation. [1967, 460–461]

Although all of these carnival folk performances in these and other Caribbean islands combine both West African and European traditions, they developed in different ways. Some have survived and others disappeared, but one strong common element is the opportunity provided for the players to demonstrate that they are men of words, men who are good talkers and good arguers, as well as men of action, men who have talent competing with other performers (Abrahams 1967, 470–471). The folk performances on Carriacou and other islands have integrated both types of verbal skills.

Carnival events provide the opportunities for men of words and men of action to demonstrate their skills. But these carnival events have even more significance. Benítez-Rojo concluded that "[o]f all possible sociocultural practices, the carnival—of any other equivalent festival—is one that best expresses the strategies that the people of the Caribbean have for speaking at once of themselves and their relation with the world, with history, with tradition, with nature, with God" (1996, 294). The Carriacou Shakespeare Mas' continues to reflect the history and tradition of this small island and to produce pleasure for the players and spectators alike.

Notes

1. Christine David, Carriacou historian and folklorist, and the Carriacou Historical Society have no data on the origins of the Shakespeare Mas', nor have any been found in research libraries in the Caribbean and the United States. Few European travelers in the 18th and 19th centuries visited Carriacou; thus this important source for early data on other islands is not available here. If the people who lived in Carriacou kept diaries, they have not survived. Government records of various types provide data about population, agriculture, and so on but not folk traditions. The early history of the Shakespeare Mas' and other folk culture in Carriacou is oral.
2. In a taped interview available at the African Caribbean Institute in Kingston, Jamaica, Mr. Hewitt recounted the last performances of the Actor Boys. The age of the players and the popularity of other types of performances are among the reasons for the disbanding of the group.

References Cited

Abrahams, Roger D. 1967. The Shaping of Folklore Traditions in the West Indies. *Journal of Inter-American Studies* 9:456–480.

———. 1973. Christmas Mummings on Nevis. *North Carolina Folklore Journal* 21:120–131.

Archer, William. 1904. *Real Conversations*. London: W. Heineman.

Belisario, Isaac M. 1837. *Sketches of Character, in Illustration of the Habits, Occupation, and Costume of the Negro Population in the Island of Jamaica*. Kingston: Isaac M. Belisario.

Benítez-Rojo, Antonio. 1996. *The Repeating Island: The Caribbean and the Postmodern Perspective*. Translated by James E. Maraniss. Durham and London: Duke University Press.

Bettelheim, Judith. 1979. Afro-Jamaican Jonkonnu Festival: Playing the Forces and Operating the Cloth. Ph.D. dissertation, Yale University. University Microfilms International.

Brody, Alan. 1970. *The English Mummers and Their Plays*. Philadelphia: University of Pennsylvania Press.

Caribbean Examinations Council (CXC). 1992. *English Syllabus Effective May 1993*. Barbados: CXC.

Carr, Andrew. 1956. Pierrot Grenade. *Caribbean Quarterly* 4:281–314.

Cassidy, Frederic G. 1961. *Jamaica Talk*. New York: MacMillan.

Chambers, Edmund K. 1933. *The English Folk-Play*. Oxford: Clarendon Press.

Craig, Hardin. 1936. *The Enchanted Glass: The Elizabethan Mind in Literature*. New York: Oxford University Press.

Crowley, Daniel J. 1956. The Midnight Robbers. *Caribbean Quarterly* 4:263–274.

David, Christine. 1985. *Folklore of Carriacou*. Wildey, St. Michael, Barbados: Cole Printery Limited.

De La Beche, Henry T. 1825. *Notes on the Present Condition of the Negroes in Jamaica*. London: T. Cadell.

Drewel, Henry John, John Pemberton III, and Rowland Abiodun. 1989. *Yoruba: Nine Centuries of African Art and Thought*. New York: The Center for African Art.

Glassie, Henry. 1975. *All Silver and No Brass*. Bloomington: Indiana University Press.

Lewis, Matthew Gregory "Monk." 1929. *Journal of a West Indian Proprietor during a Residence in the Island of Jamaica 1815–1817*. London: Murray.

Long, Edward. 1828[1774]. *The History of Jamaica*. London: T. Lowndes.

McMurray, Joan F., and Joan M. Fayer. 1996. John Bunyan's *Pilgrim's Progress*: A Folk Play. Paper delivered at the Speech Communication Association of Puerto Rico Convention, 6–7 December 1996, San Juan, Puerto Rico.

Marly. 1828. *The Life of a Planter in Jamaica*. Glasgow: Richard Griffin.

Mills, Frank L., Simon B. Jones-Hendrickson, and Bertram Eugene. 1984. *Christmas Sport in St. Kitts-Nevis: Our Neglected Heritage*. U.S. Virgin Islands: Frank L. Mills.

Nugent, Lady Maria. 1966. *Lady Nugent's Journal*. London: The West India Committee.

Nunley, John W. 1988. Masquerade Mix-Up in Trinidad Carnival: Live Once, Die Forever. In *Caribbean Festival Arts*, ed. John W. Nunley and Judith Bettelheim, pp. 85–119. Seattle: The Saint Louis Art Museum and the University of Washington Press.

Patterson, Orlando. 1967. *The Sociology of Slavery: An Analysis of the Origins, Development and Structure of Negro Slave Society in Jamaica*. London: Macgibbon and Kee.

Payne, Nellie. 1990. Grenada Mas': 1928–1988. *Caribbean Quarterly* 36(3–4).

St. George's Chronicle and Grenada Gazette. 1833. 24 August: 273.

Smith, Michael G. 1962. *Kinship and Community in Carriacou*. New Haven, Conn.: Yale University Press.

Taylor, Gary. 1991. Bardicide. In *Shakespeare and Cultural Traditions: The Selected Proceedings of the International Shakespeare Association*, ed. Roger Pringle and Stanley Wells, pp. 333–349. Newark, N.J.: University of Delaware Press.

Thompson, Robert Farris. 1983. *Flash of the Spirit*. New York: Random House.

Wynter, Sylvia. 1970. Jonkonnu in Jamaica: Toward an Interpretation of Folk Dance as a Cultural Process. *Jamaica Journal* 4:34–48.

Music and Popular Consciousness

On Interpreting Popular Music: Zouk in the West Indies

Jocelyne Guilbault

One of the dominant features of life in most Caribbean communities is the people's continuing reliance on music to help them perform the most mundane chores or to celebrate the most special events. This means that there is a great deal of social value placed on popular music. Musical value judgments constitute such a social force in the West Indies that no one in power can ignore the impact music has on the way people make political decisions. As Everold N. Hosein stated after a survey in St. Lucia (1975, p. 17), the fact that most people find music the most important criterion in determining what is their favorite radio station has important implications for using radio-music-in communication strategies for planned development changes.

The importance and usefulness of music means that the most popular music heard on radio is in a key position not only to reveal what people are, but also to help them establish a sense of identity and to clarify ideals and motivations. As the British sociologist and rock music critic Simon Frith (1987, pp. 144–48) observed: 1. pop music sets up a narrative structure: it sets up star personalities, situates the listener, and puts into play patterns of identity and opposition; 2. the specific form of the musical genre affects the relative intensity of the listener's experience, and 3. each musical genre sets the notion of "truth" for its listeners. Popular music, Frith concluded, has ultimately a role of placement. "What pop can do is put into play a sense of identity that may or may not fit the way we are placed by other social forces" (1987, p. 149). It is specifically for this last reason that we need to examine the strategies and constraints that play a decisive role in determining the impact popular music has on individuals. Whether, as Frith suggested, "we want to value most highly that music...which has some sort of collective, disruptive cultural effect" (1987, p. 149) should be indeed a prime concern for anyone interested in understanding better how people, by adhering to, or opposing themselves against, the music presented to them, are led to conceive and perceive the world.

A prime example is *zouk*, a Caribbean popular genre that has been made famous by the group called Kassav. Its members, mainly composed of Guadeloupeans and Martiniquais who now live in Paris, have recorded over twenty albums during the past five years and have already been awarded several gold records. Their music is popular in Europe and has even reached the coast of Africa, where their phenomenal success is compared with that of the Beatles. Even though the achievements of Kassav may seem spectacular abroad, their popularity in the Windward Islands has reached staggering proportions. Several groups have recently been formed and perform strictly *zouk* music.[1] Twenty-four hours a day, radio stations play *zouk* music; TV channels regularly devote entire programs to it and present daily ten-to twenty-minute videos that introduce new releases. Discotheques that are identified as the "hot" spots play *zouk* at full volume all night.

Two main questions need to be addressed: 1. How do people make value judgements about music and how do such value judgments articulate the listening experiences involved (Frith 1987,

Reprinted with permission from *Caribbean Popular Culture*, ed. John Lent, 79–97 (Ohio: Bowling Green State University Popular Press, 1990).

134). Put in more practical terms, how can the popular music called *zouk* generate a homegrown feeling for the most immediate audience for this music – that is, the inhabitants of Martinique, Guadeloupe, Dominica, and St. Lucia – whereas, say, reggae, in spite of its continued popularity in the islands, is still considered foreign music?[2] 2. Does, or can, *zouk* play a role in the regional integration of the Creole-speaking islands and if so, at what levels?[3] This last question, posed in 1981 by Yves Renard of the Caribbean Conservation Association, is perhaps more than ever an issue today. This is a dynamic period in the cultural and political history of Creole-speaking peoples, one in which the necessity of defining the Creole identity is becoming more and more urgent, in keeping with the major changes that will occur with the coming in 1992 of the "Acte Unique Européen" (Farrugia, Pépin et al 1987),[4] and the ongoing preparations of the member countries of the Organization of the Eastern Caribbean States (OECS) to form a political federation (DaBreo 1988; Demas 1988).

In an attempt to answer these questions, this paper is divided into three sections.[5] The first introduces the key elements of the social and political settings, plus the soundscapes,[6] of Martinique, Guadeloupe, St. Lucia, and Dominica that predispose people to make certain value judgements. The second section focuses on the making of *zouk* music to highlight how the composers create their music (consciously in some instances, non-consciously in others) to connect with the various social, political, and musical environments. The third section describes the relative impact this music has on people, by examining how it competes and compares with other types of popular music accessible on the islands, and how, as a social force, it fits in with other local social forces.

Social and Political Setting and Soundscape

Guadeloupe and Martinique are both French-and Creole-speaking countries that are politically, economically, and socially tied to France as departments. Although the two islands have enjoyed an average income far superior to that of any neighboring state, they have, however, felt very uneasy with French administration and law that superimpose ways of thinking and doing that do not meet their own needs and philosophies. Over time, the political dependency of Guadeloupe and Martinique has led the islanders to question their cultural identity. At times, what is defined by many Antillean writers as a "deep malaise," has had a paralyzing effect on artists and has brought creative production to a halt. At other times, this intellectual and emotional insecurity has incited several Antilleans to action, turning back to their folk traditions for inspiration in order to develop forms of expression that could help reassert their own identity. That is what the Kassav group has done.

Dominica and St. Lucia, former British colonies, are both English-and Creole-speaking islands that acquired political independence only in 1978 and 1979, respectively. Unlike the French – speaking islanders, Dominicans and St. Lucians are confronted less with questions of cultural identity than they are with problems of resources. The economies of both islands are such that, in most instances, artists have to leave home to find work. Those who do stay are faced with earning their living by working for the ministry of culture, where there is very little time to do creative work, or for commercial enterprises such as hotels, where creativity is rarely encouraged. Even when they have exceptional talent, artists do not have enough money to get their work adequately produced and promoted to reach a wide audience and be financially successful. As a result, these two islands have become great consumers of foreign products. How *zouk* music produced in the French departments is not considered foreign in St. Lucia and Dominica will be explained in the following pages.

Musical aesthetics are motivated or cultivated, not only by people's political and social surroundings, but also very much by their soundscapes. Listeners quickly assimilate familiar sounds into a series of associations that become part of their total experience. To assess the soundscape of a region and to examine its various meanings for the listeners in that region is, in fact, a prerequisite to understanding how a given music achieves its impact on the population.

The experience of music by Creole-speakers is affected by the following three powerful factors that help form their soundscape: mass media, migration patterns, and folk traditions.

The Mass Media

It is by now a truism that the overall selection of broadcast music influences the relative popularity of each musical genre. How is the selection made? As a result of programming policies, government legislation? Who supplies the recordings to the radio stations? What is the role of the broadcaster in the choice of music played on the air?

In St. Lucia, Dominica, Guadeloupe, and Martinique, there is a policy regulating the spoken content of radio programming, but there is none for the selection of music played on the program, that being totally left to the discretion of disc jockeys. The disc jockeys, who most of the time have learned the trade on the spot, follow their musical intuition and taste. Only recently, have telephone call-in shows allowed them to gauge musical tastes directly from listeners. Before the advent of call-in shows, disc jockeys picked up information by attending popular fetes and listening to friends' comments on music. At times, as in Dominica, vans provided by radio stations circulated throughout the country to do programs on the spot. During these sessions, interviewers heard people's comments on the music. To this day, there is no other organization that can provide a profile of Dominicans' musical tastes and indicate the relative degree of popularity of specific musicians or musical genres.[7] Musical intuition and the availability of records are, in fact, at the heart of the decision – making process that determines what goes on the air.

In poor countries, such as St. Lucia and Dominica, the limitations on what a disc jockey can play are often imposed by external, economic constraints. The situation is more severe in Dominica, where records are no longer given free to radio stations, and Radio Dominica, for some time, has not supplied a budget big enough to keep up to date with new releases. For each broadcast, disc jockeys have to borrow, from friends' collections, the records they want to – and, indeed, must – play to maintain their personal popularity as disc jockeys. There is no weekend chart, say, of the "top 40," since these albums, borrowed during the week, are most often not available during the weekends.

In Guadeloupe and Martinique, there is no shortage of records, thanks to the French economic system and several *zouk* producers who live on the islands and send free copies to radio stations. However, in some instances, there are political constraints. Out of the rather large number of private radio stations[8] for the relatively small population of the French islands – 29 radio stations for a population of 320,000 in Guadeloupe and 36 for a population of 360,000 in Martinique[9] – we are told that no more than five stations in each island reach a wide audience. These stations are, for the most part, each associated with a political party, which may or may not have a direct impact on the disc jockeys' selections of music. Certain separatist stations refuse to play anything other than traditional or politically-oriented music. Other stations have more liberal musical choices and, as in St. Lucia and Dominica, allow disc jockeys to be entirely responsible for the selection.

Apart from economic restraints which, as we have seen, have not yet prevented disc jockeys from finding the records they want to play, the music heard on the Creole-language radio stations in general reflects, as noted earlier, the disc jockeys' musical intuition.

Migration Patterns

Musical intuition reflects higher education which, within the political and economic systems of the four Creole-speaking islands, implies emigration. For the two former British colonies, higher education means going to Great Britain, the United States, Jamaica, Trinidad, and-for a few-Barbados. Most of the disc jockeys interviewed for this study had lived for three years or more in one of these places. Since there is little contact in these countries with Spanish or African music, none is played on the air, though the U.S. mass media have had a tremendous impact. Disc jockeys' habits, values, and models are marked by their experience abroad, and hence their taste for American music, reggae, calypso (and soca)[10] reflects it.

Disc jockeys' habits, values, and models are also marked by the continual movement within the region of the population at large. Apart from cultivating relations with the more obvious trade centers – such as Barbados, Trinidad, and Jamaica-St. Lucians and Dominicans have maintained a strong network of trade with Martinique and Guadeloupe, respectively, since the beginning of colonization.[11] The importing of goods has also meant the importing of music. Today, for example, two young businessmen from Dominica go to Guadeloupe, regularly each month, to buy records for their record shop. Several Dominicans have said these these two men alone have played a major role in promoting *zouk* on the island by making it available to radio stations, discotheques, and mobile discos. Touring groups over the years have also had an impact on the musical taste of disc jockeys, as well as the general population of the islands. The group Kassav's two visits to St. Lucia (in 1985 and 1986) helped the group to present itself more effectively and advertise its music. Kassav was already popular on the island, but after these visits, its popularity reached a peak on the local radio stations.

In Guadeloupe and Martinique, as in St. Lucia and Dominica, higher education implies leaving home. The usual destination is France, where the multi-ethnic population allows one to cultivate many tastes and meet many groups. The Antilleans are spontaneously attracted to African music and find it readily available among the many French-speaking African groups living in Paris. This interaction among Guadeloupeans, Martiniquais, and Africans, developed in France, has had a continuing influence back home through the efforts of a few disc jockeys who have become true afficionados of African music.

The blossoming of Latin music – from Cuba, Argentina, and Brazil – in the two French islands[12] comes less from migration than from the international fame of Latin music in the 1940s and 1950s and the access to it by medium-wave radios. By the mid-1960s, the popularity of Latin music was reinforced by Puerto Rican groups touring in the French island departments. The Puerto Ricans were later followed by groups from Santo Domingo (1978) and Cuba (1980). Even though Latin music is not as popular as it used to be in the French departments, it is still very much enjoyed, particularly by people over thirty-five years of age, and promoted locally by powerful artistic personalities.

Like Latin music, calypso (later soca) and reggae have entered the musical scene of Guadeloupe and Martinique via Europe, North America, and the Caribbean, where they acquired international fame. Calypso reached its peak of popularity between 1960 and 1965 when well-known artists, such as "Mighty Sparrow," visited the islands. After this period, calypso has been heard only occasionally. Reggae, too, enjoyed great popularity but only for a short time between the late 1970s and early 1980s when it came to be treated as a marginal music form.

In the French departments, *zouk* music belongs to an entirely different category; it is a homegrown product, part of the musical history and experience of the people. If today it is

recognized as homegrown, it is nevertheless related to the immigration history of the islands, as it was greatly influenced by the dance rhythm called *cadence* brought over by Haitians.[13]

Zouk also features other musical ingredients, some taken directly from Guadeloupean and Martiniquais musical folk traditions – as, for example, the *mizik vidé* (carnival music) – and others that come from the blend of their unique musical experience and the integration of American, Latin, and African music. *Zouk* has been very much a natural outcome of the particular soundscape of these French departments.

Folk Traditions

The Caribbean experience of popular music is shaped not only by the musical content of mass media and the deep effects of migration patterns, but also by what is at the root of the aesthetic sensibilities of the people – namely, folk traditions.

Folk traditions have perhaps been the strongest elements, along with the Creole language, that have contributed to the maintenance of special relations between Martinique, Guadeloupe, Dominica, and St. Lucia. The islands' history and development have followed a similar colonization pattern. The African, French, and English musical influences have developed in the region into families of musical genres that are easily recognizable today, in spite of the distinctive stylistic features that have evolved on each island.

The family of musical genres can be organized according to the following categories: 1. the *bélé* and *gwo ka* drum – accompanied song-dances; 2. the quadrille, with related ballroom dances and their typical instrumental accompaniment, and 3. carnival music and its musical ensembles. The outline is a crude representation of the rich diversity of the musical genres of each island, but the main goal is to describe the aesthetic qualities of these families that have so deeply marked the musical values and experience of the Creole-speaking peoples.[14]

The *bélé* and *gwo ka* drum-accompanied song-dances are normally enjoyed for their spectacular interactive playing, dancing, and singing. These songs are characterized by a call-and-response form, a close coordination between the dancers' steps and the rhythmic strokes of the drummer, and by an obvious, intense involvement of the lead singer, who sings constantly at full volume, with no vibrato, often exploiting the top of his or her vocal range. Active participation by everyone present in the dancing and singing is the key to a successful performance.

The quadrille and the related ballroom dances highlight another sort of musical excitement strongly linked with the colonial past. Quadrille performances have always been highly valued. Historically, demonstrations of knowledge about the choreography and social edge of the dance gave the dancers prestige and a share of the power associated with the European traditions. Musicians, too, were praised for mastering this sort of music which – everyone recognized – rested on a musical language with melodies, chords, and a bass line accompaniment rather different from the *bélé* and *gwo ka* song – dances.

Carnival music can theoretically include any music and instrument that will make people dance. Traditionally, percussive instruments of all sorts have marked the jump-up in the streets. Carnival music is characterized by lively melodies and a medium-fast marked beat, and it is played as loudly as possible. The focus of the singing, dancing, and playing of instruments is on the intensity of the act, on maximizing the effects.

To summarize the aesthetic values linked with the traditional musical scene:
1. Music rarely goes without singing, cannot go without dancing;
2. For a type of music to be "hot", it needs to be loud and intense;

3. The popularity of a musical genre is largely dependent on the way the music incites people to participate, and the more participants, the more successful the presentation is;

4. Musical performances are conceived as public entertainments and hence have to be spectacular, colorful, and well-timed;

5. Knowledge of the music of other groups and peoples is part of West Indian traditions, and versatility is highly valued;

6. A great sense of rhythmic timing, a convincing interpretation, and controlled rhythmic and melodic improvisation are associated with good and knowledgeable musicians.

These musical characteristics and the associations they arouse in the Caribbean definitely affect the way people experience music. To be aware of them, but, even more, to use these musical characteristics to make certain connections, as the musicians of Kassav have done so skillfully can be considered an integral part of that group's success.

To trace the network of the social, political, economic, and affective meanings associated with the many facets of popular music, one must first inquire about the socio-political, as well as the musical, background of the region that is, the effects of mass media, patterns of mobility, and folk traditions. Only then can one appreciate how much the form, content, and style of performance of a musical genre (such as *zouk*) draw from and build people's conceptions, perceptions, and patterns of consumption.

Narrative Structures of Zouk

How do the performers of *zouk* make up their own music and build their star image? Following is an examination of the *zouk* group that has been the most influential and the most popular, Kassav.[15]

As in any other musical genre – especially so-called popular music – the narrative structures of *zouk* refer not only to the music but also to the whole process of packaging. This includes the image (the personality) projected by the star, the language, tone of voice, gestures, pattern of identity (and opposition) put into play, and how the artist and the music performed situate the listener.

Unlike reggae artists who traditionally present themselves as nonconformists, as politicized and religious believers, *zouk* performers promote themselves as emancipated people who not only accept, but actually *reassert*, their cultural identity-that is, their multi-ethnic and musical crossbreed, their Creole language, their beliefs and customs. The "ideology" of the leading group, Kassav, is to reflect and promote a professional and cultural consciousness. The message of these *zouk*-makers is to believe in the "difference," to exhibit and exploit the plurality of their racial and musical backgrounds. *Zouk* performers, as has been noted by the linguist Felix Prudent of Martinique[16], have consciously chosen not to maintain a political stance, but instead to launch a cultural movement called by many artists, fans, and critics, the *mouvans zouk*. This movement fosters a new attitude and a particular lifestyle, of which Kassav is one of the clearest exponents.

The label *zouk*, strategically chosen by Kassav to identify the new form of Antillean music they play, is a Martiniquais word that refers to parties at which the greatest freedom of expression is allowed. By association with the term, *zouk* music has become the musical symbol of relief from normative social codes and individual autonomy.

In line with the label they chose, the group Kassav and its followers have opted to sing in the native tongue, Creole, as opposed to the two official languages in the islands, French and English. This choice, as will be explained later, has had a great impact on the Creole-speaking islands.

A choice of language can be made for political reasons and for the reaffirmation of one's cultural identity. It can become a marketing device to attract a particular audience or promote a particular area of the world. Kassav's choice of singing in Creole is linked to all of these reasons. From the several interviews published in magazines and newspapers, and in the author's personal meetings with their producers, press agents, and radio promoters, it is clear that the Kassav performers initially had their own reasons to sing in Creole. Living in Paris for over eight years, they have been confronted every day with the reminder that they are different, that they are *Antillais*. Singing in one's native tongue establishes one's identity.

At the same time, the members of Kassav also reflect the political situation back home. To sing in Creole has been as much a way to show solidarity with their compatriots in the French island departments, as it has been a marketing device to attract them and other Creole speakers to buy their records.

To hear popular tunes in Creole on the radio is indeed a special experience for Creole listeners. It not only evokes a feeling of home but it also reinforces an affective link with the Creole-speakers of other islands. This link is all the more understandable when it is recalled that, not long ago, it was forbidden to speak Creole in schoolyards and in homes that were striving for respectability. For the speakers of the language, Creole catches and embodies the full value of emotions that can be properly translated through its rhythm and the articulated sound.

Outside the Caribbean region, singing in Creole has helped Kassav to be identified quickly on the map. It has also incited other minorities to recognize and support the group, to whom they feel a bond because of similar political, economic, and social histories and because of current conditions. Whether Kassav has helped to promote tourism in the region or to create a special exotic appeal for the public at large has yet to be determined.

The song-texts produced by Kassav reflect linguistic sensitivity as much in the form as in the content. Desirous to appeal to a large audience and yet to use Creole in his songs, the leader of the Kassav group, Pierre-Edouard Décimus, has eliminated certain Creole sounds, replacing them with others more assimilable to French ears. His interest in the phonetic aspect of song-texts has eventually led the members of the group to explore the natural rhythm and inflection of Creole to produce poetic texts that not only say things, but that agreeably sound as well.[17] This new attitude toward Creole (by using it openly and exploring its full potential as a language) goes hand in hand with Kassav's will to create texts that speak about Caribbean life. Members of the group refuse to sing pornographic songs, to talk only about love, or to recount stories that could not be understood by a wide audience. Instead, they focus on making the Antilles known by speaking about generic themes that evoke Antillean ways of life and social conditions, for example, by talking about their love for music (in the song "An ba la tè"), their respect for their ancestors (in "Pou zòt"), and their philosophy of life (in "Tout la rivyè"). One notable exception is their treatment of some love songs. One Kassav singer, unlike other members of the group, is famous for writing lyrics that contrast strongly with the Antillean tradition. Instead of projecting the usual macho image, he establishes a new kind of rapport between men and women; in his texts, women are respected and men are freer to speak the words of love. His lyrics are considered by many Antilleans of both sexes to be a true revolution in the song-text tradition of their countries.

Very early in the career of the group, several members of Kassav began to star individually or in pairs under their own names, but with the same Kassav musicians for accompaniment. This strategy, as the musical director of Kassav explained, was made for commercial reasons and aimed at creating a wider market. The impact has been much more than just monetary. The group has

reached listeners in a profound and personal way; fans have been able to associate themselves closely with one star, while maintaining a connection with the group. Highly valued in West Indian societies, the image of the virile, tender, sentimental, energetic man, and the attractive female, are all represented by the group Kassav. For women, the female star has become a role model of success and emancipation.

These different personalities set up patterns both of identification and opposition; they provoke fans to react, to adopt certain behaviors, and to reject others. The *zouk* stars bring forward a heightened affirmation of the Creole identity by the use of the Creole language; the texts play with Caribbean imagery, and the music is directly linked with the Creole-speakers' soundscape. On the one hand, the *zouk* phenomenon has generated a new confidence in Creole-speakers to be able to "make it" and even excel in some sectors, as, for example, in music. On the other hand, Kassav, by reasserting its multi-ethnic background, has also encouraged fans to nurture the links they have with other cultural groups musically, to revamp their own performances, and politically and economically, to cherish this mark of solidarity.[18]

The image of emancipation projected by *zouk* performers owes much to *zouk* choreography. On stage, the performers execute carnival walking steps, and jump up, hands in the air, while their whole bodies accentuate the beat of the music. On a dance floor, however *zouk* is normally danced in closed-couple formation, in which partners are so close that, as the expression goes, *sé toufé yen yen* (not even a fly could pass between the couple without being squashed). *Zouk* music is associated with *wimé*, and with *manpa*, two qualificatives used in traditional music to refer to a "hot" (sexually charged) dance.

In 1986, in one of their concerts at the famous Zénith hall in Paris where over 8,000 people attended, Kassav performers began their show by saying:

ça va bien? Mèsi pou zòt vini oswè-a. E cho – la, sé zòt, apwè, sé nou. Donk oswè-a, sé lawmòni...

(Everything all right? Thank you for coming tonight. And this show, it's yours, and after, it's ours. So, tonight, it's harmony. . .)[19]

Kassav performers identify their listeners as a community of friends among whom racial and social differences are downplayed. The key word, as they said in their show at the Zénith, is "harmony." The crowd at their concert becomes part of the group and part of the show by being encouraged to answer back, make physical gestures, such as *lévé lanmen* (raise your hand) and *soté, soté* (jump up, jump up). The song-leader develops a warm interaction with the crowd and treats everyone present as a member of the same family.

Forms and Styles of Popular Music

The ingredients of popular music have traditionally been dismissed from serious musicological studies because of their so-called simplicity. However, some forms and particular singing styles seem to correspond to special aesthetic values for specific groups of people by raising great admiration and participation. How does the choice of musical elements influence the intensity of musical experience? This question, asked by Simon Frith (1987, pp. 144–46), will serve to guide this examination of *zouk* music.

The musical form of *zouk* songs is based on the typical West Indian tradition of alternating a song-leader with a chorus. The song-leader sings two or more melodies and the chorus sings a corresponding number of musical sections. Brass sections, most of the time in unison like most choirs in traditional West Indian music,[20] make up the bridges between sections, play

short instrumental periods, and provide punchy lines in between vocals. A range of percussive instruments play against the drum set, which, in turn, is a tributary of the bass line. The whole arrangement is based on interactive playing to the point where many *zouk* songs are very difficult to sing without the musical accompaniment.[21]

Zouk arrangements, in order for the music to be complete and to come alive, call for a smooth collaboration of the musicians and full participation of the crowd. The intensity of a *zouk* experience comes from this full-scale interaction and the feeling that everyone is as much a part of the song as a possessor of it.[22] This highly interactive form of song has a special resonance in the Caribbean. Packaged with the most modern instruments, *zouk* songs are nevertheless connected to Creole song traditions. Several traditional songs are indeed based on interactive patterns. For example, the *bélè* songs from Martinique, the *mizik gwo ka* from Guadeloupe, the *koutoumba* songs from St. Lucia, and the *lapo kabwit* from Dominica all rely on multi-parts to be performed. This principle of making music is dear to Creole-speakers and even preferred over soloists accompanied by musical instruments. The musical form of *zouk* has thus a direct impact on Creole-speakers by making a connection with their musical experience and tastes.

Singing style (verbal articulation, rhythmic vocal function, vocal inflection, and volume) also contributes to the impact of music on people. *Zouk* performers employ the familiar Caribbean duple, rather than triple, division for the lyrics, and sing the words in a syllabic fashion, as in most Caribbean songs. Also typical of the Creole singing style, the voices take on a rhythmic function by using the scat singing technique – that is, by substituting for the words of a song, improvised nonsense syllables to increase the percussive and rhythmic effect. The intensity of the singers is particularly noticeable through the sustained loudness of voice and the vocal inflection, which is energetic, dynamic, and percussive. All these qualities, held in high esteem in traditional Creole music performances, serve to heighten participation and are used to elicit crowd response.

There are rhythmic patterns in a musical culture that no one can resist. Associated with specific images, times, and places, they belong to the soundscape, to the music with which one grew up. To rely on these motifs is a sure way to reach an audience.

The musicians of Kassav are very conscious of these powerful rhythmic patterns. They rely heavily on them to create a mood and to elicit participation in order to make their listeners live a particular experience at a particular intensity.[23] An example of these rhythms is the carnival rhythmic call on a single note, to which the crowd unmistakably answers "*yè, yè*" as the key expression to show its support of the rally. This rhythm is not heard as make-believe carnival, it *becomes* carnival.

Popular Music and the Notion of "Truth" or Reality

This brings us to the next point. Pop music sets out a particular reality. The image the star personalities project, the acts they perform, the tone of voice they use, the language they choose, the relation they cultivate with the public, the concert experience they bring, all these incite fans to react. In reacting, they adopt specific attitudes and develop various ideas about their identity and ways to apprehend the world, in relation to other star images, performed acts, tones of voice, other spoken languages, other types of interaction with the public, and other lived experiences. The success of pop music, not surprisingly, is often judged by its ideological effects. In this case, the question is: how is *zouk* perceived and compared with the other musical genres heard on the islands of Martinique, Guadeloupe, Dominica, and St. Lucia.

In the French islands, one can hear, apart from *zouk*, the Caribbean merengue, salsa, reggae, calypso (and soca), African *soukous*, American disco, traditional music of Martinique and Guadeloupe, and French music. Of the many possible responses to these types of music, that of the Guadeloupeans and Martiniquais is more or less the same. Even though the majority of the population does not understand the Spanish lyrics, merengue is still very popular, especially with rural people. Its fast rhythm constitutes the main attraction for them, while the overall effect of the music is said to be a symbol of joy.

Salsa is enjoyed mainly by intellectuals and people living in the urban centers of the French islands. Its choreography and rhythm, more elaborate than those of the merengue, particularly attract the very good dancers among these groups. Even though the texts of salsa are understood by many of its devotees, it is the overall musical arrangements that are found especially captivating. Salsa is considered to be equivalent to jazz. The genre is associated with refinement, and it is acknowledged as a potential source of prestige for those who can master the music and the choreography.

Calypso and soca were once very popular in the French islands, where many calypso artists toured. Today, it has no more meaning than mere carnival accompaniment. According to many observers, the arrangements have become too traditional and cannot compete with newer music. The English lyrics also prevent this music from reaching and maintaining a connection with the French islanders.

Reggae is strongly related to Rastas from Jamaica, to a foreign music with a foreign ideology. It is appreciated mostly by a minority of young people who understand English and who participate in their own way in the Rastafarian ideology; it is enjoyed by a few others who like to dance.

For the past two or three years, African music has achieved a growing popularity in the French islands.[24] The texts of the songs and personalities of the stars are little known to the larger public, but the music is greatly appreciated for dancing. Because it is executed with great freedom of movement, African music is considered as a "musique de defoulement," a way of releasing one's surplus energy.

American music knows only a moderate success in Martinique and Guadeloupe. It attracts young people and some intellectuals, but in general, is not much appreciated. At a private party, in fact, it is said that American music will be played to signal that the evening is over.

The traditional music of the French islands is played regularly on radio stations. In the context of the French departmental system, it is linked with politics and self-identity and is associated with the local scene.

Music from France is heard mostly on RFO, the government radio station of the two French departments. As a symbol of France, it is always received with reserve, as a form of cultural expression that still remains foreign to French Creole-speakers.

Zouk music is altogether different from any other broadcast music in the French West Indies. It is a music from home, sung in Creole, that has succeeded in reaching the international market. *Zouk* has thus become a symbol of success and the ideological leaven of the Creole identity and sensibility.

In St. Lucia and Dominica, *zouk* competes with American music, reggae, calypso (and soca).

American music, particularly country and western, and soul music, has been part of the Dominican and St. Lucian soundscapes for over thirty years. Country and western is extremely popular, especially with rural people who use it as their equivalent for a slow dance and even categorize it as traditional music. Both country and western and soul music are considered to be the best channels for expressing emotions. Country and western music, because of its strong association with themes of love and stories about "real" people, is actually used by many local religious groups.

Reggae music is characterized by passionate lyrics that denounce the economic oppression of the ruling white caste. In poor counties such as St. Lucia and Dominica, these messages have had a special resonance. However, because of its association with *ganja* (drug) and some unconventional behavior, the ideology of reggae has not been supported by the majority of the population in these islands, in spite of tremendous musical success in the 1970s and early 1980s.

Calypso (and later soca) has been part of the St. Lucian and Dominican soundscapes since the 1940s. Even more than traditional music, calypso, which has kept up with the times, is now at the center of the musical environment. Calypso (and soca) lyrics have had such an impact that complete linguistic expressions and inflections are now part of the people's vocabulary. The jump-up, the walking steps, and the hands in the air-the typical choreography of calypso-have become an instant reflex, performed at the sound of any dynamic music. The social comment that pervades the lyrics of calypso tunes has alerted the population to social and political problems and has helped develop a sense of critical thinking.

The tremendous popularity of calypso (and soca) in both Dominica and St. Lucia might partly explain why *zouk* has not had quite the steamroller effect it has had in the French island departments. Calypso (and soca), like *zouk*, are up-tempo music. However, unlike *zouk*, which, in general, does not make political and social comment, calypso (and soca) lyrics are famous for condemning injustices and commenting on epidemics and other destructive phenomena that plague the world. *Zouk*, for St. Lucians and Dominicans, is decidedly exhilarating; it is close to home by being sung in Creole and by being danced with traditional choreography. But there is no more to it than that, as is explained by their attitude to the *zouk* lyrics.

As Creole-speakers, Dominicans and St. Lucians understand the general ideas expressed by the *zouk* lyrics, but they rarely pick up, or try to pick up, the details of the songs. This is not only because they do not always understand the different accents and expressions of the Guadeloupeans and Martiniquais, but rather because, according to them, this is not where the message lies. The message of *zouk* for St. Lucians and Dominicans is to free oneself from tension, to live in harmony, and to "jump up."

The ideological effect of *zouk* music, pursued through a series of strategies, has reached the Creole-speakers. The degree to which it has, however, is largely dependent on the competing musical genres that are part of the soundscape of each island. The next question, therefore, is

whether *zouk* evokes, and affirms, a sense of identity that fits (or does not fit) the way Creole-speakers find themselves situated in relation to other social forces.

Zouk as a Social Force and Its Fit with Other Social Forces

There are three key elements in the *zouk* Creole message: emancipation, social harmony, and cultural consciousness. Such themes would normally go along with times of political or social reform, or peace and free exchange. It is significant that *zouk* has become extremely popular precisely at a time when these slogans are for the most part negated by other social realities.

At present, the unemployment rate in the French island departments, as in Dominica and St. Lucia, has reached alarming proportions. More than 75 percent of the youth between the ages of 18 and 25 is unemployed. Because of this high unemployment, illegal emigrants from Dominica and St. Lucia are less than tolerated. Repeatedly, blatant racial discrimination confronts the different ethnic groups.

The political situation in Guadeloupe and Martinique is the subject of endless discussions and a source of great tension among various groups. The constant questioning by the Martiniquais about their identity periodically becomes a social malaise, a paralyzing force for people in all walks of life. Separatist parties in Guadeloupe have, on occasion, strongly protested some government decision, and at times this has led to social unrest in the entire population.

The tensions between Martiniquais and Guadeloupeans have not diminished over the years, and any talk about "harmony" between the islands will draw a smile. Not long ago, the writer was told that a group of Guadeloupean workers went on strike when they learned that a Martiniquais had been appointed head of their public institution.

The overwhelming exodus of Antillais to France has created a double source of alienation: a persistent uneasiness in their European milieu and, on their return home, a continual frustration.

In Dominica, the economic depression has severed many people's hopes of ever being able to improve their lot on the islands. Young people leave every year, with no expectation of returning.

In St. Lucia, the national income remains insufficient to support any significant industry, even though growing tourism has somewhat helped the economy. Unemployment, as in other islands, is extremely high for young people.

As can be seen, the images of emancipation, social harmony, and cultural consciousness that *zouk* projects do not reflect the desolate economic situation of the islands nor the pronounced animosity between various groups in the region. However, in contrast with (or reaction against?) this stark picture, there are numerous signs-connected with the slogans of *zouk* – that reflect a new movement toward mobilizing resources, setting up a skill-exchange network, and putting artistic talents at the service of the public.

Over the past five years in St. Lucia and Dominica, great efforts have been made to set up non-government organizations to promote the development of small enterprises, for example, National Research Development Foundation in St. Lucia and Small Project Association Team in Dominica. Numerous workshops uniting people from Guadeloupe, Martinique, St. Lucia, and Dominica have been organized to compare and trade experiences. Plays have been written as vehicles for popular education in rural areas and video programs have been produced to teach workers about new fishing, farming, and manufacturing techniques and environmental issues. As part of the same movement, many arts groups have been striving to find new means of expression that would achieve balance between the local and the international, by not denying, but affirming, their musical traditions and linking them with the present. As the economies of the islands have worsened over the past

few years, a quiet but active underground network has been formed to fight the psychological depression that has started to grow among young and old people alike.

In the French islands, there is, paradoxically, along with the ethnic tensions, a new interest, in next-door neighbors St. Lucia and Dominica. As the economic situation has deteriorated, a sense of solidarity between the islands has developed. For example, instead of always going to Europe or Venezuela for their vacations, the French islanders have now begun to travel more within the region, as is shown by the noticeable increase of tourism from the French islands to St. Lucia. In 1982, the St. Lucia Tourist Statistics Office recorded 4,545 French visitor; five years later, the number reached 7,795. No other area has shown a similar increase in number of visitors to St. Lucia.[25] In addition, several associations from Guadeloupe and Martinique have organized group exchanges with their counterparts in St. Lucia and Dominica.

It can be seen that *zouk* has undeniably had a collective cultural effect. This is confirmed by the spectacular record sales, the formation of many *zouk* groups, the talk shows organized to discuss the phenomenon, the influence of *zouk* on many other musical genres, such as soca and *zouk* – soca. But how it has been disruptive is another question.

In St. Lucia and Dominica, the popularity of *zouk* can be seen as disruptive insofar as it has raised, for the calypso organization, the problem of whether *zouk* music should enter the calypso road march competition. Ideologically speaking *zouk* has had the positive effect of encouraging some urban people to return to their Creole language which, for a long time, had been downplayed. Through its popularity, *zouk* has reinforced a feeling of solidarity among the islands' Creole-speakers.

It is in Guadeloupe and Martinique that *zouk* has perhaps had the more collective, disruptive cultural effect. *Zouk* has run counter to many established institutions. For example, it has opposed the Haitian recording industry dominant for over twenty years in the French-speaking islands, as well as the French official language; it has projected a conciliatory image, opposing the division between local political factions and the continued division between Guadeloupe and Martinique; and it has turned its back on the French islanders' confusion and constant self-questioning about their identity, and has instead affirmed the *Antillanité* of the people. The *zouk* message have come across not only in lyrics but perhaps even more forcefully in the entire packaging process. As Derek Walcott wrote, "…[West Indian art] is so visibly, physically self-expressive" (1973, pp. 305–06). *Zouk* has effectively exploited precisely this West Indian characteristic of intense physical experience in sound, beat, and choreography to counteract other realities. And it is interesting that in the process, it has alleviated the economic situation at least in one sector-the record industry-by injecting new life, developing new prospects, and opening doors for young artists.

Zouk as a Potential Factor in the Regional Integration of the Creole-Speaking Islands

In 1974, in a speech on West Indian nationhood and Caribbean integration, the former secretary-general of the Caribbean community, William G. Demas, described the process of Caribbean integration as essentially not resting on economic factors, but rather on the successful promotion, primarily, of a sense of identity on the part of the people of the region. He then illustrated how identity is connected with development, on the one hand, and with unity, on the other. By identity, Demas meant, "the kind of identity that goes with self-confidence or rather that generates self-confidence, the kind of identity that generates a feeling of self-respect, self worth and inner dignity on the part of the people" (1974, p. 26). In another portion of his speech, he was more specific, quoting Naipaul's injunction, "identity springs from achievement."

If *zouk* has anything to do with regional integration, it is in its promotion of islanders' identity and with having achieved spectacular success at home and abroad. The main goal of the members of Kassav has been clear from the outset: to show the world they are Antillais and they can make a success of their art. By fulfilling their mission, they have given new confidence to young artists and producers. Before the advent of Kassav, no local sponsors would have placed their money on a local musical group. Today, local firms believe in local talent.

To sing in Creole, to rely on local rhythms, and to sing about typical West Indian behaviors and values as Kassav does (even though many people have criticized Kassav for not being local enough), all these have contributed to the reassertion of the *Antillanité* of the group's members and their compatriots.

When Demas (1974, p. 27) says that "the identity of a nation does not result merely from that nation producing a few gifted artists and writers" and that "a sense of identity of a people [can only] spring from achievement," he fails to recognize that artists can represent a role model of achievements at an individual and social level. From the success of Kassav, Creole-speakers have understood very well that the only route to achievement lies through hardwork, discipline, the development of knowhow, and the introduction of creative innovations.

Caribbean identity and regional integration can be promoted by offering cultural alternatives to the foreign programming that invades the regional mass media. *Zouk* has helped the process of "decolonization" by putting local music into the top slot on radio. Furthermore, it has helped implant in some instances, and support in others, a process of indigenization rooted in the internal development of local cultural expression (see Paget 1983). The success of Kassav has indeed prompted many groups to reaffirm their Creole identity: 1. by taking on Creole names-after the fashion of the group "Kassav" – instead of English or Spanish names, as most groups did in the past;[26] 2. by singing in Creole instead of French, English, or Spanish; and 3. by rethinking their traditional music to find a local rhythm – as did Kassav with the Guadeloupean traditional *menndé* – that could be adapted and become a new music.

The ultimate challenge for Creole-speakers, however, remains to agree on the definition of the Creole identity, as suggested by Kassav. *Zouk* music has been provocative for many traditionalists, separatists, and other observers, because it uses a fusion of elements (apart form traditional motifs, one can sometimes hear in *zouk* the Haitian *cadence-rampa*, the American funk style, the African *soukous* riff on guitar, etc.) to revive and promote the Creole identity. By so doing, it raises in the minds of "purists" the old questions of how authentic, indigenous, or representative of the Creole-speaking countries this music is.

What Kassav has proposed is not only to accept, but to use to their full potential, the various influences that Creole-speakers have experienced musically. Translated to a broader level, Kassav has proposed recognition and celebration of the multi-ethnic background of Creole-speaking peoples. By presenting, with *zouk*, a fusion of various musics to reassert the Creole identity, the Kassav group has forced all of the islanders to come to terms with their own reality.

Acknowledgements

I am most grateful to the Social Sciences and Humanities Research Council of Canada for sponsoring this research. I want to express my heartfelt thanks to the many West Indian friends without whom this work could not have been done. I also wish to express my thanks to Line Grenier and François Tousignant for their helpful advice and criticism.

Notes

1. For example, in 1988, 65 records from Martinique and Guadeloupe were produced for the Christmas and Carnival period and as many were released only six months later for the vacation period.

2. This paper is based on several years of research in the region. The study of *zouk* music, in particular, was the main focus of two field trips covering seven months between 1987 and 1988. The research was conducted in Martinique, Guadeloupe, St. Lucia, and Dominica because of their geographic, cultural, and musical proximity and their continuous interaction. From a cultural and musical standpoint, Haiti and French Guyana, both with Creole-speaking populations that are probable listeners of *zouk* music, should also have been included in this study. But the political unrest in Haiti and the geographic distance of French Guyana from the four Creole-speaking countries mentioned above prevented their inclusion.

3. Throughout this paper, the term Creole refers to the French Creole language – for a few decades now, linguistically recognised as a language of its own – spoken in St. Lucia, Dominica, Martinique, Guadeloupe, Guyana, and Haiti.

4. An agreement among European countries to permit free travel and employment for all countries party to the agreement.

5. The following approach is a revised version of Frith's theoretical model for the study of aesthetics in popular music (1987).

6. "Soundscape" is a term used to refer to the sounds that are part of the environment through mass media, migration patterns, and folk traditions.

7. When there are chart lists, there are made up after disc jockeys on the station check with each other to determine what they played most often during the week.

8. *Le Monda* (18 May 1987) reported that in a parliamentary report, Michel Pelchat, member of the *Union des Français* (Republican party) from Esonne, responsible for describing the situation of the mass media in the French overseas departments, opposed the development of private radio stations that he judged to be "too numerous and anarchic" on the FM band. (It should be noted that the official number of private radio stations cited here does not include several pirate stations that exist in the islands.)

9. The figure for the number of radio stations in Guadeloupe comes from the last survey made in March 1988 by the Service de Presse de la Prefecture de la Guadeloupe. The report on the number of radio stations in Martinique was taken from a study made in July 1984 and published in the *Journal Officiel de la République Française* no. 47: 2451-2452, 24 February 1985.

10. Soca is an outgrowth of calypso, evolving in the late 1970s.

11. For further information on migration patterns, see Carnegie 1981, 1987.

12. I owe this information to two specialists in Latin music who are both announcers at Radio Caraïbe International: Ignace from Martinique and Maxo from Guadeloupe.

13. The tern *cadence* refers in fact to cadence-rampa, a dance originally from Haiti and attributed to the leading musician Webert Sicot (Renard 1981). More details on this music will be given in the author's forthcoming book on the *zouk* phenomenon.

14. For further information on the musical traditions of this region, see Crowlet, 1992, 1958a, 1958b; Dauphin 1980, 1983b; Dauphin and Dévieux 1985; Daryl 1987; Desroches 1985, Gallo 1979; Guilbault 1985, 1987a, 1987b, 1987c; Honorat 1955; Honychurch 1984; Jackson 1985; Jallier 1985; Lafontaine 1982, 1983, 1986; Marcel-Dubois and Pichonnet-Andral 1982; Rosemain 1986; and Saint Cyr 1981.

15. Many other *zouk* groups exist in the French islands, but none is as successful or influential as Kassav, and none has yet developed the strategies to plan the overall production and distribution of its products to the degree to which Kassav has succeeded.

16. In a personal communication with the author.

17. Before the advent of Kassav, the poet and artist Jobby Bernabé from Martinique had already begun such work. Today, he is still considered one of the most inspiring leaders in exploiting the linguistic beauties of Creole.

18. For the minority groups living in France, *zouk* canalizes energy in relations with the dominant European groups.

19. Free translation by the author.

20. It should be noted that the brass section in *zouk* music rarely backs up the chorus, unlike calypso and late 1970s Haitian arrangements of *cadence-rampa*.
21. This description pertains especially to the fast *zouk* called locally *"zouk* hard." The *"zouk* love", or slower versions with a less marked beat, can actually be built on a verse – refrain pattern.
22. Simon Frith's expression "possessing [the song]" (1987, p. 143) is, I think, one of the most appropriate ways to describe the double bind that music creates for the listener.
23. The musicians of Kassav rely on traditional music to make contact with people, but they are not prisoners of its formulas. As the musician Eric Nabajoth (1988) has pointed out, Kassav has brought together many elements in *zouk* that contrast strongly with traditional music, namely, the amplification of the voice through a sound system, the use of brass and technological equipment (such as the rhythm box and synthesizers), the use of sound effects and color changes, the funky style of playing, etc. These elements will be examined in greater detail elsewhere.
24. Its success is attributed to the fact that African music today is deeply influenced by *zouk* music and borrows many of its characteristics.
25. The fact that the Caribbean airline Liat has offered cheaper airfare packages for travel within the Caribbean has certainly contributed to this new trend, but cannot totally account for the new interest of French islanders to visit their neighbors. Airfares to Europe have always been more costly than those to neighboring islands, but this has never prevented Guadeloupenas and Martiniquais from travelling to European countries
26. This observation comes from the insightful comments of the editor of *Gwan Moun* from Guadeloupe, Danik Zandwonis, during a personal interview.

References

DaBreo, D. Sinclair. 1988. *Will insularity and Political Opportunitism Defeat Caribbean Integration?* Castries, St. Lucia: Commonwealth Publishers International Ltd.

Demas, William G. 1974. *West Indian Nationhood and Caribbean Integration*. Barbados: CCC Publishing House.

———. 1988. *Towards O. E. C. S. Political Union*. No publisher listed.

Farrugia, Pepin et al. 1987. "Débat sur l'Europe." *Grin Fos/Grain de Force* (Basse-Terre, Guadeloupe), no. 2, pp. 25–30.

Frith, Simon. 1987. "Towards an Aesthetic of Popular Music." In *Music and Society*, edited by Richard Leppert and Susan McClary, pp. 133–149. Cambridge: Cambridge University Press.

Hosein, Everold N. 1975. "Mass Media Preferences, Mass Media Credibility and CARICOM Awareness in Urban St. Lucia." *Caribbean Monthly Bulletin*. July, pp.14–20.

Renard, Yves. 1981. "Kadans: Musique Populaire de la Caraïbe Créolophone, Facteur d'Intégration Régionale?" Paper presented at Third International Colloquium on Creole Studies, St. Lucia, May 3–9.

Walcott, Derek. 1973. "Meanings." In *Consequences of Class and Color: West Indian Perspectives*, edited by David Lowenthal and Lambros Comitas, pp. 302–312. New York: Anchor Books.

States of Emergency:
Reggae Representations of the Jamaican Nation State

Nadi Edwards

Walter Benjamin, in the eighth thesis of his "Theses on the Philosophy of History", states that "the tradition of the oppressed teaches us that the 'state of emergency' in which we live is not the exception but the rule. We must attain to a conception of history that is in keeping with this insight."[1] Benjamin's aphorism, written on the eve of World War II, is uncannily echoed nearly fifty years later in the album *State of Emergency* by the Black British reggae group, Steel Pulse. The title track evokes a sense of global crisis as oppressed groups struggle for freedom in a variety of geographical and political locations from Maggie Thatcher's Britain to Pik Botha's apartheid South Africa. A chronic state of emergency prevails from "Brixton to Cape Town", a state of emergency which is both the daily reality of oppressed peoples as well as the true nature of the state. In lines such as "State of emergency/Never seen such urgency", Steel Pulse evince an awareness of the constancy of crisis that is similar to Benjamin's conclusions.[2] Steel Pulse's Rasta reggae and Benjamin's gnostic Marxism might appear to be worlds apart, but the textures of their ethnic experiences evoke similar histories of diaspora, exile, and suffering. Their respective marginalities, as a Jewish Marxist in Nazi Germany, and Rastafarian musicians of Afro-Caribbean descent in post-imperial Britain, enable them to bring a transgressive insight to bear on social and political realities, a rebel vision that perceives the instability at the heart of apparently stable systems, and the complicity of terror and domination.

This transgressive critique of prevailing systems of power underpins the particular category of reggae music broadly defined as "roots and culture", namely those songs which address social, cultural, political, and historical issues. This is only one genre of reggae, however, since not all reggae songs are oriented towards social commentary. In the house of reggae there are many mansions, and it has its share of love songs, innocuous songs, silly songs, and songs that exist only as a vehicle for a catchy phrase, melodic line or rhythm. (And even forms such as love songs can be read as subversive because to sing about love, in societies that posit human relationships in terms of domination and exploitation, is to posit a radical reshaping of human behaviour). Some "roots and culture" songs can also paradoxically approve the very system that they purport to challenge because of their marginalization of those perceived to be deviant others. Despite these variables, there is a coherent, if somewhat unsystematic, body of recurring ideas, concepts, and propositions that are produced by this category of reggae music. These ideas challenge certain mainstream concepts propagated by postcolonial elites about the postcolonial nation state, and they pose interesting questions about the claims of nationality, citizenship, and community.

In the case of Jamaica, elite notions about the nation, nationality, citizenship, and democracy, are undermined by reggae critiques that are grounded in the unresolved questions of race, class, colour, slavery, imperialism, colonialism and neo-colonialism. In these reggae songs, the state

Reprinted with permission from *Social and Economic Studies* 47, no. 1 (1998): 21–32.

is not a liberal democratic entity but rather an oppressive regime: a Babylon system, a state of emergency, and a product of crisis that also produces crises for the poor and oppressed who are described as living in an embattled state of siege, harassed and brutalized by the representatives of Babylon (the police and the military), subjected to roadblocks, curfews, imprisonment, and myriad forms of daily dehumanization. These representations might have greater or lesser degrees of sophisticated analysis and militancy, depending on the respective performers, but the fundamental themes remain the same.

The elite notions of the Jamaican nation state are evident in the apparently innocuous social studies textbook, *Civics For Young Jamaicans*, produced in 1967, five years after Independence, by L.C. Ruddock, the Principal Education Officer of the Ministry of Education. *Civics For Young Jamaicans* introduces the nation's youth to the workings of the state apparatus, the legislative and constitutional principles, the Westminster Parliamentary system, the conduct of elections, and similar information deemed necessary for the production of civic minded young people. The pedagogical project of this textbook is that of disseminating an image of the Jamaican nation and citizen that conforms to middle class, political elite constructions of nation and citizenship. Thus in the final chapter, appropriately titled "The Last Word", Mr. Ruddock makes two crucial propositions: firstly, that Independence ushered in a radical break with the past in terms of modes of governance:

> One of the essential differences between pre- and post-Independence Jamaica is that in the former, government tended to be a "controlling" agency. It sought to restrict and to conserve rather than to create. In present-day Jamaica, government exercises a "promoting" function. Ministers seek to interpret the public will, and to promote programmes and projects with urgency in order to translate this will into action and so retain support of this public will.[3]

The second proposition is announced with less confidence, and the fact that it is set out as a series of questions points to the difficulties faced by national opinion makers in dealing with the problematic relationship between race and nation:

> With so many racial groups making up the population, it becomes a national problem which racial group should help to create the national identity, or be allowed, if indeed it should to gain ascendancy. Part of the areas of conflict within the Jamaican community touches on this problem. Should we recognize a dominant racial group, and seek to give it satisfactory representation within the various areas of social and economic activity? Or should we accept ourselves as an integrated community and work towards the full development and prosperity of every individual, disregarding racial identification as such?[4]

Civics For Young Jamaicans proffers the last option as the most desirable one. Race is erased from the question of national identity by the positing of a facile multiracial, harmonious ideal which is summed up in the national motto "Out of many one people." Gordon K. Lewis scathingly describes this as an official myth that masked "a racial separatism, undeclared yet virulent, that infected every nook and cranny of inter-personal and inter-class relationships, based on a social system characterized by strongly entrenched class-colour correlations."[5] Lewis further points out that, since the majority of Jamaicans are of African descent, any "national consciousness to be real must perforce be racial consciousness."[6]

This assertion of the link between race and nation concurs with those of Marcus Garvey and the Rastafari movement. Given the overwhelming influence of Garveyite and Rastafarian philosophies on reggae artistes, it is not surprising that the most cogent critiques of Jamaican society utilize the strategy of foregrounding race in the discourse of nationhood. This strategy is twinned with a reading of history that makes no fundamental distinctions between the colonial past and the postcolonial present. Unlike Mr. Ruddock who posits a radical discontinuity between colonial

"controlling" and postcolonial "promoting", reggae roots and culture songs assert the continuity of oppression and colonialism which are depicted as having merely assumed new forms. The former Wailer, Peter Tosh, expresses this in his song, "400 Years" ("Four hundred years, four hundred years/and it's the same philosophy"),[7] while Burning Spear opts for an even longer chronology of oppression in "2000 Years."[8]

Race is confronted and claimed as the primary sign of identity. The absence of race in official discourse is challenged from every lyrical angle in roots and culture songs. For example, one of reggae's classical vocal trios, The Abyssinians, can state unequivocally that "we are slave descendants from the African race/the African race, the African race,/we are proud, it's no disgrace."[9] Bob Marley celebrates "the black survivors" of the middle passage and the brutal history of the slave plantations.[10] Peter Tosh dismisses the very concept of national identity by asserting a Pan-Africanist identity that supersedes nationality and citizenship. As he proclaims, in "African", "No matter where you come from/As long as you are a Black man, you are an African."[11]

These songs express what the African-American cultural critic, bell hooks, calls "the politics of radical black subjectivity" that reclaims and transforms a despised ethnicity into "an oppositional worldview, a consciousness, an identity, a standpoint that exists not only as that struggle which also opposes dehumanization but as that movement which enables creative, expansive self-actualization."[12] Blackness is reclaimed from the burial mounds of colonial denigration and postcolonial silence as a positive and conscious choice rather than as a mere acceptance of debilitating circumstances. This revaluing of marginality accords with bell hooks' distinction between "that marginality which is imposed by oppressive structures and that marginality one chooses as site of resistance, as location of radical openness and possibility."[13] The marginality of blackness is thus more than what hooks terms a "site of deprivation," it is also a space of resistance and possibility. The creation of this space in reggae is enabled by the articulation of the silenced histories, "the half that has never been told," of Africans in the diaspora.

Jamaica has two histories. There is an official, visible one that begins in 1492, and which weaves European colonization, African enslavement, and Asian indentureship into a narrative of racial and cultural hybridity that results in the multiracial/multicultural modern nation. Nationalism, in this version of history, is thus concerned with the attainment of political sovereignty, the transfer of power from London to Kingston. Politics, as Gordon K. Lewis points out, is thus treated as a first cause, "hence the [Jamaican] political passion, the amazing fury of the [Jamaican] political partisan, the conviction that politics will cure all."[14] As a result, the social issues of dispossession, class and racial stratification are subordinated to the national question. Modernity, for this official history, begins with the emergence of political parties, and its peak lies in the securing of state power by the postcolonial political elites.

The other history is an invisible one or, more accurately, an ignored one, whose text is produced in various reggae songs that represent it as a symbolic history, a history that alludes to another secret history behind the platitudes of official ideology. This history is a dread history that uses racial and communal memory as an antidote to the amnesia of the state. "Do you remember the days of slavery?" Burning Spear asks us again and again, and his repeated question becomes an exhortation to claim the liberatory power of memory that Milan Kundera expresses with such elegant clarity in *The Book of Laughter and Forgetting* where he states that "the struggle of man against power is the struggle of memory against forgetting."[15] Similarly, Burning Spear's "Slavery Days" alerts us to the beginnings of Caribbean modernity by reminding us of the brutal origins of West Indian nation states, and of the need to keep alive this memory. The Mighty Diamonds, in

"Cannot Say You Didn't Know," reiterate Burning Spear's memorialising of history by taking us back to the beginnings of the slave trade on the African continent:

> Listen to the story
> I am telling in this song.
> It's about our history
> Where we went wrong.
> Gave them a chance to divide us
> Gave them a chance and they ruled.
> Cannot say you didn't know,
> Cannot say you didn't know.
> Some came as traders,
> Innocent as lambs.
> Some pushed religion. They all were scamps.[16]

How, one might ask, does memory fit into the concept of a state of emergency? Simply put, from the perspective of four hundred years of memory, Black history in the New World has been lived within a long, undeclared state of emergency. Reggae memory does not organize this history into pre- and post-emancipation or colonial and postcolonial periods. Memory holds past, present and future in a seamless continuum of experience. Hence Peter Tosh's declaration in "Mystic Man" of temporal and ontological continuity:

> I am a man of the past
> living in the present
> and I am walking in the future
> standing in the future.
> I am just a mystic man.[17]

Slavery thus continues under new guises. Mental servitude replaces physical bondage, and the real struggle becomes that of emancipating the self, as Bob Marley sings, from mental slavery. Imperialism and colonialism survive in the class/colour stratification, and in the dispossession and exploitation of the poor.

Reggae originated in the slums of Kingston and it is easy to correlate its origins with its unrelenting critique of the establishment. But even this conventional wisdom does not grasp the massive scale of the dispossession of poor Jamaicans. David Lowenthal notes that, shortly after Independence, Jamaica had the dubious distinction of having the world's highest level of inequality, with the richest 5 per cent of the population having 30 per cent of the national income, and the poorest 20 per cent receiving only 2 per cent.[18] In such a context, protest, even as style, became inevitable. Dispossession and alienation became thematic staples of popular music, and with the rerouting of these attitudes through the millenarian and spiritual worldview of Rastafari, reggae was able to assemble a philosophical and verbal arsenal for its critiques of the social system.

The infusion of Rastafarian theology enables reggae's political critique to function as a prophetic critique. The extensive biblical rhetoric and typologies of reggae songs cast the experience of the African diaspora in terms of Jewish exile and bondage in Egypt and Babylon. Jamaica is thus another Babylon, another site of bondage, and "a big plantation" as the Abyssinians call it, rather than a national homeland. Africa, at least for those singers who are Rastafarians, is the spiritual homeland for the sufferers enduring Babylonian bondage. Hence the plethora of songs which evoke the total sense of exile and alienation felt by the sufferers in Jamaica. In Black Uhuru's

"Leaving to Zion," the opening lines announce that "If tomorrow I was leaving to Zion/I wouldn't stay a minute more."[19] Gregory Isaac's "Border" is a classic assertion of the imperative to cross borders and boundaries in order to return to Africa:

> If I could make the border
> Then I would step across.
> Simply take me to the border
> No matter what's the cost.
> Because I'm leavin' here
> I'm a leavin' outta Babylon
> I'm a leavin' outta Rome
> I'm a leavin' outta dis land
> Say me wan', me wan' go home
> Where the milk and honey flow
> Africa me wanna go.[20]

This theme of exile and the longing for return resonates throughout songs such as The Abyssinians' "Forward Unto Zion" and "Satta Massagana"; Bunny Wailer's "Dreamland"; Dennis Brown's "The Promised Land"; Bob Marley's "Exodus"; and Jimmy Cliff's "House of Exile." The concept of the nation state is radically subverted in these songs which rupture the supposedly organic bonds between native land, citizen, and nation. Instead of the citizen, who is the representative subject of the official narratives, these songs' representative subjects are sufferers, rastas, natty dreads, ragamuffins, all restless captives longing for freedom. The reggae subject is presented as an exile living as a permanent outsider on the postcolonial/neocolonial plantation that calls itself a nation. Nationality thus offers no safe haven nor patrimony, and the only sites of sustenance are located within the music itself or in the forms of linguistic marronage afforded by the subversion of the Queen's English and Jamaican Creole to create the special argot that Velma Pollard defines as "Dread Talk."[21]

Many reggae songs celebrate the redemptive, healing and sustaining power of the music for those who must endure the perils of Babylonian exile. Marley's repertoire has several of these self-conscious assertions of the instrumentality of music as both a form of spiritual sustenance and a weapon against oppression. In "Trench Town Rock", the singer demands to be hit with music because "when the music hit you, you feel no pain." There is the exhortation to "lively up yourself" and to "forget your troubles and dance" in "Lively up Yourself." Music is represented as a form of social action in "One Drop" which affirms the rebellious power of the reggae one drop rhythm "resisting against the system/fighting against the isms and schisms". "Trench Town" reaffirms the notion of music as a mode of emancipation: "we free the people with music, sweet music/reggae music chant down Babylon".[22] Other reggae artistes deploy similar metaphors: Third World proclaim that "the riddim haffe rule" and that in the state of siege, which is the daily reality of the poor, the oppressors have to be attacked with music.[23] Burning Spear declares, in "Built this City", that "we built this city, from King Street with reggae music"[24]

The recent history of Jamaica also provides raw material for the state of emergency sensibility which underpins the music. Political tribalism, the declaration of a state of emergency in 1966, and a decade later in 1976; and the immense powers given to the police and the judiciary by the Suppression of Crimes Act (March 20, 1974) and the Gun Court Act (April 1, 1974) respectively, have all contributed to creating the stark social realities expressed in these songs. Many of the latter function as reports from the frontlines of an endless war between ghetto dwellers and the police

who represent the state. The Mighty Diamonds' "Another Day, Another Raid" captures the reality of paramilitary policing which denies justice to the poor, and subjects them to "sometimes bullets, sometimes baton blows."[25] Bob Marley queries, in "Rebel Music/3 O'Clock Roadblock", the denial of freedom to poor people who are unable to "roam this open country" without having to endure the indignities of roadblocks and police searches. The realities of curfews are best expressed in Marley's "Burnin' and Lootin'" which describes both the experience of police repression and militant rude boy reaction in the form of "burnin' and lootin' tonight." These evocations of the denial of basic human rights and civil liberties, and the militarized nature of the inner city garrisons, are a far cry from the liberal democratic ideals that supposedly undergird the Jamaican nation state.

The prophetic criticism that is elaborated by roots and culture songs conforms to Cornel West's definition of the former as the imperative to criticize "illegitimate authority and arbitrary uses of power; a bestowal of dignity, grandeur and tragedy on the ordinary lives of everyday people; and an experimental form of life that highlights curiosity, wonder, contingency, adventure, danger and, most importantly, improvisation".[26] West identifies these elements as constituting a "democratic mode of being in the world inseparable from democratic ways of life and ways of struggle." Prophetic criticism valorizes "human empathy and compassion" and it is one of the finest products of what West calls "New World African Modernity."[27]

Many reggae singers assume the prophetic mantle as a way of invoking history and memory. They seek to retrieve the past in order to inform the present with the promise of future liberation. Thus, in "Deliverance Will Come", Dennis Brown, barely twenty years old at the time of this recording, sings with a prophetic maturity about the inevitability of deliverance. Brown's song depicts postcolonial Jamaica as a Babylonian site of crisis, a place of "war and strife, grief and terror, and the drums of hate."[28] This state of emergency is also evoked in the prophetic vision of the self-styled "bush doctor", Peter Tosh. In "Crystal Ball", Tosh's vision catalogues a host of conjunctural crises: "people victims, prices rising, gas shortening/and the dollar devaluing in the city, inna the shitty/...churches locked down, and schools closed down,/politicians promising, teachers striking/ in the city, inna the shitty/youths rising, blood running, fire burning in the city, inna the shitty." However, like Dennis Brown who sees a vision of Beulah land "from the hills of captivity", Tosh sees a vision of hope beyond the grim despair of the "shitty city." As he looks further into the crystal ball, he sees "truth revealing, people cleansing/downpressors chasing, people seeing/in the city, inna the shitty."[29]

It is this vision of the ultimate victory of good over evil that lends these reggae songs their moral certainty and resilient optimism despite the harsh socio-economic realities of contemporary Jamaica. Reggae roots and culture songs refuse to accept limitations on freedom; they deny the permanence of borders and barriers; their protagonists are always crossing territorial, cultural, and psychological borders; and they assert freedom as the inherent birthright of human beings. This emphasis on freedom is sharpened by the fact that reggae music refuses to relinquish the memory of the middle passage, racial slavery, and the inexpressible travails of four centuries of bondage and the experience of being strangers in a strange land, subject to an endless assault on the spirit. These sites of memory are claimed in Garnett Silk's "Bless Me" as he sings about finding himself in the midst of strangers without mercy,[30] and they resonate in the poignant reliving of the crack of the whip in Bob Marley and the Wailers' "Slave Driver."[31] Bunny Wailer memorializes the continuum of experience from slavery to urban dispossession in the figure of the despised "Black Heart Man", that cultural maroon who has no place in the policies and plans of the Jamaican elites who have taken over from the former colonial masters.[32]

It is necessary to avoid the analytical error of assuming that this stubborn refusal to forget the past is a form of self-indulgent wallowing in the condition of victimhood, and a refusal to face the realities of modernity by escaping into racial nostalgia and fantasies about Africa. Most songs about slavery and the historical past are directed at present conditions, and the definitive aspect of reggae's oppositional critique is not its supposed atavism and escapism but its modernity, a radical modernity that differs from Euro-American notions of modernity. In the West, modernity is depicted in terms of a linear unfolding of unique, unrepeatable events. Novelty and radical breaks with the past are thus defining features of Western modernity, whereas reggae, like other African diasporic musical forms, conceptualizes modernity in terms of repetition.[33] The past always returns, but it is altered each time. The endless versions that circulate and recirculate throughout reggae music are self-referential expressions of reggae's aesthetics of repetition which is linked to a politics of repetition that uses the model of slavery to examine the workings of the Jamaican nation state, and the biblical accounts of Jewish bondage to describe the plight of "the wretched of the earth" in the slums of Kingston and all the other "shitty" cities of the world. Bob Marley's "War" (itself a model example of the aesthetics of repetition, given its origins as a speech made by Haile Selassie I) is a messianic declaration of a universal state of emergency, a warning to those in power that until the basic human rights are guaranteed to all peoples, there will be the repeated catastrophe of war. And what is war but the most extreme manifestation of the state of emergency? It is this conception of history that Walter Benjamin declares as a necessary prerequisite for achieving "a real state of emergency" that can hasten the unfinished business of human liberation.[34]

The legacy of roots and culture representations of the postcolonial Jamaican state has carried over, with appropriate conjunctural transformations and nuances, into some areas of the dancehall scene. The Rasta Renaissance (which has seen the emergence of artistes such as Tony Rebel, Garnett Silk, Anthony B, President Brown, Determine, Capleton, Everton Blender, as well as the metamorphosed Buju Banton who has moved from quintessential rude boy lyrics to prophetic social commentary) continues the critique of the established social order, an order which is itself in the throes of chronic economic and social crises. After three decades of political tribalism, wholesale police brutality, nihilistic criminality, two states of emergencies, structural adjustment and the continuing impoverishment of the majority of the Jamaican populace, the reggae representations of the nation state can claim a certain predictive accuracy. It remains to be seen whether the redemptive vision of ultimate liberation and justice will also be realized. Until then, as the songs remind us, the state of emergency remains in effect.

Notes

1. Walter Benjamin, *Illuminations*. New York: Schocken Books, 1968. p. 257.
2. Steel Pulse, "State of Emergency," *State of Emergency*, MCA Records, 1988.
3. L. C. Ruddock. *Civics For Young Jamaicans*. Kingston, 1967: p. 180.
4. L. C. Ruddock. *Civics For Young Jamaicans*, p. 181.
5. Gordon K. Lewis. *The Growth of the Modern West Indies*. New York: Monthly Review Press, 1968, p. 191.
6. Lewis. *The Growth of the Modern West Indies*, p. 191.
7. Peter Tosh, "400 Years," *Equal Rights*, Columbia Records. Jimmy Cliff also deploys this chronology in his song, "I Have Been Dead 400 Years" (*House of Exile*).
8. Burning Spear, "2000 Years," *The Fittest of the Fittest*, Heartbeat Records C-HB-22.
9. The Abyssinians, "African Race," *Satta Massagana*, Heartbeat Records CD HB 120.
10. Bob Marley and the Wailers, "Survival," *Survival*, Island Records, 1979.
11. Peter Tosh, "African," *Equal Rights*, Columbia Records.
12. bell hooks. *Yearning: Race, Gender, and Cultural Politics*. Toronto: Between the Lines, 1990: 15.

13. bell hooks, *Yearning*, 153.
14. Lewis, *The Growth of the Modern West Indies*, pp. 398-99.
15. Milan Kundera, *The Book of Laughter and Forgetting*. Haramondsworth: Penguin, 1980:3.
16. Mighty Diamonds, "Cannot Say You Didn't Know," *Get Ready*. Music Works Records, 1988.
17. Peter Tosh, "Mystic Man," *The Toughest*, EMI Records, 1988.
18. David Lowenthal. *West Indian Societies*, 1972; 298.
19. Black Uhuru, "Leaving to Zion," *Black Uhuru: 20 Greatest Hits*, Sonic Sounds Son 0017 1991.
20. Gregory Isaacs. "Border," *Best of Gregory Isaacs, Vol. II*, GG Records, GG 0025.
21. For a discussion of the issues of exile and rejection of nationalism by Blacks in the diaspora, see Cornel West's useful if somewhat generalizing comments in his preface to *Keeping Faith: Philosophy and Race in America* (New York and London: Routledge, 1993: x-xiv). The language of Rastafari is lucidly analyzed in Velma Pollard's "Dread Talk – The Speech of the Rastafarian in Jamaica", *Caribbean Quarterly* 26.4 (1980): 32-41.
22. All of the Marley songs cited are available on the four compact disc compilation, *Bob Marley: Songs of Freedom*, Tuff Gong/Island Records 1992.
23. Third World, "Ridim Haffe Rule" and State of Siege", *Committed*, Polygram Records, 1994.
24. Burning Spear, "Built This City," *People of the World*, Slash Records, 1986.
25. Mighty Diamonds, "Another Day, Another Raid", *Get Ready*, Music Works Records 1988.
26. Cornel West, *Keeping Faith: Philosophy and Race in America*, p. xi.
27. Cornel West, *Keeping Faith:* pp. xi-xii.
28. Dennis Brown, "Deliverance Will Come", *Visions*, Joe Gibbs Records, 1978.
29. Peter Tosh, "Crystal Ball", *The Toughest*, EMI Records, 1988.
30. Garnett Silk, "Bless Me," *It's Growing*, Dynamic Sounds.
31. Bob Marley and the Wailers, "Slave Driver," *Catch A Fire*, Island Records, 1974.
32. Bunny Wailer, "Black Heart Man", *Black Heart Man*, Mango/Island Records, 1976.
33. For some interesting discussions of repetition as a paradigmatic mode of Black cultural modernism, see Leroi Jones (Amiri Baraka), *Blues People* (New York: William Morrow and Co., 1963) and "The Changing Same (R & B and New Black Music)" in *The Black Aesthetic*, ed. Addison Gayle, Jr. (New York: Anchor/Doubleday, 1971), pp. 112–25; and James A. Snead, "Repetition as a Figure of Black Culture," in *Black Literature and Literary Theory*, ed. Henry Louis Gates, Jr. (New York and London: Methuen, 1984), pp. 59–80.
34. Benjamin, p. 257.

Anraje to Angaje:
Carnival Politics and Music in Haiti

Gage Averill

At Haitian Carnival 1991, a street performer playing a doctor acted out a phone call from "the bourgeoisie" asking him to resuscitate the notorious *tonton makout* (member of the Duvalier family's militia) Roger Lafontant, who was then in prison after he failed in a coup against the newly-elected president. After various serum injections to the stuffed dummy representing Lafontant, the doctor re-examined the lifeless figure. An onlooker cried out, "Is he dead?" The doctor stuck his stethoscope into Lafontant's groin, grimaced, then screamed, "No, his cock is still twitching!" This grotesque image was understood by onlookers as a warning not to underestimate the latent power of Duvalierism to "screw" the country. In this small carnival street drama, Lafontant, strikingly like the figure of the traditional carnival king, was sacrificed to the crowd and then reborn. As the actor collected his props and passed a cup for donations, the carnival brass band Ozanna streamed down from the lower class neighborhood of Bel Aire heading to City Hall playfully singing, *"Nou mande nou mande, pou nou konyen kampe, Nou mande nou mande, lavalasaman"* (We're asking to fuck standing up, but we're asking in the spirit of President Aristide's Lavalas political movement: with the persistence and power of a deluge). A wide range of obscene, exuberant, inverted, and debasing political tropes were played out in a few moments of this carnival vignette.[1]

Carnival is the most important annual musical event in urban Haiti. As the preceeding passage indicates, Haitian carnival exuberance is thoroughly permeated with political meanings. Struck by the importance that musicians in Haiti attach to carnival and by carnival's seemingly powerful role in Haitian political history, I undertook a historical and ethnographic study of carnival under and after the Duvalier dictatorship. The period in question (1957–93) comprises three relatively distinct historical phases for a study of carnival: the reign of François (Papa Doc) Duvalier; the presidency of his son, Jean-Claude (Baby Doc) Duvalier; and the period following the exile of the Duvaliers, and these emerged as interlinked case studies. Two phonetically similar Creole adjectives—*anraje* (a charged or exuberant emotional state, used to describe people caught up in carnival ambience) and *angaje* (politically committed)—capture the complex weave of popular pleasures and political pressures that has characterized Haitian carnival musics of the last 35 years.[2]

The literature on carnivals has proliferated in the last two decades, accelerated by the publication of Sally Moore and Barbara Myerhoff's *Secular Ritual* (1977), a compilation that extended anthropological analysis of religious ritual into studies of political and celebratory secular events, and by the translation of Mikhail Bakhtin's treatise on carnivalesque tropes in the works of French Renaissance writer Rabelais (1984). Carnivals in the Americas have generated a body of scholarship rich in attention to dramaturgical and visual modes of expression (Nunley 1988; Hill 1972). Some scholars have viewed carnival as a window into class, racial, gender, sexual, and

Reprinted with permission from *Ethnomusicology* 38, no. 2 (1994): 217–47.

national identities and conflicts (Guillermoprieto 1990, DaMatta 1991, Parker 1991, Kinser 1990, Lipsitz 1990, Spitzer 1986). Scholars interested in immigrant cultural identities and transnational cultural flows have focused on the emergence of Caribbean-style carnivals in the major cities of Europe and the U.S. (Manning 1990, Nunley 1988, Hill and Abramson 1988). Few studies, with the exception of Keith Warner's book on Trinidadian calypso as oral literature (1985), demonstrate a central interest in carnival music.

A debate in cultural studies and allied disciplines has raged over the political significance of carnival, and this debate spilled over into many of the works listed above. On one end of a spectrum of viewpoints is the "instrument of social control" theory (Gross 1980, 238), which holds that carnival diverts popular attention away from oppressive social realities. Some theorists (Eagleton 1981) acknowledge carnival as a site of popular pleasures that challenge taboos, hierarchies, and social conventions, yet they argue that carnival (often licensed by the authorities) perpetuates dominant systems by functioning as a "pressure valve," venting popular anger into symbolic, rather than material, reversals. Bahktin's medieval carnival—with its grotesque humor, uncrownings, mockery, images of change and renewal, bawdy sexuality, laughter, and suspension of hierarchies— squarely opposed the official culture of church and state, celebrating the unity and fearlessness of the people and affirming their "immortal, indestructible character" (1968/84, 256). David Kertzer similarly stressed the resistant, rebellious, and revolutionary potential of carnival, which brings the powerless into collective organization and encourages the "mockery of the politically powerful" (1988, 146). In these studies, carnival is too often treated as an ideal type, an essence transposable onto different settings. What was needed, I felt, was a larger body of local case studies exploring the political implications of carnival and its music—the local meanings of carnival that defy easy cross-cultural generalization. My own findings on Haitian carnival square with the more open-ended interpretation of carnivals by John Fiske, who notes a continuous presence of rebellious potential in carnival, a potential that can be set into motion by a sharpened level of political struggle (1989, 100).

Various projects in the social sciences have attempted to theorize both emotion and the role of the body. Raymond Williams characterized the "feel" of entire generations and historical periods with a term, "structure of feeling," that purported to cover territory excluded from "ideology" and "worldview" (1977, 132). In carnival, participants expect to be moved, to be swept up in collective enthusiasm, to "lose one's body," and these expectations structure the event—or rather, the event has its own structure of feeling. I argue that these feelings are the lynchpin of carnival's political potential. Carnival also foregrounds bodily pleasures. The body (and its pleasure) occupies a crucial place in Foucault's theories of modern regimes of discipline and power/knowledge. Foucault views bodies as the sites upon which power is enacted (1978, 157) and there is a vague sense in at least some of Foucault's work that bodies are prior to, and potentially transcendent of, techniques and practices of power. In Haitian carnival, "overflowing" exuberance and "letting go of the body" create an event that pushes the limits of social control. But carnival's anti-authoritarian—and even revolutionary—potential also motivates the state and elites to intervene to contain and co-opt carnival and its meanings and to transform carnival (and carnival bodies) into a terrain of class and political conflict.

Carnival music establishes the carnivalesque ambience, sonically symbolizes and projects the power of the carnival masses, and is the vehicle for topical texts that run from playfully ambivalent to defiant, texts that are particularly effective in building mass consensus.

The Struggle for Carnival

In Haiti, as in many countries that celebrate carnival, there has been a stark division between official, elite-sponsored activities and those of a mass or popular nature. The written record on twentieth-century carnivals shows a clear contest for the "soul" of carnival. During the American occupation of Haiti (1915–1934), Haitian president Louis Bomo offered a remodeled, bourgeois-style carnival patterned on French and Italian prototypes which was meant to subordinate and undermine a popular festivity that combined the spirit of the medieval European carnival with neo-African expressive culture. The newspaper *L'Essor* saw hope for a bourgeois festival as early as 1924: "Our carnival is in full development. The evolution of carnival is already far from an African stage. It promises something splendid in the years to come" (5 March 1924, quoted in Corvington 1987, 308). After 1925, businesses such as Guilbaud Tobacco Manufacturing sponsored *cha madigra-s*[3] (Mardi Gras floats, often allegorical in nature). Elite social clubs such as Cercle Bellevue held *mardi gras* balls, typically concluding with a rendition of the traditional *mereng* (French: *méringue*) "Bonswa Danm, Mwen Kale Dodo" (Goodnight Ladies, I'm Going To Bed). A king and queen were first elected in 1927 by a new entity, the Carnival Committee. This elite carnival, aiming for a graceful and delicate spectacle (organized by the government and social elite and observed by the masses), falls into a category of events held "by the establishment for the people" (Falassi 1987, 3); however, these exclusive balls constituted events held by the establishment *for* the establishment.

The Haitian state and elite class have been remarkably unsuccessful over time in their effort to turn carnival into a parade or spectacle; official Haitian carnival has always been wedded uneasily to a popular, participatory, and political event. In occupation-era carnivals, a growing Anti-Americanism confronted the foreign presence in Haiti. In 1926, the police were forced to disperse a demonstration by a masked carnival entourage protesting the reelection of collaborationist President Louis Borno. Two years later, even the Cercle Bellevue cancelled its carnival grand ball to protest the incarceration of some of its members by the American-led Garde d'Haïti. The American fact-finding mission sent by President Hoover in 1930 had the misfortune to arrive just prior to carnival. To protest the American presence, the carnival queen returned her crown to the Commission and a general boycott of carnival kept the crowds at bay. In place of the carnival *kòtèj* (parade), a patriotic *manifestasyon* (protest march) led by a women's organization implored God to enlighten the Americans (Corvington 1987, 63).

The popular character of carnival expanded during the latter part of the occupation. The public was permitted a delirious celebration at their own "outdoor ball" at Vallière Market. A famous early carnival orchestra, the Otofonik G.B. de Hiram Dorvilmé joined in the *kòtèj* (parade) starting in 1931.[4] Otofonik's instrumentation included bongo, *tchatcha* (rattle), friction drum tambourine, and *manman tanbou* (mother drum) (Fraget 1989). Many bands also used flutes or brass instruments, as they were closely patterned on military *fanfa* (fanfares, brass bands) through which many Haitians received their first musical training. In the days before amplified carnival bands, groups such as these were referred to as *òtofonik*, a creolized version of the word Orthophonic on the old Victrola 78 rpm records, because the megaphones that the lead singers used resembled the horns from old phonograph players. Over the years some of these groups, such as Otofonik G.B. from Rue Neuf and Titato (Tic-Tac-Toe) from the neighborhood Belair, became carnival stars, attracting thousands of revelers to their entourage.

A similar tension between elite and mass or popular events survives from the occupation-era carnival to the present. While sponsorship and decisions on official themes, awards, parade routes, and security remain the responsibility of the elite, carnival's celebratory energy emanates from

the urban proletariat and peasantry. Urban workers are given two *konje*-s (days off) in addition to Sunday in which to occupy the streets. The general term for popular carnival entourages, *bann apye*-s (groups on foot), immediately distinguishes them from the official elevated floats and symbolizes the class difference. Although it is often said that Haitian carnival is a time when all classes mix freely and in mutual tolerance, there are powerful limits on the extent of interaction.

Popular Motion, Emotion, and Commotion

Hundreds of types of *bann apye sòti* (turn out) for carnival. Some bands have a life outside of carnival, notably the peasant *rara* bands (also formed by the urban poor) with their accompaniment of *vaksin* bamboo trumpets, tin horns, and percussion; maypole dance groups *(trese riban* or *ribanyè)*; and stick dancers *(batonyè)*. *Endyèn Madigra* (Mardi Gras Indians) engage in stick fighting to the accompaniment of side drums. A popular masque called *chaloska* (Charles Oscar, an infamous general and presidential aide who massacred prisoners in 1915) is patterned on Napoleonic military uniforms (Mirville 1978, 39).

In the 1959 Carnival (in the early Duvalier period), for example, *gwo tèt* (large heads, an old European masque) mimicked politicians and well-known figures; clowns with steer heads ("boeufs") cracked whips; a group called "Malades" (the sick) ran through the streets pretending to have diarrhea; Indians followed a King of Carnival; "Yoyo" featured a hula hoop demonstration and cha-cha-cha dancers; the Troupe Folklorique put on a show about Haiti's African heritage; and there was a historical float on the theme of the escaped slaves of the island. Other *bann apye*-s masqued as *zonbi*-s (zombies), Arabs, *lougawou*-s (werewolves), and *djab*-s (devils) *(Nouvelliste* 1959a, 3).

Carnival revelers march with their favorite or their neighborhood band; size is an immediate indication of a group's popularity. Bands *balanse an plas* ("rock in place," practicing in the neighborhoods without marching) on the Sundays following 6 January, the *Fètdewa* (Festival of the Kings). Many hold ceremonies in neighborhood Vodou temples to baptize the bands. As carnival approaches, these groups circumambulate their neighborhoods, rehearsing songs and building neighborhood interest and loyalty. At night, participants carrying *lanp tèt gridap*-s (oil lanterns, literally "kinky hair lamps") on their heads to illuminate the scene. Crowds attract *machandèz*, sellers of all types of food, drink, and sweets, including *frèsko* (flavored shaved ice), *tablèt pistach* (peanut brittle), *gwiyo* (fried pork), coffee, and *kleren* (raw sugar cane liquor).

The musical focus of elite carnival is the song competition; as the lyrics to one old *mereng* put it, *"San mereng, nanpwen kanaval* (without the *méringue*, there is no carnival). In the last year of the American occupation, the mayor of Port-au-Prince instituted a competition for best *mereng kanaval,*[5] although it applied at first only to instrumental compositions *(Nouvelliste* 1934). The government, through its Carnival Committee, influenced or controlled the structure of carnival song entries through the competiton.[6] The first printed description of a competition winner ("Nibo," the 1934 entry by art music composer Ludovic Lamothe) praised the "unbridled joy" elicited by this composition, although the writer neglects to mention the impending end of the occupation and departure of the American Marines, which may have boosted the effervescence of the celebration: "[T]he author, in an inspiration that one could call unbridled, appears truly to have expressed the *ohè! ohè!* [carnival refrain] soul of the reveling crowd. The rhythm is erotic and inclines, in the first measures, to the most frenetic joy. We repeat that this is not a personal opinion, rather it is supported by the delerium that this captivating composition achieved with the public on the evening of Mardi Gras. Everyone, old and young, from the most serious to the most careless, was tingling with excitement *[avaient des fourmis dans les jambes;* literally, had ants in their legs, used here to suggest a compulsion to dance]" *(Nouvelliste* 1934).

The successful carnival song is to be judged, therefore, by its affect on the crowd (delirium, frenzy, joy, eroticism, urge to dance) rather than by any specific formal musical critieria. From the first competition on, a special genre developed in and for Haitian carnival, characterized by rapid tempo and intensity as well as by a less morally-restricted content. Playful obscenities abound in songs of the *bann apye*-s as well as in the composed *mereng kanaval*-s. Skits, costumes, gestures, carnival dance, and general demeanor all reinforce this efflorescence of what Bahktin calls the "material bodily lower stratum" (1968/84) at carnival in Haiti.

The peak of carnival exuberance—the ambiance of carnival in its final days on the road—is known as *koudyay* (French, *coup de jaille*, a spontaneous bursting forth).[7] *Koudyay,* while rooted in carnival habitus, can be severed from Carnival and harnessed for events—either political or purely celebratory—at any time of year, as long as the organizers supply copious *kleren* [sugar cane liquor], crowds, and carnivalesque music. The components of *koudyay* or carnival habitus include a heightened playfulness, sexuality, expressiveness, and danger.

Carnival and *koudyay* enthusiasm, an intersubjective peak experience, is described in terms such *debòde* (overflowing, exuberant, furious), *anraje* (worked-up, turned-on, crazy, enraged), or the colorful *antyoutyout* (exuberant, excited). Carnival participants achieve these states in a progression of escalations involving music and movement. Musicians try to *chofe* (heat) the crowd with exhortations to physically respond. Revelers are encouraged to *lage ko-w!* (let go of yourself!), *mete men nan lè* (put hands in the air), *balanse* (sway), *bobinen* (spin), *souke* (shake), *vole* (fly), *gwiye* (grind the hips), and *sote* (jump). When a band has a crowd *anraje* or *antyoutyout,* they have actualized their potential power; the music is fully persuasive and the event and context are deeply internalized.

Ritualized types of combat are integrated into carnival at all levels. Muscular men, many of whom train for months each year before carnival, engage in a popular, informal carnival contest called *gagann.* In *gagann,* the combatants face each other within a semi-circle of their supporters and attempt to shove one another down with strong blows to the chest. One participant told me, "I have a reputation to uphold. I go out with the band Nouvèl Jenerasyon [a *bann apye* from Pétion-Ville]. I have never been beaten at *gagann.* So I have a lot of people who walk with me and bet on me to win" (Personal communication: Fils-Aimé 1990).

If inspired by the music and the ambience, revelers often *lese frape* ("let hit," what might be called "slam dancing" in the U.S.), hurling themselves through the crowd with their arms spread wide and colliding with others. *Lese frape* is the most commonly evoked behavior in discussions of carnival. But the threat of violence is not just from *lese frape* and escalating *gagann*; the chaotic nature of carnival provides a perfect cover for specific acts of revenge and even assassination. As one musician told me, "If somebody hate you, or have a grudge against you, carnival is the best time to kill you" (Interview: Franck 1993).

Many Haitians criticize carnival behavior from a moral standpoint. Generally these critics, from middle or upper-class backgrounds, strict Catholics or evangelical Protestants and self-identified as *moun seryè* (serious people) or *moun byenelve* (well-mannered people), concentrate on carnival's more obscene and violent tropes. They characterize carnival disorder *(dezòd, debanday)* as a blight on Haiti's reputation and as fodder for the propaganda of Haiti's enemies. "The most visible in this way have been the Haitian groups who shake themselves noisily and hit with more force than the others. Sometimes this became violence pure and simple...The foreigner who is not very habituated to this type of behavior sees in it a kind of unbridled violence. And this is in part correct, because there were many broken heads" *(Haïti-Observateur* 1989, 5–6).

At the street level, violent modes of interaction are a natural outgrowth of *anraje* exuberance and ritualized combat, competition, and polemic.[8] Haitian carnival balances between a celebration and a *deblozay* (fracas, blow-up) in which images of disorder (*dezòd*), chaotic mess *(gagòt),* and chaotic sound *(tenten)* characterize an event in which the desired ambiance teeters just short of chaos. Recalling the sense of the term *debòde* (to the brim), one friend used a Haitian proverb to describe carnival: *pise krapo kab fè rivye desann* (the frog's piss is all that's needed to make the river overflow). This ambience is the site of carnival's most important political meanings, which are formed in relation to the aforementioned struggle over individual and collective bodies. Michel Foucault, analyzing the relation of the body to political control in European societies, stressed that it is in the nature of power to repress "useless energies, the intensity of pleasures, and irregular modes of behavior" (1978, 9). The undisciplined quality of carnival behaviors qualifies them as transgressive; carnival bodies express non-normative codes. Michel de Certeau finds a "narrativity in its most delinquent form" in carnivalesque celebrations, characterized by the "privilege of the *tour* over the *state* (1984, 130, emphasis original), with "tour" standing for "spatializing action" or "practiced places." But, as John Fiske points out, "the body remains a desperately insecure site for social control" (1989, 94), and in Haitian carnival the state intervenes to constrain carnival transgression and "delinquent narrativity," attempting to impose metanarratives on carnival's meaning (stability of the state, consent of the governed, a happy people). To view this through another filter, the loss of control implied by *lage kò w* (let go of yourself) is a public, collective version of the ecstatic loss of self (Barthes's *"jouissance,"* 1975), and this becomes the target for attempts to impose a more socially-productive and normative pleasure (*'plaisir'*) on carnival.

At an outdoor Haitian Music Festival that I helped to organize in Miami at Carnival time in 1989, the final band, Miami Top Vice, launched into a spirited carnival medley. I looked out into the crowd from the stage to see a number of men spread their arms to *lese frape* (let hit) and I realized too late that I had neglected to inform the police that this might occur. As officers dove into the crowd to arrest the men for "drunk and disorderly" behavior, the announcer grabbed the microphone, silenced the music, and encouraged the crowd to surround the police to demand the release of the Haitians. A police call for help (scarcely two months after the infamous Overtown riots in Miami) yielded quick results, and what seemed like every squad car and fire engine in downtown Miami arrived on the scene within minutes. As we negotiated with the police for a tense half hour, members of the crowd began to make use of the three-toned whistles passed out as free souvenirs by the sponsor, the Nutrament Corporation (manufacturer of a sports drink). Crowd members combined the three tones into hocketed patterns resembling those of *rara* and carnival bands. Empty Nutrament cans filled in for bells, and antipolice carnival songs were composed on the spot. As I watched these makeshift carnival ensembles fire up the crowds, I remember being in awe of the power of the carnival spirit to spill over into—and animate—a confrontation of this sort.

Papa Doc's Government on Parade

One of the defining moments in modern Haitian history was the election of Dr. François Duvalier as President in 1957. Duvalier had been a leading figure in the *noiriste* movement that grew out of the *indigène* (indigenous) and *ethnologie* movements. Although the earlier movements were chiefly concerned with studying Haitian peasant culture, formulating an "authentic" Haitian cultural expression, and challenging hegemonic Europhile norms for Haitians, the *noiristes* sought to advance the political agenda of Haiti's black middle class and masses against the mulatto elite using the notion that only Blacks could authentically represent the masses. The *noiristes* captured

state power in the post-War era in two stages, first with the election of Dumarsais Estimé (1946–50) and then with the campaign for Duvalier in 1957.

Once elected, Duvalier set about ruthlessly to destroy his enemies and all potential bases of oppositional power, regardless of ideology. Duvalier perfected the tactics that Haitians had come to call *kansonfè-isme* (iron pants politics). The thugs that had terrorized his opponents in the election (*cagoulards*, from the masks or *cagoules* they wore over their heads) became a permanent fixture on the political landscape, earning the nickname *tonton makout*-s (literally "Uncle Side-bag," the name of a malevolent figure from Haitian folk tales who steals little children by placing them in his bag) due to the frequent disappearances of Duvalier's opponents. This private militia evolved into one of Haiti's only truly national organizations, giving a taste of power and the hope of getting ahead to thousands of Duvalierists (from the middle class to the lumpen proletariat). In 1962, Duvalier formalized the organization as the Volontaires de la Sécurité Nationale (VSN). With a reign of *makout* terror, with ruthless campaigns to subjugate all private and public organizations to the state (and the state to Duvalier), and with increasing control over communications and symbolic systems, the Duvalier presidency evolved into a twenty-nine-year dynastic, totalitarian dictatorship.[9]

François "Papa Doc" Duvalier masterfully orchestrated carnival and carnival-like events for political purposes, using carnival to divert popular attention from social and economic problems. A bandleader summarized this political strategy in language reminiscent of the "pressure valve" theory of carnival: "When there's a problem, the political problem for example, everybody is concerned with politics, but if the rulers or the head of the country would like to remove something from the consciousness of the people, they offer the people...a popular concert. It's the same thing with carnival" (Interview: Pierre 1988).

The first two carnivals under Duvalier were marked by press and governmental concern that the economic situation ("plus que précaire") and the diminished funds available for carnival would reflect badly on the new president. Pro-government journalists opined that the public should not hold the government responsible for the state of carnival (*Nouvelliste* 1959c). For Duvalier's first carnival in 1958, the government experimented with a stationary event, a "Foire Carnavalesque" (Carnival Fair), on the waterfront grounds of the 1949 Exposition. Duvalier promised to keep traffic out of the area in order to assure carnival's smooth functioning (*Nouvelliste* 1958b). This was perhaps the most ambitious effort to reconfigure carnival's meaning since the ascendency of bourgeois carnival under the American occupation. Traditional carnival ambiance requires moving through, taking over, transforming, and transgressing space, and carnival crowds resist map-like or tableau stagings (see de Certeau 1984, 115–30). The lack of public support for the experiment was evident on the first day, and the Committee reinstated the traditional *kòtèj* (parade) for Monday and Tuesday.

During the early years of the dictatorship, Duvalier was still perceived by the masses as anti-status-quo and anti-elite, as a *moun-pa-yo* (their guy) and even a *manje milat* (a "mulatto eater," someone willing to use violent means to subdue the elite). Accordingly, the *bann madigra*-s were mobilized in support of his revolution. In 1959, Titato carried signs proclaiming "Long Live Duvalier, the Successor to Dessalines" and "Don't touch Duvalier" (*Nouvelliste* 1959b). In the next few years, carnival groups sported names such as 22nd of May,[10] New Haiti, In Danger of Dying (*Nouvelliste* 1962a, 4), and the group Thank you Papa Doc, We Have No More Yaws (*Nouvelliste* 1965c, 1).[11] As the carnival processions wound their way to the park area known as the Champs Mars and past the front gates of Haiti's magnificent white Palais National, all the bands, whether on foot or on a float, stopped to play an *ochan* (salute) to Duvalier. Musicians have told me of the awe that they felt

as Duvalier stepped onto the distant balcony, silhouetted by the palace lights, to receive the salutes. The practice of playing *ochan* was inherited from *fanfa,* military bands, but has diffused widely in Haitian music. Various types of *ochan* are played by Vodou drummers, *contradanse* musicians, and commercial dance bands, testifying to the pervasive influence that militarism in the colonial and post-colonial eras has had on all aspects of Haitian culture. In general, musicians play *ochan*-s at the residences of dignitaries, who are then expected to bestow gifts on the ensemble. Carnival practices as diverse as *koudyay, ochan, drapo* (flags), and band hierarchies all hearken back to military culture.[12] Figure I shows my transcription of a common *ochan* melody from the playing of a Port-au-Prince *bann apye,* Zepi Band (Spice Band). They performed the *ochan* in front of City Hall; the *mèt* (director) of the band signalled it by rolling his hands, and cueing a *woule tanbou* (drum roll) from the *kès* (snare) player.

Carnival Ochan (Zepi Band, 1991)
Ochan as played by the *bann apye* Zepi (Spice) Band in front of City Hall in Port-au-Prince on Mardi Gras, February 12, 1991. This transcription is of the melody played on trumpet. Percussionists accompany the trumpet with a single-headed frame drum and a snare drum (kès), played in synchrony using the "rudiment" techniques of European signal drumming.

During the early Duvalier epoch, commercial dance bands became the center of carnival drama. The two most popular of these commercial bands, the Ensemble Nemours Jean-Baptiste and the Ensemble Wébert Sicot with their Dominican-inspired dances called, respectively, *konpa-dirèk* and *kadans ranpa* in Creole, played at carnival on flatbed trucks powered by generators (called *dèlko*-s after the battery brand name) (see Averill 1993a for a general discussion of the music and the bands). In 1958, Cadence Rampas de Wébert Sicot played for the *bann apye* "Hanté"; Nemours Jean-Baptiste outdid his rival by registering his Compas-Direct as its own carnival band. Sicot registered separately in 1962. As the two groups' popularity grew, the competition between them came to dominate discussion and interest in the urban carnival, transforming carnival into a venue of the incipient commercial music industry. The period from the late 1950s until at least 1968 is etched into Haitian popular memory as the *epok polemik Nemou ak Siko* (period of the controversy between Nemours and Sicot). The polemic provided an engaging popular theatre, a cock fight (*bat kòk)* on a national level that was a natural outgrowth of other forms of ritualized carnival combat.[13] The *polemik* was a commercial strategy that continued throughout the year, but which was polished and perfected at carnival.

Nemours and Sicot both commanded broad support throughout urban Haiti and in the rural provinces to which they regularly traveled to play *fèt chanpèt* (country festivals) and *fèt patwonal* (patron's day festivals). Fights often broke out between partisans of the two bands. Sporting the colors of their favorite band (red and white for Nemours; red, white, blue, and black for Sicot) carnival revelers marched in groups many thousands strong close to the Nemours or Sicot floats. The *tonton makout*-s were divided in their loyalties and split into two camps for carnival, each camp adding the appropriate colors to the standard *makout* uniforms (denim with red handkerchiefs and sun glasses). A prominent *makout* named Antoine Khouri (immortalized in Nemours's 1966 song "Carole") led the Nemours ensemble on a motorcycle. His counterpart, another *makout* named Jean Fils-Aimè, also on a motorcycle, led the Sicot band (Antha 1991, 26). The final float in the carnival parade was reserved for the year's favorite band, but, in one legendary instance, fourteen-year-old Jean-Claude Duvalier sent a group of *tonton makout*-s to intimidate the Nemours party into parading before Sicot. Jean-Claude, as one might surmise, preferred Sicot, while his sister Denise was a fan of Nemours Jean-Baptiste.

Government ministries and the *tonton makout*-s patronized Nemours' *konpa* and Sicot's *kadans*. The new Duvalierist *klas politik* (political class) formed a large part of the audience at nightclubs in which the bands performed. They commissioned pieces and hired the bands to play not only at carnival but at *makout* parties, campaign rallies, and for tours by the President's family. A member of the Ensemble Nemours Jean-Baptiste discussed the group's relation to the regime: "That's the way it was with the government. They give us jobs to play and they pay. That is our job, so we play... You play the government's song on radio. Sometime the government member calls you and he say, "I give you that subject, so you have to make a song." But we would never put that song on record! [He laughs] Sometime we could make a song for the president, so when we have to put that song on the record, we get the same song and put other words on it" (Interview: Lalanne 1988).

Nearly every major commercial group in Haiti played at some time or another for the government, at least tacitly cooperating with the regime.

> I had to play for Duvalier, because, let me tell you, my band was the number one band in Haiti at that time, Ambassadeurs. You don't decide to play for the government—they force you to play. I was not a Duvalierist, but they come to your house talking to you like, "I got a contract for you. You have to sign it...some papers, a little money." They say, "Listen, tomorrow morning I want to see you at the Palace at eight o'clock." That's it! You think there's any Haitian who says, "No, I'm not coming?" No way! Only if you want to kill yourself, because POW! That's it. Who can say no to those guys who had such a lot of power? They'll kill you in a second. When you are a Haitian, you have to deal with those things every day. I sang for François Duvalier [sings] "Duvalier, pala la la la la, Duvalier!" So people used to look at me –"Hmmmm!" [scornful] People want you to say no, when nobody dare say no to those people at that time. (Interview: anonymous 1993)

The government made use of *konpa* bands for carnival even in the provincial cities. A member of a 1960s-era band from the northern city of Cap-Haïtien told me: "Every time there was a political manifestation, every time there was a carnival, the mayor or police chief would come to us and give us orders to go out...The last thing they did was to arrest a guy in our band who was going to Port-au-Prince in his truck with a load of lumber in order to make him stay in Cap-Haïtien and play at carnival" (Interview: Morisseau 1988).

The 1964 carnival was organized around the theme "Papa Doc For Life" in preparation for the upcoming plebiscite on the proposed "Presidency for Life." Carnival songs became campaign theme songs, broadcast throughout Haiti in the period before the vote. The day of the plebiscite was organized as a *koudyay* with music and alcohol provided to potential voters.

With the further consolidation of his revolution, Papa Doc made his presence keenly felt at carnival. The mayor reminded the population to experience an "explosion of joy and a triumph of art under the sign of the order of the country of Duvalierists" and asked residents to decorate their houses and vehicles (*Nouvelliste* 1965b, 1).

Wébert Sicot won for best carnival song in 1965 with his "Men Jet-la" (Here Comes the Jet), encapsulating that year's carnival theme: "to pay homage to His Majestic Excellency President for Life, the Incomparable Leader Dr. Francois DUVALIER, the Inspired Constructor of New Haiti, who wrote, to the glory of the Fatherland, the most beautiful, the most dazzling page of National History after that of January 1, 1804 [Independence]: the construction of the Mais Gate INTERNATIONAL AIRPORT" (Augustin 1965).

Duvalier's grand carnival ball in honor of the airport took place at the nightclub Cabane Choucoune featuring Jazz des Jeunes in a folkloric show and l'Ensemble Nemours Jean-Baptiste playing for the dancers. The Nemours Jean-Baptiste entry that year was "Tout Limen" (All Lit Up) in recognition of Duvalier's electricity program.

In 1967, the "Year Ten of the Duvalierist Revolution," carnival enthusiasm was dampened by the economic crisis (aggravated by a hurricane) and by a short-lived guerrilla war waged by the new United Communist Party of Haiti (PUCH). The competition between Sicot's "Bon Jan Vant" (A Good Wind) and Nemours' "Pwen Fè Pa" (Merciless) was the centerpiece of the event. 1967 was also the year Duvalier celebrated his 60th birthday with a second five-day April carnival called the "Carnival au Printemps." Opponents of Duvalier (reputed to be either the Communists or close aides of Duvalier) set off a bomb at this carnival in a *frèsko* (shaved ice) cart under a float on which a band was playing a pro-Duvalier *mereng kanaval*.

1968 was the year in which Duvalier "involved himself personally in the organization of Carnival by offering four floats symbolizing important projects of his government" including the Temple of Culture, and the new Red Cross building (*Nouvelliste* 1968b, 1). The theme for carnival was "Peligré in Action," commemorating a new hydroelectric plant, and represented by a float from the Department of Economic Affairs with a giant *V* for the victory of Papa Doc over *blakawout-la* (the blackout). The *tonton makout* float represented a planned housing project, Cité Simone Olvide Duvalier, named after Duvalier's wife; Public Transportation financed a float depicting the new airport; and Foreign Affairs sponsored a float on the theme of the writings of Papa Doc (ibid.).

Nemours and Sicot continued their polemic in song texts. Nemours Jean-Baptiste's group sang, "*Siko se mawoule, nou pote fèy pou ba li medsin* "(Sicot is a goatherder, let's bring him leaves for medicine"), casting Sicot as an ignorant peasant. In return, Sicot's group boasted of the band's effect on their carnival *fanatik-s* (fans), "*Depi Siko parèt, gason pa kanpe, fanm mare tete yo sere*" (When Sicot appears, guys can't stand still, women have to tie their blouses on tight). The success of this carnival was ascribed to "the climate of peace and order installed in the country by the preeminent Man of State, his Excellency the President for Life of the Republic Doctor François Duvalier...*who has been able to muzzle and exorcize the demon of political adventurism*" (*Nouvelliste* 1968a, 2, emphasis added).

Duvalier also regularly offered a July festival called the "Carnival des Fleurs." Special carnivals and impromptu *koudyay* were essential weapons in Duvalier's politico-cultural arsenal. For example, after an attempt to kidnap his children in 1963, Duvalier launched one of the bloodiest massacres of his reign. Then, with potential victims seeking asylum in the Dominican embassy, Duvalier decreed a special carnival. Bands, floats, and masques surrounded the embassy, intensifying a diplomatic impasse that almost brought the two countries to war. Not long after, on 30 April 1963,

as an Organization of American States investigative committee arrived in Haiti, Papa Doc trucked thousands of peasants into the capital and supplied them with rum and music in order to impress the committee with Duvalier's fanatic support from the people (Diederich and Burt 1986, 211–13). A similar demonstration was staged for Nelson Rockefeller's 1969 visit to Haiti.

The data from the period of François Duvalier's presidency clarify Duvalier's strategies toward carnival and the possibilities for a state to co-opt carnival. Duvalier's early popularity with the masses resulted in an outpouring of pro-Duvalier (and anti-elite) activity by *bann apye*-s, harnessing the anti-structural impulse of carnivalesque celebration to support an emergent political force against the residual economic status quo. The Duvaliers contributed to the popularity of *konpa* ensembles and to the particular form of competition and polemic that characterized the music scene during the 1960s. This competition helped to divert popular attention from the very real difficulties faced by the country (a skyrocketing level of terrorism, a decline in tourism and foreign aid, international isolation, declining agricultural productivity, a shocking level of graft and inefficiency, and so on). Duvalier's revolution transformed carnival into an event that was saturated with the state apparatus, a "government on parade," with each carnival devoted to the achievements of the state. Carnival groups and commercial bands that tacitly supported or cooperated with the regime became part of what Trouillot calls the "unofficial network of redistribution" (1990, 189) by which a part of the state coffers (filled through taxation of peasant export produce, graft, extortion, and theft) was redistributed to secure the consent of broad segments of the population. Carnival, in turn, conferred prestige on Duvalier and his revolution, and the money spent by the government assured ordinary Haitians that Duvalier took their simple pleasures seriously. Papa Doc died on 21 April 1971, but not before appointing his teenage son, Jean-Claude ("Baby Doc") to succeed him and planning a carnival to herald the future president-for-life. A $1000 prize was offered at the 1971 carnival for the best *mereng kanaval* composed in Jean-Claude's honor.

Baby Doc's Bacchanalia

After his father's death, Jean-Claude sought to attract more American light industry and secondary manufacturing plants to the Port-au-Prince area; he also avidly courted the Haitian merchant bourgeoisie that had continued to fear the *noiriste* rhetoric of his father (however much they benefitted materially from his father's policies). *Jeanclaudisme* was the label later applied to the new, more technocratic and liberal, phase of Duvalierism.

Jean-Claude's reign also coincided with the ascendency of a new kind of musical ensemble in Haiti, *mini-djaz*. Featuring two electric guitars, drum set, congas, bell and tom, and often a tenor saxophone or organ, these groups grew directly out of the wave of young rock or *yeye* bands that were inspired by the imported American and European popular musics in the early 1960s. *Konpa* remained a dominant, although not exclusive, component of the *mini-djaz* repertoire. Jean-Claude Duvalier, who was said to care more for his motorcycle and his music lessons than for affairs of state, was a fervent fan of *konpa*. Even before becoming president, he sponsored his own *mini-djaz*, Bossa Combo, purchasing their instruments, producing their first record (on the "Dato" label, a nickname for Jean-Claude), providing them with a music tutor, and installing them as the "court musicians" of the Duvalier clan.

The 1970s are remembered by Haitians who participated in carnival as the time of Haiti's most spectacular carnivals. The floats were well-financed, there was always a large brigade of "queens" with various titles. Jean-Claude also expanded the participation of the *mini-djaz* bands in carnival. In the early 1970s, it was not unusual for the government to pay a top band $15,000 to play

carnival (Interview: Déjean 1988). This figure increased in the late 1970s, although much of the government's contribution was in equipment and instruments.

Mereng kanaval increased in tempo during the Baby Doc years, propelled by the carnival competition between *mini-djaz* such as D.P. Express and Scorpio. The hyper-tempo of the 1970s-era *mereng kanaval* stretched the abilities of the players; the songs were marketable only in the exuberant ambience of carnival. Recorded singles of carnival entries were played on radio in the weeks before carnival, but often never made their way onto albums, especially albums targeted to Creole speakers in the French Antilles. "I would never put like a Scorpio-like carnival piece on a compilation, because you can't sell it in Martinique and Guadeloupe. This kind of carnival, it's too fast, they don't like that.... Sometimes you need to take economics into account" (Interview: Paul 1991).

For the three (or sometimes five) days of carnival, bands play their carnival entries nearly continuously, a brutal exercise for the musicians. Haitian writer Ralph Boncy described the carnival route and routine during the 1970s:

> The carnival parade in Port-au-Prince represents a route of six to eight kilometers through the city. The group, mounted on a truck disguised as a "float," covered with loudspeakers and microphones, moves forward at a tortuous pace in the middle of a veritable human sea that sweats, dances, and pushes. Throughout the entire trajectory, lasting from six to seven hours, each group plays only a single composition until they arrive back at the Place de l'Hôtel de Ville [city hall] to play for a popular dance that lasts an extra two hours...still playing the same piece! Perhaps the director of the orchestra has contracted for a night-club engagement on the same evening where they have to play from midnight until three o'clock in the morning, taking care to open and close the dance with a long version of the aforementioned "méringue carnivalesque." After the three days of these bacchanals, one can deduce that the *konpa* musicians have played intermittently for nearly fifty hours under appalling conditions while consuming a good quantity of alchohol and an overdose of decibels. Moreover, the music that constitutes the core of their repertory is, in general, a hit full of energy designed to excite the crowd, and its execution on an exaggeratedly quick tempo requires expending superhuman quantities of energy. They have to hold the rhythm for three days and three nights under the sun with all the noise in an insufferable heat, even if they can't hear well. The golden rule is: Never fade. On the hundred and one stops of this competitive route, they have to win one-on-one on the applause meter before being able to claim to be the heros of the evening. (Boncy 1992, 90)

One guitarist described the ordeal in personal terms: "I made a song called 'Apye Nou Ye' (We're On Our Feet.... I played a lot of guitar on that song.... My fingers go so fast, it was painful to do playing a party. And everybody was telling me you have to play that song for carnival. I say 'Aaanngh!' When I tried, people went crazy. I was playing from 2:30 in the afternoon until 10:00 p.m. playing this...[he tunes guitar and demonstrates].... Eight hours every day from Friday until Tuesday. Okay, and after that you have to go play the parties. So I had a big arm! It was so tough!" (Interview: Franck 1993).

Bossa Combo's *mereng kanaval*, "Plante Pa Koupe Bwa" (Plant, Don't Cut Trees), won first prize in 1975. The two-measure transcription from this song [Figure 2] demonstrates the layering of a number of simple instrumental ostinati, its frenetic quarter note value (185 beats per minute), and its structural relationship to *konpa*.

Two bands, Scorpio and D.P. Express (both descendants of the early *mini-djaz*, Difficiles de Pétion-Ville) engaged in the polemic-of-the-period from the mid 1970s to the late 1980s. In 1983, Scorpio, known as *Bèt la* (the beast), used a carnival song to poke fun at the drug and mental health problems of D.P. Express's former lead singer. As late as 1990, each of the two bands were

submitting advance cassettes of their carnival songs to a radio station *as instrumental versions* to prevent their rival from responding to—and counterattacking—their lyrics.

The carnival route has been enshrined in many self-referential *mereng kanaval*, such as in the 1979 carnival song "É, É, É, É, É" from D.P. Express:

Eseye fè yon bagay	Try to do something
kap sèvi timoun kap grandi...	to benefit the children growing up...
Pa rete nan vakans...	Don't stay on vacation...
Nou wo, nou wo, e nap toujou wo...	We're high, we're high, we're always high
Sou konpa, toujou sou konpa...	On konpa, always in the groove
Men bòz	Here are the drugs (marijuana)
Nap desann Lali, desann Ri Pave	We descend Lalue Street, down Pavée Street
Nap vire Ron Pwen	We're turning at Rond Point (a night club)
Mwen di "Manman, ala yon bèl bann	I say "Mama, what a great band,
Ala yon bèl bann cho, se D.P.!"	D.P. is such a hot band!"

Figure 2. Fragment: Plante Pa Koupe Bwa (Bossa Combo)

Fragment from the winning *mereng kanaval* of Carnival 1975, "Plante Pa Koupe Pye Bwa" ("Plant, Don't Cut Trees") by the *mini-djaz* Bossa Combo. Note the very quick pulse (quarter note equals 185 beats per minute) in the bass guitar and bass drum. This—along with the fast pace of the chord changes (one per measure)—gives the composition its frenetic feeling. As is typical of *konpa*, the brass instruments and lead guitar play relatively simple riffs throughout the piece. In may details, the parts look like basic *konpa*, especially the pattern for cowbell and floor tom that is played by one percussionist (the floor tom is represented by dark noteheads). Not pictured: rhythm guitar (strummed chords) and conga (inaudible if present). *Superstar's All Stars: Carnival in Haiti, Les Plus Grands Orchestres.* Superstar Records SUP-104, 1975. Used with permission.

The first two lines that I quote from the song are political in nature, criticizing the elite who, in one Haitian proverb, are described as *"toujou nan vakans"* (always on vacation).[14] The phrase *"ala yon bèl bann cho"* (what a hot band) is constructed so as to hint at the alternate meaning of *"bann,"* an erection. "Men bòz" (Here are the drugs/marijuana, from the English "buzz," presumably) recalls a song of D.P. Express that was banned for an apparent reference to drugs, but this one, using slang and performed at carnival, slipped by the censors. The song is a typically rich D.P. Express carnival mix of politics, sex, drugs, bravado, self-aggrandizement, and *plezi* (pleasure).

The opportunities for a critical political discourse had opened up under *Jeanclaudisme,* especially after the election in the U.S. of President Jimmy Carter, and the press became more independent (occasionally even critical). Franck Etienne, the most prominent author and poet of the decade, produced his *angaje* Creole play *Tèt Pelen* and his novel *Dezafi,* which compares Haiti's intellectual slumber during the dictatorship to a zombie-like state. Various musicians, notably singer Ti-Manno from D.P. Express and troubadours Manno Charlemagne and Marco Jeanty, produced recognizably political lyrics that were distributed on records in Haiti.

The year 1980, however, was a turning point in Haitian politics. Baby Doc married Michèle Bennet, a divorcée and daughter of a disreputable, light-skinned *speculateur* (trader/speculator). The marriage contravened the wishes of the Duvalier family—including his powerful mother, Simone (Mama Doc), and grandmother—as well as his political advisors. The "dinosaurs" (old-guard Duvalierist ministers) and *tonton makout*-s considered the wedding an affront to the *négritude* principles of the late Papa Doc. To force the marriage on a resistant power structure, Baby Doc undertook the most repressive measures since his father's regime. Starting on 20 November 1980, scarcely two weeks after the election of Ronald Reagan in the U.S., Baby Doc exiled or jailed many journalists and human rights advocates and *makout*-s physically attacked a number of media organs.

The marriage alienated much of his *noiriste* support and the repression divided him from his liberal followers, and Baby Doc began to be perceived as a far more fallible figure than at any time since his teen years. Michèle's bourgeois pretensions, her million-dollar Parisian shopping sprees, and lavish state parties became legendary in Haiti. Increasingly, critics portrayed him as an indecisive character ruled by two iron-willed women of differing political outlooks: his mother and Michèle. Other problems loomed for the dictatorship. In 1981, Baby Doc signed an interdiction treaty with the United States, allowing the U.S. Coast Guard to patrol Haitian waters to interdict and repatriate Haitian nautical migrants ("boat people"). This closed off a major avenue of relief from overcrowding, joblessness, and low wages (and it slowed the growth of remittances from the emigrants to their families in Haiti, a major component of Haiti's GNP). Within two years, Baby Doc also caved into the U.S. government's fears about a possible spread of swine fever from Haiti to the U.S., and slaughtered all of Haiti's black pigs (a major source of income, savings, and food for Haiti's peasants). Tourism revenues declined precipitously after the AIDS epidemic in Haiti was publicized by the media (and at one point erroneously attributed to Haiti). The opening up of a Haitian transnational space through interchange with a Haitian diaspora concentrated in the U.S. and Canada (and through the increased incorporation of Haiti into a global political economy and information order) also contributed to the decline of dictatorial power in Haiti, breaking down the closed information space upon which most successful totalitarian regimes are based.

Between 1981 and 1985 some commercial musicians took political risks by criticizing the government, eventually aligning themselves with the movement to end the dictatorship. Haitian business pulled their patronage of carnival, leaving only the dictatorship and the mayorality of Port-au-Prince, run by *makout* Frank Romain, as sponsors. Carnival emerged as a locus for the developing

political critique of Baby Doc, his wife, and his government. Because many of the carnival songs in this period weren't recorded, I will refer in this section to a set of song texts recorded by Yves Robert Louis and interpreted in an article by Haitian journalist Jean Fragat (1989).

At the 1981 carnival, Bossa Combo, the former "orchestra of the President," ridiculed the powerful role that Michèle Bennet Duvalier had come to play already in Haiti. They sang about a woman named Janine who was driving without a license:

Janin, kote lisan-ou?	Janine, where's your license?
Janin, ou pa respèkte m	You don't respect me
Ou sou kontravansyon	You're going to get a traffic ticket
Si ou pa gen siyal	If you don't get a signal
Wa fè l ak dwèt	You'll make it with your finger
Le pouce, l'index, le majeur,	Thumb, index, middle,
L'annulaire, l'auriculaire	Ring finger, and pinky.
Ala w bon dwèt se lemajè!	What a great finger the middle finger is!

Note that Bossa Combo used French, not Creole, to name the five fingers, poking fun at Michèle's bourgeois mannerisms (with a pun on the finger gesture). The 1981 entry from D.P. Express also lampooned Michèle's power over Jean-Claude. The song was so popular that Carnival 1981 is sometimes referred to as "Carnaval Bibwon" (Baby Bottle Carnival):

Madmwazèl, wa kenbe bibwon byen	Miss, hold on to the baby bottle tight
Pou li pa cbape	To keep him from escaping
Menm si wa tonbe	Even if you fall
Kenbe bibwon pou lipa vole	Better hold the bottle so he doesn't fly away

For the 1982 Carnival, Michele was partly responsible for a luxurious stand built along the parade route with a bar, toilet, and electricity. Bossa Combo criticized the stand as a symbol of waste and excess:

Gade kijan w kite mato a glize	Watch how you let the hammer slip
Li tonbe sou dwèt w Madmwazèl woo	It falls on your finger, Miss, whoa
Se pou w di mwen	You must tell me
Ak ki bwa w fè estann sa a	With which wood did you build the stand?
Kat pa kat se byen	Four by four is fine
Wit pa wit se solid	Eight by eight is solid
Sèz pa sèz, two gwo!	Sixteen by sixteen is too big!

In 1983, Michèle was engaged in a struggle with Roger Lafontant, a minister running the country (and reputedly the *tonton makout*-s) for Baby Doc. This was the kind of tittilating Palace drama that makes for such popular carnival song texts. At carnival in 1983, Shoogar Combo sang,

Dyab pa fe dyab pè	A devil doesn't fear another devil
Gwo dyab manje ti dyab	The big devil ate the little devil
Yo kloure Toto sou lakwa	They nailed Toto to the cross
Yo foure yon paydefè sou tèt-li	They put steel wool on his head
Ala nèg inosan se Toto!	What a naive guy that Toto is!

One critic called this song "a useless blasphemy" having "no place in a carnival" *(Superstar* 1983, 9). After Michèle decisively won the battle with Jean-Claude's mother Simone, Dixie Band sang "Gwo Simone" (Big Simone): *He! Tu n'as pas de plume sur le ciboulet!* (Hey, you have no feathers on your noggin!). This song broke ground by using Simone's name and not a pseudonym. These songs accorded a certain *naiveté* to Jean-Claude. Rather than appearing as a villain, he is cast as the dupe of Michèle, his mother, or his ministers. It should be remembered that the *mini-djaz* movement reflected a middle-class perspective, and the middle class was one of Baby Doc's traditional strongholds. The breakdown in the coalition that held the dictatorship in place was a gradual one and this is reflected in a slow refocusing of the critical rhetoric upon the dictatorship itself.

As economic conditions declined and inflation rose precipitously, food riots broke out first in Gonaïves, then in Cap-Haïtien. Things became so desperate for Baby Doc in 1985, that, following the logic of carnival-as-pressure-valve, Jean-Claude offered all workers an extra two days off in order to start carnival on Friday. A common carnival expression is *"Ban nou pase"* (let us pass), from the need for *bann madigra* to make their way through the crowds at carnival. Without the direct reference to Toto, a nickname for Duvalier, the following lyrics (1985) could pass simply as an agressive and self-referential "let me pass" song. Yet here they assume an angry double entendre directed squarely at Jean-Claude, demanding that he get out of the people's way. The rapid erosion of mechanisms of control had created a situation in which a *mini-djaz* (Dixie Band) could confront the dictatorship in a carnival song.

Tonnè boule m, ban m pase!	Thunder burns me, let me pass!
Si w pa rale kò-w m ap kraze w	If you don't move I'm going to break you
Kraponnaj sa-a, mwen pa pran ladan l	I won't take this intimidation
Ma manje w wi! Ma devore w wi!	I'll eat you, yes! I'll devour you, yes!
Toto brikabrak, Cho biznis	Pawnshop Toto, Mr. Show Business
Ou son yon dasomann. Retire kò-w!	You're just a gate crasher. Get out of here!

The song content and mood of carnival 1985 carried a serious message to Jean-Claude about the steadily deteriorating base of support for his *présidence-à-vie*. The middle classes from which the *mini-djaz* arose and the destitute urban working class which formed their audience at carnival, were, for the moment, aligned. Carnival had evolved into a powerful rite of delegitimation. The danger implicit in carnival now threatened presidential security—the danger of a crowd both *anraje* and *angaje*. Jean-Claude and his family left Haiti a week before carnival 1986. He reportedly announced his decision to leave to his minister Georges Saloman saying, "The fact is, Minister Saloman, we are finished here. We must leave before carnival, before more people are killed" (Abbott 1988:324). In this report, perhaps spurious, carnival was recognized as a decisive factor in at least the timing

of Jean-Claude's departure. The timing of the departure was negotiated among the Duvaliers, their military successors, and the U.S. State Department with Col. Oliver North coordinating the effort, although the impending carnival hovered as a presence around the negotiations.

In the long, slow disintegration of the Duvalier grip on Haiti, carnival songs from both the commercial groups and the *bann apye* carved out a space for political criticism in the midst of a repressive crackdown. Like the cassette technology with which the songs were disseminated, an event like carnival is inherently "leaky," thwarting the efforts of censors and the dictatorship in general to limit public discourse. The songs could be understood only if one had access to the rumors, jokes, nicknames, and insults making the rounds at the time in what is known in Haiti as *teledjòl* (rumor mill or grapevine). The superstar popularity of the *mini-djaz* dance bands helped to insulate them from the crackdown, and guest performers from the diaspora were less concerned with ongoing implications of carnival transgressions. In addition, with songs full of metaphor, double entendre, strategic ambivalence, humor, parody and ridicule, the music of Haitian carnival in the 1980s helped to reflect—as well as sculpt—an emerging anti-Duvalier concensus.

"We're Not Afraid This Year"

Although the people's movement that resulted in Duvalier's exile was co-opted at the highest level by the military junta, the struggle against Duvalierism continued. The opposition adopted the agricultural term *dechoukay* (uprooting) to describe the many efforts to rid the country of the roots of the dictatorship, including tearing up the houses of leading *makout*-s, sacking official *makout* headquarters, and murdering known and suspected *makout*-s. In the cultural and ideological realm, the opposition sought to rid the country of attitudes that were predisposed to dictatorship and to plant democratic ideals and cooperative ethics. During *dechoukay,* many progressive artists and *mini-djaz* released albums to lend support to (and often to counsel) the movement for cultural uprooting.

Carnival was cancelled for three years under the military dictatorships (and their civilian partners) because of its potential to facilitate popular unrest. Falling each year soon after the 7th of February, the anniversary of Baby Doc's exile that was enshrined by the 1987 Haitian Constitution as the date for presidential inaugurations, carnival time has come to symbolize the fall of Duvalier.

Anti-Duvalierist forces called for the military to "*rache manyòk*" ("pull up their manioc fields," a term from agricultural tenancy, here meaning "end your tenancy in power before elections are held"). Instead the military held on, sabotaged the work of the electoral commission and engineered an election-day massacre that led to a suspension of the electoral process. In a second election, they installed a hand-picked candidate, who was soon overthrown by General Henri Namphy after the new president tangled precipitously with the military.

To consolidate his power regionally, General Namphy adopted an old Duvalier tactic, the high-visibility tour of the country. At each stop, while local leaders paid homage to Namphy, *koudyay*-s were held, organized and financed by the military, with carnival and *rara* bands carrying signs echoing pro-military graffiti, "*Anba KEP, Viv Lame!*" (Down with the Provisional Electoral Commission, Long Live the Army). This *tournée,* with each stop broadcast nightly on government television, alarmed many even among the military's supporters. Soon after, General Namphy was overthrown in a *coup d'état* that installed General Prospère Avril, another former associate of Duvalier. As part of a stabilization program leading to elections, Avril decided to reinstate carnival, and the state organized a carnival of "*fraternité.*" On the street, however, the indisputable carnival theme was *dechoukay,* hardly an issue of "*fraternité.*" The most popular song among *bann apye*-s was about the

dechoukay of the wealthy Schiller family, which had been in response to the sacking of Father Jean Bertrand Aristide's church. Thus, carnival was dominated by the counter-theme of class warfare and continuing *dechoukay*, a reading from the bottom up that eclipsed the meanings offered by the government. The dark mood of the year was also reflected in the rumor that *zenglendo*-s (literally "broken glass," a term for dangerous criminal gangs that appeared after the fall of Duvalier and that included many *ex-makout*-s) would be circulating at carnival with AIDS-infected syringes.

By 1990, the increasing maturity of the peasant organizations, unions, the *ti-legliz* (the "little" church, or Catholic liberation theology movement in Haiti), and other popular organizations had laid a groundwork upon which a new, more concerted, assault on state power could take place. The momentum and consensus for this kind of change were heated in the 1990 carnival by a band named Boukman Eksperyans (the name is a reference to a revolutionary slave leader). As cultural *dechoukay* had taken hold, the audience grew for neo-traditional popular musics incorporating influences from Vodou and from peasant *rara* celebrations. The music of rara bands and some carnival *bann apye*—fast, topical, and exuberantly danceable (and sung over a ground of hocketed bamboo trumpets and tin horns)—was adapted to commercial *mereng kanaval*. By the 1990 carnival, Boukman Eksperyans had already established themselves as the leading figures in this movement (see Averill 1994 on the *mizik rasin* or roots music movement). The movement had Afrocentric and Rastafarian influences and heralded a move by some urban progressives and intellectuals to form alliances with the peasantry and urban proletariat.

Boukman Eksperyans captured widespread resentment at the oppressive military junta and the political elite in a neo-*rara* song called "Kè-m Pa Sote" ("My Heart Doesn't Leap" or "I Am Not Afraid," *Vodou Adjae*, Mango Records 162–539 899–2):

Gade sa nèg yo fè mwen	Look what those guys do to me
Sanba san m ap koule	My blood is running, sanba
Yo ban m chay-la pote	They give me a burden to carry
M pa sa pote l...	I'm not going to carry it...
Kè m pa sote wo, kè m pa sote wo	My heart doesn't leap, I'm not afraid
Kè m pa sote ane sa	I'm not afraid this year
Boukman nan kanaval, kè m pa sote wo...	Boukman is in Carnival, I'm not afraid...
Avanse, pa frape nan bann lan!	Let's advance, don't hit others in the band!

The *sanba* they speak of is a word for a traditional peasant song leader. The last line uses the carnival throng (the band) once again as a metaphor for popular forces in the country, urging unity and persistence. The song was popularized, picked up by *rara* bands and carnival *bann apye*-s—in Haiti and in the diaspora—helping to galvanize opposition to the government. It was the most talked-about cultural development in some years in Haiti and it thrust the middle-class Vodou-rock band into the political limelight. The principal issue dominating carnival preparations was whether (and where) Boukman would play in carnival. The *mini-djaz* Scorpio offered part of their space if it would get Boukman onto a carnival stage. The mayor's office pleaded money problems and suggested they appeal to the mayor of Delmas (a district in Port-au-Prince), and the northern city of Cap-Haïtien tried to lure Boukman north for carnival. The government, the mayor's office, and corporate sponsors (SOGEBANK, le Ciment d'Haïti) negotiated under intense public pressure to get a spot for Boukman Eksperyans at the last minute.

Although Avril had vacillated, oddly unsure as to whether "Kè-M Pa Sote" was an anti- or pro-Avril composition, the popular use of the song in the weeks following carnival apparently caught him and his government by surprise (Interview: Beaubrun 1991). "Kè-M Pa Sote" became the theme song of the anti-Avril general strike a week after carnival, during which thousands marched on the National Palace to demand that the military step down. In the face of an obstinate popular movement, the U.S. brokered a compromise whereby General Avril left in favor of a caretaker government headed by Justice Ertha Pascal Trouillot. Once again, carnival and carnival music had played an integral role in the overthrow of an unpopular government. The caretaker Trouillot government promised to hold democratic elections in the fall of 1990 under international supervision. With this opening, and in the face of the candidacy of *makout* leader Roger Lafontant, popular forces rallied around priest Jean-Bertrand Aristide in a movement that became known as *Lavalas* (Deluge).

Certain intertextual relationships were established between Lavalas themes and the Boukman Eksperyans song of the previous carnival. Whereas Boukman Eksperyans complained in the song that "*Chay-la lou wo!*" (the burden is too heavy), the Lavalas campaign employed the peasant aphorism "*Men anpil, chay pa lou*" (with lots of hands, the burden isn't heavy). Boukman Eksperyans' "*Kè-m pa sote woy!*" (We're not afraid) was transformed into inaugural banners, "*Kè-m pa sote ak Titid*" ("We're not afraid with Aristide"). Moreover, the newfound importance of neo-*rara* songs as condensation symbols of populist sentiment led to a profusion of *rara* election jingles.

Carnival 1991, organized by the incoming Aristide administration (but financed by an act of the previous government) was dubbed "Carnaval Chanjman" (Carnival of Change). Women swept the city clean, decorations were hung from houses and over the streets of the capital, and Aristide's image and his symbols appeared everywhere. Chief among these was the *kòk kalite* (fighting rooster) which was widely pictured in mural art besting a *pintad* (guinea hen, the symbol of Duvalier). A new *mizik rasin* band called Koudyay (note the carnivalesque name) produced the most popular *mereng kanaval*, a neo-*rara* called "Manman Poul La" ("Chicken Mama"), the theme of which depended on this same avian symbolism:

Manman poul la	The chicken mama
kite pintad la antre nan twou yo	let the guinea hen into the holes
Pou li vin ponn nan kolòj poul la...	To lay an egg in the chicken's cage...
Manman poul la Trouillot, manman poul la	Chicken mama Trouillot, mama chicken
Gade pintad ou kite antre nan kòlòj nou	Look at the guinea hen you let into our cage

The "chicken mama" was Ertha Pascal Trouillot, provisional president of Haiti during the elections. The term manman poul refers to someone who is gullible: a fool. The use of chicken also signifies that Trouillot was neither a *pintad* (Duvalierist) nor a *kòk kalite* (Lavalasienne, Aristide supporter), but something in between. This derives from the popular belief that she tolerated widespread corruption and was unwilling to make a clean break with Duvalierist politics. A month before Aristide's inauguration, *tonton makout* Roger Lafontant had led an unsuccessful coup in which he briefly took over the palace and held Trouillot prisoner. Many Aristide supporters believed that Trouillot was somehow implicated in the coup. The reference to the cage in "Manman Poul La" is a reference to the Lafontant coup, to the *pintad* that entered into "our cage" (the National Palace). There is an additional obscene reference concerning the *pintad* that entered *twou yo* (the holes) in that the Creole pronunciation of *twou yo* is identical to that of Trouillot, the President's family

name. The masses passed their own judgement on the Trouillot presidency at carnival. Picking up on the lyrics of "Manman Poul La," singers in the *bann apye*-s substituted *manman kaka* (shit mother) and *manman bouzen* (whore mother) in the song's chorus to criticize her alleged sell-out to the bourgeoisie and rumored complicity in the coup.

The themes of the floats (most of them paid for by the City at $5–7,000 apiece) closely reflected the program and ideology of the new government. The floats included Negrye (Black Experience), Bwa Kayman (where Haitian slaves first plotted their rebellion against the French colonists), Charlmay Peralt (Charlemagne Peralte, a rebel leader against the American Occupation), Participation (one of Aristide's campaign themes), and, of course, a rooster guarding a guinea hen prisoner. The most prominent commercial float, a giant chicken advertising Maggi bouillon, became an unintentional focal point for anti-Trouillot ("Manman Poul La") ridicule.

The military coup against Aristide on 30 September 1991 installed a military-civilian *de facto* government and ushered in a tide of repression against supporters of Aristide. Manno Charlemagne, a political folk singer was arrested by the military twice. Boukman Eksperyans concerts were disrupted by gun-toting men in civilian clothes who forbade them to sing "Kè-M Pa Sote." In response, Boukman Eksperyans, employing the powerful image of the crossroads as a place of judgement in Vodou theology, produced a song for the 1992 carnival called "Kafou Danjere" ("Dangerous Crossroads," *Kalfou Danjere*, Mango Records 162-539 927-2). The song listed various types of transgression that would be met with divine retribution.

Magouye, ou chaje ak pwoblèm	Cheater, you'll be in deep trouble
Nan kalfou, kalfou nèg Kongo	At the crossroads of the Congo people
Ou manti, ou chaje ak pwoblèm	You who lie, you'll be in deep trouble
Nan kalfou, kalfou nèg Kongo...	At the crossroads of the Congo people...
Si w se asasen rale kòw...	If you're an assassin, get out of here...
Woy men moun yo	Woy here are the people
Se bann Boukman kap pase la	The Boukman entourage is passing
Woy men moun yo	Woy here are the people

The lyrics concerning the Boukman entourage reinscribe the carnival band as a metaphor for the people. In the video that accompanied the release of this song, Boukman Eksperyans created their own carnival *bann apye* that danced through the streets, stopped for ceremonies at crossroads and enacted a confrontation with a group of *tonton makout*-s. The video and song were banned from play on the national media, and the band was denied a place in carnival. Despite their absence from official carnival, their song went on to become the *cause célèbre* of "Carnaval de la Fraternité" in 1992.

Conclusion

Haitian carnival itself wears many masks. It is unlike Bakhtin's carnival, which is an idealized type "outside of and contrary to all existing forms of the coercive socioeconomic and political organization, which is suspended for the time of the festivity" (Bakhtin 1984, 255). Rather, Haitian carnival takes place in real spaces permeated with existing power structures. Carnival is understood in the Haitian milieu as an aesthetic form of politics, contradicting Frank Manning's assertion that "carnival remains, *sui generis*, an artistic event, not a political one" (1991, 60). Carnival is a

drama with an annual political tally sheet in the public's imagination (*"bilan"* or "tally" is a term commonly associated with carnival in Haiti). After Ash Wednesday, the tally is added up: How many were wounded? Did business participate or boycott? Did the government organize and finance carnival well? Was the excitement overflowing? Was the mood of the crowd for or against the government? What bands came out on top? Who was skewered in carnival songs? All of these are political questions in the broadest sense, related to the distribution and regulation of power and control.

Carnival music comes into play as part of a chaotic soundscape. Carnival groups are rarely silent. In the densely packed streets of Haitian carnival, bands can always be heard before they are seen, and sonic projections overlap at any point in carnival time and space. More than any other medium, music is the means by which groups represent and signal their collectivity; music is the acoustic projection of their size, unity, and power. Music establishes the existence of not only the groups, but of carnival itself. The preponderance of *mereng kanaval*-s everywhere (via radio and cassette) in the weeks leading up to carnival builds anticipation for carnival and instills in the urban populace the ambience of ecstatic celebration that sets carnival apart as a special frame of activity in the Haitian calendar.

Carnival music functions on an ideological level. The audience demands that carnival lyrics respond to the passions of the moment and artists attempt to anticipate the mood of the audience at carnival. Among the masses, judgements take shape at carnival. Urban Haitians listen to carnival entries to seize on the one that best expresses the national *zeitgeist*. People persuade their friends; *bann apye* adopt songs and change them to suit their needs (or compose their own); and slowly the attention of the masses focuses in on images and texts that become the most memorable features of that year's carnival. The music of Haitian carnival constitutes a public discourse with the potential to hone popular consensus. Although the songs should not be read as unmediated expressions of popular sentiment (they reflect the play of political and commercial strategies), they are important as condensations of popular outlook in a situation of widespread illiteracy and political repression that restricts channels for this type of discourse. Because of their distinct aesthetics, *mereng kanaval*-s are largely resistant to commercialization and to crossing over into other markets; they constitute a particular moment in Haitian cultural production that is still event-bound and temporally-specific.

Does carnival's exuberance consistently benefit the interests of one or another class in Haiti? Characterized by the mobilization of tens of thousands of lower class Haitians and by its exuberant modes of celebration, carnival contains the seeds of rebellious action and can be – *under the proper historical and social circumstances* – a springboard for lower class rebellion. Carnival becomes a lesson in popular power. A crowd that is *anraje* and in control of the streets displays to itself and to the authorities its own power and revolutionary potential. For this reason, though, carnival is the focus for a concerted effort by the establishment to limit symbolic expression and contain popular discontent. Carnival, although it enables lower class solidarity and mobilization, becomes a site of contest for symbolic mastery and not an *a priori* expression of any single class interest. Carnival bodies and their pleasures, unfortunately, are subject to the same co-optations by power regimes as other human domains.

Notes

1. This paper is based on research carried out between 1987 and 1993 in Haiti and in Haitian communities in Miami and New York. I am greatly indebted to the Mellon Fellowships in the Humanities which supported much of this work. An additional carnival research residency in Haiti was funded by Wesleyan University Grants in Support of Scholarship. Research for this article included: over fifty interviews with Haitian musicians, industry personnel, and carnival participants; archival research on Haitian daily newspapers from 1934 to the present and Haitian weeklies in the United States since the early 1970s; participation as a *vaksin* (bamboo trumpet) player in a Haitian carnival band in the Caribbean Carnival in Brooklyn (1990) and as a bell player in a neighborhood carnival band from Bel-Aire, Port-au-Prince (1991); participant observation and video documentation of carnivals from 1990–92; and examination of available sound recordings and their texts for the relevant periods. Early versions of this paper were presented at a meeting of the Latin American Studies Association in Miami, at Columbia University and at Wesleyan University. I would like to thank T. M. Scruggs, Christopher Alan Waterman, Dieter Christensen, Mark Slobin, Alex Dupuy, Giovanna Perot-Averill, Lydia Goehr, David Yih, and the graduate students at the Columbia University Center for Ethnomusicology and the Wesleyan University World Music Program for their comments. All translations herein from French and Creole are my own.

2. The French term *engagée*, the source of the Creole *angaje*, was widely used throughout the Francophone world to categorize socially concerned musics in the wake of the revolutionary movements of the 1960s.

3. The -*s* added to the Creole word *madigra* denotes a plural and is the convention I employ throughout this article. In Haitian Creole, the plural signifier *yo* (also "they," "them," "theirs") would serve this function, but I have opted for the -*s* for better comprehension in English. In general, I employ the Creole orthography known as the IPN system (from the Institut Pédagogique National d'Haïti).

4. Fragat reports that the G.B. in the name Otofonik G.B. may stand for Grande Bretagne, the source of most 78 rpm recordings at the time, *gwo bouzen* (big prostitute), or an obscure Masonic reference (Masonry is popular among the Haitian elite and its symbols and mysteries have been incorporated in popular or "folk" forms into Vodou) (1986).

5. The term *mereng kanaval*, synonymous with *mereng koudyay*, does not necessarily identify the composition stylistically as a *mereng*, a creolized section of the French *contredanse* that evolved into a couple dance in post-independence Haiti and was later incorporated into elite parlor and art musics. Dubbed the "national" dance rhythm of Haiti, it was structurally quite similar to the Cuban *danzòn* and Dominican *merengue*, with which it may share historical provenience (Fouchart 1988). In a looser use of the term, *mereng* can refer to any secular peasant-style song. Jean Fouchard states that the *mereng koudyay* evolved out of fast, celebratory songs of Haitian soldiers that celebrated military victories and were later adopted by carnival groups that were, themselves, militaristic or at least highly competitive (1988:38–9). *Mereng kanaval* has continued as the inclusive term for all carnival compositions, despite the fact that later compositions were essentially fast *konpa-s*, *mini-djaz konpa-s*, or roots music neo-*rara-s*. I will use *mereng kanaval* in the broader sense throughout this article, regardless of a composition's style or structure.

6. For example, the 1962 Committee (with bandleader Raoul Guillaume and the composer Antalcidas O. Murat of the neo-traditional big band, Jazz des Jeunes) decreed that *mereng kanaval* should be in 2/4 meter, quick (*allegro furioso*), formed of at least two phrases of eight measures apiece, in a Vodou rhythm known as Petwo-Mazonn, in major or minor modes, and that texts should not affront manners nor morals (*Nouvelliste* 1962b).

7. In the Haitian military tradition, a *koudyay* was one of the three types of fife, drum, and bugle corps, which played specifically at celebratory events. These events—and their music—also became known as *koudyay*.

8. This conflict of carnival aesthetics is parallel to the conflicts of taste mapped onto class by Pierre Bourdieu in which images of strength, dirt, and disorderly deportment mark the "natural body" of working class tastes and the source of bourgeois and petite bourgeois revulsion (1984). In Haiti, class aesthetics are reinforced by the idealized Europhile outlook of the upper classes. For a discussion of class and race in Haitian music, see Averill 1989.

9. It is impossible to detail the political history of the Duvalier reign in a short article devoted to music and carnival. The reader is directed to any of the better popular histories (Diederich and

Burt 1986; Heinl and Heinl 1978; and Abbott 1988) and academic treatments (Nicholls 1979; and Trouillot 1990) of this period. Michel-Rolph Trouillot, especially, explores the relationship between popular consent and official coercion under Duvalier. A number of works on Haitian political economy and development contextualize the dictatorship and explore its ideology and practice, such as Bellgarde-Smith 1990, Dupuy 1989, Fass 1990, Nicholls 1985, and Lundahl 1983.

10. Duvalier's mystic number was 22. He was elected on 22 September, and he timed many of his important political events to fall on the 22nd of the month. After his death (21 April 1971) his son was installed as President for Life on 22 April.

11. Yaws is a syphilitic disease that was common in the Haitian countryside and that resulted in gaping sores on the bodies of the afflicted. Duvalier had participated in a U.S.-sponsored campaign to eradicate yaws in Haiti.

12. *Ochan* appears to have come from eighteenth-century French military signal drummers who named a rhythm after the battle cry *"aux champs"*("to the fields," equivalent to "forward march"). David Yih examines a variety of contemporary *ochan* performances and details the military influence on Haitian Vodou (1994).

13. The polemic was often explained using a Haitian proverb, *De kòk kalite pa ka rete nan menm lakou* (Two fighting cocks can't stay in the same courtyard). I follow Haitian popular convention when abbreviating the names of the band leaders. Wéber Sicot is always referred to by his family name, while Nemours Jean-Baptiste is called by his given name; thus, Nemours and Sicot.

14. The album that this song appeared on, "David" (Superstar Records SUP-111), is regarded by many as an opening salvo by commercial musicians in the battle with Duvalierism, and it helped to establish Ti-Manno, lead singer of D.P. Express, as Haiti's most prominent musical dissident.

References
Abbott, Elizabeth. 1988. *Haiti: The Duvaliers and Their Legacy.* New York: McGraw Hill.
Averill, Gage. 1989. "Haitian Dance Bands, 1915–1970: Class, Race, and Authenticity." *Latin American Music Review* 10 (2): 203–35.
———. 1993. "Toujou Sou Konpa: Issues of Change and Interchange in Haitian Popular Dance Music." In *Zouk: World Music in the West Indies,* edited by Jocelyne Guilbault. Chicago: University of Chicago.
———. 1994. "'Se Kreyòl Nou Ye' (We're Creole): Musical Discourse on Haitian Identities." In *Music and Black Ethnicity in Latin America and the Caribbean,* edited by Gerard H. Béhague. New Brunswick, NJ: Transaction.
Bakhtin, Mikhail. 1984. *Rabelais and his World.* Cambridge: MIT.
Barthes, Roland. 1975. *The Pleasure of Text.* New York: Hill and Wang.
Bellgarde-Smith, Patrick. 1990. *Haiti: The Breached Citadel.* Boulder and London: Westview.
Boncy, Ralph. 1991. *La Chanson d'Haïti, Tome 1(1965-1985).* Montreal: Le Centre International de Documentation et d'Information Haïtienne, Caraïbéene.
Bourdieu, Pierre. 1984. *Distinction: A Social Critique of the Judgement of Taste.* Cambridge: Harvard University.
Corvington, Georges. 1987. *Port-au-Prince au Cours des Ans: La Capitale d'Haïti sous l'Occupation, 1922–1934.* Port-au-Prince: Imprimerie Henri Deschamps.
DaMatta, Roberto. 1991. *Carnivals, Rogues, and Heroes: An Interpretation of the Brazilian Dilemma.* London: University of Notre Dame.
de Certeau, Michel. 1984. *The Practice of Everyday Life.* Berkeley: University of California.
Diederich, Bernard, and Al Burt. 1986. *Papa Doc and the Tonton Macoutes.* Port-au-Prince: Editions Henri Deschamps.
Dupuy, Alex. 1989. *Haiti in the World Economy: Class, Race, and Underdevelopment Since 1700.* London: Westview.
Eagleton, Terry. 1981. *Walter Benjamin: Towards a Revolutionary Criticism.* London: Verso.
Falassi, Alessandro. 1987. "Festival: Definition and Morphology." In *Time Out of Time: Essays on the Festival,* edited by Alessandro Falassi. Albuquerque: University of New Mexico.
Fass, Simon M. 1990. *Political Economy in Haiti: The Drama of Survival.* London: Transaction.
Fiske, John. 1989. *Understanding Popular Culture.* Boston: Unwin Hyman.
Foucault, Michel. 1978. *The History of Sexuality, Volume I: An Introduction.* New York: Vintage Books.
Fouchard, Jean. 1988. *La Meringue: Danse Nationale d'Haïti.* Port-au-Prince: Editions Henri Deschamps.
Gross, Bertram. 1980. *Friendly Fascism: The New Face of Power in America.* New York: M. Evans.

Guillermoprieto, Alma. 1990. *Samba*. New York: Vantage Books.

Heinl, Robert Debs, and Nancy Gordon Heinl. 1978. *Written in Blood: The Story of the Haitian People, 1492–1971*. Boston: Houghton Mifflin.

Hill, Errol. 1972. *The Trinidad Carnival: Mandate for a National Theatre*. Austin: University of Texas.

Hill, Errol, and Roger Abrahamson. 1988. "West Indian Carnival in Brooklyn." *Natural History* 88:73–85.

Kertzer, David I. 1988. *Ritual, Politics, and Power*. New Haven: Yale University.

Kinser, Samuel. 1990. *Carnival American Style: Mardi Gras at New Orleans and Mobile*. Chicago: University of Chicago.

Lipsitz, George. 1990. *Time Passages: Collective Memory and American Popular Culture*. Minneapolis: University of Minnesota.

Lundahl, Mats. 1983. *The Haitian Economy: Man, Land, and Markets*. New York: St. Martin's.

Manning, Frank E. 1990. "Overseas Caribbean Carnivals." In *Caribbean Popular Culture*, edited by John Lent. Bowling Green: Popular Press.

Mirville, Ernst. 1978. *Considérations Ethno-psychoanalytiques sur le Carnaval Haïtien*. Port-au-Prince: Collection Koukouy.

Marcus, George E. 1986. "Contemporary Problems of Ethnography in the Modern World System." In *Writing Culture: The Poetics and Politics of Ethnography*, edited by James Clifford and George E. Marcus. Berkeley: University of California.

Moore, Sally F., and Barbara Meyerhoff, eds. 1977. *Secular Ritual*. Seattle: University of Washington.

Nicholls, David. 1979. *From Dessalines to Duvalier: Race, Color, and National Independence in Haiti*. Cambridge: Cambridge University.

———. 1985. *Haiti in Caribbean Perspective: Ethnicity, Economy, and Revolt*. New York: St. Martin's.

Nunley, John W. 1988. "Festival Diffusion Into the Metropole." In *Caribbean Festival Arts*, edited by John W. Nunley and Judith Bettleheim. Seattle: University of Washington.

Parker, Richard D. 1991. *Bodies, Pleasures, and Passions: Sexual Culture in Contemporary Brazil*. Boston: Beacon.

Spitzer, Nicholas Randolph. 1986. *Zydeco and Mardi Gras: Creole Identity and Performance Genres in Rural French Louisiana*. Ph.D. Diss., University of Texas at Austin.

Trouillot, Michel-Rolph. 1990. *Haiti, State Against Nation: The Origins and Legacy of Duvalierism*. New York: Monthly Review.

Warner, Keith Q. 1985. *Kaiso! The Trinidad Calypso: A Study of the Calypso as Oral Literature*. Washington: Three Continents.

Williams, Raymond. 1977. *Marxism and Literature*. London: Oxford University.

Yih, David. 1994. *Music of Haitian Vodou*. Ph.D. Diss., Wesleyan University.

Permission to reprint lyrics to "E,E,E,E,E" by D.P. Express from the album *Konbit: Burning Rhythms of Haiti* (A&M Records SP 5281) granted by Fred Paul, Mini Records.

Black Music in a Raceless Society: Afrocuban Folklore and Socialism

Robin Moore

> The existence and character of a civilization are located in its cultural forms, and in their capacity to influence others. Cuban blacks have been fundamentally influential in both senses. On the one hand they created, through music, the nucleus of our national culture. On the other, they have influenced the world with it, making Cuba famous and leaving their mark on cultures abroad.
>
> Enrique Patterson, "Cuba: discursos sobre la identidad"

Introduction

Throughout the Americas, the expressive forms of African descendants have proven central to the emergence of distinct regional and national identities. Slaves brought forcibly to the New World had no choice but to adapt to radically new social conditions, forms of labor, and language. While in many cases they perpetuated traditions brought with them across the Atlantic, it is not surprising that, in their new environment, Afrocubans were among the first to fashion a distinct cultural sensibility by fusing elements from their past with the practices of their colonial masters.[1] Following abolitionist and independence movements in the nineteenth century, postcolonial leaders of all backgrounds learned (slowly) to embrace the culture of African descendants as symbols of local heritage. Nowhere is this more the case than in Cuba, where nationalist discourse since the late 1920s has described African-influenced music as representative of everyone. Folkloric traditions of many sorts exist in Cuba, but the most influential and widespread for centuries have been those of African origin. Perhaps for this reason the term "folklore" there is now synonymous with "Afrocuban folklore."[2]

Since the mid-nineteenth century, virtually all innovations in Cuban music have come from the Afrocuban community. The wealth of their expression has served as inspiration for numerous commercial genres such as the *son*, conga, chachachá, and mambo. These styles demonstrate European influences, yet also incorporate sub-Saharan African elements in tangible ways. The formal structure of such music consists largely of repeated, ostinato-like vamping. Musical interest is created through a process of layering melodies; the inter-locking instrumental figures, together with accompanying percussion, create patterns that serve as a basis for improvisation. Formal organization of this sort bears striking similarities to traditional music from countries such as Ghana and Nigeria.[3] One might describe the development of all Cuban music from the nineteenth century onward as involving movement away from strophic, sectional, European-derived models and toward cyclic, improvisational, African-derived forms.

The decades immediately prior to the Cuban Revolution witnessed an increasing prominence of black, working-class performers in commercial entertainment, most of whom grew up playing folkloric music of various sorts (Valdés Cantero 1986, 22, 44). For these individuals, music

Reprinted with permission from *Cuban Studies* 37, no. 1 (2006): 1–32.

making represented one of many job skills that frequently included agricultural labor, construction, carpentry, or cigar making. Many lived in poorer, segregated neighborhoods and struggled to make ends meet. Even the most successful — Chano Pozo, Sindo Garay, María Teresa Vera — were often functionally illiterate. Yet their very social marginality and lack of access to formal education seems to have led to the development of oral and performative skills fundamental to the appeal of popular musicians. Percussionists on conga drums not only found a place within dance bands in the 1940s and 1950s, but became featured soloists in their own right for the first time. Candido Camero, Armando Peraza, Chano Pozo, Mongo Santamaría, Carlos "Patato" Valdés, and a host of others achieved artistic acclaim on instruments that had been widely spurned only a few decades earlier.

Paradoxically, the colonial legacy also perpetuated strong bias against noncommercial drumming and African-derived religious music. Middle-class audiences of the 1950s, while arguably proud of their country's mixed ethnicity in the abstract, dismissed African-derived traditions as primitive. Beginning in 1959, Castro's revolutionaries changed this dynamic for the better in a number of respects by creating more opportunities for folkloric ensembles and establishing centers for the study of Afrocuban heritage. Black working-class dance bands and singers of popular music achieved unprecedented levels of national exposure as part of the same trend. By the same token, biases inherited from earlier decades continued to affect cultural programming, especially related to noncommercial drumming. One might argue that Marxist philosophy itself also contributed to ambivalence toward folklore, at least in its traditional form. While one of the avowed aims of socialists has been the preservation of traditional music, such expression is often "ethnic, regional and conservative," traits at odds with the emergence of a united international proletariat (Silverman 1983, 55).

This essay provides an overview of traditional Afrocuban drumming and dance ensembles that gained prominence after 1959, foregrounding the activity of folk musicians in the 1960s. Later sections describe decreasing opportunities for such performance, and then a resurgence of drumming events in formal, staged contexts. Analysis focuses primarily on secular traditions rather than sacred repertoire,[4] and addresses limits the revolutionary leadership has imposed on the dissemination of Afrocuban folklore and the discussion of racial concerns.

The Cultural Legacy of the Republic in the Revolution

Any study of Afrocuban folklore and its place in revolutionary society must begin with an appreciation for controversies surrounding it before 1959. Afrocuban studies since its inception has been mired in racism and cultural misunderstanding of the worst sort. Writings of the Cuban Anthropological Society from the late nineteenth century, for instance, suggested that blacks and mulattos belonged to an inherently inferior race and questioned whether it was worth the trouble to educate them (León 1966, 5–6). Members regularly exhumed black bodies from graveyards in order to support theories of racial superiority through the measurement of skulls and cranial cavities. The prominence of Afrocuban soldiers in the War of Independence (1895–1898), together with the efforts of political leaders such as José Martí, Rafael Serra, and Juan Gualberto Gómez, brought an end to openly racist discourse of this sort. Nevertheless, elite society remained decidedly anti-African, as was manifested in attitudes toward culture. Newspapers such as *La Prensa* stated in the 1910s that the nation was doomed to failure as long as it tolerated, among other things, rumba and African-derived dances (Pappademos 2003, 1). Many percussion instruments studied by scholars Jesús Castellanos (1879–1912) and Fernando Ortiz (1881–1969) came from police stations where they had been confiscated in campaigns to rid the island of "degenerate" cultural practices.[5] African

labor had provided the economic foundation for the Republic, but in the twentieth century Cubans went to considerable lengths to purge African elements from national expression (Carbonell 1961, 12).

Middle-class Cubans even in the 1940s and 1950s considered Afrocuban folklore distasteful (Ortiz García 2003, 701). Few ever went to see performances of rumba, *makuta*, or *yuka* drumming in black neighborhoods, let alone religious events. Researchers who took an interest in Afrocuban arts did so in isolation from the public and largely at their own expense. Ortiz supported ongoing work through his law practice; Lydia Cabrera (1899–1991) eventually found a benefactress, María Teresa Rojas, who supported her.[6] José Luciano Franco (1891–1988) wrote on Afrocuban history while employed as a journalist and city administrator. Rómulo Lachatañeré (1909–1951) eventually immigrated to the United States in the 1940s because of his interest in pursuing research on Afrocuban culture and the difficulty of supporting himself while doing so in Cuba. With the exception of Lachatañeré, the study of Afrocuban culture remained in the hands of white Cubans. The black working class did not have the educational preparation or economic means to promote their own expressive forms. Black middle-class writers on the whole distanced themselves from stigmatized African-influenced culture and instead embraced European arts.

Few courses on Afrocuban history or culture could be taken at the University of Havana prior to 1959, and virtually none constituted required courses. Ortiz offered occasional summer seminars on Cuban ethnography beginning in 1943, however, which included Afrocuban subjects (Barnet 1983, 132). Students in the first of these included composers Gilberto Valdés (1905–1971) and Argeliers León (1918–1991) as well as Isaac Barreal (1918–1994), later a researcher in the revolution's Institute of Ethnology. Toward the end of the 1940s, León himself offered courses on Afrocuban music, as did others. Elective seminars of this sort continued into the 1950s, but with chronically low enrollment.[7] They had a limited impact because mainstream students considered them a waste of time, as they did history courses with Afrocuban content offered by José Luciano Franco.

Very little Afrocuban drumming or song could be heard or seen in the mass media prior to 1959. This was symptomatic of racial barriers that pervaded Cuban society. Most citizens of color attended poorly funded public schools; a significant number never graduated high school, dropping out early in order to support themselves and their families. Afrocubans represented less than 10 percent of all university graduates in every field in the midcentury, despite constituting roughly one-third of the total population (de la Fuente 1995, 151). Those who managed to educate themselves and enter the professions received lower salaries than their white counterparts.

In the first months after 1959, the revolutionary leadership began to address these problems. Legislation in February 1959 mandated the desegregation of all neighborhoods, parks, hotels, cabarets, and beaches (Serviat 1986, 164). Both Fidel Castro and Ernesto Guevara made strong statements against racism, especially as it affected access to employment. Beginning in January 1960, the Ministry of Labor began to oversee the hiring of employees in order to ensure that positions were distributed fairly to blacks and whites.[8] The government took possession of private homes abandoned by exiles and reassigned them to poorer, frequently black or racially mixed families. Changes such as the lowering of utility rates and rental prices, the national literacy campaign, and the creation of free medical clinics benefited the Afrocuban population disproportionately in tangible ways. Over time, these policies contributed to a decline in racial inequality as manifested in key social indicators such as life expectancy, infant mortality, and educational levels. As a result, working-class Afrocubans tended to be among the most enthusiastic supporters of the revolution.

Yet despite their beneficial effects, the new racial policies proved controversial. The desegregation of private clubs and recreational areas caused an outcry among white professionals, many of whom had no desire to mingle with Cubans of color. Perhaps realizing that he had underestimated the divisiveness of the issue, Castro backpedaled on initial statements and avoided the subject. The campaign against racial inequality of 1959 and 1960 soon disappeared from the media and did not surface again for over twenty years. Few Afrocubans found positions in the new government, further limiting public discussion about race.[9] Leaders clearly wished to improve the social conditions of the Afrocuban population, but did not immediately cede its members any political authority. On the contrary, they forbade them to organize interest groups based on race. The government allowed Afrocubans to express opinions as students or through professional associations, "but never as blacks, the social construct within which they were most vulnerable to discrimination" (Patterson 2000, 8).

The closing of the *sociedades de color* in 1962, while well intended, resulted in the loss of one of blacks' few spaces for socializing and independent discussion. *Sociedades de color* had been important not only as centers for social activity, but also for musical performance and instruction. Most dance band musicians of the 1950s did not learn their art in conservatories, but rather from family and friends in relatively informal venues such as these (Neustadt 2002, 143). Societies of Spanish descendants as well as those of Jews and Arabs did not suffer the same fate, though their buildings and assets also came under state control (Patterson 1996, 64). The Centro Gallego, for instance, passed into government hands and was known thereafter as the Sociedad de Amistad Cubana-Española.

Those interested in promoting greater awareness of racism found their efforts hampered as the result of the militarized state of the nation following the Bay of Pigs attack; for some time, officials equated the discussion of such problems with criticism of the revolution. They feared that assertions of racial difference might be used by enemies to divide the Cuban people and thus discouraged the study or projection of a distinct Afrocuban identity. Writers hoping to use revolutionary society as a vehicle for rethinking Cuba's history – to revisit the brutality of the slave trade, the importance of figures such as José Antonio Aponte, or the Guerrita del Doce – thus found little opportunity to publish. Blacks and mulattos continued to find themselves at a "frank disadvantage" in many white-collar professions and facets of the entertainment industry such as radio, television, and acting (Prieto 1996). Those promoting Afrocuban folklore encountered similar limitations. Reynaldo Fernández Pavón suggests that socialism strives to create a type of citizen who sheds individual differences and is converted into "a social entity for and with the socialist cause, a single undivided mass."

> When the leadership is faced with expressions of ethnic identity among various groups that are manifest in folklore, they view them as something that must be eliminated or erased because they demonstrate difference, and the leadership doesn't know how to manage such difference.[10]

Afrocuban Arts in the Early 1960s

The revolutionary government has always recognized Afrocuban arts as a repository of Cuba's unique character, a powerful populist symbol of the nation. It knows they are among "the most authentic creations of the masses" and have served historically to represent their interests (Martínez Furé 1979, 259). For this reason, Afrocuban drumming has always received promotion through folklore troupes and recordings and has been the focus of some academic study. The government recognizes that support from the black community is crucial to the success of the revolution, and

that valorization of its artistic forms contributes to that end. Castro himself went so far as to define Cubans as "an African Latin people" in 1976, becoming the first head of state in the hemisphere to make such a pronouncement (Casal 1979, 24). Progressive individuals in charge of cultural affairs such as Ramiro Guerra, Argeliers León, and Odilio Urfé called for the study and promotion of Afrocuban folklore during the first months of the revolution (Orejuela Martínez 2004, 53).

On the other hand, officials have also referred to Afrocuban folklore as "*atrasada*" or "backward," primarily because of its associations with "primitive" West African societies and their "superstitious" beliefs. Composer Gonzalo Roig, interviewed in 1961, described traditional rumba as marginal, even barbaric, and having no place in "true" Cuban culture (Orejuela Martínez 2004, 127–28). Ernesto Guevara came out publicly against Afrocuban cultural or historical study in 1963. When asked by students from abroad about the absence of textbooks in schools concerning Africa and its peoples, Guevara responded "...I see no more purpose in black people studying African history in Cuba than in my children studying Argentina ...Black people need to study Marxist-Leninism, not African history" (C. Moore 1964, 217–18). Carlos Moore concludes his documentation of this exchange with the following:

> Did it ever cross Dr. Guevara's mind that...[a black Cuban], a product of a culture and a civilization which, from his earliest days in school has been *misrepresented, confused, distorted, and lied about,* does need the fullest and most precise knowledge of the African peoples, their culture and achievements, for his own *self-appreciation*?

In spite of tepid formal support, Afrocuban music and culture became demonstrably more visible across the island during the early 1960s owing to the large number of semiprofessional ensembles that emerged as part of the Amateurs' Movement.[11] Little information exists on the formation of such groups nationwide,[12] but Millet and Brea (1989, 92–118) discuss representative ensembles that appeared in the Santiago area. They include the Conjunto Folklórico de Oriente, founded in 1960 by Bertha Armiñán and Roberto Salazar; the Conjunto Folklórico Cutumba established soon thereafter by Roberto Sánchez; Los Tambores de Enrique Bonne, founded in 1960; the Cabildo Teatral Santiago directed by Ramiro Herrero; the Conjunto Folklórico Abolengo, established in 1964 and specializing in Afro-Haitian folklore; and the Grupo Folklórico Guillermón Moncada, founded in 1967 by Walfrido Valerino. Similar groups from Havana date from the early 1960s as well including Guaguancó Marítimo Portuario, created by stevedores, the majority of whom belonged to the same Abakuá society. This group changed its name in 1985 to Yoruba Andabo.[13] Juanito García affirms that although only a handful of folklore ensembles received support from the state, hundreds of *aficionado* groups came into existence.[14]

The presence of so many folklore groups must have contributed to a dramatic expansion of public drumming and dance. The only groups prior to 1959 that achieved any level of recognition were the Conjunto Folklórico Antillano, a short-lived (1949–1950) experimental dance ensemble known for blending Afrocuban folkloric elements with modern dance; and the Guaguancó Matancero, founded in 1952, whose members eventually changed their name to the Muñequitos de Matanzas.[15] During the early years of the revolution, not even members of the Muñequitos received recognition as full-time professional artists from the Consejo Nacional de Cultura (CNC). Yet at least a few television programs featured them to an unprecedented degree, such as a broadcast of rumba, *comparsa*, and Abakuá music and dance on 10 October 1959 (Urfé 1982, 165). *Tumba francesa* groups and Carabalí *cabildos* performed traditional songs and dances in Havana's theaters soon thereafter, something that would have been unheard of before the revolution (Orejuela Martínez 2004, 126). Work undertaken at the Institute of Ethnology and Folklore, created in 1961, also

demonstrated a new level of commitment on the part of the government to valorize and promote Afrocuban arts. Miguel Barnet commented approvingly on the prominence of folklore in public venues in 1963.

> The Cuban public is getting accustomed to seeing manifestations of our musical folklore on theater stages. In times past, popular music was only heard in theaters with bad reputations…but now the most authentic, popular creations of our country have been brought to the best concert stages… These efforts to valorize music that our people have created over the centuries have culminated in the Festivals of Popular Culture…they take the *guaguancó* from the marginal neighborhoods, the *cocoyé* from the streets of Santiago, rescue Elena Burke from the nightclubs, and bring them all to the theater so that everyone can appreciate them. (Orejuela Martínez 2004, 126)

The Festivals of Popular Culture referred to by Barnet constituted an important forum for the presentation of Afrocuban and other heritage. The first took place in August 1962 and included a wide variety of music: *changüí* from Guantánamo, *punto* and *tonada* from Spanish-derived *campesino* traditions, *sucusucu* from the Isle of Pines, a Santiago carnival band, traditional rumba drumming and *coros de clave*, as well as dance music by the Conjunto Chappottín, Pacho Alonso, and others. A second festival took place in August of 1963.

Carnival ensembles (*comparsas*) remained a strong presence across the island, yet before long state-controlled unions urged that they organize by work center rather than by city neighborhood. This seems to represent an attempt to regulate what was considered an unruly cultural manifestation, and perhaps also to encourage members to identify across racial and neighborhood lines. Government warehouses represented virtually the only source of materials for costumes, instruments, parade floats, and so on, and thus officials had leverage to influence the theme songs and imagery adopted by participants. By 1963 the names of traditional *comparsas* appeared alongside new ones such as "Musical Review of the Construction Workers' Union." Critics demonstrated ambivalent attitudes toward *comparsas*. Disdain blends with messages of anti-imperialism in this quote from *Bohemia*.

> Citizen President Dr. Osvaldo Dorticós Torrado has inaugurated the carnival event before the tribunal, lending with his presence a revolutionary dimension to the frivolous spectacle of more than five hundred men and women…responding to the ancestral call of jungle drums…. These individuals display combative exuberance that Cuba presents as a vivacious response to the insolent threat of aggression on the part of impotent and yet rapacious imperialism.[16]

Older neighborhood *comparsas* in Havana never disappeared but received less recognition than their newly created counterparts for some time. Toward the end of the 1960s, leaders made the decision to move Havana's carnival to 26 July. This created more time for the spring sugar harvest, distanced the celebration from its Catholic origins, and added to the festive atmosphere surrounding the anniversary of Castro's attack on the Moncada garrison in Santiago. Since the late 1990s, the event has reverted to its original pre-Lenten dates.

Enrique Bonne, Pacho Alonso, and Pello el Afrokán

The career of Enrique Alberto Bonne Castillo (b. 1926) illustrates the role that many Afrocuban performers played in promoting drumming traditions during the early revolution. Born on the outskirts of Santiago into a musical working-class family, Bonne studied classical piano with his mother and involved himself in folkloric events. His father composed *danzones* and played popular music in theaters when not cutting sugarcane (Bonne 1999). By the 1950s, Bonne gained recognition as a composer himself, writing commercial jingles, chachachás, and theme songs for the Santiago carnival group La Placita. After the revolutionaries came to power, he worked on

radio for a time and then in 1960 organized about fifty *comparsa* musicians from the barrio of Los Hoyos into Los Tambores de Enrique Bonne, also known as Enrique Bonne y sus Tambores. The instrumentation of the ensemble included twenty-seven drums of various kinds (conga drums in several sizes, *bombos* or bass drums, *bocues*, a regional drum from Santiago), three *chéqueres* (a Yoruba gourd percussion instrument), three brake shoes, two *cornetas chinas* (a Chinese double reed), a *catá* or piece of hollowed wood struck with sticks, maracas, and singers (Ginori 1968, 60–61). This apparently represented the first revolutionary experiment with a mass percussion ensemble.

Los Tambores debuted in the carnival celebrations of 1962, owing in part to the support of Lázaro Peña, a prominent Afrocuban politician who at that time directed the Cuban Workers Union (CTC). Los Tambores' repertoire featured a diversity of rhythms including *chachalokefún* (associated with sacred *batá* performance), *bembé* rhythms (also sacred), *comparsa* drumming patterns from Santiago and Havana, *rumba guaguancó*, and other hybrids of Bonne's own invention. None of the group's musicians read music with the exception of the director, and they learned the arrangements by rote (Bonne 1999). Bonne experimented in many ways with Los Tambores: by creating percussive accompaniment to traditional boleros ("Como el arrullo de palmas"), or presenting dramatic poetry with Afrocuban themes ("La tragedia de saber") backed by drumming, the latter often featuring Afrocuban actor Alden Knight. The group collaborated with other famous stage personalities of the day including Omara Portuondo, Rosita Fornés, even classical composers Rafael Somavilla and Adolfo Guzmán.

One is struck with the elaborate nature of Bonne's arrangements which incorporated frequent breaks, timbral shifts, and which alternated between multiple rhythms within the same piece. He recognized a diversity of influences on his work including Cuban folklore, traditional *trova*, dance music, even U.S. jazz. A great deal of prejudice existed against drumming within Cuba in the early 1960s; Bonne viewed his efforts as a way of changing such attitudes by presenting percussion in new ways and performing a wide variety of repertoire (Bonne 1999). Los Tambores continue to exist and to perform occasionally today, though funding from the state has been intermittent.

Enrique Bonne's *pilón* rhythm as performed by José Luis Quintana and Rebeca Mauleón and Yaroldi Abreu Robles (Quintana and Mauleón, 1996; Abreu Robles, interview). The implicit clave pattern in this cell is 2–3. In the conga sketch, P = palm, T = touch, and B = Bass. The conga part uses an "x" notehead to indicate a slap. Stems up on the timbales and conga lines indicate that the part should be played by the strong hand, stems down with the weak hand. Round noteheads indicate open tones.

The most famous dance style popularized by Bonne is the *pilón* (literally, "pestle"). This is the name of the largest *bombo* drum used in Santiago carnival celebrations. Traditionally, the *comparsa pilón* drum plays a characteristic two-measure rhythm in 4/4 time consisting of three pulses on strong beats followed by a sharp attack on the "and-of-four" of the second measure. It is similar to but distinct from Bonne's *pilón* rhythm for dance band that also alternates straight beats with a syncopated accent but emphasizes the "and-of-two" and "three." Although carnival rhythms seem to have been the model for Bonne's *pilón*, he suggests that he also took inspiration from rural workers grinding up coffee beans (Bonne 1999). The sketch below demonstrates how the melody of Bonne's *pilón* results from the intersecting patterns of the congas and *timbales*.

Bonne first tried to popularize the *pilón* rhythm and dance in 1961 without much success.[17] Only later, through collaborations with singer Pacho Alonso (1928–1982), did it become a national craze. Alonso, son of a Cuban mother and Puerto Rican father, also spent his childhood in the Santiago area. After studying to be a schoolteacher in Havana, he returned to Santiago in 1951 and became a vocalist in the orchestra of Mariano Mercerón. Beginning in 1957, Alonso recorded several popular songs written by Bonne including "Que me digan Feo" with his first group, Pacho Alonso y los Modernistas.[18] Bonne and Alonso slowly gained popularity together in subsequent years, the former as composer and the latter as his interpreter (Martínez Rodríguez 1988, 20). In 1962, Alonso formed Los Bocucos. This ensemble first brought the *pilón* to national attention, performing as of 1965 on national television, in cabarets, and in regional carnivals throughout the island.

The *pilón* dance is a creation of Alonso's, also based in part on motions associated with coffee grinding. It involves holding one's hands out in front of one's body as if around a pestle and rotating the hips. During early television appearances, Alonso filled the stage with young, attractive women in miniskirts holding oversized pestles in order to teach the audience the appropriate movements. In 1968, he reorganized his band yet again under the name Los Pachucos. They continued to popularize new rhythms invented by Bonne such as the *simalé*, touring France, Spain, Panama, and the USSR in addition to Cuba.

The career of Pedro Izquierdo (1933–2000), better known as Pello El Afrokán, also underscores the prominence of black folkloric artists after 1959. Izquierdo is significant for being the percussionist to receive widest recognition during the early revolution. He was born in the predominantly black neighborhood of Jesús María, Havana, and collaborated on drums with his father in the orchestra of Belisario López from an early age. During the day he worked as a stevedore on the docks of Havana, and occasionally upholstering furniture (Piñeiro 1965, 24). Izquierdo's family exposed him to a variety of folkloric styles and instilled in him a sense of pride in his African ancestry. In interviews after becoming a celebrity, he made a point of mentioning that he was an Abakuá, that his grandmother was of Mandinga heritage, and his grandfather a *curro* or free black Ladino.[19] He described choosing the name *mozambique* for his new dance rhythm not because it had anything directly to do with that country, but because he wanted to emphasize its African roots. Many viewed the popularity of the genre in the mid-1960s as a statement of the government's support for African-influenced culture. In a newspaper article from 1965, for instance, Izquierdo himself asserted that "Only now, within the revolution, has Cuba given the drum its rightful place."[20]

Izquierdo began performing music for a percussion ensemble as part of a construction workers' band in 1963, with more than one hundred other musicians, but first achieved national recognition in the carnival of February 1964. His group and its music became an overnight sensation. Band members consisted almost entirely of Cubans of color and performed on a wide variety of

traditional percussion instruments. Never before had a folklore troupe appeared so prominently in the national media. In part, the attention focused on Izquierdo was due to genuine interest about his music on the part of the public, his gifts as a showman, and the band's fancy costumes. Victoria Eli Rodríguez links their prominence to the government's campaign against racism, believing that the promotion of new cultural forms was part of that process (Perna 2001, 36). The press saturation also seems to have been an attempt on the part of the state to cover for the departure of many famous musicians during the same period, as well as to focus attention on national styles of music rather than international influences such as rock (Vázquez 1988, 5). Rock music, especially, had largely disappeared from the media as of 1964 (Orejuela Martínez 2004, 180). Izquierdo caused such a stir locally with the *mozambique* that through 1967 he was asked to host a program on television called *Ritmos de Juventud*. His orchestra drew steady crowds to live performances in the Salón Mambí outside the Tropicana until the onset of the *ofensiva revolucionaria*. They made frequent international tours in the mid-1960s, one of only a few groups permitted to do so.

Izquierdo's compositions influenced a number of musicians in the New York area and in Puerto Rico — the Palmieri brothers, Ritchie Ray, Bobby Valentín, El Gran Combo — who recorded *mozambiques* from Cuba, and of their own creation. The first artist to adopt the genre was Eddie Palmieri, who recorded the LP *Mambo + Conga = Mozambique* in 1965. Palmieri later claimed to have invented the rhythm himself, apparently because he substantially altered and adapted it.

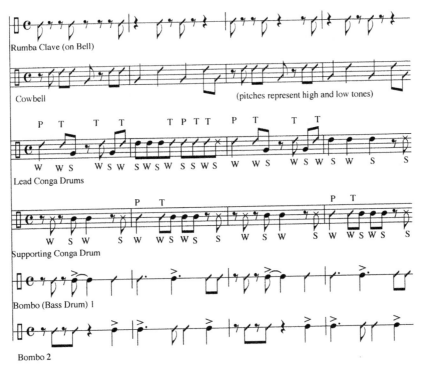

Rhythmic sketch of basic *mozambique* rhythms as performed by Kim Atkinson (1996). In this transcription, P = palm, T = touch, W = weak hand, and S = strong hand. The conga parts use an "x" notehead to indicate a slap and a regular notehead to indicate a tone. The two different pitches in the top conga line indicate which instruments of the pair should be played. In the *bombo* transcriptions, a normal note head indicates a strong open tone while the slash heads represent softer tones that are muted with the weak hand resting against the drum head. All *bombo* strokes are played with a mallet.

However, Palmieri's recordings strike listeners as derivative of Izquierdo's, and of traditional *comparsa* rhythms. This is apparent in the timbales' "and-of-two" punch every other measure, similar to the *bombo* drum pattern in the *mozambique,* and in the prominent bell patterns much like those played on the *sartenes* (frying pans) in carnival bands. In a recent lecture,[21] Palmieri mentioned that the release of the 1965 album created serious problems for himself and his orchestra. The Cuban government threatened to sue his record label, Tico, for having popularized the *mozambique* in the United States without compensating its Cuban inventor. Members of the Cuban exile community also contacted Tico to make bomb threats, attempting to keep it from promoting music they associated with socialist Cuba. Understandably, Palmieri's enthusiasm for the new style soon waned.

As in the case of Bonne's *pilón,* the *mozambique* of Pedro Izquierdo represented an elaboration of traditional Afrocuban rhythms and their incorporation into a large dance ensemble. His initial group consisted of twelve conga drums tuned to four different pitches, two *bombo* drums, three bells, a *sartén,* five trombones, five trumpets, and accompanying female dancers. Thereafter, electric bass and piano were added. Izquierdo claims to have adapted rhythms into his drum battery from a diversity of sources including carnival music, *rumba guaguancó, rumba columbia, rumba yambú,* and Abakuá drum and bell patterns (Piñeiro 1965, 24). The dance step associated with the genre involved slow steps forward with both feet in alternation, as well as a slight dip and turning motion to the side using the hips.

While secular, the *mozambiques* recorded by Izquierdo included notable influences from Yoruba and Iyesá sacred music, some of the most obvious that had ever been heard in popular recordings. On the release *Pello El Afrokan. Un sabor que canta,*[22] for instance, entire liturgical melodies from Santeria are performed with new secular lyrics. The melody of "La pillé" (I Saw Her) is actually a devotional song to Oyá: its lyrics in Yoruban, *"Oya L'oya e adi-e adi-e Oya,"* were transformed by the composer into *"Mama Lola é, la pillé, la pillé mamá"* (Mama Lola, hey, I saw her, woman).[23] Another example from the same recording is the song "Ara-ñakiña." It is a *son*-based piece, but the title comes from a phrase (*Bara ñakiñá, ñakiña loro, bara ñakiñá*) sung repeatedly by Santeria practitioners when preparing to sacrifice a bird to the *orichas.*[24] Another line, *"Ogún cholo cholo,"* is similarly associated with ritual offerings. Others mention prominent *santeros* of the period.

Fidel Castro is not known to take much personal interest in music, but a photo from 13 April 1965 in the newspaper *Hoy* shows him talking with Pedro Izquierdo. According to the accompanying story, Castro approached the band-leader and urged him to write a song that would help inspire volunteer workers to take part in the yearly sugar harvest. Izquierdo's resulting composition, based on "Arrímate pa' 'ca" (Come Over Here) by Juanito Márquez, was retitled "Bailando mozambique me voy a cortar caña" (Dancing Mozambique I'm Going to Cut Cane). It may have contributed to the government's labor efforts, but its humorous double-entendre lyrics — "Ay, how tasty the cane is, honey...bring your cart over here" — contained other messages as well. Castro accompanied the group to its recording session at the CMQ Television studios and is reported to have enthusiastically monitored Pello's efforts there.[25]

During the early years of his group's popularity, Izquierdo created significant controversy by inviting white women into his troupe as dancers and by interacting with them on stage. This was a period in which interracial marriages and even open interracial affairs were unacceptable to a majority of the population. Many disapproved of Pello's group for this reason, refused to go see him perform, and criticized him in the press. One of his white dancers eventually became the subject of the famous *mozambique* "María caracoles." Its title referred to the fancy beehive hairstyle she adopted with many seashell-like curls.

As of 1968, Izquierdo had difficulty maintaining his former prominence. A faltering economy resulted in the closure of many performance spaces. Izquierdo also became a victim of the heavy promotion state radio gave his music; listeners recall hearing his songs virtually every half hour and eventually tiring of them (Perna 2001, 27). The increasing popularity of *nueva trova* after 1973 also led to a decline in the *mozambique*. Yet in 1979, with the creation of the television show *Para bailar* under the direction of Eduardo Cáceres Manso, the *mozambique* experienced a resurgence. This program helped disseminate a wide variety of folk music. Particular segments featured young people dancing *rumba guaguancó* and *mozambique*, for instance, as well demonstrating international dance styles such as samba, flamenco, and merengue. The directors also invited in local dancers who mixed *son*-style steps with those of the *rumba columbia*.[26]

Government-Sponsored Ensembles: The Example of the CFN

Folklore ensembles have achieved recognition on national and international levels. By far the most famous is the Conjunto Folklórico Nacional (CFN), founded in May 1962 in Havana by ethnographer Rogelio Martínez Furé and Mexican choreographer Rodolfo Reyes Cortés. In 1964, the CFN became the first revolutionary institution devoted exclusively to the performance of national folklore (Hagedorn 1995, 225). It has always offered performances in which songs from Santería ceremony might appear next to ballroom *contradanzas*, turn-of-the-century *coros de clave y guaguancó*, Spanish-derived *música guajira* traditions, Haitian-derived folklore from eastern Cuba, or carnival music. Nevertheless, its fundamental goal has been staging Afrocuban expression which is too often hidden from public view, and educating the public as to its beauty and complexity.

As mentioned, the early 1960s generated a tremendous sense of excitement in the Afrocuban community, leading many to conclude that they would no longer have to hide their culture or struggle vainly for artistic recognition (Hagedorn 2001, 137). Founding members of the CFN began as an amateur group with this expectation. In the early years they relied heavily on the expertise of master percussionists Trinidad Torregrosa (1893–1977) and Jesús Pérez (1925–1985), dancer Nieves Fresneda (1900–1980), and singer Lázaro Ros (1925–2005), among others (Martínez Furé 1982, 4). Most participants were themselves Afrocuban and had grown up surrounded by the traditions they hoped to bring to the stage, though they did eventually collaborate with professionals such as choreographer Ramiro Guerra. The CFN presented its first formal concert in the Teatro Mella in 1963. Shortly thereafter, ensemble members began to receive a small monthly stipend from the government (35–40 pesos a month) in recognition of their efforts. By the end of the decade, the CNC recognized them as full-time performers; salaries increased to approximately 170 pesos a month, allowing them to devote themselves more exclusively to their art.

The history of the CFN demonstrates ways in which the government has supported Afrocuban folklore, but also provides evidence of the limits of such support. For years, this professional ensemble was the only one of its kind in the Havana area, a region with a population of millions.[27] After government support became available, salaries in the group remained low relative to those of other full-time artists. It also received little airtime on television and few opportunities to record. CFN directors themselves recognize that the group's presentations generated little enthusiasm among a majority of the public, especially among white Cubans and professionals. Their music continued to be viewed as a "*cosa de negros*," expression that lacked "universal" relevance.[28] In fact, few white Cubans watch their performances even today. Hagedorn mentions that "underneath the newly varnished layer of Revolutionary enthusiasm" for the CFN project "were several rougher layers of mistrust and wariness, as well as a hair-trigger readiness to lose faith in the endeavor" (Hagedorn 1995, 242).

State-supported ensembles served multiple purposes; they were intended to valorize elements of traditional culture while simultaneously supporting ideological or educational initiatives. As in the case of the Eastern Bloc, a nationalist ideology supported musical genres and instruments as symbols of the nation, while a socialist ideology demanded the presentation of those same genres in contexts suitable to the construction of new values (Rice 1994, 229). Cultural advisors wished to "elevate" folk expression, professionalize it, and make it more intelligible for urban audiences. They often altered the structure and content of traditional genres for this reason. Advisors supported collaborations with conservatory-trained composers, musicians, and dancers, and freely recombined rhythms, dance steps, and instruments in new ways. As one example, the ensemble Oru, consisting of several members of the CNF, performed a "Requiem for Che Guevara" in 1968. Composed and sung by Rogelio Martínez Furé, the "Requiem" was an aleatoric, "new music" composition that involved the use of traditional Yoruba chants.[29]

Even in more traditional presentations, changes were made. Improvisation and spontaneity associated with community performance tended to disappear. Ritual songs that might be repeated or elaborated in sacred contexts would be selected ahead of time and presented in a particular order so that they could be choreographed more precisely.[30] Artistic advisors added new musical or dramatic elements, as documented by the writings of Ramiro Guerra: vocal harmonies might be extended and sung more precisely in tune, lighting and costumes might be altered from one piece to the next, dances steps would be drilled until they could be flawlessly executed in unison, etc. (Guerra 1989). The end result was an enjoyable and technically demanding but rather static spectacle that little resembled events in black neighborhoods (Hagedorn 2001, 122).

Some have criticized the circumscribed support for Afrocuban folklore and the changes instituted in its performance. Helio Orovio, for instance, describes the CFN as a sort of "cultural reservation."[31] He believes that the CNC intended the Conjunto to be the only significant outlet for many forms of traditional Afrocuban expression that it ultimately did not want to see perpetuated. Eugenio Matibag concurs, suggesting that the decidedly limited support of Afrocuban traditions in secularized, stylistically altered, and commodified form represented a "strategy of containment." "Folklorization serves to relegate a vital, lived cultural form to the category of the artistic and picturesque, thus neutralizing its ideological power" (Matibag 1990, 247). Perhaps the most virulent criticism of the staged folklore movement came from Carlos Moore during the first years of the revolution. From his perspective, folklorization constituted nothing less than a subtle form of cultural "whitening" and "de-Africanization" such as were associated with the prerevolutionary period. His critique here discusses sacred practices but applies to all folklore.

> Dances and music which are part of the ceremonial *complex* of creeds and tenets of these adherents — considered, quite reasonably, as *sacred* . . . and bearing a functional meaning in their practices — are being *prostituted* and presented in theaters as "people's folklore." Why isn't the same applied to the sacred practices of the Judeo-Christian faiths? The subtle motives beneath this outrage are simple: (a) to emasculate the faith, through a prostitution of its most cherished religious values and a demoralization of its followers as a result; (b) to systematically destroy what are considered to be "pagan" and "savage" religious "cults" by means of "civilizing" them into a *palatable* "people's" folklore. (C. Moore 1964, 220; italics original)

Attitudes toward religion clearly affected official pronouncements on culture. Ostensibly, the state's position beginning in the mid-1960s was neutral, involving neither attempts to "stimulate, support or aid any religious group" nor to impede such activities (Ministerio de Educación 1971, 201). Communist party doctrine explicitly guarantees citizens the right to devote themselves to any belief system as long as it does not incorporate anti-revolutionary ideology (PCC 1978, 101).

Yet in practice, socialists intervened vigorously to suppress religious worship from the first years of the revolution. Conflicts with Christians surfaced early on, in part because of the close ties between Catholicism and the social elite. Tensions with Afrocuban groups surfaced somewhat later, derived from longstanding prejudices in middle-class Cuban society against African-derived culture and aggravated by Marxist philosophy. Most believers suffered some persecution through the late 1980s. The growing intolerance of drumming and dance had a racial dimension, as noted previously, but was also driven by the desire to create an atheistic state.

Religious-associated folklore never disappeared from public view entirely, however. Many *aficionado* ensembles continued performing within their own communities, often as part of events scheduled in neighborhood *casas de cultura* or local festivals. Modern dancers based at the National Arts School (ENA) incorporated sacred movements into their choreographies and performed with traditional drummers. Members of the CFN performed religious repertoire in public on an ongoing basis. After 1979, advanced percussion students began to receive limited instruction on *batá* drums and other religious instruments as part of state-sponsored curricula.

It is difficult to interpret a government policy which supported the performance of folklore with religious roots in particular settings, yet allowed few publications on African-derived traditions and suppressed the religions themselves. Tomás Fernández Robaina has explained this by suggesting that while officials believed Afrocuban religions to be undesirable, they nevertheless recognized that the music and dance associated with them had aesthetic value and thus chose to authorize some presentations. The support of dances and drumming associated with Santeria and Palo has not been, therefore, a statement in support of religion, but of a secularized and thus "purified" national folklore. Socialist educators felt that folkloric elements — music, dance, instruments, etc. — should be assimilated into educational programs such as those of the CFN, while "divesting themselves of mystical elements" so that they did not "serve to maintain customs and practices alien to scientific truth."[32] Similar policies have been documented in socialist Eastern Europe (Kundera 1992, 47).

Sadly, the actions of CFN members often reinforced the negative attitudes toward black performers held by some administrators. Racial and class divisions led to frequent misunderstandings and conflicts. Percussionists in the ensemble had little experience with the exigencies of performance; they tended not to meet professional expectations, arriving late, refusing to rehearse at particular moments, or drinking on the job. Additionally, drummers had grown up in a culture of machismo and frequently refused to take orders from women. The group's first director, Marta Blanco, resigned as the result of conflicts with male performers. In 1965, similar tensions led to a confrontation between one particularly violent individual, Miguel Valdés, and director María Teresa Linares over salary issues (Hagedorn 1995, 240). Valdés eventually brought a gun to a rehearsal and fired multiple shots, leaving Linares and other members of the troupe severely wounded. Co-founder Rodolfo Reyes resigned after the incident and returned to Mexico, throwing the group's leadership into disarray. CFN members unused to the privileges afforded them on tour abroad in the mid-1960s also drank heavily, smoked marijuana, tore apart hotel rooms, and engaged in petty theft. Several defected while in Spain, in the early 1970s, resulting in much tighter controls placed upon all members and fewer opportunities for travel (Prieto 1996).

In many respects, individuals fortunate enough perform in ensembles such as the CFN benefited professionally as well as economically. Felipe García Villamil recalled that as a result of involvement in a Matanzas troupe he learned drumming styles from ethnic groups; styles which he had heard of but never before attempted to play, such as *música arará* and *música iyesá* (Vélez

1996, 90). However, members of the black community did not always consider public concerts appropriate. Villamil found himself physically threatened for performing Abakuá rhythms on stage, for instance (Vélez 1996, 84). Older members usually expressed greater reservations about such presentations, while younger artists were more receptive to them. It took a decade or two before the idea of "universalized" or "folklorized" stage events became accepted as part of everyday life.

Folklore in Higher Education and the Media

As might be expected, the relative indifference to Afrocuban folklore which existed among music educators before 1959 continued to manifest itself in revolutionary society. Many of the same individuals who had been directing music schools earlier continued to do so in the 1960s and 1970s, and found little reason to alter their curricula. This attitude had less to do with racism in the typical sense than with ignorance, inflexibility, and the weight of established precedent. In Cuba, the United States, and elsewhere, attitudes toward marginal expression developed over centuries have proven difficult to modify. Acosta notes that music education consistently demonstrates a "colonized optic" in which repertoire from Europe is viewed as inherently more sophisticated than its counterpart from the Americas (Acosta 1983, 23). He distinguishes between typical "academic music history," with its tendency to focus exclusively on elites, and "real music history" which he suggests should be more inclusive and politically engaged. Even in revolutionary Cuba, however, the creation of "real" music history or music education programs has proven difficult.

Afrocuban folklore and popular music remained almost totally excluded from curricula through the late 1970s. More recently, percussionists with special interest in Cuban rhythms have been able to spend two years studying them after completing three years' work in orchestral percussion.[33] Students majoring in other instruments continue to learn little about folklore, yet the status of folklore in music conservatories, however marginal, is more prominent than in universities, where Afrocuban subjects remain largely absent to the present day. The University of Havana, for example, has never formed an Afrocuban Studies department or allowed students to specialize in such an area. Fields such as literature, philosophy, history, and art history include a few courses that touch on Afrocuban themes, but the number of students allowed into such programs is quite small, perhaps twenty-five per subject per year, and of these only a fraction demonstrate interest in Afrocuban culture.

As of 1996, the university still offered only a single course devoted exclusively to Afrocuban culture: Lázara Menéndez's "Estudios afrocubanos," part of elective postgraduate seminars in literature. Faculty members such as Enrique Sosa have occasionally offered additional elective courses.[34] Most instruction on Afrocuban subjects for the general student body continues to come in the form of poorly attended extracurricular lectures or noncredit summer seminars. In the 1960s and 1970s, Alejo Carpentier, Mirta Aguirre, Vicentica Antuña, and José Antonio Portuondo offered presentations of this sort. Others in recent decades have included Tomás Fernández Robaina, Jesús Guanche, Lázara Menéndez, and Guadalupe Ordaz.

The lack of attention to Afrocuban themes is symptomatic of a broader problem, namely that all research in the humanities and social sciences has received meager support in recent decades. Anthropology never existed as a university program before 1959 and did not represent a priority to the socialist leadership in later years. The few students selected to pursue such study through the mid-1980s trained in the Eastern Bloc.[35] Initially, students found flexibility within the university to study Afrocuban subject matter on their own if they cared to. Later, work on history and culture was subject to greater regulation. Since 1970, entire departments including psychology, philosophy, and

sociology have atrophied and/or disappeared for years at a time. To their credit, Cuban academics now recognize the deficiency of domestic social science programs[36] and are exploring options for addressing the situation.

Because the leadership did not strongly encourage scholarship on Afrocuban subject matter, the work of researchers from the prerevolutionary period — Fernando Ortiz, Lydia Cabrera, Pedro Deschamps Chapeaux, Rómulo Lachatañeré — has yet to be superceded in most respects. This is a serious deficiency in a country with a large Afrocuban population and in which black history has never received much attention. Even older books have not always been available for purchase — because their authors went into exile and their work came under censure for a time (as in the case of Lydia Cabrera), because of the controversial topics they addressed, or both. Authors from the revolutionary period have published valuable material on Afrocuban religion, music, and history. For the most part, however, their essays are rather introductory. Most avoid topics related to ongoing social problems.[37]

Publications on black social history from the 1980s have often been subject to significant delays in printing, as was the case with Tomás Fernández Robaina's *El negro en Cuba 1902–1958*. The author completed his book ten years before it appeared. Publishers initially passed it over and released Pedro Serviat's *El negro en Cuba y su solución definitiva*, a book whose content is less rigorous and whose concepts are more in line with government pronouncements on race.

As a rule, Afrocuban folklore has not featured prominently on revolutionary radio or television. This imbalance has been improving, albeit slowly. Alberto Faya, a white Cuban, recalled that he had to fight tenaciously to get permission to include traditional rumba and related music on his weekly radio show *Son del Caimán* which aired from 1979–1985.[38] Folklore groups had difficulty recording their music as well. The CFN made one record in 1964, two years after they began performing, but were not able to do so again until 1975 (Martínez Furé 1982, 27). Additional LPs have yet to appear. Yoruba Andabo, an excellent but less widely known group, rehearsed and performed for over twenty years before making their first album. Cristóbal Sosa, involved in Cuban radio for over twenty-five years, said of noncommercial folk genres in 1996, *"ni se oía, ni se oye,"* they have not been heard on the air in the past nor are they heard today.[39] In recent years, however, this may have to do in part with the dynamics of the marketplace.

Greater Opportunities for Folkloric Performance

Given the limitations on academic study and local dissemination described above, visitors to Cuba might be surprised to find large numbers of folkloric groups performing across the island. The past twenty years have unquestionably witnessed the emergence of much greater opportunities for folk musicians in terms of presenting shows, recording, and touring, as they have for virtually all musicians. Carlos Moore documents a gradual increase of cultural tolerance in this sense. He notes greater support for African and African American culture — though not necessarily in local Afrocuban forms — as early as the 1970s and describes this period as the "Africa Decade" because of the frequent presence of visiting black celebrities on the island. This change reflects the broader political activities of the leadership and especially the involvement of the Cuban military in Africa. Castro himself demonstrated an interest in African culture, possibly for the first time, while visiting Guinea in 1972 (C. Moore 1988, 293). That year marked the beginning of a stream of visitors to Cuba from the United States, West Africa, and the Caribbean, including the performance group Perú Negro, singers Harry Belafonte and Miriam Makeba, and the Dance Collective of Nigeria (Flores 1978, 146). Activist Angela Davis created a sensation in Havana during her visit at approximately

the same time, largely because of her large "afro" hairstyle, considered inappropriate by some officials. Carlos Moore suggests that the presence of visitors from abroad who openly embraced African aesthetics, dress, and music had an electrifying effect on Cubans of color. Starved as they were for symbols of cultural identity, they closely followed the activities of each new arrival.

The 1980s is significant for having given rise to a number of new institutions within Cuba dedicated to the presentation of Afrocuban folklore and to increasing numbers of related publications. The year 1986 marked the beginning of what is now an ongoing celebration, the Wemilere Festival of Music and Dance of African Roots based in Guanabacoa.[40] It attracts international as well as local participants and includes academic lectures, theater, and performance events. In the same year, the Casa de Africa opened in the old colonial section of Havana. Designed as an ethnographic museum, a library resource, and a center for scholarly presentations related to African and African diaspora culture, the Casa contains a permanent display of musical instruments. Some were gifts given to Castro during his African travels while others represent collections originally owned by Fernando Ortiz. The center coordinates cultural activities with other institutions including the University of Havana and the Ministry of the Exterior. It has become a locus of music making. More publications on Afrocuban themes appeared in the 1980s, most notably Tomás Fernández Robaina's impressive *Bibliografía de temas afrocubanos* based on work in the National Library (Fernández Robaina 1985). A few other books on Afrocuban history appeared as well, for instance Julio Angel Carreras's *Esclavitud, abolición, y racismo* (Carreras 1985) and Pedro Serviat's *El problema negro*, mentioned earlier. Tellingly, both focus on race relations prior to 1959 and deny the existence of significant problems in later years.

Writings by government spokesmen show greater support for Afrocuban culture and folkloric traditions in the 1980s than in the 1970s, but continue to manifest ambivalence. Authors recognize, for instance, that "the values of African culture...were systematically discriminated against" in colonial and Republican Cuba and call for measures to redress this legacy (Serviat 1986, 150). Yet they also suggest that Afrocuban culture was somehow stunted or debased in the colonial past and will never compare favorably with European forms. It is only "when the integrating factors of our nationality gel" into syncretic expression, argues one anonymous official quoted by Serviat, that black music and dance will "acquire a substantial level of development" (Serviat 1986, 150).

Since the reorientation of Cuba's economy toward tourism and foreign investment in the mid-1990s, the study and performance of Afrocuban music has flourished as never before. This renaissance is the combined result of liberalized policies regarding the economics of music making, demonstrated interest in such repertoire on the part of foreign visitors, and ongoing attempts on the part of the Afrocuban community to promote their traditions. Socialist policy makers are now genuinely interested in catering to the capitalist market; this had never been a concern, let alone a priority. Increased music circulation also results from decisions by the U.S. Congress to allow for the importation of Cuban cultural products. The de-penalization of foreign currency in 1993 and the ability of musicians to negotiate recording contracts independently have led to an exponential increase in the availability of Cuban music abroad.

Havana is now replete with centers of folkloric drumming and dance (i.e., the Hurón Azul, the Callejón de Hamel, the patio of the Conjunto Folklórico); clubs and cabarets offer many similar presentations. The government organizes courses for those interested in coming to Cuba to study percussion. Some of the first, known as FolkCuba Workshops, date from the 1980s. They involved the participation of Alberto Villareal, Mario Abreu, and other prominent members of the Conjunto Folklórico Nacional (Hagedorn 1995, 304). Many programs have developed since. Folklore singers

who had fallen into relative obscurity (Lázaro Ros, Merceditas Valdés) found their careers revived in the 1990s. Their repertoire has appeared on a host of new videos, compact discs, and tapes.

Books by Fernando Ortiz, Rómulo Lachatañeré, and others that were out of print have been re-released; new publications on folklore appear regularly.[41] In 1991, the Union of Cuban Writers and Artists (UNEAC) published *Los orichas en Cuba*, the first book specifically discussing Santeria in decades. It appeared at roughly the same time as Lázara Menéndez's four-volume *Estudios afrocubanos* series dealing with all facets of the Afrocuban experience (1998), Lino Neira's *Como suena un tambor abakuá* (1991), and Tomás Fernández Robaina's *Hablen paleros y santeros* (1994). Cuba hosts frequent international conferences on Afrocuban culture. Academic periodicals such as *Anales del Caribe, Catauro, Del Caribe* (based in Santiago), and *Temas* have devoted entire issues to Afrocuban themes.[42]

Documentaries on Afrocuban folklore and religion appear with greater frequency on Cuban television, and recordings of drumming and dance receive more representation on the radio. The government helped establish a Yoruba Cultural Society in December of 1991. It currently boasts 5,000 members, over 1,500 of whom are spiritual leaders in their respective communities. Dance bands which had never produced recordings with significant folkloric content suddenly began to do so; one example is the *Soy todo* album from 2000 by Los Van Van that includes ritual Abakuá language learned painstakingly by the group's leader, Juan Formell (de la Hoz 2000, 59).

Touring has become easier for performers as well. Touring artists have achieved recognition as independent workers, a special sort of *cuentapropista*. The state no longer claims the right to all the income they earn abroad, only a percentage, typically between 10 and 50 percent.[43] Rates of taxation ostensibly vary as a function of services provided to groups by their unions while on the road (housing, meals, insurance, costumes, equipment transport, and technical support). As the details of the new system were being established, many musicians described it as unfair, complaining about low net earnings and the "bestial corruption" of many officials (D'Rivera 1988, 54). Now, for the most part, the system functions more smoothly and continues to improve, especially for those traveling abroad. A host of new drumming ensembles have formed to exploit the expanded market for folklore including Afroamérica, Clave y Guaguancó, Grupo Folklórico de Turarte, Grupo Oba-Ilú, and Raíces Profundas.[44]

To Cristóbal Sosa, the greater prominence of African-derived folklore in the present represents a resurgence of what has always been popular among the people, rather than an increase of interest in the subject.[45] As in the 1960s, the recent boom results from individual efforts to promote forms which were overlooked or under-supported during the revolution. Artists recognize that economic and political changes have made their expression more viable, and strive to capitalize on the new possibilities. Working on street corners or developing stage presentations for tourist hotels, they generate income for themselves and establish vital professional contacts.

On the negative side, the widespread commercialization of Afrocuban expression has led to a phenomenon that Rogelio Martínez Furé variously describes as "pseudo-folklorism," "autoexoticism," and "*jineterismo cultural*" (Martínez Furé 1994, 32). Many who had never before demonstrated interest in Afrocuban subject matter now do so for financial gain. They often market local traditions in a superficial way or portray them as bizarre and unnatural. This might include stylized representations of Afrocuban religions, for instance, in which drooling, convulsing, or other behavior associated with possession is emphasized. Martínez Furé laments that traditions are "being converted into tourist merchandise" and calls for additional educational programs to ensure that Cubans themselves will achieve a more profound understanding of their own heritage.

Conclusion

Afrocubans as a whole have benefited from the revolutionary experiment in important ways. They more than any other group have experienced gains in educational and job opportunities and in access to social services. Cuba is a much more integrated country than it was in the 1950s, with larger numbers of black professionals and civic leaders. One might add that it is much more integrated than the United States, where most of the population lives in racially divided neighborhoods. By the same token, racial problems persist which are not always effectively addressed or even widely discussed. As one example, Alejandro de la Fuente and Laurence Glasco (1997) published a survey from the mid-1990s revealing that 58 percent of white Cubans considered blacks to be less intelligent, 69 percent believed they did not have the same "values" or "decency" as whites, and 68 percent were opposed to racial intermarriage. Many Cubans are unaware of the present-day racism which manifests itself in everyday attitudes and verbal terminology. This is partly the result of a political structure in which Cubans of color have had no independent voice, but it also derives from a national discourse that strongly emphasizes unity. Publications frequently suggest that socialist Cuba has become "a single indivisible entity" in cultural terms.[46] With *cubanidad* defined in this way, it has been difficult for the population of color to assert its difference.

During the first seven or eight years of the revolution, performers in the black community created hundreds of new amateur folklore ensembles. The same period witnessed the invention of new dance rhythms such as the *pilón* and *mozambique* and an unprecedented valorization of Afrocuban folkloric expression on the part of government-controlled institutions and media. This renaissance of drumming was part of a larger process of social transformation that did away with elite institutions and celebrated the arts of the masses. Festivals of National Culture organized by Odilio Urfé, sponsorship of integrated dance events, the Amateurs' Movement, the founding of the Conjunto Folklórico Nacional, and the educational efforts of Ramiro Guerra, Argeliers León, and others helped combat prejudice and make the public more receptive to Afrocuban culture. Acceptance of such heritage represented part of a larger process of social transformation that empowered the disenfranchised, allowing them access to beaches, hotels, and cabarets. Rogelio Martínez Furé recognized the symbolic importance of this period in describing the *mozambique* craze as "the definitive consecration of percussion" in Cuba and adding that his nation, "free of social poisons, in full realization of its historic and cultural realities, now dances to rhythms played with bare hands on the drum" (Orejuela Martínez 2004, 179).

Beginning in the late 1960s, folklore groups found fewer opportunities to perform for large audiences. The actual substance of their performances, especially of professional groups, came under greater scrutiny as well. The state continued to promote folkloric expression to an extent, but strove to modify it. Through an active process of reinterpretation, of "discriminating inclusion and exclusion" (Williams 1977, 123), administrators adapted public presentations of folklore so that they conformed to a particular conception of what national culture should be. Artists who received the strongest support were not usually traditional drummers. On the contrary, they were highly trained professionals who had knowledge of folklore and incorporated elements of it into "high" culture. The poetry of Nicolás Guillén has been extolled as an ideal for precisely this reason;[47] symphonic works such as Guido López Gavilán's "Camerata en guaguancó" fall into the same category.[48] Afrocuban drumming, and especially its religious manifestations, were often derided as barbaric and replete with "antisocialist tendencies" resulting from ignorance and under-development (Matibag 1996, 227).

Drumming, song, and dance testify in certain ways to racial divisions that persist in Cuban society. Most folklore groups are still comprised of Afrocuban performers rather than of an integrated membership, for instance. James Robbins notes that carnival groups in Santiago de Cuba where he worked in the late 1980s remained divided into black and white ensembles. The black groups included San Augustín, La Conga de los Hoyos, Paso Franco, Heredia, and Guayabito. He describes another group, Textilera, as "a *comparsa* for whites" (Robbins 1990, 310–12). The same divisions can be seen in the United States in the bifurcation between white rock and black soul and hip hop.

The last twenty years have witnessed a growing appreciation for Afrocuban arts. The state has renewed efforts to document drumming traditions and has created additional performance spaces for them. Folkloric musicians find new ways to promote their heritage locally and internationally as instrumentalists, teachers, and educators. Their music appeals strongly to foreigners who support it through the purchase of recordings or by taking music lessons. Many established educators in the humanities continue to express disinterest in African-derived music, however,[49] and few institutions exist that promote its study. Ironically, more foreigners probably receive formal instruction in folkloric traditions, through tourist workshops, than do Cubans themselves. Martínez Furé blames the situation on "historical traumas and inferiority complexes" (Martínez Furé 1998, B57). He suggests that the so-called New World has yet to come to terms with its cultural legacy, and that as long as it does not accept the centrality of African heritage it will continue to perpetuate longstanding biases.

The importance of Cuban folklore is precisely that it is not a static remnant from a bygone age, but rather a dynamic mode of expression rooted in the everyday lives of the population, and one that continues to develop. The creation of rhythms and dances through the years has been part of the black community's attempt to project its frequently deprecated culture into the mainstream. Recent experiments such as *songo, batum-batá, batarumba*, and Cuban rap all constitute part of this trend. The creative recombination of traditional genres and instruments in new ways, and their fusion in some cases with foreign elements, reflect the extent of cultural diversity on the island. Cuba continues to serve as a locus of international influences, and its folklore continues to manifest important issues facing Cubans of color.

Notes

My thanks to various institutions that have made research for this article possible including Temple University, the Rockefeller Foundation, the Center for Black Music Research, and the National Humanities Center. The epigraph is taken from Patterson 1996, 60.

1. The term "Afrocuban" continues to be polemical because it is not used frequently by Cubans themselves and because to some it appears to create a distinction between "Cubans" (implicitly white/Hispanic Cubans) and Cubans of color. I employ "Afrocuban," for lack of a better term, in alternation with "Hispanocuban" (also rarely used on the island), to refer to the black community, those who perceive themselves as black or racially mixed. This is the approach adopted by Cuban writers Fernando Ortiz and Rogelio Martínez Furé (Hernández and Coatsworth 2001, 67), among others.

2. "Folklore" here refers to music and dance traditionally performed within particular community groups by and for themselves. Usually, its performers are amateurs who play and sing without the expectation of financial gain. Folklore may also be presented to broader audiences through the media or on stage, and thus becomes part of "popular" or "commercial" entertainment. In socialist Cuba, the status of folklore vis-à-vis particular communities has become somewhat ambiguous owing to its regulation by state agencies.

3. Consider David Locke's discussion of Ewe musical style in Titon 2002, 100–12.
4. It is difficult to distinguish between secular and sacred folklore in the Afrocuban community, and I make the somewhat artificial separation here only in order to analyze a manageable segment of a large and diverse body of music. Those interested in reading more about sacred performance since 1959 and related topics are encouraged to consult my book *Music and Revolution* (University of California Press, 2006), of which this essay is a part.
5. These same instruments are now on view in the revolution's National Music Museum in Old Havana.
6. L. Menéndez, interviewed by the author 5 October 1996, Havana.
7. L. Menéndez, interviewed by the author 5 October 1996, Havana.
8. N. Fernandez, pers. comm.
9. During the first decades of the revolution, the only prominent Afrocubans in the government were Commander Juan Almeida, a veteran of the guerrilla struggle with Castro in the Sierra Maestra, and Lázaro Peña, a labor activist and former member of the PSP.
10. Fernández Pavón, interviewed by the author 9 March 1998, Philadelphia, Pennsylvania.
11. This was a utopian attempt, based on Marx's writings, to directly involve as many people as possible in the arts. Some of its most visible manifestations included neighborhood mural projects, the formation of theater and dance troupes, choruses, and amateur music ensembles. The initiative began in 1960 under the direction of the CNC and reached a peak in about 1965, though it persisted for decades.
12. Vélez (1996, 79) includes information about one ensemble from Matanzas called Emikeké that began performing in approximately 1970. It received some support from the Consejo Nacional de Cultura (CNC) and performed actively until its leader went into exile during the Mariel crisis. Other groups that received at least some financing during the same period include the Grupo Folklórico Universitario and Conjunto Afro-Cuba in Havana, and a few of the Santiago-based groups mentioned above (Ministerio de Cultura 1982, 76, 145).
13. Neris Gonález Bello, pers. comm.
14. García, interviewed by the author 24 June 2003, Havana. Support here refers to salaries for members. The groups he cites are the Conjunto Folklórico Nacional, the Conjunto Folklórico de Oriente, and the Muñequitos de Matanzas. All three troupes resulted from grassroots initiatives, but achieved professional status in 1968.
15. The Muñequitos are especially important for having made some of the first recordings of traditional rumba on the Panart label beginning in 1953.
16. Sánchez Lalebret 1963, 63. "Frente a la tribuna que inauguró el ciudadano Presidente, doctor Osvaldo Dorticós Torrado, dándole con su presencia dimensión revolucionaria al frívolo espectáculo de más de quinientos hombres y mujeres . . . respondiendo al llamado ancestral de los selváticos tambores . . . Alegría combatiente que Cuba opone como viva respuesta a las insolentes amenazas de agresión del imperialismo impotente y rapaz."
17. The first pieces are said to have been "El bajo cun-cun" and "Baila José Ramón" (Ginori 1968, 60–61).
18. Initial members included Manuel Couto Pavón on piano, Modesto Balvuena on bass, Manuell Coobas "Quenque" on congas, Miguel A. Albear Manzano on *timbales*, Raúl Bosque Grillo, Epifanio Rabell Selva, and Pedro J. Crespo Pérez y Oreste Suárez on trumpet, as well as vocalists Ibrahím Ferrer and Carlos Querol.
19. See, e.g., Robinson Calvet 1990, 9. Much of this information about Izquierdo comes from unreferenced newspaper clippings in the Museo Nacional de la Música.
20. *Hoy* (15 April 1965): no page.
21. Palmieri spoke on the history of salsa music at the Annenberg Center in Philadelphia, 22 November 2003.
22. This Areíto/EGREM recording has been re-released by Vitral Records on compact disc (VCD-4122).
23. Mason (1992, 328) includes a translation of most of this ritual phrase, and Altmann (1998, 200) contains a notated version of the sacred melody which he entitles "Mama Loya E." The musical transformation seen here on Izquierdo's album brings to mind similar phenomena in music from the United States, for instance Ray Charles' use of the spiritual "This Little Light of Mine" as the basis for his R&B hit "This Little Girl of Mine."
24. Michael Mason, pers. comm.

25. *Revolución* (12 April 1965): 1–2.

26. Alexis Esquivel, pers. comm.

27. The only arguable exception was the Grupo de Danza Contemporanea, a modern classical troupe that incorporated stylized Afrocuban dance steps into some of their choreographies.

28. Pedrito, interviewed by the author 25 June 1998, Havana.

29. Martínez Furé 1994, 35. The core of this ensemble consisted of Rogelio Martínez Furé, Sergio Vitier, Jesús Pérez, and Carlos Aldama. Oru continued to perform as an experimental offshoot of the CFN through 1986.

30. Prieto, interviewed by the author 22 September 1996, Havana.

31. Orovio, interviewed by the author 9 February 2001, Havana.

32. Partido Comunista de Cuba 1982. "Los valores culturales folklóricos — música, danza, instrumentos musicales, etcétera — que aportan las etnias representadas en estos grupos, deben asimilarse, depurándolos de elementos místicos, de manera que la utilización de sus esencias no sirva al mantenimiento de costumbres y criterios ajenos a la verdad científica." This quote comes from the Instituto de Lingüística in Havana; no page number is available.

33. Pedrito, interviewed by the author 25 June 1998, Havana.

34. L. Menéndez, interviewed by the author 5 October 1996, Havana. Enrique Sosa passed away in the 1990s.

35. Examples of Cuban anthropologists and ethnomusicologists trained in the Eastern Bloc include Olavo Alén, Victoria Eli Rodríguez, Jesús Gómez Cairo, and Lourdes Serrano. Around 1990 an "anthropology group" was created as part of the philosophy faculty with designs to create masters-level study options. At the time of my initial inquiries in 1996 they had not yet been realized, but apparently at least the beginnings of a masters program in anthropology now exist at the University of Havana, with guidance from the independently staffed Centro de Antropología (L. Menéndez, interviewed by the author 5 October 1996, Havana).

36. See, e.g., Hernández 2004.

37. Prominent publications from the revolutionary period on Afrocuban subjects include essays and books by Argeliers León (e.g., 1969, 1982), Miguel Barnet's *El cimarrón* (1966) and *La fuente viva* (1983), José Luciano Franco's *Ensayos historicos* (1974), and Rogelio Martínez Furé's *Diálogos imaginarios* (1979). Martínez Furé's book is especially useful in linking Cuban cultural traditions to African antecedents and to the larger circum-Caribbean region. Barnet's writings are also important. *La fuente viva*, for instance, is the first study to include essays on the history of Cuban folklore studies. For years, however, these individuals and a handful of others were the only ones publishing on Afrocuban topics. In the mid-1990s the Centro Juan Marinello, Fundación Fernándo Ortiz, and Centro de Antropología have emerged as new sources of information on Afrocuban culture and religion.

38. Faya, interviewed by the author 2 September 1996, Havana.

39. Sosa, interviewed by the author 12 November 1997, Havana.

40. The festival is organized by the Casa de Cultura "Rita Montaner," Calle Máximo Gómez, 59.

41. Examples of less than rigorous publications apparently intended for the tourist market include Andreu Alonso (1992) and Fernández de Juan (1996). Scholarly works from the same period have been written by Tato Quiñones, José Millet, and other authors cited in the essay.

42. See for example *Anales del Caribe*, nos. 14–15, 16–18, and 19–20.

43. Cantor (1997, 24) describes this percentage as approximately 10 to 15 percent, but the documents I have seen suggest that it can be considerably higher.

44. Pedrito, interviewed by the author 25 June 1998, Havana.

45. Sosa, interviewed by the author 12 November 1997, Havana.

46. See, e.g., Barnet 1983, 152.

47. See, e.g., Hart Dávalos 1988, 39. Though an overview of Guillén's poetry and its use by musicians is beyond the scope of this essay, readers should be aware that many performers have taken inspiration from it. Writers of popular song from the 1930s such as Eliseo Grenet first set Guillén's poems to music; classical composers Amadeo Roldán and Alejandro García Caturla soon followed suit. *Nueva trova* star Pablo Milanés has created lovely pieces in the same tradition ("De que callada manera," "Tú no sabe inglé"). New York *salseros* Willie Colón and Hector Lavoe recorded a dance piece entitled "Sóngoro cosongo" after the Guillén publication of the same name, while David Calzado's "El temba" makes reference to the poem "Tengo." Cuban rap groups have

recorded versions of Guillén's poetry as well: Cuarta Imagen ("La muralla"), Hermanos de Causa ("Tengo"), Instinto ("Kirino"), etc. Though Guillén is generally recognized as a "high culture" figure, many adaptations of his poetry are decidedly populist.

48. This piece uses a nineteenth-century rumba melody as the basis for a chamber orchestra composition. It can be found on the Camerata Romeu's compact disc *La Bella Cubana* (Magic Music CD C-0029-3, Barcelona 1996).

49. L. Menéndez, interviewed by the author 5 October 1996, Havana.

References

Acosta, Leonardo. 1982. *Música y descolonización*. Mexico City: Presencia Latinoamericana.

———. 1983. *Del tambor al sintetizador*. Havana: Editorial Letras Cubanas.

Altmann, Thomas. 1998. *Cantos Lucumí a los Orichas*. New York: Descarga.

Andreu Alonso, Guillermo. 1992. *Los arará en Cuba: Florentina, la princesa dahomeyana*. Havana: Editorial José Martí.

Atkinson, Kim. 1996. *Mozambique video*. Vol. 1, *Cuban style in 3-2 clave*. Sebastapol, Calif.: Pulse Wave Percussion video.

Barnet, Miguel. 1966. *Biografía de un cimarrón*. Havana: Instituto de Etnología y Folklore.

———. 1983. *La fuente viva*. Havana: Editorial Letras Cubanas.

Bonne, Enrique. 1999. Interview by Dr. Raúl Fernández in Santiago de Cuba, for the Smithsonian Institute.

Cantor, Judy. 1997. "Bring on the Cubans!" *Miami New Times* (19–25 June 1997): 15–33.

Carbonell, Walterio. 1961. *Crítica: Cómo surgió la cultura nacional*. Havana: published by author.

Carreras, Julio Angel. 1985. *Esclavitud, abolición, y racismo*. Havana: Editorial de Ciencias Sociales.

Casal, Lourdes. 1979. "Race Relations in Contemporary Cuba." In *The Position of Blacks in Brazilian and Cuban Society*, edited by Anani Dzidzienyo and Lourdes Casal. London: Minority Rights Group Report, No. 7.

de la Fuente, Alejandro. 1995. "Race and Inequality in Cuba, 1899–1981." *Journal of Contemporary History* 30, no. 1 (January 1995): 131–68.

de la Fuente, Alejandro, and Lawrence Glasco. 1997. "Are Blacks 'Getting Out of Control'? Racial Attitudes, Revolution, and Political Transition in Cuba." In *Toward a New Cuba? Legacies of a Revolution*, edited by Miguel A. Centeno and Mauricio Font. Boulder: Lynn Rienner Publishers.

de la Hoz, Pedro. 2000. "Qué tiene Van Van." *Granma* (28 July 2000): no page. (Archives, ICRT.)

D'Rivera, Paquito. 1998. *Mi vida saxual*. Puerto Rico: Editorial Plaza Mayor.

Fernandez, Nadine. 1996. "Race, Romance, and Revolution: The Cultural Politics of Interracial Encounters in Cuba." Ph.D. dissertation. University of California at Berkeley.

———. 2002. "What's Love Got to Do With It?: Despair, Hope, and the Anthropology of Interracial Couples in Cuba." Unpublished manuscript.

Fernández de Juan, Adelaida, et al. 1996. *Cuentos africanos*. Havana: Editorial de Ciencias Sociales.

Fernández Robaina, Tomás. 1985. *Bibliografía de temas afrocubanos*. Havana: Biblioteca Nacional José Martí.

———. 1990. *El negro en Cuba 1902–1958. Apuntes para la historia de la lucha contra la discriminación racial*. Havana: Editorial de Ciencias Sociales.

———. 1994. *Hablen paleros y santeros*. Havana: Editorial de Ciencias Sociales.

———. 1997. "La cultura y la historia afrocubana valorada por Juan René Betancourt, Gustavo Urrutia y Fernando Ortiz, entre otros." Unpublished manuscript.

Flores, Bernardo, ed. 1978. *Perfiles culturales. Cuba 1977*. Havana: Editorial Orbe.

Ginori, Pedraza. 1968. "Lo más santiaguero que pueda imaginarse." *Cuba* (June 1968): 57–61.

Guerra, Ramiro. 1989. *Teatralización del folklore y otros ensayos*. Havana: Editorial Letras Cubanas.

———. 1999. *Coordenadas danzarias*. Havana: Ediciones Unión.

Hagedorn, Katherine J. 1995. "*Anatomía del Proceso Folklórico*: The 'Folkloricization' of Afro-Cuban Religious Performance in Cuba." Ph.D. dissertation. Brown University.

———. 2001. *Divine Utterances: The Performance of Afro-Cuban Santería*. Washington, D.C.: Smithsonian Press.

Hart Dávalos, Armando. 1988. *Adelante el arte*. Havana: Editorial Letras Cubanas.

Hernández, Rafael, ed. 2004. "Las ciencias sociales en la cultura cubana contemporanea." *Temas*, no. 9 (January–March 1997): 68–86.

Hernández, Rafael, and John Coatsworth, eds. 2001. *Culturas encontradas: Cuba y los Estados Unidos.* Havana: Centro Juan Marinello; Harvard, Mass.: David Rockefeller Center for Latin American Studies.

Kundera, Milan. 1992. *The Joke.* New York: Harper Collins Perennial.

León, Argeliers. 1964. *Música folklórica cubana.* Havana: Ediciones del Departamento de Música de la Biblioteca Nacional José Martí.

———. 1966. "El instituto de etnología y folklore de la academia de ciencias de Cuba." *Etnología y Folklore*, no. 1: 5–16.

———. 1969. "Música popular de origen africano en América Latina." *América Indígena. órgano oficial del Instituto Indigenista Interamericano* 29, no. 3: 627–64.

———. 1982. "El Folklore: su estudio y recuperación." In *La cultura en Cuba socialista*, edited by the Ministry of Culture. Havana: Editorial Arte y Letras.

———. 1984. *Del canto y el tiempo.* Havana: Letras Cubanas.

———. 1985. "La música como mercancía." In *Musicología en Latinoamérica*, edited by Zoila Gómez García. Havana: Editorial Arte y Literatura.

Luciano Franco, José. 1974. *Ensayos históricos.* Havana: Editorial de Ciencias Sociales.

Martínez Furé, Rogelio. 1961a. "Los collares." *Actas del Folklore* 1, no. 3 (March 1961): 23–24.

———. 1961b. "El bando azul." *Actas del Folklore* 1, no. 7 (July 1961): 21–23.

———. 1979. *Diálogos imaginarios.* Havana: Editorial Arte y Literatura.

———. 1982. *Conjunto folklórico de Cuba: XX aniversario (1962–1982), apuntos cronológicos.* Havana: Ministerio de Cultura. (Pamphlet.)

———. 1994. "Modas y modos: Psuedofolklorismo y folklor." Interview by Evangelina Chio. *Revolución y Cultura* 33, no. 5 (September–October 1994): 32–35.

———. 1998. "No caimos con el último aguacero." *Bohemia* 90, no. 9 (24 April 1998): B56–58.

Martínez Rodríguez, Raúl. 1988. "Pacho Alonso." *Revolución y cultura* 10 (October 1988): 20–26.

Mason, John. 1992. *Orin Orisa: Songs for Selected Heads.* New York: Yoruba Theological Arch-ministry.

Matibag, Eugenio. 1990. *Afro-Cuban Religious Experience: Cultural Reflections in Narrative.* Gainsville: University Press of Florida.

Menéndez, Lázara. 1998. *Estudios afrocubanas. Selección de lecturas,* 4 vols. Havana: Editorial Félix Varela.

Millet, José, and Rafael Brea. 1989. *Grupos folklóricos de Santiago de Cuba.* Santiago de Cuba: Editorial Oriente.

Ministerio de Cultura, ed. 1982. *La cultura en Cuba socialista.* Havana: Editorial Arte y Letras.

Ministerio de Educación. 1971. *Memorias: Congreso nacional de educación y cultura.* Havana: Ministerio de Educación.

Moore, Carlos. 1964. "Cuba: The Untold Story." *Présence Africaine: Cultural Review of the Negro World* (English Edition) 24, no. 52 (fourth quarterly 1964): 177–229.

———. 1988. *Castro, the Blacks, and Africa.* Los Angeles: Center for Afro-American Studies, UCLA.

Moore, Robin. 1994. "Representations of Afrocuban Expressive Culture in the Writings of Fernando Ortiz." *Latin American Music Review* 15, no. 1 (spring/summer 1994): 32–54.

———. 1997. *Nationalizing Blackness: Afrocubanismo and Artistic Revolution in Havana, 1920–1940.* Pittsburgh: University of Pittsburgh Press.

Neira Betancourt, Lino A. 1991. *Como suena un tambor abakuá.* Havana: Editorial Pueblo y Educación.

Neustadt, Robert. 2002. "Buena Vista Social Club versus La Charanga Habanera: The Politics of Rhythm." *Journal of Popular Music Studies* 14, no. 2 (2002): 139–62.

Orejuela Martínez, Adriana. 2004. *El son no se fue de Cuba: Claves para una historia 1959–1973.* Bogotá: Ediciones Arte, Sociedad y Cultura.

Ortiz García, Carmen. 2003. "Cultura popular y construcción nacional: La institucionalización de los estudios de folklore en Cuba." *Revista de Indias* 63, no. 229 (2003): 695–736.

Pappademos, Melina. 2003. "Black Consciousness and Black Societies, 1900–1915." Paper presented at the Latin American Studies Association meeting in Dallas, 29 March 2003.

Partido Comunista de Cuba. 1976. *Tesis y Resoluciones: Primer Congreso del Partido Comunista de Cuba.* Havana: Departamento de Orientación Revolucionaria del Comité Central del Partido Comunista de Cuba.

———. 1978. *Plataforma programática del Partido Comunista de Cuba: Tesis y resolución.* Havana: Editorial de Ciencias Sociales.

———. 1982. *Selección de Documentos del I y II Congresos del Partido Comunista de Cuba*. Havana: Editora Política.

Patterson, Enrique. n.d. "The Role of Race in Cuba–United States Relations." Unpublished manuscript.

———. 1996. "Cuba: discursos sobre la identidad." *Revista Encuentro de la Cultura Cubana* 2 (autumn 1996): 49–67.

———. 1998. "Nacionalismo vs. anexionismo." *Nuevo Herald* (15 June 1998): no page. (Archives, Cristóbal Díaz Ayala.)

———. 1999a. "¿Revolución eterna?" *Nuevo Herald* (11 January 1999): no page. (Archives, Cristóbal Díaz Ayala.)

———. 1999b. "¿Cuándo levantan el otro embargo?" *Nuevo Herald* (16 January 1999): no page. (Archives, Cristóbal Díaz Ayala.)

———. 2000. "Nuevos rumbos de la revolución." *Nuevo Herald* (16 August 2000): no page. (Archives, Cristóbal Díaz Ayala.)

Perna, Vincenzo A. 2001. "Timba: the sound of the Cuban crisis. Black dance music in Havana during the Período Especial." Doctoral thesis. University of London.

Piñeiro, Alebardo. 1965. "Ton, qui, pa." *Cuba internacional* 4, no. 37 (May 1965): 24–25.

Prieto, Jorge (author and researcher). 1996. Interview by the author, 22 September 1996, Havana.

Quintana, José Luis "Changuito," and Rebeca Mauleón Santana. 1996. *The History of Songo/La historia del songo*. DCI Music Video VH0277. Miami: Warner Brothers.

Rice, Timothy. 1994. *May it Fill Your Soul: Experiencing Bulgarian Music*. Chicago: University of Chicago Press.

Robbins, James Lawrence. 1990. "Making Popular Music in Cuba: A Study of the Cuban Institutions of Musical Production and the Musical Life of Santiago de Cuba." Ph.D. dissertation. University of Illinois at Urbana-Champaign.

———. 1991. "Institutions, Incentives, and Evaluations in Cuban Music-Making." In *Essays on Cuban Music: North American and Cuban Perspectives*. Lanham, Md.: University Press of America.

Robinson Calvet, Nancy. "Gracias, por tanta algegría." *Trabajadores* (14 May 1990): no page. (Archives, ICRT.)

Sánchez Lalebret, Rafael. 1962. "Festival de música popular cubana." *Bohemia* (14 September 1962): no page. (Archives, Cristóbal Díaz Ayala.)

———. 1963. "Carnavales con alegría combatiente: La revista musical de los obreros de las construcciones." *Bohemia* (22 March 1963): 63–65.

Serviat, Pedro. 1986. *El problema negro en Cuba y su solución definitiva*. Havana: Editora Política.

Silverman, Carol. 1983. "The Politics of Folklore in Bulgaria." *Anthropological Quarterly* 56, no. 2 (April 1983): 55–61.

Titon, Jeff Todd, ed. 2002. *Worlds of Music: An Introduction to the Music of the World's Peoples*, 4th ed. New York: Schirmer.

Urfé, Odilio. 1982. "La música folklórica, popular y del teatro cubano." In *La cultura en Cuba socialista*, edited by the Ministry of Culture. Havana: Editorial Arte y Letras.

Valdés Cantero, Alicia. 1986. *El músico en Cuba: Ubicación social y situación laboral en el período 1939–1946*. Havana: Editorial Pueblo y Educación.

Vázquez, Omar. 1988. "El mozambique de Pello el Afrokan: 25 años de una aventura musical." *Granma* (22 July 1988): 5.

Vélez, María Teresa. n.d. "Drumming for the Gods: The Life and Times of Felipe García Villamil." Unpublished manuscript.

———. 1996. "The Trade of an Afrocuban Religious Drummer: Felipe García Villamil," 2 vols. Ph.D. dissertation. Wesleyan University.

———. 2000. *Drumming for the Gods: The Life and Times of Felipe García Villamil, Santero, Palero y Abakuá*. Philadelphia: Temple University Press.

West-Durán, Alan. 2004. "Rap's Diasporic Dialogues: Cuba's Redefinition of Blackness." *Journal of Popular Music Studies* 16, no. 1 (2004).

Williams, Raymond. 1977. *Marxism and Literature*. New York: Oxford University Press.

Love, Sex, and Gender

Deborah Pacini Hernández

Romantic music in the Dominican Republic—as elsewhere in the Hispanic world—has never been intended to be neutral, merely providing suitable background sound for courtship; instead, the power of song is used to construct and deconstruct emotions and emotional states. Romantic music serves as a surrogate voice for people who feel incapable of articulating their emotions and publicly expressing private feelings, and it helps them to negotiate their relationships, whether in the early stages of courtship, in the fullness of a mutually satisfying relationship, or in the painful and bitter moments of separation and solitude. In the Dominican Republic, there has been a long tradition of men actively using songs in courtship: giving a serenade, singing along with a romantic song while dancing with a woman, giving a woman a record with particularly appropriate lyrics, or sitting in a bar and playing a relevant song on the jukebox over and over again in order to reinforce feelings that may be expressed later in person. Similarly, if a relationship does not develop as desired, or if it falls apart, music about these aspects of a relationship is used to cope with the resulting feelings.

Love and the drama of courtship is without question the most common subject of popular songs all over the world; on this level, then, there was nothing particularly unique about bachata. What was noteworthy, however, was that bachata was transformed from a musical genre defined by its concern with romantic love into one concerned primarily with sexuality, and moreover, a specific kind of sexuality: casual sex with no pretense to longevity or legitimacy, often mediated by money, and whose principal social context was the bar/brothel. Bachata songs in the 1980s still related to the emotional domain, but the nature of male-female relationships was being conceptualized differently from that in the 1960s. In this chapter, I argue that these changes reflected deteriorating social and economic conditions that characterized the late 1970s and 1980s, which devastated the traditional family and community structures of bachata's practitioners and patrons.

Corruption and Economic Crisis in the PRD Years (1978–86)

In 1978, the almost universal repudiation of Balaguer's policies and political machinations resulted in the landslide election of the PRD's Antonio Guzmán, who took office with enormous popular support. It soon became apparent, however, that Guzmán was not the reformer the country had hoped for. He appointed friends and family to high government offices, and he added thousands of employees to the public payroll in order to solidify his base of support, swelling the bureaucracy by over 50 percent. When the increased government expenditures coupled with declining revenues inevitably created budget deficits, social programs were the first to be cut. Making matters worse, the international oil crisis raised the cost of food and other basic necessities, badly hurting the country's poor majority. Guzmán was not permitted by law to seek

Reprinted with permission from *Bachata: A Social History of Dominican Popular Music* (Philadelphia: Temple University Press, 1995), 153–84.

a second presidential term, but before leaving, his family and associates brazenly began emptying the government coffers. Humiliated by the public revelations of his family's misdeeds, Guzmán committed suicide just before relinquishing office (Moya Pons 1992:557–58).

In spite of Guzmán's corruption and suicide, the PRD's Salvador Jorge Blanco won the 1982 elections on promises to run a clean government; he inherited, however, an almost bankrupt bureaucracy. In 1983, unable to improve the country's economy, he turned to the International Monetary Fund (IMF) for help. The IMF package placed onerous austerity measures on the country, the most painful of which were the elimination of government subsidies or price supports for essential items, such as petroleum and medicine, and the devaluation of the Dominican peso. Both measures caused sharp price increases for locally produced as well as imported goods, many of which were primary necessities, while wages were deliberately kept low. Moreover, inflation cut into workers' salaries: between 1984 and 1990 the real hourly minimum wage declined by 62 percent, while in the same period the cost of a family food basket more than doubled (Safa 1995). Debt servicing caused even more cuts in government services such as health and education.

At the same time, ill-conceived government economic policies coupled with cuts in the U.S. sugar quotas devastated the agricultural sector, which had long been the backbone of the country's economy, while favoring the rapid expansion of a new economic sector—export manufacturing. Thousands of displaced rural workers left the countryside to seek work in the new factories established in free trade zones in or around urban areas. The new jobs created in the free trade zones, however, could not compensate for those lost in the agricultural sector, and unemployment rates for the country as a whole increased, reaching 29 percent in 1986, with another 40 percent "underemployed." By the end of the decade, 59 percent of a population that only two decades earlier had been primarily agricultural now lived in urban areas (Safa 1995). Conditions in the urban shantytowns, where most of the migrants ended up, were dismal, because of the lack of basic services such as water and sewage and also because of intense crowding. Three of Santo Domingo's barrios, for example, had more than 50,000 people per square kilometer, and most others had around 30,000—compared to between 5000 and 14,000 for the city's upper- and middle-class neighborhoods (Gómez Carrasco 1984, 5).

Not everybody suffered from the economic crisis, however. Businessmen and politicians in favor with the government were able to obtain loans from the $467 million borrowed from the IMF to invest in their businesses. The military continued to enjoy generous wages and benefits, and an ever-increasing bureaucracy added more and more loyal party followers to the government payroll. Bankers and financiers made instant fortunes playing in the money market. Those with access to the IMF money flowing through the economy were able to buy the foreign luxury goods such as automobiles and appliances that flooded into the country after import restrictions were lifted. What was worse, in spite of Jorge Blanco's campaign promises to eliminate corruption, he and his associates gorged themselves shamelessly from the IMF trough, cynically taking advantage of the country's desperate economic situation to enrich themselves with the money borrowed at such a high cost to ordinary citizens.

As a result of the PRD's betrayal, the political activism and idealism that had characterized the opposition to Joaquín Balaguer's government throughout the turbulent decade of the 1970s turned into a potent concoction of cynicism, anger, and resentment that poisoned the social environment. So bankrupt was the PRD that in 1986 Joaquín Balaguer, by then almost eighty and virtually blind, won the presidential election and resumed power. No one had any illusions about Balaguer, but at least he was no hypocrite.

Changing Gender Roles

The economic crisis that ensued in the wake of Antonio Guzmán's failed economic policies and Salvador Jorge Blanco's draconian 1983 IMF package placed tremendous stresses on traditional Dominican family and community structure. Men found it increasingly difficult to fulfill their traditional roles as primary breadwinners, and women were forced to move into the workplace to supplement family income (Safa 1995). Families were dispersed when able-bodied members were forced to migrate in search of work; those who could went to the United States, but the less fortunate ended up in the shantytowns surrounding the country's already overcrowded cities. Of the new arrivals in the city, more than half were women; a 1983 study found that 56 percent of the migrants to Santo Domingo and 57 percent of those to Santiago were women (Duarte 1986; 188). Women were expelled from rural areas at greater rates because they were less central to the rural agricultural economy and because they were able to find employment more easily in the rapidly expanding export manufacturing sector or in the informal sector. Statistics illustrate the dramatic changes in male and female participation in the labor force: in 1960 only 9 percent of the country's total labor force was comprised of women; in 1980 it was up to 28 percent and by 1991 it had risen to 38 percent. Men's labor force numbers in that same period actually declined, from almost 80 percent to 72 percent (Safa 1995).

The most common option for recent female migrants was to work as domestic servants in the homes of the Dominican bourgeoisie; 26 percent of the economically active women in Santo Domingo worked as domestics (Duarte 1986: 198). Domestic service was not only poorly paid (less than half the country's minimum wage), it also severely limited a woman's free time and ability to socialize—but it offered the security of food and lodging to women arriving in the city for the first time. Once adjusted to urban life, however, many women rejected domestic service and sought other forms of employment. The lucky ones found work in factories or the public sector, but most women, only semiliterate and unskilled, needed to turn to other means of support within the informal sector, such as selling prepared food on the street or taking in washing and ironing; others were forced to turn to prostitution.[1] In 1983, over half of those underemployed in the informal economy were women (Duarte 1986:205).

The fact that women were working more and contributing more to household maintenance at the same time that men were working and earning less had profound consequences on men's traditional role as primary breadwinners and on traditional patterns of marriage. Helen Safa notes that in a study published in 1991, almost a third of the unions between Dominican men and women were consensual rather than legal. Among women working in export manufacturing, the number of consensual unions was twice as high as legal marriages, suggesting an inverse relationship between the degree of economic independence and the stability of marriage. Because consensual unions were also linked to lower educational levels and lower socio-economic status (Safa 1995), it is possible to extrapolate that in shantytowns, where most women were poorly educated and unemployed, consensual unions were even more common than among the better educated, salaried women working in export manufacturing.

Safa notes that "women in consensual unions often assume greater responsibility for the household and are less economically dependent on men than legally married women" (Safa 1995). Still, she observed, ideologically many of these women still subscribed to traditional patriarchal values wherein men should support the family, suggesting that these women would have preferred a stable union in which the man shared more of the financial responsibility (Safa 1995). Isis Duarte observed, "The woman is obligated to work because the man (father, brother, husband, or other

family member) does not have regular employment or works independently. This irregularity of income leads to a situation in which, although the man may be present in the home, it is the woman who provides the family food" (Duarte 1986, 246–47, translation mine). Whether by choice or by necessity, then, women were more frequently becoming heads of their households: in 1984 nearly one-quarter of all Dominican households were headed by women rather than men (Safa 1995).

Women who were not dependent on men were more prone to challenge their partners/husbands over household decisions, and more likely to leave them if differences could not be reconciled: "When male bread-winning inadequacy becomes chronic and women become co-breadwinners on a permanent basis, men are no longer able to maintain their superior and authoritarian position vis-à-vis their wives" (Constantina Safilios-Rothschild, cited in Safa 1995). Clara Báez noted the consequences of this change: "In the Dominican Republic a women's social movement has been emerging that is breaking with traditional customs that confined them to the domestic sphere, which demands a voice and participation in public life equal to that of men, and which is threatening to upset the old hierarchic order in all aspects of social life" (Báez 1985, 43, translation mine).

Women, no longer tied to a stable home, family, and kinship and community networks, experienced far more sexual and social flexibility than they had in rural areas. On the other hand, they lost the social supports they had enjoyed in rural areas, and they were required to struggle, just like men, to define and maintain a space for themselves within the social and economic context of the overcrowded and impoverished shantytowns. With men becoming increasingly dependent on women for support and no longer being able to control women's movements, the relationships between men and women became more conflictive. In these circumstances, sex ceased to be solely a physical/emotional activity; it could also be related to a man's very economic survival. Moreover, the emotions of love and pain and the physicality of sex and loneliness assumed social meanings as well: the inability to attract and keep a woman undermined a man's social competence and identity as provider and authority figure.

Finally, it is important to note that in the shantytowns recreational activity, which had always included music, dancing, and drinking, shifted from domestic to public spaces such as colmados or barras. Colmados and barras had long been loci of social interaction and musical activity for both men and women; barras, however, were more male-oriented spaces, and many of them were associated with brothels; as such, they were off limits to women with more traditional values.[2] Men, less connected to stable job and home, tended to spend more time in bars and brothels, where sex could be easily purchased without any strings attached, and where alcohol became a favored way to combat the hopelessness and depression of urban life. Alcohol consumption rose dramatically: in 1983 the Dominican Republic's per capita consumption of alcohol was second only to Yugoslavia's (Arvelo 1983), and a 1987 article reported that Dominicans spent more than 30 percent of their annual income on alcoholic beverages and cigarettes—more than on any other product except food (*Master* 1, no. 1, 1987).

As a result of these socio-economic changes, interactions between men and women, which in rural areas had taken place in family and community settings and according to traditional patriarchal values, became more anonymous, conflictive, and increasingly mediated by money. These transformations in male-female relationships and the conflicts they generated were clearly evident in the lyrics of bachata songs, a number of which I will reproduce below in their entirety so that readers can appreciate how these concerns were conceptualized and articulated.

Changing Lyrics

When the first bachata songs were recorded in the early 1960s, they were still unequivocally part of the broad, Pan-Hispanic tradition of the romantic song usually modeled after the quintessentially romantic bolero, they tended to be highly emotional expressions of lost or unrequited love. As the social and economic transformations described above unfolded, bachata songs began to address a wider range of possible relationships between men and women, suggesting that extended romantic courtship and a lifetime of cohabitation were no longer expected or desired. On the contrary, these songs implied that unions were likely to be short-lived and often mediated by money. Whereas in early bachatas a man might lament that a woman had left him, in bachatas of the late 1970s and 1980s, he was more likely to express anger, disillusion, and often an implacable hostility not only toward the individual woman but toward all women as a group. There were, to be sure, still many unequivocally romantic love songs, and in fact, some singers such as Luis Segura and Leonardo Paniagua specialized in such songs. But a growing proportion of bachata production in the 1980s communicated, either explicitly or symbolically, the growing social and economic as well as emotional tensions between men and women. If song texts serve to deal publicly with private emotions, then these songs revealed conflictive and indeed disturbing changes in gender relations.

In the late 1970s and 1980s bachata's most common theme had gone beyond the problems of love desired or lost, encompassing a broader range of emotions and experiences concerning male-female relationships that included: (1) sexual appetite and lust; (2) *engaño* (deception) by a woman; (3) abandonment, despair, and isolation; (4) the bar–as the location for male camaraderie or as the place to find a woman with whom to have sexual relations; (5) drinking—as a prelude to finding a woman, as therapy for heartbreak or anger, or simply as a pleasurable recreational activity in itself. What was *not* mentioned in the songs tells us as much as what *was* mentioned: marriage, family, children, commitment, jobs, home; while there were, of course, occasional exceptions, the absence of these themes reflected men's lack of a relationship with—or responsibility to—the domestic domain. In contrast to this situation, work, wives, and long-term relationships are not unusual themes in numerous popular music forms similarly associated with lower socio-economic classes such as U.S. blues and country music (country more than blues, however). Ruben George Oliven's 1988 study of Brazilian popular music of the 1930s and 1940s provides another comparative case, which points out that women and work are seen as threatening to the freedom of the vagrant's life exalted in the songs. Nevertheless, work and women, who are associated with family and stability, were at least part of the thematic landscape within which the Brazilian singers situated themselves as bohemians. With few exceptions, work and family were seldom mentioned in bachata.

Furthermore, there was little sense of place in bachata songs–rarely was a specific place name mentioned or invoked, in marked contrast to other Caribbean musical genres, particularly those associated with performers and listeners of rural origins, in which place names are constantly invoked for affective purposes. The people and events in bachata songs did not seem to have an identifiable location–except the bar, which, I suggest, was a metaphor for the urban shantytown itself. Neither was there a sense of movement, of going anywhere: there was no imagery of journey or travel, unlike other musics, such as Brazilian popular or U.S. country music, in which the road and trucks figure prominently. People were not being pulled or pushed anywhere–neither away from nor toward home or work. Life, as expressed in bachata songs, was spatially and socially rootless, fragmentary and lacking coherency–and in that sense, these songs were thoroughly modern.

The following song by Rafael Encarnación was typical of bachatas from the 1960s: its tempo was appropriately slow, the singer's voice was plaintive, almost sobbing, as if to suggest great emotional sensitivity, and the dialogue was addressed directly to the beloved woman. Its lyrics, even while expressing the heartbreak of abandonment, nevertheless vowed eternal love; it was pain without anger. The implied relationship was not situated in any particular space or time—it could be taking place in an urban or a rural setting, in a home, a party, or a serenade, in the past, present, or future: Encarnación's love existed in a timeless emotional space defined only by the presence of feelings of love.

Muero contigo
(I die with you)
Singer: Rafael Encarnación

Ay mi vída	Oh my darling
Tú tienes toda la culpa	Everything is your fault
Tú has logrado comprender	You have come to understand
Pensé que me quieres	But I know you love me
Escucha, mi amor	Listen, my love
Las notas de esta canción	To the notes of this song
Los recuerdos más queridos de mis sueños	The most precious memories of my dreams
Vas conmigo	You are going with me
Comprende, tú sabes que te quiero	Understand, you know I love you
Todo a ti	Only you
No me niegues la esperanza de volverte a besar	Don't deny me the hope of kissing you again
Mi vida	My love
Tú, tú pretendes ver	You, you pretend to see
Que mi destino y tu amor se han separado	That my destiny and yours have been separated
Por rutas diferentes	By different paths
No puede ser	It can't be
Comprende, tú sabes que te quiero	Understand, you know that I love you
Sólo a ti	Only you
No puedo ya vivir sin tu querer	I can't live without your love
Ay mi vida	Oh my darling
Cómo he sufrido tu ausencia	How I've suffered your absence
Tu desdén, tu indiferencia	Your disdain, your indifference
Si ese dolor es por ti yo te perdono	If that pain is for you I forgive you
Muero contigo	I die with you

In subsequent decades, the narrative space constructed in bachata evolved from an intimate one occupied by only the two people involved in an emotional relationship (into which a listener to the song could insert him/herself) to a wider, more inclusive public space occupied by a group of people—the male companions of the singer: fewer songs were directed to the woman herself and more of them to the man's drinking companions. I analyzed dozens of bachata songs from the 1960s and found that most of them referred to the female subject of the song directly, in the second person familiar, *tú*. By the 1980s only about half the songs referred to the female subject directly: the other half were directed at other men and referred to the woman indirectly, in the third person, *ella*. In others, the singer shifted halfway through the song from the third person to the second person, or vice versa, again de-emphasizing a primary two-way relationship between the singer and a woman. The use of the third person not only distanced the woman from the singer, but objectified her as well: she became the problematic "other." These later bachata songs, then, were not so much imaginary dialogues between a man and a woman, but a dialogue between men *about* women. The following is a typical example of such bachatas:

A ésa me la llevo yo
(I'm taking that one)
Singer: Marino Pérez

Me cansé de llamar	I got tired of calling
Y ella no me hizo caso	But she paid me no mind
Pensé que estaba celosa	I thought she was jealous
O par otro hombre	Or because of another man
Me estaba olvidando	She was forgetting me
Ahora me doy cuenta	Now I realize
Que se está llevando	That she was being swayed
De gente que quiere	By people who want
Vernos separados	To see us separated
¿Por qué? me digo, mi amigo	Why, I ask myself, my friend?
Voces masculinos: No la quiera más, no la quiera más	Male voices: Don't love her anymore, don't love her anymore
No puedo...	I can't...
Voces masculinos: Aprenda a olvidar, aprenda a olvidar, aprenda a olvidar	Male voices: Learn to forget, learn to forget, learn to forget
¿Y cómo?	But how?
Voces masculinos: No la busques más, no la busques más, no la busques más	Male voices: Don't see her anymore, don't look for her anymore, don't see her anymore

No aguanto	I can't take it
Que me arranca el corazón de pleno	It's ripping my heart out
Pero a ésa no la olvido yo	I can't forget this one
Hablado: Dios mío, si no encuentro a esa mujer en esta noche soy capaz de matarme al amanecer, ¡que Dios me perdone!	Spoken: Dear God, if I don't find that woman tonight I'm capable of killing myself at dawn, may God forgive me!

During the same period a close relationship developed between bachata and the barra. Songs about eternal love and family were inappropriate in these contexts; instead, the songs tended to refer to the problems of transient relationships mediated not by traditional values of romantic love, but by the harsh social and economic realities of the urban shantytown. But most important, the bar and bachata songs about the bar became structural features of a male social space in which men, not women, were the providers of emotional support. Women's place in the barra context was to provide sexuality, not reliable companionship, and in fact they were perceived as forces of social disorder and emotional pain rather than of social stability and emotional warmth. The following songs by Bolívar Peralta illustrate this point.

Espero por mi morena
(I'm waiting for my dark woman)
Singer: Bolívar Peralta

Desde temprano yo estoy	I've been here a long time
Sentado aquí en esta mesa	Sitting at this table
Dígame usted, por favor	Tell me, please
Si no ha visto a mi morena	If you've seen my morena
Y no pregunte, señor	And don't ask, sir
Qué hago yo en este lugar	What I'm doing in this place
Ando en busca de mi hembra	I'm looking for my female
Y no la voy a dejar	And I'm not going to leave her
Porque hasta que ella no venga	Because until she really doesn't come back
No me canso de—	I won't tire of []
Que venga, que venga	I want her to come, to come
Mi morena otra vez...	My morena, to come again
Espero por mi morena	I'm waiting for my morena
Que me sabe comprender	She knows how to understand me
Ya te dije que yo estoy	I already told you I've been
Bebiendo desde temprano	Drinking for some time
Ando en busca de mi amor	I'm looking for my love
Y aquí la estoy esperando	And I'm waiting for her here

Y si la tiene escondida	And if he is hiding her
Anda buscándose un lío	He's looking for a problem
Porque es la que me domina	Because she's the one who dominates me
Cuando yo estoy más prendí'o	When I'm most turned on
Hablado: ¡Morena mía, corre!	Spoken: Morena, run, a fire is burning, it's the
¡Quema prendi'o, que es un Ingenio!	sugar mill![3]

Que me sirva ella
(I want her to serve me)
Singer: Bolívar Peralta

La de mi tormenta	The one who torments me
Por la que yo brindo	The one I'm toasting
En un momento	In a while
La llevo conmigo	I'll take her with me
Señor cantinero	Mister barman
Monde la botella	Send me a bottle
Y yo lo que quiero	But what I want
Que me sirva ella	Is for her to serve me
Que me sirva ella	I want her to serve me
Y al temblor sus manos	And as her hands tremble
Cierto que me quieres	It's true that you love me
Tú me estás acabando	You are finishing me off
Sientes las caricias	You feel the caresses
De un amor sediento	Of a thirsty love
Y sus nervios tiemblan	And her nerves tremble
Con el pensamiento	With the thought
Te miro nerviosa	You seem nervous
Pero te comprendo	But I understand you
Porque una cosita	Because that little thing
Sé que estás sintiendo	I know you're feeling it
Con el pensamiento	With your thoughts
Se imagina todo	You can imagine everything
Y yo la contemplo	And I think about her
Cuando estemos solos	When we are alone

Contrasting these songs to the one by Encarnación cited above, we can see that while they concerned the singer's ardent desire for a woman, most of the lyrics were directed not to the woman herself, but to implied third persons. Furthermore, unlike the intimate relationship invoked by Encarnación, which existed in a nonspecific, ethereal realm, the listener to these songs was situated in a more public narrative space whose location was quite mundane, clear, and explicit—and masculine: Peralta is in a bar, where the woman he desires works as a bar girl (i.e., prostitute). And what Peralta wants from her is not undying love but rather the satisfaction of his sexual needs. Peralta's voice, although still plaintive, has none of the soft sensitivity of Encarnación's and instead is more demanding, like a child's. "Espero por mi morena" also refers to the social tension intrinsic to relationships with bar girls and prostitutes, whose sexuality, available to all men, becomes a potentially disruptive element in the male environment.

In this sort of bachata song, men were not merely talking to each other about their emotional problems; they were teaching each other as well. Bachata, like other forms of popular music, had cognitive as well as recreational functions, serving as a sort of audio-textbook that instructed young men about women and what to expect from them emotionally and sexually.[4] Composers of popular bachata songs tended to be men with enough urban experience to express the complex relationship between rural expectations and urban constraints. Those who listened to bachata, whether they were long-time shantytown residents, recent arrivals, or campesinos who had not yet left the countryside, learned how to negotiate gender relationships in the urban shantytown context. Bachata's didactic functions could be implicit in songs about emotional pain and disruption, but sometimes were quite explicit. In the following song the singer informs his listeners that when women come to the city traditional female behavior is replaced by disruptive new customs: they begin to act independently, betray their husbands, abandon the home, and threaten friendships between men.

Aquí la mujer se daña
(Women go bad here)
Singer: Manuel Chalas

Voy a hablar de la mujer	I'm going to tell you about the woman
Que viene a la capital	Who comes to the capital
A los tres días se pone	After three days she gets
Que no se puede aguantar	So you can't put up with her
Y se tira a caminar	And she starts to walk
A la calle sin compaña	In the streets alone
Y hasta con otro te engaña	And she even deceives you
Quizás con tu propia amigo	Perhaps with your own friend
Y por eso es que te digo	And that's why I'm telling you
Que aquí la mujer sedaña	That women here go bad
Oye, hermano mío	Listen, my brother
Aquí la mujer se daña	Women go bad here
Si te hace falta el calor	If you miss the warmth
De tu linda mujercita	Of your beautiful woman

No, no vendas tu casita	Don't, don't sell your house
Pa' traerla a la capital	To bring her to the capital
Que aunque sea la más formal	Because even if she's well behaved
Aquí coge mala maña	Here she'll take on bad ways
Y hasta con otro te engaña	She'll deceive you with another
Quizás con tu propio amigo	Maybe even your own friend
Y por eso es que te digo	And that's why I'm telling you
Que aquí la mujer se daña	That women go bad here
Oye, Miguelito	Listen, Miguelito
Aquí la mujer se daña	Women go bad here
Yo tengo un amigo mío	I have a friend
Que vino y buscó trabajo	Who came to look for work
Cuando la mujer se trajo	When he brought his woman
Se le fue a los cuatro días	She left him after four days
Como una que yo tenía	Like one that I had
Que bajé de la montaña	I brought her down from the mountain
Y que cortaba la caña	Where she used to cut cane
Para mi mayor testigo	And I'm a witness
Y por eso es que te digo	That's why I'm telling you
Que aquí la mujer se daña	That women go bad here
Lo sé, lo sé, lo sé, lo sé	I know, I know, I know, I know
Lo digo con experiencia	I say it from experience
Aquí la mujer se daña	Women go bad here

The following song is equally explicit. Here, the singer taunts another man, calling him a *pariguayo*, a Dominican slang word that technically refers to an inexperienced fool, but which implicitly suggests the naive and unsophisticated rural manner of a country bumpkin. The male voices at the end of each verse calling out "Pariguayo!" challenge the social competency—and hence the very masculinity—of any man who trusts a woman, and urge any listeners with these or similar delusions to wise up as soon as possible.

Pariguayo
Singer: Toribio Jiménez

Esa mujer que tú tienes	That woman you have
Te dice, "Lloro por ti"	Says, "I cry for you"
Esa es mentira de un peso	That's a big lie
Y tú, como un pariguayo al fin	And you, like a bumpkin after all
Pariguayo, aprende a vivir	Pariguayo, learn to live
Si está tomando contigo	If she's drinking with you

Te dice, "Espérame aquí"	And she says, "Wait for me here"
Te deja y se va con otro	She leaves you and goes off with another
Y tú, como on pariguayo al fin	And you, like a pariguayo after all
Pariguayo, aprende a vivir	Pariguayo, learn to live
Cuando por ti le preguntan	When they ask her about you
Le dan ganas de reír	She feels like laughing
Ella dice que te trata	She says she treats you
Como un pariguayo al fin	Like a pariguayo after all
Pariguayazo, aprende a vivir	You big pariguayo, learn to live
Cuando te ve por la calle te dice,	When she sees you on the street she says,
"Estoy buscándote a ti." ¡Mentira!	"I've been looking for you." Lies!
Ella le está buscando, y tú	She is looking for him, and you
Como un pariguayo al fin	Like a pariguayo after all
Pariguayo, aprende a vivir	Pariguayo, learn how to live
Piénsalo bien patantún	Think about it carefully, dum-dum
Esa mujer no es un maíz	That women is no fool
Es machete de dos filos, y tú	She's a two-edged machete, and you
Como un pariguayo al fin	Like a pariguayo after all
Pariguayo, aprende a vivir	Pariguayo, learn how to live

These songs suggest that women were unreliable because they had no sense of self-control and therefore could not resist sexual desire. The idea of women's sexuality as a potentially dangerous natural force that can only be controlled by containment was part of the cultural baggage inherited from the country's Spanish/Mediterranean colonizers. Women's sexuality had been kept under control in the confines of patriarchal rural home and community settings but was unleashed when they discovered freedom of movement in the city. Because uncontrolled female sexuality could conveniently be blamed for most of the bachateros' problems, it absolved them from assuming any responsibility for failed relationships; songs almost never mention other possible reasons— for example, men's failure to provide affection, respect, faithfulness, or economic support—that a woman might leave a man.

Because there were fewer social or economic constraints binding a woman to unwanted relationships, men found that their power to make women change their behavior when they failed to fulfill men's needs or expectations became limited in urban contexts. When men's potency or prerogatives had no effect on women's behavior, men railed at women through bachata. As one young man explained to me, "Dominican men are machistas, they want their orders to be obeyed. But their women don't like to obey them, and from this come their conflicts. Bachata is a defense of men."

When a woman decided to establish a relationship with another man, men complained of *engaño* (deception)—one of bachata's most common themes. Unlike the early bachatas, in which abandonment caused extreme grief, bachatas from the 1980s responded with *despecho* (spite or indignation) and rage. The following song, a virulent expression of despecho, interestingly contains a rare mention of children, whose existence are invoked to draw attention to the woman's perfidy.

La allantosa
(Deceitful woman)
Singer: Luis Emilio Félix

Desde el día que te fuiste	Since the day you left
No habías vuelto	You haven't been back
Ahora vienes a llorar adonde mí	Now you come crying to me
Sigue, y sigue tu camino con quien quieras	Get going with whomever you want
Que este negro no quiere saber de ti	This *negro* doesn't want to hear about you
En el mundo hay mujeres desgraciadas	In this world there are miserable women
Pero tú, tú no tienes compañera	But you, you don't have a match
Abandonaste a tus dos hijos enfermos	You abandoned your two sick children
Y ahora vienes a pedirme que te quiera	And now you're asking me to love you
Las mujeres como tú no valen nada	Women like you aren't worth a thing
Tú no tienes nada, nada de valor	You've got nothing, nothing of value
Sólo un hombre que esté ciego o esté loco	Only a man who's blind or who's crazy
Puede dar una moneda par tu amor	Would give anything at all for your love

In bachata, men could also compensate for their inability to control women by bragging and other sorts of posturing that reaffirmed their masculine authority. Usually, boasting was directed at other men rather than at women—although presumably the boaster hoped that women as well would be impressed by the show of bravado. Bachateros boasted about a variety of features prized in a macho culture: their ability to attract many women and to satisfy them all sexually; their ability to physically challenge and overcome other men; and their ability to drink heavily. The following song by Bolívar Peralta expresses a common male boast that he is unfettered by responsibility or commitment to any one woman because he is charming enough to attract others.

Que venga otra mujer
(Let another woman come)
Singer: Bolívar Peralta

Mundo de amor y desengaño	World of love and disillusion
Hoy nada es raro para mí	Today nothing is strange to me
Y si uno hoy me ha olvidado	And if one has forgotten me today
Otra conmigo ha de venir	Another's bound to come along
Quien quiera ven, mira mi mesa	Whoever wants to, come to my table
Hoy siento ganas de brindar	Today I feel like toasting

Uno por la que ya se aleja	One for her who is leaving
Y otro por la que ha de llegar	Another for the one who will come
Me va la vida, pasó el ayer	My life goes on, yesterday passed
Si una me olvida, que venga otra mujer	If one forgets me, let another woman come
Junta tu copa con mi copa	Join your cup to mine
No hay diferencia, son igual	There's no difference, they're the same
Si trago a trago ella se agota	If drink after drink it gets empty
Hasta el presente ha de pasar	Even the present will pass

The pain of separation and disillusion was also expressed in bachata as *amargue*, a word that literally means bitterness—specifically the bitterness caused by deception, not the more generalized feelings of sadness brought on by unrequited love or separation due to causes other than deception. The concept of 'amargue' is similar but not identical to the U.S. concept of 'blues.' Blues suggest a certain emotional depression, even despair, perhaps caused by a woman, but they can also be caused by the hopelessness of the singer's socio-economic reality. Amargue, on the other hand, is an emotional state caused by women: a man who is *amargado* (embittered) is one who has been deceived, who has lost a presumed innocence at the hands of a treacherous woman. Indeed, so many bachata songs expressed this bitterness that in the early 1980s, bachata began to be called *música de amargue*. The embittered man typically consoles himself in a bar, drinking with friends who commiserate with his plight, as the following song by Confesor González illustrates:

No te amargues por ella
(Don't get bitter over her)
Singer: Confesor González

Ya me desengané	I've lost my illusions
De toditas las mujeres	About all women
Porque a un amigo mío	Because I saw what happened
Yo vi lo que le pasó	To a friend of mine
El confiaba en su señora	He trusted his wife
Y le daba hasta la vida	He would have given her his life
Y fue tanta la confianza	And he trusted her so much
Que con otro lo engañó	She betrayed him with another
Ya no creo en ninguna de las mujeres	I don't believe in any woman anymore
Porque cada día ellas se ponen peor	Because every day they get worse
Ellas se vuelven mariposas en los jardines	They become butterflies[5] in the garden
Y van cogiendo el sabor de cada flor	And take the flavor from each flower
Amigo mío, siéntate en mi mesa	My friend, come sit at my table
Que te voy a brindar un trago de licor	I'm going to offer you a toast of liquor
No te amargues por ella	Don't get bitter over her
Que un hombre vale más que una mujer	A man's worth more than a woman

While we must consider the verbal denigration of women as a form of violence, physical violence towards women—which certainly occurred—was seldom if ever mentioned in song texts. When physical violence was mentioned, it was directed at other men who threatened to interfere with a man's control over a woman. Songs in which men boast about their ability and willingness to fight other men were not particularly common in other Caribbean popular musics—although they were in one of bachata's important antecedent genres, the Mexican ranchera. The following song exemplifies this sort of macho bravado.

El cañón
(The cannon)
Singer: Silvestre Peguero

Voy a comprar una pistola	I'm going to buy a pistol
Con cuarenta cargadores	With forty rounds
Para quitarles la vida	To take away the life
A todos los hombres traidores	Of all treacherous men
Es que yo la quiero mi amigo	It's just that I love her, friend
Es que yo la amo	It's that I love her
Y no quiero ver	And I don't want to see
Otro aquí a su lado	Another here at her side
Lo digo por el vecino	It's because of the neighbor
Que es un hombre traicionero	Who is a treacherous man
Ahora quiere quitarme	Now he wants to take away
La mujer que yo más quiero	The woman I most love
Y si con esa pistola	*And if with that pistol*
No lo puedo resolver	*I can't resolve the problem*
Voy a compraime [sic] un cañón	*I'm going to buy me a cannon*
Para defender a mi mujer	*To defend my woman*

While most of this boasting aggressively asserted the singer's sexual and physical prowess, in a few cases unfettered male sexuality was celebrated with noncombative, pastoral imagery, as in following verses sung by Sijo Osoria:

636 | Caribbean Popular Culture

El negro más bello
(The most beautiful black man)
Singer: Sijo Osoria

Yo soy el negro más bello	I'm the most beautiful black man
Que reside entre las flores	Who lives among the flowers
A las mujeres picando	Nibbling at women
Y ellas me dan sus amores	And they give me their love
Nunca me siento amargado	I never feel embittered
Me chupo aquellas flores	I suck those flowers

In others, the metaphor for sexual prowess was thoroughly urban:

Yo soy como el dólar
(I'm like the dollar)
Singer: Manuel Chano

Yo soy como el dólar	I'm like the dollar
Que vale en el mundo entero	That's valued all over the world
Y dondes quiera que voy	And wherever I go
Consigo lo que yo quiero	I get what I want
Ando p'arriba y p'abajo	I wander here and there
Enamorando mujeres	Seducing women
Y par mi forma de ser	And because of the way I am
Consigo la que yo quiero	I get the one I want
El amor y el interés	Love and interest
Son dos cosas parecidas	Are two similar things
Y yo por una mujer	And me, for a woman
Me atrevo a perder la vida	I'd risk losing my life
Yo me encuentro ser dichoso	I'm a happy man
Dichoso soy de verdad	Truly happy I am
Yo no le pido a ninguna	I don't ask women for anything
Y todas me quieren dar	And they all want to give to me

Interestingly, the arena of struggle between the sexes transcended the material world and extended into the realm of the supernatural. Dominicans, especially those of rural origins, firmly believe that spirits, or *misterios* (see Davis 1987), can be enlisted in the effort to either obtain (or retain) a partner or, conversely, to resist the efforts of enemies to manipulate them through similar magical strategies. In the following song a man boasts that his magical powers are stronger than those of an unfaithful woman he has abandoned, who has been using magic to try to get him back.

No soy un maíz
(I'm no fool)
Singer: Sijo Osoria

La mujer que yo tenía	The woman I had,
Amigo mío, la boté	My friend, I threw away
Por andar de bochinchera	Because she ran around
Yo por otra la cambié	I exchanged her for another
La que quiera traicionarme	She who betrays me
La boto lejos de mí	I'll throw far away from me
Porque aunque a veces me desgrano	Because while I might lose my kernels [come apart]
Pero no soy un maíz	I'm no fool
Tú creíste muchachita	You thought, little girl
Que por ti me iba a morir	That I'd die for you
Pero te has equivocado	But you were wrong
Ahora es que estoy feliz	It's now that I'm happy
Ahora tú te estás muriendo	Now you're the one who's dying
Porque no te tengo a ti	Because you don't belong to me
No me importa que tú llores	I don't care if you cry
Tu llanto me hace feliz	Your tears make me happy
De nada te valieron tus mechitas	Your little candleswere useless
Soy más malo que el demonio Lilí	I'm worse than the devil Lilí
El dinero que le diste al brujo	The money you gave the witch
Junto con él, mujer, me lo pedí	Together with him, woman, I asked for it
He sabido que lo está vendiendo todo	I hear you are selling everything
Para a las fuerzas tenerme junto a ti	To forcefully keep me at your side
No me des risa, mujer, te lo repito	Don't make me laugh, woman, I tell you again
No botes tus cheles, yo no soy un maíz	Don't throw away your money, I'm no fool

Hablado: No me importa que tú digas que ando detrás de ti. Quiero que comprendas que tú, tú no estás en nada, y tú ya no significas nada para mí	Spoken: I don't care if you say I'm after you. I want you to understand that you, you are nowhere, and you don't mean a thing to me

The economic basis of male-female relationships in the shantytown context was evident in bachateros' frequent references to being the *dueño* (owner) of a woman, suggesting that women were considered an economic resource much like any other possession; "owning" a woman bestowed upon a man all sorts of benefits of which her sexuality was only one. In some cases, the references to ownership implied a pimp-prostitute relationship, but it could also refer to any man involved with a woman who was supporting him, even partially. If a man lost a woman, it meant

an economic as well as an emotional loss and, moreover, dealt a serious blow to his social status and self-esteem. The following song (whose title and singer are not identified on tape) typifies the references to a man's ownership of a woman and the necessity of defending his "property" from usurpation by others.

Sabes que soy tu dueño	You know I'm your owner
Y que vengo prendí'o	And that I've come here inflamed
No quiero nada de él, no	I don't want anything of his
Yo reclamo lo mío	I'm demanding what's mine
Quizás hay otro con ella	If there's anyone else with her
Va a haber tremendo lío	There's going to be big trouble
A nadie lo soporto	I won't put up with anyone
Que juege con lo mío	Playing with what's mine
Amí no tengo moda	I don't care
Porque me vean prendí'o	If people see me inflamed
Sabes como me pongo	You know how I get
Por defender lo mío	Defending what's mine
Mis amigos me dicen	My friends tell me
Que ya estoy perdí'o	That I'm already lost
Yo vengo a partir brazos	I've come here to break arms
A rescatar lo mío	To reclaim what's mine

Other bachata songs revealed a different, more acceptable model of male dependence on women: that of child to mother (mami). Mami was capable of fulfilling a man's every need and could be the source of well-being when she lavished her attention on a man. The following song expresses the bachatero's deep satisfaction with a woman/mother who unquestioningly fulfills his needs.

Ay mami
Singer: Marino Pérez

Que mujer tan chula	What a great woman
La que yo tengo	The one I have
Siempre me paga	She always pays
Lo que yo me bebo	For whatever I drink
Si me voy a la barra	If I go to the bar
Pido una botella	I order a bottle
Si yo no la pago	If I don't pay for it
Me la paga ella	She'll pay it for me

Espero que vuelva	I hope she comes back
Que de verdad me quiere	Because she really loves me
Para que me sobe	So that she can rub me
Adonde me duele	Where it hurts
A veces de noche	Sometimes at night
Me da mi traguito	She gives me a little drink
Para que le cante	So that I'll sing to her
Con el quejaíto	With a little moan
Yo te quiero mucho	I love you a lot
Mi dulce negrita	My sweet little negra
Nunca te me vayas	Don't ever leave me
Negra de mi vida	negra of my life

While the use of the word *mami* as a term of endearment is very common in the Dominican Republic, in bachata it was emblematic: dozens if not hundreds of bachata songs contain calls to "mami!" either in verse or in the spoken phrases uttered between verses, such as the following phrases called out by Marino Pérez in one of his songs:

Mecho! [nickname for Mercedes] Mecho my darling, mami, I love you so much I can't forget you! I won't forget you; come soon, I'm dying for you, my love! I love you very much, *chichí*, mami, I love you too much; I dream of you all night long. How could I leave you, my love, how could I forget you, if you are my only delirium in life, darling? Tell me, love, tell me.

Many of the calls to mami expressed deep fears of abandonment, because if mami were to leave, men would be deprived of her comfort and support; for example, Tony Santos cries out, "¡Regresa, mami! ¿O acaso es que no me quieres, mami mía? ¡Vuelve, mami!" (Come back, mami! Is it that you don't love me, mami? Come back, mami!).[6]

Vendiendo Huevo: The Packaging and Selling of Sex

During this same period (late 1970s and 1980s), another category of bachata song became widely popular—*canciones de doble sentido* (double-entendre songs) which were unconcerned with the social or emotional consequences of sex. They were very much interested in sex itself, however: most of them were extended narratives in which sexual activity was graphically described by replacing the words for body parts or sexual acts with words for ordinary objects or activities. The explicit sexual references in these songs clearly distinguished them from both the romantic bachatas by the likes of Luis Segura as well as from the baladas listened to by the middle classes, in which singers might make veiled allusions to a night of bliss or mention a woman's beautiful lips or eyes, but they would never—like the later bachateros—refer to her sexual organs.

In spite of their sexual subjects, these canciones de doble sentido were not only about sex; they were also about the mutability and imprecision of language as well: composers played a game of making words mean what they wanted them to mean, subverting what they were supposed to mean. Listeners, in turn, derived pleasure as much from appreciating the composer's ability to manipulate language as from the sexual subject of the song itself. Several bachateros specialized in

these songs, among them Tony Santos, Blas Durán, and Julio Angel, and it was they who produced the most commercially successful bachata songs in the 1980s; clearly there were economic rewards for producing this type of song. Double entendres had been fairly common in the spicy, topical merengue (mostly in the traditional merengue típico and occasionally in the orquesta merengue as well), but they had not been used in romantic music, nor had they been as deliberately (and successfully) used as a commercial strategy.

Interestingly enough, it was not always men's needs and pleasure, but the woman's as well, that were the subject of these songs. Female sexual desire in itself—when not complicated by emotional and social considerations—seems to have been accepted as natural, fun, even if physically exhausting: doble sentido songs often referred to sexually voracious women who besiege the hapless singer with endless sexual demands. But this seems to have been considered a humorous rather than a threatening situation. The following example by Tony Santos was typical of the period:

El aparato de mi mujer
(My woman's gadget)
Singer: Tony Santos

Los vecinos de mi casa	My next-door neighbors
Fueron a la policía	Went to the police
A poner una denuncia	To make a complaint
En contra de la negra mía	Against my negra
Ellos no pueden dormir	They say they can't sleep
Ni de noche ni de día	By night or by day
Porque mi morena vive	Because my morena always
Con la música subí'a	Has the music turned up loud
Y la negra, incomodada	And negra, irritated
Así se puso a grítar	Started to cry
Ella por darme cachú	In order to []
Así se puso a gritar, "Papi	She started to cry out, "Papi!
Súbeme el volúmen	Turn up the volume
Que aquí nadie está asustado	No one here is frightened
Que este aparatico es mío	This little gadget is mine
Yo no lo cogí presta'o"	I didn't borrow it"
Yo le bajaba el volúmen	I turned down the volume
Sin que ella se diera cuenta	Without her realizing it
Pero ella me gritaba	But she cried to me
"Sube hasta que amanezca"	"Turn it up until dawn"
Yo se lo desconectaba	I disconnected it
Y en eso el brazo caía	And the tonearm dropped
Y la negra con sus manos	And negra with her hands
Ella volvía y lo ponía	Put it back again

While these songs certainly objectified women and their bodies, men's organs were objectified as well. Moreover, they also revealed a humorous and frank approach to sexuality very different from the tragic, violent, and contemptuous songs about emotional loss that characterized some of the "straight" songs. In fact, double-entendre songs were never used to condemn women or their sexuality. The following *canción de doble sentido* by Blas Durán is interesting because it makes explicit reference to a man who, because he cannot find work, has nothing to give his woman but his virility.

El huevero
(The egg man)
Singer: Bias Durán

Hablado: ¡Señores, llegó el huevero, a diez centavos las vendo!	Spoken: Gentlemen, the egg man has arrived, I sell them for ten cents!
Coma no encuentro trabajo	Since I can't find a job
Me dedico a vender huevo	I sell eggs
Y a mi morena querida	And it's that way
Con eso yo la mantengo	That I support my dear morena
Todos los días por la mañana	Every day in the morning
Cuando le doy desayuno	When I give her breakfast
Quiere que le busque huevo	She wants me to get her eggs
Y que se lo dé bien duro	And to give them to her real hard
Con pique o sin pique	With or without spice
Yo vendo mis huevos	I sell my eggs
Y bien sabrositos	And very tasty
Que yo tengo mis huevos	My eggs are
Y a la hora de las doce	At the noon hour
Cuando empezamos a comer	When we start to eat
Quiere que le dé más huevo	She wants me to give her more egg
Ese bendita mujer	That blessed woman
Esa mujer que yo tengo	That woman that I have
Legustan los huevos grandes	She loves big eggs
No le gustan los chiquitos	She doesn't like little ones
Porque se queda con hambre	Because they leave her hungry
Hablado: Lo que tiene uno que hacer para ganarse la vida	Spoken: What one has to do to earn a living!

In the bachatas de doble sentido, women's sexual organs were typically represented by fruits and other foodstuffs (e.g., *ñame* [a tropical tuber], coconut, onions, cotton), while men's penises were more often represented by mechanical devices such as cars, combs, light bulbs, and record players. This suggests that women were considered as belonging to the natural world, while men belonged to the cultural world of man-made objects. On the other hand, although I could not find a single example of a woman's organs being represented by a manufactured object, men's organs were represented not only by mechanical devices but by natural objects as well. For example, penises could also become birds, sticks, or trees, as illustrated in the example below, suggesting that men, unlike women, can straddle the natural and man-made (i.e., cultural) domains.

El pichoncito comelón
(The hungry little pigeon)
Singer: Sergio Correa

Yo tengo un pajarito	I have a little bird
Un pichoncito comelón	A hungry little pigeon
Pero yo vivo solito	But I live all alone
Yo no tengo	I don't have anyone
Quien me atienda mi pichón	To take care of my pigeon
Todos los días bien temprano	Every day very early
Yo tengo que trabajar	I have to go to work
Y él levanta la cabeza	He lifts up his head
El quiere desayunar	He wants some breakfast
El pajarito tan comelón	Such a hungry little bird
Pero yo no tengo	But I don't have anyone
Quien atienda mi pichón	To take care of my pigeon
Yo le pedí a una muchacha	I asked a girl
Comida para el pichón	For food for the pigeon
Pero ella le cogió miedo	But she got scared
Al verlo tan cabezón	When she saw his big head
Estoy buscando una morena	I'm looking for a morena
Que lo sepa comprender	Who will understand him
Para que él coma de noche	So that he can eat at night
Y siempre al amanecer	And always at dawn

That women's sexual organs were substituted by items such as coconuts, onions, cotton, and ñame is related to the common Spanish Caribbean practice of referring to women as food, who are eaten by men in the sex act. This could be seen as crass sexism, with men wishing to obliterate

women by consuming them, but other ideas also might be resonating as well. Fruits and vegetables are living, growing things, and hence suggest fertility—unlike manufactured items which offer no possibility of growth or reproduction. The images of fertility and assimilation could be the bachateros' way of symbolizing their relationship with the natural world: by equating women with natural objects and assimilating them, they reestablished their connection with a natural world from which they were becoming increasingly alienated.

The bachatas de doble sentido, like the songs of drinking and carousing, were severely criticized as immoral and indecent. But these songs also represented bachateros' resistance to the double standards of a society obsessed with sex but that feigned respectability by masking its lasciviousness with the trappings of luxury. For example, when the Puerto Rican *vedette* (sex starlet) Iris Chacón visited Santo Domingo in 1987, the major newspapers displayed large photos of her famous ample and shapely buttocks that were worthy of any pornography magazine. Advertisers also consistently employed explicit sexual images to sell products, often using visual double entendres; for example, one television beer commercial alternated pictures of scantily clad women with a beer bottle transparently representing a phallus. Clearly, what determined whether sexually explicit material was accepted or rejected was the class of its consumers rather than the content of the images themselves. As Janice Perlman has pointed out, what is accepted as mainstream or rejected as marginal is "determined less by what is done by the numerical majority or minority, and more by what is done specifically by the middle and upper classes. If the criteria for normalcy were prevalence-determined rather than class-determined, then playing the numbers would be called mainstream, while attending the opera would be marginal. Clearly this is not the case" (Perlman 1976:92). Thus, a nearly nude, blonde white woman publicly displaying her body in sexually suggestive poses in an elegant Santo Domingo hotel and in newspaper photographs was acceptable and normal, but the candid, earthy images of sexuality expressed in bachata lyrics—for example, comparing the female genitalia to vegetables—were considered vulgar and deviant.

It is important to remind the reader that while in the 1980s more angry songs of despecho and doble sentido were being produced than in the 1960s, romantic bachatas resembling those of the 1960s continued to be released; using the bachata records I collected in 1986–87 as a sample, about one-third were still of the romantic variety. These romantic songs, however, tended to be extremely tragic, and death was a constant theme:

Dime que me quieres
(Tell me you love me)
Singer: Luis Segura

No sé qué hiciste de mí	I don't know what you've done to me
Para adorarte haces falta	I miss adoring you
Ni de día ni de noche	Neither by day nor by night
Dejo de pensar en ti	Can I stop thinking of you
Aunque estemos distanciados	Although we may be far apart
No sé si piensas en mí	I don't know if you think of me
Porque dicen que otro hombre	Because they say another man
Se ha hecho dueño de ti	Has become your owner
Dime que no es cierto	Tell me it's not true

Dime que es mentira	Tell me it's a lie
Que sólo me quieres a mí	That you love only me
Dime que me quieres	Tell me you want me
Dime que me amas	Tell me you love me
Dime que sí corazón	Tell me it's so, darling
Aunque digan que eres falsa	Even if they say you are false
Yo no te dejo de hablar	I won't stop talking to you
Tú te has metido en mi alma	You have gotten into my soul
Y no te puedo olvidar	And I can't forget you
Me está matando este amor	This love is killing me
Me está llevando al abismo	Its taking me to the abyss
Desde que te conocí	Since I met you
Me estoy muriendo de amor	I'm dying of love

Because songs such as these still adhered to the generalized romantic tradition of the love song and did not invoke the realities of urban shantytown life, they were considered more "refined," more "decent," and these singers themselves tried to disassociate themselves from those who made the "vulgar" bachatas. Nevertheless, while their songs were in fact less sexually explicit than those of their counterparts, they still displayed the exaggerated emotionality and the popular language (as well as the guitar-based music) that defined the genre. The following song by Leonardo Paniagua begins with a poetic and quintessentially romantic lament by a man abandoned by his lover. But in the last verse, the song loses its poetic refinement and expresses sentiments that would be highly unlikely in a balada or bolero.

Tú sin mí
(You without me)
Singer: Leonardo Paniagua

Acuérdate	Remember
Del amor que has cortado	The love you have scorned
De las cosas que eran	The things that were
Todas para ti	All for you
De las últimas caricias	The last caresses
Que me diste	You gave me
Del silencio que dejaste	The silence you left
Al despedirte	When you said good-bye
De las noches que faltaban	The nights that were yet
Por vivir	To be lived

Acuérdate	Remember
¿Quién eres tú sin mí?	Who are you without me?
Acuérdate	Remember
De las luces que se apagan	The lights that are turning out
De la soledad del alma	The solitude of the soul
De lo grande que es tu cama	The wideness of your bed
Sin mi amor	Without my love
De lo largo que es un día	How long a day is
Sin palabras	Without words
De lo triste que es saber	How sad it is to know
Que no te aman	That you are not loved
Del cariño inmenso que te di	The immense affection I gave you
Acuérdate	Remember
¿Quién eres tú sin mí?	Who are you without me?
Dando vueltas por el mundo	Going around the world
A buscar otro querer	Looking for another love
Tú sin mí	You without me
Como perro vagabundo	Like a vagabond dog
Esperando que comer	Looking for something to eat
Tú sin mí	You without me

The Silent Voices: Women in Bachata

Readers will note that I have referred to bachata composers and singers as if they were always men, and my discussion has been focused on perceptions of women expressed by men. This is because, with but a few exceptions, most bachatas were (and continue to be) written and sung by men. I was able to collect the names of several women bachateras: Carmen Francisco, Alida Liranzo "la Chiquitica del Norte," Leonida Alejo, Lisette (a very young woman recording in 1987), Leonida y la Mischer, and Carmen Lidia Cedeño "Zorangis la Soberbia" (Zorangis the arrogant one—who sang with a group called Los Reyes del Este, from San Pedro de Macorís). Only two bachateras, however—Mélida Rodríguez and Aridia Ventura—have become widely known. Otherwise, most bachateras have made so little impact that no one knew much about them, and it was difficult (and in some cases impossible) to locate their records.

Interestingly enough, Mélida Rodríguez, undeniably bachata's most unique and powerful female voice, emerged in the 1960s, bachata's formative period. In addition to having an extraordinarily expressive voice, Mélida composed her own songs. Unfortunately she recorded only one LP and a few singles before she died young sometime in the late 1960s or early 1970s. Nevertheless, the songs she left are truly haunting and compelling statements of her experiences of social and economic dislocation, which, according to Mélida, were suffused with solitude and suffering. In the following song, she alludes to leaving her small hometown to go to the city, where she ends up alone, in a bar, cut off from all family supports.

La solitaria

(Solitary woman)

Singer: Mélida Rodríguez

Ya no te quiero	I don't love you anymore
Tú bien lo sabes	You know it well
No quiero un hombre	I don't want a man
Que me haga sufrir	Who makes me suffer
Me voy de tu lado	I'm leaving your side
Me voy para siempre	I'm leaving for good
Y salgo un día	I'm leaving one day
No nos volvamos a ver	We won't see each other again
Oye, mi amiga	Listen, my friend [female]
Oiga un consejo	Hear this advice
Tú no sabes	You don't know
La que me ha pasado a mí	What has happened to me
Míreme los ojos	Look at my eyes
Que ya no tienen lágrimas	They have no more tears
Que por los hombres	Don't let yourself
No se deje sufrir	Suffer for men
No tengo madre	I have no mother
No tengo padre	I have no father
Ni un hermanito	Not even a brother
Que me venga a acompañar	To come and keep me company
Yo vivo triste	I live in sadness
Vivo solitaria	I live in solitude
En mi barquito	In my little boat
Yo me voy a navegar	I'm going to sail off
Dejé a un pueblito solitario	I left a lonely little town
Entré a una barra	I went into a bar
Y me puse a tomar	And started to drink
Ey, cantinero	Hey, barman
Sírvame otra copa	Serve me another glass
Porque mis penas	Because I've come here
Aquí las vengo a ahogar	To drown my troubles

The fact that most of Mélida's songs are situated in the bar was highly unusual, given that most songs by her male counterparts at the time were still in the indefinite and nebulous space of romantic love that I discussed above: in her songs, the bar clearly emerges as a symbol of urban alienation. Mélida also openly embraces drinking (which even today women seldom do publicly) not only as a panacea for emotional pain but as a way to have fun.

Esta noche me quiero emborrachar
(I want to get drunk tonight)
Singer: Mélida Rodríguez

Esta noche me quiero emborrachar	Tonight I'm going to get drunk
Para ver lo que puedo encontrar	To see what I can find
Tengo un hombre muy bueno	I've got a good man
Me da todos sus besos	He gives me all his kisses
Me entrega sus cariños	He gives me his caresses
Y todo el corazón	And all his heart

Even more extraordinarily, she openly discusses her decidedly nontraditional sexuality. She makes quite clear that her sexual behavior is her personal prerogative—she is seeking pleasure—and it is independent of the constraints imposed by men or family. She admits, however, that sexuality cannot substitute for the kind of emotional intimacy and support she desires:

La trasnochadora
(The night owl)
Singer: Mélida Rodríguez

Dicen que soy trasnochadora	They say I'm a night owl
Porque vivo tomando de bar en bar	Because I live drinking from bar to bar
Lo que busco son mitad de cariño	I'm looking half for affection
Y dinero que me puede remediar	And half for money that can heal me
Vivo en un mundo de placeres	I live in a world of pleasures
Perdida en esta oscuridad	Lost in this darkness
Pero se lo pido al infinito	But I ask the infinite
Que me guíe por la claridad	To guide me to the light
Yo no sé lo que me pasa a mí	I don't know what's happening to me
[]que yo las tengo así	[] I have them this way
Le pido al señor que me acompañe	I ask the lord to stay with me
Y me quite este mal de mis pesares	And to take away this burden of sorrows

In another song she openly admits she engages in extramarital sex (she stops short of declaring herself a prostitute), but she adamantly rejects the social stigma attached to women who are sexually active and refuses to equate a woman's value with the nature or extent of her sexual activity.

La sufrida
(Suffering woman)
Singer: Mélida Rodríguez

Ya no me importa	I don't care anymore
Que me digan qu'estoy mala	If they tell me I'm bad
En esta vida yo me siento feliz	In this life I feel happy
En la otra vida	In another life
Que es la que llaman la buena	The one they call good
Yo sufrí mucho	I suffered a lot
Y por eso la cambié	And that's why I changed it
Ahora me culpan	Now my friends blame me
Mis amigos porque ignoran	Because they don't know
Lo sufrida que yo he sido	The suffering I've endured
Por ser buena	For being good
Yo sólo se la amargura que se pasa	Only I know how bitter it is
Siendo buena y que me culpen de mala	To be good and be blamed for being bad
Yo soy mala	I'm bad
Y seguiré siendo mala	And I'll keep on being bad
Porque es mucho	Because I suffered
Que sufrí por ser buena	Too much for being good
Es mejor sermala	Its better to be bad
Y parecer buena	And seem good
Que ser buena	Than to be good
Y que me culpen de mala	And be blamed for being bad

Apart from Mélida, no other woman presented such direct challenges, both to the broad domain of traditional ideas about female sexuality, as well as to the more specific male domain of bachata; since her death, the only bachatera to achieve national stature was Aridia Ventura. While Ventura did in fact sing and compose songs from a female point of view, I was told that many of her songs were composed by others and had been selected by Radhames Aracena, upon whom she remained dependent throughout most of her career. Nevertheless, her songs did provide an alternative viewpoint to that of male bachateros. The following song, like many bachatas, expresses contempt for a former lover, but from a female point of view, and, moreover, it is situated in the feminine sphere—the home—rather than a bar.

La fiesta
(The party)
Singer: Aridia Ventura

Si es cierto que te vas	If it's true you're leaving
Voy a pedirte un favor	I'm asking you a favor
Que revises bien la casa	Check the house well
Lo que te vas a llevar	For what your taking with you
Que no se te olvide nada	Don't forget anything
No tengas que regresar	So you won't have to come back
Y si puedes darte prisa	And if you can, hurry up
Que voy a usar el lugar	I'm going to use your place
Si es cierto que te vas	If it's true you're leaving
Te lo pido por favor	I ask you please
No te tomes tanto tiempo	Don't take such a long time
Cuando vayas a empacar	When you pack
Que no se te olvide nada	Don't forget anything
Que puedas necesitar	You might need
No vaya a ser que par eso	So that to get it
Se te ocurra regresar	You even consider coming back
Si es cierto que te vas	If it's true you're leaving
Una fiesta voy a dar	I'm going to give a party
Porque la verdad sea dicha	Because if the truth be said
Ya no te aguantaba más	I couldn't stand you anymore
Y no intentes regresar	And don't try to come back
Con mi fiesta en la mitad	In the middle of my party
Que pueda ser que te atienda	The one who answers the door
Quien ocupa tu lugar	Could be the one taking your place
Si con alguien tú me ves	If you see me with someone
No te pongas a botear	Don't have a fit
Porque fui tuya sola	Because I was yours alone
Y no me supiste aprovechar	And you didn't appreciate me
Puedes seguir tu camino	You can keep going
Por aquí no vuelvas más	Don't come back here
Porque yo ya tengo en lista	Because I already have on the list
Quien ocupará tu lugar	Someone to take your place

The songs recorded by another bachatera, Carmen Francisco, on the other hand, sometimes echoed the male voice in bachata, condemning women for being treacherous creatures that disturb social order.

Mentirosa y traicionera
(Liar and traitor)
Singer: Carmen Francisco

Tú me vives criticando	You're always criticizing me
Porque soy de esta manera	Because I am the way I am
Dices que no andas conmigo	You say you won't be with me
Porque soy una cualquiera	Because I'm a nobody [i.e., slut]
Pero tú siendo casada	But you, being married
Eres falsa y traicionera	Are false and treacherous
Que teniendo tu marido	Having a husband
A otro hombre te le entregas	You give yourself to another man
Sabiendo que a dos personas	Knowing that for two persons
L'estás buscando problemas	You are creating problems
Y yo mejor prefiero	I'd much rather
Ser de esta manera	Be this way
No quiero ser	I don't want to be
Una señora placentera	A lady of pleasure
Como eres tú	Like you are
Mujer de conciencia negra	Woman of black conscience
Eres mala y mentirosa	You are bad and a liar
Y traicionera	And treacherous

I cannot offer adequate explanations as to why women have been so peripheral in bachata. It has nothing to do with a cultural prejudice against women making music: in fact, the Dominican Republic probably has more women making commercial music than any other Latin American country—and I do not mean just singing and composing, which women commonly do all over Latin America—but playing instruments and constituting the core of the musical ensemble. There have been several all-women merengue orquestas, among them Las Chicas del Can, La Media Naranja, and Las Chicas del País; and in merengue típico, both Fefita la Grande and María Díaz play the lead instrument—the accordion—and the bands go by their names. While some songs sung by these women musicians have been written by men, many have been composed by the women themselves and reflect the female point of view; furthermore, these women, playing trombones, saxophones, congas, accordions, and the other instruments traditionally played by males, have offered a highly potent visual and auditory image of women as artistic creators. The absence of women in bachata is especially noticeable when compared to other Latin American popular musics associated with the underclasses, in which women have had a more prominent voice. For example, in the guitar-based Colombian *música carrilera* —in which songs were also situated principally in the bar/brothel

context—*carrilera* was sung as often by women as by men, often mincing no words in commenting on the irresponsible behavior of men.[7] In bachata, however, women never achieved similar levels of participation.

Moreover, while Dominican men were able to articulate their emotional pain, their vulnerability, their frustrations, and their anger through bachata, women did not have comparable opportunities to voice their concerns and grievances. Given that both men and women experienced the difficulty and anguish of shantytown life, it seems peculiar that bachateros manifested no solidarity with women, no interest in cooperating with them in order to cope with their shared social and economic troubles—as can sometimes be found in rock songs, for example, in which singers invoke the power of a couple's love to overcome economic hardship or social prejudice. On the contrary, women in bachata songs were frequently portrayed as the aggressors and men as victims. Bachateros complained about betrayal, alienation, and hopelessness, yet they did not blame these problems on the economic and political elite who had indeed betrayed and abandoned the poor as a class, but on women. Men certainly knew that even if they could no longer control women as they once had, they nevertheless exercised more power over their own lives than could women, who were even more vulnerable and exploited than men. In bachata songs, men explored the tensions between male and female, owner and property, aggressor and victim, freedom and control, order and chaos. But in failing to understand that the root problems were economic exploitation, unemployment, poverty, overcrowding, and social disruption, these tensions remained unresolved, and women have remained the silent subjects of men's commentary.

Notes

1. There are many levels of prostitution; not all prostitutes are "professional" – i.e., they do not practice full-time, and not all of them are connected with brothels. Some women act independently and simply expect some sort of payment for sexual favors. Others have some sort of arrangement with the owner of a bar, whereby the owner receives a fee (paid by the client) for allowing the woman to work out of his establishment, but he has no control over what the couple does or where they go. Some bars have rooms in the back that can be rented for the night or by the hour, but the women do not reside on the premises. Finally, there are brothels as we tend to think of them, with women residing at an establishment dedicated principally to prostitution, although there would probably be a bar associated with it (Juan Valoy, personal communication).
2. Not all barras were disreputable: in spite of their often seamy appearance, many were simply the only public spaces that offered barrio residents a place to dance and socialize. I witnessed children with their families sitting in neighborhood barras on Sunday afternoons, listening to bachata (and other musics), drinking sodas, and dancing; at night, of course, the environment became less familial. On the other hand, while patrons in a neighborhood bar certainly might know each other well, barras, unlike homes, are open to strangers, and they operate under a completely different set of social rules than do family homes.
3. The imagery linking the heat of sexual desire to the heat of a burning sugar mill clearly reveals the composer's rural origin.
4. Simon Frith and Angela McRobbie (1978: 4) develop this idea in relation to rock, claiming that rock is "a necessary part of understanding how sexual feelings and attitudes are learnt."
5. In Dominican street slang, *mariposa de la noche* (butterfly of the night) is a prostitute.
6. One could seek explanations for obsession with *mami* in several places. One possibility would be a Freudian analysis of mother-son relationships; another would be a consideration of what Franco Ferrán (1985) refers to as the typical Dominican sense of *orfandad* (orphanage), which has two roots: on the one hand, the abandonment by Spain and on the other, the orphaned Africans.

7. The following song, from a commercial Colombian cassette lacking song titles or singers, shows what is possible when women are given a chance to express their anger:

Ojalá que te dé harta fiebre aftosa	I hope you get a bad case of hoof-and-mouth disease
Y te llenes de niguas las dos patas	And both your legs fill up with parasitic sores
Que se te llene to'itico el cuero 'e rollas	And that your whole body gets covered with fungus
Y la cabeza tupí'a de garrapatas	And your head fills with ticks
Que cuando 'tés por debajo de otra guasca	That when you're underneath another country girl
Me vea yo con l'alcahueta de tu mamá	I run into that procurer who's your mother
Pa' quebrarles a los dos el sentadero	So I can break both your butts
Con to'iticas las tablas de la cama	With the boards of the bed
Que pagues caro y sucia	May you pay dear and dirty
Tu amor negro y falsario	For your black and false love
Y que un veterinario	And may a veterinarian
Te ha de desahuciar	Pronounce you a hopeless case
Y que mis propias patas	And may my own legs
Te vea arrodillado	See you on your knees
Rogando que te quiera	Begging me to love you
Más que sea por caridad	If nothing else than for pity
Acordáte gran flechudo de la estera	Remember, you big prick, the pallet
Donde jurastes por la Virgin ser me fiel	Where you swore by the Virgin to be faithful
Y mientras yo me mataba trabajando	And while I was killing myself working
Vos con los otros pasando luna 'e miel	You were off with others on a honeymoon
Y hoy que vas sin vergüenciando por la vida	And today you're bumming through life
Dando por nada el morrito de tu amor	Giving away free the scrap of your love
Ya te veré por la calleenvilecí'o	I'll be seeing you filthy on the streets
Y hasta embutí'o entre las llantas de un camión	Stuffed below the wheels of a truck

Transnational Soca Performances, Gendered Re-Narrations of Caribbean Nationalism

Susan Harewood

Academics continue to be interested in nationalism particularly because, as the pace of global integration intensifies, more and more questions emerge about the ways in which "the nation" is imagined by populations in motion. This article seeks to utilize motion, and movement in general, as analytical tools to illuminate the ways in which some Caribbean women imagine the Barbadian nation through soca performances. The focus is on leading soca singer Alison Hinds and her fans as they circulate through a number of sites within Caribbean communities in the region, in North America, in England and in cyberspace. It is argued that through soca performances these women articulate a flexible view of citizenship and nationhood. These definitions of the nation are lower frequency challenges[1] (Gilroy 1993; Aching 2002) to masculinist, bourgeois state definitions of the nation and thus the challenges contribute to the heteroglossic narration of the Barbadian nation. This article, therefore, re-examines academic discourses on nationalism and the nationalist subtexts that are part of traditional calypso research as these discourses frequently suggest that the narration of nations is an elite, male-centered practice. I argue that national narratives are, in fact, multi-authored projects, though clearly not egalitarian ones. Thus, by paying attention to the embodied narratives of women, we can begin to understand the complex imaginings of the nation at this time.

I have selected Alison Hinds and her fans for this examination because of her status within the Caribbean transnational music industry (Guilbault 2002). Hinds has been extremely successful in this music industry. Until 2004 she was the lone female in the highly recognized, seven member band, Square One, from Barbados. She has won a number of national and international awards including Tune of the Crop 1996 and 1997, Party Monarch 1997, Barbadian Entertainer of the Year 1997, Best International Artist 1998, and International Music Award 2000. In 2006 Alison continued to garner awards as a solo artist; she won Best Soca Female Artist and Best Soca Song at the Reggae Soca Music Awards. Square One and Alison Hinds were very active circuits on the Caribbean transnational music scene. They would tour the circuit practically every weekend. In fact the research for this paper took place in Barbados, New York and Chicago.

In addition to Alison's success the emphasis on a *Barbadian* female singer contributes to the slowly growing amount of work that looks beyond the calypso industry in Trinidad. For the purposes of a study such as this Barbados also serves as a valuable example because of the ways in which nationalist projects and responses to the challenges of globalization have been articulated within cultural policies and gender policies. There has been a concerted effort to shape cultural policy in such ways as to create desirable national subjects (Bennett 1995). Don Marshall (2001) describes this as "defensive nationalism". He points out that Barbadian political and economic elites, faced with the threats that globalization poses to their control over an economy which still displays vestiges of the plantation economic structure, have avoided restructuring that economy

Reprinted with permission from *Social and Economic Studies* 55, nos. 1&2 (2006): 25–48.

and, instead, have resorted to legitimizing their power through the use of nationalist symbols and events. This conservative move maintains the status quo but leaves Barbados, and average Barbadians particularly, vulnerable to the vagaries of the global market. Eudine Barriteau (2001) has identified similarly conservative policy decisions in the area of gender policy. She points out that there has been growing hypermasculinization of the state and increasing ideological hostility towards women. There has emerged a discourse of "male marginalization" that seeks to (re)center the focus of gender policy on men, particularly young men and boys:

> At the end of the twentieth century, commentators often typecast Caribbean women as the witches of medieval Europe. Women are responsible for the destruction of families (but not crops as yet), high rates of divorce, male economic and social marginalization, and the comparatively poorer performance of boys and men in every education level. Newspaper articles and editorials warn of the damage being done to boys by being in female-headed households, attending co-educational schools and being taught primarily by female teachers (Barriteau 2001: 45-46).

Thus Hinds is performing at a time characterized by defensive masculinist nationalism. I hope to demonstrate that her performances and her audience's co-performances re-accent this nationalism specifically by positing a re-narration of the place of women in the nation-state.

National Narratives, Gender and Caribbean Popular Music

We have grown used to the idea of the nation as a creative project. The nation is imagined in the content, form and ritual of communication practices – print capitalism (Anderson 1991), electronic capitalism (Appadurai 1996) and, I would argue, academic discourses. Locating "nation-ness" in communication immediately suggests to me the type of question often posed by feminist media scholars: how are these communication rituals gendered? In other words, how are the narrations of nation (Bhabha 1990) shaped by the relations of gender and how does this shape the ways in which "the nation" is imagined? Attempting to answer questions such as these is key to understanding the different ways in which nations are imagined and the variegated nature of nationalist projects. This is because these questions call upon us to pay attention to the "marginalized narratives of nation" (Liu 1994). Essentially I am examining nationalist stories/narratives/imaginings by drawing from a Bakhtinian (1981) notion of heteroglossia which highlights the ways in which 'official' and 'unofficial' voices are deeply enmeshed. Though nationalist elites might seek to suggest that there is one discourse of nationalism, in fact there always exists a hybridized exchange of centripetal and centrifugal voices each dependent upon the other, each being shaped by the other. There is a tendency in nationalism research to pay attention to the centripetal discourse of nationalism, however less attention is given to the centrifugal discourses that are not only vital to the maintenance of the nation, but also are fundamentally important if we are to imagine different ways of existing in a nation. This article pays attention specifically to the nation as imagined by particular Caribbean women and the ways in which they put nationalism to use in political ways that seek to re-accent gender hierarchies. This becomes particularly important because, according to Nira Yuval-Davis (1997) research on nationalism has rarely addressed the issues of gender. Often when the topic of women and nationalism is addressed women are seen as the symbol of the nation and the putative justification for nationalistic violence (see for example in the work of Grewal & Caren 1994; Appadurai 1996; McClintock et al. 1997). Very little of the work addresses women as agents in nationalist movements. Jill Vickers (2002) suggests that these homogenizing views of gender and nationalism tend to characterize women involved in nationalist movements as "dupes". How, then does one attend to the unheard voices of national narrative?

Partha Chatterjee (1993) suggests that in order to hear women's narration of the nation, one must find alternatives to the conventional archives of political history. He undertakes this task by examining women's autobiographies. Such a search for alternative archives is vitally important. Nevertheless, in the Caribbean context, the search must be extended beyond Chaterjee's emphasis on autobiographies and the written word due to gendered claims of authority over both the written and the spoken word.[2] The Word has been claimed as the space of rational discourse and the legitimate medium of political leadership. Yet the Word has also been claimed as practically the exclusive province of Caribbean males. This has been effectively explored by Belinda Edmonson (1999). She explores the difficulty that Caribbean women have had in thinking of themselves as writers. Even celebrated Caribbean female writers such as Jamaica Kincaid state that, whilst growing up in the Caribbean, they were unable to imagine themselves writing. By contrast, Edmonson suggests, leadership both intellectual and political, has been imagined to be the province of the Caribbean "gentleman scholar". We see similar gendering over the spoken word. Roger Abrahams' (1983) influential work on Caribbean verbal performance, in describing the importance of the "man of words" performances, almost seems to silence women. It depicts women as the silent guardians of private sphere respectability.

The marginalization of women's voices and words should, therefore, lead one to look at other archives in order to understand their narratives. Caribbean popular music would seem to be an ideal site at which to attend to these narratives. However the silencing of women's voices and the emphasis on The Word as the rational and male-dominated path to legitimate power has shaped both the practices of calypso and soca performance and the academic criticisms of calypso and soca with its assumptions about the ways in which they have contributed to the formation of the modern Caribbean nation states. Calypso research has tended to emphasize the literary over performance. In writing historiographies that stress calypso's contribution to the decolonization of, particularly, Trinidad and Tobago, emphasis on lyrics has far outweighed attention to other elements of performance such as music, movement, costuming, props etc. The calypso, often described as "the poor man's newspaper", has been asked to stand as the authentic medium for mass representation for the modern Caribbean nation state. Calypsonians have been cast in the role of the American Fourth Estate, or the Commonwealth Westminster Loyal Opposition.

However, limiting the research focus to lyrics, detracts from the multidimensionality of the art form. In some instances it has had the effect of limiting the "political calypso" only to those songs that *lyrically* address agendas set by the political elites. Thus it tends to legitimize the political status quo. This has broad level implications. It is particularly relevant to attending to the narrations of female performers and their fans – it silences these women because so few of them write their own lyrics (Ottley 1992; Maison-Bishop 1994; Mahabir 2001). In addition to this, the emphasis on lyrics has contributed to a particular type of bifurcation of the perceived roles of Anglo-Caribbean popular music. Calypso, marked as the political music of lyrics, has attained a certain level of respectability and legitimacy; soca with its emphasis on party rhythms has been identified as "fast food music" (Rohlehr 1998) and has been deemed non-political. Highlighting this division is, again, significant to understanding of the ways in which the political work of women is marginalized as it is in the soca arena that more and more women are engaging in public performance. I would suggest therefore, that if cultural critics are to attend to the political work of soca in general and the political work of soca divas and their fans in particular it is important to broaden the focus beyond the lyrics. It is vitally important that those lyrics and their interpretation be placed within the context of other elements of performance; in this way we can begin to explore women's embodied critiques and broader political agendas.

Methodological notes

In this study I conduct a close analysis of Alison Hinds' performance through a number of sites. The article focuses on consistent performance practices replicated in Hinds' recorded and live performances. Thus earlier videotaped performances from the late 1990s are linked to live performances in the 2000s. These performances took place in Barbados, Chicago and New York. Though this article is part of a larger project that draws together different practices of performance analysis – those from ethnomusicology, performance studies, and dance studies – given the limitations of space and the particular focus of this article a great deal of the focus here is on the theatrical and dance performance practices.

The performances analyzed here are taken to be in dialogue with larger discourses and thus the performance practices are further illuminated through qualitative interviews with Alison Hinds fans, by analysis of the now defunct Square One message board and by analysis of media reports. The emphasis has been on understanding the meaning-making processes that are constituted within soca performance.

Embodying the Nation

Calypso and soca, as one would expect with most forms of music, are rich in performance. Though the recorded aspect of the industry is extremely important (and growing ever more so), live performance remains the lifeblood of the calypso soca music industry. Thus cultural critics who wish to examine meaning-making processes in the music need to examine performance practices. These meaning-making performance practices articulate contestatory imaginings of the nation. In this article the specific focus will be on the uses of the body because disciplining the body is at the heart of bourgeois nationalist projects. Though popular and influential theories of nationalism and state building are premised upon the denial of the body, modern governance is actually predicated upon the meticulous control of the body. Thus Benedict Anderson's (1983) conceptualization of nations as imagined communities and Jürgen Habermas (2000) model of the ideal public sphere both work through the idea of the disincorporation of the body (see Calhoun 1997; Warner 1993). However, as a number of scholars point out (see for example Landes 1998; Fraser 1993; Warner 1993; Meehan 1995) this disincorporation, which is identified as a key qualification for access to power, is not available to all bodies. Nationalism and state building, therefore, do not work so much by ignoring the particularities of different bodies; rather, they work by delimiting bodies and assigning differing values to different bodies. In other words, these projects seek to use bodies in the service of political and economic gain. This is what Michel Foucault (1995) has identified as the governmental production of docile bodies. Of course, when one writes of the Caribbean these efforts at defining and controlling the body join a long, brutal legacy of enacting punishment both *on* the body and the meticulous control *of* the operations of the body within the plantation economy system. For all of these reasons it would be a serious mistake for academia to continue ignoring or dismissing the importance of the body to calypso and soca performance. Such attention to the body should focus, not only on the body as text, but also the body's movements as texts. Concentrating on the dancing body makes clear the discursive regimes that contest one-dimensional uses of the body. Thus I will begin by concentrating on Alison Hinds' use of dance.

One of the key aspects of Alison Hinds' performances has been her use of the social dance form 'wukking up'. The Dictionary of Caribbean English defines wukking up in the following terms: "to dance suggestively or erotically, with vigorous gyrations of the waist and hips." There are undertones of moral censure in the definition; nevertheless. Hinds' and her fans' co-performances

build upon the idea of wukking up as an example of Bajan cultural distinctiveness and yet move that claim of cultural uniqueness beyond the limits of the territorial nation to effect an empowering form of Caribbean regionalism.

Alison Hinds' first big soca hit was *Ragamuffin* in 1996. Different performances of this song highlight the way in which Hinds uses the hook "Leh muh see yuh wukking up" to both display and invite wukking up. For example in the video of her performance at the 1996 Party Monarch competition one can witness the style of performing practices that she consistently uses when performing that hook. She sings this hook with her feet planted slightly apart, all movement is at her hips and waist which are thrust slightly forward, her head is down slightly as she specifically looks at each section of the crowd in front of her; it is as if she is showing them what she can do and simultaneously inviting them to wuk up. In the production of the music video for the same song, freed from the limitations of a hand-held microphone, she adds to the invitation by beckoning with her hands. In the *Four Sides* video Alison, who emerges from the back of the Frank Collymore Hall moves through the audience and as she gets to one rendition of this key hook she encounters a young girl of about twelve. Alison and the girl co-perform the lines; Alison uses the same stance she has used in previous performances but she points at the girl with both her finger and her wukking up waist invoking the youngster to dance. The girl happily obliges. Bent at the waist, arms spread out slightly to her sides, the girl allows her small frame to take over more of the space around her. Then the girl circulates her hips and bumper³ keeping her torso stationary, though she twists her neck from side to side peeking behind at her bumper. A newspaper columnist's comment and a laser show can highlight the ways in which wuk up performances like these have become part of narratives about Bajan cultural distinctiveness.

During the height of debates in Barbados over the acceptable limits of wukking up in 1994 columnist Al Gilkes stated:

> (Wukking up) is a talent which I am convinced is uniquely Bajan. Trinis sing about wining and that's exactly what they do. They wind their hips and backsides but they cannot wuk up like a Bajan. Nor can Jamaicans, Americans, Europeans, Japanese, Chinese, Russians, Indians or anybody else on the face of the earth.

> Africans come close but what they do is more like choreographed movements than the natural, free and innovative rhythmic wuk-up of the Bajan. (Gilkes, 1994: July 31).

In 1997 the Cohobblopot⁴ show opened with a well received laser display that repeatedly interspersed the figure of a wukking up woman with the logo of the National Cultural Foundation,⁵ the word Cohobblopot, and the names of the different parishes in Barbados, a map of Barbados, the flag, a dolphin (one of the images from the national coat of arms) the sun, and the logos for the 1997 Crop Over.

The comment by Al Gilkes reflects many similar comments made to me as I conducted my research. The comment, and others like it, highlights the way wukking up has been defined as a form of Barbadian authenticity. Despite the fact that similar movements can be found elsewhere, and notwithstanding that US Virgin Islanders also refer to their social dance form as wukking up (see Oliver, 2002), Al Gilkes and many other Barbadians mark wukking up as distinctly and uniquely Bajan. Wukking up becomes part of the processes of making traditions and histories that narrate the nation. Frequently the only histories that are taken seriously in nationalist projects and nationalism research are those that are almost exclusively logocentric. However Celeste Fraser Delgado & Jose Esteban Mufioz, (1997) point out that often alternate histories are articulated in movement. They argue that dancing performs political and historical work:

> Dance sets politics in motion, bringing people together in rhythmic affinity where identification takes the form of histories written on the body through gesture...Dance promises the potential reinscription of those bodies with alternate interpretations of history. (Fraser Delgado & Esleban Mufioz 1997:11)

Wukking up, therefore, can be understood as narrating a historiography of the Barbadian nation; specifically, in wukking up Barbadians have sought to define Barbados by selecting particular understandings of the island's African history and by creating specific notions of what constitutes "authentic" African movement, wukking up is generally identified as being related to African movement. These history-making processes fall into two broad categories (though there is a great deal of heterogeneity within these two categories) those undertaken by the elite and those undertaken by citizens further from the seats of power.

The Black political elite, conscious that colonials emphasized the Little Englishness of Barbados, has reinforced its legitimacy by strategically drawing upon Barbados' historical connection to Africa. However, it is an emphasis on Africa that remains tied to the dark, rhythmic, sexual, dangerous mobility of the colonial racist imagination. This has given rise to a certain amount of ambivalence about wukking up by political and economic elites. State administrators are not above promoting wukking up as "distinctly Afro-Barbadian." This can be seen in the way in which the wukking up woman is promoted as part of the nationalist iconography in the Cohobblopot laser show. However, at the same time, state administrators often appear alarmed by any perceived excessiveness of wuk up movement and seek to control it by defining where wukking can take place, when it can take place, who can do it, and how much is considered vulgar. The most obvious example of this occurred in 1994 when NCF administrators threatened revelers that the NCF would set up a task force (from that moment known as "the wuk up police") who would monitor wukking up on Kadooment Day and remove those who carried it too far. For example a news report during the debates quotes both the Director of the NCF Dr. Elliot Parris and one of the major sponsors:

> "There is some misinterpretation in the public's mind," Parris said. "We're out to set standards, but we're not saying don't wine, wuk up or juck." "Everybody should know what extreme vulgarity is," he added, "and the responsibility is on the band and section leaders to keep that out. Parris noted that the NCF is currently discussing with the police the question of lewdness on the road, "since the issue came up."

Peter Marshall of Mount Gay Distilleries, who spoke as one of the sponsors of Crop-Over, said: "As sponsors we want everyone to enjoy themselves, but within a limit. There are extremes on Spring Garden that are not called for. Wining and wukking up is part of Barbadian and Caribbean in culture. I am not averse to a little wukking up myself," he added (Alleyne 1994, July 21).

Here then we have the deployment of ideas of taste, institutionalization, self-regulation and cultural authenticity all in an effort to impose a type of order that can serve both political and economic elite interests (see Bourdieu 1984; Bennett 1995; Miller 2002). These efforts at control in 1994 were the most overt (though they were met with a great deal of hilarity by Barbadians and provided much fodder for calypsonians); nevertheless elite efforts to control Bajan bodies by defining the limits of wukking up continue. These efforts seek to claim for elites monopoly control over bodies, over the meaning of the symbols of the nation and thus the right to define the nation. Such claims have consequences for a broad range of Barbadian citizens. However, given space, my focus here is on women.

The above description of the laser show opening for Cohobblopot 1997 is a graphic representation of what feminist scholars have asserted about nationalism that much of the work of nationalism

is marked on the female body and that women are often marginalized as symbols of the nation rather than as agents of the nation. In these opening moments of Cohobblopot the dancing female body is merely part of the repertoire of nationalist representation. The wukking up woman in this presentation is as devoid of agency as the map, the corporate logos, the images from the coat of arms etc. One might draw other examples. For instance, up until quite recently visitors to the official site of the Barbados Tourism Authority were invited to click on a picture of a woman's behind – and only her behind – dressed in her Crop Over costume to set it in wukking up motion. Currently there is no need to even click on the bottom – dissected from its body and made available for the pornographic gaze (Hooks 2003), this behind remains constantly in motion. The question, therefore arises, how does one challenge these efforts to represent and use the female body for elite purposes? It is here that Mikhail Bakhtin's (1984) notion of the unfinalizability of language is important. Bakhtin argues that any word can be re-accented to serve different purposes and I believe it is vitally important to extend this idea beyond the re-accenting of words to the re-accenting of other meaning-making systems such as movement. In their co performances Alison and her fans seek to re-accent the wukking up woman and thus challenge elite monopoly over nationalist symbol-making.

Re-accenting the wukking up woman

If political and economic elites seek to map the Barbadian nation by defining and delimiting the uses of Bajan women's bodies, Bajan women (quite broadly defined) seek to create an alternate story of the nation. In this story women are much more than mere voiceless symbols of the nation. When talking about Alison, or writing about her in cyberspace, fans consistently describe the significance of Alison's public performances to Caribbean women. They state that their participation in her performances is important to their own definitions of nation-home, and they link much of their positive engagement with Alison's performances to their perception that Alison is strong and in control. Alison and her fans performance practices seek to re-position women moving them from the margins, where they might only be visible as symbols, to the center. Performance analysis and discussions with fans, suggest that important practices of performance include the invitation to wuk up collectively and the expression of power through the use of the bumper, choice and the voice.

Leh me see you wukkin up

I have already implied that the invitation to dance, specifically to wuk up, should be interpreted within the context of elite efforts to manage wukking up bodies. Thus it is possible to return to the *Four Sides* performance in which the young girl gleefully responds to Alison's invitation to wuk up. This is a particularly instructive invitation as it is an invitation for co-performance. This song, many of Square One's songs, and in fact many soca songs in general, are "instruction songs," i.e. songs in which those in the dancehall are given instructions by those on stage as to how to dance, where and when to move. These have often been disparaged by critics. For example, Gordon Rohlehr (1998) states that these songs are often sung by men and frequently herd women into spaces to make them available for male consumption. His argument is valuable up to a point, though it tends to portray women as dupes unable to decide when they will dance and when they will not. What is missing from his description is the diversity of meanings that these types of performances might have for those participating. In different ways Alison's fans said that moving together is part of their processes of community formation (particularly national and regional group formation) that extend beyond the dancehall. Thus some of the interviewees suggested that they took their ability

to do the dances as a relatively open-ended qualification for membership to a variously constructed Barbadian/Caribbean transnational community. This transnational community formation crisscrossed at various points in online communities, and at soca fetes and carnivals in the wider Caribbean community. For some, these communities served as an important buffer between them and their lives outside of the Caribbean – a way of connecting with home. For others this also led to greater financial opportunities as they were able to get involved in the transnational Caribbean carnival industry.

Bumper politics

Another way in which this *Four Sides* performance is related to consistent performance practices used by Alison and her fans is in the use of the bumper. Bumpers have been particularly important to the history of soca music. Lord Kitchener's *Sugar Bum Bum* in 1978 which extols the virtues of Audrey's sweet ass is generally acknowledged as the first really big soca hit out of Trinidad, and *Put Your Hand on the Bumper* in 1994 by Grandmaster was one of the first really big hits in Barbados that emerged out of the technological and sonic transformations of soca into hardcore soca (Best 2001). In the 1990s Barbadian male calypsonians produced a slew of bumper songs thereby participating in the ways in which the elites defined and made use of women's bodies. The behind or bumper has been such a touchstone in the politics of race and gender that a number of scholars have considered whether it is possible for women to reclaim their bodies from these representations. African American and Latina feminist scholars trace a line between prurient interest in Black women's bodies as a mark of difference during the imperial period to contemporary sexualized representations of Black and Latina women in hip hop, salsa, sports and film (see Rose 1994; Hayes 1999; hooks 2003; Barerra 2000; Negrón-Muntaner 2000; Beltrán 2002; Hobson 2003; Molina & Valdivia 2004). These writers point out that Black and Latina women have often been reduced to their bottoms and that their bottoms have been defined as abnormal, contravening accepted (read Eurocentric) standards of beauty. In hip hop, especially, one sees similarities between the male rap artists focus on the booty and the soca artists focus on the bumper. Scholars state that, though hip hop booty songs might be seen as subversive because they critique White beauty standards, the music and videos still reduce women of color to one essential body part. Where some of these scholars see opportunities to seriously challenge these stereotypical representations is in the cases in which women have greater control over their representations, particularly where these representations fall outside disciplinary control of the bottomphobic North American mainstream.

Thus those who write about the behind within circum-Caribbean contexts, scholars such as Carolyn Cooper (1995), Francis Negrón-Muntaner (1997) and Maude Dikobe (2004), seem to identify more opportunities for women to speak back to the stereotypical representations. Whereas in the North-American focused literature the legacy of Saartje Baartman[7] seems to shape the bottom's meaning, in the literature that focuses on the Caribbean the legacy of Nanny of the Maroons[8] offers the possibility of re-coding the meaning of the bumper. The international circulation of discourses in the colonial period and contemporary revolutions in communication technology which lead to even more rapidly distributed and replicated images perhaps make it unrealistic to carve such a strict line, as currently exists in the literature, between the consequences of the Baartman legacy and the possibilities of the Nanny legacy. Both women form part of the discursive regimes that shape understandings about women's bodies. One woman allows us to pay attention to capitalism's continuing exhibition and exploitation of women's bodies. One woman allows us to identify the

"small but potent culturally reflexive public space(s)" (Rose 1994) from which women re-accent the meanings of the bottom.

Alison's performances seek to take part in these bumper politics. She engages in the same type of triple coding that Negrón-Muntaner assigns to Jennifer Lopez:

> "showing ass" as a sign of identity and pride, "kiss my ass" as a form of revenge against a hostile cultural gaze, and "I'm going to kick your ass" viz-a-viz the economic exploitation implicated in racism (Negrón-Muntaner 1997:187)

Alison achieves this in two consistent practices in her performance: in her wuk up style which involves pushing out her bumper and secondly in pushing or pooching back on a man she selects from the audience. As indicated above the analphobia of White supremacy denigrates the Black and Latina bumper for its excessive protrusion. In the wuk up style of pooching back, rather than accepting the idea that one must tuck the ass in, Alison and her co-performing audience push the bumper out even further, they respond to the call to «Back, back push it back, right back right back push it back» in songs like *Ragamuffin*. In addition to this, pooching back also includes looking back at one's own bumper. It was for this reason that the young girl in the *Four Sides* concert kept craning her neck to look over her shoulder. This self-regarding of one's own bumper seems to do a number of things. First it re emphasizes the idea of the bumper as resistantly beautiful, showing ass as a sign of identity and pride, and second it deflects the centrality of the male gaze (without making it irrelevant). Self-regarding one's own bumper seeks to challenge male authority over symbol-making. Women engaging in this move become part of "the spin pooch posse" and qualifications for membership are much more open than one might think. Whereas male soca singers at times imply that Black women who do not have large bottoms are beneath notice "if you got no projection, you can't pass inspection" Lil' Rick sings in his hit *Bumper Inspector* – female soca singers like Alison extend membership in the spin pooch posse to women of different body types. This extension often takes place in their ad lib interactions with the crowd.

The second way that Alison's performances work bottom politics is through the way in which she interacts with selected male members of the audience. For example at American Thanksgiving/Barbados Independence 2002 in Chicago Alison invited a man in the audience to come on the stage and wuk up on her behind in order to test his wining skill. At the Birthday Bash Concert at the Boatyard in Barbados in 2002 she selected someone who she called "a young fella" to fulfill this role. Fans said that they had seen similar performances a number of times. In these performances the progression of the interaction is the same. When she invites the man on stage, she presents herself as a teacher who will teach him to wuk up. She also makes it clear that the man's success will be evaluated on his ability to keep up with her. She starts the lesson facing him with a slow wine. As the lesson progresses however, she gets faster and faster. Then she breaks, and, speaking to the audience, indicates that the real test will now begin. She then turns around presenting her bumper to the man and again the tempo rises to a crescendo as the man attempts to keep up with Alison.

This is a highly contentious presentation. It would be nonsensical to ignore the dangers here; this presentation can be very clearly accented to fit sexist and racist ends. Alison makes a spectacle of herself in a manner that can be deployed in a number of ways. Carnival theory has focused on the ways in which public performances simultaneously destabilize and buttress existing social structures (Russo 1986). Alison's performance can be seen as reinforcing sexist and racist tropes about Black and/or Caribbean women. Nevertheless, it is also important to recognize the complex

negotiations over power that take place in this performance. Maude Dikobe (2004), making a similar argument about bottom politics in Trinidadian female performance, suggests that it is important to acknowledge the intricate verbal and non-verbal negotiations that take place between dancing partners. Although Dikobe seeks to differentiate between Denise Belfon and other soca divas, including Alison Hinds, Belfon's description of her dance encounters with men as a negotiation over control, echoes the way Alison and her fans view Alison's encounters and their own dance experiences in the dancehall. Dikobe states of Belfon:

> It is also extremely important to note that Denise differentiates between offering herself to her male audience as a sexual object, and celebrating her own sexual power. "I might call a male audience member up on stage to dance with me," she says. "What I ensure though is that he wines *with* me...not *on me*" (Dikobe 2004).

In interviews with me and in the media Alison makes similarly subtle differentiations and it is through these differentiations that she emphasizes her control of the situation. This control is very important to both Alison and her fans. Their repeated emphases on control seemed to be working in argument with particular ideas about women, namely who should make women's choices, how might women skillfully *and* pleasurably use their own bodies and what historical iconography would they draw upon.

In the matter of choice Alison, the fans, and Dikobe's article all put a great deal of weight on the fact that within these dance situations the soca diva, or any woman within the carnival road/dancehall environment, chooses who can and who cannot wine on her bumper. This element of choice might seem like a small measure of control; however Angela Davis' (1999) exploration of sexuality in women's Blues performance is instructive. She emphasizes that choice and selection of partners (sexual or, in this case, dance) acquires a greater level of significance when one considers that the denial of such choices was a fundamentally important part of slavery; to which I would add that patriarchy at its most savage still operates through the denial of female choice.

Perhaps the threat of Alison's wuk up style and the ways it draws its power from the mythos of the bottom is most clearly demonstrated in the rumour-mongering that sought to undercut this power. It was rumored in Barbados for a long time that Alison's bottom was not real; that she would pad her bottom prior to each performance. It was a rumor she even had to respond to on the regionally televised interview program *Talk Caribbean* and in the Trinidadian press.

Let me hear the ragamuffin call

These issues of control and power are further emphasized in the fans' admiration of Alison's vocal style. I would link Alison's use of her voice to the rest of her embodied critique. As Simon Frith (1978) and Roland Barthes (1977), suggest the voice is body. It is sound produced by the body and it calls attention to the body. It is from the sound of the voice that we conjure up embodied feelings – such as sadness and happiness. Body sound creates ideas of physicality – such as strength or weakness. And the voice conjures up gender and even race.

Alison uses her voice to conjure strength. Part of Alison's vocally embodied critique comes from the way her voice announces her presence. Women and their bodies in the public framing of calypso competition have conventionally been present mostly in the background as backup singers. When Alison started singing with Square One she tended to sing mostly in the background. Fans often said that their appreciation for her began when she moved up front, both physically and vocally. Alison's upfront performance style specifically challenges the state's use of the silenced wukking up woman.

At the same 1997 performance that opened with the laser show and the wukking up woman, Alison's *Ragamuffin* performance began with her usual call to action: "African children, Selassie I children, let me hear the ragamuffin call!" She then moved to each area of the stage calling out:

> Stands, stands posse, right here, right here, wunna far away but I aint fuhget wunna. I wanna see dem hands, I wanna see dem hands, show me dem hands. C stand C stand! Leh muh see dem hands, leh muh see dem hands, leh muh see dem hands. VIP Posse Leh muh see dem hands, leh muh see dem hands, leh muh see dem hands. D stand, de ghetto stand Leh muh see dem hands, leh muh see dem hands, leh muh see dem hands. Grounds posse all o' de grounds put your hands in the air; put your flags in the air. I wanna hear you scream! Yeah posse!

Here, then, in a way that provides a stark contrast to the voiceless, unfleshed, laser wukking up woman used as national emblems, Alison purposely appropriates the entire National Stadium performance space and thus symbolically the entire national space by drawing on the conventions of the DJ/MC/Soca fete "shout out." In other words, she hails each section of the stadium; and it is the ability of her voice to carry to each of the stands that gives rise to the perception of control that most of her fans attribute to her. Part of that authority comes from the relatively low pitch of her voice, what theatre voice specialists call the chest voice (McCallion 1988; Hendrick 1998) and part of it comes from the timbre of her voice – its "roughness". This "necessary roughness" comes from her utilization of the chant conventions of hardcore soca performance and from her own needs to reinterpret the conventions of male soca performance.

Alison says that when she first emerged on the soca scene there were no women from whom she could learn soca performance style. She therefore looked to male performers such as Edwin Yearwood, Machel Montano and Iwer George. In addition to this, her performance also works through a type of sounding of power. In thinking this through conventions became important, again, to my understanding. How do we hear James Earl Jones and the late Barry White? Power, it seems can be heard in the ability to be loud i.e. cover (colonize?) a great deal of sonic space. The overall effect is a sound somewhat like a re-fashioned field holla. To put it in Kamau Brathwaite's terms it's a voice "like a howl, or a shout or a machine gun or the wind or wave" (Brathwaite 1984). Again the voice demands attention. It refuses the silencing of women's voices I referred to earlier. Alison appropriates the male privilege of speaking and being heard, and, doing so in such a sensual and hyper feminized body, allows her to transgress the boundaries of male roles and female roles.

Concluding discussion

Mary Russo states:

> Women and their bodies, certain bodies in certain public framings in certain public spaces are always already transgressive – dangerous and in danger (Russo 1986:216).

Her insight is helpful in thinking about Alison Hinds' performances. Often both academics and activists have sought a zero-sum politics from popular culture in which clear winners can be identified by their successful appropriation of power. This is understandable, perhaps, as the needs for social justice are so dire. However, whereas the desire to declare the winners is understandable it is neither realistic nor wholly innocent as it often requires that popular culture be stripped of its complexity so that it can meet standards of progressive politics that are predetermined by academics. However, popular culture participates so much in the rich, messy, complexity of the social that it is rarely, if ever, wholly emancipatory or wholly disciplined. Thus Alison Hinds' embodied performances are dangerous and in danger.

They are a danger to those who wish to impose a monologic narrative on the nation – one in which women are merely the symbols, but not agents in the nation. Alison Hinds' performances demand visibility, they advance the possibilities of women's power and thus re-imagine a nation of greater gender equality. However, her performances are also in danger. One must recognize that these performances can never be wholly innocent of racist and sexist understandings about women's bodies. This is perhaps the danger of using the female body for feminist ends. Janet Wolff says "(The body's) pre-existing meaning as a sex object for the male gaze, can always prevail and re-appropriate the body, despite the intentions of the woman herself" (Wolff 1997:32). However, her statement implies that meaning-making stops, that there is some original meaning of the body, a feminist answer, a sexist re-appropriation, and then meaning stops. Besides the impossibility of identifying some clear original meaning for the body, the idea that meaning making stops is successfully challenged by the Bakhtinian idea of a chain of mean. Meanings are constantly available to be accented and re-accented and constantly crisscrossing each other in a rich social dialogue. It is the role of academic work to acknowledge this heteroglossia and as Robert Stam puts it, draw attention "to the voices at play in the text, not only those heard in aural 'close up', but also those voices distorted or drowned out by the text" (Stam,1993). Because it is by paying attention to the multiplicity of voices that the possibility of imagining a new politics, new ideas of community, and new means of achieving social justice exists.

Notes

1. Gerard Aching (2002) draws on Gilroy's notion of lower frequency challenges: in order "to imagine resistance and opposition to political leadership without measuring their efficacy in absolute terms of a successful or failed appropriation of political power." Gilroy and Aching's use of this idea seems helpful to understanding political actions and alliances formed within oppressive structures that attempt to reformulate and re-accent the oppressive discourses. Such an understanding of politics allows one to perceive the possibility of nationalism from the margins aimed at "maintaining the nation" for reasons that are different from those of the elites and middle groups who so often are identified as having almost exclusive authority over how the nation is imagined.
2. There are also class issues associated with logocentrisim which I don't have time to deal with in this paper.
3. Bumper is Bajan nation language for the bottom. The word bumper is used a great deal in the soca and calypso arenas.
4. A Cohobblopot or Cohobbleopot is "a stew comprised of a variety of ingredients" (Collymore, 1970: 25). The word was adopted to name the penultimate event of the Crop Over Festival. The use of Cohobblopot is used to signify the variety of performances within the show.
5. The National Cultural Foundation is the statutory board, established in 1984, that implements and administers the majority of Barbados' cultural policies and projects, particularly the Crop Over Festival. Crop Over is a month long cultural festival held in Barbados. It culminates in a costumed parade called Kadooment Day on the first Monday in August.
6. Even though Negrón-Muntaner focuses on Jennifer Lopez (and Selena) and her representation in mainstream US American media, she locates a great deal of Lopez›s resistive power in her Puerto Rican-ness, thus she describes Lopez as the "next big butt of the Puerto Rican cultural imaginary and our great avenger of Anglo analphobia" (Negrón-Muntaner, 1997: 186).
7. Saartje Baartman was a Khoikhoi woman who was taken from South Africa to Europe in 1810. She was put on display in various exhibitions where the focus was on her genitalia and protruding buttocks. Baartman›s body was made to stand for the limited humanity and the hypersexuality of black women. Even in death her body was made to emit racist, sexist colonial signs as her body was dissected and her vagina and brain were exhibited in France up until 1985.
8. During the slave period Nanny was a Maroon leader who is said to have led attacks against the British military forces. In the legend, Nanny is said to have defeated British soldiers by deflecting

their bullets with her bottom (Cooper 1995 and Hobson 2003 list a number of accounts and interpretations of this myth).

References

Abrahams, R. 1983. *The Man-of-words in the West Indies.* Baltimore: Johns Hopkins University Press.

Aching, G. 2002. *Masking and Power: Carnival and Popular Culture in the Caribbean.* Minneapolis: University of Minnesota Press.

Alleyne, P. 1994, June 10. Tough manners for Kadooment bands. *Weekend Nation*, 7.

AUsopp, R. ed. 1996. *Dictionary of Caribbean English Usage.* Oxford & NY: Oxford University Press.

Anderson, B. 1991. *Imagined Communities: Reflections on the Origin and Spread of Nationalism.* London & NY: Verso.

Appadurai, A. 1996. *Modernity at Large: Cultural Dimensions of Globalization.* Minneapolis: University of Minnesota Press.

Bakhtin, M.M. 1981. *Discourse in the Novel.* In *The Dialogic Imagination. Four Essays by M. M. Bakhtin,* ed. M. Holquist, 259–422. Texas: University of Texas Press.

——. 1984. *Rabelais and His World,* (trans. H. Iswolsky). Bloomington, IN: Indiana University Press.

Barrera, M. 2000. Hottentot 2000: "Jennifer Lopez and Her Butt" in *Sexualities in History: A Reader,* eds. K. Phillips and B. Reay. New York: Routledge.

Barriteau, E. 2001. *The Political Economy of Gender in the Twentieth-century Caribbean.* Hampshire: Palgrave.

Barthes, R. 1977. *Image, Music, Text.* Translated by Stephen Heath. NY: Hilland Wang.

Behauge, G. ed. 1984. *Performance practice: Ethnomusicological perspectives.* Westport, CT: Greenwood Press.

Beltran, M.C. 2002. The Hollywood Latina body as site of social struggle: Media constructions of stardom and Jennifer Lopez's "Cross-Over Butt." *Quarterly Review of Film and Video.* 19, 71–86.

Bennett, T. 1995. *The Birth of the Museum: History, Theory, Politics.* London & NY: Routledge.

Best, C. 2001. Technology constructing culture: Tracking Soca's first "post" *Small Axe,* 9, 27–43.

Bhabha, H.K. 1990. *Nation and Narration.* London: Routledge.

Bourdieu, P. 1984. *Distinction: A Social Critique of the Judgment of Taste.* (R.Nice, Trans.) Cambridge, MA: Harvard University Press.

Brathwaite, E.K. 1984. *History of the Voice: the Development of Nation Language in Anglophone Caribbean Poetry.* London: New Beacon Books.

Calhoua C. 1997. Nationalism and the Public Sphere. In *Public and Private in Thought and Practice: Perspectiveson a Grand Dichotomy,* eds. J. Weintraub & K. Kumar, 75–102. Chicago, IL: University of Chicago Press.

Chatterjee, P. 1993. *The Nation and its Fragments: Colonial and Postcolonial Histories.* NJ: Princeton University Press.

Cooper, C. 1995. *Noises in the Blood: Orality, Gender, and the 'Vulgar' Body of Jamaican Popular Culture.* Durham: Duke University Press.

Davis, A.Y. 1998. *Blues Legacies and Black Feminism: Gertrude "Ma" Rainey, Bessie Smith and Billie Holiday.* NY: Vintage Books.

Dikobe, M. 2004. "Bottom in de road: Gender and sexuality in calypso." *Proudflesh: A New Afrikan Journal of Culture, Politics & Consciousness.* 3.http://www.proudfleshjoumal.com/issue3/dikobe.htm. Downloaded June 2, 2005.

Edmonson, B. 1999. *Making Men: Gender, Literary, Authority, and Women's Writing in Caribbean Narrative.* Durham & London: Duke UniversityPress.

Foucault, M. 1995. *Discipline and Punish: the Birth of the Prison.* Middlesex: Penguin Books.

Fraser Delgado, C. and J. Esteban Munoz. 1997. *Everynight Life.* Durham: Duke University Press.

Fraser, N. 1993. Rethinking the public sphere: A contribution to the critique of actually existing democracy. In C. Calhoun, *Habermas and the Public Sphere,* 109–42. Cambridge, MA: The MIT Press.

Frith, S. 1978. The body electric. *Critical Quarterly.* 37 (2).

Gilkes, A. 1994, July 31. No ring bang no wuk up. *Sunday Sun,* 48.

Gilroy, P. 1993. *The Black Atlantic: Modernity and Double Consciousness.* Cambridge, MA: Harvard University Press.

Grewal, I. & K. Caren eds. 1994. *Scattered Hegemonies: Postmodernity and Transnational Feminist Practices.* Minneapolis: University of Minnesota Press.

Guilbault, J. 2002. Beyond the "World Music" label: An ethnography of transnational musical practices. *Grounding Music,* May. http://www2.rz.hu-berlin.de/fpm/texte/guilbau.htm.

Habermas, J. 2000. *The Structural Transformation of the Public Sphere: An Inquiry into a Category of Bourgeois Society. Translated by Thomas Burger with the assistance of Frederick Lawrence.* Cambridge, MA: The MIT Press.

Hayes, E.M. 1999. Black women performers of women-identified music: "They cut of my voice I grew two voices." Unpublished doctoral dissertation. University of Washington.

Hobson, J. 2003. The 'batty' politic: Toward an aesthetic of the Black female body. *Hypatia,* 18(4), 87–105.

hooks, b. 2003. Selling hot pussy: Representations of Black female sexuality in the cultural marketplace. In R. Weitz ed., *The Politics ofWomen's Bodies: Sexuality, Appearance and Behavior,* 166–83. NY: OUP

Landes, Joan B. ed. 1998. *Feminism, the Public and the Private.* Oxford & New York: Oxford University Press.

Liu, L. 1994. The female body and nationalist discourse: *The field of life and death* Revisited In I. Grewal and K. Caren eds. 1994. *Scattered Hegemonies: Postmodernity and Transnational Feminist Practices.* Minneapolis: University of Minnesota Press.

Mahabir, C. 2001. The rise of calypso feminism: Gender and musical politics in the calypso. *Popular Music.* 20 (3).

Maison-Bishop, C. 1994. Women in calypso hearing the voices. Unpublished doctoral dissertation. Alberta University, Canada.

Marshall, D.D. 2001. Gather forces: Barbados and the viability of the national option. In *The Empowering Impulse: The Nationalist Tradition of Barbados,* eds. G.D. Howe and D.D. Marshall, 256–68. Jamaica: Canoe Press.

McClintock, A., M. Aamir and E. Shohat, eds. 1997. *Dangerous Liaisons: Gender, Nation, and Postcolonial Perspectives.* Minneapolis: University of Minnesota Press.

Meehan, J. 1995. *Feminists Read Habermas: Gendering the Subject of Discourse.* NY & London: Routledge.

Miller, T, and G. Yudice, G. 2002. *Cultural Policy* (Core Cultural Theorists Series) NY, London, New Delhi: Sage Publications.

Molina Guzman, I. and A.N. Valdivia. 2004. Brain, Brow or Booty: Latina Iconicity in U.S. Popular Culture. *Communication Review.*

Negrón-Muntaner, F. 1997. Jennifer's butt. *Aztldn,* 22(2), 182–95.

Oliver, C. 2002. Winin' yo' wais': The changing tastes of dance on the U.S.Virgin Island of St. Croix. In S. Sloat Ed., *Caribbean Dance from Abakua to Zouk.* Gainesville: University Press of Florida, 199–218.

Ottley R. 1992. *Women in Calypso.* Arima, Trinidad.

Rohlehr, G. 1998. 'We getting the kaiso we deserve': Calypso and the world music market. *Drama Review.* Fall 42 (3).

Rose, T. 1994. *Black Noise: Rap Music and Black Culture in Contemporary America.* Middletown, CT: Wesleyan University Press.

Russo, M. 1986. Female Grotesques: carnival and theory. In T de Lauretis,ed. *Feminist Studies Critical Studies.* Bloomington: Indiana University Press, 1986.

Stam, R. 1993. Bakhtin, polyphony and ethnic racial representation. In R. Sunder Rajan, *Real and Imagined Women, Gender, Culture and Postcolonialism,* 251–76. NY & London: Routledge.

Vickers, J. 2002. Feminists and nationalism. In Dhruvarajan, V. and J. Vickers eds. *Gender, Race and the Nation: A Global Perspective.* Toronto: University of Toronto Press.

Warner, M. 1993. The mass public and the mass subject. In C. Calhoun, *Habermas and the Public Sphere,*377–401. Cambridge, MA: The MIT Press.

Wolff, J. 1997. Reinstating corporeality: feminism and body politics. In J.C. Desmond, *Meaning in Motion: New Cultural Studies of Dance.* Durham, NC: Duke University Press

Yuval-Davis, N. 1997. *Gender and Nation.* London: Sage Publications.

Timba Brava:
Maroon Music in Cuba

Umi Vaughan

Yo traigo la verdad, pa' tí y pa' tu mama...
I bring the truth, for you and your mother too...
– JOSE LUIS CORTES EL TOSCO
(a chorus from his song "Masca la cachimba")

Nowadays all musicians and close observers of Cuban culture acknowledge the boom of Cuban popular dance music that occurred at the opening of the 1990s and maintained itself until the closing of that decade. The sound that was born during that period – the musical practices, instrumentation, treatments of traditional themes, and all-new thematic content based on emergent realities (having, of course, roots in previous epochs) – formed a legitimate and new kind of popular music, first called "Cubansalsa," then "timba." This chapter describes timba and argues that it is an important Cuban phenomenon-where several processes and social debates intersect. Specifically, I look at economic policy, identity formation, gender roles, and especially at race struggles. Definitions of the term *timba* itself give clues to its nature both as a musical genre and as a form of social action.

Fernando Ortiz suggests that the word *timbá* is onomatopoeia – like *batá* or *tambó* – replicating the sound of drums (1994, 8). *Timba* was an old word that used to mean a group of gamblers in the Spanish army deriving from the word *timbal*, because they would use the kettledrum as a card

table (Sublette 2004, 272). In the *solares* (tenements or ghettos) of Havana and Matanzas during the nineteenth century, a meeting of men with drums and rum was synonymous with *rumba de solar*, one of the roughest, "of the people" (*del pueblo*) manifestations of rumba; "¡La timba se ha puesto buena!" (This joint is jumpin') (García Meralla 1997). Here, we understand *rumba* or timba as a kind of fiesta or social activity that would always include food, drink, song, dance, drums, invited guests from the neighborhood, and so on (Acosta 2004, 40; Sublette 2004, 272). Journalist and scholar of Cuban music Maya Roy tells us, "Timba and timbero are expressions that appear frequently in the context of the rumba, exclamations with which one called out to the drummers, to encourage them" (Roy 2002, 180).

Not only does timba imply sound, but also it implies people (especially marginalized people) and collective action.[1]

Figure 1. Timba Brava, 2003.

Guava paste eaten with bread as an inexpensive snack called "pan con timba" is another common usage in Cuba. Timba also means "belly" (*vientre*) and refers, some say, to the feminine energy of the drum, pregnant with sound and power; thus it is delicious and full of possibilities. Los Papines first recorded the term; "I like to hear a bolero, guaracha, or son montuno if it has timba, bonkó" (Luis Hernández Abreu, interview, 2003). Timba is Arsenio Rodríguez and Benny Moré (García Meralla 1997). There is timba in the swaying stride of Cuban women, in any neighborhood sidewalk, and even in the desire of foreigners to imitate the way Cubans dance (García Meralla 1997). These references to El Benny, Arsenio, and the swaying hips of Cuban women invoke notions of essential Afro-Cuban male and female energy, and issues of race, class, and gender are worked out through timba music-making and dancing.

Timba is also a jam session with percussive piano and horns, mixing jazz, a great deal of *son*, and, to round it all off, bass guitar that takes on the voice and musical vocabulary of rumba. Many Cuban musicians, including Ángel Bonne, David Calzado, and César Pedroso refer to occasions when they played this way during breaks while studying at the Escuela Nacional de Arte (ENA) or Instituto Superior de Arte (ISA).They agree too that timba is Cuban dance music in its highest degree of development, made contemporary by incorporating popular music (rhythms or songs, instrumentation, ways of playing) from around the world. Timba is the transposition and extension of Cuba's musical roots to a new era, accentuated by different harmonic concepts and different technologies (Roy 2002, 200). Some identify timba with abstract values like "strength" (Bamboleo, interview, 2003), referring on one hand to its sound but also to the way Cubans rely on music as sustenance ("strength") to carry on under difficult circumstances.

One of the best timba bands is Manolito y su 'Trabuco'–which literally means a firearm from the times of the Independence War of 1895 and figuratively refers to anything forceful or strong (Manolito Simonet, interview, 2003). According to Roy, "Originally timba designated the marginalized neighborhoods of large cities" (2002, 180). La Timba is a working-class neighborhood in Havana, evolved from a shantytown on the outskirts of prosperous Vedado (Scarpaci, Segre, and Coyula 2002, 73). The famous *rumbero* Chano Pozo, who played with Dizzy Gillespie and brought Latin jazz to the fore, was born in a *solar* called Pan con Timba (Cluster and Hernández 2006, 146). Timba is a "Cuban attitude toward music and dance" (García Meralla 1997), and a social movement or subculture (Perna 2005). Leymarie calls this music "nueva timba," and identifies it as an expression derived from the word timba designating a conga" (Leymarie 2002, 253). Whether she means the conga drum itself (*tumbadora*) or the drum rhythm and procession from eastern Cuba, the connection makes sense. The term was recontextualized by Juan Formell as Cuba's answer to salsa, which had long been rejected by many on the island as an imperialist product. Timba is the "convergence of politics and pleasure" (Aparicio 1998, 92).

As a musical style or genre, timba helps to mark identity and is closely related to associated cultural features such as recreational activities, use of language, attitudes toward sex, and so on, which similarly contribute to forming and maintaining group identity. Timba is intrinsically related to the social context in which it has developed and in which it takes place. The discernible patterns that distinguish timba from other types of dance music reflect cultural meanings shared (and possibly contested) by all those who participate in a communicative event such as musical performance. These meanings are related in fundamental ways to conceptions of identity–the way people perceive and define themselves, especially in relation to other groups. The corollary to this is that social change is reflected in stylistic change. These alterations will reveal survival strategies as well as the perceptions and values of the social group that is experiencing the change (Pacini-Hernández 1995, 18).

Considering both journalistic and academic writings about timba, one perceives the surprise, frenzy, scandal, rejection, and passion that the timba movement has aroused, and also the acceptance – still contested – that it finally seems to have earned. The discourse on timba places it as a brash music, threatening for various reasons, but at once respected for its virtuosity, daring, and success. Like Caliban (Retamar 2000) timba appropriates language (both spoken and musical) to express its subaltern perspective. It is a musical performance that has created "a resistant space beyond the realm of politics in which rebelliousness of various sorts or identifications with alternate ideologies may be emphasized" (Moore 2006, 8). It is part of an "unruly musical wave that exploded in Havana in the late 1980s" (Sublette 2004, 272). The uneasy relationship of popular music and the state has existed since colonial times and has only assumed new details after the triumph of the revolution. The tension is caused by the fact that popular music is made by individuals and groups (to some extent) independent of the state, "and in some cases in opposition to it" (Sublette 2004, 272).

Virtuoso musicians often come from, and are still rooted and producing in, the marginal barrios of Havana. Few people would dare attack the skill of timba musicians, trained as many of them are in the country's best schools. Nevertheless some lament the use of skills that were developed through study at state-run schools to make music that is perceived as vulgar, shamelessly commercial, or simply too black. (Imagine if the architects of early hip-hop were conservatory trained!) As we explore timba and social action in Cuban dance spaces, it is important to recall José Martí's claim that to be Cuban is more than black, white, or mulato. He insisted that there is no such thing as race; that it was merely a tool used locally to divide the anticolonial effort and globally by men who invented "textbook races" in order to justify expansion and empire (Ferrer 1999, 4). One aim of Martí's work was to persuade white Cubans to drop their fear of blacks (Brock and Castañeda 1998, 128). Cuba's mulato poet Nicolás Guillén extended Martí's ideas about racial unity in Cuba claiming that, "Cuba's soul is mestizo," and it is from the soul, not the skin, that we derive our definite color. Someday it will be called "Cuban color" (de la Fuente 2001, 182). We will see how timba is survival music that emanates from Cuba's black communities and is inspired by Martí's and Guillén's ideal of racial equality and fusion. Timba seeks integration, not separation, through sound.

A Long Tradition of Mixed Music

Timba is *música mulata*, as Puerto Rican sociologist Ángel Quintero Rivera would say; a fusion of multiple elements in which it is difficult to distinguish and separate the ingredients, so well integrated are they in the final product. Cuban music specialist Danilo Orozco has coined the term *intergénero*, or "between-genre," to describe timba: "a concrete hybrid that has been nourished by a very dynamic and specific mixture of juxtaposed elements in constant tension, which does not permit untangling the components" (Orozco n.d., 4). Musical "alchemists" (García Meralla 1997) blend many influences: rumba, son, Afro-Cuban ritual music, jazz, songo, Puerto Rican bomba, North American folk music, reggae, Caribbean and New York salsa, hip-hop, rock, funk, samba and European classical music (Orovio 1998). Cuban pianist Gonzalo Rubalcaba, who is renowned as a jazzman but also participates in important popular dance music projects (very notably with Issac Delgado), says that "of all the music in the world Cuban music is among the most capable of assimilating influences of other cultures and sounds without losing its own authenticity, rather enriching it" (Gonzalo Rubalcaba, interview, 2001).

In general, popular dance music of Cuba has a long tradition of fusion, demonstrated by hybrid forms and mulato styles. *Danzón* for example, melded derivations of the English country-dance, French *contredanse*, and Spanish *contradanza* with contributions from Afro-Cubans and black Haitian immigrants to create the first truly Cuban music/dance form. In his novel *Cecilia* Valdés, Cirilo Villaverde describes the "moaning" character of danzón as "from the heart of a people enslaved" even without the congas, clave, cowbells, and so on that would enliven later genres (Cluster and Hernández 2006, 55). (*Danzón* is mentioned as the traditional Cuban dance par excellence in Cuba's constitution.) The fusion that makes timba is equally dramatic and diverse of sources.

Figuratively, timba is what happens when various worlds make contact-local and foreign, high and low class, socialist and capitalist, black and white. Timba, like salsa and other music from the Black Atlantic, is a "sociomusical practice claimed by diverse communities for radically diverse purposes" (Aparicio 1998, 67). Specific factors affecting the content and performance of timba, its development and boom, include a long tradition of black popular music in Cuba, excellent musicians trained under the Revolution, economic and social crises during the special period, new approaches to international visitors and trade markets, and revitalized debate on race relations.

The Evolution of Cuban Dance Music before Timba

The earliest forms of uniquely Cuban music were enriched by African and European sources (Carpentier 1946; Alén 1999), which merged on the island to create totally new creole forms through an ongoing process of transculturation (Ortiz 1995; Morejon 1988, 188). For example, nourished by Yoruba, Bantu, Fon/Ewe, Calabar, and Spanish roots, Cuban rumba evolved by the mid-1800s as a popular music/song/dance complex among poor urban blacks (Daniel 1995; Alén 1999, 47-60). Rumba functioned as a site where oral histories were constructed, protests raised, and diversion from life's hardships found. Many Cubans rejected rumba because of its African sound – the musical ensemble consisting of clave, three drums or boxes, a lead singer (*el gallo*), and a chorus – and the overt sexual references within the dance. Although it was a form created and developed primarily by black Cubans, because rumba took place in marginalized spaces some poor whites participated too.

Haitian colonists and their slaves, who had fled the aftermath of the Haitian Revolution of 1791, stimulated a craze for the French *contredanse* in Cuba. The Cuban version of Spanish *contradanza* and French *contredanse* added African percussion instruments–güiro (a serrated gourd scraped with a stick) and *timbal*, plus a slower cadence that gave it a different, decidedly Caribbean feeling. Cuban contradanza received severe criticism during its early days. This fits musicologist Maya Roy's description of Cuban music as the "creolization" of a European musical foundation under the influence of musicians of African origin (2002, 2).[2] After Miguel Faílde – a black man and devotee of Afro-Cuban religion – "invented"*danzón* in 1879, commentaries in Cuban newspapers attacked it also as "diabolical" and "contrary to Christianity" because of its association with "prostitution and improper race mixing" (Carpentier 1946, 27). It was not until later in the 1920s and 1930s that *mestizaje* (race mixing) would be accepted as a root of Cuban culture, though that reality was already long present on the island.

Though it was played before, perhaps as early as the 1800s, *son* came to Havana from eastern Cuba in the early twentieth century, and by the 1920s it emerged as a genre of international importance (Alén 1999, 27-28). Like earlier forms, it was criticized as too wild and barbaric. The dance step was described as "lascivious" and dangerous! Ethnomusicologists Robin Moore (1997)

and Leonardo Acosta (1989) remind us that both *danzón* and *son* were initially repudiated for being black and then later appropriated by the dominant white classes that had rejected them. *Danzón* and *son* were eventually used to represent Cubanness and to defend the national culture against the influences of U.S. jazz and Europeanized tango, which invaded the island in the 1920s. In their day, when Arcaño y sus Maravillas mixed *danzón* and *son*, and Arsenio Rodríguez developed the orchestra format called "conjunto" (incorporating the conga drum), both were criticized for their "música negra" and relegated to play in marginal spaces due to the color of their skin. Even still, *son* remains the strongest reference point for all Cuban dance music that has been produced since. The Cuban love-hate relationship with black music and black people has helped to shape timba, which, like any good son of *son*, has grown and claimed its space despite initial rejection.

The influence of African American jazz started to appear in Cuban music during the 1930s when Latin jazz bands began incorporating instrumentation and arrangement ideas from Count Basie, Duke Ellington, and others (Moore 1997; Roberts 1979). Jazz strongly influenced Cuban musicians – such as the López brothers, Armando Romeu, Pedro "Peruchín" Justiz, Chico O'Farril, Bebo Valdés, and El Niño Rivera – who through their work in the Cuban jazz band format mixed North American jazz with Cuban flavor. These bands played all genres of dance music (*guaracha*, *lindyhop*, *son*, etc.), and introduced Cuban percussion to jazz, opening the way for Afro-Cuban or Latin jazz, led by Dámaso Perez Prado in Mexico and Frank "Machito" Grillo, Mario Bauzá, Chano Pozo (all Cubans), and Dizzy Gillespie (African American) in New York in the 1940s and 1950s. Cuban music and bebop became "cubop … a marriage of love" (Leymarie 2002, 2). In the 1940s, riding the wave of the big band sound, *mambo* emerged, also led by Pérez Prado, spawning a craze that swept the United States and Western Europe. Cuban popular dance music since that time has cultivated the jazz root, cubanizing it in the process to develop the musical language of timba. The sassy horn licks of the past became the *mambos* and *champolas* (horn phrases) that make timba so rich and exciting today.

In the 1950s, Enrique Jorrín created *chachachá*, a derivative of *danzón* that was based on the rhythm he heard in dancers' footsteps (López 1997). This style was so popular that it remained current into the 1960s, inspiring a North American version of the dance, as well as cha interpretations by North American artists like Nat "King" Cole. Despite the popularity of Cuban music in the States, its continued development was largely hidden from North American listeners due to the U.S. trade embargo imposed on Cuba in 1962. Revolutionary policy on the island affected the development of music in significant ways as well.

Focusing on ending crime and prostitution, the Revolution curbed much of Havana's nightlife, which had supported the development of dance music (Acosta 1999, 9). As a result of the closure of most clubs and theaters, musical innovation languished. Also many musicians put down their instruments to take on other important work of the Revolution – like cutting sugarcane (Armando Valdés, interview, 2003). During the 1960s several rhythms were introduced but none with the mass appeal or longevity of *son*, *mambo*, or *chachachá*. Each incorporated elements of conga and iyesá, while keeping elements of *son* and *mambo* (Acosta 2004, 141). The *pachanga* by Eduardo Davidson, pa' cá by Juanita Márquez, *pilón* by Pacho Alonso and Enrique Bonne, *dengue* by Pérez Field and Roberto Faz, and *Mozambique* by Pella el Afrokan each made a splash but failed to achieve international, or even extended national, popularity (Acosta 1999). Each was a rhythm with its own dance step. Despite their limited success, they exemplified the tight link between music and dance that has been inherited by the timberos.

In the 1960s a new generation of Cuban singer-songwriters endeavored to create music that was "different from [popular dance music] produced before the Revolution." In their view, Cuban music had been too focused on "love, dark cafes, bars, etc." and had not given enough attention to meaningful lyrics (Sarusky 2004, 10). They wanted to counteract what they perceived as banality and commercialism in Cuban music of the 1950s (Benmayor 1981, 14). They took inspiration from turn-of-the-century *trovadores* (troubadours) like Sindo Garay, who pioneered a style called canción, known for beautiful, socially engaged lyrics sung to guitar accompaniment. The new movement came to be called Nueva Canción or Nueva Trova. Its mission was to create new, poetic music of the future, as opposed to what was considered "bar music" of the past (Sarusky 2004, 18).

Singer-songwriters like Pablo Milanés, Silvio Rodrigues, Sara Gonzalez, and Amaury Perez recorded prolifically and toured widely throughout Latin America. They collaborated with rock and jazz musicians and composers like Leo Brouwer, Sergio Vitier, and Leonardo Acosta. Their records were the first in Cuba not to specify a particular dance rhythm (Sarusky 2004, 53). By the end of the 1960s the pioneers of Nueva Canción founded Grupo de Experimentación Sonora with the specific mission of analyzing and transforming the Cuban musical repertory. They criticized popular music as too "imitative" and static, because untrained musicians made it and transmitted it by ear. Rhythms and melodies were overly dominant, while texts "did not exist." Despite instances of state censorship (Sarusky 2004), the musicians of the Nueva Trova became "cultural ambassadors of the Revolution...a voice for new values" (Benmayor 1981, 11, 13).

Nineteen sixty-eight was a turning point. In that year all the nightclubs and parlors of Havana closed for at least one year (as if acting on the critiques by the Nueva Trova movement). Nevertheless several dance orchestras were born that would be important for the new musical language they elaborated, and which would later be taken up and extended by the timberos. Elio Revé y su Charangón (was founded in 1968 and gained popularity based on changes imposed by then-member Juan Formell, modernizing *changüí* (a proto-son rhythm from Guantánamo) under the influence of jazz, *filin* (a melancholy U.S. American-styled ballad deriving its name from the English word *feeling*), the *son* compositions of Benny Moré and Chapottín, and the rock and roll of the Beatles.

In 1969 Juan Formell split with Revé and founded Los Van Van. They introduced a new style called *songo* and were among the first and definitely the most successful in incorporating rock and roll, synthesizers, drum machines, sound effects, and new harmonic concepts in Cuban dance music (González 1999, 51-52), making an early step toward today's timba sound. Los Van Van reinterpreted tradition with rock and roll-styled breaks on the snare drum, jazz electric flute alongside traditional five-hole flute, and a violin section that emphasized rhythm over harmony (González 1999, 51-52). Perhaps their best-known instrumental innovation has been the incorporation of trombones to the charanga format.

Speaking of Los Van Van and its contributions, Orozco mentions a peculiar way of combining violins and flutes, subtle harmonic approaches based on the blues, vocal renditions that evoke something of the American vocal quartets of the 1960s and the ethos of the soul singer, overtones of pop-rock, and a dynamic, varied sense of rhythm and time. According to Cuban music scholar José Loyola Fernández, Van Van's rhythmic-harmonic interweaving of percussion, bass guitar, and piano with freer, more figurative interpretation of *tumbaos* and polyrhythmic percussion was definitely a precursor of today's timba. In the case of Los Van Van and their *songo*, perhaps due to the passage of time, their innovations have been accepted because they constitute "a style that brings the music closer to the contemporary dancers, moving within a modern framework of tones

more relevant in the musical context of their sociocultural environment" (Loyola 2000, 10-15). They are emblematic of the evolution of Cuban dance music: they innovate and enrich, always honoring *la clave*, and never abandoning *el son*.

In 1973, Irakere was founded under the leadership of pianist Chucho Valdés and contributed elements that opened new horizons for popular dance music. They incorporated Afro-Cuban religious instruments (batá drums, chequeré, agogó, etc.) until then used only in ceremonies, or on occasion in a few cabaret shows or academic demonstrations. Among the contributions of Irakere to popular dance music (which have been expanded in timba), Cuban musicologist Helio Orovio names the jazz piano of Chucho Valdés, the harmonic-unorthodox guitar of Carlos Emilio, the jazz-reggae guitar of Carlos del Puerto, the conga rumbera of Jorge Alfonso, the trap drum playing of Enrique Plá, and the jazzy attack of saxophones and trumpets so characteristic of the group and members like Arturo Sandoval and Paquito D'Rivera. Irakere changed the horn format to two trumpets and two saxophones, the pattern followed by many timba orchestras. Los Van Van and Irakere developed the format and playing style of dance-band horn sections, borrowing concepts from U.S. funk and soul bands like Parliament and Earth, Wind and Fire.

Los Van Van and Irakere enjoyed great popularity throughout the 1970s and 1980s during the height of the New York salsa movement. Despite the U.S. embargo against Cuba, the stance of old-guard Cuban musicians (Padura 1997; interview, 2003), and the government's position (Perna 2005) against "refashioning or co-opting" of vintage Cuban music, there was contact between salseros from New York and Latin America (in Cuba called "salsa from the outside") and Cuban popular musicians on the island. For example, in the late 1970s and early 1980s, there were visits made to Cuba by the Fania All-Stars, Típica 73, Dimensión Latina, and Óscar d'León. Also, Nuyorican bandleader Willie Colon and the Panamanian Rubén Blades – both popular U.S. artists – were played on Cuban radio.

Cuban band leaders, like Juan Formell and Adalberto Álvarez, made format and recording adjustments based on influences from New York salsa (Formell 2002).[3] According to Cuban musician and historian Leonardo Acosta, young musicians accepted the adjustments and additions; they exchanged ideas and experiences with the salseros of the Caribbean and New York. In fact, Formell recognizes that the leveling of the various tracks that make up his recordings originates from the style used by the salseros from New York, who situate the drums almost as prominently as the solo voice, a strategy that provokes the dancer. At the same time, he denies that the trombones of his orchestra have anything to do with Willie Colón (famous for his trombone sound) or any other salsero. Rather, he says he added them to compensate for a deficiency in the middle range that was inherent to the charanga format (Formell 2002).

Adalberto always stayed informed about the latest developments in New York and Caribbean salsa; in his words, it was his "obsession," and he determined to use elements of that style to avoid making music that was too local. He always conceived his musical production to please dancers throughout the Caribbean and the world, and he considered it crucial artistically to compose with the sound of the other salsa in mind. The fact that many salseros were winning popularity and using his compositions also convinced him to enter that market with his own orchestra, appropriating elements from its best exponents (Padura 1997).

Percussionist Yoel Driggs "The Showman," former member of Los Van Van and current musical director of Puro Sabor, told me that he owes a great deal of his own artistic personality and charisma to his experience playing with the great Venezuelan salsero Óscar d'León on his legendary trip to Cuba in 1983 (interview, 2003). This was a "turning point" that reawakened young

people's interest in Cuban popular music, now with a fresh new sound (Leymarie 2002, 173). Clearly the timberos with their subaltern voice and unique flavor owe something to the New York and Latin American salsa of the 1970s and 1980s as well.

All of the styles discussed so far were created and practiced most widely and intensely by Cubans of color. They incorporated elements from other styles within the black diaspora.[4] For example, Orquesta Aragón traveled the world and became Cuba's number one band of the mid-twentieth century spreading the chachachá, a rhythm developed primarily in dialogue with black dancers in Cuba. Though Cubans of all colors danced chachachá, it was undeniably a black creation. Afro-Cuban or Latin jazz is heard everywhere and at the Cuban Jazz Festival. Like the styles of the past, timba is undergoing a similar process. It is heavily criticized as "uncouth," "indelicate," and so on (Casanella 1999), yet it is increasingly recognized as a valid genre rather than just a vulgar fad (Perna 2005). In 1999, Chucho Valdés told me "no pasa nada," nothing is happening with timba (personal communication, October 1999). Nevertheless, at that time and even now, timba is heard everywhere in Cuba, and there have been government-commissioned "national anthems" in timba style – for example, "Aquí estamos, los cubanos" (Here we are, the Cubans) on Cuban television. Chucho's Irakere (reincarnated in the 1990s sometimes as a dance band after a long embrace of mostly jazz) has recorded timba numbers, and in 2003 he honored timbero Paulito F.G. by performing with him at Paulito's record-release concert at the Karl Marx Theater in Havana.

Diasporic Connections

Many authors have discussed the existence of certain African Diaspora components that are found across a wide array of music and performance practices (Carpentier 1946; Chernoff 1979; Merriam 1960; Ortiz 1965; Bilby 1985; Rivera 2003; Sloat 2002). It comes as no surprise that these sociomusical concepts are present in timba because it was created by Afro-Cubans in dialogue mostly with other African musics: "la musique modern" of the Democratic Republic of Congo; jazz, funk, and hip-hop from the United States; Brazilian samba; Jamaican reggae; and so on. Argeliers León, the dean of Cuban musicology, writes, "People appropriate those elements that have some similarity or proximity with what they already have, they search for a kind of link by analogy" (1984). Jazz, hip-hop, reggae, and samba are all subaltern forms (in some moments of their history or in some aspect of their present projection), forms that, like timba, are bold, and dreaded by some. It is partly an untamed, "maroon" identity that links timba with other diaspora music forms.

Like Trinidadian *soca*, for example, timba can be evasively political, using double entendre and coded language to veil social commentary. It is also an important vehicle for masses of people to find ecstasy through dance (Moonsammy 2009). Like *Congolese rumba* or *soukous*, timba draws on a history of musical syncretization and oral traditions in the form of old and new folk wisdom (Stewart 2000). It speaks for "the common man," incorporates influences from religious music, carnival traditions, and folklore, and employs modern instruments (synthesizers, drum machines, etc.) and Western harmony. Like Jamaican dancehall, timba gives free rein to ways of expression considered vulgar and improper since the expressions touch on race, class, gender, and national identity (Cooper 2004; Stolzoff 2000; Hope 2006). Opposition to dominant ideology and determination to "tell it like it is, no matter what" are part of timba and part of the scene – an attitude demonstrated through gesture, dance, and dress, as well as lyrics.

A few concepts set out by ethnomusicologist Peter Manuel (1995) are useful to understanding timba. Collective participation is a characteristic applicable to timba events in which musicians and

audience/ dancers are mutually dependent, locked in a complementary relationship that makes the performance "happen." If a band's sound is uninspiring then no one dances. If there is no dance, *there is no musical event,* even if the musicians continue to play. As in many African and Caribbean contexts music, song, and dance form a complex whole.

One of the most important characteristics of timba is call-and-response. In timba's musical structure improvised *inspiraciones* from a lead singer alternate and interact textually with a refrain that is repeated by a chorus. Cuban philologist Liliana Casanella has noted a kind of linguistic dialogue between singers and the public (see below). I argue here that there is a dialogue, a performative group conversation, taking place in the dance spaces under consideration. Collective participation, call-and-response, and total atmosphere combine to establish behaviors, which are then used strategically to create a specific identity. These behaviors are not only performed during the musical event, but beyond in everyday life. In this way, the performances-behaviors, interactions – in the dance spaces actively *produce,* just as much as they reflect, the contours and choreography of social relations in Cuba today.

Timba is part of a process of transculturation in which the presence of Latin American culture in the international market is increasing and has resulted in more references to Latino culture through Spanish melodies, lyrics, choreography and dancers in music videos, and so forth (see songs by African American Puff Daddy, Nuyorican Fat Joe, Haitian American Wycleff Jean, and Jamaican Beanie Man among others). The reggaetón craze, which has swept many parts of the world including the United States and Spanish Caribbean, is part of this tendency too and is criticized by many for being excessively "pop" or commercial (see Rivera, Marshall, and Pacini-Hernández 2009). Like the forms mentioned, timba runs the risk (perhaps inevitable) of losing some of its power through commercialization and its resultant creative stagnation.

Timba: A Way of Making Music

The instrumentation of timba bands and the particular ways of executing specific instruments in timba reveal increased timbric resources and enriched expressive and technical arsenals for arrangers, allowing infinite possibilities for the music in general. It is important to note that there is not a fixed or obligatory musical format that is aligned with or designated for timba. In fact, *changüí* groups or *charangas* (for example, the famous Orquesta Aragón) at times play in timba style, using traditional instrumentation for their respective formats.[5] This suggests the lasting effect timba may have on Cuban popular dance music in general. Throughout Havana, small groups entertain at bars and restaurants performing traditional *son* that is integrated with clear inflections of timba in their arrangements. For example, at a local bar called Siete Mares (the seven seas), a quintet with bongó, flute, guitar, violin, and a singer played traditional Cuban music for most of the evening, including songs by Benny Moré, Pablo Milanés, Elena Bourke, and others. They would regularly infuse these compositions with timba-style breakdowns, thereby using the same acoustic instrumentation in a different way.

Following Charles Kiel's analysis of the African American blues (1996) and Deborah Pacini-Hernández's discussion of Dominican bachata (1995), I examine timba in terms of four main stylistic elements: structure, timbre and texture, content, and context. In addition, I trace the history and describe the performance of timba dance.

Structure

In timba the traditional organization and interpretation of *son* composition sections, that is, "introduction, exposition and *montuno,*" are altered. Challenging conventional configuration,

arrangers often displace the introduction and begin with a rap or a short tease of an *estribillo* or chorus, which is reintroduced or stated fully later in the *montuno* of the song. At times, the presence of *estribillos* throughout compositions, right from the start, separated by song verses or spoken sections by soloists, makes the entire piece sound like one extended *montuno*. At times, songs are voiced as full ensemble singing until the montuno begins, at which time a soloist then dialogues with the chorus. Sometimes the role of soloist is passed among the main singers of the orchestra right from the song's opening.

Most often, there are four sections in timba: (1) *la salsa*, which is of moderate tempo and performed by a soloist; (2) *el montuno*, which is a refrain that is introduced in call-and-response pattern as the tempo markedly increases; (3) then *los pedales*, which features a hip-hop/R&B like backbeat and strong movement in the bass guitar as the tempo recedes and the soloist talks rhythmically, introducing another (more dynamic) refrain. During these first three sections most people dance *casino*. The next section is (4) *el despelote* (the breakdown), where a rapping chorus answers the soloist, and both dancers and musicians go into a frenzy, inspired now by the percussive slapping and plucking of the bass guitar (á la Bootsy Collins of funk bass guitar fame in the 1960s and 1970s in the United States). During this section, people dance *reparto* (the neighborhood) and *tembleque* (the quake), which are discussed below under timba dance. The band then returns to *el montuno*, *los pedales*, and so on, at will to add new refrains and change the intensity of the performance (La Charanga Forever, personal communication, 1999). The image of a train pulling out from the station (*la salsa*), riding steadily on a plateau (*el montuno*), pushing harder at a slower pace to climb a hill, then pausing at its peak (*los pedales*), and rushing down (*el despelote*) gives a rough idea of how energy is manipulated over the course of a song. Each of the added chorus refrains can also be called *sobremontuno*, as in above and beyond the first. Compositions often end with a cooling-down section that acts as a coda or ending, returning to the mellower salsa style used in the opening.

Such structural changes in form have opened the way for free combinations of instruments and uninhibited ways of playing. These take Cuban *son* and *rumba* as points of departure for experimentation, and feature patterns from other music styles in the Caribbean, (Black) North America, Brazil, and so on. Orchestras like those of El Médico de la Salsa and Paulito F.G. incorporate the electric guitar noticeably, at times in rock-style solos, while the group Dan Den of Juan Carlos Alfonso distinguished itself by adding a set of bells that originated from the rural outskirts of Havana. Changes in instrumentation correspond to jazz and rock sources (e.g., the drums, the keyboard, the electric guitar played rock style à la Carlos Santana), Afro-Cuban folk music (batá drums, agogó bells, etc.), and borrowings from earlier formats within Cuban popular music forms (such as the *orquesta típica* and the Cuban jazz band with emphasis on trombone and saxophone).

Timbre and Texture

Musician Orderquis Revé, brother of the late great orchestra leader and dancer of the 1950s Elio Revé, says that "without Changüí there is no son, and without son there is no salsa" *(sin Changüí no hay son, sin son no hay salsa)* (Orderquis Revé, interview, 2002). In addition, master percussionist and singer Luis Abreu Hernández of Los Papines says that without rumba, without *clave* and *tumbadora* (conga drums), timba could not exist (Luis Abreu Hernández, interview, 2003). Describing timba in general, music researcher Danilo Orozco emphasizes the predominance of the *clave* or rhythmic pattern from rumba-guaguancó, at times substituted by the *clave* of son or other related rhythmic patterns that appear at various points within the same composition. Generally

there is a tendency to vary and to fragment phrases, lyrics, and choruses, which he illustrates by the use of the bass guitar, which no longer marks the stable tumbao pattern that is closely associated with Cuban *son,* but instead attacks in a disjointed way that is still graceful in its propulsion of the music and the dancers. The classical harmonic and rhythmic tumbao of the *son*[6] has been left behind, replaced now by musical phrases that are more related to *reggae* and *funk* in terms of their harmonic progressions and their rhythmic attack, but which nevertheless remain very Cuban and danceable with steps derived from *son.*

Cuban popular dance music specialists Liliana Casanella and Neris Gonzalez also refer to the extreme fragmentation of the classical tumbao, the reoccurring counteraccentuations, and the juxtaposition of elements and textures with hard and tense sounds. More specifically, they cite the rhythmic and percussive use of horns and the melodic execution of disjointed phrases, performed often in the sharpest, most strident registers, which gives timba its aggressive sound. With regard to actual percussion instruments, the authors underline the segmented polyrhythm of the different timbric or qualitative sound layers, as well as the break from the timbric-expressive functions of previous eras. Now, groups incorporate trap drums, congas, bongó, and timbales with bass drum (bombo) – all improvising freely-along with güiro, maracas, claves, chequeré, and bell. The piano part in this new tumbao is called *guajeo* (Leymarie 2002, 254); it uses a percussive attack that is enriched by jazz harmonies. The simple enumeration of so many elements gives an idea of the infinite combinations and effects that are possible rhythmically.

Variation in the patterns of all the instruments mentioned causes a perceived acceleration, which can be real or only suggested. In addition, we have a formula to make dancers delirious when we consider the rhythmic role of the horn section leading to climactic moments inside compositions, working in the polyphony of incredible counterpoint and polyrhythm called *mambos* or *champolas.* For example, the horn section of NG La Banda is affectionately known as "los metales del terror" or metals of terror. So important is the work of the horn section inside the timba format that this naming of the horn section itself has become common – take, for example, "los metales de la salsa" of Issac Delgado, "Los chamacos" (the boys) of El Medico, "La zorra y el cuervo" (the fox and the raven) of Aramis Galindo, "Los metales de la élite" (the horns of the elite) of Paulito F.G., or "Los metales del cariño" (The horns of tenderness) of Manolito Simonet y su Trabuco – that respond to exhortations such as "¡,Dále mambo!" (Give it mambo/flavor/energy) or "Champola pa' tí!" (Take this horn lick). This tendency in timba is closely related to its roots in jazz.

In his composition "El secreto de la liga de mi son con rumba" (The secret of the link of my *son* with rumba) César Pedroso warns, "Don't get confused, the secret I bring is the blend of son with rumba." Certainly! Rumba has been recognized as an important source inside Cuban music, incorporated by Cuban composers of great renown such as Amadeo Roldán, Arsenio Rodríguez, Benny Moré, Pablo Milanés, and others. It has also been utilized for community projects-performances to promote solidarity among Cubans and to stimulate tourism (e.g., Rumba Saturday, El Callejón de Hamel; see Daniel 1995). Still, rumba continues to be a marginal music whose penetration in the Cuban mainstream represents a transculturation with consequences for both the recipient mainstream culture and the marginal donor culture. The mainstream is disturbed as it assimilates and/or rejects the new sounds, the jive talk, and the appearances/self-representations that enter its domain. The marginal donor culture tastes the ethics of the market, feels the bitterness of rejection and repression, and, as a result, sometimes changes its own song.

Timba vocal style, in turn, is more emphatic than the singing of past eras, as a result of the direct influence of rap with whole sections spoken in hip-hop style rather than sung in the way of the

traditional Cuban *sonero*. Timba song style also has characteristics from *rumba* and black American R&B, especially in the phrasing and adornments that bend and play in between written notes. Casanella and Gonzalez cite Mario "Mayito" Rivera, former singer of Los Van Van, as an example par excellence of this first tendency –phrasing and adornment (as was ÓscarValdés with Irakere in the previous generation). Singers Michel Maza (who set the vocal style still used by new members of La Charanga Habanera) and Ricardo "Amaray" Macías from Manolito y su Trabuco are good examples of the second tendency – to use vocal riffs patterned after Luther Vandross, Keith Sweat, and other African American R&B and gospel stars.

Content

There are several general categories into which timba song texts fall. As in other styles of diasporic popular music, timba songs deal with so-called Western style and heterosexual relationships. Issac Delgado – an excellent *salsero* whose music exists at the frontier of timba and international salsa with influences from Puerto Rico, New York, and Colombia–sings in "Mi romántica."

> *Ella es muy linda por fuera pero más bella por dentro*
> *Donde están los sentimientos más sinceros del amor*
> *Donde se resume la vida en un segunda*
> *Donde se abre una flor, donde ha crecido el mundo...*
> (Chorus)
> *La niña más linda, la niña más bonita, la niña que yo quería*
> *¿Quién lo diría?*
>
> She is very pretty, and even more beautiful within
> Where the sincerest feelings of love are
> Where life is summed up in a second
> Where flowers bloom and the world grows
> (Chorus)
> The prettiest girl, the most beautiful, the one I always wanted
> Who would have thought?

Songs of betrayal address situations in which a woman deserts her man in favor of a rich foreigner, often depicted as Italian. Playfully, Manolín, El Médico de al Salsa plans to torment a lover who has scorned him this way by making constant collect phone calls.

> *Te di mi amor del alma*
> *Te brindé amor sincero*
> *Pero más pudo el interés*
> *Por todo ese dinero.*
> *Y sé que me dejaste*
> *Y sé que me fallaste*
> *Adiós, qué te vaya bien*
> Good-bye, my love, *te quiero*
>
> (Chorus)
> *Te voy a hacer*
> *Una llamada telefónica*
> *A pagar allá*

I gave you love from my soul
I gave you sincere love
But greed was stronger because of all that money
I know you left me
I know you failed me
Adios, farewell
Goodbye, my love, I love you

(Chorus)
I'm going to call you
By telephone
Collect!!!

There are boasting songs, which parallel hip-hop, dancehall reggae,[7] and soca[8] in their references to the singer's skill as a musician and a lover. In these two veins respectively El Médico toasts:

Somos lo que hay
Lo que se vende como pan caliente
Lo que prefiere y pide la gente
Lo que se agota en el mercado
Lo que se escucha en todos lados
Somos lo máximo

We are it
What sell like hot bread
What people prefer and request
What sells out in the stores
What's listened to all about
We are the most

and La Charanga Habanera (1996) boasts:

Yo soy caballero
Tengo mi medida
Fundo la cabilla que tú necesitas

I'm an ironworker
I've got my size
I do the pipe work that you need

As time has gone on, more and more songs have contained references to Afro-Cuban religious practices and have used pieces of ritual chants or made percussive references to ritual rhythms or *toques*. According to Adalberto Álvarez, the early 1990s "coincided with a time when religious spirituality found a space within the institutional life of the country" (de la Hoz 1997). In October 1991 Communist Party membership was opened up to revolutionary Christians and other religious

believers (Braun 1990, 80). After this, "Catholics, Protestants, and Jews return[ed] to their churches and synagogues openly, and Santería practitioners no longer [hid] their rituals" (Behar 2007, 274). In 1992 the Cuban Constitution was changed to reflect that the state is now "secular" rather than "atheist" (274). In jest, but accurately, people say that religion was "depenalized" around the same time as the dollar. As a result, "to sing of the orishas became fashionable in popular music, for good and bad," says Álvarez. On one hand, "one of our cultural roots was being recovered, and, on the other, many imitators appeared on the scene with a pseudo folklore that bothers me" (de la Hoz 1997).

El Tosco and his NG La Banda often sang *los santos* or the *orisha*. In "Santa Palabra" (holy word), they actually incorporated ritual gestures associated with a Lucumí (Yoruba) cleansing ceremony called *ebbó*, in which negative energy is removed and then thrown backward over one's shoulders.

> *Hay muchas personas que esconden los santos*
> *Por el día y por la noche llanto*
> *Para abrir el camino Echu Beleke busca un Eleguá*
> *Pues sin este santo todo va pa' tras...*
> (Chorus)
> *Despójate, quítate lo malo*
> *Échalo pa' tras, límpiate mi hermano*

> Many people hide the saints
> Crying day and night
> In order to open the road, Echu Beleke, find an Eleguá
> Without that saint nothing goes right
> (Chorus)
> Strip away, get rid of the bad
> Throw it backward, clean yourself, my brother

César Pedroso, who is a *babalawo* (diviner and ritual specialist) in addition to being a composer and pianist, has used batá drums in timba compositions. Another group, La Charanga Habanera, makes a clear reference to *los santos* when the *timbal* performs a rhythmic sequence in the song "El Bony" that is traditionally played on batá drums for Ochun in ritual settings. The very popular singer and timbera Haila Monpié was initiated and wore white, as is custom, during stage performances, and regularly sings to the orishas on her recordings. (She was a former member of the popular group Bamboleo, founded by pianist Lázaro Valdés in 1995 and known for its complex jazz-influences arrangements as well as the shocking crew cut hairstyle of its two excellent female vocalists, Haila Monpié and Vania Borges.) Many say that when times get tough, religion becomes more important, and perhaps this is a factor in the development of timba song texts.

Timba has evolved during a time of intense social change as one way in which Cubans have responded to socioeconomic stress–musically. Timba is festive and irreverent. As stated earlier, it developed at the start of the 1990s, coinciding with the Soviet bloc collapse and the so-called special period in Cuba when rationing and resource management increased. The image it portrays is rough and sometimes contrary to authority. For this reason it has been compared to hip-hop, particularly *gangsta rap* (Acosta 1999). Compare the following song lyrics, which were performed by Chispa y sus Cómplices, at La Casa de la Música in April 2003. They talk caustically and directly about the continuing slippage of the Cuban peso in relation to the U.S. dollar.

¡A veinticinco!
¡A veintiséis!
¿Cómo se ha puesto el fula?
¡Duro pero duro de matar!

At twenty-five!
Then at twenty-six [pesos to one dollar]!
What's happened to the greenback?
It's playing hard to get!

Like rappers, timberos defend their music (lyrics and image) as a reflection of reality, what takes place daily in the street (Acosta 1999). After years of playing traditional Cuban music for tourists at foreign resorts, La Charanga Habanera had been relaunched in 1992 under the direction of David Calzado with a raucous new style that helped to define the timba movement. By 1997, La Charanga was infamous and even banned by the state for its "vulgar" lyrics and risqué stage show. In a song entitled "No estamos locos" (We're not crazy), they sing, "Pero, ¿qué loco de qué? Si lo que canto es lo que es" (Why am I crazy, if what I sing is what is?).

Controversial texts are common in timba. González and Casamella (2001) assert that timba expresses definite sociological messages through both its lyrics and its sound. In terms of lyrics and song structure, the estribillo, by its repetitive and catchy nature, is a favored vehicle that employs double entendre with the function of social criticism to salute los barrios, personages, and tourist places of Havana or to share an anecdote or *dicharacho* (slang term) from everyday life. In an interview with Emir García Meralla for the magazine *Cuban Salsa*, singer Issac Delago says that "an estribillo makes or breaks a tune, there is no in between," and El Médico adds that "estribillos speak and summarize popular wisdom... one is obliged to add a touch of *guapería*, of street talk, so that you can feel the authenticity of *Afro-Cubanness*" (emphasis added).

This last comment comes from the entertainer known as the "King of the estribillos." El Médico is the one responsible for commandeering day-to-day speech of the people and placing it into many timba refrains: for example, take "Hay que estar arriba de la bola" (You've got to be on the ball) "Prepárate pa'lo que viene" (Get ready for what's next), "Pelo suelto y carretera" (Hair down, open road), "Te mate con el detalle" (I killed you with the detail, outwitted you), among many more (Casanella 1998). All of these phrases have an undeniable Afro-Cuban swing, which marks the origin and one primary audience of the style. According to Paulito F.G., "the estribillo is the synthesis of the message that one wants to express...[and] the secret lies in the treatment of the estribillo inside the literary body of the song" (Tabares 1997, 26). For some, like Juan Carlos Alfonso, director of Dan Den, too much emphasis on the chorus is also a danger: "People are abusing the chorus a great deal, the majority of the lyrics do not say anything" (Armenteros 1997).

Casanella, a philologist, discusses the linguistic exchanges between musicians and the public, in which phrases from colloquial slang are taken by musicians and used to popularize compositions (because this is the language of many of their fans), and vice versa. In the latter case, musicians invent a phrase or take it from a small circle of use (which makes it unknown to most), popularize it and spread it, inserting it into popular speech momentarily or even permanently. For example, take "Tunturuntun" by Adalberto Álvarez, which during 1999 and 2000 was on everyone's lips and meant "Get outta here," or "No es fácil" (It ain't easy), which was coined in the 1980s by Juan Formell and to this day is commonly used.

On many occasions, song texts are also related to timba choreography. The steps and accompanying gestures match the lyrics, for example, in "Masca la cachimba" (Chew the pipe) of NG La Banda, "El baile del toca toca" (Do the touch dance) by Adalberto Álvarez, or "Te pone la cabeza mala" (It drives you crazy) of Los Van Van. "Arriba de la bola" (On the ball) by El Médico had its own dance and coded meaning. Penned during the special period, many say that "to be on the ball" meant that one had to hustle or survive by any means necessary. About the dance that accompanied the song, Cuban dance historian Balbuena writes, "It is characterized by the execution of very sensual, sometimes exotic movements. It is done with arms in the air, bent, hands open, pretending to manipulate a ball or something round [perhaps a globe]. At the same time the hips, waist, and torso are rotated" (2003, 89). Like the texts themselves, choreographies are submitted to the creative reinterpretation of the public, and thus *la cachimba* (the pipe) or *la bola* (the ball) semiotically and choreographically take on meanings beyond the intention of their authors. A song called "De La Habana" (About Havana) by Paulito F.G. (discussed later) in which he talks about so-called *especulación* seems a clear example.

In a kind of intertextuality, timba compositions make reference to works from diverse musical traditions, both Cuban and foreign. This practice serves to dynamize the improvisations of the soloists and (when the reference is only musical) specific passages of songs, recontextualizing borrowed licks that momentarily evoke the experience and meanings of other musical works. "¿Qué pasa con ella?" (What's wrong with her?), on the famous 1997 album *Te Pone La Cabeza Mala* by Juan Formell y Los Van Van, is a good example. When the *montuno* begins, after the opening argument of the song, most of the improvisations by the lead singer are bits and pieces from other Los Van Van hits within its thirty-year career. In this case, the fragments are used to invoke the humor or quality of a particular song and underline the group's staying power over such a long time. "When the singer improvises on the main theme of a song, he or she created new utterances and also rearticulates and culls phrases from other songs of various traditions. The singer opens up a sonorous space of freedom, improvisation, and innovation, clinging simultaneously to tradition and reaffirming collective memory" (Aparicio 1998, 84). Overall, timba shares its approach to content with international salsa and many other popular music styles of the African Diaspora.

Context

Timba's association with Afro-Cuban culture and with shifts in the Cuban economy as well as Cuban social life plays an important role in perceptions of it as rebellious music. The genre was closely linked to the promotion of tourism in Cuba and was aided by legislation that sought to engage Cuba, at least partly, in the world capitalist economy. For example, take Paulito F.G.'s song "De La Habana" with its famous refrain ¿Dónde están los especuladores? (Where are the speculators?) from 1997 (perhaps the height of the timba boom); it was irresistible dance music with a striking message. In contemporary slang, *especulador* (literally speculator) means a "show off" eager to accumulate, enjoy, and flaunt wealth, a polemical identity in a socialist nation. The word echoes and puns on the older use of speculator referring to those who, at the start of the Revolution, were too slow in embracing necessary sacrifices (surrendering businesses, properties, etc.). Whereas leaders exhort musicians to "think about their society and its values and to write pieces that reflect such [socialist] values," works that depart from the mission or seem to question it become problematic (Moore 2006, 24). In the words of Latin American literary scholar and cultural critic José Quiroga, "This is where the vanguard of expression collides with the vanguard that wants to preserve tradition" (2005: 147).

The liberating force is music, but the beat of the music is never allowed to stray from the beat of the state. Music and the state seem to dance around each other, and with each other: music involves musicians and dancer, and these demand venues, and the venues produce a collective expression that may or may not fall into line with what government policies seek to promote (2005, 147).

It seems that some, especially the ones that criticize timba, imagine that timba has nothing to do with authentic Cuban music, that of yesteryear, or other contemporary forms of good (or better) taste. We have seen that what is considered proper music is a highly contested and shifting terrain. Acosta calls timba "the most important phenomenon of the 1990s and the first [Cuba] music of international popularity and importance since the 1950s" (Acosta 1998). He corroborates what other writers say, noting the fierce passages from the horn sections, elaborate arrangements, rhythmic patterns from rumba and Santería, hip-hop style vocals in a context of call-and-response, disorienting tempo changes, the spontaneous nature of timba music and dance, the use of street language with a festive and irreverent character, lyrics considered vulgar, violent, sexist, and "ghetto." But even more interesting, he asserts that timba is heir to a long musicosocial tradition in which Afro-Cuban forms debut only to face very strong opposition, which is nourished by racial prejudice and the desire that Cuba (and therefore the music that represents Cuba) not be considered black.

Timba Dance

For some, timba's customary meter and tempo changes (both increasing and decreasing) make timba difficult to dance. Aggressive sound, as performed by top bands like La Charanga Habanera, Manolito y su Trabuco, and others, is characterized musically by driving staccato piano patterns, virtuoso cascades of notes and percussive blasts from the horn sections, funked-out bass lines, and rapped lyrics that affect dance movement (Acosta 1999, 12). Orozco says that timba relies on tension and that it is hard or aggressive at times; he describes the dance, timba's corporal expression, as "disconnected" or "disjointed." For Orozco, these movements impede couple dancing in closed partner dance position and favor open-pair or group dancing. In the process Cuban *rueda de casino* (casino wheel) dance has been lost. He concludes that timba represents "a transgression and subversion of musical, dance, and sociocommunicative values."

According to Casanella and González, timba dance is a constellation of abrupt movements, dislocated and aggressive, with strong sexual innuendo in which the traditional custom of the couple dance is practically lost (agreeing with Orozco). However, others contend that timba rescued the "casino wheel" dance after a long period of decline, because timba inspired new interest in contemporary Cuban popular music (Balbuena 2003; Nieves Armas Rigal, interview, 2003). Timba enticed people back onto the dance floor.

In my personal and fieldwork experience, a few styles of dance are used with timba music. Some performers dance traditional Cuban *son*, emphasizing the "and" count of beats two and four with their shoulders and feet. Most folk dance *casino*. Cuban dance historian Bárbara Balbuena has done an excellent social history of *casino* dance, which she calls the most recent development in the progression of Cuban *bailes de salon* (ballroom dances), starting with *danzón*. She notes that *casino* was part of Cuba's folkloric dance curriculum where she studied during the 1970s. She traces the basic step that developed from the characteristic formations and open partner positions of various "country dances" from Spain, England, and France; then she incorporates the continuous spinning of dancers embraced in closed partner position from the waltz, which would become the main pattern for Cuban (and Latin) popular dance thereafter (2003, 29). This *paso básico* entails alternating the feet in four musical beats– advancing or retreating in space, or dancing in place. In

the first three beats/counts, the foot is fully on the ground, and on the fourth, it only taps the floor, permitting the pattern to alternate on each foot and begin again. Cuban *son* gave *casino* a special emphasis on rhythm, dancing just so (*con sabor*), *with and also purposefully against* the *clave* of the music. *Son, chachachá,* and finally timba would be danced this way also.

According to Balbuena, *casino* developed into its current form over three epochs. During the first epoch of the 1950s, influences such as stellar musical production, vibrant and plentiful dance spaces, and foreign influences– especially rock-and-roll (black) dance– established *casino* as a major form of expression and entertainment among Cubans. She notes that the taste for acrobatic elements and turns, and the common back-and-forth movement "Pa' tí, pa' mí" (for you and for me), are derived from U.S. rock-and-roll dance (2003, 40). Television, introduced in 1950 to Cuba, also popularized the dance.

In the second epoch, from 1960 through 1980, casino became even more widely popular. It was promoted by state organizations like the Consejo Nacional de Cultura (under whose auspices Conjunto Danza Moderna researched, developed, and instituted the form in dance curricula of ISA and all technique training of national dance companies), and it grew through innovation by individuals and groups– among them cabildo-descended *comparsas* like Los Guaracheros de Regla (Balbuena 2003, 61).[9] New innovations like "Díle que no" (Tell her no) were added and have become part of standard *casino* dance vocabulary. In the third stage, from 1981 to the present, inspired by the resurgence of Cuban music, both on the island and abroad, *casino* gained new popularity after waning in the 1970s. The energy of the timba musical movement and the fiery compositions of NG La Banda, El Médico, Paulito F.G., and others translated into dance.

In the current era, *casino* has maintained its basic form while adding new elements. Male dancers continue to lead the dance (except when women dance together, one of them leading the other), deciding on the turns and figures executed, while women show their skill by allowing themselves to be led without losing the beat or getting out of step (Balbuena 2003, 72). But whereas before, the majority of the time people danced in closed partner position and let go only to *guarachar* (improvise, groove) briefly and return immediately (72), dancing nowadays is much more open. It can be danced in closed partner position, in separated partnered couples, in a circle, or in rows. Rafael (an informant we will meet again) had this to say.

> I'm at my best when I dance casino! It's my favorite and I've created my own style. I like to add steps from different kinds of dance into casino – mambo, chachachá, rumba, guanguancó, folklore, hip-hop. It's my way of expressing myself. It's a question of spirit (interview, 2003).

The other dances that can be added to *casino* include the *reparto* (the neighborhood), a kind of vibrating "robot" dance, and the *tembleque* or *pingüe*, a hip-rolling dance similar to the *whining* performed by Jamaican "dancehall queens" or Congolese "dancing girls." The complex of dances, gestures, and physical attitudes surrounding timba reaffirm the genre's quality of unpredictability; it revitalized one of the roots of Cuban popular dance (*la rueda*/the wheel dance) and at the same time approaches dance styles from Africa and its diaspora (such as reggae and soukous) because they emphasize community dance (in groups and in couples) and deemphasize or eliminate closed partner position dancing. According to Rafael:

> *Repartero* is the name for someone who dances to salsa music all by themselves without a partner. [dancing now] You have to pop and drop and move different because you're dancing alone. It's a way of heating yourself up.

The dances that accompany timba music seem to be combinations of the steps and gestures that made up the dances for several rhythms of the past – pachanga, bembón, collude, pilón, and so on.

History, fashion, and popular dance repeat themselves. According to Nieves Armas Rigal, coauthor of *Bailes populares tradicionales cubanas,* the dances called the *despelote* and the *tembleque* (also a coconut-flavored pudding) performed today within timba are no less than the derived product of the above-mentioned dances, that besides summarizing and extending the Cuban popular dance tradition through movement and gesture also emphasize the African roots that nourished it (Nieve Armas Rigal, interview, 2003). This jibes with anthropologist and dancer Pearl Primus's assertion that "the spirit...responsible for the dynamic [African] dances of yesterday is merely underground... sometimes it will spring forth in a seemingly new form" (De Frantz 2002, 121). About this, César "Pupy" Pedroso says, "Our idiosyncrasy as Cubans is very African. We are descendants of the Africans [and] all these dances that have come and gone, what we call timba today, the despelote– all of it is nothing more than African dance" (César "Pupy" Pedroso, interview, 2003).[10] Hip-hop *crumpin'* (featured in the documentary film *Rize* by David LaChapelle) and the *dutty whine* craze in dancehall reggae exemplify a similar spirit of eroticism, aggression, and "African revival" in different genres of popular music/dance from the Black Atlantic.

In 2000 during carnival festivities in Matanzas, a city known as an important center of Afro-Cuban culture, I observed a salsa/timba band perform an *oro cantado* to the principal Yoruba orishas (mixing Yoruba and Spanish, this means "tradition sung," an ordered series of songs and chants in acknowledgment and praise of the various Yoruba deities still venerated in Cuba). During this performance, the soloist asked that children or initiates of each orisha join him on stage to dance the steps traditionally associated with them, performed now however to the timba beat. The dancers always began with traditional, Afro-Cuban religious movements, and as the music intensified their style changed, evolving quickly into timba, with its own strong African energy. This illustrates well the sacred-profane, ancient-modern continuum spanned by Cuban popular music, this time incarnated as timba.

Like other forms of popular dance music, the movements represent "the fundamental connection between the pleasures of the sound and their social realization in the libidinal movement of bodies, styles, and sensual forms" (Chambers 1986, 135). The dance, then, is "a social encounter, which can be [in] a dancehall, a club. Or a party, where bodies are permitted to respond to physical rhythms that elsewhere would not be tolerated; the moment when romanticism brushes against reality, and a transitory step out of the everyday can be enjoyed" (Chambers 1986, 135). Timba dance implies "a going out of one's self, the creation of alternative space, a state of mind that may function as therapeutic or political liberation" (Aparicio 1998, 103).

Beyond mimicking the lyrics as described earlier, dance also responds to broader political events and their local consequences. This is readily seen in rueda steps that signal Cuba's sudden isolation during the special period with motion and distance between partners (Leymarie 2002, 254). The maroon is present in dance too, as timba dance draws upon "the rumba, drumming, and the merengue [that] were prohibited in the colonial [and postcolonial] societies of the Caribbean" including Cuba (Aparicio 1998, 103).

Maroon Musicians: "The Wild Deer Is No House Pet"

Two periods or attitudes can be perceived in the timba production of the 1990s: one spontaneous, visceral, impassioned, of music in frank dialogue with the Cuban experience, the other in which the music is commodified for the international record market. Copying the best of the timba produced in the first period led to the homogenization of the music, a dizzying number of new brands (mostly fragments broken off from established projects), and audience burnout. Some artist abandoned the timba sound for the smoother, more reserved sound associated with international salsa of New

York and Latin America. Of these two moments, the first best exemplifies the maroon spirit due to its sincerity and power. Most anthemic timba songs date from this golden era that lasted between approximately 1993 (a year marketed by the opening of El Palacio de la Salsa and the legalization of the U.S. dollar) and 2001 (when El Médico defected to Miami).

NG La Banda was born in 1988 for the purpose of breaking obsolete molds and breaking new ground in the field of popular dance music. Through the creativity of its director, José Luis Cortés, and the talented daredevil musicians that accompanied him, the group unified the classical and the popular, traditional and contemporary, at the service of the dancer. NG is known for the virtuosity of its arrangements and the confidence with which they move (very often in one piece) between musical reference points, citing son, funk, and Caribbean musics, including soca, merengue, and reggae, and exhibiting a clear command of the language of jazz. According to Casanella and González, within timba and within José Luis Cortés "flow[s] the deepest inheritance of Cuban son, the footprint of funk, Caribbean music, flamenco and rumba, specific reference to hip-hop/rap and the clearest jazz influence, as well as a solid formation and systematic understanding of the codes of classical music." They conclude that the work of the orchestra is a "real fusion of songo, rumba, afro and jam session in [the] function of dance."

During the early 1990s the orchestra enjoyed tremendous popularity, daring to call itself "la banda que manda" (the band that rules), and with good reason. Many of NG's successes of the period marked true revolutions in how Cuban dance bands would make music. For example, their hits "La Bruja" (The Witch) and "La Expresividad" (Expressiveness) by Cortés show the complexity of composition and arrangement (especially in the first piece), the hard sound that would earn for their music (and that of the timba movement they initiated) the denomination of "heavy salsa" or the "heavy metal de la salsa." From the start, strong use of the colloquial extremes of Cuban slang earned them harsh criticism from the academic world and various defenders of "good taste," among them religious zealots. The very personality of director Cortés is offensive to many, although his talent and mastery as an artist cannot be denied. People say that his is a "pesao," a clown, a monkey, a thug: "I can't stand him... but he is good." A great deal of what is said of NG, its music, and the personality of its director echoes the criticism that has faced popular dance music and all types of expression that have been generated clearly from "el pueblo," in Cuba and many other countries as well.

In the past and in another artistic genre, Cuban poet Nicolás Guillén was criticized for his work *Motivos de son* based on black rhythms. Intellectuals like Ramon Vasconcelos asked why he spent his vast creativity on such a thing, and to them Guillén attributed a tendency to think with "imported heads," despising their own culture and seeking to be European (Guillén 2002, 16-18). According to writer and literary critic Carolyn Cooper, the same thing happens today in Jamaica where dancehall reggae is criticized for its frequent, lewd sexual references, descriptions of violence, promotion of deplorable values, and use of the lingua franca of the country, patois– for some, backward and embarrassing. Not to mention the case of hip-hop which many accuse of being little more than noise.

For this reason also, in her book *Black Noise*, Tricia Rose affirms that the hip-hop genre was born from the margins of U.S. American society, the poor black and Latin districts of New York. It utilized forms of expression through sound and wordplay that shocked many because they did not understand and did not want to understand (Rose 1998). It is well documented that what is happening at present with timba has happened in Cuba with previous manifestations of popular dance music, specifically *danzón, guaracha,* and *son* (see Acosta 1998, Carpentier 1946, González

and Casanella 2001, Feijoó 1986, León 1985, Moore 1997). Similar perceptions of El Tosco and timba as untamed and unwelcome should be no surprise, and connections between timba and other musical forms from the African Diaspora make sense as well.

In an article entitled "José Luis Cortés: Between el barrio and Beethoven" by Jaime Sarusky (1999), the topic of people's perceptions of this timba musician comes up.

> JS: Would you say that it is NG or your own personality that has been criticized?

> JLC: Musically it would be difficult to criticize NG. Like so many things, it has a great deal to do with hidden racism, with our different economic situation, with envy harbored by many right now.

Subsequently, in answer to another question, Cortés explains how some see him "as a flashy, eccentric, self absorbed person" because NG never had musical competition and was very successful artistically and economically. "[People would always say] 'These guys come out of nowhere, succeed in the street and in the theatre, do jazz, do rock, do classical music, go to the best places in Europe, the United States, and then this black guy shows up with a tank top jersey on' and they wanted to see me with a briefcase and suit, but that is not my image. I am a black man from the neighborhood, *el barrio*. I was born in El Condado and this is still very deeply rooted within me."

Here he asserts the validity of his own will; the fact that he should not necessarily follow the dictates of a society that is dominated by folks who are unlike him in many ways.

> JS: Let's return to your image, since just as you wear a tank top jersey you also know how to wear a suit.

> JLC: I have a few.

> JS: But it is not only having them but knowing how to use them.

> JLC: I am responding metaphorically to your question.

> JS: Well then, as a musician, as an artist that must project himself to the public, do you project that image to a certain sector of the public with which you especially want to communicate?

> JLC: I think that I would enjoy playing with the symphony orchestra dressed in jeans and a T-shirt with my cap turned to the back, and I'd like to perform in the neighborhood in a suit and tie, because it is what you respect more.

The first shall be last and the last first. In this interview we note a confidence/defiance based on Cortés's tremendous capacity as an artist and his decision to be himself despite the expectations and desires of others, a characteristic that links him to the maroon, who is also respected and hated. Cortés shows his refusal to be dominated or trapped, in this case by the questions of his interviewer, and his capacity to confound with his intelligence and, metaphorically, to escape. All familiar with him know that he dresses with great charisma and a unique flavor – whether or not you believe his red suits, wide-brim hats, and alligator skin boots are really elegant. It is fascinating that he would dress casually for the people of high society (for him aliens) and formally for the people of the neighborhood, his "pueblo yoruba" (Yoruba people) as he often calls them. He enjoys breaking rules and "crashing" closed social spaces, bringing with him styles and behaviors that are alien to specific contexts. We know that his music is multidimensional and aims to reach diverse audiences with different tastes; nevertheless, he establishes a special focus for his creativity, and it is el barrio, the marginal world, to which he orients himself and pays highest respect. He exalts "the school of the street," placing it on par with the academy, recognizing the value of popular knowledge and creativity (Roy 2002, 180).

Seeking antecedents of timba and its image, and indicating contradictory perceptions, it is interesting to consider that the personal and artistic projections of José Luis Moré– who although he has no exact comparison is an important marker in the history of Cuban (and Caribbean) music and society for the boundaries of the race and class that he crossed. Both artists, under discriminatory and adverse conditions (although different), were determined to show their ability, to shine their inner light out into the world and, once their greatness was recognized (though not without criticism), show an irreverent attitude in their self-presentation– speech, dress, gestures, and so forth. What is irreverence but self-affirmation against the grain of accepted societal rules? Those who have fought a great deal to success, at time offending with the intruson of their presence (like Benny creating a jazz band of blacks and mulatos that he called his "tribe," when normally these bands were composed of white musicians), when their time comes to shine they express the pain and frustration they have experienced as eccentricity (for example, take African American jazz guru Miles Davis).

"After reaching the height of popularity, Benny wanted to continue living as he had before becoming a legend. That was the origin of all the clashes with those who tried to change him. It is nearly impossible to impose unnatural rules on a man accustomed to living free, and so Miguel Matamoros said of Benny '*Muchachos,* leave Benny alone, the deer is no house pet' " (Faget 1999). This episode recalls Cortés's affirmations that he was just "a black man from the neighborhood" and that fame would not change him. Although the two musicians are considered *escapao* or *fugao* (colloquial words that express great skill in a specific activity, in this case music, and at the same time evoke the maroon, literally meaning "escaped" or "fled"), they do not enjoy equal popular acceptance, perhaps for several reasons.

Undoubtedly Benny Moré is one of the most important musicians of Latin America and one of the most representative figures of Cuban culture. In the words of Leonardo Acosta, he was a "figure of synthesis"[11] of Cuban music, the creator of an opus that is timeless. Keeping in mind this fact, and also that Cortés has marked Cuban music history, it is the element of time that helps Benny to be more easily digested. The truth is that both have been considered "niggers that don't know their place" (Faget 1999, 30). The historical (i.e., absent) maroon is preferred over the present-day rebel for the danger that the latter represents. Again, Carolyn Cooper (in her book *Sound Clash* about dancehall reggae in Jamaica) argues that the work of new artists who critique life on the island is often despised or ignored, while Bob Marley is held up as the only true and timeless voice of reggae music, partly in order to silence the new artists.

An anecdote I heard told about José Luis Cortés recounts an instance of his "provocative nose thumbing" at polite society and the powers that be (Roy 2002, 199). In a television program interview, he was asked just why he represents Cuban music in such a vulgar, offensive fashion; and instead of responding he changed the subject, offering to play a piece of classical music for flute supposedly known by all "cultured" people. The host assured him that she was familiar with the work. Cortés proceeded to play a masterpiece of colors and arpeggios and afterward asked if the famous piece was well performed. The interviewer said yes, and at that, Cortés declared that what he had just played was no famous composition at all, but rather his own virtuoso improvisation, which embarrassed the host and surely many who shared her perspective. The maroon escaped; but not before landing a painful blow. ¡Qué peligro! What danger! As in the words of Cuban scholar Antonio Benítez-Rojo about the marginalized Caribbean identity in general, Cortés is "a consummate performer with recourse to the most daring improvisations to keep from being trapped" (1996, 24).

Timba was born as a maroon music in the face of challenges posed by a radically changing Cuban society in crisis throughout the decade of the 1990s. It has been necessary for certain Cubans – blacks and mulatos especially – to reaffirm their identity, presence, and importance in their own terms inside the culture and social structure of Cuba. In terms of maroon aesthetics, timba employs the strategies of "raiding" (borrowing elements from diverse musical sources) and "improvisation" (creating new musical language and styles for emergent social circumstances, according to old performance principles). Like maroons of the colonial period, *timberos* are in relationship with national/colonial governments and/or international markets, negotiating power and opportunity from a marginalized position.

The penetration of marginal Afro-Cuban culture into mainstream Cuban culture in the form of aggressive sounds, marginal themes, vulgar coded lyrics, and eccentric or "ghetto" self-representations is but an affirmation of identity that intends not to destroy Cuban society but rather to find a just position within it, as has always been the case in the fight of blacks and mulatos in Cuba (Fernández 1994). So it is that timba and the reaction of Cubans toward it (and similar movements) are quite significant, complex and impassioned. Timba will have many repercussions, not only musically, but also within the history of Cuba and its Revolution.

How can we pin down the relationship between the music and the constellation of important extramusical social phenomena that influence it? African heritage impregnates all of Cuban culture and is one of the matrices that sustain popular music– knowledge that has been maintained, transmitted, and transformed across generations since the period of slavery (Roy 2002, 11). The next chapter describes the social environment that gave birth to timba; it examines the performance of individual and communities who construct identity to the timba beat. It focuses sharply on the black experience in Cuba as a backdrop for further discussion of timba's development. By exploring the notion of Afro Cuba we better understand timba and its meaning as maroon music in the context of Cuban culture and dance music.

Notes
1. The idea of lower-class blacks being more culturally invested in music and dance is reiterated throughout this entire volume, by my informants and by many writers. It may seem stereotypical and implausible, but there is something to it. In Cuba, "popular music has long been dominated by people of color" because music was considered an unstable, even immoral line of work. According to Alejo Carpentier, the scarcity of musicians and the need for music made it impossible to discriminate against blacks in this profession, even within the Catholic Church (Carpentier 1946, 38). Throughout the colonial period, much, if not most, of the European military and religious music on the island was performed by blacks and mulatos. By 1831, there were three times more black musicians than whites (Leymarie 2002, 10). "Blacks and mulatos filled the working class positions of street vendors, tailors, cooks, silversmiths, *musicians*, stevedores, etc. that upper-class whites found demeaning, and lower-class whites were unable or unwilling to do" (Cluster and Hernández 2006, 50; emphasis added). According to Helio Orovio, "For many years almost all [professional] music activity was carried on by blacks" (1984, 181). This strong identification of blacks with music does not, however, imply lack of ability, interest, or achievement in other areas.
2. This is by no means true for all styles of Cuban music. Others genres like rumba and comparsa are "creolizations" of primarily African musical traditions, which were influences by Spanish music and culture in Cuba.
3. Adjustments have been made by Cuban groups based on encounters with music from other parts of the African Diaspora as well. For example, Edmundo "Mundele" Pina, trombonist from Los Van Van, says that they incorporated synthesizers to augment what had been a "soft" charanga sound in order to compete with French Caribbean bands like Kassav (interview, 2003). Of course, hip-hop influences their incorporation of the electronic drum pad.

4. Many of the genres from which timba borrows have themselves been rejected by some as immoral, inelegant, degenerate, or even anti-nation. Tango, cumbia, reggae, merengue, samba, son, and hip-hop have each come to be recognized as signature rhythms of their respective nations (Savigliano 1995; Wade 2000; Cooper 2004; Austerlitz 1997; Pacini-Hernández 1995; Guillermoprieto 1995; Moore 1997; Rose 1999).

5. *Changüí* is a variant of *son* from Guantánamo in eastern Cuba and is considered to be one of the oldest forms of *son*. A *charanga* is an orchestra format that developed at the start of the twentieth century primarily to play *danzón*. Originally, flute, violin, piano, upright bass, timbal, and guiro made up the musical group. Later conga drums, two more violins, and three singers were added. This augmented charanga format is considered to be the standard for playing *chachachá* (Orovio 1992, 132, 133).

6. The classic tumbao for *son* progresses harmonically I-IV-V-IV-I or alternately I-II-VI bemol V-I (Fabián 1997). Rhythmically, emphasis is placed on the "and" of the second and fourth beats (Moore 1997).

7. *Dancehall* is a form of popular music that developed in Jamaica in the 1980s as an evolution of reggae, characterized by explicitly sexual or violent lyrics and computerized, rhythm tracks.

8. *Soca* is a Trinidadian music style originating in the 1970s as an evolution of calypso incorporating electronic music and geared primarily to dancing at fetes and during Carnival parades.

9. *Comparsas* are neighborhood-based music groups that perform in carnival processions; *comparsa* is also another name for the *conga* rhythm that they play.

10. In the Cuban context the term *African* refers to manifestations of black culture "informed by ancient African organizing principles" that crossed the Atlantic from the Old World to the New (Thompson 1984, xiii). Sometimes these cultural patterns are identifiable as derived from specific ethnic groups or sometimes only recognizable as a general "Negro type" (read Afro-Cuban) (Bastide 1971, 8, 10), which is the result of transculturation among original African ethnic groups, Europeans, and Asians on Cuba (Ortiz 1995). In both cases creation is based largely on a common "understanding, attitude of mind, logic and perception" (Mbiti 1969, 2) shared by the various African ethnic groups who were introduced on the island and used by them to adopt the new circumstances (Brandon 1997; Herskovits 1990; Ortiz 1951).

11. These so-called figures of synthesis create art that is not centered in the reinterpretation of some form but is rather the gelling of various influences and tendencies, and for this reason they are unique, singular cases. Neither is it possible to consider perpetuating their style, because their accomplishment implies rupture, climax, and end. Theirs is a paradigm that invalidates continuation and demands search in new creative directions, not better or worse, but certainly different (Orejuela 1999, citing Leonardo Acosta in *Benny Moré* [Havana: Perfil Libre de Amin Nasser, UEAC, 1985]).

The Caribbean Creative

The Creative Economy and Creative Entrepreneurship in the Caribbean

Keith Nurse

Introduction

Small Developing States (SDS) are crossroads of human cultural interaction. SDS are plural and hybrid sites for identity formation, intangible heritage and global inter-connectivity from pre-colonial times to the contemporary phase of globalization. In effect they are hotspots of cultural diversity on account of the penetration levels of global trade, global diasporas, global tourism, and global media. It is this diversity that makes SDS an important contributor to world-wide creativity and gives them some competitive advantage in the production, design and exhibition of creative content.

Many SDS have a narrow and declining industrial and economic base and view the creative industries as an engine for economic growth and a mechanism for diversifying their economies and improving global competitiveness. On account of this there is increasing interest in the role of the creative industries/economy and a greater need to understand how economies can benefit from the wider synergistic effects. As such, the aim of this paper is to assess how the small developing states of the Caribbean can maximize on the potential of the creative economy by fostering innovation and generating new business models. The paper will also assess the context for creative entrepreneurship and identify key policy mechanisms that are required to maximize on the developmental potential of the creative sector.

The Rise of Creative Capital

The creative sector is generally understood to encompass the creative arts and the creative industries. However, the impact of the sector has widened over time to generate what some have described as the creative economy[1] and more recently creative capital. This is related to the shift in thinking towards seeing economic and value-added flows that include the role of the creative class[2] and the contribution of creative cities[3] in making economies globally competitive. What is observed is that the creative sector plays a vital role in differentiating and enhancing the value proposition in multiple sectors that are increasingly reliant on the use of creative content and creative experiences to generate growth in global markets.[4]

In addition, new digital, mobile and Internet technologies offer alternative business models and markets which make creative industries a critical resource for economic development in multiple spheres. However, in many countries, the main focus has been on the creative industries as a stand alone sector in spite of the fact that the sector is a key driver of consumer demand for information and communication technologies, ecommerce, Internet services as well as tourism. For example, analysts at UNCTAD argue "the creative economy reflects contemporary lifestyles increasingly associated with social networking, innovation, connectivity, style, status, brands, cultural experiences, and co-creations".[5]

The concept of "creative capital" best elaborates the synergistic impact of the creative industries on the wider economy and society. For example, Krathe argues that "the "creative capital of cities" thus denotes a capacity to create value from interactive knowledge generation in urban economic settings which are at the same time characterized by the geographic clustering of specific subsectors and by the presence of a diversity of manufacturing activities and knowledge resources."[6] In effect, creative capital can be defined as strategic cultural assets that facilitate innovation within and outside of the creative sector. As such, creative capital can be viewed as the synergistic assets of society that when combined strategically generate new best-practices and world-class capabilities.

The creative sector is a major growth pole in the new knowledge economy as exemplified by the shift towards a post-industrial economy where personal, recreational, and audiovisual services have expanded as a share of the expenses of the average household and as a share of the economy.[7] Furthermore, it is increasingly recognized that creativity is a critical element of innovation and global competitiveness.[8] Some analysts have argued "the industries of the twenty-first century will depend increasingly on the generation of knowledge through creativity and innovation."[9]

The transformation of the creative sector towards creative capital is accounted for by rapid techno-economic change in products, distribution and marketing (e.g., e-books, iPods, iTunes, Amazon.com, Google, NetFlix), the increasing commercialisation of intellectual property in the digital world (e.g., digital rights management), the growth of social networking (e.g. Facebook, YouTube, Twitter, Instagram) and through the synergies forged by value enhancing activities (e.g. cultural tourism, intellectual property and destination branding) and the convergence of content, media and telecoms (e.g. the Internet, mobile and ecommerce) (see Figure 1).

Figure 1: The Rise of Creative Capital

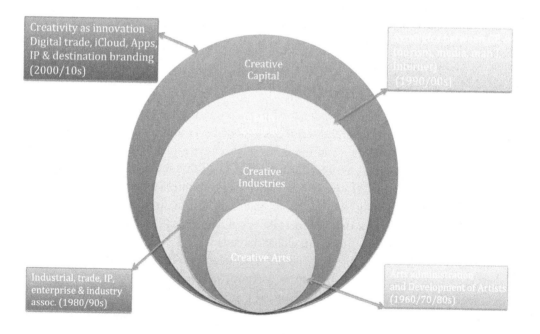

Figure 2:
World Trade in Creative Goods and Services, 2008 - 2011, US$ billion
Source: UNCTAD 2012

Creative Industries and Trade

The creative industries are one of the fastest growing trade sectors of the world economy with an average annual growth rate of 8.8 per cent between 2002 and 2011. Global trade in creative goods and services were estimated at US$ 624 billion in 2011 after rebounding from a slump in the aftermath of the global economic crisis and downturn (see Figure 2). Developing countries exports of creative goods have grown faster than the world rate at 12.1 per cent between 2002 and 2011, amounting to $227 billion by 2011. Data on trade in creative services are largely underdeveloped on account of the weak informational infrastructure, particularly in developing country regions. Best estimates put the size of the creative services sector at $172 billion in 2011 up from $89 billion in 2005, $62 billion in 2002, and $52.2 billion in 2000.[10] This growth is also evident in national economies. For example, in the UK the creative industries gross value-added has grown by 15.6 per cent compared with 5.4 per cent for the overall economy during the period 2008 to 2012. The impact of the sector on employment is also significant with an annual growth rate in 2012 measured at 8 per cent compared with 0.7 per cent for the UK economy.[11]

In short, in the midst of the worst global economic depression in living memory this sector has outperformed most other sectors. Transformations in the creative industries sector have been complimented by the emergence of a trade policy framework and regime in terms of the harmonization and internationalization of copyright regulations (WTO-TRIPs; WIPO copyright & digital treaties); the liberalization of cultural industries under WTO-GATS; and, the protection of cultural diversity (e.g. UNESCO *Convention on the Protection and Promotion of the Diversity of Cultural Expressions.* The diagram (Figure 1) that follows illustrates the expansive range of issues affecting creative industries and highlights the need for close coordination of trade, industrial and intellectual property policies.

In many developing countries the creative industries sector is making an increased contribution to GDP, exports and employment. However, most operate with a large trade imbalance, the exception being countries like China, India, Brazil, South Korea and Mexico that have strong industrial and export capabilities in creative goods, services and intellectual property and have large home and diasporic markets. It is on this basis that the following quote makes the linkage between trade imbalances and the challenge of promoting cultural diversities globally.

> While the developing countries are rich in terms of creativity and cultural expressions, there is a genuine disparity between capacities of the developed and developing countries when it comes to producing and disseminating their own cultural expressions, thereby reducing the opportunities of developing countries to contribute actively to diversity at the international level.[12]

The area of policy as it relates to culture and development has expanded in the last decade. Figure 3 provides an overview of the policies and conventions that have been implemented within key global trade and cultural institution. While the list is not exhaustive it provides a useful taxonomy and view to the ways in which culture has become increasingly institutionalized in the development arena and provides a framework for cultural cooperation. The list also illustrates that there is some convergence as exemplified by how the UNESCO Convention (2005) promotes cooperation between developed and developing countries through Article 16 on preferential treatment. This approach to cultural cooperation has been replicated under the CARIFORUM-EU Economic Partnership Agreement (2008) that has instituted a protocol on cultural cooperation within a trade agreement, the first of its kind in the history of international trade policy.[13]

The key global institution that has been promoting this agenda has been UNESCO. The UNESCO *Convention on the Protection and Promotion of the Diversity of Cultural Expressions* that was adopted in October 2005:

1. Recognizes that "cultural diversity forms a common heritage of humanity";

2. Notes that "cultural activities, goods and services have both an economic and cultural nature because they convey identities, values and meanings, and must therefore not be treated as solely having commercial value";

3. And, reaffirms the rights of sovereign states to "maintain, adopt and implement policies and measures that they deem appropriate for the protection and promotion of the diversity of cultural expressions on their territory".[14]

The Convention calls for the parties to incorporate culture into sustainable development and for international cooperation to support the development of the cultural industries and policies in developing countries through technology transfer, financial support and preferential treatment.

Figure 3: Culture and International Trade

However, the key challenge for many developing countries is that while the convention is a legal instrument that is binding it does not generate commitments to signatories nor does it provide a clear road map for development cooperation. In this sense the convention encourages collaboration between artists and creative entrepreneurs between developed and developing countries but it does not guarantee space in the global cultural market. This brings the issue of creative entrepreneurship to the forefront of the discussion because no legal or institutional framework can legislate what cultural content will get into the market. The principal issue therefore is to ensure flexibility within the evolving rules-based system such that developing countries can promote cultural diversity through an expansion of creative entrepreneurship.

Creative Economy and Trade - The Case of the Caribbean

The Caribbean region has produced for decades many globally recognizable artists like Harry Belafonte, Sydney Poitier, Louise Bennett, Vidia Naipaul, Derek Walcott, Wilfredo Lam, Geoffrey Holder, Celia Cruz, Wycley Jean, Juan Luis Guerra, Shaggy, Eddy Grant, Peter Minshall, Oscar de la Renta, Euzhan Palcy, Raoul Peck, Jean-Michel Basquiat, Heather Headley, Nicky Minaj and Rihanna to name but a few. The most famous of all is Bob Marley whose music catalogue is worth US$100 million and the Estate $30 million.[15] These artists have generated global reach beyond what the region's size would suggest.

The significance of the sector is reflected in the economic contribution of the copyright industries (share of GDP) of which the cultural and creative industries are the main sub-sectors. For example, based upon the WIPO data from 40 national studies Caribbean countries such as St. Lucia and St. Kitts & Nevis are above average in terms of the contribution of the copyright industries to GDP with rates of 9 per cent and 7 per cent, respectively. For other countries like St. Vincent & the Grenadines, Jamaica, Trinidad and Tobago, Grenada and Dominica, the contribution to GDP ranged from around 3 per cent to 5 per cent of GDP (see Figure 4). Caribbean countries are below the average for the countries listed in Figure 5 but exhibit a significant share of copyright industries in employment. Trinidad and Tobago, St. Vincent and St. Lucia are the top Caribbean performers.

Figure 4: Contribution of Copyright Industries to GDP

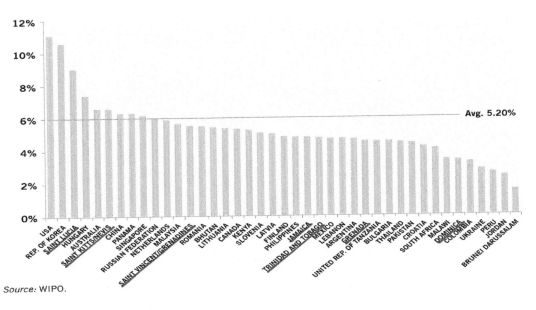

Source: WIPO.

Figure 5: Contribution of Copyright Industries to national employment

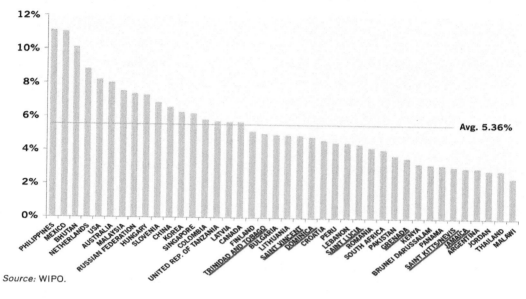

Source: WIPO.

In spite of the impressive share of copyright or cultural/creative industries in the regional economy there is a deficit in the trade of cultural products. The region has long suffered from a significant trade imbalance in cultural goods, particularly books and music on account of the declining capabilities and investment in manufacturing in these sub-sectors. The trade imbalance in the services and intellectual property sectors are less marked but there is no verifiable source of data for export earnings. In part this scenario may be explained by the weak data capture in trade in services and information on royalty earnings. These sectors are key exports along with cultural, heritage and festival tourism but there is no information infrastructure to collate and analyze this data on a continuous basis.[16]

Figure 6: Caribbean Creatives Goods Exports to the World and EU, 2002–2011

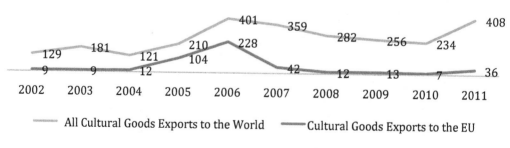

Source: UNCTAD

The creative goods exports from the CARIFORUM region for the period 2002 to 2011 experienced two distinct growth periods (see Figure 6). In the period 2002 to 2006 exports tripled from US$129 to $401 million with a decline in 2004. In the second period exports declined year on year until 2010 with export earnings of $234 million. The year 2011 experienced a significant recovery with US$408 million in export earnings. What is noteworthy is that cultural goods exports to the EU jumped significantly in 2005 and 2006 with export earnings of $104 million and $228 million, respectively. For these two years of increased exports, the EU's import share of CARIFORUM's total cultural goods exports was as much as 50 per cent and 57 per cent (UNCTADstat, 2013). In the subsequent period, 2007 to 2010, the EU's share of total exports plummeted to a low of 5 per cent in 2010. 2011 saw a small recovery to 10 per cent share.

The EU's imports of CARIFORUM's cultural goods decreased significantly during the years of 2007 to 2010. This is evident in the drastic drop in CARIFORUM's cultural goods exports from a high of 228 USD million in the year 2006, to 42 USD million in the year 2007. This downward trend continued until the year 2010. There was an upswing in the year 2011, exemplified by a five-fold increase in export sales to the EU, from 7 USD million in 2010 to 36 USD million in the year 2011.

In the period 2002 to 2011, the top items for CARIFORUM's cultural goods exports to the world were in the product areas of Visual Arts (41 per cent), Paintings (35 per cent), Design, Interior and Fashion (10 per cent), Publishing (9 per cent) and Sculpture (5 per cent) (see Figure 7).

The main cultural goods exported from the CARIFORUM region to the EU in the pre EPA period were dominated by visual arts, paintings and sculpture. In comparison, the exports in the post EPA period are less in value but more diversified with expansion into areas such as audiovisuals, art crafts and design. Increased activity was also observed in the export of paintings in the post EPA timeframe accompanied by a drastic decrease in the export of sculpture and slight decrease in recorded media.

Figure 7: CARIFORUM's main cultural good exports during 2002 to 2011 to the World (USD million)

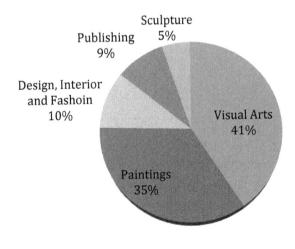

Source: UNCTAD

Creative Services

The analysis of trade in the creative sector needs to move beyond the goods sector to incorporate trade in the services sectors as well as trade in copyright and royalties. Services trade is manifested in different modes. Table 1 outlines the various modes of services supply as it would apply to the creative sector. Mode I is cross-border supply which refers to services that is transmitted via some form of telecommunications, for example, sound engineering (a soundtrack) or architectural services (e.g. blueprints) that are sent to a client via email. This is an area where Caribbean countries have expanding capabilities on account of the importance of the diaspora as markets in the EU, US and Canada. Consumption abroad is where consumers from one country travel to use services in another country. This involves tourism related activities such as cultural, heritage and festival tourism where Caribbean countries have strong export capabilities given the importance of the tourism sector to their economies. Mode III refers to a firm establishing commercial presence in another country to provide a service, for example, setting up a radio station or a booking agency. This is an area where Caribbean countries have weak capabilities in spite of the importance of the diasporic markets. The last mode (IV) speaks to the movement of natural persons, for example, a visual artist or a music band on tour. This is the area which accounts for the largest share of the services exports for the Caribbean creative sector.

Data on trade in creative services is very weak or non-existent because most developing countries do not capture data on the extended balance of payments in services. In addition, because industry associations do not adequately represent the sector it is very difficult to get an appreciation of the volume or value of trade in creative services emanating from the region. The only area for which there is any reliable data is in mode II activities (consumption abroad) such as cultural, festival and heritage tourism.[17]

The Caribbean country for which there is some published data on trade in creative services is Jamaica. Table 2 shows that Jamaica has consistently increased its exports of personal, cultural and recreational services from $20 million in 2003 rising to $54 million in 2012. Imports have also been rising from $4 million in 2003 to $27 million in 2011. The balance in creative services has been positive but declining from a peak of $27 million in 2008 to a low of $10 million in 2011.

Table 1: Modes of Supply in Trade in Creative Services

Mode I: Cross-border supply	Supply of services from one country to another, for example, sound engineering services or architectural services transmitted via telecommunications.
Mode II: Consumption abroad	Consumers from one country using services in another country, for example, cultural, festival and heritage tourism.
Mode III: Commercial presence	A company from one country establishes a subsidiary or branch to provide services in another country, for example, setting up a booking agency.
Mode IV: Movement of natural persons	Individuals travelling from their own country to offer services in another, for example, an artist or band on tour.

Table 2: Trade in Creative Services: Jamaica, 2003 – 2012, US$ million.

	2003	2004	2005	2006	2007	2008	2009	2010	2011	2012
Exports										
Personal, Cultural & Recreational Services	20	28	30	31	29	39	34	37	37	54
Imports										
Personal, Cultural & Recreational Services	2	3	2	4	2	6	10	13	14	9
Audiovisual & Related Services		2	1	4	2	6	9	13	13	
Other Services	2	0	1	1	0	0				
Total Imports	4	5	4	9	4	12	19	26	27	9
Net Balance	16	23	26	22	25	27	15	11	10	

Source: UNCTADstats.

Intellectual property is a key growth area in the global economy and one of the core features of the creative sector. Copyright and related rights are the main forms of intellectual property through which the creative goods and services are protected and commercialized. Royalties earnings and licensing fees are a key source of income for rights-owners such as authors, composers and producers.

In terms of the global trade in intellectual property in the creative sector the most recent data on global authors' rights and royalty collections worldwide in 2012 reached 7.8 billion Euros.[18]. Of this amount Europe accounts for approximately 59 per cent or 4.6 billion Euros. Asia-Pacific is the next largest region in terms of collections with 18.6 per cent. This region outpaced North America for the first time this year which now accounts for 16.4 per cent of total global collections. The other regions are Africa with 0.6 per cent and Latin America and the Caribbean, which has expanded its share of global royalties collections between from 3.0 per cent in 2006 to 5.6 per cent in 2012.

Prospects for royalty-based creative trade (i.e. digital content like Internet TV and mobile music) appear to be very strong as this is a burgeoning element of the creative economy. Estimates show that the top exporters of new media from the developing world are the key industrial economies in Asia (China, Singapore, Korea, Taiwan, India and Malaysia) and other developing country regions like Latin America and the Caribbean and Africa are not active participants.[19] It is also important to note that these countries are faced with the problem of under-reporting in relation to the public performance of copyright works by the collective management organizations in OECD countries, particularly the US.[20]

These systemic challenges along with the problems of the ongoing global economic downturn, especially in key source markets like North America and Europe suggest that the regional Copyright Management Organizations should adopt a more strategic approach to the exploitation of musical copyright works. Efforts have moved in this direction with the creation of the Association of Caribbean Copyright Societies (ACCS).[21] Its mandate is to strengthen collective rights management in the region and in so doing expand the royalty-based earnings of rights owners. This is exemplified

by expanded royalty collections from US$1.2 million in 1999 to US$2.6 million in 2005, US$3.8 in 2009 and US$5.9 milion in 2013.[22]

Strategic Industry Analysis

The creative industries have emerged to be a key growth sector in the Caribbean economy through its contribution to GDP, exports, employment and intellectual property earnings. Caribbean governments and other key stakeholders have recently begun to recognize this potential and are implementing strategic frameworks to capitalize on this opportunity. The Barbados government published a Cultural Industries bill in 2013 that aims to offer a range of tax and fiscal incentives targeted at facilitating growth in the sector. The Trinidad and Tobago government has recently created the Creative Industries Company, which aims to foster investment and allow for trade facilitation.

However, when an analysis of the documented economic flows is done, Caribbean countries have a significant and widening deficit in the trade of cultural goods. What this means is that the region imports more merchandise (e.g. CDs, DVDs, books, magazines and paintings) than it exports. This should be of no surprise to anyone familiar with the sector. The region's competitiveness in the creative goods sector is relatively weak due to the decline of manufacturing in sectors like record and book production. The producers in the region did not make the shift to the digital and Internet economy and so the region has become even more import dependent in the creative goods sector.

It is well recognized that merchandise trade does not accurately reflect total exports for the sector because much of what the region exports escapes capture in the trade statistics. For example, data from trade in services (e.g. fees from live performances, tours, concerts, etc.) and intellectual property (e.g. royalties from designs, authors and composers rights, and digital trade, etc.) are largely undocumented in spite of the fact that these are the areas where the Caribbean has fairly strong export earnings and increasing potential for growth in the new digital and Internet based economy.

The creative sector has strong cross-promotional linkages with tourism[23] which is the largest global industry and the key driver of the Caribbean economy with the largest share of GDP, export earnings and employment. In this regard one of the key areas where countries have potential for growth is in exploiting the value of destination and intellectual property branding. An example of this is the video campaign where Rihanna promotes the natural and cultural heritage of Barbados as part of a three-year deal signed in 2011 between the Barbados Tourism Authority and the global pop star.[24]

Further evidence of the value of the creative sector to the wider economy is exemplified through the ways that the regions major festivals impact on visitor arrivals and expenditure, hotel occupancy rates, car rentals, telecoms and so on. Cultural events also generate significant media impact and destination branding as illustrated by the market appeal of festivals like the Trinidad and Tobago carnival, the Havana Biennale, Reggae Sunsplash of Jamaica, St. Lucia Jazz festival, the Dominica World Creole Music festival, the Barbados Cropover festival, the Jonkanoo festival of the Bahamas and the Calabash literary festival in Jamaica.

The creative or cultural industry sector has experienced some expansion in industrial and export capabilities in the last few decades with the growth of the festivals sector and the expansion of the music and audiovisual industries, in particular. In addition, shifts in the structure and operation of the global economy, for example, the negotiated market access in the CARIFORUM-EU Economic Partnership Agreement, presents new opportunities for expansion and diversification. The

projections are that the sector can grow multi-fold over the next decade once the required strategic investments, business support and trade facilitation mechanisms are put in place.[25]

All told it can be argued that the creative sector makes an important contribution to the Caribbean economy and ranks in the top export earning sectors. As such for many small developing economies like the Caribbean with a narrow and declining industrial base, the creative industries are an engine for economic growth and a mechanism for diversifying economies, improving competitiveness and promoting youth entrepreneurship.[26] In this regard, funding new start-up companies and facilitating cluster development in the creative sector are key policy priorities with potentially high returns on investment.

To achieve these results the region would be required to shift the industrial paradigm from the stand-alone artist or firm operating in isolation to a context where there is a higher level of collaboration and coordination. For example, there is a clear opportunity for the aggregation of content to take advantage of the expanding digital trade in online, streaming and subscription services. As it now stands the supply of Caribbean content, whether it be music, films, visual arts, pictures or books, is highly fragmented and there is no identifiable marketplace to access the content. Maximizing on the opportunities of the digital market is the area of greatest potential. To do so would require an innovation governance framework where the key owners of copyright are working in concert to offer their creative content to a global market.

Towards a Framework for Creative Entrepreneurship in the Caribbean

Key constraints and recommendations are elaborated in this section. The objective is to provide a panoramic view of the key issues that need to be dealt with to achieve industrial upgrading and expand the possibilities for creative entrepreneurship.

The key internal challenges affecting or constraining creative entrepreneurship in the Caribbean are lack of investment and access to working capital, the absence of strategic industrial and business planning, low human capital formation in the artistic and entrepreneurial areas and an inadequate and expensive supply of key materials inputs. Notably high import duties and shipping costs were identified as important constraints to entrepreneurial activity in the creative sector.

The issues identified relate to the challenge of building an industry structure. For many countries this is an emerging and crosscutting area for intervention. Most governmental agencies are not well-equipped in terms of financial resources, staffing, training and policy tools to respond to these challenges. Reducing the risk and cost of doing business in the sector should be a key and overarching recommendation. Enterprise development would involve initiatives such as start-up capital schemes, cluster networking, business incubators, duty free imports of key inputs and technological upgrading.

Marketing and distribution are major challenges facing the creative sector. In regards to this it can be argued that one of the key external challenges is the changing demographics of consumers and tourists and the shifting technological requirements (e.g. digital trade, internet shopping, Apps market) of the regional, diasporic and international markets. The inability of firms and the sector as a whole to quickly adapt to these trends in the global marketplace is a worrying feature. The slow uptake of ecommerce is characteristic of this particular concern.

The most important support that creative entrepreneurs need to address this set of constraints is clear ideas of the key target markets and their evolution. Understanding the requirements of

the marketplace can be achieved through a variety of <u>trade facilitation mechanisms</u>: marketing development grants, exposure and participation in international trade fairs, and the establishment of appropriate distribution mechanisms (e.g. ecommerce and digital distribution).

Lack of marketing skills and an overall marketing/business/export plan were identified as key constraints to the growth of creative entrepreneurs and the firms. This problem is reflected in the low level of training among entrepreneurs in the sector. A commitment to excellence and professionalism is a key concern. Many arts and cultural practitioners are not meeting global best practice. A related concern is the weak managerial and leadership skills in the sector. High levels of insecurity abounds due to irregular contractual practices resulting in fears of violation of intellectual property, combined with a lack of collaboration amongst industry practitioners.

The expansion of opportunities for training and broader <u>human resource development</u> is a critical recommendation. Many of the entrepreneurs in the creative sector enter the business as artists and lack the required training to make the conversion to creative entrepreneurship. Learning how to write a business or export plan are fundamental to building successful firms, industries and sectors. Professional networking and business clubs should back up formal training.

Lack of funding/grants or start-up capital stymies the entrepreneurial drive and weakens the global competitiveness of the sector. In short, many of the enterprising initiatives and ventures are still born and thus are unable to take advantage of existing opportunities to increase market share, expand brand recognition and build intellectual property capital. A weak business support infrastructure is a systemic limit, exemplified by under-resourced governmental agencies, bureaucratic and inter-ministerial inertia, restrictions on the movement of artists within the CARICOM space, low airplay and audience access to local and regional cultural content, and limited investment in venues and cultural spaces.

The key recommendation that evolves from this extensive list of constraints is the establishment of industry associations that would lobby and advocate on behalf of the sector (e.g. local content regulation, free movement of artists and cultural practitioners) as well as facilitate industry networking and cohesion. Without this kind of investment in institutional capacity it is very difficult for the key constraints to be tackled in a systematic and concerted way.

Another key concern is **the low status of the sector** when compared with other economic sectors. There is a general perception that the arts and creative industries are not viewed as businesses that contribute to the national and regional economies in terms of employment, exports, foreign exchange earnings and share of GDP. The principal explanation for this is the absence of consistent, reliable and accessible data on the economic performance of the creative sector. As a consequence business and strategic planning are burdened by a weak information system.

Building a robust and consistent <u>information and policy infrastructure</u> is vital to ensure that the key stakeholders in the economy are getting credible data on the sector's economic performance. This requires investment in building databases as well as the policy infrastructure. The establishment of dedicated investment and export development agencies along with think tanks is a key strategic investment arena.

Conclusion

The case of the Caribbean illustrates that there is a window of opportunity for small states given the rise of the creative economy and the increasing commercialization of the arts. The creative industries offer scope for innovation, economic diversification and global competiveness since they

draw on the creativity and enterprise of local artists and the youth. As such in the context of rising unemployment among the youth investing in the creative industries represents a viable option that the Caribbean should give priority to. The conclusion is that the creative industries should be viewed as a critical strategic resource in the move towards creating sustainable development options.

Notes

1. Howkins, J. (2001). *The Creative Economy: How people make money from ideas*. London, Penguin.
2. Florida, R. (2002). *The Rise of Creative Class — and how it is transforming leisure, community and everyday life*. New York: Basic Books.
3. Landry, C (2000) *The Creative City: A toolkit for urban innovators*, London, Earthscan.
4. Pine, J. and Gilmore, J. (1999) *The Experience Economy*, Harvard Business School Press, Boston, 1999.
5. Kindly see UNCTAD Press Release http://unctad.org/en/pages/newsdetails.aspx?OriginalVersion ID=498
6. Kratke, S (2011) *The Creative Capital of Cities: Interactive Knowledge Creation and he Urbanization Economies of Innovation*. Volume 77 of Studies in Urban and Social Change. Wiley-Blackwell: West Sussex, 195.
7. Michael Masnick and Michael Ho (2012) The Sky is Rising: A Detailed Look at the State of the Entertainment Industry. Floor 64 *http://www.techdirt.com/skyisrising/*; Lury, Celia. (1996) *Consumer Culture*. Cambridge: Polity Press.
8. OECD (2005) *Governance of Innovation Systems*. Organization for Economic Cooperation and Development, Paris, p. 19.
9. Landry, C. & F. Bianchini (1995), *The Creative City*, Demos: 4.
10. See UNDP/UNESCO (2013) *The Creative Economy Report 2013: Widening Local Development Pathways* UNDP/UNESCO, New York/Paris, p. 161-163.
11. See DCMS (2014) Creative Industries Economic Estimates https://www.gov.uk/government/uploads/system/uploads/attachment_data/file/271008/Creative_Industries_Economic_Estimates_-_January_2014.pdf
12. See Ministry of Education, *Fair Culture – Culture for Sustainable Development*. Background Paper on Cultural Sector and Development Work in the Nordic Countries. *http://www.minedu.fi* accessed May 2008.
13. Keith Nurse, "The Economic Partnership Agreement and the Creative Sector: Implications and Prospects For Cariforum" in *The Cariforum-EU Economic Partnership Agreement: A Practitioners' Analysis*, edited by A. Beviglia Zampetti and J. Lodge, London, Kluwer International 2011, 149–163.
14. See http://www.unesco.org/culture/en/diversity/convention/
15. http://www.forbes.com/special-report/2012/1024_dead-celebrities.html
16. For an analysis of the data infrastructure for the creative industries in the Caribbean see Keith Nurse and Alicia Nicholls, Enhancing Data Collection in the Creative Industries Sector in CARIFORUM. Prepared for Inter-Agency (ITC, UNCTAD, WTO and WIPO) presentation to the 32nd COTED Meeting, Georgetown, Guyana, May 16–17th, 2011.
17. For further details see Keith Nurse (2006) *The Cultural Industries in CARICOM: Trade and Development Challenges* (EU PROINVEST and Caribbean Regional Negotiating Machinery).
18. This is data based on the earnings from CISAC members which cover royalty collections from the national societies and not the royalty payments between collection management organizations, for example, inflows and outflows to foreign collections societies. CISAC, Sustaining Creativity: Growth in Creators' Royalties as Markets go Digital: Paris, 2014.
19. See UNCTAD/UNDP (2008) *The Creative Economy Report 2008: the Challenge of Assessing the Creative Economy: Towards informed policy-making*. UNCTAD/UNDP, Geneva, p. 134.
20. See Keith Nurse, "Copyright and Music in the Digital Age: Prospects and Implications for the Caribbean" *Social and Economic Studies* 49.1 (2000): 53–81.
21. Founded in 2000, Association of Caribbean Copyright Societies serves as a Regional Center, whose task it is to accurately monitor and maintain a centralized Caribbean database, ensuring

acceptable data standards for all incoming and exported information on the works stored within this database. ACCS also acts as the communications "link" between the Caribbean copyright societies, facilitating regional integration and concentrated efforts in one common direction. Sourced from: http://www.accscaribbean.com

22. Based on data supplied by members of ACCS.
23. OECD (2009) *The Impact of Culture on Tourism*. Organization for Economic Cooperation and Development, Paris.
24. The promotional deal was launched with a concert in Barbados in 2011 and Rihanna released in January 2013 a video campaign to promote the island's beaches and other natural attractions. http://www.caribjournal.com/2013/01/04/rihanna-unveils-barbados-tourism-video/
25. Keith Nurse, "The Economic Partnership Agreement and the Creative Sector: Implications and Prospects For Cariforum" in *The Cariforum-EU Economic Partnership Agreement: A Practitioners' Analysis*, edited by A. Beviglia Zampetti and J. Lodge, London, Kluwer International 2011, 149–63.
26. Keith Nurse and Zhen Ye,(2012) *Youth Entrepreneurship and the Rise of the Creative Industries.* UNIDO, Vienna. http://www.unido.org/fileadmin/user_media/Publications/Neue_Broschuere_Stand_08_01_2013.pdf

Globalisation and Commercialisation of Caribbean Music

Mike Alleyne

In recent years globalisation has been identified, particularly by developing nations, as a source of major challenges, and in some cases a threat to their very survival. However, its musical manifestation precedes the widespread use of the term in political contexts, and the representation of the Caribbean's popular music provides key evidence of this. A central concern of most small cultures is the assimilation and utilisation of foreign influences without distorting the content and representation of the local. Typically, the recording industry's corporate motivations have been capitalist rather than cultural, rarely synthesising the two successfully. This raises concerns about the legitimate representation of the music and the communities from which it emerges, when commercialisation dilutes the art to the point where it may become *only* product.

The homogenising tendencies of globalisation are frequently recognized, when, for example, the expansion of large corporations, such as McDonalds, impinge themselves upon the daily consciousness of the average person from Jamaica to Japan. However, where popular music is concerned, the encroachments of commerce are not always as readily evident, nor are their long-term consequences. This discussion attempts to shed some light on the historical and textual aspects of Anglophone Caribbean music and ways in which they are relevant to the music's "authenticity". Primarily, I will examine how some early forms of international commercialisation continue to influence the marketing and representation of Caribbean music, with a particular focus on the reggae era and the marketing of Bob Marley. This approach is important since most studies of Caribbean popular music forms describe them solely as products without acknowledging that they are also "texts" with which audiences engage.[1] This engagement drives processes of consumption without which the designation of popular music as product has little meaning.

Corporations and Authenticity

The exoticism associated with the Caribbean as a tropical tourist destination also permeates the production and consumption of the region's music in the industry's Western metropolitan centres. This exoticism can be found in perceptions of calypso, which was the first mass marketed Caribbean music that suffered cultural and aesthetic dilution in corporate hands. Rather than attempting to sell the music on the basis of its aesthetic strengths, the major record companies reconfigure the material to penetrate larger markets. While individual artists may have profited from such commercialisation in the short-term, it is rarely the foundation upon which career longevity is built.

The music corporations have conglomerated rapidly in the past twenty years, and are currently represented by four major companies: Universal Music, Sony Music International, EMI, and the Warner Music Group. While the rapid rise of the internet as an alternative distribution channel has outpaced regulatory legislation and challenged the business models and practices of the

Reprinted with permission from *World Music: Roots and Routes*, ed. Tuulikki Pietilä, 76–101 (Helsinki: Helsinki Collegium for Advanced Studies, 2009).

majors, they still dominate the international music industry by their almost 80% market share of the global sales.[2] The efforts to turn marginal music into a mainstream commodity are often led by the visions of the large companies and their assumptions about audience preferences. The Euro-American recording industry's way of refining Caribbean music for the global markets is comparable to the historical exploitation of sugar plantations and labour in the region. When this refining process removes the creative heart of the music's organic character, the perennial conflict between culture and commerce resurfaces. Although friction between these two elements is not necessarily inevitable, there has been an ongoing tension plaguing efforts to bring Caribbean music from its peripheral position to wider, mainstream international audiences without undue dilution. In this regard, the record industry functions as an integral component of a hegemonic global political economic order.

Because of its limited economies and small populations, the Caribbean region does not form a particularly large consumer market for the music products. Through the commercial alterations of its own music in the international centres of production, the Caribbean is made, however, a consumer of the mainstream production *practices*. This often generates a continuity between local and global whereby the two become virtually indistinguishable as the result of a reverse cultural flow of reformulated versions of Caribbean music from commercial centre to island periphery. The corporate representations of Caribbean music establish new stylistic norms, which influence what is being created in the Caribbean. Almost invariably, the ensuing music sounds less distinctive and more generic. Consequently, the "local" comes to reflect the "global", replicating the mainstream chart trends and undermining the character of the local.

This chapter examines the rearrangement of Caribbean music by the international record companies in ways that erode its audible musical "locality". It discusses the production and representational processes of the various musical forms from calypso to reggaeton. However, the primary focus is on reggae because this genre has been subject to a greater degree of commercialisation over a lengthy time span and a wider geographical area than any other music from the Anglophone Caribbean. Even though the major label marketing of calypso precedes the debut of reggae by almost sixty years, there is comparatively little scope for discussing its contemporary global cultural influence beyond the growing adoption of the steelpan as a musical instrument.

In an era of increasingly globalised popular cultures, the idea of authenticity remains highly valid in assessing the value of artistic changes and fusions. The notion of authenticity always requires some degree of descriptive essentialism of the music in question. It is nonetheless apparent that different musical styles, including reggae, possess core characteristics, which contribute to defining them aurally. These features establish fluid but identifiable borders, which highlight the contrast between what is perceived either as genuine departures or misrepresentations by audiences. Authenticity is not represented here as a norm from which there can be no departure, but as a means of measuring *degrees* of departure.

Reggae music subcultures have developed in different countries and sometimes successful local interpretations of reggae have emerged. One example of this is the album Volcanic Dub (2001) by Twilight Circus from Holland, which contains dub's authentic trademark: organic sonic textures created through progressive remixing accentuated by echo, delay, reverb and various inversions of sound. This album is an example of a white European-based musician creating dub that is authentic in its sonic deconstruction, atmosphere and overall sensibility despite the artist's seemingly limited cultural relationship to the stylistic originators beyond what is transmitted through the

music. A distinction should thus be made between music that is commercially and aesthetically divorced from the lyrical, instrumental and production realism of reggae, on the one hand, and interpretations that embrace and validate rather than fragment core components, on the other.

The analysis in this chapter will focus especially on the instrumental texts and the mechanics of recorded popular music in order to underscore how seemingly minor alterations in the soundscape can have significant cultural impact. The lyrical and literary dimensions will be discussed, too, but the extent to which they have been historically foregrounded in research has undermined possibilities for holistic reading or hearing of the music. Since Bob Marley is by far the most recognisable Caribbean musical figure, he forms the core of this analysis. This chapter is not promoting a puritanical anti-eclectic cultural perspective, but instead explores ways in which musical fusion and sonic reorganisation have been shaped by commercial goals often unrelated to the aesthetic or cultural quality of musical expression. As I have discussed in another essay (Alleyne 1998), the Marley case clearly becomes a template for the hegemonic relationships between major reggae acts and major labels. Moreover, the influence of the "Marley model" can still be witnessed in the twenty-first century, in reggae and other genres, such as dancehall. I will argue that major label involvement in post-Marley reggae culture has been devoid of an understanding of the genre's aesthetic essentials, and that this has ironically limited economic returns for the recording industry.

The term "appropriation" is used in this chapter primarily to describe the textual utilisation of fragmented rhythmic syntax (isolated parts of the musical text) without effectively "speaking" the language, which leads to diluting the music whilst simultaneously harnessing aspects of its economic potential. The concept of "sonic reorganisation" underscores the contrast between musical elements, which have either been foregrounded or subordinated in local or global contexts. Identification of these reconfigurations helps to exemplify precisely how differences in commercially transformed texts manifest themselves. In order to assess relative degrees of change, some basic historical background is necessary.

The Pre-Marley Era

The year 1912 is usually cited as the date for the first international recordings of Caribbean music. Lovey's Trinidad String Band made calypso recordings, reportedly for both the Victor Talking Machine Company and the Columbia Gramophone Company. Calypso is centred in Trinidad, and it is a polyrhythmic style influenced by the cultures of West African slaves, Indian indentured labourers, European modes of musical performance, and the subsequent indigenisation of these elements under and after British colonial rule.[3]

Calypso historian, Gordon Rohlehr describes the early recordings as the beginning of a "process of commercialisation", implying that the more dynamic aspects of the arrangements were de-emphasised to maximize mass market appeal (Rohlehr 1990, 140; Cowley 1985, 3). It was not until the 1920s that American releases of Trinidad's calypso recordings became more frequent, establishing the foundation for a more consistently viable market base (Cowley 1985, 3, 7). By the mid-1930s, top calypsonians, such as Attila the Hun, Roaring Lion and Lord Executor were recording in New York as a result of sponsorship by a Trinidadian record dealer, and they also featured in live radio broadcasts with American show business celebrities, leading to releases on the Decca label, which subsequently licensed material in Britain (Rohlehr 1990, 78).

However, mainstream America's encounter with calypso was more forcefully shaped by bandleader Paul Whiteman, who already carried the alarming misnomer of "King of Jazz".

His appropriation of fragments of calypso aesthetics in his cover version of "Sly Mongoose", for example, assured the genre's exploitation as a novelty soundtrack for urban Western exotic visions of the tropics. This was an extension of Whiteman's distorted sanitisation of jazz in which he employed many of the instruments of the genre without emulating any of its improvisational or emotional dynamics. Amidst all this industry activity surrounding calypso in the early decades of the twentieth century, exploitation of performers was rampant and characterised by contractual reversion of royalties into the hands of record companies and distributors, beyond the calypsonians' grasp (*ibid.*,149–150).

The full impact of American appropriation and commercialisation of calypso became most apparent in the earliest decades following World War II, with two separate occurrences especially illustrating the inimical role of the record industry in its textual/cultural encroachment on Caribbean music. "Rum and Coca Cola", recalled as "undoubtedly the most famous calypso describing the impact of the American presence on Trinidad" became a major U.S. hit in 1944, made popular by the white singing trio, The Andrews Sisters (*ibid.*, 360). Ultimately, the purported American author, comedian Morey Amsterdam, was proven in court to have stolen the song from Trinidad's Lord Invader who had published the work in a pamphlet in March 1943, and is the song's legitimate owner although the melody's legacy can be traced to a French folk song from Martinique in the 1890s. It is also worth noting that the arranger of the original version of "Rum and Coca Cola", Barbados-born Lionel Belasco, sued successfully in 1947 for plagiarism (Cowley 1985, 9–28).

This song, which reportedly sold over five million copies worldwide in its pirated form, also featured significantly altered lyrics to accommodate the Western conservative cultural sensibilities of the time. The prostitution theme, which identified the American presence as socially disruptive and erosive, readily evident in the "better price" derived from the soldiers, could hardly have received widespread airplay in 1940s' America in its original form, thus prompting a more polite and politically uncontroversial rendition from The Andrews Sisters. Invader's version subversively addresses the social situation, as exemplified in this verse:

> Since the Yankees came to Trinidad
> They have the young girls going mad
> The young girls say they treat them nice
> And they give them a better price.
> (Cowley 1993, 22)

Conversely, the same verse in the Andrews Sisters' version presents a markedly different cultural picture:

> Since the Yankee came to Trinidad
> They got the young girls all going mad
> [The] Young girls say they treat 'em nice
> Make Trinidad like Paradise.
> (Cowley 1993, 22)

The anti-imperialistic commentary of the original "Rum and Coca Cola" is therefore thoroughly undermined in the better-known hit version. Indeed, the hegemonic reinterpretation co-opted a challenge to an externally imposed status quo, transforming it into a statement which could be safely articulated by those against whom the satirical polemic was originally aimed. This is a key demonstration of the manner in which access to marketplace discourse has been heavily influenced by international record companies and publishers.

Harry Belafonte's enormously successful 1956 *Calypso* album, released by RCA (which had recently signed Elvis Presley), commodified folk songs and Trinidadian calypsoes with acutely hyperbolic performances. Both the vocal and instrumental articulations were so exaggerated as to bear only minimal relationship to the genre that the album purported to represent. Far from being a mere footnote in the industry's history, Belafonte's album was the first by a solo artist to sell a million copies in the United States, although calypso failed to become more than a passing novelty there. This lack of longevity was no doubt due in part to Belafonte's dilution at a time when few calypso originators were heard or seen in the media mainstream. As Rohlehr (1990, 533) notes,

> [I]t hurt Trinidadians deeply in 1957 to learn that Harry Belafonte had become famous world wide for his "calypsoes", some of them watered down sweetish versions of originals which Trinidad normally censored from her radio each Lenten season, and at times beyond.

This commercial de-contextualisation of calypso has limited its marketplace appeal since that era, largely restricting it to carnival related activities and the stifling representation of tropical stereotypes. It has been difficult for major record companies and distributors to transcend specialist audiences when no widespread appetite apparently exists for the music as sociopolitical commentary rather than merely as a party supplement.

The Rise of Reggae

Until the 1960s, indigenous Jamaican popular music lacked a strong identity; it was divided between the calypso/folk music orientation of mento, on the one hand, and imitation of American big band and rhythm & blues performers, on the other. The confluence of the birth of ska and the independence from Britain in 1962 set a series of evolutionary processes in motion, although ska was itself subject to considerable international commodification and evolved from a fusion of American rhythm & blues influences and local rhythms.

The independent Blue Beat label tried to fill the U.K.'s marketplace vacuum for ska, but the label probably appealed more towards hardcore followers than potential new audiences. The situation began to change with the emergence of Chris Blackwell and Island Records via Millie Small's multi-million selling version of the R&B hit, "My Boy Lollipop" in 1964. Firstly, distribution was facilitated through licensing the record to Philips. This proved a remarkably portentous alliance since Philips became part of Polygram, which purchased Island Records decades later. Eventually Polygram became part of Universal Music, which now controls Island's reggae (and other) catalogues.

However, what purported to be ska on Millie Small's recording was replete with anomalous evidence of commercial streamlining. Simon Jones (1988, 58) describes the instrumental framework of the recording:

> The song was recorded by mainly English session musicians and employed a full orchestral backing. It was a highly polished production, its clean treble oriented sound far removed from the vigorous, bass-dominated recordings emanating from Jamaica during the same period.

This template was utilised later by Island-owned Trojan Records on its string-laden pop-reggae productions for a host of artists (e.g., Bob & Marcia, Nicky Thomas, Greyhound), and set the stage for the commercial framework that would be expanded with The Wailers. Thus, even as an influential independent label, Island's aesthetic formula was directly shaped by the commercial imperatives of achieving airplay by developing a crossover sound.

After the economic potentialities of political independence remained unrealised in the mid-1960s, rocksteady supplanted ska, exerting a reduction of rhythmic pace, creating space for greater instrumental and vocal expression, and reflecting the country's changing social temperament. The metamorphosis of rocksteady into the even slower reggae around 1968 further reflected Jamaica's deepening poverty and despair while facilitating more of the soulful vocalisations that extended the ongoing influence of American R&B on Jamaican popular music. Through the musical and philosophical influence of Rastafarians whose Jamaican presence began in the 1930s, much reggae adopted theological narratives of spiritual and political liberation, though the very name "reggae" is derived from a dancing style to which the music was also subsequently tailored (Gayle 1996, 29). But apart from minor novelty hit singles in the U.K. and the anomalous transatlantic success of Desmond Dekker's "The Israelites" (1969), reggae lacked the profile and critical credibility as an album-based genre until the marketing of The Wailers in the early 1970s. This eventually led to Bob Marley's emergence as the band's central figure and the genre's first superstar.

The impact of white mainstream pop acts also helped create a mainstream market for reggae especially in the 1970s, with high-profile singles from Paul Simon, Paul McCartney, Eric Clapton, The Eagles, and The Police, altering lyrical and/or instrumental preconceptions, usually in the context of heavily diluted vocal articulation (Alleyne 2000, 15–30). Carl Gayle, writing at the time of reggae's seventies imminent commercial breakthrough, suggests that Paul Simon's 1972 hit single, "Mother and Child Reunion" (for which the instrumentation was recorded in Jamaica),

> can't be considered a reggae record just because the backing was done by reggae musicians, and, like many blues copyists, Simon falls down because of his voice... [T]he imitators (like Paul Simon) should be ready to admit that they are imitators and that they can't achieve a true sound, or at least, not yet... White musicians like Paul McCartney... are, so far, wrongly attempting to duplicate it instead of using it to add something to their own type of music". (Gayle 1996, 31)

However, in the same essay Gayle acknowledges the necessity of exposing otherwise inaccessible audiences to reggae to ensure its success and survival, regardless of dilution (*ibid.*,32). The appropriation of the vocabulary of reggae by these artists led a large segment of the previously underexposed audience to accept this articulation as authentic since this was the form receiving the widest physical distribution, airplay, and general media recognition. However, at this stage in the globalisation of reggae, white performers were usually unable to replicate the syntactical fluidity and organic interaction of the component elements despite having clearly identified several central instrumental and linguistic constituents. For example, comparison between Bob Marley & The Wailers original version of "I Shot The Sheriff" (*Burnin'* album, 1973) and Eric Clapton's massive pop hit cover reveals the degree to which vocal enunciation is often connected to the veracity of the protagonist's social experience, and how Clapton's instrumental and vocal articulations lack comparable cultural and ontological urgency. Furthermore, despite Clapton's utilisation of the same basic band format, the elements do not cohere in the same manner as Marley's text because in the latter intangible elements of feeling and rhythmic interlocution are involved in conveying the song's anguished realities. In this sense, authenticity or the lack thereof is heavily defined by the incisiveness of the creative statement, instrumentally as well as lyrically.

Marley's material is regarded by many audiences as the apex of "roots reggae", a style which usually describes the representation of specific, harsh sociocultural actualities in appropriately intense and gritty musical contexts. According to one appraisal, "to most Jamaicans a roots record is simply one that concerns itself with the life of the ghetto sufferer – with "reality". Though often informed by the millennial cult of Rastafarianism, it takes in a range of music" (Barrow & Dalton 2004, 135).

The Marketing of Marley

The 1999 release of the Classic Albums series DVD documentary on The Wailers' 1972 *Catch a Fire* album finally confirmed what some critics had highlighted several years earlier; that the record, which heralded reggae's breakthrough as an album-oriented genre resulted from a series of creative compromises, which potentially undermined its authenticity as reggae. This issue is particularly important because of a mainstream tendency to elevate Marley as an untouchable icon status. There is also a reactionary impulse to treat any critique that is less than unreservedly positive as an undervaluation of his rich artistic and sociopolitical legacy, rather than to contextualise such analyses as indictments of record industry capitalism. Furthermore, as Cooper (2004) has noted, the readings of Marley's lyrical texts have become conveniently amnesiac at worst, and historically revisionist at the very least.

The Wailers were specially selected by former Island Records head, Chris Blackwell, who had monitored Marley's performance evolution for a decade before the group was signed to his label. The clear objective had always been to create a platform for the internationalisation of reggae through their debut album. Although initial sales were quite poor, with only 14.000 copies sold in England after the first year, *Catch a Fire* ultimately created the template for the marketing of Marley and a succession of other reggae bands signed to both Island and major labels in the wake of his breakthrough. Although Marley's eventual chart success was preceded by several of the Trojan label's pop productions (including hits by Jimmy Cliff on both Island and Trojan), these all represented a limited singles-based approach to reggae. Desmond Dekker's "007" (1967) is one of the songs referred to in the *Catch a Fire* Deluxe Edition liner notes as an example of the typical reggae one-off hit "despised by the British rock audience as a kind of dumb novelty music without quality or value" (Williams 2001, 5). *Catch a Fire* ostensibly attempted to be a cohesive album in ways which no previous reggae release had achieved. As a result, the funding of the album (the given figures vary, but generally it is estimated to be £4,000) was unprecedented for a genre with unproven longevity, and certainly for Caribbean artists. Marley's position as the first regional Anglophone artist to receive this level of financial support is pivotal, particularly in the ways in which it established long-term precedents for the hegemonic mainstream commodification of Caribbean music.

The key issues arising from *Catch a Fire* involve questions of cultural authenticity especially relative to instrumental norms in Jamaican popular music before and during Marley's emergence from The Wailers as a major creative force. Under the supervision of Chris Blackwell, the original 8-track recording in Jamaica was substantially remixed, overdubbed and edited in London to fit the perceived needs of the target Western audience. Although this process undeniably involved Marley himself, the capitalist power to determine the overall character of the finished product is at issue here.[4] As I have argued in other writings, prioritising these commercial considerations "weakened the creative authenticity of the work by introducing musical statements divorced from its cultural context" (Alleyne 1999, 95).

Specifically, and perhaps most significantly, the album featured a distinctly treble oriented mix, which is fundamentally at odds with the instrumental and aesthetic heart of reggae with its drum and bass lower frequency emphasis from which its essential earthy life-force energy is derived. To reinforce the cultural recontextualisation, the speed of tracks was accelerated, Marley's voice was brought forward in the mix, and guitar and keyboard overdubs were executed by British and American session men who, by their own admission, had either barely or never played reggae before these recordings. Texan keyboardist, John "Rabbit" Bundrick, had worked with Johnny

Nash, but Nash's decidedly polished pop leanings meant that Bundrick was ill-prepared for The Wailers' gritty roots articulation. Alabama guitarist, Wayne Perkins speaks of feeling completely unfamiliar and uncomfortable with the music as they were attempting to record his overdubs. Notably, in order to play his parts, he requested that the engineer turn down the *bass*. Blackwell refers to his changes in "Stir It Up" as designed to "make it much less of the reggae rhythm and more of a drifting feel". He adds that "This record had the most overdubs on it. This record was the most – I don't say softened, but more...enhanced to try and reach a rock market because this was the first record and they wanted to reach into that market". (*Catch a Fire* Classic Albums DVD.)

Alarming degrees of creative concession were thus made in the production of reggae's first high-profile album. Richard Williams conversely claims that despite the passage of three decades since its release, "the unity and integrity of the music are undiminished either by time or Blackwell's post-production work" (Williams 2001, 8). However, this argument requires rigorous interrogation.

As suggested earlier, the 2001 Deluxe Edition sheds substantial light on the production alterations on the album, while simultaneously emphasising Universal Music's unflinching determination to maximise income from repackaging Marley's catalogue. This two-CD release includes a disc featuring the original Jamaican tracks prior to remixing in London. While some song versions consist of an entirely different set of audio tracks, what is most striking is the absence of lead guitar and rock-styled keyboards, yielding further evidence of the extent of later textual transformation in the London phase of production. The introduction to the internationally released version of the *Catch a Fire* album features Wayne Perkins' decidedly blues-rock guitar vocabulary which, despite being performed with suitable competency, clearly "articulates a different cultural background and experience from that of the Wailers" (Alleyne 2005, 292).

The album's visual text also demands comment. The Deluxe Edition re-issue features a restored original album cover featuring the Zippo lighter concept, as if to metaphorically and literally invite listeners to ignite the album. It is somewhat ironic that the music contained within was "lighter" in hardcore reggae content. In the early seventies, this cover was soon replaced (partly due to manufacturing problems) by Marley's rebellious spliff pose, representing the semiotic stereotypes of reggae – dreadlocks and marijuana – as commercial shorthand for the musical contents. Interestingly, this monolithic reading was later partially undermined by the black American punk-driven rock band, Bad Brains, whose frequent album cover displays of dreadlocks led many a confused listener and record dealer to assume that they played only reggae. Similarly, following the success of his 1982 *Killer on the Rampage* album, Guyanese-born Barbados-based musician, Eddy Grant, was motivated to title his 1988 album, *File Under Rock*, to combatively address the cultural reflex of trapping dreadlocks solely within reggae's stereotypical contexts.

These album cover concerns also have more recent significance, as illustrated by the controversy surrounding the 2005 reggae album by country music artist Willie Nelson, and the creation of two separate album covers, one featuring a marijuana leaf, and the other a palm tree. Retailers could choose to accommodate more conservative consumers, but the apparent plan of the record label (Universal Music, i.e. the keeper of Marley's catalogue) to issue two versions of the cover from the start says volumes about the connotations of imagery allied to music.

Posthumous Marley Releases

There have been at least 50 *authorised* posthumous compilations of Marley's music. Even in view of the quarter century since his passing, this is a remarkably high number reflecting commercial opportunism (by both independent and major labels) rather than any effort to appropriately

anthologise a vitally important musician.[5] In this case, as in other similar instances, there have been too many re-issues and compilations with only fractional differences from previous releases of the same album. The odd bonus track being added to an original album track sequence, prior to the release of a far more extensive deluxe edition has been a typical strategy of Island's various corporate parent companies in the years since Marley's death. It is, at the very least, highly questionable whether Marley's legacy is positively served by the vast majority of these compilations on a multiplicity of labels.

The status of the *Legend* compilation (1984) as the best selling reggae album of all-time (with more than 10 million copies sold in the U.S.) is a clear indicator of what sells best in the mainstream as reggae. This album is dominated by Marley's lighter more melodic fare, understating the sociopolitical incisiveness of his most lyrically and musically potent albums. For example, there are no selections from the powerful 1979 *Survival* album, which restated Marley's ability to meaningfully address larger issues than the politics of love relationships, which had featured heavily on *Kaya* (1978). It is also particularly interesting that the more politically focused *Rebel Music* (1986) and *Talkin' Blues* (1991) compilations failed to match the sales performance of the much more commercial *Legend*, suggesting a probable disengagement of a large sector of his audience from the key philosophical thematic concerns of his music.

The 1992 release of the song "Iron Lion Zion" is understatedly described as being "comprehensively reproduced after Bob's death" (McCann & Hawke 2004, 113). In effect, the transformation of this song from a sparse, raw roots rendition into a technological extravaganza audibly utilising tools neither desired by or available to Marley in his lifetime constitutes another kind of death; the demise of temporal and textual authenticity in representing his work. The purported original version, allegedly recorded either in 1972 or 1973, is included on the 1992 four-CD boxed set, *Songs of Freedom*. This basic, folk-oriented outing is fully indicative of the time in which it was made. However, in an effort to boost contemporary interest in Marley, Island Records decided to release a radically transmogrified version featuring an extremely bright mix, digital synthesizer bass, an entirely new digital drum track, and newly recorded backing vocals pushed forward in the mix. In effect, the song is taken completely out of its pre-digital era temporal context. Perhaps equally alarming was the lack of critical resistance from reggae fans to this type of aural historical revision and its cultural and aesthetic implications.[6]

By the turn of the new millennium, *Time* magazine had declared Marley's *Exodus* as the Best Album of the Century. This international recognition might be viewed as a tremendous victory for music from small cultures, but the album choice is quite conservative in the context of Marley's repertoire, and it certainly does not constitute his best or most representative work. In *Time*'s (1999, 1) analysis, *Exodus* is described in the following terms: "Every song is a classic, from the messages of love to the anthems of revolution. But more than that, the album is a political and cultural nexus, drawing inspiration from the Third World and then giving voice to it the world over".

This choice of what is arguably one of Marley's least "revolutionary" albums as the pinnacle of musical excellence for an entire century further suggests a mainstream audience preference, which reinforces the sense of a creative straitjacket being imposed on Caribbean artists, and it also raises further questions about what is perceived as authentic. The corporate dimension of Marley's success during his lifetime is reinforced by the confluence of his American commercial breakthrough album, 1976's *Rastaman Vibration*, with Island Records' distribution association with what was then Warner Communications. Without this important means of access to discourse with U.S. audiences, Marley's career contours and the marketplace presence of reggae would have

been significantly altered since he would not have achieved the same degree of market penetration at that point, if at all. Despite the inventiveness of independent labels, alternative distribution has always posed a major challenge to sustaining market visibility even for distinctive artists. It is entirely possible that very few of us would be aware of Bob Marley today without the capitalist channels, which ironically spread his messages of individual and collective liberation from the type of economic tyranny associated with commercial enterprises.

The Post-Marley Era, Dancehall, and the Digital Dilemma

The immediate post-Marley era saw an increasing emphasis placed on acts which had already developed core audiences, but which had not yet established a consistent mainstream presence despite access to wide distribution. Three such acts, Steel Pulse, Aswad, and Third World, had all been signed to Island Records prior to Marley's death, but departed the label in search of wider success through a succession of major labels. In each instance, the band's career declined as a direct result of blatant crossover attempts, which appealed to neither their old constituencies nor potential new audiences.[7] These releases were beset by an over-emphasis on R&B and hip-hop elements at the expense of the reggae components at the core of the bands' identities. Fusion and transformation are not actually the central issues here; it is the ways in which sonic change occurs and the commercial premises for it. In each of the mentioned case, there was a clear imbalance between what might be considered to be reggae, and the trend-driven contemporary urban American component, with the latter overshadowing the former. Interestingly, this costly compromise was later publicly recognized by Steel Pulse on their last major label album, *Vex* (1994, MCA) in a song titled "Back To My Roots":

So we took that commercial road
Searching for some fame and gold
And gained the whole wide world
And almost lost our souls
Some say we should have led the way
Take it over from Bob Marley
Got brainwashed by the system, yeah
What a heavy price we paid.

This succinctly illustrates the cooptation and homogenisation of reggae in the post-Marley era, and its erosive effects on the value of the musical content.

Perhaps paradoxically, one Jamaican rock/reggae fusion outfit, Native, had virtually no commercial impact in the immediate post-Marley era major label gold rush to find the genre's next phenomenon. This anonymity occurred perhaps because the group's organic sound and image were less exotic than that of a typical reggae unit. Native's 1981 RCA album, *In a Strange Land*, features a brand of rock influenced reggae characterised by bold edgy guitars over a solid rhythmic foundation, and integrated with highly literate lyricism. Significantly though, unlike the reggae-tinged pop-rock of their mainstream white British and American counterparts, their instrumental articulation and syntactical execution in both rock and reggae proves equally convincing, thus making Native an excellent point of contrast between reggae integrated with rock, and rock superimposed on reggae.

The commercial failure of the album may have been due in part to its innovative artistic quality, which challenged reggae and "island" music stereotypes in combative fashion. It also highlighted one of the more legitimate, less calculated paths for the development of reggae, though

the group's descent into virtual oblivion was accompanied by line-up attrition and major stylistic changes encompassing R&B and mainstream pop, duplicating the plight of their less ambitious counterparts.

Despite Native's marginal position, the importance of their earlier stylistic approach has been magnified by the emergence of Orange Sky, a black rock band from Trinidad signed to Granite Records, a recently formed independent American label distributed by the ubiquitous Universal Music. Their international debut album, *Upstairs* released in September 2005, is a new gauge for market reaction to black rock, which remains a comparatively rare musical phenomenon in the Caribbean despite precedents like Native and, even earlier in 1971, Luv Machine, which recorded its debut in the U.K. for Polydor featuring musicians from Barbados among its four members. Orange Sky's current marketing positioning through their alliance with a known rock figure and ready access to an international major label distribution offers tremendous possibilities, but whether audience preconceptions about what constitutes Caribbean music can be overcome remains to be seen. The group's sound is as dynamic live as it is on record, and their integration of reggae rhythms and Trinidadian vocal accents further challenges assumptions that rock from the Caribbean cannot be authentic. As popular music academic, Roy Shuker (1998, 81) has noted, "Locally produced texts cannot be straightforwardly equated with local national cultural identity, and imported product is not to be necessarily equated with the alien".

In terms of the more globally influential dancehall reggae, which first became a significant commercial phenomenon in the early 1980s, the impact of globalising influences can be identified on several levels. One is the effect of digital music technology, which democratised music making globally, but simultaneously has led to replicating the soundscapes designated by the machinery's makers in industrialised countries. As Negus (1992, 31) has noted, "Technology has never been passive, neutral or natural", implying that the music created, particularly in smaller nations, is a direct by-product of externally conceived sonic hierarchies and aural palates. So while more musicians achieved greater access to technology, there was a remarkable homogeneity in the recordings they made, featuring minimalist programming frequently lacking intuitive human dynamics. Digital technology took music production beyond the realms of the rich, propelling genres such as rap and dancehall into the consumer mainstream. Such previously marginal styles were often characterised by different aesthetics from pop norms, projecting sonic abrasiveness that initially reflected considerable social alienation. The contrast to standard pop production practices was often manifested in a mechanical lack of tonal and rhythmic variation typified by drum machine programming, which implicitly rejected the dynamic fluctuations of speed and volume of live percussion performance.

The most progressive technological innovations in Caribbean music preceded the digital era with the deconstruction of dub as a remixed counterpart to the roots reggae of the 1970s. Moving light years beyond mainstream sonic conventions, dub osmotically reconfigured the soundscape of popular music without ever becoming a major commercially lucrative genre in its own right. From the early days of disco through to more recent developments in multiple ambient and techno subgenres, dub continues to bestow a futuristic aura on all styles, which are able to successfully assimilate its organic conceptual strategies (Alleyne 2002, 469–475). Nonetheless, despite or because of its transcendent sonic characteristics, dub has always been commercially marginal at best, emblematising a Caribbean consciousness beyond stereotypes.

Localising the Global: the Case of Barbados

Popular music from Barbados – the most easterly island of the West Indies – has had significant impact on the Caribbean in the past decade, but comparatively little on the world's major markets until recently. The character of the music from the island which has emerged internationally underlines how commercial influences impact on musical identity. In 2001 in a 132-page study titled *The Caribbean Music Industry Database*, Barbados was only mentioned three times, and even then only in incidental contexts. Less than a decade later, closer consideration is required.

Commodification has also taken on a literary dimension, with writers seeking to establish territorial authority. Where Barbados is concerned, this has produced at least three high-profile incidents of inaccurate international documentation, which, in part, reflect the island's marginal status on the global musical map until now. One of Barbados' most historically important musical figures, the late Jackie Opel, is often incorrectly identified in more than one edition of *Reggae: The Rough Guide* as both Trinidadian and Jamaican, due to his extensive session work in the latter country with many prominent musicians, including Bob Marley.[8] Opel died tragically in a car accident in 1970 after developing a new rhythm called spouge (pronounced "sp-oo-j"), designed to become the indigenous popular music of Barbados, but which never really flourished after his early demise. In *The Virgin Directory of World Music*, Philip Sweeney incorrectly describes Trinidad's soca as a forerunner to spouge; however, there was no soca when spouge first emerged several years earlier, thus the chronology is distorted. Similarly, the Barbadian pop band Ivory recorded its international debut album in 1977 for the U.K. based NEMS Records, but in a curious collection of album covers in *Naked Vinyl*, the authors mistakenly assert that the group is from Australasia (O'Brien & Savage 2002, 208–209). Their enormous geographical leap raises crucial questions about the relationships of these writers to their subject matter, ironically further marginalizing what they intend to make popular.

No Barbadian artist had achieved major album sales in America until the respective gold and platinum certifications of the first two albums from the teenager Rihanna. Prior to her slew of hit singles, which began in 2005, the only other Barbadian U.S. chart success was achieved by Rupee, whose "Tempted To Touch" single[9] edged into the U.S. Top 40 in November 2004. Significantly, both artists scored their breakthroughs signed to major labels, thus following the template of major market success traceable back to Bob Marley.

Rupee's career momentum with Atlantic Records was adversely affected by the label's failure to release his album concurrent with the single's chart presence. In fact, Atlantic's release schedule indicated that a further nine months would pass before his international album debut. However, this could not have been due to the unavailability of the finished recorded product since at least half of the material subsequently released on the *1 On 1* album was already recorded before the deal with Atlantic was signed, having been previously issued on a smaller scale through the Barbadian independent label, CRS Music. This particular situation highlights Atlantic's marketing myopia with a Caribbean artist directly signed to the label as opposed to the joint venture deal the label has engaged in with the dancehall independent, VP Records (from which Sean Paul arose).

The case of Rihanna provides an almost completely converse scenario. The styles adopted to achieve her mainstream success are largely disconnected from indigenous Barbadian musical identities. Her example challenges the assertions that the cultural imperialism thesis is flawed because it underestimates the potential of local appropriation of the global (Shuker 1998, 79–82). Rihanna's case is, however, an example of a localisation of the global, in which the text is returned to the primary source of its commercial influence, America. A "local" presence in the music

appears marginal, if not invisible and inaudible. Cultural hegemony is here merely disguised in more streetwise attire, all the while reinforcing global cultural homogenisation. As Shuker(*ibid.*,81) incisively notes, "local music is frequently qualitatively indistinct from its overseas counterpart", and this instance exemplifies the phenomenon.

A crucial question then is whether there is any evidence in the instrumental or lyrical texts of Rihanna's songs which speaks of or to Barbados. The title of her 2005 debut album, *Music of the Sun*, invokes a Caribbean aura, which is rarely evident in the music. The growing domestic replication of dancehall and pop styled fusions squarely aimed at hip-hop-conscious youth audiences is precisely reflected in her recordings, further demonstrating the ongoing tension in the Caribbean musical community between creolised sonic identity and an urban American influenced template. "Local" cultural identity as expressed through popular music is now a bricolage of colliding commercial genres whose impact occurs at the crossroads of capitalism. It is between and within the space created by these cultural dis/locations that the R&B/hip-hop/dancehall/pop amalgam exemplified by Rihanna exists.

Essentially, the heightened commercialisation of a performer who was arguably already a commodity first and artist second has meant that her musical identity is distinctly non-Caribbean. As one key example, we should consider the content of her global 2006 hit single, "SOS". Apart from her performance persona, which she freely admits is influenced by contemporary American acts such as Destiny's Child, "SOS" recycles the central riff from Soft Cell's 1982 international chart hit, "Tainted Love", which was itself first recorded by U.S. singer Gloria Jones in 1964. The main minor alteration to Rihanna's cover version is almost solely embodied in new lyrics. The liberal sonic reference to the Soft Cell version underscores the politics of commercial safety surrounding Rihanna's career in which being an artist is not an end in itself, but a means to wealth through product endorsements. Moreover, her talented main producers, Evan Rogers and Carl Sturken, come from a distinctly pop based background, which has never before encompassed Caribbean musical identity.

Rihanna's overtly constructed sound and image reflect an urban market crossover consciousness, which shares little in common with what might normally be described as Caribbean music, despite *Billboard* magazine describing "Pon De Replay" as "Caribbean infused", while she has also been erroneously described as a "reggae artist" (Libby 2005, 45; George 2005, 55). According to one radio DJ in Phoenix, "It's just a good summer song. It's fun, it's kind of mindless, you don't have to think about it" (Libby 2005, 45). Unwittingly, this DJ has perhaps succinctly described what the mass market requires of Caribbean music. On paper, the international chart success presents the ideal commercial scenario, at least in the short term, with major label distribution and marketing yielding massive sales dividends. But in view of Rihanna's teen market appeal and limited creative self-sufficiency, it seems questionable whether her legacy will be positively resonant in a decade.[10]

In any event, the most widely distributed and commercially effective releases featuring performers from Barbados have occurred under the auspices of major labels. Sporadic associations with independent labels such as VP and Putamayo have usually involved compilations rather than individual artist releases, thus limiting the breadth and depth of any marketplace impact. The internet can play a progressive role in developing Caribbean music outlets in general, but only if there is sufficient marketing autonomy to circumvent reliance on major label distribution. For example, it's significant that Apple's iTunes categorizes Rupee's material under "R&B/Soul", while Rihanna can be found under "Hip-Hop/Rap", indicating the identity crisis which Caribbean music is facing, both internally and externally, as an inherent by-product of its mainstream commodification.

Soundscape Peculiarities

The commercial perceptions of Caribbean musical identities are also being influenced by recordings, which reflect its cross-cultural flexibility, but which simultaneously transmute its character. The New York based Easy Star All Stars album, *Dub Side of the Moon*, is a somewhat unusual example of a (primarily) reggae reinterpretation of a major rock album in its entirety, with the source material being Pink Floyd's *Dark Side of the Moon* (1973). Since neither Pink Floyd nor the album's original music have any specific roots in reggae culture or common themes other than concerns with the human condition and its inherent sonic ambient spatiality, this seems in many ways one of the least likely cross-genre adaptations. However, Easy Star's musical director Michael Goldwasser stresses that "the lyrics concepts of the [Pink Floyd] album are universal" (Reising 2005, 225). The Easy Star All Stars album, reported to have sold over 70,000 copies, may be an unwitting commentary on reggae crossover politics, loosely parallel to the transformative ideas reshaping The Wailers' *Catch a Fire*. Although the Easy Star All Stars established their market identity with two reggae albums prior to *Dub Side of the Moon*, there's little doubt that their Pink Floyd adaptation coinciding with the thirtieth anniversary of the original album has outsold their other works. This release also demonstrates a fascinating, more visibly emergent cultural intertextuality wherein progressive rock becomes a text reinterpreted by reggae, rather than reggae solely being the object of reinterpretation by rock artists. To some limited extent, this counterbalances the typical centre-periphery relationship with World Music genres on the fringe, but such releases rarely achieve commercial success comparable to the hit albums that inspire them.

Willie Nelson's apparently long-awaited reggae album, referred to earlier in relation to its controversial cover art, is a far more recent oddity. Nelson includes collaborations with several reggae veterans whose individual releases do not achieve the same degree of commercial impact. It is by no means an unusual use of artistic license for a musician to pay tribute to a source of inspiration. However, it was somewhat puzzling to see Nelson's *Countryman* release as America's top selling reggae album at the end of July 2005, having debuted at the top of that *Billboard* chart, outranking even the omnipresent Bob Marley. The fact that his album only sold a rather modest 21,000 copies in its first week also highlights the limited commercial impact of reggae in America despite the decades over which it has been present (Price 2005, 16). If we view this situation in the context of a similarly recent reggae album tribute to Bob Dylan, it is perhaps uncertain how the genre can hope to assert itself independently of associations with major labels and artists.

The international success of dancehall artist, Sean Paul, is also inextricably linked to major label participation. VP Records, with offices in New York and Miami, has its origins in Jamaica. It had achieved street level marketing credibility with Sean Paul's breakthrough album, but the label appeared to lack the necessary infrastructure and connections to penetrate the mainstream market. Notably though, following the agreement of a wide-ranging international marketing and distribution deal with a major label, Atlantic Records, Sean Paul's *Dutty Rock* album achieved double platinum status in the U.S., selling 2.5 million copies and reaching the Top 10 of the album charts in an almost unprecedented dancehall crossover success. It is quite instructive to witness the terms in which Atlantic's co-president described the deal in 2002: "It's going to be an all encompassing deal to bring reggae to the mainstream in a way that we haven't seen since Chris Blackwell and Island Records" (Hall 2002). Given the context and consequences of Marley's commercialisation previously outlined here, this otherwise innocuous statement becomes auspicious, and it reinforces my argument that the Marley template still looms large in the twenty-first century marketing of Caribbean music.

Reggaeton, initially rooted in Puerto Rico but now ubiquitous across urban Latin America and North America[11], has integrated in itself the dancehall personae, rhythms and identity. The rising economic and cultural power of the Hispanic populations in the US, coupled with dancehall alliances with the hip-hop world have created a level of mainstream commercial success rarely experienced by any Jamaican dancehall artist. My main point in this brief appraisal of reggaeton is that the Jamaican dancehall has now been commercially overshadowed by its own progeny. Daddy Yankee's 2005 reggaeton album, *Barrio Fino*, (featuring the urban hit "Gasolina") has gone platinum in the U.S. (with sales exceeding 1 million copies) despite its Spanish language focus (Cobo 2005b, 35; Cobo 2005c, 8). This unlikely scenario, originally centred on independent labels, has attracted majors, now pursuing joint ventures and signing acts at a rapid pace. *Barrio Fino* "became the first reggaeton album to debut at No.1 on the *Billboard* Top Latin Albums chart" making both that release and Daddy Yankee the focal points for the analysis of the genre's commercial explosion (Cobo 2005a, 39). From a developmental viewpoint – and in stark contrast to the Rihanna scenario – it is remarkable that Yankee released the record on his own label and under his own publishing company, thereby maximizing the long term benefits of his work (*ibid.*). However, the distribution involvement of Universal Music (again) has proved crucial to its North American success and subsequent invasion of Europe. Universal was the first major label displaying tangible interest in reggaeton as early as 2002, and has subsequently established itself as the avenue of choice for the genre's premier acts (*ibid.*,41).

Reggaeton's market penetration has been enhanced through the hip-hop alliance courted by dancehall artists, although there is also a Latin hip-hop movement from which reggaeton can draw extensively. The genre's rise to power was initially achieved through compilation albums reminiscent of VP's long-running *Strictly the Best* dancehall series. However, the parallels seem to end there as reggaeton is arguably yielding more globally commercially successful artists than dancehall had produced in the preceding decade. The American Hispanic population has driven urban stations to respond to the trend and acknowledge both its long-term viability and the growing spending power of its primary consumers. As one radio programmer noted, "It's not just about Latin listeners; white suburban kids have a lot of passion for it" (Taylor 2005, 47). The sociology of non-English language cultural texts penetrating suburban enclaves and converting that presence into major economic capital requires serious consideration if Caribbean artists and their management associates are to understand the peculiarities of their potential target audiences.

As far as reggaeton's broader international reach is concerned, Daddy Yankee's "Gasolina" also registered significant sales in Japan and across Europe (Brandle 2005, 48). We should also note that he was "expected to gross $5 million in ticket sales" during his 2005 U.S. tour (Lannert 2005, 42). It is difficult to identify many Anglophone Caribbean artists capable of generating this much live income (with individual tickets in the $90 range) so soon after their career breakthrough release (*ibid.*,45). Commenting on the commercial power of reggaeton in an interview to promote his 2005 album, *The Trinity*, Sean Paul notes that he has been inspired by Daddy Yankee, but also mentions that he does not know what the reggaeton artists are saying, thereby highlighting the holistic crosscultural power of instrumental texts and their rhythmic relationship to vocal articulation without the consumer having a specific sociocultural grasp of the lyrical content or its relevance to the culture(s) in question (Jones 2005, 61).

The extent of reggaeton's commercial seizure is easily underscored with reference to the *Billboard* Reggae Chart for 26th March, 2005, in which eleven of the top fifteen selling releases were reggaeton, and not Anglophone Jamaican (or other Caribbean) reggae. This clearly indicates

that a revolution is already well underway, encompassing both the cultural and economic spheres. However, it should be noted that reggaeton, like dancehall has been susceptible to criticisms of promoting violence and misogyny and has yet to consistently assert itself as a medium for social and political commentary in order to sustain and broaden its relevance instead of becoming a transient event (Romero 2005, 119).

Diasporic Dissemination

We also need to view the Caribbean from a wider diasporic perspective. It is with considerable postcolonial irony that much of the Caribbean's contribution to global popular music culture has come both directly and indirectly through the pop and R&B genres, and through the black British music scene. The list of examples is probably longer than most people might imagine, including Cymande, Billy Ocean, Joan Armatrading, Eddy Grant, Loose Ends, and Des'ree, but perhaps the most useful example in the context of this essay is Soul II Soul. So much of the successful music they created at the turn of the 1990s was directly influenced by Caribbean musical and cultural practices that it constitutes another manifestation of the region's identity.

According to one source describing the collective's breakthrough hit, "The combination of reggae rhythm and dance shuffle propelled 'Keep On Movin' to the top of the American R&B chart, a rare feat for a British soul band" (White and Bronson 1993, 448). Group leader, Jazzy B, demonstrates clear consciousness of the cultural, musical and commercial significance of the Soul II Soul success story:

> What we want to accomplish is for British black music to be taken more seriously. Being exposed to the British culture produces some different things and it's important for the world to realise that black people in Europe have something unique to offer with all the influences we've had – Caribbean, African, American, and European. We went to a major company like Virgin so we could penetrate the U.S. market and get some form of recognition for what we're doing. British companies hadn't been open to local black music until it became hip to be black. There were those who came before me, like Cymande, David Grant, Light of the World, and Beggar's Banquet, but British black music hasn't been respected universally. (White and Bronson 1993, 455)

This statement raises the issue of artists using the major label as a vehicle for the fulfilment of cultural objectives. It might, however, be argued that in this instance the major label association ultimately eroded the creative strength of the group whose visibility and commercial success thereafter was extremely limited.

The Caribbean cultural connection critical to the group's concept is underlined by Mykaell Riley, an original member of Black British reggae band, Steel Pulse, who had arranged and performed strings on the successful Soul II Soul debut album. He asserts the aesthetic relevance of the sonic perspective:

> Soul II Soul was saying 'We want to make an R&B thing from a reggae perspective, from a Caribbean perspective.' So the bass would drop like a reggae bass so it had to be fat, seriously fat, because right next to that you'd be dropping a reggae tune. It had to sit alongside. So in terms of the tempo, in terms of the beat, in terms of the frequency on the bass end that had to respect where reggae was coming from… [T]he main catalyst was Caribbean references. (Personal interview by the author 2002)

The considerable Black British musical contribution in the context of extending the influence of the Caribbean diaspora requires separate analysis (Alleyne 2003). It is, however, clear from observations made within the British recording industry that Black British artists receive very little domestic support and recognition, even when they have conquered America (Harris 2002, 28). So

despite more organic integration of the Caribbean musical elements, commercialisation politics have incredibly reified Black British music as virtually a foreign product. The marginalisation of the local in this case has ironically occurred because of the cultural and media preference for the perceived authenticities of Black American music.

Closing Chords

There are several inferences which may be drawn from this discussion, many of which revolve around polarities of autonomy and cooptation, independence and incorporation. The idealistic, stereotypical opposition between the innovative "indie" record labels versus the capitalistic major companies does not apply universally; many independent labels are replicating the commercial aesthetic models of majors with whom they have established joint venture deals, reflecting a growing similarity of objectives.

A cursory analysis of reggae market statistics for 2005 published by *Billboard* magazine underscores the extent of the commercial interdependence between the small and large labels. Nine of the Top 10 Reggae Albums Artists of 2005 were affiliated with major labels either directly through special subsidiaries or through joint ventures giving wider distribution and promotional support. Three acts in the list are reggaeton performers, and country music's Willie Nelson makes an appearance, as does Hasidic Jewish dancehall-styled vocalist Matisyahu. This variety affirms the music's intercultural appeal, but it also supports arguments of ongoing over-commercialisation. Moreover, this Top 10 listing also features two Bob Marley compilations and another album by one of his sons, Damian Marley, who had previously been dropped form Universal's artist roster before the company resigned him to release *Welcome To Jamrock*. Six of the Top 15 Reggae Albums of 2005 were by reggaeton acts, five of whom were associated with Universal Music, while only one entirely independent label made that list.

These business factors are not, by themselves, conclusive evidence of cultural imperialism. However, if we examine the musical texts of the top-selling releases, we witness a vacillation between hedonism and nostalgia, while very little creative innovation is evident. In view of the statistical and musical evidence, any argument that the music is evolving and creative despite the commercial determination of the major labels and distribution seems untenable. Most of the analyses of the Caribbean music industry have focused on economics and infrastructure with little reference to the musical text. Such empirical studies are valuable, but they should incorporate in the analysis the less readily quantifiable cultural effects.

The Caribbean's continued reliance on major labels to provide the industrial capital and primary marketing muscle has increased the breadth, but lessened the depth of its global impact. A greater degree of economic and representational autonomy and authenticity are essential if the region is to develop its artistic assets in a less mediated manner and to effectively challenge a re-colonisation of its cultural space.

The numbing commercial norms of sonic loops, and pedestrian portrayal of narrative themes of love, lust and loot need to be counterbalanced by alternative creative exploration. Apart from occasional occurrences within dancehall, which in any event is largely afflicted by digital homogenisation, and the remnants of the genre's roots manifestation, reggae culture's cutting edge has been softened by crossover imperatives. The profound and still developing global impact of reggaeton raises particular questions regarding distinctive branding of Anglophone centred music forms, now effectively sold under a different cultural banner, and with almost unprecedented sales. Reggaeton has co-opted rhythmic elements of both dancehall and soca, and so what was previously

distinct Anglo-Caribbean musical expression now assumes a Hispanic identity in the global marketplace. This circumstance also re-emphasises the complexities of cultural appropriation, further echoed by the anomalies inherent in the relative success of Willie Nelson's reggae album and the ubiquitous role of Universal Music as a key international vendor of Caribbean music. It is precisely this type of major label dominance which profoundly affects the production, consumption and perception of the music in the international marketplace.

As evidenced by the longevity and frequency of Bob Marley compilations, his aura remains a potent commercial force, not solely as a means of transmitting oppositional ideology, but also as a blueprint for creating and marketing Caribbean popular music after more than twenty years since his passing. The potential futures of Caribbean music forms will rely on the abilities of both artists and entrepreneurs to transcend the aesthetic and economic frameworks within which they are presently restricted due to choice or coercion.

Notes

1. See, for instance, Kozul-Wright and Stanbury (1998) for an example of a clinical dissection of industry infrastructure with only occasional allusion to musical textual content.
2. See the BBC News Story, "Sony BMG Deal Under New Scrutiny" July 13, 2006. <<*http://news.bbc. co.uk/2/hi/business/5175650.stm*>>.
3. Despite changes due to shifting technologies and audience tastes, today calypso remains firmly interlinked with carnival activities and its lyrical content largely maintains the same thematic focus as in its past, utilising "satire, ridicule, gossip, and sexual innuendo, and with much emphasis on the highly prized skill of extemporizing, or making up new verses and lines on the spot" (Mason 1998, 21).
4. In a 2006 conversation with Tony Platt (the recording engineer for the *Catch a Fire* overdubs), he told me that Marley displayed a clear willingness to refashion the album for a wider audience.
5. Ian McCann and Harry Hawke (2004) contains a comprehensive listing of Marley's recordings up to that point.
6. "Iron Lion Zion" was unavailable in album form until the 1995 release of the *Natural Mystic* compilation by Island Records.
7. This phenomenon is discussed in more detail in my essay "Babylon Makes the Rules" (Alleyne 1998).
8. Their collaborations can be heard on a CD titled *Wailers & Friends* on the Studio One label.
9. This song is also available in a reggaeton remix, which bears no rhythmic difference to its original form, its only addition being Spanish-language rapping.
10. Editor's Note: The stunning success of Rihanna since this article was written has caused Alleyne to significantly revise his position. See Mike Alleyne, "International Identity: Rihanna and the Barbados Music Industry," in *Rihanna: Barbados World-Gurl in Global Popular Culture*, ed. Hilary Beckles and Heather Russell, 74–95 (Kingston, Jamaica: UWI Press, 2015).
11. For a broad cultural assessment of reggaeton, see Raquel Rivera's 2003 book, *New York Ricans in the Hip Hop Zone* (New York: Palgrave Macmillan)

References

Alleyne, Mike 1998. " 'Babylon Makes the Rules': The Politics of Reggae Crossover", *Social & Economic Studies* 47(1), 65–77.

———. 1999. Positive Vibration? Capitalist Textual Hegemony & Bob Marley. In B. Edmondson (ed.) *Caribbean Romances: The Politics of Regional Representation*. Charlottesville & London: University Press of Virginia. 92–104.

———. 2000. "White Reggae: Cultural Dilution in the Record Industry", *Popular Music & Society* 24(1), 15–30.

———. 2002. Echoes of Dub: Spatiality, Assimilation & Invisibility. In K. Kärki, R. Leydon& H. Terho (eds.) *Looking Back, Looking Ahead: Popular Music Studies 20 Years Later – IASPM Conference Proceedings*, IASPM Norden. 469–475.

——. 2003. "Atlantic Crossover: Black British Music in America", unpublished Conference Paper, IASPM International Conference, Montreal, Canada.

——. 2005. International Crossroads: Reggae, Dancehall & the U.S. Recording Industry. In Christine Ho & Keith Nurse (eds.) *Globalization, Diaspora & Caribbean Popular Culture*. Kingston: Ian Randle Press. 283–296.

Barrow, Steve & Peter Dalton 2004. *The Rough Guide To Reggae*. 3rd Ed. London: Rough Guides.

Brandle, Lars 2005. "Going Global", *Billboard*, 10 Sept, 48.

Catch a Fire -DVD 1999. Classic Albums Series. London: Eagle Rock.

Cobo, Leila 2005a. "Catch Reggaeton Fever", *Billboard, 10 Sept, 39–42*.

——. 2005b. "Latin Rap Makes Its Move", *Billboard*, 30 April, 35.

——. 2005c. "Home Run For Yankee", *Billboard*, 6 August, 8.

Cooper, Carolyn 2004. *Sound Clash: Jamaican Dancehall Culture At Large*. New York: Palgrave Macmillan.

Cowley, John 1985. *West Indian Gramaphone Records in Britain: 1927–1950*. Coventry: University of Warwick.

——. 1993. "L'AnneePassee: Selected Repertoire in English-Speaking West Indian Music, 1900–1960", *Keskidee: A Journal of Black Musical Traditions* 3, 2–42.

Gayle, Carl 1996. Are You Ready For Rude and Rough Reggae? In Charlie Gillett & Simon Frith (eds.) *The Beat Goes On: The Rock File Reader*. London: Pluto Press. 29–42.

George, Raphael 2005. "Between the Bullets", *Billboard*, 17 September, 55.

Hall, Rashaun 2002. "Indie Reggae Label VP Pacts With Atlantic", *Billboard*, 19 October <<http://www.billboard.biz/bb/biz/archivesearch/article_display.jsp?vnu_content id=1739030>>.

Harris, Keith 2002. "Squandering Natural Resources", *PRS Members Music Magazine* 5, Autumn, 28.

James, Vanus 2001. *The Caribbean Music Industry Database*. UNCTAD/WIPO.

Jones, Ivory 2005. "Paul: No *Dutty* Redux", *Billboard*, 24 September, 61.

Jones, Simon 1988. *Black Culture, White Youth: The Reggae Tradition from JA to UK*. London: Macmillan.

Kozul-Wright, Zeljka& Lloyd Stanbury 1998. *Becoming a Globally Competitive Player: The Case of The Music Industry in Jamaica*, UNCTAD.

Lannert, John 2005. "Cardenas' Drive For Live Success", *Billboard*, 8 October, 42–45.

Libby, Michael 2005. "Rihanna Makes 'Play' For Stardom", *Billboard*, 13 August, 45.

McCann, Ian & Harry Hawke 2004. *Bob Marley: The Complete Guide to His Music*. London: Omnibus.

National Cultural Foundation <<http://cropover.ncf.bb/index.php?ZZZ=500_1051>>.

Negus, Keith 1992. *Producing Pop: Culture and Conflict in the Popular Music Industry*. New York: Edward Arnold.

No Author 2006. "Sony BMG Deal Under New Scrutiny", BBC News, 13 July. <<http://news.bbc.co.uk/2/hi/business/5175650.stm >>.

O'Brien, Tim & Mike Savage 2002. *Naked Vinyl: Bachelor Album Cover Art*. New York: Chrysalis.

Price, Deborah Evans 2005. "Some Retailers Not High On Nelson Album Art", *Billboard*, 30 July, 16.

Recording Industry Association of America -website <<http://www.riaa.com/gp/database/search_results.asp>>.

Reising, Russell (ed.) 2005. *"Speak To Me": The Legacy of Pink Floyd's The Dark Side of the Moon*. Aldershot: Ashgate.

Riley, Mykaell 2002. Personal interview by the author, 25 July, Barbados.

Rohlehr, Gordon 1990. *Calypso & Society in Pre-Independence Trinidad*. Trinidad: Gordon Rohlehr.

Romero, Angie 2005. "Latin Kings", *Vibe*, November, 118–122.

Shuker, Roy 1998. *Key Concepts in Popular Music*. London: Routledge.

Sweeney, Philip 1991. *The Virgin Directory of World Music*. New York: Henry Holt.

Taylor, Chuck 2005. "Radio Flips for Reggaeton", *Billboard*, 10 September, 47.

Taylor, Timothy 1997. *Global Pop: World Music, World Markets*. New York: Routledge.

Time Magazine 1999. "Best of the Century", 31 December <<http://www.time.com/time/magazine/articles/0.3266.36533.00.html>>.

White, Adam & Fred Bronson 1993. *The Billboard Book of Number One Rhythm & Blues Hits*. New York: Billboard Books.

Williams, Richard 2001. Liner Notes. In Bob Marley and The Wailers, *Catch a Fire Deluxe Edition* Audio CD-box. Tuff Gong/Universal.

Literary Arts and Book Publishing in the Anglophone Caribbean

Suzanne Burke

(In the Caribbean) 'we could mark out three moments in literary production – first as an act of survival, then as a dead end or a delusion, finally as an effort or passion of memory'. *Edouard Glissant.*[1]

Introduction

Glissant's analysis of the origin and development of the literary arts in Caribbean plantation societies – primarily as acts of resistance, survival and memory – are the guiding principles that still generally govern the sector today. In the Caribbean, the socio-political imperatives of literary production have generally been afforded more significance than any economic benefits that can be derived from the sector. In this regard, the Caribbean is a relative newcomer to the global book publishing industry. While there is evidence to suggest that books were published in this region from as early on as the 18th century, these forays can best be described as piecemeal. Generally, the masses in pre and post emancipation Caribbean societies employed oral communication to record their lives through story telling, songs and proverbs.

According to Randle,[2] the evolution of publishing in the Caribbean can be divided into three discrete phases. The first period during colonialism was distinguished by sporadic outputs from individuals who were generally temporary residents of the islands and who produced books for internal consumption. During this period, self-publishing was the dominant form of production. However, a notable exception to this was Pioneer Press of Jamaica that was established around 1920.[3] They were responsible for publishing a range of novels, children's books, poetry, history and biographies up until their demise in the early 1960's. The second wave of Caribbean publishing (1950s–1970s) gave birth to the concept of the West Indian novel and is usually referred to as the 'golden age of West Indian literature'. This period was characterized by the explosion of writing by academics, intellectuals and writers of West Indian origin who had migrated to Britain from 1948 onwards. Generally, their books were published by major UK based publishing companies such as Collins, Macmillan and Longman. During this phase, these companies also expanded their operations to the Caribbean and established alliances with local business interests to solidify their control over the trade in the lucrative textbook market.[4] By the 1970s, smaller, independent Black British owned publishing houses such as New Beacon Books appeared, and gave voice to a radical Black worldview that was emerging during that period.

The current phase (1980s–onwards) has witnessed the expansion of Caribbean book publishing due in large part to the withdrawal of many of the UK based companies from the region.[5] However, book publishing in the Caribbean struggles to sustain a viable place in regional and global markets. The operating environment is characterized by limited access to the new

Reprinted with permission from *Policing the Transnational: Cultural Policy Development in the Anglophone Caribbean (1962–2008)* (Saarbrücken, Germany: LAP Lambert Academic Publishing, 2010), 216–51.

communication technologies, undercapitalized and inexperienced entrepreneurs, and the paucity of strategic policy responses from both the private and public sectors.

The main purpose of this paper is to discuss the evolution of the literary arts and book publishing sectors in the Caribbean and to examine how state policies have influenced their growth. It also explores the intersection of the two sectors and reflects on the ways that cultural policies can work as vehicles to bring about a more synergistic relationship between the two sectors within the overall cultural industry framework. The first section provides an overview of international trends where particular attention is paid to developments in the major production markets in the United Kingdom and the United States. The idea is to show how these trends influence, and compare with the Caribbean reality. The following section examines the Caribbean publishing industry. It begins with a historical overview of the literary tradition and continues with a more detailed analysis of the current structure,[6] size and business norms of the publishing industry. This is followed by a discussion of the various state-led policies and examines how they have either facilitated or impeded the development of the publishing sector. The paper concludes with a general analysis of the policy responses, by detailing some of the major gaps and possible areas for future action.

The use of the terms 'literary arts and publishing industry' in the paper is influenced by Throsby's[7] explanation of the cultural industries. According to Throsby, the cultural industries can be seen as comprising an aggregate of art forms that are creative but which spread out to include cultural commodities. He represents all the activities by a series of four concentric circles including the core creative arts, the cultural industries, the wider cultural industries and related industries. The core group is defined as the creative arts and includes music, dance, literature, theatre, visual arts and craft, while the wider creative industries refer to book and magazine publishing, television and radio, newspapers, film and sound recording and heritage services. As such, this paper is concerned with literary arts as the creative product and book publishing as the ancillary commodity and examines how they operate within the overall cultural industry framework. In terms of the Caribbean context, the chapter draws heavily on references from Jamaica and Trinidad and Tobago. However, general observations and recommendations about the main characteristics of the industry, such as its structure, business norms and government support can generally be applied across the entire English speaking Caribbean.

Global Scan and Key Characteristics of the Book Publishing Industry

Literary arts and book publishing represent two of the most productive areas in the creative industries sector worldwide. In 2015, book publishing accounted for $US 103 billion in world trade and employed 814,000 persons operating in 69,706 businesses. The sector is expected to grow by 1.1% between 2013 and 2017, with a 17.1% growth expected in the digital books sector.[8] The United States and the United Kingdom are the biggest producers and consumers of English Language books in the world. Readers spend approximately 118b Euro on books every year and there is a fair amount of concentration in the consumption of books. Six countries including the US, China, Germany, Japan, France and the United Kingdom account for sixty percent of all trade as shown in Table One below. The emerging markets in the BRICS[9] trading block experienced steady growth of between six to eight percent during the first decade of the 2000s accounting for eighteen percent of the overall trade in books. However, in the past three years this growth has slowed to about three percent.

Table 1: Largest Book Markets in the World (2013)

No:	Country	% Share of global market
1	USA	26%
2	China	12%
3	Germany	8%
4	Japan	7%
5	France	4%
6	UK	3%
7	Rest of the world	39%

Source: www.publishers.org.uk

However, like all the other sectors in the creative industry economy, book publishing has experienced fundamental changes over the past two decades, due in large part to advances in communication technology, the fastening pace of globalisation and the rapid consolidation of business interests. These factors have altered the structure, size and operating norms of the book publishing industry and fundamentally revolutionized the ways in which books are produced, sold and consumed. As a result, a small group of companies are dominant in the major English Language book markets located in the UK, USA and Germany. For instance, sales of the top ten book publishing companies account for 55% of global trade. Major players such as Pearson, John Wiley and McGraw Hill are now concentrating on one of the three streams of publishing,[10] signaling a major change from the 1990's when all the majors operated in all the three areas. The United Kingdom consistently publishes the most titles, but in the last two years this place has gone to the US with 292,014 in 2011 followed by China with 241,986 and the UK with 149,800. In the US, it is reported that consumers spend more on books than any other medium except television.[11]

Generally, sales in the consumer/trade categories Adult (Hardbound and Paperback) and Juvenile (Hardbound and Paperback) are the highest in the major English Language world markets. While sales in the adult market are dominant, recent figures suggest that this sector is continuously recording the slowest growth. The new communication technologies have influenced the publishing industry as sales of audio books and electronic books are growing exponentially. In 2012, there was an exception to this trend as the sale of hard cover books increased by 11.5%, compared to 4.5% for ebooks. Sales of hard cover books were boosted by the popularity of two titles, namely *Fifty Shades of Grey* and *The Hunger Games*.

Another change in global book sales is the introduction of Amazon's Kindle that allows readers to download books directly. The device also has an audio function that facilitates listening to audio versions of newspapers, magazines, blogs and books. Books are also becoming increasingly more affordable because of mass production. For instance, it is reported that 50% of all books in the UK are sold at discounted prices. However, there is still slow growth of the general book publishing industry in the more mature book markets such as the UK, the US and Canada. For instance in 2013, ninety-eight UK publishing houses became insolvent as compared to sixty-nine from the previous year. The majority of these failed businesses were small enterprises.

Amazon is now the biggest book retailer in the major markets, representing a shift away from the traditional bookstore. Bookstore sales have suffered greatly as evidenced by the closure of big chains such as Borders in 2011 and the well documented struggles of Barnes and Noble. Book

sales through retailers are way below normal and decreased by 13.2% between 2002 and 2012. In fact close to half (43.5%) of all books purchased in the US are from online sales, followed by 31.6% from large retail chains, independent bookstores, supermarkets and mass merchandising. In 2012, online channels grew by about 8 %, while large book retail chains suffered the biggest market share decline of 18.7% of book purchases versus 28.7% from the previous year. Meanwhile in 2012, UK chain bookstores gained a point in market share rising to 27.6% of all book purchases[12] from the previous year. Overall, physical retail accounted for 58.8% of all book purchases versus 37.7% for online retail during 2012.

New technologies provide increased accessibility to books. These include audio books, ebooks, digital printing and Print on Demand services. While the use of new technologies has grown exponentially in the largest book markets, they have been slower to catch on in developing countries because of the large initial investment that is required. In addition, the smaller market size in these countries decreases the rate of return on these high-end investments. However, overall online purchases accounted for one-third of global book purchases in 2011.[13]

The new technological approaches to printing as described above have also created major problems for publishing companies. Chief among these is the intractable challenge of piracy, which is one of the key obstacles to the growth of the book publishing industry. For instance, it is estimated that piracy of digitized books has already cost the US publishers $2.8b.[14] The new reprographic technology has resulted in the establishment of thousands of copy centres that copy entire books on a routine basis. This problem is particularly acute in and around university campuses all over the world where there is a market for illegal copies of textbooks. This type of illegal commercial copying usually takes place on a 'print to order' basis to avoid stockpiling., Advances in technology also make it possible to produce photocopies with scanned digital covers that look identical to those of the legitimate product. Sometimes these illegal operations obtain masters or copies of books and run unauthorized editions off a printing press, while in other cases, licensed local distributors or publishers undertake print overruns and sell the extra copies at a reduced price. The frequency of digital piracy is also increasing as publishing companies face growing numbers of illegal downloads of online journals by individuals or by libraries. However, new data seems to suggest that digital piracy may be overstated. Although statistics are hard to come by, Amazon says that US Kindle owners buy three times more books than its other clients.[15]

The preceding discussion has shown that the global publishing industry generates billions of dollars and is dominated by a few major players, similar to what applies in the music industry. However, communication technologies are forcing disruptions in this model, resulting in ongoing volatility.

The Caribbean Context

The Caribbean literary arts and publishing industries have also been influenced by the global trends described above. For instance, the new technologies have affected the production processes, slowed the sales of books, and increased the levels of illegal copying throughout the region. However, due to major variations in market size and structure, resource capability and the legislative regimes there are significant differences between the Caribbean industry and its counterparts in Europe and North America. The following section will examine the Caribbean book sector in greater detail and will attempt to account for its unique organizational development through a reading of its genesis and evolution over the past sixty years.

Historical Overview of Caribbean Literary Arts and Book Publishing

The Caribbean literary tradition is a relatively new one, and only assumed some structure from about the 1950s onwards. During that time, the majority of publishing in the region took the form of academic journals and literary magazines. Some of these included *Focus* and *Planter's Punch* (Jamaica), *Beacon* (Trinidad and Tobago), *Bim* (Barbados) and *Kyk over al* (British Guiana). Meanwhile, West Indian writers who migrated to the United Kingdom were creating what was to be subsequently known as the West Indian novel and helped to insert a Caribbean voice and aesthetique into world literature. Most notable among this group were George Lamming, Frank Collymore, and Kamau Braithwaite (Barbados), V.S. Naipaul and Samuel Selvon (Trinidad and Tobago), Andrew Salkey (Jamaica) and Wilson Harris (Guyana). According to Lamming:[16]

> There was a sense that one only became West Indian outside of the West Indies. The real Pleasure of Exile (meeting the Caribbean in England) explored the irony of an imperial organization such as the BBC being responsible (in the 1950's and 1960's) for bringing together a cadre of Caribbean writers in a way that would not have been possible in the Caribbean.

The pleasure of exile also afforded these writers a level of artistic and political freedom that was not generally afforded them in the Caribbean. This was particularly true for writers whose views did not coincide with those of the governing elite in their homelands. These writers faced varying levels of hardship that included censorship of their work. For example, the government of Eric Williams in Trinidad and Tobago seized and held copies of CLR James' 'Modern Politics' in 1960, and placed him under house arrest for a brief period in 1965 for fear that he would become involved in the country's labour unrest (Bolland, 2004:396).

In addition to much needed artistic freedom, living in exile in the UK, also provided writers with international exposure, primarily through the BBC's 'Caribbean Voices',[17] which was produced by Henry Swanzy. In addition to exposure, Caribbean Voices provided W.I. writers with much needed paid work as readers, and also helped to make linkages with renowned publishing houses such as Collins and Heinemann. During this time, the writers concerned themselves with a wide range of issues including the traumas of dislocation, exile, alienation, West Indian identity, and the burning question of nationalism in the West Indies. They were stimulated by the 'new reality of political independence, pushing the society to want to interpret itself to itself' (Nettleford 1989:294).

This generation of writers also interrogated and changed the form and style of British writing, to the extent that there was now a considerable discourse on the characteristics of *The West Indian novel*.[18] One of the most profound components of this style involved the use of the once castigated 'nation languages' from the various islands. Among its many objectives were the boosting of cultural confidence, and the creation of a symbolic Creole community. Jamaica's Louise Bennett was perhaps one of the most tireless advocates of this genre, and throughout her long and distinguished career legitimised the use of *patwa* in formal, public spaces. Initially, this position resulted in ostracism from mainstream Jamaican literary circles, because nation language was viewed by the ruling elites as dialect, and not functional where 'serious' literature was concerned. In fact, Bennett was referred to as a dialect poet, and her work was relegated to the genre of 'popular entertainment, not serious art' (Hoenisch 1993:183). However, by the 1970s, what had been considered the main limitation of her work became its greatest asset, as nation language came to be viewed as central to the definition of Jamaican identity.

Meanwhile, the Caribbean Arts Movement was formed in the United Kingdom by John La Rose, Andrew Salkey and Kamau Braithwaite in 1966. Together they established the first wave of Caribbean owned publishing houses and bookstores, determined to print material that the more

mainstream publishers such as Collins and Heinemann, were not willing to support. Trinidadian John La Rose's *New Beacon Bookstore*, Guyanese Jessica and Eric Huntley's *Bogle L'Ouverture*, Trinidadian Darcus Howe's *Race Today Publications*, and Ghanian/Trinidadian Margaret Busby's *Allison and Busby*, were to be the key players in the establishment of publishing houses dedicated to the promotion of the radical, new black writing, as well as reissuing old classics. For example, *Bogle L'Ouverture* published Walter Rodney's seminal book *How Europe Underdeveloped Africa* as well as many of Andrew Salkey's explorations of the Caribbean folklore character, Anancy the Spider. Therefore, it is fair to say that the a sizeable segment of the region's writing talent was shaped and molded outside of the Caribbean - primarily in the United Kingdom.

These writers made an invaluable contribution to the discourse on Caribbean identity and influenced the shaping of cultural sensibilities within the region. However, it must be noted that even though many of these writers achieved international notoriety, their work was not widely consumed by the masses of Caribbean people, and basically circulated among the academic, artistic and political elites. This pattern developed as a result of the distribution and retail arrangements that were formulated by the international publishers who owned the rights to distribute their books. Meanwhile, within the region, publications such as The Journal of West Indian Literature, Savacou and Callaloo had been established and were engaging the minds of Caribbean academics and artists on the nature and role of the literary arts in post-colonial societies.

From the 1970s onwards, the voice of the woman writer increasingly claimed a space within the Caribbean literary landscape. Their body of work addressed a wide range of issues including childhood, female sexuality, sexism, matriarchy, family, community development and nationhood. These women were committed to inserting their politics into the discourse on Caribbean identity and 'insisted that the patriarchal basis of the West Indian literary canon be challenged and women's stories be written back into the representation of the quilt/braid/mosaic hybrid' (Conde & Lonsdale 1999:172). Among the most notable were U.S. based writers such as Audre Lorde, Jamaica Kincaid, and Michelle Cliff who negotiated spaces for Caribbean feminist discourse within the framework of international feminist criticism. Caribbean-based writers such as Lorna Goodison, Merle Hodge, Olive Senior and Erna Brodber tackled the complex issues of Caribbean patriarchy and the matrifocal tradition of West Indian societies. They had many of their stories issued in anthologies such as *Jamaica Women* (1980; 1985), *Lionhearted Gal* (1986) *From Our Yard* (1987), and *Creation Fire* (1993).

Profile: Merle Hodge - Writer and Activist

Merle Hodge was born in Trinidad in 1944. In 1962, she won the prestigious National Island Scholarship for girls, and chose to attend the University College in London. There she studied French Literature and graduated with a Bachelor of Arts degree in 1965. Two years later, she completed a Master of Philosophy degree that was based on the work of French Guyanese poet Léon Damas. While living and studying in London, she was invigorated by the burgeoning West Indian writing scene and continued her childhood practice of writing in earnest. After completing her studies, Hodge traveled to Europe Senegal and Gambia, and finally returned to Trinidad in the early 1970s. At home, she taught briefly at the secondary school level, before leaving once again to pick up a teaching position in the French Department of the University of the West Indies, in Jamaica. In 1979, she left Trinidad to be a part of the 'people's revolution' that was taking place in Grenada. There she assumed the position of consultant in the National In-Service Teacher Education Programme (NISTEP). However, this experiment came to an abrupt and unpleasant end

when Prime Minister Maurice Bishop and eight members of his cabinet were assassinated in 1983. She is also well known as an ardent advocate for women's and children's rights, and fulfills these mandates through an NGO that she founded in 1985 called 'Women Working for Social Progress'.

Hodge's written work includes both scholarly and fictional pieces, with a central focus on exploring the lives of women and children in the Caribbean. In this regard, she has contributed to the strengthening of women's voices in what was once the male-dominated realm of West Indian literature. Both her works of fiction, *Crick Crack Monkey* and *For the Life of Laetitia*' are transitional stories of young girls living in Trinidad. *Crick Crack* appeared in 1970, and tells the story of Tee, whose life is torn between the competing values of her Creole existence with her Aunt, 'Tantie' in rural Trinidad, and those of her middle-class Aunt, Beatrice who lives in the city. Through Tee's rite of passage, the reader is exposed to the deleterious effects of a colonial upbringing on a young Caribbean girl. *Laetitia* follows where *Crick Crack* left off, as we see an older girl's struggle with the changes of her first year in high school, away from home. Hodge says she is continuing the Afro-Creole tradition of 'telling story' about women.[19]

Both novels have been produced by foreign publishers and are published in several languages. *Crick Crack* is used as a literature book in the secondary school curricula. She says that the operating environment for writers is difficult, and that successive governments have not developed policies that nurture writing. She sees the need for more training in creative writing, and co-facilitates an annual workshop for writers, which is funded by a local NGO, the Cropper Foundation. Hodge says that as a writer, she tries to unlock the violence that has marred the Caribbean because 'the violence of our history has not evaporated. It is still there. It is there in the relations between adult and child, between black and white, between man and woman. It has been internalized, it has seeped down into our personal lives.' She believes that through her work she can help in the liberation of the Caribbean from 'the shadow of the whip'.

<div align="center">***</div>

Meanwhile, the Caribbean publishing industry has experienced some growth, primarily in two areas, namely, elementary and high school textbooks, and scholarly and academic works. According to Ian Randle,[20] the growth of the former is due to the establishment of CXC curricula in the region's secondary schools, precipitated by the withdrawal of many multinational publishing companies from the Caribbean beginning in the 1980s. Growth in the second area is a direct result of the development of Caribbean Studies programmes in universities and colleges in the United States. Randle believes that the interest in Caribbean literature in the US academy can be attributed to the ascension of the second generation of Caribbean academics to management positions within the university system. This situation has allowed them to influence policy in terms of course and text selection. Additionally, in an effort to connect to their roots, the third generation of Caribbean people living abroad displays an interest in Caribbean Studies while attending university and college. In this regard, the production of Caribbean scholarly work is shared disproportionately by scholars residing in the diaspora or elsewhere outside of the region. Generally, these writers find it easier to publish and distribute work because they have greater access to the global publishing industry. However, this situation is being challenged by two publishers from the region, namely, the University of West Indies Press (UWI Press) and Ian Randle Publishers (IRP). Both companies have increased their production capacity and have established distribution arrangements that would place their books in selected areas of the US academic market. However, it remains to be seen if this momentum can be maintained without an enabling book publishing policy environment.

Meanwhile, over the last two decades there has been a surge in in fictional writing from the region. In this regard, the current body of Caribbean writing generally explores a wider array of genres than its predecessor, engaging in topics as diverse as fantasy, crime, surrealism, erotica and speculative fiction. This 'new' literature while looking back to its source, is far more self-confident about its own position globally, and is generally no longer marginalised as 'Black', 'Commonwealth' or any other kind of literature that puts it at the edges, but as a fully-fledged member of the international literary circuit . The work of the second and third generation Caribbean writers is still imbued with the region's flavour and aesthetique, but unlike the older generation who had the tendency to avoid confrontation with the establishment, 'these younger exiles walk on their heels, ready for battle' (Lamming, 2005).[21]

From the previous discussion, it can be seen that the West Indian literary tradition and the publishing industry gained momentum outside of the region. In fact, during the first two phases of development the majority of West Indian writers lived outside the region, firstly in England and later on in North America. They were enticed by the lure of greater artistic freedom, the presence of a network of writers and intellectuals and more lucrative publishing opportunities. During this time, their work was primarily published by multinational UK owned publishing houses or by Black British independent companies. These books were then exported to the Caribbean. All of these factors had a great impact on the development of literature and publishing within the region. Consequently, the independent Caribbean publishing industry was started by small-scale entrepreneurs in the diaspora to support the plethora of writing – especially the more radical forms – that were being produced at the time. The present state of the publishing sector is the focus of the next section.

Current Structure of Caribbean Literary and Publishing Industry

The most recent figures from CARICOM indicate that there are approximately one thousand seven hundred and seventy-nine publishers in the Anglophone Caribbean as shown in Table Two below. They are listed in the Directory of Caribbean Publishers (DCP), 22 which provides current information on publishers registered with the Caribbean Regional ISBN agency – the institution entrusted with the administration of the ISBN system in the Caribbean. However this figure may give an enhanced picture of the operating environment since it includes occasional, personal and institutional publishers and not solely enterprises whose core business is publishing. However, what the figures do suggest is that there is an increasing interest in publishing within the region as evidenced by the eighty-five percent (85%) increase in publishers between 2006 and 2013.

Table 2: Number of Book Publishers in the Anglophone Caribbean by Country (2013)

No:	Country	No: of publishers	No:	Country	No: of publishers
1.	Jamaica	685	7.	St. Vincent	15
2.	Trinidad & Tobago	427	8.	Grenada	15
3.	Barbados	415	9.	Antigua & Barbuda	11
4.	Guyana	131	10.	St. Kitts & Nevis	11
5.	St. Lucia	42	11.	Montserrat	9
6.	Grenada	15		TOTAL	1779

Source: Directory of Caribbean Publishers – 9th Edition – Caricom Secretariat.

An examination of the directory also reveals that most entrants are recent start-up operations. According to Randle, most of these enterprises 'operate without trained staff or management below the level of owner whose financial resources do not extend beyond the ability to meet the printer's bills for the next book that is on press'.[23] Many of these businesses succumb to the realities of small Caribbean markets, poor business models and competition from the larger foreign firms and other forms of entertainment. The sector is generally devoid of critical business approaches including long-term strategic planning, market research and promotion, and human resource development. Few of the enterprises are able to obtain the necessary injection of capital due to the conservative nature of the financial institutions, as evidenced by their unwillingness to support businesses in the creative sector. Generally, creative enterprises are viewed as high risk and are regarded as *dilettante* operations by the gatekeepers in both the public and private sectors.

In spite of these challenges, the book publishing industry in the Anglophone Caribbean continues to survive in a volatile global marketplace. One of the key factors for this is the talented pool of writers that continue to emerge from the region. This gives the publishers good material to produce and market. In its relatively short foray into the publishing field, the region has developed a reputation for producing world-renowned writers in both the literary and academic spheres who are the recipients of the highest awards and accolades in their respective fields. Another advantage is that the writers and academics use English, which is growing tremendously as a world language. Currently, there is an estimated 400 million native English speakers worldwide, while the numbers of non-native speakers is steadily increasing. These numbers can convert into lucrative markets for the regional industry.

In the past decade, book publishers have sought to strengthen their position in the global marketplace by forming a regional trade association. The Caribbean Publishing Network (CAPNET) was formed in 2000 with the aims of (i.) promoting indigenous publishing in the Caribbean, (ii.) uniting publishers from all the language areas, and (iii.) increasing the profile of the industry. The organization has been an important vehicle for training, exchange of information between members, and for gaining international exposure for their projects and publications. However, CAPNET has experienced great difficulty in terms of uniting publishers across the English, Spanish and French speaking Caribbean, finding common ground to keep all of its members interested and soliciting support from the various private and public sector agencies throughout the region as is seen in a profile of the organization below.

Profile: The Caribbean Publishers Network (CAPNET)

Founded in June 2000, CAPNET was born out of a dire need to strengthen and revitalize a fledging Caribbean publishing industry. Its members recognized that although the Caribbean has produced world-renowned writers, artists and intellectuals, very few of them have used publishers from the region. Although the literary arts experienced some growth during the post independence period, this was not sustained, and by the 1990s, the sector experienced significant decline, with a number of important international publishing houses going out of business. Unfortunately, no new publishing entities emerged to replace them. As a result, by the turn of the century, book publishing was the poor relation of the media and culture industries.

CAPNET was established in this environment and is governed by the central operating principle that situates literature at the centre of the region's overall development. The organization has over seventy members that span the Spanish, French, Dutch and English speaking Caribbean. Its main goals include promoting and accelerating the rate of inter regional trade in books, increasing the

profile of the book industry, influencing state policy, encouraging the implementation of copyright protection, supporting excellence in writing and establishing a Caribbean Book Fair.

CAPNET has attracted funding from a wide range of international agencies including UNESCO, the Ford Foundation, the Prince Claus Foundation, the European Union, and The Department for International Development (DFID). With these grants, the organization has been able to accomplish some of its objectives. The main successes have been in the areas of promotion, trade facilitation and training. Since its inception, CAPNET has attended several international trade fairs (i.e. London, Frankfurt, Bogotá, Harare and Caracas) and has an active website and Facebook page. The organization has also facilitated two International Conferences on Publishing and produced joint catalogues showcasing members' products. Most importantly, CAPNET has made some headway in addressing the challenge of distribution by establishing an arrangement with one of Canada's largest book distributors.

However, the challenges have been many. A central problem has been maintaining the links between members whose operations span various language as well as cultural and physical barriers. This goal has proven to be very costly, and has unfortunately meant that membership from the French, Spanish and Dutch territories have not been sustained. Another challenge is the fact that members are at various stages of business development and therefore require different levels of support. However, scarce resources limit the organization's focus to selective activities that do not always meet the needs of all its members. This strategic problem has resulted in the falling off of interest among many of the smaller publishers. An interview[24] with one member from Trinidad and Tobago revealed that the bigger publishing concerns are better poised to benefit from CAPNET's core activities such as the attendance at international book fairs. According to Kelvin Scoon of Media Net, the bigger publishers attend book fairs *'but they promote their own work. The problem with CAPNET is that the members are in the same business and compete with themselves'*. Clearly, the need for CAPNET's membership to find a common ground to stay together is threatened by the every day expediency of surviving in a difficult and highly competitive environment.

CAPNET members also cite limited resource capacity as a major constraint to the organisation's development. The company has one staff member to co-ordinate the activities of the secretariat, but even that is for only two days a week. Meanwhile, most members operate with tight budgets and sometimes experience difficulty in paying membership fees or subsidizing other activities that are required to keep CAPNET relevant and operational. But perhaps the most instructive and consistent problem has been the lack of government support for the initiative. According to Randle (2004:4/5):

> 'CAPNET has had virtually no support from any regional institution or government ... and I cannot point to a single area where any regional organization has done anything positive to promote the development of a regional publishing industry – not CXC, not CDB, not CARICOM; not CARIBBEAN EXPORT, not CARIFORUM – to name the obvious ones'.

Therefore, it seems that ongoing malaise of the regional governments might just prove to be the most debilitating barrier to CAPNET's survival.

<p style="text-align:center">***</p>

Attempts at building the publishing industry have been hampered by several structural challenges. One of the key barriers is the size of the national and regional markets, and the lack of proper marketing strategies. For instance, a best seller in Jamaica, the most vibrant market in the region, represent sales of about 10,000 units. To break even, a publisher has to move at

least 2,500 units. These figures may seem insubstantial but according to Jamaican publisher Pamela Mordecai,[25] the national and regional markets are small, disjointed, and threatened by the decreasing buying power of Caribbean people resulting in a fragile operating environment:

> 'I think first of all it's how to access the national markets, but the national markets are small for all kinds of reasons, including the fact that books are now expensive and not many people have extra disposable income. To reach a regional market, one must discover an efficient distributor. This is not the easiest thing – we have now resumed attempting to distribute our books ourselves. The distribution equation is sometimes a bit of a bumpy ride' (Mordecai, 1994:171)

While the size of the regional book publishing market is small, there are not enough resources to obtain the necessary market intelligence. Traditionally, the biggest segment has been for academic and tertiary level books, but there is reason to believe that this market is shrinking. This trend can probably be attributed to the high costs of textbooks at the secondary and tertiary levels and the concurrent rise in illegal copying of books at commercial copy centres. Therefore, poor market intelligence continues to thwart efforts to realize the full potential of the book publishing market in the Anglophone Caribbean as seen in the profile of Lexicon Publishers based in Trinidad.

The volatility of the regional operations results in an outward search for markets. However, this strategy is also hampered by the poor intelligence about these markets and the inherent difficulties in acquiring distribution agents who are willing to work with the small publishing enterprises in the Caribbean. According to Mordecai:

> 'I think the international markets are difficult ones. I have decided that the sensible thing to do is make co-publishing arrangements. We are about to complete our first co-publishing arrangement with an Australian publishing house, and this is very important, because about 250 books in the next run we will do, of the next poet we will publish, will go to Australia. This is an increase of 250 because virtually no books go to Australia now, and very few Caribbean books actually reach Australia.' (1994:171)

Beyond these extra-regional markets, there is some evidence to suggest that markets for Caribbean literature can be found among the younger generation of Caribbean born people in the diaspora who are eager to learn more about their culture. This group is creating a demand for books from mainstream bookstores, on-line service providers such as Amazon, and on college and university campuses in the metropoli of North America and Europe. There is also some indication that beyond these markets, there is a growing demand for Caribbean cultural products, such as music and books among non-Caribbean populations in Europe, North America and South East Asia.

Regional book publishers do not generally promote their products in markets where there is a potential for growth. For example, until very recently, most publishers did not attend the more established international book fairs due to the lack of capital or insufficient knowledge of the global industry. To exacerbate matters, the region does not have its own Book Fair, which means that a key strategy for the industry's development is not being employed. It is generally felt that a dedicated Book Fair can create sustainable avenues for the promotion of products. CAPNET cites this as one of the major barriers to the growth of the industry and claims that 'this region (the English speaking Caribbean) remains the only discrete area anywhere in the world that does not host an International Book Fair'.[26]

Another critical barrier to the publishing sector is distribution. For instance, the majority of publishers handle their own distribution, a task for which most are ill prepared to do. This situation is the opposite to what obtains in the global industry, where very few publishers distribute their own

books and its associated costs. The related responsibilities of shipping and handling are tedious, extremely costly and time consuming. In terms of the mode of delivery, airfreighting is not a popular option because of the weight of books. On the other hand, shipping by sea also has problems. Caribbean publishers do not generally benefit from the lower costs of bulk sea shipping because the typical orders from retailers in export markets are never large enough to fill an entire container. The smaller cargo sizes generally cause delays,[27] which affect the timeliness of distribution in foreign markets. All of these factors put regional book publishers at a real disadvantage in the global marketplace.

Profile: Lexicon Publishers Trinidad and Tobago Limited

Lexicon Publishers is one of the more recognisable publishing imprints in Trinidad and Tobago. The business was first established in 1971 as Longman Caribbean Limited – a subsidiary of Longman UK. Its purpose at the time was to distribute Longman titles in the Caribbean region, and its major business was in educational books. By 1980, Longman UK had pulled out of the region and the company was bought over by local conglomerate, Neal & Massy Limited. Their ownership of the company also came to an end in 1994, and at that time, Ken Jaikaransingh became the majority shareholder and established Lexicon Publishers. Distribution of foreign titles was the company's core business until 2001 when it made some initial forays into the publishing arena. By 2006, Lexicon had published fourteen titles, all in the academic and scholarly market.

Mr. Jaikaransingh claims that there has been some growth in the industry since the 1990's, and attributes this in part to the vacuum that was left when many UK publishers left the region. This opportunity helped to create a cadre of indigenous professionals with expertise in ancillary areas such as graphic design. He also points to the government policy that waives all duties on the importation of books, printers, and ink as an incentive for those in the book business. The formation of national and regional trade associations has also raised the profile of the industry and has created linkages with other key sectors such as tourism, health and education. More importantly, Mr. Jaikaransingh anticipates that the activation of regional trading agreements such as the Caribbean Single Market and Economy (CSME), which promotes the free movement of labour and product, can provide a major boost to the publishing industry.

However, like most other publishing establishments in the region, Lexicon is challenged by the operating environment. The small size of national and regional markets remains a critical factor in the growth of the industry. The problem of market size is exacerbated by the lack of timely and sufficient market intelligence. For instance, Mr. Jaikaransingh reported that the results of a 2006 survey showed that academic and tertiary books accounted for only 3% of the books sold in Trinidad and Tobago during the previous year. Even though he agreed that this segment represented his core market, he could not say whether there was scope for further growth, whether the market was saturated or whether the company should turn its attention to other market segments. Return on investment was very slow in this market, and Mr. Jaikaransingh reported that he has only ever recovered his investment on one his titles.

The problem of capacity was also identified as a barrier, aided in large part by the under capitalisation of the industry. According to Jaikaransingh, publishers do not generally have the capital to invest in the latest technological advances, and private financial institutions are wary of financing entrepreneurs in the cultural industry. The lack of resources to market and distribute product also influences the type of writers that are attracted to local publishers. For example, even though the Caribbean has spawned world-renowned fictional writers, very few have signed

with indigenous publishers because of the publishers' inability to offer attractive advances, and to engage in widespread promotion and distribution of product. Distribution was identified as the most under developed component of the value chain and the area in need of the most urgent attention. Attempts at co-operative distribution arrangements are currently being explored, but the lack of trust between entrepreneurs is a major disincentive to this approach.

The absence of a National Book Policy was identified as one of the greatest challenges for the industry. Mr. Jaikaransingh felt that successive governments have lacked the necessary vision to activate the literary arts and publishing industry. He said that policy makers generally did not understand that books are cultural artifacts and a part of national heritage. He dreams of a day when more people read and when government policies actively invest in the art and people of Trinidad and Tobago.[28]

The slow acquisition of new technologies is another factor that affects the quality of books from the region. Most entrepreneurs cite the cost of new printing and design technology and the shortage of skilled personnel as the chief factors. For instance, Print on Demand technology has made very small print-runs more commercially viable, which theoretically should be a welcome operational input for the smaller Caribbean enterprises. However, the high cost of the technology has created a situation whereby very few publishers who can afford the machinery. The same scenario applies to the introduction of digital printing, ebooks, and audio books.

However, competition from foreign book publishers remains the biggest threat to the regional industry. The major publishers are able to move large numbers of books at lower costs, thereby ensuring market domination. As a result, the book market is dominated by cheaper, foreign fare. For example, the UK's English Language Book Scheme (ELBS)[29] facilitated the 'dumping' of tertiary level textbooks in the region. The Jamaican book publishers lodged an official protest with their government, citing unfair competition since the imported books under the ELBS were not taxed, while textbooks produced in Jamaica were subject to the General Consumption Tax. They eventually won their fight, but not before a rift was created between the book sellers who favoured the cheaper, foreign books to sell in their shops, and the book publishers who were at a real disadvantage from the cheap imports.[30]

Table 3 – UK Trade in Books 2012 to selected Caribbean countries

Rank	Country	2012 Exports £ sterling	2011 Exports £ sterling	% Change
43.	Trinidad & Tobago	6,694,555	4,270,625	57%
46.	Jamaica	4979,553	5,050,859	-1.4%
84.	Barbados	1,361,410	1,494,482	-8.9%
97.	St. Vincent & Grenadines	772,093	538,855	43.3%
100.	St. Lucia	609,797	428,716	42%
101.	Antigua & Barbuda	588,437	491,019	20%

Source: BIS Value of UK book exports 2009-2012, www.publishers.org.uk

Notwithstanding the case of the ELBS, there is a consistent trade deficit between the Caribbean and the UK and US markets in the areas of books and other printed matter. The region remains a prime importer of books from these regions and ranks fairly high on the list of UK book exports as shown below. For example, Trinidad and Tobago ranked forty-third in UK book exports in 2013 with trade valued at £6,694,555, while Jamaica ranked forty-sixth with exports valued at £4,979,553 as shown in Table Three. In spite of these challenges, there are several opportunities for the industry. Currently, there are no international publishing houses or groups with a presence in the Anglophone Caribbean. This situation is likely to remain unchanged in the foreseeable future because of the small size of the Caribbean market and the importance of national curricula in key areas of the textbook market. This situation can be shaped to benefit the entrepreneurs in the region. For instance, publishers in Jamaica and Trinidad and Tobago have already started to capitalize on the lucrative textbook market. A 2001 CAPNET survey reported that textbooks that were published and printed in Trinidad and Tobago accounted for close to 50 percent of all the books used in their primary school system, while UK publishers still dominated in the secondary and tertiary level textbook markets. The overall growth in Trinidad and Tobago's textbook production is forcing a widespread re-tooling of the printing sector and creating a new cadre of human resources, with positive implications for the entire publishing industry. In addition, there is growth among the firms engaged in academic, scholarly and general trade book publishing. According to CAPNET, the majority of the recently established publishing concerns in the Caribbean are in the area of general trade books including popular fiction, poetry, local history, biography and the cultural studies genres.

Several areas for joint venture arrangements are now possible, given the presence of regional trade associations such as CAPNET. For example, book publishers can come together to acquire some of the more expensive digital technologies and Print on Demand services. Initially, the small print runs that are characteristic of most Caribbean publishing houses can be pooled and produced from machines that are jointly owned by several firms operating in close proximity to each other. The challenge of international distribution can also be addressed through co-operative arrangements. For example, a joint facility can be established in Miami, which can service both regional and international markets.

Meanwhile, co-publishing and licensing partnerships with international publishers is another strategy that has been used to address the critical problem of distribution of books produced in the Caribbean. Regional publishers can enter agreements that would allow the foreign partner to publish a Caribbean book under their own imprint. In this arrangement, the foreign partner assumes the rights for their markets, leaving the Caribbean publisher free from the costly burden of international marketing, distributing and selling, while allowing him to earn royalties or a fixed return for his initial investment. The success of this arrangement assumes that the foreign partners know their own markets better than the Caribbean publisher and invest their own money, giving them a vested interest in the project's success, while absolving them of the costs for shipping books to the Caribbean.

This model has already been used by some Caribbean publishers and has reaped mixed results. The trade-offs include the lack of signage (i.e. company logo) on the product, which means that the Caribbean company does not gain name recognition in the foreign market as well as the potential loss of control over the product. This arrangement can also be reversed to accommodate foreign publishers who want their product in the Caribbean market. For example, in 2002, Ian Randle Publishers (IRP) bought the Caribbean rights to Austin Clarke's novel, *The Polished Hoe*. Clarke is

a Barbadian writer living in Canada, whose book won the Commonwealth Prize for Literature in 2003. The rights were owned by a Canadian publisher, Thomas Allen. IRP, which has better name recognition than Thomas Allen in the Caribbean market, was able to earn considerable mileage from the book's success, and sold thousands of copies without having to bear a lot of the initial production costs.

Another example involved a co-publishing and distribution arrangement between CAPNET and HB Fenn, a Canadian publisher in 2003. However, interviews with CAPNET members revealed that the deal did not yield the expected returns because the quantities of Caribbean titles were too small for HB Fenn to continue with the arrangement. In addition, the titles did not sell well in the North American market, resulting in a high number of returns to the Caribbean publishers. A personal interview with Media Net's Kelvin Scoon revealed that many of the returns came back damaged, and the Caribbean publishers were charged high fees for storage of their books. In the final analysis, Media Net saw close to 40 percent of the sales from this deal eaten up by storage and shipping costs.

Meanwhile, there have been ongoing attempts to strengthen the environment for the promotion of literature, albeit mostly at the national level. For instance, there has been an increase in the number of literary festivals throughout the region as shown in Table Four. These have provided a much-needed avenue for writers to showcase their work, network with other writers and connect with their audiences. In addition, there are book prizes that recognize the works of authors such as the newly established Burt Award that is part of the Trinidad and Tobago's Bocas Literature Festival. The Award specifically targets young writers between the ages of twelve to eighteen with prizes ranging from CAD$5,000 to $10,000 for the first three places, along with a guaranteed purchase of 2,500 books from the winner. The prize is sponsored in part by the Canadian William Burt and the Literary Foundation.

The cultural industries have been identified by many regional governments as one of the emerging sectors that can develop into engines of growth for the small-island economies of the Caribbean. The commitment of both the public and private sectors to this goal depends largely on the strength of the industry and its ability to lobby the key gatekeepers to implement the relevant policies and programmes. It is the critical issue of government support that will be the focus of the next section.

Table 4: Literary Festivals in the Anglophone Caribbean

No:	Festival	Location	Date Established
1.	International Literature Festival	Antigua & Barbuda	2006 – on hiatus
2.	Anguilla Literature Festival	Anguilla	2012
3.	Bim Literary Festival	Barbados	2012
4.	Nature Island Literature Festival	Dominica	2007
5.	Calabash Literature Festival	Jamaica	2001
6.	Kingston Book Festival	Jamaica	2011
7.	Alliouagana Book Festival	Montserrat	2009
8.	Word Alive Literary Festival	St. Lucia	2005
9.	Bocas Literature Festival	Trinidad & Tobago	2011

Source: Various

State-led Initiatives and policies

The approach of regional governments to Caribbean literary arts and the publishing industry can best be described as ad hoc. This is primarily because the connections between the creative arts and the cultural industries have never been clearly established, and therefore policy interventions have not always facilitated those linkages. For example, tax and regulatory regimes have generally not gone far enough in offering the levels of protection and incentives that are necessary to encourage growth in a developing industry such as publishing. The region represents a 'free trade' zone for books, as regional governments have not placed any taxes on their importation. For example, a Caribbean publisher can produce any number of books anywhere in the world and import them into the Caribbean, free of duty. The same rule applies for individuals, bookstores or institutions importing books into the region. However, the same treatment is not afforded book production that takes place in the region. So for instance, Caribbean publishers are made to pay taxes on incoming manuscripts, art work, paper, and printing. Even photographs that are digitally stored (i.e. on CD format) and imported are subject to General Consumption Taxes (GCT) because CDs are classified as consumer items. All of these taxes result in an average of 15 percent mark up on books produced in the Caribbean.[31] However, after a protracted lobbying effort, the Book Industry Association of Jamaica (BIAJ) succeeded in having the GCT removed from books in 2012. Even though governments have tasked entrepreneurs to keep abreast with global technological changes, they have not generally introduced the regulatory regime that would put Caribbean firms at a competitive advantage.

The emergence of the cultural industries as a new growth area has prompted the enactment of IP legislation and the establishment of supporting institutions and mechanisms. Many states have introduced modern copyright legislation to protect the industry, and a CAPNET survey reported that seventeen of the twenty-one member states had copyright legislation, while sixteen were signatories to international conventions. However, the challenge for most countries is acquiring the resources to implement and enforce these laws. As a result, the problems of copyright infringement, book piracy, and illegal duplication are still not adequately addressed. While foreign textbooks are subject to the highest levels of copyright infringement, this trend is also affecting locally published books. However, the formation of national book associations in many territories is heartening, given their commitment to advocacy on these critical issues. They have also attempted to increase dialogue between supporting institutions. For example, there have been ongoing discussions between regional trade organizations and associations like CAPNET to discuss the intersection of culture and trade issues specific to the publishing industry, with the view of informing the region's position at future WTO negotiations.

The development of talent in the production areas of publishing is also a critical factor. For example, on the job training remains the most popular form of skill acquisition, which often results in varying standards and approaches throughout the region. According to Randle (2004:6) 'no pool of skilled and experienced publishing professionals exists which means that firms are constantly engaged in training entry level or inexperienced staff which is an extremely costly exercise.'

In the main, state-led initiatives have generally had a greater focus on the development of the literary arts, in keeping with a longer regional tradition and commitment to the arts. Since the 1960s, the role of literature has been actively promoted through the promulgation of more relevant education policies, the increased accessibility to books through the expansion of libraries, and the establishment of various institutions of support for creative writing throughout the region. However, government support for book publishing still lacks for a coherent set of strategies. This

situation can be partially attributed to the fact that for a long time the Caribbean depended on either the UK based companies and their representatives in the region, or on Caribbean enterprises in the diaspora to provide publishing services. Later on, when the transnational companies left the region, discordant approaches were made to support the indigenous publishing sector. As a result, current approaches do not seem to have a clear understanding of the interdependence between the literary arts and the publishing sector as evidenced by the different levels of support that are afforded each area. This type of policy support has generally undermined the growth of both areas and resulted in their uneven development. In addition, state initiatives have not generally given ample consideration to the continued role of the Caribbean Diaspora in the future development of the two sectors, both as a potential market and as a crucial link in strengthening the creative and distribution components along the value production chain.

Conclusion

The preceding discussion has illustrated that there are some fundamental differences between the operating environments in the more established book markets of North America and Europe with those in the Anglophone Caribbean. The major divergences involve four major dynamics. The first is the small, and rather underdeveloped markets that exist in the region. This market problem when coupled with the relatively high cost of books, declining incomes and increasing competition, make the business of writing and publishing within the region an arduous endeavour. The immaturity of the publishing firms is yet another consideration. Most of the enterprises are small, undercapitalized, and employ improvised business models that generally do not incorporate human resource development, technological advances or marketing as part of their managerial practices. Finally, the role of state in facilitating an appreciation for the literary arts, and developing the publishing industry have both suffered for the lack of vision. State led interventions have generally lacked cohesion and have not shown a clear understanding of the connections between art, culture and industry. Therefore, interventions have generally focused on one sector (i.e. literature) or on one particular challenge affecting a sector (i.e. piracy) without making the necessary linkages between other sectors, institutions or public policies. All of these factors converge to create a sector that is not exploiting its full potential.

The challenge in creating a policy framework that can address all of these limitations is a complex one. As such, a critical shift in the thinking about how culture is perceived, produced and consumed must be attained if the cultural policies are to achieve any degree of success. In the main, the need to integrate art and creativity as vectors of wealth generation and well-being seems difficult to envisage or activate. Therefore, a crucial point of departure for cultural policies is the stimulation of more dialogue around the linkages between art and industry, and uncovering the ways in which these synergies can be further developed.

In terms of specific interventions, the areas of artist development, market facilitation and industrial strengthening seem to require the most urgent attention. The normal cultural industry policy tools can be applied in each area, including the provision of subsidies, public ownership of enterprises, investment incentives, tax concessions, education and training, and the provision of research and market intelligence. However, to these standard set of interventions must be added innovative strategies that specifically address the Caribbean reality. For instance, a more comprehensive policy regime can be formulated by recognizing and building on the existing strengths of the industry. The production of writers is one such area, and therefore incentives such as book prizes, scholarships, and internships can be formalized to further encourage excellence

in literature. All of the book publishers who were interviewed were unanimous in their call for national book policies, the establishment of book funds and a regional book fair.

Further, the proliferation of self-publishing in the Caribbean market can also be encouraged within the ambit of the regional thrust towards micro entrepreneurship. In this regard, the structure and operations of small independent publishers in the European and North American markets should be examined with a view to identifying their best practices, and applying the relevant lessons to the Caribbean scenario. In terms of the weaknesses, the lack of a coordinated and well-established distribution network was consistently identified as the least developed link in the value production chain. Policy and programming can encourage private sector engagement in this area, and can also promote distribution linkages with other cultural products such as music, sport and the culinary and performing arts within diasporic markets.

Meanwhile, trade associations such as CAPNET must be strengthened and revitalised to provide co-distribution services to its members. A more successful cultural policy framework can also be realized by capitalizing on the opportunities in the operating environment. The fact that the Caribbean publishing industry is in its embryonic stages can be converted into a strength, because it is uniquely placed to respond to rapid technological changes and can exploit this adaptability to gain competitive advantage in many areas including internet marketing and Print on Demand services. Governments will obviously have to work closely with industry practitioners to devise cost effective ways of acquiring the new technologies. According to Randle, being late starters mean that Caribbean publishers do not have to cast aside outdated paradigms that have governed the industry in the more established world markets. In fact, their smallness can make them more responsive to the volatility of global market conditions because they do not carry the baggage of the old technologies. It should also be noted that while the internal markets are under exploited, the small size of national economies and the pre eminence of national curricula make investment in regional publishing unattractive to foreign publishers, but signal an opportunity for regional entrepreneurs. In this regard, incentives for start-up in the areas of printing and publishing can facilitate industry growth.

The preceding discussion has shown that the Caribbean literary arts and book publishing industries have developed around a unique set of historical circumstances, and acquired the organizational structures that responded to these conditions. However, these models are now generally at odds with the new opportunities in the global creative economy. Therefore, the current challenge has to do with the ability of these sectors to re-invent themselves in ways that reflect the contemporary global Caribbean society. The role of all the major stakeholders in unearthing innovative approaches that would identify the opportunities and synergies for future growth will prove critical. It is my argument that a cultural policy regime that promotes these joined-up ways of thinking can be a very useful tool to ensure that Glissant's analysis of the Caribbean literary production 'as an effort or passion of memory' is sustained for future generations.

Notes

1. "Closed Place, Open Word" from *Poetics of Relation* by E. Glissant. Translated by Betsy Wing 1997.
2. Ian Randle "Caribbean Realities and Challenges", Paper that was delivered to the Congress of the International Publishers Association – Berlin, 21–24 June 2004.
3. Pioneer Press was a subsidiary of Jamaica's first national newspaper, The Daily Gleaner.
4. During this period, the education system in the Caribbean was still aligned to UK's. It followed the same curricula, used the same texts, and culminated in examinations from the same assessment bodies such as the University of Cambridge and London University.

5. This withdrawal was more acute in the textbook market. However, the education policies of many governments in the region at this time, called for indigenous curricula, and as such created an opportunity for many of the region's textbook publishers to expand and retool their operations.
6. A situational analysis of the sector is ongoing throughout this section.
7. David Throsby "Economics and Culture". 2001.
8. http://www.statista.com/statistics/307315/growth-of-global-book-publishing-revenue-by-platform/.
9. BRICS – Brazil, Russia, India, China and South Africa.
10. These three areas are newspaper, books and magazines.
11. Source: Association of American Publishers Annual Industry Report 2005 press release.
12. www.publishers.org.uk. Accessed June 21st 2014.
13. Ibid.
14. www.venturebeat.com 'Ebook piracy cost US publishers $3b'.
15. www.bbc.co.uk.
16. George Lamming speaking on the television series 'Bois Bande' on Gayelle TV, Trinidad and Tobago - January 13, 2005.
17. Caribbean Voices began as a programme known as 'Calling the West Indies', where West Indians serving in World War 11 (1939-45) could call home. At that time, it was produced by Jamaican writer Una Marson. Henry Swanzy took over production of "Caribbean Voices' in 1946, and provided twenty nine minutes of valuable airtime for short stories, plays, poems and literary criticism.
18. Notable contributions to this discourse include Kenneth Ramchand's 'The West Indian novel and its Background (1970).
19. Personal interview with author, January 28th, 2007.
20. Personal interview with Ian Randle on February 18th 2006, (Kingston, Jamaica).
21. Bois Bande - January 13, 2005, Gayelle TV, (Port of Spain, Trinidad and Tobago).
22. The Directory of Caribbean Publishers – 9th Edition, (2013).
23. Personal Interview with Ian Randle on February 18th 2006 (Kingston, Jamaica).
24. Personal Interview with Kelvin Scoon of Media Net on February 14 2006, (Trinidad and Tobago).
25. Interview with Holger G Ehling, 'Publishing in the Caribbean – An Interview with Pamela Mordecai'. 1994.
26. www.capnet.org.
27. Shipping companies usually wait until the containers are completely full before sailing.
28. Personal interview – 13th December 2004.
29. A programme developed by the British government as part of their Overseas Development Administration (ODA) activities. The ELBS provided subsidies for British publishers, which allowed them to produce textbooks at low prices for sale in fifty-four countries in the developing world.
30. Personal Interview with Ian Randle, February 18th, 2006 (Kingston).
31. Interview with Kelvin Scoon on February 14, 2006 - Trinidad and Tobago.

References

Bolland, O.N. 2004. 'Introduction' in *The Birth of Caribbean Civilisation – A Century of Ideas about Culture and Identity, Nation and Society.* Kingston: Ian Randle Publishers.

Caribbean Regional Negotiating Machinery – CRNM. 2004. The Creative Industries and International Trade Negotiations – An Overview of Issues. Background paper for the CRNM Workshop on The Impact of Trade and Technology on Caribbean Creative Industries. Port of Spain, Trinidad. October 28–29, 2004.

CARICOM Secretariat. 2013. *Directory of Caribbean Publishers* 9th *edition.* Georgetown, Guyana: Documentation Centre, CARICOM.

Conde, M. and T. Lonsdale. 1999. *Caribbean Women Writers – Fiction in English,* London: Macmillan, St. Martin's Press.

Glissant, E. 1997. Poetics of Relation. Michigan: University of Michigan Press.

Harney, S. 1996. *Nationalism and Identity – Culture, and the Imagination in a Caribbean Diaspora.* London and New York: Zed Books.

Hesmondhalgh, D. 2002. *The Cultural Industries.* London: Sage.

Hoenich, M. 1993. Louis Bennett: Between Subcultures. In *Alternative Cultures in the Caribbean* ed. M. Hoenich. Germany: Vervuert Verlag.

Howkins, J. 2001. The Creative Economy – How People Make Money from Ideas. London: Penguin Press.

Randle, Ian. 2004. The Impact of Trade and Technology on the Caribbean Publishing Industry. Paper delivered at the Caribbean Regional Negotiating Machinery workshop – The Impact of Trade and Technology on Caribbean Creative Industries. Port of Spain, Trinidad. October 28–29, 2004.

——. 2004. *Caribbean Realities and Challenges.* Paper delivered at the Congress of International Publishers Association Meeting. Berlin. June 21–24, 2004.

Mordecai, M. and P. Mordecai. 2001. *Culture and Customs of Jamaica.* Westport, CN: Greenwood Press.

Throsby, D. 2001. *Economics and Culture.* Cambridge: Cambridge University Press.

Development, "Culture," and the Promise of Modern Progress

Deborah A. Thomas

In thinking through the links between cultural development and economic growth, we are confronted with a constant tension: culture as a set of symbolic goods vs. culture as a "way of life." Attempts to institutionalize these links entrench us within another tension, that between cultural policy for economic development and cultural policy for social development. While the latter raises issues related to the preservation of national, regional, and local cultures as foundations for community identities, the former interrogates processes of modernization (and currently, globalization). Both directions are undergirded by a series of assumptions about the relationships between states and citizens, between leaders and "ordinary people," and between values and economic productivity. In this essay, I want to explore some of these assumptions by thinking through the ways culture becomes mobilized through policy as an instrument of governance. To do this, and to raise questions about the act of cultural policy-making more generally, I will offer a critical ethnographic reading of Jamaica's new cultural policy, "Toward Jamaica the Cultural Superstate." Ultimately, I will argue that "culture" is a tricky and potentially dangerous site upon which to hinge national development goals, even though the expansion of cultural industries may well represent a viable and potentially lucrative strategy for economic development. This is because invariably, "culture" cannot do the work policy-makers would like it to do, and its invocation within policy spheres usually already signals a kind of developmental distress, a perceived need for retooling through a form of social engineering. In other words, while "culture" (in the anthropological sense) reflects and shapes the worldviews and institutional arrangements of this (or any) society, it cannot in and of itself solve society's most pressing challenges. That is, if we understand "culture" to be the totality of what people do, and not as some sphere of life that is separate from others, then we must understand it as ever-evolving based on changing experiences and contexts.

"Soft Power" and Cultural Governance

Foucault's notions of governmentality and biopower represent a rethinking of power as a field of multiple forces. In this view, the state is a contradictory ensemble of practices and processes of governance that manage both the subjugation of populations and the elaboration of subjectivities by naturalizing the arbitrary (1991, 2003). For Foucault, governance is not only enacted in the juridical realm of law and policy, but also through the various institutions that discipline populations to have particular understandings of belonging and deviance, and in so doing, to accept the social hierarchies that shape those understandings (see also Bourdieu 1984, 1998). Like Gramsci, Foucault is interested in the cultural dimensions of power – its unmaking and remaking – but he does not see civil society as distinct from political society. In other words, where Gramsci locates counter-hegemony within the public sphere of intellectual and (to some extent) popular

Reprinted with permission from *Social and Economic Studies* 54, no. 3 (2005): 97–125.

artistic production, Foucault sees the power of the state as "capillary" (1979). For Foucault, there is no "outside," as the process of governance always shapes even the parameters of the imagination. Yet while the art of governmentality creates a particular configuration of possibilities, subjects also work within this configuration to reshape it according to their own agendas. Thus, there is a sense of dynamism in relation to socio-political fields, within which actors at various levels both reproduce and re-produce relations of power, not only institutionally but also informally.

One of the ways that states become social actors in everyday life is through the establishment of national cultural narratives. That states "have actively engaged in the production of national fantasies of communitas" (Aretzaga 2003: 396) is amply demonstrated by the plethora of anthropological and historical studies of cultural policies, and the concomitant literature on cultural politics and cultural struggles.[1] As an aspect of governance, cultural policy formulation embodies a form of social engineering because it creates blueprints for the generation of ideal citizens. Within Europe and the United States, cultural policy formulation has often been viewed as legitimating social hierarchies through metaphors of "distinction" or "taste" (Bourdieu 1984). However, within postcolonial contexts there has been a sense that cultural policy-making is a form of counter-hegemonic practice geared toward reorienting national sensibilities away from European colonial aesthetic hierarchies toward a valuation of that which is seen to be indigenously generated. This has especially been the case for states that have maintained complex political ties to empire during the post-colonial period (e.g. Puerto Rico, see Davila 1997), but is also a more general phenomenon in which newly-independent states are faced with the prospect of defining cultural difference while maintaining significant political and economic connections. From the point of view of state officials, the emphasis here is on modernization with a difference. But citizens, of course, enact their own visions of cultural modernity both through and beyond the spaces made available to them by policy-makers.

Virginia Dominguez (1992) has evocatively suggested that the whole enterprise of post-colonial cultural policy development is not, as it has generally been perceived, a counter-hegemonic act. Instead it represents a continuation of a form of European ideological hegemony that positions "culture" as a sphere of life separate from other spheres such as political organization, economic production, and technological innovation about which one might also formulate policies. This separation, she argues, is what provides the basis for the consolidation of particular class interests in and through post-colonial development projects:

> Cultural policies in [post-colonial] countries don't just describe what there is that the government, the elites, or even the nonelites seek to value; they usually prescribe a particular direction the country should take 'culturally' in order to correct for some perceived societal flaw, such as internalized oppression, technological backwardness, destructive ingroup fighting, or a lack of historical awareness (Dominguez 1992, 36).

In other words, in carving out a distinctive place for the elaboration of a cultural heritage, anti-colonial elites both cultivate a notion of cultural identity and legitimate structures of post-colonial political authority – two key dimensions of nationalist discourse that Percy Hintzen has already identified (1997). In this way, Hintzen argues, "national elites became the agents of modernity and the instruments of equality" (1997, 63) through a developmental discourse that masks post-colonial relations of power and undermines "the symbolic power of ethnic nationalism," which is essentially, in his view, a discourse of race (1997, 66).

Indeed, in Jamaica the tension between blackness and creole multiracialism has informed cultural politics from establishment of Crown Colony rule to the present. On one hand, the early

movement to cultivate a local aesthetic and promote a new vision of cultural citizenship remained wedded to British institutions and to the idea that these institutions would socialize the population within values that had, by then, been constructed as uniquely belonging to the middle classes – discipline, temperance, collective work, thrift, industry, Christian living, community uplift, and respect for the leadership of the educated middle classes. On the other hand, it gave symbolic primacy to historical events and select cultural practices deemed relevant to the majority of the population. This two-step emphasized social modernization with a difference – the cultivation of "middle-class values," "respectable" family structures, community mobilization, and political participation would facilitate Jamaica's economic growth while the population learned to publicly value those aesthetic practices which had previously been denigrated by colonial authorities.

Elsewhere, I outline the connections between broader political and economic initiatives and the development of a creole multiracial cultural nationalist project over time (Thomas 1999, 2004). Here, I will just mention that Seaga's first cultural policy in 1963 reflected an emphasis on presenting an indigenous cultural history (a "folk blackness") that was understood as constituting Jamaica's African heritage. This policy sought to increase access to participation in the arts and to provide an institutional infrastructure for the preservation and presentation of the folk music, dances, games, and foods that had come to represent Jamaica's African heritage. However, the emphasis on a folk culture did not necessarily extend to support for lower- and working-class black Jamaicans' efforts toward racial and economic justice and self-determination. While the government's legitimation of aspects of Jamaica's African cultural heritage broadened the public space in which notions of national identity could be debated, the actual process of privileging particular elements of Jamaica's African cultural heritage also marginalized alternative visions. The attempt to consolidate a nationalist state, to inculcate soon-to-be-ex-subjects with a sense of national belonging and loyalty that would naturalize new relations of authority, validated a particular kind of citizen and a specific vision of cultural "progress" and "development" that prioritized creole multi-racial integration around the model of nationalist "respectability". Thus, Seaga's 1963 cultural policy reflected an apprehension, on the part of the nationalist leadership, about conceding symbolic ground to aspects of black Jamaicans' cultural productions within a country stratified along lines of race and class. This was particularly important during the early years of independence when the government needed to mobilize the population toward accepting a particular strategy of political and economic development, and at a time when the ideologies and mobilizing strategies of other sectors of the population potentially threatened the integrity of political parties' vision of multi-racial modernization and economic growth through the implementation of industrialization programmes (Lewis 1950, 1955).

But this was not the only vision of progress available to Jamaicans at the time of independence or afterwards. Competing understandings of Jamaican identity and political struggle have been rooted in a sense of racialized (and to a degree, transnational) citizenship. Brian Meeks has conceptualized the jockeying for position between these two understandings of citizenship by noting that while leaders have tended to define social movements in relation to national or class identities, "the people have invariably redefined [them] in terms of race" (2000, 169). These conflicting positions are supported by different institutional spaces and are expressed through different cultural practices, and it is the struggle between them that has shaped both the content of development policies, and the context within which they are conceived. For these reasons, we can think of the formulation of cultural policies as constituting what Toby Miller and George Yudice have called "a privileged terrain of hegemony":

[Cultural policies] provide a means of reconciling contending cultural identities by holding up the nation as an essence that transcends particular interests. In keeping with the negotiated conflict that lies at the heart of hegemony, the cultural domain produces challenges from those sectors that the contingency of history has moved into contestatory positions (2002, 8).

Cultural policy-making, in this view, provides a space in which to devise ways to relate the past to the present, and to a more emancipated future. However, it also seeks to organize and discipline populations through suggested behaviours toward the realization of a collective national subjectivity. It mobilizes a cultural identity for the national body, but masks the ways that "identity is a source of equality and simultaneously an instrument through which social and cultural hierarchies are reinforced" (Khan 2004, 13).

Cultural Policy Studies

The emergence of cultural policy studies in the 1970s was facilitated by the global institutional framework of UNESCO, and reflected a concern with the relationships between economic and social policymaking and the elaboration of a cultural framework for development. This was especially the case for the states that became politically independent after World War II. On one hand, the funding of conferences dedicated to the formulation of cultural policies reflected a nationalist common sense that the territorial reach of states should bound some set of unique (and shared) cultural practices and visions, practices and visions that should be identified and valued (Marriott 1963). On the other hand, the 1970s flurry of cultural policy development betrays a recognition of the need to provide a kind of bulwark against the ill effects of modernizationist projects (Rostow 1960, Parsons 1951, Lipset and Bendix 1959), to protect "indigenous" aesthetic practices in the face of attempts to socialize people into an acceptance of a unilinear model of development that conceived of local cultures as "backward" but ultimately recuperable by their relocation to the categories of "heritage" or "patrimony." Cultural policy studies gained a political agenda through cultural studies (and critical anthropology), most particularly through the destabilization of the idea that cultures exist as stable knowable entities that provide the foundations for identities. Stuart Hall's oft-invoked phrase that identities are always processes of "becoming" rather than states of "being" (1990) worked to transform paradigms that viewed cultures as functionally integrated and unchanging through time.

In the contemporary period, cultural policy studies have generally been concerned with the place of cultural production within neo-liberal economic frameworks, mirroring UNESCO's 1996 shift away from viewing the state as primarily a supplier of cultural services to the public, and toward the privatization or localization of cultural services (Wise 2002). This changed context requires increased attention to issues of hegemony and difference *within* national communities, which has led scholars to investigate the diminished role of the public sector in formulating ideas about cultural "goods." For example, Javier Stanziola's (2002) analysis of how the shift toward empowering non-profit organizations in Chile has led to a more pluralistic proliferation of cultural expressions reflects a broader transition that has been occurring throughout Latin America. Where early government support for cultural development initiatives tended to take a paternalistic approach to culture that was rooted in colonial history and that therefore emphasized the creation of "high art," since the 1970s there has been a move to diversify cultural initiatives. This move broadened the scope of cultural manifestations that were now included within the realm of nationalist representations, and was itself the result of increased schooling and literacy rates, the emergence of economies of scale resulting from more diversified economic development, the introduction of information technology, and the expansion of urban growth (Stanziola 2002). Within the new context, the state

works more collaboratively with an emergent non-profit sector – and, in the case of Puerto Rico and elsewhere (Davila 1997, 2001), a private sector.

Scholars interested in cultural policy have also begun to investigate the effects of cultural institutionalization. For example, Vincent Dubois (2004) analyzes the ways French cultural policy, institutionalized in the 1970s and 1980s, led to processes of cultural specialization, professionalization, and cultural "promotion" that turned the focus in cultural development initiatives from emphasizing "everyday" culture and local democracy to a more "technical" orientation, which in turn displaced local activists who had previously been at the forefront of these activities in favour of a professional class of cultural arbiters. Institutionalization, within this context, also detached cultural mobilization from other sectors (youth, education, sports) and created new avenues for career specialization. For those who believed they could change social and political relations through cultural involvement, these transformations generated a broad sense of disillusionment.

More generally, cultural policy scholars have concerned themselves with how the context of neo-liberal globalization has transformed cultural policy formulation toward the identification of cultural products to sell (through various kinds of arrangements) in a competitive global market. This is not only the case in many Latin American contexts (Yudice 2003), or in the United States (where it is framed as urban renewal), but also in countries like South Korea, where beginning in the mid-1990s the establishment of cultural identity has been geared toward promoting "a sense of competitiveness within cultural industries in a global society" (Yim 2002, 40). During the 1960s and 1970s in South Korea, culture was positioned as a motivating factor supporting the government's priority of achieving economic growth through an export-oriented industrialization strategy. Within this context, an emphasis on "traditional" values was seen to serve economic development. During the 1980s, when the growth strategy was reaching its peak, culture and the arts were re-conceptualized as solutions to social problems, and were mobilized in order to counter the effects of intensified materialism, commercialism, individualism, hedonism, and violence – "isms" seen as resulting from an influx of Western culture. Since the mid-1990s, the rationale for Korea's cultural policy has been rooted in the exchange value of culture, and as such the government has sought to promote contemporary arts and popular culture as a means to encourage "the creativity of the people," seen as an "important element of economic development in a knowledge-based information society" (Yim 2002, 44).

In the Korean case (as well as others that I've cited here), we see a move toward diversifying the cultural *content* of what can legitimately represent the nation, toward working with civic non-profit and private institutions to promote what is understood as "cultural development," and toward finding ways to be economically competitive within the contemporary global situation. This is a process that has also occurred in Jamaica. During the late 1990s and early 2000s, for example, the Jamaican Cultural Development Commission began to move beyond an emphasis on preserving and presenting "folk culture" by co-sponsoring many of the food festivals that were popping up in areas around the country and by spearheading the return of the Independence Day street dance. Beyond the specific actions taken in particular countries, however, more general questions have emerged, questions that have to do with why attention to "culture" takes on an urgency in particular moments and not others, and with how "culture" becomes seen as useful for "development" within specific contexts. These question require that we look more closely at the ways interested links are posited between "culture" and "development," an issue to which I will return later in this essay.

Within the Anglophone Caribbean, the last two decades of economic crisis have eroded many of the previous gains in health and nutrition, literacy and education, employment and social services, gender empowerment and political stability (Barrow 1998; Dupuy 2001). Structural adjustment programmes have mandated repeated currency devaluations, which, alongside privatization drives, have resulted in a higher cost of living and an increase in poverty. Unemployment has escalated, especially among women and youth, and crime rates have skyrocketed, especially those related to drug trafficking and domestic violence. Caribbean nations, though rich in natural resources, are increasingly competing with each other, in addition to competing as a region with other regions. The key economic sectors – agriculture, mineral extraction, offshore assembly production, and tourism – are dominated by foreign firms and are dependent on external demand or foreign consumers for their services. As a result, the region is increasingly reliant upon exporting more of its work force to the United States, and at the same time it is becoming a magnet for illegal drug trafficking and money laundering (Dupuy 2001, 524-526, 529). Moreover, the shift to service- and information-based industries worldwide has increasingly encouraged female-generated labour migration at the same time that local opportunities for both women and under-educated and unskilled young men have contracted.

Since capital has become increasingly flexible and labour markets have become increasingly differentiated (within and across national borders), it has become more difficult for states throughout the Global South to provide for and socialize their citizens. As a result, many state functions have been redirected to new sites (Sassen 2000; Trouillot 2001). It has also become progressively more of a challenge for states to legislate the "cultural content" of the nation (Trouillot 2001). This represents a significant change from the nationalist period, when cultural policy emerged as part of an attempt to provide institutional spaces that would help Jamaicans move beyond Euro-centric notions of cultural value at a time when many were worried about the extent to which the "pluralities" within Anglophone Caribbean societies hindered the creation of unified nation-states. The current context raises other concerns about the proliferation of violent crimes, about the paucity of avenues for economic development, and about a reassertion of racial and national hierarchies that recall earlier imperial moments. These are the concerns that shape the context for current efforts to reposition "culture" as useful for development.

"Toward Jamaica, The Cultural Superstate"

If context is everything, then it is striking that Jamaica's new cultural policy is introduced with an epigraph, Claude McKay's "If We Must Die." This poem was written in 1919 following the explosions of urban violence against blacks in cities across the United States. The "Red Summer" of 1919 reflected white backlash to the various changes wrought by World War I, such as the massive migration of African-Americans from south to north (which increased competition for factory jobs and transformed residential neighbourhoods), the return of black veterans whose experience of discrimination in America was made more bitter by the fact that they had just returned from fighting a war that was justified in terms of freedom and democracy, and the re-establishment of the Ku Klux Klan whose violent intimidation campaign played on white rage and fear, sentiments that were stoked by popular cultural products such as the film "Birth of a Nation." To begin with "If We Must Die," then, is to draw parallels between the racial terrorism of the post-World War I period in the United States and the contemporary moment in Jamaica.

Indeed, the policy starts by outlining today's context, listing increased crime and violence, drug trafficking and Americanization as some of the urgent challenges facing Jamaicans:

Jamaica must contend with the paradoxical opportunities and threats of globalization, the penetrating cultural presence of the United States with its influence on the cultural integrity and identity of our population, and the leadership role Jamaica must play in Caribbean cultural activities (9).

The sense that Jamaica has a leadership role to play within the Caribbean is underlain by a more general and profound disillusionment with a creole nationalist project that has collapsed (Bogues 2002; Carnegie 2002; Meeks 1994; Scott 1999). Within this context, the domain of "culture" is held up as a way to get back on track, to rebuild a national community in the face of both internal and external threats. And the invocation of the term "cultural superstate," though nowhere defined in the policy, could perhaps be seen as a call to action in this regard.

The stated goals of the cultural policy are to affirm national identity and a sense of pride that is "founded in the historic courage and resilience of our people," to "foster the participation of all in national life and promote investment in national cultural development" (5), to "discover the things that make for peace and build up the modern life" (8); and to "reflect in its expression the notion of cultural excellence and international achievement that our people have established over the years" (8). The assumptions that undergird these goals are as follows: 1) Jamaica's social "chaos" is due, at least in part, to a lack of self-esteem and sense of belonging among the mass of (black) people; 2) this lack of self-esteem is due to the belittling of "things African" (and by corollary, "things Jamaican"), a belittling that is related to the persistence of colonial hierarchies of color and class as well as to contemporary global inequalities; 3) to develop self-esteem and a sense of belonging, it is necessary to engage people with events in their history and their cultural heritage with which they should identify; 4) higher self-esteem will result in greater national pride; and, 5) greater national pride will lead not only to a more productive economy, but will also strengthen people's ability to "live well together."

Culture, here, is seen as an active force, one that has the ability to transform both intimate and public domains:

> Culture must therefore be used positively to motivate community action and enrich and animate community life so that they may willingly engage in nation building. It is the only means to achieve sustainable development (24).

Yet, this concept of culture – as a sphere of action that is separate from, and therefore able to autonomously influence, other spheres – raises some critical problems. Within the policy, culture is defined as "the way of life of a people," as "the dynamic reservoir of ways of thinking and doing accumulated over time" and "the knowledge, experience, beliefs, values, customs, traditions, distinctive institutions and its ways of making meaning in life" (Ministry, 9). Here, there is an emphasis on a holistic and dynamic definition of culture as "what people do" in all spheres of life. But this is an emphasis that is difficult to sustain. The policy goes on to also argue that culture "is central to the definition of the basic unit of economic development – the individual and the human spirit – and the eventual unleashing of creative energies" (9-10). With this, we move from a generically anthropological definition of culture to an instrumental one – one, in fact, that links culture and economic development in ways that are reminiscent of mid-twentieth century modernizationist paradigms. In this way, "culture" becomes a problem to be solved, and at the same time, the basis for solutions. This is quite a lot of work for one concept to do.

In spite of a stated desire to maintain a holistic concept of culture, the new cultural policy often slips into more instrumentalist visions that maintain two rather static visions of culture. The first – culture as possession – usually manifests as commentary regarding cultural "loss" and pleads a

"return to values." This commentary positions Jamaican culture as an entity that is "under siege" by "foreign cultural influences" that are running rampant and unfettered. The second – culture as having purportedly "positive" or "negative" elements, or as UNESCO Representative Simon A. Clarke put it during the 1996 consultations in Kingston, as "either a help or a hindrance to overall development" – often maps specific cultural practices onto particular groups of people. In this way, racial, ethnic, and class antagonisms are coded through the language of culture, and are further obscured through discourses of multiculturalism. This slippage produces three tensions that provide an animating structure for the discussions of challenges and potential interventions throughout the new policy.

Culture is Dynamic v. Culture has Boundaries

This first tension underlies the assertions that there are "unique cultural manifestations and distinctive style that can be considered to be quintessentially Jamaican" (Ministry, 5), or that there is a Jamaican "cultural integrity" (9) that can be penetrated – and subsequently diluted and made inauthentic – by other ("foreign") cultures. From this vantage point, "culture" needs to be protected by the government, which, it is argued, must

> recognize, protect and promote all cultural expressions and products developed by the Jamaican people in the course of our history, including all forms of African retentions, European-based traditions, intellectual expressions and products, nation language, Rastafarianism, folklore, jerk concept, *et al*, including any form or expression notable or recognizable as Jamaican and which would be a source of national pride and identity (17).

The sense here is that Jamaican culture is quantifiable and recognizable, though the terms of this recognition are unclear. On one hand, what is recognized is a sense of heritage – "our connection to our past" (29) – which, as the "reservoir of creativity in Jamaican society" (30), is to provide inspiration for action in the present. But the framing of culture as heritage always puts us in the bind of viewing change as loss. That is, if "heritage" implies that there exists a cauldron filled with cultural practices developed in the past that we can now draw upon to confront contemporary situations, then change must mean loss. This equation evokes a kind of Herskovitsian model of culture as a quantifiable series of traits that might be retained, reinterpreted, or abandoned, rather than a more processual view of cultural transformation that instead privileges people's own creativity and responsiveness to a broader context (Gilroy's "changing same," or Mintz and Price's "underlying grammatical principles").

But "heritage" is important in the cultural policy not only because of the kinds of insights past practices may bring to bear on the present, but also because it is a potential source of income. In assessing the extent to which public and private agencies have mobilized to showcase Jamaica's heritage to a global audience (by gaining recognition, for example, as a UNESCO World Heritage Site), the policy concludes that "there have been serious inadequacies as over the last few years we have failed to capitalize on our heritage product for economic advantage" (30). With this statement, heritage becomes "product," a commodity for sale in a competitive global marketplace, and as with all products, we must then be concerned with uniqueness and quality control. This raises the issue of "authenticity," a concept that comes up in several places throughout the policy. For example, it is argued that we must "assure authenticity" in relation to "traditional knowledge bearers" (30), that within the tourism industry we must promote a "more authentic cultural expression of the Jamaican people" (38), and that when training tourist workers, we must ensure "the authenticity of our product and information" (39). Whereas in an earlier moment, claims to "cultural

authenticity" were "a crucial element in resistance to colonialism" (Khan 2004, 11), providing the tools to dismantle colonial assertions that black and brown West Indians were either culture-less or culturally inferior, these claims are now mobilized mainly within the frame of commodification. Yet defining the "authenticity" of a particular product or practice is never a neutral proposition, but involves a process of external evaluation that, as many scholars have pointed out, is always interested and always reflects a political agenda (Jackson 2005).

The tension between viewing culture as either dynamic or bounded also emerges in relation to the policy's approach to social engineering. It is argued that the cultural policy must "be concerned about the type of person we seek to shape through our culture, education and social systems" (10). The view of culture as dynamic is reflected in the statement that "we create the culture that simultaneously creates us" (10), yet a more and more bounded vision emerges as the policy outlines the need to "seek consensus on the Jamaican person that we need to create" (10). According to the policy, this person is ideally committed to national and regional development, should understand Jamaica and the region, should "assume his/her role in the unending process that is called human development" (11), should know the history of Jamaica and the Caribbean and should see him/ herself both in national and regional terms, should be multi-lingual so he or she can be "competitive in a global economy" (11), should recognize "his/her place within the cultural diversity of Jamaica and thereby promote tolerance, respect for others, and peace in communities," and should be "open to experiencing other cultures" (11).

The focus on developing particular kinds of citizens is where the policy is most explicit about its disciplinary objective. Here, the aim is to generate the sense that the state is not outside its citizens, but is imminent within each of us (Althusser 1971). This becomes more transparent if we raise the questions that haunt each of the above statements: How would a commitment to national and regional development be learned and subsequently manifested? What are the aspects of Jamaica and the region that must be understood? What is our role in the process of human development? What aspects of Jamaican and Caribbean history should be foregrounded? How do we come to find our "place" in relation to other sub-national communities, and does this necessarily breed peaceful respect? And finally, how "open" should Jamaicans be to "other cultures"? Which ones, and in what ways? None of the answers to these questions are givens, yet calling attention to the processes of naturalizing ideological positions into "common sense" also allows us to make visible how broader power dynamics shape the notions of appropriateness, "authenticity," and value that are institutionalized through the educational system and other civil society spheres.

These dynamics hide in commentary such as the argument that the cultural policy "must also reflect on the inflated, even destructive air of superiority or distorted sense of being by certain sections of our population, also as a result of slavery and colonialism" (8). To be sure, what is being quietly referenced here are the internal hierarchies of class and color that are so acutely felt by Jamaicans of all stripes, but rooting these hierarchies only in relation to historical processes of slavery and colonialism obscures the ways they are actively produced and reproduced in the present at multiple levels (locally, nationally, and internationally) and in various institutional sites.

Promoting Cultural Diversity v. Protecting Cultural Integrity

This brings me to the second of three tensions, that between the "promotion of cultural diversity as an important element of national identity" (9) and the sense that Jamaicans must be protected vis-à-vis those "foreign" cultural influences assumed to be deleterious to the cultivation of the ideal citizen delineated above. This tension is most evident in discussions about the arts and the idea of cultural loss or endangerment:

On one hand, communities benefit from contact with other cultures, receiving a kind of cultural stimulation and fertilization from this exposure and openness. On the other hand however, cultures in communities require special considerations and programmes for their development and may be endangered by the imposition or dominance of other cultures, especially those of more technologically advanced societies (10).

The policy thus suggests that there is an important equilibrium to be maintained between embracing cosmopolitanism and valuing that which is considered to be distinctly Jamaican, that there must be a way to be global on Jamaicans' own terms.

With the following statement, the policy also implicitly alludes to the global dimensions of racial prejudice and discrimination by defining those elements of Jamaican experience that should be privileged:

> While not restricting our global capacity, there is a need to foster and promote as a means of priority our Caribbean and African international identity, while mindful of the importance of all other aspects of our diverse reality (14).

A delicate balance is being performed here, a two-step that seeks to privilege the histories, cultural practices, and experiences of black Jamaicans without undoing the creole model of national cultural identity. This issue arises again in the discussion of "excellence" (the assertion that Jamaica is *likkle but tallawah*). Excellence, the policy states, is the

> reflection of the undying, unrelenting spirit of a people determined to rise from the ashes of enslavement to the prowess that was the history of their earlier civilization. It is the embodiment of that vigour and energy that fashioned the tales of protest and rebellion so notable in the pages of our history (18).

Here, "prowess" is attributed to Jamaicans' African heritage, which while unstated, is positioned as the fount not only of a history of protest and rebellion, but also of current achievements worldwide. By carefully privileging blackness in these two examples, diversity emerges within the policy as a problem in two registers – internally and internationally.

Internally, diversity is a problem of national inclusion or exclusion. The policy recognizes over and over again that Jamaica is "composed of several and varied communities, each with its own cultural characteristics" (9), and that therefore a national cultural identity must "include aspects of each community as they interact to create a common system of being, thinking and doing, and the individual's cultural identity will be based on his/her familiarity with the cultural characteristics of the community of which s/he is a part as well as in relation to the surrounding community/communities" (9). The national motto is invoked to talk about the "historical reality" of Jamaicans who were "forced to discover ways and means to live together in relative racial and cultural harmony" (16). However, the problem that is identified within the cultural policy is that the diversity of Jamaica "can only be successfully expressed if each community is afforded opportunities to promote their specific and unique identity and expression" (16), but that "over the years our formal processes have emphasized our European past far more than our African, Indian, Chinese and other heritage" (29). Appeals to creolization, therefore, have not been seen to remove the conditions that have made possible a continued marginalization of (especially) cultural practices that are seen as "African" in derivation.

This is because, as most recent work on creolization has maintained, cultural mixing does not occur in a vacuum, but is shaped by broader power dynamics (Khan 2001; Puri 2004; Sheller 2003). By emphasizing processes of rupture and creativity, and by stressing the development of a shared cultural and social repertoire that could provide the basis for a national identity, much of the

early work on creolization tended to obscure the actual conflicts that occurred and power relations that shaped these developments (Bolland 1997; Price 1998). In fact, the process of creolization has taken place *within* historical and contemporary relations of domination and subordination at local, regional, national, and global levels (Mintz 1996; Mintz and Price 1992). These dynamic relations of power have constrained the extent to which the various visions, practices, and aesthetic norms of particular groups (in the case at hand, lower-class black Jamaicans) have been represented within the creole formation at any given moment. This is implicitly referenced by the policy when it calls for the government to "foster and promote opportunities for full expression of Jamaica's vibrant grassroots culture, recognizing the contribution of this sector to the dynamic Jamaican product that we now boast" (17). Here, we see a recognition that ideologies of creole-ness have tended to obscure actually existing (racial, class, and ethnic) inequalities.

Shalini Puri extends this point in her study of the centrality of notions of hybridity in Caribbean nationalist treatises more generally. "Discourses of hybridity," she argues, "perform several functions:"

> They elaborate a syncretic New World identity, distinct from that of its 'Mother Cultures'; in doing so, they provide a basis for national and regional legitimacy. Second, they offer a way of balancing and/or displacing discourses of equality, which has led to their importance in many instances for securing bourgeois hegemony. Third, discourses of hybridity have been implicated in managing racial politics – either by promoting cultural over racial hybridity or by producing racial mixtures acceptable to the elite. For all these reasons, post-colonial nationalisms in the Caribbean have canonized nonthreatening hybridities such as those embodied at particular times by the callaloo, the creole, and the mestizo (Puri 2004, 45).

Puri suggests, however, that we might productively read hybridity discourses as manifestos, as hopeful visions of what Aisha Khan has identified as "democratic (equal) political representation, a cosmopolitan worldview, and therefore consummate modernity in a global context" (Khan 2004, 8). Indeed, this is the kind of reading that provides a basis for imagining that a cultural policy could make a difference in the ways people think about their relationships to cultural practice, to each other, and to national structures of material and ideological power.

Because there is often an unwillingness to talk about these structures in explicit terms, the power dynamic shaping both cultural expression and the formulation of cultural policy is often displaced to dynamics occurring outside the purported cultural boundaries of the nation-state. In other words, if diversity is something that must be carefully managed internally, it is all the more critical to intervene to protect Jamaican cultural integrity from what is often portrayed as a foreign (US) cultural "invasion," while at the same time acknowledging how important particular cultural "interactions" have been:

> Our cultural diversity has been enriched not only by the strong spiritual forces that have co-habited within our borders . . . but also by the constant interaction with foreign cultures over the years (16).

By privileging "interaction," the policy positions a particular sense of cultural transformation, one in which the partners in the process of cultural exchange are more or less equally positioned. From this point of view, it becomes important to call for the government "to provide and promote opportunities for Jamaicans to engage or interact with foreign cultures" (17), and to "provide for our people opportunities to experience the excellence of foreign cultural expressions through exchanges and co-production agreements both within our shores and in other parts of the world" (19).

However, this sense of interaction also feeds into a notion that cultures are bounded (that "foreign" cultures are not always already present within Jamaica), and that therefore there are

instances in which cultural interaction would be perceived as a threat. This is what leads the policy to emphasize the development of stronger links between the educational system and cultural institutions in the section on "Culture and Education." It is posited that if there were a greater "cultural component in the school's curricula" (26) and if youth learned more about Jamaican history, then Jamaicans would be empowered "to participate fully in national development" (27). Again, this places the burden of social and economic development on "culture" rather than on, say, a good land reform or job creation policy.

What is even more critical, though, is the assumption that what underlies the "upsurge in violence and anti-social behaviour" (26) about which people are justifiably concerned is a cultural *absence,* one that is "aggravated by the extensive diet of foreign influences provided to [youth] by an expanding cable market" (27). That youth are singled out as especially vulnerable is made clear in the following passage:

> This [media expansion] has serious implications for a Jamaica whose population is essentially a young one, with more than 60% of the Jamaican population comprised of persons in the 0-30 age cohort. This group represents active participation in the cultural process. They watch more television, use the internet and consume certain cultural products like popular music, and are usually confronted with a wider range of social and cultural problems (27).

These issues resurface in the "Culture, Technology, and Media" section of the policy, where it is stated that:

> One of the fundamental challenges of culture from age to age is the tension between traditional knowledge as promoted and upheld by societies and transmitted, largely through orature to the next generation as somewhat sacrosanct, and the quasi-sacrilegious embracing of new technologies by the now generation" (41).

The idea presented here is that "local cultures, especially in developing societies like Jamaica, are at risk of disappearing as the young embrace the new values and realities brought to their living room by way of these new technologies. Because of these technologies, our societies, and especially our young, are constantly bombarded by foreign influences and values" (41).

In these two areas, the policy links current "anti-social" trends in the behavioural patterns of children and youth in Jamaica directly to "worrying deficits in their social skills, personal integrity, self and national awareness," and relates these "deficits" to "declining parental care and supervision, the absence of positive role models and deficiencies in the formal and informal educational and cultural systems" (27). The argument here is that there is a direct correlation between "alternative communications media, drug abuse, teenage pregnancy, and, increasingly, to crime and violence" (27).

That all of Jamaica's most pressing social problems are here attributed to US media is striking in the degree to which it rehearses Frankfurt School critiques of the centrality of mass culture and mediation to the social reproduction of domination. Moreover, the vision that youth are somehow endangered and uncritical consumers reflects an inability to think through the ways local hierarchies of power shape the assessment that "foreign cultural influences" are solely negative. The fact that youth often symbolically occupy the contested terrain of nationalists' deferred (or even derailed) development dreams does not preclude them from elaborating their own. In other words, on one hand, current processes of globalization throughout the Caribbean have generated increased rates of violent crime, unemployment, and poverty at the same time as structural adjustment programs have reduced government expenditure on health care, education, literacy programs, and other social services thereby heightening conditions of instability for the majority of Jamaican families. On the

other hand, contemporary neo-liberal capitalist development has also created new possibilities for realizing ambition, and new opportunities for advancing new or previously marginalized ideologies and practices regarding citizenship and subjectivity.

In Jamaica, for example, youth have actively (if not intentionally) worked to transform aspects of old colonial hierarchies of race and gender, in part through their consumption and re-signification of aspects of African-American cultural production and style, and in part through a renegotiation of public representations through the space of dancehall. Indeed, many of the young people among whom I have conducted research believe that the circulation of ideas, practices, and styles between Jamaica and the United States is reciprocal, if unevenly so. Because they felt that as much as America had influenced Jamaican culture, Jamaicans also influenced culture in the United States, they tended to have a somewhat different outlook than either the older generation of middle-class professionals or the generation of working-class Jamaicans politicized by the various social movements during the 1970s. Contrary to the dominant image of the culturally bombarded and besieged Jamaican, powerless either to resist or critique that which is imposed from "elsewhere" – the image often proliferated by those who disparaged the growing influence of the United States – these youth often asserted to me that David could not only challenge Goliath, but could also influence what Goliath listened to, how he dressed, and what he liked. In other words, youth *critically engage* the full range of cultural practices and mediations with which they come into contact.

Nevertheless, the antidotes to Jamaica's various social ills that are presented in the cultural policy are to "encourage the development of programmes that reinforce the attitudes and values relevant and necessary for social cohesion and peaceful co-existence, devising as well policies and programmes to arrest the negative and dysfunctional cultural values and practices to which children and young people are increasingly and uniquely susceptible" (28), to "give direction and support to programmes that encourage children and youth to think creatively and to learn about diverse cultures in order to encourage national pride and openness to other cultures, nurture a sense of national identity and awareness and foster tolerance and respect and faith in one's own culture" (28), and to "strengthen and consolidate domestic experiences of local expression in order to reduce the impact of these foreign cultural products" (41). These formulations reproduce the idea that youth are particularly endangered, reflecting a more general problem – the inability to see their aspirations (expressed through their cultural productions and practices) as valid expressions of their understanding of their own social positions.

It is true that one of the hallmarks of the current period is that media is perhaps more central to the formation of social worlds and imaginative possibilities (Appadurai 1991). However, ethnographic research might help us to move beyond the panic that is palpable within the cultural policy by giving us a sense of how media operates within wider social fields, and allowing us to see "not only how media are embedded in people's quotidian lives but also how consumers and producers are themselves imbricated in discursive universes, political situations, economic circumstances, national settings, historical moments, and transnational flows" (Ginsburg et al. 2002). In this way, we might be more attuned to the processes of negotiation that surround media consumption, and less likely to position media as transcendently powerful.

Cultural Practices v. Cultural Goods

This last tension reflects the difficulty of reconciling an anthropological understanding of culture with a market-driven vision of cultural goods, especially in relation to what might be thought of as the "goals" of these two approaches. That there is tension between the competing notions of culture

as a commodity that can be exploited for national development within the global marketplace, and culture as uncommodifiable and central to shaping the life-dynamic is acknowledged in the policy's section on Cultural Industries and Entrepreneurship:

> One of the challenges that face culture is the tension between cultural practices or expression that form a natural base for the social and spiritual order of their community and the translation of that knowledge/expression into tools/goods/-services/products for economic power and development (32).

The pervasiveness of the market-oriented vision within the cultural policy – and particularly in the sections on Cultural Industries, Culture and Trade, and Culture and Tourism – is the result of a new move whereby capitalizing on "culture" is seen as a strategy that might replace traditional industries (seen as in a phase of decline) in mitigating the effects of globalization.

The argument presented is that Jamaica's cultural industries are potentially critical to new economic growth strategies and might, "if developed through greater and concentrated investment ...provide a real alternative to failing traditional industries" (6). The contention that *Jamaicans* should benefit from exploiting their "culture" is justified through assertions that others (such as the US recording industry) *already are:*

> It is ironic that our cultural products continue to be undervalued here at home even when they have crossed borders and established significant market niches in a large number of developed countries. Our products in music are played everywhere while many of our images, textiles, fashion, traditional knowledge and dances are the subjects of or have inspired documentaries, films, sculptures and art works in those societies (36).

The parallel to these observations lies in the policy's recognition of the dual role of the Jamaican diaspora in relation to economic development. On one hand, the policy emphasizes that Jamaicans abroad should be included in "the processes, programmes and strategies geared to nation building" (14). On the other hand, the importance of what Louise Bennett called "reverse colonization" is also acknowledged, and the government is called upon to position "our cultural products, like our people, in the global markets of the world, to national economic, social and cultural advantage" (14). Again, the idea here is that Jamaica "exports" so many people who have made significant and publicly recognized contributions to the world in the realm of sports, art, academia, and science without those contributions redounding back to Jamaica.

The policy therefore promotes a kind of FUBU ("for us, by us")[2] initiative through which Jamaican cultural products and Jamaican cultural industries would be supported and protected, even while taking advantage of new technologies and networks:

> Now there is an even greater need to ensure that more of our stories are told, and by us...Our people need to see ourselves in film and on television, hear our voices on radio networks and through all communications media, to take the message as far afield as we would, based on provisions made through the global network (21-22).

Further, the policy argues that by encouraging cultural entrepreneurship among, in particular, lower-class youth, the cultural industries might play a role "in the reduction of poverty and violence and the promotion of youth employment in Jamaica" (7, see also Kelley 1997). Yet it is difficult to see specifically how this kind of entrepreneurship might be promoted and talent channeled (beyond encouraging participation in festivals like CARIFESTA and PANAFEST).[3]

Where the policy is clearer in this regard is in its discussion of cultural tourism. Here, the policy promotes the (environmentally-sustainable) development of heritage sites, the coordination

of educational and cultural agencies in tourist areas, the marketing of "Jamaica's cultural goods and services" (40) within hotels and tourism centres, and the provision (for tourists) of "real opportunities to enjoy the people's way of life in communities, and experience the cultural traditions and expressions for which Jamaica is well known" (38). Yet two issues remain unaddressed. First, while the policy indicts the expansion of the all-inclusive sector for making it more difficult for smaller properties, restaurants, and craft vendors to stay afloat, these concerns are not addressed in the position statements. And second, international attention to Jamaica's high rates of violent crime makes its tourism industry vulnerable within a competitive region. How, within this context, will cultural tourism and cultural industries more broadly replace sugar, bauxite, bananas and coffee? FTZs and remittances? What does it mean, ultimately, to sell "culture" in a global marketplace? And what are the long-term possibilities and constraints of building an economy around this particular niche?

Conclusion

These questions bring us back to the initial concern with the purported relationships between cultural development and economic growth, and with the ways cultural citizenship is always mapped in relation to broader development goals. These are relationships that, as Michaeline Crichlow (2005) and others have pointed out, change over time as both state actors and state subjects reformulate their relationships to development initiatives. Post-independence cultural policy-making in Jamaica was geared toward *changing people's minds* about Jamaica's African heritage. This was done in order to shift ideas about relative cultural value that were institutionalized throughout the colonial period in the hopes of spurring economic development. While this project has been of critical importance, many of the people in the community where my research is based did not feel that the cultural project was sufficiently bolstered by an economic one. That is, they felt that the economic policies pursued since independence did not appreciably *change people's positions* within Jamaica's colour-class-culture nexus. Despite the various shifts within ethnic divisions of labour that arose as a result of policies pursued during the 1970s as well as later privatization initiatives, many community members felt that the lives of poorer Jamaicans remain institutionally structured in disadvantageous ways that were reminiscent of the colonial period. In this respect, valuing a cultural heritage could do little, as they didn't believe that the answer to their problems lay in plumbing the past for moral lessons.

What Alan Stanbridge's study of cultural policy in England shows us is that neither the economistic model of cultural development (promoting the economic potential of the arts) nor the paternalistic model (promoting "excellence" in artistic expression) has been successful in transforming notions of cultural *value,* despite England's official emphasis on multiculturalism (2002). These transformations, while supported by cultural and educational initiatives, must ultimately be generated through real political and economic change on a global scale. Within Jamaica's current context, then, as Crichlow argues, it should not be surprising that people seem to be "interested in agendas which aid them in seeing through the state" (2005, 226), rather than those seeking to align them directly with particular state projects and visions.

Yet the new cultural policy continues to struggle with these issues, while also attempting to identify the spaces within the global economy where Jamaican culture might find a market. Despite the various critiques I've made throughout this essay, the new policy does raise many important issues (several of which I've not discussed here, such as the importance of foregrounding environmental concerns in cultural development initiatives, and the need to strengthen copyright

and intellectual property protections). Moreover, within the current global political economy, there seem to be few alternative avenues through which economic growth might be promoted. In fact, several other countries are attempting to begin harnessing the economic potential of what they are referring to as "soft power," a sort of Gramscian understanding of the ways particular kinds of cultural products – such as Japanese children's toys, cartoons, and *animé* – shape global cultural imaginaries beyond the conventional sense of political influence (Anne Allison, personal communication).

Yet, we would do well to reposition the development of self-esteem and national pride and the prioritizing of cultural industries in economic development as separate issues. There is a hazard to invoking "culture" as a vehicle for the cultivation of pride that would then presumably give people a greater stake in national economic futures. This is because it implies that "culture" is something more profound than "what people do," something that is merely a proxy for other identities and social positions (such as race, class, nationality) that then become naturalized. This is Walter Benn Michaels' (1995) argument against the way anthropologist James Clifford supported Mashpee claims to Native American status, claims that would then afford them particular land rights as delineated by the US government. In his attempt to destabilize assertions that the Mashpee claimants no longer participated in cultural practices that were thought to be "traditionally" Mashpee and therefore were not eligible for land rights, Clifford (1988) argued that because culture is not fixed, the legitimacy of cultural identities should not be judged in relation to the cultural practices of past generations. While this argument would appear to be in line with more general anthropological critiques of essentialism, Michaels argues that instead it propagates a different kind of essentialism. For Michaels, the danger of Clifford's argument is that it roots Mashpee-ness in something that *precedes* cultural practice, thereby also fixing relationships between people beyond sociality. In other words, culture *is* flexible and fluid, but if we can then say that there is something about Mashpee-ness that is transcendent, we are invoking biology, and therefore slipping into older essentialisms that grounded racist assumptions and practice. When we imply that there are some things that are so fundamentally Jamaican that they shouldn't change, that they *can't* change, or when we assert that cultural change can be engineered to support other kinds of goals, we risk trafficking in similar assumptions. Positioning culture outside of practice, and more importantly, outside contexts of practice, forestalls a more nuanced and complex analysis of social process.

Acknowledgements

This essay has benefited from the critical commentary of several individuals including Patricia Northover, Annie Paul, Sonjah Stanley-Niaah and the anonymous readers for Social and Economic Studies. I am also indebted to Pat Northover for inviting me to present a version of this essay at the 6th Annual Conference of the Sir Arthur Lewis Institute of Social and Economic Studies, 17–18 March 2005, and to my fellow panelists Michaeline Crichlow and Pat Northover, Percy Hintzen, Sidney Bartley, discussant Sonjah Stanley-Niaah, and several students in the audience for the rigourous and thoughtful discussion that ensued.

Notes

1. The literature on national cultures and cultural politics is too vast to list here, but for review essays, see Alonso 1994; Fox 1990; Foster 1991; Glick Schiller 1997; Slocum and Thomas 2003; Yelvington 2001.
2. FUBU is an extremely popular hip hop clothing brand that was started by four young African-American men in New York City, and that uses notions of community identity and solidarity both to define itself as different from the mainstream and to sell itself as a racially-specific commodity in a global marketplace.

3. CARIFESTA is the Caribbean Festival of the Arts, first held in 1972 in Georgetown, Guyana, and is designed to showcase the creative and artistic skills of the member countries of CARICOM, as well as the wider Caribbean and its diasporas. PANAFEST is a biennial festival of arts and culture that is held in Guyana that is designed to promote Pan-Africanism.

References

Alonso, Ana Maria (1994). "The Politics of Space, Time, and Substance: State Formation, Nationalism, and Ethnicity." *Annual Review of Anthropology* v. 23: 379–405.

Althusser, Louis (1972). "Ideology and Ideological State Apparatus," In *Lenin and Philosophy and Other Essays,* London: New Left Books.

Appadurai, Arjun (1991). "Global Ethnoscapes: Notes and Queries for a Transnational Anthropology," In *Recapturing Anthropology: Working in the Present,* Ed. Richard Fox, pp. 191–210, Santa Fe: School of American Research.

Aretxaga, Begoña (2003). "Maddening States." *Annual Review of Anthropology* v. 32:393–410.

Barrow, Christine (1998). "Introduction and Overview: Caribbean Gender Ideologies." In *Caribbean Portraits: Essays on Gender Ideologies and Identities,* Ed. Christine Barrow, pp. xi–xxxviii. Kingston: Ian Randle Press.

Bogues, Anthony (2002). "Politics, Nation, and PostColony: Caribbean Inflections." *Small Axe* v. 6(1): 1–30.

Bolland, O. Nigel (1997). *Struggles for Freedom: Essays on Slavery, Colonialism and Culture in the Caribbean and Central America,* Kingston: Ian Randle Press.

Bourdieu, Pierre (1984). *Distinction: A Social Critique of the Judgment of Taste,* Cambridge: Harvard University Press.

Bourdieu, Pierre (1998). *Practical Reason: On the Theory of Action,* Stanford: Stanford University Press.

Carnegie, Charles (2002). *Postnationalism Prefigured: Caribbean Borderlands,* New Brunswick: Rutgers University Press.

Clifford, James (1988). *The Predicament of Culture: Twentieth Century Ethnography, Literature, and Art,* Cambridge: Harvard University Press.

Crichlow, Michaeline (2005). *Negotiating Caribbean Freedom: Peasants and the State in Development,* New York: Lexington Books.

Davila, Arlene (1997). *Sponsored Identities: Cultural Politics in Puerto Rico,* Philadelphia: Temple University Press.

Davila, Arlene (2001). *Latinos, Inc.: The Marketing and Making of a People,* Berkeley: University of California Press.

Dominguez, Virginia (1992). "Invoking Culture: the Messy Side of 'Cultural Politics.'" *South Atlantic Quarterly* v. 91(1); 19–42.

Dubois, Vincent (2004). "The Dilemmas of Institutionalisation: From Cultural Mobilisation to Cultural Policies in a French Suburban Town (Bron, 1970–1006)." *International Journal of Cultural Policy* v. 10(3): 331–349.

Dupuy, Alex (2001). "The New World Order, Globalization, and Caribbean Politics." In *New Caribbean Thought: A Reader,* Eds. Brian Meeks and Folke Lindahl, pp. 521–536. Mona: University of the West Indies Press.

Foster, Robert (1991). "Making National Cultures in the Global Ecumene." *Annual Review of Anthropology* v. 20: 235–260.

Foucault, Michel (1979). *Discipline and Punish: The Birth of the Prison,* New York: Vintage Books.

Foucault, Michel (1991). "Governmentality," In *The Foucault Effect: Studies in Governmentality,* Eds. Graham Burchell, Colin Gordon, and Peter Miller, pp. 87–104, London: Harvester/Wheatsheaf.

Foucault, Michel (2003). *Society Must Be Defended: Lectures at the Collège de France, 1975-1976,* Eds. Mauro Bertani and Alenssandro Fontana, Trains. David Macey, New York: Picador.

Fox, Richard, ed. (1990). *Nationalist Ideologies and the Production of National Cultures,* Washington DC: American Anthropological Association.

Ginsburg, Faye, Lila Abu-Lughod, and Brian Larkin (2002). "Introduction," In *Media Worlds: Anthropology on New Terrain,* pp. 1–36, Berkeley: University of California Press.

Glick Schiller, Nina (1997). "Cultural Politics and the Politics of Culture." *Identities* v. 4(1): 1–7.

Hall, Stuart (1990). "Cultural Identity and Diaspora," In *Identity, Community and Culture,* Ed. J. Rutherford. New York: Lawrence and Wishart.

Hintzen, Percy (1997). "Reproducing Domination Identity and Legitimacy Constructs in the West Indies." *Social Identities* v. 3(1): 42–75.

Jackson, John L. (2005). *Real Black: Adventures in Racial Sincerity,* Chicago: University of Chicago Press.

Kelley, Robin D.G. (1997). "Looking to Get Paid: How Some Black Youth Put Culture to Work," In *Yo' Mama's Dysfunktional: Fighting the Culture Wars in Urban America,* pp. 43–77, Boston: Beacon.

Khan, Aisha (2001). "Journey to the Center of the Earth: The Caribbean as Master Symbol." *Cultural Anthropology* v. 16(3): 271–302.

Khan, Aisha (2004). *Callaloo Nation: Metaphors of Race and Religious Identity Among South Asians in Trinidad.* Durham: Duke University Press.

Lewis, W. Arthur (1950). *The Industrialization of the British West Indies,* Barbados: Government Print Office.

Lewis, W. Arthur (1955). *The Theory of Economic Growth,* Homewood, IL: R.D. Irwin.

Lipset, Seymour and Reinhard Bendix (1959). *Social Mobility in Industrial Society,* Berkeley: University of California Press.

Marriott, McKim (1963). "Cultural Policy in the New States," In *Old Societies and New States: The Quest for Modernity in Asia and Africa,* Ed. Clifford Geertz, pp. 27–56, Glencoe, IL: Free Press.

Meeks, Brian (1994). "The Political Moment in Jamaica: the Dimensions of Hegemonic Dissolution," In *Radical Caribbean: From Black Power to Abu Bakr,* pp. 123–143, Mona: The University Press of the West Indies.

Michaels, Walter Benn (1995). *Our America: Nativism, Modernism, and Pluralism,* Durham: Duke University Press.

Miller, Toby and George Yudice (2002). *Cultural Policy,* Thousand Oaks, CA: Sage Publications.

Ministry of Education, Youth, and Culture (2003). *Towards Jamaica the Cultural Superstate: The National Cultural Policy of Jamaica,* Kingston: Division of Culture.

Mintz, Sidney (1996). "Enduring Substances, Trying Theories: The Caribbean Region as Oikoumene." *Journal of the Royal Anthropological Institute* v. 2(2).

Mintz, Sidney and Richard Price (1992). *The Birth of African-American Culture: An Anthropological Perspective,* Boston: Beacon.

Parsons, Talcott (1951). *The Social System,* Glencoe, IL: Free Press.

Price, Richard (1998). *The Convict and the Colonel: A Story of Colonialism and Resistance in the Caribbean,* Boston: Beacon.

Puri, Shalini (2004). *The Caribbean Postcolonial: Social Equality, Post-Nationalism, and Cultural Hybridity,* New York: Palgrave.

Rostow, Walt (1960). *The Stages of Economic Growth: A Non-Communist Manifesto,* Cambridge: Cambridge University Press.

Sassen, Saskia (2000). *Globalization and Its Discontents: Essays on the New Mobility of People and Money.* New York: The New Press.

Scott, David (1999). *Refashioning Futures: Criticism after Postcoloniality.* Princeton: Princeton University Press.

Sheller, Mimi (2003). *Consuming the Caribbean: From Arawaks to Zombies.* New York: Routledge.

Slocum, Karla and Deborah A. Thomas (2003). "Rethinking Global and Area Studies: Insights from Caribbeanist Anthropology." *American Anthropologist* v. 105 (3): 553–565.

Stanbridge, Alan (2002). "Detour or Dead End? Contemporary Cultural Theory and the Search for New Cultural Policy Models." *International Journal of Cultural Policy* v. 8 (2): 121–134.

Stanziola, Javier (2002). "Neo-Liberalism and Cultural Policies in Latin America: The Case of Chile." *International Journal of Cultural Policy* v. 8 (1): 21–35.

Trouillot, Michel-Rolph (2001). "The Anthropology of the State in the Age of Globalization." *Current Anthropology* 42(1): 125–138.

Wise, Patricia (2002). "Cultural Policy and Multiplicities." *International Journal of Cultural Policy* v. 8(2):221–231.

Yelvington, Kevin (2001). "The Anthropology of Afro-Latin America and the Caribbean: Diasporic Dimensions." *Annual Review of Anthropology* v. 30: 227–260.

Yim, Haksoon (2002). "Cultural Identity and Cultural Policy in South Korea." *International Journal of Cultural Policy* v. 8(1): 37–48.

Yudice, George (2003). *The Expediency of Culture: Uses of Culture in the Global Era,* Durham: Duke University Press.

References

Further Readings: Framing the Caribbean Popular

Beckles, Hilary. 1998. *The Development of West Indies Cricket Volume 1: The Age of Nationalism.* Mona, Jamaica: University of the West Indies Press.

Browne, Kevin Adonis. 2013. *Tropic Tendencies: Rhetoric, Popular Culture, and the Anglophone Caribbean.* Pittsburgh: University of Pittsburgh Press.

Burton, Richard D.E. 1997. *Afro-Creole: Power, Opposition and Play in the Caribbean.* Ithaca and London: Cornel University Press.

Edmonson, Belinda, ed. 1999. *Caribbean Romances: The Politics of Regional Representation.* Charlottesville & London: University of Virgina Press.

Edwards, Nadi, ed. "The Popular". Special issue of *Small Axe* 9 (2001).

Hall, Stuart. 1981. "Notes on Deconstructing the Popular," In Raphael Samuel ed., *People's History and Socialist Theory.* London: Routledge, 227-240.

———. 1992. What is Black in Black Popular Culture? *Black Popular Culture: A Project by Michele Wallace.* Edited by Gina Dent, 21–33. Seattle: Bay Press.

Ho, Christine, & Nurse, Keith. 2005. Eds. *Globalisation, Diaspora and Caribbean Popular Culture.* Kingston, Jamaica: Ian Randle Publishers.

James, C. L. R. 1963. *Beyond a Boundary.* London: Hutchinson, 1963.

Lent, John., ed. 1990. *Caribbean Popular Culture.* Ohio: Bowling Green State University Popular Press.

Meeks, Brian., ed. 2007. *Culture, Politics, Race and Diaspora: The Thought of Stuart Hall.* Kingston, Jamaica: Ian Randle Publishers.

Morley, David and Kuan-Hsing Chen eds. 2006. *Stuart Hall: Critical Dialogues in Cultural Studies.* London & New York: Routledge.

Nettleford, Rex. 1992. *Inward Stretch, Outward Reach: A Voice form the Caribbean.* London: Macmillan.

Paul, Annie. ed. 2007. *Caribbean Culture: Soundings on Kamau Brathwaite.* Mona, Jamaica: University of the West Indies Press.

Puri, Shalini. 2003. "Beyond Resistance: notes toward a new Caribbean Cultural Studies." *Small Axe* 7, 2: 23-38.

Scher, Philip W. 2009. *Perspectives on the Caribbean: a reader in Culture, History, and Representation.* Blackwell.

Sheller, Mimi. 2003. *Consuming the Caribbean: from Arawaks to Zombies.* London: Routledge,

Shepherd, Verene A. And Glen L. Richards eds. 2002. *Questioning Creole: Creolisation Discourses in Caribbean Culture.* Kingston, Jamaica: Ian Randle Publishers.

Taylor, Patrick. 1989. *The Narrative of Liberation: Perspectives on Afro-Caribbean Literature, Popular Culture, and Politics.* Ithaca, New York: Cornell University Press.

Walmsley, Anne. 1992. *The Caribbean Artists Movement 1966-1972: A Literary and Cultural History.* London: New Beacon Books.

Wynter, Sylvia. 1992. "Rethinking "Aesthetics": Notes Towards a Deciphering Practice," in *Ex-Iles: Essays on Caribbean Cinema* edited by Mbye B. Cham. Trenton, NJ: Africa World Press, 237-279.

Further Readings: Language and Orality

Abrahams, Roger. 1983. *The Man-of-Words in the West Indies: Performance and the Emergence of Creole Culture.* Baltimore: John Hopkins University Press.

Balutansky, Kathleen and Marie-Agnès Sourieau, eds. 1998. *Caribbean Creolization: Reflections on the Cultural Dynamics of Language, Literature, and Identity*. Mona, Jamaica: University of the West Indies Press.

Bernabé, Jean, Patrick Chamoiseau, Raphael Confiant. 1990. "In Praise of Creoleness." Translated by Mohamed B. Taleb Khyar. *Callaloo* 13: 886-909.

Brathwaite, Kamau. 1984. *History of the Voice: The Development of Nation Language in Anglophone Caribbean Poetry*. London: New Beacon Books.

Brown, Stewart, Mervyn Morris and Gordon Rohlehr eds. 1989. *Voiceprint: An Anthology of Oral and related Poetry from the Caribbean*. San Juan, Trinidad: Longman Caribbean.

Bucknor, Michael. 2011. "Dub Poetry as a Postmodern Art Form." In *The Routledge Companion to Anglophone Caribbean Literature*. Edited by Michael A. Bucknor and Alison Donnell. London and New York: Routledge, 255-64.

Chamberlin, J. Edward. 1993. *Come Back to Me My Language: Poetry and the West Indies*. Kingston, Jamaica: Ian Randle Publishers.

Cooper, Carolyn. 1995. *Noises in the Blood: Orality, Gender, and the Vulgar Body of Jamaican Popular Culture*. Durham and London: Duke University Press.

Devonish, Hubert. 1986. *Language and Liberation: Creole Language Politics in the Caribbean*. London: Karia,.

Glaser, Marlies and Marion Pausch. 1994. *Caribbean Writers: Between Orality and Writing*. Atlanta, GA: Rodopi.

Glissant, Edouard. 1989. *Caribbean Discourse: Selected Essays*. Translated by Michael Dash. Charlottesville, Virginia: University of Virginia Press.

Habekost, Christian. 1993. *Verbal Riddim: The Politics and Aesthetics of Afro-Caribbean Dub-Poetry*. Amsterdam: Rodopi.

Morris, Mervyn. 1999. *Is English We Speaking and Other Essays*. Kingston: Ian Randle Publishers.

Narain, Denise D. 2002. *Contemporary Caribbean Women's Poetry: Making Style*. London: Routledge.

Pollard, Velma. 2000. *Dread Talk: The Language of Rastafari*. Kingston: Canoe Press.

Roberts, Peter. 1997 *From Oral to Literate Culture: Colonial Experience in the English West Indies*. Kingston, Jamaica: University Press of the West Indies.

Roberts, Peter. 2007. *West Indians and their Language*. Cambridge University Press.

Rohlehr, Gordon. 1992. "West Indian Poetry: Some Problems of Assessment." In *My Strangled City and Other Essays*. Port-of-Spain, Trinidad: Longman.

Simmons-McDonald, Hazel and Ian Robertson eds., 2006. *Exploring the Boundaries of Caribbean Creole Languages*. Jamaica: University of the West Indies Press.

Warner, Keith Q. 1983. *The Trinidad Calypso: A Study of the Calypso As Oral Literature*. London: Heinemann.

Further Readings: The Caribbean Sacred Arts

Arturo, Lindsay, ed. 1996. *Santeria Aesthetics in Contemporary Latin American Art*. Washington DC: Smithsonian Institution Press.

Bellegarde-Smith, Patrick, ed. 2005. *Fragments of Bone: Neo-African Religions in a New World*. Urbana and Chicago: University of Illinois Press.

Bellegarde-Smith, Patrick and Claudine Michel, eds. 2006. *Vodou in Haitian Life and Culture: Invisible Powers*. New York and England: Palgrave Macmillan.

Bettelheim, Judith. 2005. "Caribbean Espiritismo (Spiritist) Altars: The Indian and the Congo." *The Art Bulletin* 87, 2:312-330.

Brown, David H. 1999. *Santeria Enthroned: Art, Ritual, and Innovation in an Afro-Cuban Religion*. Chicago: University of Chicago Press.

——. 2003. *The Light Inside: Abakuá Society Arts and Cuban Cultural History*. Washington: Smithsonian.

Brown, Karen McCarthy. 1995. *Tracing the Spirit: Ethnographic essays in Haitian Art*. Devenport, Iowa: Davenport museum of Art.

Cabrera, Lydia. 1975. *Anaforuana: ritual y símbolos de la iniciación en la Sociedad Secreta Abakuá*. Madrid: Ediciones R.

Cosentino, Donald J. 1995. *Sacred Arts of Haitian Vodou*. University of California, Los Angeles: Fowler Museum of Cultural History.

Daniel, Yvonne. 2005. *Dancing Wisdom: Embodied Knowledge in Haitian Vodou, Cuban Yoruba, and Bahian Candomblé.*. Urbana & Chicago: University of Illinois Press.

De Jong, Nanette. 2012. *Tambú: Curaçao's African-Caribbean Ritual and the Politics of Memory.* Bloomington: Indiana University Press.

Fernández Olmos, Margarite and LizabethParavisini-Gebert. 2011. *Creole Religions of the Caribbean: An Introduction from Vodou and Santeria to Obeah and Espiritismo, 2nd Ed.* New York and London: New York University Press.

———. eds. 2001. *Healing Cultures: Art and Religion as Curative Practices in the Caribbean and Its Diaspora.* New York: Palgrave-St Martin's Press.

Fleurant, Gerdès. 1996. *Dancing Spirits: Rhythms and Rituals of Haitian Vodun, the Rada Rite.* Connecticut and London· Greenwood Press.

Flores-Peña, Yasmur and Robert J. Evanchuk. 1994. *Santería Garments and Altars: Speaking Without a Voice.* Jackson: University of Mississippi.

Hagerdorn, Katherine. 2001. *Divine Utterances: The Performance of Afro-Cuban Santeria.* Washington D.C.: Smithsonian Institution Press.

Houk, James T. 1995. *Spirits, Blood and Drums: The Orisha Religion in Trinidad.* Philadelphia: Temple University Press.

Johnson, Christopher Paul. 2007. *Diaspora Conversions: Black Carib Religion and the Recovery of Africa.* Berkley and LA: University of California Press.

Korom, Frankl J. 2002. *Hosay Trinidad: Muharram Performances in an Indo-Caribbean Diaspora.* Philadelphia: University of Pennsylvania Press.

Martínez-Ruiz, Bárbaro. 2012. *Kongo Graphic Writings and Other Narratives of the Sign.* Philadelphia: Temple University Press.

Ramsey, Kate. *The Spirits and the Law: Vodou and Power in Haiti.* Chicago and London: University of Chicago Press, 2011.

Roach, Joseph R. 1996. *Cities of the Dead: Circum-Atlantic Performance.* New York: Columbia University Press.

Thompson, Robert Farris and Joseph Cornet. 1981. *The Four Moments of the Sun: Kongo Art in Two Worlds.* Washington: National Gallery of Art.

Thompson, Robert Farris. 1983. *Flash of the Spirit: African and Afro-American Art and Philosophy.* New York: Random House.

———. (1993). *Face of the Gods: Art and Altars of Africa and the African*

Further Readings: Visuality and the Caribbean Imaginary

Bailey, David A., Alissandra Cummins, Axel Lapp and Allison Thompson, eds. 2012. *Curating in the Caribbean.* Berlin: The Green Box.

Barringer, Timothy, Gillian Forrester and Barbaro Martinez-Ruiz. 2007. *Art and Emancipation in Jamaica: Isaac Mendes Belisario and His Worlds.* New Haven: Yale Center for British Art.

Camnitzer, Luis. 1994. *New Art of Cuba.* Austin: University of Texas Press.

Cham, Mbye, ed. 1992. *Ex-Iles: Essays on Caribbean Cinema.* New Jersey: African World Press.

Cosentino, Donald J. ed. 2012. *In Extremis: Death and Life in 21st Century Haitian Art.* University of California, Los Angeles: Fowler Museum of Cultural History.

Cozier, Christopher and Annie Paul eds. 1999. "Debating the Contemporary in Caribbean Art" Special Issue of *Small Axe* 6.

Cozier, Christopher and Tatiana Flores ed. 2011. *Wrestling with the Image: Caribbean Interventions.* The World Bank Art Program.

Cullen, Deborah and Elvis Fuentes. eds. 2012. *Caribbean: Art at the Crossroads of the World.* New York and New Haven: Yale University Press.

Cummins, Alissandra, Kevin Farmer and Roslyn Russell, eds. 2013. *Plantation to Nation: Caribbean Museums and National Identity.* Illinois: Common Ground Publishing LLC.

Farquharson, Alex and Leah Gordon, eds. 2012. *Kafou: Haiti, Art and Vodou.* Nottingham,United Kingdom: Nottingham Contemporary.

Hezekiah, Gabrielle A. 2010. *Phenomenology's Material Presence: Video, Vision and Experience.* Bristol and Chicago: Intellect Ltd.

Lewis, Samella S. ed. 1995. *Caribbean Visions: Contemporary Painting and Sculpture.* Art Services Intl.

Martinez, Juan A. 1994. *Cuban Art and National Identity: The Vanguardia Painters, 1927-1950.* United States: University Press of Florida.

Mohammed, Patricia. 2010. *Imaging the Caribbean: Culture and Visual Translation.* New York and England: Palgrave Macmillan.

Mosaka, Tumelo, ed. 2007. *Infinite Island: Contemporary Caribbean Art.* New York: Brooklyn Museum.

Mosquera, Gerardo ed. 1996. *Beyond the Fantastic: Contemporary Art Criticism from Latin America.* The MIT Press.

Paul, Annie and Krista Thompson eds. 2004. "Caribbean Locales and Global Artworlds." Special issue of *Small Axe* 16.

Poupeye, Veerle. 1998. *Caribbean Art.* London: Thames and Hudson.

Poupeye, Veerle, David Boxer and David Randle. 1998. *Modern Jamaican Art.* Kingston, Jamaica:Ian Randle Publishers.

Thompson, Krista. 2006. *An Eye For the Tropics: Tourism, Photography and Framing the Caribbean Picturesque.* Durham, NC: Duke University Press.

——. 2015. *Shine: The Visual Economy of Light in African Diasporic Aesthetic Practice.* Durham, NC: Duke University Press.

Walmsley, Anne and Stanley Greaves. 2010. *Art in the Caribbean: an Introduction.* London: New Beacon Books Ltd.

Walmsley, Anne. *The Caribbean Artists Movement 1966-1972: A Literary and Cultural History.* London: New Beacon Books Ltd, 1992.

Wainwright, L. 2011. *Timed Out: Art and the Transnational Caribbean.* Manchester: Manchester University Press.

Warner, Keith Q. 2000. *On Location: Cinema and Film in the Anglophone Caribbean.* London: Macmillan Education Ltd.

Yung-Hing, Renée-Paule ed. 2012. *L'Art Contemporain de la Caraibe: Mythes, Croyances, Religions et Imaginaires.* Paris: HC Editions et Fort de France: Conseil régional de la Martinique.

Further Readings: Caribbean Masqurade and Festival Politics

Aching, Gerard. 2002. *Masking and Power: Carnival and Popular Culture in the Caribbean.* Minneapolis and London: University of Minnesota Press.

Bettelheim, Judith, ed. 1993. *Cuban Festivals: An Illustrated Anthology.* New York and London: Garland Publishing, Inc.

Cowley, John. 1996. *Carnival, Canboulay and Calypso: Traditions in the Making.* Cambridge and New York: Cambridge University Press.

Craton, Michael. 1995. "Decoding Pitchy Patchy: The Roots, Branches and Essence of Junkanoo." *Slavery and Abolition,* Vol. 16(1): 14-44.

Ferguson, Arlene Nash. 2000. *I Come To Get Me!: An Inside look at the Junkanoo Festival.* Bahamas: Doongalik Studios.

Garth L. Green and Philip W. Scher, eds. 2007. *Trinidad Carnival: The Cultural Politics of a Transnational Festival.* Bloomington: Indiana University Press.

Henry, Jeff. 2008. *Under The Mas': Resistance and Rebellion in the Trinidad Masquerade.* Trinidad: Lexicon Trinidad Limited.

Hill, Errol. 1997. *The Trinidad Carnival: Mandate for a National Theatre.* London: New Beacon Books Limited.

Koningsbruggen, Peter van. 1997. *Trinidad Carnival: A Quest for National Identity.* London and Basingstoke: Macmillan Education Ltd.

Liverpool, Hollis. 2001. *Rituals of Power and Rebellion: The Carnival Tradition in Trinidad and Tobago – 1763-1962.* Chicago, Jamaican and London: Research Associates School Times Publications/ Frontline Distribution International Incorporated.

Mansingh, Ajai and Laxmi Mansingh. 1995. "Hosay and its Creolization." *Caribbean Quarterly,* Vol 41(1): 25-39.

Marie-Jeanne, Alfred, ed. 2007. *Le Carnaval: Sources, Tradition, Modernité.* Fort de France: Les Cahiers du Patrimoine – Conseil Régional de Martinique. Musee Regional d'Historie et d'Ethnographie de la Martinique, Numéro Double 23 & 24.

Mason, Peter. 1998. *Bacchanal!: The Carnival Culture of Trinidad*. Philadelphia: Temple University Press.

McAlister, Elizabeth. 2002. *Rara!: Vodou, Power, and Performance in Haiti and Its Diaspora*. Berkeley, Los Angeles and London: University of California Press.

Miller, Rebecca S. 2007. *String Band Serenade: Performing Identity in the Eastern Caribbean*. Middletown, Ct: Wesleyan University Press.

Nicholls, Robert Wyndham. 2012. *The Jumbies Playing Ground: Old World Influences on Afro-Creole Masquerades in the Eastern Caribbean*. Jackson: University Press of Mississippi.

Nunley, John and Judith Bettelheim. 1998. *Caribbean Festival Arts: Each and Every Bit of Difference*. Seattle and St. Louis: University of Washington Press.

Nurse, Keith. "Globalization and Trinidad Carnival: Diaspora, Hybridity and Identity in Global Culture". *Cultural Studies* 13(4): 661-690.

Norton, Noel. 1990. *Noel Norton's 20 Years of Trinidad Carnival*. Trinidad: Trinidad and Tobago Insurance Limited.

Palacio, Joseph. 2005. "Music Behind the Mask: Men, Social Commentary and Identity in Wanaragua." In *The Garifuna: A Nation Across Borders*, Joseph Palacio, ed., 196-229. Cubola

Riggio, Milla Cozart, ed. 2004. *Carnival: Culture in Action – The Trinidad Experience*. New York and London: Routledge.

Rohlehr, Gordon. 1990. *Calypso & Society in Pre-independence Trinidad*. Port of Spain, Trinidad: Gordon Rohlehr.

Smart, Ian Isidore and Koren Allyson Bedeau, eds. 2010. *Decoding Bachanal: Pan-African Festival*. Washington: Original World Press.

Smart, Ian Isidore and Kimani S.K.Nehusi, eds. 2000. *Ah Come Back Home: Perspectives on the Trinidad and Tobago Carnival*. Washington, D.C. and Port-of-Spain: Original World Press.

Wynter, Sylvia. 1970. Jonkonnu in Jamaica. *Jamaica Journal* 4(2):34-48.

Further Readings: Music and Consciousness

Austerlitz, Paul. 1997. *Merengue: Dominican Music and Dominican Identity*. Philadelphia: Temple University Press.

Averill, Gage. 1997. *A Day for the Hunter, A Day for the Prey: Popular Music and Power in Haiti*. Chicago: University of Chicago Press.

Béhague, Gerard H. 1994. *Music and Black Ethnicity: The Caribbean and South America*. New Brunswick: Transaction Publishers.

Berrian, Brenda. 2000. *Awakening Spaces: French Caribbean Popular Songs, Music, and Culture*. Chicago: University of Chicago Press.

Best, Curwen. 2004. *Culture @the Edge: Tracking Caribbean Popular Music*. Kingston: University of the West Indies Press.

Bilby, Kenneth. 1999. "Roots Explosion: Indigenization and Cosmopolitanism in Contemporary Surinamese Popular Music." *Ethnomusicology*, Vol. 43(2): 256-296.

Carpentier, Alejo. *Music in Cuba*. 2001. Translated by Alan West-Durán, edited with an introduction by Timothy Brennan. Minneapolis: University of Minnesota Press.

Cooper, Carolyn. 2004. *Sound Clash: Jamaican Dancehall Culture at Large*. NY: Palgrave Macmillan

Dudley, Shannon. 2004. *Carnival Music in Trinidad: Experiencing Music, Expressing Culture*. Oxford & NY: Oxford University Press.

Flores, Juan. 2000. *From Bomba to Hip-Hop: Puerto Rican Culture and Latino Identity*. New York: Columbia University Press.

Fulani, Ifeona. 2012. *Archipelagos of Sound: Transnational Caribbeanities, Women and Music*. Kingston: University of the West Indies Press.

Giovenetti, Jorge L. 2001. *Sonidos de condena: sociabilidad, historia y política en la música reggae de Jamaica*. Mexico, D.F.: Siglo XXI Editores Mexico

Guadeloupe, Francio. 2009. *Chanting Down the New Jerusalem: Calypso, Christianity and Capitalism in the Caribbean*. Berkeley: University of California Press.

Guilbault, Jocelyne. 2007. *Governing Sound: The Cultural Politics of Trinidad's Carnival Music*. Chicago: University of Chicago Press.

———. 1993. *Zouk: World Music in the West Indies*. Chicago: University of Chicago Press.

Manuel, Peter. 2006 *Caribbean Currents: Caribbean Music From Rumba to Reggae.* Philadelphia: Temple University Press.

Moore, Robin. D. 1997. *Nationalizing Blackness: Afrocubanismo and Artistic Revolution in Havana 1920-1940.* Pittsburg: University of Pittsburg Press.

——. 2006. *Music and Revolution: Cultural Change in Socialist Cuba.* Berkley and Los Angeles: University of California Press.

Pacini Hernandez, Deborah. 1995. *Bachata: A Social History of Dominican Popular Music.* Philadelphia: Temple University Press.

Ramnarine, Tina. 2001. *Creating their own Space: The Development of an Indo-Caribbean Musical Tradition.* Kingston: University of the West Indies Press.

Rivera, Raquel, Wayne Marshall and Deborah Pacini Hernandez, eds. 2009. *Reggaeton.* Durham & London: Duke University Press.

Rohlehr, Gordon. 2004. *A Scuffling of Islands: Essays on Calypso.* San Juan, Trinidad: Lexicon Press.

Steumpfle, Stephen. 1996. *The Steelband Movement: The Forging of a National Art in Trinidad.* Philadelphia: University of Pennsylvania Press.

Veal, Michael. 2007. *Dub: Soundscapes and Shattered Songs in Jamaican Reggae.* Middleton: Wesleyan University Press.

Vaughan, Umi. 2012. *Rebel Dance, Renegade Stance: Timba Music and Black Identity in Cuba.* Ann Arbor: University of Michigan Press.

Further Readings: Caribbean Creative

Critical research and writing on the Caribbean Creative has only developed in the last two decades, and most of the more detailed and important writing can be found within technical reports produced for governments and international agencies. An early analysis of a specific sector can be found in Keith Nurse's "Bringing Culture into Tourism: Festival Tourism and Reggae Sunsplash." *Social and Economic Studies* 51, 1 (2002): 127-143. Also see here Susan Harewood's "Policy and Performance in the Caribbean." *Popular Music* 27, 2 (2008): 209-223, and Suzanne Burke's monograph *Policing the Transnational: Cultural Policy Development in the Anglophone Caribbean 1962-2008* (Germany: Lambert Academic Publishing, 2010). Bruce Paddington has produced a noteworthy study on Caribbean film, "Caribbean Cinema: Cultural Articulations, Historical Formation, and Film Practices." PhD dissertation, University of the West Indies, St Augustine, 2005. The journal *Caribbean Creatives* is perhaps the best place to assess the research within this sub-field, see specifically its issues on The Audiovisual Sector (Vol. 1), The Barbados Creative Economy (Vol. 2), Promoting Caribbean Creative Industries (Vol. 3) and Mapping the Creative Industries (Vol. 4) at [http://creativeindustriesexchange.com/index.php?option=com_content&view=article&id=26&Itemid=57]

CPSIA information can be obtained
at www.ICGtesting.com
Printed in the USA
BVOW07s2138071116

467102BV00022B/5/P

9 789766 376215